2014
PHOTOGRAPHER'S
MARKET®

ArtistsMarketOnline.com

Where & How to Sell What You Create

THE ULTIMATE MARKET RESEARCH TOOL FOR PHOTOGRAPHERS

UPDATED MARKET LISTINGS

EASY-TO-USE SEARCHABLE DATABASE • RECORD-KEEPING TOOLS

INDUSTRY NEWS • PROFESSIONAL TIPS & ADVICE

*Valid through 12/31/14

ArtistsMarketOnline.com
Where & How to Sell What You Create

Activate your FREE ArtistsMarketOnline.com subscription to get instant access to:

- **UPDATED MARKET LISTINGS** — Find additional listings, updated contact information and more. ArtistsMarketOnline.com provides the most comprehensive database of verified markets available anywhere.

- **EASY-TO-USE SEARCHABLE DATABASE** — Looking for a specific magazine or book publisher? Just type in its name or other relevant keywords. Or widen your prospects with the Advanced Search. You can also receive notifications for listings that have been recently updated!

- **PERSONALIZED TOOLS** — Store your best-bet markets, and use our popular record-keeping tools to track your submissions. Plus, get new and updated market listings, query reminders, and more – every time you log in!

- **PROFESSIONAL TIPS & ADVICE** — From pay rate charts to sample query letters, and from how-to articles to Q&As, we have the resources creative freelancers need.

YOU'LL GET ALL OF THIS WITH YOUR FREE SUBSCRIPTION TO

ArtistsMarketOnline.com
Where & How to Sell What You Create

PHOTO14

2014

PHOTOGRAPHER'S MARKET®

Mary Burzlaff Bostic, Editor

NORTH LIGHT BOOKS
CINCINNATI, OHIO

artistsmarketonline.com

Publisher and Community Leader, Fine Art Community: Jamie Markle
Content Director, North Light Books: Mona Clough
Market Books Assistant, North Light Books: Michael Miller

Artist's Market Online website: artistsmarketonline.com
Artist's Network website: artistsnetwork.com
North Light Shop website: northlightshop.com

Other fine North Light Books are available from your local bookstore, art supply store or online supplier. Visit our website at fwmedia.com.

Distributed in Canada by Fraser Direct
100 Armstrong Avenue
Georgetown, ON, Canada L7G 5S4
Tel: (905) 877-4411

Distributed in the U.K. and Europe by F&W Media International, LTD
Brunel House, Forde Close, Newton Abbot, Devon, TQ12 4PU, UK
Tel: (+44) 1626 323200, Fax: (+44) 1626 323319
E-mail: enquiries@fwmedia.com

Distributed in Australia by Capricorn Link
Loder House, 126 George Street
Windsor, NSW 2756 Australia
Tel: (02) 4560-1600, Fax: (02) 4577-5288
E-mail: books@capricornlink.com.au

ISSN: 0147-247X
ISBN-13: 978-1-4403-2942-5
ISBN-10: 1-4403-2942-7

Cover design by Wendy Dunning
Interior layout by Angela Wilcox and Laura Yoder
Interior design by Claudean Wheeler
Production coordinated by Greg Nock

Attention Booksellers: This is an annual directory of F+W Media, Inc. Return deadline for this edition is December 31, 2014.

fw
media

CONTENTS

FROM THE EDITOR..7

BUSINESS BASICS

HOW TO USE THIS BOOK..9

HOW TO START SELLING YOUR WORK.....................................13

RUNNING YOUR BUSINESS...17

 Submitting Your Work...17

 Digital Submission Guidelines...18

 Using Essential Business Forms...21

 Stock List...23

 Charging for Your Work...23

 Figuring Small Business Taxes...29

 Self-Promotion..31

 Organizing & Labeling Your Images.....................................33

 Protecting Your Copyright..34

© Lewis Kemper

ARTICLES & INTERVIEWS

THE BUSINESS MIND-SET
by Ilise Benun ... 38

BUILDING YOUR FINANCIAL TEAM
by Vik Orenstein ... 44

NEGOTIATING FEES AND RIGHTS
by Ric Deliantoni... 50

SOCIAL MEDIA MARKETING 102
Pinterest, LinkedIn and Google+
by Lori McNee ... 54

HOW TO REALLY USE LINKEDIN
Learn How to Maximize This Social Networking Tool's Potential
by Ilise Benun ... 61

E-MAIL MARKETING
Manage E-Mail Lists and Create Professional-Looking Newsletters
by Linda Fisler ... 66

SITES THAT FIND CLIENTS FOR YOU
Stop Selling and Start Marketing
by Mark O'Brien... 71

GIVING GREENLANCING A GO
Make Sustainability a Core Value of Your Business
by Tom N. Tumbusch ... 76

ADDING VIDEO TO YOUR REPERTOIRE
Develop the Skills You Need to Stay Viable
by Ric Deliantoni... 80

ROWLAND EGERTON
From Still Photography to Motion Picture Rigging
by Luke McLaughlin and Neely McLaughlin ... 84

ADAM LADD
HOW Magazine Art Director
by Ric Deliantoni... 92

MATTHEW BRANDT
Secret Ingredients
by Luke McLaughlin... 96

© Stormi Greener

© Rowland Egerton

MARKETS

CONSUMER PUBLICATIONS .. 104

NEWSPAPERS .. 202

TRADE PUBLICATIONS .. 210

BOOK PUBLISHERS .. 250

GREETING CARDS, POSTERS & RELATED PRODUCTS 270

STOCK PHOTO AGENCIES ... 282

ADVERTISING, DESIGN & RELATED MARKETS 342

GALLERIES ... 358

ART FAIRS ... 436

CONTESTS ... 478

PHOTO REPRESENTATIVES ... 490

WORKSHOPS & PHOTO TOURS ... 500

RESOURCES

STOCK PHOTOGRAPHY PORTALS 527

PORTFOLIO REVIEW EVENTS ... 528

GRANTS: STATE, PROVINCIAL & REGIONAL 530

PROFESSIONAL ORGANIZATIONS 538

PUBLICATIONS .. 541

WEBSITES ... 547

GLOSSARY ... 550

INDEXES

GEOGRAPHIC INDEX .. 556

INTERNATIONAL INDEX ... 576

SUBJECT INDEX .. 580

GENERAL INDEX ... 662

Matthew Brandt, *American Lake, WA G4*, 2011
© Matthew Brandt, Courtesy Yossi Milo Gallery, New York

FROM THE EDITOR

Whether you're just starting out or you want to take your photography career to the next level, you need a plan. Here at *Photographer's Market* we pride ourselves on giving photographers the tools they need to achieve their goals, and this year's edition will do just that. The Articles and Interviews section will give you the know-how and inspiration you need to get started, and the 1,500+ market listings provide the contact and submission details you need to sell your work. So sit down, grab a pencil, and start reading—your dreams are within your grasp!

First, get into the nitty-gritty of running your business by reading "The Business Mind-Set." Then work your way through the other articles to learn everything, from how to build your financial team and negotiate fees and rights to mastering the latest social media marketing trends and creating a professional e-newsletter and successful website.

With your business and marketing plans in place, it's time to develop the new skills you need to stay viable and increase the value of your services. Find out how to make sustainability a core value of your business in "Giving Greenlancing a Go," then learn about the equipment and skills you need to develop a videography service in "Adding Video to Your Repertoire."

After all that work, you deserve a healthy dose of inspiration. Read our interviews with Rowland Egerton, who used the lighting skills he learned as a photographer to start a career in motion picture rigging; Adam Ladd, *HOW* magazine's new art director and photo buyer; and Matthew Brandt, who uses "secret" ingredients in his fine art photography.

What are you waiting for? Read on, keep creating and good luck!

Mary Burzlaff Bostic

Mary Burzlaff Bostic
photomarket@fwmedia.com
www.artistsmarketonline.com

P.S. Don't forget to register at **Artist's Market Online, which you get FREE for a year with the purchase of this book**. With your free 1-year subscription, you'll be able to search market contacts, track your submissions, read up on the latest market news, and much more. Use the activation code from the front insert to access your free subscription today.

HOW TO USE THIS BOOK

//

The first thing you'll notice about most of the listings in this book is the group of symbols that appears before the name of each company. Scanning the listings for symbols can help you quickly locate markets that meet certain criteria. (You'll find a quick-reference key to the symbols as well as a sample listing on the back inside cover of the book.) Here's what each symbol stands for:

 ⊕ This photo buyer is new to this edition of the book.

 ⟳ This photo buyer is located in Canada.

 ⦿ This photo buyer is located outside the U.S. and Canada.

 ◉ This photo buyer uses only images created on assignment.

 ⊕ This photo buyer uses only stock images.

COMPLAINT PROCEDURE

If you feel you have not been treated fairly by a company listed in *Photographer's Market*, we advise you to take the following steps:

- First, try to contact the listing. Sometimes one phone call, e-mail, or letter can quickly clear up the matter.
- Document all your correspondence with the listing. If you write to us with a complaint, provide the details of your submission, the date of your first contact with the listing, and the nature of your subsequent correspondence.
- We will enter your letter into our files.
- The number and severity of complaints will be considered in our decision whether to delete the listing from the next edition.

○ This photo buyer accepts submissions in digital format.

✪ This photo buyer uses film or other audiovisual media.

♡ This art fair is a juried event; a juror or committee of jurors views applicants' work and selects those whose work fits within the guidelines of the event.

Pay scale

We asked photo buyers to indicate their general pay scale based on what they typically pay for a single image. Their answers are signified by a series of dollar signs before each listing. Scanning for dollar signs can help you quickly identify which markets pay at the top of the scale. However, not every photo buyer answered this question, so don't mistake a missing dollar sign as an indication of low pay rates. Also keep in mind that many photo buyers are willing to negotiate.

⑤ Pays $1–150

⑤⑤ Pays $151–750

⑤⑤⑤ Pays $751–1,500

⑤⑤⑤⑤ Pays more than $1,500

Openness

We also asked photo buyers to indicate their level of openness to freelance photography. Looking for these symbols can help you identify buyers who are willing to work with newcomers, as well as prestigious buyers who only publish top-notch photography.

○ Encourages beginning or unpublished photographers to submit work for consideration; publishes new photographers. May pay only in copies or have a low pay rate.

◐ Accepts outstanding work from beginning and established photographers; expects a high level of professionalism from all photographers who make contact.

● Hard to break into; publishes mostly previously published photographers.

⊘ May pay at the top of the scale. Closed to unsolicited submissions.

Subheads

Each listing is broken down into sections to make it easier to locate specific information (see sample listing on the back inside cover of this book). In the first section of each listing you'll find mailing addresses, phone numbers, e-mail and website addresses, and the name of the person you should contact. You'll also find general information about photo buyers, including when their business was established and their publishing philosophy. Each listing will include one or more of the following subheads:

Needs. Here you'll find specific subjects each photo buyer is seeking. (Use the subject index at the end of the book to help you narrow your search.) You'll also find the average

FREQUENTLY ASKED QUESTIONS

1 How do companies get listed in the book?

No company pays to be included—all listings are free. Every company has to fill out a detailed questionnaire about their photo needs. All questionnaires are screened to make sure the companies meet our requirements. Each year we contact every company in the book and ask them to update their information.

2 Why aren't other companies I know about listed in this book?

We may have sent these companies a questionnaire, but they never returned it. Or if they did return a questionnaire, we may have decided not to include them based on our requirements.

3 Some publishers say they accept photos with or without a manuscript. What does that mean?

Essentially, the word *manuscript* means a written article that will be published by a magazine. Some magazines will only consider publishing your photos if they accompany a written article. Other publishers will consider publishing your photos alone, without a manuscript.

4 I sent a CD with large digital files to a photo buyer who said she wanted to see my work. I have not heard from her, and I am afraid that my photos will be used without my permission and without payment. What should I do?

Do not send large, printable files (300 dpi or larger) unless you are sure the photo buyer is going to use them, and you know what you will be paid for their usage and what rights the photo buyer is requesting. If a photo buyer shows interest in seeing your work in digital format, send small JPEGs at first so they can "review" them—i.e., determine if the subject matter and technical quality of your photos meet their requirements. Until you know for sure that the photo buyer is going to license your photos and you have some kind of agreement, do not send high-resolution files. The exception to this rule would be if you have dealt with the photo buyer before or perhaps know someone who has. Some companies receive a large volume of submissions, so sometimes you must be patient. It's a good idea to give any company listed in this book a call before you submit anything and be sure nothing has changed since we contacted them to gather or update information. This is true whether you submit slides, prints, or digital images.

5 A company says they want to publish my photographs, but first they will need a fee from me. Is this a standard business practice?

No, it is not a standard business practice. You should never have to pay to have your photos reviewed or to have your photos accepted for publication. If you suspect that a company may not be reputable, do some research before you submit anything or pay their fees. The exception to this rule is contests. It is not unusual for some contests listed in this book to have entry fees (usually minimal—between five and twenty dollars).

number of freelance photos a buyer uses each year, which will help you gauge your chances of publication.

Audiovisual Needs. If you create images for media such as filmstrips or overhead transparencies, or you shoot videotape or motion picture film, look here for photo buyers' specific needs in these areas.

Specs. Look here to see in what format the photo buyer prefers to receive accepted images. Many photo buyers will accept both digital and film (slides, transparencies, prints) formats. However, many photo buyers are reporting that they accept digital images only, so make sure you can provide the format the photo buyer requires before you send samples.

Exhibits. This subhead appears only in the Galleries section of the book. Like the Needs subhead, you'll find information here about the specific subjects and types of photography a gallery shows.

Making Contact & Terms. When you're ready to make contact with a photo buyer, look here to find out exactly what they want to see in your submission. You'll also find what the buyer usually pays and what rights they expect in exchange. In the Stock section, this subhead is divided into two parts, Payment & Terms and Making Contact, because this information is often lengthy and complicated.

Handles. This subhead appears only in the Photo Representatives section. Some reps also represent illustrators, fine artists, stylists, make-up artists, etc., in addition to photographers. The term "handles" refers to the various types of "talent" they represent.

Tips. Look here for advice and information directly from photo buyers in their own words.

HOW TO START SELLING YOUR WORK

If this is your first edition of *Photographer's Market*, you're probably feeling a little overwhelmed by all the information in this book. Before you start flipping through the listings, read the eleven steps below to learn how to get the most out of this book and your selling efforts.

1. Be honest with yourself. Are the photographs you make of the same quality as those you see published in magazines and newspapers? If the answer is yes, you may be able to sell your photos.

2. Get someone else to be honest with you. Do you know a professional photographer who would critique your work for you? Other ways to get opinions about your work: join a local camera club or other photo organization; attend a stock seminar led by a professional photographer; attend a regional or national photo conference or a workshop where they offer daily critiques.

- You'll find workshop and seminar listings in the Markets section.
- You'll find a list of photographic organizations in the Resource section.
- Check your local camera store for information about camera clubs in your area.

3. Get organized. Create a list of subjects you have photographed and organize your images into subject groups. Make sure you can quickly find specific images and keep track of any sample images you send out. You can use database software on your home computer to help you keep track of your images.

Other resources:

- *Photo Portfolio Success* by John Kaplan (Writer's Digest Books)
- *Sell and Re-Sell Your Photos* by Rohn Engh (Writer's Digest Books)

- *The Photographer's Market Guide to Building Your Photography Business* by Vik Orenstein (Writer's Digest Books)

4. Consider the format. Are your pictures color snapshots, black-and-white prints, color slides, or digital captures? The format of your work will determine, in part, which markets you can approach. Below are some general guidelines for where you can market various photo formats. Always check the listings in this book for specific format information.

- **digital**—nearly all newspapers, magazines, stock agencies, ad agencies, book and greeting card publishers
- **black-and-white prints**—some galleries, art fairs, private collectors, literary/art magazines, trade magazines, newspapers, book publishers
- **color prints**—some newsletters, very small trade or club magazines
- **large color prints**—some galleries, art fairs, private collectors
- **color slides (35mm)**—a few magazines, newspapers, some greeting card and calendar publishers, a very few book publishers, textbook publishers, stock agencies
- **color transparencies (2¼×2¼ and 4×5)**—a few magazines, book publishers, calendar publishers, ad agencies, stock agencies. Many of these photo buyers have begun to accept only digital photos, especially stock agencies.

5. Do you want to sell stock images or accept assignments? A stock image is a photograph you create on your own and then sell to a publisher. An assignment is a photograph created at the request of a specific buyer. Many of the listings in *Photographer's Market* are interested in both stock and assignment work.

> 👄 Listings that are only interested in stock photography are marked with this symbol.

> ◎ Listings that are only interested in assignment photography are marked with this symbol.

6. Start researching. Generate a list of the publishers that might buy your images—check the newsstand, go to the library, search the Web, read the listings in this book. Don't forget to look at greeting cards, stationery, calendars, and CD covers. Anything you see with a photograph on it, from a billboard advertisement to a cereal box, is a potential market.

7. Check the publisher's guidelines. Do you know exactly how the publisher you choose wants to be approached? Check the listings in this book first. If you don't know the format, subject, and number of images a publisher wants in a submission, you should check their website first. Often, guidelines are posted there. Or you can send a short letter with a self-addressed, stamped envelope (SASE) or e-mail asking those questions. A quick call to the receptionist might also yield the answers.

8. Check out the market. Get in the habit of reading industry magazines.

9. Prepare yourself. Before you send your first submission, make sure you know how to respond when a publisher agrees to buy your work.

Pay rates

Most magazines and newspapers will tell you what they pay, and you can accept or decline. However, you should become familiar with typical pay rates. Ask other photographers what they charge—preferably ones you know well or who are not in direct competition with you. Many will be willing to tell you to prevent you from devaluing the market by undercharging.

Other resources:

- *Pricing Photography: The Complete Guide to Assignment & Stock Prices* by Michal Heron and David MacTavish (Allworth Press)
- *fotoQuote*, a software package that is updated each year to list typical stock photo and assignment prices, (800)679-0202, www.cradocfotosoftware.com
- *Negotiating Stock Photo Prices* by Jim Pickerell (www.jimpickerell.com)

Copyright

You should always include a copyright notice on any slide, print, or digital image you send out. While you automatically own the copyright to your work the instant it is created, the notice affords extra protection. The proper format for a copyright notice includes the word or symbol for copyright, the date and your name: © 2014 Jane Photographer. To fully protect your copyright and recover damages from infringers, you must register your copyright with the Copyright Office in Washington DC.

Rights

In most cases, you will not actually be selling your photographs, but rather, the rights to publish them. If a publisher wants to buy your images outright, you will lose the right to resell those images in any form or even display them in your portfolio. Most publishers will buy one-time rights and/or first rights.

Other resources:

- *Legal Guide for the Visual Artist* by Tad Crawford (Allworth Press)

Contracts

Formal contract or not, you should always agree to any terms of sale in writing. This could be as simple as sending a follow-up letter restating the agreement and asking for confirmation, once you agree to terms over the phone. You should always keep copies of any correspondence in case of a future dispute or misunderstanding.

Other resources:

- *Business and Legal Forms for Photographers* by Tad Crawford (Allworth Press)

10. Prepare your submission. The number one rule when mailing submissions is: "Follow the directions." Always address letters to specific photo buyers. Always include a SASE of sufficient size and with sufficient postage for your work to be safely returned to you. Never send originals when you are first approaching a potential buyer. Try to include something in your submission that the potential buyer can keep on file, such as a tearsheet and your résumé. In fact, photo buyers prefer that you send something they don't have to return to you. Plus, it saves you the time and expense of preparing a SASE.

Other resources:

- *Photo Portfolio Success* by John Kaplan (Writer's Digest Books)

11. Continue to promote yourself and your work. After you've made that first sale (and even before), it is important to promote yourself. Success in selling your work depends in part on how well and how often you let photo buyers know what you have to offer. This is known as self-promotion. There are several ways to promote yourself and your work. You can send postcards or other printed material through the mail; send an e-mail with an image and a link to your website; and upload your images to a website that is dedicated to showcasing your work and your photographic services.

RUNNING YOUR BUSINESS

Photography is an art that requires a host of skills, some which can be learned and some which are innate. To make money from your photography, the one skill you can't do without is business savvy. Thankfully, this skill can be learned. We'll cover:

- Submitting Your Work
- Digital Submission Guidelines
- Using Essential Business Forms
- Stock List
- Charging for Your Work
- Figuring Small Business Taxes
- Self-Promotion
- Organizing & Labeling Your Images
- Protecting Your Copyright

SUBMITTING YOUR WORK

Editors, art directors, and other photo buyers are busy people. Many spend only 10 percent of their work time actually choosing photographs for publication. The rest of their time is spent making and returning phone calls, arranging shoots, coordinating production, and doing a host of other unglamorous tasks that make publication possible. They want to discover new talent, and you may even have the exact image they're looking for, but if you don't follow a market's submission instructions to the letter, you have little chance of acceptance.

To learn the dos and don'ts of photography submissions, read each market's listing carefully and make sure to send only what they ask for. Don't send prints if they only want slides. Don't send color if they only want black and white. Check their website or send for guidelines

whenever they are available to get the most complete and up-to-date submission advice. When in doubt, follow these ten rules when sending your work to a potential buyer:

1. Don't forget your SASE. Always include a self-addressed, stamped envelope whether you want your submission back or not. Make sure your SASE is big enough, has enough packaging, and has enough postage to ensure the safe return of your work.

2. Don't over-package. Never make a submission difficult to open and file. Don't tape down all the loose corners. Don't send anything too large to fit in a standard file.

3. Don't send originals. Try not to send things you must have back. Never, ever send originals unsolicited.

4. Label everything. Put a label directly on the slide mount or print you are submitting. Include your name, address, and phone number, as well as the name or number of the image. Your slides and prints will almost certainly get separated from your letter.

5. Do your research. Always research the places to which you want to sell your work. Request sample issues of magazines, visit galleries, examine ads, look at websites, etc. Make sure your work is appropriate before you send it out. A blind mailing is a waste of postage and a waste of time for both you and the art buyer.

6. Follow directions. Always request submission guidelines. Include an SASE for reply. Follow *all* the directions exactly, even if you think they're silly.

7. Include a business letter. Always include a cover letter, no more than one page, that lets the potential buyer know you are familiar with their company, what your photography background is (briefly), and where you've sold work before (if it pertains to what you're trying to do now). If you send an e-mail, follow the same protocol as you would for a business cover letter and include the same information.

8. Send to a person, not a title. Send submissions to a specific person at a company. When you address a cover letter to Dear Sir or Madam, it shows you know nothing about the company you want to buy your work.

9. Don't forget to follow through. Follow up major submissions with postcard samples several times a year.

10. Have something to leave behind. If you're lucky enough to score a portfolio review, always have a sample of your work to leave with the art director. Make it small enough to fit in a file but big enough not to get lost. Always include your contact information directly on the leave-behind.

DIGITAL SUBMISSION GUIDELINES

Today, almost every publisher of photographs prefers digital images. Some still accept "analog" images (slides and prints) as well as digital images, but most accept only digital images. There are a few who still do not accept digital images at all, but their number is rapidly decreasing. Follow each buyer's size and format guidelines carefully.

STARTING A BUSINESS ///

To learn more about starting a business:

- Take a course at a local college. Many community colleges offer short-term evening and weekend courses on topics like creating a business plan or finding financial assistance to start a small business.
- Contact the Small Business Administration at (800)827-5722 or check out their website at www.sba.gov. The U.S. Small Business Administration was created by Congress in 1953 to help America's entrepreneurs form successful small enterprises. Today, SBA's program offices in every state offer financing, training, and advocacy for small firms.
- Contact the Small Business Development Center at (202)205-6766. The SBDC offers free or low-cost advice, seminars, and workshops for small business owners.
- Read a book. Try *Commercial Photography Handbook: Business Techniques for Professional Digital Photographers* by Kirk Tuck (Amhearst Media) or *The Business of Studio Photography* by Edward R. Lilley (Allworth Press). The business section of your local library will also have many general books about starting a small business.

Previews

Photo buyers need to see a preview of an image before they can decide if it will fit their needs. In the past, photographers mailed slides or prints to prospective photo buyers so they could review them, determine their quality, and decide whether or not the subject matter was something they could use. Or photographers sent a self-promotion mailer, often a postcard with one or more representative images of their work. Today, preview images can be e-mailed to prospective photo buyers, or they can be viewed on a photographer's website. This eliminates the hassle and expense of sending slides through the mail and wondering if you'll ever get them back.

The important thing about digital preview images is size. They should be no larger than 3×5 inches at 72 dpi. E-mailing larger files to someone who just wants a peek at your work could greatly inconvenience them if they have to wait a long time for the files to open or if their e-mail system cannot handle larger files. If photo buyers are interested in using your photographs, they will definitely want a larger, high-resolution file later, but don't overload their systems and their patience in the beginning with large files. Another option is sending a CD with preview images. This is not as efficient as e-mail or a website since the photo buyer has to put the CD in the computer and view the images one by one. If you send a CD, be sure to include a printout of thumbnail images: If the photo buyer does not have time to put the CD in the computer and view the images, she can at least glance at the printed thumbnails. CDs and DVDs are probably best reserved for high-resolution photos you know the photo buyer wants and has requested from you.

Size & quality

Size and quality might be the two most important aspects of your digital submission. If the quality is not there, photo buyers will not be interested in buying your image regardless of its subject matter. Find out what the photo buyer needs. If you scan your slides or prints, make sure your scanning quality is excellent: no dirt, dust, or scratches. If the file size is too small, they will not be able to do much with it either. A resolution of 72 dpi is fine for previews, but if a photo buyer wants to publish your images, they will want larger, high-resolution files. While each photo buyer may have different needs, there are some general guidelines to follow. Often digital images that are destined for print media need to be 300 dpi and the same size as the final, printed image will be (or preferably a little larger). For example, for a full-page photo in a magazine, the digital file might be 8×10 inches at 300 dpi. However, always check with the photo buyer who will ultimately be publishing the photo. Many magazines, book publishers, and stock photo agencies post digital submission guidelines on their websites or will provide copies to photographers if they ask. Photo buyers are usually happy to inform photographers of their digital guidelines since they don't want to receive images they won't be able to use due to poor quality.

Note: Many of the listings in this book that accept digital images state the dpi they require for final submissions. They may also state the size they need in terms of megabytes (MB). See subhead "Specs" in each listing.

Formats

When you know that a photo buyer is definitely going to use your photos, you will then need to submit a high-resolution digital file (as opposed to the low-resolution 72 dpi JPEGs used for previews). Photo buyers often ask for digital images to be saved as JPEGs or TIFFs. Again, make sure you know what format they prefer. Some photo buyers will want you to send them a CD or DVD with the high-resolution images saved on it. Most photo buyers appreciate having a printout of thumbnail images to review in addition to the CD. Some may allow you to e-mail images directly to them, but keep in mind that anything larger than 9 megabytes is usually too large to e-mail. Get the permission of the photo buyer before you attempt to send anything that large via e-mail.

Another option is FTP (file transfer protocol). It allows files to be transferred over the Internet from one computer to another. This option is becoming more prevalent.

Note: Most of the listings in this book that accept digital images state the format they require for final digital submissions. See subhead "Specs" in each listing.

Color space

Another thing you'll need to find out from the photo buyer is what color space they want photos to be saved in. RGB (red, green, blue) is a very common one. You might also encounter

CMYK (cyan, magenta, yellow, black). Grayscale is for photos that will be printed without any color (black and white). Again, check with the photo buyer to find out what color space they require.

USING ESSENTIAL BUSINESS FORMS

Using carefully crafted business forms will not only make you look more professional in the eyes of your clients, it will make bills easier to collect while protecting your copyright. Forms from delivery memos to invoices can be created on a home computer with minimal design skills and printed in duplicate at most quick-print centers. When producing detailed contracts, remember that proper wording is imperative. You want to protect your copyright and, at the same time, be fair to clients. Therefore, it's a good idea to have a lawyer examine your forms before using them.

The following forms are useful when selling stock photography, as well as when shooting on assignment:

Delivery memo

This document should be mailed to potential clients along with a cover letter when any submission is made. A delivery memo provides an accurate count of the images that are enclosed, and it provides rules for usage. The front of the form should include a description of the images or assignment, the kind of media in which the images can be used, the price for such usage, and the terms and conditions of paying for that usage. Ask clients to sign and return a copy of this form if they agree to the terms you've spelled out.

FORMS FOR PHOTOGRAPHERS

Where to learn more about forms for photographers:
- Editorial Photographers (EP), www.editorialphoto.com
- *Business and Legal Forms for Photographers* by Tad Crawford (Allworth Press)
- *Legal Guide for the Visual Artist* by Tad Crawford (Allworth Press)
- *ASMP Professional Business Practices in Photography* (Allworth Press)
- The American Society of Media Photographers offers traveling business seminars that cover issues from forms to pricing to collecting unpaid bills. Write to them at 14 Washington Rd., Suite 502, Princeton Junction NJ 08550, for a schedule of upcoming business seminars, or visit www.asmp.org.
- The Volunteer Lawyers for the Arts, 1 E. 53rd St., 6th Floor, New York NY 10022, (212)319-2910. The VLA is a nonprofit organization, based in New York City, dedicated to providing all artists, including photographers, with sound legal advice.

PROPERTY RELEASE

In consideration of $_____ and/or _____, receipt of which is acknowledged, I being the legal owner of or having the right to permit the taking and use of photographs of certain property designated as _____, do hereby give _____, his/her assigns, licensees, and legal representatives the irrevocable right to use this image in all forms and media and in all manners, including composite or distorted representations, for advertising, trade, or any other lawful purposes, and I waive any rights to inspect or approve the finished product, including written copy that may be created in connection therewith.

Short description of photographs: _____

Additional information: _____

I am of full age. I have read this release and fully understand its contents.

Please Print:

Name _____

Address _____

City _____ State _____ Zip Code _____

Sample property release

Terms & conditions

This form often appears on the back of the delivery memo, but be aware that conditions on the front of a form have more legal weight than those on the back. Your terms and conditions should outline in detail all aspects of usage for an assignment or stock image. Include copyright information, client liability, and a sales agreement. Also, be sure to include conditions covering the alteration of your images, the transfer of rights, and digital storage. The more specific your terms and conditions are to the individual client, the more legally binding they will be. If you create your forms on your computer, seriously consider altering your standard contract to suit each assignment or other photography sale.

Invoice

This is the form you want to send more than any of the others, because mailing it means you have made a sale. The invoice should provide clients with your mailing address, an explanation of usage, and the amount due. Be sure to include a reasonable due date for payment, usually thirty days. You should also include your business tax identification number or Social Security number.

Model/property releases

Get into the habit of obtaining releases from anyone you photograph. They increase the sales potential for images and can protect you from liability. A model release is a short form, signed by the person(s) in a photo, that allows you to sell the image for commercial purposes. The property release does the same thing for photos of personal property. When photographing children, remember that a parent or guardian must sign before the release is legally binding. In exchange for signed releases, some photographers give their subjects copies of the photos; others pay the models. You may choose the system that works best for you, but keep in mind that a legally binding contract must involve consideration, the exchange of something of value. Once you obtain a release, keep it in a permanent file.

You do not need a release if the image is being sold editorially. However, magazines now require such forms in order to protect themselves, especially when an image is used as a photo illustration instead of as a straight documentary shot. You always need a release for advertising purposes or for purposes of trade and promotion. In works of art, you only need a release if the subject is recognizable. When traveling in a foreign country, it is a good idea to carry releases written in that country's language. To translate releases into a foreign language, check with an embassy or a college language professor.

STOCK LIST

Some market listings in this book ask for a stock list, so it is a good idea to have one on hand. Your stock list should be as detailed and specific as possible. Include all the subjects you have in your photo files, breaking them into logical categories and subcategories.

CHARGING FOR YOUR WORK

No matter how many books you read about what photos are worth and how much you should charge, no one can set your fees for you. If you let someone try, you'll be setting yourself up for financial ruin. Figuring out what to charge for your work is a complex task that will require a lot of time and effort. But the more time you spend finding out how much you need to charge, the more successful you'll be at targeting your work to the right markets and getting the money you need to keep your business, and your life, going.

MODEL RELEASE

In consideration of $ _____ and/or _____, receipt of which is acknowledged, I, _____, do hereby give _____, his/her assigns, licensees, and legal representatives the irrevocable right to use my image in all forms and media and in all manners, including composite or distorted representations, for advertising, trade, or any other lawful purposes, and I waive any rights to inspect or approve the finished product, including written copy that may be created in connection therewith. The following name may be used in reference to these photographs:

My real name, or _____

Short description of photographs: _____

Additional information: _____

Please print:

Name _____

Address _____

City _____ State _____ Zip code _____

Country _____

CONSENT

(If model is under the age of 18) I am the parent or guardian of the minor named above and have the legal authority to execute the above release. I approve the foregoing and waive any rights in the premises.

Please print:

Name _____

Address _____

City _____ State _____ Zip code _____

Country _____

Signature _____

Witness _____ Date _____

Sample model release

STOCK LIST

INSECTS
Ants
Aphids
Bees
Beetles
Butterflies
Grasshoppers
Moths
Termites
Wasps

PROFESSIONS
Bee Keeper
Biologist
Firefighter
Nurse
Police Officer
Truck Driver
Waitress
Welder

LANDMARKS
Asia
Angkor Wat
Great Wall of China

Europe
Big Ben
Eiffel Tower
Louvre
Stonehenge

United States
Empire State Building
Grand Canyon
Liberty Bell
Mt. Rushmore
Statue of Liberty

TRANSPORTATION
Airplanes and helicopters
Roads
Country roads
Dirt roads
Interstate highways
Two-lane highways

WEATHER
Clouds
Cumulus
Cirrus
Nimbus
Stratus
Flooding
Lightning
Snow and Blizzards
Storm Chasers
Rainbows
Tornadoes
Tornado Damage

Sample stock list

Keep in mind that what you charge for an image may be completely different from what a photographer down the street charges. There is nothing wrong with this if you've calculated your prices carefully. Perhaps the photographer works in a basement on old equipment and you have a brand new, state-of-the-art studio. You'd better be charging more. Why the disparity? For one thing, you've got a much higher overhead, the continuing costs of running your business. You're also probably delivering a higher-quality product and are more able to meet client requests quickly. So how do you determine just how much you need to charge in order to make ends meet?

Setting your break-even rate

All photographers, before negotiating assignments, should consider their break-even rate—the amount of money they need to make in order to keep their studios open. To arrive at the actual price you'll quote to a client, you should add onto your base rate things like usage, your experience, how quickly you can deliver the image, and what kind of prices the market will bear.

Start by estimating your business expenses. These expenses may include rent (office, studio), gas and electric, insurance (equipment), phone, fax, Internet service, office supplies, postage, stationery, self-promotions/portfolio, photo equipment, computer, staff salaries and taxes. Expenses like film and processing will be charged to your clients.

Next, figure your personal expenses, which will include food, clothing, medical, car and home insurance, gas, repairs and other car expenses, entertainment, and retirement savings and investments, etc.

PRICING INFORMATION

Where to find more information about pricing:

- *Pricing Photography: The Complete Guide to Assignment and Stock Prices* by Michal Heron and David MacTavish (Allworth Press)
- *ASMP Professional Business Practices in Photography* (Allworth Press)
- fotoQuote, a software package produced by the Cradoc Corporation, is a customizable, annually updated database of stock photo prices for markets from ad agencies to calendar companies. The software also includes negotiating advice and scripted telephone conversations. Call (800)679-0202, or visit www.cradocfotosoftware.com for ordering information.
- Stock Photo Price Calculator, a website that suggests fees for advertising, corporate and editorial stock, photographersindex.com/stockprice.htm.
- Editorial Photographers (EP), www.editorialphoto.com.

Before you divide your annual expenses by the 365 days in the year, remember you won't be shooting billable assignments every day. A better way to calculate your base fee is by billable weeks. Assume that at least one day a week is going to be spent conducting office business and marketing your work. This amounts to approximately ten weeks. Add in days for vacation and sick time, perhaps three weeks, and add another week for workshops and seminars. This totals fourteen weeks of non-billable time and thirty-eight billable weeks throughout the year.

Now estimate the number of assignments/sales you expect to complete each week and multiply that number by 38. This will give you a total for your yearly assignments/sales. Finally, divide the total overhead and administrative expenses by the total number of assignments. This will give you an average price per assignment, your break-even or base rate.

As an example, let's say your expenses come to $65,000 per year (this includes $35,000 of personal expenses). If you complete two assignments each week for thirty-eight weeks, your average price per assignment must be about $855. This is what you should charge to break even on each job. But, don't forget, you want to make money.

Establishing usage fees

Too often, photographers shortchange themselves in negotiations because they do not understand how the images in question will be used. Instead, they allow clients to set prices and prefer to accept lower fees rather than lose sales. Unfortunately, those photographers who shortchange themselves are actually bringing down prices throughout the industry. Clients realize if they shop around they can find photographers willing to shoot assignments at very low rates.

There are ways to combat low prices, however. First, educate yourself about a client's line of work. This type of professionalism helps during negotiations because it shows buyers that you are serious about your work. The added knowledge also gives you an advantage when negotiating fees because photographers are not expected to understand a client's profession.

For example, if most of your clients are in the advertising field, acquire advertising rate cards for magazines so you know what a client pays for ad space. You can also find print ad rates in the *Standard Rate and Data Service* directory at the library. Knowing what a client is willing to pay for ad space and considering the importance of your image to the ad will give you a better idea of what the image is really worth to the client.

For editorial assignments, fees may be more difficult to negotiate because most magazines have set page rates. They may make exceptions, however, if you have experience or if the assignment is particularly difficult or time-consuming. If a magazine's page rate is still too low to meet your break-even price, consider asking for extra tearsheets and copies of the issue in which your work appears. These pieces can be used in your portfolio and as

mailers, and the savings they represent in printing costs may make up for the discrepancy between the page rate and your break-even price.

There are still more ways to negotiate sales. Some clients, such as gift and paper product manufacturers, prefer to pay royalties each time a product is sold. Special markets, such as galleries and stock agencies, typically charge photographers a commission of 20 to 50 percent for displaying or representing their images. In these markets, payment on sales comes from the purchase of prints by gallery patrons, or from fees on the "rental" of photos by clients of stock agencies. Pricing formulas should be developed by looking at your costs and the current price levels in those markets, as well as on the basis of submission fees, commissions, and other administrative costs charged to you.

Bidding for jobs

As you build your business, you will likely encounter another aspect of pricing and negotiating that can be very difficult. Like it or not, clients often ask photographers to supply bids for jobs. In some cases, the bidding process is merely procedural and the assignment will go to the photographer who can best complete it. In other instances, the photographer who submits the lowest bid will earn the job. When asked to submit a bid, it is imperative that you find out which bidding process is being used. Putting together an accurate estimate takes time, and you do not want to waste your efforts if your bid is being sought merely to meet some budget quota.

If you decide to bid on a job, it's important to consider your costs carefully. You do not want to bid too much on projects and repeatedly get turned down, but you also don't want to bid too low and forfeit income. When a potential client calls to ask for a bid, consider these dos and don'ts:

1. Always keep a list of questions by the telephone so you can refer to it when bids are requested. The answers to the questions should give you a solid understanding of the project and help you reach a price estimate.
2. Never quote a price during the initial conversation, even if the caller pushes for a "ballpark figure." An on-the-spot estimate can only hurt you in the negotiating process.
3. Immediately find out what the client intends to do with the photos, and ask who will own copyrights to the images after they are produced. It is important to note that many clients believe if they hire you for a job they'll own all the rights to the images you create. If they insist on buying all rights, make sure the price they pay is worth the complete loss of the images.
4. If it is an annual project, ask who completed the job last time, then contact that photographer to see what he charged.

5. Find out who you are bidding against and contact those people to make sure you received the same information about the job. While agreeing to charge the same price is illegal, sharing information about reaching a price is not.

6. Talk to photographers not bidding on the project and ask them what they would charge.

7. Finally, consider all aspects of the shoot, including preparation time, fees for assistants and stylists, rental equipment, and other materials costs. Don't leave anything out.

FIGURING SMALL BUSINESS TAXES

Whether you make occasional sales from your work or you derive your entire income from your photography skills, it's a good idea to consult with a tax professional. If you are just starting out, an accountant can give you solid advice about organizing your financial records. If you are an established professional, an accountant can double-check your system and maybe find a few extra deductions. When consulting with a tax professional, it is best to see someone who is familiar with the needs and concerns of small business people, particularly photographers. You can also conduct your own tax research by contacting the Internal Revenue Service.

Self-employment tax

As a freelancer it's important to be aware of tax rates on self-employment income. All income you receive over $400 without taxes being taken out by an employer qualifies as self-

TAX INFORMATION

To learn more about taxes, contact the IRS. There are free booklets available that provide specific information, such as allowable deductions and tax rate structure:

- Tax Guide for Small Business, 334
- Travel, Entertainment, Gift, and Car Expenses, 463
- Tax Withholding and Estimated Tax, 505
- Business Expenses, 535
- Accounting Periods and Methods, 538
- Business Use of Your Home, 587

To order any of these booklets, phone the IRS at (800)829-3676. IRS forms and publications, as well as answers to questions and links to help, are available on the Internet at www.irs.gov.

employment income. Normally, when you are employed by someone else, the employer shares responsibility for the taxes due. However, when you are self-employed, you must pay the entire amount yourself.

Freelancers frequently overlook self-employment taxes and fail to set aside a sufficient amount of money. They also tend to forget state and local taxes. If the volume of your photo sales reaches a point where it becomes a substantial percentage of your income, then you are required to pay estimated tax on a quarterly basis. This requires you to project the amount of money you expect to generate in a three-month period. However burdensome this may be in the short run, it works to your advantage in that you plan for and stay current with the various taxes you are required to pay. Read IRS Publication 505 (Tax Withholding and Estimated Tax).

Deductions

Many deductions can be claimed by self-employed photographers. It's in your best interest to be aware of them. Examples of 100-percent-deductible claims include production costs of résumé, business cards and brochures; photographer's rep commissions; membership dues; costs of purchasing portfolio materials; education/business-related magazines and books; insurance; and legal and professional services.

Additional deductions can be taken if your office or studio is home-based. The catch here is that your work area must be used only on a professional basis; your office can't double as a family room after hours. The IRS also wants to see evidence that you use the work space on a regular basis via established business hours and proof that you've actively marketed your work. If you can satisfy these criteria, then a percentage of mortgage interests, real estate taxes, rent, maintenance costs, utilities, and homeowner's insurance, plus office furniture and equipment, can be claimed on your tax form at year's end.

In the past, to qualify for a home-office deduction, the space you worked in had to be "the most important, consequential, or influential location" you used to conduct your business. This meant that if you had a separate studio location for shooting but did scheduling, billing and record keeping in your home office, you could not claim a deduction. However, as of 1999, your home office will qualify for a deduction if you "use it exclusively and regularly for administrative or management activities of your trade or business and you have no other fixed location where you conduct substantial administrative or management activities of your trade or business." Read IRS Publication 587 (Business Use of Your Home) for more details.

If you are working out of your home, keep separate records and bank accounts for personal and business finances, as well as a separate business phone. Since the IRS can audit tax records as far back as seven years, it's vital to keep all paperwork related to your business. This includes invoices, vouchers, expenditures and sales receipts, canceled checks, deposit

slips, register tapes, and business ledger entries for this period. The burden of proof will be on you if the IRS questions any deductions claimed. To maintain professional status in the eyes of the IRS, you will need to show a profit for three years out of a five-year period.

Sales tax

Sales taxes are complicated and need special consideration. For instance, if you work in more than one state, use models or work with reps in one or more states, or work in one state and store equipment in another, you may be required to pay sales tax in each of the states that apply. In particular, if you work with an out-of-state stock photo agency that has clients over a wide geographic area, you should explore your tax liability with a tax professional.

As with all taxes, sales taxes must be reported and paid on a timely basis to avoid audits and/or penalties. In regard to sales tax, you should:

- Always register your business at the tax offices with jurisdiction in your city and state.
- Always charge and collect sales tax on the full amount of the invoice, unless an exemption applies.
- If an exemption applies because of resale, you must provide a copy of the customer's resale certificate. If an exemption applies because of other conditions, such as selling one-time reproduction rights or working for a tax-exempt, nonprofit organization, you must also provide documentation.

SELF-PROMOTION

There are basically three ways to acquaint photo buyers with your work: through the mail, over the Internet, or in person. No one way is better or more effective than another. They each serve an individual function and should be used in concert to increase your visibility and, with a little luck, your sales.

IDEAS FOR GREAT SELF-PROMOTION

Where to find ideas for great self-promotion:
- *HOW* magazine's self-promotion annual (October issue)
- *Photo District News,* magazine's self-promotion issue (October issue)
- *The Photographer's Guide to Marketing & Self-Promotion* by Maria Piscopo (Allworth Press)
- *The Business of Photography: Principles and Practices* by Mary Virginia Swanson, available at www.mvswanson.com

Self-promotion mailers

When you are just starting to get your name out there and want to begin generating assignments and stock sales, it's time to design a self-promotion campaign. This is your chance to do your best, most creative work and package it in an unforgettable way to get the attention of busy photo buyers. Self-promotions traditionally are sample images printed on card stock and sent through the mail to potential clients. If the image you choose is strong and you carefully target your mailing, a traditional self-promotion can work.

But don't be afraid to go out on a limb here. You want to show just how amazing and creative you are, and you want the photo buyer to hang onto your sample for as long as possible. Why not make it impossible to throw away? Instead of a simple postcard, maybe you could send a small, usable notepad with one of your images at the top, or a calendar the photo buyer can hang up and use all year. If you target your mailing carefully, this kind of special promotion needn't be expensive.

If you're worried that a single image can't do justice to your unique style, you have two options. One way to get multiple images in front of photo buyers without sending an overwhelming package is to design a campaign of promotions that builds from a single image to a small group of related photos. Make the images tell a story and indicate that there are more to follow. If you are computer savvy, the other way to showcase a sampling of your work is to point photo buyers to an online portfolio of your best work. Send a single sample that includes your Internet address, and ask buyers to take a look.

Websites

Websites are steadily becoming more important in the photographer's self-promotion repertory. If you have a good collection of digital photographs—whether they have been scanned from film or are from a digital camera—you should consider creating a website to showcase samples of your work, provide information about the type of work you do, and display your contact information. The website does not have to be elaborate or contain every photograph you've ever taken. In fact, it is best if you edit your work very carefully and choose only the best images to display on your website. The benefit of having a website is that it makes it so easy for photo buyers to see your work. You can send e-mails to targeted photo buyers and include a link to your website. Many photo buyers report that this is how they prefer to be contacted. Of course, your URL should also be included on any print materials, such as postcards, brochures, business cards, and stationery. Some photographers even include their URL in their credit line.

Portfolio presentations

Once you've actually made contact with potential buyers and piqued their interest, they'll want to see a larger selection of your work—your portfolio. Once again, there's more than

one way to get this sampling of images in front of buyers. Portfolios can be digital—stored on a disk or CD-ROM, or posted on the Internet. They can take the form of a large box or binder and require a special visit and presentation by you. Or they can come in a small binder and be sent through the mail. Whichever ways you choose to showcase your best work, you should always have more than one portfolio, and each should be customized for potential clients.

Keep in mind that your portfolios should contain your best work (dupes only). Never put originals in anything that will be out of your hands for more than a few minutes. Also, don't include more than twenty images. If you try to show too many pieces you'll overwhelm the buyer, and any image that is less than your best will detract from the impact of your strongest work. Finally, be sure to show only work a buyer is likely to use. It won't do any good to show a shoe manufacturer your shots of farm animals or a clothing company your food pictures. For more detailed information on the various types of portfolios and how to select which photos to include and which ones to leave out, see *Photo Portfolio Success*, by John Kaplan (Writer's Digest Books).

Do you need a résumé?

Some of the listings in this book say to submit a résumé with samples. If you are a free-lancer, a résumé may not always be necessary. Sometimes a stock list or a list of your clients may suffice, and may be all the photo buyer is really looking for. If you do include a résumé, limit the details to your photographic experience and credits. If you are applying for a position teaching photography or for a full-time photography position at a studio, corporation, newspaper, etc., you will need the résumé. Galleries that want to show your work may also want to see a résumé, but, again, confine the details of your life to significant photographic achievements.

ORGANIZING & LABELING YOUR IMAGES

It will be very difficult for you to make sales of your work if you aren't able to locate a particular image in your files when a buyer needs it. It is imperative that you find a way to organize your images—a way that can adapt to a growing file of images. There are probably as many ways to catalog photographs as there are photographers. However, most photogra-

IMAGE ORGANIZATION & STORAGE

To learn more about selecting, organizing, labeling and storing images, see:
- *Photo Portfolio Success* by John Kaplan (Writer's Digest Books)
- *Sell & Re-Sell Your Photos* by Rohn Engh, 5th edition (Writer's Digest Books)

phers begin by placing their photographs into large, general categories such as landscapes, wildlife, countries, cities, etc. They then break these down further into subcategories. If you specialize in a particular subject—birds, for instance—you may want to break the bird category down further into cardinal, eagle, robin, osprey, etc. Find a coding system that works for your particular set of photographs. For example, nature and travel photographer William Manning says, "I might have slide pages for Washington, DC (WDC), Kentucky (KY), or Italy (ITY). I divide my mammal subcategory into African wildlife (AWL), North American wildlife (NAW), zoo animals (ZOO)."

After you figure out a coding system that works for you, find a method for naming your digital files or captioning your slides. Images with complete information often prompt sales: Photo editors appreciate having as much information as possible. Always remember to include your name and the copyright symbol © on each image. If you're working with slides, computer software can make this job a lot easier. Programs such as Caption Writer (www.hindsightltd.com), allow photographers to easily create and print labels for their slides.

The computer also makes managing your photo files much easier. Programs such as fotoBiz (www.cradocfotosoftware.com) and StockView (www.hindsightltd.com) are popular with freelance assignment and stock photographers. FotoBiz has an image log and is capable of creating labels. It can also track your images and allows you to create documents such as delivery memos and invoices. StockView also tracks your images, has labeling options, and can create business documents.

PROTECTING YOUR COPYRIGHT

There is one major misconception about copyright: Many photographers don't realize that once you create a photo it becomes yours. You (or your heirs) own the copyright, regardless of whether you register it for the duration of your lifetime plus seventy years.

The fact that an image is automatically copyrighted does not mean that it shouldn't be registered. Quite the contrary. You cannot even file a copyright infringement suit until you've registered your work. Also, without timely registration of your images, you can only recover actual damages—money lost as a result of sales by the infringer plus any profits the infringer earned. For example, recovering $2,000 for an ad sale can be minimal when weighed against the expense of hiring a copyright attorney. Often this deters photographers from filing lawsuits if they haven't registered their work. They know that the attorney's fees will be more than the actual damages recovered, and, therefore, infringers go unpunished.

Registration allows you to recover certain damages to which you otherwise would not be legally entitled. For instance, attorney fees and court costs can be recovered. So too can statutory damages—awards based on how deliberate and harmful the infringement was.

PROTECTING YOUR COPYRIGHT

How to learn more about protecting your copyright:

- Call the United States Copyright Office at (202)707-3000 or check out their website, www.copyright.gov, for answers to frequently asked questions.
- American Society of Media Photographers (ASMP), www.asmp.org/ tutorials/copyright-overview.html
- Editorial Photographers (EP), www.editorialphoto.com
- *Legal Guide for the Visual Artist* by Tad Crawford, Allworth Press
- Society of Photographers and Artists Representatives (SPAR), www.spar.org

Statutory damages can run as high as $100,000. These are the fees that make registration so important.

In order to recover these fees, there are rules regarding registration that you must follow. The rules have to do with the timeliness of your registration in relation to the infringement:

- **Unpublished images** must be registered before the infringement takes place.
- **Published images** must be registered within three months of the first date of publication or before the infringement began.

The process of registering your work is simple. Visit the United States Copyright Office's website at www.copyright.gov to file electronically. Registration costs $35, but you can register photographs in large quantities for that fee. For bulk registration, your images must be organized under one title, for example, "The works of John Photographer, 2011–2014." It's still possible to register with paper forms, but this method requires a higher filing fee ($65). To request paper forms, contact the Library of Congress, Copyright Office-COPUBS, 101 Independence Avenue, SE, Washington, DC 20559-6304, (202) 707-9100, and ask for Form VA (works of visual art).

The copyright notice

Another way to protect your copyright is to mark each image with a copyright notice. This informs everyone reviewing your work that you own the copyright. It may seem basic, but in court this can be very important. In a lawsuit, one avenue of defense for an infringer is "innocent infringement"—basically the "I didn't know" argument. By placing a copyright notice on your images, you negate this defense for an infringer.

The copyright notice basically consists of three elements: the symbol, the year of first publication, and the copyright holder's name. Here's an example of a copyright notice for an image published in 2014: © 2014 John Q. Photographer. Instead of the symbol ©, you can use the word "Copyright" or simply "Copr." However, most foreign countries prefer © as a common designation.

Also consider adding the notation "All rights reserved" after your copyright notice. This phrase is not necessary in the U.S. since all rights are automatically reserved, but it is recommended in other parts of the world.

Know your rights

The digital era is making copyright protection more difficult. As this technology grows, more and more clients will want digital versions of your photos. Don't be alarmed, just be careful. Your clients don't want to steal your work. When you negotiate the usage of your work, consider adding a phrase to your contract that limits the rights of buyers who want digital versions of your photos. You might want them to guarantee that images will be removed from their computer files once the work appears in print. You might say it's okay to perform limited digital manipulation, and then specify what can be done. The important thing is to discuss what the client intends to do and spell it out in writing.

It's essential not only to know your rights under the Copyright Law, but also to make sure that every photo buyer you deal with understands them. The following list of typical image rights should help you in your dealings with clients:

- **One-time rights.** These photos are "leased" or "licensed" on a one-time basis; one fee is paid for one use.
- **First rights.** This is generally the same as purchase of one-time rights, though the photo buyer is paying a bit more for the privilege of being the first to use the image. He may use it only once unless other rights are negotiated.
- **Serial rights.** The photographer has sold the right to use the photo in a periodical. This shouldn't be confused with using the photo in "installments." Most magazines will want to be sure the photo won't be running in a competing publication.
- **Exclusive rights.** Exclusive rights guarantee the buyer's exclusive right to use the photo in his particular market or for a particular product. A greeting card company, for example, may purchase these rights to an image with the stipulation that it not be sold to a competing company for a certain time period. The photographer, however, may retain rights to sell the image to other markets. Conditions should always be put in writing to avoid any misunderstandings.
- **Electronic rights.** These rights allow a buyer to place your work on electronic media such as CD-ROMs or websites. Often these rights are requested with print rights.
- **Promotion rights.** Such rights allow a publisher to use a photo for promotion of a publication in which the photo appears. The photographer should be paid for promotional use in addition to the rights first sold to reproduce the image. Another form of this—agency promotion rights—is common among stock photo agencies. Likewise, the terms of this need to be negotiated separately.

- **Work for hire.** Under the Copyright Act of 1976, section 101, a "work for hire" is defined as: "(1) a work prepared by an employee within the scope of his or her employment; or (2) a work … specially ordered or commissioned for use as a contribution to a collective, as part of a motion picture or audiovisual work or as a supplementary work . . . if the parties expressly agree in a written instrument signed by them that the work shall be considered a work made for hire."
- **All rights.** This involves selling or assigning all rights to a photo for a specified period of time. This differs from work for hire, which always means the photographer permanently surrenders all rights to a photo and any claims to royalties or other future compensation. Terms for all rights—including time period of usage and compensation—should only be negotiated and confirmed in a written agreement with the client.

It is understandable for a client not to want a photo to appear in a competitor's ad. Skillful negotiation usually can result in an agreement between the photographer and the client that says the images will not be sold to a competitor, but could be sold to other industries, possibly offering regional exclusivity for a stated time period.

THE BUSINESS MIND-SET

by Ilise Benun

"You get what you demand, not necessarily what you deserve."

— *Mikelann Valterra, Certified Financial Recovery Coach and author*

Can you make a successful living doing what you love?

Yes, you can—but only if you decide to take it seriously and treat it like a business.

Let's start by looking back. When you started your career, was money even in the equation, and how so? Was it love of the craft and creative expression that drove you? Did you assume money would take care of itself or you would figure it out eventually?

Most people who go into business do so because they want, first and foremost, to be a business owner. That's not usually the case with creative professionals. You see yourself as a creative first, and you love the creative work. You're in business, whether as a freelancer or running a larger entity, by accident rather than by design. You may have jumped or perhaps were pushed. If you're lucky, with a combination of talent and excellent timing, you have ridden a wave of "success." If you aren't so lucky, it's been a struggle, but you're still

Ilise Benun, founder of Marketing Mentor and co-producer of the Creative Freelancer Conference (www.creativefreelancerconference.com), works with creative freelancers who are serious about building healthy businesses. Sign up for her Quick Tips at www.marketing-mentortips.com.

here. Either way, there are aspects of the business that are not your favorite, and dealing with money is probably one of them.

Self-employment offers an opportunity to take control of so many aspects of your life, to become less dependent on one entity to provide everything for you. Being your own boss—whether you choose to be a solopreneur or run a firm of any size—allows you to take on that responsibility, in essence that freedom.

And yet, so few self-employed people are actually in control of their business. This does not come naturally to many creative professionals, nor is it taught in art school. And there is a lot to learn—especially about money—if you want to have a profitable and healthy enterprise with high-quality clients, interesting projects and a strong foundation that doesn't collapse the moment the economy shifts.

SEE YOURSELF AS A BUSINESS

Many creative professionals hang out their shingles or open their doors for business, then proceed to wait and hope: hoping clients will find them, hoping they'll get enough work, hoping the client will pay the bill, hoping the checks add up at the end of the month so all the bills get paid. If you think about it, it's a very passive position, taking what comes along instead of deciding what you want and pursuing it.

There is an alternative, and it is within your reach. You can replace the passive mind-set with planning and action. The first step is to re-envision yourself as a business. But what exactly does that mean?

At the core, it's a shift in the way you see yourself, a small shift that can affect every little detail about how you do your work and especially how far you go.

Understand the Difference Between Spending and Investing

Whether you realize it or not, your personal perspective on money affects your decision-making process in business and, therefore, your ultimate success. In fact, if you have had no training in finances or business, it can be the difference between a prosperous and a struggling business.

One essential concept to understand is the difference between spending and investing. When you, as an individual, buy something, you are spending money. The more you spend, the less you have. Even if you spend your personal money as an investment—in your comfort, your happiness or your children's education—the goal isn't a tangible "return" on that investment, as it is in business.

When a business spends money—this includes your business—there is an expected return. When purchases are made with the express intention of making more money, the price paid is not as important as the return on the investment (ROI). Ideally, the greater the investment, the greater the potential return on investment.

This difference between spending and investing is also important when you make financial decisions for your business. Whatever your business decides to purchase should have a benefit (return) that outweighs its cost. For example, upgrades in computers or software should pay back more than their cost by enabling faster workflow, or by allowing you to attract enough new clients to more than pay for itself. Or, if you decide to invest between $5,000 and $10,000 to exhibit at a trade show, you should be able to project the potential return on that investment before deciding whether to do it.

Remembering the difference between spending and investing will also help when it comes to pricing your services. Your prices, whether high or low, are for services designed to help your clients achieve their goals, to get a return on their investment—by expanding their organization, enhancing their brand or increasing their sales. That means your price may not be the deal-breaker you imagine. Often it is only one of many factors in their decision-making process. You must be able to confidently make the argument that a greater investment (i.e., a higher price) can provide a greater return. When you have adopted a business mind-set, you will.

Be Objective About Your Work

Taking your business seriously also means being as objective as possible. But as a creative, your work is more than a "job." You are probably emotionally attached to the work you do. You may even pour your heart and soul into it.

This can present a problem. According to Jon Weiman, designer and adjunct professor at Pratt Institute, "Creative professionals have trouble because they tie their ego and self-worth to the work in a way that is not businesslike. It becomes too personal."

Know There Is No Absolute Value to Your Work

Many creatives complain about working with clients who don't value their work. But the problem isn't the clients or the work. You can't force a client to value your work the way you do. You can only seek, and hopefully find, the clients who do value what you do. But that requires time and effort. They don't always come knocking unbidden on your door.

There is much hand-wringing around the idea of getting "what you're worth" or "what you deserve." In fact, there is nothing objective about it. Value itself is both subjective and subject to change. What has value to you may have less or more value to a client. And what has value to one client today may have more or less value tomorrow because of any number of factors, including a shift in their priorities, in the economy and in what they perceive to be their options—most of this you don't control or even know about.

With a business mind-set, you are aware of this subjectivity and fluidity. You learn about your prospect or client, you come to an agreement on price and you do your best work. When you make a mistake, you learn from it for the next time.

Get Out of the Financial Fog

What? You're not a "numbers person"? Your head goes fuzzy when someone starts talking numbers? All the intelligence you exhibit in other areas of your life seems to evaporate? Somehow you can no longer do the multiplication you learned at age nine?

One of the reasons this aspect of your business may be confusing is because you have not been trained in the financial aspects of business like a business school graduate has. Which isn't to say you need a business degree to run a business. But you do need training and guidance from professionals.

Creatives often say, "I'm not good with money." That, more than anything, is a self-fulfilling prophecy, primarily of a psychological nature, and it's important to deal with. Suffice it to say, you're not alone. There is hope, as this fuzziness is not a genetic condition.

Also, there are few common financial definitions. In fact, the accounting field is filled with terms that all mean the same thing, and no organization has been successful in coming up with a standard glossary. Don't get hung up on terminology and don't throw up your hands in confusion. Instead, get educated and get help.

In reality, money is simple and logical. It doesn't conflict with or corrupt your creativity. It's math, after all, and most of it is not all that complicated. Numbers either add up or they don't. If they don't, there's something wrong, and if you look closely, you can usually figure out what it is. But not if you've already decided you can't or just don't get it. That's up to you. It just takes attention—focused attention.

"There is a lot of shame that surrounds issues of money," says Mikelann Valterra, director of the Women's Earning Institute. "It is as if we say to ourselves, 'What is wrong with me that I can't figure this out?' It is frustrating, because we know we are intelligent. But why then do we fall into self-defeating patterns around money? The truth is that money issues go far beyond our intellect. Money taps into our deepest emotions and symbolizes what we fear, hope for and desire in life."

Be Confident About Money

Your prospects and clients need you to be confident. They are looking for confidence in their vendors and resources. They want to be persuaded that they will be in good hands if they choose you.

But many creative professionals experience a lack of confidence, which usually has nothing to do with the quality of the work. Instead it seems to stem from comparisons you make between you and your competitors, who are sometimes also your friends and colleagues, which makes it tricky. You may feel "less than" if you are self-taught at your profession and they have a degree or some other credential that is perceived as valuable. Or perhaps you don't feel comfortable calling yourself an "expert," or, worse, you imagine yourself as an

imposter and therefore can't charge prices level with someone with more credentials. All of this may prevent you from reassuring your prospects and securing the projects you want.

Self-confidence is an element of taking your business seriously. It requires that you shift your attention away from what you imagine others think and refocus your attention on real-time actions—yours and theirs. It takes time, practice and experience to develop this confidence, so be patient with yourself. And as it develops, you might need to fake it a bit, speaking and acting as if you already possess it. That's okay because confidence sometimes begets confidence. And it builds when you earn at your potential. Valterra says, "There is nothing that compares to the feeling of self-confidence and self-reliance that making money provides us."

THE TROUBLE WITH MONEY

So what's the problem with money? Granted, it's a complex issue and it's different for everyone. But here are a few things to consider.

Money Is Taboo

Did you learn growing up that it is impolite to talk about money? That may be true in social settings but certainly not in business.

After all, we live in a capitalist culture! As a business owner, if you don't talk about money, then you can't ask for a client's budget or negotiate a contract. You can't raise your prices or advise a client that it's going to cost more when their project's scope starts to creep.

The fact is, clients appreciate it when you are straightforward about money. It conveys professionalism and confidence. Likewise, when you are cagey or avoid talking about money, it conveys amateurism and weakness.

That said, there is an art to talking about money. Sometimes it's appropriate to be direct about it; other times, it's best to put it in writing. The art is knowing the difference.

Money Is Emotional

Valterra writes, "Many of us are very conflicted about money in general—about having it, earning it and spending it. And many of us desperately don't want to think about it. Money should just be there, not interfering with how we live our lives. But we need it. And some of us hate that we need it."

In addition, creatives tend to practice "emotional pricing." That means quoting a fee based on nothing but a "feeling" and without calculating how much real time and effort is actually required. "They sit in a comfy chair, close their eyes, think about their work and say, 'Now what do I think I am worth?'" recounts Valterra. "And guess what—the number that pops into their heads is, on average, 20 percent lower than their true market value. Sometimes a lot lower."

PRACTICE MAKES CONFIDENT

One way to break the cycle of avoiding the "money conversation" is to do exactly the opposite: make a habit of talking money from the very beginning of a project and keep bringing it up all the way through.

Dana Manciagli, general manager of a large division of Microsoft, suggests making it a part of your process to talk money during the last five minutes of every conversation. "I want a proactive business partner, not just a creative. I would love it if a creative said, 'I understand you're accountable for every dime you spend, so every Friday I will call or send you a message about where you stand on your budget.' Like a weekly budget check-in. That way, there are no surprises."

Emotional pricing is not "wrong," it's just not rational. You have much more sophisticated tools at your disposal. Yes, be aware of what your gut says, but don't go only by your gut. When you make an emotional pricing decision and you realize later a better decision could have been made, take the time to investigate what drove you to make that decision so you can learn from those experiences.

Money Conversations Are Minefields

Many creatives work alone. You may like it that way. You may need solitude or quiet to do your work. But business is social, and if you expect to earn a living then don't ignore the social aspect or you may find yourself in more solitude than you bargained for.

Money represents—and forces—an exchange with those other people, clients, colleagues, vendors and more. Talking money is one crucial aspect of business and rarely the smoothest part. There's usually some dissonance to deal with. You should expect that. Sometimes the client is shocked when you give your price, other times pleasantly surprised. Rarely are you "right on the money."

You may experience these exchanges as confrontations, but they are probably not as antagonistic as you may imagine. And if you welcome these exchanges and learn how to communicate ever more clearly, things are likely to go much more smoothly.

Kit Hinrichs, owner of Studio Hinrichs and longtime partner at Pentagram, says, "Money conversations are minefields because they tend to be emotional for both the creative and the client. Not knowing what to say can stir enough anxiety to prevent you from having the conversation at all."

If you're going to run a successful business, you have to be a clear communicator, especially when it comes to talking about money. Not only that, you need to be willing to stay in the conversation, through whatever discomfort arises, to keep the conversation going as long as necessary until each detail is resolved.

BUILDING YOUR FINANCIAL TEAM

...............................

by Vik Orenstein

I don't know why there are so many lawyer jokes and almost no accountant jokes. My Certified Public Accountant (CPA) is a pretty funny guy. His name is Jim Orenstein (no relation). When I first started working with him twenty years ago, I had just opened my first studio and my gross that year was about $9,000. A couple of years later, he said, "Hey, I think you're going to break six figures gross this year." A couple of years after that, he said, "Looks like you're going to break half a million gross this year. If you do that, I'm going to start telling people we're related."

But I guess that's not an accountant joke, it's an accountant making a joke. Maybe there are no accountant jokes because having a good CPA is the keystone to building your successful business—and that's not a laughing matter.

GET THEE TO A CPA

"Most people go to a lawyer first when they're looking to start up their own business," says Orenstein. "That's a mistake. You need to start with a reputable CPA who specializes in small businesses. He can start you out from ground zero: getting a tax ID number, helping you

Vik Orenstein is a photographer, writer and teacher. She founded KidCapers Portraits in 1988, followed by Tiny Acorn Studio in 1994. In addition to her work creating portraits of children, she has photographed children for such commercial clients as Nikon, Pentax, Microsoft and 3M. Vik teaches several photography courses at BetterPhoto.com.

Excerpted from *The Photographer's Market Guide to Building Your Photography Business* © 2010 by Vik Orenstein. Used with the kind permission of Writer's Digest Books, an imprint of F+W Media, Inc. Visit www.writersdigestshop.com or call (800)448-0915 to obtain a copy.

structure your business, choosing what type of entity you should be. Going to a CPA first can save you some needless expenses. Then, when he's got you up to speed, he can refer you to the other professionals you'll need to help make your business successful."

Not Just Another Pretty Face

You don't just want an accountant—you want a CPA. And you don't want just any CPA, you want one who specializes in small businesses like your own. Preferably someone whose firm is also relatively small.

"Larger firms can't afford to put experienced CPAs in their small business divisions because they can't charge them as much as they do their big clients, so the small business person gets the newbie, who can't offer the same level of service a more experienced person would bring to the table, and who might not even be at that firm next year. If you choose a CPA with a small firm, you'll pay less for a higher experience level."

A portrait of playwright August Wilson by Stormi Greener.

How Not to Find a CPA

Do not pick one randomly out of the yellow pages—that doesn't give you enough information to make one of your most important business choices. Do not pick one because he's in the neighborhood. You don't pick your doctors or your dentists because they're close by, you pick them because you trust them with your health and your teeth. It should be the same with your CPA.

The Best Way: Word of Mouth

The only way to choose your CPA is through word of mouth. Get referrals from people you know and trust, and who have businesses of a similar size to yours. Then once you have your CPA, he can help you assemble that team of advisors you're going to need.

IT TAKES A VILLAGE

Orenstein says you need a team of advisors to help you in your business. Your CPA should be the director of this team. "He's the one you see the most—well, hopefully he's the one you see the most, if you see your lawyer the most there's probably something wrong," Orenstein says, exhibiting that accountant humor once again.

Who comprises the rest of the team?

A macro nature image by Kerry Drager.

Your Future: Be Sure You Can Bank on It

"Your banker is very, very important to the success of your business. Not just the bank, the institution, but the person," says Orenstein. "You should get to know him, socialize with him. This is one guy you should take out for lunch and establish a relationship with so when you need him, he already knows and trusts you and he'll help you out." Most people never talk to their banker until they're in trouble, and that's a less than ideal time to establish rapport. Pick a banker who will be around for a long time. Typically, larger institutions have higher turnover. So choose an established individual who's affiliated with a small- to medium-sized service-oriented bank.

Someone to Keep Your Ducks in a Row

Perhaps as important as your banker is your bookkeeper. "In all likelihood you won't need a full-time bookkeeper, you just need an independent contractor. You need someone called a 'full charge' bookkeeper. Not someone who used to foot columns for [a department store]," says Orenstein.

There is no "full charge" certification for bookkeepers, so you'll have to rely on your CPA's recommendations about who to hire—another reason it's essential to have a CPA you trust. Beware the CPA who offers to do your bookkeeping for you himself—a full charge bookkeeper can do anything your accountant can do for you for much less.

What about all those stories about bookkeepers running off to Brazil after embezzling the company funds? "You never give the bookkeeper access to cash—never," says Orenstein. He also advises keeping separate duties. The person who collects the money shouldn't be the one to disburse it. People are less likely to collude than to act on their own to siphon funds.

Your bookkeeping is best done by a hired hand rather than a family member. "People will come in here and say, 'My wife is going to do the books. We bought QuickBooks, and that's going to save me loads of money over having to hire a bookkeeper.' But that's penny-wise and pound-foolish. Doing bookkeeping is not where you make your money. Creating, marketing and selling your product is where you make your money, and where you should focus your time and energy."

Orenstein also warns against the allure of programs like QuickBooks. While they're efficient tools for some situations, they often take time and energy from your main focus—creating, marketing and selling your work.

Special Agents

The next folks to add to your village are insurance agents—several of them.

Life insurance and disability insurance. What do you think you need more—life insurance or disability insurance? Yes, this is a trick question. "Everybody thinks they need life insurance," says Orenstein. "Everybody has life insurance. Hardly anybody has disability insurance. But you are much, much more likely to become unable to work than you are to die prematurely. So disability insurance is much more important to have. You need an insurance agent who will assess your personal needs and honestly guide you to the best products for you. Buying insurance is like buying a car: They can load it up with accessories that drive up the cost unnecessarily. For instance, you can buy an inflation rider. But that's ridiculous. Because if inflation goes through the roof, wouldn't you just buy more insurance? They're asking you to insure your insurance! That's why you need an honest agent, someone who will tell you when you really don't need the bells and whistles."

Business insurance. Many items fall under this category: worker's compensation, unemployment insurance, liability insurance; health/medical insurance and casualty insurance. "You want a good agent who knows how to write a plan that covers everything you need covered," continues Orenstein. "For instance, let's say all your cameras are stolen or destroyed. You go to make a claim, and you find out your cameras weren't covered—your most important tool for your business!"

No matter what type of insurance you're buying, you need an agent who isn't loyal to just one company, because he only gets paid if he sells you their products. You also want someone who stays in touch with you, who calls you now and then, and checks to see if your situation has changed—your needs can change, and insurance products are changing all the time.

Legal Eagles

You will need a lawyer or lawyers. There's a whole smorgasbord of different specialties,

A landscape by Brenda Tharp.

A nature image by Lewis Kemper.

including employment law, tax law and others. Is it okay to use a generalist for your business law needs?

"I think it's fine to do that," says Orenstein, "because a good, reputable generalist will point you in the direction of another professional if they find themselves in over their head." Another advantage to using a generalist is that you'll see them more frequently than if you have a whole stable of attorneys for different issues, and you'll establish a better relationship.

What About a Financial Planner?

"Ideally your CPA also acts as your financial advisor," says Orenstein. "I don't believe in financial planners—the person advising you shouldn't also be making commissions on investment products he's selling you. Often the brokerage houses underwrite the stocks they're selling."

Orenstein recommends picking a solid-performing stock in each of several different industries: energy, medical and technology, for instance. Then buy the shares, stick them in your safe-deposit box and forget you have them. Stay in for the long haul—the only person you'll make rich by doing a lot of buying and selling is a broker.

"The best place to invest your money is in your own business. That's where your big returns will be," Orenstein concludes.

GET A CREDIT LINE BEFORE YOU NEED ONE

Early along, when your business is showing a healthy profit and regular growth, you should establish a line of credit. It doesn't cost you anything, and you may never use it, but it should be there if you need it. If you wait until you're in trouble, no one will extend you credit. It's the old "you can get it if you don't need it, but you can't get it if you do need it" routine.

TO BORROW, OR NOT TO BORROW

Let's say you want to open a photo studio and you've already got some adequate camera and lighting equipment. It's not pretty, but it does the trick. Thing is, you'd like some nicer, fancier stuff so you can put your best foot forward when you open your new business. Is it justifiable to take out a loan to cover this expense?

"You have to make realistic projections," says Orenstein. "Let's say you've been working at a big studio for a while, and you have some loyal clients who will follow you when you open your own place. They amount to maybe $30,000 worth of business each year. You figure that to make your business expenses that first year, and to feed your family and have enough to live on, you need to make $75,000. Then you go month by month and figure out what gross you can expect. $1,500 the first month because it'll be slow to begin with. $2,500 the second month, because that's the beginning of your busy season. $3,500 your third month, because you'll have picked up one new client by then. With some luck, hard work and marketing, you'll be able to realistically turn that $30,000 worth of clients into $40,000. That still leaves you $35,000 short. So you march down to your banker and you get yourself a line of credit, but you don't use it if you don't have to. Wait on that fancy equipment until you see your projections and your basic expenses being met. Then you'll be able to justify that kind of equipment purchase. But not right away. You need to prepare yourself for your worst-case scenario."

Your CPA has the business knowledge and experience to make accurate projections. Trust him to help you, and you'll avoid stretching your funds too tight.

A portrait by Vik Orenstein.

NEGOTIATING FEES AND RIGHTS

....................................

by Ric Deliantoni

Negotiating fees and rights for your photography is key to getting jobs and retaining clients. Increasingly, buyers and clients are looking for more usage options in a broad range of applications for print, the Web and a growing number of mobile devices. This applies to assignment or contract work as well as stock photography, and may include one contract for print and another for electronic usage. The minefield gets more difficult to navigate each day, so keeping up with this aspect of your business takes more time and effort. Taking the time and doing the research is necessary if you want to stay viable.

Successful negotiation is not possible unless both you and your clients clearly understand what is actually being bought and sold. As the creator of your work, you own the copyright. Many buyers may not grasp this concept, so educating them is a key aspect in the negotiation process. Clear, concise licenses in writing, outlining what you are selling, and the terms you agree upon, are a benefit to both sides in the process.

While fees and rights are often talked about together, they should be considered separate items in the negotiating process. One part is the present, and the other is the future. The fee you charge in the present to make the image is for the production part of a job, which includes time, materials, overhead, and the profit due to you for your experience and talent in creating the image. The rights fee is what you charge for the future use of your image, or the profit you make over the life of the image based on how a client will use it. It may also

Ric Deliantoni is a professional photographer and director with thirty years of experience, with a focus on still-life and lifestyle imagery for advertising, design and publishing. He has developed a unique style that has been described as impressionistic and bold. Ric has also spent much of his career teaching and mentoring students of all levels to better themselves as artists.

include the money you can make selling that image as stock photography once the license has expired for the original usage.

Photography or Creative Fees

Your day rate or fee for the work is something you need to set before you enter into any negotiations, and it should take into consideration several factors. Most professionals refer to this as the creative fee. Many photographers may have different fees or rates based on the client or the job, taking into consideration what they're shooting and what the production of the work costs. Higher rates should be negotiated for your specialized expertise and knowledge, for unique looks and techniques you have developed, and extra equipment that a specific job may require. After all, we are in this business to make money, so your overhead or your out-of-pocket costs need to be assessed before you add in the margin you want to make on any given job or sale. The key is to come up with your bottom-line fee, your costs of doing business, plus the percent of profit or margin you can live with, and stick to it.

You should also carefully consider the longevity of a client in your negotiations. I can't tell you how many times a new prospective client has mentioned that concessions on my part may lead to more work in the future. Don't fall into this trap by cutting your fees to the bone to get a job. When and if they contact you for future work, getting your fee back to your bottom line will be all but impossible. Once you've set a price, that's generally where it stays. There may be exceptions to the rule, but you're setting yourself up for a lot of extra work to get what you need to be profitable. The worst of these clients will pigeonhole you into low-budget, low-priority jobs and spread the word to others. You can see how this scenario can spiral out of control.

Rights or Usage Fees

Rights fees to the work you own are another key element in the negotiating process, and how you assess these fees should take into account several factors. This charge can also be called a usage fee, which is a more accurate way to describe it. These fees can range from a one-time limited use included in the creative fee to a full buyout. The fee should increase as the usage does.

Usage terminology is fairly self-explanatory and basic, but a usage contract is rarely that simple in today's world. Most likely you will grant one term of usage for printed material and another for the Web or electronic usage. Some basic rules to follow when considering these fees are based on a percentage of the creative fee and what you can negotiate.

When you're considering these charges it's a good idea to spend some time thinking from the client's perspective. Concerns an advertising agency might consider are the life of the product or subject, and whether the project is a part of an extended ad campaign. In

editorial photography, the timeliness of the subject and the audience that will view or read the article you've illustrated are key factors.

If you're shooting images for packaging, the design firm would look at the product life cycle. Basic everyday subjects will have a much longer life than electronics that will quickly become obsolete. For example, an image used in food packaging may be used for a very long time (and should command a much higher usage fee), while a new computer or gadget that will be usurped in six months by the next best thing and would not be worth as much. For these long-lived images, the client may want a full buyout or rights transfer. A standard fee for this would be 100 percent of the creative fee. For the short-lived products, 25 percent or less may be all clients are willing to pay.

The rights you keep should also be considered, as they are just as important as the rights you sell. The longevity of the image also comes into play here. An image that can be put into your stock photography library may have value to you long after the client is gone, so consider this in the negotiating process. Before selling all your rights to a client, remember that what you sell today may come back to haunt you when another client wants that image and you no longer own it.

The Negotiation Process

Being flexible is important in negotiations, but you must apply clear limits and stick to the success of your business. When you're just starting out and trying to grow your client list, the temptation to make concessions to get the job may be strong. It is OK to bend a little— just don't take this to the break-even point. You must consider the photography industry as a whole: Undercutting your competition can build animosity in the community, and it encourages people to think of photography as a commodity diminishing in value. You will also set a bad precedent with that client. Don't give in and be perceived as weak. Be strong and gain respect.

Being an entrepreneur is a daily battle to succeed, even more so when you are at the negotiations table. Preparation, research and confidence will give you the tools you need to come away with a win. This may sound like a coach's pep talk before a big game, and it is. I've been in this business for 30 years and have never found a magic trick I can pass along. Striking the right deal and coming to a win-win agreement depends on experience, a clear understanding of your market, and your clients' needs.

Resources, Forms and Templates

Once you've closed the deal, getting it in writing is the final piece of the process (other than getting paid!). The agreement becomes a contract and license between you and the client and will require proper legal forms. Here are some resources that may help:

There are several online portals that have both free and paid forms for this purpose. Most of these forms are generic but will give you a starting point to customize.

Professional photography association such as the Professional Photographers of America (PPA), American Society of Media Photographers (ASMP) or American Photographic Artists (APA), also provide these forms and support to members. These are specifically designed for selling and licensing the photography you create and sell.

Many local and regional groups also offer member support. For more info, please see my Artist's Market Online blog post "The Lowdown on Professional Photo Associations" (bit.ly/AMOlowdown).

Networking in your region or market, attending workshops, or taking classes in marketing and negotiation will help you gain the experience and tools you need to become a successful negotiator and a more successful photographer.

SOCIAL MEDIA MARKETING 102

Pinterest, LinkedIn and Google+

...

by Lori McNee

Only a few years ago the social media phenomenon was new to many creative individuals. Since then, we have rapidly moved into an era where social media is considered mainstream media because of its quality, reach, frequency, usability, immediacy and permanence. Social media is here to stay, and it is speedily evolving.

My *2012 Photographer's Market* article "Secrets to Social Media Success" explains how to harness the power of social media on Facebook, Twitter and YouTube. (If you missed this article, you can read it on ArtistsMarketOnline.com.) Some important newcomers have arrived in the social scene since then. Adding these sites to your online strategy will take your social media marketing to the next level.

PINTEREST

This popular social bookmarking site allows users to collect, upload and share all the beautiful things they find on the Web. No more need for bookmarking on your Web browser, or rummaging through scrap files cabinets—Pinterest's visual collections are neatly stored into virtual pinboards.

Pinterest also lets you browse pinboards created by other talented people. Over 80 percent of the content shared on Pinterest are repins of pictures from other users, and 80 percent of these users are women. Last year, Pinterest was the fastest growing website of all

Lori McNee is an exhibiting member of Oil Painters of America and ranks as one of the most influential artists and powerful women on Twitter. She was named a Twitter Powerhouse by *The Huffington Post*. Lori shares valuable fine art tips, art business tips and social media advice on her blog, FineArtTips.com. She has been a talk show host for Plum TV, and has been featured in and written for magazine and book publications and serves on the *Plein Air Magazine* board of advisors.

time, and it ranked highest among social network for user time spent across PC, mobile Web and apps.

Getting started on Pinterest is quick and easy. Once you've set up your account, it is simple to drive traffic back to your site, art portfolio or product. When pinning images from your blog or site, be sure to include your URL so all repins link back to your site. It's also a good idea to verify your website.

Pinterest is a visual feast for the eyes! This makes Pinterest a wonderful platform to share art and photography. I have one pinboard dedicated to my own LoriMcNee.com paintings and another for my FineArtTips. com blog posts.

LINKEDIN

This site isn't new to the social scene, but it is a site that some creatives haven't embraced, and it continues to be the No. 1 social media platform for sales professionals, recruiters, and job seekers. At first glace, LinkedIn may not seem well suited for photographers. However, LinkedIn offers artists of all kinds opportunities to showcase their credentials, recommendations and strengths.

As with any of the other social sites, the key to LinkedIn success is consistency and engagement. Your goal here is to add to your overall brand and not to detract from it. Here are a few LinkedIn tips to get you started:

- Your profile must be in your own name.

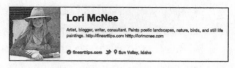

Use a friendly photo of yourself and a short bio for your Pinterest profile.

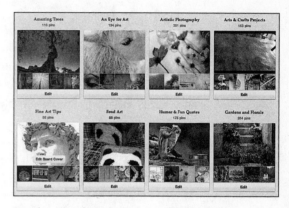

People use pinboards to plan weddings, gain artistic inspiration, collect quotes, decorating and fashion ideas, or their favorite recipes.

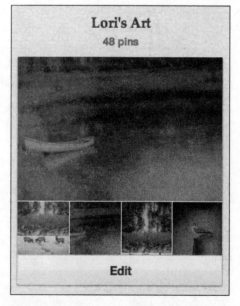

Shameless self-promotion is frowned upon on Pinterest. Even so, Pinterest accounts for a large part of my website's traffic.

- Keep your profile and connections current, rather than just reaching out to people when you need something.
- Be sure and ask for recommendations and return the favor.
- Optimize your public portion of your profile for Google search.
- Use keywords in your headline.

Next, follow LinkedIn's help section to improve your profile.

- Use a friendly, no-nonsense head shot for your photo. A smile will get more clicks.
- Each profile is allowed to list three links.
- Be sure to add your website and choose "other" to add your own interesting description rather than just "website" or "blog."

Take advantage of LinkedIn's custom feature that allows you to create your own vanity URL. This will be an SEO-friendly link that looks professional on business cards instead of their standard URL with random numbers. For example, my custom URL is www.linked in.com/in/lorimcnee.

Optimize your job titles, professional headline, summary section, specialties section, and skills section with keywords. These will show up as h3 tags. Your job description should be creative, truthful, and to the point. Use bullet points that include keywords.

Find and join groups that are relevant to your occupation or industry. You can do a keyword search on groups, or even start your own.

TIPS FOR ENGAGING ON LINKEDIN:

- Don't be shy about engaging.
- Visit a group and leave a comment and share.
- Join a discussion and post a provoking comment.
- If you blog, share your relevant posts with your network.
- Review and comment on your own timeline.
- Read updates, comment and share.
- Try LinkedIn's mobile app designed to help you manage your daily LinkedIn tasks.
- Sign up for job alerts and let LinkedIn do the work for you!
- Give recommendations and ask for your connections to return the favor.
- Articulate the value and influence you have made on current and past positions, and projects.
- Keep your profile and skills section up to date.

Once you have your LinkedIn profile looking professional and in good shape, start giving recommendations and endorsements and ask for them, too. This will help enhance relationships and grow your brand.

Luckily, LinkedIn is not a social site like Twitter, so there is no need for excessive daily postings. However, it is a good idea to keep a fresh update underneath your head shot because they will disappear after a few days. Updating three to five times a week is plenty.

It is good to note that most social sharing is during the workweek, Monday through Friday. However, the best social engagement happens Thursday through Sunday.

Follow these simple steps and you will be well on your way to boosting your online professionalism.

GOOGLE+

Not just another social network, Google+ is a popular blogging platform, news feed, chat, e-mail and video service. The G+ button is used over 5 million times a day. Google+ has borrowed the best features from Twitter, Facebook and LinkedIn to create a different and many would say better social networking experience.

Graphically pleasing and intuitive to use, Google+ is a favorite with photographers and other creatives. Before you jump into becoming a "G-plusser," there are a few things you need to do:

Complete Your Profile

Start by creating your profile. Use your real name without any symbols, numbers or extra words that might cause Google to flag your account. Fill out your entire profile, your in-

Add a photo of yourself, making sure it reflects you and your brand. Make your Google+ cover photo. I added my links to my photos for an extra marketing opportunity. See my blog post explaining how to make a custom Google+ cover photo: bit.ly/CustomGoogleCover.

troduction and tagline, and then list your blog and other important links. You can control your privacy settings on your profile, and you can turn on and customize the e-mail feature.

Create Your Circles

Circles are an important aspect of Google+. Circles allow you to create friendship circles like we make in real life. You can organize the people you interact with into groups such as friends, art buddies, social media tips, collectors, and so on.

Circles can be used to send out public or limited updates, images, links, or recent blog posts to a specific circle of friends. For instance, you can create a "collectors circle" and send them specific information about your art and upcoming events.

Just remember, public postings are seen all over the Web and have the best SEO potential. Circles are another great way to market your niche. You can even create a circle to bookmark interesting posts. Just create an empty circle, name it and then share the post to that empty circle!

Sign Up For Google Authorship

Now you are ready to begin posting. Understand that Google+ is completely integrated with Google itself.

If you are a writer or blogger, Google+ will be very good for your online visibility. Make sure you have linked Google+ to your blog homepage. This, along with verifying authorship, is the first step in getting results from Google+. This is very important because it will link the content you publish on a specific domain to your Google+ profile.

Once you have authorship, your post will appear with your name and picture beside them in searches. Here's the link to verify your authorship: plus.google.com/authorship.

If you are a WordPress user with Genesis, it is very easy to get Google to associate your blog content with your Google+ profile:

1. Add your Google+ profile link. Go to the profile section from your WP admin dashboard. Scroll down and copy/paste your Google+ profile link into the empty box.
2. Next, add your Google+ contributor link to your Google+ plus profile page. Add your other social media profiles, too.
3. You can check to make your authorship has been properly set up: bit.ly/Wordpress-GoogleAuthorship.

Posting on Google+

Google+ is emerging as a backdoor to search results since your postings and updates are searchable and indexed by Google. This presents an exciting opportunity for real-time marketers using Google+.

If your Google+ posts are SEO friendly and include good content, they could show up strongly in search results. In fact, if you are very active on Google+, your posts might even start popping up in results before your website (or your competitors' websites).

Google likes your updates to be more than a few sentences. Strive to have your posts shared, and do your best to get comments. Google will favor popular posts. You can tag your friends in posts and updates. Just use either the @ or + symbol followed by the actual name of the person.

One of the best features about posting on Google+ is that you can edit your update. This comes in handy when you return to your stream and find a typo!

As I mentioned before, Google+ is a photo-driven community. Therefore, it is best to upload a photo first, and then add the link with your post content. This will make for a larger photo than just adding the link itself.

Themes and Hashtags

One of the best ways to share your images is with the use of themes and hashtags. Themes are user-sponsored topics that help you engage within a targeted Google+ community. You target these themes with the use of hashtags.

Google+ has created a hashtag search feature similar to that of Instagram. For example, today is #NatureMonday. People who want to participate can upload nature-inspired photos or paintings. Add your photo, then in the post section use the correspond-

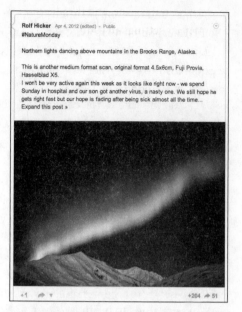

Here's an example of how one popular photographer uses Google+ themes.

One Saturday, I joined the fun with the #caturday hashtag. Look how many shares and plusses my photo received—it went viral!

ing hashtag and mention the sponsor of the theme like this: "#NatureMonday curated by +Rolf Hicker and +JenBaptist" to tag the sponsors.

Discovering new themes and hashtags is fun. Here is a great list of daily photo themes to explore: bit.ly/PhotoThemes. You can also click the "Explore" button in the left sidebar to see what is trending on Google+.

Hangouts

It is important to get out into the Google+ community and a great way to do this is to try a Google+ hangout.

Hangouts are live video chat rooms kind of like Skype or Facetime, but even better. They are a great place to meet up with your G+ friends and a place to connect with new people.

You can use hangouts to connect with your circles or with new people. Use the great Google+ API (application program interface) to run meetings, chats, and classes, share presentations with SlideShare, or draw and color with your friends on the "whiteboard." You can invite people to your hangout by scheduling and creating an event.

The best way to become familiar with hangouts is to give it a try. Click the Start a Hangout button on the side of your stream (or go to plus.google.com/hangouts).

You can even broadcast your hangouts via YouTube. With Hangouts On Air go live with friends and fans.

Once "on air," up to nine others can join your hangout (as usual), and anyone can watch your live broadcast: bit.ly/GoogleHangoutsOnAir.

Google+ Communities

Google+ communities are groups of like-minded individuals. These communities provide a space where anyone can create and build a community of fans who are eager to engage with their brand.

Similar to Facebook's business pages, Google+ communities allow you to directly connect and converse with your fans. This is another way to build online credibility.

Some experts think that Google+ will replace Facebook and nearly every form of online communication. With its advance user interface, Google+ can radically simplify your life for all your online social networking.

Social media is not a one-size-fits-all kind of thing. I encourage you to join and try the different networks and decided for yourself which ones work best for you and your business. Begin networking with friends and business associates, and following influential people. Don't be afraid to start experimenting and engaging, and watch to see what happens with your brand.

HOW TO REALLY USE LINKEDIN

Learn How to Maximize This Social Networking Tool's Potential

by Ilise Benun

You've probably joined LinkedIn (www.linkedin.com), meaning that you threw a profile up a while back. But are you using LinkedIn effectively (or at all) to find and reach out to your best prospects?

I thought so.

LinkedIn is my favorite—and the largest—online social network for business because it's made up of real people with accurate profiles, and because it's all about business—the perfect place to announce the new project you finished or your latest blog post or thought leadership piece.

Most important, no matter who your prospects are, you're almost sure to find them among the more than 135 million people who have also posted their profiles on what is essentially an international database of professionals. But there are a few things you need to do before you begin to use LinkedIn to find new clients.

Part 1: Your Profile

First, you need to make sure your profile is current and complete. Here are the most important profile elements for creative professionals:

Ilise Benun, founder of Marketing Mentor and co-producer of the Creative Freelancer Conference (www.creativefreelancerconference.com), works with creative professionals who are serious about building a healthy business. Follow Benun on Twitter (@MMToolbox) or sign up for her Quick Tips at www.marketing-mentortips.com.

1. Your headline. That's the short line of text right under your name. Unless someone is on your actual profile page, this is all they'll see, so make it descriptive, clear and, if possible, compelling.

Most people use this "headline" area for their job title, but since yours isn't a typical job, be more creative and use the space to highlight your expertise. Here are a few examples to use as models:

- Sustainable print and web design for the natural products industry
- Direct Marketing and Advertising Expert
- (Company Name): A virtual marketing department for growing businesses
- Bringing your ideas to life through design
- Helping nonprofits and universities reach out

2. Your summary. This is the second most important element of your profile because it may be the first (and perhaps only) part of your actual profile that your potential contact will read. Find it directly below your basic profile information.

The goal of your summary should be to engage your best prospects. But most summaries are dry, generic text that don't make anyone want to read more, much less hire you for a project. Highlight the aspects of your work that you most want those prospects to know about. Elaborate on your headline, going into detail about your area of expertise. This is also a good place to list awards, accomplishments and other credentials.

The "specialities" section should be keyword rich—essentially, a comma-separated list of keywords—because this section is indexed for search. In fact, your LinkedIn profile may even come up before your personal or business website when someone searches for you on a general search engine like Google.

3. Your recommendations. Recommendations about you or your work—also called endorsements or testimonials—are important because what other people say about you is often taken more seriously than what you say about yourself. Moreover, people perceive a recommendation on LinkedIn as even more credible than one posted on your own website because the recommender must post it; you can't post it for them.

So the more recommendations, the better. People may not read all of them, but it doesn't matter; sheer volume makes a strong impression here. Find them under "Recommendations For" at the bottom of the "Experience" section.

With just a few clicks, LinkedIn makes it easy to ask for recommendations from clients and colleagues who can vouch for your abilities. The best way to get, of course, is by giving. So spend time providing unsolicited and thoughtful recommendations to those from whom you'd like the same.

4. Your work. Perhaps you've noticed that the typical LinkedIn profile resembles a résumé—it's almost all text. Recently, however, LinkedIn partnered with Behance.com, an online platform for creative professionals, to create an app that allows visitors to see exam-

ples of your work without leaving your profile (see details in the Online Resources sidebar). Install this app on your profile and use it to show a range of capabilities that support the expertise highlighted in your summary.

..

LinkedIn is most effective when you use it to find and reach out to your best prospects by building and cultivating relationships.

..

Part 2: Your Network

Once your profile is ready, the fun begins. Don't wait for people to link to you. LinkedIn is most effective when you actually use it to find and reach out to your best prospects by building and cultivating relationships, which is what marketing is all about anyway. Focus on these two areas:

1. Your connections. This is your personal network, which should always be growing. Add at least five connections to your network each day. You can add people you know and people you don't know as well.

It's easy to find people you know. Just search for them by name in the "People" search field in the upper right corner. Finding people you don't know is easy, too. In the same search field, enter the name of a company you're interested in. When you click on the company, it will show anyone who is one of your first- or second-level connections at that company. (First-level connections are already part of your network; second-level connections are those with whom you have a mutual connection.) Review the profiles you see and then choose those most likely to be prospects for your outreach.

Click "Add to my Network" and send a personal message. Don't use the generic message that's pre-loaded. You know the one: "I'd like to add you to my professional network on LinkedIn." This is the lazy way out. Always, always, always customize the message. Make it concise and to the point. Tell the person why you want to connect. Be sure to mention any shared connections or anything you have in common, such as an alma mater. Then be patient and wait for them to respond. Most of them will.

Copywriter Alisa Bonsignore has noticed that there are two main types of LinkedIn users: open networkers who will connect with anyone who asks, and selective networkers who only connect with people who they know well enough to speak about their work firsthand, treating LinkedIn as a sort of online Rolodex of past colleagues and contacts. If someone rejects your request to connect, don't take it personally. Just move on to those who are more receptive.

Keep in mind that, while it's not a connection competition, the more people in your network, the better access and higher visibility you'll enjoy.

2. Your groups. This is where the real action is on LinkedIn. The goal is to find the LinkedIn groups where your prospects hang out so you can get to know them and vice versa. This can pay off in spades. One freelancer wrote: "Quite a few of my LinkedIn group members have gotten in touch with me to discuss projects. Even though we didn't know each other personally (yet), the fact that we were in the same group meant we shared connections and common interests. I had known their names from seeing their comments and contributions, and they had known mine for the same reason."

To find groups, use the groups directory. Some groups you'll find represent the online presence of an existing offline group, such as IABC/Toronto, the Toronto chapter of the International Association of Business Communicators (an excellent networking group for creative professionals). They host a group on LinkedIn with more than 1,000 members. Other groups with no offline component simply sprout up on LinkedIn because an individual or small group decides to start one. Many groups are open to everyone, but some are closed, so you'll need to make that distinction before you decide which ones to join. You can also search for groups by exploring the groups your ideal prospects are already members of, which you can see on their profile. As you search for groups, LinkedIn will suggest similar groups to you. Explore them all and join as many as you can to see which ones have your best prospects and are most active—the more activity and discussion the better your chances for interaction and, ultimately, prospects.

Keep looking and lurking until you find one or two where you can spend time regularly and get to know the members. To raise your visibility and demonstrate your expertise, initiate and participate in ongoing discussions with them.

Once you've identified your best groups, you can search for specific prospects within the membership. Then reach out to them by adding them to your network using the simple technique outlined above.

There's a lot more you can do with LinkedIn, such as adding your blog and Twitter feeds, a reading list, even events you're attending. Carve out 30–60 minutes every day to do online networking, research and outreach to your prospects. That's how connections are made.

ONLINE RESOURCES

Search for the Creative Freelancer Conference Group on LinkedIn to find lively discussions and people sharing information. You probably won't find your prospects here, but there are all types of creative freelancers who are likely to be referral sources.

Check out tips and tutorials produced by LinkedIn:
Learn.linkedin.com

Learn how to use LinkedIn groups:
Learn.linkedin.com/groups

Read this post on the LinkedIn blog about the Behance
Creative Portfolio Display:
Blog.linkedin.com/2010/07/28/linked in-behance

E-MAIL MARKETING

Manage E-Mail Lists and Create Professional-Looking Newsletters

by Linda Fisler

E-mail newsletters to your followers and clients are a necessary tool in your arsenal to promote your brand and your work. With these easy tips, you'll be gaining new subscribers, managing your subscriptions and creating newsletters to spread the news about your work!

Why a Newsletter?

Your newsletter should be a personal message to your customers as people you know and value—your followers, collectors, friends and potential clients with whom you want to share your good news, activities and special events—and your latest work. A newsletter's objective is to create a buzz or interest in what you're doing, keep your customer base informed about your progress, and build that customer base. To use the newsletter effectively to market your work, it's necessary to find an easy, efficient way to obtain new subscribers, manage your subscriptions and create the newsletter.

I've heard horror stories about the time and effort it's taken some creatives to try to reap the benefits of a regular newsletter—and why they've abandoned the idea. When the Internet was first used as a marketing vehicle, newsletters were very difficult to create, and managing e-mail distribution lists was a time-consuming task. Later, the only alternative was to use an expensive Web-based system. But today, with literally hundreds of free e-mail marketing desktop software packages available, the newsletter has become a necessary component of any serious marketing plan.

Linda Fisler is an artist, writer, blogger and business mentor at www.artistmentorsonline.com.

Adapted from the July/August 2012 issue of *The Artist's Magazine*. Used with the kind permission of *The Artist's Magazine*, a publication of F+W Media, Inc. Visit www.artistsnetwork.com to subscribe.

Creating E-mail Marketing Lists

Each and every page of your website should also contain a link or button that allows your visitors to subscribe to your newsletter. Provide some incentive for them to do so. A message such as "Sign up for my newsletter! It's Free!" with a link to a sign-up page is one way to do this. Some photographers offer opportunities for new subscribers to win a photo. While this may get you some quick sign-ups, you may also experience a number of people unsubscribing after the giveaway. If the subscription process is completely automatic, you shouldn't have to spend time adding or deleting subscribers. Engaging subscribers so they want to see your work and continue to keep an eye on you for a possible future purchase is the purpose of your newsletter—and it can be accomplished without using hard sales tactics.

Sendblaster's website homepage features some of its shortcuts and most common tasks and capabilities.

The information you want to capture from your visitors consists of their names and e-mail addresses—that's it. So the sign-up process should be quick and easy for them. If your photography and information on your website are doing their job, you've begun the process of engagement. Your newsletter will be the marketing tool that continues to build the relationship between you and your visitors.

So what will you do with all these names and e-mail addresses? In the past, you'd have to enter everything into a separate e-mail account or software. With today's options, this is no longer true. You may need to be a bit computer-savvy, but the next step isn't like building an entire website. If you know how to embed a video in a webpage or embed a link to a website in your e-mails, you can link your newsletter subscription information on your website to the subscription software you choose.

Choosing the Right Software

There are free software packages available that provide a subscription process and a way to manage subscriptions with very little to no interaction required from you. These packages also have a "WYSIWYG" (what-you-see-is-what-you-get) editor, so you can build your newsletter without writing code. You should test any software first by sending the e-mail to yourself before you send it out to your e-mail distribution list. In addition you should al-

DO'S OF NEWSLETTER DESIGN

Do use a balanced ratio of text to images in your newsletter. Spam filters look at text to image ratios. An excessive number of images or too much text will get it flagged as spam.

Do assume embedded images won't appear properly. Ask yourself, if the images don't appear, does your newsletter still get your message across?

Do use a table of contents for newsletters with multiple sections. Provide links to the section directly from the table of contents. Make the table of contents simple and eye-catching.

Do include a call-to-action. List the most important and relevant information first. "Sign up for Linda's newsletter today" and "Click here to see more artwork from my latest trip" are calls-to-action.

ways review your e-mail by sending it to yourself or a friend to double- or triple-check for mistakes (spelling, layout, design and so on).

Most newsletter packages available on the Internet today either come with a free trial or have a free version available with reduced bells and whistles, plus the fancier version of the software that you can purchase. If you do a search for "free newsletter software," you'll see thousands upon thousands of offerings.

MailChimp

MailChimp (www.mailchimp.com) is quickly becoming a favorite newsletter generator across the global network. One reason is the company's Forever Free Plan. This plan has the ability to store up to 2,000 subscribers and helps you manage the subscriptions. It allows you to send up to 12,000 e-mails per month. You can even personalize your e-mails. Personalizing newsletters helps to engage your subscribers—addressing your client personally means you've taken notice of them. Note that personalizing e-mails is pretty much the norm for any e-mail marketing campaign. Don't overdo the greeting.

MailChimp also boasts no expiring trials and no contracts. The company doesn't even ask for a credit card. Statistical data—such as the e-mail status, the number of e-mails opened, bounced and forwarded—are also provided. Sounds great, right? Well, you get what you pay for, and the company doesn't hide the fact that there are some catches. Keep in mind you're sending your newsletter in bulk (hitting the send button to your whole subscriber list at once). You're sending out a lot of e-mails, which can get flagged as spam by the servers that are processing these messages. Some of your recipients may never see the messages appear in their in-boxes; instead some messages may end up in the spam folder.

Optional monthly and pay-as-you-go Mailchimp plans allow for different numbers of subscribers and unlimited numbers of e-mails. These plans also deliver additional features.

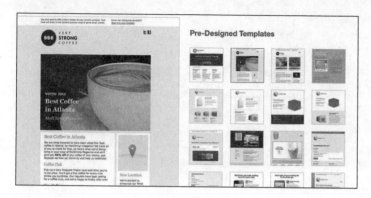

MailChimp provides hundreds of customizable e-mail templates for everyone from beginners to seasoned pros.

SendEmails

Another free software program is SendEmails (www.sendemails.com), which is very similar to MailChimp. SendEmails also sends out bulk e-mails to your subscribers. With this software you can send up to 200 e-mails a month and get statistical data on the number of e-mails sent and opened by recipients, plus the number of people who visited your site. You can also purchase, for a monthly fee, SendEmails Professional Editor and Enterprise Editor versions, which offer additional features. One difference between MailChimp and SendEmails is that SendEmails has a personalized e-mail-sending engine, which prevents a spamming process to make sure that your newsletters are delivered to your followers' in-boxes.

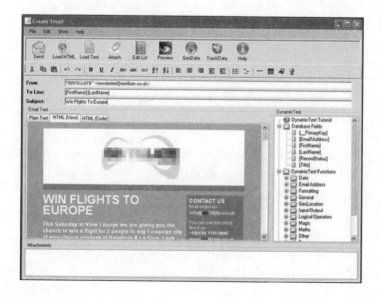

You can create personalized HTML e-mails with SendEmails's Dynamic-Text. You can drag and drop database fields on any part of the e-mail, which will be replaced with database contents when the e-mail is sent.

SOME FACTS ABOUT E-MAIL MARKETING

- E-mail marketing outperforms all other forms of direct marketing. (Source: Direct Marketing Association (2009)
- 89% of retailers report that e-mail marketing is the most successful marketing tactic. (Source: Forrester Research and Shop.org "Retailing Online 2009: Marketing Report" (2009)
- 94% of daily e-mail users have subscribed to marketing messages. (Source: ExactTarget "Subscribers, Fans, and Followers: The Social Profile" (2010)

Sendblaster

The most highly recommended software of this type is called Sendblaster (www.sendblaster. com). The product's free version—Sendblaster2—has a great interface for creating newsletters and is available in a stand-alone, run-off-your-computer version and in a plug-in for WordPress users (one of the fastest growing open-source website development tools). This free version allows you to send 100 e-mails to two manageable contact lists but has no attachment capabilities or tech support (there are some video tutorials and a help page). The Sendblaster Pro 2 version, which the company markets fairly aggressively, offers unlimited messages and lists. Pro 2 also has attachment capabilities and full tech support, plus a couple of additional features for $129.

With both software versions, you can manage your subscribers (with sign-up and unsubscribe options), manage and save your newsletters, personalize your messages, select your contact list at the same time you create a newsletter, and run a test to obtain a spam rating, which gives the likelihood of your message ending up in someone's spam folder.

Working with Sendblaster2's editor program is like creating a document in Microsoft Word. Helpful toolbars include options for inserting photos and hyperlinks. Sendblaster2 has wizards that help you to send e-mails from this software versus sending from your e-mail's software interface. This is a full, robust software offering and may take a bit of time to learn, but the rewards are worth it.

As I've explained, MailChimp, SendEmails and Sendblaster offer various levels of functionality. Visit each site and find the software package that best fits your needs and pocketbook. Your newsletter should be a vital part of your marketing plan. Create and distribute your newsletter like the professionals by using one of the newsletter software packages available to you today!

SITES THAT FIND CLIENTS FOR YOU

Stop Selling and Start Marketing

...

by Mark O'Brien

Regardless of your job title or the size of your company, one thing is universally true: If there's not enough business coming through the door, bad things are going to happen.

We're all able to do the work we love because someone decided it was worth paying us—and there's no guarantee that will always be the case. Ensuring that there's enough paying work isn't something any of us can afford to leave to chance; you need to intentionally and constantly pursue it. But how?

We all have this slimy image of the stereotypical sales guy in our heads, and none of us ever wants to be that person. In fact, you may have gotten into the creative field in part to avoid all that soulless "businessy" stuff. But then, one day, you found yourself owning or managing part of a business.

Time to break out the power suit and hair gel, right? Or not. The Web has changed what was once called the sales cycle into what's now called the buying cycle.

That slight but important shift in wording happened because we can no longer expect to "sell" anybody on anything. The best we can do is put ourselves out there and hope our prospects are interested in our expertise and our work. While this sounds scary, it's actually a great thing, and the smaller your firm is, the better it can work. The Web has leveled the playing field for everyone.

Mark O'Brien (@NewfangledMark) is the president of Newfangled, a web development company that partners with creative services firms to help them build conversion-focused websites for themselves and their clients. He's the author of *A Website That Works*. www.newfangled.com

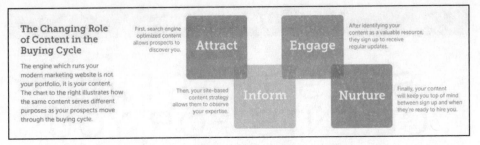

The Changing Role of Content in the Buying Cycle

The engine which runs your modern marketing website is not your portfolio, it is your content. The chart to the right illustrates how the same content serves different purposes as your prospects move through the buying cycle.

First, search engine optimized content allows prospects to discover you.

Attract

After identifying your content as a valuable resource, they sign up to receive regular updates.

Engage

Then, your site-based content strategy allows them to observe your expertise.

Inform

Nurture

Finally, your content will keep you top of mind between sign up and when they're ready to hire you.

The traditional concept of sales is passé. To ensure the long-term viability of your business, you need to focus on effective marketing. If you invest the time it takes to market your firm properly, you'll find that sales becomes easier and easier. Ultimately, sales should be about answering the phone when a qualified prospect calls and deciding whether or not you'd like to work with them. This isn't some utopian dream—it's entirely achievable. The only thing standing in the way of you and this reality is your willingness to put in the work to market properly from now on. Market hard so the selling is easy.

Marketing is about constantly demonstrating your expertise through your website.

How to Market Creative Firms

The first step in effective marketing is to be an expert in a narrow field. If you do everything for everyone, you're a generalist and compete against many thousands of other generalists. Generalists are tied to their local market because they aren't differentiated enough to compete in markets outside of their immediate geography. When you're a specialized expert, you break the chains that geographically bind you. When you're an expert, your marketing, which is grounded in your website, has the potential to create an endless stream of business for your firm.

But just being an expert and having a website isn't enough. You need to have a website that's constantly attracting, informing, engaging and nurturing your prospect base—every hour of every day. This is a lot to expect from a website, and the truth is, it takes quite a lot of effort to make this happen.

I'll be the last person to say that this sort of marketing is easy—it's really quite difficult. But it's the most reliable way to create a constant flow of well-qualified leads. And however tough this approach is, it absolutely beats the traditional sales tactics of cold-calling, sending mass e-mail blasts and standing at lonely trade show booths for perpetuity. Marketing is no longer about writing a white paper and blasting it out to a paid list when your pipeline

DEVELOPING YOUR CONTENT STRATEGY

This selection of books, articles and online courses will help you develop a content strategy that will work for your unique business needs.

The Elements of Content Strategy
by Erin Kissane,
A Book Apart, $18

Make a WordPress Website in 21 Days
(HOWinteractivedesign.com/how-to-build-a-wordpress-website)

Principles of Information Architecture
online course with Brian Miller
(HOWdesignuniversity.com)

SEO and Content Strategy
for Designers
by Mark O'Brien, $49.99
(HOW Interactive Design Conference session),
(MyDesignShop.com/seo-and-content-strategy-for-designers)

The Web Designer's Content Strategy
DesignCast series
by Mark O'Brien, $99
(MyDesignShop.com/content-strategy-designcast)

A Website That Works
by Mark O'Brien, $24.95
(MyDesignShop.com)

is looking a little dry. Marketing is about constantly demonstrating your expertise through your website.

The engine that runs your modern marketing website isn't your portfolio—it's your content. Content you add to your site, blogs and newsletters needs to educate your prospects, not promote your firm.

The heart of your marketing is your content strategy, which I define as a plan for regularly adding unique, expert and indexable content to your site. Your content strategy may consist of writing and adding a 2,000-word newsletter to your site once a month and e-mailing it to your subscribers. Or you might prefer writing four 500-word blog posts each month and sending a monthly e-mail digest of your posts to your prospects, for example.

If your website excels at attracting, informing, engaging and nurturing your prospects, I guarantee it will create business for your firm. Let's take a look at each of these roles in detail.

Attract

If you decide to implement a content strategy, your website has the potential to attract prospects who desire your expertise but don't know that you exist. This is pret-

ty amazing. No other marketing platform can do this, and it doesn't cost you anything but your time. When your site is full of content that describes your expertise, Google indexes your site, and when prospects search Google for keywords that relate to your expertise, Google refers them to you. Referrals are always the best source of new business, and Google is the world's largest referral engine.

Inform

Once your prospects land on your site, the site needs to first intuitively guide them to the areas they are most interested in, then communicate your expertise in detail.

Is your site intuitively navigable? Take this quick test to find out. Go to the deepest, darkest, most obscure page on your site (or your blog if it's separate from your main site), and ask yourself, "If this page were the first experience I had with our company, would I understand who we are and what we do? Would I be able to get to any other page on my site within one click?"

If the answer is "yes," your site is probably intuitive to navigate. If not, it's time for an information architecture redesign.

When the prospect we described in the previous section arrives on your site from a search engine, they are most likely going to land on a page other than our homepage. That's because they asked Google a detailed question and Google sent them to the exact page on your site that had the right answer. That means that any page on your site could be the first experience your top prospect might have with your brand—so treat every page like your homepage. If your prospects can easily glide through your site and access the content that's of the most interest to them, they'll quickly (within a few clicks) be able to develop a sense of who you are and whether or not your site is a good resource for them, which it hopefully is.

Engage

After your site attracts a prospect and communicates your expertise through your content strategy and portfolio, its next role is to engage them. This is done through clear, concise and compelling calls to action, like an e-newsletter sign-up form. It's just a short form that lets the visitor give you their name and e-mail in exchange for the convenience of receiving monthly e-mails with links to the newest articles you've added to your site.

There should be at least one and no more than three calls to action on every single page of your site, and these forms will only be effective if you're actually implementing a content strategy and have something your prospects can sign up for. No one is going to sign up for your e-newsletter about the latest awards you've won. If you're not creating content that's educating your prospect base, you're not implementing an effective content strategy.

Nurture

Most prospects who discover you through search engines and sign up for your e-newsletter are doing research today in order to hire someone like you down the road. This is why the fourth goal of the marketing website is to nurture.

When a prospect signs up to receive your e-newsletter, they're basically saying, "Please remind me of your expertise once a month so I'll remember you when I'm ready to hire a firm like yours." Your content strategy gives you a great excuse to keep in touch with all of your prospects on a regular basis in a helpful and unobtrusive way.

If you called your prospect once a month and asked if they were ready to hire you yet, they wouldn't be a prospect for long. If you send them a monthly e-mail with an article that speaks to the overlap between your expertise and their pain points, you're steadily increasing your reputation—and the likelihood that they'll hire you.

GIVING GREEN-LANCING A GO

Make Sustainability a Core Value of Your Business

by Tom N. Tumbusch

In late 2009, I made sweeping changes to my freelance writing business. I not only renamed and rebranded my company, but I also added a major focus on sustainability. It's one of the most satisfying choices I've ever made, and I've never looked back.

Ever since I made the switch, I've received occasional inquiries from other solopreneurs who are interested in pursuing a similar career path. It's a commitment, to be sure, but the good news is that getting started takes less effort than most people realize.

Are You "Green" Enough?

Many creatives who want to get into green marketing are skittish about making the jump because they worry their lifestyle won't bear the scrutiny of more sustainable colleagues and neighbors. They fret about being branded as a fraud unless they eat a strict vegan diet, do all business and household errands on a bicycle, recycle every scrap of household waste, flush only under certain circumstances, and water a four-acre organic garden with graywater from their solar-powered homes.

If you can live that way, great. But if fear of having your home office picketed by greener-than-thou protestors is the only thing holding you back, I give you permission to let this anxiety go right this minute. A sincere desire to walk the talk is a good thing. Unearned guilt is not.

Tom N. Tumbusch is a freelance writer who specializes in creating action for green businesses and creative agencies. His tiny solar-powered corner of the internet can be found at www.wordstreamcopy.com. Sign up for his newsletter of monthly writing tips at www.wordstreamcopy.com/newsletter.

Excerpted from the November 2012 issue of *HOW* magazine. Used with the kind permission of *HOW* magazine, a publication of F+W Media, Inc. Visit www.howdesign.com to subscribe.

First of all, if you work from home, you're already greener than the vast majority of the workforce because you're not commuting. About five years ago, the American Electronics Association (now part of TechAmerica) estimated that telecommuting could save 1.35 billion gallons of gas every year if every worker who could do it stayed home just 1.6 days a week. Work from home every day and you can legitimately claim substantial green cred out of the gate.

With that as your baseline, make at least one additional commitment. My first lifestyle change was an Eco-Drive wristwatch: Eight hours of direct sunlight provides enough power to charge the battery for a year. It cost a bit more at the time, but I haven't bought a new watch battery since 2007.

Make Small Choices, Then Larger Ones

Once you've made your initial commitment, periodically take things up a notch. Incremental changes are easier to stick to, and they make larger changes more, well, sustainable later on. My solar watch led to a backpack solar charger, which I use to juice up my phone and other small devices as often as I can. It's also a great icebreaker when I go to networking events and prospect meetings. Sometime after that I switched my e-mail and web hosting over to a solar-powered ISP. Every month or so I try to find some new way to reduce my impact.

Again, it's OK to start small. Any effort that you make to decrease your footprint has value, and we can't all afford to install geothermal heating systems on day one. Switch to paperless invoicing. Set up your home office to make the most of natural light. Recycle as much as possible. Replace auto travel with walking or bicycling when you're able. Make do with the Apple gizmos you already own as long as you can.

One of the best places to get practical, attainable ideas is Practicallygreen.com, a free website that suggests ways to make your personal life more sustainable based on what you're already doing. The company has also announced a business-oriented service they have in the works. You can request a demo on their website.

Whatever you choose, you don't have to be perfect. Seriously, don't beat yourself up if you slip once in a while. You won't have to. Once you commit to a green lifestyle, life will send you plenty of gentle reminders to keep you on track. The day I wrote this article, I had to pay 50 cents extra for my coffee because I forgot to bring my travel mug to the shop where I was writing. Use lessons like this as reminders to solidify habits, not judgments about your value as a person.

Decide What Green Means to You

Just because you promote yourself to clients who value sustainability doesn't let you off the hook from defining your target market. "Green" is a nebulous term that's used to refer to everything from electric vehicles to organic food, and if there's one thing you'll find in this

market, it's diversity. The marketing needs of a general contractor working with the U.S. Green Building Council are vastly different from those of a nonprofit charity protecting coral reefs.

Trying to be every shade of green will drive you crazy. You may even find that running your business sustainably has more appeal than pursuing green clients.

Here's another tip: Not all of your prospects will be neo-hippies, liberals or Democrats. They're still the majority, but today's major sustainability advocates also include the U.S. military, corporate behemoths, Libertarians eager to get off the grid, and some evangelical Christians.

Face Green Marketing Challenges

Many people want to live more responsibly, but only one consumer in five is willing to buy merely for greenness. Three common problems repeatedly confront green marketers:

- The pervasive myth that green equals greater cost
- The fear that green requires some kind of sacrifice
- Consumer fatigue from the growing number of fraudulent claims about sustainability.

Your job as a greenlancer will often involve confronting these issues proactively. The cost problem is the most common, as exemplified by the Toyota Prius, which is more expensive up front but saves money over time. Many green products face similar challenges.

Whenever possible, imagine how a green product stacks up against its competition without its green benefits. Use infographics and other design elements to show how it's just as good or better than the alternatives—then follow up with the kicker that it's better for the planet too. A great case study for this approach is Tide Coldwater, which provides immediate benefits without cost increases or major changes in consumer behavior—just wash clothes in cold water instead of hot water.

Look for Green Opportunities

There are plenty of startup businesses founded on sustainable goals, but going after the green market doesn't limit you to new or struggling companies. Some big names are already on the green bandwagon, including Apple, Continental Airlines, Ford, General Electric, General Motors, Goldman Sachs, Google, Hewlett-Packard, Honda, Procter & Gamble, Toyota and even Walmart.

If medium-sized firms are your ideal prospects, look for companies that support larger organizations with a green agenda. For example, the supply chains for P&G and Walmart favor vendors who follow sustainable practices over comparable competitors who don't. Companies who want to play with these giants have a vested interest in greening their image legitimately, not just looking the part.

Incremental changes are easier to stick to, and they make larger changes more, well, sustainable later on.

Green construction is another field that's being propelled into sustainability by outside forces. Building owners and government agencies are starting to realize that green buildings are good for more than just public relations—they're more cost-effective to operate, retain tenants longer and can command higher rents. Many architects, contractors and interior designers are being dragged into this movement kicking and screaming, but growing demand and generous incentives are making the trend difficult to ignore. Forming a relationship with your local chapter of the U.S. Green Building Council is a great way to get your foot in the door with this crowd. Visit www.usgbc.org to find a group in your area.

One final word about greenlancing: Don't do it unless you sincerely believe in it. Green enthusiasts may not hound you if they doubt your credibility, but they can still smell "greenwashing" miles away. Don't try to green your business just to look hip and responsible. Do it because it enriches your life on some level. You can waste a lot of time splitting hairs about whether you should pursue the green market, but the bottom line is that enthusiasm, a few small commitments and a willingness to learn more are enough to get you started.

ADDING VIDEO TO YOUR REPERTOIRE

Develop the Skills You Need to Stay Viable

by Ric Deliantoni

Over the past few years video has become more and more in demand in our market. Those who considered it a passing fad have lost market share en masse. We might consider the creation of YouTube in 2005 as the start of this trend. YouTube's initial raw campy posts may have contributed to the fad attitude of many, but Google's acquisition of the company in 2006 marked the beginning of regular access to video in the social media landscape.

Social media is now one of the biggest driving factors in marketing and delivery of photography. What once was a personal platform, has transitioned into the commercial world. No self-respecting company would consider this a fad any longer. The tagline "like us on …" is now a part of the advertising lexicon.

You'd have to be living under a rock not to see the major changes coming from all the major camera manufacturers. Over the past few years it seem that every new camera captures both still and video with equal quality. The sensor size of most new DSLRs blows away that of video-only cameras in the same price range, and these cameras offer many of the same features. The mid-level video-only cameras seem to be a dying breed. Manufacturers such as Canon have taken this to the extreme with the new EOS C series video cameras going after the feature film industry with a vengeance.

Ric Deliantoni is a professional photographer and director with thirty years of experience, with a focus on still-life and lifestyle imagery for advertising, design and publishing. He has developed a unique style that has been described as impressionistic and bold. Ric has also spent much of his career teaching and mentoring students of all levels to better themselves as artists.

WHAT ARE THE SKILLS YOU NEED TO ADD TO STAY VIABLE?

The good news is that much of what you know as a still photographer can easily translate into video. In fact, I would argue that still photographers who make this transition are better videographers then those that have never learned the craft of photography. Your eye as a photographer and your skills with light are not always a part of the training in a video program. (See the interview with Rowland Egerton, a still photographer who now works as a grip in the motion picture industry.) The story-telling aspect of video adds more to what we now do. Telling a story with moving images—how cool is that?

The challenges you will face and skills you need to add include acquiring new programs, becoming an audio expert, and learning a whole new lingo. There are some basic production rules you may need to learn, but, once you master these, you can rewrite them to suit your style. If you already use Adobe products, the transition will be less challenging since the layout and tools are very similar.

The expense, on the other hand, can be quite daunting. However, as with any new venture, if you acquire the equipment gradually while you gain the skills, the expense will not be as difficult to handle. The eventual increase in your bottom line will more than pay for the struggles in the beginning.

IS THIS FOR EVERYBODY IN THE PHOTO INDUSTRY?

This is a very open-ended question and largely depends on your clients and the market you are in. The short answer to this question is yes. As I stated in the beginning, the trends are there, and they are growing. Even if your clients don't need video now, the likelihood that they will in the future is strong if they want to keep up with their competition. For wedding photographers, this is a significant service you can add. Are you tired of fighting with the video crew in the church and at a reception? Why not eliminate that hassle and offer both services to your clients? For those with clients in smaller markets, with local TV affiliates, shooting their ads and the TV spots at the same time will add revenue to your business. These are just a few of the issues you should consider no matter what market or genre of photography you are in.

WHAT ARE THE COSTS I CAN EXPECT TO INCUR?

Cameras

Most of you with newer cameras already have the first part of the necessary toolset. As mentioned earlier, the DSLR you already have most likely captures the quality video content you need. If you have been thinking about updating your camera, maybe this is the excuse you need to take that step. The costs of these cameras have remained fairly stable and, in fact, have actually come down as quality and features have increased. You can expect to

pay $1,500–$2,500 for a new camera that will cover your needs at the entry level and up to $6,800 for the top of the line.

Lighting

Your lighting requirements will largely depend on the type of video you intend to capture. Shooting with available light is always an option and may be where you want to start. The lower end of lighting includes tungsten or hot lights, and there are a ton of entry-level kits that start around $250 and range up to several thousand dollars. The drawback to hot lights is their color balance, around 3200K. If you shoot in a controlled environment, this won't be an issue. If you intend to shoot in locations where you don't have control over the ambient lighting, hot light will require filtration to correct it to the specific situation.

Other inexpensive lighting options are CFLs (compact florescent lights) and LEDs (light-emitting diodes). These lights fall in the daylight range of the Kelvin scale, or around 5000–5500K. CFLs and LEDs have made big advances over the past few years. Their advantages include low- to mid-level price point, very low power consumption, low heat operation and long life. There are many light kits available, ranging from $100 for a single light kit to $5,000 for a studio setup.

HMIs (hydrargyrum medium-arc iodide) are much higher in cost and require higher power consumption. These are typically used in cinema productions and would not be the place to start. HMI kits start at around $1,500 and easily get in to the mid five figures for studio set-ups. If these are required for a project, renting a kit would be the place to start. In fact, before you jump into any of these lighting purchases, renting will get you the knowledge you need to make an informed purchase to match what you intend to do with your lighting solutions.

Audio

Audio equipment is the next item on our list, and, again, what you get depends on what you will be shooting. The onboard mics included with video cameras and with DSLRs are improved, but they still have drawbacks. Trying to get clean sound in noisy environments is a battle with these mics.

There are a few basic types of mics, and each have their advantages. The first mics we'll discuss are omnidirectional, which means that the pick-up pattern is fairly broad and will pick up ambient sound on the set. The basic "stick" mic and handheld mic are both available in wired and wireless versions. If ENG (Electronic News Gathering) type work is your goal, the stick will work well. A stick mic can double as a boom mic when placed over the set, just out of your crop. A basic stick mic will run from $30 to several hundred dollars, depending on the quality.

The second choice is a lavalier setup. This consists of a receiver and a transmitter with a mic attached. The receiver is attached to the audio input on the camera, and the transmit-

ter and mic are attached to the subject. This provides a wireless connection and allows the subject hands-free freedom from the mic. A lavalier kit ranges from $50 to several thousand dollars, again depending on the quality.

The shotgun mic, our last choice, has a much more focused pick-up pattern, and it does a good job of controlling ambient sounds. In this category there are several choices specific to a DSLR setup that will attach to the hot-shoe on your camera. The shotgun setup starts around $50 and goes up to about $5,000.

Editing Software

The last piece in this puzzle is the editing software. Again, there are many choices depending on what you want to accomplish. Apple iMovie comes with the OS on your machine and is a very basic program to get started. For PC-based machines, there is a basic editing tool included with the OS that can introduce you to the process.

My recommendation for editing software is based on my experience as managing photographer at F+W Media. When we made the transition to video production, we chose Apple's Final Cut Pro, due partly to price and because of its reputation and use in major Hollywood productions. Later, Apple updated to Final Cut Pro X, which was a big disappointment and has really affected the market share Apple has in video editing.

As our workload grew, and we needed to upgrade our editing capabilities, we decided to switch to Adobe's Production Premium. The vast majority of photographers use Adobe products every day, so, if you can afford it, I strongly recommend going with Adobe Premier Pro. There is a less expensive Elements version of Premiere Pro, which may be a good start point, but the full version is quickly becoming the industry standard and offers everything you will need and more. On Adobe's new subscription model, it runs at about $19.99 a month for the stand-alone version, or, since you most likely use Photoshop and other Adobe products already, you can subscribe to the entire Creative Cloud for $49.99 a month. This includes all the tools you need for both your still photography and any video production you may run into.

Learning and mastering the lingo and how the tools work will require commitment. But, again, one of the advantages of using Adobe products is that the setup, tools and workflow are similar to those of Photoshop, making the learning curve a bit less challenging.

Video is here to stay, so adding the necessary skills and equipment to your business is a very smart decision if you want to grow. Whether you jump in with both feet or take it in small bites, it is time to seriously evaluate your present clients and where you want to go in the world of photography. My guess is that you will see the viability of adding video services to your offerings, and, once you do, your business will experience the growth in clients and revenue we all want.

ROWLAND EGERTON

From Still Photography to Motion Picture Rigging

by Luke McLaughlin and Neely McLaughlin

During the late 1980s, Rowland Egerton was working for a road construction company that built interstate highways. During the winter, the company would lay off its workers, and Egerton used this time to learn photography, taking an adult continuing education class. A guest speaker at one of the classes told him that the commercial photography program at Jefferson Community College in Louisville, Kentucky, would teach him about the commercial market in photography. Egerton explains, "So, the next winter, I decided to take a couple of classes at Jefferson Community College while I was laid off, and I got even more excited about photography. And so, at the end, when I got called back to work, I told my wife I wasn't going back. I was going to go to school and study photography. Shortly after that we were divorced."

Egerton is now one of the owners of Hellfire Rigging, a specialist camera and electrical rigging company in the motion picture industry. He spent much of his career as a photographer, and used the expertise that he gained from his photography experience to transfer from still photography work into film.

Taking Classes

Egerton says that he had a positive experience in school, but that he learned more on the job than in the classroom. He notes, "I always found out that in school you're only as up to date

Luke McLaughlin is an American writer based in Oxford, England. In addition to writing about art and music, he designs independent games and music apps.

Neely McLaughlin is a writer and visiting assistant professor of English at the University of Cincinnati, Blue Ash, in Cincinnati, Ohio.

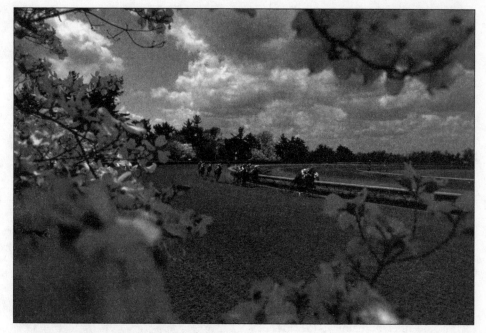

In the evenings, after his classes, Egerton learned photography tricks not in the textbooks by working for a photographer and graphic designer.

as when your instructor got out of that world and moved to teaching." While he was going to school, he was working as a photography assistant for a photographer and a graphic designer. "Some of the projects that we were doing in the street where we were working were the same that we were doing in school," says Egerton, "but the way that we went about them in the present day and the way that he was teaching us was two different ways. So we kind of clashed but we really ended up being good buddies in the end because he saw that I was really serious about what I was trying to do."

Egerton had additional motivation to work hard and start a career because he was a mature student and already had bills to pay, including the cost of the classes he was taking. "I wanted to get as much out of it as I could, and I would go from there straight to work and work 6 or 7, 8 hours, whatever it took." When he was offered his first job as a photographer, his instructor advised him to go ahead and take the job. Egerton completed the photography course on his own time while working as a photographer.

A Nightmare

Egerton's first job was not the kind of work he had hoped for, but he saw it as a stepping stone to the career that he wanted. He explains, "It was a catalog factory. It was so depressing. It was just shooting cheesy product on plain background and just, over and over, day in

day out, the same thing. It was really terrible. So I kept looking around for jobs." After taking one more disappointing job, Egerton finally got the break that he had been working towards. One day, in a local photography shop, he met Michael Brohm, a photographer on the board of directors of the commercial photography course that he was enrolled in. Egerton asked Brohm if he needed an assistant, and eventually managed to get an interview.

Egerton learned on the job, shooting and developing countless rolls of film. They often shot and developed slide film, which has a very low tolerance for incorrect exposure, but offers exceptional color quality. He learned how to tweak the development process and use different chemicals to bring out different colors in the days before computer color correction was commonplace.

With Brohm, Egerton photographed the Kentucky Derby, famous for lasting only two minutes. To photograph such an event, every second must be perfectly planned, and every shot must be planned in advance in order to get the settings exactly right for each shot. "When Michael and I would go out and shoot the Kentucky Derby, we would go out all week, and all I would do all week is practice. Practice exposure and reading the meter," Egerton recalls. After shooting at the racetrack during the day, at

His first few jobs were disappointing, but Egerton knew that if he kept working he would be able to find more rewarding work.

night they would develop the film and analyze the results. The advent of digital photography changed all of this and changed the shape of the photography industry.

The Digital Age

A new generation of digital photographers come along and started offering to shoot a job for half of what the traditional photographers like Egerton would have charged. They might

not have years of dark room experience, but they didn't need it. They could edit their photographs on a computer. Faced with having to replace all of his equipment in order to remain competitive, Egerton decided to try something new. He moved to the Caribbean and took up underwater photography. "I thought underwater photography is cool; I need to learn how to scuba dive first. So I went and met those guys and learned how to scuba dive. Through that, I became a scuba instructor, and that was a way to subsidize my diving habit and my diving photography habit." Egerton soon realized that this was not the career he wanted. He decided to move back to Kentucky and find a new job that used some of the various skills that he had picked up along the way.

When shooting the Kentucky Derby with Michael Brohm, they would spend the week before the race practicing to make sure they would get the perfect shots during the two-minute race.

Back to the Bluegrass

Egerton returned to Kentucky and began working for Kay Milam, an independent film producer and production coordinator that he had met while shooting the Kentucky Derby. While working as a production assistant on the set of a commercial, he realized that he could be a grip and electrician, someone responsible for setting up the lighting and electrical equipment that he was familiar with from his work as a still photographer.

For the next job, Milam hired Egerton as a grip/electrician, and Egerton began to make contacts in the industry. He worked for a few days on the set of *Elizabethtown* (2005), a feature film set mostly in Kentucky, which required him to be a member of the International Alliance of Theatrical Stage Employees and Motion Picture Technicians (IATSE) union.

Egerton stopped working as a still photographer and started looking for jobs in the motion picture industry that would benefit from his experience as a photographer. This is the exterior White House set from *Abraham Lincoln: Vampire Hunter* (2012).

Chartered Flights

A week after he had finished his work on the film, while driving to a baseball game, he got a call from Jim Drew, one of his friends in the union, who asked him if he could fly to Oklahoma City that night to start work on a film the next day. Egerton immediately turned his car around, went home and packed his bags. He arrived in Oklahoma on an early flight the next morning, and started working the same day. After two days, he moved on with the crew to Scotts Bluff, Nebraska, this time on a chartered flight in a jet used by the Minnesota Timberwolves during the NBA season. Egerton was working for Herb Ault, one of the industry's leading grips. After this temporary assignment was over, Egerton returned to Kentucky, but now he knew what he needed to do.

Egerton began working as a grip, helping to create huge lighting setups like these 400-square-foot lightboxes and this giant green screen.

Louisiana

Egerton decided that he needed to move to somewhere where films were being made on a regular basis. At first he thought he would move to Los Angeles, but a friend told him to look into Louisiana. Egerton loaded up his truck, left enough money in the bank to make his next truck payment, and took the rest with him to New Orleans. Before leaving, he researched where all of the production offices were and booked a room for a week in an extended stay hotel. He recalls, "So I started hitting the doors and talking to people and passing my résumé around. I had a job in four days. I rented an apartment."

Egerton still has an eye for photography, and his work enables him to capture some remarkable images like this shot of Bourbon Street in New Orleans.

A New Partner

On his second job in New Orleans, Egerton met his eventual business partner, Frankie Jones, a rigging grip with years of experience setting up lighting and rigging for the rock 'n roll circuit. They worked together on films for a year until Hurricane Katrina hit and forced the New Orleans film crews to scatter and find jobs elsewhere. Later that year, Egerton got a job based on his experience with underwater photography. He heard that a state-of-the-art wave pool was being built in Shreveport, Louisiana, and was hired to work on *The Guardian* (2006). The movie featured extensive underwater scenes and required expert divers to light sets. "Because I was also a certified rescue diver and a scuba diver, it meant that I might be able to make some extra money as a rigging diver and a rigging grip," Egerton explains.

Egerton continued to work in Shreveport, sometimes on a contract for an entire film, and sometimes on a day-to-day basis. While working on a small rig on the set of *Harold & Kumar Escape from Guantanamo Bay* (2008), Egerton was offered a job as the key rigging grip on a show, and he saw an opportunity to start a partnership with Frankie Jones that led to the creation of their company, Hellfire Rigging. He recommended Jones for the job, and offered to be the best boy grip, the key grip's right-hand man.

When they were starting out, they owned almost no equipment, but they weren't in a position to turn down work. Egerton explains, "We told them we had all

This immense 1,400-square-foot green screen makes live actors look like miniatures.

Egerton can't be afraid of heights setting up a 2,400-square-foot blue screen with a 180-foot-tall crane.

of this stuff, and they said okay, and we were really glad that they didn't ask to see it, because we didn't have it, and they wrote us a check for $1,950 every week. Every week we would take that check and buy as much stuff as we could. By the end of the show, we had quite a little bit of stuff."

Their friends in the industry helped them out and offered them discounted rental of equipment. Egerton recalls, "The guy Dink Adams at the rental house would say, 'Am I just giving them to you, or am I renting them to you?' and I'd say, 'You can rent them to us.' And he would rent us a whole complement of ladders for the whole show for like sixty bucks, you know? They wanted to see us succeed because we were working really hard."

They worked on six shows back to back, continuing to buy and rent equipment. Egerton noticed that renting out equipment was a lucrative area in the motion picture industry. He explains, "You rent them the gear, and then they send you a check every week for the rental. You're not even working on the job; your gear is working for you."

They soon needed a bigger truck to move their equipment from job to job. Not being able to get to the equipment they needed quickly was slowing them down. Egerton explains, "So while we are doing *Jonah Hex* (2010), we run into this guy who has a line on this company in California that is taking semi trailers and making production vans out of them." Initially, Egerton was worried about the cost of such a large vehicle, but Jones, his partner, told

Spanish moss drifts in front of a blue screen on the set of *Abraham Lincoln: Vampire Hunter* (2012).

Egerton takes a break on the *Looper* (2012) set.

him the expense was necessary if they wanted to continue to grow. "We paid it off in 25 months," Egerton recalls.

Back to New Orleans

By now, New Orleans had started to recover from Hurricane Katrina, and business was slowing down in Shreveport. "So we move back to New Orleans and everybody goes, 'Oh my god, I am so glad that you are back,'" Egerton remembers. In New Orleans, they work constantly, the business continues to grow, and they lease a 3,500-square-foot warehouse to store their equipment.

It takes a lot of light to film a movie, and Egerton's company offers a complete lighting package to the motion picture industry.

From the start, they were determined not to go into debt, but to invest the business's profits directly back into more equipment. "We don't owe anybody anything. It makes it really easy to do business," says Egerton. They now prefer rigging for television series. He explains, "You can do three series at once. You can go and hang the show because they will have a stage. You figure out what their lighting plan is. You hang a grid over the whole thing, or however you want to do it, and you rent them the gear, and then they send you a check every week for the rental."

Egerton says the company has now outgrown its warehouse. "Now we could move into an 8,000-square-foot place. We have more stuff than we can fit into a warehouse, and we keep getting bigger and bigger, and it's all paid for." But this business is not something he could have started without gaining the experience that he got from his previous work. He explains, "All of the jobs that I have had in my whole life, all of the skills that I learned in my various jobs have brought me to where I am now. The photography end, it gave me a leg up in the motion picture industry because I understood the ways that light interacted with film and different kinds of film stocks, tungsten and daylight film, etc. It helped me learn how to light motion pictures easier than some of the guys I was working with because I already had that experience as a still photographer. So it was a little easier to rise up from the basement, so to speak, and make my way onto a permanent crew before we started our business."

ADAM LADD

HOW Magazine Art Director

..

by Ric Deliantoni

Adam Ladd is F+W Media's newest art director at *HOW*, one of the leading magazines in the graphic design industry. As a photo buyer, Ladd provides a unique perspective and view of the photography business as it stands today. After getting insight into his thoughts and style, I'm confident Ladd will shine in this new role. I am impressed with his outlook and his passion when it comes to photography and the overuse of stock imagery in today's design work. Ladd's attitude bodes well for up and coming photographers.

Tell us about yourself and your career.

I've been a professional in the design industry for nine years as a graphic designer and art director. The first five years were spent as an in-house designer for a large, contemporary church in Cincinnati. The next three to four years were spent in a variety of contract and freelance positions, collaborating with firms and working with my own clients. January of 2013 I started at *HOW* magazine as art director and designer.

Do you have a formal arts education?

A 2-year diploma and portfolio in advertising and design to get me in the door. I grew from there.

Ric Deliantoni is a professional photographer and director with thirty years of experience, with a focus on still-life and lifestyle imagery for advertising, design and publishing. He has developed a unique style that has been described as impressionistic and bold. Ric has also spent much of his career teaching and mentoring students of all levels to better themselves as artists.

How would you rate an education vs. a mentor program?

I had both, education first from a small portfolio school, then a mentor/friend in my art director at my first job. He helped me immensely to grow.

Do you have a mentor or someone you look up to?

Not personally, but I do look up to many professionals, both current and from the past. I do a lot of research to stay current and knowledgeable of where the design industry has been.

What inspires you to create?

It is hard for me to just go to town on a blank canvas (like an artist). I am indeed more of a designer in that I need a problem to solve, and that gets the creative juices pumping.

Talk a bit about your creative process and how you approach your assignment work.

As often as I can, I try to make sure I understand the need thoroughly before I start, whether that means asking a bunch of questions or getting a creative brief in place. From that point I will do a lot of pencil sketching to rough out quick, instinctual ideas. Then I massage out the ones that seem to have potential.

Does this differ when you create for your portfolio or for personal projects?

Not really. The process is pretty similar in how I approach them. There is often more creative latitude in personal projects, but client projects are more "real-world" and can sometimes carry more weight for my portfolio. I do show a mix of both personal and client projects, and try to limit it to only the best stuff.

What are your thoughts on specializing in specific fields, and why have you come to these conclusions?

I think it is very important to be a specialist. Your name becomes synonymous with that area, and it's typically what you're most passionate about. I want to be an expert in what I'm most passionate about in the design field. But you can't be too narrow-minded.

Talk a bit about how you like to view photography from prospective vendors.

Though I, unfortunately, have to throw away a lot of them, I like seeing photos that are mailed to me because it feels a little more pure and shows me how well the photo can be produced when printed. A clean online portfolio is always good, too.

Talk about your thoughts on effective marketing. What do you feel works and what falls short?

If you send me that postcard in the mail that clearly displays your style, and it intrigues, I need to easily be able to see more. So make sure your portfolio online is current and easy for me to see your work and find out more about you as a professional photographer.

What are your thoughts on social networking in the marketing process?

Crucial. If I want to research someone more, I don't want to go digging for scraps. They need to be very present so that I find what I'm looking for quickly. Being active in social media (namely Twitter) helps exposure. Make sure that if you're trying to represent your business that you keep it professional. I don't want to sort through a bunch of random posts that are irrelevant to your profession.

Talk about your experiences with artist's representatives, if any.

The reps do a good job to help an artist's exposure, but it can also be a pain because of the overhead costs that are factored into the artist's fees to pay their rep. The backend of invoices and communication can be a little trickier too. But, if your work is good enough, it really is not too much of a factor. I'll want you regardless.

When you are looking to hire a photographer, what steps do you take in this search?

I almost always check out their work online first, then contact them usually via e-mail if I'm confident they will be a good fit for a project. I'll already have a set budget and timeline to discuss with them.

What are your thoughts on professional associations, and do you belong to any?

They are good as they can provide a sense of credibility. I am affiliated with some, but do not actually belong.

What are the reasons for this decision?

Sometimes it's just a matter of costs or if I have the time to maintain a relationship with the association.

In recent years there has been some talk about developing a set of professional standards to govern the business of photography. What are your thoughts on this subject?

It's a slippery slope to implement standards, but the ride can prove promising as technical things like file formatting, resolution, color spaces, etc. can become more consistent for people like me, who may deal with a bunch of different images from different sources.

What are your thoughts on the subject of licensing photographers, akin to other professionals such as contractors, CPAs, and the like?

I don't see a problem with it. You're getting paid for work on a hopefully more regular basis.

Do you feel participating in competitions affects the career path positively, win or lose?

It helps to see a person has won some awards and been recognized by peers who understand the profession. So I think competitions are a good thing. If you lose, you just don't mention it.

What are your thoughts on the digital age, and how has it affected the industry as a whole?

I know as a designer, I feel for photographers. We fight the same battles. A client can too easily find someone posing as a professional to do work cheaper. But the quality is poor. This hurts our credibility and saturates the market with too many cheap alternatives. It changes the general population's perception of how much things should cost. We become devalued. But, at the same time, if you need to make some money, there are now more outlets to do so. Plus, if your work is good, there are people who recognize that. You just need to focus your marketing efforts on them.

Talk a bit about your workflow, your process, and the tools you use.

I primarily use Adobe InDesign, Photoshop, and Illustrator. If it's an editorial design I'm working on, I make sure to do it in InDesign (which is made to handle multiple pages and gives you preflight quality checks). Some people like to place photos in Illustrator, I just don't think that is a best practice. I also try to keep the original image saved if I need to manipulate it. I don't want to save over top of it in case I need to refer back.

Give us a list of what tools you use to create your work, both hard and software.

Apple Mac computer. Adobe Creative Suite (InDesign, Photoshop, Illustrator).

Have you had the occasion to work on any digital video projects?

I've done a few personal video projects for self-promotion efforts, nothing fancy.

What are your thoughts on how digital video may affect your work in the future?

With iPads and e-readers, it's hard to avoid some element of motion. People expect it. So quality video is important.

Do you have any parting words of wisdom you would like to share about the future of the photography profession?

For the photographers who care about their craft, please don't sell out. While I appreciate a good stock image as much as the next for the reasons you would typically list, it is at the same time hard to find someone who loves their craft on those sites. And the images reflect that. It also stinks when you see a stock image that you used appear on someone else's material. So those who can create custom imagery, take direction, and provide expertise are of great value. Please keep fighting for quality and distinction as things that those who need images should value.

MATTHEW BRANDT

Secret Ingredients

..

by Luke McLaughlin

Matthew Brandt has made photographic prints with Chinese barbecue sauce, peanut butter and jelly, ketchup and mustard, mole sauce, coffee, circuit boards, inkjets, dust, and even a swarm of bees ground up into a fine powder. "I have pretty much used everything that I can get my hands on," says Brandt, a Los Angeles-based photographer. While experimenting with various ingredients to recreate the CMYK color spectrum, he filled his refrigerator with sauces. "I was having better meals at the same time, too," he laughs.

Brandt has been involved in the process of creating photographic prints from infancy. His father was a commercial photographer, and he has baby photos of himself holding up test cards. But, while he was growing up, he didn't want to be a photographer. Though he often helped his father with the process and learned to set up lighting for his work as a commercial photographer, it took him years to realize that he would be, or even was a photographer. Brandt explains, "I grew up around photography but never really embraced it as an art form. I remember people would ask, 'Oh, are you going to be a photographer like your dad?' and I would say, 'No way! I'm just going to paint and draw.'"

This early exposure to photography meant that Brandt took quickly to the technical side of photography. He already knew a lot of the technical aspects of photography such as f-stops, lighting, and the basic principles of composition. He notes, "I guess I already knew that stuff without necessarily studying it, from just hanging around my dad's studio, helping him."

Eventually, he began to think of himself as a photographer. He explains, "Later, when I moved away from home to go to school in New York, I really started to think about and do

Luke McLaughlin is an American writer based in Oxford, England. In addition to writing about art and music, he designs independent games and music apps.

Here Brandt uses a water sample from the lake in this picture to strip away some of the layers from the color print, creating a watercolor-like interplay between the layers.
Matthew Brandt, *American Lake, WA G4*, 2011
© Matthew Brandt, Courtesy Yossi Milo Gallery, New York

photography and take it a little more seriously. I studied with some interesting people who used photography in, for lack of a better word, an artistic way."

He started working as an assistant to the photographer Robert Polodori, who specializes in architectural photography. Brandt recalls, "He does a sort of cross between fine art and commercial work. I did a lot of his assisting. I learned some tricks on how to make nice prints. In school I was doing my own photography as an undergraduate at Cooper Union." Brandt became obsessed with materials and developed techniques to incorporate different materials into his work. "I have always been doing photography, but now in a sort of gray area. Doing photo-based work, but then a lot of it involves drawing or sculpture, things like that. Using other materials to make more material-related photography."

Education

While completing his BFA, Brandt realized by watching his teachers and the other students work that he could always improve. He explains, "The environment of always working on something and always trying to push it, the constant critiques always helped, definitely."

Brandt learned how the rigid lines of architecture could be the subject of artistic photography while working as an assistant to Robert Polodori.
Matthew Brandt
Caloptima City Parkway (East) Suite 400, 2012
© Matthew Brandt, Courtesy Yossi Milo Gallery, New York

He would often incorporate photography into his work for sculpture classes, and started to think about photography in a different way. He became influenced by the tight, conceptual style in New York, and started to think about the responsibility of making objects and putting more things into the world. After completing his BFA, he continued working for Polodori. He was happy with his job and would have continued, if his MFA application to UCLA, the only school he applied to, had not been accepted.

Back Home

Brandt says his MFA allowed him to focus on his own practice. He had moved back in with his parents and was able to do exactly what he wanted artistically. In addition, he was able to do a lot of networking and learn how the business side of the art market works and learn about the gallery world. "I had no idea," he recalls, "after doing an MFA you start to realize 'oh, you sell it for this much,' and so forth."

Brandt was also exposed to the different art world in Los Angeles. He explains, "When I was in New York, there was a dominant interest in conceptually tight work. Real estate is scarce in New York, so you make smaller work, and you make it more deliberate and more conceptual." This all changed on the West Coast. "In L.A., I got a bigger studio space, and you learn to fill that pretty fast. I became more experimental, and I had room to do whatever I wanted," Brandt recalls. He soon started to fill his larger studio space with objects that he collected, including some Chia pets and a box of dead bees that he had collected one day at the beach.

The Process: New Materials and Old Techniques

Brandt's work explores the technical process of developing photographs that he first learned from his father. Over the years he has learned to develop photographs with a wide variety of methods, both traditional and modern. Much of Brandt's work incorporates part of the subject into the development of the image itself. This has led to experiments with a wide

Some of Brandt's techniques seem destructive, but he is able to create new shapes, lines, swirls, and colors in photographs that he has already taken.
Matthew Brandt, *American Lake, WA F6*, 2011
© Matthew Brandt, Courtesy Yossi Milo Gallery, New York

variety of photography techniques that are almost completely extinct. He combines these antiquated techniques with high-tech shooting, using a high-resolution digital camera and then stitching together multiple images to form an even higher resolution image.

Brandt does not like to rely too much on technical tricks to make an artistic statement. He says that images should be satisfying in and of itself, though knowledge of some of the process can add to the viewer's understanding: "I feel like it doesn't necessarily need a photographic language. I like the ambiguities in the mysteries of photography in understanding my work. Some people don't know how a silver gelatin print is made, but they know that there is some sort of process. There is some sort of chemistry involved." He feels that despite, or even because of the digital camera revolution, people now appreciate hand-printing as a process.

The nineteenth-century style of gum bichromate printing allows Brandt to use almost anything to develop an image. Brandt explains, "You make a light sensitive gel out of potassium bichromate and gum Arabic, and they used to use a watercolor to develop the image. Instead of using watercolor, I figured that dust [from the building subject] would work just

Brandt used the dust from this office building to create this print, using the old-fashioned gum bichromate print-making technique.
Matthew Brandt
Caloptima City Parkway (West) Suite 400, 2012
© Matthew Brandt, Courtesy Yossi Milo Gallery, New York

as good as a pigment. I used the same process to print the photographs of bees, but, instead of using dust that I swept from the building, I used ground-up bees."

Architectural Photography

Brandt has continued to explore architectural photography using his own techniques and methods. He recalls, "For the architectural photographs, I was looking for buildings with a reflective panopticon corporate mirrored facade." He feels that the building is about power structure: "I can see you, but you can't see me." He continues, "I was interested in this architecture as a side note, but just decided to photograph it, and it seemed appropriate to print it with its own dust." His images of a glass cube office building show a structure emerging from a foreground of trees, with the trees reflecting in the surface of the building.

Brandt's interest in structures continued from the hivelike architecture of corporate America to his bee photography. Inside a hive, bees create architectural, geometric forms, but outside they move in a chaotic swarm. For this series, Brandt attempted to recreate the illusion of randomness of a swarm of bees by carefully arranging hundreds of dead bees he had collected.

Brandt recalls the way he collected the dead bees: "I was on the beach and I saw all of these bees that were speckled along the beach, and I thought it was such a surreal image. I had been reading about colony collapse in the headlines, and people were freaking out about the apocalyptic situation that could happen if all of the bees died." He didn't do anything with the bees for about a year. Later, when he was reading about gum bichromate, he realized that he could potentially make a picture with bees. His experiments resulted in the series *Honeybees*.

Most of Brandt's bee photography shows the bees carefully arranged, but, for years, they were just a pile of dead bees in a box in his studio. "It is interesting to think of them as still lifes," he notes, "I photograph them laying there." Recently he has been getting more bees from honey farms in California. Brandt remarks, "I had this huge heap of bees and decided to just photograph it. The other ones that look a bit more animated are composed as swarms of bees, so very much they are like still lifes. I am sure if you flipped the picture around, it would just look like a bunch of dead bees. They are just so fragile."

Brandt realized that he could continue his theme of using part of the subject to develop an image with a series of photographs printed with ground-up bees. Matthew Brandt, *Bees of Bees 3*, 2012 © Matthew Brandt, Courtesy Yossi Milo Gallery, New York

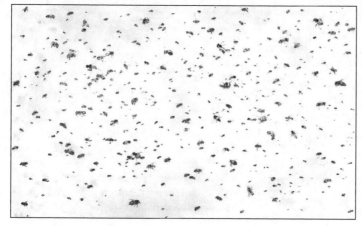

*From one angle, the carefully arranged bees seem lifelike, but, from another, they are merely empty shells. Matthew Brandt, *Bees of Bees 2*, 2012 © Matthew Brandt, Courtesy Yossi Milo Gallery, New York

Making Paper

Not content with simply printing with substances derived from the subject of his photography, Brandt, for his *Trees* series, collected fallen branches to make the paper upon which he would print the images of the branches' parent trees. Brandt recalls, "The trees were my attempt at making paper. I went to George Bush Park and found this ... sprawling area of land with trees planted out like polka dots. As I was photographing each tree, I collected branches and tree material that I found on the ground around me." He later ground up the branches and made paper. To make the pigment for the prints, Brandt burned some of the wood he had collected to make charcoal. Each tree image is made almost entirely of the tree pictured. He observes, "It ended up being a labor-intensive project that took me three or four years to do. The subject of George Bush trees seemed to be appropriate to me. But, in some ways, it just happened to be like that. I went to George Bush Park because I liked the loaded content of the name."

Lakes

After working with nineteenth-century techniques such as salt paper and gum bichromate printing, Brandt moved on to twentieth-century technology with his *Lakes and Reservoirs* series, using chromogenic color prints or C-prints. He explains, "I was interested in using the subject's fluid to make its own image. It was about the interaction between the subject and the photograph. I guess that is a theme in a lot of my work."

Brandt had collected water from various places for salted paper prints, and he was learning about the complicated nature and technical genius in color photography. He started making his own C-prints and learning how color photographs are made. He recalls, "It seemed to make sense to deconstruct that, so I tested it out. I took a C-print and put it in lake water, and it just happened to break apart in an interesting way." Brandt is still making this type of print. He notes, "The exciting thing about it is … I don't really know exactly what is going to happen, so it is sort of a surprise each time, and I think that is what keeps me coming back to it."

Brandt's photographs of trees consist almost exclusively of materials collected from the trees themselves, using charcoal and paper made from the trees.
Matthew Brandt, *Tree 38*, 2009–2011
© Matthew Brandt, Courtesy Yossi Milo Gallery, New York

Brandt has a structural interest in how images are made, and he was able to explore this with traditional C-prints by breaking up the image. He explains, "Literally soaking the C-print in lake water was a way to investigate the inherent 'magical' qualities of color photography. It's amazing to me to know that a regular traditional color photograph is layers of red, blue and yellow on this super-miniscule thin film layer and how that becomes a photograph."

Imperfections and Layers

Some of Brandt's earlier work dealt with the imperfections inherent in an experimental process. There were accidents that happened with developing salt-water prints of bodies of water. He recalls, "Sometimes the image would be really light because maybe there isn't enough salt content in that lake to make its own image. There is already this kind of collaboration with the subject, and this is just more exaggerated." Color adds complexity to the process

of developing photographs, and Brandt is able to use this complexity to create images that work on multiple layers both visually and conceptually.

Brandt's work with the layers of C-prints walks the line between constructive and destructive. He says although he often describes the process as destructive, to him, it is ultimately more a constructive process. He explains, "It's amazing how it looks when you strip away the different layers. It is very much like the principles of regular watercolor. You have the red layer mixing with the blue layer to make purples, and the blue layer mixing with the yellow layer to make greens." The individual layers of color would normally go unnoticed, but dissolving part of the layers allows the viewer to see behind the facade of the original image.

The distortion achieved by pouring lake water on this photograph of a lake echoes the ripples and reflections of the surface of a lake.
Matthew Brandt, *Big Bear Lake, CA 4*, 2012
© Matthew Brandt, Courtesy Yossi Milo Gallery, New York

In this image, the lake water pitted the surface of the print, compressing the color spectrum and creating a pointillist-style texture.
Matthew Brandt, *Mary's Lake, MT 10*, 2012
© Matthew Brandt, Courtesy Yossi Milo Gallery, New York

CONSUMER PUBLICATIONS

Research is the key to selling any kind of photography. If you want your work to appear in a consumer publication, you're in luck. Magazines are the easiest market to research because they're available on newsstands and at the library and at your doctor's office and . . . you get the picture. So, do your homework. Before you send your query or cover letter and samples, and before you drop off your portfolio on the prescribed day, look at a copy of the magazine. The library is a good place to see sample copies because they're free, and there will be at least a year's worth of back issues right on the shelf.

Once you've read a few issues and feel confident your work is appropriate for a particular magazine, it's time to hit the keyboard. Most first submissions take the form of a query or cover letter and samples. So, what kind of letter do you send? That depends on what kind of work you're selling. If you simply want to let an editor know you're available for assignments or have a list of stock images appropriate for the publication, send a cover letter, a short business letter that introduces you and your work and tells the editor why your photos are right for the magazine. If you have an idea for a photo essay or plan to provide the text and photos for an article, you should send a query letter, a one- to one-and-a-half-page letter explaining your story or essay idea and why you're qualified to shoot it. You can send your query letter through the U.S. postal system, or you can e-mail it along with a few JPEG samples of your work. Check the listing for the magazine to see how they prefer to be contacted initially.

Both kinds of letters can include a brief list of publication credits and any other relevant information about yourself. Both also should include a sample of your work—a tearsheet, a slide or a printed piece, but never an original negative. Be sure your sample photo is of something the magazine might publish. It will be difficult for the editor of a biking magazine to appreciate your skills if you send a sample of your fashion work.

If your letter piques the interest of an editor, she may want to see more. If you live near the editorial office, you might be able to schedule an appointment to show your portfolio in person. Or you can inquire about the drop-off policy—many magazines have a day or two each week when artists can leave their portfolios for art directors to review. If you're in Wichita and the magazine is in New York, you'll have to send your portfolio through the mail. Consider using FedEx or UPS; both have tracking services that can locate your book if it gets waylaid on its journey. If the publication accepts images in a digital format (most do these days), you can send more samples of your work via e-mail or on a CD—whatever the publication prefers. Make sure you ask first. Better yet, if you have a website, you can provide the photo buyer with the link.

To make your search for markets easier, consult the Subject Index. The index is divided into topics, and markets are listed according to the types of photographs they want to see.

⑨ ○ 4-WHEEL ATV ACTION

25233 Anza Dr., Valencia CA 91355. (661)295-1910. **Fax:** (661)295-1278. **E-mail:** atv@hi-torque.com. **Website:** www.4wheelatv.com. **Contact:** Joe Kosch, editor-at-large (joeatvaction@yahoo.com); Tim Tolleson, editor (timt@hi-torque.com). Estab. 1986. Circ. 65,000. Monthly. Emphasizing all-terrain vehicles and anything closely related to them.

NEEDS Buys 4 photos from freelancers/issue; 50 photos/year. Needs photos of adventure events, hobbies, sports. "We are interested only in ATVs and UTVs and very closely related ride-on machines with more than two wheels—no cars, trucks, buggies or motorcycles. We're looking for scenic riding areas with ATVs or UTVs in every shot, plus unusual or great looking ATVs." Reviews photos with or without a manuscript. Model/property release preferred. Photo captions preferred; include location, names.

SPECS Uses 8×10 glossy color prints; 35mm transparencies. Accepts images in digital format. Send via ZIP, e-mail as JPEG files at 300 dpi.

MAKING CONTACT & TERMS Send query letter with photocopies or e-mail JPEGs. Does not keep samples on file; cannot return material. Responds only if interested; send nonreturnable samples. Simultaneous submissions and previously published work OK. Pays $50-100 for color cover; $15-25 for color inside. Credit line given. Buys one-time rights, first rights; negotiable.

TIPS "*4-Wheel ATV Action* offers a good opportunity for amateur but serious photographers to get a credit line in a national publication."

⑨ ◑ 540 RIDER

TMB Publications, P.O. Box 1156, Lake Oswego OR 97035. (503)236-2524. **Fax:** (503)620-3800. **E-mail:** dank@youthrunner.com. **Website:** www.540rider. com. **Contact:** Dan Kesterson, publisher. Estab. 2002. Circ. 100,000. Quarterly. Emphasizes action sports for youth: snowboarding, skateboarding and other board sports. Features high school teams, results, events, training, "and kids that just like to ride." Sample copy available with 8×10 SASE and 75¢ first-class postage. Photo guidelines available by e-mail request or online.

NEEDS Buys 10-20 photos from freelancers/issue; 40-80 photos/year. Needs photos of sports. Reviews photos with or without a manuscript. Model/property release preferred. Photo captions preferred.

SPECS Accepts images in digital format only. Send via CD as TIFF files at 300 dpi.

MAKING CONTACT & TERMS Send query via e-mail. Provide self-promotion piece to be kept on file for possible future assignments. Responds only if interested; send nonreturnable samples. Simultaneous submissions OK. Pays $25 minimum for b&w and color covers and inside photos. Pays on publication. Credit line given. Buys all rights.

TIPS "Send an e-mail ahead of time to discuss. Send us stuff that even you don't like because we just might like it."

◐ ⑨ ◑ AAA MIDWEST TRAVELER

AAA Auto Club of Missouri, 12901 N. 40 Dr., St. Louis MO 63141. (314)523-7350 ext. 6301. **Fax:** (314)523-6982. **E-mail:** dreinhardt@aaamissouri.com. **Website:** www.aaa.com/traveler. **Contact:** Deborah Reinhardt, managing editor. Estab. 1901. Circ. 500,000. Bimonthly. Emphasizes travel and driving safety. Readers are members of the Auto Club of Missouri. Sample copy and photo guidelines free with SASE (use large manila envelope) or online.

NEEDS Buys 3-5 photos/issue. "We use four-color photos inside to accompany specific articles. Our magazine covers topics of general interest, historical (of Midwest regional interest), profile travel, car care and driving tips. Our covers are full-color photos mainly corresponding to an article inside. Except for cover shots, we use freelance photos only to accompany specific articles." Model release preferred. Photo captions required.

SPECS Accepts images in digital format. Send via ZIP as TIFF files at minimum of 300 dpi.

MAKING CONTACT & TERMS Send query letter with résumé of credits and list of stock photo subjects. Does not keep samples on file; include SASE for return of material. Responds in 1 month. Simultaneous submissions and previously published work OK. Pays $400 for color cover; $75-200 for color inside. **Pays on acceptance.** Credit line given. Buys first, second and electronic rights.

TIPS "Send an 8½×11 SASE for sample copies and study the type of covers and inside work we use. Photo needs driven by an editorial calendar/schedule. Write to request a copy and include SASE."

⑨ ◑ ADIRONDACK LIFE

P.O. Box 410, Route 9N, Jay NY 12941-0410. (518)946-2191. **Fax:** (518)946-7461. **E-mail:** aledit@adirondack

life.com; astoltie@adirondacklife.com; alprod@ad
irondacklife.com. **Website:** www.adirondacklife.
com. **Contact:** Annie Stoltie editor; Kelly Hofschnei-
der, photo editor. Estab. 1970. Circ. 50,000.

NEEDS Photos of environmental, landscapes/scenics,
wildlife. Reviews photos with or without a manu-
script.

SPECS Accepts color transparencies of any size; b&w
prints no larger than 8×10. Digital images output to
paper may be submitted.

MAKING CONTACT & TERMS Pays $400 maxi-
mum for color cover. Pays $150 maximum for b&w
or color inside. Credit line given.

ADVENTURE CYCLIST

Adventure Cycling Assn., Box 8308, Missoula MT
59807. (406)721-1776, ext. 222. **Fax:** (406)721-8754.
E-mail: magazine@adventurecycling.org. **Website:**
www.adventurecycling.org. **Contact:** Greg Siple art
director; Michael Deme editor. Estab. 1975. Circ.
45,500.

NEEDS People riding bicycles, cultural, detail, archi-
tectural, people, historic, vertical, horizontal. Identifi-
cation of subjects, model releases required.

SPECS Reviews color transparencies and digital files.

TIPS Sample copy and photo guidelines free with
9×12 SAE and 4 first-class stamps. Guidelines also
available on website at www.adventurecycling.org/
mag/submissions.cfm.

ADVOCATE, PKA'S PUBLICATION

1881 Little Westkill Rd., Prattsville NY 12468.
(518)299-3103. **Website:** Advocatepka.weebly.com;
www.facebook.com/Advocate/PKAPublications;
www.facebook.com/GaitedHorseAssociation. ad-
voad@localnet.com. **Contact:** Patricia Keller, pub-
lisher. Estab. 1987. Circ. 7,000.

NEEDS Equine of strong interest but look at many
different types and styles.

SPECS Accepts print photos in b&w and color, no
larger than 8×10.

O AFRICAN AMERICAN GOLFER'S DIGEST

80 Wall St., Suite 720, New York NY 10005. (212)571-
6559. **E-mail:** debertcook@aol.com. **Website:** www.
africanamericangolfersdigest.com. **Contact:** Debert
Cook, managing editor. Estab. 2003. Circ. 20,000.
Quarterly. Emphasizes golf lifestyle health, travel
destinations, golfer profiles, golf equipment reviews.
Editorial content focuses on the "interests of our mar-
ket demographic of African Americans and categories
of high interest to them—historical, artistic, musi-
cal, educational (higher learning), automotive sports,
fashion, entertainment." Sample copy available for $6.

NEEDS Photos of golf, golfers, automobiles, enter-
tainment, health/fitness/beauty, sports. Interested
in lifestyle.

SPECS Accepts images in digital format. Send JPEG
or GIF files, 4×6 at 300 dpi.

TIPS Reviews photos with or without a ms.

AFRICAN PILOT

Wavelengths 10 (Pty) Ltd., 6 Barbeque Heights, 9
Dytchley Rd., Barbeque Downs, Midrand 1684
South Africa. +27 11 466-8524. **Fax:** +27 11 466 8496.
E-mail: editor@africanpilot.co.za. **Website:** www.af
ricanpilot.co.za. **Contact:** Athol Franz, editor. Estab.
2001. Circ. 7,000+ online; 6,600+ print. "*African Pilot*
is southern Africa's premier monthly aviation maga-
zine. It publishes a high-quality magazine that is well-
known and respected within the aviation community
of southern Africa. The magazine offers a number of
benefits to readers and advertisers, including a weekly
e-mail newsletter, annual service guide pilot training
supplement, executive wall calendar and an exten-
sive website that mirrors the paper edition. The maga-
zine offers clean layouts with outstanding photogra-
phy and reflects editorial professionalism as well as
a responsible approach to journalism. The magazine
offers a complete and tailored promotional solution
for all aviation businesses operating in the African
region."

MAKING CONTACT & TERMS Send e-mail with
samples. Samples are kept on file. Portfolio not re-
quired. Credit line given.

TIPS "*African Pilot* is an African aviation specific pub-
lication, and, therefore, preference is given to articles,
illustrations and photographs that have an African
theme. The entire magazine is online in exactly the
same format as the printed copy for the viewing of
our style and quality. Contact me for specific details
on our publishing requirements for work to be sub-
mitted. Articles together with a selection of about 10
thumbnail pictures to be submitted so that a decision
can be made on the relevance of the article and what
pictures are available to be used to illustrate the ar-
ticle. If we decide to go ahead with the article we will
request high-resolution images from the portfolio al-
ready submitted as thumbnails."

AKRON LIFE

Baker Media Group, 1653 Merriman Rd., Suite 116, Akron OH 44313. (330)253-0056. **Fax:** (330)253-5868. **E-mail:** info@bakermediagroup.com; editor@ bakermediagroup.com; acymerman@bakermedia group.com. **Website:** www.akronlife.com. **Contact:** Abby Cymerman, managing editor. Estab. 2002. Circ. 15,000. "*Akron Life* is a monthly lifestyles publication committed to providing information that enhances and enriches the experience of living in or visiting Akron and the surrounding region of Summit, Portage Medina and Stark counties. Each colorful, thoughtfully designed issue profiles interesting places, personalities and events in the arts, sports, entertainment, business, politics and social scene. We cover issues important to the Greater Akron area and significant trends affecting the lives of those who live here."

NEEDS Essays, general interest, historical, how-to, humor, interview photo feature travel. Query with published clips.

ⓢ ◑ ALABAMA LIVING

Alabama Rural Electric Association, 340 Techna-Center Dr., Montgomery AL 36117. (800)410-2737. **Website:** www.alabamaliving.com. **Contact:** Lenore Vickrey, editor; Michael Cornelison, art director. Estab. 1948. Circ. 400,000. Monthly. Covering topics of interest to rural and suburban Alabamians.

NEEDS Photos of Alabama specific scenes, particularly seasonal. Special photo needs include vertical scenic cover shots. Photo captions preferred; include place and date.

SPECS Accepts images in digital format. Send via CD, ZIP as EPS, JPEG files at 400 dpi.

MAKING CONTACT & TERMS Send query letter with stock list or transparencies ("dupes are fine") in negative sleeves. Keeps samples on file; include SASE for return of material. Responds in 1 month. Simultaneous submissions and previously published work OK "if previously published out-of-state."

ALARM

Alarm Press, 205 N. Michigan Ave., Suite 3200, Chicago IL 60601. (312)341-1290. **E-mail:** info@alarm press.com. **Website:** www.alarmpress.com/alarm-magazine. Published 6 times/year. "It does one thing, and it does it very well: it publishes the best new music and art. From our headquarters in a small Chicago office along with a cast of contributing writers spread across the country, we listen to thousands of CDs, view hundreds of gallery openings, and attend lectures and live concerts in order to present inspirational artists who are fueled by an honest and contagious obsession with their art."

MAKING CONTACT & TERMS Submit by e-mail with the subject line "ALARM Magazine Submissions." "Please send your work as part of the body of an e-mail; we cannot accept attachments." Alternatively, submissions may be sent by regular mail to Submissions Dept. "*ALARM* is not responsible for the return, loss of, or damage to unsolicited manuscripts, unsolicited art work, or any other unsolicited materials. Those submitting manuscripts, art work, or any other materials should not send originals." Art event listings should be e-mailed to artlistings@alarmpress. com.

ⓢⓢⓢ ALASKA

301 Arctic Slope Ave., Suite 300, Anchorage AK 99518-3035. (907)272-6070. **Fax:** (907)258-5360. **E-mail:** tim.woody@alaskamagazine.com; andy.hall@ alaskamagazine.com. **Website:** www.alaskamaga zine.com. **Contact:** Tim Woody, editor. Estab. 1935. Circ. 180,000. *Alaska* actively solicits photo-feature ideas having in-depth treatments of single subjects. The ideal photo essay would tell a story of a subject while having compelling content with vibrant color and contrast, and would include both the macro and the micro. Buys 500 photos/year, supplied mainly by freelancers. Photo captions required.

NEEDS Photographic submissions must be high-res digital images that are sharp and properly exposed. Please note: slides, transparencies and prints will not be accepted. Also, no digital composites, please. Historical b&w prints for which negatives are not available can be submitted in any size. All photo submissions will be carefully packaged before being returned. *Alaska* assumes no responsibility for unsolicited photographs.

SPECS Images made with a digital camera of 5 megapixels or better are acceptable. Images may be submitted on CD, DVD or flash drive. Photo manipulations of any kind must be clearly noted and defined. Digital composites will not be accepted.

MAKING CONTACT & TERMS Send carefully edited, captioned submission of 35mm, 2¼ ×2¼ or 4×5 transparencies. Include SASE for return of material. Also accepts images in digital format; check guide-

lines before submitting. Responds in 1 month. Send submissions to Alaska Magazine Photo Submissions.

ALTERNATIVES JOURNAL

200 University Ave. W., Waterloo ON N2L 3G1, Canada. (519)888-4505. **Fax:** (519)746-0292. **E-mail:** editor@alternativesjournal.ca; marcia@alternatives journal.ca. **Website:** www.alternativesjournal.ca. **Contact:** Eric Rumble editor; Marcia Ruby, creative director. Estab. 1971. Circ. 5,000. Bimonthly. Emphasizes environmental issues. Readers are activists, academics, professionals, policy makers. Sample copy free with 9×12 SASE and 2 first-class stamps.

> "*Alternatives* is a nonprofit organization whose contributors are all volunteer. We are able to give a small honorarium to artists and photographers. This in no way should reflect the value of the work. It symbolizes our thanks for their contribution to *Alternatives*."

NEEDS Buys 4-8 photos from freelancers/issue; 48-96 photos/year. Subjects vary widely depending on theme of each issue. "Strong action photos or topical environmental issues are needed—preferably with people. We also print animal shots. We look for positive solutions to problems and prefer to illustrate the solutions rather than the problems. Freelancers need a good background understanding of environmental issues." Check website for upcoming themes. Reviews photos with or without a ms. Photo captions preferred; include who, when, where, environmental significance of shot.

SPECS Accepts images in digital format. Send via CD, e-mail as JPEG files at 300 dpi. "E-mail your web address/electronic portfolio." Simultaneous submissions and previously published work OK. Pays on publication. Buys one-time rights; negotiable.

TIPS "You need to know the significance of your subject before you can powerfully present its visual perspective."

AMC OUTDOORS

Appalachian Mountain Club, 5 Joy St., Boston MA 02108. (617)523-0636. **Fax:** (617)523-0722. **E-mail:** amcpublications@outdoors.org. **Website:** www.outdoors.org. Estab. 1908. Circ. 70,000. Published 6 times/year. "Our 94,000 members do more than just read about the outdoors; they get out and play. More than just another regional magazine, *AMC Outdoors* provides information on hundreds of AMC-sponsored adventure and education programs. With award-winning editorial, advice on Northeast destinations and trip planning, recommendations and reviews of the latest gear, AMC chapter news and more, *AMC Outdoors* is the primary source of information about the Northeast outdoors for most of our members." Photo guidelines available at www.outdoors.org/publications/outdoors/contributor-guidelines.cfm.

NEEDS Buys 6-12 photos from freelancers/issue; 75 photos/year. Needs photos of adventure environmental, landscapes/scenics, wildlife, health/fitness/beauty, sports, travel. Other specific photo needs: people, including older adults (50+ years), being active outdoors. "We seek powerful outdoor images from the Northeast U.S., or non-location-specific action shots (hiking, skiing, snowshoeing, paddling, cycling, etc.). Our needs vary from issue to issue, based on content, but are often tied to the season."

SPECS Uses color prints or 35mm slides. Prefers images in digital format. Send via CD or e-mail as TIFF, JPEG files at 300 dpi. Low-res OK for review of digital photos.

MAKING CONTACT & TERMS Previously published work OK. Pays $300 (negotiable) for color cover; $50-100 (negotiable) for color inside. Pays on publication. Credit line given.

TIPS "We do not run images from other parts of the U.S. or from outside the U.S. unless the landscape background is 'generic.' Most of our readers live and play in the Northeast, are intimately familiar with the region in which they live, and enjoy seeing the area and activities reflected in living color in the pages of their magazines."

AMERICAN ANGLER

735 Broad St., Augusta GA 30904. (706)828-3971. **E-mail:** steve.walburn@morris.com; wayne.knight@morris.com. **Website:** www.americanangler.com. **Contact:** Steve Walburn, editor; Wayne Knight, art director. Estab. 1976. Circ. 35,000. Bimonthly. Covers fly fishing. "More how-to than where-to, but we need shots from all over. More domestic than foreign. More trout, salmon and steelhead than bass or saltwater." Photo guidelines available on website. Buys 10 photos from freelancers/issue; 60 photos/year. "Most of our photos come from writers of articles."

NEEDS Photos that convey "the spirit, essence and exhilaration of fly fishing. Always need good fish-behavioral stuff—spawning, rising, riseforms, etc."

SPECS Prefers slides or digital images via CD or e-mail at 300 dpi; must be very sharp with good contrast.
MAKING CONTACT & TERMS "We prefer to work from e-mailed queries whenever possible and you should send an e-mail outlining your article before submitting a manuscript. A query can save you the frustration and disappointment of making a futile submission, and it allows us to fine-tune an idea to suit our editorial needs. We read and respond to all queries, but expect at least a six-week wait for that response. Be patient, please. But squeak gently if you don't hear from us within 6-8 weeks. Send query letter with samples, brochure stock photo list, tearsheets. Provide résumé, business card, self-promotion piece or tearsheets to be kept on file for possible future assignments. Portfolio review by prior arrangement. Query deadline: 6-10 months prior to cover date. Submission deadline: 5 months prior to cover date. Responds in 6 weeks to queries; 1 month to samples. Simultaneous submissions considered only with notification, and previously published work OK but "only for inside 'editorial' use—not for covers, prominent feature openers, etc."
TIPS "We don't want the same old shots: grip and grin, angler casting, angler with bent rod, fish being released. Sure we need them, but there's a lot more to fly fishing. Don't send us photos that look exactly like the ones you see in most fishing magazines. Think like a storyteller. Let me know where the photos were taken, at what time of year, and anything else that's pertinent to a fly fisher."

AMERICAN ARCHAEOLOGY

The Archaeological Conservancy, 5301 Central Ave. NE #902, Albuquerque NM 87108. (505)266-9668. **Fax:** (505)266-0311. **E-mail:** tacmag@nm.net. **Website:** www.americanarchaeology.org. **Contact:** Michael Bawaya, editor; Vicki Singer, art director. Estab. 1997. Circ. 35,000. Quarterly. "We're a popular archaeology magazine. Our readers are very interested in this science. Our features cover important digs, prominent archaeologists, and most any aspect of the science. We only cover North America." Sample copies available.
SPECS Uses 35mm, 2¼×2¼, 4×5 transparencies. Accepts images in digital format.
MAKING CONTACT & TERMS Prefer digital submissions at 300 dpi or higher. Send query letter with résumé, photocopies and tearsheets. Provide résu-

mé, business card, self-promotion piece to be kept on file for possible future assignments. Responds in 2 months to queries. Previously published work OK.
TIPS "Read our magazine. Include accurate and detailed captions."

🟢 AMERICAN FITNESS

15250 Ventura Blvd., Suite 200, Sherman Oaks CA 91403. (800)446-2322, ext. 200. **E-mail:** americanfit ness@afaa.com. **Website:** www.afaa.com. **Contact:** Meg Jordan, editor. Estab. 1983. Circ. 42,900. Buys 20-40 photos from freelancers/issue; 120-240 photos/year. Assigns 90% of work. Payment is issued post-publication. Send query letter with samples, list of stock photo subjects; include SASE for return of material. Responds in 2 weeks. Simultaneous submissions and previously published work OK. Pays $10-35 for b&w or color photo; $50 for text/photo package. Pays 4-6 weeks after publication. Credit line given. Buys first North American serial rights.
NEEDS Action photography of runners, aerobic classes, swimmers, bicyclists, speedwalkers, in-liners, volleyball players, etc. Also needs food choices, babies/children/teens, celebrities, couples, multicultural, families, parents, senior fitness, people enjoying recreation, cities/urban, rural, adventure, entertainment, events, hobbies, humor, performing arts, sports, travel, medicine, product shots/still life, science. Interested in alternative process, fashion/glamour, seasonal. Model release required.
SPECS Uses b&w prints; 35mm, 2¼×2¼ transparencies. Cover: Color slides, transparencies (2" preferred size) or high-res 300 dpi, TIFF, or PDF files of at least 8.75×11.5. Interior/editorial: color slides, transparencies or high-res 300 dpi, TIFF, PDF, or JPEG files; glossy print.
TIPS "Over-40 sports leagues, youth fitness, family fitness and senior fitness are hot trends. Wants high-quality, professional photos of people participating in high-energy activities—anything that conveys the essence of a fabulous fitness lifestyle. Also accepts highly stylized studio shots to run as lead artwork for feature stories. Since we don't have a big art budget, freelancers usually submit spin-off projects from their larger photo assignments."

🟢 🟡 THE AMERICAN GARDENER

7931 E. Boulevard Dr., Alexandria VA 22308-1300. (703)768-5700. **Fax:** (703)768-7533. **E-mail:** editor@ ahs.org; myee@ahs.org. **Website:** www.ahs.org. **Con-**

tact: Mary Yee art director. Estab. 1922. Circ. 20,000. Bimonthly. "This is the official publication of the American Horticultural Society (AHS), a national, nonprofit, membership organization for gardeners, founded in 1922." Sample copy available for $5. Photo guidelines free with SASE or via e-mail request. Uses 35-50 photos/issue. Reviews photos with or without a manuscript. "Lists of plant species for which photographs are needed are sent out to a selected list of photographers approximately 10 weeks before publication. We currently have about 20 photographers on that list. Most of them have photo libraries representing thousands of species. Before adding photographers to our list, we need to determine both the quality and quantity of their collections. Therefore, we ask all photographers to submit digital samples of their work and a list indicating the types and number of plants in their collection. After reviewing both, we may decide to add the photographer to our photo call for a trial period of 6 issues (1 year)."

NEEDS Photos of plants, gardens, landscapes.

SPECS Digital images—high-res JPEG or TIFF files with a minimum size of 5×7 at 300 dpi—should be submitted on a CD or posted to an online photo gallery.

MAKING CONTACT & TERMS Send query letter with samples, stock list via mail or e-mail. Will contact for portfolio review if interested.

🟢🟢 AMERICAN HUNTER

National Rifle Association, 11250 Waples Mill Rd., Fairfax VA 22030-9400. (703)267-1336. **Fax:** (703)267-3971. **E-mail:** publications@nrahq.org; americanhunter@nrahq.org; lcromwell@nrahq.org. **Website:** www.americanhunter.org. **Contact:** J. Scott Olmsted, editor-in-chief. Circ. 1,000,000. Monthly magazine of the National Rifle Association. "*American Hunter* contains articles dealing with various sport hunting and related activities both at home and abroad. With the encouragement of the sport as a prime game management tool, emphasis is on technique sportsmanship and safety. In each issue hunting equipment and firearms are evaluated, legislative happenings affecting the sport are reported, lore and legend are retold and the business of the Association is recorded in the Official Journal section." Uses wildlife shots and hunting action scenes. Seeks general hunting stories on North American and African game.

SPECS Send via CD as TIFF, GIF, or RAW files at 300 dpi. Vertical format required for cover.

MAKING CONTACT & TERMS Sample copy and photo guidelines free with 9×12 SASE. Send material by mail for consideration; include SASE for return of material.

TIPS "Most successful photographers maintain a file in our offices so editors can select photos to fill holes when needed. We keep files on most North American big game, small game, waterfowl, upland birds, and some exotics. We need live hunting shots as well as profiles and portraits in all settings. Many times there is not enough time to call photographers for special needs. This practice puts your name in front of the editors more often and increases the chances of sales."

AMERICAN MOTORCYCLIST

American Motorcyclist Association, 13515 Yarmouth Dr., Pickerington OH 43147. (614)856-1900. **E-mail:** grassroots@ama-cycle.org. **Website:** www.americanmotorcyclist.com. **Contact:** Bill Wood, director of communications; Grant Parsons, managing editor. Estab. 1947. Circ. 260,000. Monthly. Emphasizes people involved in, and events dealing with, all aspects of motorcycling. Readers are "enthusiastic motorcyclists, investing considerable time in road riding or all aspects of the sport."

NEEDS "The cover shot is tied in with the main story or theme of that issue and generally needs to be submitted with accompanying manuscript. Show us experience in motorcycling photography, and suggest your ability to meet our editorial needs and complement our philosophy."

SPECS Prefers images in digital format. Send via CD as TIFF, GIF, JPEG files at 300 dpi.

MAKING CONTACT & TERMS Send query letter with samples to be kept on file for possible future assignments. Responds in 3 weeks.

🟢 🟡 🔵 AMERICAN TURF MONTHLY

747 Middle Neck Rd., Great Neck NY 11024. (516)773-4075. **Fax:** (516)773-2944. **E-mail:** jcorbett@americanturf.com; editor@americanturf.com. **Website:** www.americanturf.com. **Contact:** Joe Girardi, editor. Estab. 1946. Circ. 30,000. Monthly. Covers Thoroughbred horse racing, especially aimed at horseplayers and handicappers.

NEEDS Buys 10 photos from freelancers/issue; 120 photos/year. Needs photos of celebrities, racing action, horses, owners, trainers, jockeys. Reviews photos

with or without a manuscript. Photo captions preferred; include who, what, where.

SPECS Uses glossy color prints. Accepts images in digital format. Send via CD, floppy disk, ZIP as TIFF, JPEG files at 300 dpi.

MAKING CONTACT & TERMS Send query letter with CD, prints. Provide business card to be kept on file for possible future assignments. Responds only if interested; send nonreturnable samples.

TIPS "Like horses and horse racing."

ANCHOR NEWS

75 Maritime Dr., Manitowoc WI 54220. (920)684-0218; (866)724-2356. **Fax:** (920)684-0219. **E-mail:** nbishop@wisconsinmaritime.org; museum@wisconsinmaritime.org. **Website:** www.wisconsinmaritime.org. **Contact:** Norma Bishop, executive director. Circ. 1,100. Quarterly publication of the Wisconsin Maritime Museum. Emphasizes Great Lakes maritime history. Readers include learned and lay readers interested in Great Lakes history. Sample copy available with 9×12 SASE and $3 postage. Photo guidelines free with SASE.

NEEDS Uses 8-10 photos/issue; infrequently supplied by freelance photographers. Needs historic/nostalgic; personal experience; Great Lakes environmental issues, including aquatic invasive species and other topics of interest to environmental educators; and general interest articles on Great Lakes maritime topics. How-to and technical pieces and model ships and shipbuilding are OK. Special needs include historic photography or photos that show current historic trends of the Great Lakes; photos of waterfront development, bulk carriers, sailors, recreational boating, etc. Model release required. Photo captions required.

SPECS Accepts images in digital format. Send via CD, e-mail as JPEG files at 300 dpi minimum.

MAKING CONTACT & TERMS Send 4×5 or 8×10 glossy b&w prints by mail for consideration; include SASE for return of material. Simultaneous submissions and previously published work OK. Pays in copies on publication. Credit line given. Buys first North American serial rights.

TIPS "Besides historic photographs, I see a growing interest in underwater archaeology, especially on the Great Lakes, and underwater exploration—also on the Great Lakes. Sharp, clear photographs are a must. Our publication deals with a wide variety of subjects; however, we take a historical slant with our publication. Therefore, photos should be related to a historical topic in some respect. Also, there are current trends in Great Lakes shipping. A query is most helpful. This will let the photographer know exactly what we are looking for and will help save a lot of time and wasted effort."

ANIMAL TRAILS MAGAZINE

E-mail: animaltrails@yahoo.com. **Website:** animaltrailsmagazine.doodlekit.com. **Contact:** Shannon Bridget Murphy. Quarterly. "*Animal Trails* is an anchor for memories that are made as a result of experiences with animals. Through writing, photography and illustrations animals are given a voice."

NEEDS Photos of environmental, landscapes/scenics, wildlife, architecture, cities/urban, gardening, interiors/decorating, pets, religious, rural, performing arts, agriculture, product shots/still life—as related to animals. Interested in alternative process, avant garde, documentary, fashion/glamour, fine art, historical/vintage, seasonal. Reviews photos with or without a MS. Model/property release preferred.

SPECS Uses glossy or matte color and b&w prints.

MAKING CONTACT & TERMS Send query letter via e-mail or online form at website. Provide résumé, business card, self-promotion piece to be kept on file for possible future assignments. "A photograph or two is requested but not required. Illustrations and artwork are also accepted." Responds within 1 month to queries; 1 week to portfolios. Simultaneous submissions and previously published work OK. **Pays on acceptance**. Credit line given. Buys one-time rights, first rights; negotiable.

APERTURE

547 W. 27th St., 4th Floor, New York NY 10001. (212)505-5555. **E-mail:** magazine@aperture.org. **Website:** www.aperture.org. **Contact:** Michael Famighetti, managing editor. Circ. 30,000. Quarterly. Emphasizes fine-art and contemporary photography, as well as social reportage. Readers include photographers, artists, collectors, writers.

NEEDS Uses about 60 photos/issue; biannual portfolio review. Model release required. Photo captions required.

MAKING CONTACT & TERMS Submit portfolio for review in January and July; include SASE for return of material. Responds in 2 months. No payment. Credit line given.

TIPS "We are a nonprofit foundation. Do not send portfolios outside of January and July."

APOGEE PHOTO MAGAZINE

Jacksonville FL (904)619-2010. **E-mail:** meier@qa das.com. **Website:** apogeephoto.com. **Contact:** Marla Meier, editorial director. A free online monthly magazine designed to inform, educate and entertain photographers of all ages and levels.

NEEDS Digital photography, photo technique articles, product reviews, business and marketing, nature and wildlife photography, photographer profiles/interviews and all other photography-related articles.

TIPS "Please do a search by subject before submitting your article to see if your article covers a new subject or brings a new perspective on a particular subject or theme."

APPALACHIAN TRAIL JOURNEYS

P.O. Box 807, Harpers Ferry WV 25425. (304)535-6331. **Fax:** (304)535-2667. **E-mail:** jfolgar@appalachiantrail.org. **Website:** www.appalachiantrail.org. Estab. 2005. Circ. 45,000. Bimonthly publication of the Appalachian Trail Conservancy. Uses only photos related to the Appalachian Trail. Readers are conservationists, hikers. Photo guidelines available on website.

NEEDS Buys 4-5 photos from freelancers/issue in addition to 2- to 4-page "Vistas" spread each issue; 50-60 photos/year. Most frequent need is for candids of hikers enjoying the trail. Photo captions and release required.

SPECS Accepts high-res digital images (300 dpi). Uses 35mm transparencies.

MAKING CONTACT & TERMS Send query letter with ideas by mail, e-mail. Duplicate slides preferred over originals for query. Responds in 3 weeks. Simultaneous submissions and previously published work OK. Pays on publication. Pays $300 for cover; variable for inside. Credit line given. Rights negotiable.

APPALOOSA JOURNAL

2720 West Pullman Rd., Moscow ID 83843. (208)882-5578. **Fax:** (208)882-8150. **E-mail:** editor@appaloosajournal.com; designer2@appaloosajournal.com. **Website:** www.appaloosajournal.com. **Contact:** Dana Russell, editor; John Langston, art director. Estab. 1946. Circ. 25,000.

NEEDS Photos for cover, and to accompany features and articles. Specifically wants photographs of high-quality Appaloosa horses, especially in winter scenes. Model release required. Photo captions required.

SPECS Uses glossy color prints; 35mm transparencies; digital images 300 dpi at 5×7 or larger, depending on use. Send query letter with résumé, slides, prints, or e-mail as PDF or GIF. Keeps samples on file. Responds only if interested; send nonreturnable samples. Simultaneous submissions OK.

MAKING CONTACT & TERMS "Send a letter introducing yourself and briefly explaining your work. If you have inflexible preset fees, be upfront and include that information."

TIPS "Be patient. We are located at the headquarters; although an image might not work for the magazine, it might work for other printed materials. Work has a better chance of being used if allowed to keep on file. If work must be returned promptly, please specify. Otherwise, we will keep it for other departments' consideration."

ARCHAEOLOGY

Archaeological Institute of America, 36-36 33rd St., Long Island NY 11106. (718)472-3050. **Fax:** (718)472-3051. **E-mail:** cvalentino@archaeology.org. **E-mail:** editorial@archaeology.org. **Website:** www.archaeology.org. **Contact:** Editor-in-chief. Estab. 1948. Circ. 750,000. *ARCHAEOLOGY* combines worldwide archaeological findings with photography, specially rendered maps, drawings, and charts. Covers current excavations and recent discoveries, and includes personality profiles, technology updates, adventure, travel and studies of ancient cultures

ARIZONA WILDLIFE VIEWS

5000 W. Carefee Hwy., Phoenix AZ 85086. (800)777-0015. **E-mail:** awv@azgfd.gov; hrayment@azgfd.gov. **Website:** www.azgfd.gov/magazine. **Contact:** Heidi Rayment. Circ. 22,000. Bimonthly official magazine of the Arizona Game and Fish Department. "*Arizona Wildlife Views* is a general interest magazine about Arizona wildlife, wildlife management and outdoor recreation (specifically hunting, fishing, wildlife watching, boating and off-highway vehicle recreation). We publish material that conforms to the mission and policies of the Arizona Game and Fish Department. Topics also include habitat issues and historical articles about wildlife and wildlife management."

NEEDS Photos of sports, environmental, landscapes/scenics, wildlife in Arizona. Reviews photos with or without a manuscript. Model release required only if the subject matter is of a delicate or sensitive nature. Captions required.

SPECS "We prefer and primarily use professional-quality 35mm and larger color transparencies. Submitted transparencies must be numbered, identified by artist, and an inventory list must accompany each shipment. The highest resolution digital images are occasionally used." Send JPEG or GIF files. See new information for photographers online at website.

MAKING CONTACT & TERMS Before contacting, please read the appropriate submission guidelines: www.azgfd.gov/i_e/pubs/contributorguidelines. shtml. "Half of the written content of *Arizona Wildlife Views* magazine is generated by freelance writers and photographers. Payment is made upon publication. We prefer queries by e-mail. Sample copies are available on request. The magazine does not accept responsibility for any submissions. It is the artist's responsibility to insure his work." Pays $400 for front cover; $350 for back cover; $250 for inside half-page or larger; $150 for inside smaller than half-page. Pays following publication. Credit line given. Buys one-time rights.

TIPS "Unsolicited material without proper identification will be returned immediately."

ASTRONOMY

Kalmbach Publishing, 21027 Crossroads Circle, P.O. Box 1612, Waukesha WI 53187-1612. (800)533-6644. **Fax:** (262)798-6468. **Website:** www.astronomy.com. David J. Eicher, editor. **Contact:** LuAnn Williams Belter, art director (for art and photography). Estab. 1973. Circ. 108,000. Monthly. Emphasizes astronomy, science and hobby. Median reader: 52 years old, 86% male. Submission guidelines on website. Buys 70 images from freelancers/issue, 840 images/year.

NEEDS Send high-res digital files. Captions, photo details and identification of subjects required; model/property releases preferred. Pays $25/photo, $200 for cover image. Photos of astronomical images.

SPECS "If you are submitting digital images, please send TIFF or JPEG files to us via our FTP site. Send duplicate images by mail for consideration." Keeps samples on file. Responds in 1 month. Pays on publication. Credit line given.

ATLANTA HOMES AND LIFESTYLES

Network Communications, Inc., 1100 Johnson Ferry Rd., Suite 685, Atlanta GA 30342. (404)252-6670. **Fax:** (404)252-6673. **E-mail:** gchristman@nci.com. **Website:** www.atlantahomesmag.com. **Contact:** Clinton Ross Smith, editor; Elizabeth Anderson, art director.

Estab. 1983. Circ. 30,000. Monthly. Covers residential design (home and garden); food, wine and entertaining; people, lifestyle subjects in the metro Atlanta area. Sample copy available for $4.95.

NEEDS Photos of homes (interior/exterior), people decorating ideas, products, gardens. Model/property release required. Photo captions preferred.

SPECS Accepts images in digital format only.

MAKING CONTACT & TERMS Contact creative director to review portfolio. Provide résumé, business card, brochure, flyer or tearsheets to be kept on file for possible future assignments. Responds in 2 months. Simultaneous submissions and previously published work OK. Pays $150-750/job. **Pays on acceptance**. Credit line given. Buys one-time rights.

AUTO RESTORER

Bowtie, Inc., P.O. Box 57900, Los Angeles CA 90057. (213)385-2222. **Fax:** (213)385-8565. **E-mail:** tkade@bowtieinc.com. **Website:** www.autorestorermagazine.com. **Contact:** Ted Kade, editor. Estab. 1989. Circ. 60,000. Offers no additional payment for photos accepted with ms. "Interview the owner of a restored car. Present advice to others on how to do a similar restoration. Seek advice from experts. Go light on history and nonspecific details. Make it something that the magazine regularly uses. Do automotive how-tos."

NEEDS Photos of auto restoration projects and restored cars.

SPECS Prefers images in high-res digital format. Send via CD at 240 dpi with minimum width of 5 inches. Uses transparencies, mostly 35mm, 2¼×2¼.

MAKING CONTACT & TERMS Submit inquiry and portfolio for review. Provide résumé, business card, brochure, flyer or tearsheets to be kept on file for possible future assignments. Responds in 1 month. Simultaneous submissions OK.

BABYTALK

Bonnier Corp., 460 N. Orlando Ave., Suite 200, Winter Park FL 32789. (407)628-4802. **Website:** www.babytalk.com. **Contact:** Donna Reiss, art director. Estab. 1937. Monthly. Non-newstand circulation of 2 million; distributed via subscription and through physicians' offices and retail outlets. Readers are new mothers and pregnant women. Sample copies available upon request.

MAKING CONTACT & TERMS Send query letter and printed samples; include URL for your website. After introductory mailing, send follow-up postcard

every 3 months. Samples are kept on file. Responds only if interested. Portfolios not required. **Pays on acceptance.** Buys one-time rights, reprint rights, all rights, electronic rights. Finds freelancers through agents, artists' submissions, word of mouth and sourcebooks.

TIPS "Please, no calls or e-mails. Postcards or mailers are best. We don't look at portfolios unless we request them. Websites listed on mailers are great."

BACKHOME

Wordsworth Communications, Inc., P.O. Box 70, Hendersonville NC 28793. (828)696-3838. **Fax:** (828)696-0700. **E-mail:** backhome2622@att.net. **Website:** www.backhomemagazine.com. Estab. 1990. Circ. 42,000. Bimonthly. "*BackHome* encourages readers to take more control over their lives by doing more for themselves: productive organic gardening; building and repairing their homes; utilizing renewable energy systems; raising crops and livestock; building furniture; toys and games and other projects; creative cooking. *BackHome* promotes respect for family activities, community programs, and the environment."

SPECS Reviews color prints, 35mm slides, JPEG photo attachments at 300 dpi.

MAKING CONTACT & TERMS Identification of subjects required. Buys one-time rights.

BACKPACKER MAGAZINE

Cruz Bay Publishing, Inc., an Active Interest Media Co., 2520 55th St., Suite 210, Boulder CO 80301. E-mail: gfullerton@backpacker.com. **Website:** www.backpacker.com. Dennis Lewon, editor-in-chief (features & people), dlewon@backpacker.com; Rachel Zurer, associate editor (destinations & heroes), rzurer@backpacker.com; Kristy Holland, associate editor (skills & survival), kholland@aimmedia.com; Kristin Hostetter, gear editor, khostetter1@gmail.com. Estab. 1973. Circ. 340,000.

MAKING CONTACT & TERMS Sometimes considers simultaneous submissions and previously published work. Pays $500-1,000 for color cover; $100-600 for color inside. Pays on publication. Credit line given. Rights negotiable.

◐ BASEBALL

2660 Petersborough St., Herndon VA 20171. **E-mail:** shannonaswriter@yahoo.com. **Contact:** Shannon Bridget Murphy. Quarterly. Covers baseball. Photo guidelines available by e-mail request. Request photographer's sample copy for $3 through PayPal to scribblesbyshannon@yahoo.com.

NEEDS Photos of baseball scenes featuring children and teens; photos of celebrities, couples, multicultural, families, parents, environmental, landscapes/scenics, wildlife, agriculture—as related to the sport of baseball. Interested in alternative process, avant garde, documentary, fine art, historical/vintage, seasonal. Reviews photos with or without a MS.

SPECS Uses glossy or matte color and b&w prints.

MAKING CONTACT & TERMS Send query letter via e-mail. "If possible, please do not include photographs in files if they are sent through e-mail. A disk with your photographs is acceptable. If you plan to send a disk, photographs or portfolio, please send an e-mail stating this." Provide résumé, business card, self-promotion piece to be kept on file for possible future assignments. "Photographs sent with CDs are requested but not required. Write to request guidelines for artwork and illustrations." Responds within 1 month to queries; 1 week to portfolios. Simultaneous submissions and previously published work OK. **Pays on acceptance.** Credit line given. Buys one-time, first rights; negotiable.

♲ ◎ BC OUTDOORS HUNTING AND SHOOTING

Outdoor Group Media, #201a-7261 River Place, Mission BC T4S 0A2, Canada. (604)820-3400. **Fax:** (604)820-3477. **E-mail:** info@outdoorgroupmedia.com; mmitchell@outdoorgroupmedia.com; production@outdoorgroupmedia.com. **Website:** www.bcoutdoorsmagazine.com. **Contact:** Mike Mitchell, editor. Estab. 1945. Circ. 30,000.

NEEDS Buys 30-35 photos from freelancers/issue; 60-70 photos/year. Prefers images in digital format. Send via e-mail at 300 dpi. Send by mail for consideration actual 5×7 or 8×10 color prints; 35mm, 2¼×2¼, 4×5 or 8×10 color transparencies; color contact sheet. If color negative, send jumbo prints, then negatives only on request. E-mail high-res electronic images. Send query letter with list of stock photo subjects. Include SASE or IRC. Pays in Canadian currency. Simultaneous submissions not acceptable if competitor. Editor determines payments. Pays on publication. Credit line given. Buys one-time rights for inside shots; for covers, "we retain the right for subsequent promotional use."

⚙ BC OUTDOORS SPORT FISHING

7261 River Place, 201 A, Mission BC V4S 0AZ, Canada. (604)820-3400. **E-mail:** production@outdoor groupmedia.com. **Website:** www.bcosportfish ing.com. **Contact:** Paul Bielicky. Estab. 1945. Circ. 35,000. Published 7 times/year. Emphasizes fishing, both fresh and salt water. Sample copy available for $4.95 Canadian.

NEEDS Buys 30-35 photos from freelancers/issue; 180-210 photos/year. "Fishing (in our territory) is a big need—people in the act of catching or releasing fish. Family oriented. By far, most photos accompany manuscripts. We are always on the lookout for good covers—fishing, wildlife, recreational activities, people in the outdoors—of British Columbia, vertical and square format. Photos with manuscripts must, of course, illustrate the story. There should, as far as possible, be something happening. Photos generally dominate lead spread of each story. They are used in everything from double-page bleeds to thumbnails. Column needs basically supplied in-house." Model/ property release preferred. Photo captions or at least full identification required.

SPECS Prefers images in digital format. Send via e-mail at 300 dpi.

MAKING CONTACT & TERMS *No unsolicited submissions.* Send by mail for consideration actual 5×7 or 8×10 color prints; 35mm, 2¼×2¼, 4×5 or 8×10 color transparencies; color contact sheet. If color negative send jumbo prints, then negatives only on request. E-mail high-resolution electronic images. Send query letter with list of stock photo subjects. Include SASE or IRC. Pays in Canadian currency. Simultaneous submissions not acceptable if competitor. Editor determines payments. Pays on publication. Credit line given. Buys one-time rights for inside shots; for covers, "we retain the right for subsequent promotional use."

💲 ⚫ THE BEAR DELUXE MAGAZINE

Orlo, 810 SE Belmont, Studio 5, Portland OR 97214. (503)242-1047. **E-mail:** bear@orlo.org. **Website:** www. orlo.org. **Contact:** Tom Webb, editor-in-chief; Kristin Rogers Brown, art director. Estab. 1993. Circ. 19,000. *"The Bear Deluxe Magazine* is a national independent environmental arts magazine publishing significant works of reporting, creative nonfiction, literature, visual art and design. Based in the Pacific Northwest, it reaches across cultural and political divides to engage readers on vital issues effecting the environment.

Published twice per year, *The Bear Deluxe* includes a wider array and a higher-percentage of visual artwork and design than many other publications. Artwork is included both as editorial support and as stand alone or independent art. It has included nationally recognized artists as well as emerging artists. As with any publication, artists are encouraged to review a sample copy for a clearer understanding of the magazine's approach. Unsolicited submissions and samples are accepted and encouraged. *The Bear Deluxe* has been recognized for both its editorial and design excellence."

MAKING CONTACT & TERMS "Send us your current work samples and a brief cover letter outlining your availability and turn-around time estimates. Let us know if you'd like to be considered for editorial illustration/photography, or only independent art. Send slides (not more than one sheet), prints, high-quality photocopies, or high-res scans (TIFF files please) on a ZIP drive or CD. If you submit via e-mail, send PDF format files only, or a URL address for us to visit. (Note on e-mail submissions and URL suggestions, we prefer hard-copy work samples but will consider electronic submissions and links. We cannot, however, guarantee a response to electronic submissions.) Send SASE for the return of materials. No faxes. Assumes no liability for submitted work samples."

⚪ BELLINGHAM REVIEW

Mail Stop 9053, Western Washington University, Bellingham WA 98225. (360)650-4863. **E-mail:** bhre view@wwu.edu. **Website:** www.bhreview.org. Brenda Miller, editor-in-chief. **Contact:** Tyler Koshakow managing editor. Estab. 1977. Circ. 1,500. Annual nonprofit magazine. "Literature of palpable quality: poems stories and essays so beguiling they invite us to touch their essence. *Bellingham Review* hungers for a kind of writing that nudges the limits of form, or executes traditional forms exquisitely."

NEEDS Babies/children/teens, couples, multicultural, families, parents, senior citizens, architecture, cities/ urban, gardening, pets, rural, disasters, environment, landscapes, wildlife, adventure event.

MAKING CONTACT & TERMS Send an e-mail with sample photographs. Accepts JPEG samples at 72 dpi. Samples not kept on file. Portfolio not required. Pays on publication.

THE BINNACLE

University of Maine at Machias, 116 O'Brien Ave., Machias ME 04654. **E-mail:** ummbinnacle@maine.

edu. **Website:** www.umm.maine.edu/binnacle. Estab. 1957. Circ. 300. Semiannual alternative paper format covering general arts. "We publish an alternative format journal of literary and visual art. *The Binnacle* accepts submissions from the students, faculty, and staff of the University of Maine at Machias and from writers and artists anywhere in the world. Please submit photography and other works of visual art, both color and b&w."

SPECS Files in JPEG, GIF, or PSD are preferable; BMP or TIFF are normally fine.

MAKING CONTACT & TERMS "We prefer submissions of all types in electronic form. Digital images should be submitted via postal mail on a CD or posted on a website for our viewing. Please do not send these in attachments. Please include SASE if you would like the media returned." Buys one-time rights.

🐟 💲 🔆 BIRD WATCHER'S DIGEST

P.O. Box 110, Marietta OH 45750. (740)373-5285; (800)879-2473. **Fax:** (740)373-8443. **E-mail:** editor@birdwatchersdigest.com. **E-mail:** submissions@birdwatchersdigest.com. **Website:** www.birdwatchersdigest.com. **Contact:** Bill Thompson III, editor. Estab. 1978. Circ. 125,000. Bimonthly; digest size. Emphasizes birds and bird watchers. "We use images to augment our magazine's content, so we often look for non-traditional shots of birds, including images capturing unusual behavior or settings. For our species profiles of birds we look for more traditional images: sharp, well-composed portraits of wild birds in their natural habitat." Readers are bird watchers/birders (backyard and field, veterans and novices). Sample copy available for $3.99. Photo guidelines available online.

NEEDS Buys 25-35 photos from freelancers/issue; 150-210 photos/year. "If you are just starting out, we suggest an initial submission of 20 or fewer images so that we can judge the quality of your work." Needs photos of North American species.

SPECS Accepts high-res (300 dpi) digital images via CD or DVD. "We appreciate quality thumbnails to accompany digital images. Our preferred formats for digital images are JPEG or TIFF. Images taken with digital cameras should be created using the highest-quality JPEG setting (usually marked fine or high) on your camera. TIFF images should be saved with LZW compression. Please make all images Mac compatible."

MAKING CONTACT & TERMS Send query letter with list of stock photo subjects, samples, SASE to Editorial Dept. Responds in 2 months. *Work previously published in other bird publications should not be submitted.* Pays $75 for color inside. Credit line given. Buys one-time rights.

TIPS "Query with slides or digital images on a CD to be considered for photograph want-list. Send a sample of no more than 20 images for consideration. Sample will be reviewed and responded to in 8 weeks."

🐟 💲 ◎ 🔆 BIRD WATCHING

Bauer Active, Media House, Lynch Wood, Peterborough PE2 6EA Wales. 01733 468 201. **E-mail:** sheena.harvey@bauermedia.co.uk. **Website:** www.birdwatching.co.uk. **Contact:** Sheena Harvey, editor. Estab. 1986. Circ. 22,000. Monthly hobby magazine for bird watchers. Sample copy free with SASE (first-class postage/IRC).

NEEDS Photos of "wild birds photographed in the wild, mainly in action or showing interesting aspects of behavior. Also stunning landscape pictures in birding areas and images of people with binoculars, telescopes, etc." Also considers travel, hobby and gardening shots related to bird watching. Reviews photos with or without a manuscript. Photo captions preferred.

SPECS Uses 35mm, 2¼×2¼ transparencies. Accepts images in digital format. Send via CD, e-mail as TIFF, EPS, JPEG files at 200 dpi.

MAKING CONTACT & TERMS Provide résumé, business card, self-promotion piece or tearsheets to be kept on file for possible future assignments. Returns unsolicited material if SASE enclosed. Responds in 1 month. Simultaneous submissions OK. Pays on publication. Buys one-time rights.

TIPS "All photos are held on file here in the office once they have been selected. They are returned when used or a request for their return is made. Make sure all slides are well labeled: bird, name, date, place taken, photographer's name and address. Send sample of images to show full range of subject and photographic techniques."

◎ ◎ 🔆 BLACKFLASH

P.O. Box 7381, Station Main, Saskatoon SK S7K 4J3, Canada. (306)374-5115. **E-mail:** letters@blackflash.ca; editor@blackflash.ca. **Website:** www.blackflash.ca. **Contact:** John Shelling, managing editor. Estab.

1983. Circ. 1,700. Canadian journal of photo-based and electronic arts published 3 times/year.

NEEDS Lens-based and new media contemporary fine art and electronic arts practitioners. Reviews photos with or without a manuscript.

SPECS Accepts images in digital format. Send via CD, ZIP, e-mail as TIFF, EPS, BMP, JPEG files at 300 dpi.

MAKING CONTACT & TERMS Send query letter with résumé, digital images. Does not keep samples on file; will return material with SASE only. Simultaneous submissions OK. Pays when copy has been proofed and edited. Credit line given. Buys one-time rights.

TIPS "We need alternative and interesting contemporary photography. Understand our mandate and read our magazine prior to submitting."

💲 ◐ BLUE RIDGE COUNTRY

Leisure Publishing, 3424 Brambleton Ave., Roanoke VA 24018. (540)989-6138. **Fax:** (540)989-7603. **E-mail:** krheinheimer@leisurepublishing.com. **Website:** www.blueridgecountry.com. **Contact:** Kurt Rheinheimer, editor. Estab. 1988. Circ. 425,000. Bimonthly. Emphasizes outdoor scenics, recreation, travel destinations in 9-state Blue Ridge Mountain region. Photo guidelines available for SASE or on website.

○ "We're looking for feature photography and cover images, and we're connecting covers to the stories inside the magazine, so we're not just looking for general mountain scenics. We're looking for scenes with and without people, for outdoor recreation from soft to extreme. We can especially use more images from Kentucky, South Carolina and Alabama as well as our other coverage states: Virginia, West Virginia, Maryland, Georgia, Tennessee and North Carolina. For each issue's travel destinations and weekend getaways, we are looking for scenics, town shots, people, outdoor recreation, historical attractions, etc. All should be shot within the season they are to appear (green, autumn, winter)."

NEEDS Buys 20-40 photos from freelancers/issue; 100-300 photos/year. Photos of travel, scenics and wildlife. Seeking more scenics with people in them. Model release preferred. Photo captions required.

SPECS Uses 35mm, 2¼×2¼, 4×5 transparencies. Accepts images in digital format. Send via CD, e-mail, or FTP (contact editor for information) at 300 dpi; low-res images OK for initial review, but accepted images must be high-res.

MAKING CONTACT & TERMS Send query letter with list of stock photo subjects, samples with caption info and SASE. Responds in 2 months.

💲 ♠ ○ BOROUGH NEWS

2941 N. Front St., Harrisburg PA 17110. (717)236-9526. **Fax:** (717)236-8164. **E-mail:** caccurti@boroughs.org. **Website:** www.boroughs.org. **Contact:** Courtney Accurti, editor. Estab. 2001. Circ. 6,000. Monthly magazine of Pennsylvania State Association of Boroughs. Emphasizes borough government in Pennsylvania. Readers are officials in municipalities in Pennsylvania. Sample copy free with 9×12 SASE and 5 first-class stamps.

NEEDS Number of photos/issue varies with inside copy. Needs "color photos of scenics (Pennsylvania), local government activities, Pennsylvania landmarks, ecology—for cover photos only; authors of articles supply their own photos." Special photo needs include street and road maintenance work; wetlands scenic. Model release preferred. Photo captions preferred; include identification of place and subject.

SPECS Uses color prints and 35mm transparencies. Accepts images in digital format. Send via CD, ZIP, e-mail as TIFF, EPS, JPEG, PSD files at 300 dpi.

MAKING CONTACT & TERMS Send query letter with résumé of credits and list of stock photo subjects. Send unsolicited photos by mail for consideration; include SASE for return of material. Provide résumé, business card, brochure, flyer or tearsheets to be kept on file for possible future assignments. Responds in 1 month. Pays on publication. Buys one-time rights.

TIPS "We're looking for a variety of scenic shots of Pennsylvania for front covers of the magazine, especially special issues such as engineering, street/road maintenance, downtown revitalization, technology, tourism and historic preservation, public safety and economic development, and recreation."

BOWHUNTER

InterMedia Outdoors, 6385 Flank Dr., Suite 800, Harrisburg PA 17112. (717)695-8085. **Fax:** (717)545-2527. **E-mail:** curt.wells@imoutdoors.com. **Website:** www.bowhunter.com. Mark Olszewski, art director; Jeff Waring, publisher. **Contact:** Curt Wells, editor. Estab. 1971. Circ. 126,480. Published 9 times/year. Emphasizes bow and arrow hunting. Sample copy available for $2. Submission guidelines free with SASE.

NEEDS Buys 40-50 photos/year. Wants scenic (showing bowhunting) and wildlife (big and small game of North America) photos. "No cute animal shots or poses. We publish informative, entertaining bowhunting adventure, how-to and where-to-go articles."

SPECS Digital submissions should be 300 dpi in RAW JPEG, or TIFF format; CMYK preferred, provided on CD or DVD named in a simple and logical system with accompanying contact sheet.

MAKING CONTACT & TERMS Send query letter with samples, SASE. Responds in 2 weeks to queries; 6 weeks to samples. Reviews high-res digital images. Reviews photos with or without a manuscript. Offers $50-300/photo. Pays $50-125 for b&w inside; $75-300 for color inside; $600 for cover, "occasionally more if photo warrants it." **Pays on acceptance**. Captions required. Credit line given. Buys one-time publication rights.

TIPS "Know bowhunting and/or wildlife and study several copies of our magazine before submitting any material. We're looking for better quality, and we're using more color on inside pages. Most purchased photos are of big game animals. Hunting scenes are second. In b&w we look for sharp, realistic light, good contrast. Color must be sharp; early or late light is best. We avoid anything that looks staged; we want natural settings, quality animals. Send only your best, and, if at all possible, let us hold those we indicate interest in. Very little is taken on assignment; most comes from our files or is part of the manuscript package. If your work is in our files, it will probably be used."

BOWHUNTING WORLD

Grand View Media Group, 5959 Baker Rd., Suite 300, Minnetonka MN 55345. (888)431-2877. **E-mail:** molis@grandviewmedia.com. **Website:** www.bowhuntingworld.com. **Contact:** Mark Olis. Estab. 1952. Circ. 95,000. Bimonthly magazine with 3 additional issues for bowhunting and archery enthusiasts who participate in the sport year-round.

BOYS' LIFE

Boy Scouts of America, P.O. Box 152079, 1325 West Walnut Hill Lane, Irving TX 75015. (972)580-2366. **Fax:** (972)580-2079. **Website:** www.boyslife.org. **Contact:** J.D. Owen, editor-in-chief; Michael Goldman, managing editor; Paula Murphey, senior editor; Aaron Derr, senior writer. Estab. 1911. Circ. 1.1 million. Photo guidelines free with SASE. Boy Scouts of America Magazine Division also publishes *Scouting*

magazine. "Most photographs are from specific assignments that freelance photojournalists shoot for *Boys' Life*. Interested in all photographers, but do not send unsolicited images."

MAKING CONTACT & TERMS Send query letter with list of credits. Pays $500 base editorial day rate against placement fees, plus expenses. **Pays on acceptance.** Buys one-time rights.

TIPS "Learn and read our publications before submitting anything."

BRIARPATCH

2138 McIntyre St., Regina SK S4P 2R7, Canada. (306)525-2949. **E-mail:** editor@briarpatchmagazine.com. **Website:** www.briarpatchmagazine.com. **Contact:** Valerie Zink, co-editor/publisher; Andrew Loewen, co-editor/publisher. Estab. 1973. Circ. 3,000. Published 6 times/year. Emphasizes Canadian and international politics, labor, environment, women, peace. Readers are socially progressive and politically engaged. Sample copy available for $6 plus shipping.

NEEDS Buys 5-20 photos from freelancers/issue; 30-120 photos/year. Photos of Canadian and international politics, labor, environment, women, peace and personalities. Model/property release preferred. Photo captions preferred; include names in photo.

SPECS Minimum 300 dpi color or b&w prints.

MAKING CONTACT & TERMS Send query letter with samples or link to online portfolio. Do not send slides. Provide résumé, business card, brochure, flyer, or tearsheets to be kept on file for possible future assignments. Include SASE for return of material. Responds in 1 month. Simultaneous submissions and previously published work OK. Pays a "very modest compensation." Credit line given. Buys one-time rights. Submission guidelines available online.

BRIDAL GUIDES MAGAZINE

E-mail: BridalGuides@yahoo.com. **Contact:** Shannon Bridget Murphy. Estab. 1998. Quarterly. Photo guidelines available by e-mail request. Request photographer's sample copy for $6 through paypal to scribblesbyshannon@yahoo.com.

NEEDS Buys 12 photos from freelancers/issue; 48-72 photos/year. Photos of babies/children/teens, celebrities, couples, multicultural, families, parents, cities/urban, environmental, landscapes/scenics, wildlife, architecture, gardening, interiors/decorating, pets, religious, rural, adventure, entertainment, events, food/drink, health/fitness, performing arts, travel,

agriculture—as related to weddings. Interested in alternative process, avant garde, documentary, fashion/glamour, fine art, historical/vintage, seasonal. Also wants photos of weddings "and those who make it all happen, both behind and in front of the scene." Reviews photos with or without a manuscript. Model/property release preferred.

SPECS Uses glossy or matte color and b&w prints.

MAKING CONTACT & TERMS Send query letter via e-mail. "If possible, please do not include photographs in files if they are sent through e-mail. A disc with your photographs is acceptable. If you plan to send a disc, photographs or portfolio, please send an e-mail stating this." Provide résumé, business card or self-promotion piece to be kept on file for possible future assignments. A photograph or 2 sent with CD is requested but not required. Illustrations and artwork are also accepted. Write to request guidelines for artwork and illustrations. Responds within 1 month to queries; 1 week to portfolios. Simultaneous submissions and previously published work OK. **Pays on acceptance.** Credit line given. Buys one-time rights, first rights; negotiable.

THE BRIDGE BULLETIN

American Contract Bridge League, 6575 Windchase Dr., Horn Lake MS 38637-1523. (662)253-3156. **Fax:** (662)253-3187. **E-mail:** editor@acbl.org. **E-mail:** brent.manley@acbl.org. **Website:** www.acbl.org. Paul Linxwiler, managing editor. **Contact:** Brent Manley, editor. Estab. 1938. Circ. 155,000. Monthly association magazine for tournament/duplicate bridge players. Sample copies available. Buys 6-10 photos/year.

SPECS Prefers high-res digital images, color only.

MAKING CONTACT & TERMS Query by phone. Responds only if interested; send nonreturnable samples. Previously published work OK. Credit line given. Photos must relate to bridge. Call first.

BURKE'S BACKYARD

Locked Bag 1000, Artarmon NSW 1570, Australia. (61)(2)9414-4800. **Fax:** (61)(2)9414-4850. **E-mail:** magazine@burkesbackyard.com.au; photos@burkesbackyard.com.au. **Website:** www.burkesbackyard.com.au. Circ. 60,000. Monthly. Provides trusted, informative ideas and information for Australian homes and gardens.

SPECS The ideal format is 300 dpi (high-res) or a JPEG saved to "best quality."

BUSINESS NH MAGAZINE

55 S. Commercial St., Manchester NH 03101. (603)626-6354. **Fax:** (603)626-6359. **E-mail:** hcopeland@BusinessNHmagazine.com. **Website:** www.millyardcommunications.com. **Contact:** Heidi Copeland, publisher. Estab. 1983. Circ. 15,000. Monthly. Covers business, politics, and people of New Hampshire. Readers are male and female top management, average age 45. Sample copy free with 9×12 SASE and 5 first-class stamps. Offers internships for photographers. Looks for "people in environment shots, interesting lighting, lots of creative interpretations, a definite personal style."

NEEDS Photos of couples, families, rural, entertainment, food/drink, health/fitness, performing arts, travel, business concepts, industry, science, technology/computers.

SPECS Uses 3-6 photos/issue. Accepts images in digital format.

MAKING CONTACT & TERMS Send via CD, ZIP as TIFF, JPEG files at 300 dpi. Arrange personal interview to show portfolio. Provide résumé, business card, brochure, flyer or tearsheets to be kept on file for possible future assignments. Responds in 3 weeks.

TIPS "If you're just starting out and want excellent statewide exposure to the leading executives in New Hampshire, you should talk to us. Send letter and samples, then arrange for a portfolio showing."

CALLIOPE

30 Grove St., Suite C, Peterborough NH 03458-1454. (603)924-7209. **Fax:** (603)924-7380. **E-mail:** customerservice@caruspub.com. **Website:** www.cobblestonepub.com. **Contact:** Rosalie Baker and Charles Baker, co-editors; Lou Waryncia, editorial director; Ann Dillon, art director. Estab. 1990. Circ. 13,000. Published 9 times/year (May/June, July/August, November/December). Emphasis on non-U.S. history. Readers are children ages 8-14. "To be considered for publication, photographs must relate to a specific theme. Writers are encouraged to submit available photos with their query or article." Sample copies available for $5.95 with 9×12 or larger SASE and 5 first-class stamps. Photo guidelines available on website or free with SASE.

NEEDS Contemporary shots of historical locations, buildings, artifacts, historical reenactments and costumes.

SPECS Uses b&w and color prints; 35mm transparencies.

MAKING CONTACT & TERMS If you have photographs pertaining to any upcoming theme, please contact the editor by mail or fax or send them with your query. You may also send images on speculation. Send query letter with stock photo list. Provide résumé, business card, brochure, flyer or tearsheets to be kept on file for possible future assignments. Responds within 5 months. Simultaneous submissions and previously published work OK.

TIPS "Given our young audience, we like to have pictures that include people, both young and old. Pictures must be dynamic to make history appealing. Submissions must relate to themes in each issue."

☻ ⑤ ◑ CANADA LUTHERAN

302-393 Portage Ave., Winnipeg MB R3B 3H6, Canada. (204)984-9171; (204)984-9172. **Fax:** (204)984-9185. **E-mail:** editor@elcic.ca. **Website:** www.elcic.ca/clweb. **Contact:** Susan McIlveen, editor. Estab. 1986. Circ. 8,000. Monthly publication of Evangelical Lutheran Church in Canada. Emphasizes faith/religious content, Lutheran denomination. Readers are members of the Evangelical Lutheran Church in Canada. Sample copy available for $5 Canadian (includes postage). **NEEDS** Buys 1-2 photos from freelancers/issue; 12-24 photos/year. Photos of people in worship, at work/play, diversity, advocacy, youth/young people, etc. Canadian sources preferred.

SPECS Accepts images in digital format. Send via CD, e-mail as JPEG at 300 dpi minimum.

MAKING CONTACT & TERMS Send sample prints and photo CDs by mail (include SASE for return of material) or send low-res images by e-mail. Pays on publication (in Canadian dollars). Credit line given. Buys one-time rights.

TIPS "Portfolio submissions welcome. We keep photographer contacts on file for approximately one year. "

☻ ⑤ ◎ CANADIAN HOMES & COTTAGES

The In-Home Show, Ltd., 2650 Meadowvale Blvd., Unit 4, Mississauga ON L5N 6M5, Canada. (905)567-1440. **Fax:** (905)567-1442. **E-mail:** jnaisby@homesandcottages.com; editorial@homesandcottages.com. **Website:** www.homesandcottages.com. **Contact:** Janice E. Naisby, editor-in-chief. Estab. 1987. Circ. 92,340.

NEEDS Photos of landscapes/scenics, architecture, interiors/decorating. Does not keep samples on file; cannot return material.

MAKING CONTACT & TERMS Photo guidelines free with SASE. Responds only if interested; send non-returnable samples.

☻ THE CANADIAN ORGANIC GROWER

39 McArthur Ave., Ottawa ON K1L 8L7, Canada. **E-mail:** editor@cog.ca; office@cog.ca. **Website:** magazine.cog.ca. **Contact:** Managing editor. Estab. 1975. Circ. 4,000. Magazine published 3 times/year. For organic gardeners, farmers and consumers in Canada. Depends entirely on freelancers. Deadlines: October 15 for winter issue, January 15 for spring, and July 15 for fall. Visit www.cog.ca/our-services/magazine/guide-for-magazine-contributors/ for more guidelines.

NEEDS Photos of gardening, rural, agriculture, organic gardening and farming in Canada.

SPECS Accepts images in digital format. Send JPEG or GIF files. With digital photos, we need high-res shots. A good rule of thumb is to ensure that the file size of the photo is at least 800 KB (preferably 1-3 MB) in size.

TIPS "Try to get pictures of people actively working in their gardens or field. Please indicate who or what is in each photo. List groups of people from left to right and from back row to front row. Try to capture the same person, place or thing from more than one angle as you take pictures. Tell us who the photographer is for the list of credits."

☻ ⑤ ◎ ◑ CANADIAN RODEO NEWS

272245 RR2, Airdrie AB T4A 2L5, Canada. (403)945-7393. **Fax:** (403)945-0936. **E-mail:** editor@rodeocanada.com. **Website:** www.rodeocanada.com. **Contact:** Darell Hartlen, editor. Estab. 1964. Circ. 4,000. Monthly tabloid. Promotes professional rodeo in Canada. Readers are male and female rodeo contestants and fans of all ages.

NEEDS Photos of professional rodeo action or profiles.

SPECS Uses color and b&w prints. Accepts images in digital format. Send via CD or e-mail as JPEG or TIFF files at 300 dpi.

MAKING CONTACT & TERMS Send low-res unsolicited photos by e-mail for consideration. Call to confirm if photos are usable. Keeps samples on file. Simultaneous submissions and previously published

work OK. Pays on publication. Credit line given. Rights negotiable. Media/photographer release form available online.

TIPS "Photos must be from or pertain to professional rodeo in Canada. Phone to confirm if subject/material is suitable before submitting. *CRN* is very specific in subject."

☼ ⑤ CANADIAN YACHTING

538 Elizabeth St., Midland ON L4R 2A3, Canada. (705)527-7666. **E-mail:** pdueck@kerrwil.com; aadams@kerrwil.com; eakerr@kerrwil.com. **Website:** www.canadianyachting.ca. **Contact:** Petra Dueck, art director; Andy Adams, managing editor. Estab. 1976. Circ. 31,000. Bimonthly. Emphasizes sailing (and powerboats). Readers are mostly male highly educated, high income, well read. Sample copy free upon request.

NEEDS Buys 28 photos from freelancers/issue; 168 photos/year. Needs photos of all sailing/boating-related (keelboats, dinghies, racing, cruising, etc.). Model/property release preferred. Photo captions preferred.

MAKING CONTACT & TERMS Submit portfolio for review or query with SASE stock photo list and transparencies. Responds in 1 month. Simultaneous submissions and previously published work OK. Pays on publication. Buys one-time rights.

⊕ ⑤⑤ ① CANOE & KAYAK

GrindMedia, LLC, 236 Avenida Fabricante Suite 201, San Clemente CA 92672. (425)827-6363. **E-mail:** jeff@canoekayak.com; joe@canoekayak.com; dave@canoekayak.com. **Website:** www.canoekayak.com. **Contact:** Jeff Moag, editor-in-chief; Joe Carberry, senior editor; Dave Shively, managing editor. Estab. 1972. Circ. 70,000. Published 6 times a year, in March, May, June, July, August, December. Packed with destination reviews and features a different region of North America, paddling techniques, photography from seasoned canoeists and expert reviews of paddle and camping gear. It is the world's largest paddle sports publication. Emphasizes a variety of paddle sports, as well as how-to material and articles about equipment. For upscale canoe and kayak enthusiasts at all levels of ability. Also publishes special projects. Sample copy free with 9×12 SASE.

NEEDS Buys 25 photos from freelancers/issue; 150 photos/year. Photos of canoeing, kayaking, ocean touring, canoe sailing, fishing when compatible to the main activity, canoe camping but not rafting. No photos showing disregard for the environment, be it river or land; no photos showing gasoline-powered, multi-hp engines; no photos showing unskilled persons taking extraordinary risks to life, etc. Accompanying manuscripts for "editorial coverage striving for balanced representation of all interests in today's paddling activity. Those interests include paddling adventures (both close to home and far away), camping, fishing, flatwater, whitewater, ocean kayaking, poling, sailing, outdoor photography, how-to projects, instruction and historical perspective. Regular columns feature paddling techniques, conservation topics, safety, interviews, equipment reviews, book/movie reviews, new products and letters from readers." Photos only occasionally purchased without accompanying manuscript. Model release preferred "when potential for litigation." Property release required. Photo captions preferred.

SPECS Uses 5×7, 8×10 glossy b&w prints; 35mm, 2¼×2¼, 4×5 transparencies; color transparencies for cover; vertical format preferred. Accepts images in digital format. Send via CD, ZIP as TIFF, EPS, JPEG files at 300 dpi.

MAKING CONTACT & TERMS Include SASE for return of material. Responds in 1 month. Simultaneous submissions and previously published work OK, in noncompeting publications. Pays $500-700 for color cover; $75-200 for b&w inside; $75-350 for color inside. Captions, identification of subjects, model releases required. Pays on publication. Credit line given. Buys one-time rights, first serial rights and exclusive rights.

TIPS "We have a highly specialized subject, and readers don't want just any photo of the activity. We're particularly interested in photos showing paddlers' *faces*; the faces of people having a good time. We're after anything that highlights the paddling activity as a lifestyle and the urge to be outdoors." All photos should be "as natural as possible with authentic subjects. We receive a lot of submissions from photographers to whom canoeing and kayaking are quite novel activities. These photos are often clichéd and uninteresting. So consider the quality of your work carefully before submission if you are not familiar with the sport. We are always in search of fresh ways of looking at our sport. All paddlers must be wearing life vests/PFDs."

CAPE COD LIFE

13 Steeple Street, Suite 204, P.O. Box 1439, Mashpee MA 02649. (508)419-7381. **Fax:** (508)477-1225. **Website:** www.capecodlife.com. **Contact:** Amanda Mc-Cole, art director; Patty Dysart, art director. Circ. 45,000. Emphasizes Cape Cod lifestyle. Also publishes *Cape Cod & Islands Home*. Readers are 55% female, 45%, male upper income, second home, vacation homeowners. Sample copy available for $4.95, photo guidelines free, send SASE. Buys 30 photos from freelancers/issue; 180 photos/year.

NEEDS "Photos of Cape and island scenes, south shore and south coast of MA people, places, general interest of this area. Subjects include boating, beaches, celebrities, families, environmental, landscapes/scenics, wildlife, architecture, gardening, interiors/decorating, rural, adventure, events, travel. Interested in fine art, historical/vintage, seasonal. Reviews photos with or without a manuscript. Model release required; property release preferred. Photo captions required, include location.

SPECS Uses 35mm, 2¼×2¼, 4×5 transparencies. Accepts images in digital format. Send via e-mail or FTP as TIFF files at 300 dpi.

MAKING CONTACT & TERMS "Photographers should not drop by unannounced. We prefer photographers to mail portfolio, then follow up with a phone call 1-2 weeks later." Send unsolicited photos by mail for consideration. Keeps samples on file. Simultaneous submissions and previously published work OK. Pays $225 for color cover; $25-175 for b&w or color inside depending on size. Pays 30 days after publication. Credit line given. Buys one-time rights, reprint rights for *Cape Cod Life* reprints, negotiable.

TIPS Write for photo guidelines. Photographers who do not have images of Cape Cod, Martha's Vineyard, Nantucket or the Elizabeth Islands should not submit. Looks for "clear, somewhat graphic slides. Show us scenes we've seen hundreds with a different twist and elements of surprise. Photographers should have a familiarity with the magazine and the region first. Prior to submitting, photographers should send a SASE to receive our guidelines. They can then submit works (via mail) and follow up with a brief phone call. We love to see images by professional-calibre photographers who are new to us, and prefer it if the photographer can leave images with us at least 2 months if possible."

○ ⑤⑤ THE CAPILANO REVIEW

2055 Purcell Way, North Vancouver BC V7J 3H5, Canada. (604)984-1712. **E-mail:** tcr@capilanou.ca. **Website:** www.thecapilanoreview.ca. **Contact:** Tamara Lee, managing editor. Estab. 1972. Circ. 800. Publishes an 8- to 16-page visual section by 1 or 2 artists/issue. "Read the magazine before submitting. *TCR* is an avant garde literary and visual arts publication that wants innovative work. We've previously published photography by Barrie Jones, Roy Kiyooka, Robert Keziere, Laiwan, and Colin Browne."

NEEDS Work that is new in concept and in execution.

MAKING CONTACT & TERMS Send an artist statement and list of exhibitions. Submit a group of photos with SASE (with Canadian postage or IRCs). "We do *not* accept submissions via e-mail or on disc."

CAPPER'S/GRIT

Ogden Publications, Inc., 1503 SW 42nd St., Topeka KS 66609-1265. CAPPER's: (800)678-4883; Grit: (800)803-7096. **E-mail:** editor@cappers.com; editor@grit.com. **Website:** www.cappers.com; www.grit.com. **Contact:** Caleb Regan, managing editor. Estab. 1879. Circ. 250,000. Bimonthly. Emphasizes small town life, country lifestyle, or "hobby" farm-oriented material. Readership is national. Sample copy available for $6.

NEEDS Buys 24+ photos/year with accompanying stories and articles; 90% from freelancers. Needs, on a regular basis, photos of small-farm livestock, animals, farm labor, gardening, produce and related images. "Be certain pictures are well composed, properly exposed and pin sharp. Must be *shot* at high-res (no less than 300 dpi). No cheesecake. No pictures that cannot be shown to any member of the family. No pictures that are out of focus or over- or under-exposed. No ribbon-cutting, check-passing or hand-shaking pictures. Story subjects include all aspects of the hobby or country lifestyle farm, such as livestock, farm dogs, barn cats, sowing and hoeing, small tractors, fences, etc." Photo captions required. "Any image that stands alone must be accompanied by 50-100 words of meaningful caption information."

SPECS Uses 35mm, high-res digital images.

⑤ CAREERFOCUS

7300 W. 110th St., 7th Floor, Overland Park KS 66210. (913)317-2888. **Fax:** (913)317-1505. **E-mail:** michelle.webb@cpgcommunications.com. **Website:** www.cpgpublications.com/focus.php. **Contact:** N. Michelle Paige, executive editor. Estab. 1988. Circ. 250,000.

Bimonthly. Emphasizes career development. Readers are male and female African-American and Hispanic professionals, ages 21-45. Sample copy free with 9×12 SASE and 4 first-class stamps. Photo guidelines available online.

NEEDS Uses approximately 40 photos/issue. Needs technology photos and shots of personalities; career people in computer, science, teaching, finance, engineering, law, law enforcement, government, high-tech, leisure. Model release preferred. Photo captions required; include name, date, place, why.

MAKING CONTACT & TERMS Send query letter via e-mail with résumé of credits and list of stock photo subjects. Keeps samples on file. Simultaneous submissions and previously published work OK. Responds in 1 month. Pays $10-50 for color photos; $5-25 for b&w photos. Pays on publication. Credit line given. Buys one-time rights.

TIPS "Freelancer must be familiar with our magazine to be able to submit appropriate manuscripts and photos."

ⓢⓢ CARIBBEAN TRAVEL & LIFE

460 N. Orlando Ave., Suite 200, Winter Park FL 32789. (407)571-4704; (407)628-4802. **E-mail:** editor@caribbeantravelmag.com. **Website:** www.caribbeantravelmag.com. Estab. 1985. Circ. 150,000. Published 9 times/year. Emphasizes travel, culture and recreation in islands of Caribbean, Bahamas and Bermuda. Readers are male and female, frequent Caribbean travelers, ages 32-52. Sample copy available for $4.95. Photo guidelines free with SASE.

NEEDS Uses about 100 photos/issue; 90% supplied by freelance photographers: 10% assignment and 90% freelance stock. "We combine scenics with people shots. Where applicable, we show interiors, food shots, resorts, water sports, cultural events, shopping and wildlife/underwater shots. We want images that show intimacy between people and place. Provide thorough caption information. Don't submit stock that is mediocre."

SPECS Uses 4-color photography.

MAKING CONTACT & TERMS Query by mail or e-mail with list of stock photo subjects and tearsheets. Responds in 3 weeks. Pays after publication. Buys one-time rights. Does not pay shipping, research or holding fees.

TIPS Seeing trend toward "fewer but larger photos with more impact and drama. We are looking for particularly strong images of color and style, beautiful island scenics and people shots—images that are powerful enough to make the reader want to travel to the region; photos that show people doing things in the destinations we cover; originality in approach, composition, subject matter. Good composition, lighting and creative flair. Images that are evocative of a place, creating story mood. Good use of people. Submit stock photography for specific story needs; if good enough can lead to possible assignments. Let us know exactly what coverage you have on a stock list so we can contact you when certain photo needs arise."

CARLSBAD MAGAZINE

Wheelhouse Media, P.O. Box 2089, Carlsbad CA 92018. (760)729-9099. **Fax:** (760)729-9011. **E-mail:** tim@wheelhousemedia.com. **Website:** www.clickoncarlsbad.com. **Contact:** Tim Wrisley. Estab. 2004. Circ. 35,000. Photos of gardening, entertainment, events, performing arts. Interested in historical/vintage lifestyle. "People, places, events, arts in Carlsbad."

CARUS PUBLISHING COMPANY

30 Grove St., Suite C, Peterborough NH 03458. **Website:** www.cricketmag.com. Publishes *Cricket, Ladybug, Babybug, Cidada*.

◎ ⓢ ◑ CAT FANCY

I-5 Publishing, P.O. Box 6050, Mission Viejo CA 92690. (949)855-8822. **Fax:** (949)855-3045. **E-mail:** slogan@bowtieinc.com. **E-mail:** query@catfancy.com. **Website:** www.catchannel.com. **Contact:** Susan Logan, editor. Estab. 1965. Circ. 290,000. "*Cat Fancy* is the undisputed premier feline magazine that is dedicated to better lives for pet cats. Always a presence within the cat world, *Cat Fancy* and its sister website, CatChannel.com, are where cat owners, lovers and rescue organizations go for education and entertainment." Monthly. Readers are men and women of all ages interested in all aspects of cat ownership.

NEEDS Editorial "lifestyle" shots of cats in beautiful, modern homes; cats with attractive people (infant to middle-age, variety of ethnicities); cat behavior (good and bad, single and in groups); cat and kitten care (grooming, vet visits, feeding, etc.); household shots of CFA- or TICA-registered cats and kittens. Buys 20-30 photos from freelancers/issue; 240-360 photos/year.

SPECS "Sharp, focused images only (no prints). Accepts images in digital format. Send via CD as TIFF or JPEG files at 300 dpi minimum; include contact sheet

(thumbnails with image names). Also accepts 35mm slides and 2¼" color transparencies; include SASE. Lifestyle focus. Indoor cats preferred. Send SASE for list of specific photo needs."

MAKING CONTACT & TERMS Photo guidelines and needs free with SASE or on website.

CHA

E-mail: editors@asiancha.com; j@asiancha.com. **E-mail:** submissions@asiancha.com. **Website:** www.asiancha.com. **Contact:** Tammy Ho Lai-Ming, founding co-editor; Jeff Zroback, founding co-editor; Eddie Tay, reviews editor. Estab. 2007. "*Cha* is the first Hong Kong-based English online literary journal; it is dedicated to publishing quality poetry, fiction, creative non-fiction, reviews, photography and art. *Cha* has a strong focus on Asian-themed creative work and work done by Asian writers and artists. It also publishes established and emerging writers/artists from around the world. *Cha* is an affiliated organization of the Asia-Pacific Writing Partnership and is catalogued in the School of Oriental and African Studies (SOAS) Library, among other universities."

SPECS Submit all visual work in JPEG format.

MAKING CONTACT & TERMS Submit 1-5 pieces. Include a brief biography (no more than 100 words). "Simultaneous submissions are accepted, but notify us as soon as possible if your work is accepted for publication elsewhere."

CHARISMA

600 Rinehart Rd., Lake Mary FL 32746. (407)333-0600. **Fax:** (407)333-7100. **E-mail:** charisma@charismamedia.com; sean.roberts@charismamedia.com. **Website:** www.charismamedia.com. **Contact:** Joe Deleon, magazine design director. Circ. 200,000. Monthly. Emphasizes Christian life. General readership. Sample copy available for $2.50.

NEEDS Buys 3-4 photos from freelancers/issue; 36-48 photos/year. Needs editorial photos—appropriate for each article. Model release required. Photo captions preferred.

SPECS Accepts images in digital format. Send via CD as TIFF, JPEG, EPS files at 300 dpi. Low-res images accepted for sample submissions.

MAKING CONTACT & TERMS Send unsolicited photos by mail for consideration. Provide brochure, flyer or tearsheets to be kept on file for possible future assignments. Simultaneous submissions and previously published work OK. Cannot return material.

Responds ASAP. Pays $650 for color cover; $150 for b&w inside; $50-150/hour or $400-750/day. Pays on publication. Credit line given. Buys all rights; negotiable.

TIPS In portfolio or samples, looking for "good color and composition with great technical ability."

CHESAPEAKE BAY MAGAZINE

1819 Bay Ridge Ave., Annapolis MD 21403. (410)263-2662, ext. 32. **Fax:** (410)267-6924. **E-mail:** editor@chesapeakeboating.net. **Website:** www.chesapeakeboating.net. **Contact:** Ann Levelle, managing editor; T.F. Sayles, editor. Estab. 1972. Circ. 46,000. Monthly. Emphasizes boating—Chesapeake Bay only. Readers are "people who use Chesapeake Bay for recreation." Sample copy available with SASE. "Interested in reviewing work from newer, lesser-known photographers."

Chesapeake Bay is CD-equipped and does corrections and manipulates photos in-house.

NEEDS Buys 27 photos from freelancers/issue; 324 photos/year. Needs photos that are Chesapeake Bay related (must); "vertical powerboat shots are badly needed (color)." Special needs include "vertical 4-color slides showing boats and people on Bay."

SPECS Uses 35mm, 2¼×2¼, 4×5, 8×10 transparencies. Accepts images in digital format. Send via CD as TIFF files at 300 dpi, at least 8×10 (16×10 for spreads). "A proof sheet would be helpful."

MAKING CONTACT & TERMS Send query letter with samples or list of stock photo subjects. Responds only if interested. Simultaneous submissions OK.

TIPS "We prefer Kodachrome over Ektachrome. Looking for boating, bay and water-oriented subject matter. Qualities and abilities include fresh ideas, clarity, exciting angles and true color. We're using larger photos—more double-page spreads. Photos should be able to hold up to that degree of enlargement. When photographing boats on the Bay, keep safety in mind. People hanging off the boat, drinking, women 'perched' on the bow are a no-no! Children must be wearing life jackets on moving boats. We must have IDs for *all* people in close-up to medium-view images."

CHESS LIFE

P.O. Box 3967, Crossville TN 38557. (931)787-1234. **Fax:** (931)787-1200. **E-mail:** dlucas@uschess.org; fbutler@uschess.org. **Website:** www.uschess.org. **Contact:** Daniel Lucas, editor; Francesca "Frankie"

Butler, art director. Estab. 1939. Circ. 85,000. Monthly publication of the U.S. Chess Federation. Emphasizes news of all major national and international tournaments; includes historical articles, personality profiles, columns of instruction, occasional fiction, humor for the devoted fan of chess. Sample copy and photo guidelines free with SASE or on website.

NEEDS News photos from events around the country; shots for personality profiles.

SPECS Accepts prints or high-res digital images. Send digital images as JPEG or TIFF files at 300 dpi—via CD for multiple-image submissions; e-mail for single-shot submission. Contact art director for further details on submission options and specifications.

MAKING CONTACT & TERMS Query with samples via e-mail (preferred). Responds in 1 month, "depending on when the deadline crunch occurs." Simultaneous submissions and previously published work OK.

TIPS Using "more color, and more illustrative photography. The photographer's name address and date of the shoot should appear on the back of all photos. Also, name of persons in photograph and event should be identified." Looks for "clear images, good composition and contrast with a fresh approach to interest the viewer. Typical 'player sitting at chessboard' photos are not what we want. Increasing emphasis on strong portraits of chess personalities, especially Americans. Tournament photographs of winning players and key games are in high demand."

CHESS LIFE FOR KIDS

P.O. Box 3967, Crossville TN 38557. (732)252-8388; (931)787-1234. **E-mail:** gpetersen@uschess.org. **Website:** www.uschess.org. **Contact:** Glenn Petersen, editor. Estab. 2006. Circ. 9,000 print; 17,000 online. Bimonthly association magazine geared for the young reader, age 12 and under, interested in chess; fellow chess players; tournament results; and instruction. Sample copy available with SASE and first-class postage. Photo guidelines available via e-mail.

NEEDS Photos of babies/children/teens, celebrities, multicultural, families, senior citizens, events, humor. Some aspect of chess must be present: playing, watching, young/old contrast. Reviews photos with or without a manuscript. Property release is required. Captions required.

SPECS Accepts images in digital format. Send via ZIP or e-mail. Contact Frankie Butler at catseyephotogra

phy@mac.com for more information on digital specs. Uses glossy color prints.

MAKING CONTACT & TERMS E-mail query letter with link to photographer's website. Provide self-promotion piece to be kept on file. Responds in 1 week to queries and portfolios. Simultaneous submissions and previously published work OK. Pays $150 minimum/$300 maximum for color cover. Pays $35 for color inside. Pays on publication. Credit line given. Rights are negotiable. Will negotiate with a photographer unwilling to sell all rights.

TIPS "Read the magazine. What would appeal to *your* 10-year-old? Be original. We have plenty of people to shoot headshots and award ceremonies. And remember, you're competing against proud parents as well."

CHICKADEE

10 Lower Spadina Ave., Suite 400, Toronto ON M5V 2Z2, Canada. (416)340-2700, ext. 318. **Fax:** (416)340-9769. **E-mail:** owl@owlkids.com. **Website:** www.owl kids.com. **Contact:** Tracey Jacklin. Estab. 1979. Circ. 79,800. Published 10 times/year. A discovery magazine for children ages 6-9. Sample copy available for $4.95 with 9×12 SASE and $1.50 money order to cover postage. Photo guidelines available with SASE or via e-mail.

chickaDEE has received Magazine of the Year, Parents' Choice, Silver Honor, Canadian Children's Book Centre Choice and several Distinguished Achievement awards from the Association of Educational Publishers.

NEEDS Photo stories, photo puzzles, children ages 6-10, multicultural, environmental, wildlife, pets, adventure, events, hobbies, humor, performing arts, sports, travel, science, technology, animals in their natural habitats. Interested in documentary, seasonal. Model/property release required. Photo captions required.

SPECS Prefers images in digital format. E-mail as JPEG files at 72 dpi; 300 dpi required for publication.

MAKING CONTACT & TERMS Previously published work OK. Credit line given. Buys one-time rights.

CHIRP

10 Lower Spadina Ave., Suite 400, Toronto ON M5V 2Z2, Canada. (416)340-2700, ext. 318. **Fax:** (416)340-9769. **E-mail:** owl@owlkids.com. **Website:** www.owl kids.com. **Contact:** Tracey Jacklin. Estab. 1997. Circ. 64,700. Published 10 times/year. A discovery maga-

zine for children ages 3-6. Sample copy available for $4.95 with 9×12 SASE and $1.50 money order to cover postage. Photo guidelines available with SASE or via e-mail.

○ *Chirp* has received Best New Magazine of the Year, Parents' Choice, Canadian Children's Book Centre Choice and Distinguished Achievement awards from the Association of Educational Publishers.

NEEDS Photo stories, photo puzzles, children ages 5-7, multicultural, environmental, wildlife, adventure events, hobbies, humor, animals in their natural habitats. Interested in documentary, seasonal. Model/property release required. Photo captions required.

SPECS Prefers images in digital format. E-mail as TIFF, JPEG files at 72 dpi; 300 dpi required for publication.

MAKING CONTACT & TERMS Request photo packages before sending photos for review. Responds in 3 months. Previously published work OK. Credit line given. Buys one-time rights.

ⓢ ◎ ◐ THE CHRONICLE OF THE HORSE

P.O. Box 46, Middleburg VA 20118. (540)687-6341. **Fax:** (540)687-3937. **E-mail:** slieser@chronofhorse. com. **E-mail:** bethr@chronofhorse.com (feature stories); results@chronofhorse.com (news stories). **Website:** www.chronofhorse.com. **Contact:** Sara Lieser, managing editor; Beth Rasin, executive editor. Estab. 1937. Circ. 18,000. Weekly. Emphasizes English horse sports. Readers range from young to old. "Average reader is a college-educated female middle-aged, well-off financially." Sample copy available for $2. Photo guidelines free with SASE or on website. Buys 10-20 photos from freelancers/issue.

NEEDS Photos from competitive events (horse shows, dressage, steeplechase, etc.) to go with news story or to accompany personality profile. "A few stand alone. Must be cute, beautiful or newsworthy. Reproduced in b&w." Prefers purchasing photos with accompanying manuscript.

SPECS Uses b&w and color prints, slides (reproduced b&w). Accepts images in digital format at 300 dpi.

MAKING CONTACT & TERMS "We do not want to see portfolio or samples. Contact us first, preferably by letter; include SASE for reply. Responds in 6 weeks.

TIPS "Know horse sports."

ⓢ ◐ CHRONOGRAM

314 Wall St., Kingston NY 12401. (845)334-8600. **E-mail:** dperry@chronogram.com. **Website:** www. chronogram.com. **Contact:** David Perry, art director. Estab. 1993. Circ. 50,000. Monthly arts and culture magazine with a focus on green living and progressive community building in the Hudson Valley. Tends to hire regional photographers, or photographers who are showing work regionally. Sample copy available for $5. Photo guidelines available on website.

NEEDS Buys 16 photos from regional freelancers/issue; 192 photos/year. Interested in alternative process, avant garde fashion/glamour, fine art, historical/vintage artistic representations of anything. "Striking, minimalistic and good! Great covers!" Reviews photos with or without a manuscript. Model/property release preferred. Photo captions required; include title date artist, medium.

SPECS Prefers images in digital format. Send via CD as TIFF files at 300 dpi or larger at printed size.

MAKING CONTACT & TERMS E-mail sample work at 72 dpi or mail work with SASE for return. Provide self-promotion piece to be kept on file for possible future assignments. Responds only if interested; send nonreturnable samples. Credit line given. Buys one-time rights; negotiable.

TIPS "Colorful, edgy, great art! See our website—look at the back issues and our covers, and check out back issues and our covers before submitting."

◐ CITY LIMITS

Community Service Society of New York, 105 E. 22nd St., Suite 901, New York NY 10010. (212)614-5397. **E-mail:** magazine@citylimits.org; editor@citylimits.org. **Website:** www.citylimits.org. **Contact:** Mark Anthony Thomas, director; Jarrett Murphy, editor-in-chief. Estab. 1976. "*City Limits* is an urban policy monthly offering intense journalistic coverage of New York City's low-income and working-class neighborhoods." Sample copy available for 8×11 SAE with $1.50 first-class postage. Photo guidelines available for SASE.

NEEDS Assigned portraits, photojournalism, action, ambush regarding stories about people in low-income neighborhoods, government or social service sector, babies/children/teens, families, parents, senior citizens, cities/urban. Interested in documentary. Reviews photos with or without a manuscript. Special photo needs: b&w photo essays about urban issues.

SPECS Uses 5×7 and larger b&w prints. Accepts images in digital format. Send via CD, ZIP, e-mail as TIFF, EPS, JPEG files at 600 dpi. Inside photos are b&w; cover is 4-color.

MAKING CONTACT & TERMS Send query letter with samples, tearsheets, self-promotion cards. Provide résumé, business card, self-promotion piece or tearsheets to be kept on file for possible future assignments. Art director will contact photographer for portfolio review if interested. Portfolio should include b&w prints and tearsheets. Keeps samples on file; cannot return material. Responds only if interested; send nonreturnable samples. Simultaneous submissions and previously published work OK.

TIPS "We need good photojournalists who can capture the emotion of a scene. We offer huge pay for great photos."

CLEVELAND MAGAZINE

City Magazines, Inc., 1422 Euclid Ave., Suite 730, Cleveland OH 44115. (216)771-2833. **Fax:** (216)781-6318. **E-mail:** gleydura@clevelandmagazine.com; miller@clevelandmagazine.com. **Website:** www.clevelandmagazine.com. **Contact:** Kristen Miller, art director; Steve Gleydura, editor. Estab. 1972. Circ. 50,000. Monthly. Emphasizes Cleveland, Ohio. General interest to upscale audience.

NEEDS Photos of architecture business concepts, education, entertainment, environmental, events, food/drink, gardening, health/fitness, industry, interiors/decorating, landscapes/scenics, medicine, people (couples, families, local celebrities, multicultural, parents, senior citizens), performing arts, political, product shots/still life, sports, technology, travel, interested in documentary and fashion/glamour.

SPECS Prefers images in digital format.

MAKING CONTACT & TERMS Please provide self-promotions, JPEG samples or tearsheets via e-mail or mail to be kept on file for possible future assignments. We will respond if interested. Send via CD, e-mail as TIFF, JPEG files at 300 dpi. Also uses color and b&w prints.

➕ ☯ COAST&KAYAK MAGAZINE

Wild Coast Publishing, P.O. Box 24 Stn. A Nanaimo BC V9R 5K4, Canada. (250)244-6437; (866)984-6437. **Fax:** (866)654-1937. **E-mail:** editor@coastandkayak.com. **Website:** www.coastandkayak.com. **Contact:** John Kimantas, editor. Estab. 1991. Circ. 65,000 print and electronic readers. Quarterly. Emphasizes safe,

ecologically sensitive paddling. For sample copy, see downloadable PDF version online.

NEEDS Buys 10 photos from freelancers/issue ("usually only from authors"); 60 photos/year. Needs kayaking shots. Photos should have sea kayak in them. Reviews photos with or without a manuscript. Model/property release preferred. Photo captions preferred.

SPECS Prefers digital submissions, but only after query. Send as low-res for assessment.

MAKING CONTACT & TERMS Send query letter first. Provide business card or self-promotion piece to be kept on file for possible future assignments. Responds in 2 months to queries. Absolutely no simultaneous submissions or previously published work accepted. Pays $100-200 for color cover; $25-50 for inside. Pays on publication. Credit line given. Buys one-time print rights including electronic archive rights.

TIPS "Look at free downloadable version online and include kayak in picture wherever possible. Always need vertical shots for cover!"

➍➍ ⓞ COBBLESTONE

Carus Publishing, 30 Grove St., Suite C, Peterborough NH 03458. (800)821-0115. **Fax:** (603)924-7380. **E-mail:** customerservice@caruspub.com. **Website:** www.cobblestonepub.com. Circ. 15,000. Published 9 times/year, September-May. Emphasizes American history; each issue covers a specific theme. Writers are encouraged to submit available photos with their query or article. We buy one-time use. Readers are children ages 9-14, parents, teachers. Sample copy available for $6.95 plus $2.00 s&h. Photo guidelines free with SASE. Mail queries to Editorial Dept. "Reporting dates depend on how far ahead of the issue the photographer submits photos. We work on issues 6 months ahead of publication." Simultaneous submissions and previously published work OK. See guidelines on website at: www.cobblestonepub.com/guides_cob.html.

NEEDS Buys 10-20 photos from freelancers/issue; 90-180 photos/year. Photos of children, multicultural, landscapes/scenics, architecture, cities/urban, agriculture, industry, military. Interested in fine art, historical/vintage, reenacters. "We need photographs related to our specific themes (each issue is theme-related) and urge photographers to request our themes list."

SPECS Uses 8×10 glossy prints; 35mm, 2¼×2¼ transparencies. Accepts images in digital format.

MAKING CONTACT & TERMS Send via CD, Sy-Quest, ZIP as TIFF files at 300 dpi, saved at 8×10 size. Send query letter with samples or list of stock photo subjects; include SASE for return of material.

TIPS "Most photos are of historical subjects, but contemporary color images of, for example, a Civil War battlefield, are great to balance with historical images. However, the amount varies with each monthly theme. Please review our theme list and submit related images."

⑤ ⓞ COLLECTIBLE AUTOMOBILE

7373 N. Cicero Ave., Lincolnwood IL 60712. (847)676-3470. **Fax:** (847)329-5690. **E-mail:** jbiel@pubint.com. **Contact:** John Biel, editor-in-chief. Estab. 1984. Bimonthly. "*CA* features profiles of collectible automobiles and their designers as well as articles on literature scale models, and other topics of interest to automotive enthusiasts." Sample copy available for $8 and 10½×14 SASE with $3.50 first-class postage. Photo guidelines available with #10 SASE.

NEEDS "For digital photography, we require our files to have a minimum resolution of A) no less than 25MB in their uncompressed state or B) approximately 3500-4000 pixels on the largest side or C) 12-14" on the largest side at 300 dpi. Raw TIFF is best, but lightly compressed JPEGs are acceptable as well. For film shoots, 2-3 rolls of 35mm, 2-3 rolls of 2¼×2¼, and 4-8 4×5 exposures. Complete exterior views, interior and engine views, and close-up detail shots of the subject vehicle are required."

SPECS Uses 35mm, 2¼×2¼, 4×5 transparencies.

MAKING CONTACT & TERMS Send query letter with transparencies and stock list. Provide business card to be kept on file for possible future assignments. Responds only if interested; send nonreturnable samples. Previously published work OK. Pays bonus if image is used as cover photo; $300-350 plus costs for standard auto shoot. **Pays on acceptance**. Photography is credited on an article-by-article basis in an "Acknowledgments" section at the front of the magazine. Buys all intellectual and digital property rights.

TIPS "Read our magazine for good examples of the types of backgrounds, shot angles and overall quality that we are looking for."

⑤ COLLEGE PREVIEW

7300 W. 110th St., 7th Floor, Overland Park KS 66210. (913)317-2888. **E-mail:** michelle.webb@cpgcommunications.com; nmpaige@collegepreviewmagazine.com; editorial@collegepreviewmagazine.com. **Website:** www.collegepreviewmagazine.com. **Contact:** Michelle Paige, executive editor. Circ. 600,000. Quarterly. Emphasizes college and college-bound African-American and Hispanic students. Readers are African American, Hispanic, ages 16-24. Sample copy free with 9×12 SASE and 4 first-class stamps.

NEEDS Uses 30 photos/issue. Needs photos of students in class, at work, in interesting careers, on campus. Special photo needs include computers, military, law and law enforcement, business, aerospace and aviation, health care. Model/property release required. Photo captions required; include name, age, location, subject.

MAKING CONTACT & TERMS Send query letter with résumé of credits. Simultaneous submissions and previously published work OK. Pays $10-50 for color photos; $5-25 for b&w inside. Pays on publication. Buys first North American serial rights.

COMMUNITY OBSERVER

Ann Arbor Observer Co., 2390 Winewood, Ann Arbor MI 48103. (734)769-3175. **Fax:** (734)769-3375. **E-mail:** editor@arborweb.com. **Website:** www.washtenawguide.com. John Hilton, editor. Circ. 20,000. Quarterly. "*Community Observer* serves three historic communities facing rapid change. We provide an intelligent, informed perspective on the most important news and events in the communities we cover." Sample copy available for $2.

SPECS Uses contact sheets, negatives, transparencies, prints. Accepts images in digital format; GIF or JPEG files.

MAKING CONTACT & TERMS Negotiates payment individually. Pays on publication. Buys one-time rights.

COMPLETE WOMAN

Associated Publications, Inc., 875 N. Michigan Ave., Suite 3434, Chicago IL 60611. (312)266-8680. **Fax:** (312)573-3020. **Website:** www.thecompletewomanmagazine.com. Kourtney McKay, art director. Estab. 1980. Circ. 300,000. Bimonthly general interest magazine for women. Readers are "females, ages 21-40, from all walks of life."

NEEDS Uses 50-60 photos/issue; 300 photos/year. High-contrast shots of attractive women, how-to beauty shots, celebrities, couples, health/fitness/beauty, business concepts. Interested in fashion/glamour. Model release required.

SPECS Uses color transparencies (slide and large-format). Accepts images in digital format. Send via CD as TIFF, JPEG files at 300 dpi.

MAKING CONTACT & TERMS Portfolio may be dropped off and picked up by appointment only. Provide résumé, business card, brochure, flyer or tearsheets to be kept on file for possible future assignments. Send color prints and transparencies. "Each print/transparency should have its own protective sleeve. Do not write or make heavy pen impressions on back of prints; identification marks will show through, affecting reproduction." Responds in 1 month. Simultaneous submissions and previously published work OK. Pays $75-150 for color inside. Pays on publication. Credit line given. Buys one-time rights.

TIPS "We use photography that is beautiful and flattering, with good contrast and professional lighting. Models should be attractive, ages 18-28, and sexy. We're always looking for nice couple shots."

CONDE NAST TRAVELER

4 Times Square, 14th Floor, New York NY 10036. (212)286-2860. **Fax:** (212)286-2258. **E-mail:** cntraveler@condenast.co.uk; hazel.lubbock@condenast.co.uk; elinor.block@condenast.co.uk. **Website:** www.cntraveler.com. **Contact:** Esin Ili Göknar, photo editor; Alice Walker and Hazel Lubbock, editorial assistants; Sarah Miller, editor. Provides the experienced traveler with an array of diverse travel experiences encompassing art, architecture, fashion, culture, cuisine and shopping. This magazine has very specific needs and contacts a stock agency when seeking photos.

⊗ ⊕ ○ CONSCIENCE

Catholics for Choice, 1436 U St. NW, Suite 301, Washington D.C. 20009. (202)986-6093. **E-mail:** conscience@catholicsforchoice.org. **Website:** www.catholicsforchoice.org. **Contact:** Jon O'Brien, executive editor. Estab. 1980. Circ. 12,000. Quarterly news journal of Catholic opinion. "Conscience offers in-depth coverage of a range of topics, including contemporary politics, Catholicism, women's rights in society and in religions, U.S. politics, reproductive rights, sexuality and gender, ethics and bioethics, feminist theology, social justice, church and state issues, and the role of religion in formulating public policy."

NEEDS Photos of multicultural, religious, Catholic-related news.

SPECS Uses glossy color and b&w prints. Accepts high-res digital images. Send as TIFF, JPEG files.

MAKING CONTACT & TERMS Send query letter with tearsheets. Responds only if interested; send nonreturnable samples. Simultaneous submissions and previously published work OK. Model/property release preferred. Photo captions preferred; include title subject, photographer's name. Pays $300 maximum for color cover; $50 maximum for b&w inside. Pays on publication. Credit line given.

CONTEMPORARY BRIDE

North East Publishing, Inc., 216 Stelton Rd., Unit D-1, Piscataway NJ 08854. (908)561-6010; (732)968-0123. **E-mail:** valerie@contemporarybride.com; gary@contemporarybride.com. **Website:** www.contemporarybride.com. **Contact:** Gary Paris, publisher. Estab. 1994. Circ. 120,000. Biannual bridal magazine with wedding planner; 4-color publication with editorial, calendars, check-off lists and advertisers. Sample copy available for first-class postage.

NEEDS Photos of travel destinations, fashion, bridal events. Reviews photos with accompanying manuscript only. Model/property release preferred. Photo captions preferred; include photo credits.

SPECS Accepts images in digital format. Send as high-res files at 300 dpi.

MAKING CONTACT & TERMS Send query letter with samples. Art director will contact photographer for portfolio review if interested. Provide b&w and color prints, disc. Keeps samples on file; cannot return material. Responds only if interested; send nonreturnable samples. Simultaneous submissions and previously published work OK. Payment negotiable. Buys all rights, electronic rights.

TIPS "Digital images preferred with a creative eye for all wedding-related photos. Give us the *best* presentation."

⊗ ⊕ ○ CONTINENTAL NEWSTIME

Continental Features/Continental News Service, Inc., 501 W. Broadway, Plaza A PMB #265, San Diego CA 92101-3802. (858) 492-8696. **E-mail:** continentalnewsservice@yahoo.com. **Website:** www.continentalnewsservice.com. **Contact:** Gary P. Salamone, editor-in-chief. Estab. 1987.

NEEDS Buys variable number of photos from freelancers. Photos of public figures, U.S. and foreign government officials/cabinet ministers, breaking/unreported/under-reported news. Reviews photos with

or without a manuscript. Model/property release required. Photo captions required.

SPECS Uses 8×10 color and b&w prints.

MAKING CONTACT & TERMS Send query letter with résumé, photocopies, tearsheets, stock list. Provide résumé to be kept on file for possible future assignments. Responds only if interested in absence of SASE being received; send nonreturnable samples. Simultaneous submissions OK. Pays $10 minimum for b&w cover. Pays on publication. Credit line given. Buys one-time rights.

TIPS "Read our magazine to develop a better feel for our photo applications/uses and to satisfy our stated photo needs."

⊕ CONVERGENCE: AN ONLINE JOURNAL OF POETRY AND ART

E-mail: clinville@csus.edu. **E-mail:** clinville@csus.edu. **Website:** www.convergence-journal.com. **Contact:** Cynthia Linville, managing editor. Estab. 2003.

NEEDS Ethnic/multicultural, experimental, feminist, gay/lesbian.

MAKING CONTACT & TERMS Send up to 6 JPEGs no larger than 4MB each to clinville@csus.edu with "Convergence" in the subject line. Include full name, preferred e-mail address, and a 75-word bio (bios may be edited for length and clarity). A cover letter is not needed. Absolutely no simultaneous or previously published submissions. Acquires electronic rights.

TIPS "Work from a series or with a common theme has a greater chance of being accepted. Seasonally-themed work is appreciated (spring and summer for the January deadline, fall and winter for the June deadline)."

⊘ COSMOPOLITAN

224 W. 57th St., 8th Floor, New York NY 10019. (212)649-2000. **E-mail:** cosmo@hearst.com. **Website:** www.cosmopolitan.com. *Cosmopolitan* targets young women for whom beauty, fashion, fitness, career, relationships and personal growth are top priorities. It includes articles and columns on nutrition and food, travel, personal finance, home/lifestyle and celebrities. *Query before submitting.*

💲💲 COUNTDOWN

Juvenile Diabetes Research Foundation, 26 Broadway, 14th Floor, New York, NY 10004. (800)533-2873. **Fax:** (212)785-9595. **E-mail:** info@jdrf.org. **Website:** www.jdrf.org. Estab. 1970. Produces online magazine to deliver research information to a lay audience.

NEEDS Buys 60 photos/year; offers 20 freelance assignments/year. Photos of babies/children/teens, families, events, food/drink, health/fitness, medicine, product shots/still life, science. Needs "mostly portraits of people, but always with some environmental aspect." Reviews stock photos. Model release preferred. Photo captions preferred.

SPECS Accepts images in digital format. Send via CD, ZIP, as TIFF, EPS, JPEG files at 300 dpi.

MAKING CONTACT & TERMS Send query letter with samples. Provide résumé, business card, brochure, flyer or tearsheets to be kept on file for possible future assignments. Cannot return material. Responds as needed. Also pays by the job—payment depends on how many days, shots, cities, etc. Credit line given. Buys nonexclusive perpetual rights.

TIPS Looks for "a style consistent with commercial magazine photography—upbeat, warm, personal, but with a sophisticated edge. See samples on our website before submitting any of your own samples so you will have an idea of what we are looking for in photography. Nonprofit groups have seemingly come to depend more on photography to get their messages across. The business seems to be using a variety of freelancers, as opposed to a single in-house photographer."

COUNTRY WOMAN

Reiman Publications, 5400 S. 60th St., Greendale WI 53129. (414)423-0100. **E-mail:** editors@countrywomanmagazine.com. **Website:** www.countrywomanmagazine.com. **Contact:** Lori Lau Grzybowski, editor. Estab. 1970. Bimonthly. Supported entirely by subscriptions and accepts no outside advertising. Emphasizes rural life and a special quality of living to which country women can relate; at work or play, in sharing problems, etc. Sample copy available for $2. Photo guidelines free with SASE.

NEEDS Uses 75-100 photos/issue; most supplied by readers, rather than freelance photographers. "Covers are usually supplied by professional photographers; they are often seasonal in nature and generally feature a good-looking country woman (mid-range to close up, shown within her business setting or with a hobby, craft or others; static pose or active)." Photos purchased with or without accompanying manuscript. Also interested in unique or well-designed country homes and interiors. Some work assigned for interiors.

Works 6 months in advance. "No poor-quality color prints, posed photos, etc." Photo captions required.

SPECS Prefers color transparencies, all sizes. Accepts images in digital format. Send via lightboxes, CD/DVD with printed thumbnails and caption sheet, or e-mail if first review selection is small (12 or less).

MAKING CONTACT & TERMS Send material by mail for consideration; include SASE. Provide brochure, calling card, letter of inquiry, price list, résumé and samples to be kept on file for possible future assignments. Responds in 3 months. Previously published work OK. "If the material you are submitting has been published previously, we ask that you please let us know. We accept color prints, slides or high-res digital photos. Digital images should be about 4×6 at a minimum resolution of 300 dpi and sent as JPEGs on a CD or via e-mail. We cannot use photos that are printed on an ink-jet printer. After you share a story and photos, please be patient. We receive a lot of mail, and it takes our small staff a while to catch up. We may hold your material for consideration in a future issue without informing you first, but we will let you know if we publish it. If we publish your material, we will send you a complimentary copy of the issue and any payment mentioned in the original solicitation upon publication, or at our normal contributor's rates." Pays $300-800 for text/photo package depending on quality of photos and number used; $300 minimum for front cover; $200 minimum for back cover; $100-300 for partial page inside, depending on size. No b&w photos used. **Pays on acceptance.** Buys one-time rights.

TIPS Prefers to see "rural scenics, in various seasons; include a variety of country women—from traditional farm and ranch women to the new baby-boomer, rural retiree; slides appropriately simple for use with poems or as accents to inspirational, reflective essays, etc."

CRUISING WORLD

The Sailing Co., 55 Hammarlund Way, Middletown RI 02842. (401)845-5100. **Fax:** (401)845-5180. **E-mail:** cw.manuscripts@gmail.com; elaine.lembo@cruising world.com; bill.roche@bonniercorp.com. **Website:** www.cruisingworld.com. **Contact:** Elaine Lembo, deputy editor; Bill Roche, art director. Estab. 1974. Circ. 155,000. Emphasizes sailboat maintenance, sailing instruction and personal experience. For people interested in cruising under sail. Sample copy free with 9×12 SASE.

NEEDS Buys 25 photos/year. Needs "shots of cruising sailboats and their crews anywhere in the world. Shots of ideal cruising scenes. No identifiable racing shots, please." Also wants exotic images of cruising sailboats, people enjoying sailing, tropical images, different perspectives of sailing, good composition, bright colors. For covers, photos "must be of a cruising sailboat with strong human interest, and can be located anywhere in the world." Prefers vertical format. Allow space at top of photo for insertion of logo. Model release preferred; property release required. Photo captions required; include location, body of water, make and model of boat. See guidelines at www.cruisingworld. com/cruising-world-guidelines-for-writers-and-pho tographers.

SPECS Prefers images in digital format via CD. Accepts 35mm color slides.

MAKING CONTACT & TERMS "Submit original 35mm slides—*no* duplicates—or digital images. We look for good color balance very sharp focus, the ability to capture sailing, good composition and action. Always looking for *cover shots*." Responds in 2 months. Pays $600 for color cover; $50-300 for color inside. Pays on publication. Credit line given. Buys all rights, but may reassign to photographer after publication; first North American serial rights; or one-time rights.

CYCLE CALIFORNIA! MAGAZINE

1702-L Meridian Ave. #289, San Jose CA 95125. (408)924-0270. **Fax:** (408)292-3005. **E-mail:** tcor ral@cyclecalifornia.com; BMack@cyclecalifornia. com. **Website:** www.cyclecalifornia.com. **Contact:** Tracy L. Corral; Bob Mack, publisher. Estab. 1995. Circ. 26,000 print; 4,700 digital. Monthly. Provides readers with a comprehensive source of bicycling information, emphasizing the bicycling life in northern California and northern Nevada; promotes bicycling in all its facets. "While we do not exclude writers from other parts of the country, articles should reflect a Californian slant." Sample copy available with 9×12 SASE and $1.39 first-class postage. Photo guidelines available with SASE.

NEEDS Buys 3-5 photos from freelancers/issue; 45 photos/year. Needs photos of recreational bicycling, bicycle racing, triathlons, bicycle touring and adventure racing. Cover photos must be vertical format, color. All cyclists must be wearing a helmet if riding.

Reviews photos with or without ms. Model release required; property release preferred. Photo captions preferred; include when and where photo is taken; if an event, include name, date and location of event; for nonevent photos, location is important.

SPECS High-res TIFF images preferred (2000×3000 pixel minimum). Cover photos are 7×9.

MAKING CONTACT & TERMS Send query letter with CD/disc or e-mail. Keeps usable images on file; include SASE for return of material. Responds in 3 weeks. Simultaneous submissions OK. Pays $125 for color cover; $50 for inside. Pays on publication.

TIPS "We are looking for photographic images that depict the fun of bicycle riding. Your submissions should show people enjoying the sport. Read the magazine to get a feel for what we do. Label images so we can tell what description goes with which image."

⑨ CYCLE WORLD

15255 Alton Pkwy., Irvine CA 92618. (760)707-0100. **E-mail:** hotshots@cycleworld.com. **Website:** www.cycleworld.com. **Contact:** Mark Hoyer, editor-in-chief. Circ. 300,000. Monthly. Readers are active motorcyclists who are "affluent, educated and very perceptive."

NEEDS Buys 10 photos/issue. Wants "outstanding" photos relating to motorcycling. Prefers to buy photos with manuscripts. For "Slipstream" column, see instructions in a recent issue.

SPECS Prefers high-res digital images at 300 dpi or quality 35mm color transparencies.

MAKING CONTACT & TERMS Send photos for consideration; include SASE for return of material. Responds in 6 weeks. "Cover shots are generally done by the staff or on assignment." Pays on publication. Buys first publication rights.

TIPS "Editorial contributions are welcomed, but must be guaranteed exclusive to *Cycle World*. We are not responsible for the return of unsolicited material unless accompanied by SASE."

ⓓ DANCE

2660 Petersborough St., Herndon VA 20171. **E-mail:** shannonaswriter@yahoo.com. **Contact:** Shannon Bridget Murphy. Quarterly. Features international dancers.

NEEDS Performing arts, product shots/still life as related to international dance for children and teens. Interested in alternative process, avant garde, documentary, fashion/glamour, fine art, historical/vintage,

seasonal. Reviews photos with or without a manuscript. Model/property release preferred.

SPECS Uses glossy or matte color and b&w prints.

MAKING CONTACT & TERMS Send query letter via e-mail. Provide résumé, business card, self-promotion piece to be kept on file for possible future assignments. "Photographs sent along with CDs are requested but not required. Write to request guidelines for artwork and illustrations." Responds within 1 month to queries; 1 week to portfolios. Simultaneous submissions and previously published work OK. **Pays on acceptance.** Credit line given. Buys one-time rights, first rights; negotiable.

DEER & DEER HUNTING

F+W Media, Inc., 700 E. State St., Iola WI 54990. (715)445-2214. **E-mail:** dan.schmidt@fwmedia.com. **Website:** www.deeranddeerhunting.com. **Contact:** Dan Schmidt, editor-in-chief. Estab. 1977. Circ. 200,000. Published 10 times/year. Emphasizes whitetailed deer and deer hunting. Readers are "a cross-section of American deer hunters—bow, gun, camera." Sample copy and photo guidelines free with 9×12 SASE with 7 first-class stamps. Photo guidelines also available on website.

NEEDS Buys 20 photos from freelancers/issue; 180 photos/year. Photos of deer in natural settings. Model release preferred. Photo captions preferred.

SPECS Accepts images in digital format. Send contact sheet.

MAKING CONTACT & TERMS Send query letter with résumé of credits and samples. "If we judge your photos as being usable, we like to hold them in our file. Send originals—include SASE if you want them returned." Responds in 2-4 weeks. Pays $800 for color cover; $75-250 for color inside; $50 for b&w inside. Pays net 30 days of publication. Credit line given. Buys one-time rights.

TIPS Prefers to see "adequate selection of 35mm color transparencies; action shots of whitetail deer only, as opposed to portraits. We also need photos of deer hunters in action. We are currently using almost all color—very little b&w. Submit a limited number of quality photos rather than a multitude of marginal photos. Include your name on all entries. Cover shots must have room for masthead."

ⓢ ⑨ ⓓ DIGITAL PHOTO

Bauer Consumer Media, Media House, Lynch Wood, Peterborough PE2 6EA United Kingdom. 44 1733 468

000. **E-mail:** dp@bauerconsumer.co.uk. **Website:** www.photoanswers.co.uk. Estab. 1997. Circ. 60,792. Monthly. "UK's best-selling photography and imaging magazine."

NEEDS Stunning, digitally manipulated images of any subject and Photoshop or Elements step-by-step tutorials of any subject. Reviews photos with or without a manuscript. Model/property release preferred. Photo captions preferred.

SPECS Accepts images in digital format. Send via CD as PSD, TIFF or JPEG files at 300 dpi, or via e-mail as JPEG.

MAKING CONTACT & TERMS Send e-mail with ré-sumé, low-res tearsheets, low-res JPEGs. Responds in 1 month to queries. Rates negotiable, but typically 60 GBP per page. Pays on publication. Credit line given. Buys first rights.

TIPS "Study the magazine to check the type of images we use and send a sample of images you think would be suitable. The broader your style, the better for general acceptance, while individual styles appeal to our Gallery section. Step-by-step technique pieces must be formatted to house style, so check magazine before submitting. Supply a contact sheet or thumbnail of all the images supplied in electronic form to make it easier for us to make a quick decision on the work."

DOG FANCY

BowTie Inc., P.O. Box 6050, Mission Viejo CA 92690. (949)855-8822. **Fax:** (949)855-3045. **E-mail:** barkback@dogfancy.com. **Website:** www.dogfancy.com; www.dogchannel.com. Estab. 1970. Circ. 268,000. Monthly. Readers are "men and women of all ages interested in all aspects of dog ownership." Photo guidelines free with SASE or on website.

NEEDS Three specific breeds featured in each issue. Prefers "photographs that show the various physical and mental attributes of the breed. Include both environmental and action photographs. Dogs must be well groomed and, if purebred, good examples of their breed. By good example, we mean clean, healthy-looking dogs who conform to their breed standard (found at www.akc.org or www.ukcdogs.com). We also need for high-quality, interesting photographs of pure or mixed-breed dogs in canine situations (dogs with veterinarians; dogs eating, drinking, playing, swimming, etc.) for use with feature articles. Shots should have natural, modern background, style and

setting, avoiding studio backgrounds. Photographer is responsible for model releases.

SPECS Prefers high-res digital images either TIFF or JPEG at least 5" at 300 dpi. Can be sent on disc or via FTP site. Instructions for FTP submittal provided upon request. Send CD or DVD.

MAKING CONTACT & TERMS Address submission to "Photo Editor." Present a professional package, disc with photographer's name on it separated by subject with contact sheets. Pays $300 for color cover; $25-100 for color inside; $200 for 4-color centerspreads. Credit line given. Buys first North American print rights and non-exclusive rights to use in electronic media.

TIPS "Send a variety of shots. We mainly want to see candid outdoor and action photos of dogs alone and dogs with people. Once we review your images, we will notify you whether we will be adding you to our list of freelance photographers. Poor lighting, focus, and composition in photographs are what make a particular photographer a likely candidate for rejection."

DOWNBEAT

102 N. Haven Rd., Elmhurst IL 60126. (651)251-9682; (877)904-5299. **E-mail:** editor@downbeat.com. **Website:** www.downbeat.com. Estab. 1934. Circ. 90,000. Monthly. Emphasizes jazz musicians. Sample copy available with SASE.

NEEDS Buys 20 photos from freelancers/issue; 240 photos/year. Needs photos of live music performers/posed musicians/equipment, primarily jazz and blues. Photo captions preferred.

SPECS Accepts images in digital format. "Do not send unsolicited high-res images via e-mail!"

MAKING CONTACT & TERMS Send 8×10 b&w prints; 35mm, 2¼×2¼, 4×5, 8×10 transparencies; b&w or color contact sheets by mail. Unsolicited samples will not be returned unless accompanied by SASE. Provide résumé, business card, brochure, flyer or tearsheets to be kept on file for possible future assignments. Responds only when needed. Simultaneous submissions and previously published work OK. Pay rates vary by size. Credit line given. Buys one-time rights.

TIPS "We prefer live shots and interesting candids to studio work."

THE DRAKE MAGAZINE

P.O. Box 11546, Denver CO 80211. (949)218-8642. **E-mail:** info@drakemag.com. **Website:** www.drakemag.com. Estab. 1998. Quarterly. For flyfishing enthusiasts.

NEEDS Buys 50 photos from freelancers/issue. Needs creative flyfishing shots. Reviews photos with or without a ms.

SPECS Uses digital photos only.

MAKING CONTACT & TERMS Responds in 6 months to queries. Pays $200 minimum for color cover; $40 minimum for b&w inside. Pays on publication. Credit line given. Buys one-time rights.

TIPS "No 'grip and grins' for fishing photos. Think creative. Show me something new."

🦆 💲 DUCKS UNLIMITED MAGAZINE

One Waterfowl Way, Memphis TN 38120. (901)758-3864. **E-mail:** jhoffman@ducks.org. **Website:** www.ducks.org. **Contact:** John Hoffman, photo editor. Estab. 1937. Circ. 700,000. Bimonthly association magazine of Ducks Unlimited Inc., a nonprofit organization. Emphasizes waterfowl hunting and conservation. Readers are professional males, ages 40-50. Sample copy available for $3. Photo guidelines available on website via e-mail or with SASE.

NEEDS Images of wild ducks and geese, waterfowling and scenic wetlands. Special photo needs include waterfowl hunters, dynamic shots of waterfowl interacting in natural habitat. Buys 84 photos from freelancers/issue; 504 photos/year

SPECS Accepts images in digital format. Send via CD as TIFF, JPEG, EPS files at 300 dpi; include thumbnails.

MAKING CONTACT & TERMS Responds in 1 month. Previously published work *will not be considered*. Pays on publication. Credit line given. Buys one-time rights "plus permission to reprint in our Mexican and Canadian publications."

💲 EASYRIDERS

P.O. Box 3000, Agoura Hills CA 91376. (818)889-8740. **E-mail:** davenichols@easyriders.net. **Website:** www.easyriders.com. **Contact:** Dave Nichols, editorial director. Estab. 1971. Monthly. Emphasizes "motorcycles (Harley-Davidsons in particular), motorcycle women, bikers having fun." Readers are "adult men who own, or desire to own, custom motorcycles; the individualist—a rugged guy who enjoys riding a custom motorcycle and all the good times derived from it." Sample copy free. Photo guidelines free with SASE.

NEEDS Uses about 60 photos/issue; majority supplied by freelancers; 70% assigned. Photos of "motorcycle riding (rugged chopper riders), motorcycle women, good times had by bikers, etc." Model release

required. Also interested in technical articles relating to Harley-Davidsons.

SPECS Prefers images in digital format ("raw from camera, no effects added").

MAKING CONTACT & TERMS Use online submission form. 3 megapixel, 300 dpi minimum. "Acceptable formats: TIFF, Photoshop (PSD), Kodak Photo CDs, JPEG. GIF format is NOT acceptable." Other terms for bike features with models to satisfaction of editors. Pays 30 days after publication. Credit line given. Buys all rights. All material must be exclusive.

TIPS Trend is toward "more action photos, bikes being photographed by photographers on bikes to create a feeling of motion." In samples, wants photos "clear, in-focus, eye-catching and showing some emotion. Read magazine before making submissions. Be critical of your own work. Check for sharpness. Also, label photos/slides clearly with name and address."

THE ELKS MAGAZINE

2750 N. Lakeview Ave., Chicago IL 60614. (773)755-4740. **E-mail:** elksmag@elks.org. **Website:** www.elks.org/elksmag. **Contact:** Cheryl T. Stachura, editor/publisher. Estab. 1922. Circ. 1,037,000.

NEEDS Buys 10 cover photos/year; mostly from stock photo houses; approximately 20 photos/month for interior use. "Photographs of elks in action are particularly welcome." Reviews photos with or without a manuscript. Photo captions required; include location.

SPECS Accepts high-res digital images.

MAKING CONTACT & TERMS Send query letter with samples. Does not keep samples on file; include SASE for return of material. Responds in 2 months to queries. Simultaneous submissions OK. Pays $475 for color cover. Pays on publication. Credit line given. Buys one-time rights.

TIPS "Artistry and technical excellence are as important as subject matter. We are now purchasing 90% of our photographs from photographic stock houses."

🦌 💲 ⓘ ENTREPRENEUR

2445 McCabe Way, Suite 400, Irvine CA 92614. (949)261-2325. **Website:** www.entrepreneur.com. **Contact:** Richard R. Olson, design director; Megan Roy, creative director. Estab. 1977. Circ. 650,000. Monthly. Emphasizes business. Readers are existing and aspiring small business owners.

NEEDS Uses 40 photos/issue; 10% supplied by freelance photographers; 80% on assignment; 10% from

stock. Needs people at work, home office, business situations. "I want to see colorful shots in all formats and styles." Model/property release preferred. Photo captions required; include names of subjects.

SPECS Accepts images in digital format and film. Send via ZIP, CD, e-mail as TIFF, EPS, JPEG files at 300 dpi.

MAKING CONTACT & TERMS All magazine queries should be e-mailed to: queries@entrepreneur. com. Responds in 6 weeks. No phone calls, please. Entrepreneur Media Inc. assumes no responsibility for unsolicited manuscripts or photos. Provide résumé, business card, brochure, flyer or tearsheets to be kept on file for possible future assignments. **Pays on acceptance.** Credit line given. Buys one-time North American rights; negotiable.

TIPS "I am looking for photographers who use the environment creatively; I do not like blank walls for backgrounds. Lighting is also important. I prefer medium-format for most shoots. I think photographers are going back to the basics—a good, clean shot, different angles and bright colors. I also like gelled lighting. I prefer examples of your work—promo cards and tearsheets—along with business cards and résumés."

● ⑤ ○ EOS MAGAZINE

Robert Scott Publishing, The Old Barn, Ball Lane, Tackley, Kidlington, Oxfordshire 0X5 3AG, United Kingdom. (44)(186)933-1741. **Fax:** (44)(186)933-1641. **E-mail:** editorial@eos-magazine.com. **Website:** www. eos-magazine.com. **Contact:** Robert Scott, editor. Estab. 1993. Circ. 20,000. Quarterly. For all users of Canon EOS cameras. Photo guidelines at bit.ly/WuAA86.

NEEDS Looking for quality stand-alone images as well as photos showing specific photographic techniques and comparison pictures. All images must be taken with EOS cameras but not necessarily with Canon lenses. Photo captions required; include technical details of photo equipment and techniques used.

SPECS Accepts images in digital format exclusively.

MAKING CONTACT & TERMS Pays on publication. Credit line given. Buys one-time rights.

○ EVENT

Douglas College, P.O. Box 2503, New Westminster BC V3L 5B2, Canada. (604)527-5293. **Fax:** (604)527-5095. **E-mail:** event@douglascollege.ca. **Website:** www. event.douglas.bc.ca. Estab. 1971. Circ. 1,250. Published every 4 months. Emphasizes literature (short stories, reviews, poetry, creative nonfiction).

NEEDS Only publishes photography by B.C.-based artists. Buys approximately 3 photographs/year. Has featured photographs by Mark Mushet, Lee Hutzulak, and Anne de Haas. Assigns 50% of photographs to new and emerging photographers. Uses freelancers mainly for covers. "We look for art that is adaptable to a cover, particularly images that are self-sufficient and don't lead the reader to expect further artwork within the journal."

MAKING CONTACT & TERMS "Please send photography/artwork (no more than 10 images) to *Event*, along with SASE (Canadian postage or IRCs only) for return of your work. We also accept e-mail submissions of cover art. We recommend that you send low-res versions of your photography/art as small JPEG or PDF attachments. If we are interested, we will request high-res files. We do not buy the actual piece of art; we only pay for the use of the image." Simultaneous submissions OK. Pays $150 on publication. Credit line given. Buys one-time rights.

FACES

Cobblestone Publishing, 30 Grove St., Suite C, Peterborough NH 03458. (603)924-7209; (800)821-0115. **Fax:** (603)924-7380. **E-mail:** customerservice@carus pub.com. **Website:** www.cobblestonepub.com. Estab. 1984. Circ. 15,000. Photo guidelines and themes available online or free with SASE.

NEEDS Uses about 30-35 photos/issue; 75% supplied by freelancers. "Photos (color) for text must relate to themes; cover photos (color) should also relate to themes." Send SASE for themes. Photos purchased with or without accompanying manuscript. Model release preferred. Photo captions preferred.

MAKING CONTACT & TERMS Query with stock photo list and/or samples. Responds in 1 month. Simultaneous submissions and previously published work OK. Pays $200-350 for color cover; $25-100 color inside. Pays on publication. Buys one-time rights. Credit line given.

TIPS "Photographers should request our theme list. Most of the photographs we use are of people from other cultures. We look for an ability to capture people in action—at work or play. We primarily need photos showing people, young and old, taking part in ceremonies, rituals, customs and with artifacts and architecture particular to a given culture. Appropriate scenics and animal pictures are also needed. All submissions must relate to a specific future theme."

☼ 🐟 ○ FAITH & FRIENDS

The Salvation Army, 2 Overlea Blvd., Toronto ON M4H 1P4, Canada. (416)422-6226. **Fax:** (416)422-6120. **E-mail:** faithandfriends@can.salvationarmy. org. **Website:** www.faithandfriends.ca. **Contact:** Geoff Moulton, senior editor. Circ. 43,000. Monthly. "Our mission: To show Jesus Christ at work in the lives of real people, and to provide spiritual resources for those who are new to the Christian faith."

NEEDS Photos of religion.

SPECS Accepts images in digital format. Send JPEG or GIF files. Uses prints.

MAKING CONTACT & TERMS Payment negotiated. Captions required. Buys one-time rights.

FAMILY MOTOR COACHING

8291 Clough Pike, Cincinnati OH 45244. (513)474-3622. **Fax:** (513)388-5286. **E-mail:** rgould@fmca. com; magazine@fmca.com. **Website:** www.fmca. com. **Contact:** Robbin Gould, editor. Estab. 1963. Circ. 140,000. Monthly publication of the Family Motor Coach Association. Emphasizes motor homes. Readers are members of national association of motor home owners. Sample copy available for $3.99 ($5 if paying by credit card). Writer's/photographer's guidelines free with SASE or via e-mail.

NEEDS Buys 55-60 photos from freelancers/issue; 660-720 photos/year. Each issue includes varied subject matter—primarily needs photos depicting motor home travel, travel with scenic shots, couples, families, senior citizens, hobbies and how-to material. Photos purchased with accompanying manuscript only. Model release preferred. Photo captions required.

SPECS Accepts images in digital format. Send via CD as EPS, TIFF files at 300 dpi.

MAKING CONTACT & TERMS Send query letter with résumé of credits, samples, contact sheets; include SASE for return of material. Responds in 3 months. Pays $100 for color cover; $25-100 for b&w and color inside. $125-500 for text/photo package. **Pays on acceptance.** Credit line given if requested. Prefers first North American rights, but will consider one-time rights on photos *only*.

TIPS Photographers are "welcome to submit brochures or copies of their work. We'll keep them in mind should a freelance photography need arise."

✛ FCA MAGAZINE

Fellowship of Christian Athletes, 8701 Leeds Rd., Kansas City MO 64129. (816)921-0909. **Fax:** (816)921-

8755. **E-mail:** mag@fca.org. **Website:** www.fca.org/ mag. **Contact:** Clay Meyer, editor; Matheau Casner, creative director. Estab. 1959. Circ. 80,000. Monthly association magazine featuring stories and testimonials of prominent athletes and coaches in sports who proclaim a relationship with Jesus Christ. Sample copy available for $1 and 9×12 SASE. Photo guidelines available at www.fca.org/mag/media-kit.

NEEDS Photos of sports. "We buy photos of persons being featured in our magazine. We don't buy photos without story being suggested first." Reviews photos with accompanying manuscript only. "All submitted stories must be connected to the FCA Ministry." Model release preferred; property release required. Photo captions preferred.

SPECS Uses glossy or matte color prints; 35mm, 2¼×2¼ transparencies. Accepts images in digital format. Send via CD, ZIP, e-mail as TIFF, JPEG files at 300 dpi.

MAKING CONTACT & TERMS Contact through e-mail with a list of types of sports photographs in stock. Do not send samples. Simultaneous submissions OK. Pays $150 maximum for color cover; $100 maximum for color inside. Pays on publication. Credit line given. Buys one-time rights.

TIPS "We would like to increase our supply of photographers who can do contract work."

⑤ ○ FELLOWSHIP

P.O. Box 271, Nyack NY 10960. (845)358-4601 ext. 42. **E-mail:** editor@forusa.org. **Website:** www.forusa.org. **Contact:** Ethan Vesely-Flad, editor. Estab. 1935. Circ. 5,000. Publication of the Fellowship of Reconciliation published 4 times/year. Emphasizes peace-making, social justice, nonviolent social change. Readers are interested in peace, justice, nonviolence and spirituality. Sample copy available for $7.50.

NEEDS Buys up to 2 photos from freelancers/issue; 4-10 photos/year. Needs stock photos of people, civil disobedience, demonstrations—Middle East, Latin America, Caribbean, prisons, anti-nuclear, children, gay/lesbian, human rights issues, Asia/Pacific. Captions required.

MAKING CONTACT & TERMS Provide résumé, business card, brochure, flyer or tearsheets to be kept on file for possible future assignments. "Call for specs." Responds in 4-6 weeks. Simultaneous submissions and previously published work OK. Pays $100 for

color cover; $35 for b&w inside. Pays on publication. Credit line given. Buys one-time rights.

TIPS "You must want to make a contribution to peace movements. Money is simply token."

FIELD & STREAM

2 Park Ave., New York NY 10016. (212)779-5296. **Fax:** (212)779-5114. **E-mail:** fsletters@bonniercorp. com. **Website:** www.fieldandstream.com. Estab. 1895. Circ. 1,500,000. Broad-based monthly service magazine published 11 times/year. Editorial content ranges from very basic "how it's done" filler stories that tell in pictures and words how an outdoor technique is accomplished or device is made, to feature articles of penetrating depth about national conservation, game management and resource management issues; also recreational hunting, fishing, travel, nature and outdoor equipment.

NEEDS Photos using action and a variety of subjects and angles in color and occasionally b&w. "We are always looking for cover photographs, in color, vertical or horizontal. Remember, a cover picture must have room for cover lines." Also looking for interesting photo essay ideas related to hunting and fishing. Query photo editor by e-mail. Needs photo information regarding subjects, the area, the nature of the activity and the point the picture makes. First Shots: these photos appear every month (2/issue). Prime space, 2-page spread. One-of-a-kind, dramatic, impactful images, capturing the action and excitement of hunting and fishing. Great beauty shots. Unique wildlife images. See recent issues.

MAKING CONTACT & TERMS Please do not submit images without reviewing past issues and having a strong understanding of our audience. Uses 35mm slides. Will also consider large-format photography. Accepts images in digital format. Send via CD, e-mail as JPEG files at 300 dpi. Submit photos by registered mail. Send slides in 8½×11 plastic sheets and pack slides and prints between cardboard. Include SASE for return of material. Drop portfolios at receptionist's desk, 9th floor. Buys first North American rights.

FINESCALE MODELER

Kalmbach Publishing Co., 21027 Crossroads Circle, P.O. Box 1612, Waukesha WI 53187-1612. (414)796-8776. **Website:** www.finescale.com. Circ. 60,000. Published 10 times/year. Emphasizes "how-to information for hobbyists who build non-operating scale models." Readers are "adult and juvenile hobbyists who build non-operating model aircraft, ships, tanks and military vehicles, cars and figures." Photo and submission guidelines free with SASE or online.

NEEDS Buys 10 photos from freelancers/issue; 100 photos/year. Needs "in-progress how-to photos illustrating a specific modeling technique; photos of full-size aircraft, cars, trucks, tanks and ships." Model release required. Photo captions required.

SPECS Prefers prints and transparencies; will accept digital images if submission guidelines are followed.

MAKING CONTACT & TERMS Provide résumé, business card, brochure, flyer or tearsheets to be kept on file for possible future assignments. "Will sometimes accept previously published work if copyright is clear. Pays for photos on publication, for text/photo package on acceptance. Credit line given. Buys all rights.

TIPS Looks for "sharp color prints or slides of model aircraft, ships, cars, trucks, tanks, figures and science-fiction subjects. In addition to photographic talent, must have comprehensive knowledge of objects photographed and provide complete caption material. Freelance photographers should provide a catalog stating subject, date, place, format, conditions of sale and desired credit line before attempting to sell us photos. We're most likely to purchase color photos of outstanding models of all types for our regular feature, 'Showcase.'"

FLAUNT

1422 N. Highland Ave., Los Angeles CA 90028. (323)836-1000. **E-mail:** info@flauntmagazine.com. **Website:** www.flaunt.com. **Contact:** Luis Barajas, editor-in-chief. Estab. 1998. Circ. 100,000. Monthly. Covers culture, arts, entertainment, literature. "*Flaunt* features the bold work of emerging photographers, writers, artists and musicians. The quality of the content is mirrored in the sophisticated, interactive format of the magazine, using advanced printing techniques, fold-out articles, beautiful papers, and inserts to create a visually stimulating, surprisingly readable and intelligent book that pushes the magazine format into the realm of art object."

NEEDS Photos of celebrities, architecture, cities/urban, entertainment, performing arts, avant garde, lifestyle. Reviews photos with or without a manuscript. Model release required. Captions required; include identification of subjects.

SPECS Accepts images in digital format. Send JPEG or GIF files. Reviews contact sheets, any size transparencies and prints.

MAKING CONTACT & TERMS E-mail query letter with link to photographer's website. Credit line given. Buys one-time rights.

FLORIDA SPORTSMAN

Wickstrom Communications, Intermedia Outdoors, 2700 S. Kanner Hwy., Stuart FL 34994. (772)219-7400. **Fax:** (772)219-6900. **E-mail:** editor@floridasports man.com. **Website:** www.floridasportsman.com. Circ. 115,000. Edited for the boatowner and offshore, coastal, and fresh water fisherman. It provides a how, when, and where approach in its articles, which also includes occasional camping, diving, and hunting stories—plus ecology; in-depth articles and editorials attempting to protect Florida's wilderness, wetlands, and natural beauty.

SPECS High-res digital images on CD preferred. Reviews 35mm transparencies, 4×5 and larger prints.

MAKING CONTACT & TERMS Pays up to $750 for cover photos. Buys all rights.

⊘ ⊕ ◐ FLY ROD & REEL

P.O. Box 370, Camden ME 04843. (207)594-9544. **Fax:** (207)594-5144. **E-mail:** gthomas@flyrodreel.com; ed itor@flyrodreel.com. **Website:** www.flyrodreel.com. **Contact:** Greg Thomas, editor. Estab. 1979. Circ. 61,941. Quarterly. Emphasizes fly-fishing. Readers are primarily fly-fishers ages 30-60. Sample copy and photo guidelines free with SASE; photo guidelines also available via e-mail.

NEEDS Buys 15-20 photos from freelancers/issue; 90-120 photos/year. Needs "photos of fish, scenics (preferably with anglers in shot), equipment." Photo captions preferred; include location, name of model (if applicable).

SPECS Uses 35mm slides; 2¼×2¼, 4×5 transparencies.

MAKING CONTACT & TERMS Send query letter with list of stock photo subjects. Send unsolicited photos by mail for consideration; include SASE for return of material. Provide résumé, business card, brochure, flyer or tearsheets to be kept on file for possible future assignments. Responds in 1 month. Pays $600-800 for color cover photo; $75 for b&w inside (seldom needed); $75-200 for color inside. Pays on publication. Credit line given. Buys one-time rights.

TIPS "Photos should avoid appearance of being too 'staged.' We look for bright color (especially on covers), and unusual, visually appealing settings. Trout and salmon are preferred for covers. Also looking for saltwater fly-fishing subjects. Ask for guidelines, then send 20 to 40 shots showing breadth of work."

◐ FOLIATE OAK LITERARY MAGAZINE

University of Arkansas-Monticello, P.O. Box 3460, Monticello AR 71656. (870)460-1247. **E-mail:** foliate oak@uamont.edu. **Website:** www.foliateoak.uamont. edu. Magazine: foliateoak.weebly.com. **Contact:** Online submission manager. Estab. 1973. Circ. 500. "We are a university general literary magazine publishing new and established artists." Has featured Terry Wright, Brett Svelik, Lucita Peek, David Swartz and Fariel Shafee. No samples kept on file.

NEEDS People, architecture, cities, gardening, landscapes, wildlife, environmental, natural disasters, adventure, humor, alternative, avant garde, documentary, erotic, fashion/glamour, fine art, historical, and lifestyle photographs. Photo captions are preferred.

MAKING CONTACT & TERMS Online submission manager must be used to submit all artwork.

TIPS "We are unable to pay our contributors but we love to support freelancers. We solicit work for our online magazine and our annual print anthology. Read submission guidelines online."

◑ FOLIO

10 Gate St., Lincoln's Inn Fields, London WCZA 3HP, United Kingdom. +44 0207 242 9562. **Fax:** +44 0207 242 1816. **E-mail:** info@folioart.co.uk. **Website:** www. folioart.co.uk. "Folio is an illustration agency based in London. We pride ourselves on representing illustrators and artists of a particularly high quality and versatility." Exclusive representation required. Finds new talent through submissions and recommendations.

NEEDS "We look after around 50 artists who cover the entire spectrum of styles. These styles range from classic oil and acrylic painting, watercolor techniques, classic airbrush, model making, through to contemporary illustration and digital multi-media."

FOOD & WINE

(212)382-5600. **Fax:** (212)764-2177. **Website:** www. foodandwine.com. Circ. 964,000. Monthly. Emphasizes food and wine. Readers are "upscale people who cook, entertain, dine out and travel stylishly."

NEEDS Uses 25-30 photos/issue; 85% freelance photography on assignment basis, 15% freelance stock.

"We look for editorial reportage specialists who do restaurants, food on location, and travel photography." Model release required. Photo captions required. **MAKING CONTACT & TERMS** Drop off portfolio on Wednesday. Call for pickup. Submit flyers, tearsheets, etc., to be kept on file for future assignments and stock usage. **Pays on acceptance.** Credit line given. Buys one-time world rights.

FORTUNE

Time, Inc., 1271 Avenue of the Americas, New York NY 10020. (212)522-1212. **Fax:** (212)522-0810. **E-mail:** letters@fortune.com. **Website:** www.fortune.com. Andrew Serwer, managing editor. Circ. 1,066,000. Emphasizes analysis of news in the business world for management personnel.

MAKING CONTACT & TERMS Picture editor reviews photographers' portfolios on an overnight drop-off basis. Photos purchased on assignment only. Day rate on assignment (against space rate): $500; page rate for space: $400; minimum for b&w or color usage: $200.

🌐 💲 🔧 🔵 FRANCE MAGAZINE

Archant House, Oriel Rd., Cheltenham, Gloucestershire GL50 1BB, United Kingdom. +44 1242 216050. **E-mail:** editorial@francemag.com. **Website:** www.francemag.com. **Contact:** art editor. Estab. 1990. Circ. 40,000. Monthly about France. Readers are male and female, ages 45 and over; people who holiday in France.

NEEDS Photos of France and French subjects: people, places, customs, curiosities, produce, towns, cities, countryside. Photo captions required; include location and as much information as is practical.

SPECS Uses 35mm, medium-format transparencies; high-quality digital.

MAKING CONTACT & TERMS "E-mail in the first instance with list of subjects. Please do not send digital images. We will add you to our photographer list and contact you on an ad-hoc basis for photographic requirements."

FT. MYERS MAGAZINE

15880 Summerlin Rd., Suite 189, Fort Myers FL 33908. (941)433-3884. **E-mail:** ftmyers@optonline.net. **Website:** www.ftmyersmagazine.com. Estab. 2001. Circ. 20,000. Bimonthly. Covers regional arts and living for educated, active, successful and creative residents of Lee and Collier counties (FL) and guests at resorts and hotels in Lee County.

NEEDS Buys 3-6 photos from freelancers/year. Photos of celebrities, architecture, gardening, interiors/decorating, medicine, product shots/still life, environmental, landscapes/scenics, wildlife, entertainment, events, food/drink, health/fitness/beauty, performing arts, sports, travel. Interested in alternative process, avant garde, documentary, fashion/glamour, fine art, historical/vintage. Also needs beaches, beach scenes/sunsets over beaches, boating/fishing, palm trees. Reviews photos with or without a MS. Model release required. Photo captions preferred; include description of image and photo credit.

SPECS Uses 4×5, 8×10 glossy or matte color and b&w prints; 35mm, 2×2, 4×5, 8×10 transparencies ("all are acceptable but we prefer prints or digital"). Accepts images in digital format. Send via CD or e-mail (preferred) as TIFF, EPS, PICT, JPEG, PDF files (prefers TIFF or JPEG) at 300-600 dpi.

MAKING CONTACT & TERMS Send query letter via e-mail with digital images and stock list. Responds only if interested; send nonreturnable samples. Simultaneous submissions and previously published work OK. Pays $100 for b&w or color cover; $25-100 for b&w or color inside. Pays on publication. Credit line given. Buys one-time rights.

FUR-FISH-GAME

2878 E. Main St., Columbus OH 43209-9947. **E-mail:** ffgcox@ameritech.net. **Website:** www.furfishgame.com. **Contact:** Mitch Cox, editor. Estab. 1900. Circ. 118,000. Monthly. For outdoorsmen of all ages who are interested in hunting, fishing, trapping, dogs, camping, conservation, and related topics.

NEEDS Buys 4 photos from freelancers/issue; 50 photos/year. Photos of freshwater fish, wildlife, wilderness and rural scenes. Reviews photos with or without a ms. Photo captions required; include subject.

SPECS Reviews transparencies, color 5×7 or 8×10 prints, digital photos on CD only with thumbnail sheet of small images and a numbered caption sheet.

MAKING CONTACT & TERMS Send query letter "and nothing more." Does not keep samples on file; include SASE for return of material. Responds in 1 month to queries. Simultaneous submissions (but no previously published work) OK. Pays $35 minimum for b&w and color inside. Pays on publication. Credit line given. Buys first North American serial rights, print and digital publication one-time rights.

GAME & FISH

2250 Newmarket Pkwy., Suite 110, Marietta GA 30067. (770)953-9222. **Fax:** (678)279-7512. **E-mail:** ken.dunwoody@imoutdoors.com. **Website:** www.gameandfishmag.com. **Contact:** Ken Dunwoody, editorial director; Ron Sinfelt, photo editor; Allen Hansen, graphic artist. Estab. 1975. Circ. 570,000 for 28 state-specific magazines. Publishes several different monthly outdoors magazines: *Alabama Game & Fish, Arkansas Sportsman, California Game & Fish, Florida Game & Fish, Georgia Sportsman, Illinois Game & Fish, Indiana Game & Fish, Iowa Game & Fish, Kentucky Game & Fish, Michigan Sportsman, Minnesota Sportsman, Mississippi/Louisiana Game & Fish, New England Game & Fish, New York Game & Fish, North Carolina Game & Fish, Ohio Game & Fish, Oklahoma Game & Fish, Pennsylvania Game & Fish, Rocky Mountain Game & Fish, South Carolina Game & Fish, Tennessee Sportsman, Texas Sportsman, Washington-Oregon Game & Fish, West Virginia Game & Fish, Wisconsin Sportsman*, and *North American Whitetail*. All magazines are for experienced hunters and fishermen and provide information about where, when, and how to enjoy the best hunting and fishing in their particular state or region, as well as articles about game and fish management, conservation and environmental issues. Photo guidelines and current needs list free with SASE.
NEEDS 50% of photos supplied by freelance photographers; 5% assigned. Photos of live game animals/birds in natural environments and hunting scenes; game fish photos and fishing scenes. Photo captions required; include species identification and location. Number slides/prints.
SPECS Accepts images in digital format. Send via CD at 300 dpi with output of 8×12.
MAKING CONTACT & TERMS Send 5×7, 8×10 glossy b&w prints or 35mm transparencies (preferably Fujichrome, Kodachrome) with SASE for consideration. Responds in 1 month. Simultaneous submissions not accepted. Pays 60 days prior to publication. Tearsheet provided. Credit line given. Buys one-time rights.
TIPS "Send separate CD and proof sheet for each species, with digital submissions. We'll return photos we don't expect to use and hold remainder in-house so they're available for monthly photo selections. Please do not send dupes. Photos will be returned upon publication or at photographer's request."

GARDENING HOW-TO

12301 Whitewater Dr., Minnetonka MN 55343. **E-mail:** editors@gardeningclub.com. **Website:** www.gardeningclub.com. **Contact:** Mark Simpson, executive art director. Estab. 1996. Circ. 708,000. Association magazine published 6 times/year. Emphasizes gardening subjects for the avid home gardener, from beginner to expert. Readers are 78% female, average age of 51. Sample copies available.
NEEDS Buys 50 photos from freelancers/issue; 300 photos/year. Needs photos of gardening. Offers assignment work shooting specific gardens around the country. Reviews photos with or without a manuscript. Model/property release preferred. Photo captions preferred.
SPECS Prefers images in digital format. Send via CD as TIFF, EPS, JPEG files at 300 dpi. "FTP site available for digital images." Also uses 35mm, 2¼×2¼, 4×5, 8×10 transparencies.
MAKING CONTACT & TERMS Query art director. Provide self-promotion piece to be kept on file for possible future assignments. Responds only if interested; send nonreturnable samples. Previously published work OK. **Pays on acceptance.** Credit line given. Buys one-time rights, first rights, electronic rights; negotiable.
TIPS "Looking for tack-sharp, colorful general gardening photos and will send specific wants if interested in your work. Send a complete list of photos along with slides or CD in package."

GEORGIA STRAIGHT

1701 W. Broadway, Vancouver BC V6J 1Y3, Canada. (604)730-7000. **Fax:** (604)730-7010. **E-mail:** contact@straight.com; photos@straight.com. **Website:** www.straight.com. **Contact:** Charlie Smith, editor. Estab. 1967. Circ. 117,000. Weekly tabloid. Emphasizes entertainment. Readers are generally well-educated people, ages 20-45. Sample copy free with 10×12 SASE.
NEEDS Buys 3 photos from freelancers/issue; 364 photos/year. Needs photos of entertainment events and personalities. Photo captions essential.
MAKING CONTACT & TERMS Send query letter with list of stock photo subjects. Provide résumé, business card, brochure, flyer or tearsheets to be kept on file for possible future assignments. Responds in 1 month. Simultaneous submissions and previously published work OK. Include SASE for return of ma-

terial. Pays on publication. Credit line given. Buys one-time rights.

TIPS "Almost all needs are for in-Vancouver assigned photos, except for high-quality portraits of film stars. We rarely use unsolicited photos, except for Vancouver photos for our content page."

⊖ ○ GERMAN LIFE

Zeitgeist Publishing, Inc., 1068 National Hwy., LaVale MD 21502. (301)729-6190. **Fax:** (301)729-1720. **E-mail:** mslider@germanlife.com. **Website:** www. germanlife.com. **Contact:** Mark Slider. Estab. 1994. Circ. 40,000. Bimonthly. Focusing on history, culture and travel relating to German-speaking Europe and German-American heritage. Sample copy available for $5.95.

MAKING CONTACT & TERMS Reviews color transparencies, 5×7 color or b&w prints. Buys one-time rights.

GHOST TOWN

E-mail: shannonsdustytrails@yahoo.com. **Contact:** Shannon Bridget Murphy. Estab. 1998. Quarterly. Photo guidelines available by e-mail request.

NEEDS Buys 12 photos from freelancers/issue; 48-72 photos/year. Photos of babies/children/teens, celebrities, couples, multicultural, families, parents, disasters, environmental, landscapes/scenics, wildlife, architecture, cities/urban, education, gardening, interiors/decorating, pets, religious, rural, adventure, events, food/drink, sports, travel, agriculture, medicine, military, political, product shots/still life, science, technology—as they are related to archaeology and ghost towns. Interested in alternative process, avant garde, documentary, fashion/glamour, fine art, historical/vintage, seasonal. Wants photos of archaeology sites and excavations in progress of American ghost towns. "Would like photographs from ghost towns and western archaeological sites." Reviews photos with or without a manuscript. Model/property release preferred.

SPECS Uses glossy or matte color and b&w prints.

MAKING CONTACT & TERMS Send query letter via e-mail. "If possible, please do not include photographs in files if they are sent through e-mail. A CD sent with your photographs is acceptable." Provide résumé, business card or self-promotion piece to be kept on file for possible future assignments. "Photographs sent with CDs are requested but not required. Illustrations and artwork are

also accepted." Responds within 1 month to queries; 1 week to portfolios. Simultaneous submissions and previously published work OK. **Pays on acceptance.** Credit line given. Buys one-time rights, first rights; negotiable.

GIRLS' LIFE

Monarch Publishing, 4529 Harford Rd., Baltimore MD 21214. (410)426-9600. **Fax:** (410)254-0991. **E-mail:** jessica@girlslife.com. **Website:** www.girlslife. com. **Contact:** Jessica D'Argenio Waller, associate fashion editor; Chun Kim, art director. Estab. 1994. Circ. 363,000. Emphasizes advice, relationships, school, current news issues, entertainment, quizzes, fashion and beauty pertaining to preteen girls. Readers are preteen girls (ages 10-15). *Girls' Life* accepts unsolicited manuscripts on a speculative basis only. First, send an e-mail or letter query with detailed story ideas. No telephone solicitations, please. Guidelines available online.

NEEDS Buys 65 photos from freelancers/issue. Submit seasonal materials 3 months in advance. Uses 5×8, 8½×11 color and b&w prints; 35mm, 4×5 transparencies.

MAKING CONTACT & TERMS Send query letter with stock list. E-mail queries are responded to within 90 days. Works on assignment only. Keeps samples on file. Responds in 3 weeks. Simultaneous submissions and previously published work OK. Pays on usage. Credit line given. Please familiarize yourself with the voice and content of *Girls' Life* before submitting.

GO

INK Publishing, 68 Jay St., Suite 315, Brooklyn NY 11201. (347)294-1220. **Fax:** (917)591-6247. **E-mail:** editorial@airtranmagazine.com. **Website:** www. airtranmagazine.com. **Contact:** Orion Ray-Jones, editor-in-chief; Jaime Lowe, executive editor; Sophie-Claire Hoeller, assistant editor. Estab. 2003. Circ. 100,000. *"Go* is an inflight magazine covering travel, general interest and light business."

MAKING CONTACT & TERMS Reviews GIF/JPEG files. Buys one-time rights.

○ ⊖ GOLF CANADA

Chill Media Inc., 482 S. Service Rd. E., Suite 103, Oakville ON L6J 2X6, Canada. (905)337-1886. **Fax:** (905)337-1887. **E-mail:** scotty@ichill.ca; alison@ichill. ca. **Website:** www.golfcanada.ca. Alison King, managing editor. **Contact:** Scott Stevenson, publisher. Estab. 1994. Circ. 159,000. Published 4 times/year. Cov-

ers Canadian golf. The official magazine of the Royal Canadian Golf Association, published to entertain and enlighten members about RCGA-related activities and to generally support and promote amateur golf in Canada.

GOLF TIPS

Werner Publishing Corp., 12121 Wilshire Blvd., 12th Floor, Los Angeles CA 90025-1176. (310)820-1500. **Fax:** (310)826-5008. **E-mail:** editors@golftipsmag. com. **Website:** www.golftipsmag.com. Estab. 1986. Circ. 300,000. Published 9 times/year. Readers are "hardcore golf enthusiasts." Sample copy free with SASE. Submission guidelines at www.golftipsmag. com/submissions.html.

NEEDS Buys 40 photos from freelancers/issue; 360 photos/year. Photos of golf instruction (usually pre-arranged, on-course), equipment; health/fitness, travel. Interested in alternative process, documentary, fashion/glamour. Reviews photos with accompanying ms only. Model/property release preferred. Photo captions required.

SPECS Uses prints; 35mm, 2¼×2¼, 4×5, 8×10 transparencies. Accepts images in digital format. Send via ZIP as TIFF files at 300 dpi.

MAKING CONTACT & TERMS Send query letter with résumé of credits. Submit portfolio for review. Cannot return material. Responds in 1 month. Pays $500-1,000 for b&w or color cover; $100-300 for b&w inside; $150-450 for color inside. Pays on publication. Buys one-time rights; negotiable.

GOOD HOUSEKEEPING

Hearst Corp., 300 W. 57th St., 28th Floor, New York NY 10019. (212)649-2200. **Website:** www.goodhouse keeping.com. **Contact:** Rosemary Ellis, editor. Circ. 4,000,000. Articles focus on food, fitness, beauty and childcare drawing upon the resources of the Good Housekeeping Institute. Editorial includes human interest stories and articles that focus on social issues, money management, health news and travel. Photos purchased mainly on assignment. *Query before submitting.*

☺ ○ GOSPEL HERALD

5 Lanking Blvd., Toronto ON M4J 4W7, Canada. (416)461-7406. **Fax:** (416)424-1850. **E-mail:** edito rial@gospelherald.org. **Website:** www.gospelherald. org. **Contact:** Max Craddock, managing editor. Estab. 1936. Circ. 1,300. Monthly. Emphasizes Christianity.

Readers are primarily members of the Churches of Christ. Sample copy free with SASE.

NEEDS Uses 2-3 photos/issue. Photos of babies/children/teens, families, parents, landscapes/scenics, wildlife seasonal, especially those relating to readership—moral, religious and nature themes.

SPECS Uses b&w any size and any format. Accepts images in digital format. Send via CD, ZIP, e-mail as JPEG files.

MAKING CONTACT & TERMS Send unsolicited photos by mail for consideration. Payment not given, but photographer receives credit line.

TIPS "We have never paid for photos. Because of the purpose of our magazine, both photos and stories are accepted on a volunteer basis."

GRACE ORMONDE WEDDING STYLE

Elegant Publishing, Inc., P.O. Box 89, Barrington RI 02806. (401)245-9726. **Fax:** (401)245-5371. **E-mail:** contact@weddingstylemagazine.com. **Website:** www. weddingstylemagazine.com. **Contact:** Human Resources. Estab. 1997. Circ. 400,000. Quarterly. Covers weddings catering to the affluent bride.

MAKING CONTACT & TERMS Reviews transparencies. Negotiates payment individually.

GRAND RAPIDS FAMILY MAGAZINE

Gemini Publications, 549 Ottawa Ave. NW, Suite 201, Grand Rapids MI 49503-1444. (616)459-4545. **Fax:** (616)459-4800. **E-mail:** cvalade@geminipub.com. **Website:** www.grfamily.com. **Contact:** Carole Valade, editor. Circ. 30,000. Monthly. Covers local parenting issues. *Grand Rapids Family* seeks to inform, instruct, amuse, and entertain its readers and their families.

NEEDS Buys 20-50 photos from freelancers/issue; 240-600 photos/year. Needs photos of families, children, education, infants, play, etc. Model/property release required. Photo captions preferred; include who, what, where, when.

MAKING CONTACT & TERMS Send query letter with résumé of credits, stock list. Sometimes keeps samples on file; include SASE for return of material. Responds in 1 month, only if interested. Simultaneous submissions and previously published work OK. Pays $200 minimum for color cover; $35-75 for inside. Pays on publication. Credit line given. Buys one-time rights, all rights; negotiable.

TIPS "We are not interested in clip art variety photos. We want the honesty of photojournalism; photos

that speak to the heart, that tell a story, that add to the story told."

GRAND RAPIDS MAGAZINE

Gemini Publications, 549 Ottawa Ave. NW, Suite 201, Grand Rapids MI 49503. (616)459-4545. **Fax:** (616)459-4800. **E-mail:** cvalade@geminipub.com. **Website:** www.grmag.com. Estab. 1964. Circ. 20,000. Monthly magazine. Emphasizes community-related material of metro Grand Rapids area and West Michigan; local action and local people.

NEEDS Photos of animals, nature, scenic, travel, sport, fashion/beauty, photo essay/photo feature, fine art, documentary, human interest, celebrity/personality, humorous, wildlife, vibrant people shots and special effects/experimental. Wants, on a regular basis, West Michigan photo essays and travel-photo essays of any area in Michigan. Model release required. Photo captions required.

SPECS Prefers images in digital format. Send via CD at 300 dpi minimum. Also uses 2¼×2¼, 4×5 color transparencies for cover, vertical format required. "High-quality digital also acceptable."

MAKING CONTACT & TERMS Send material by mail for consideration; include SASE for return. Provide business card to be kept on file for possible future assignments; "only people on file with us are those we have met and personally reviewed." Arrange a personal interview to show portfolio. Responds in 3 weeks. Pays $35-100 for color photos; $100 minimum for cover. Buys one-time rights, exclusive product rights, all rights; negotiable.

TIPS "Most photography is by our local freelance photographers, so you should sell us on the unique nature of what you have to offer."

THE GREYHOUND REVIEW

P.O. Box 543, Abilene KS 67410. (785)263-4660. **E-mail:** nga@ngagreyhounds.com. **Website:** www. ngagreyhounds.com. Estab. 1911. Circ. 3,500. Monthly publication of The National Greyhound Association. Emphasizes Greyhound racing and breeding. Readers are Greyhound owners and breeders. Sample copy free with SASE and 11 first-class stamps.

NEEDS Buys 1 photo from freelancers/issue; 12 photos/year. Needs "anything pertinent to the Greyhound that would be of interest to Greyhound owners." Photo captions required.

MAKING CONTACT & TERMS Query via e-mail first. After response, send b&w or color prints and contact sheets by mail for consideration. Provide résumé, business card, brochure, flyer or tearsheets to be kept on file for possible future assignments. Can return unsolicited material if requested; include SASE for return of material. Responds in 1 month. Simultaneous submissions and previously published work OK. Pays $85 for color cover; $25-100 for color inside. **Pays on acceptance**. Credit line given. Buys one-time and North American rights.

TIPS "We look for human-interest or action photos involving Greyhounds. No muzzles, please, unless the Greyhound is actually racing. When submitting photos for our cover, make sure there's plenty of cropping space on all margins around your photo's subject; full breeds on our cover are preferred."

GUERNICA MAGAZINE

112 W. 27th St., Suite 600, New York NY 10001. **E-mail:** editors@guernicamag.com; art@guernicamag.com; publisher@guernicamag.com. **Website:** www.guernicamag.com. **Contact:** Erica Wright, poetry; Dan Eckstein, art/photography. Estab. 2005. Biweekly. "*Guernica* is one of the Web's most acclaimed new magazines. *Guernica* is called a 'great online literary magazine' by *Esquire*. Contributors come from dozens of countries and write in nearly as many languages."

◎◎ ◑ GUIDEPOSTS

P.O. Box 5814, Harlan IA 51593. (800)431-2344. **E-mail:** submissions@guidepostsmag.com. **Website:** www.guideposts.org. **Contact:** Candice Smilow, photo editor. Estab. 1945. Circ. 2.6 million. Monthly. Emphasizes tested methods for developing courage strength and positive attitudes through faith in God. Free sample copy and photo guidelines with 6×9 SASE.

NEEDS Uses 90% assignment, 10% stock on a story-by-story basis. Photos are mostly environmental portraiture editorial reportage. Stock can be scenic, sports, fine art, mixed variety. Model release required.

SPECS Uses 35mm, 2¼×2¼ transparencies; vertical for cover, horizontal or vertical for inside. Accepts images in digital format. Send via CD at 300 dpi.

MAKING CONTACT & TERMS Send photos or arrange a personal interview. Responds in 1 month. Simultaneous submissions OK. Pays by job or on a per-photo basis. **Pays on acceptance.** Credit line given. Buys one-time rights.

TIPS "I'm looking for photographs that show people in their environment; straight portraiture and people interacting. We're trying to appear more contemporary. We want to attract a younger audience and yet maintain a homey feel. For stock—scenics; graphic images in color. *Guideposts* is an 'inspirational' magazine. No violence, nudity, sex. No more than 20 images at a time. Write first and ask for a sample issue; this will give you a better idea of what we're looking for."

GUITAR WORLD

NewBay Media, LLC, E. 28th St., 12th Floor, New York NY 10016. (212)378-0400. **Fax:** (212)281-4704. **E-mail:** soundingboard@guitarworld.com. **Website:** www.guitarworld.com. Circ. 150,000. Written for guitar players categorized as either professionals, semi-professionals or amateur players. Every issue offers broad-ranging interviews that cover technique, instruments, and lifestyles.

NEEDS Buys 20 photos from freelancers/issue; 240 photos/year. Photos of guitarists. Reviews photos with or without a manuscript. Property release preferred. Photo captions preferred.

SPECS Uses glossy or matte color and b&w prints; 35mm, 2¼×2¼ transparencies. Accepts images in digital format. Send via e-mail as TIFF, EPS, JPEG files at 300 dpi.

MAKING CONTACT & TERMS Send query letter with slides, prints, photocopies, tearsheets. Keeps samples on file. Responds in 2 weeks to queries. Previously published work OK. Pay rates vary by size. **Pays on acceptance.** Credit line given. Buys one-time rights.

HADASSAH MAGAZINE

50 W. 58th St., New York NY 10019. (212)688-0227. **Fax:** (212)446-9521. **E-mail:** magazine@hadassah. org. **Website:** www.hadassah.org/magazine. **Contact:** Elizabeth Goldberg. Circ. 243,000. Bimonthly publication of the Hadassah Women's Zionist Organization of America. Emphasizes Jewish life, Israel. Readers are 85% females who travel and are interested in Jewish affairs, average age 59. Photo guidelines free with SASE.

NEEDS Uses 10 photos/issue; most supplied by freelancers. Photos of travel, Israel and general Jewish life. Photo captions preferred; include where, when, who and credit line.

SPECS Accepts images in digital format. Send via CD as JPEG files at 300 dpi. High-res, digital photos preferred.

MAKING CONTACT & TERMS Submit portfolio for review. Send unsolicited photos by mail for consideration. Keeps samples on file; include SASE for return of material. Responds in 3 months. Payment depends on size and usage. Pays on publication. Credit line given. Buys one-time rights with web use.

TIPS "We frequently need travel photos, especially of places of Jewish interest."

⚙ HAMILTON MAGAZINE

Town Media, a division of Sun Media, 1074 Cooke Blvd., Burlington ON L7T 4A8, Canada. (905)522-6117 or (905)634-8003. **Fax:** (905)634-7661 or (905)634-8804. **E-mail:** marc.skulnick@sunmedia. ca; tm.info@sunmedia.ca. **Website:** www.hamilton magazine.com. **Contact:** Marc Skulnick, editor; Kate Sharrow art director. Estab. 1978. "Our mandate: to entertain and inform by spotlighting the best of what our city and region have to offer. We invite readers to take part in a vibrant community by supplying them with authoritative and dynamic coverage of local culture, food, fashion, and design."

NEEDS Photos of cities/urban, entertainment, food/drink, health/fitness/beauty, fashion/glamour, lifestyle. Reviews photos with or without a manuscript. Captions required; include identification of subjects.

SPECS Accepts images in digital format. Send JPEG files at 8×10 at 300 dpi. Uses 8×10 prints.

MAKING CONTACT & TERMS Pays on publication. Credit line given.

HARPER'S MAGAZINE

666 Broadway, 11th Floor, New York NY 10012. (212)420-5720. **Fax:** (212)228-5889. **E-mail:** read ings@harpers.org. **Website:** www.harpers.org. Estab. 1850. Circ. 230,000. Monthly literary magazine. "The nation's oldest continually published magazine providing fiction, satire, political criticism, social criticism, essays." *Harper's Magazine* encourages national discussion on current and significant issues in a format that offers arresting facts and intelligent opinions.

NEEDS Buys 8-10 photos from freelancers/issue; 120 photos/year. Needs photos of human rights issues, environmental, political. Interested in alternative process, avant garde, documentary, fine art, historical/vintage. Model/property release preferred.

SPECS Uses any format. Accepts images in digital format. Send preferably via e-mail to alyssa@harpers.org or on CD; TIFF, EPS, JPEG files at 72 dpi.

MAKING CONTACT & TERMS Send query letter with résumé, slides, prints, photocopies, tearsheets, transparencies. Portfolio may be dropped off last Wednesday of the month. Provide self-promotion piece to be kept on file for possible future assignments. Responds in 1 week. Pays $200-800 for b&w/color cover; $250-400 for b&w/color inside. Pays on publication. Credit line given. Buys one-time rights; negotiable.

TIPS "*Harper's* is geared more toward fine art photos or artist's portfolios than to 'traditional' photo usages. For instance, we never do fashion, food, travel (unless it's for political commentary), lifestyles or celebrity profiles. A good understanding of the magazine is crucial for photo submissions. We consider all styles and like experimental or nontraditional work. Please don't confuse us with *Harper's Bazaar*!"

HEALING LIFESTYLES & SPAS MAGAZINE

JLD Publications, P.O. Box 271207, Louisville CO 80027. (303)917-7124. **Fax:** (303)926-4099. **E-mail:** melissa@healinglifestyles.com. **Website:** www.healinglifestyles.com. **Contact:** Melissa B. Williams, editorial director. Estab. 1997. *HL&S* is an online-only publication—a trusted leading social media platform for the spa/wellness industry, focusing on spas, retreats, therapies, food and beauty geared toward a mostly female audience, offering a more holistic and alternative approach to healthy living. Photo guidelines available with SASE.

NEEDS Buys 3 photos from freelancers/issue; 6-12 photos/year. Photos of multicultural, environmental, landscapes/scenics, adventure, health/fitness/beauty, food, yoga, travel. Reviews photos with or without a manuscript. Model/property release preferred. Photo captions required; include subject, location, etc.

SPECS Prefers images in digital format. Send via CD, ZIP, e-mail as TIFF, EPS, JPEG files at 300 dpi. Also uses 35mm or large-format transparencies.

MAKING CONTACT & TERMS Send query letter with résumé, prints, tearsheets. Provide résumé, business card, self-promotion piece to be kept on file for possible future assignments. Responds in 1 month. Responds only if interested; send nonreturnable samples. Simultaneous submissions OK. Pays on assignment. Credit line given. Buys one-time rights.

TIPS "We strongly prefer digital submissions, but will accept all formats. We're looking for something other than the typical resort/spa shots—everything from at-home spa treatments to far-off, exotic locations. We're also looking for reliable lifestyle photographers who can shoot yoga-inspired shots, healthy cuisine, ingredients, and spa modalities in an interesting and enlightening way."

HEARTLAND BOATING

The Waterways Journal, Inc., 319 N. Fourth St., Suite 650, St. Louis MO 63102. (314)241-4310. **Fax:** (314)241-4207. **E-mail:** lbraff@heartlandboating.com. **Website:** www.heartlandboating.com. **Contact:** Brad Kovach, editor. Estab. 1989. Circ. 10,000. "*Heartland Boating*'s content is both informative and humorous—describing boating life as the heartland boater knows it. The content reflects the challenge, joy, and excitement of our way of life afloat. We are devoted to both power and sailboating enthusiasts throughout middle America; houseboats are included. The focus is on the freshwater inland rivers and lakes of the heartland, primarily the waters of the Arkansas, Tennessee, Cumberland, Ohio, Missouri, Illinois, and Mississippi rivers, the Tennessee-Tombigbee Waterway, the Gulf Intracoastal Waterway, and the lakes along these waterways."

NEEDS Hobby or sports photos, primarily boating.

MAKING CONTACT & TERMS No follow-ups. Samples kept on file. Portfolio not required. Credit line given.

TIPS "Please read the magazine first. Go to the website to obtain three free copies. Our rates are low, but we do our best to take care of and promote our contributors. *Note: any e-mail submission will be deleted unread.* Submissions must come during our window, May 1-July 1, and be hard-copy form only. Remember to include all of your contact info!"

HERITAGE RAILWAY MAGAZINE

P.O. Box 43, Horncastle Lincolnshire LN9 6JR, United Kingdom. (44)(507)529529. **Fax:** (44)(507)529301. **Website:** www.heritagerailway.co.uk. **Contact:** Mr. Robin Jones, editor. Circ. 15,000. Monthly leisure magazine emphasizing preserved railways; covering heritage steam, diesel and electric trains with over 30 pages of news in each issue.

NEEDS Interested in railway preservation. Reviews photos with or without a manuscript. Photo captions required.

SPECS Uses glossy or matte color and b&w prints; 35mm, 2¼×2¼, 4×5, 8×10 transparencies. No digital images accepted.

MAKING CONTACT & TERMS Send query letter with slides, prints, transparencies. Query with online contact form. Does not keep samples on file; include SASE for return of material. Responds in 1 month to queries. Simultaneous submissions OK. Buys one-time rights.

HIGHLIGHTS FOR CHILDREN

803 Church St., Honesdale PA 18431. (570)253-1080. **Fax:** (570)251-7847. **Website:** www.highlights.com. **Contact:** Christine French Cully, editor-in-chief; Drew Hires, art director. Estab. 1946. Circ. approximately 2 million.

○ *Highlights* is currently expanding photographic needs.

NEEDS Buys 100 or more photos/year. "We will consider outstanding photo essays on subjects of high interest to children." Reviews photos with accompanying ms only. Wants no single photos without captions or accompanying ms.

SPECS Accepts images in digital format. Send via CD at 300 dpi. Also accepts transparencies of all sizes.

MAKING CONTACT & TERMS Send photo essays with SASE for consideration. Responds in 7 weeks. Pays $30 minimum for b&w photos; $50 minimum for color photos; $100 minimum for ms. Buys all rights.

TIPS "Tell a story that is exciting to children. We also need mystery photos, puzzles that use photography/collage, special effects, anything unusual that will visually and mentally challenge children."

HIGHWAYS

Affinity Group, Inc., 2575 Vista Del Mar Dr., Ventura CA 93001. (805)667-4100. **E-mail:** highways@goodsamclub.com. **Website:** www.goodsamclub.com/highways. Estab. 1966. Circ. 975,000. Monthly magazine covering recreational vehicle lifestyle. Sample copy free with 8½×11 SASE.

SPECS Accepts images in digital format. Send via CD or e-mail at 300 dpi.

MAKING CONTACT & TERMS Editorial director will contact photographer for portfolio review if interested. Pays $500 for cover; $75-350 for inside. Buys one-time rights.

HOME EDUCATION MAGAZINE

P.O. Box 1083, Tonasket WA 98855. (800)236-3278; (509)486-1351. **Fax:** (509)486-2753. **E-mail:** articles@homeedmag.com. **Website:** www.homeedmag.com. **Contact:** Jeanne Faulconer, articles editor. Estab. 1983. Circ. 120,000. Bimonthly. Emphasizes homeschooling. Readership includes parents, educators, researchers, media—anyone interested in homeschooling. Sample copy available for $6.50. Photo guidelines free with SASE or via e-mail.

NEEDS Number of photos used/issue varies based on availability; 50% supplied by freelance photographers. Photos of babies/children/teens, multicultural, families, parents, senior citizens, education. Special photo needs include homeschool personalities and leaders. Model/property release preferred. Photo captions preferred.

SPECS Uses color prints in normal print size. "Enlargements not necessary." Accepts images in digital format. Send via CD, ZIP, e-mail as TIFF files at 300 dpi.

MAKING CONTACT & TERMS Send unsolicited color prints by mail with SASE for consideration. Responds in 1 month. Pays $100 for color cover; $12.50 for color inside; $50-150 for photo/text package. Pays on publication. Credit line given. Buys first North American serial rights.

TIPS In photographer's samples, wants to see "sharp, clear photos of children doing things alone in groups, or with parents. Know what we're about! We get too many submissions that are simply irrelevant to our publication."

HOOF BEATS

750 Michigan Ave., Columbus OH 43215. **E-mail:** hoofbeats@ustrotting.com. **Website:** www.hoofbeatsmagazine.com. Estab. 1933. Circ. 10,000. Monthly publication of the U.S. Trotting Association. Emphasizes harness racing. Readers are participants in the sport of harness racing. Sample copy free.

NEEDS Buys 6 photos from freelancers/issue; 72 photos/year. Needs "artistic or striking photos that feature harness horses for covers; other photos on specific horses and drivers by assignment only."

MAKING CONTACT & TERMS Send query letter with samples; include SASE for return of material. Responds in 3 weeks. Simultaneous submissions OK. Pays $150 minimum for color cover; $25-150 for b&w inside; $50-200 for color inside; freelance assignments

negotiable. Pays on publication. Credit line given if requested. Buys one-time rights.

TIPS "We look for photos with unique perspective and that display unusual techniques or use of light. Send query letter first. Know the publication and its needs before submitting. Be sure to shoot pictures of harness horses only, not thoroughbred or riding horses. We always need good night racing action or creative photography."

THE HORSE

P.O. Box 919003, Lexington KY 40591. (859)278-2361. **Fax:** (859)276-4450. **E-mail:** editorial@thehorse. com. **Website:** www.thehorse.com. Estab. 1983. Circ. 55,000. Monthly. Emphasizes equine health. Readers are equine veterinarians, hands-on horse owners, trainers and barn managers. Sample copy free with large SASE. Photo guidelines free with SASE and on website.

NEEDS Buys 20-30 photos from freelancers/issue; 240-360 photos/year. Needs generic horse shots, horse health such as farrier and veterinarian shots. "We use all breeds and all disciplines." Model/property release preferred. Photo captions preferred.

SPECS Uses color transparencies. Accepts images in digital format. Send via CD, floppy disk, ZIP, e-mail as TIFF, EPS, JPEG files at 300 dpi (4×6). "All photos must have metadata included in them before sending to photo editor."

MAKING CONTACT & TERMS Send unsolicited photos by mail for consideration. Keeps samples on file. Previously published work OK. Pays $350 for color cover; $40-120 for color inside. Pays on publication. Buys one-time rights.

TIPS "Please include name, address, and phone number of photographer; date images were sent; whether images may be kept on file or should be returned; date by which images should be returned; number of images sent. Usually 10-20 samples is adequate. Do not submit originals. E-mail photo editor before you send photos."

HORSE ILLUSTRATED

I-5 Publishing, P.O. Box 8237, Lexington KY 40533. (859)260-9800. **Fax:** (859)260-1154. **E-mail:** horse illustrated@bowtieinc.com. **Website:** www.horseill ustrated.com. **Contact:** Elizabeth Moyer, editor. Estab. 1976. Circ. 160,660. Readers are "primarily adult horsewomen, ages 18-40, who ride and show mostly for pleasure, and who are very concerned about the well being of their horses. Editorial focus covers all breeds and all riding disciplines." Sample copy available for $4.99. Photo guidelines on website.

NEEDS Buys 30-50 photos from freelancers/issue. Needs stock photos of riding and horse care. "Photos must reflect safe, responsible horsekeeping practices. We prefer all riders to wear protective helmets; prefer people to be shown only in action shots (riding, grooming, treating, etc.). We like all riders—especially those jumping—to be wearing protective headgear."

SPECS Prefer digital images—high-res JPEGs on a CD with printout of thumbnails.

MAKING CONTACT & TERMS Send by mail for consideration. Responds in 2 months. Pays $250 for color cover; $65-250 for color inside. Credit line given. Buys one-time rights.

TIPS "Looks for clear, sharp color shots of horse care and training. Healthy horses, safe riding and care atmosphere is standard in our publication. Send SASE for a list of photography needs, photo guidelines, and to submit work. Photo guidelines are also available on our website."

HUNGER MOUNTAIN

Vermont College of Fine Arts, 36 College St., Montpelier VT 05602. (802)828-8517. **E-mail:** hungermtn@ vcfa.edu. **Website:** www.hungermtn.org. Estab. 2002.

NEEDS Buys no more than 10 photos/year. Interested in avant garde, documentary, fine art, seasonal. Reviews photos with or without a manuscript.

MAKING CONTACT & TERMS Send query letter with résumé, slides, prints, tearsheets. Does not keep samples on file; include SASE for return of material. Responds in 3 months to queries and portfolios. Simultaneous submissions OK. Pays $30-45 for inside photos; cover negotiable. Pays on publication. Credit line given. Buys first rights.

IMAGE BY DESIGN LICENSING

Suite 3, 107 Bancroft, Hitchin, Herts SG4 1NB, United Kingdom. 44(0) 1462 422244. **E-mail:** lucy@ibd-licensing.co.uk. **Website:** www.ibd-licensing.co.uk. **Contact:** Lucy Brenham. Agency specializing in art licensing. Serves fine artists, illustrators, and photographers. Interested in reviewing fine art, design, and photography.

MAKING CONTACT & TERMS Send a link to a website with résumé, bio, brochure of work, photocopies or digital images in low-res JPEG format.

TIPS Be aware of current trends.

⊙⊙ INDIANAPOLIS MONTHLY

Emmis Communications, 1 Emmis Plaza, 40 Monument Circle Suite 100, Indianapolis IN 46204. (317)237-9288. **E-mail:** deborah@emmis.com. **Website:** www.indianapolismonthly.com. **Contact:** Deborah Paul, editorial director. Estab. 1977. Circ. 50,000. *"Indianapolis Monthly* attracts and enlightens its upscale well-educated readership with bright, lively editorial on subjects ranging from personalities to social issues, fashion to food. Its diverse content and attention to service make it the ultimate source by which the Indianapolis area lives." Sample copy available for $4.95 and 9×12 SASE.

NEEDS Buys 10-12 photos from freelancers/issue; 120-144 photos/year. Needs seasonal, human interest, humorous, regional; subjects must be Indiana- or Indianapolis-related. Model release preferred. Photo caption information required.

SPECS Glossy prints; transparencies, digital. Send via CD, e-mail as TIFF, EPS, JPEG files at 300 dpi at actual size.

MAKING CONTACT & TERMS Send query letter with samples, SASE. Responds in 1 month. Previously published work on occasion OK, if different market. Pays $300-1,200 for color cover; $75-350 for b&w inside; $75-350 for color inside. Pays on publication. Credit line given. Buys first North American serial rights.

TIPS "Read publication. Send photos similar to those you see published. If you see nothing like what you are considering submitting, it's unlikely we will be interested. We are always interested in photo essay queries if they are Indiana-specific."

⊙ INSIDE TRIATHLON

9477 Waples St., Suite 150, San Diego CA 92121. (858)768-6773. **Fax:** (858)768-6806. **E-mail:** insidetri@competitorgroup.com; bmavis@competitorgroup.com. **Website:** www.triathlon.competitor.com. Circ. 40,000 (paid). Monthly journal of triathlons; includes news, features, profiles.

NEEDS Looking for "action and feature shots that show the emotion of triathlons, not just finish-line photos with the winner's arms in the air. Need shots of triathletes during training sessions (non-racing) for our 'Training' section." Reviews photos with or without a manuscript. Photo captions required; include identification of subjects.

SPECS Uses digital files, negatives and transparencies.

MAKING CONTACT & TERMS Send samples of work or tearsheets with assignment proposal. Query before sending manuscript. Responds in 3 weeks. Pays on publication. Credit line given. Buys one-time rights.

TIPS "Photos must be timely."

⊙⊙ ◑ INSIGHT MAGAZINE

55 W. Oak Ridge Dr., Hagerstown MD 21740. (301)393-4038. **E-mail:** insight@rhpa.org. **Website:** www.insightmagazine.org. Estab. 1970. Circ. 16,000. Weekly Seventh-Day Adventist teen magazine. "We print teens' true stories about God's involvement in their lives. All stories, if illustrated by a photo, must uphold moral and church organization standards while capturing a hip, teen style." Sample copy $2 and #10 SASE.

NEEDS Model/property release required. Photo captions preferred; include who, what, where, when.

MAKING CONTACT & TERMS "Send query letter with photo samples so we can evaluate style." Provide résumé, business card, self-promotion piece or tearsheets to be kept on file for possible future assignments. Responds only if interested; send nonreturnable samples. Simultaneous submissions and previously published work OK. Pays $200-300 for color cover; $200-400 for color inside. Pays 30-45 days after receiving invoice and contract. Credit line given. Buys first rights. Submission guidelines available online.

◑ INSTINCT MAGAZINE

303 N. Glenoaks Blvd., Suite L-120, Burbank CA 91502. (818)286-0071; (818)843-1536 x102. **E-mail:** editor@instinctmag.com. **Website:** instinctmagazine.com. **Contact:** Mike Wood, editor-in-chief. Estab. 1997. Circ. 115,000. Monthly gay men's magazine. *"Instinct* is geared towards a gay male audience. The slant of the magazine is humor mingled with entertainment, travel, and health and fitness." Sample copies available. Photo guidelines available via website.

NEEDS Buys 50-75 photos from freelancers/issue; 500-750 photos/year. Needs photos of celebrities, couples, cities/urban, entertainment, health/fitness, humor, travel. Interested in lifestyle, fashion/glamour. High emphasis on humorous and fashion photography. Reviews photos with or without a ms. Model release required; property release preferred. Photo captions preferred.

SPECS Uses 8×10 glossy color prints; 2¼×2¼ transparencies. Accepts images in digital format. Send via CD, Jaz, ZIP as TIFF files at least 300 dpi.

MAKING CONTACT & TERMS Portfolio may be dropped off every weekday. Provide résumé, business card, self-promotion piece to be kept on file for possible future assignments. Responds in 2 weeks. Simultaneous submissions OK. Payment negotiable. Pays on publication. Credit line given.

TIPS "Definitely read the magazine. Keep our editor updated about the progress or any problems with the shoot."

INTERVAL WORLD

P.O. Box 431920, Miami FL 33243-1920. (305)666-1861. **E-mail:** kimberly.dewees@intervalintl.com. **Website:** www.intervalworld.com. **Contact:** Kimberly Dewees, photo editor. Estab. 1982. Circ. 1,080,000. Quarterly publication of Interval International. Emphasizes vacation exchange and travel. Readers are members of the Interval International vacation exchange network.

NEEDS Uses 100 or more photos/issue. Needs photos of travel destinations, vacation activities. Model/property release required. Photo captions required; all relevant to full identification.

MAKING CONTACT & TERMS Send query letter with stock list. Provide business card, brochure, flyer or tearsheets to be kept on file for possible future assignments. Cannot return materials. Simultaneous submissions and previously published work OK. Payment negotiable. Pays on publication. Credit line given for editorial use. Buys one-time rights; negotiable.

TIPS Looking for beautiful scenics; family-oriented, fun travel shots; superior technical quality.

IN THE FRAY

113 Schumacher Dr., New Hyde Park NY 11040-3644. (347)850-3935. **E-mail:** art@inthefray.org. **Website:** www.inthefray.org. **Contact:** Benjamin Gottlieb, art director. Estab. 2001.

NEEDS Buys stock photos and offers assignments. Encourages beginning or unpublished photographers to submit work for consideration. Publishes new photographers, may only pay in copies or have a low pay rate. Buys 2 photos from freelancers/issue. 24 photos/year.

SPECS Accepts images in digital format. Send e-mail with JPEG samples at 72 dpi. Keeps samples on file, please provide business card to be kept on file for possible future assignments. Responds only if interested, send nonreturnable samples. Company will contact artist for portfolio review if interested.

MAKING CONTACT & TERMS Reviews photos with or without a manuscript. Photo captions are preferred. Finds freelancers through submissions, word-of-mouth and Internet. Payment range: $20-75. Paid on publication.

THE IOWAN MAGAZINE

300 Walnut, Suite 6, Des Moines IA 50309. (515)246-0402; (877)899-9977. **E-mail:** brussie@pioneermaga zines.com. **Website:** www.iowan.com. **Contact:** Bobbie Russie, art director. Estab. 1952. Circ. 22,000. Bimonthly. Emphasizes "Iowa's people, places, events, nature and history." Readers are over age 40, college-educated, middle-to-upper income. Sample copy available for $4.50 plus shipping/handling; call the distribution center toll-free at (877)899-9977. Photo guidelines available on website or via e-mail.

NEEDS "We print only Iowa-related images from Iowa photographers, illustrators, and artists. Show us Iowa's residents, towns, environmental, landscape/scenics, wildlife, architecture, rural, entertainment, events, performing arts, travel." Interested in Iowa heritage, historical/vintage, seasonal. Accepts unsolicited stock photos related to above. Editorial stock photo needs available on website or via e-mail. Model/property release preferred. Photo captions required.

SPECS Digital format preferred, see website for details. Press resolution is 300 dpi at 9×12. "If electronic means are not available, mail protected prints with complete contact information and details of items enclosed. NOTE: *The Iowan* does not return any mailed materials."

MAKING CONTACT & TERMS Pays $50-150 for stock photo one-time use, depending on size printed; pays on publication.

ISLANDS

Bonnier Corporation, 460 N. Orlando Ave., Suite 200, Winter Park FL 32789. (407)628-4802. **Fax:** (407)628-7061. **E-mail:** editor@islands.com. **Website:** www.is lands.com. **Contact:** Lori Barbely, photo editor. Circ. 200,000. Published 8 times/year. "From Bora Bora to the Caribbean, Tahiti to Bali and beyond, *Islands* is your passport to the world's most extraordinary destinations. Each issue is filled with breathtaking photography and detailed first-hand accounts of the fas-

cinating cultural experiences and tranquil, relaxing escapes unique to each vibrant locale."

NEEDS Buys 50 photos from freelancers/issue; 400 photos/year. Needs photos of island travel. Reviews photos with or without a manuscript. Model/property release preferred. Detailed captions required (please use metadata); include name, phone, address, subject information.

SPECS Prefers images in digital format. Send via CD, e-mail, web gallery, FTP site as JPEG files at 72 dpi (must have 300 dpi file available if image is selected for use). Film is not desired.

MAKING CONTACT & TERMS Send query letter with tearsheets. Provide business card and self-promotion piece or tearsheets to be kept on file for possible future assignments. You will be contacted if additional information or a portfolio is desired. Keeps samples on file. Simultaneous submissions OK. Pays $600-1,000 for color cover; $100-500 for inside. Pays 45 days after publication. Credit line given. Buys one-time rights. No phone calls.

ITALIAN AMERICA

219 E St. NE, Washington DC 20002. (202)547-2900. **Fax:** (202)546-8168. **E-mail:** ddesanctis@osia.org. **Website:** www.osia.org. **Contact:** Dona De Sanctis, editor. Estab. 1996. Circ. 65,000. *Italian America* is the official publication of the Order Sons of Italy in America, the nation's oldest and largest organization of American men and women of Italian heritage. Italian America strives to provide timely information about OSIA while reporting on individuals, institutions, issues and events of current or historical significance in the Italian-American community. Sample copy and photo guidelines free and available online

NEEDS Buys 5-10 photos from freelancers/issue, 25 photos/year. Needs photos of travel, history, personalities, anything Italian or Italian-American. Reviews photos with or without a manuscript. Special photo needs include travel in Italy. Model releases preferred. Photo captions required.

MAKING CONTACT & TERMS Accepts images in digital format. Send via CD, e-mail as TIFF, EPS, PICT, BMP, GIF or JPEG files at 400 dpi. Send query letter with tearsheets. Provide résumé, business card, self-promotion piece or tearsheets to be kept on file for possible future assignments. Art director will contact photographer for portfolio review if interested. Portfolio should include color tearsheets. Responds only

if interested, send nonreturnable samples. Simultaneous submissions OK. Pays on publication. Credit line given. Buys one-time rights.

⑤⑤ JEWISH ACTION

Orthodox Union, 11 Broadway, New York NY 10004. (212)613-8146. **Fax:** (212)613-0646. **E-mail:** ja@ou.org. **Website:** www.ou.org/jewish_action. **Contact:** Nechama Carmel, editor; Rashel Zywica, assistant editor. Estab. 1986. Circ. 40,000. Quarterly. Covers a vibrant approach to Jewish issues, Orthodox lifestyle, and values. Sample copy available for $5 or on website.

NEEDS Buys 30 photos/year. Photos of Jewish lifestyle landscapes and travel photos of Israel, and occasional photo essays of Jewish life. Reviews photos with or without a manuscript. Model/property release preferred. Photo captions required; include description of activity, where taken, when.

SPECS Uses color and b&w prints. Accepts images in digital format. Send CD, Jaz, ZIP as TIFF, GIF, JPEG files.

MAKING CONTACT & TERMS Send query letter with samples, brochure or stock photo list. Keeps samples on file. Responds in 2 months. Simultaneous submissions OK. Pays $250 maximum for b&w cover; $400 maximum for color cover; $100 maximum for b&w inside; $150 maximum for color inside. Pays within 6 weeks of publication. Credit line given. Buys one-time rights.

TIPS "Be aware that models must be clothed in keeping with Orthodox laws of modesty. Make sure to include identifying details. Don't send work depicting religion in general. We are specifically Orthodox Jewish."

⑤⑤ JOURNAL OF ASIAN MARTIAL ARTS

Via Media Publishing Co., 941 Calle Mejia, #822, Santa Fe NM 87501. (505)983-1919. **E-mail:** info@goviamedia.com. **Website:** www.goviamedia.com. Estab. 1991. Circ. 10,000. "An indexed, notch-bound quarterly magazine exemplifying the highest standards in writing and graphics available on the subject. Comprehensive, mature and eye-catching. Covers all historical and cultural aspects of Asian martial arts." Sample copy available for $10. Photo guidelines free with SASE.

NEEDS Buys 120 photos from freelancers/issue; 480 photos/year. Photos of health/fitness, sports, action shots; technical sequences of martial arts; photos that

capture the philosophy and aesthetics of Asian martial traditions. Interested in alternative process, avant garde, digital, documentary, fine art, historical/vintage. Model release preferred for photos taken of subjects not in public demonstration; property release preferred. Photo captions preferred; include short description, photographer's name, year taken.

SPECS Uses color and b&w prints; 35mm, 2¼×2¼, 4×5, 8×10 transparencies. Accepts images in digital format. Send via CD, ZIP as TIFF files at 300 dpi.

MAKING CONTACT & TERMS Send query letter with samples, stock list. Provide résumé, business card, self-promotion piece or tearsheets to be kept on file for possible future assignments. Art director will contact photographer for portfolio review if interested. Keeps samples on file. Responds in 2 months. Previously published work OK. Pays $100-500 for color cover; $10-100 for b&w inside. Credit line given. Buys first rights and reprint rights.

TIPS "Read the journal. We are unlike any other martial arts magazine and would like photography to complement the text portion, which is sophisticated with the flavor of traditional Asian aesthetics. When submitting work, be well organized and include a SASE."

➕ ◎ JOURNEY MAGAZINE

AAA 1745 114th Ave., SE, Bellevue WA 98004. (800)562-2582. **E-mail:** sueboylan@aaawin.com; robbhatt@aaawin.com. **Website:** www.aaajourney.com/magazine. **Contact:** Susan Boylan, art director. Circ. 550,000. Bimonthly. For members of AAA Washington; reaches readers in Washington and northern Idaho.

◖ "Photographers interested in submitting work to *Journey* magazine are encouraged to send a link to their website, along with a stock listing of regions and subjects of specialty for us to review. You are encouraged to familiarize yourself with *Journey* before sending in submissions. We review photographers' stock lists and samples and keep the names of potential contributors on file to contact as needed. We do not post our photo needs online or elsewhere. To be considered for an assignment, send links to journey@aaawin.com."

MAKING CONTACT & TERMS "We run all articles with high-quality photographs and illustrations. If you are a published photographer, let us know but please do not submit any photos unless requested. To be considered for an assignment, mail a query along with 3 samples of published work or send links to journey@aaawin.com."

💲💲 ◑ JUDICATURE

2700 University Ave., Des Moines IA 50311. (541)737-9512. **E-mail:** judicature@oregonstate.edu. **Website:** www.ajs.org. **Contact:** Rorie Solberg, editor. Estab. 1917. Circ. 5,000. Bimonthly publication of the American Judicature Society. Emphasizes courts, administration of justice. Readers are judges, lawyers, professors, citizens interested in improving the administration of justice. Sample copy free with 9×12 SASE and 6 first-class stamps.

NEEDS Buys 1-2 photos from freelancers/issue; 6-12 photos/year. Needs photos relating to courts, the law. "Actual or posed courtroom shots are always needed." Interested in fine art, historical/vintage. Model/property release preferred. Photo captions preferred.

SPECS Uses b&w and color prints. Accepts images in digital format. Send via CD, ZIP, e-mail as JPEG files at 600 dpi.

MAKING CONTACT & TERMS Submit samples via e-mail. Simultaneous submissions and previously published work OK. Pays on publication. Credit line given. Buys one-time rights.

💲💲 ◑ KANSAS!

1000 S.W. Jackson St., Suite 100, Topeka KS 66612-1354. (785)296-3479. **Fax:** (785)296-6988. **E-mail:** kansas.mag@travelks.com. **Website:** www.kansas mag.com. Estab. 1945. Circ. 45,000. Quarterly magazine published by the Travel & Tourism Development Division of the Kansas Department of Commerce. Emphasizes Kansas travel, scenery, arts, recreation, and people. Photo guidelines available on website.

NEEDS Buys 60-80 photos from freelancers/year. Subjects include animal, human interest, nature, seasonal, rural, scenic, sport, travel, wildlife, photo essay/photo feature, all from Kansas. No nudes, still life or fashion photos. Will review photographs with or without a ms. Model/property release mandatory.

SPECS Images must be digital at 300 dpi for 8×10.

MAKING CONTACT & TERMS Send material by mail for consideration. Previously published work is accepted if no longer under contract. Pays on acceptance. Credit line given. Buys one-time first North American reprint for 90 days or perpetual rights depending on assignment/gallery/cover/calendar.

TIPS Kansas-oriented material only. Prefers Kansas photographers. "Follow guidelines, submission dates specifically. Shoot a lot of seasonal scenics."

🟢 🌓 KASHRUS MAGAZINE

The Kashrus Institute, P.O. Box 204, Brooklyn NY 11204. (718)336-8544. **E-mail:** editorial@kashrus magazine.com. **Website:** www.kashrusmagazine. com. **Contact:** Rabbi Wikler, editor. Estab. 1981. Circ. 10,000. "The periodical for the kosher consumer. We feature updates including mislabeled kosher products and recalls. Important for vegetarians, lactose intolerant and others with allergies."

NEEDS 25% freelance written. Prefers to work with published/established writers, but will work with new/unpublished writers.

SPECS Uses 2¼×2¼, 3½×3½ or 7½×7½ matte b&w and color prints.

MAKING CONTACT & TERMS Send unsolicited photos by mail with SASE for consideration. Provide business card, brochure, flyer or tearsheets to be kept on file for possible future assignments. Responds in 1 week. Simultaneous submissions and previously published work OK. Pays $40-75 for b&w cover; $50-100 for color cover; $25-50 for b&w inside; $75-200/job; $50-200 for text for photo package. Pays part on acceptance, part on publication. Buys one-time rights, first North American serial rights, all rights; negotiable. Byline given. Submit seasonal materials 2 months in advance. Responds in 2 weeks.

TIPS "Seriously in need of new photo sources, but *call first* to see if your work is appropriate before submitting samples."

🟢 🔵 KENTUCKY MONTHLY

P.O. Box 559, Frankfort KY 40602-0559. (502)227-0053; (888)329-0053. **Fax:** (502)227-5009. **E-mail:** kymonthly@kentuckymonthly.com; steve@ken tuckymonthly.com. **Website:** www.kentuckymonthly. com. **Contact:** Stephen Vest, editor. Estab. 1998. Circ. 42,000. Monthly. Focuses on Kentucky and Kentucky-related stories. Sample copy available for $5.

NEEDS Buys 10 photos from freelancers/issue; 120 photos/year. Photos of celebrities, wildlife, entertainment, landscapes. Reviews photos with or without a manuscript. Model release required. Photo captions required.

SPECS Uses glossy prints; 35mm transparencies. Accepts images in digital format. Send via CD, e-mail at 300 dpi.

MAKING CONTACT & TERMS Send query letter. Provide self-promotion piece to be kept on file for possible future assignments. Responds in 1 month. Simultaneous submissions OK. Pays $25 minimum for inside photos. Pays the 15th of the following month. Credit line given. Buys one-time rights.

KIWANIS

Kiwanis International, 3636 Woodview Trace, Indianapolis IN 46268-3196. (317)217-6223; (317)875-8755; (800)549-2647 [dial 411] (US and Canada only). **Fax:** (317)879-0204. **E-mail:** magazine@kiwanis. org; shareyourstory@kiwanis.org. **Website:** www. kiwanis.org. **Contact:** Jack Brockley, editor; Kasey Jackson, managing editor. Estab. 1917. Circ. 240,000. Published 6 times/year. Emphasizes organizational news, plus major features of interest to business and professional men and women involved in community service. Sample copy available with SASE and 5 first-class stamps. Photo guidelines available via website at www.kiwanismagazine.org. Look for "magazine submission guidelines" link.

NEEDS Photos of babies/children/teens, multicultural, families, parents, senior citizens, landscapes/scenics, education, business concepts, medicine, science, technology/computers. Interested in fine art. Reviews photos with or without ms.

SPECS Uses 5×7 or 8×10 glossy b&w prints; accepts 35mm but prefers 2¾×2¾ and 4×5 transparencies. Accepts images in digital format. Send via CD, e-mail as TIFF, BMP files.

MAKING CONTACT & TERMS Send résumé stock photos. Provide brochure, business card or flier to be kept on file for future assignments. Assigns 95% of work. Pays $100-1,000 for color photos. Buys primarily one-time rights.

TIPS "We can offer the photographer a lot of freedom to work *and* worldwide exposure. And perhaps an award or two if the work is good. We are now using more conceptual photos. We also use studio set-up shots for most assignments. When we assign work, we want to know if a photographer can follow a concept into finished photo without on-site direction." In portfolio or samples, wants to see "studio work with flash and natural light."

🟢 🟢 ⚫ KNOWATLANTA

450 Northridge Pkwy., Suite 202, Atlanta GA 30350. (770)650-1102. **Fax:** (770)650-2848. **E-mail:** gwyn@ knowatlanta.com. **Website:** www.knowatlanta.com.

Contact: Gwyn Herbein, editor. Estab. 1986. Circ. 48,000. Quarterly. Serves as a relocation guide to the Atlanta metro area with a corporate audience. Photography reflects regional and local material as well as corporate-style imagery.

NEEDS Buys more than 10 photos from freelancers/issue; more than 40 photos/year. Photos of cities/urban, events, performing arts, business concepts, medicine technology/computers. Reviews photos with or without a manuscript. Model release required; property release preferred. Photo captions preferred.

SPECS Uses 8×10 glossy color prints; 35mm, transparencies. Accepts images in digital format. Send via CD, ZIP, e-mail as TIFF, EPS, JPEG files at 300 dpi.

MAKING CONTACT & TERMS Send query letter with photocopies. Provide résumé, business card, self-promotion piece to be kept on file for possible future assignments. Responds only if interested; send non-returnable samples. Pays $600 maximum for color cover; $300 maximum for color inside. Pays on publication. Credit line given. Buys first rights.

TIPS "Think like our readers. What would they want to know about or see in this magazine? Try to represent the relocated person if using subjects in photography."

◎ ⑤ ○ LACROSSE MAGAZINE

113 W. University Pkwy., Baltimore MD 21210. (410)235-6882. **Fax:** (410)366-6735. **E-mail:** feedback@laxmagazine.com. **Website:** www.laxmagazine.com; www.uslacrosse.org. **Contact:** Matt DaSilva, editor; Gabriella O'Brien, art director;. Estab. 1978. Circ. 235,000. Publication of U.S. Lacrosse. Monthly. Emphasizes sport of lacrosse. Readers are male and female lacrosse enthusiasts of all ages. Sample copy free with general information pack.

NEEDS Buys 15-30 photos from freelancers/issue; 120-240 photos/year. Needs lacrosse action shots. Photo captions required; include rosters with numbers for identification.

SPECS Accepts images in digital format. Digital photographs should be submitted in the form of original, unedited JPEGs. Suggested captions are welcome. Photographs may be submitted via CD or e-mail. Prints also are accepted and are returned upon request. Photographer credit is published when supplied. Original RAW/NEF files or 300 dpi TIFFs.

MAKING CONTACT & TERMS Send unsolicited photos by mail with SASE for consideration. Provide résumé, business card, brochure, flyer or tearsheets to be kept on file for possible future assignments. Responds in 3 weeks. Simultaneous submissions and previously published work OK. Pays $250 for color cover; $75-150 inside. Pays on publication. Credit line given. Buys one-time rights.

⑤ ⑤ LADIES HOME JOURNAL

125 Park Ave., 20th Floor, New York NY 10017. (212)499-2087. **Website:** www.lhj.com. Circ. 6 million. Monthly. Features women's issues. Readership consists of women with children and working women in 30s age group.

NEEDS Uses 90 photos/issue; 100% supplied by freelancers. Needs photos of children, celebrities and women's lifestyles/situations. Reviews photos only without manuscript. Model release preferred. Photo captions preferred.

MAKING CONTACT & TERMS Provide résumé, business card, brochure, flyer or tearsheet to be kept on file for possible assignment. "Do not send slides or original work; send only promo cards or disks." Responds in 3 weeks. **Pays on acceptance.** Credit line given. Buys one-time rights.

⑤ LAKELAND BOATING MAGAZINE

727 South Dearborn St., Suite 812, Chicago IL 60605. (312)276-0610. **Fax:** (312)276-0619. **E-mail:** cbauhs@lakelandboating.com; ljohnson@lakelandboating.com. **Website:** www.lakelandboating.com. **Contact:** Lindsay Johnson, editor. Estab. 1945. Circ. 60,000. Monthly magazine. Emphasizes powerboating in the Great Lakes. Readers are affluent professionals, predominantly men over age 35.

NEEDS Shots of particular Great Lakes ports and waterfront communities. Model release preferred. Photo captions preferred.

MAKING CONTACT & TERMS Send query letter with list of stock photo subjects. Provide résumé, business card, brochure, flyer or tearsheets to be kept on file for possible future assignments. Pays on publication. Credit line given.

⑤ ◑ LAKE SUPERIOR MAGAZINE

Lake Superior Port Cities, Inc., P.O. Box 16417, Duluth MN 55816-0417. (218)722-5002. **Fax:** (218)722-4096. **E-mail:** edit@lakesuperior.com. **Website:** www.lakesuperior.com. **Contact:** Konnie LeMay, editor. Estab. 1979. Circ. 20,000. Bimonthly. "Beautiful picture magazine about Lake Superior." Readers are male and

female ages 35-55, highly educated, upper-middle and upper-management level through working. Sample copy available for $4.95 plus $5.95 S&H. Photo guidelines free with SASE or via website.

NEEDS Buys 21 photos from freelancers/issue; 126 photos/year. Also buys photos for calendars and books. Needs photos of landscapes/scenics, travel, wildlife, personalities, boats, underwater—all Lake Superior-related. Photo captions preferred.

SPECS Uses mainly images in digital format. Send via CD with at least thumbnails on a printout.

MAKING CONTACT & TERMS Send unsolicited photos by mail with SASE for consideration. Provide résumé, business card, brochure, flyer or tearsheets to be kept on file for possible future assignments. Responds in 2 months. Simultaneous submissions OK. Pays $150 for color cover; $50 for b&w or color inside. Pays on publication. Credit line given. Buys first North American serial rights; reserves second rights for future use.

TIPS "Be aware of the focus of our publication—Lake Superior. Photo features concern only that. Features with text can be related. We are known for our fine color photography and reproduction. It has to be tops. We try to use images large; therefore, detail quality and resolution must be good. We look for unique outlook on subject, not just snapshots. Must communicate emotionally. Some photographers send material we can keep in-house and refer to, and these will often get used."

🌐 LINCOLNSHIRE LIFE

9 Checkpoint Court, Sadler Rd., Lincoln LN6 3PW United Kingdom. (44)(152)252-7127. **Fax:** (44)(152)228-2000. **E-mail:** editorial@lincolnshirelife.co.uk; studio@lincolnshirelife.co.uk. **Website:** www.lincolnshirelife.co.uk. Estab. 1961. Circ. 10,000. Monthly county magazine featuring the culture and history of Lincolnshire. Sample copy available for £2. Photo guidelines free.

NEEDS Buys 10 photos from freelancers/issue; 120 photos/year. Needs photos of Lincolnshire scenes, animals, people. Photo captions required.

SPECS Color transparencies with vertical orientation for cover. Accepts color prints for inside.

MAKING CONTACT & TERMS Send query letter with samples. Art director will contact photographer for portfolio review if interested. Portfolio should include slides or transparencies. Keeps samples on file.

Responds in 1 month. Previously published work OK. Payment negotiable. Pays on publication. Credit line given. Buys first rights.

LION

Lions Clubs International, 300 W. 22nd St., Oak Brook IL 60523-8842. **Fax:** (630)571-1685. **E-mail:** magazine@lionsclubs.org. **Website:** www.lionsclubs.org. **Contact:** Jay Copp, senior editor. Estab. 1918. Circ. 490,000. Monthly magazine for members of the Lions Club and their families. Emphasizes Lions Club activities and membership. Sample copy and photo guidelines free.

NEEDS Uses 50-60 photos/issue. Needs photos of Lions Club service or fund-raising projects. All photos must be as candid as possible, showing an activity in progress. Please, no award presentations, meetings, speeches, etc. Generally, photos are purchased with manuscript (300-1,500 words) and used as a photo story. We seldom purchase photos separately. Model release preferred for young or disabled children. Photo caption is required. Uses 5×7, 8×10 glossy color prints, 35mm transparencies, also accepts digital images in JPEG or TIFF format via e-mail at 300 dpi or larger.

MAKING CONTACT & TERMS Works with freelancers on assignment only. Provide résumé to be kept on file for possible future assignments. Query first with résumé of credits or story idea. Must accompany story on the service or fund-raising project of the Lions Club. Pays on acceptance. Buys all rights, negotiable.

TIPS Query on specific project and photos to accompany ms.

💲 ⭕ LIVING FREE

P.O. Box 969, Winnisquam NH 03289. (603)455-7368. **E-mail:** free@natnh.com. **Website:** www.natnh.com/lf/mag.html. **Contact:** Tom Caldwell, editor-in-chief. Estab. 1987. Quarterly electronic magazine succeeding Naturist Life International's online e-zine. Emphasizes nudism. Readers are male and female nudists. Sample copy available on CD for $10. Photo guidelines free with SASE. We periodically organize naturist photo safaris to shoot nudes in nature.

NEEDS Buys 36 photos from freelancers/issue; 144 photos/year. Photos depicting family-oriented nudist/naturist work, recreational activity and travel. Reviews photos with or without a manuscript. Model

release required (including Internet use) for recognizable nude subjects. Photo captions preferred.

SPECS Prefers digital images submitted on CD or via e-mail; 8×10 glossy color and b&w prints.

MAKING CONTACT & TERMS Send query letter with résumé of credits. Send unsolicited photos by mail or e-mail for consideration; include SASE for return of material. Provide résumé, business card, brochure, flyer or tearsheets to be kept on file for possible future assignments. Responds in 2 weeks. Pays $50 for color cover; $10-25 for others. Pays on publication. Credit line given. "Prefer to own all rights but sometimes agree to one-time publication rights."

TIPS "The ideal photo shows ordinary-looking people of all ages doing everyday activities, in the joy of nudism. We do not want 'cheesecake' glamour images or anything that emphasizes the erotic."

LOG HOME LIVING

Home Buyer Publications, Inc., 4125 Lafayette Center Dr., Suite 100, Chantilly VA 20151. (703)222-9411; (800)826-3893. **Fax:** (703)222-3209. **E-mail:** editor@timberhomeliving.com. **Website:** www.loghomeliving.com. Estab. 1989. Circ. 132,000. Monthly. Emphasizes planning, building and buying a log home. Sample copy available for $4. Photo guidelines available online.

NEEDS Buys 90 photos from freelancers/issue; 120 photos/year. Needs photos of homes—living room, dining room, kitchen, bedroom, bathroom, exterior, portrait of owners, design/decor—tile sunrooms, furniture, fireplaces, lighting, porch and deck, doors. Close-up shots of details (roof trusses, log stairs, railings, dormers, porches, window/door treatments) are appreciated. Model release required.

SPECS Prefers to use digital images or 4×5 color transparencies/Kodachrome or Ektachrome color slides; smaller color transparencies and 35mm color prints also acceptable.

MAKING CONTACT & TERMS Send unsolicited photos by mail for consideration. Keeps samples on file. Responds only if interested. Previously published work OK. Pays $2,000 maximum for color feature. Cover shot submissions also accepted; fee varies, negotiable. **Pays on acceptance.** Credit line given. Buys first World-one-time stock serial rights; negotiable.

TIPS "Send photos of log homes, both interiors and exteriors."

LOYOLA MAGAZINE

820 N. Michigan Ave., Chicago IL 60611. (312)915-6930. **E-mail:** abusiek@luc.edu. **Website:** www.luc.edu/loyolamagazine. **Contact:** Anastasia Busiek, editor. Estab. 1971. Circ. 120,000. Loyola University alumni magazine. Quarterly. Emphasizes issues related to Loyola University Chicago. Readers are Loyola University Chicago alumni—professionals, ages 22 and up.

NEEDS Buys 20 photos from freelancers/issue; 60 photos/year. Needs Loyola-related or Loyola alumni-related photos only. Model release preferred. Photo captions preferred.

SPECS Uses 8×10 b&w and color prints; 35mm, 2¼×2¼ transparencies. Accepts high-res digital images. Query before submitting.

MAKING CONTACT & TERMS Best to query by mail before making any submissions. If interested, will ask for résumé, business card, brochure, flyer or tearsheets to be kept on file for possible future assignments. Simultaneous submissions and previously published work OK. **Pays on acceptance.** Credit line given.

TIPS "Send us information, but don't call."

LULLWATER REVIEW

Emory University, P.O. Box 122036, Atlanta GA 30322. **E-mail:** lullwater@lullwaterreview.com. **Website:** www.lullwaterreview.com. **Contact:** Laura Kochman, editor-in-chief; Tonia Davis, managing editor. Estab. 1990. Circ. 2,000. "We're a small, student-run literary magazine published out of Emory University in Atlanta, GA with 2 issues yearly—one in the fall and one in the spring. You can find us in the *Index of American Periodical Verse*, the *American Humanities Index* and as a member of the Council of Literary Magazines and Presses. We welcome work that brings a fresh perspective, whether through language or the visual arts." Magazine: 6×9; 100 pages; 60-lb. paper; photos. "*Lullwater Review* seeks submissions that are strong and original. We require no specific genre or subject."

NEEDS Architecture, cities/urban, rural, landscapes, wildlife, alternative process, avant garde, fine art and historical/vintage photos.

MAKING CONTACT & TERMS Send an e-mail with photographs. Samples kept on file. Portfolio should include b&W color, photographs and finished, original art. Credit line given when appropriate.

TIPS "Read our magazine. We welcome work of all different types, and we encourage submissions that bring a fresh or alternative perspective. Submit at least 5 works. We frequently accept 3-5 pieces from a single artist and like to see a selection."

⑨⑨ ⑩ THE LUTHERAN

8765 W. Higgins Rd., 5th Floor, Chicago IL 60631-4183. (800)638-3522, ext. 2540. **Fax:** (773)380-2409. **E-mail:** michael.watson@thelutheran.org; lutheran@thelutheran.org. **Website:** www.thelutheran.org. **Contact:** Michael Watson, art director. Estab. 1988. Circ. 300,000. Monthly publication of Evangelical Lutheran Church in America. "Please send samples of your work that we can keep in our files. Though we prefer to review online portfolios, a small number of slides, prints or tearsheets, a brochure, or even a few photocopies are acceptable as long as you feel they represent you."

NEEDS Buys 10-15 photos from freelancers/issue; 120-180 photos/year. Current news, mood shots. Subjects include babies/children/teens, couples, multicultural, families, parents, senior citizens, disasters, landscapes/scenics, cities/urban, education, religious. Interested in fine art, seasonal. "We usually assign work with exception of 'Reflections' section." Model release required. Photo captions preferred.

SPECS Accepts images in digital format. Send via CD or e-mail as TIFF or JPEG files at 300 dpi.

MAKING CONTACT & TERMS Send query letter with list of stock photo subjects. Provide résumé, brochure, flyer or tearsheets to be kept on file for possible future assignments. Pays on publication. Credit line given. Buys one-time rights; credits the photographer.

TIPS Trend toward "more dramatic lighting; careful composition." In portfolio or samples, wants to see "candid shots of people active in church life, preferably Lutheran. Church-only photos have little chance of publication. Submit sharp, well-composed photos with borders for cropping. Send printed or duplicate samples to be kept on file; no originals. If we like your style, we will call you when we have a job in your area."

⊕ THE MACGUFFIN

18600 Haggerty Rd., Livonia MI 48152. (734)462-4400, ext 5327. **E-mail:** macguffin@schoolcraft.edu. **Website:** www.macguffin.org. **Contact:** Steven A. Dolgin, editor; Nicholle Cormier, managing editor; Elizabeth Kircos, fiction editor. Estab. 1984. "*The MacGuffin* is a literary magazine that publishes a range of material including poetry, creative non-fiction, fiction and art. Material ranges from traditional to experimental. Our periodical attracts a variety of people with many different interests."

NEEDS Architecture, cities/urban, gardening, rural, environmental, landscapes, wildlife, fine art and historical/vintage photographs. Reviews photos in TIFF, EPS, JPEG formats. Captions required.

MAKING CONTACT & TERMS Send an e-mail with samples. "Please submit name and contact information with your work, along with captions." Samples not kept on file. Portfolio not required. Credit line given.

TIPS "We look for colorful, interesting cover art and high-quality b&w photos for use inside each magazine. Visit www.macguffin.org for cover samples."

THE MAGAZINE ANTIQUES

Brant Publications, 575 Broadway #5, New York NY 10012. (212)941-2800. **Fax:** (212)941-2819. **E-mail:** tmaedit@brantpub.com (JavaScript required to view). **Website:** www.themagazineantiques.com. **Contact:** Editorial. Estab. 1922. Circ. 61,754. Bimonthly magazine. Emphasizes art, antiques, architecture. Readers are male and female collectors, curators, academics, interior designers, ages 40-70. Sample copy available for $10.50. Buys 24-48 photos from freelancers/issue; 288-576 photos/year. Needs photos of interiors, architectural exteriors, objects. Reviews photos with or without a ms. Uses 8×10 glossy prints; 4×5 transparencies; JPEGs at 300 dpi. Submit portfolio for review; phone ahead to arrange drop-off. Does not keep samples on file; include SASE for return of material. Responds in 6 weeks. Previously published work OK. Payment negotiable. Pays on publication. Credit line given.

MAKING CONTACT & TERMS E-mail: tmaedit@brantpub.com (JavaScript required to view).

⑨⑨ MARLIN

P.O. Box 8500, Winter Park FL 32790. (407)628-4802. **Fax:** (407)628-7061. **E-mail:** editor@marlinmag.com. **Website:** www.marlinmag.com. Estab. 1982. Circ. 50,000. Published 8 times/year. Emphasizes offshore big game fishing for billfish, tuna and other large pelagics. Readers are 94% male, 75% married, average age 43, very affluent businessmen. Sample copy free with 8×10 SASE. Photo guidelines free with SASE or online.

NEEDS Buys 45 photos from freelancers/issue; 270 photos/year. Photos of fish/action shots, scenics and how-to. Special photo needs include big game fishing action and scenics (marinas, landmarks, etc.). Model release preferred. Photo captions preferred.

SPECS Uses 35mm transparencies. Also accepts high-res images on CD or via FTP.

MAKING CONTACT & TERMS Contract required. Send unsolicited photos by mail with SASE for consideration. Responds in 1 month. Simultaneous submissions OK with notification. Pays $1,200 for color cover; $100-300 for color inside. Pays on publication. Buys first North American rights.

TIPS "Send sample material with SASE. No phone call necessary. Don't hesitate to call Editor Dave Ferrel or Managing Editor Charlie Levine at (407)628-4802 anytime you have any general or specific questions about photo needs, submissions or payment."

🌑🌓 ◯ METROSOURCE MAGAZINE

137 W. 19th St., 2nd Floor, New York NY 10011. (212)691-5127. **E-mail:** letters@metrosource.com. **Website:** www.metrosource.com. Estab. 1990. Circ. 145,000. Upscale, gay men's luxury lifestyle magazine published 6 times/year. Emphasizes fashion, travel, profiles, interiors, film, art. Sample copies free.

NEEDS Buys 10-15 photos from freelancers/issue; 50 photos/year. Photos of celebrities, architecture interiors/decorating, adventure, food/drink, health/fitness, travel, product shots/still life. Interested in erotic, fashion/glamour, seasonal. Also needs still-life drink shots for spirits section. Reviews photos with or without a ms. Model/property release preferred. Photo captions preferred.

SPECS Uses 8×10 glossy or matte color and b&w prints; 2¼×2¼, 4×5 transparencies. Prefers images in digital format. Send via CD, ZIP, e-mail as TIFF, EPS, JPEG files at 300 dpi.

MAKING CONTACT & TERMS Send query letter with self-promo cards. "Please call first for portfolio drop-off." Provide self-promotion piece to be kept on file for possible future assignments. Responds only if interested; send nonreturnable samples. Simultaneous submissions and previously published work OK. Pays $500-800 for cover; up to $300 for inside. Pays on publication. Credit line given. Buys one-time rights.

TIPS "We work with creative established and newly-established photographers. Our budgets vary depending on the importance of story. Have an e-mail address on card so we can see more photos or whole portfolio online."

MICHIGAN OUT-OF-DOORS

P.O. Box 30235, Lansing MI 48909. (517)371-1041. **Fax:** (517)371-1505. **E-mail:** thansen@mucc.org; magazine@mucc.org. **Website:** www.michiganoutofdoors. com. **Contact:** Tony Hansen, editor. Estab. 1947. Circ. 40,000. Monthly. For people interested in "outdoor recreation, especially hunting and fishing; conservation; environmental affairs." Sample copy available for $3.50; editorial guidelines free.

NEEDS Buys 6-12 photos from freelancers/issue; 72-144 photos/year. Photos of animals/wildlife, nature, scenics, sports (hunting, fishing, backpacking, camping, cross-country skiing, other forms of noncompetitive outdoor recreation). Materials must have a Michigan slant. Photo captions preferred.

MAKING CONTACT & TERMS Digital photos only. Include SASE for return of material. Responds in 1 month. Pays $275 for cover; $20 minimum for b&w inside; $40 for color inside. Credit line given. Buys first North American serial rights.

🌑 📷 ◐ MINNESOTA GOLFER

Minnesota Golf Association, 6550 York Ave. S., Suite 211, Edina MN 55435. (952)927-4643; (800)642-4405. **Fax:** (952)927-9642. **E-mail:** editor@mngolf.org; wp@mngolf.org. **Website:** www.mngolf.org. **Contact:** W.P. Ryan, editor. Estab. 1970. Circ. 60,000. Bimonthly association magazine covering Minnesota golf scene. Sample copies available.

NEEDS Works on assignment only. Buys 25 photos from freelancers/issue; 150 photos/year. Photos of golf, golfers, and golf courses only. Will accept exceptional photography that tells a story or takes specific point of view. Reviews photos with or without manuscript. Model/property release required. Photo captions required; include date, location, names and hometowns of all subjects.

SPECS Accepts images in digital format. Send via DVD or CD, e-mail as TIFF files.

MAKING CONTACT & TERMS Send query letter with digital medium. Portfolios may be dropped off every Monday. Provide business card or self-promotion piece to be kept on file for possible future assignments. Responds only if interested; send nonreturnable samples. Pays on publication. Credit line given. Buys one-time rights. Will negotiate one-time or all

rights, depending on needs of the magazine and the MGA.

TIPS "We use beautiful golf course photography to promote the game and Minnesota courses to our readers. We expect all submissions to be technically correct in terms of lighting, exposure, and color. We are interested in photos that portray the game and golf courses in new unexpected ways. For assignments, submit work with invoice and all expenses. For unsolicited work, please include contact, fee, and rights terms submitted with photos; include captions where necessary. Artist agreement available upon request."

MISSOURI LIFE

501 High St., Suite A Boonville MO 65233. (660)882-9898. **Fax:** (660)882-9899. **E-mail:** lauren@missouri life.com. **Website:** www.missourilife.com. **Contact:** Lauren Licklider, associate editor. Estab. 1973. Circ. 96,800. Bimonthly. "*Missouri Life* celebrates Missouri people and places, past and present, and the unique qualities of our great state with interesting stories and bold, colorful photography." Sample copy available for $4.95 and SASE with $2.44 first-class postage. Photo guidelines available on website.

NEEDS Buys 80 photos from freelancers/issue; more than 500 photos/year. Needs photos of environmental, seasonal, landscapes/scenics, wildlife, architecture, cities/urban, rural, adventure, historical sites, entertainment, events, hobbies, performing arts, travel. Reviews photos with or without manuscript. Model/property release required. Photo captions required; include location, names and detailed identification (including any title and hometown) of subjects.

SPECS Prefers images in high-res digital format (minimum 300 ppi at 8×10). Send via e-mail, CD, ZIP as EPS, JPEG, TIFF files.

MAKING CONTACT & TERMS Send query letter with résumé, stock list. Provide self-promotion piece to be kept on file for possible future assignments. Responds in 1 month. Pays $100-150 for color cover; $50 for color inside. Pays on publication. Credit line given. Buys first rights, nonexclusive rights, limited rights.

TIPS "Be familiar with our magazine and the state of Missouri. Provide well-labeled images with detailed caption and credit information."

🌐 📷 🌓 MORPHEUS TALES

116 Muriel St., London N1 9QU, United Kingdom. **E-mail:** morpheustales@blueyonder.co.uk. **Website:** www.morpheustales.com. **Contact:** Adam Bradley,

publisher. Estab. 2008. Circ. 1,000. Publishes experimental fiction, fantasy, horror, and science fiction. Publishes 4-6 titles/year.

NEEDS "Look at magazine and website for style."

MAKING CONTACT & TERMS Portfolio should include b&w color, finished and original art. Responds within 30 days. Model and property release are required.

MOTHER JONES

Foundation for National Progress, 222 Sutter St., Suite 600, San Francisco CA 94108. (415)321-1700. **E-mail:** mmurrmann@motherjones.com; query@mother jones.com. **Website:** www.motherjones.com. **Contact:** Mark Murrmann, associate photo editor; Monika Bauerlein and Clara Jeffery, editors. Estab. 1976. Circ. 240,000. "Recognized worldwide for publishing groundbreaking work by some of the most talented photographers, *Mother Jones* is proud to include the likes of Antonin Kratochvil, Eugene Richards, Sebastião Salgado, Lana Šlezić, and Larry Sultan as past contributors. We remain committed to championing the best in photography and are always looking for exceptional photographers with a unique visual style. It's best to give us a URL for a portfolio website. For photo essays, describe the work that you've done or propose to do; and if possible, provide a link to view the project online. We will contact you if we are interested in seeing more work. Or you can mail non-returnable samples or discs to: Mark Murrmann."

TIPS "Please do not submit original artwork or any samples that will need to be returned. *Mother Jones* cannot be responsible for the return or loss of unsolicited artwork."

MOTOR BOATING MAGAZINE

Bonnier Corporation, 460 N. Orlando Ave., Suite 200, Winter Park FL 32789. (407)628-4802. **Fax:** (407)628-7061. **E-mail:** editor@boatingmag.com; editor@yachtingmagazine.com; via online contact form. **Website:** www.boatmag.com. Estab. 1907. Circ. 132,000. Monthly. Addresses the interests of both sail and powerboat owners, with the emphasis on high-end vessels. Includes boating events, boating-related products, gear and how-to.

MAKING CONTACT & TERMS Send query letter with tearsheets. Provide self-promotion piece to be kept on file for possible future assignments. Responds only if interested; send nonreturnable samples. Pays on publication. Buys first rights.

TIPS "Read the magazine, and have a presentable portfolio."

⬤ ⬤ ○ MOTORING & LEISURE

Britannia House, 21 Station St., Brighton BN1 4DE United Kingdom. **E-mail:** magazine@csmaclub.co.uk. **Website:** www.csma.uk.com. Circ. 300,000. In-house magazine of CSMA (Civil Service Motoring Association); 144 pages printed 10 times/year (double issue July/August and November/December). Covers car reviews, worldwide travel features, lifestyle and leisure, gardening. Sample copy available.

NEEDS Innovative photos of cars and motorbikes, old and new, to give greater choice than usual stock shots; motoring components (tires, steering wheels, windscreens); car manufacturer logos; UK traffic signs, road markings, general traffic, minor roads and motorways; worldwide travel images; UK villages, towns and cities; families on UK outdoor holidays; caravans, motor homes, camping, picnics sites. Reviews photos with or without manuscript. Photo captions preferred; include location.

SPECS Prefers images in digital format. Send JPEG files via e-mail, 300 dpi where possible, or 72 dpi at the largest possible image size. Maximum limit per e-mail is 8MB so may need to send images in separate e-mails or compress byte size. Most file formats (EPS, TIFF, PDF, PSD) accepted for PC use. Unable to open Mac files. TIFFs and very large files should be sent on a CD.

MAKING CONTACT & TERMS Prefers to be contacted via e-mail. Simultaneous submissions and previously published work OK. Payment negotiated with individual photographers and image libraries. Credit line sometimes given if asked. Buys one-time rights.

⬤ ⬤ MOUNTAIN LIVING

Network Communications, Inc., 1780 S. Bellaire St., Suite 505, Denver CO 80222. (303)248-2060. **Fax:** (303)248-2066. **E-mail:** hscott@mountainliving. com; cdeorio@mountainliving.com. **Website:** www. mountainliving.com. **Contact:** Holly Scott, publisher; Christine DeOrio, editor-in-chief. Estab. 1994. Circ. 48,000. Published 10 times/year covering architecture, interior design, and lifestyle issues for people who live in, visit, or hope to live in the mountains.

NEEDS Buys 10 photos from freelancers/issue; 120 photos/year. Photos of home interiors, architecture. Reviews photos with accompanying manuscript only.

Model/property release required. Photo captions preferred.

SPECS Prefers images in digital format. Send via CD as TIFF files at 300 dpi. Also uses 35mm, 2¼×2¼, 4×5 transparencies.

MAKING CONTACT & TERMS Submit portfolio for review. Send query letter with stock list. Provide résumé, business card, brochure, flyer or tearsheets to be kept on file for possible future assignments. Responds in 6 weeks. Pays $500-600/day; up to $600 for color inside. **Pays on acceptance.** Credit line given. Buys one-time and first North American serial rights as well as rights to use photos on the *Mountain Living* website and in promotional materials; negotiable.

⬤ ⬤⬤ ⬤ MUSCLEMAG INTERNATIONAL

Robert Kennedy Publishing, 400 Matheson Blvd., W., Mississauga ON L5R 3M1, Canada. (888)254-0767; (905)507-3545. **Fax:** (905)507-2372. **Website:** www. emusclemag.com. **Contact:** Art director. Estab. 1974. Circ. 300,000. Monthly. Emphasizes hardcore bodybuilding for men and women. Sample copy available for $6.

NEEDS Buys 3,000 photos/year; 50% assigned; 50% stock. Needs bodybuilding, celebrity/personality, swimsuit, how-to, special effects/experimental and spot news. "We require action exercise photos of bodybuilders and fitness enthusiasts training with sweat and strain." Wants on a regular basis "different" pics of top names, bodybuilders or film stars famous for their physiques (e.g., Schwarzenegger, The Hulk). No photos of mediocre bodybuilders. "They have to be among the top 100 in the world or top film stars exercising." Photos may be purchased with accompanying manuscript. Photo captions preferred.

SPECS Uses 8×10 glossy b&w prints; 35mm, 2¼×2¼ or 4×5 transparencies; high-resolution digital thumbnails; vertical format preferred for cover.

MAKING CONTACT & TERMS Send material by mail for consideration; send $3 for return postage. Send query letter with contact sheet. Responds in 1 month. Pays on publication. Credit line given. Buys all rights.

TIPS "We would like to see photographers take up the challenge of making exercise photos look like exercise motion. In samples we want to see sharp, color-balanced, attractive subjects, no grain, artistic eye. Someone who can glamorize bodybuilding

on film. To break in get serious: read, ask questions, learn, experiment and try, try again. Keep trying for improvement—don't kid yourself that you are a good photographer when you don't even understand half the attachments on your camera. Immerse yourself in photography. Study the best; study how they use light, props, backgrounds, angles. Current biggest demand is for swimsuit-type photos of fitness men and women (splashing in waves, playing/posing in sand, etc.). Shots must be sexually attractive."

🗣 ⑤ ◑ MUSHING.COM MAGAZINE

P.O. Box 1195, Willow AK 99688. (907)495-2468. **E-mail:** editor@mushing.com. **Website:** www.mushing.com. **Contact:** Greg Sellentin, managing editor. Estab. 1987. Circ. 10,000.

NEEDS Uses 50 photos/issue; most supplied by freelancers. Needs action photos: all-season and wilderness; still and close-up photos: specific focus (sledding, carting, dog care, equipment, etc.). Special photo needs include skijoring, feeding, caring for dogs, summer carting or packing, 1- to 3-dog-sledding, and kids mushing. Model release preferred. Photo captions preferred.

SPECS Accepts images in digital format. Send via CD, ZIP, e-mail as JPEG files at 300 dpi.

MAKING CONTACT & TERMS Send unsolicited photos by mail for consideration. Responds in 6 months. Pays $175 maximum for color cover; $15-40 for b&w inside; $40-50 for color inside. Pays $10 extra for 1 year of electronic use rights on the Web. Pays within 60 days after publication. Credit line given. Buys first serial rights and second reprint rights.

TIPS Wants to see work that shows "the total mushing adventure/lifestyle from environment to dog house." To break in, one's work must show "simplicity, balance and harmony. Strive for unique provocative shots that lure readers and publishers. Send 10-40 images for review. Allow for 2-6 months' review time for at least a screened selection of these."

MUSKY HUNTER MAGAZINE

P.O. Box 340, 7978 Hwy. 70 E., St. Germain WI 54558. (715)477-2178. **Fax:** (715)477-8858. **E-mail:** editor@muskyhunter.com. **Website:** www.muskyhunter.com. **Contact:** Jim Saric, editor. Estab. 1988. Circ. 37,000. Serves the vertical market of musky fishing enthusiasts. "We're interested in how-to, where-to articles."

🗣 ⑤ MUZZLE BLASTS

P.O. Box 67, Friendship IN 47021. (812)667-5131. **Fax:** (812)667-5136. **E-mail:** mblastdop@seidata.com. **Website:** www.nmlra.org. Estab. 1939. Circ. 18,500. Publication of the National Muzzle Loading Rifle Association. Monthly. Emphasizes muzzleloading. Sample copy free. Photo guidelines free with SASE.

NEEDS Interested in muzzleloading, muzzleloading hunting, primitive camping. "Ours is a specialized association magazine. We buy some big-game wildlife photos but are more interested in photos featuring muzzleloaders, hunting, powder horns and accoutrements." Model/property release required. Photo captions preferred.

SPECS Accepts images in digital format. Send via e-mail or on a CD in JPEG or TIFF format. Also accepts 3×5 color transparencies, quality color and b&w prints; sharply contrasting 35mm color slides are acceptable.

MAKING CONTACT & TERMS Send query letter with stock list. Keeps samples on file; include SASE for return of material. Responds in 2 weeks. Simultaneous submissions OK. Pays $300 for color cover; $25-50 for b&w inside. Pays on publication. Credit line given. Buys one-time rights.

⑤ ◑ NA'AMAT WOMAN

505 8th Ave., Suite 2302, New York NY 10018. (212)563-5222. **Fax:** (212)563-5710. **E-mail:** naamat@naamat.org; judith@naamat.org. **Website:** www.naamat.org. **Contact:** Judith Sokoloff, editor. Estab. 1926. Circ. 12,000. Quarterly organization magazine focusing on issues of concern to contemporary Jewish families and women.

NEEDS Buys 5-10 photos from freelancers/issue; 50 photos/year. Photos of Jewish themes, Israel, women, babies/children/teens, families, parents, senior citizens, landscapes/scenics, architecture, religious, travel. Interested in documentary, fine art, historical/vintage, seasonal. Reviews photos with or without manuscript. Photo captions preferred.

SPECS Uses color and b&w prints. Accepts images in digital format. Contact editor before sending.

MAKING CONTACT & TERMS Provide résumé, business card, self-promotion piece or tearsheets to be kept on file for possible future assignments. Art director will contact photographer for portfolio review if interested. Keeps samples on file; include SASE for return of material. Responds in 6 weeks. Pays $200

maximum for cover; $35-75 for inside. Pays on publication. Credit line given. Buys one-time, first rights.

NATIONAL GEOGRAPHIC

P.O. Box 98199, Washington DC 20090-8199. **Fax:** (202)828-5460. **E-mail:** ngsforum@nationalgeographic.com. **Website:** www.nationalgeographic.com. **Contact:** Chris Johns, editor-in-chief. Estab. 1888. Circ. 9 million. Monthly publication of the National Geographic Society.

This is a premiere market that demands photographic excellence. *National Geographic* does not accept unsolicited work from freelance photographers. Photography internships and faculty fellowships are available. Contact Susan Smith, deputy director of photography, for application information.

NATIONAL PARKS MAGAZINE

National Parks Conservation Association, 777 Sixth St. NW, Suite 700, Washington DC 20001. (202)223-6722; (800)628-7275. **Fax:** (202)454-3333. **E-mail:** npmag@npca.org. **Website:** www.npca.org/magazine. **Contact:** Scott Kirkwood, editor-in-chief. Estab. 1919. Circ. 340,000. Quarterly. Emphasizes the preservation of national parks and wildlife. Sample copy available for $3 and 8½×11 or larger SASE. Photo guidelines available online.

SPECS "Photographers who are new to *National Parks* may ONLY submit digitally for an initial review—we prefer links to clean, easily-navigable and searchable websites, or lightboxes with well-captioned images. We DO NOT accept and are not responsible for unsolicited slides, prints, or CDs."

MAKING CONTACT & TERMS "The best way to break in is to send a brief, concise e-mail message to Sarah Rutherford. See guidelines online. Less than 1 percent of our image needs are generated from unsolicited photographs, yet we receive dozens of submissions every week. Photographers are welcome to send postcards or other simple promotional materials that we do not have to return or respond to." Photographers who are regular contributors may submit images in the following forms: digitally, via CD, DVD, or e-mail (as in attachments or a link to a lightbox or FTP site) physically, as slides or prints, via courier mail. Pays within 30 days after publication. Buys one-time rights.

TIPS "When searching for photos, we frequently use www.agpix.com to find photographers who fit our needs. If you're interested in breaking into the magazine we suggest setting up a profile and posting your absolute best parks images there."

NATIVE PEOPLES MAGAZINE

5333 N. Seventh St., Suite C-224, Phoenix AZ 85014. (602)265-4855. **Fax:** (602)265-3113. **E-mail:** dgibson@nativepeoples.com; kcoochwytewa@nativepeoples.com. **Website:** www.nativepeoples.com. **Contact:** Daniel Gibson, editor; Kevin Coochwytewa, art director. Estab. 1987. Circ. 40,000. Bimonthly. "Dedicated to the sensitive portrayal of the arts and lifeways of the native peoples of the Americas." Photo guidelines upon request.

NEEDS Buys 20-50 photos from freelancers/issue; 120-300 photos/year. Needs Native American lifeways photos (babies/children/teens, celebrities, couples, multicultural, families, parents, senior citizens, events). Also uses photos of entertainment, performing arts, travel. Interested in fine art. Model/property release preferred. Photo captions preferred; include names, location and circumstances.

SPECS Accepts images in digital format. Send via CD, ZIP, e-mail as TIFF, JPEG, EPS files at 300 dpi.

MAKING CONTACT & TERMS Submit portfolio for review. Responds in 1 month. Pays on publication. Buys one-time rights.

NATURAL HISTORY

105 W. Highway 54, Suite 265, Durham NC 27713-6650. (919)933-1867. **E-mail:** nhmag@naturalhistorymag.com. **Website:** www.nhmag.com. Circ. 200,000. Printed 10 times/year. Readers are primarily well-educated people with interests in the sciences. Free photo guidelines available by request.

NEEDS Buys 400-450 photos/year. Subjects include animal behavior, photo essay, documentary, plant and landscape. "We are interested in photo essays that give an in-depth look at plants, animals, or people and that are visually superior. We are also looking for photos for our photographic feature, 'The Natural Moment.' This feature focuses on images that are both visually arresting and behaviorally interesting." Photos used must relate to the social or natural sciences with an ecological framework. Accurate, detailed captions required.

SPECS Uses 35mm, 2¼×2¼, 4×5, 6×7, 8×10 color transparencies; high-res digital images. Covers are always related to an article in the issue.

MAKING CONTACT & TERMS Send query letter with résumé of credits. "We prefer that you come in and show us your portfolio, if and when you are in New York. Please don't send us any photographs without a query first, describing the work you would like to send. No submission should exceed 30 original transparencies or negatives. However, please let us know if you have additional images that we might consider. Potential liability for submissions that exceed 30 originals shall be no more than $100 per slide." Responds in 2 weeks. Previously published work OK but must be indicated on delivery memo. Pays (for color and b&w) $400-600 for cover; $350-500 for spread; $300-400 for oversize; $250-350 for full-page; $200-300 for ¼ page; $175-250 for less than ¼ page. Pays $50 for usage on contents page. Pays on publication. Credit line given. Buys one-time rights.

🞄 🅢 🅞 NATURE FRIEND MAGAZINE

4253 Woodcock Lane, Dayton VA 22821. (540)867-0764. **E-mail:** info@naturefriendmagazine.com; editor@naturefriendmagazine.com; photos@naturefriendmagazine.com. **Website:** www.naturefriendmagazine.com. **Contact:** Kevin Shank, editor. Estab. 1982. Circ. 13,000.

NEEDS Buys 5-10 photos from freelancers/issue; 100 photos/year. Photos of wildlife, wildlife interacting with each other, humorous wildlife, all natural habitat appearance. Reviews photos with or without ms. Model/property release preferred. Photo captions preferred.

SPECS Prefers images in digital format. Send via CD or DVD as TIFF files at 300 dpi at 8×10 size; provide color thumbnails when submitting photos. "Transparencies are handled and stored carefully; however, we do not accept liability for them so discourage submissions of them."

MAKING CONTACT & TERMS Responds in 1 month to queries; 2 weeks to portfolios. "Label contact prints and digital media with your name address, and phone number so we can easily know how to contact you if we select your photo for use. Please send articles rather than queries. We try to respond within 4-6 months." Simultaneous submissions and previously published work OK. Pays $75 for front cover; $50 for back cover; $15-25 for inside photos. Pays on publication. Credit line given. Buys one-time rights.

TIPS "We're always looking for photos of wild animals doing something unusual or humorous. Please label every sheet of paper or digital media with name address, and phone number. We may need to contact you on short notice, and you do not want to miss a sale. Also, photos are selected on a monthly basis, after the articles. What this means to a photographer is that photos are secondary to writings and cannot be selected far in advance. High-res photos in our files the day we are making selections will stand the greatest chance of being published. "

🅢 NATURE PHOTOGRAPHER

P.O. Box 220, Lubec ME 04652. (207)733-4201. **E-mail:** nature_photographer@yahoo.com. **Website:** www.naturephotographermag.com. Estab. 1990. Circ. 41,000. Quarterly 4-color, high-quality magazine. Emphasizes "conservation-oriented, low-impact nature photography" with strong how-to focus. Readers are male and female nature photographers of all ages. Sample copy available with 10×13 SASE with 6 first-class stamps.

🅞 *Nature Photographer* charges $80/year to be a "field contributor."

NEEDS Buys 90-120 photos from freelancers/issue; 400 photos/year. Needs nature shots of "all types—abstracts, animals/wildlife, flowers, plants, scenics, environmental images, etc. Shots must be in natural settings; no set-ups, zoo or captive animal shots accepted." Reviews photos (slides or digital images on CD) with or without ms 4 times/year: May (for fall issue); August (for winter issue); November (for spring issue); and January (for summer issue). Photo captions required; include description of subject, location, type of equipment, how photographed.

MAKING CONTACT & TERMS Contact by e-mail or with SASE for guidelines before submitting images. Prefers to see 35mm transparencies or CD of digital images. Send digital images via CD.

TIPS Recommends working with "the best lens you can afford and slow-speed slide film; or, if shooting digital, using the RAW mode." Suggests editing with a 4× or 8× loupe (magnifier) on a light board to check for sharpness, color saturation, etc. "Color prints are not normally used for publication in our magazine. When editing digital captured images, please enlarge

to the point that you are certain that the focal point is tack sharp. Also avoid having grain in the final image."

ⓔ ○ NECROLOGY SHORTS: TALES OF MACABRE AND HORROR

Isis International, P.O. Box 510232, St. Louis MO 63151. **E-mail:** editor@necrologyshorts.com; submit@necrologyshorts.com. **Website:** www.necrologyshorts.com. **Contact:** John Ferguson, editor. Estab. 2009. Circ. 20,000. Consumer publication published online daily and through Amazon Kindle. Also offers an annual collection. "*Necrology Shorts* is an online publication that publishes fiction, articles, cartoons, artwork, and poetry daily. Embracing the Internet, e-book readers, and new technology, we aim to go beyond the long-time standard of a regular publication to bring our readers a daily flow of entertainment. We will also be publishing an annual collection for each year in print, e-book reader, and Adobe PDF format. Our main genre is suspense horror, similar to H.P. Lovecraft and Robert E. Howard. We also publish science fiction and fantasy. We would love to see work continuing the Cthulhu Mythos, but we accept all horror. We also hold contests, judged by our readers, to select the top stories and artwork. Winners of contests receive various prizes, including cash."

NEEDS Alternative process, avant garde, documentary, erotic, fine art, historical/vintage, lifestyle, seasonal.

MAKING CONTACT & TERMS Submit transparencies, prints, or GIF/JPEG files by e-mail at submit@necrologyshorts.com. Requires model releases and identification of subjects.

TIPS "*Necrology Shorts* is looking to break out of the traditional publication types to use the Internet, e-book readers, and other technology. We not only publish works of artists, we let them use their published works to brand themselves and further their profits of their hard work. We love to see traditional artwork, but we also look forward to those that go beyond that to create multimedia works. The best way to get to us is to let your creative side run wild and not send us the typical fare. Don't forget that we publish horror, sci-fi, and fantasy. We expect deranged, warped, twisted, strange, sadistic, and things that question sanity and reality."

ⓢⓢ ⓢ NEW MEXICO MAGAZINE

Lew Wallace Bldg., 495 Old Santa Fe Trail, Santa Fe NM 87501-2750. (505)827-7447. **E-mail:** letters@nm magazine.com. **E-mail:** queries@nmmagazine.com. **Website:** www.nmmagazine.com. Estab. 1923. Circ. 100,000. Monthly. For affluent people ages 35-65 interested in the Southwest or who have lived in or visited New Mexico. Sample copy available for $4.95 with 9×12 SASE and 3 first-class stamps. Photo guidelines available online.

NEEDS Buys 10 photos from freelancers/issue; 120 photos/year. Needs New Mexico photos only—landscapes, people, events, architecture, etc. Model release preferred.

SPECS Uses 300 dpi digital files with contact sheets (8-12 per page). Photographers must be in photodata. Photo captions required; include who, what, where.

MAKING CONTACT & TERMS Submit portfolio; include SASE for return of material, or e-mail with web gallery link. Pays $450/day; $300 for color or b&w cover; $60-100 for color or b&w stock. Pays on publication. Credit line given. Buys one-time rights.

TIPS "*New Mexico Magazine* is the official magazine for the state of New Mexico. Photographers should know New Mexico. We are interested in the less common stock of the state. The magazine is editorial driven, and all photos directly relate to a story in the magazine." Cover photos usually relate to the main feature in the magazine.

NEWSWEEK

The Daily Beast, 251 W. 57th St., New York NY 10019. (212)445-4000. **Website:** www.newsweek.com. Circ. 3,180,000. *Newsweek* reports the week's developments on the newsfront of the world and the nation through news, commentary and analysis. News is divided into National Affairs; International; Business; Society; Science & Technology; and Arts & Entertainment. Relevant visuals, including photos, accompany most of the articles. Query before submitting.

ⓢ ○ NEW YORK STATE CONSERVATIONIST MAGAZINE

NYSDEC, 625 Broadway, Albany NY 12233-4502. (518)402-8047. **E-mail:** magazine@gw.dec.state.ny.us. **Website:** www.dec.ny.gov. **Contact:** Eileen Stegemann, assistant editor. Estab. 1946. Circ. 100,000. Bimonthly nonprofit, New York State government publication. Emphasizes natural history, environmental and outdoor interests pertinent to New York State. Sample copy available for $3.50. Photo guidelines free with SASE or online.

NEEDS Uses 40 photos/issue; 80% supplied by freelancers. Needs wildlife shots, people in the environment, outdoor recreation, forest and land management, fisheries and fisheries management, environmental subjects. Also needs landscapes/scenics, cities, travel, historical/vintage, seasonal. Model release preferred. Photo captions required.

SPECS Accepts images in digital format. Send via CD as TIFF files at 300 dpi. Also uses 35mm, 2¼×2¼, 4×5, 8×10 transparencies.

MAKING CONTACT & TERMS Send material by mail for consideration, or submit portfolio for review. Provide résumé, bio, business card, brochure, flyer or tearsheets to be kept on file for possible future assignments. Responds in 3 weeks. Simultaneous submissions and previously published work OK. Pays $50 for cover photos; $15 for b&w or color inside. Pays on publication. Buys one-time rights.

TIPS Looks for "artistic interpretation of nature and the environment; unusual ways of picturing environmental subjects (even pollution, oil spills, trash, air pollution, etc.); wildlife and fishing subjects at all seasons. Try for unique composition, lighting. Technical excellence a must."

THE NEW YORK TIMES MAGAZINE

620 8th Ave., New York NY 10018. (212)556-1234. **Fax:** (212)556-3830. **E-mail:** magazine@nytimes.com; nytnews@nytimes.com; executive-editor@nytimes.com. **Website:** www.nytimes.com/pages/magazine. **Contact:** Margaret Editor, public editor. Circ. 1.8 million. *The New York Times Magazine* appears in *The New York Times* on Sunday. The *Arts and Leisure* section appears during the week. The *Op Ed* page appears daily.

NEEDS Number of freelance photos purchased varies. Model release required. Photo captions required.

MAKING CONTACT & TERMS "Please FedEx all submissions." Include SASE for return of material. Responds in 1 week. Pays $345 for full page; $260 for half page; $230 for quarter page; $400/job (day rates); $750 for color cover. **Pays on acceptance.** Credit line given. Buys one-time rights.

NORTH AMERICAN WHITETAIL

2250 Newmarket Pkwy., Suite 110, Marietta GA 30067. (678)589-2000. **Fax:** (678)279-7512. **E-mail:** patrick.hogan@imoutdoors.com; whitetail@imoutdoors.com. **Website:** www.northamericanwhitetail.com. Estab. 1982. Circ. 125,000. Published 7 times/year (July-February) by InterMedia Outdoors. Emphasizes trophy whitetail deer hunting. Sample copy available for $4. Photo guidelines free with SASE.

NEEDS Buys 5 photos from freelancers/issue; 35 photos/year. Needs photos of large, live whitetail deer, hunter posing with or approaching downed trophy deer, or hunter posing with mounted head. Also uses photos of deer habitats and signs. Model release preferred. Photo captions preferred; include when and where scene was photographed.

SPECS Accepts images in digital format. Send via CD at 300 dpi with output of 8×12 inches. Also uses 35mm transparencies.

MAKING CONTACT & TERMS Send query letter with résumé of credits and list of stock photo subjects. Will return unsolicited material in 1 month if accompanied by SASE. Simultaneous submissions not accepted. Tearsheets provided. Pays 60 days prior to publication. Credit line given. Buys one-time rights.

TIPS "In samples we look for extremely sharp, well-composed photos of whitetailed deer in natural settings. We also use photos depicting deer hunting scenes. Please study the photos we are using before making submission. We'll return photos we don't expect to use and hold the remainder for potential use. Please do not send dupes. Use an 8×10 envelope to ensure sharpness of images, and put name and identifying number on all slides and prints. Photos returned at time of publication or at photographer's request."

NORTH CAROLINA LITERARY REVIEW

East Carolina University, ECU Mailstop 555 English, Greenville NC 27858-4353. (252)328-1537. **Fax:** (252)328-4889. **E-mail:** nclrsubmissions@ecu.edu. **Website:** www.nclr.ecu.edu. **Contact:** Gabrielle Freeman. Estab. 1992. Circ. 750. Annual literary magazine with North Carolina focus. *NCLR* publishes poetry, fiction and nonfiction by and interviews with NC writers, and articles and essays about NC literature, literary history and culture. Photographs must be NC-related. Sample copy available for $15. Photo guidelines available on website.

NEEDS Buys 3-6 photos from freelancers/issue. Model/property release preferred. Photo captions preferred.

SPECS Accepts images in digital format, 5×7 at 300 dpi. Inquire first; submit TIFF, GIF files at 300 dpi to nclrsubmissions@ecu.edu only after requested to.

MAKING CONTACT & TERMS Send query letter with website address to show sample of work. If selected, art acquisitions editor will be in touch. Pays $50-250 for cover; $5-100 for b&w inside. Pays on publication. Credit line given. Buys first rights.

TIPS *"Only NC photographers.* Look at our publication—1998-present back issues. See our website."

⊕ ⦿⦿ ◑ NORTH DAKOTA HORIZONS

1605 E. Capitol Ave., Suite 101, Bismarck ND 58502. (866)462-0744. **Fax:** (701)223-4645. **E-mail:** ndhorizons@btinet.net. **Website:** www.ndhorizons.com. **Contact:** Andrea W. Collin, editor. Estab. 1971. Quality regional magazine. Photos used in magazines, audiovisual, calendars.

NEEDS Buys 50 photos/year; offers 25 assignments/year. Scenics of North Dakota events, places and people. Also wildlife, cities/urban, rural, adventure, entertainment, events, hobbies, performing arts, travel, agriculture, industry. Interested in historical/vintage, seasonal. Model/property release preferred. Photo captions preferred.

SPECS Prefers images in digital format. Send via CD, as TIFF, EPS files at 600 dpi.

MAKING CONTACT & TERMS Prefers e-mail query letter. Pays by the project, varies ($125-300); negotiable. Pays on usage. Credit line given. Buys one-time rights; negotiable.

NORTHERN WOODLANDS MAGAZINE

Center for Woodlands Education, Inc., 1776 Center Rd., P.O. Box 471, Corinth VT 05039-0471. (802)439-6292. **Fax:** (802)439-6296. **E-mail:** dave@northernwoodlands.org. **Website:** www.northernwoodlands.org. Estab. 1994. Circ. 15,000. Quarterly. "Created to inspire landowners' sense of stewardship by increasing their awareness of the natural history and the principles of conservation and forestry that are directly related to their land; to encourage loggers, foresters, and purchasers of raw materials to continually raise the standards by which they utilize the forest's resources; to increase the public's awareness and appreciation of the social, economic, and environmental benefits of a working forest; to raise the level of discussion about environmental and natural resource issues; and to educate a new generation of forest stewards." Sample copies available for $6. Photo guidelines available on website.

NEEDS Buys 10-50 photos from freelancers/year. Photos of forestry, environmental, landscapes/scenics, wildlife, rural, adventure, travel, agriculture, science. Interested in historical/vintage, seasonal. Other specific photo needs: vertical format, photos specific to assignments in northern New England and upstate New York. Reviews photos with or without a manuscript. Model release preferred. Photo captions required.

SPECS Prefers images in digital format. Send via CD, ZIP, e-mail as TIFF, JPEG, EPS files at 300 dpi maximum. No e-mails larger than 5MB.

MAKING CONTACT & TERMS Send cover photo submissions as either slides or digital photos. Digital photos, less than 1MB each, can be e-mailed in JPEG, PDF, or TIFF format. If yours is chosen, we will request a higher-res image. You may also mail us a CD of your images to Attn: Cover Photos. Send query letter with slides. We have an online e-mail form available. Provide self-promotion piece to be kept on file for possible future assignments. Responds only if interested; send nonreturnable samples. Previously published work OK. Pays $150 for color cover; $25-75. "We might pay upon receipt or as late as publication." Credit line given. Buys one-time rights. "We will hold your photos until publication of the magazine for which they are being considered, unless you ask otherwise. All materials will be returned by certified mail."

◎ ⦿ ◑ NOTRE DAME MAGAZINE

University of Notre Dame, 500 Grace Hall, Notre Dame IN 46556-5612. (574)631-5335. **E-mail:** ndmag@nd.edu. **Website:** magazine.nd.edu. Kerry Prugh, art director. Estab. 1972. Circ. 150,000. "We are a university magazine with a scope as broad as that found at a university, but we place our discussion in a moral, ethical, and spiritual context reflecting our Catholic heritage."

NEEDS People, cities, education, architecture, business, science, environmental, and landscapes. Model and property releases are required. Photo captions are required.

MAKING CONTACT & TERMS E-mail (JPEG samples at 72 dpi) or send a postcard sample.

NOW & THEN; THE APPALACHIAN MAGAZINE

East Tennessee State University, Box 70556, Johnson City TN 37614-1707. (423)439-5348. **Fax:** (423)439-6340. **E-mail:** nowandthen@etsu.edu. **E-mail:** wardenc@etsu.edu. **Website:** www.etsu.edu/cass/

nowandthen. **Contact:** Jane Woodside, editor. Estab. 1984. Circ. 1,000. *Now & Then* tells the stories of Appalachia. The magazine presents a fresh, revealing picture of life in Appalachia, past and present, with engaging articles, personal essays, fiction, poetry, reviews and photography. Sample copy available for $8 plus $3 shipping. Photo guidelines free with SASE.

MAKING CONTACT & TERMS Send query letter with résumé, photocopies. Provide self-promotion piece to be kept on file for possible future assignments. Responds only if interested; send nonreturnable samples. Simultaneous submissions OK. Credit line given along with a free issue of the magazine in which the photography is featured.

TIPS Know what our upcoming themes are. Keep in mind, we cover only the Appalachian region (see the website for a definition of the region).

OCEAN MAGAZINE

P.O. Box 84, Rodanthe NC 27968-0084. (252)256-2296. **E-mail:** diane@oceanmagazine.org. **Website:** www.oceanmagazine.org. Estab. 2004. Circ. 40,000. "*OCEAN* magazine serves to celebrate and protect the greatest, most comprehensive resource for life on earth, our world's ocean. *OCEAN* publishes articles, stories, poems, essays, and photography about the ocean—observations, experiences, scientific and environmental discussions—written with fact and feeling, illustrated with images from nature."

NEEDS People, disasters, environmental, adventure, landscape wildlife pets, documentary, sports, travel, fine art, lifestyle and seasonal photographs. Identification of subjects, model releases required. Reviews 3×5, 4×6, 5×7, 8×10, 10×12 prints, JPEG files. Negotiates payment individually. Buys one-time rights.

MAKING CONTACT & TERMS E-mail with photographs and samples. Samples kept on file. Portfolio not required.

TIPS "Purchase an issue to learn what *OCEAN* publishes."

OFF THE COAST

Resolute Bear Press, P.O. Box 14, Robbinston ME 04671. (207)454-8026. **E-mail:** poetrylane2@gmail.com. **Website:** www.off-the-coast.com. **Contact:** Valerie Lawson, editor/publisher. Estab. 1994. "The mission of *Off the Coast* is to become recognized around the world as Maine's international poetry journal, a publication that prizes quality, diversity and honesty in its publications and in its dealings with poets. *Off the Coast*, a quarterly journal, publishes poetry, artwork and reviews. Arranged much like an anthology, each issue bears a title drawn from a line or phrase from one of its poems."

MAKING CONTACT & TERMS "We accept b&w graphics and photos to grace the pages of *Off the Coast*, and color or b&w for the cover. Send 3-6 images in TIFF, PNG, or JPEG format, minimum 300 dpi resolution. We prefer you select and send images rather than send a link to your website."

OHIO MAGAZINE

Great Lakes Publishing Co., 1422 Euclid Ave., Suite 730, Cleveland OH 44115. (216)771-2833. **E-mail:** editorial@ohiomagazine.com. **E-mail:** vpospisil@ohiomagazine.com; lblake@ohiomagazine.com. **Website:** www.ohiomagazine.com. **Contact:** Vivian Pospisil, executive editor; Lesley Blake, art director. Estab. 1978. Circ. 80,000. E-mail 5-10, low-resolution published samples to art director. Only qualified photographers from Ohio and bordering states will be considered. Slides and hard copies discouraged.

OKLAHOMA TODAY

P.O. Box 1468, Oklahoma City OK 73101-1468. (405)230-8450. **Fax:** (405)230-8650. **E-mail:** steffie@oklahomatoday.com. **Website:** www.oklahomatoday.com. **Contact:** Steffie Corcoran, editor. Estab. 1956. Circ. 45,000. Bimonthly. "We cover all aspects of Oklahoma, from history to people profiles, but we emphasize travel." Readers are "Oklahomans, whether they live in-state or are exiles; studies show them to be above average in education and income." Sample copy available for $4.95. Photo guidelines free with SASE or online.

NEEDS Buys 45 photos from freelancers/issue; 270 photos/year. Needs photos of "Oklahoma subjects only; the greatest number are used to illustrate a specific story on a person, place or thing in the state. We are also interested in stock scenics of the state." Other areas of focus are adventure—sport/travel, reenactment, historical and cultural activities. Model release required. Photo captions required.

SPECS Uses 8×10 glossy b&w prints; 35mm, 2¼×2¼, 4×5, 8×10 transparencies. Accepts images in digital format. Send via CD or e-mail.

MAKING CONTACT & TERMS Send query letter with samples; include SASE for return of material. Responds in 2 months. Simultaneous submissions and previously published work OK (on occasion).

Pays $50-150 for b&w photos; $50-250 for color photos; $125-1,000/job. Pays on publication. Buys one-time rights with a 4-month from publication exclusive, plus right to reproduce photo in promotions for magazine without additional payment with credit line.

TIPS To break in, "read the magazine. Subjects are normally activities or scenics (mostly the latter). I would like good composition and very good lighting. I look for photographs that evoke a sense of place, look extraordinary and say something only a good photographer could say about the image. Look at what Ansel Adams and Eliot Porter did and what Muench and others are producing, and send me that kind of quality. We want the best photographs available, and we give them the space and play such quality warrants."

ⓘ ONBOARD MEDIA

1691 Michigan Ave., Suite 600, Miami Beach FL 33139. (305)673-0400. **Fax:** (305)673-3575. **E-mail:** gail. abrams@onboardmedia.com; info@onboard.com. **Website:** www.onboard.com. **Contact:** Gail Abrams, creative services director. Estab. 1990. Circ. 792,184. 90 annual and quarterly publications. Emphasize travel in the Caribbean, Europe, Mexican Riviera, Bahamas, Alaska, Bermuda, Las Vegas. Custom publications reach cruise vacationers and vacation/resort audience. Photo guidelines free with SASE.

NEEDS Photos of scenics, nature, prominent landmarks based in Caribbean, Mexican Riviera, Bahamas, Alaska, Europe and Las Vegas. Model/property release required. Photo captions required; include where the photo was taken and explain the subject matter. Credit line information requested.

SPECS Uses 35mm, 2¼×2¼, 4×5, 8×10 transparencies. Prefers images in digital format RAW data. Send via CD at 300 dpi.

MAKING CONTACT & TERMS Send query letter with stock list. Provide résumé, business card, brochure, flyer or tearsheets to be kept on file for possible future assignments. Keeps samples on file. Responds in 3 weeks. Previously published work OK. Rates negotiable per project. Pays on publication. Credit line given.

ONE

Catholic Near East Welfare Association, 1011 First Ave., New York NY 10022-4195. (212)826-1480. **Fax:** (212)838-1344. **E-mail:** cnewa@cnewa.org. **Website:** www.cnewa.org. **Contact:** Deacon Greg Kandra, executive editor. Estab. 1974. Circ. 100,000. Official publication of Catholic Near East Welfare Association, "a papal agency for humanitarian and pastoral support." *ONE* informs Americans about the traditions, faiths, cultures and religious communities of the Middle East, Northeast Africa, India and Eastern Europe. Sample copy and photo guidelines available for 8½×11 SASE. Freelancers supply 80% of photos. Prefers to work with writer/photographer team.

NEEDS Looking for evocative photos of people—not posed—involved in activities: work, play, worship. Liturgical shots also welcome. Extensive captions required if text is not available.

MAKING CONTACT & TERMS Send query letter first. "Please do not send an inventory; rather, send a letter explaining your ideas." Include 8½×11 SASE. Responds in 3 weeks, acknowledges receipt of material immediately. Simultaneous submissions and previously published work OK, but "neither is preferred. If previously published please tell us when and where." Pays on publication. Credit line given. "Credits appear on page 3 with masthead and table of contents." Buys first North American serial rights.

TIPS Stories should weave current lifestyles with issues and needs. Avoid political subjects, stick with ordinary people. Photo essays are welcome. Write requesting sample issue and guidelines, then send query. We rarely use stock photos, but have used articles and photos submitted by a single photojournalist or writer/photographer team.

OREGON COAST

4969 Hwy. 101 N, Suite 2, Florence OR 97439. (800)348-8401. **E-mail:** Alicia@nwmags.com. **Website:** www.northwestmagazines.com. **Contact:** Alicia Spooner. Estab. 1982. Circ. 50,000. Bimonthly. Emphasizes Oregon coast life. Sample copy available for $6, including postage. Photo guidelines available with SASE or on website.

NEEDS Buys 3-5 photos from freelancers/issue; 18-30 photos/year. Needs scenics. Especially needs photos of typical subjects—waves, beaches, lighthouses—with a fresh perspective. Needs mostly vertical format. Model description in megadata and on caption sheet. "Now only accepting digital images. We recommend acquiring model releases for any photos that include people but we don't require releases except for photos used on covers or in advertising. Photos must be current, shot within the last five years."

MAKING CONTACT & TERMS Digital photos must be sent on CDs as high-res (300 dpi) TIFF, JPEG, or EPS files without compression. Images should be 8½×11. Include clear, color contact sheets of all images (no more than 8 per page). CDs are not returned. To be considered for calendars, photos must have horizontal formats. The annual deadline for calendars is August 15. Responds in 3 months. Pays $425 for color cover; $100 for calendar usage; $25-50 for b&w inside; $25-100 for color inside; $100-250 for photo/text package. Credit line given. Buys one-time rights. We do not sign for personal delivery. SASE or return postage required.

OUTDOOR CANADA MAGAZINE

54 St. Patrick St., Toronto ON M5T 1V1, Canada. (416)599-2000. **E-mail:** editorial@outdoorcanada.ca. **Website:** www.outdoorcanada.ca. Estab. 1972. Circ. 90,000. 4-color magazine for Canadian anglers and hunters. Stories on fishing, hunting and conservation. Readers are 81% male. Publishes 8 regular issues/year. "We are looking for strong, attention-grabbing images that capture the love our readers have for hunting and fishing. We're interested in finding and cultivating new Canadian talent and appreciate submissions from new photographers and illustrators to add to our list."
NEEDS Buys 200-300 photos/year. Needs photos of wildlife; fishing, hunting, ice-fishing; action shots. *Canadian content only.* Photo captions required; include identification of fish, bird or animal.
SPECS Accepts images in digital format. Photographers interested in sending originals should send a small portfolio of 100 (or less) well-edited images. Naturally, we would expect photographers to send images that are in line with the magazine's content (i.e., fishing, hunting, conservation). Label each frame with your name and provide details such as species of fish or shot location. We usually do not purchase images in advance, but will solicit images from your library when packaging stories or features. We'll return them by Express Post as soon as we can after viewing. We also are happy to accept electronic submissions via e-mail.
MAKING CONTACT & TERMS "Send a well-edited selection of transparencies with return postage for consideration. E-mail/CD portfolios also accepted." Responds in 1 month. Pays on invoice. Buys one-time rights.

TIPS "When sending unsolicited submissions, please send dupes, color copies or tearsheets of your work that we can keep on file. We get hundreds of promotional pieces each year, so we can't possibly respond to them all, but we'll do our best. If we'd like to see more of your portfolio or assign work to you, we'll contact you. Art guidelines are available."

OWL MAGAZINE

10 Lower Spadina Ave., Suite 400, Toronto ON M5V 2Z2, Canada. (416)340-2700. **Fax:** (416)340-9769. **E-mail:** tracey.jacklin@owlkids.com. **Website:** www.owlkids.com. **Contact:** Tracey Jacklin, photo researcher. Estab. 1976. Circ. 80,000. Published 10 times/year. A discovery magazine for children ages 9-13. Sample copy available for $4.95 and 9×12 SAE with $1.50 money order for postage. Photo guidelines free with SAE or via e-mail.
NEEDS Photo stories, photo puzzles, photos of children ages 12-14, extreme weather, wildlife, science, technology, environmental, pop culture, multicultural, events, adventure, hobbies, humor, sports, extreme sports. Interested in documentary, seasonal. Model/property release required. Photo captions required. Will buy story packages.
SPECS Accepts images in digital format. E-mail as JPEG files at 72 dpi. Requires 300 dpi for publication.
MAKING CONTACT & TERMS Accepts no responsibility for unsolicited material. Previously published work OK. Credit line given. Buys one-time rights.
TIPS "Photos should be sharply focused with good lighting, and engaging for kids. We are always on the lookout for humorous, action-packed shots; eye-catching, sports, animals, bloopers, etc. Photos with a 'wow' impact."

OXYGEN

Robert Kennedy Publishing, 400 Matheson Blvd., W., Mississauga ON L5R 3M1, Canada. (905)507-3545; (888)254-0767. **Fax:** (905)507-2372. **Website:** www.oxygenmag.com. Estab. 1997. Circ. 340,000. Monthly. Emphasizes exercise and nutrition for women. Readers are women ages 20-39. Sample copy available for $5.
NEEDS Buys 720 photos from freelancers/issue. Needs photos of women weight training and exercising aerobically. Model release required. Photo captions preferred; include names of subjects.
SPECS Accepts high-res digital images. Uses 35mm, 2¼×2¼ transparencies. Prints occasionally acceptable.

MAKING CONTACT & TERMS Send unsolicited photos by mail for consideration. Does not keep samples on file; include SASE for return of material. Responds in 3 weeks. Pays $200-400/hour; $800-1,500/day; $500-1,500/job; $500-2,000 for color cover; $50-100 for color or b&w inside. **Pays on acceptance.** Credit line given. Buys all rights.

TIPS "We are looking for attractive, fit women working out on step machines, joggers, rowers, treadmills, ellipticals; with free weights; running for fitness; jumping, climbing. Professional pictures only, please. We particularly welcome photos of female celebrities who are into fitness; higher payments are made for these."

OYEZ REVIEW

Roosevelt University, Dept. of Literature & Languages, 430 S. Michigan Ave., Chicago IL 60605-1394. (312)341-3500. **E-mail:** oyezreview@roosevelt.edu. **Website:** legacy.roosevelt.edu/roosevelt/edu/oyezreview. Estab. 1965. Circ. 600. Annual magazine of the Creative Writing Program at Roosevelt University, publishing fiction, creative nonfiction, poetry, and art. There are no restrictions on style, theme, or subject matter. Each issue has 100 pages: 92 pages of text and an 8-page b&w or color spread of one artist's work (usually drawing, painting or photography) with the front and back covers totaling 10 pieces. Accepts outstanding work from beginning and established photographers. Expects a high level of professionalism from all photographers who make contact. Reviews photos with or without a manuscript.

NEEDS Accepts 10 photos from freelancers/issue; 10 photos/year. Needs babies/children/teens, senior citizens, cities/urban, pets, religious, rural, military, political, product shots/still life, disasters, environmental, landscapes/scenics, wildlife, adventure, automobiles, events, hobbies, humor, performing arts, sports, travel, avant garde, documentary, fine art, seasonal

SPECS Submit in b&w or color. Send via CD, e-mail as JPEG files.

MAKING CONTACT & TERMS Now accepting submissions through Submittable as well as regular mail. No longer accepting e-mail submissions. Model and property release is preferred. Photo captions are preferred.

☼ PACIFIC YACHTING

OP Publishing, Ltd., 200 West Esplanade Suite 500, North Vancouver BC V7M 1A4, Canada. (604)998-3310. **Fax:** (604)998-3320. **E-mail:** editor@pacificyachting.com. **Website:** www.pacificyachting.com. **Contact:** Dale Miller, editor; Arran Yates, art director. Estab. 1968. Circ. 19,000. Monthly. Emphasizes boating on West Coast. Readers are ages 35-60; boaters, power and sail. Sample copy available for $6.95 Canadian plus postage.

NEEDS Buys 75 photos from freelancers/issue; 900 photos/year. Photos of landscapes/scenics, adventure, sports. Interested in historical/vintage, seasonal. "All should be boating related. Reviews photos with accompanying manuscript only. Always looking for covers; must be shot in British Columbia."

MAKING CONTACT & TERMS Keeps samples on file. Simultaneous submissions and previously published work OK. Pays $400 Canadian for color cover. Payment negotiable. Credit line given. Buys one-time rights.

PAKN TREGER

National Yiddish Book Center, 1021 West St., Amherst MA 01002. (413)256-4900. **E-mail:** aatherley@bikher.org; pt@bikher.org;. **Website:** www.yiddishbookcenter.org. **Contact:** Anne Atherley, editor's assistant. Estab. 1980. Circ. 20,000. Literary magazine published 3 times/year; focuses on modern and contemporary Jewish and Yiddish culture.

NEEDS Photos of families, parents, senior citizens, education, religious, humor, historical/vintage, Jewish and Yiddish culture. Reviews photos with or without a manuscript. Captions required; include identification of subjects.

SPECS Accepts images in digital format. Send JPEG or GIF files.

MAKING CONTACT & TERMS Negotiates payment. Pays on publication. Credit line given. Buys one-time rights.

⊛⊛ PENNSYLVANIA ANGLER & BOATER

P.O. Box 67000, Harrisburg PA 17106-7000. (717)705-7835. **E-mail:** ra-pfbcmagazine@pa.gov. **Website:** www.fish.state.pa.us. Bimonthly. "*Pennsylvania Angler & Boater* is the Keystone State's official fishing and boating magazine, published by the Pennsylvania Fish & Boat Commission." Readers are anglers and boaters in Pennsylvania. Sample copy and photo guidelines free with 9×12 SASE and 9 oz. postage, or online.

NEEDS Buys 8 photos from freelancers/issue; 48 photos/year. Needs "action fishing and boating shots." Model release required. Photo captions required.

MAKING CONTACT & TERMS "Don't submit without first considering contributor guidelines, available online. Then send query letter with résumé of credits. Send 35mm or larger transparencies by mail for consideration; include SASE for return of material. Send low-res images on CD; we'll later request high-res images of those shots that interest us." Responds in about 8 weeks. Pays $400 maximum for color cover; $30 minimum for color inside; $50-300 for text/photo package. Pays between acceptance and publication. Credit line given.

PENNSYLVANIA GAME NEWS

2001 Elmerton Ave., Harrisburg PA 17110-9797. (717)787-3745. **Website:** www.pgc.state.pa.us. Circ. 75,000. Monthly. Published by the Pennsylvania Game Commission. Readers are people interested in hunting, wildlife management and conservation in Pennsylvania. Sample copy available with 9×12 SASE. Editorial guidelines free.

NEEDS Considers photos of "any outdoor subject (Pennsylvania locale), except fishing and boating." Reviews photos with accompanying manuscript. Manuscript not required.

MAKING CONTACT & TERMS The agency expects all photos to be accompanied with a photo credit (e.g., Jake Dingel/PGC Photo). E-mail Robert Mitchell at robmitchel@state.pa.us with questions about images and policy. Send prints or slides. "No negatives, please." Include SASE for return of material. Will accept electronic images via CD only (no e-mail). Will also view photographer's website if available. Responds in 2 months. Pays $40-300. **Pays on acceptance.**

PENNSYLVANIA MAGAZINE

P.O. Box 755, Camp Hill PA 17001. (717)697-4660. **E-mail:** editor@pa-mag.com. **Website:** www.pa-mag.com. **Contact:** Matthew K. Holliday, editor. Circ. 30,000. Bimonthly. Emphasizes history, travel and contemporary topics. Readers are 40-70 years old, professional and retired. Samples available upon request. Photo guidelines free with SASE or via e-mail.

NEEDS Uses about 40 photos/issue; most supplied by freelancers. Needs include travel, wildlife and scenic. All photos must be taken in Pennsylvania. Reviews photos with or without accompanying manuscript. Photo captions required.

MAKING CONTACT & TERMS Send query letter with samples. Send digital submissions for consideration. Sharpness is more important than pixel size. If your submitted images are of interest, the editor will communicate as to sizes needed. Responds in 1 month. Simultaneous submissions and previously published work OK with notification. Pays $100-150 for color cover; $35 for color inside; $50-500 for text/photo package. Credit line given. Buys one-time, first rights or other rights as arranged.

TIPS Look at several past issues and review guidelines before submitting.

PENTHOUSE

General Media Communications, 2 Penn Plaza, 11th Floor, New York NY 10121. (212)702-6000. **Fax:** (212)702-6279. **E-mail:** pbloch@pmgi.com. **Website:** www.penthouse.com. Estab. 1969. Circ. 640,000. Monthly. For the sophisticated male. Editorial scope ranges from outspoken contemporary comment to photography essays of beautiful women. Features interviews with personalities, sociological studies, humor, travel, food and wines, and fashion and grooming for men. Query before submitting.

PERIOD IDEAS

21-23 Phoenix Court, Hawkins Rd., Colchester, Essex CO2 8JY, United Kingdom. (44)(1206)505976. **E-mail:** susan.dickerson@aceville.co.uk. **Website:** www.periodideas.com. **Contact:** Susan Dickerson. Circ. 38,000. Monthly home interest magazine for readers with period properties which they wish to renovate sympathetically.

NEEDS Photos of architecture interiors/decorating, gardens, events. Reviews photos with or without ms.

SPECS Uses glossy color prints; 35mm transparencies. Accepts images in digital format. Send via CD as TIFF, JPEG files at 300 dpi.

MAKING CONTACT & TERMS Send query letter with prints, transparencies. Does not keep samples on file; include SASE for return of material. Responds only if interested; send nonreturnable samples. Previously published work OK. Prices for covers/packages/single shots negotiated one-on-one (please indicate expectations. Pays at the end of the cover-dated publication date. Credit line sometimes given. Buys one-time rights.

TIPS "Label each image with what it is, name and contact address/telephone number of photographer."

⑤⑤ ◐ PERSIMMON HILL

1700 NE 63rd St., Oklahoma City OK 73111. (405)478-2250, ext. 213. **Fax:** (405)478-4714. **E-mail:** editor@nationalcowboymuseum.org. **Website:** www.nationalcowboymuseum.org. **Contact:** Judy Hilovsky. Estab. 1970. Circ. 7,500. Biannual publication of the National Cowboy and Western Heritage Museum. Emphasizes the West, both historical and contemporary views. Has diverse international audience with an interest in preservation of the West. Sample copy for $11.

◖ This magazine has received Outstanding Publication honors from the Oklahoma Museums Association, the International Association of Business Communicators, Ad Club and Public Relations Society of America.

NEEDS Buys 65 photos from freelancers/issue; 260 photos/year. "Photos must pertain to specific articles unless it is a photo essay on the West." Western subjects include celebrities, couples, families, landscapes, wildlife, architecture, interiors/decorating, rural, adventure, entertainment, events, hobbies, travel. Interested in documentary, fine art, historical/vintage, seasonal. Model release required for children's photos. Photo captions required; include location, names of people, action. Proper credit is required if photos are historic.

SPECS Accepts images in digital format. Send via CD.

MAKING CONTACT & TERMS Responds in 6 weeks. Pays $150-500 for color cover; $100-150 for b&w cover; $50-150 for color inside; $25-100 for b&w inside. Credit line given. Buys first North American serial rights.

TIPS "Make certain your photographs are high quality and have a story to tell. We are using more contemporary portraits of things that are currently happening in the West and using fewer historical photographs. Work must be high quality, original, innovative. Photographers can best present their work in a portfolio format and should keep in mind that we like to feature photo essays on the West in each issue. Study the magazine to understand its purpose. Show only the work that would be beneficial to us or pertain to the traditional Western subjects we cover."

PHOTOGRAPHER'S FORUM MAGAZINE

813 Reddick St., Santa Barbara CA 93103. (805)963-6425. **Fax:** (805)965-0496. **E-mail:** julie@serbin.com.

Website: www.pfmagazine.com. **Contact:** Julie Simpson, managing editor. Quarterly magazine for the serious student and emerging professional photographer. Includes feature articles on historic and contemporary photographers, interviews, book reviews, workshop listings, and new products.

♲ ⑤ ◎ ◐ PHOTO LIFE

Apex Publications, 185 St. Paul St., Quebec City QC G1K 3W2, Canada. (800)905-7468. **Fax:** (800)664-2739. **E-mail:** editor@photolife.com. **Website:** www.photolife.com. **Contact:** Editor. Circ. 60,000. Published 6 times/year. Readers are amateur, advanced amateur and professional photographers. Sample copy free with SASE. Photo guidelines available on website. Priority is given to Canadian photographers.

NEEDS Buys 70 photos from freelancers/issue; 420 photos/year. Needs landscape/wildlife shots, fashion, scenics, b&w images and so on.

SPECS Accepts images in digital format, must be TIFF or high-res JPEG. Send via CD at 300 dpi.

MAKING CONTACT & TERMS Send query letter with résumé of credits, SASE. Pays on publication. Buys first North American serial rights and one-time rights.

TIPS "Looking for good writers to cover any subject of interest to the amateur and advanced photographer. Fine art photos should be striking, innovative. General stock and outdoor photos should be presented with a strong technical theme."

⑤⑤ ◐ PHOTO TECHNIQUES

Editorial Offices, Preston Publications, 6600 W. Touhy Ave., Niles IL 60714. (847)647-2900. **E-mail:** wendy@phototechmag.com; pschranz@phototechmag.com. **Website:** www.phototechmag.com. **Contact:** Wendy Erickson, editor. Estab. 1979. Circ. 20,000. Bimonthly. For advanced traditional and digital photographers. Sample copy available on website or at select book stores. Writer's guidelines available online.

NEEDS Publishes expert technical articles about photography. Prefers work that has not been previously published in any competing photography magazine; small, scholarly, or local publication OK.

MAKING CONTACT & TERMS Include 5-6 photos, a short bio, website link, mailing address and telephone number. All files should start with your last then first name, example: Smith_John.doc. Send only small JPEG or PDF images. Do not send ZIP files. Un-

known attachments will not be opened. Payment for writers is $200 per page including images and $350 per cover image for most submissions. Pays on publication. Credit line given. Buys one-time rights

TIPS ONLY SUBMIT VIA E-MAIL. Please do not mail submissions.

PILOT GETAWAYS MAGAZINE

Airventure Publishing LLC, P.O. Box 550, Glendale CA 91209. (818)241-1890. **Fax:** (818)241-1895. **E-mail:** info@pilotgetaways.com; editor@pilotgetaways.com. **Website:** www.pilotgetaways.com. **Contact:** John T. Kounis, editor. Estab. 1999. Circ. 25,000. Bimonthly. Focuses on travel by private aircraft. Includes sections on back-country, bush and mountain flying. Emphasizes private pilot travel—weekend getaways, fly-in dining, bush flying, and complete flying vacations. Readers are mid-life males, affluent.

NEEDS Uses assignment photos. Needs photos of adventure, travel, product shots/still life. Model release required. Photo captions required.

SPECS Accepts medium-format and 35mm slides. Accepts images in digital format. Send via CD as TIFF files at 300 dpi.

MAKING CONTACT & TERMS Provide résumé, business card or tearsheets to be kept on file for possible future assignments; contact by e-mail. Simultaneous submissions OK. Prefers previously unpublished work. Pays 30 days after publication. Credit line given. Buys all rights; negotiable.

TIPS "Exciting, fresh and unusual photos of airplanes used for recreation. Aerial landscapes, fly-in destinations. Outdoor recreation: skiing, hiking, fishing and motor sports. Affluent back-country lifestyles: homes, hangars and private airstrips. Query first. Don't send originals—color copies or low-res digital OK for evaluation."

🌐 💲 PILOT MAGAZINE

3 The Courtyard, Denmark St., Wokingham, Berkshire RG40 2AZ, United Kingdom. +44(0)118 989 7246. **Fax:** +44(0)7834 104843. **Website:** www.pilotweb.aero. Estab. 1968. Circ. 14,418. "The UK's bestselling aviation monthly magazine." Photo guidelines available.

NEEDS Photos of aviation. Reviews photos with or without a manuscript. Photo captions required.

SPECS Accepts images in digital format. Send via CD, ZIP as JPEG files at 300 dpi.

MAKING CONTACT & TERMS Does not keep samples on file; include SASE for return of material. Previously published work OK. Pays £30 for color inside. Pays on publication. Credit line given. Buys one-time rights.

TIPS "Read our magazine. Label all photos with name and address. Supply generous captions."

🌐 💲 ⓘ PLANET

P.O. Box 44, Aberystwyth SY23 3ZZ, Wales. (44) (1970)611255. **Fax:** (44)(1970)611197. **E-mail:** planet.enquiries@planetmagazine.org.uk. **Website:** www.planetmagazine.org.uk. Estab. 1970. Circ. 1,400. Bi-monthly cultural magazine devoted to Welsh culture, current affairs, the arts, the environment, but set in broader international context. Audience based mostly in Wales.

NEEDS Photos of environmental, performing arts, sports, agriculture, industry, political, science. Interested in fine art, historical/vintage. Reviews photos with or without manuscript. Model/property release preferred. Photo captions required; include subject, copyright holder.

SPECS Uses glossy color and b&w prints; 4×5 transparencies. Accepts images in digital format. Send as JPEG files at 300 dpi.

MAKING CONTACT & TERMS Send query letter with résumé, slides, prints, photocopies. Does not keep samples on file; include SASE for return of material. Simultaneous submissions and previously published work OK. Pays on publication. Credit line given. Buys first rights.

TIPS "Read the magazine first to get an idea of the kind of areas we cover so incompatible/unsuitable material is not submitted. Submission guidelines available online."

ⓘ POPULAR PHOTOGRAPHY & IMAGING

Bonnier Corporation, 460 N. Orlando Ave., Suite 200, Winter Park FL 32789. (407)628-4802. **Fax:** (407)628-7061. **E-mail:** mleuchter@hfmus.com; popeditor@hfmus.com. **Website:** www.popularphotography.com. **Contact:** Miriam Leuchter, managing editor. Estab. 1937. Circ. 450,000. Monthly. Readers are male and female photographers, amateurs to professionals of all ages. Photo guidelines free with SASE.

NEEDS "We are primarily interested in articles on new or unusual phases of photography which we have not covered recently or in recent years. We do not want general articles on photography which could just

as easily be written by our staff. We reserve the right to rewrite, edit, or revise any material we are interested in publishing."

MAKING CONTACT & TERMS "Queries should be accompanied by a sampling of how-to pictures (particularly when equipment is to be constructed or a process is involved), or by photographs which support the text. Please send duplicates only; do not send negatives or original slides. We are not responsible for the loss of original work. The sender's name and address should be clearly written on the back of each print, on the mount of each slide, watermarked on digitally sent sample images, and on the first and last pages of all written material, including the accompanying letter. Technical data should accompany all pictures, including the camera used, lens, film (or image format if digital), shutter speed, aperture, lighting, and any other points of special interest on how the picture was made. Material mailed to us should be carefully wrapped or packaged to avoid damage. All submissions must be accompanied by a SASE. The rate of payment depends upon the importance of the feature, quality of the photographs, and our presentation of it. Upon acceptance, fees will be negotiated by the author/photographer and the editors of the magazine. We are unable to accept individual portfolios for review. However, we do welcome samples of your work in the form of promotional mailers, press kits, or tear sheets for our files. These should be sent to the attention of Miriam Leuchter, managing editor, at the above address or via e-mail at mleuchter@hfmus.com"

TIPS The Annual Reader's Picture Contest gives photographers the opportunity to have their work recognized in the largest photo magazine in the world, as well as on PopPhoto.com. See website for submission guidelines, or e-mail acooper@hfmus.com.

⊕ ◑ POTOMAC REVIEW

Montgomery College, 51 Mannakee St., MT/212, Rockville MD 20850. (301)251-7417. **Fax:** (301)738-1745. **E-mail:** PotomacReviewEditor@montgomery college.edu. **Website:** www.montgomerycollege.edu/potomacreview. **Contact:** Julie Wakeman-Linn, editor-in-chief. Estab. 1994. Circ. 750.

POWER & MOTORYACHT

10 Bokum Rd., Essex CT 06426. (860)767-3200. **E-mail:** gsass@aimmedia.com; cwhite@aimmedia.com. **Website:** www.powerandmotoryacht.com. Aimee Colon, art director. **Contact:** George Sass, editor-in-

chief; Chris White, managing editor. Estab. 1985. Circ. 157,000. Monthly. Covers powerboats 24 feet and larger with special emphasis on the 35-foot-plus market. "Readers have an average of 33 years experience boating, and we give them accurate advice on how to choose, operate, and maintain their boats as well as what electronics and gear will help them pursue their favorite pastime. In addition, since powerboating is truly a lifestyle and not just a hobby for them, *Power & Motoryacht* reports on a host of other topics that affect their enjoyment of the water: chartering, sportfishing, and the environment, among others."

POZ

CDM Publishing, LLC, 462 Seventh Ave., 19th Floor, New York NY 10018. (212)242-2163. **Fax:** (212)675-8505. **E-mail:** website@poz.com; editor-in-chief@poz.com. **Website:** www.poz.com. **Contact:** Doriot Kim, art director. Estab. 1994. Circ. 125,000. Monthly. Focuses exclusively on HIV/AIDS news, research, and treatment.

NEEDS Buys 10-25 photos from freelancers/issue; 120-300 photos/year. Reviews photos with or without a ms. Model release preferred. Photo captions required.

SPECS Prefers online portfolios.

MAKING CONTACT & TERMS Send query letter with nonreturnable samples. Provide self-promotion piece to be kept on file for possible future assignments. Responds only if interested; send nonreturnable samples. Simultaneous submissions and previously published work OK. Pays $400-1,000 for color cover; $100-500 for color inside. Pays on publication. Credit line given.

↻ ◲ ⊛ ○ THE PRAIRIE JOURNAL

P.O. Box 68073, 28 Crowfoot Terrace NW Calgary AB Y3G 3N8, Canada. **E-mail:** editor@prairiejournal.org (queries only); prairiejournal@yahoo.com. **Website:** www.prairiejournal.org. **Contact:** A.E. Burke, literary editor. Estab. 1983. Circ. 650-750. Literary magazine published twice/year. Features mainly poetry and artwork. Sample copy available for $6 and 7×8½ SAE. Photo guidelines available for SAE and IRC.

NEEDS Buys 4 photos/year. Needs literary only, artistic.

SPECS Uses b&w prints. Accepts images in digital format. Send via e-mail "if your query is successful."

MAKING CONTACT & TERMS Send query letter with photocopies only (no originals) by mail. Provide

self-promotion piece to be kept on file. Responds in 6 months, only if interested; send nonreturnable samples. Pays $10-50 for b&w cover or inside. Pays on publication. Credit line given. Buys first rights.

TIPS "Black & white literary, artistic work preferred; not commercial. We especially like newcomers. Read our publication or check out our website. You need to own copyright for your work and have permission to reproduce it. We are open to subjects that would be suitable for a literary arts magazine containing poetry, fiction, reviews, interviews. We do not commission but choose from your samples."

○ ◑ ○ PRAIRIE MESSENGER

Benedictine Monks of St. Peter's Abbey, P.O. Box 190, Muenster SK S0K 2Y0, Canada. (306)682-1772. **Fax:** (306)682-5285. **E-mail:** pm.canadian@stpeterspress. ca. **Website:** www.prairiemessenger.ca. **Contact:** Maureen Weber, associate editor. Estab. 1904. Circ. 5,000. Weekly Catholic publication published by the Benedictine Monks of St. Peter's Abbey in Muenster, SK, Canada. Has a strong focus on ecumenism, social justice interfaith relations, aboriginal issues, arts and culture.

NEEDS People, religious, agriculture, industry, military, environmental, entertainment, performing arts, lifestyle seasonal photographs. Buys 50 photos/year. "I usually need photos to illustrate columns and occasionally use 'filler' feature photos with captions I either make up or seek quotations for. This means a range of themes is possible, including seasonal, environmental, religious, etc. Also, we carry a weekly poem submitted by freelancers, but I use stock photos to illustrate the poems."

MAKING CONTACT & TERMS Accepts photos as TIFF or JPEG format. E-mail with JPEG samples at 72 dpi. Credit line given.

◐ PRICK OF THE SPINDLE

P.O. Box 6816, New Orleans LA 70174-6816. (985)886-6145. **E-mail:** pseditor@prickofthespindle.com. **Website:** www.prickofthespindle.com. **Contact:** Cynthia Reeser, editor-in-chief. Estab. 2007. Circ. 6,200 hits/day. Literary magazine published quarterly online, biannually in print. We accept artwork that shows imagination and skill that covers a broad range of themes and subjects. Sample copy available for $10. Art/photo submission guidelines available on website.

MAKING CONTACT & TERMS Send query letter or e-mail with résumé, prints and SASE (regular mail) or

JPEG samples at 72 dpi. Keeps samples on file, provide résumé, business card or self-promotion piece to be kept on file for future assignments. Samples only return with SASE. Responds in 7 days. Will contact artist for portfolio review if interested. Portfolio should include b&W color, finished art, original art, photographs. Considers simultaneous submissions and previously published work. Credit line given. Buys first North American rights. Willing to negotiate. Finds freelancers through submissions.

PRINCETON ALUMNI WEEKLY

194 Nassau St., Suite 38, Princeton NJ 08542. (609)258-4722. **Fax:** (609)258-2247. **E-mail:** federici@princeton.edu; mnelson@princeton.edu. **Website:** www.princeton.edu/paw. **Contact:** Katherine Federici Greenwood, editor; Marianne Nelson, art director. Circ. 60,000. Published 15 times/year. Emphasizes Princeton University and higher education. Readers are alumni, faculty, students, staff and friends of Princeton University. Sample copy available for $2 with 9×12 SASE and 2 first-class stamps.

NEEDS Assigns local and out-of-state photographers and purchases stock. Needs photos of people, campus scenes; subjects vary greatly with content of each issue.

MAKING CONTACT & TERMS Arrange a personal interview to show portfolio. Provide sample card to be kept on file for possible future assignments. Payment varies according to usage, size, etc. Pays on publication. Buys one-time rights.

◎ ⑤ ○ THE PROGRESSIVE

409 E. Main St., Madison WI 53703. (608)257-4626. **Fax:** (608)257-3373. **E-mail:** editorial@progressive. org; mattr@progressive.org. **Website:** www.progressive.org. **Contact:** Matthew Rothschild, editor. Estab. 1909. Monthly political magazine. "Grassroots publication from a left perspective interested in foreign and domestic issues of peace and social justice." Photo guidelines free and online.

NEEDS Buys 5-10 photos from freelancers/issue; 50-100 photos/year. Looking for images documenting the human condition and the social/political environments of contemporary society. Special photo needs include "labor activities, environmental issues and political movements." Photo captions required; include name, place, date, credit information.

SPECS Accepts low-res JPEGs via e-mail.

MAKING CONTACT & TERMS Send query letter with photocopies; include SASE. Provide stock list to

be kept on file for possible future assignments. Art director will contact photographer for portfolio review if interested. Responds once every month. Simultaneous submissions and previously published work OK. Pays $50-150 for b&w inside. Pays on publication. Credit line given. Buys one-time rights. All material returned with SASE.

TIPS "Most of the photos we publish are of political actions. Interesting and well-composed photos of creative actions are the most likely to be published. We also use 2-3 short photo essays on political or social subjects per year." For detailed photo information, see the website.

RACQUETBALL MAGAZINE

1685 W. Uintah, Suite 103, Colorado Springs CO 80904-2906. (719)635-5396. **Fax:** (719)635-0685. **E-mail:** jhiser@usra.org. **Website:** www.usaracquetball.com. **Contact:** Jim Hiser, program manager. Estab. 1990. Circ. 30,000. Bimonthly magazine of USA Racquetball. Emphasizes racquetball. Sample copy available for $4.50. Photo guidelines available.

NEEDS Buys 6-12 photos from freelancers/issue; 36-72 photos/year. Needs photos of action racquetball. Model/property release preferred. Photo captions required.

SPECS Accepts images in digital format. Send via CD as EPS files at 900 dpi.

MAKING CONTACT & TERMS Provide résumé, business card, brochure, flyer or tearsheets to be kept on file for possible future assignments. Responds in 1 month. Previously published work OK. Pays on publication. Credit line given. Buys all rights; negotiable.

REFORM JUDAISM

633 Third Ave., 7th Floor, New York NY 10017-6778. (212)650-4240. **Fax:** (212)650-4249. **E-mail:** rjmagazine@urj.org. **Website:** www.reformjudaismmag.org. **Contact:** Joy Weinberg, managing editor. Estab. 1972. Circ. 310,000. Quarterly publication of the Union for Reform Judaism. Offers insightful, incisive coverage of the challenges faced by contemporary Jews. Readers are members of Reform congregations in North America. Sample copy available for $3.50. Photo guidelines available via e-mail or on website.

NEEDS Buys 3 photos from freelancers/issue; 12 photos/year. Needs photos relating to Jewish life or Jewish issues, Israel, politics. Model release required for children. Photo captions required.

MAKING CONTACT & TERMS Provide website. Responds in 1 month. Simultaneous submissions and previously published website work OK. Include self-addressed, stamped postcard for response. Pays on publication. Credit line given. Buys one-time rights, first North American serial rights.

TIPS Wants to see "excellent photography: artistic, creative evocative pictures that involve the reader."

RELOCATING TO THE LAKE OF THE OZARKS

Showcase Publishing, 2820 Bagnell Dam Blvd., #1B, Lake Ozark MO 65049. (573)365-2323. **Fax:** (573)365-2351. **E-mail:** spublishingco@msn.com. **Website:** www.relocatingtothelakeoftheozarks.com. **Contact:** Dave Leathers, publisher. Semi-annual relocation guide; free for people moving to the area.

SPECS "Only digital images are accepted. Digital images must be submitted with resolutions of 300 dpi and can be submitted as JPEG, EPS, TIFF or PSD files. They must be submitted with physical width of 6" wide at the very least and should preferably be submitted as being set to CMYK mode."

REVOLUTIONARY WAR TRACKS

E-mail: revolutionarywartracks@yahoo.com. **Contact:** Shannon Bridget Murphy. Estab. 2005. Quarterly. "Bringing Revolutionary War history alive for children and teens." Photo guidelines available by e-mail request.

NEEDS Buys 12-24 photos/year. Photos of babies/children/teens, multicultural, families, parents, disasters, environmental, landscapes/scenics, wildlife cities/urban, education, religious, rural, adventure, events, food/drink, sports, travel, agriculture, medicine, military, political, product shots/still life, science, technology—as related to Revolutionary War history. Interested in alternative process, avant garde, documentary, fashion/glamour, fine art, historical/vintage, seasonal. Reviews photos with or without a manuscript. Model/property release preferred.

SPECS Uses glossy or matte color and b&w prints.

MAKING CONTACT & TERMS Send query letter via e-mail. "If possible, please do not include photographs in files if they are sent through e-mail. A disc with your photographs is acceptable." Provide résumé, business card or self-promotion piece to be kept on file for possible future assignments. "Photographs sent with CDs are requested but not required." Responds within 1 month to queries; 1 week to port-

folios. Simultaneous submissions and previously published work OK. **Pays on acceptance.** Credit line given. Buys one-time rights, first rights; negotiable.

RHODE ISLAND MONTHLY

717 Allens Ave., Suite 105, Providence RI 02905. (401)649-4800. **E-mail:** tstrasberg@rimonthly.com. **Website:** www.rimonthly.com. **Contact:** Tina Strasberg, art director. Estab. 1988. Circ. 41,000. Monthly regional publication for and about Rhode Island. *Rhode Island Monthly* is a general interest consumer magazine with a strict Rhode Island focus.

NEEDS Buys 15 photos from freelancers/issue; 200 photos/year. "Almost all photos have a local slant: portraits, photo essays, food, lifestyle, home, issues."

SPECS Accepts images in digital format.

MAKING CONTACT & TERMS Portfolio may be dropped off. Provide self-promotion piece to be kept on file for possible future assignments. Will return anything with SASE. Responds in 2 weeks. Pays "a month after invoice is submitted." Credit line given. Buys one-time rights.

TIPS "Freelancers should be familiar with *Rhode Island Monthly* and should be able to demonstrate their proficiency in the medium before any work is assigned."

THE ROANOKER

Leisure Publishing Co., 3424 Brambleton Ave., Roanoke VA 24018. (540)989-6138. **Fax:** (540)989-7603. **E-mail:** jwood@leisurepublishing.com; krheinheimer@leisurepublishing.com. **Website:** www.theroanoker.com. **Contact:** Kurt Rheinheimer, editor; Austin Clark, creative director; Patty Jackson, production director. Estab. 1974. Circ. 10,000. Bimonthly. Emphasizes Roanoke region and western Virginia. Readers are upper-income educated people interested in their community. Sample copy available for $3.

NEEDS Buys 30 photos from freelancers/issue; 180 photos/year. Needs photos of couples, multicultural, families, parents, senior citizens, architecture, cities/urban, education, interiors/decorating, entertainment, events, food/drink, health/fitness/beauty, performing arts, sports, travel, business concepts, medicine technology/computers, seasonal. Needs "travel and scenic photos in western Virginia; color photo essays on life in western Virginia." Model/property release preferred. Photo captions required.

MAKING CONTACT & TERMS Accepts digital format. Send via CD, e-mail as TIFF, EPS, JPEG files at 300 dpi, minimum print size 8×10 with cutlines and thumbnails. Responds in 1 month. Simultaneous submissions and previously published work OK. Pays $100-150 for color cover; $15-25 for b&w inside, $25-100 for color inside; $100/day. Pays on publication. Credit line given. Rights purchased vary; negotiable.

ROLLING STONE

Wenner Media, 1290 Avenue of the Americas, New York NY 10104. (212)484-1616. **Fax:** (212)484-1664. **E-mail:** rseditors@rollingstone.com; photo@rollingstone.com. **Website:** www.rollingstone.com. Circ. 1,464,943. Monthly. Emphasizes film, CD reviews, music groups, celebrities, fashion. Readers are young adults interested in news of popular music, politics, and culture.

NEEDS Photos of celebrities, political, entertainment, events. Interested in alternative process, avant garde, documentary, fashion/glamour.

SPECS Accepts images in digital format. Send as TIFF, JPEG files at 300 dpi.

MAKING CONTACT & TERMS Portfolio may be dropped off every Wednesday and picked up on Friday afternoon. Provide business card, self-promotion piece to be kept on file for possible future assignments. Responds only if interested; send nonreturnable samples.

TIPS "It's not about a photographer's experience, it's about a photographer's talent and eye. Lots of photographers have years of professional experience but their work isn't for us. Others might not have years of experience but they have this amazing eye."

ROMANTIC HOMES

Y-Visionary Publishing, 2400 East Katella Ave., Suite 300, Orange CA 92868. **E-mail:** jdemontravel@beckett.com. **Website:** www.romantichomesmag.com. **Contact:** Jacqueline DeMontravel, editor. Estab. 1994. Circ. 200,000. Monthly. For women who want to create a warm, intimate and casually elegant home. Provides how-to advice, along with information on furniture home decorating ideas, floor and window coverings, artwork, travel, etc. Sample copy available with SASE.

NEEDS Buys 20-30 photos from freelancers/issue; 240-360 photos/year. Needs photos of gardening, interiors/decorating, travel. Reviews photos with accompanying manuscripts only. Model/property release required. Photo captions preferred.

SPECS Uses 2¼×2¼ transparencies.

MAKING CONTACT & TERMS Send query letter with transparencies, stock list. Provide self-promotion piece to be kept on file for possible future assignments. Responds in 3 weeks. Simultaneous submissions OK. Pays net 30 days for images and on publication for articles. Credit line/byline given. Buys all rights; negotiable.

THE ROTARIAN

Rotary International, One Rotary Center, 1560 Sherman Ave., Evanston IL 60201. (847)866-3000. **Fax:** (847)328-8554. **E-mail:** rotarian@rotary.org. **Website:** www.rotary.org. Estab. 1911. Circ. 510,000. Monthly organization magazine for Rotarian business and professional men and women and their families. "Dedicated to business and professional ethics, community life, and international understanding and goodwill." Sample copy and photo guidelines free with SASE.

NEEDS Assigns photography to freelancers and staff photographers. Subject varies from studio to location, from environmental portraiture to photojournalism, but there is always a Rotary connection.

SPECS Digital images only. Prefers RAW files, but will accept high-res JPEG.

MAKING CONTACT & TERMS Send query e-mail, fee schedule and link to online portfolio. Clearly identify your location in the subject of your e-mail. Creative director will contact photographer. No calls please. Keeps e-mail, promotion samples on file. Do not send unsolicited originals. Responds in 3 weeks. Payment negotiable. **Pays on acceptance.** Credit line given. Buys one-time rights; occasionally all rights; negotiable.

TIPS "We prefer high-res digital images in most cases. The key words for the freelance photographer to keep in mind are *internationality* and *variety*. Study the magazine. Read the kinds of articles we publish. Think how your photographs could illustrate such articles in a dramatic, storytelling way."

RUNNING TIMES

Rodale, Inc., 400 S. 10th St., Emmaus PA 18098-0099. (610)967-5171. **Fax:** (610)967-8964. **E-mail:** editor@runningtimes.com. **Website:** www.runningtimes.com. **Contact:** Jonathan Beverly, editor-in-chief. Estab. 1977. Circ. 102,000. Published 10 times/year. Covers distance running and racing. "*Running Times* is the national magazine for the experienced running participant and fan. Our audience is knowledgeable about the sport and active in running and racing. All editorial relates specifically to running: improving performance, enhancing enjoyment, or exploring events, places, and people in the sport."

MAKING CONTACT & TERMS Identification of subjects required. Negotiates payment individually. Buys one time rights.

RURAL HERITAGE

P.O. Box 2067, Cedar Rapids IA 52406. (319)362-3027. **E-mail:** info@ruralheritage.com. **Website:** www.ruralheritage.com. **Contact:** Joe Mischka, editor. Estab. 1976. Circ. 9,500. Bimonthly journal in support of modern-day farming and logging with draft animals (horses, mules, oxen). Sample copy available for $8 ($10 outside the U.S.). Photo guidelines available online or via e-mail.

NEEDS "Quality photographs of draft animals working in harness."

SPECS "For interior pages we use glossy color prints, high-quality slides, or high-res images (300 dpi or greater) shot with a quality digital camera. For covers we use 5×7 glossy color prints, large-format transparencies, or high-res images shot with a quality digital camera. Digital images must be original (not resized, cropped, etc.) files from a digital camera; scans unacceptable."

MAKING CONTACT & TERMS Send query letter with samples. "Please include SASE for the return of your material, and put your name and address on the back of each piece." Pays $100 for color cover; $10-25 for b&w inside. Also provides 2 copies of issue in which work appears. Pays on publication.

TIPS "Animals usually look better from the side than from the front. We like to see all the animal's body parts, including hooves, ears and tail. For animals in harness, we want to see the entire implement or vehicle. We prefer action shots (plowing, harvesting hay, etc.). Watch out for shadows across animals and people. Please include the name of any human handlers involved, the farm, the town (or county), state, and the animals' names (if possible) and breeds. You'll find current guidelines in the 'Business Office' of our website."

RUSSIAN LIFE

RIS Publications, P.O. Box 567, Montpelier VT 05601. **Website:** www.russianlife.com. Estab. 1956. Circ. 15,000. Bimonthly. Uses 25-35 photos/issue. Offers 10-15 freelance assignments/year.

NEEDS Photojournalism related to Russian culture, art and history.

SPECS Send 35mm, 2¼×2¼, 4×5, 8×10 transparencies; digital format.

MAKING CONTACT & TERMS Send query letter. After inquiry and response, be prepared to send digital thumbnails or links to same online. We no longer accept submissions by mail. Responds in 1 month. Pays $20-50 (color photo with accompanying story), depending on placement in magazine. Pays on publication. Credit line given. Buys one-time and nonexclusive electronic rights.

TIPS "Our readers are informed Russophiles with an avid interest in all things Russian. But we do not publish personal travel journals or the like."

SAIL

98 N. Washington St., Suite 107, Boston MA 02114. (617)720-8600. **Fax:** (617)723-0912. **E-mail:** sailmail@sailmagazine.com. **Website:** www.sailmagazine.com. **Contact:** Peter Nielsen, editor-in-chief. Estab. 1970. Circ. 180,000. Monthly. Emphasizes all aspects of sailing. Readers are managers and professionals, average age 44. Photo guidelines free with SASE and on website.

NEEDS Buys 50-100 images/issue. Particularly interested in photos for cover and 'pure sail' sections. Ideally, these photos would be digital files @300 dpi with a run size of approximately 9×12 for cover, 9×16 for 'pure sail.' Also accepts 35mm transparencies. Vertical cover shots also needed. Photo captions required.

SPECS Accepts images in digital format. Send high-res JPEG, TIFF and RAW files via CD, DVD or FTP (contact for FTP log-in info). Also accepts all forms of transparencies and prints with negatives.

MAKING CONTACT & TERMS Send unsolicited 35mm and 2¼×2¼ transparencies by mail with SASE for consideration. Pays $1,000 for color cover; $50-800 for color inside; also negotiates prices on a per day, per hour and per job basis. Pays on publication. Credit line given. Buys one-time North American rights. Photo shoots commissioned using half- or full-day rates.

💲💲 🅾 SAILING MAGAZINE

P.O. Box 249, Port Washington WI 53074. (262)284-3494. **Fax:** (262)284-7764. **E-mail:** editorial@sailingmagazine.net. **Website:** www.sailingmagazine.net. **Contact:** Greta Schanen, managing editor. Circ. 50,000. Monthly. Emphasizes sailing. Readers are experienced sailors who race cruise and daysail on all types of boats: dinghies, large and small mono and multihulls. Sample copy available with 11×15 SASE and 9 first-class stamps. Photo guidelines free with SASE.

NEEDS "We are a large-format journal, with a strong emphasis on top-notch photography backed by creative insightful writing. Need photos of sailing, both long shots and on-deck. We encourage creativity; send me a sailing photograph I have not seen before." Photo captions required; include boat and people IDs, location, conditions, etc.

SPECS Uses 35mm and larger transparencies. Accepts images in digital format. Send via CD as TIFF, JPEG files at 300 dpi. Include printed thumbnails with CD. If photos are also being submitted by e-mail, they should be sent as low-res attachments, and under no circumstances be embedded in a Word document. Only submit photos via e-mail or ftp upon request.

MAKING CONTACT & TERMS Send query letter with samples; include SASE for return of material. Portfolios may be dropped off by appointment. Send submissions by mail; e-mail samples or portfolios will not be considered. Responds in 3 months. "Tell us of simultaneous submissions; previously published work OK if not with other sailing publications who compete with us." Pays $50-500. Pays 30 days after publication.

SAILING WORLD

Bonnier Corporation, 55 Hammarlund Way, Middletown RI 02842. (401)845-5100. **Fax:** (401)848-5180. **E-mail:** editor@sailingworld.com. **Website:** www.sailingworld.com. **Contact:** Dave Reed, editor. Estab. 1962. Circ. 65,000. Monthly. Emphasizes performance sailing and racing for upper-income sailors. Readers are males ages 35-45, females ages 25-35 who are interested in sailing. Sample copy available for $7. Photo guidelines available online.

NEEDS Freelance photography in a given issue: 20% assignment and 80% freelance stock. Covers most sailing races. Needs photos of adventure, health/fitness, humor, sports. "We will send an updated e-mail listing our photo needs on request."

SPECS Uses 35mm for covers; vertical and square (slightly horizontal) formats; digital 300-dpi 5×7 JPEGs.

MAKING CONTACT & TERMS Responds in 1 month. Pays $650 for cover; $75-400 for inside. Pays

on publication. Credit line given. Buys first North American serial rights.

TIPS "We look for photos that are unusual in composition, lighting and/or color that feature performance sailing at its most exciting. We would like to emphasize speed, skill, fun and action. Photos must be of high quality. We prefer Fuji Velvia film. We have a format that allows us to feature work of exceptional quality. A knowledge of sailing and experience with on-the-water photography is a requirement. Please call with specific questions or interests. We cover current events and generally only use photos taken in the past 30-60 days."

○ SALT HILL LITERARY JOURNAL

E-mail: salthillart@gmail.com. **Website:** www.salthilljournal.net. **Contact:** Art editor. Circ. 1,000. *Salt Hill* seeks unpublished 2D art-drawings, paintings, photography, mixed media, documentation of 3D art, typographic art diagrams, maps, etc., for its semiannual publication. We offer all colors, shapes, and stripes.

NEEDS Seeking graphic novels, literary and experimental art. Sample copy available for $6. Responds in 3 months.

MAKING CONTACT & TERMS See website for specifications.

SALT WATER SPORTSMAN

Bonnier Corporation, 460 N. Orlando Ave., Suite 200, Winter Park FL 32789. (407)628-4802. **E-mail:** editor@saltwatersportsman.com. **Website:** www.saltwatersportsman.com. **Contact:** John Brownlee, editor-in-chief. Circ. 170,000. Monthly. Emphasizes all phases of saltwater sport fishing for the avid beginner-to-professional saltwater angler. "No. 1 monthly marine sport fishing magazine in the U.S." Sample copy free with 9×12 SASE and 7 first-class stamps. Photo guidelines free.

NEEDS Buys photos (including covers) without manuscript; 20-30 photos/issue with manuscript. Needs saltwater fishing photos. "Think fishing action, scenery, mood, storytelling close-ups of anglers in action. Make it come alive—and don't bother us with the obviously posed 'dead fish and stupid fisherman' back at the dock." Wants, on a regular basis, cover shots (clean verticals depicting saltwater fishing action). For accompanying manuscript, needs fact/feature articles dealing with marine sport fishing in the U.S., Canada, Caribbean, Central and South America. Emphasis on how-to.

SPECS Uses 35mm or 2¼×2¼ transparencies; vertical format preferred for covers. Accepts images in digital format. Send via CD, ZIP; format as 8-bit, unconverted, 300 dpi, RGB TIFF. A confirming laser or proof of each image must accompany the media. A printed disk directory with each new name written next to each original name must be provided.

MAKING CONTACT & TERMS Send material by mail for consideration, or query with samples. Provide résumé or tearsheets to be kept on file for possible future assignments. Holds slides for 1 year and will pay as used; include SASE for return of material. Responds in 1 month. Pays $2,500 maximum for cover; $100-500 for color inside; $500 minimum for text-photo package. **Pays on acceptance.**

TIPS "Prefer to see a selection of fishing action and mood; must be sport fishing-oriented. Read the magazine! No horizontal cover slides with suggestions it can be cropped, etc. Don't send Ektachrome. We're using more 'outside' photography—that is, photos not submitted with manuscript package. Take lots of verticals and experiment with lighting."

⑤ ❶ SANDLAPPER MAGAZINE

Sandlapper Society, Inc., 3007 Millwood Ave., Columbia SC 29205. (803)779-8763. **Fax:** (803)254-4833. **E-mail:** elaine@sandlapper.org. **Website:** www.sandlapper.org. **Contact:** Elaine Gillespie executive director. Estab. 1969. Circ. 8,000. Quarterly. Emphasizes South Carolina topics only.

NEEDS Uses about 10 photographers/issue. Photos of anything related to South Carolina in any style, "as long as they're not in bad taste." Model release preferred. Photo captions required; include places and people.

SPECS Uses 8×10 color and b&w prints; 35mm, 2¼×2¼, 4×5, 8×10 transparencies. Accepts images in digital format. Send via CD, ZIP as TIFF, JPEG files at 300 dpi. "Do not format exclusively for PC. RGB preferred. Submit low- and high-res files, and label them as such."

MAKING CONTACT & TERMS Send query letter with samples. Keeps samples on file; include SASE for return of material. Responds in 1 month. Pays 1 month *after* publication. Credit line given. Buys first rights plus right to reprint.

TIPS "We see plenty of beach sunsets, mountain waterfalls, and shore birds. Would like fresh images of people working and playing in the Palmetto state."

SANTA BARBARA MAGAZINE

2064 Almeda Padre Serra, Suite 120, Santa Barbara CA 93103. (805)965-5999. **Fax:** (805)965-7627. **E-mail:** alisa@sbmag.com. **Website:** www.sbmag.com. **Contact:** Alisa Baur, art director; Gina Tolleson, editor. Estab. 1975. Circ. 40,000. Bimonthly. Emphasizes Santa Barbara community and culture. Sample copy available for $4.95 with 9×12 SASE.

NEEDS Buys 64-80 photos from freelancers/issue; 384-480 photos/year. Needs portrait, environmental, architectural, travel, celebrity, etc. Reviews photos with accompanying manuscript only. Model release required. Photo captions preferred.

MAKING CONTACT & TERMS Provide résumé, business card, brochure, flyer or tearsheets to be kept on file for possible future assignments; "portfolio drop-off 24 hours." Cannot return unsolicited material. Pays $75-250 for b&w or color. Pays on publication. Credit line given. Buys first North American serial rights.

ⓢ SCHOLASTIC MAGAZINES

557 Broadway, New York NY 10012. (212)343-7147. **Fax:** (212)389-3913. **E-mail:** sdiamond@scholastic.com. **Website:** www.scholastic.com. **Contact:** Steven Diamond, executive director of photography. Estab. 1920. Publication of magazines varies from weekly to monthly. "We publish 27 titles on topics from current events, science math, fine art, literature and social studies. Interested in featuring high-quality, well-composed images of students of all ages and all ethnic backgrounds. We publish hundreds of books on all topics, educational programs, Internet products and new media."

NEEDS Photos of various subjects depending upon educational topics planned for academic year. Model release required. Photo captions required. "Images must be interesting, bright and lively!"

SPECS Accepts images in digital format. Send via CD, e-mail.

MAKING CONTACT & TERMS Send query letter with résumé, business card, brochure, flyer or tearsheets to be kept on file for possible future assignments. Material cannot be returned. Previously published work OK. Pays on publication.

TIPS Especially interested in good photography of all ages of student population. All images must have model/property releases.

THE SCHOOL ADMINISTRATOR

1615 Duke St., Alexandria VA 22314. (703)875-0753. **Fax:** (703)841-1543. **E-mail:** lgriffin@aasa.org; info@aasa.org. **Website:** www.aasa.org. **Contact:** Liz Griffin, managing editor. Circ. 20,000. Monthly magazine of the American Association of School Administrators. Emphasizes K-12 education. Readers are school district administrators including superintendents, ages 50-60. Sample copy available for $10.

NEEDS Uses 8-10 photos/issue. Needs classroom photos (K-12), photos of school principals, superintendents and school board members interacting with parents and students. Model/property release preferred for physically handicapped students. Photo captions required; include name of school, city, state, grade level of students, and general description of classroom activity.

SPECS Accepts images in digital format: TIFF, JPEG files at 300 dpi. Send via link to FTP site.

MAKING CONTACT & TERMS "Send a link to your FTP site with photos of children in public school settings, grades K-12. Do not send originals or e-mails of your work or website. Check our website for our editorial calendar. Familiarize yourself with topical nature and format of magazine before submitting work." Work assigned is 3-4 months prior to publication date. Keeps samples on file; include SASE for return of material. Simultaneous submissions and previously published work OK. Credit line given. Buys one-time rights.

TIPS "Prefer photos with interesting, animated faces and hand gestures. Always looking for the unusual human connection where the photographer's presence has not made subjects stilted."

SCIENTIFIC AMERICAN

75 Varick St., 9th Floor, New York NY 10013-1917. (212)451-8200. **E-mail:** editors@sciam.com. **Website:** www.sciam.com. **Contact:** Mariette DiChristina, editor-in-chief. Estab. 1845. Circ. 710,000. Emphasizes science policy, technology and people involved in science. Seeking to broaden our 20-40 year-old readership.

NEEDS Buys 100 photos from freelancers/issue. Needs all kinds of photos. Model release required; property release preferred. Photo captions required.

MAKING CONTACT & TERMS Arrange a personal interview to show portfolio. "Do not send unsolicited photos." Provide résumé, business card, brochure, flyer or tearsheets to be kept on file for possible future assignments and note photo website. Cannot return material. Responds in 1 month. Pays $600/day; $1,000 for color cover. Pays on publication. Credit line given. Buys one-time rights and world rights. Frequently leads to re-use buying and develops relationships with scientists and writers needing photo work.

TIPS Wants to see strong natural and artificial lighting, location portraits and location shooting. Intelligent artistic photography and photo-illustration welcomed. Send business cards and promotional pieces frequently when dealing with magazine editors. Find a niche.

SCRAP

1615 L St., NW, Suite 600, Washington DC 20036-5664. (202)662-8547. **Fax:** (202)626-0947. **E-mail:** kentkiser@scrap.org. **Website:** www.scrap.org. **Contact:** Kent Kiser, publisher. Estab. 1987. Circ. 8,451. Bimonthly magazine of the Institute of Scrap Recycling Industries. Emphasizes scrap recycling for owners and managers of recycling operations worldwide. Sample copy available for $8.

NEEDS Buys 0-15 photos from freelancers/issue; 15-70 photos/year. Needs operation shots of companies being profiled and studio concept shots. Model release required. Photo captions required.

SPECS Accepts images in digital format. Send via CD, ZIP, e-mail as JPEG or TIFF file at 300 dpi.

MAKING CONTACT & TERMS Provide résumé, business card, brochure, flyer or tearsheets to be kept on file for possible future assignments. Previously published work OK. Pays $800-1,500/day; $100-400 for b&w inside; $200-600 for color inside. Pays on delivery of images. Credit line given. Rights negotiable.

TIPS Photographers must possess "ability to photograph people in corporate atmosphere, as well as industrial operations; ability to work well with executives, as well as laborers. We are always looking for good color photographers to accompany our staff writers on visits to companies being profiled. We try to keep travel costs to a minimum by hiring photographers located in the general vicinity of the profiled company. Other photography (primarily studio work) is usually assigned through freelance art director."

⑤ ○ SEA

Duncan McIntosh Co., 17782 Cowan, Suite C, Irvine CA 92614. (949)660-6150. **Fax:** (949)660-6172. **E-mail:** editorial@seamag.com; mikew@seamag.com. **Website:** seamag.com. **Contact:** Mike Werling, managing editor. Circ. 50,000. Monthly. Emphasizes "recreational boating in 13 Western states (including some coverage of Mexico and British Columbia) for owners of recreational power boats." Sample copy and photo guidelines free with 10×13 SASE.

NEEDS Uses about 50-75 photos/issue; most supplied by freelancers; 10% assignment; 75% requested from freelancers, existing photo files, or submitted unsolicited. Needs "people enjoying boating activity (families, parents, senior citizens) and scenic shots (travel, regional); shots that include parts or all of a boat are preferred." Photos should have West Coast angle. Model release required. Photo captions required.

SPECS Accepts images in digital format. Send via CD, FTP, e-mail as TIFF, EPS, JPEG files at least 300 dpi. Contact via online form to query.

MAKING CONTACT & TERMS Send query letter with samples; include SASE for return of material. Responds in 1 month. Pay rate varies according to size published. Pays on publication. Credit line given. Buys one-time North American rights and retains reprint rights via print and electronic media.

TIPS "We are looking for sharp images with good composition showing pleasure boats in action, and people having fun aboard boats in a West Coast location. Digital shots are preferred; they must be at least 5" wide and a minimum of 300 dpi. We also use studio shots of marine products and do personality profiles. Send samples of work with a query letter and a résumé or clips of previously published photos. *Sea* does not pay for shipping; will hold photos up to 6 weeks."

⊕ SEVENTEEN MAGAZINE

300 W. 57th St., 17th Floor, New York NY 10019. (917)934-6500. **Fax:** (917)934-6574. **E-mail:** mail@seventeen.com. **Website:** www.seventeen.com. Estab. 1944. Circ. 2,000,000. *Seventeen* is a young women's fashion and beauty magazine. Tailored to young women in their teens and early 20s, *Seventeen* covers fashion, beauty, health, fitness, food, cars, college, careers, talent, entertainment, plus crucial personal and global issues. Photos purchased on assignment only. Query before submitting.

SHINE BRIGHTLY

GEMS Girls' Clubs, P.O. Box 7259, Grand Rapids MI 49510. (616)241-5616. **Fax:** (616)241-5558. **E-mail:** shinebrightly@gemsgc.org. **Website:** www.gemsgc. org. **Contact:** Jan Boone, executive director; Kelli Gilmore, managing editor. Estab. 1970. Circ. 17,000. Monthly publication of GEMS Girls' Club. Emphasizes girls ages 9-14 in action. The magazine is a Christian girls' publication that inspires, motivates, and equips girls to become world changers. Sample copy and photo guidelines available for $1 with 9×12 SASE. **NEEDS** Uses about 5-6 photos/issue. Photos suitable for illustrating stories and articles: photos of babies/children/teens, multicultural, religious, girls aged 9-14 from multicultural backgrounds, close-up shots with eye contact." Model/property release preferred. **SPECS** Uses 5×7 glossy color prints. Accepts images in digital format. Send via ZIP, CD as TIFF, BMP files at 300 dpi.

MAKING CONTACT & TERMS Send 5×7 glossy color prints by mail (include SASE), electronic images by CD only (no e-mail) for consideration. Will view photographer's website if available. Responds in 2 months. Simultaneous submissions OK. Pays $50-75 for cover; $35 for color inside. Pays on publication. Credit line given. Buys one-time rights.

TIPS "Make the photos simple. We prefer to get a spec sheet or CDs rather than photos, and we'd really like to hold photos for our annual theme update and try to get photos to fit the theme of each issue." Recommends that photographers "be concerned about current trends in fashions, hair styles, and realize that all girls don't belong to 'families.' Please, no slides, no negatives and no e-mail submissions."

SHOOTING SPORTS USA

11250 Waples Mill Rd., Fairfax VA 22030. (703)267-1310. **E-mail:** shootingsportsusa@nrahq.org; publications@nrahq.org; clohman@nrahq.org. **Website:** www.nrapublications.org. **Contact:** Chip Lohman, editor. Monthly publication of the National Rifle Association of America. Emphasizes competitive shooting sports (rifle, pistol and shotgun). Readers range from beginner to high master. Past issues available online. Editorial guidelines free via e-mail.

NEEDS 15-25 photos from freelancers/issue; 180-300 photos/year. Needs photos of how-to, shooting positions, specific shooters. Quality photos preferred with accompanying manuscript. Model release required. Photo captions preferred.

SPECS Accepts images in digital format. Send via CD or e-mail as TIFF files at 300 dpi.

MAKING CONTACT & TERMS Send query letter with photo and editorial ideas by e-mail. Include SASE. Responds in 1 week. Previously published work OK when cleared with editor. Pays $150-400 for color cover; $50-150 for color inside; $250-500 for photo/text package; amount varies for photos alone. Pays on publication. Credit line given. Buys first North American serial rights.

TIPS Looks for "generic photos of shooters shooting, obeying all safety rules and using proper eye protection and hearing protection. If text concerns certain how-to advice, photos are needed to illuminate this. Always query first. We are in search of quality photos to interest both beginning and experienced shooters."

SHOTGUN SPORTS MAGAZINE

P.O. Box 6810, Auburn CA 95604. (530)889-2220. **Fax:** (530)889-9106. **E-mail:** shotgun@shotgunsportsmagazine.com. **Website:** www.shotgunsportsmagazine. com. **Contact:** Johnny Cantu, editor-in-chief.

SPECS On disc or e-mailed at least 5" and 300 dpi (contact graphics artist for details).

SHOTS

P.O. Box 27755, Minneapolis MN 55427-0755. **E-mail:** shots@shotsmag.com. **Website:** www.shotsmag.com. **Contact:** Russell Joslin, editor/publisher. Circ. 2,000. Quarterly fine art photography magazine. "We publish b&w fine art photography by photographers with an innate passion for personal, creative work." Sample copy available for $6.50. Photo guidelines free with SASE or on website.

NEEDS Fine art photography of all types accepted for consideration (but not bought). Reviews photos with or without a manuscript. Model/property release preferred. Photo captions preferred.

SPECS Uses 8×10 b&w prints. Accepts images in digital format. Send via CD as TIFF files at 300 dpi. "See website for further specifications."

MAKING CONTACT & TERMS Send query letter with prints. There is a $16 submission fee for nonsubscribers (free for subscribers). Include SASE for return of material. Responds in 3 months. Credit line given. Does not buy photographs/rights.

◉ SHOWBOATS INTERNATIONAL

Boat International Media, 41-47 Hartfield Rd., London SW19 3RQ United Kingdom. (954)522-2628 (U.S. number). **Fax:** (954)522-2240. **E-mail:** marilyn. mower@boatinternationalmedia.com. **Website:** www. boatinternational.com. **Contact:** Marilyn Mower, editorial director - U.S.; Richard Taranto, art director. Estab. 1995. Circ. 55,000. "Luxury yachting publication aimed at the world's discerning yachting audience. We provide the most exclusive coverage of superyachts over 100 feet worldwide."

SIERRA

85 Second St., 2nd Floor, San Francisco CA 94105. (415)977-5656. **Fax:** (415)977-5799. **E-mail:** sierra. magazine@sierraclub.org. **Website:** www.sierraclub. org. **Contact:** Martha Geering, art director. Estab. 1893. Circ. 695,000. Bimonthly. Emphasizes conservation and environmental politics for people who are well educated, activist, outdoor-oriented, and politically well informed with a dedication to conservation.

◎ ⊗⊗ SKI CANADA

117 Indian Rd., Toronto ON M6R 2V5, Canada. (416)538-2293. **Fax:** 416-538-2475. **E-mail:** mac@ skicanadamag.com; design@skicanadamag.com. **Website:** www.skicanadamag.com. **Contact:** Iain MacMillan, editor. Circ. 50,000. Published monthly, September-February. Readership is 65% male, ages 25-44, with high income. Sample copy free with SASE. **NEEDS** Buys 80 photos from freelancers/issue; 480 photos/year. Needs photos of skiing—travel (within Canada and abroad), new school, competition, equipment, instruction, news and trends. Photo captions preferred.
SPECS Uses 35mm color transparencies. Accepts images in digital format. Send via e-mail.
MAKING CONTACT & TERMS Send unsolicited photos by mail for consideration; include SASE for return of material. "The publisher assumes no responsibility for the return of unsolicited material." Provide résumé, business card, brochure, flyer or tearsheets to be kept on file for possible future assignments. Responds in 1 month. Simultaneous submissions OK. Pays within 30 days of publication. Credit line given.

SKIING MAGAZINE

Bonnier Corp., 5720 Flatiron Pkwy., Boulder CO 80301. (303)253-6300. **Fax:** (303)448-7638. **E-mail:** editor@skiingmag.com. **Website:** www.skinet.com/

skiing. Estab. 1936. Circ. 430,000. *Skiing Magazine* is an online ski-lifestyle publication written and edited for recreational skiers. Its content is intended to help them ski better (technique), buy better (equipment and skiwear), and introduce them to new experiences, people and adventures.

◎ ⊙ SKIPPING STONES: A MULTICULTURAL LITERARY MAGAZINE

P.O. Box 3939, Eugene OR 97403-0939. (541)342-4956. **E-mail:** editor@skippingstones.org. **Website:** www. skippingstones.org. **Contact:** Arun Toké, editor. Estab. 1988. Circ. 2,000 print, plus Web. "We promote multicultural awareness, international understanding, nature appreciation, and social responsibility. We suggest authors not make stereotypical generalizations in their articles. We like when authors include their own experiences, or base their articles on their personal immersion experiences in a culture or country." Has featured Xuan Thu Pham, Soma Han, Jon Bush, Zarouhie Abdalian, Elizabeth Zunon and Najah Clemmons.
NEEDS Buys /teens/children, celebrities, multicultural, families, disasters, environmental, landscapes, wildlife, cities, education, gardening, rural, events, health/fitness/beauty, travel, documentary and seasonal. Reviews 4×6 prints, low-res JPEG files. Captions required.
MAKING CONTACT & TERMS Send query letter or e-mail with photographs (digital JPEGs at 72 dpi).
TIPS "We are a multicultural magazine for youth and teens. We consider your work as a labor of love that contributes to the education of youth. We publish photoessays on various cultures and countries/ regions of the world in each issue of the magazine to promote international and intercultural (and nature) understanding. Tell us a little bit about yourself, your motivation, goals, and mission."

SKYDIVING

1665 Lexington Ave., Suite 102, DeLand FL 32724. (386)736-9779. **Fax:** (386)736-9786. **E-mail:** sue@ skydivingmagazine.com; mike@skydivingmagazine. com. **Website:** www.skydivingmagazine.com. **Contact:** Sue Clifton, editor; Mike Truffer, publisher. Estab. 1979. Circ. 14,200. "*Skydiving* is a news magazine. Its purpose is to deliver timely, useful and interesting information about the equipment, techniques, events, people and places of parachuting. Our scope is national. *Skydiving*'s audience spans the entire spectrum

of jumpers, from first-jump students to veterans with thousands of skydives. Some readers are riggers with a keen interest in the technical aspects of parachutes, while others are weekend 'fun' jumpers who want information to help them make travel plans and equipment purchases. Readers are sport parachutists worldwide dealers and equipment manufacturers." Sample copy available for $3. Photo guidelines free with SASE or online.

NEEDS Buys 5 photos from freelancers/issue; 60 photos/year. Selects photos from wire service, photographers who are skydivers and freelancers. Interested in anything related to skydiving—news or any dramatic illustration of an aspect of parachuting. Model release preferred. Photo captions preferred; include who, what, why, when, how.

SPECS Digital files are preferred. Send via CD, DVD, FTP, e-mail as JPEG, TIFF files at 300 dpi (minimum). Also accepts prints and transparencies.

MAKING CONTACT & TERMS Send digital files after reviewing guidelines, or send 5×7 or larger b&w or color prints or 35mm or 2¼×2¼ transparencies by mail for consideration. Keeps samples on file; include SASE for return of material. Responds in 1 month. Pays $50 for color cover; $5-25 for b&w inside; $25-50 for color inside. Pays on publication. Credit line given. Buys all rights.

SMITHSONIAN MAGAZINE

Capital Gallery, Suite 6001, MRC 513, P.O. Box 37012, Washington DC 20013. (202)275-2000. **E-mail:** smithsonianmagazine@si.edu. **Website:** www.smithsonianmag.com. **Contact:** Molly Roberts, photo editor; Jeff Campagna, art services coordinator. Circ. 2,300,000. Monthly. *Smithsonian* chronicles the arts, environment, sciences and popular culture of the times for today's well-rounded individuals with diverse, general interests, providing its readers with information and knowledge in an entertaining way. Visit website for photo submission guidelines. *Does not accept unsolicited photos or portfolios.* Use online submission form. Query before submitting.

SOLDIER OF FORTUNE

2135 11th St., Boulder CO 80302. (303)449-3750. **E-mail:** editorsof@aol.com. **Website:** www.sofmag.com. **Contact:** Lt. Col. Robert A. Brown, editor/publisher. Estab. 1975. Circ. 60,000. Monthly. Covers military, paramilitary, police, combat subjects, and action/adventure.

MAKING CONTACT & TERMS Reviews contact sheets, transparencies. Captions, identification of subjects required. Pays $500 for cover photo. Buys one-time rights.

SOUTHCOMM PUBLISHING COMPANY, INC.

541 Buttermilk Pike, Suite 100, Crescent Springs KY 41017. (678)624-1075; (800)933-3909. **Fax:** (678)623-9979; (800)488-3101. **E-mail:** cwwalker@southcomm.com. **Website:** southcommpublishing.com. **Contact:** Carolyn Williams-Walker. Estab. 1985. "We publish approximately 35 publications throughout the year. They are primarily for chambers of commerce throughout the Southeast (Georgia, Tennessee, South Carolina, North Carolina, Alabama, Virginia, Florida). We are expanding to the Northeast (Pennsylvania) and Texas. Our publications are used for tourism, economic development and marketing purposes. We also are a custom publishing company, offering brochures and other types of printed material."

NEEDS "We are only looking for photographers who can travel to the communities with which we're working as we need shots that are specific to those locations. We will not consider generic stock-type photos. Images are generally for editorial purposes; however, advertising shots sometimes are required." Model/property release preferred. Photo captions required. "Identify people, buildings and as many specifics as possible."

SPECS Prefers images in digital format. Send via CD, saved as TIFF, GIF or JPEG files for Mac at no less than 300 dpi. "We prefer digital photography for all our publications."

MAKING CONTACT & TERMS Send query letter with résumé and photocopies. Keeps samples on file; provide business card. Responds only if interested; send nonreturnable samples. Pays $40 minimum; $60 maximum for color inside. Pays a flat rate that ranges between $400 and $1,200 for projects. Each has its own specific budget, so rates fluctuate. We pay the same rates for cover images as for interior shots because at times, images identified for the cover cannot be used as such. They are then used in the interior instead." **Pays on acceptance.** Credit line given. "Photos that are shot on assignment become the property of SouthComm Publishing Company, Inc. They cannot be released to our clients or another third party. We will purchase one-time rights to use images from pho-

tographers should the need arise." Will negotiate with a photographer unwilling to sell all rights.

TIPS "We are looking for photographers who enjoy traveling and are highly organized and can communicate well with our clients as well as with us. Digital photographers *must* turn in contact sheets of all images shot in the community, clearly identifying the subjects."

SOUTHERN BOATING

Southern Boating & Yachting, Inc., 330 N. Andrews Ave., Ft. Lauderdale FL 33301. (954)522-5515. **Fax:** (954)522-2260. **E-mail:** liz@southernboating.com; jon@southernboating.com. **Website:** www.southernboating.com. **Contact:** Liz Pasch, executive editor; Jon Hernandez, art director. Estab. 1972. Circ. 40,000. Monthly. Emphasizes "powerboating, sailing, and cruising in the southeastern and Gulf Coast U.S., Bahamas, and the Caribbean." Readers are "concentrated in 30-60 age group, mostly male, affluent, very experienced boat owners." Sample copy available for $7.

NEEDS Number of photos/issue varies; many supplied by freelancers. Seeks "boating lifestyle" cover shots. Buys stock only. No "assigned covers." Model release required. Photo captions required.

SPECS Accepts images in digital format. Send via CD or e-mail as JPEG, TIFF files, minimum 4×6 at 300 dpi.

MAKING CONTACT & TERMS Send query letter with list of stock photo subjects, SASE. Response time varies. Simultaneous submissions and previously published work OK. Pays within 30 days of publication. Credit line given. Buys one-time print and electronic/website rights.

TIPS "We want lifestyle shots of saltwater cruising, fishing or just relaxing on the water. Lifestyle or family boating shots are actively sought."

SOUTHWEST AIRLINES SPIRIT

Spirit Magazine Editorial Office, Pace Communications, Inc., 2811 McKinney Ave., Suite 360, Dallas TX 75204. (214)580-8070. **Fax:** (214)580-2491. **Website:** www.spiritmag.com. **Contact:** Emily Kimbro, art director. Circ. 350,000. Monthly in-flight magazine. "Reader is college-educated business person, median age of 45, median household income of $82,000. Spirit targets the flying affluent. Adventurous perspective on contemporary themes." Sample copy available for $3. Photo guidelines available.

NEEDS Buys 5-10 photos from freelancers/issue; 120 photos/year. Needs photos of celebrities, couples, multicultural, environmental, landscapes/scenics, wildlife, architecture, cities/urban, adventure, automobiles, entertainment, events, food/drink, health/fitness, hobbies, humor, performing arts, sports, travel, business concepts, industry, medicine, political, product shots/still life, science, technology. Interested in alternative process, avant garde, documentary, fashion/glamour. Reviews photos with or without a manuscript. Model/property release required. Photo captions required; include names of people in shot, location, names of buildings in shot.

SPECS Uses 35mm, 2¼×2¼, 4×5 transparencies. Accepts images in digital format. Send via CD as TIFF, EPS files at 300 dpi.

MAKING CONTACT & TERMS "Queries are accepted by mail only; e-mail and phone calls are strongly discouraged." Send query letter with slides, prints, photocopies, tearsheets, transparencies, SASE. Portfolio may be dropped off Monday through Friday. Provide self-promotion piece to be kept on file for possible future assignments. Responds only if interested; send nonreturnable samples. Pays $1,000-1,500 for cover; $900-2,500 for inside. **Pays on acceptance.** Credit line given. Buys one-time rights.

TIPS "Read our magazine. We have high standards set for ourselves and expect our freelancers to have the same or higher standards."

SPECIALIVING

P.O. Box 1000, Bloomington IL 61702. (309)962-2003. **E-mail:** gareeb@aol.com. **Website:** www.specialiving.com. Estab. 2001. Circ. 12,000. Quarterly. For physically disabled people. Emphasizes travel, home modifications, products, info, inspiration. Sample copy available for $5.

NEEDS Any events/settings that involve physically disabled people (who use wheelchairs), not developmentally disabled. Reviews photos with or without a manuscript. Model release preferred. Photo captions required.

SPECS Uses glossy or matte color and b&w prints. Accepts images in digital format. Send via CD, ZIP, e-mail as TIFF, JPEG files at 300 dpi.

MAKING CONTACT & TERMS Send query letter with prints. Online e-mail form available on website.

Does not keep samples on file; include SASE for return of material. Responds in 3 weeks. Simultaneous submissions and previously published work OK. Pays $50 minimum for b&w cover; $100 maximum for color cover; $10 minimum for b&w or color inside. Pays on publication. Credit line given. Buys one-time rights. **TIPS** "Need good-quality photos of someone in a wheelchair involved in an activity. Need caption and where I can contact subject to get story if wanted."

⊕ SPILLWAY

P.O. Box 7887, Huntington Beach CA 92615. (714)968-0905. **E-mail:** mifanwy.kaiser@gmail.com; spill way2@tebotbach.org. **Website:** tebotbach.org/spillway.html. **Contact:** Mifanwy Kaiser, publisher; Susan Terris, editor. Estab. 1991. Published semi-annually in June and December, *Spillway* celebrates "writing's diversity and power to affect our lives." Open to all voices, schools, and tendencies.

○ *Spillway* is about 125 pages, digest-sized, attractively printed, perfect-bound, with 2-color or 4-color card cover. Press run is 2,000. "We recommend ordering a sample copy before you submit, though acceptance does not depend upon purchasing a sample copy." Single copy is $13.50, includes shipping and handling; 1 year subscription is $23, includes shipping and handling; 2 year subscription is $40, includes shipping and handling. To order, visit the website and use PayPal, or make checks payable to Tebot Bach with "Spillway" in the notation line.

NEEDS Reviews b&w photography, and color artwork and photography for the cover.

MAKING CONTACT & TERMS Contact by e-mail. Responds in up to 6 months. Acquires one-time rights.

SPORT FISHING

Bonnier Corporation, 460 N. Orlando Ave., Suite 200, Winter Park FL 32789. (407)628-4802. **Fax:** (407)628-7061. **E-mail:** Editor@sportfishingmag.com. **Website:** www.sportfishingmag.com. Estab. 1985. Circ. 250,000. "*Sport Fishing*'s readers are middle-aged, affluent, mostly male, who are generally proficient in and very educated to their sport. We are about fishing from boats, not from surf or jetties." Emphasizes saltwater sport fishing. Sample copy available for $2.50, 9×12 SASE and 6 first-class stamps. Photo guidelines available on website via e-mail or with SASE.

NEEDS Buys 50% or more photos from freelancers/issue. Needs photos of saltwater fish and fishing—es-pecially good action shots. "Are working more from stock—good opportunities for extra sales on any given assignment." Model release not generally required. **SPECS** Prefers images in RAW unaltered/undoctored digital format, especially for the option to run images very large, with accompanying low-res JPEGs for quick review. Original 35mm (or larger) transparencies are accepted for smaller images, but no longer for the cover or two-page spreads. All guidelines, rates, suggestions available online; click on "Editorial Guidelines" at bottom of home page.

MAKING CONTACT & TERMS Send query letter with samples. Send unsolicited photos by mail or low-res digitals by e-mail for consideration. Provide business card, brochure, flyer or tearsheets to be kept on file for possible future assignments. Responds in 3 weeks. Pays $1,000 for cover; $75–400 for inside. Buys one-time rights unless otherwise agreed upon.

TIPS "Sharp focus critical; avoid 'kill' shots of big game fish, sharks; avoid bloody fish in/at the boat. The best guideline is the magazine itself. Know your market. Get used to shooting on, in or under water using the RAW setting of your camera. Most of our needs are found in the magazine. If you have first-rate photos and questions, e-mail us."

SPORTS AFIELD

Field Sports Publishing, 15621 Chemical Ln., Suite B, Huntington Beach CA 92649. (714)373-4910. **E-mail:** letters@sportsafield.com. **Website:** www.sportsafield.com. **Contact:** Jerry Gutierrez, art director. Estab. 1887. Circ. 50,000.

NEEDS Hunting/wildlife themes only. Considers all media.

SPECS Reviews 35mm slides transparencies, TIFF/JPEG files.

MAKING CONTACT & TERMS Captions, model releases required. Buys first time rights.

SPORTS ILLUSTRATED

Time, Inc., 1271 Avenue of the Americas, New York NY 10020. (212)522-1212. **E-mail:** story_queries@simail.com. **Website:** www.si.com. Terry McDonell, editor. Estab. 1954. Circ. 3,339,000. *Sports Illustrated* reports and interprets the world of sports, recreation and active leisure. It previews, analyzes and comments on major games and events, as well as those noteworthy for character and spirit alone. In addition, the magazine has articles on such subjects as fash-

ion, physical fitness and conservation. Query before submitting.

⑤ ○ STICKMAN REVIEW

E-mail: art@stickmanreview.com. **Website:** www.stickmanreview.com. **Contact:** Anthony Brown, editor. Estab. 2001. Biannual literary magazine publishing fiction, poetry, essays and art for a literary audience. Sample copies available on website.
NEEDS Accepts 1-2 photos from freelancers/issue; 4 photos/year. Interested in alternative process, avant garde, documentary, erotic, fine art. Reviews photos with or without a manuscript.
SPECS Accepts images in digital format. Send via e-mail as JPEG, GIF, TIFF, PSD files at 72 dpi (500K maximum).
MAKING CONTACT & TERMS Contact through e-mail only. Does not keep samples on file; cannot return material. Do not query, just submit the work you would like considered. Responds 2 months to portfolios. Simultaneous submissions OK. Credit line given.
TIPS "Please check out the magazine on our website. We are open to anything, so long as its intent is artistic expression."

⊕ STIRRING: A LITERARY COLLECTION

c/o Erin Elizabeth Smith, Department of English, 301 McClung Tower, University of Tennessee, Knoxville TN 37996. **E-mail:** eesmith81@gmail.com. **Website:** www.sundresspublications.com/stirring. **Contact:** Erin Elizabeth Smith, managing and poetry editor. Estab. 1999.
MAKING CONTACT & TERMS For photography, send all submissions as JPEG attachments to Erin Elizabeth Smith. "We will look at either a website with an index of photos or up to 5 e-mailed photographs."

THE SUN

107 N. Roberson St., Chapel Hill NC 27516. (919)942-5282. **Fax:** (919)932-3101. **Website:** www.thesunmagazine.org. Sy Safransky, editor. **Contact:** Luc Sanders, assistant editor. Estab. 1974. Circ. 69,500. Monthly literary magazine featuring personal essays, interviews, poems, b&w photos and photo essays. Sample copy available for $5. Photo guidelines free with SASE or on website.
NEEDS Buys 10-30 photos/issue; 200-300 photos/year. Needs "slice of life" photographs of people and environments. Photographs that relate to political, spiritual, and social themes. Documentary-style images considered. "Most of our photos of people feature unrecognizable individuals, although we do run portraits in specific places, including the cover." Model/property release strongly preferred.
SPECS Uses 5×7 to 11×17 glossy or matte b&w prints. Slides are not accepted, and color photos are discouraged. "We cannot review images via e-mail or website. If you are submitting digital images, please send high-quality digital prints first. If we accept your images for publication, we will request the image files on CD or DVD media (Mac or PC) in uncompressed TIFF grayscale format at 300 dpi or greater."
MAKING CONTACT & TERMS Include SASE for return of material. Responds in 3 months. Simultaneous submissions and previously published work OK. "Submit no more than 30 of your best b&w prints. Please do not e-mail images." Pays $500 for b&w cover; $100-250 for b&w inside. Pays on publication. Credit line given. Buys one-time rights.

◎ ◐ SURFACE MAGAZINE

140 W. 26th St., Street Level W., New York NY 10001. (212)229-1500. **E-mail:** editorial@surfacemag.com. **Website:** www.surfacemag.com. Estab. 1994. Circ. 112,000. Published 6 times/year. "*Surface* is the definitive American source for engaging, curated content covering all that is inventive and compelling in the design world. Contains profiles of emerging designers and provocative projects that are reshaping the creative landscape."
NEEDS Buys 200 photos from freelancers/issue; 1,600 photos/year. Needs photos of environmental, landscapes/scenics, architecture, cities/urban, interiors/decorating, performing arts, travel, product shots/still life, technology. Interested in avant garde, fashion, portraits, fine art, seasonal.
SPECS Uses 11×17 glossy matte prints; 35mm, 2¼×2¼, 4×5, 8×10 transparencies. Accepts images in digital format. Send via CD, ZIP as TIFF, JPEG files at 300 dpi.
MAKING CONTACT & TERMS Contact through rep or send query letter with prints, photocopies, tearsheets. Provide self-promotion piece to be kept on file for possible future assignments. "Portfolios are reviewed on Friday each week. Submitted portfolios must be clearly labelled and include a shipping account number or postage for return. Please call for more details." Responds only if interested; send non-returnable samples. Simultaneous submissions OK. Credit line given.

⊗ ⊗ ● SURFING MAGAZINE

E-mail: tony.perez@sorc.com; peter@surfingmagazine.com. **Website:** www.surfingthemag.com. **Contact:** Tony Perez, publisher; Peter Taras, photo editor. Circ. 180,000. Monthly. "Emphasizes surfing action and related aspects of beach lifestyle. Travel to new surfing areas covered as well. Average age of readers is 17 with 95% being male. Nearly all drawn to publication due to high-quality, action-packed photographs." Sample copy available with legal-size SASE and 9 first-class stamps. Photo guidelines free with SASE or via e-mail.

NEEDS Buys an average of 10 photos from freelancers/issue. Needs "in-tight, front-lit surfing action photos, as well as travel-related scenics. Beach lifestyle photos always in demand."

SPECS Uses 35mm transparencies. Accepts digital images via CD; contact for digital requirements before submitting digital images.

MAKING CONTACT & TERMS Send samples by mail for consideration; include SASE for return of material. Responds in 1 month. Pays on publication. Credit line given. Buys one-time rights.

TIPS Prefers to see "well-exposed, sharp images showing both the ability to capture peak action, as well as beach scenes depicting the surfing lifestyle. Color, lighting, composition and proper film usage are important. Ask for our photo guidelines prior to making any film/camera/lens choices."

TECHNICAL ANALYSIS OF STOCKS & COMMODITIES

4757 California Ave., SW, Seattle WA 98116. (206)938-0570. **E-mail:** editor@traders.com. **Website:** www.traders.com. **Contact:** Jayanthi Gopalakrishnan, editor; Christine Morrison, art director; Elizabeth M.S. Flynn, managing editor. Estab. 1982. Circ. 60,000. "Magazine covers methods of investing and trading stocks, bonds and commodities (futures), options, mutual funds, and precious metals using technical analysis."

MAKING CONTACT & TERMS Captions, identification of subjects, model releases required. Pays $60-350 for b&w or color negatives with prints or positive slides. Buys one-time and reprint rights.

TEXAS GARDENER

Suntex Communications, Inc., P.O. Box 9005, Waco TX 76714. (254)848-9393. **Fax:** (254)848-9779. **E-mail:** info@texasgardener.com. **Website:** www.texasgardener.com. Estab. 1981. Circ. 20,000. Bimonthly. Emphasizes gardening. Readers are "51% male, 49% female, home gardeners, 98% Texas residents." Sample copy available for $4.

NEEDS Buys 18-27 photos from freelancers/issue; 108-162 photos/year. Needs color photos of gardening activities in Texas. Special needs include cover photos shot in vertical format. Must be taken in Texas. Photo captions required.

SPECS Prefers high-res digital images. Send via e-mail as JPEG files at 300 dpi.

MAKING CONTACT & TERMS Send query letter with samples, SASE. Responds in 3 weeks. Pays $100-200 for color cover; $25-100 for color inside. Pays on publication. Credit line given. Buys one-time rights.

TIPS "Provide complete information on photos. For example, if you submit a photo of watermelons growing in a garden, we need to know what variety they are and when and where the picture was taken."

TEXAS HIGHWAYS

P.O. Box 141009, Austin TX 78714-1009. (800)839-4997. **Website:** www.texashighways.com. Estab. 1974. Circ. 250,000. Monthly. "Texas Highways interprets scenic, recreational, historical, cultural and ethnic treasures of the state and preserves the best of Texas heritage. Its purpose is to educate and entertain, to encourage recreational travel to and within the state, and to tell the Texas story to readers around the world." Readers are ages 45 and over (majority), $24,000 to $60,000/year salary bracket with a college education. Photo guidelines and online submission form available on website.

NEEDS Buys 30-60 photos from freelancers/issue; 360-420 photos/year. Needs "travel and scenic photos in Texas only." Special needs include "fall, winter, spring and summer scenic shots and wildflower shots (Texas only)." Photo captions required; include location, names, addresses and other useful information.

SPECS "We take only color originals, 35mm or larger transparencies. No negatives or prints." Accepts images in digital format. Prefers camera RAW files with tweaks and captions in sidecar files. Consult guidelines before submitting.

MAKING CONTACT & TERMS Send query letter with samples, SASE. Provide business card and tearsheets to be kept on file for possible future assignments. Responds in 1 month. Simultaneous submissions OK. Pays $400 for color cover; $60-170 for color

inside. Pays $15 extra for electronic usage. Pays on publication. Credit line given. Buys one-time rights. Online feedback form is used for correspondence with all magazine staff.

TIPS "Look at our magazine and format. We accept only high-quality, professional-level work—no snapshots. Interested in a photographer's ability to edit own material and the breadth of a photographer's work. Look at 3-4 months of the magazine. Query not just for photos but with ideas for new/unusual topics."

TEXAS MONTHLY

Emmis Publishing LP, P.O. Box 1569, Austin TX 78767. (512)320-6900. **Fax:** (512)476-9007. **E-mail:** lbaldwin@texasmonthly.com. **Website:** www.texas monthly.com. **Contact:** Jake Silverstein, editor; Leslie Baldwin, photo editor; Andi Beierman, deputy art director. Estab. 1973. Circ. 300,000. *Texas Monthly* is edited for the urban Texas audience and covers the state's politics, sports, business, culture and changing lifestyles. It contains lengthy feature articles, reviews and interviews, and presents critical analysis of popular books, movies and plays.

NEEDS Uses about 50 photos/issue. Photos of celebrities, sports, travel.

MAKING CONTACT & TERMS "Please feel free to submit your photography or illustration portfolio to us. The best way to do this is by e-mailing us a link to your work. If you do not have a website, simply attaching a few images of your work in an e-mail is fine. Send samples or tearsheets. No preference on printed material—b&w or color. Responds only if interested. Keeps samples on file."

TIPS "Visit www.texasmonthly.com/artguide for information on sending portfolios."

⊕ THEMA

Thema Literary Society, P.O. Box 8747, Metairie LA 70011-8747. **E-mail:** thema@cox.net. **Website:** the maliterarysociety.com. **Contact:** Gail Howard, poetry editor. Estab. 1988. Literary magazine published 3 times/year emphasizing theme-related short stories, poetry, creative nonfiction, photography, and art. Sample copy available for $10.

NEEDS Photo must relate to one of *THEMA*'s upcoming themes (indicate the target theme on submission of photo). Upcoming themes (submission deadlines in parenthesis); The Printer's Out of Ink (March 1, 2014); Was That Today? (July 1, 2014); We Thought He'd Never Leave (November 1, 2014).

SPECS Uses 5×7 glossy color and/or b&w prints. Accepts images in digital format. Send via ZIP as TIFF files at 200 dpi.

MAKING CONTACT & TERMS Send query letter with prints, photocopies. Does not keep samples on file; include SASE for return of material. Responds in 1 week to queries; 3 months after deadline to submissions. Simultaneous submissions and previously published work OK. Pays $25 for cover; $10 for b&w inside. **Pays on acceptance.** Credit line given. Buys one-time rights.

TIPS "Submit only work that relates to one of *THEMA*'s upcoming themes. Be sure to specify target theme in cover letter. Contact by snail mail preferred."

THIN AIR MAGAZINE

English Department, Northern Arizona University, Bldg. 18, Room 133, Flagstaff AZ 86011. (928)523-0469. **E-mail:** editors@thinairmagazine.com; jmh522@nau.edu. **Website:** thinairmagazine.com. Estab. 1995. Circ. 400. Annual literary magazine. Emphasizes arts and literature—poetry, fiction and essays. Readers are collegiate, academic, writerly adult males and females interested in arts and literature. Sample copy available for $6.

NEEDS Buys 2-4 photos from freelancers/issue; 4-8 photos/year. Needs scenic/wildlife shots and b&w photos that portray a statement or tell a story. Looking for b&w or color cover shots. Model/property release preferred. Photo captions preferred; include name of photographer, date of photo.

SPECS Uses 8×10 b&w prints.

MAKING CONTACT & TERMS Send unsolicited photos by mail with SASE for consideration. Photos accepted August through May only. Keeps samples on file. Responds in 3 months. Simultaneous submissions and previously published work OK. Pays 2 contributor's copies. Credit line given. Buys one-time rights.

�
 🟢🟢 🔵 TIDE MAGAZINE

6919 Portwest Dr., Suite 100, Houston TX 77024. (713)626-4234; (800)201-FISH. **Fax:** (713)626-5852. **E-mail:** ccantl@joincca.org. **Website:** www.joincca. org. Estab. 1979. Circ. 80,000. Bimonthly magazine of the Coastal Conservation Association. Emphasizes coastal fishing, conservation issues—exclusively along the Gulf and Atlantic Coasts. Readers are mostly male ages 25-50, coastal anglers and professionals.

NEEDS Buys 12-16 photos from freelancers/issue; 72-96 photos/year. Needs photos of *only* Gulf and Atlan-

tic coastal activity, recreational fishing and coastal scenics/habitat, tight shots of fish (saltwater only). Model/property release preferred. Photo captions not required, but include names, dates, places and specific equipment or other key information.

MAKING CONTACT & TERMS Send query letter with stock list. Responds in 1 month. Simultaneous submissions and previously published work OK. Pays on publication. Credit line given. Buys one-time rights; negotiable.

TIPS Wants to see "fresh twists on old themes—unique lighting, subjects of interest to my readers. Take time to discover new angles for fishing shots. Avoid the usual poses, i.e., 'grip-and-grin.' We see too much of that already."

TIKKUN

2342 Shattuck Ave., Suite 1200, Berkeley CA 94704. (510)644-1200. **Fax:** (510)644-1255. **E-mail:** magazine@tikkun.org. **Website:** www.tikkun.org. **Contact:** Managing editor. Estab. 1986. Circ. 41,000. Quarterly. Jewish and interfaith critique of politics, culture and society.

NEEDS Uses 70 photos/issue mostly from the public domain; 5% supplied by freelancers. Needs political, social commentary; Middle East and U.S. photos. Reviews photos with or without a manuscript.

SPECS Uses b&w and color prints. Accepts images in digital format for Mac.

MAKING CONTACT & TERMS Response time varies. "Turnaround is 4 months, unless artist specifies other." Previously published work OK. As a non-profit publication with barely any image budget, we seek donation of most images. Pays on publication. Credit line given. Artists must agree to these terms: Non-exclusive worldwide publishing rights for use of the images in *Tikkun* is, in the whole or in part, distributed, displayed and archived, with no time restriction. Art guidelines are available online.

TIPS "Look at our magazine and suggest how your photos can enhance our articles and subject material. Send samples."

⊘ TIME

1271 Avenue of the Americas, New York NY 10020. **E-mail:** letters@time.com. **Website:** www.time.com. Estab. 1923. Circ. 4,034,000. *TIME* is edited to report and analyze a complete and compelling picture of the world, including national and world affairs, news of

business, science, society and the arts, and the people who make the news. Query before submitting.

⑨ TIMES OF THE ISLANDS

Times Publications, Ltd., P.O. Box 234, Lucille Lightbourne Bldg., #1, Providenciales Turks & Caicos Islands, British West Indies. (649)946-4788. **Fax:** (649)946-4788. **E-mail:** timespub@tciway.tc. **Website:** www.timespub.tc. Estab. 1988. Circ. 10,000. Quarterly. Focuses on in-depth topics specifically related to Turks and Caicos islands. Targeted beyond mass tourists to homeowners, investors, developers and others with strong interest in learning about these islands. Sample copy available for $6. Photo guidelines available on website.

NEEDS Buys 5 photos from freelancers/issue; 20 photos/year. Needs photos of environmental, landscapes/scenics, wildlife, architecture, adventure, travel. Interested in historical/vintage. Also scuba diving, islands in TCI beyond main island of Providenciales. Reviews photos with or without a manuscript. Photo captions required; include specific location, names of any people.

SPECS Prefers high resolution digital images. Send via CD or e-mail as JPEG files.

MAKING CONTACT & TERMS Send query e-mail with photo samples. Provide business card, self-promotion piece to be kept on file for possible future assignments. Responds in 6 weeks to queries. Simultaneous submissions and previously published work OK. Pays $150 for color cover; $15-50 for inside. Pays on publication. Credit line given. Buys one-time rights; negotiable.

TIPS "Make sure photo is specific to Turks & Caicos and location/subject accurately identified."

⑤ ⓞ TRACK & FIELD NEWS

2570 El Camino Real, Suite 220, Mountain View CA 94040. (650)948-8188. **Fax:** (650)948-9445. **E-mail:** editorial@trackandfieldnews.com. **Website:** www.trackandfieldnews.com. **Contact:** Jon Hendershott, associate editor (features/photography). Estab. 1948. Circ. 18,000. Monthly. Emphasizes national and world-class track and field competition and participants at those levels for athletes, coaches, administrators and fans. Sample copy free with 9×12 SASE. Photo guidelines free.

NEEDS Buys 10-15 photos from freelancers/issue; 120-180 photos/year. Wants, on a regular basis, photos of national-class athletes, men and women, pref-

erably in action. "We are always looking for quality pictures of track and field action, as well as offbeat and different feature photos. We also welcome shots from road and cross-country races for both men and women. Any photos may eventually be used to illustrate news stories in *T&FN*, feature stories in *T&FN*, or may be used in our other publications (books, technical journals, etc.). Any such editorial use will be paid for, regardless of whether material is used directly in *T&FN*. About all we don't want to see are pictures taken with someone's Instamatic. No shots of someone's child or grandparent running. Professional work only." Photo captions required; include subject name (last name first), meet date/name.

SPECS Images must be in digital format. Send via CD, e-mail; all files at 300 dpi.

MAKING CONTACT & TERMS Send query letter with samples, SASE. Responds in 10–14 days. Pays $225 for color cover; $25 for b&w inside (rarely used); $50 for color inside ($100 for full-page interior color; $175 for interior 4-color poster). Payment is made monthly. Credit line given. Buys one-time rights.

TIPS "No photographer is going to get rich via *T&FN*. We can offer a credit line, nominal payment and, in some cases, credentials to major track and field meets. Also, we can offer the chance for competent photographers to shoot major competitions and competitors up close, as well as being the most highly regarded publication in the track world as a forum to display a photographer's talents."

TRAIL RUNNER

Big Stone Publishing, 2567 Dolores Way, Carbondale CO 81623. (970)704-1442. **Fax:** (970)963-4965. **E-mail:** aarnold@bigstonepub.com. **Website:** www.trailrunnermag.com. **Contact:** Michael Benge, editor; Ashley Arnold, associate editor. Estab. 1999. Circ. 29,000. Bimonthly. The nation's only magazine covering all aspects of trail running. *Trail Runner* regularly features stunning photography of trail running destinations, races, adventures and faces of the sport. Sample copy available for 9×12 SAE with $1.65 postage. Photo guidelines available on website.

NEEDS Buys 5-10 photos from freelancers/issue; 50-100 photos/year. Needs photos of landscapes/scenics, adventure, health/fitness, sports, travel. Interested in anything related to running on trails and the outdoors. Reviews photos with or without a manuscript.

Model/property release preferred. Photo captions required.

SPECS Uses glossy color prints; 35mm transparencies. Accepts images in digital format. Send via CD, e-mail as TIFF files at 600 dpi.

MAKING CONTACT & TERMS Send query letter via e-mail to photo editor. Contact photo editor for appointment to drop off portfolio. Provide résumé, business card or self-promotion piece to be kept on file for possible future assignments. Responds in 3 weeks. Simultaneous submissions OK. Pays $500 for color cover; $50-200 for b&w inside; $50-250 for color inside; $350 for spread (color). Pays 30 days from date of publication. Credit line given. Buys one-time rights, first rights; negotiable.

TIPS "Read our magazine. Stay away from model shots, or at least those with make-up and spandex clothing. No waving at the camera."

TRAVEL + LEISURE

1120 Avenue of the Americas, 9th Floor, New York NY 10036-6700. (212)382-5600. **Website:** www.travelandleisure.com. **Contact:** Bernard Scharf, creative director. Monthly magazine emphasizing travel, resorts, dining and entertainment.

MAKING CONTACT & TERMS "If mailing a portfolio, include a SASE package for its safe return. You may also send it by messenger Monday–Friday, 11-5. We accept work in book form exclusively—no transparencies, loose prints, nor scans on CD, disk or e-mail. Send photo copies or photo prints, not originals, as we are not responsible for lost or damaged images in unsolicited portfolios. We do not meet with photographers if we haven't seen their book. However, please include a promo card in your portfolio with contact information, so we may get in touch with you if necessary."

TRAVELLER MAGAZINE & PUBLISHING

45-49 Brompton Road, London SW3 1DE United Kingdom. (44)(207)590-0610. **Fax:** (44)(207)581-8476. **E-mail:** travel@wexas.com. **Website:** www.wexas.com/traveller-magazine. **Contact:** Amy Sohanpaul, editor. Circ. 25,000. Quarterly. Readers are predominantly male, professional, ages 35 and older. Sample copy available for £4.95.

NEEDS Uses 75-100 photos/issue; all supplied by freelancers. Needs photos of travel, wildlife, tribes.

Reviews photos with or without a manuscript. Photo captions preferred.

MAKING CONTACT & TERMS Send at least 20 original color slides or b&w prints. Or send at least 20 low-res scans by e-mail or CD (include printout of thumbnails); high-res (300 dpi) scans will be required for final publication. Does not keep samples on file; include SASE for return of material. Responds in 3 months. Pays £150 for color cover; £80 for full page; £50 for other sizes. Pays on publication. Buys one-time rights.

TIPS Look at guidelines for contributors on website.

🅢 🅞 TRAVELWORLD INTERNATIONAL MAGAZINE

150 S. Arroyo Pkwy., Pasadena CA 91105. (626)376-9754. **E-mail:** helen@natja.org. **Website:** www.natja.org, www.travelworldmagazine.com. **Contact:** Helen Hernandez, CEO. Estab. 1992. Circ. 75,000. Quarterly online magazine of the North American Travel Journalists Association (NATJA). Emphasizes travel, food, wine, and hospitality industries.

NEEDS Photos of food/drink, travel.

SPECS Uses color and b&w. Prefers digital images.

MAKING CONTACT & TERMS Send query via e-mail.

TIPS Only accepts submissions from members.

TRICYCLE

1115 Broadway, Suite 1113, New York NY 10010. (646)461-9847. **E-mail:** editorial@tricycle.com. **Website:** www.tricycle.com. Estab. 1991. Circ. 50,000. Quarterly magazine providing a unique and independent public forum for exploring Buddhist teachings and practices, establishing a dialogue between Buddhism and the broader culture, and introducing Buddhist thinking to Western disciplines.

NEEDS Buys 10 photos from freelancers/issue; 40 photos/year. Reviews photos with or without a manuscript. Model/property release preferred. Photo captions preferred.

SPECS Uses glossy b&w and color prints; 35mm transparencies. Accepts images in digital format. Send via CD, ZIP, e-mail as TIFF, EPS, BMP, GIF, JPEG files at 300 dpi.

MAKING CONTACT & TERMS "We prefer to receive copies or CDs of photographs or art, rather than originals, in both color and b&w. For the safety of your own work, please do not send anything which you would fear losing, as we cannot assume responsi-

bility for the loss of unsolicited artwork. If you would like to receive a reply from us and wish your work returned, you must include a SASE with sufficient postage."

TIPS "Read the magazine to get a sense of the kind of work we publish. We don't only use Buddhist art; we select artwork depending on the content of the piece."

TURKEY & TURKEY HUNTING

F+W Media, Inc., 700 E. State St., Iola WI 54990. (715)445-4612. **E-mail:** brian.lovett@fwmedia.com. **Website:** www.turkeyandturkeyhunting.com. **Contact:** Brian Lovett, editor. Estab. 1982. Circ. 40,000. Published 6 times/year. Provides features and news about wild turkeys and turkey hunting.

🅠 Contact editor before sending photos.

TURKEY COUNTRY

National Wild Turkey Federation, P.O. Box 530, Edgefield SC 29824-0530. (803)637-3106. **Fax:** (803)637-0034. **E-mail:** info@nwtf.net; turkeycountry@nwtf.net. **E-mail:** klee@nwtf.net. **Website:** www.turkeycountrymagazine.com. **Contact:** Karen Lee, editor; Gregg Powers, managing editor; P.J. Perea, senior editor; Matt Lindler, photo editor. Estab. 1973. Circ. 180,000. Bimonthly. For members of the National Wild Turkey Federation—people interested in conserving the American wild turkey. Sample copy available for $5 with 9×12 SASE. Images may be submitted to accompany specific assignments or on speculation. See photograph submission information and send speculative images to the photo editor at the NWTF shipping address. Photo guidelines free with SASE or on website at www.turkeycountrymagazine.com/contributor_guidelines.html.

NEEDS Buys at least 100 photos/year. Needs photos of "wildlife, including wild turkeys, upland birds, North American Big Game; wild turkey hunting; wild turkey management techniques (planting food, trapping for relocation, releasing); wild turkey habitat; families, women, children and people with disabilities hunting or enjoying the outdoors." Photo captions required.

SPECS Prefers images in digital format from 6mp or higher resolution cameras. Send via CD/DVD at 300 dpi with thumbnail page (see guidelines for more details).

MAKING CONTACT & TERMS Send copyrighted photos to editor for consideration; include SASE. Responds in 6 weeks. Pays $800 for cover; $400 maxi-

mum for color inside. We purchase both print rights and for electronic usage on turkeycountrymagazine.com, which includes a digital version of the magazine. Additional usage on the website, other than in the digital magazine, will be negotiated. Pays on publication. Credit line given. Buys one-time rights.

TIPS "No poorly posed or restaged shots, no mounted turkeys representing live birds, no domestic animals representing wild animals. Photos of dead animals in a tasteful hunt setting are considered. Contributors must agree to the guidelines before submitting."

TV GUIDE

11 W. 42nd St., 16th Floor, New York NY 10036. (212)852-7500. **Fax:** (212)852-7470. **Website:** www.tvguide.com. **Contact:** Debra Birnbaum, editor-in-chief. Estab. 1953. Circ. 9,097,762. *TV Guide* watches television with an eye for how TV programming affects and reflects society. It looks at the shows and the stars, and covers the medium's impact on news, sports, politics, literature, the arts, science and social issues through reports, profiles, features, and commentaries.

MAKING CONTACT & TERMS Works only with celebrity freelance photographers. "Photos are for one-time publication use. Mail self-promo cards to photo editor at above address. No calls, please."

UP HERE

P.O. Box 1350, Yellowknife NT X1A 3T1, Canada. (867)766-6710. **Fax:** (867)873-9876. **E-mail:** aaron@uphere.ca; katharine@uphere.ca. **Website:** www.uphere.ca. **Contact:** Aaron Spitzer, editor; Eva Holland, associate editor; Samia Madwar, associate editor. Estab. 1984. Circ. 22,000. Published 8 times/year. Emphasizes Canada's North. Readers are educated, affluent men and women ages 30 to 60.

NEEDS Buys 18-27 photos from freelancers/issue; 144-216 photos/year. Needs photos of Northern Canada environmental, landscapes/scenics, wildlife, adventure, performing arts. Interested in documentary, seasonal. Purchases photos with or without accompanying manuscript. Photo captions required.

SPECS Accepts images in digital format. Send via CD, e-mail. Also uses color transparencies, not prints, labeled with the photographer's name, address, phone number, and caption.

MAKING CONTACT & TERMS Provide résumé, business card, brochure, flyer or tearsheets to be kept on file for possible future assignments. Pays $350-400

for color cover, up to $300 for color inside. Pays on publication. Credit line given. Buys one-time rights.

TIPS "We are a *people* magazine. We need stories that are uniquely Northern (people, places, etc.). Few scenics as such. We approach local freelancers for given subjects, but routinely complete commissioned photography with images from stock sources. Please let us know about Northern images you have." Wants to see "sharp, clear photos, good color and composition. We always need verticals to consider for the cover, but they usually tie in with an article inside."

VELONEWS

Inside Communications, Inc., 3002 Sterling Circle, Suite 100, Boulder CO 80301. (303)440-0601. **Fax:** (303)444-6788. **E-mail:** webletters@competitorgroup.com. **E-mail:** nrogers@competitorgroup.com. **Website:** www.velonews.com. **Contact:** Neal Rogers, editor-in-chief. Estab. 1972. Circ. 48,000.

Covers road racing, mountain biking and recreational riding. Sample copy free with 9×12 SASE.

NEEDS Uses photos of bicycle racing (road, mountain and track). "Looking for action and feature shots that show the emotion of cycling, not just finish-line photos with the winner's arms in the air." No bicycle touring. Photos purchased with or without accompanying manuscript. Uses news, features, profiles. Photo captions required.

SPECS Uses negatives and transparencies.

MAKING CONTACT & TERMS Send samples of work or tearsheets with assignment proposal. Query first. Pays on publication. Credit line given. Buys one-time rights.

TIPS "Photos must be timely."

VERMONT MAGAZINE

P.O. Box 900, Arlington VT 05250. (802)375-1366. **E-mail:** prj@vermontmagazine.com. **Website:** www.vermontmagazine.com. **Contact:** Philip Jordan, editor. Estab. 1989. Circ. 50,000. Bimonthly. Emphasizes all facets of Vermont culture, business, sports, restaurants, real estate, people, crafts, art, architecture, etc. Readers are people interested in Vermont, including residents, tourists and second home owners. Sample copy available for $4.95 with 9×12 SASE and 5 first-class stamps. Photo guidelines free with SASE.

NEEDS Buys 10 photos from freelancers/issue; 60 photos/year. Needs animal/wildlife shots, travel, Vermont scenics, how-to, products and architecture. Spe-

cial photo needs include Vermont activities such as skiing, ice skating, biking, hiking, etc. Model release preferred. Photo captions required.

MAKING CONTACT & TERMS Send query letter with résumé of credits, samples, SASE. Send 8×10 b&w prints or 35mm or larger transparencies by mail for consideration. Submit portfolio for review. Provide tearsheets to be kept on file for possible future assignments. Responds in 2 months. Previously published work OK, depending on "how it was previously published." Pays on publication. Credit line given. Buys one-time rights and first North American serial rights; negotiable.

TIPS In portfolio or samples, wants to see tearsheets of published work and at least 40 35mm transparencies. Explain your areas of expertise. Looking for creative solutions to illustrate regional activities, profiles and lifestyles. "We would like to see more illustrative photography/fine art photography where it applies to the articles and departments we produce."

🌑 VERSAL

Website: www.wordsinhere.com. **Contact:** Shayna Schapp, assistant art editor (artists); Megan Garr, editor (writers and designers). Estab. 2002. Circ. 650. "*Versal*, published each May by *wordsinhere*, is the only literary magazine of its kind in the Netherlands and publishes new poetry, prose and art from around the world. *Versal* and the writers behind it are also at the forefront of a growing translocal European literary scene, which includes exciting communities in Amsterdam, Paris and Berlin. *Versal* seeks work that is urgent, involved and unexpected."

MAKING CONTACT & TERMS Submission guidelines online. Samples not kept on file. Portfolio not required. Credit line is given. Work accepted by submission period (September–January).

TIPS "After reviewing the journal, if you are interested in what we're doing and would like to get involved, please send a query and CV to editor Megan Garr at Megan@wordsinhere.com. Artists submitting to *Versal* must follow our submission guidelines online and submit during our review period, September to January. Others interested in helping should always send an inquiry with a cover letter and CV. Please do not submit images of artwork via e-mail."

🔘 🔘 THE VIEW FROM HERE

E-mail: submit.your.words@gmail.com. **Website:** www.viewfromheremagazine.com. **Contact:** Mike

French, senior editor. Estab. 2008. Circ. 8,000. "We are a print and online literary magazine with author interview, book reviews, original fiction and poetry and articles. Designed and edited by an international team we bring an entertaining mix of wit, insight and intelligence all packaged in beautifully designed pages that mix the new with the famous. We publish our fiction at *The Front View* and our poetry at *The Rear View*, where we showcase the weird, unusual, thought provoking and occasionally bizarre. We classify ourselves as 'Bohemian Eclectic'—yes, we coined the term. Our stories and poems will make you wonder, laugh, cry and generally *feel* something."

NEEDS Avant garde, entertainment and fine art photographs.

MAKING CONTACT & TERMS Send an e-mail with résumé and JPEG samples. Portfolio not required. Credit line given.

💲💲 🔘 VILLAGE PROFILE

33 N. Geneva St., Elgin IL 60120. (847)468-6800. **Fax:** (847)468-9751. **E-mail:** mholmesy@aol.com. **Website:** www.villageprofile.com. **Contact:** Mike Holmes, manager. Estab. 1988. Circ. 5-15,000 per publication; average 240 projects/year. Publication offering community profiles, chamber membership directories, maps. "Village Profile has published community guides, chamber membership directories, maps, atlases and builder brochures in 45 states. Community guides depict the towns served by the chamber with 'quality of life' text and photos, using a brochure style rather than a news or documentary look." Sample copy available with 10×13 SASE. Photo guidelines free with SASE.

NEEDS Buys 50 photos from freelancers/issue; 5,000 photos/year. Photos of babies/children/teens, multicultural, families, parents, senior citizens, cities/urban, food/drink, health/fitness/beauty, business concepts, industry, medicine, technology/computers. Interested in historical/vintage, seasonal. Points of interest specific to the communities being profiled. Reviews photos with or without a manuscript. Model/property release preferred. Photo captions required.

SPECS Uses up to 8×10 glossy prints; 35mm, 2¼×2¼ transparencies. Accepts images in digital format. Send via ZIP as TIFF files at 300 dpi.

MAKING CONTACT & TERMS Send query letter with photocopies, tearsheets, stock list, locale/travel ability. Provide résumé, business card, self-promotion

piece to be kept on file for possible future assignments. Responds in 1 week to queries. Previously published work OK. **Pays on acceptance.** Credit line given. Buys all rights.

TIPS "We want photographs of, and specific to, the community/region covered by the *Profile*, but we always need fresh stock photos of people involved in healthcare shopping/dining, recreation, education and business to use as fillers. E-mail anytime to find out if we're doing a project in your neighborhood. Do NOT query with or send samples or tearsheets of scenics, landscapes, wildlife, nature—see stock needs list above. We only purchase stock images in batches if the price is comparable to stock photo CDs available on the market—don't expect $100 per image."

THE WASHINGTON BLADE

P.O. Box 53352, Washington DC 20009. (202)747-2077. **Fax:** (202)747-2070. **E-mail:** knaff@washblade.com. **Website:** www.washblade.com. **Contact:** Kevin Naff, editor. Estab. 1969. Circ. 30,000. Weekly tabloid for and about the gay community. Readers are gay men and lesbians; moderate- to upper-level income; print readers primarily in Washington DC metropolitan area, web audience is global. Sample copy free with 10×13 SASE plus 11 first-class stamps.

O *The Washington Blade* stores images on CD; manipulates size, contrast, etc.—but not content.

NEEDS Uses about 6–7 photos/issue. Needs "gay-related news, sports, entertainment, events; profiles of gay people in news, sports, entertainment, other fields." Photos purchased with or without accompanying manuscript. Model release preferred. Photo captions preferred.

SPECS Accepts images in digital format. Send via e-mail.

MAKING CONTACT & TERMS Send query letter with résumé of credits. Provide résumé, business card and tearsheets to be kept on file for possible future assignments. Responds in 1 month. Simultaneous submissions and previously published work OK. Pays $10 fee to go to location, $15/photo, $5/reprint of photo; negotiable. Pays within 30 days of publication. Credit line given. Buys all rights when on assignment, otherwise one-time rights.

TIPS "Be timely! Stay up-to-date on what we're covering in the news, and call if you know of a story about to happen in your city that you can cover. Also, be able to provide some basic details for a caption (*tell*

us what's happening, too). It's especially important to avoid stereotypes."

WASHINGTON TRAILS

705 Second Ave., Suite 300, Seattle WA 98104. (206)625-1367. **E-mail:** eli@wta.org. **Website:** www.wta.org/trail-news/magazine. **Contact:** Eli Boschetto, editor. Estab. 1966. Circ. 9,000. Magazine of the Washington Trails Association. Published 6 times/year. Emphasizes "backpacking, hiking, cross-country skiing, all nonmotorized trail use, outdoor equipment and minimum-impact camping techniques." Readers are "people active in outdoor activities, primarily backpacking; residents of the Pacific Northwest, mostly Washington; age group: 9-90; family-oriented; interested in wilderness preservation, trail maintenance." Photo guidelines free with SASE or online.

NEEDS Uses 10–15 photos from volunteers/issue; 100–150 photos/year. Needs "wilderness/scenic; people involved in hiking, backpacking, skiing, snowshoeing, wildlife; outdoor equipment photos, all with Pacific Northwest emphasis." Photo captions required.

MAKING CONTACT & TERMS Send JPEGs by e-mail for consideration. Responds in 1–2 months. Simultaneous submissions and previously published work OK. No payment for photos. A 1–year subscription offered for use of color cover shot. Credit line given.

TIPS "Photos must have a Pacific Northwest slant. Photos that meet our cover specifications are always of interest to us. Familiarity with our magazine will greatly aid the photographer in submitting material to us. Contributing to *Washington Trails* won't help pay your bills, but sharing your photos with other backpackers and skiers has its own rewards."

⊙⊙ O WATERCRAFT WORLD

(805)667-4100. **Fax:** (805)667-4336. **E-mail:** gmansfield@affinitygroup.com. **Website:** www.watercraftworld.com. **Contact:** Gregg Mansfield, editorial director. Estab. 1987. Circ. 75,000. Published 6 times/year. Emphasizes personal watercraft (Jet Skis, Wave Runners, Sea-Doo). Readers are 95% male, average age 37, boaters, outdoor enthusiasts. Sample copy available for $4.

NEEDS Buys 7-12 photos from freelancers/issue; 42-72 photos/year. Needs photos of personal watercraft travel, race coverage. Model/property release required. Photo captions preferred.

SPECS Accepts images in digital format. Send via CD, ZIP, e-mail as TIFF, EPS, GIF, JPEG files at 300 dpi.

MAKING CONTACT & TERMS Send query letter with résumé of credits. Provide résumé, business card, brochure, flyer or tearsheets to be kept on file for possible future assignments. "Call with ideas." Responds in 1 month. Pays on publication. Credit line given. Rights negotiable.

TIPS "Call to discuss project. We take and use many travel photos from all over the United States (very little foreign). We also cover many regional events (e.g., charity rides, races)."

⑤⑤ WATERSKI

460 N. Orlando Ave., Suite 200, Winter Park FL 32789. (407)628-4802. **Fax:** (407)628-7061. **E-mail:** todd.ristorcelli@bonniercorp.com. **Website:** www.waterskimag.com. **Contact:** Todd Ristorcelli, editor. Estab. 1978. Circ. 105,000. Published 8 times/year. Emphasizes water skiing instruction, lifestyle, competition, travel. Readers are 36-year-old males, average household income $65,000. Sample copy available for $2.95. Photo guidelines free with SASE.

NEEDS Buys 20 photos from freelancers/issue; 160 photos/year. Needs photos of instruction, travel, personality. Model/property release preferred. Photo captions preferred; include person, trick described.

MAKING CONTACT & TERMS Query with good samples, SASE. Keeps samples on file. Responds within 2 months. Pays $200–500/day; $500 for color cover; $50–75 for b&w inside; $75–300 for color inside; $150/color page rate; $50–75/b&w page rate. Pays on publication. Credit line given. Buys first North American serial rights.

TIPS "Clean, clear, tight images. Plenty of vibrant action, colorful travel scenics and personality. Must be able to shoot action photography. Looking for photographers in other geographic regions for diverse coverage."

THE WATER SKIER

1251 Holy Cow Rd., Polk City FL 33868. (863)324-4341. **Fax:** (863)325-8259. **E-mail:** satkinson@usawaterski.org. **Website:** www.usawaterski.org. **Contact:** Scott Atkinson, editor. Estab. 1951. Circ. 30,000. Magazine of USA Water Ski. Published 7 times/year. Emphasizes water skiing. Readers are male and female professionals, ages 20-45. Sample copy available for $3.50. Photo guidelines available.

NEEDS Buys 1-5 photos from freelancers/issue; 9-45 photos/year. Needs photos of sports action. Model/property release required. Photo captions required.

MAKING CONTACT & TERMS Call first. Pays $50-150 for color photos. Pays on publication. Credit line given. Buys all rights.

WATERWAY GUIDE

P.O. Box 1125, 16273 General Puller Hwy., Deltaville VA 23043. (804)776-8999. **Fax:** (804)776-6111. **E-mail:** joan@waterwayguide.com. **Website:** www.waterwayguide.com. **Contact:** Tom Hale, editor. Estab. 1947. Circ. 30,000. Cruising guide with 4 annual regional editions. Emphasizes recreational boating. Readers are men and women ages 25-65, management or professional, with average income $138,000. Sample copy available for $39.95 and $3 shipping. Photo guidelines free with SASE.

NEEDS Buys 10-15 photos from freelancers/issue. Needs aerial photos of waterways. Expects to use more coastal shots from Maine to the Bahamas; also Hudson River, Great Lakes, Lake Champlain and Gulf of Mexico. Model release required. Photo captions required.

SPECS Accepts images in digital format. Send as EPS, TIFF files at 300 dpi.

MAKING CONTACT & TERMS Send unsolicited photos by mail with SASE for consideration. Responds in 4 months. Pay varies; negotiable. Pays on publication. Credit line given. Must sign contract for copyright purposes.

⑤⑤ ❶ WESTERN OUTDOORS

185 Avenida La Pata, San Clemente CA 92673. (949)366-0030. **E-mail:** rich@wonews.com. **Website:** www.wonews.com. **Contact:** Rich Holland, editor. Estab. 1961. Circ. 100,000. Published 9 times/year. Emphasizes fishing and boating "for Far West states." Sample copy free. Editorial and photo guidelines free with SASE.

NEEDS Uses 80-85 photos/issue; 70% supplied by freelancers; 80% comes from assignments, 25% from stock. Needs photos of fishing in California, Oregon, Washington, Baja. Most photos purchased with accompanying manuscript. Model/property release preferred for women and men in brief attire. Photo captions required.

SPECS Prefers images in digital format.

MAKING CONTACT & TERMS Query or send photos with SASE for consideration. Responds in 3 weeks.

Pays on acceptance. Buys one-time rights for photos only; first North American serial rights for articles; electronic rights are negotiable.

TIPS "Submissions should be of interest to Western fishermen, and should include a 1,120- to 1,500-word manuscript; a Trip Facts Box (where to stay, costs, special information); photos; captions; and a map of the area. Emphasis is on fishing how-to, somewhere-to-go. Submit seasonal material 6 months in advance. Query only; no unsolicited manuscripts. Make your photos tell the story, and don't depend on captions to explain what is pictured. Get action shots, live fish. In fishing, we seek individual action or underwater shots. For cover photos, use vertical format composed with action entering picture from right; leave enough left-hand margin for cover blurbs, space at top of frame for magazine logo. Add human element to scenics to lend scale. Get to know the magazine and its editors. Ask for the year's editorial schedule (available through advertising department), and offer cover photos to match the theme of an issue. In samples, looks for color saturation, pleasing use of color components; originality, creativity; attractiveness of human subjects, as well as fish; above all—sharp, sharp, sharp focus!"

❸ ◑ WEST SUBURBAN LIVING MAGAZINE

C2 Publishing, Inc., P.O. Box 111, Elmhurst IL 60126. (630)834-4995. **Fax:** (630)834-4996. **E-mail:** wsl@westsuburbanliving.net. **Website:** www.westsuburbanliving.net. Estab. 1995. Circ. 25,000. Bimonthly regional magazine serving the western suburbs of Chicago. Sample copies available.

NEEDS Photos of babies/children/teens, couples, families, senior citizens, landscapes/scenics, architecture, gardening, interiors/decorating, entertainment, events, food/drink, health/fitness/beauty, performing arts, travel. Interested in seasonal. Model release required. Photo captions required.

MAKING CONTACT & TERMS Responds only if interested; send nonreturnable samples. Simultaneous submissions and previously published work OK. Credit line given. Buys one-time rights, first rights, all rights; negotiable.

WHISKEY ISLAND MAGAZINE

Rhodes Tower 1636, Cleveland OH 44115. (216)687-2000. **E-mail:** whiskeyisland@csuohio.edu. **Website:** www.csuohio.edu/class/english/whiskeyisland. "This is a nonprofit literary magazine that has been published (in one form or another) by students of Cleveland State University for over 30 years. Also features the Annual Student Creative Writing Contest ($5000-$400-$250)." Biannual literary magazine publishing extremely contemporary writing. Sample copy available for $6. Photo guidelines available with SASE.

NEEDS Uses 10 photos/issue; 20 photos/year. Interested in mixed media, alternative process, avant garde fine art. Surreal and abstract are welcome. Do not send sentimental images, "rust-belt" scenes, photos of Cleveland, straight landscapes, or anything that can be viewed as "romantic." Model/property release preferred. Photo captions required; include title of work, photographer's name, address, phone number, e-mail, etc.

SPECS Accepts images in digital format. Send via e-mail attachment as individual, high-res JPEG files. No TIFFs. No disks.

MAKING CONTACT & TERMS E-mail with sample images. Do not just send your website link. Does not keep samples on file; responds in 3 months. Pays 2 contributor's copies and a 1-year subscription. Credit line given. Include as much contact information as possible.

❸ ❸ WINE & SPIRITS

2 W. 32nd St., Suite 601, New York NY 10001. (212)695-4660, ext. 15. **E-mail:** elenab@wineandspiritsmagazine.com; info@wineandspiritsmagazine.com. **Website:** www.wineandspiritsmagazine.com. **Contact:** Elena Bessarabova-Leone, art director. Estab. 1985. Circ. 70,000. Bimonthly. Emphasizes wine. Readers are male, ages 39-60, married, parents, $70,000-plus income, wine consumers. Sample copy available for $4.95; Special issues are $4.95-6.50 each.

NEEDS Buys 0-30 photos from freelancers/issue; 0-180 photos/year. Needs photos of food, wine, travel, people. Photo captions preferred; include date, location.

SPECS Accepts images in digital format. Send via SyQuest, ZIP at 300 dpi.

MAKING CONTACT & TERMS Submit portfolio for review. Provide résumé, business card, brochure, flyer or tearsheets to be kept on file for possible future assignments. Responds in 2 weeks, if interested. Simultaneous submissions OK. Pays on publication. Credit line given. Buys one-time rights.

⊕ WISCONSIN SNOWMOBILE NEWS

P.O. Box 182, Rio WI 53960-0182. (920)992-6370. **Website:** www.sledder.net. **Contact:** Cathy Hanson, editor. Estab. 1969. Circ. 28,000. Published 7 times/year. Official publication of the Association of Wisconsin Snowmobile Clubs. Emphasizes snowmobiling. Sample copy free with 9×12 SASE and 5 first-class stamps.

NEEDS Buys very few stand-alone photos from freelancers. "Most photos are purchased in conjunction with a story (photo/text) package. Photos need to be Midwest region only!" Needs photos of family-oriented snowmobile action, travel. Model/property release preferred. Photo captions preferred; include where, what, when.

SPECS Uses 8×10 glossy color and b&w prints; 35mm, 2¼×2¼, 4×5, 8×10 transparencies. Digital files accepted at 300 dpi.

MAKING CONTACT & TERMS Submit portfolio for review. Send unsolicited photos by mail for consideration; include SASE for return of material. Provide résumé, business card, brochure, flyer or tearsheets to be kept on file for possible future assignments. Responds in 2 weeks. Pays on publication. Credit line given. Buys one-time rights, all rights; negotiable.

⊕⊕ WOODMEN LIVING

Woodmen Tower, 1700 Farnam St., Omaha NE 68102. (402)342-1890. **Fax:** (402)271-7269. **E-mail:** service@woodmen.com. **Website:** www.woodmen.org. **Contact:** Billie Jo Foust, editor. Estab. 1890. Circ. 480,000. Quarterly magazine published by Woodmen of the World/Omaha Woodmen Life Insurance Society. Emphasizes American family life. Sample copy and photo guidelines free.

NEEDS Buys 10-12 photos/year. Needs photos of the following themes: historic, family, insurance, humorous, photo essay/photo feature, human interest and health. Model release required. Photo captions preferred.

SPECS Uses 8×10 glossy b&w prints on occasion; 35mm, 2¼×2¼, 4×5 transparencies; for cover: 4×5 transparencies, vertical format preferred. Accepts images in digital format. Send high-res scans via CD.

MAKING CONTACT & TERMS Send material by mail with SASE for consideration. Responds in 1 month. Previously published work OK. **Pays on acceptance.** Credit line given on request. Buys one-time rights.

TIPS "Submit good, sharp pictures that will reproduce well."

WRITER'S DIGEST

F+W Media, Inc., 10151 Carver Rd., Suite #200, Blue Ash OH 45242. (513)531-2690. **E-mail:** wdsubmissions@fwmedia.com. **Website:** www.writersdigest.com. Estab. 1920. Monthly consumer magazine. "Our readers write fiction, nonfiction, plays and scripts. They're interested in improving their writing skills and the ability to sell their work, and finding new outlets for their talents." Photo guidelines free with SASE or via e-mail.

NEEDS Occasionally buys photos from freelancers. Needs photos of education, hobbies, writing life, business concepts, product shots/still life. Other specific photo needs: photographers to shoot authors on location for magazine cover. Model/property release required. Photo captions required; include your copyright notice.

SPECS Uses 8×10 color or digital (resizable) images. Accepts images in digital format if hired. Send via CD as TIFF, EPS, JPEG files at 300 dpi (at hire).

MAKING CONTACT & TERMS Prefers postal mail submissions to keep on file. Final art may be sent via e-mail. Buys one-time rights. **Pays on acceptance:** $500-1,000 for color cover; $100-800 for color inside. Responds only if interested; send nonreturnable samples. Credit line given. Buys one-time rights.

TIPS "I like having several samples to look at. Online portfolios are great. Submissions are considered for other *Writer's Digest* publications as well. For stock photography, please include pricing/sizes of b&w usage if available."

⊕⊕ ◎ ● YANKEE MAGAZINE

1121 Main St., P.O. Box 520, Dublin NH 03444. (603)563-8111. **E-mail:** heatherm@yankeepub.com. **Website:** www.yankeemagazine.com. **Contact:** Heather Marcus, photo editor; Lori Pedrick, art director. Estab. 1935. Circ. 350,000. Monthly. Emphasizes general interest within New England, with national distribution. Readers are of all ages and backgrounds; majority are actually outside of New England. Sample copy may be viewed on our website. "We give assignments to experienced professionals. If you want to work with us, show us a portfolio of your best work. Contact our photo editor before sending any photography to our art department. Please do not send any unsolicited original photography or artwork."

NEEDS Buys 10-30 photos from freelancers/issue; 60–180 photos/year. Needs photos of landscapes/scenics, wildlife, gardening, interiors/decorating. "Always looking for outstanding photo essays or portfolios shot in New England." Model/property release preferred. Photo captions required; include name, locale, pertinent details.

MAKING CONTACT & TERMS Submit portfolio for review. Keeps samples on file; include SASE for return of material. Responds in 1 month. Simultaneous submissions and previously published work OK. Credit line given. Buys one–time rights; negotiable.

⊙ YOUTH RUNNER MAGAZINE

P.O. Box 1156, Lake Oswego OR 97035. (503)236-2524. **Fax:** (503)620-3800. **E-mail:** photos@youthrunner. com. **Website:** www.youthrunner.com. Estab. 1996. Circ. 100,000. Publishes 10 issues per year. Features track, cross country and road racing for young athletes, ages 8-18. Photo guidelines available on website.

NEEDS Uses 30–50 photos/issue. Also uses photos on website daily. Needs action shots from track, cross country and indoor meets. Model release preferred; property release required. Photo captions preferred.

SPECS Accepts images in digital format only. Send via e-mail or CD.

MAKING CONTACT & TERMS Send low-res photos via e-mail first or link to gallery for consideration. Responds to e-mail submissions immediately. Simultaneous submissions OK. Pays $25 minimum. Credit line given. Buys electronic rights, all rights.

NEWSPAPERS

//

When working with newspapers, always remember that time is of the essence. Newspapers have various deadlines for each of their sections. An interesting feature or news photo has a better chance of getting in the next edition if the subject is timely and has local appeal. Most of the markets in this section are interested in regional coverage. Find publications near you and contact editors to get an understanding of their deadline schedules.

More and more newspapers are accepting submissions in digital format. In fact, most newspapers prefer digital images. However, if you submit to a newspaper that still uses film, ask the editors if they prefer certain types of film or if they want color slides or black-and-white prints. Many smaller newspapers do not have the capability to run color images, so black-and-white prints are preferred. However, color slides and prints can be converted to black and white. Editors who have the option of running color or black-and-white photos often prefer color film because of its versatility.

Although most newspapers rely on staff photographers, some hire freelancers as stringers for certain stories. Act professionally and build an editor's confidence in you by supplying innovative images. For example, don't get caught in the trap of shooting "grip-and-grin" photos when a corporation executive is handing over a check to a nonprofit organization. Turn the scene into an interesting portrait. Capture some spontaneous interaction between the recipient and the donor. By planning ahead you can be creative.

When you receive assignments, think about the image before you snap your first photo. If you are scheduled to meet someone at a specific location, arrive early and scout around. Find a proper setting or locate some props to use in the shoot. Do whatever you can to show the editor you are willing to make that extra effort.

Always try to retain resale rights to shots of major news events. High news value means high resale value, and strong news photos can be resold repeatedly. If you have an image with national appeal, search for larger markets, possibly through the wire services. You also may find buyers among national news magazines such as *Time* or *Newsweek*.

While most newspapers offer low payment for images, they are willing to negotiate if the image will have a major impact. Front-page artwork often sells newspapers, so don't underestimate the worth of your images.

⊗⊗ ⊗ AMERICAN SPORTS NETWORK

Box 6100, Rosemead CA 91770. (626)280-0000. **Fax:** (626)280-0001. **E-mail:** info@asntv.com. **Website:** www.fitnessamerica.com. Circ. 873,007. Publishes 4 newspapers covering "general collegiate, amateur and professional sports, e.g., football, baseball, basketball, wrestling, boxing, powerlifting and bodybuilding, fitness, health contests." Also publishes special bodybuilder annual calendar, collegiate and professional football pre-season and post-season editions.

NEEDS Buys 10–80 photos from freelancers/issue for various publications. Needs "sport action, hard-hitting contact, emotion-filled photos." Model release preferred. Photo captions preferred.

MAKING CONTACT & TERMS Send 8×10 glossy b&w prints, 4×5 transparencies, video demo reel, or film work by mail for consideration. Include SASE for return of material. Provide résumé, business card, brochure, flyer or tearsheets to be kept on file for possible future assignments. Simultaneous submissions and previously published work OK. Negotiates rates by the job and hour. Pays on publication. Buys first North American serial rights.

⊙ THE ANGLICAN JOURNAL

(416)924-9192. **Fax:** (416)921-4452. **E-mail:** editor@anglicanjournal.com. **E-mail:** story queries: jthomas@national.anglican.ca; photography queries: sfielder@national.anglican.ca. **Website:** www.anglicanjournal.com. **Contact:** Janet Thomas; Saskia Rowley Fielder. Estab. 1875. Circ. 150,000. Covers news of interest to Anglicans in Canada and abroad.

SPECS Reviews GIF/JPEG files (high res at 300 dpi).

MAKING CONTACT & TERMS Identification of subjects required. Negotiates payment individually. Buys all rights.

⊙ ⊙ AQUARIUS

1035 Green St., Roswell GA 30075. (770)641-9055. **Fax:** (770)641-8502. **E-mail:** felicia@aquarius-atlanta.com; gloria@aquarius-atlanta.com. **Website:** www.aquarius-atlanta.com. **Contact:** Felicia Hicks, creative director; Gloria Parker, publisher/editor. Estab. 1991. Circ. 50,000; readership online: 110,000. Monthly. "Emphasizes New Age, metaphysical, holistic health, alternative religion; environmental audience primarily middle-aged, college-educated, computer-literate, open to exploring new ideas. Our mission is to publish a newspaper for the purpose of expanding awareness and supporting all those seeking spiritual growth. We are committed to excellence and integrity in an atmosphere of harmony and love." Sample copy available with SASE.

NEEDS "We use photos of authors, musicians, and photos that relate to our articles, but we have no budget to pay photographers at this time. We offer byline in paper, website, and copies." Needs photos of New Age and holistic health, celebrities, multicultural, environmental, religious, adventure, entertainment, events, health/fitness, performing arts, travel, medicine, technology, alternative healing processes. Interested in coverage on environmental issues, genetically altered foods, photos of "anything from Sufi Dancers to Zen Masters." Model/property release required. Photo captions required; include photographer's name, subject's name, and description of content.

SPECS Uses color and b&w photos. Accepts images in digital format. Send via ZIP, e-mail as JPEG files at 300 dpi.

MAKING CONTACT & TERMS Send query letter with photocopies and/or tearsheets, or e-mail samples with cover letter. Provide résumé, business card or self-promotion piece to be kept on file for possible future assignments. Pays in copies, byline with contact info (phone number, e-mail address published if photographer agrees).

⊙ ⊙ ⊙ CATHOLIC SENTINEL

P.O. Box 18030, Portland OR 97218. (503)281-1191 or (800)548-8749. **E-mail:** sentinel@catholicsentinel.org. **E-mail:** bobp@ocp.org. **Website:** www.sentinel.org. **Contact:** Robert Pfohman, editor. Estab. 1870. Circ. 8,000. Weekly. "We are the newspaper for the Catholic community in Oregon." Sample copies available with SASE. Photo guidelines available via e-mail.

NEEDS Buys 15 photos from freelancers/issue; 800 photos/year. Needs photos of religious and political subjects. Interested in seasonal. Model/property release preferred. Photo captions required; include names of people shown in photos, spelled correctly.

SPECS Prefers images in digital format. Send via e-mail or FTP as TIFF or JPEG files at 300 dpi. Also uses 5×7 glossy or matte color and b&w prints; 35mm 2×2, 4×5, 8×10 transparencies.

MAKING CONTACT & TERMS Send query letter with résumé and tearsheets. Portfolio may be dropped off every Thursday. Keeps samples on file. Responds only if interested; send nonreturnable samples. Simultaneous submissions and previously published work

OK. Pays on publication or on receipt of photographer's invoice. Credit line given. Buys first rights and electronic rights.

TIPS "We use photos to illustrate editorial material, so all photography is on assignment. Basic knowledge of Catholic Church (e.g., don't climb on the altar) is a big plus. Send accurately spelled cutlines. Prefer images in digital format."

CHILDREN'S DEFENSE FUND

25 E St. NW, Washington DC 20001. (800)233-1200. **E-mail:** cdfinfo@childrensdefense.org. **Website:** www.childrensdefense.org. Children's advocacy organization.

NEEDS Buys 20 photos/year. Buys stock and assigns work. Wants to see photos of children of all ages and ethnicity—serious, playful, poor, middle class, school setting, home setting and health setting. Subjects include babies/children/teens, families, education, health/fitness/beauty. Some location work. Domestic photos only. Model/property release required.

SPECS Uses b&w and some color prints. Accepts images in digital format. Send via e-mail as TIFF, EPS, JPEG files at 300 dpi or better.

MAKING CONTACT & TERMS Provide résumé, business card, self-promotion piece or tearsheets to be kept on file for possible future assignments. Keeps photocopy samples on file. Previously published work OK. Pays on usage. Credit line given. Buys one-time rights; occasionally buys all rights.

TIPS Looks for "good, clear focus, nice composition, variety of settings and good expressions on faces."

THE CHURCH OF ENGLAND NEWSPAPER

14 Great College St., London SW1P 3RX, United Kingdom. 44 20 7222 8700. **E-mail:** cen@churchnewspaper.com; colin.blakely@churchnewspaper.com. **Website:** www.churchnewspaper.com. **Contact:** Colin Blakely, editor; Peter May, graphic designer. Estab. 1828. Circ. 12,000. Weekly religious newspaper. Sample copies available.

NEEDS Buys 2-3 photos from freelancers/issue; 100 photos/year. Needs political photos. Reviews photos with or without a manuscript. Photo captions required.

SPECS Uses glossy color prints; 35mm transparencies.

MAKING CONTACT & TERMS Does not keep samples on file; include SASE for return of material. Responds only if interested; send nonreturnable samples. Pays on publication. Credit line given. Buys one-right rights.

THE CLARION-LEDGER

P.O. Box 40, Jackson MS 39205. (601)961-7000; (601)7175; (877)850-5343. **E-mail:** btolley@jackson.gannett.com. **Website:** www.clarionledger.com. **Contact:** Brian Tolley, executive editor. Circ. 95,000. Daily. Emphasizes photojournalism: news, sports, features, fashion, food and portraits. Readers are in a very broad age range of 18-70 years, male and female. Sample copies available.

NEEDS Buys 1-5 photos from freelancers/issue; 365-1,825 photos/year. Needs news, sports, features, portraits, fashion and food photos. Special photo needs include food and fashion. Model release required. Photo captions required.

SPECS Uses 8×10 matte b&w and color prints; 35mm slides/color negatives. Accepts images in digital format. Send via CD, e-mail as JPEG files at 200 dpi.

MAKING CONTACT & TERMS Provide résumé, business card, brochure, flyer or tearsheets to be kept on file for possible future assignments. Pays on publication. Credit line given. Buys one-time or all rights; negotiable.

FULTON COUNTY DAILY REPORT

190 Pryor St. SW, Atlanta GA 30303. (404)521-1227. **Fax:** (404)659-4739. **E-mail:** jbennitt@alm.com. **Website:** www.dailyreportonline.com. **Contact:** Jason R. Bennitt, art director. Daily (5 times/week). Emphasizes legal news and business. Readers are male and female professionals, age 25+, involved in legal field, court system, legislature, etc. Sample copy available for $2 with 9¾×12¾ SASE and 6 first-class stamps.

NEEDS Buys 2–4 photos from freelancers or wire per week; 100-200 photos/year. Needs informal environmental photographs of lawyers, judges and others involved in legal news and business. Some real estate, etc. Photo captions preferred; include complete name of subject and date shot, along with other pertinent information. Two or more people should be identified from left to right.

SPECS Accepts images in digital format. Send via CD or e-mail as JPEG files at 200–600 dpi.

MAKING CONTACT & TERMS Submit portfolio for review. Mail or e-mail samples. Keeps samples on file. Simultaneous submissions and previously pub-

lished work OK. "Freelance work generally done on an assignment-only basis." Pays $75–125 for color cover; $50–75 for color inside. Credit line given.

TIPS Wants to see ability with "casual, environmental portraiture, people—especially in office settings, urban environment, courtrooms, etc.—and photojournalistic coverage of people in law or courtroom settings." In general, needs "competent, fast freelancers from time to time around the state of Georgia who can be called in at the last minute. We keep a list of them for reference. Good work keeps you on the list." Recommends that "when shooting for *FCDR*, it's best to avoid law-book-type photos if possible, along with other overused legal clichés."

⊙ ⑤ ◑ GRAND RAPIDS BUSINESS JOURNAL

549 Ottawa Ave. NW, Suite 201, Grand Rapids MI 49503-1444. (616)459-4545. **Fax:** (616)459-4800. **E-mail:** editorial@grbj.com. **Website:** www.grbj.com. Estab. 1983. Circ. 6,000. Weekly tabloid. Emphasizes West Michigan business community. Sample copy available for $1.

NEEDS Buys 5–10 photos from freelancers/issue; 520 photos/year. Needs photos of local community, manufacturing, world trade, stock market, etc. Model/property release required. Photo captions required.

MAKING CONTACT & TERMS Send query letter with résumé of credits, stock list. Responds in 1 month. Simultaneous submissions and previously published work OK. Pays on publication. Credit line given. Buys one-time rights and first North American serial rights; negotiable.

◐ ⑤ ◑ THE LAWYERS WEEKLY

123 Commerce Valley Dr. E., Suite 700, Markham ON L3T 7W8, Canada. (905)479-2665; (800)668-6481. **Fax:** (905)479-3758. **E-mail:** robert.kelly@lexisnexis.ca. **Website:** www.thelawyersweekly.ca. **Contact:** Rob Kelly, editor-in-chief. Estab. 1983. Circ. 20,300.

NEEDS Uses 12-20 photos/issue; 5 supplied by freelancers. Needs head shots of lawyers and judges mentioned in stories, as well as photos of legal events.

SPECS Accepts images in digital format. Send as JPEG, TIFF files.

MAKING CONTACT & TERMS Provide résumé, business card, brochure, flyer or tearsheets to be kept on file for possible future assignments. Deadlines: 1- to 2-day turnaround time. Does not keep samples on file; include SASE for return of material. Responds

only when interested. **Pays on acceptance.** Credit line not given.

TIPS "We need photographers across Canada to shoot lawyers and judges on an as-needed basis. Send a résumé, and we will keep your name on file. Mostly b&w work."

⑤ ⊚ ◑ THE LOG NEWSPAPER

17782 Cowan, Suite C, Irvine CA 92614. (949)660-6150. **Fax:** (949)660-6172. **E-mail:** eston@thelog.com. **Website:** www.thelog.com. **Contact:** Eston Ellis, editor. Estab. 1971. Circ. 41,018.

NEEDS Buys 5-10 photos from freelancers/issue; 130-260 photos/year. Needs photos of marine-related, recreational sailing/powerboating in Southern California. Photo captions required; include location, name and type of boat, owner's name, race description if applicable.

SPECS Accepts images in digital format. Send via e-mail as TIFF, EPS, JPEG files at 300 dpi or greater.

MAKING CONTACT & TERMS Simultaneous submissions and previously published work OK. Pays on publication. Credit line given. Buys all rights; negotiable.

TIPS "We want timely and newsworthy photographs! We always need photographs of people enjoying boating, especially power boating. 95% of our images are of California subjects."

⑤ NATIONAL MASTERS NEWS

P.O. Box 1117, Orangevale CA 95662. (916)989-6667. **E-mail:** nminfo@nationalmastersnews.com. **Website:** www.nationalmastersnews.com. **Contact:** Randy Sturgeon. Estab. 1977. Circ. 8,000. Monthly tabloid. Official world and U.S. publication for Masters (ages 30 and over) track and field, long distance running, and race walking.

NEEDS Uses 25 photos/issue; 30% assigned and 70% from freelance stock. Needs photos of Masters athletes (men and women over age 30) competing in track and field events, long distance running races or race-walking competitions. Photo captions required.

MAKING CONTACT & TERMS Send photos digitally by e-mail for consideration. Responds in 1 month. Simultaneous submissions and previously published work OK. Pays on publication. Credit line given. Buys one-time rights.

THE NEW YORK TIMES ON THE WEB

620 Eighth Ave., New York NY 10018. **E-mail:** nytnews@nytimes.com. **E-mail:** executive-editor@ny

times.com. **Website:** www.nytimes.com. Circ. 1.3 million. Daily newspaper. "Covers breaking news and general interest." Sample copy available with SASE or online.

NEEDS Photos of celebrities, architecture, cities/urban, gardening, interiors/decorating, industry, medicine, military, political, product shots/still life, science, technology/computers, disasters, environmental, landscapes/scenics, wildlife, automobiles, entertainment, events, food/drink, health/fitness/beauty, hobbies, performing arts, sports, travel, alternative process, avant garde, documentary, fashion/glamour, fine art, breaking news. Model release required. Photo captions required.

SPECS Accepts images in digital format. Send via CD, e-mail as TIFF, JPEG files.

MAKING CONTACT & TERMS E-mail query letter with link to photographer's website. Provide business card, self-promotion piece to be kept on file for possible future assignments. Simultaneous submissions OK. Pays on publication. Credit line given. Buys one-time rights and electronic rights.

🚫 ☺ ◐ STREETPEOPLES WEEKLY NEWS

P.O. Box 270942, Dallas TX 75227-0942. **E-mail:** sw_n@yahoo.com. **Contact:** Lon G. Dorsey, Jr., publisher. Estab. 1977. Sample copy no longer available temporarily. "Seeking help to launch homeless television show and photo gallery."

💬 Photographers needed in every metropolitan city in the U.S.

NEEDS Photos of babies/children/teens, celebrities, couples, multicultural, families, parents, senior citizens, cities/urban, education, pets, religious, rural, events, food/drink, health/fitness, hobbies, humor, political, technology/computers. Interested in alternative process, documentary, fine art, historical/vintage, seasonal. Subjects include: photojournalism on homeless or street people. Model/property release required. "All photos *must* be accompanied by *signed* model releases." Photo captions required.

SPECS Accepts images in digital format. Send via CD, e-mail as GIF, JPEG files. "Items to be considered for publishing must be in PDF from a *SWNews*-certified photographer. Write first to gain certification with publisher."

MAKING CONTACT & TERMS "Hundreds of photographers are needed to show national state of America's homeless." Do not send unsolicited materials. Responds promptly. Pay scale information provided to *SWNews*-certified photographers. Pays extra for electronic usage (negotiable). Pays on acceptance or publication. Credit line sometimes given. Buys all rights; negotiable.

🚫 ◐ SUN

9801 Gulf Dr., P.O. Box 1189, Boca Raton FL 34216. (941)778-3986. **Fax:** (941)778-6988. **E-mail:** news@amisunmag.com. Weekly tabloid. Readers are housewives, college students, middle Americans. Sample copy free with extra-large SASE.

NEEDS Buys 30 photos from freelancers/issue; 1,560 photos/year. Wants varied subjects: prophesies and predictions, amazing sightings (e.g., Jesus, Elvis, angels), stunts, unusual pets, health remedies, offbeat medical, human interest, inventions, spectacular sports action; offbeat pix and stories; and celebrity photos. "We are always in need of interesting, offbeat, humorous stand-alone pics." Model release preferred. Photo captions preferred.

SPECS Uses 8×10 b&w prints; 35mm transparencies. Accepts images in digital format.

MAKING CONTACT & TERMS Send query letter with stock list and samples. Responds in 2 weeks. Simultaneous submissions and previously published work OK. Pays on publication. Buys one-time rights.

TIPS "We are specifically looking for the unusual, offbeat, freakish true stories and photos. *Nothing* is too far out for consideration. We suggest you send for a sample copy and take it from there."

🌀 🚫 ◐ THE SUNDAY POST

2 Albert Square, Dundee DD1 9QJ, Scotland. (44)(1382)223131. **E-mail:** mail@sundaypost.com. **Website:** www.sundaypost.com. Estab. 1919. Circ. 328,129. Readership 901,000. Weekly family newspaper.

NEEDS Photos of "UK news and news involving Scots," sports. Other specific needs: exclusive news pictures from the UK, especially Scotland. Reviews photos with accompanying manuscript only. Model/property release preferred. Photo captions required; include contact details, subjects, date. "Save in the caption field of the file info metadata so they can be viewed on our picture desk system. Mac users should ensure attachments are PC-compatible as we use PCs."

SPECS Prefers images in digital format. Send via e-mail as JPEG files. "We need a minimum 11MB file

saved at quality level 9/70% or above, ideally at 200 ppi/dpi."

MAKING CONTACT & TERMS Send query letter with tearsheets, stock list. Does not keep samples on file; include SASE for return of material. Responds in 2 weeks to queries. Simultaneous submissions OK. Pays $150 (USD) for b&w or color cover; $100 (USD) for b&w or color inside. Pays on publication. Credit line not given. Buys single use, all editions, one date, worldwide rights; negotiable.

TIPS "Offer pictures by e-mail before sending: lo-res only, please—72 ppi, 800 pixels on the widest side; no more than 10 at a time. Make sure the daily papers aren't running the story first and that it's not being covered by the Press Association (PA). We get their pictures on our contracted feed."

SYRACUSE NEW TIMES

Alltimes Publishing, LLC, 1415 W. Genesee St., Syracuse NY 13204. **E-mail:** ldietrich@syracusenew times.com. **E-mail:** editorial@syracusenewtimes. com. **Website:** www.syracusenewtimes.com. **Contact:** Larry Dietrich. Estab. 1969. Circ. 40,000. *"Syracuse New Times is an alternative weekly that is topical, provocative, irreverent, and intensely local."* 50% freelance written. Publishes ms an average of 1 month after acceptance. Submit seasonal material 3 months in advance. Sample copy available with 8×10 SASE.

NEEDS Photos of performing arts. Interested in alternative process, fine art, seasonal. Reviews photos with or without a manuscript. Model/property release required. Photo captions required; include names of subjects.

SPECS Uses 5×7 b&w prints; 35mm transparencies.

MAKING CONTACT & TERMS Send query letter with résumé, stock list. Does not keep samples on file; include SASE for return of material. Responds in 6 weeks. Responds only if interested; send nonreturnable samples. Previously published work OK. Pays on publication. Credit line given. Buys one-time rights.

TIPS "Realize the editor is busy and responds as promptly as possible."

☼ ⑤⑤ TORONTO SUN PUBLISHING

333 King St. E., Toronto ON M5A 3X5, Canada. (416)947-2399. **Fax:** (416)947-1664. **E-mail:** kevin. hann@sunmedia.ca. **E-mail:** torsun.photoeditor@ sunmedia.ca. **Website:** www.torontosun.com. **Contact:** Kevin Hann, deputy editor. Estab. 1971. Circ.

180,000. Daily. Emphasizes sports, news and entertainment. Sample copy free with SASE.

NEEDS Uses 30–50 photos/issue; occasionally uses freelancers (spot news pics only). Needs photos of Toronto personalities making news out of town. Also disasters, beauty, sports, fashion/glamour. Reviews photos with or without a manuscript. Photo captions preferred.

SPECS Accepts images in digital format. Send via CD or e-mail.

MAKING CONTACT & TERMS Arrange a personal interview to show portfolio. Send any size color prints; 35mm transparencies; press link digital format. Deadline: 11 p.m. daily. Does not keep samples on file. Responds in 1–2 weeks. Simultaneous submissions and previously published work OK. Pays on publication. Credit line given. Buys one-time and other negotiated rights.

TIPS "The squeaky wheel gets the grease when it delivers the goods. Don't try to oversell a questionable photo. Return calls promptly."

VENTURA COUNTY REPORTER

700 E. Main St., Ventura CA 93001. (805)648-2244. **E-mail:** editor@vcreporter.com. **Website:** www.vcre porter.com. art director (artdirector@vcreporter. com). **Contact:** Michael Sullivan, editor. Circ. 35,000. Weekly tabloid covering local news (entertainment and environment).

NEEDS Uses 12-14 photos/issue; 40-45% supplied by freelancers. "We require locally slanted photos (Ventura County CA)." Model release required.

SPECS Accepts images in digital format. Send via e-mail or CD.

MAKING CONTACT & TERMS Send sample b&w or color original photos; include SASE for return of material. Simultaneous submissions OK. Pays on publication. Credit line given. Buys one-time rights.

⑤ WATERTOWN PUBLIC OPINION

120 Third Ave. NW, P.O. Box 10, Watertown SD 57201. (605)886-6901. **Fax:** (605)886-4280. **E-mail:** maryt@ thepublicopinion.com; rogerwhittle@thepublicopin ion.com. **Website:** www.thepublicopinion.com. **Contact:** Mary Tuff, editorial assistant; Roger Whittle, managing editor. Estab. 1887. Circ. 15,000. Daily. Emphasizes general news of the region; state, national and international news.

NEEDS Uses up to 8 photos/issue. Reviews photos with or without a manuscript. Model release required. Photo captions required.

SPECS Uses b&w or color prints. Accepts images in digital format. Send via CD.

MAKING CONTACT & TERMS Send unsolicited photos by mail for consideration. Does not keep samples on file; include SASE for return of material. Responds in 1-2 weeks. Simultaneous submissions OK. Pays on publication. Credit line given. Buys one-time rights; negotiable.

⟳ ⑤ ◑ THE WESTERN PRODUCER

P.O. Box 2500, 2310 Millar Ave., Saskatoon SK S7K 2C4, Canada. (306)665-3544. **Fax:** (306)934-2401. **E-mail:** newsroom@producer.com. **Website:** www.producer.com. Estab. 1923. Circ. 48,000. Weekly. Emphasizes agriculture and rural living in western Canada.

NEEDS Photos of various farm situations with people engaged in some activity—reparing equipment, feeding livestock, enjoying leisure time on the farm, etc., or of animals in natural behavior; are more appealing than horizons, antiques or derelict buildings.

SPECS Photos must be current (taken within the last month). Submissions should include as much cutline information as possible—who, what, where, when and why. Include the date when the picture was taken. Accepts digital images, at 200 dpi and at least 2MB. Save images in JPEG format. Send digital images to newsroom@producer.com. Photo guidelines mailed or e-mailed.

MAKING CONTACT & TERMS Address submissions sent by mail to the attention of the news editor; include SASE for return of material. Previously published work OK, but must let producer know. Pays on publication. Credit line given. Buys one–time rights.

TRADE PUBLICATIONS

//

Most trade publications are directed toward the business community in an effort to keep readers abreast of the ever-changing trends and events in their specific professions. For photographers, shooting for these publications can be financially rewarding and can serve as a stepping stone toward acquiring future assignments.

As often happens with this category, the number of trade publications produced increases or decreases as professions develop or deteriorate. In recent years, for example, magazines involving new technology have flourished as the technology continues to grow and change.

Trade publication readers are usually very knowledgeable about their businesses or professions. The editors and photo editors, too, are often experts in their particular fields. So, with both the readers and the publications' staffs, you are dealing with a much more discriminating audience. To be taken seriously, your photos must not be merely technically good pictures, but also should communicate a solid understanding of the subject and reveal greater insights.

In particular, photographers who can communicate their knowledge in both verbal and visual form will often find their work more in demand. If you have such expertise, you may wish to query about submitting a photo/text package that highlights a unique aspect of working in a particular profession or that deals with a current issue of interest to that field.

Many photos purchased by these publications come from stock—both freelance inventories and stock photo agencies. Generally, these publications are more conservative with their freelance budgets and use stock as an economical alternative. For this reason, some listings in this section will advise sending a stock list as an initial method of contact. (See

sample stock list in "Running Your Business.") Some of the more established publications with larger circulations and advertising bases will sometimes offer assignments as they become familiar with a particular photographer's work. For the most part, though, stock remains the primary means of breaking in and doing business with this market.

⑤ ⬤ ◑ AAP NEWS

141 Northwest Point Blvd., Elk Grove Village IL 60007. (847)434-4755. **Fax:** (847)434-8000. **E-mail:** mhayes@aap.org. **Website:** www.aapnews.org. **Contact:** Michael Hayes, art director/production coordinator. Estab. 1985. Monthly tabloid newspaper. Publication of American Academy of Pediatrics.

NEEDS Uses 60 photos/year. Needs photos of babies/children/teens, families, health/fitness, sports, travel, medicine, pediatricians, health care providers—news magazine style. Interested in documentary. Model/property release required as needed. Photo captions required; include names, dates, locations and explanations of situations.

SPECS Accepts images in digital format. Send via CD or e-mail as TIFF, EPS or JPEG files at 300 dpi.

MAKING CONTACT & TERMS Provide résumé, business card or tearsheets to be kept on file (for 1 year) for possible future assignments. Cannot return material. Simultaneous submissions and previously published work OK. Pays $50–150 for one-time use of photo. Pays on publication. Buys one-time or all rights; negotiable.

TIPS "We want great photos of real children in real-life situations—the more diverse the better."

⑤⑤⑤ ⬤ ABA BANKING JOURNAL

Simmons-Boardman Publishing Corp., 55 Broad St. 26th Floor, New York NY 10004. (212)620-7200. **E-mail:** scocheo@sbpub.com; wwilliams@sbpub.com. **Website:** www.ababj.com. **Contact:** Steve Cocheo, executive editor; Wendy Williams, art director. Estab. 1909. Circ. 30,000. Monthly magazine. Emphasizes "how to manage a bank better. Bankers read it to find out how to keep up with changes in regulations, lending practices, investments, technology, marketing and what other bankers are doing to increase community standing."

NEEDS Buys 6 photos/year; freelance photography is 20% assigned, 80% from stock. Personality, and occasionally photos of unusual bank displays or equipment. "We need candid photos of various bankers who are subjects of articles." Photos purchased with accompanying ms or on assignment.

SPECS Uses 35mm transparencies. Accepts images in digital format. Send via CD, e-mail as CMYK JPEG files at 300 dpi.

MAKING CONTACT & TERMS Send query letter with samples, postcards; include SASE for return

of material. Responds in 1 month. Pays $400-1,500/photo. **Pays on acceptance.** Credit line given. Buys one-time rights.

TIPS "Send postcard. We hire by location, city."

ACRES U.S.A.

P.O. Box 301209, Austin TX 78703. (512)892-4400. **Fax:** (512)892-4448. **E-mail:** editor@acresusa.com. **Website:** www.acresusa.com. Estab. 1970. Circ. 18,000. "Monthly trade journal written by people who have a sincere interest in the principles of organic and sustainable agriculture."

SPECS Reviews GIF/JPEG/TIFF files.

MAKING CONTACT & TERMS Captions, identification of subjects required. Negotiates payment individually. Buys one-time rights.

AG WEEKLY

Lee Agri-Media, P.O. Box 918, Bismarck ND 58501. (701)255-4905. **Fax:** (701)255-2312. **E-mail:** mark.conlon@lee.net. **Website:** www.agweekly.com. **Contact:** Mark Conlon, editor. Circ. 12,402. *Ag Weekly* is an agricultural publication covering production, markets, regulation, politics.

SPECS Reviews GIF/JPEG files.

MAKING CONTACT & TERMS Captions required. Offers $10/photo. Buys one-time rights.

⬤ AMERICAN BAR ASSOCIATION JOURNAL

321 N. Clark St., 20th Floor, Chicago IL 60654. (312)988-5822. **E-mail:** debora.clark@americanbar.org. **Website:** www.abajournal.com. **Contact:** Debora Clark, deputy design director. Estab. 1915. Circ. 330,000. Monthly membership magazine of the American Bar Association. Emphasizes law and the legal profession. Readers are lawyers. Photo guidelines available.

NEEDS Buys 50 photos and illustrations/graphics from freelancers/issue; 1,00 photos/illustrations and graphics per year. Needs vary; mainly shots of lawyers and clients by assignment only.

SPECS Prefers digital images sent as TIFF files at 300 dpi.

MAKING CONTACT & TERMS "Send us your website address to view samples." Cannot return unsolicited material. Payment negotiable. Credit line given. Buys first-time world-wide rights.

TIPS "No phone calls! The *ABA Journal* does not hire beginners."

AMERICAN BEE JOURNAL

51 S. Second St., Hamilton IL 62341. (217)847-3324. **Fax:** (217)847-3660. **E-mail:** editor@americanbeejournal.com. **Website:** www.americanbeejournal.com. **Contact:** Joe B. Graham, editor. Estab. 1861. Circ. 13,500. Monthly magazine. Emphasizes beekeeping for hobby and professional beekeepers. Sample copy free with SASE.

NEEDS Buys 1–2 photos from freelancers/issue; 12–24 photos/year. Needs photos of beekeeping and related topics, beehive products, honey and cooking with honey. Special needs include color photos of seasonal beekeeping scenes. Model release preferred. Photo captions preferred.

MAKING CONTACT & TERMS Send query e-mail with samples. Send thumbnail samples to e-mail. Send 5×7 or 8½×11 color prints by mail for consideration; include SASE for return of material. Responds in 2 weeks. Pays on publication. Credit line given. Buys all rights. Submission guidelines available online.

AMERICAN POWER BOAT ASSOCIATION

17640 E. Nine Mile Rd., Box 377, Eastpointe MI 48021-0377. (586)773-9700. **Fax:** (586)773-6490. **E-mail:** apbahq@apba.org. **Website:** www.apba.org. Estab. 1903. Sanctioning body for U.S. power boat racing; monthly online magazine printed quarterly. Majority of assignments made on annual basis. Photos used in monthly magazine, brochures, audiovisual presentations, press releases, programs and website.

NEEDS Photos of APBA boat racing—action and candid. Interested in documentary, historical/vintage. Photo captions or class/driver ID required.

SPECS Accepts images in digital format. Send via CD, e-mail as TIFF, EPS, JPEG files at 300 dpi.

MAKING CONTACT & TERMS Initial personal contact preferred. Suggests initial contact by e-mail; JPEG samples or link to website welcome. Responds in 2 weeks when needed. Payment varies. Standard is $25 for color cover; $15 for interior pages. Credit line given. Buys one-time rights; negotiable. Photo usage must be invoiced by photographer within the month incurred.

TIPS Prefers to see selection of shots of power boats in action or pit shots, candids, etc., (all identified). Must show ability to produce clear color action shots of racing events. "Send a few samples with e-mail, especially if related to boat racing."

ANGUS BEEF BULLETIN

Angus Productions, Inc., 3201 Frederick Ave., St. Joseph MO 64506-2997. (816)383-5270. **Fax:** (816)233-6575. **E-mail:** shermel@angusjournal.com. **Website:** www.angusbeefbulletin.com. **Contact:** Shauna Rose Hermel, editor. Estab. 1985. Circ. 65,000-70,000. Mailed free to commercial cattlemen who have purchased an Angus bull and had the registration transferred to them and to others who sign a request card.

SPECS Reviews 5×7 transparencies, 5×7 glossy prints.

MAKING CONTACT & TERMS Identification of subjects required. Offers $25/photo. Buys all rights.

ANGUS JOURNAL

Angus Productions Inc., 3201 Frederick Ave., St. Joseph MO 64506-2997. (816)383-5270. **Fax:** (816)233-6575. **E-mail:** shermel@angusjournal.com. **Website:** www.angusjournal.com. Estab. 1919. Circ. 13,500. The *Angus Journal* is the official magazine of the American Angus Association. Its primary function as such is to report to the membership association activities and information pertinent to raising Angus cattle.

SPECS Reviews 5×7 glossy prints.

MAKING CONTACT & TERMS Identification of subjects required. Offers $25-400/photo. Buys all rights.

ANIMAL SHELTERING

2100 L St. NW, Washington DC 20037. (202)452-1100. **Fax:** (301)721-6468. **E-mail:** asm@humanesociety.org. **Website:** www.animalsheltering.org. **Contact:** Shevaun Brannigan, production/marketing manager; Carrie Allan, editor. Estab. 1978. Circ. 6,000. Published 6 times a year. Magazine of The Humane Society of the United States. Magazine for animal care professionals and volunteers, dealing with animal welfare issues faced by animal shelters, animal control agencies, and rescue groups. Emphasis on news for the field and professional, hands-on work. Readers are shelter and animal control directors, kennel staff, field officers, humane investigators, animal control officers, animal rescuers, foster care volunteers, general volunteers, shelter veterinarians, and anyone concerned with local animal welfare issues. Sample copy free.

NEEDS Buys about 2–10 photos from freelancers/issue; 30 photos/year. Needs photos of pets interacting with animal control and shelter workers; animals in shelters, including farm animals and wildlife; gener-

al public visiting shelters and adopting animals; humane society work, functions, and equipment. Photo captions preferred.

SPECS Accepts color images in digital or print format. Send via CD, ZIP, e-mail as TIFF, JPEG files at 300 dpi.

MAKING CONTACT & TERMS Provide samples of work to be kept on file for possible future use or assignments; include SASE for return of material. Responds in 1 month. Pays $150 for cover; $75 for inside. Pays on publication. Credit line given. Buys one-time and electronic rights.

TIPS "We almost always need good photos of people working with animals in an animal shelter or in the field. We do not use photos of individual dogs, cats and other companion animals as often as we use photos of people working to protect, rescue or care for dogs, cats, and other companion animals. Contact us for upcoming needs."

⊖ ⊖ ◐ AOPA PILOT

421 Aviation Way, Frederick MD 21701. (301)695-2371. **Fax:** (301)695-2375. **E-mail:** pilot@aopa.org; mike.kline@aopa.org. **Website:** www.aopa.org. **Contact:** Michael Kline, design director. Estab. 1958. Circ. 400,000. Monthly association magazine. "The world's largest aviation magazine. The audience is primarily pilot and aircraft owners of General Aviation airplanes." Sample copies and photo guidelines available online.

NEEDS Buys 5–25 photos from freelancers/issue; 60–300 photos/year. Photos of couples, adventure, travel, industry, technology. Interested in documentary. Reviews photos with or without a manuscript. Model/property release preferred. Photo captions preferred.

SPECS Uses images in digital format. Send via CD, DVD as TIFF, EPS, JPEG files at 300 dpi. *AOPA Pilot* prefers original 35mm color transparencies (or larger), although high-quality color enlargements sometimes can be used if they are clear, sharp, and properly exposed. (If prints are accepted, the original negatives should be made available.) Avoid the distortion inherent in wide-angle lenses. Most of the photographs used are made with lenses in the 85mm to 135mm focal length range. Frame the picture to the focal length rather than the other way around, and avoid the use of zoom lenses unless they are of professional optical quality. Slides should be sharp and properly exposed; slower-speed films (ISO 25 to ISO 100) generally provide the best results. We are not responsible for unsolicited original photographs; send duplicate slides and keep the original until we request it.

MAKING CONTACT & TERMS Send query letter. Provide self-promotion piece to be kept on file for possible future assignments. Responds only if interested; send nonreturnable samples. Pays $800–2,000 for color cover; $200–720 for color inside. **Pays on acceptance.** Credit line given. Buys one-time, all rights; negotiable.

TIPS "A knowledge of our subject matter, airplanes, is a plus. Show range of work and not just one image."

APA MONITOR

750 First St. NE, Washington DC 20002-4242. (202)336-5500; (800)374-2721. **Website:** www.apa.org/monitor. Circ. 150,000. Monthly magazine. Emphasizes "news and features of interest to psychologists and other behavioral scientists and professionals, including legislation and agency action affecting science and health, and major issues facing psychology both as a science and a mental health profession." Sample copy available for $3 and 9×12 SASE envelope.

NEEDS Buys 60-90 photos/year. Photos purchased on assignment. Needs portraits, feature illustrations and spot news.

SPECS Prefers images in digital format; send TIFF files at 300 dpi via e-mail. Uses 5×7 and 8×10 glossy prints.

MAKING CONTACT & TERMS Arrange a personal interview to show portfolio or query with samples. Pays by the job. Pays on receipt of invoice. Credit line given. Buys first serial rights.

TIPS "Become good at developing ideas for illustrating abstract concepts and innovative approaches to clichés such as meetings and speeches. We look for quality in technical reproduction and innovative approaches to subjects."

⊖ ⊖ AQUA MAGAZINE

22 E. Mifflin St., Suite 910, Madison WI 53703. (608)249-0186. **E-mail:** scott@aquamagazine.com. **Website:** www.aquamagazine.com. **Contact:** Scott Webb, executive editor; Eric Herman, senior editor; Cailley Hammel, associate editor; Scott Maurer, art director. Estab. 1976. Circ. 15,000. Athletic Business Publications, Inc. Business publication for spa and pool professionals. Monthly magazine. "*AQUA* serves spa dealers, swimming pool dealers and/or builders, spa/swimming pool maintenance and service, casual

furniture/patio dealers, landscape architects/designers and others allied to the spa/swimming pool market. Readers are qualified owners, GM, sales directors, titled personnel."

NEEDS Photos of residential swimming pools and/or spas (hot tubs) that show all or part of pool/spa. "The images may include grills, furniture, gazebos, ponds, water features." Photo captions including architect/builder/designer preferred.

MAKING CONTACT & TERMS "OK to send promotional literature, and to e-mail contact sheets/web gallery or low-res samples, but do not send anything that has to be returned (e.g., slides, prints) unless asked for." Simultaneous submissions and previously published work OK, "but should be explained." Pays $400 for color cover (negotiable); $200 for color inside. Pays on publication. Credit line given. Buys all rights; negotiable.

TIPS Wants to see "visually arresting images, high quality, multiple angles, day/night lighting situations. Photos including people are rarely published."

🄢🄢 🄷 🄾 ARCHITECTURAL LIGHTING

One Thomas Circle NW, Suite 600, Washington DC 20005. (202)729-3647. **Fax:** (202)785-1974. **E-mail:** edonoff@hanleywood.com. **Website:** www.archlighting.com. **Contact:** Elizabeth Donoff, editor. Estab. 1981. Circ. 25,000. Published 7 times/year. Emphasizes architecture and architectural lighting. Readers are architects and lighting designers. Sample copy free.

NEEDS Buys 3-5 photos/feature story. Needs photos of architecture and architectural lighting.

SPECS Prefers images in digital format. Send via e-mail as TIFF files at 300 dpi, minimum 4×6 inches.

MAKING CONTACT & TERMS Query *first* by e-mail to obtain permission to e-mail digital samples. Keeps samples on file. Cannot return material. Responds in 1-2 weeks. Simultaneous submissions OK. Pays $300-400 for color cover; $50-125 for color inside. Pays net 40 days point of invoice submission. Credit line given. Buys all rights for all media, including electronic media.

TIPS "Looking for a strong combination of architecture and architectural lighting."

🄢 🄷 🄾 ASIAN ENTERPRISE MAGAZINE

Asian Business Ventures, Inc., P.O. Box 1126, Walnut CA 91788. (909)896-2865; (909)319-2306. **E-mail:** willyb@asianenterprise.com; alma.asianent@gmail. com;almag@asianenterprise.com. **Website:** www.asianenterprise.com. Estab. 1993. Circ. 100,000. Monthly trade magazine. "Largest Asian American small business focus magazine in U.S." Sample copy available with SASE and first-class postage. Editorial calendar available online.

NEEDS Buys 3-5 photos from freelancers/issue; 36-60 photos/year. Needs photos of multicultural, business concepts, senior citizens, environmental, architecture, cities/urban, education, travel, military, political, technology/computers. Reviews photos with or without a manuscript. Model/property release required.

SPECS Uses 4×6 matte b&w prints. Accepts images in digital format. Send via ZIP as TIFF, JPEG files at 300-700 dpi.

MAKING CONTACT & TERMS Send query letter with prints. Provide self-promotion piece to be kept on file for possible future assignments. Responds only if interested; send nonreturnable samples. Simultaneous submissions OK. Pays $50-200 for color cover; $25-100 for b&w inside. Pays on publication. Credit line given. Buys one-time rights.

🄾 THE ATA MAGAZINE

11010 142nd St. NW, Edmonton AB T5N 2R1, Canada. (780)447-9400. **Fax:** (780)455-6481. **E-mail:** government@teachers.ab.ca. **Website:** www.teachers.ab.ca. Estab. 1920. Circ. 42,100. Quarterly magazine covering education.

SPECS Reviews 4×6 prints.

MAKING CONTACT & TERMS Captions required. Negotiates payment individually. Negotiates rights.

🄢🄢 ATHLETIC BUSINESS

Athletic Business Media, Inc., 22 E. Mifflin St., Suite 910, Madison WI 53703. (800)722-8764, x119. **Fax:** (608)249-1153. **E-mail:** editors@athleticbusiness.com. **Website:** www.athleticbusiness.com. **Contact:** Sadye Ring, graphic designer. Estab. 1977. Circ. 42,000. The leading resource for athletic, fitness and recreation professionals. Monthly magazine. Emphasizes athletics, fitness and recreation. Readers are athletic, park and recreational directors and club managers, ages 30-65. Sample copy available for $8. The magazine can also be viewed digitally at www.athleticbusiness.com. Become a fan on Facebook or LinkedIn.

NEEDS Buys 2-3 photos from freelancers per issue; 24-26 photos/year. Needs photos of college and high school team sports, coaches, athletic equipment, rec-

reational parks, and health club/multi-sport interiors." Model/property release preferred. Photo captions preferred.

MAKING CONTACT & TERMS Use online e-mail to contact. "Feel free to send promotional literature, but do not send anything that has to be returned (e.g., slides, prints) unless asked for." Simultaneous submissions and previously published work OK, "but should be explained." Pays $300 for color cover (negotiable); $100 for color inside. Pays on publication. Credit line given. Buys all rights; negotiable.

TIPS Wants to see "visually arresting images, ability with subject and high quality photography." To break in, "shoot a quality and creative shot (that is part of our market) from more than one angle and at different depths."

ATHLETIC MANAGEMENT

20 East Lake Road, Ithaca NY 14850-9785. (607)257-6970. **Fax:** (607)257-7328. **E-mail:** ef@momentum media.com. **Website:** www.athleticmanagement.com. **Contact:** Eleanor Frankel, editor-in-chief. Estab. 1989. Circ. 30,000. Bimonthly magazine. Emphasizes the management of athletics. Readers are managers of high school and college athletic programs.

NEEDS Uses 10–20 photos/issue; 50% supplied by freelancers. Needs photos of athletic events and athletic equipment/facility shots; college and high school sports action photos. Model release preferred.

MAKING CONTACT & TERMS Previously published work OK. Pays on publication. Credit line given. Buys first North American serial rights; negotiable.

AUTOINC.

Automotive Service Association, P.O. Box 929, Bedford TX 76095-0929. (800)272-7467. **Fax:** (817)685-0225. **E-mail:** editor@asashop.org. **Website:** www. autoinc.org. Estab. 1952. Circ. 14,000. The mission of *AutoInc.*, ASA's official publication, is to be the informational authority for ASA and industry members nationwide. Its purpose is to enhance the professionalism of these members through management, technical and legislative articles, researched and written with the highest regard for accuracy, quality, and integrity.

SPECS Reviews 2×3 transparencies, 3×5 prints, high resolution digital images.

MAKING CONTACT & TERMS Captions, identification of subjects, model releases required. Negoti-

ates payment individually. Buys one-time and electronic rights.

AUTOMATED BUILDER

CMN Associates, Inc., 2401 Grapevine Dr., Oxnard CA 93036. (805)351-5931. **Fax:** (805)351-5755. **E-mail:** cms03@pacbell.net. **Website:** www.automatedbuilder. com. **Contact:** Don O. Carlson, editor/publisher. Estab. 1964. Circ. 75,000 when printed. Published bimonthly on the Internet. Emphasizes home, apartment and commercial in-plant construction. Readers are in-plant and site builders plus dealers of all types of homes, apartments and commercial buildings. Each *Automated Builder* has 2 segments, In-Plant Builders and Home and Commercial Buyers.

NEEDS In-plant and/or job site construction photos with the stories. Reviews photos purchased with accompany manuscripts only.

SPECS Photos may be glossies or disks.

AUTOMOTIVE NEWS

1155 Gratiot Ave., Detroit MI 48207-2997. (313)446-0371. **E-mail:** rjohnson@crain.com. **Website:** www. autonews.com. **Contact:** Richard Johnson, managing editor. Estab. 1926. Circ. 77,000. Weekly tabloid. Emphasizes the global automotive industry. Readers are automotive industry executives, including people in manufacturing and retail. Sample copies available.

NEEDS Buys 5 photos from freelancers/issue; 260 photos/year. Needs photos of automotive executives (environmental portraits), auto plants, new vehicles, auto dealer features. Photo captions required; include identification of individuals and event details.

SPECS Uses 8×10 color prints; 35mm, 2¼×2¼, 4×5 transparencies. Accepts images in digital format. Send as JPEG files at 300 dpi (at least 6 inches wide).

MAKING CONTACT & TERMS Send unsolicited photos by mail with SASE for consideration. Provide résumé, business card, brochure, flyer or tearsheets to be kept on file for possible future assignments. Keeps samples on file. Responds in 2 weeks. Simultaneous submissions and previously published work OK. Pays on publication. Credit line given. Buys one-time rights, possible secondary rights for other Crain publications.

AUTO RESTORER

BowTie, Inc., P.O. Box 57900, Los Angeles CA 90057. (213)385-2222. **Fax:** (213)385-8565. **E-mail:** tkade@ bowtieinc.com. **Website:** www.autorestorermaga zine.com. **Contact:** Ted Kade, editor. Estab. 1989. Circ.

60,000. Offers no additional payment for photos accepted with ms. "Interview the owner of a restored car. Present advice to others on how to do a similar restoration. Seek advice from experts. Go light on history and nonspecific details. Make it something that the magazine regularly uses. Do automotive how-tos."
NEEDS Photos of auto restoration projects and restored cars.
SPECS Prefers images in high-res digital format. Send via CD at 240 dpi with minimum width of 5". Uses transparencies, mostly 35mm, 2¼×2¼.
MAKING CONTACT & TERMS Submit inquiry and portfolio for review. Provide résumé, business card, brochure, flyer or tearsheets to be kept on file for possible future assignments. Responds in 1 month. Simultaneous submissions OK.

AVIONICS MAGAZINE

(310) 354-1820. **E-mail:** efeliz@accessintel.com. **Website:** www.avionicsmagazine.com. **Contact:** Emily Feliz, editor-in-chief. Estab. 1978. Circ. 20,000. Monthly magazine. Emphasizes aviation electronics. Readers are avionics and air traffic management engineers, technicians, executives. Sample copy free with 9×12 SASE.
NEEDS Buys 1–2 photos from freelancers/issue; 12–24 photos/year. Needs photos of travel, business concepts, industry, technology, aviation. Interested in alternative process, avant garde. Reviews photos with or without a manuscript. Photo captions required.
SPECS Prefers images in digital format. Send as JPEG files at 300 dpi minimum.
MAKING CONTACT & TERMS Query by e-mail. Provide résumé, business card, brochure, flyer or tearsheets to be kept on file for possible future assignments. Simultaneous submissions OK. Responds in 2 months. Pay varies; negotiable. **Pays on acceptance.** Credit line given. Rights negotiable.

BALLINGER PUBLISHING

41 N. Jefferson St., Suite 402, Pensacola FL 32502. (850)433-1166. **E-mail:** rita@ballingerpublishing.com. **Website:** www.ballingerpublishing.com. **Contact:** Rita Laymon, art director. Estab. 1990. Circ. 15,000. Monthly magazines. Emphasize business, lifestyle. Readers are executives, ages 35-54, with average annual income of $80,000. Sample copy available for $1.
NEEDS Photos of Florida topics: technology, government, ecology, global trade, finance, travel, regional

and life shots. Model/property release required. Photo captions preferred.
SPECS Uses 5×7 b&w and color prints; 35mm. Prefers images in digital format. Send via CD, ZIP as TIFF, EPS files at 300 dpi.
MAKING CONTACT & TERMS Send unsolicited photos by mail or e-mail for consideration; include SASE for return of material sent by mail. Provide résumé, business card, brochure, flyer or tearsheets to be kept on file for possible future assignments. Pays on publication. Buys one-time rights.

BARTENDER MAGAZINE

Foley Publishing, P.O. Box 158, Liberty Corner NJ 07938. (908)766-6006. **Fax:** (908)766-6607. **E-mail:** barmag@aol.com. **Website:** www.bartender.com. **Contact:** Jackie Foley, editor. Estab. 1979. Circ. 150,000. Magazine published 4 times/year. *Bartender Magazine* serves full-service drinking establishments (full-service means able to serve liquor, beer and wine). "We serve single locations, including individual restaurants, hotels, motels, bars, taverns, lounges and all other full-service on-premises licensees." Sample copy available for $2.50. Number of photos/issue varies; number supplied by freelancers varies. Reviews photos with or without a ms.
NEEDS Photos of liquor-related topics, drinks, bars/bartenders
MAKING CONTACT & TERMS Model/property release required. Photo captions preferred. Provide résumé, business card, brochure, flyer or tearsheets to be kept on file for possible future assignments; include SASE for return of material. Previously published work OK. Payment negotiable. Pays on publication. Credit line given. Buys all rights; negotiable.

BEDTIMES

501 Wythe St., Alexandria VA 22314-1917. (571)482-5442. **Fax:** (703)683-4503. **E-mail:** jpalm@sleep products.org. **Website:** www.bedtimesmagazine. com. **Contact:** Julie Palm, editor-in-chief. Estab. 1917. Monthly association magazine; 40% of readership is overseas. Readers are manufacturers and suppliers in bedding industry. Sample copies available.
NEEDS Head shots, events, product shots/still life, conventions, shows, annual meetings. Reviews photos with or without a manuscript. Photo captions required; include correct spelling of name, title, company, return address for photos.
SPECS Prefers digital images sent as JPEGs via e-mail.

MAKING CONTACT & TERMS Send query letter with résumé, photocopies. Responds in 3 weeks to queries. Simultaneous submissions and previously published work may be OK—depends on type of assignment. Pays on publication. Credit line given. Buys one-time rights; negotiable.

BEE CULTURE

P.O. Box 706, Medina OH 44256-0706. **Fax:** (330)725-5624. **E-mail:** kim@beeculture.com. **Website:** www.beeculture.com. **Contact:** Mr. Kim Flottum, editor. Estab. 1873. Monthly trade magazine emphasizing beekeeping industry—how-to, politics, news and events. Sample copies available. Photo guidelines available on website. Buys 1-2 photos from freelancers/issue; 6-8 photos/year.

NEEDS Photos of honey bees and beekeeping, honey bees on flowers, etc.

SPECS Send via e-mail as TIFF, EPS, JPEG files at 300 dpi. Low-res for review encouraged.

MAKING CONTACT & TERMS Reviews photos with or without a manuscript. Accepts images in digital format. Does not keep samples on file; include SASE for return of material. E-mail contact preferred. Responds in 2 weeks to queries. Payment negotiable. **Pays on acceptance.** Credit line given.

TIPS "Read 2-3 issues for layout and topics. Think in vertical!"

BEEF TODAY

P.O. Box 958, Mexico MO 65265. (210)957-4474. E-mail: kwatson@farmjournal.com. **Website:** www.agweb.com. **Contact:** Kim Watson Potts, editor. Circ. 220,000. Monthly magazine. Emphasizes American agriculture. Readers are active farmers, ranchers or agribusiness people. Sample copy and photo guidelines free with SASE.

NEEDS Buys 5–10 photos from freelancers/issue; 180–240 photos/year. "We use studio-type portraiture (environmental portraits), technical, details, scenics." Wants photos of environmental, livestock (feeding transporting, worming cattle), landscapes/scenics (from different regions of the U.S.). Model release preferred. Photo captions required.

SPECS Accepts images in digital format. Send via CD or e-mail as TIFF, EPS, JPEG files, color RGB only.

MAKING CONTACT & TERMS Arrange a personal interview to show portfolio. Send query letter with résumé of credits along with business card, brochure, flyer or tearsheets to be kept on file for possible future assignments. Do not send originals! Responds in 2 weeks. Simultaneous submissions OK. Payment negotiable. "We pay a cover bonus." **Pays on acceptance.** Credit line given. Buys one-time rights.

TIPS In portfolio or samples, likes to see "about 20 slides showing photographer's use of lighting and ability to work with people. Know your intended market. Familiarize yourself with the magazine and keep abreast of how photos are used in the general magazine field."

BEVERAGE DYNAMICS

17 High St., 2nd Floor, Norwalk CT 06851. (203)855-8499. **E-mail:** ksage@specialtyim.com. **Website:** www.adamsbevgroup.com. **Contact:** Kathleen Sage, art director; Liza Zimmerman, editor. Circ. 67,000. Quarterly. Emphasizes distilled spirits, wine and beer. Readers are retailers (liquor stores, supermarkets, etc.), wholesalers, distillers, vintners, brewers, ad agencies and media.

NEEDS Uses 5-10 photos/issue. Needs photos of retailers, products, concepts and profiles. Special needs include good retail environments, interesting store settings, special effect photos. Model/property release required. Photo captions required.

MAKING CONTACT & TERMS Send query letter with samples and list of stock photo subjects. Provide business card to be kept on file for possible future assignments. Keeps samples on file; send nonreturnable samples, slides, tearsheets, etc. Simultaneous submissions OK. Pays on publication. Credit line given. Buys one-time rights or all rights.

TIPS "We're looking for good location photographers who can style their own photo shoots or have staff stylists. It also helps if they are resourceful with props."

BIZTIMES MILWAUKEE

BizTimes Media, 126 N. Jefferson St., Suite 403, Milwaukee WI 53202-6120. (414)277-8181. **Fax:** (414)277-8191. **E-mail:** shelly.tabor@biztimes.com. **Website:** www.biztimes.com. **Contact:** Shelly Tabor, art director. Estab. 1994. Circ. 13,500. Biweekly business news magazine covering southeastern Wisconsin.

NEEDS Buys 2-3 photos from freelancers/issue; 200 photos/year. Needs photos of Milwaukee, including cities/urban, business men and women, business concepts. Interested in documentary.

SPECS Uses various sizes of glossy color prints. Accepts images in digital format. Send via CD as TIFF files at 300 dpi.

MAKING CONTACT & TERMS Provide résumé, business card, self-promotion piece to be kept on file for possible future assignments. Responds only if interested; send nonreturnable samples. Simultaneous submissions and previously published work OK. Pays $250 maximum for color cover; $80 maximum for inside. **Pays on acceptance.**

TIPS "Photographers: Readers are owners/managers/CEOs. Cover stories and special reports often need conceptual images and portraits. Clean, modern and cutting edge with good composition. Covers have lots of possibility! Approximate 1-week turnaround. Most assignments are for the Milwaukee area."

☺ ⑤ ◐ BOXOFFICE MAGAZINE

Boxoffice Media, LLC, 230 Park Ave., Suite 1000, New York NY 10169. (310) 876-9090. **E-mail:** peter@boxoffice.com. **Website:** www.BoxOffice.com. Estab. 1920. Circ. 6,000. Magazine about the motion picture industry for executives and managers working in the film business, including movie theater owners and operators, Hollywood studio personnel and leaders in allied industries.

NEEDS All photos must be of movie theaters and management. Reviews photos with accompanying manuscript only.

SPECS Send via CD, ZIP as TIFF files at 300 dpi.

MAKING CONTACT & TERMS Send query letter with résumé, tearsheets. Does not keep samples on file; cannot return material. Responds in 1 month to queries. Responds only if interested; send nonreturnable samples. Previously published work OK.

◑ CANADIAN GUERNSEY JOURNAL

5653 Highway 6 N, RR 5, Guelph ON N1H 6J2, Canada. (519)836-2141. **Fax:** (519)763-6582. **E-mail:** info@guernseycanada.ca. **Website:** www.guernseycanada.ca. **Contact:** Jessie Weir. Estab. 1927. Annual journal of the Canadian Guernsey Association. Emphasizes dairy cattle, purebred and grade guernseys. Readers are dairy farmers and agriculture-related companies. Sample copy available for $15.

NEEDS Photos of guernsey cattle: posed, informal, scenes. Photo captions preferred.

MAKING CONTACT & TERMS Contact through administration office. Keeps samples on file.

⑤ CASINO JOURNAL

2401 W. Big Weaver Rd., Troy MI 48084. (248)786-1728. **Fax:** (248)362-0317. **E-mail:** gizickit@bnpmedia.com. **Website:** www.casinojournal.com. **Contact:** Tammie Gizicki, art director. Estab. 1985. Circ. 35,000. Monthly journal. Emphasizes casino operations. Readers are casino executives, employees and vendors. Sample copy free with 11×14 SASE. Ascend Media Gaming Group also publishes *IGWB*, *Slot Manager*, and *Indian Gaming Business*. Each magazine has its own photo needs.

NEEDS Buys 0-2 photos from freelancers/issue; 12-24 photos/year. Needs photos of gaming tables and slot machines, casinos and portraits of executives. Model release required for gamblers, employees. Photo captions required.

MAKING CONTACT & TERMS Send query letter with résumé of credits, stock list. Pays on publication. Credit line given. Buys all rights; negotiable.

TIPS "Read and study photos in current issues."

CATHOLIC LIBRARY WORLD

205 W. Monroe St. Suite 314, Chicago IL 60606. (312)739-1776. **Fax:** (312)236-7230. **E-mail:** mmccarthy@cathla.org; cla@cathla.org. **Website:** www.cathla.org/cathlibworld.html. **Contact:** Malachy R. McCarthy, president. Estab. 1929. Circ. 1,100. Quarterly magazine of the Catholic Library Association. Emphasizes libraries and librarians (community/school libraries; academic/research librarians; archivists). Readers are librarians who belong to the Catholic Library Association; other subscribers are generally employed in Catholic institutions or academic settings. Sample copy available for $25.

NEEDS Uses 2-5 photos/issue. Needs photos of authors of children's books, and librarians who have done something to contribute to the community at large. Special needs include photos of annual conferences. Model release preferred for photos of authors. Photo captions preferred.

MAKING CONTACT & TERMS Send electronically in high-res, 450 dpi or greater. Deadlines: January 2, April 1, July 1, October 1. Responds in 2 weeks. Credit line given. Acquires one-time rights.

⑤ CEA ADVISOR

Connecticut Education Association, Capitol Place, Suite 500, 21 Oak St., Hartford CT 06106. (860)525-5641; (800)842-4316. **Fax:** (860)725-6356; (860)725-6323. **E-mail:** kathyf@cea.org. **Website:** www.cea.

org. **Contact:** Kathy Frega, director of communications; Michael Lydick, managing editor. Circ. 42,000. Monthly tabloid. Emphasizes education. Readers are public school teachers. Sample copy free with 6 first-class stamps.

NEEDS Buys 1-2 photos from freelancers/issue; 12-24 photos/year. Needs "classroom scenes, students, school buildings." Model release preferred. Photo captions preferred.

MAKING CONTACT & TERMS Send b&w contact sheet by mail for consideration. Provide résumé, business card, brochure, flyer or tearsheets to be kept on file for possible future assignments. Cannot return material. Responds in 1 month. Simultaneous submissions and previously published work OK. Pays $50 for b&w cover; $25 for b&w inside. Pays on publication. Credit line given. Buys all rights.

CHILDHOOD EDUCATION

17904 Georgia Ave., Suite 215, Olney MD 20832. (301)570-2111; (800)423-3563. **Fax:** (301)570-2212. **E-mail:** abauer@acei.org; bherzig@acei.org; editorial@acei.org. **Website:** www.acei.org. **Contact:** Anne Watson Bauer, editor/director of publications; Deborah Kravitz; Bruce Herzig, assistant editor. Estab. 1924. Circ. 15,000. Bimonthly journal of the Association for Childhood Education International. Emphasizes the education of children from infancy through early adolescence. Readers include teachers, administrators, day-care workers, parents, psychologists, student teachers, etc. Sample copy free with 9×12 SASE and $1.44 postage. Submission guidelines available online.

NEEDS Uses 1 photos/issue; 2-3 supplied by freelance photographers. Uses freelancers mostly for covers. Subject matter includes children, infancy-14 years, in groups or alone, in or out of the classroom, at play, in study groups; boys and girls of all races and in all cities and countries. Wants close-ups of children, unposed. Reviews photos with or without accompanying manuscript. Special needs include photos of minority children; photos of children from different ethnic groups together in one shot; boys and girls together. Model release required.

SPECS Accepts images in digital format, 300 dpi.

MAKING CONTACT & TERMS Send unsolicited photos by e-mail to abauer@acei.org and bherzig@acei.org. Responds in 1 month. Simultaneous submissions and previously published work are discouraged

but negotiable. Pays on publication. Credit line given. Buys one-time rights.

TIPS "Send pictures of unposed children in educational settings, please."

THE CHRONICLE OF PHILANTHROPY

1255 23rd St. NW, 7th Floor, Washington DC 20037. (202)466-1200. **Fax:** (202)466-2078. **E-mail:** creative@chronicle.com; editor@philanthropy.com. **Website:** philanthropy.com. **Contact:** Sue LaLumia, art director. Estab. 1988. Biweekly tabloid. Readers come from all aspects of the nonprofit world such as charities, foundations and relief agencies such as the Red Cross. Sample copy free.

NEEDS Buys 10-15 photos from freelancers/issue; 260-390 photos/year. Needs photos of people (profiles) making the news in philanthropy and environmental shots related to person(s)/organization. Most shots arranged with freelancers are specific. Model release required. Photo caption required.

SPECS Accepts images in digital format. Send via CD, ZIP.

MAKING CONTACT & TERMS Arrange a personal interview to show portfolio. Send 35mm, 2¼×2¼ transparencies and prints by mail for consideration. Provide résumé, business card, brochure, flyer or tearsheets to be kept on file for possible future assignments. Responds in 2 days. Previously published work OK. Pays (color and b&w) $275 plus expenses/half day; $450 plus expenses/full day; $100 for web publication (2-week period). Pays on publication. Buys one-time rights.

CIVITAN MAGAZINE

P.O. Box 130744, Birmingham AL 35213-0744. (205)591-8910. **E-mail:** magazine@civitan.org. **Website:** www.civitan.org. Estab. 1920. Circ. 24,000. Quarterly publication of Civitan International. Emphasizes work with mental retardation/developmental disabilities. Readers are men and women, college age to retirement, usually managers or owners of businesses. Sample copy free with 9×12 SASE and 2 first-class stamps.

NEEDS Buys 1-2 photos from freelancers/issue; 6-12 photos/year. Always looking for good cover shots (multicultural, travel, scenic, how-to), babies/children/teens, families, religious, disasters, environmental, landscapes/scenics. Model release required. Photo captions preferred.

SPECS Accepts images in digital format. Send via CD or e-mail at 300 dpi only.

MAKING CONTACT & TERMS Send sample of unsolicited 2¼×2¼ or 4×5 transparencies by mail for consideration. Provide résumé, business card, brochure, flyer or tearsheets to be kept on file for possible future assignments. Responds in 1 month. Simultaneous submissions and previously published work OK. Pays $50-200 for color cover; $20 for color inside. **Pays on acceptance.** Buys one-time rights.

⑤ CLASSICAL SINGER

P.O. Box 1710, Draper UT 84020. (801)254-1025; (877)515-9800. **Fax:** (801)254-3139. **E-mail:** info@ classicalsinger.com. **Website:** www.classicalsinger.com. **Contact:** Blaine Hawkes. Estab. 1988. Circ. 9,000. Glossy monthly trade magazine for classical singers. Sample copy free.

NEEDS Looking for photos in opera or classical singing. E-mail for calendar and ideas. Photo captions preferred; include where, when, who.

SPECS Uses b&w and color prints or high-res digital photos.

MAKING CONTACT & TERMS Responds in 1 month to queries. Simultaneous submissions and previously published work OK. Pays honorarium plus 10 copies. Pays on publication. Credit line given. Buys one-time rights. Photo may be used in a reprint of an article on paper or website. "In an effort to reduce spam, we are no longer providing our e-mail addresses from our website. Please use the online form to contact individual staff members."

TIPS "Our publication is expanding rapidly. We want to make insightful photographs a big part of that expansion."

⑤ ◐ CLEANING & MAINTENANCE MANAGEMENT

NTP Media, 19 British American Blvd. West, Latham NY 12110. (518)783-1281, ext. 3137. **Fax:** (518)783-1386. **E-mail:** marty@grandviewmedia.com; rdipaolo@ntpmedia.com. **Website:** www.cmmonline.com. **Contact:** Marty Harris, art director. Estab. 1963. Circ. 38,300. Monthly. Emphasizes management of cleaning/custodial/housekeeping operations for commercial buildings, schools, hospitals, shopping malls, airports, etc. Readers are middle- to upper-level managers of in-house cleaning/custodial departments, and managers/owners of contract cleaning companies. Sample copy free (limited) with SASE.

NEEDS Uses 10-15 photos/issue. Needs photos of cleaning personnel working on carpets, hardwood floors, tile, windows, restrooms, large buildings, etc. Model release preferred. Photo captions required.

MAKING CONTACT & TERMS Provide résumé, business card, brochure, flyer or tearsheets to be kept on file for possible future assignments. "Send query letter with specific ideas for photos related to our field." Responds in 1-2 weeks. Simultaneous submissions and previously published work OK. Pays $25 for b&w inside. Credit line given. Rights negotiable.

TIPS "Query first and shoot what the publication needs."

⊘ COMMERCIAL CARRIER JOURNAL

3200 Rice Mine Rd. NE, Tuscaloosa AL 35406. (800)633-5953. **Fax:** (205)750-8070. **E-mail:** production@ccjdigital.com. **Website:** www.ccjmagazine.com. **Contact:** David Watson, art director. Estab. 1911. Circ. 105,000. Monthly magazine. Emphasizes truck and bus fleet maintenance operations and management.

NEEDS Spot news (of truck accidents, Teamster activities and highway scenes involving trucks). Photos purchased with or without accompanying manuscript, or on assignment. Model release required. Detailed captions required.

SPECS Prefers images in digital format. Send via e-mail as JPEG files at 300 dpi. For covers, uses medium-format transparencies (vertical only).

MAKING CONTACT & TERMS Does not accept unsolicited photos. Query first; send material by mail with SASE for consideration. Responds in 3 months. Pays on a per-job or per-photo basis. **Pays on acceptance.** Credit line given. Buys all rights.

TIPS Needs accompanying features on truck fleets and news features involving trucking companies.

CONSTRUCTION EQUIPMENT GUIDE

470 Maryland Dr., Ft. Washington PA 19034. (215)885-2900 or (800)523-2200. **E-mail:** production@cegltd.com; editorial@cegltd.com. **Website:** www.cegltd.com. **Contact:** Craig Mongeau, editor-in-chief. Estab. 1957. Circ. 120,000. Biweekly trade newspaper. Emphasizes construction equipment industry, including projects ongoing throughout the country. Readers are males and females of all ages; many are construction executives, contractors, dealers and manufacturers. Free sample copy.

NEEDS Buys 35 photos from freelancers/issue; 910 photos/year. Needs photos of construction job sites and special event coverage illustrating new equipment applications and interesting projects. Call to inquire about special photo needs for coming year. Model/property release preferred. Photo captions required for subject identification.

MAKING CONTACT & TERMS Send any size matte or glossy b&w prints by mail with SASE for consideration. Provide résumé, business card, brochure, flyer or tearsheets to be kept on file for possible future assignments. Responds in 3 weeks. Payment negotiable. Pays on publication. Credit line given. Buys all rights; negotiable.

THE COOLING JOURNAL

3000 Village Run Rd., Suite 103, #221, Wexford PA 15090. (724)799-8415. **Fax:** (724)799-8416. **E-mail:** info@narsa.org. **Website:** www.narsa.org. Estab. 1956. Magazine of NARSA—The International Heat Exchange Association. Publishes 10 issues a year. Emphasis on thermal management products and services for transportation, energy and industry.

NEEDS Buys photos, images, and stories about people, organizations, processes, technologies, and products in heat exchange industry which includes: automotive, heavy truck and mobile machinery engine and transmission cooling; automotive, heavy truck, and mobile machinery air conditioning and cabin heating; engine and transmission cooling for marine applications; engine and transmission cooling for vehicle high performance and racing; heat exchange for energy exploration and generation; construction, mining, agricultural applications for heat exchange products and services; metals joining including welding and brazing; heat exchange product fabrication, design and engineering.

MAKING CONTACT & TERMS Send inquiry for current story board, rates, and deadlines. Pays on publication.

COTTON GROWER MAGAZINE

Meister Media Worldwide, Cotton Media Group, 8000 Centerview Pkwy., Suite #114, Cordova TN 38018-4246. (901)756-8822. **E-mail:** hgantz@meister media.com. **Website:** www.cotton247.com. **Contact:** Harry Gantz, editor. Circ. 43,000. Monthly magazine. Emphasizes "cotton production; for cotton farmers." Sample copies and photo guidelines available.

NEEDS Photos of agriculture. "Our main photo needs are cover shots of growers. We write cover stories on each issue."

SPECS Prefers high-res digital images; send JPEGs at 300 dpi via e-mail or CD. Uses high-quality glossy prints from 35mm.

MAKING CONTACT & TERMS Send query letter with slides, prints, tearsheets. **Pays on acceptance.** Credit line given. Buys all rights.

TIPS Most photography hired is for cover shots of cotton growers.

💲💲 CROPLIFE

37733 Euclid Ave., Willoughby OH 44094. (440)942-2000. **E-mail:** erics@croplife.com. **Website:** www.croplife.com. Estab. 1894. Circ. 24,500. Monthly magazine. Serves the agricultural distribution channel delivering fertilizer, chemicals and seed from manufacturer to farmer. Sample copy and photo guidelines free with 9×12 SASE.

NEEDS Buys 6-7 photos/year; 5-30% supplied by freelancers. Needs photos of agricultural chemical and fertilizer application scenes (of commercial—not farmer—applicators), people shots of distribution channel executives and managers. Model release preferred. Photo captions required.

SPECS Uses 8×10 glossy b&w and color prints; 35mm slides, transparencies.

MAKING CONTACT & TERMS Send query letter first with résumé of credits. Simultaneous submissions and previously published work OK. **Pays on acceptance.** Buys one-time rights.

💲💲 DAIRY TODAY

P.O. Box 958, Mexico MO 65265. (573)581-6387. **E-mail:** jdickrell@farmjournal.com. **Website:** www.agweb.com/livestock/dairy/. **Contact:** Jim Dickrell, editor. Circ. 50,000. Monthly magazine. Emphasizes American agriculture. Readers are active farmers, ranchers or agribusiness people. Sample copy and photo guidelines free with SASE.

NEEDS Buys 5-10 photos from freelancers/issue; 60-120 photos/year. "We use studio-type portraiture (environmental portraits), technical, details, scenics." Wants photos of environmental, landscapes/scenics, agriculture, business concepts. Model release preferred. Photo captions required.

MAKING CONTACT & TERMS Arrange a personal interview to show portfolio. Send query letter with résumé of credits along with business card, brochure,

flyer or tearsheets to be kept on file for possible future assignments. "Portfolios may be submitted via CD." *Do not send originals!* Responds in 2 weeks. Simultaneous submissions OK. "We pay a cover bonus." **Pays on acceptance.** Credit line given, except in advertorials. Buys one-time rights.

TIPS In portfolio or samples, likes to see "about 40 slides showing photographer's use of lighting and ability to work with people. Know your intended market. Familiarize yourself with the magazine and keep abreast of how photos are used in the general magazine field."

◎ ◑ DISPLAY DESIGN IDEAS

1145 Sanctuary Pkwy., Suite 355, Alpharetta GA 30004. (770)291-5510. **E-mail:** jessie.dowd@ddionline.com. **Website:** www.ddimagazine.com. **Contact:** Jessie Bove Dowd, managing editor/web editor. Estab. 1988. Circ. 21,500. Monthly magazine. Emphasizes retail design, store planning, visual merchandising. Readers are retail architects, designers and retail executives. Sample copies available.

NEEDS Buys 7 or fewer photos from freelancers/issue; 84 or fewer photos/year. Needs photos of architecture, mostly interior. Property release preferred.

SPECS Prefers digital submissions. Send as TIFF or JPEG files at 300 dpi.

MAKING CONTACT & TERMS Send query letter with résumé of credits. Provide résumé, business card, brochure, flyer or tearsheets to be kept on file for possible future assignments. Responds in 3 weeks. Credit line given. Rights negotiable.

TIPS Looks for architectural interiors, ability to work with different lighting. "Send samples (photocopies OK) and résumé."

DM NEWS

Haymarket Media, Inc., 114 W. 26th St., New York NY 10001. (646)638-6186. **E-mail:** melissa.mazza@dmnews.com; carol.krol@dmnews.com; news@dmnews.com. **Website:** www.dmnews.com. Estab. 1979. Circ. 50,300. Company publication for Courtenay Communications Corporation. Weekly newspaper. Emphasizes direct, interactive and database marketing. Readers are decision makers and marketing executives, ages 25-55. Sample copy available for $2.

NEEDS Uses 20 photos/issue; 3-5 supplied by freelancers. Needs news head shots, product shots. Reviews photos purchased with accompanying manuscript only. Photo captions required.

MAKING CONTACT & TERMS Provide résumé, business card, brochure, flyer or tearsheets to be kept on file for possible future assignments. Responds in 1-2 weeks. Payment negotiable. **Pays on acceptance.** Buys worldwide rights.

TIPS "News and business background are a prerequisite."

ELECTRICAL APPARATUS

Barks Publications, Inc., Suite 901, 500 N. Michigan Ave., Chicago IL 60611. (312)321-9440. **Fax:** (312)321-1288. **E-mail:** eamagazine@barks.com. **Website:** www.barks.com/eacurr.html. **Contact:** Elsie Dickson, acting publisher; Kevin N. Jones, senior editor. Estab. 1967. Circ. 16,000. Monthly magazine. Emphasizes industrial electrical machinery maintenance and repair for the electrical aftermarket. Readers are "persons engaged in the application, maintenance and servicing of industrial and commercial electrical and electronic equipment." Sample copies available.

NEEDS "Assigned materials only. We welcome innovative industrial photography, but most of our material is staff-prepared." Photos purchased with accompanying manuscript or on assignment. Model release required "when requested." Photo captions preferred.

MAKING CONTACT & TERMS Send query letter with résumé of credits. Contact sheet or contact sheet with negatives OK; include SASE for return of material. Responds in 3 weeks. Pays $200 for color. Pays on publication. Credit line given. Buys all rights, but exceptions are occasionally made.

❸❸ ◑ ELECTRIC PERSPECTIVES

701 Pennsylvania Ave. NW, Washington D.C. 20004. (202)508-5584. **E-mail:** eblume@eei.org; bcannon@eei.org. **Website:** www.eei.org/magazine/Pages/ElectricPerspectivesIssues.aspx. **Contact:** Eric Blume, editor; LaVonne Rose, photo coordinator. Estab. 1976. Circ. 11,000. Bimonthly magazine of the Edison Electric Institute. Emphasizes issues and subjects related to shareholder-owned electric utilities. Sample copy available on request.

NEEDS Photos relating to the business and operational life of electric utilities—from customer service to engineering, from executive to blue collar. Model release required. Photo captions preferred.

SPECS Uses 8×10 glossy color prints; 35mm, 2¼×2¼, 4×5 transparencies. Accepts images in digital format. All high-res non-postscript formats accepted. Send

via ZIP, e-mail as TIFF, JPEG files at 300 dpi and scanned at a large size, at least 4×5.

MAKING CONTACT & TERMS Send query letter with stock list or send unsolicited photos by mail for consideration. Provide electronic résumé, business card, or brochure to be kept on file for possible future assignments. Keeps samples on file. Pays on publication. Buys one-time rights; negotiable (for reprints).

TIPS "We're interested in annual-report-quality images in particular. Quality and creativity are often more important than subject."

EL RESTAURANTE MEXICANO

P.O. Box 2249, Oak Park IL 60303-2249. (708)267-0023. **E-mail:** kfurore@comcast.net. **Website:** www.restmex.com. **Contact:** Kathleen Furore, editor. Estab. 1997. Circ. 27,000. Bimonthly magazine for restaurants that serve Mexican, Tex-Mex, Southwestern and Latin cuisine. Sample copies available.

NEEDS Buys at least 1 photo from freelancers/issue; at least 6 photos/year. Needs photos of food/drink. Reviews photos with or without a manuscript.

SPECS Uses 35mm transparencies. Accepts images in digital format. Send via e-mail as TIFF, JPEG files of at least 300 dpi.

MAKING CONTACT & TERMS Send query letter with slides, prints, photocopies, tearsheets, transparencies or stock list. Provide résumé, business card, and self-promotion piece to be kept on file for possible future assignments. Responds in 2 months to queries. Previously published work OK. Pays $450 maximum for color cover; $125 maximum for color inside. Pays on publication. Credit line given. Buys all rights; negotiable.

TIPS "We look for outstanding food photography; the more creatively styled, the better."

ESL TEACHER TODAY

2660 Petersborough St., Herndon VA 20171. **E-mail:** shannonaswriter@yahoo.com. **Contact:** Shannon Bridget Murphy. Quarterly magazine. Photo guidelines available via e-mail. Request photographer's sample copy for $3 sent through PayPal to scribbles byshannon@yahoo.com.

NEEDS Buys 12-24 photos/year. Photos of babies/children/teens, multicultural, families, parents, disasters, environmental, landscapes/scenics, wildlife, cities/urban, education, religious, rural, adventure, events, food/drink, sports, travel, agriculture, medicine, military, political, product shots/still life, sci-

ence, technology—as related to teaching ESL (English as a Second Language) around the globe. Interested in alternative process, avant garde, documentary, fashion/glamour, fine art, historical/vintage, seasonal. Reviews photos with or without a manuscript. Model/property release preferred.

SPECS Uses glossy or matte color and b&w prints.

MAKING CONTACT & TERMS Send query letter via e-mail. "If possible, please do not include photographs in files if they are sent through e-mail. A disc with your photographs sent to *ESL Teacher Today* is acceptable." Provide résumé, business card or self-promotion piece to be kept on file for possible future assignments. Responds within 1 month to queries; 1 week to portfolios. Simultaneous submissions and previously published work OK. **Pays on acceptance.** Credit line given. Buys one-time rights, first rights; negotiable.

💲💲 FARM JOURNAL

P.O. Box 958, Mexico MO 65265. **Website:** www.agweb.com/farmjournal. Estab. 1877. Circ. 375,000. *Farm Journal*, the largest national U.S. farm magazine, is a prime source of practical information on crops and livestock for farm families. Published 12 times a year, the magazine emphasizes agricultural production, technology and policy.

NEEDS Photos having to do with the basics of raising, harvesting and marketing of all the farm commodities (primarily corn, soybeans and wheat) and farm animals. All photos must relate to agriculture.

SPECS Accepts images in digital format.

MAKING CONTACT & TERMS Send online portfolios to the e-mail address above or send photo/thumbnails by mail.

TIPS Provide calling card and samples to be kept on file for possible future assignments.

FIRE CHIEF

Primedia Business, 330 N. Wabash Ave., Suite 2300, Chicago IL 60611. (312)595-1080. **Fax:** (312)595-0295. **E-mail:** lisa@firechief.com. **Website:** www.firechief.com. **Contact:** Lisa Allegretti, editor. Estab. 1956. Circ. 53,000. Monthly magazine. Focus on fire department management and operations. Readers are primarily fire officers and predominantly chiefs of departments. Sample copy free. Request photo guidelines via e-mail.

NEEDS "Fire and emergency response, especially leadership themes—if you do not have fire or EMS experience, please do not contact."

SPECS Digital format preferred, file name less than 15 characters. Send via e-mail, CD, ZIP as TIFF, EPS files at highest possible resolution.

MAKING CONTACT & TERMS Send JPEGs or TIFFs at no larger than 300 dpi for consideration along with caption, date, time, and location. Samples are kept on file. Expect confirmation/response within 1 month. Payment 90 days after publication. Buys first serial rights; negotiable.

TIPS "As the name *Fire Chief* implies, we prefer images showing a leading officer (white, yellow, or red helmet) in action—on scene of a fire, disaster, accident/rescue, hazmat, etc. Other subjects: administration, communications, decontamination, dispatch, EMS, foam, heavy rescue, incident command, live fire training, public education, SCBA, water rescue, wildland fire."

FIRE ENGINEERING

PennWell Corporation, 21-00 Rt. 208 S., Fair Lawn NJ 07410-2602. (800)962-6484, ext. 5047. **E-mail:** dianef@pennwell.com. **Website:** www.fireengineering.com. **Contact:** Diane Feldman, executive editor. Estab. 1877. Training magazine for firefighters. Photo guidelines free.

NEEDS Uses 400 photos/year. Needs action photos of disasters, firefighting, EMS, public safety, fire investigation and prevention, rescue. Photo captions required; include date, what is happening, location and fire department contact.

SPECS Accepts images in digital format. Send via e-mail or mail on CD as JPEG files at 300 dpi minimum.

MAKING CONTACT & TERMS Send unsolicited photos by mail for consideration. Pays on publication. Credit line given. "We retain copyright."

TIPS "Firefighters must be doing something. Our focus is on training and learning lessons from photos."

🌑🌑 🜨 🌑 FIREHOUSE MAGAZINE

3 Huntington Quadrangle, Suite 301N, Melville NY 11747. (631)845-2700; (800) 547-7377 ext. 6262. **E-mail:** marianne.mcintyre@cygnuspub.com. **Website:** www.firehouse.com. **Contact:** Marianne McIntyre, art director. Estab. 1976. Circ. 90,000. Monthly. Emphasizes "firefighting—notable fires, techniques, dramatic fires and rescues, etc." Readers are "paid and volunteer firefighters, EMTs." Sample copy available

for $5 with 9×12 SASE and 7 first-class stamps. Photo guidelines free with SASE or online.

NEEDS Buys 20 photos from freelancers/issue; 240 photos/year. Needs photos of fires, terrorism, firefighter training, natural disasters, highway incidents, hazardous materials, dramatic rescues. Model release preferred.

SPECS Uses 3×5, 5×7, 8×10 matte or glossy b&w or color prints; 35mm transparencies. Accepts images in digital format. Send via CD, e-mail as TIFF, EPS, JPEG files at 300 dpi.

MAKING CONTACT & TERMS "Photos must not be more than 30 days old." Include SASE. "Photos cannot be returned without SASE." Responds ASAP. Pays on publication. Credit line given. Buys one-time rights.

TIPS "Mostly we are looking for action-packed photos—the more fire, the better the shot. Show firefighters in full gear; do not show spectators. Fire safety is a big concern. Much of our photo work is freelance. Try to be in the right place at the right time as the fire occurs. Be sure that photos are clear, in focus, and show firefighters/EMTs at work. Firehouse encourages submissions of high-quality action photos that relate to the firefighting/EMS field. Please understand that while we encourage first-time photographers, a minimum waiting period of 3-6 months is not unusual. Although we are capable of receiving photos online, please be advised that there are color variations. Include captions. Photographers must include a SASE and we cannot guarantee the return of unsolicited photos. Mark name and address on the back of each photo."

🜨 🌑 FIRERESCUE

525 B St., Suite 1800, San Diego CA 92101. (619)699-6807. **Fax:** (619)699-6396. **E-mail:** janellef@pennwell.com. **Website:** www.firefighternation.com. **Contact:** Janelle Foskett, managing editor. Estab. 1997. Circ. 50,000. Monthly. Emphasizes techniques, equipment, action stories of fire and rescue incidents. Editorial slant: "Read it today, use it tomorrow."

NEEDS Photos of fires, fire ground scenes, commanders operating at fires, company officers/crews fighting fires, disasters, emergency medical services, rescue scenes, transport, injured victims, equipment and personnel, training, earthquake rescue operations. Special photo needs include strong color shots showing newsworthy rescue operations, including a unique or difficult firefighting, rescue/extrication,

treatment, transport, personnel, etc.; b&w showing same. Photo captions required.

SPECS Accepts images in digital format. Prefers digital format submitted via e-mail or FTP (info.jems.com/ftp/). Send via ZIP, e-mail, Jaz, CD as TIFF, EPS, JPEG files at 300 dpi.

MAKING CONTACT & TERMS Pays $300 for cover; $22-137 for color inside. Pays on publication. Credit line given. Buys one-time rights.

⑤⑤ ◎ ❶ FLORAL MANAGEMENT MAGAZINE

1601 Duke St., Alexandria VA 22314. (703)836-8700; (800) 336-4743. **Fax:** (703)836-8705. **E-mail:** kpenn@ safnow.org. **Website:** www.safnow.org. **Contact:** Kate Penn, editor-in-chief. Estab. 1894. National trade association magazine representing growers, wholesalers and retailers of flowers and plants. Photos used in magazine and promotional materials.

NEEDS Offers 15-20 assignments/year. Needs photos of floral business owners, employees on location, and retail environmental portraits. Reviews stock photos. Model release required. Photo captions preferred.

SPECS Prefers images in digital format. Send via CD or e-mail as TIFF files at 300 dpi. Also uses b&w prints; transparencies.

MAKING CONTACT & TERMS Send query letter with samples. Provide résumé, business card, brochure, flyer or tearsheets to be kept on file for possible future assignments. Responds in 1 week. Credit line given. Buys one-time rights.

TIPS "We shoot a lot of tightly composed, dramatic shots of people, so we look for these skills. We also welcome input from the photographer on the concept of the shot. Our readers, as business owners, like to see photos of other business owners. Therefore, people photography, on location, is particularly popular." Photographers should approach magazine "via letter of introduction and sample. We'll keep name in file and use if we have a shoot near photographer's location."

⑤ ❶ ◯ FOREST LANDOWNER

900 Circle 75 Pkwy., Suite 205, Atlanta GA 30339. (800)325-2954; (404)325-2954. **Fax:** (404)325-2955. **E-mail:** info@forestlandowners.com. **Website:** www. forestlandowners.com. Estab. 1942. Circ. 10,000. Bi-monthly magazine of the Forest Landowners Association. Emphasizes forest management and policy issues for private forest landowners. Readers are for-

est landowners and forest industry consultants; 94% male between the ages of 46 and 55. Sample copy available for $3 (magazine), $30 (manual).

NEEDS Uses 15-25 photos/issue; 3-4 supplied by freelancers. Needs photos of unique or interesting private southern forests. Other subjects: environmental, regional, wildlife, landscapes/scenics. Model/property release preferred. Photo captions preferred.

SPECS Accepts images in digital format. Send via CD, ZIP, e-mail as TIFF, EPS files at 300 dpi.

MAKING CONTACT & TERMS Send ZIP disk, color prints, negatives or transparencies by mail or e-mail for consideration. Send query letter with stock list. Keeps samples on file. SASE. Responds in 3 weeks. Simultaneous submissions and previously published work OK. Pays on publication. Credit line given. Buys one-time and all rights; negotiable.

TIPS "We most often use photos of timber management, seedlings, aerial shots of forests, and unique southern forest landscapes. Mail ZIP, CD or slides of sample images. Captions are important."

FRAME BUILDING NEWS

F+W Media, Inc., 700 E. State St., Iola WI 54990. (715)445-4612, ext. 428. **Fax:** (715)445-4087. **E-mail:** jim.austin@fwmedia.com. **Website:** www.frame buildingnews.com. Estab. 1990. Circ. 20,000. "*Frame Building News* is the official publication of the National Frame Builders Association, which represents contractors who specialize in post-frame building construction."

SPECS Reviews GIF/JPEG files.

MAKING CONTACT & TERMS Captions, identification of subjects required. Negotiates payment individually. Buys all rights.

FRUIT GROWERS NEWS

Great American Publishing, P.O. Box 128, Sparta MI 49345. (616)887-9008. **Fax:** (616)887-2666. **E-mail:** fgnedit@fruitgrowersnews.com. **Website:** www.fruit-growersnews.com. **Contact:** Matt Milkovich, managing editor; Lee Dean, editorial director. Estab. 1961. Circ. 16,429. Monthly. Emphasizes all aspects of tree fruit and small fruit growing as well as farm marketing. Readers are growers but include anybody associated with the field. Sample copy available.

NEEDS Buys 3 photos from freelancers/issue; 25 photos/year. Needs portraits of growers, harvesting, manufacturing, field shots for stock photography—

anything associated with fruit growing. Photo captions required.

SPECS Accepts images in digital format. Send via CD as JPEG, TIFF or EPS files at 300 dpi, at least 4×6.

MAKING CONTACT & TERMS Query about prospective jobs. Simultaneous submissions and previously published work OK. Payment rates to be negotiated between editorial director and individual photographer. Pays on publication. Credit line given. Buys first North American rights.

TIPS "Learn about the field. Great American Publishing also publishes *The Vegetable Growers News*, *Spudman*, *Fresh Cut*, *Museums & More*, *Party & Paper Retailer and Stationery Trends*. Contact the editorial director for information on these publications."

GEOSYNTHETICS

1801 County Road B W., Roseville MN 55113. (651)222-2508 or (800)225-4324. **Fax:** (651) 631-9334; (651)225-6966. **E-mail:** generalinfo@ifai.com; rwbyg ness@ifai.com. **Website:** www.geosyntheticsmaga zine.com; www.ifai.com. **Contact:** Ron Bygness, editor. Estab. 1983. Circ. 18,000. Association magazine published 6 times/year. Emphasizes geosynthetics in civil engineering applications. Readers are civil engineers, professors and consulting engineers. Sample copies available.

NEEDS Uses 10-15 photos/issue; various number supplied by freelancers. Needs photos of finished applications using geosynthetics; photos of the application process. Reviews photos with accompanying manuscript only. Model release required. Photo captions required; include project, type of geosynthetics used and location.

SPECS Prefers images in high-res digital format.

MAKING CONTACT & TERMS "Please call before submitting samples!" Keeps samples on file. Responds in 1 month. Simultaneous submissions OK. Credit line given. Buys all rights; negotiable.

⑤ ① GOVERNMENT TECHNOLOGY

100 Blue Ravine Rd., Folsom CA 95630. (916)932-1300. **Fax:** (916)932-1470. **E-mail:** kmartinelli@govtech. com. **Website:** www.govtech.com. **Contact:** Kelly Martinelli, creative director. Estab. 2001. Circ. 60,000. Monthly trade magazine. Emphasizes information technology as it applies to state and local government. Readers are government executives.

NEEDS Buys 2 photos from freelancers/issue; 20 photos/year. Needs photos of government officials, disas-

ters, environmental, political, technology/computers. Reviews photos with accompanying manuscript only. Model release required; property release preferred. Photo captions required.

SPECS Accepts images in digital format only. Send via DVD, CD, ZIP, e-mail as TIFF, JPEG files at 300 dpi.

MAKING CONTACT & TERMS Send query letter with résumé, prints, tearsheets. Provide business card, self-promotion piece to be kept on file for possible future assignments. Responds only if interested; send nonreturnable samples. Simultaneous submissions and previously published work OK. Payment is dependent upon pre-publication agreement between photographer and *Government Technology*. Pays on publication. Credit line given. Buys one-time rights, electronic rights.

TIPS "View samples of magazines for style, available online at www.govtech.com/gt/magazines."

GRAIN JOURNAL

Country Journal Publishing Co., 3065 Pershing Court, Decatur IL 62526. (800)728-7511. **E-mail:** ed@grain net.com. **Website:** www.grainnet.com. **Contact:** Ed Zdrojewski, editor. Estab. 1972. Circ. 12,000. Bimonthly magazine. Emphasizes grain industry. Readers are "elevator and feed mill managers primarily, as well as suppliers and others in the industry." Sample copy free with #10 SASE.

NEEDS Uses about 1-2 photos/issue. "We need photos concerning industry practices and activities. We look for clear, high-quality images without a lot of extraneous material." Photo captions preferred.

SPECS Accepts images in digital format minimum 300 dpi resolution. Send via e-mail, floppy disk, ZIP.

MAKING CONTACT & TERMS Send query letter with samples and list of stock photo subjects. Responds in 1 week. Pays $100 for color cover; $30 for b&w inside. Pays on publication. Credit line given. Buys all rights; negotiable.

HARD HAT NEWS

Lee Publications, Inc., 6113 State Hwy. 5, P.O. Box 121, Palatine Bridge NY 13428. (518)673-3237. **Fax:** (518)673-2381. **E-mail:** jcasey@leepub.com. **Website:** www.hardhat.com. **Contact:** Jon Casey, editor. Estab. 1980. Circ. 15,000. Biweekly trade newspaper for heavy construction. "Our readers are contractors and heavy construction workers involved in excavation, highways, bridges, utility construction, and under-

ground construction." Readership includes owners, managers, senior construction trades. Photo guidelines available via e-mail only.

NEEDS Buys 12 photos from freelancers/issue; 280 photos/year. Specific photo needs: heavy construction in progress, construction people. Reviews photos with accompanying ms only. Property release preferred. Photo captions required.

SPECS Only high-res digital photographs. Send via e-mail as JPEG files at 300 dpi.

MAKING CONTACT & TERMS E-mail only. Simultaneous submissions OK. Pays on publication. Credit line given. Buys first rights.

TIPS "Include caption and brief explanation of what picture is about."

☺ HEARTH AND HOME

P.O. Box 1288, Laconia NH 03247. (800) 258-3772; (603)528-4285. **Fax:** (888) 873-3610; (603)527-3404. **E-mail:** production@villagewest.com. **Website:** hearth andhome.com. **Contact:** Kristan Gage, graphic coordinator. Circ. 16,000. Monthly magazine. Emphasizes hearth, barbecue and patio news and industry trends for specialty retailers and manufacturers of solid fuel and gas appliances, barbeque grills, hearth appliances inside and outside and casual furnishings. Sample copy available for $5.

NEEDS Buys 3 photos from freelancers/issue; 36 photos/year. Photos of inside and outside fireplace and patio furnishings, gas grills, outdoor room shots emphasizing BBQs, furniture, and outdoor fireplaces. Assignments available for conferences." Model release required. Photo captions preferred.

SPECS Accepts digital images with color proof; high-res, 300 dpi preferred.

MAKING CONTACT & TERMS Contact before submitting material. Responds in 2 weeks. Simultaneous and photocopied submissions OK. Pays within 30 days after publication prints. Credit line given. Buys various rights.

TIPS "Call first and ask what we need. We're *always* on the lookout for gorgeous outdoor room material."

☺ HEREFORD WORLD

Hereford Cattle Association, P.O. Box 014059, Kansas City MO 64101. (816)842-3757. **Fax:** (816)842-6931. **E-mail:** lgraber@hereford.org. **Website:** www.here fordworld.org. **Contact:** Lindsay Graber, creative services coordinator. Estab. 1947. Circ. 5,600. Monthly (11 issues with 7 glossy issues) association magazine.

Emphasizes Hereford cattle for registered breeders, commercial cattle breeders and agribusinessmen in related fields. A tabloid-type issue is produced 4 times—January, February, August and October— and mailed to an additional 20,000 commercial cattlemen. "We also publish a commercial edition with a circulation of 20,000."

NEEDS "*Hereford World* includes timely articles and editorial columns that provide readers information to help them make sound management and marketing decisions. From basic how-to articles to in-depth reports on cutting-edge technologies, *Hereford World* offers its readers a solid package of beef industry information."

SPECS Uses b&w and color prints.

MAKING CONTACT & TERMS Query. Responds in 2 weeks. Pays on publication.

TIPS Wants to see "Hereford cattle in quantities, in seasonal and scenic settings."

☺ HPAC: HEATING PLUMBING AIR CONDITIONING

(416)764-1549. **Fax:** (416)422-5600. **E-mail:** sma cisaac@hpacmag.com; kerry.turner@hpacmag.rog ers.com. **E-mail:** smacisaac@hpacmag.com. **Website:** www.hpacmag.com. **Contact:** Sandy MacIsaac, art director; Kerry Turner, editor. Estab. 1923. Circ. 16,500. Bimonthly magazine plus annual buyers guide. Emphasizes heating, plumbing, air conditioning, refrigeration. Readers are predominantly male mechanical contractors, ages 30-60. Sample copy available for $4.

NEEDS Buys 5-10 photos from freelancers/issue; 30-60 photos/year. Photos of mechanical contractors at work, site shots, product shots. Model/property release preferred. Photo captions preferred.

SPECS Prefers images in digital format. Send via CD, e-mail as TIFF, JPEG files at 300 dpi minimum. Also uses 4×6 glossy/semi-matte color and b&w prints; 35mm transparencies.

MAKING CONTACT & TERMS Send unsolicited photos by mail for consideration. Cannot return material. Responds in 1 month. Simultaneous submissions and previously published work OK. Pays $400 for b&w or color cover; $50-200 for b&w or color inside (payment in Canadian dollars). Pays on publication. Credit line given. Buys one-time rights; negotiable.

🌓🌓 🌓 IEEE SPECTRUM

3 Park Ave., New York NY 10016. (212)419-7555. **E-mail:** r.silberman@ieee.org. **Website:** www.spectrum.ieee.org. **Contact:** Randi Silberman Klett, photo editor. Circ. 375,000. Monthly magazine of the Institute of Electrical and Electronics Engineers, Inc. (IEEE). Emphasizes electrical and electronics field and high technology for technology innovators, business leaders, and the intellectually curious. Spectrum explores future technology trends and the impact of those trends on society and business. Readers are technology professionals and senior executives worldwide in the high technology sectors of industry, government, and academia. Subscribers include engineering managers and corporate and financial executives, deans and provosts at every major engineering university and college throughout the world; males/females, educated, ages 20-70.

NEEDS Uses 20-30 photos/issue. Purchases stock photos in following areas: technology, energy, medicine, military, sciences and business concepts. Hires assignment photographers for location shots and portraiture, as well as product shots. Model/property release required. Photo captions required.

SPECS Accepts images in digital format. Send via CD as TIFF, JPEG files at 300 dpi.

MAKING CONTACT & TERMS Provide promos or tearsheets to be kept on file for possible future assignments. Pays $1,200 for color cover; $200-600 for inside. **Pays on acceptance.** Credit line given. Buys one-time rights.

TIPS Wants photographers who are consistent, have an ability to shoot color and b&w, display a unique vision, and are receptive to their subjects. "As our subject matter is varied, *Spectrum* uses a variety of imagemakers."

🌓 IGA GROCERGRAM

8745 W Higgins Rd., Suite 350, Chicago IL 60631. (773)693-5902. **E-mail:** apage@igainc.com. **Website:** www.iga.com/igagrocergram.aspx. **Contact:** Ashley Page, communications. Quarterly magazine of the Independent Grocers Alliance. This comprehensive quarterly magazine—which evolved from the monthly that has chronicled the Alliance since its birth in 1926—is published in 4 seasonal editions each year and distributed to a worldwide audience. The glossy keep-sake issues profile IGA and its members through in-depth stories featuring stimulating interviews and informative analyses. Emphasizes food industry. Readers are IGA retailers. Sample copy available upon request.

NEEDS In-store shots, food (appetite appeal). Prefers shots of IGA stores. Model/property release required. Photo captions required.

SPECS Accepts images in digital format. Send as TIFF files at 300 dpi.

MAKING CONTACT & TERMS Send samples by e-mail or link to website for consideration. Provide résumé, business card, brochure, flyer or tearsheets to be kept on file for possible future assignments. Keeps samples on file. Responds in 3 weeks. Simultaneous submissions and previously published work OK. Pay negotiable. **Pays on acceptance.** Credit line given. Buys one-time rights.

🌓 INDEPENDENT RESTAURATEUR

P.O. Box 917, Newark OH 43058. (740)345-5542. **Fax:** (740)345-5557. **E-mail:** editor@theindependentrestaurateur.com; jim@theindependentrestaurateur.com. **Website:** www.theindependentrestaurateur.com. **Contact:** Jim Young, publisher. Estab. 1986. Circ. 32,000. (Formerly *My Foodservice News.*) Bimonthly magazine. "*Independent Restaurateur* is designed and written exclusively for the independent restaurant owner. Our editorial style is crisp and relevant. Each issue highlights the originality and exceptional qualities of peer restaurants, restaurateurs or chefs worthy of national attention. Plus useful news and ideas on topics like food and beverage, equipment and technology, staff training and service, menus and recipes, industry and consumer trends, food safety, and marketing. In short, every issue is packed with stories that specifically seek to inform, inspire and invigorate independent restaurateurs."

NEEDS Upon request.

SPECS Accepts images in digital format only. Send via CD, e-mail as JPEG files at 300-800 dpi.

MAKING CONTACT & TERMS Send e-mail. Provide self-promotion piece to be kept on file for possible future assignments. Responds only if interested; send nonreturnable samples. Simultaneous submissions OK. Pay is based on experience. Pays on publication. Credit line given. Buys first rights.

🌓 🌓 ITE JOURNAL

1627 Eye St. NW, Suite 600, Washington DC 20006. (202)785-0060. **Fax:** (202)785-0609. **E-mail:** msaglam@ite.org. **Website:** www.ite.org. **Contact:** M.

Saglam, managing editor. Estab. 1930. Circ. 17,000. Monthly journal of the Institute of Transportation Engineers. Emphasizes surface transportation, including streets, highways and transit. Readers are transportation engineers and professionals.

NEEDS One photo used for cover illustration per issue. Needs "shots of streets, highways, traffic, transit systems. No airports, airplanes, or bridges." Also considers landscapes, cities, rural, automobiles, travel, industry, technology, historical/vintage. Model release required. Photo captions preferred; include location, name or number of road or highway, and details.

MAKING CONTACT & TERMS Send query letter with list of stock photo subjects. Send EPS, JPEG, GIF or PDF files via e-mail to msaglam@ite.org. Provide résumé, business card, brochure, flyer or tearsheets to be kept on file for possible future assignments. Simultaneous submissions and previously published work OK. Pays up to $100 for color cover. Pays on publication. Credit line given. Buys multiple-use rights.

TIPS "Send files via e-mail."

⑤ ◐ JOURNAL OF ADVENTIST EDUCATION

12501 Old Columbia Pike, Silver Spring MD 20904-6600. (301)680-5075. Fax: (301)622-9627. **E-mail:** goffc@gc.adventist.org. **Website:** jae.adventist.org. **Contact:** Beverly J. Robinson-Rumble, editor. Estab. 1939. Circ. 14,000 in English; 13,000 in other languages. Published 5 times/year in English, 2 times/year in French, Spanish and Portuguese. Emphasizes procedures, philosophy and subject matter of Christian education. Official professional organization of the Department of Education covering elementary, secondary and higher education for all Seventh-day Adventist educational personnel (worldwide).

NEEDS Buys 5-15 photos from freelancers/issue; up to 75 photos/year. Photos of children/teens, multicultural, parents, education, religious, health/fitness, technology/computers with people, committees, offices, school photos of teachers, students, parents, activities at all levels, elementary though graduate school. Reviews photos with or without a ms. Model release preferred. Photo captions preferred.

SPECS Uses mostly digital color images but also accepts color prints; 35mm, 2¼×2¼, 4×5 transparencies. Send digital photos via ZIP, CD or DVD (preferred); e-mail as TIFF, GIF, JPEG files at 300 dpi. Do not send large numbers of photos as e-mail attachments.

MAKING CONTACT & TERMS Send query letter with prints, photocopies, transparencies. Provide self-promotion piece to be kept on file for possible future assignments. Responds in 1 month to queries. Simultaneous submissions and previously published work OK. Pays $100-350 for color cover; $50-100 for color inside. Willing to negotiate on electronic usage of photos. Pays on publication. Credit line given. Buys one-time rights for use in magazine and on website.

TIPS "Get good-quality people shots—close-ups, verticals especially; use interesting props in classroom shots; include teacher and students together, teachers in groups, parents and teachers, cooperative learning and multi-age, multicultural children. Pay attention to backgrounds (not too busy) and understand the need for high-res photos!"

⑤ JOURNAL OF PSYCHOACTIVE DRUGS

856 Stanyan St., San Francisco CA 94117. (415)752-7601. **E-mail:** hajpdeditor@comcast.net; hajournal@comcast.net. **Website:** www.hajpd.com. Estab. 1967. Circ. 1,400. Quarterly. Emphasizes "psychoactive substances (both legal and illegal)." Readers are "professionals (primarily health) in the drug abuse treatment field."

NEEDS Uses 1 photo/issue; supplied by freelancers. Needs "full-color abstract, surreal, avant garde or computer graphics."

MAKING CONTACT & TERMS Send query letter with 4×6 color prints or 35mm slides. Online and e-mail submissions are accepted. Include SASE for return of material. Responds in 2 weeks. Simultaneous submissions and previously published work OK. Pays $50 for color cover. Pays on publication. Credit line given. Buys one-time rights.

⑤⑤ ◐ JUDICATURE

2700 University Ave., Des Moines IA 50311. (541)737-9512. **E-mail:** judicature@oregonstate.edu. **Website:** www.ajs.org. **Contact:** Rorie Solberg, editor. Estab. 1917. Circ. 5,000. Bimonthly publication of the American Judicature Society. Emphasizes courts, administration of justice. Readers are judges, lawyers, professors, citizens interested in improving the administration of justice. Sample copy free with 9×12 SASE and 6 first-class stamps.

NEEDS Buys 1-2 photos from freelancers/issue; 6-12 photos/year. Needs photos relating to courts, the law. "Actual or posed courtroom shots are always needed."

Interested in fine art, historical/vintage. Model/property release preferred. Photo captions preferred.

SPECS Uses b&w and color prints. Accepts images in digital format. Send via CD, ZIP, e-mail as JPEG files at 600 dpi.

MAKING CONTACT & TERMS Submit samples via e-mail. Simultaneous submissions and previously published work OK. Pays on publication. Credit line given. Buys one-time rights.

THE LAND

Free Press Co., P.O. Box 3169, Mankato MN 56002-3169. (507)345-4523. **E-mail:** editor@thelandonline. com. **Website:** www.thelandonline.com. Estab. 1976. Circ. 33,000. Weekly tabloid covering farming in Minnesota and Northern Iowa.

SPECS Reviews contact sheets.

MAKING CONTACT & TERMS Negotiates payment individually. Buys one-time rights.

❸ LANDSCAPE ARCHITECTURE

636 Eye St. NW, Washington DC 20001-3736. (888) 999-2752; (202)898-2444. **Fax:** (202)898-1185. **E-mail:** cmcgee@asla.org; lspeckhardt@asla.org. **Website:** www.asla.org. **Contact:** Christopher McGee, art director; Lisa Speckhardt, managing editor. Estab. 1910. Circ. 22,000. Monthly magazine of the American Society of Landscape Architects. Emphasizes "landscape architecture, urban design, parks and recreation, architecture, sculpture" for professional planners and designers.

NEEDS Buys 5-10 photos from freelancers/issue; 50-120 photos/year. Needs photos of landscape- and architecture-related subjects as described above. Special needs include aerial photography and environmental portraits. Model release required. Credit, caption information required.

MAKING CONTACT & TERMS Send query letter with samples or list of stock photo subjects. Provide brochure, flyer or tearsheets to be kept on file for possible future assignments. Response time varies. Previously published work OK. Pays on publication. Credit line given. Buys one-time rights.

TIPS "We take an editorial approach to photographing our subjects."

♻ ❸ ◉ THE MANITOBA TEACHER

191 Harcourt St., Winnipeg MB R3J 3H2, Canada. (204)888-7961; (800)262-8803. **Fax:** (204)831-0877; (800)665-0584. **E-mail:** gstephenson@mbteach.org. **Website:** www.mbteach.org. **Contact:** George Stephenson, editor. Magazine of the Manitoba Teachers' Society published 7 times/year. Emphasizes education in Manitoba—specifically teachers' interests. Readers are teachers and others in education. Sample copy free with 10×12 SASE and Canadian stamps.

NEEDS Buys 3 photos from freelancers/issue; 21 photos/year. Needs action shots of students and teachers in education-related settings. Model release required.

MAKING CONTACT & TERMS Send 8×10 glossy b&w prints by mail for consideration; include SASE for return of material. Submit portfolio for review. Provide résumé, business card, brochure, flyer or tearsheets to be kept on file for possible future assignments. Responds in 1 month.

TIPS "Always submit action shots directly related to major subject matter of publication and interests of readership."

♻ ❸❸❸ MANUFACTURING AUTOMATION

Annex Publishing and Printing, 222 Edward St., Aurora ON L4G 1W6, Canada. (905)727-0077 or (905)713-4378. **E-mail:** editor@automationmag.com. **Website:** www.automationmag.com. **Contact:** Mary Del Ciancio, editor. Estab. 1998. Circ. 19,020. Published seven times a year, providing a window into the world of advanced manufacturing and industrial automation. Sample copies available for SASE with first-class postage.

NEEDS Occasionally buys photos from freelancers. Subjects include industry and technology. Reviews photos with or without a manuscript. Model release required. Photo captions preferred.

SPECS Uses 5×7 color prints; 4×5 transparencies. "We prefer images in high-res digital format. Send as FTP files at a minimum of 300 dpi."

MAKING CONTACT & TERMS Send query letter with résumé, stock list. Provide self-promotion piece to be kept on file for possible future assignments. Responds only if interested. Simultaneous submissions and previously published work OK. Pays $400-600 for color cover and inside images. Pays 30-45 days after invoice date. Credit line given. Buys one-time rights, electronic rights; negotiable.

TIPS "Read our magazine. Put yourself in your clients' shoes. Meet their needs and you will excel. Understand your audience and the editors' needs. Meet deadlines, be reasonable and professional."

⊗⊗ ❶ MARKETING & TECHNOLOGY GROUP

1415 N. Dayton, Chicago IL 60622. (312)274-2216. **E-mail:** qburns@meatingplace.com. **Website:** www.meatingplace.com. **Contact:** Queenie Burns, vice president of design and production. Estab. 1993. Circ. 18,000. Publishes magazines that emphasize meat and poultry processing. Readers are predominantly male, ages 35-65, generally conservative. Sample copy available for $4.

NEEDS Buys 1-6 photos from freelancers/issue. Needs photos of processing plant tours and product shots. Model/property release preferred. Photo captions preferred.

MAKING CONTACT & TERMS Provide résumé, business card, brochure, flyer or tearsheets to be kept on file for possible future assignments. Submit portfolio for review. Keeps samples on file. Responds in 1 month. Simultaneous submissions and previously published work OK. Payment negotiable. Pays on publication. Credit line given.

TIPS "Work quickly and meet deadlines. Follow directions when given; and when none are given, be creative while using your best judgment."

◐ ❶ MEETINGS & INCENTIVE TRAVEL

(416)442-5600 ext 3239; (416)764-1635. **E-mail:** sferrie@meetingscanada.com. **Website:** www.meetingscanada.com. **Contact:** Stephen Ferrie, art director. Estab. 1970. Circ. 10,500. Bimonthly trade magazine emphasizing meetings and travel.

NEEDS Buys 1-5 photos from freelancers/issue; 7-30 photos/year. Needs photos of environmental, landscapes/scenics, cities/urban, interiors/decorating, events, food/drink, travel, business concepts, technology/computers. Reviews photos with or without a manuscript. Model/property release required. Photo captions required; include location and date.

SPECS Uses 8×12 prints depending on shoot and size of photo in magazine. Accepts images in digital format. Send via CD as TIFF files at 300 dpi.

MAKING CONTACT & TERMS Contact through rep or send query letter with tearsheets. Portfolio may be dropped off every Tuesday. Provide résumé, business card, self-promotion piece to be kept on file for possible future assignments. Responds only if interested; send nonreturnable samples. Simultaneous submissions and previously published work OK. "Payment depends on many factors." Credit line given. Buys one-time rights.

TIPS "Send samples to keep on file."

MIDWEST MEETINGS®

Hennen Publishing, 302 Sixth St. W, Brookings SD 57006. (605)692-9559. **Fax:** (605)692-9031. **E-mail:** info@midwestmeetings.com; editor@midwestmeetings.com. **Website:** www.midwestmeetings.com. **Contact:** Randy Hennen. Estab. 1996. Circ. 28,500.

⑤ MILITARY OFFICER MAGAZINE

201 N. Washington St., Alexandria VA 22314. (703)549-2311. **E-mail:** editor@moaa.org. **Website:** www.moaa.org/militaryofficer. **Contact:** Jill Akers, photo editor. Estab. 1945. Circ. 400,000. Monthly publication of the Military Officers Association of America. Represents the interests of military officers from the 7 uniformed services: Army, Navy, Air Force, Marine Corps, Coast Guard, Public Health Service and National Oceanic and Atmospheric Administration. Emphasizes military history (particularly Vietnam and Korea), travel, health, second-career job opportunities, military family lifestyle and current military/political affairs. Readers are commissioned officers or warrant officers and their families. Sample copy available on request with 9×12 SASE.

NEEDS Buys 8 photos from freelancers/issue; 96 photos/year. "We're always looking for good color images of active-duty military people and healthy, active mature adults with a young 50s look—our readers are 55-65."

SPECS Uses digital images as well as 2¼×2¼ or 4×5 transparencies. Send digital images via e-mail as JPEG files at 300 dpi.

MAKING CONTACT & TERMS Send query letter with list of stock photo subjects. Provide résumé, brochure, flyer to be kept on file. "Do NOT send original photos unless requested to do so." Payment negotiated. "Photo rates vary with size and position." Pays on publication. Credit line given. Buys one-time rights. Pays $75 for ⅛ page; $125 for ¼ page; $175 for ½ page; $250 for full page. 5×7 or 8×10 b&w glossies occasionally acceptable. $20 for each b&w photo used. captions and credit lines should be on separate sheets of paper. Include SASE for return. Submission guidelines available online.

⊗⊗ ❶ NAILPRO

Creative Age Publications, 7628 Densmore Ave., Van Nuys CA 91406. (800) 442-5667; (818)782-7328.

Fax: (818)782-7450. E-mail: nailpro@creativeage. com. Website: www.nailpro.com. Contact: Stephanie Yaggy, executive editor. Estab. 1989. Circ. 65,000. Monthly magazine published by Creative Age Publications. Emphasizes topics for professional manicurists and nail salon owners. Readers are females of all ages. Sample copy available for $2 with 9×12 SASE.

NEEDS Buys 10-12 photos from freelancers/issue; 120-144 photos/year. Needs photos of beautiful nails illustrating all kinds of nail extensions and enhancements; photographs showing process of creating and decorating nails, both natural and artificial. Also needs salon interiors, health/fitness, fashion/glamour. Model release required. Photo captions required; identify people and process if applicable.

SPECS Accepts images in digital format. Send via ZIP, e-mail as TIFF, EPS files at 300 dpi or better.

MAKING CONTACT & TERMS Send query letter; responds only if interested. Call for portfolio review. "Art directors are rarely available, but photographers can leave materials and pick up later (or leave nonreturnable samples)." Send color prints; 35mm, 2¼×2¼, 4×5 transparencies. Keeps samples on file. Responds in 1 month. Previously published work OK. Pays $500 for color cover; $50-250 for color inside.

TIPS "Talk to the person in charge of choosing art about photo needs for the next issue and try to satisfy that immediate need; that often leads to assignments. Submit samples and portfolios with letter stating specialties or strong points."

⑤ NAILS MAGAZINE

Bobit Business Media, 3520 Challenger St., Torrance CA 90503. (310)533-2400 (main); (310)533-2537 (art director). Fax: (310)533-2507. E-mail: danielle.parisi@bobit.com. Website: www.nailsmag.com. Contact: Danielle Parisi, art director. Estab. 1982. Circ. 60,000. Monthly trade publication for nail technicians and beauty salon owners. Sample copies available.

NEEDS Buys up to 10 photos from freelancers/issue. Needs photos of celebrities, buildings, historical/vintage. Other specific photo needs: salon interiors, product shots, celebrity nail photos. Reviews photos with or without a ms. Model release required. Photo captions preferred.

SPECS Uses 35mm transparencies. Accepts images in digital format. Send via CD, Zip as TIFF, EPS files at 266 dpi.

MAKING CONTACT & TERMS Send query letter with résumé, slides, prints. Keep samples on file. Responds in 1 month on queries. Pays on acceptance. Credit line sometimes given if it's requested. Buys all rights.

⑤⑤ THE NATIONAL NOTARY

9350 De Soto Ave., Chatsworth CA 91311-4926. (800)876-6827. E-mail: publications@nationalnotary.org. Website: www.nationalnotary.org. Circ. 300,000+. Bimonthly association magazine. Emphasizes "Notaries Public and notarization—goal is to impart knowledge, understanding and unity among notaries nationwide and internationally." Readers are employed primarily in the following areas: law, government, finance and real estate.

NEEDS Number of photos purchased varies with each issue. "Photo subject depends on accompanying story/theme; some product shots used." Reviews photos with accompanying manuscript only. Model release required.

MAKING CONTACT & TERMS Send query letter with samples. Provide business card, tearsheets, résumé or samples to be kept on file for possible future assignments. Prefers to see prints as samples. Cannot return material. Previously published work OK. Pays on publication. Credit line given "with editor's approval of quality." Buys all rights.

TIPS "Since photography is often the art of a story, the photographer must understand the story to be able to produce the most useful photographs."

⑤ ⓟ Ⓞ NAVAL HISTORY

U.S. Naval Institute, 291 Wood Rd., Annapolis MD 21402. (410)295-1048. Fax: (410)295-1049. E-mail: avoight@usni.org. Website: www.usni.org/magazines/navalhistory. Contact: Amy Voight, photo editor. Estab. 1873. Circ. 50,000. Bimonthly association publication. Emphasizes Navy, Marine Corps, Coast Guard. Readers are male and female naval officers (enlisted, retirees), civilians. Photo guidelines free with SASE.

NEEDS 40 photos from freelancers/issue; 240 photos/year. Needs photos of foreign and U.S. Naval, Coast Guard and Marine Corps vessels, industry, military, personnel and aircraft. Interested in historical/vintage. Photo captions required.

SPECS Uses 8×10 glossy or matte b&w and color prints (color preferred); transparencies. Accepts im-

ages in digital format. Send via CD, ZIP, e-mail as JPEG files at 300 dpi.

MAKING CONTACT & TERMS "We prefer to receive photo images digitally. We accept cross-platform (must be Mac and PC compatible) CDs with CMYK images at 300 dpi resolution (TIFF or JPEG). If e-mailing an image, send submissions to photo editor. We do not return prints or slides unless specified with a SASE so please do not send original photographs. We negotiate fees with photographers who provide a volume of images for publication in books or as magazine pictorials. We sponsor 3 annual photo contests." For additional information please contact the photo editor. Responds in 1 month. Simultaneous submissions and previously published work OK. Pays on publication. Credit line given. Buys one-time and electronic rights.

⑤ NEVADA FARM BUREAU AGRICULTURE AND LIVESTOCK JOURNAL

2165 Green Vista Dr., Suite 205, Sparks NV 89431. (775)674-4000; (800) 992-1106. **E-mail:** zacha@nvfb. org. **Website:** www.nvfb.org. **Contact:** Zach Allen, editor. Circ. 1,500. Monthly magazine. Emphasizes Nevada agriculture. Readers are primarily Nevada Farm Bureau members and their families; men, women and youth of various ages. Members are farmers and ranchers. Sample copy free with 10×13 SASE with 3 first-class stamps.

NEEDS Uses 5 photos/issue; 30% occasionally supplied by freelancers. Needs photos of Nevada agriculture people, scenes and events. Model release preferred. Photo captions required.

MAKING CONTACT & TERMS Send 3×5 and larger b&w or color prints, any format and finish, by mail with SASE for consideration. Responds in 1 week. Pays $10 for b&w cover, $50 for color cover; $5 for b&w inside. **Pays on acceptance.** Credit line given. Buys one-time rights.

TIPS In portfolio or samples, wants to see "newsworthiness, 50%; good composition, 20%; interesting action, 20%; photo contrast/resolution, 10%. Try for new angles on stock shots: awards, speakers, etc. We like 'Great Basin' agricultural scenery such as cows on the rangelands and high desert cropping. We pay little, but we offer credits for your résumé."

● ⑤ ❶ NEWDESIGN

Media Culture 46 Pure Offices, Plate Close Leamington Spa, Warwick, Warwickshire CV34 6WE United

Kingdom. +44 (0)1926 408207. **E-mail:** info@new designmagazine.co.uk; tanya@newdesignmagazine. co.uk. **Website:** www.newdesignmagazine.co.uk. Estab. 2000. Circ. 5,000. Published 10 times/year. Emphasizes product design for product designers: informative, inspirational. Sample copies available.

NEEDS Photos of product shots/still life, technology. Reviews photos with or without a manuscript.

SPECS Uses glossy color prints; 35mm transparencies. Accepts images in digital format. Send via CD as TIFF, JPEG files at 300 dpi.

MAKING CONTACT & TERMS Send query letter with résumé. Provide self-promotion piece to be kept on file for possible future assignments. Cannot return material. Responds only if interested; send nonreturnable samples. Pays on publication. Credit line given.

NFPA JOURNAL

1 Batterymarch Park, Quincy MA 02169-7471. (617) 770-3000; (617)984-7568. **E-mail:** ssutherland@nfpa. org. **Website:** www.nfpa.org. **Contact:** Scott Sutherland, executive editor. Circ. 85,000. Bimonthly magazine of the National Fire Protection Association. Emphasizes fire and life safety information. Readers are fire professionals, engineers, architects, building code officials, ages 20-65. Sample copy free with 9×12 SASE or via e-mail.

NEEDS Buys 5-7 photos from freelancers/issue; 30-42 photos/year. Needs photos of fires and fire-related incidents. Model release preferred. Photo captions preferred.

MAKING CONTACT & TERMS Send query letter with list of stock photo subjects. Provide résumé, business card, brochure, flyer or tearsheets to be kept on file for possible future assignments. Send color prints and 35mm transparencies in 3-ring slide sleeve with date. Responds in 3 weeks. Payment negotiated. Pays on publication. Credit line given.

TIPS "Send cover letter, 35mm color slides, preferably with manuscripts and photo captions."

◯ NORTHWEST TERRITORIES EXPLORER'S GUIDE

P.O. Box 610, Yellowknife NT X1A 2N5, Canada. (867) 873- 5007; (800)661-0788. **Fax:** (867)873-4059. **E-mail:** info@spectacularnwt.com. **Website:** www. spectacularnwt.com. Estab. 1996. Circ. 90,000. Annual tourism publication for Northwest Territories. Sample copies available.

NEEDS Photos of babies/children/teens, couples, multicultural, families, senior citizens, landscapes/scenics, wildlife, adventure, automobiles, events, travel. Interested in historical/vintage, seasonal. Also needs photos of Northwest Territories, winter and road touring.

SPECS Uses 35mm transparencies.

MAKING CONTACT & TERMS Send query letter with résumé, slides, prints, photocopies, tearsheets, transparencies, stock list. Portfolio may be dropped off Monday–Saturday. Provide résumé, business card, self-promotion piece to be kept on file for possible future assignments. Responds in 1 week to queries. Simultaneous submissions OK. **Pays on acceptance.**

☼ ⑤ THE ONTARIO TECHNOLOGIST

10 Four Seasons Pl., Suite 404, Etobicoke ON M9B 6H7, Canada. (416)621-9621. **Fax:** (416)621-8694. **E-mail:** editor@oacett.org. **Website:** www.oacett.org. Circ. 23,000. Bimonthly publication of the Ontario Association of Certified Engineering Technicians and Technologists. Emphasizes engineering and applied science technology. Sample copy free with SASE and IRC.

NEEDS Uses 10-12 photos/issue. Needs how-to photos—:"building and installation of equipment; similar technical subjects." Model release preferred. Photo captions preferred.

MAKING CONTACT & TERMS Prefers business card and brochure for files. Send 5×7 glossy color prints or high-res digital images at 300 dpi for consideration. Responds in 1 month. Previously published work OK. Payment varies; negotiable. Pays on publication. Credit line given. Buys one-time rights.

⑤⑤ ⊕ PEDIATRIC ANNALS

6900 Grove Rd., Thorofare NJ 08086. (856)848-1000. **Fax:** (856)848-6091. **E-mail:** editor@healio.com. **Website:** www.healio.com/pediatrics/journals/Ped Ann. Monthly journal. Readers are practicing pediatricians. Sample copy free with SASE.

NEEDS Uses 5-7 photos/issue; primarily stock. Occasionally uses original photos of children in medical settings.

SPECS Color photos preferred. Accepts images in digital format. Send as EPS, JPEG files at 300 dpi.

MAKING CONTACT & TERMS Request editorial calendar for topic suggestions. E-mail query with links to samples. Simultaneous submissions and previously published work OK. Pays varies; negotiable.

Pays on publication. Credit line given. Buys unlimited North American rights including any and all subsidiary forms of publication, such as electronic media and promotional pieces.

☺ ⑤ ◗ PEOPLE MANAGEMENT

151 The Broadway London, London SW19 1JQ United Kingdom. **E-mail:** editorial@peoplemanagement.co.uk. **Website:** www.peoplemanagement.co.uk. **Contact:** Rob MacLachlan, editor. Circ. 120,000. Official publication of the Chartered Institute of Personnel and Development. Biweekly trade journal for professionals in personnel, training and development.

NEEDS Photos of industry, medicine. Interested in alternative process, documentary. Reviews photos with or without a manuscript. Model release preferred. Photo captions preferred.

SPECS Accepts images in digital format. Send via CD, Jaz, ZIP, e-mail, ISDN as TIFF, EPS, JPEG files at 300 dpi.

MAKING CONTACT & TERMS Send query letter with samples. To show portfolio, photographer should follow-up with call. Portfolio should include b&w prints, slides, transparencies. Keeps samples on file. Responds only if interested; send nonreturnable samples. Pays on publication. Rights negotiable.

⑤ ◗ PET PRODUCT NEWS

BowTie, Inc., P.O. Box 6050, Mission Viejo CA 92690-6040. (949)855-8822. **Fax:** (949)855-3045. **E-mail:** ppneditor@i5publishing.com. **Website:** www.petproductnews.com. **Contact:** Sherri Collins, editor. Monthly B2B tabloid. Emphasizes pets and the pet retail business. Readers are pet store owners and managers. Sample copy available for $5. Photo guidelines upon request via e-mail.

NEEDS Buys 5-10 photos from freelancers/issue; 60-120 photos/year. Needs photos of retailers interacting with customers and pets, pet stores and pet product displays. Also needs wildlife, events, industry, product shots/still life. Interested in seasonal. Reviews photos with or without a manuscript. Model/property release preferred. "Enclose a shipment description with each set of photos detailing the type of animal, name of pet store, names of well-known subjects and any procedures being performed on an animal that are not self-explanatory."

SPECS Accepts images in digital format only. Send via CD, ZIP, e-mail as TIFF, EPS, JPEG files at 300 dpi.

MAKING CONTACT & TERMS "We cannot assume responsibility for submitted material, but care is taken with all work. Freelancers must include a SASE for returned work." Send sharp 35mm color slides or prints by mail for consideration. Responds in 2 months. Previously published work OK. Pays $75 for cover; $50 for inside. Pays on publication. Photographer also receives 1 complimentary copy of issue in which their work appears. Credit line given; name and identification of subject must appear on each image. Buys one-time rights.

TIPS Looks for "appropriate subjects, clarity and framing, sensitivity to the subject. No avant garde or special effects. We need clear, straight-forward photography. Definitely no 'staged' photos; keep it natural. Read the magazine before submission. We are a trade publication and need business-like, but not boring, photos that will add to our subjects."

THE PHOTO REVIEW

140 E. Richardson Ave., Suite 301, Langhorne PA 19047. (215)891-0214. **Fax:** (215)891-9358. **E-mail:** info@photoreview.org. **Website:** www.photoreview. org. Estab. 1976. Circ. 2,000.

⊛⊛ PLANNING

American Planning Association, 205 N. Michigan Ave., Suite 1200, Chicago IL 60601. (312)431-9100. **Fax:** (312)786-6700. **E-mail:** slewis@planning.org. **Website:** www.planning.org. **Contact:** Sylvia Lewis, editor; Joan Cairney, art director. Estab. 1972. Circ. 44,000. Monthly magazine. "We focus on urban and regional planning, reaching most of the nation's professional planners and others interested in the topic." Published 10 times a year.

NEEDS Buys 4-5 photos from freelancers/issue; 60 photos/year. Photos purchased with accompanying manuscript and on assignment. Photo essay/photo feature (architecture, neighborhoods, historic preservation, agriculture); scenic (mountains, wilderness, rivers, oceans, lakes); housing; transportation (cars, railroads, trolleys, highways). "No cheesecake; no sentimental shots of dogs, children, etc. High artistic quality is very important. We publish high-quality nonfiction stories on city planning and land use. Ours is an association magazine but not a house organ, and we use the standard journalistic techniques: interviews, anecdotes, quotes. Topics include energy, the environment, housing, transportation, land use,

agriculture, neighborhoods and urban affairs." Photo captions required.

SPECS Accepts images in digital format. Send via ZIP, CD as TIFF, EPS, JPEG files at 300 dpi and around 5×7 in physical size.

MAKING CONTACT & TERMS Send query letter with samples; include SASE for return of material. Responds in 1 month. Previously published work OK. Pays $50-100 for b&w photos; $75-200 for color photos; $375 maximum for cover; $200-600 for manuscript. Pays on publication. Credit line given.

TIPS "Subject lists are only minimally useful, as are website addresses. How the work looks is of paramount importance. Please don't send original slides or prints with the expectation of them being returned. Your best chance is to send addresses for your website showing samples of your work. We no longer keep paper on file. If we like your style we will commission work from you."

⊖ PLASTICS NEWS

1725 Merriman Rd., Suite 300, Akron OH 44313-5283. (330)836-9180. **Fax:** (330)836-2322. **E-mail:** dloepp@ crain.com. **Website:** www.plasticsnews.com. **Contact:** Don Loepp, managing editor. Estab. 1989. Circ. 60,000. Weekly tabloid. Emphasizes plastics industry business news. Readers are male and female executives of companies that manufacture a broad range of plastics products; suppliers and customers of the plastics processing industry. Sample copy available for $1.95.

NEEDS Buys 1-3 photos from freelancers/issue; 52-156 photos/year. Needs photos of technology related to use and manufacturing of plastic products. Model/ property release preferred. Photo captions required.

MAKING CONTACT & TERMS Send unsolicited photos by mail for consideration. Provide résumé, business card, brochure, flyer or tearsheets to be kept on file for possible future assignments. Send query letter with stock list. Keeps samples on file; include SASE for return of material. Responds in 2 weeks. Simultaneous submissions and previously published work OK. Pays $125-175 for color cover; $100-150 for b&w inside; $125-175 for color inside. Pays on publication. Credit line given. Buys one-time and all rights.

⊛⊛⊛ ❶ PLASTICS TECHNOLOGY

6915 Valley Ave., Cincinnati OH 45244. (513)527-8800, (800)950-8020. **Fax:** (646)827-4859. **E-mail:** sbriggs@gardnerweb.com. **Website:** www.ptonline.

com. **Contact:** Sheri Briggs, art director. Estab. 1954. Circ. 50,000. Monthly trade magazine. Sample copy available for first-class postage.

NEEDS Buys 1-3 photos from freelancers/issue. Needs photos of agriculture, business concepts, industry, science, technology. Model release required. Photo captions required.

SPECS Accepts images in digital format. Send via CD, ZIP, e-mail as TIFF, EPS, JPEG files at 300 dpi.

MAKING CONTACT & TERMS Send query letter with résumé, photocopies, tearsheets. Provide business card, self-promotion piece to be kept on file for possible future assignments. Responds only if interested; send nonreturnable samples. Simultaneous submissions OK. Pays $1,000-1,300 for color cover; $300 minimum for color inside. Pays on publication. Credit line given. Buys one-time rights, all rights; negotiable.

POETS & WRITERS MAGAZINE

90 Broad St., Suite 2100, New York NY 10004. (212)226-3586. **E-mail:** editor@pw.org. **Website:** www.pw.org/magazine. **Contact:** Kevin Larimer, editor. Estab. 1987. Circ. 60,000. Bimonthly literary trade magazine. "We offer poets and literary prose writers in-depth information about the publishing industry, details about writers conferences and workshops, practical advice about how to get published, essays about the writing life, listings of grants and awards available to writers, as well as interviews and profiles of contemporary authors."

NEEDS Photos of contemporary writers: poets, fiction writers, writers of creative nonfiction. Photo captions required.

SPECS Digital format.

MAKING CONTACT & TERMS Provide URL, self-promotion piece or tearsheets to be kept on file for possible future assignments. Pays on publication. Credit line given.

POLICE AND SECURITY NEWS

DAYS Communications, Inc., 1208 Juniper St., Quakertown PA 18951-1520. (215)538-1240. **Fax:** (215)538-1208. **E-mail:** dyaw@policeandsecuritynews.com. **Website:** www.policeandsecuritynews.com. **Contact:** David Yaw, publisher. Estab. 1984. Circ. 24,000. Bimonthly trade journal. *"Police and Security News* is edited for middle and upper management and top administration. Editorial content is a combination of articles and columns ranging from the latest in tech-

nology, innovative managerial concepts, training, and industry news in the areas of both public law enforcement and Homeland security." Sample copy free with 13×10" SASE and $2.24 first-class postage.

NEEDS Buys 2 photos from freelancers/issue; 12 photos/year. Needs photos of law enforcement and security related. Reviews photos with or without a manuscript. Photo captions preferred.

SPECS Uses color and b&w prints.

MAKING CONTACT & TERMS Provide résumé, business card, self-promotion piece or tearsheets to be kept on file for possible future assignments. Art director will contact photographer for portfolio review if interested. Portfolio should include b&w and/or color prints or tearsheets. Keeps samples on file; include SASE for return of material. Simultaneous submissions and previously published work OK. Pays $20-40 for color inside. Pays on publication. Credit line given. Buys one-time rights; negotiable.

💲 ⭕ POLICE TIMES/CHIEF OF POLICE

6350 Horizon Dr., Titusville FL 32780. (321)264-0911. **E-mail:** peterc@aphf.org. **Website:** www.aphf.org. **Contact:** Peter Connolly, publications editor. Circ. *Police Times:* quarterly trade magazine (circ. 155,000); *Chief of Police:* bimonthly trade magazine (circ. 33,000). Readers are law enforcement officers at all levels. *Police Times* is the official journal of the American Federation of Police and Concerned Citizens. Sample copy available for $2.50. Photo guidelines free with SASE.

NEEDS Buys 60-90 photos/year. Needs photos of police officers in action, civilian volunteers working with the police, and group shots of police department personnel. Wants no photos that promote other associations. Police-oriented cartoons also accepted on spec. Model release preferred. Photo captions preferred.

MAKING CONTACT & TERMS Send glossy b&w and color prints for consideration; include SASE for return of material. Responds in 3 weeks. Simultaneous submissions and previously published work OK. **Pays on acceptance.** Credit line given if requested; editor's option. Buys all rights, but may reassign to photographer after publication; includes online publication rights.

TIPS "We are open to new and unknowns in small communities where police are not given publicity."

⊕ PONDS USA AND WATER GARDENS

BowTie, Inc., P.O. Box 6050, Mission Viejo CA 92690. (949)855-8822. **Fax:** (949)855-3045. **E-mail:** ponds@ bowtieinc.com. **Website:** www.pondsmagazine.com. **Contact:** Patricia Knight, editor. Estab. 1998. Annual consumer magazine. *Ponds USA* publishes articles about various subjects, focusing on setup and maintenance of ponds (including plants and fish) and the pondkeeping lifestyle (stress relief, water gardening, etc.). Photography submission guidelines are free with SASE or via e-mail. Buys stock photos only. Accepts outstanding work from beginning and established photographers; expects a high level of professionalism from all photographers who make contact. Purchases 60 photos a year.

SPECS Reviews photos with or without a manuscript. Accepts images in digital format on CD as TIFF or JPEG files as 300 dpi. Images must be at least 5×7 print size at 300 dpi. Please see our photo guidelines before submitting. Responds to queries in 1 week. Varies for submissions. Finds freelancers through submissions.

MAKING CONTACT & TERMS Send a query letter via SASE or e-mail.

TIPS "We prefer photos of ponds that are well-cared-for (not a lot of algae, etc.). We also take photos of water features (pondless). Please read our guidelines before submitting."

🔊 ⑤ ○ PROCEEDINGS

U.S. Naval Institute, 291 Wood Rd., Annapolis MD 21402-5034. (410)268-6110. **Fax:** (410)295-7940. **E-mail:** articlesubmissions@usni.org. **Website:** www. usni.org/magazines/proceedings. **Contact:** Richard G. Latture, editor-in-chief; Amy Voight, photo editor. Estab. 1873. Circ. 60,000. Monthly trade magazine dedicated to providing an open forum for national defense. Sample copy available for $3.95. Photo guidelines on website.

NEEDS Buys 10 photos from freelancers/issue; 120 photos/year. Needs photos of industry, military, political. Model release preferred. Photo captions required; include time, location, subject matter, service represented—if necessary.

SPECS Uses glossy color prints. Accepts images in digital format. Send via CD, ZIP as TIFF, JPEG files at 300 dpi.

MAKING CONTACT & TERMS Send query letter with résumé, prints. Does not keep samples on file; include SASE for return of material. Responds only

if interested; send nonreturnable samples. Simultaneous submissions and previously published work OK. Pays $200 for color cover; $25-75 for color inside. Pays on publication. Credit line given. Buys one-time and sometimes electronic rights.

TIPS "We look for original work. The best place to get a feel for our imagery is to see our magazine or look at our website."

◎ ⑤ PRODUCE RETAILER

Vance Publishing Corp., 10901 West 84th Ter. Suite 200, Lenexa KS 66214. (913) 438-0603; (512)906-0733. **E-mail:** pamelar@produceretailer.com; treyes@pro duceretailer.com. **Website:** produceretailer.com. **Contact:** Pamela Riemenschneider, editor; Tony Reyes, art director. Estab. 1988. Circ. 12,000. Monthly magazine, e-mail newsletters, and online. Emphasizes the retail end of the fresh produce industry. Readers are male and female executives who oversee produce operations in US and Canadian supermarkets as well as in-store produce department personnel. Sample copies available.

NEEDS Buys 2-5 photos from freelancers/issue; 24-60 photos/year. Needs in-store shots, environmental portraits for cover photos or display pictures. "Photo captions required; include subject's name, job title and company title—all verified and correctly spelled."

SPECS Accepts images in digital format. Send via e-mail as TIFF, JPEG files.

MAKING CONTACT & TERMS E-mail only. Response time "depends on when we will be in a specific photographer's area and have a need." Pays $500-750 for color cover; $25-50/color photo. **Pays on acceptance.** Credit line given. Buys all rights.

TIPS "We seek photographers who serve as our on-site 'art director' to ensure capture of creative angles and quality images."

PROFESSIONAL PHOTOGRAPHER

Professional Photographers of America, 229 Peachtree St. NE, Suite 2200, International Tower, Atlanta GA 30303. (404)522-8600, ext. 260. **Fax:** (404)614-6406. **E-mail:** jgaboury@ppa.com; cbish opp@ppa.com. **Website:** www.ppmag.com. Debbie Todd, art director. Estab. 1907. Circ. 26,000. Monthly magazine. Emphasizes professional photography in the fields of portrait, wedding, commercial/advertising, sports, corporate and industrial. Readers include professional photographers and photographic services and educators. Approximately half the circulation

is Professional Photographers of America members. Sample copy available for $5 postpaid.

○ PPA members submit material unpaid to promote their photo businesses and obtain recognition. Images sent to *Professional Photographer* should be technically perfect, and photographers should include information about how the photo was produced.

NEEDS Buys 25-30 photos from freelancers/issue; 300-360 photos/year. "We only accept material as illustration that relates directly to photographic articles showing professional studio, location, commercial and portrait techniques. A majority are supplied by Professional Photographers of America members." Reviews photos with accompanying manuscript only. "We always need commercial/advertising and industrial success stories; how to sell your photography to major accounts, unusual professional photo assignments. Also, photographer and studio application stories about the profitable use of electronic still imaging for customers and clients." Model release preferred. Photo captions required.

SPECS Prefers images in digital format. Send via CD, e-mail as TIFF, EPS, JPEG files at 72 dpi minimum. Also uses 8×10 unmounted glossy b&w and color prints; 35mm, 2¼×2¼, 4×5, 8×10 transparencies.

MAKING CONTACT & TERMS Send query letter with résumé of credits. "We prefer a story query, or complete manuscript if writer feels subject fits our magazine. Photos will be part of manuscript package." Responds in 2 months. Credit line given.

◎ PUBLIC POWER

1875 Connecticut Ave. NW, Suite 1200, Washington DC 20009-5715. (202)467-2900. **Fax:** (202)467-2910. **E-mail:** magazine@publicpower.org; dblaylock@publicpower.org. **Website:** www.publicpowermedia.org. **Contact:** David L. Blaylock, editor. Estab. 1942. Publication of the American Public Power Association, published 8 times a year. Emphasizes electric power provided by cities, towns, and utility districts. Sample copy and photo guidelines free.

NEEDS Buys photos on assignment only.

SPECS Prefers digital images; call art director (Robert Thomas) at (202)467-2983 to discuss.

MAKING CONTACT & TERMS Send query letter with samples. Provide résumé, business card, brochure, flyer or tearsheets to be kept on file for possible future assignments. **Pays on acceptance.** Credit line given. Buys one-time rights.

⑨⑤ ◑ QSR

4905 Pine Cone Dr., Suite 2, Durham NC 27707. (919)945-0703; (919)489-1916. **Fax:** (919)489-4767. **E-mail:** sam@qsrmagazine.com. **Website:** www.qsrmagazine.com. **Contact:** Sam Oches, editor. Estab. 1997. Trade magazine directed toward the business aspects of quick-service restaurants (fast food). "Our readership is primarily management level and above, usually franchisors and franchisees. Our goal is to cover the quick-service and fast, casual restaurant industries objectively, offering our readers the latest news and information pertinent to their business." Photo guidelines free.

NEEDS Buys 10-15 photos/year. Needs corporate identity portraits, images associated with fast food, general food images for feature illustration. Reviews photos with or without MS. Model/property release preferred.

SPECS Prefers images in digital format. Send via CD/DVD, ZIP as TIFF, EPS files at 300 dpi.

MAKING CONTACT & TERMS Send query letter with samples, brochure, stock list, tearsheets. Art director will contact photographer for portfolio review if interested. Portfolio should include slides and digital sample files. Keeps samples on file. Responds only if interested; send nonreturnable samples. Simultaneous submissions and previously published work OK. Pays on publication. Publisher only interested in acquiring all rights unless otherwise specified.

TIPS "Willingness to work with subject and magazine deadlines essential. Willingness to follow artistic guidelines necessary but should be able to rely on one's own eye. Our covers always feature quick-service restaurant executives with some sort of name recognition (e.g., a location shot with signage in the background, use of product props which display company logo)."

⑤ ◑ QUICK FROZEN FOODS INTERNATIONAL

2125 Center Ave., Suite 305, Fort Lee NJ 07024-5898. (201)592-7007. **Fax:** (201)592-7171. **E-mail:** JohnQFFI@aol.com. **Website:** www.qffintl.com. **Contact:** John M. Saulnier, chief editor/publisher. Circ. 15,000. Quarterly magazine. Emphasizes retailing, marketing, processing, packaging and distribution of frozen foods around the world. Readers are international ex-

ecutives involved in the frozen food industry: manufacturers, distributors, retailers, brokers, importers/exporters, warehousemen, etc. Sample copy available for $20.

NEEDS Buys 10-25 photos/year. Uses photos of agriculture, plant exterior shots, step-by-step in-plant processing shots, photos of retail store frozen food cases, head shots of industry executives, etc. Photo captions required.

SPECS Accepts digital images via CD at 300 dpi, CMYK. Also accepts 5×7 glossy b&w or color prints.

MAKING CONTACT & TERMS Send query letter with résumé of credits. Responds in 1 month. Payment negotiable. Pays on publication. Buys all rights but may reassign to photographer after publication.

TIPS A file of photographers' names is maintained; if an assignment comes up in an area close to a particular photographer, she/he may be contacted. "When submitting your name, inform us if you are capable of writing a story if needed."

RANGEFINDER

770 Broadway, 8th Floor, New York NY 10003. (646) 654-4500. **Fax:** (310)481-8037. **E-mail:** bhurter@rf publishing.com. **Website:** www.rangefindermag.com. Bill Hunter, editor. **Contact:** Carl Lozada, art director. Estab. 1952. Circ. 61,000. Monthly magazine. Emphasizes topics, developments and products of interest to the professional photographer. Readers are professionals in all phases of photography. Sample copy free with 11×14 SASE and 2 first-class stamps. Photo guidelines free with SASE.

NEEDS Buys very few photos from freelancers/issue. Needs all kinds of photos; almost always run in conjunction with articles. "We prefer photos accompanying 'how-to' or special interest stories from the photographer." No pictorials. Special needs include seasonal cover shots (vertical format only). Model release required; property release preferred. Photo captions preferred.

MAKING CONTACT & TERMS Send query letter with résumé of credits. Keeps samples on file; include SASE for return of material. Responds in 1 month. Previously published work occasionally OK; give details. Payment varies. Covers submitted gratis. Pays on publication. Credit line given. Buys first North American serial rights; negotiable.

⊖ ❶ RECOMMEND

Worth International Media Group, 5979 NW 151st St., Suite 120, Miami Lakes FL 33014. (305)828-0123; (800)447-0123. **Fax:** (305)826-6950. **E-mail:** paloma@recommend.com. **Website:** www.recommend.com; www.worthit.com. **Contact:** Paloma de Rico, editor-in-chief. Estab. 1985. Circ. 55,000. Monthly. Emphasizes travel. Readers are travel agents, meeting planners, hoteliers, ad agencies.

NEEDS Buys 16 photos from freelancers/issue; 192 photos/year. "Our publication divides the world into 7 regions. Every month we use travel destination-oriented photos of animals, cities, resorts and cruise lines; feature all types of travel photography from all over the world." Model/property release required. Photo captions preferred; identification required on every photo.

SPECS Accepts images in digital format. Send via CD, ZIP as TIFF, EPS files at 300 dpi minimum. "We do not accept 35mm slides or transparencies."

MAKING CONTACT & TERMS "Contact via e-mail to view sample of photography." Simultaneous submissions and previously published work OK. Pays 30 days after publication. Credit line given. Buys one-time rights.

TIPS Prefers to see high-res digital files.

❶ ⊖ ❶ REFEREE

Referee Enterprises, Inc., 2017 Lathrop Ave., Racine WI 53405. (800)733-6100. **Fax:** (262)632-5460. **E-mail:** submissions@referee.com. **Website:** www.ref eree.com. **Contact:** Julie Sternberg, managing editor. Estab. 1976. Circ. 40,000. Monthly magazine. Readers are mostly male, ages 30-50. Sample copy free with 9×12 SASE and 5 first-class stamps. Photo guidelines free with SASE.

NEEDS Buys 25-40 photos from freelancers/issue; 300-400 photos/year. Needs action officiating shots—all sports. Photo needs are ongoing. Photo captions required; include officials' names and hometowns.

SPECS Prefers to use digital files (minimum 300 dpi submitted on CD only—no DVDs) and 35mm slides. Also uses color prints.

MAKING CONTACT & TERMS Send unsolicited photos by mail or to submissions@referee.com for consideration. Responds in 2 weeks. Simultaneous submissions and previously published work OK. Pays $100 for color cover; $35 for color inside. Pays

on publication. Credit line given. Rights purchased negotiable.

TIPS "Prefer photos that bring out the uniqueness of being a sports official. Need photos primarily of officials at or above the high school level in baseball, football, basketball, softball, volleyball and soccer in action. Other sports acceptable, but used less frequently. When at sporting events, take a few shots with the officials in mind, even though you may be on assignment for another reason. Don't be afraid to give it a try. We're receptive, always looking for new freelance contributors. We are constantly looking for pictures of officials/umpires. Our needs in this area have increased. Names and hometowns of officials are required."

RELAY MAGAZINE

417 E. College Ave., Tallahassee FL 32301. (850)224-3314, ext. 4 or ext. 5. **Fax:** (850)224-2831. **E-mail:** gholmes@publicpower.com. **Website:** publicpower.com/relay-magazine. **Contact:** Garnie Holmes, editor. Estab. 1957. Circ. 5,000. Quarterly industry magazine of the Florida Municipal Electric Association. Emphasizes energy, electric, utility and telecom industries in Florida. Readers are utility professionals, local elected officials, state and national legislators, and other state power associations.

NEEDS Number of photos/issue varies; various number supplied by freelancers. Needs photos of electric utilities in Florida (hurricane/storm damage to lines, utility workers, power plants, infrastructure, telecom, etc.); cityscapes of member utility cities. Model/property release preferred. Photo captions required.

SPECS Uses 3×5, 4×6, 5×7, 8×10 b&w and color prints. Accepts images in digital format.

MAKING CONTACT & TERMS Send query letter with description of photo or photocopy. Keeps samples on file. Simultaneous submissions and previously published work OK. Payment negotiable. Rates negotiable. Pays on use. Credit line given. Buys one-time rights, repeated use (stock); negotiable.

TIPS "Must relate to our industry. Clarity and contrast important. Always query first."

🟢 🔵 REMODELING

HanleyWood, LLC, One Thomas Circle NW, Suite 600, Washington DC 20005. (202)452-0800. **Fax:** (202)785-1974. **E-mail:** salfano@hanleywood.com; ibush@hanleywood.com. **Website:** www.remodeling magazine.com. **Contact:** Sal Alfano, editorial director; Ingrid Bush, managing editor. Estab. 1985. Circ. 80,000. Published 13 times/year. "Business magazine for remodeling contractors. Readers are small contractors involved in residential and commercial remodeling." Sample copy free with 8×11 SASE.

NEEDS Uses 10-15 photos/issue; number supplied by freelancers varies. Photos of remodeled residences, both before and after. Interior and exterior photos of residences that emphasize the architecture over the furnishings. Reviews photos with "short description of project, including architect's or contractor's name and phone number. We have 1 regular photo feature: *Before and After* describes a whole-house remodel. Request editorial calendar to see upcoming design features."

SPECS Accepts images in digital format. Send via ZIP as TIFF, GIF, JPEG files at 300 dpi.

MAKING CONTACT & TERMS Provide résumé, business card, brochure, flyer or tearsheets to be kept on file for possible future assignments. Responds in 1 month. **Pays on acceptance.** Credit line given. Buys one-time rights; Web rights.

➕ 🟢🔵 RENTAL MANAGEMENT

1900 19th St., Moline IL 61265. (800) 334-2177; (309)764-2475. **Fax:** (309) 764-1533; (309)764-2747. **E-mail:** wayne.walley@ararental.org. **Website:** www.rentalmanagementmag.com. **Contact:** Wayne Walley, editor. Estab. 1970. Circ. 18,000. Monthly business management magazine for managers in the equipment rental industry—no appliances, furniture, cars, "rent to own" or real estate (property or apartments). Sample copies available.

NEEDS Buys 0-5 photos from freelancers/issue; 5-10 photos/year. Photos of business concepts, technology/computers. Projects: construction, landscaping, remodeling, parties, and events with rental companies involved. Business scenes: rental stores, communication, planning, training, financial management, HR issues, etc. Reviews photos with or without a manuscript. Model/property release preferred. Photo captions preferred; include identification of people.

SPECS Digital format requested. Send via CD, FTP, e-mail, ZIP as TIFF, EPS, JPEG files at 300 dpi/8×10 minimum (CMYK).

MAKING CONTACT & TERMS Send query letter with résumé, samples, stock list. Provide résumé, business card or self-promotion piece to be kept on file for possible future assignments. Responds only if

interested; send nonreturnable samples. Previously published work OK "if not in our industry." Negotiates fee and rights prior to assignment or purchase of existing photos. **Pays on acceptance.** Credit line given. Buys one-time rights, first rights.

TIPS "We occasionally use photographers to shoot pictures to accompany freelance articles. We also sometimes buy stock shots to help illustrate freelance and staff-written articles."

◎ ⑤ ◑ REP.

1166 Avenue of the Americas, 10th Floor, New York NY 10036. (212)204-4260. **E-mail:** sean.barrow@penton.com. **Website:** www.wealthmanagement.com. **Contact:** Sean Barrow, art director. Estab. 1976. Circ. 100,000. Monthly trade publication provides stockbrokers and investment advisors with industry news and financial trends. Monthly magazine. Emphasizes stock brokerage and financial services industries. Magazine is "requested and read by 90% of the nation's top financial advisors."

NEEDS Uses about 8 photos/issue—3 supplied by freelancers. Needs environmental portraits of financial and brokerage personalities, and conceptual shots of financial ideas—all by assignment only. Model/property release is photographer's responsibility. Photo captions required.

SPECS Prefers 100 ISO film or better. Accepts images in digital format. Send electronically, or via CD.

MAKING CONTACT & TERMS Provide brochure, flyer or tearsheets to be kept on file for possible future assignments. Cannot return material. Due to space limitations, please obtain permission *prior* to sending digital samples via e-mail. Simultaneous submissions and previously published work OK. Pays $500-1,500 for cover; $500-1,000 for inside. Pays 30 days after publication. Credit line given. Buys one-time rights. Publisher requires signed rights agreement.

TIPS "We're always looking for young talent. The focus of our magazine is on design, so talent and professionalism are key."

⑤⑤ ◑ RESTAURANT HOSPITALITY

Penton Media, 1300 E. Ninth St., Cleveland OH 44114. (216)931-9942. **Fax:** (216)696-0836. **E-mail:** chris.roberto@penton.com. **Website:** www.restaurant-hospitality.com. **Contact:** Chris Roberto, group creative director; Michael Sanson, editor-in-chief. Estab. 1919. Circ. 100,000. Monthly. Emphasizes "ideas for full-service restaurants" including business strategies and industry menu trends. Readers are restaurant owners/operators and chefs for full-service independent and chain concepts.

NEEDS Assignment needs vary; 10-15 photos from freelancers/issue, plus stock; 120 photos/year. Needs "on-location portraits, restaurant interiors and details, and occasional project specific food photos." Special needs include subject-related photos: industry chefs, personalities and food trends. Model release preferred. Photo captions preferred.

SPECS Accepts images in digital format. Send via FTP, download link or e-mail.

MAKING CONTACT & TERMS Send postcard samples and e-mail with link to website. Previously published work OK. Pay varies; negotiable. Cover fees on per project basis. **Pays on acceptance.** Credit line given. Buys one-time rights plus usage in all media.

TIPS "Send a postcard that highlights your work and website."

⑤ RETAILERS FORUM

383 E. Main St., Centerport NY 11721. (800)635-7654. **E-mail:** forumpublishing@aol.com. **Website:** www.forum123.com. **Contact:** Martin Stevens, publisher. Estab. 1981. Circ. 70,000. Monthly magazine. Readers are entrepreneurs and retail store owners. Sample copy available for $7.50.

NEEDS Buys 3-6 photos from freelancers/issue; 36-72 photos/year. "We publish trade magazines for retail variety goods stores and flea market vendors. Items include jewelry, cosmetics, novelties, toys, etc. (five-and-dime-type goods). We are interested in creative and abstract impressions—not straight-on product shots. Humor a plus." Model/property release required.

SPECS Uses color prints. Accepts images in digital format. Send via e-mail at 300 dpi.

MAKING CONTACT & TERMS Send unsolicited photos by mail or e-mail for consideration. Does not keep samples on file; include SASE for return of material. Responds in 2 weeks. Simultaneous submissions and previously published work OK. Pays $100 for color cover; $50 for color inside. **Pays on acceptance.** Buys one-time rights.

RTOHQ: THE MAGAZINE

1504 Robin Hood Trail, Austin TX 78703. (800)204-2776. **Fax:** (512)794-0097. **E-mail:** nferguson@rtohq.org; bkeese@rtohq.org. **Website:** www.rtohq.org. **Contact:** Neil Ferguson, art director; Bill Keese, ex-

ecutive editor. Estab. 1980. Circ. 5,500. Bimonthly magazine published by the Association of Progressive Rental Organizations. Emphasizes the rental-purchase industry. Readers are owners and managers of rental-purchase stores in North America, Canada, Great Britain, and Australia.

NEEDS Buys 1-2 photos from freelancers/issue; 6-12 photos/year. Needs "strongly conceptual, cutting-edge photos that relate to editorial articles on business/management issues. Also looking for photographers to capture unique and creative environmental portraits of our members." Model/property release preferred.

MAKING CONTACT & TERMS Provide brochure, flyer, or tearsheets to be kept on file for possible future assignments. Simultaneous submissions and previously published work OK. Pays $200-450/job; $350-450 for cover; $200-450 for inside. Pays on publication. Credit line given. Buys one-time and electronic rights.

TIPS "Understand the industry and the specific editorial needs of the publication, e.g., don't send beautiful still-life photography to a trade association publication."

⑤ SCIENCE SCOPE

National Science Teachers Association, 1840 Wilson Blvd., Arlington VA 22201. (703)243-7100. **Fax:** (703)243-7177. **E-mail:** wthomas@nsta.org; scope@nsta.org. **Website:** www.nsta.org. **Contact:** Will Thomas, art director. Journal published 9 times/year during the school year. Emphasizes "activity-oriented ideas—ideas that teachers can take directly from articles." Readers are mostly middle school science teachers. Sample copy available for $6.25. Photo guidelines free with SASE.

NEEDS About half our photos are supplied by freelancers. Needs photos of classroom activities with students participating. "In some cases, say for interdisciplinary studies articles, we'll need a specialized photo." Model release required. Need for photo captions "depends on the type of photo."

SPECS Uses slides, negatives, prints. Accepts images in digital format. Send via CD, e-mail as TIFF, EPS files at 300 dpi minimum.

MAKING CONTACT & TERMS Arrange a personal interview to show portfolio. Send query letter with stock list. Provide résumé, business card, brochure, flyer or tearsheets to be kept on file for possible future assignments. Considers previously published work;

"prefer not to, although in some cases there are exceptions." Pays on publication. Sometimes pays kill fee. Credit line given. Buys one-time rights; negotiable.

TIPS "We look for clear, crisp photos of middle-level students working in the classroom. Shots should be candid with students genuinely interested in their activity. (The activity is chosen to accompany manuscript.) Please send photocopies of sample shots along with listing of preferred subjects and/or listing of stock photo topics."

SECURITY DEALER & INTEGRATOR

Cygnus Business Media, 12735 Morris Rd., Bldg. 200, Suite 180, Alpharetta GA 30004. (800)547-7377, ext 2730. **E-mail:** deborah.omara@cygnus.com. **Website:** www.securityinfowatch.com/magazine. **Contact:** Deborah O'Mara, editor-in-chief. Circ. 25,000. Monthly. Emphasizes security subjects. Readers are business owners who install alarm, security, CCTV, home automation, and access control systems. Sample copy free with SASE. "*SD&I* seeks credible, reputable thought leaders to provide timely, original editorial content for our readers—security value-added resellers, integrators, systems designers, central station companies, electrical contractors, consultants and others—on rapidly morphing new communications and signaling technologies, networking, standards, business acumen, project information, and other topics to hone new skills and build business. Content must add value to our pages and provide thought-provoking insights on the industry and its future. In most cases, content must be vendor-neutral, unless the discussion is on a patented or proprietary technology."

◘ "Photographs and graphics, drawings and white papers are encouraged."

NEEDS Uses 2-5 photos/issue; none at present supplied by freelance photographers. Photos of security-application-equipment. Model release preferred. Photo captions required.

SPECS Photos must be JPEG, TIFF or EPS form for any section of the magazine, including product sections (refer to the editorial calendar). "We require a 300 dpi image at a minimum 100% size of 2×3 for product submissions."

MAKING CONTACT & TERMS Send b&w and color prints by mail for consideration; include SASE for return of material. Responds "immediately." Simultaneous submissions and/or previously published work OK.

TIPS "Do not send originals; send dupes only, and only after discussion with editor."

SPECIALTY TRAVEL INDEX
Alpine Hansen, P.O. Box 458, San Anselmo CA 94979. (415)455-1643. **E-mail:** info@specialtytravel.com. **Website:** www.specialtytravel.com. Estab. 1980. Circ. 35,000. Biannual trade magazine. Directory of special interest travel. Readers are travel agents. Sample copy available for $6.

NEEDS Contact for want list. Buys photo/ms packages. Photo captions preferred.

SPECS Uses digital images. Send via CD or photographer's website. "No e-mails for photo submissions."

MAKING CONTACT & TERMS Send query letter with résumé, stock list and website link to view samples. Does not keep samples on file; include SASE for return of material. Responds in 2 months to queries. Simultaneous submissions and previously published work OK. Pays $25/photo. **Pays on acceptance.** Credit line given.

SUCCESSFUL MEETINGS
Northstar Travel Media, Northstar Travel Media, 100 Lighting Way, Secaucus NJ 07094. (646)380-6247. **E-mail:** valonzo@ntmllc.com; jruf@ntmllc.com. **Website:** www.successfulmeetings.com. **Contact:** Vincent Alonzo, editor-in-chief; Jennifer Ruf, art director. Estab. 1955. Circ. 70,000. Monthly. Emphasizes business group travel for all sorts of meetings. Readers are business and association executives who plan meetings, exhibits, conventions and incentive travel. Sample copy available for $10.

NEEDS Special needs include high-quality corporate portraits; conceptual, out-of-state shoots.

MAKING CONTACT & TERMS Arrange a personal interview to show portfolio. Send query letter with résumé of credits and list of stock photo subjects. Responds in 2 weeks. Simultaneous submissions and previously published work OK, "only if you let us know." Pays $500-750 for color cover; $50-150 for b&w inside; $75-200 for color inside; $150-250/b&w page; $200-300/color page; $50-100/hour; $175-350/3/4 day. **Pays on acceptance.** Credit line given. Buys one-time rights.

THE SURGICAL TECHNOLOGIST
6 W. Dry Creek Circle, Suite 200, Littleton CO 80120-8031. (303)694-9130. **Fax:** (303)694-9169. **E-mail:** kludwig@ast.org. **Website:** www.ast.org. **Contact:** Karen Ludwig, editor/publisher. Circ. 23,000. Monthly journal of the Association of Surgical Technologists. Emphasizes surgery. Readers are operating room professionals, well educated in surgical procedures, ages 20-60. Sample copy free with 9×12 SASE and 5 first-class stamps. Photo guidelines free with SASE.

NEEDS "Surgical, operating room photos that show members of the surgical team in action." Model release required.

MAKING CONTACT & TERMS Send low-res JPEGs with query via e-mail. Responds in 4 weeks after review by editorial board. Simultaneous submissions and previously published work OK. Payment negotiable. **Pays on acceptance.** Credit line given. Buys all rights.

TECHNIQUES
1410 King St., Alexandria VA 22314. (703)683-3111; 800-826-9972. **Fax:** (703)683-7424. **E-mail:** techniques@acteonline.org. **Website:** www.acteonline.org. **Contact:** Margaret Mitchell, managing editor. Estab. 1926. Circ. 42,000. Monthly magazine of the Association for Career and Technical Education. Emphasizes education for work and on-the-job training. Readers are teachers and administrators in high schools and colleges. Sample copy free with 10×13 SASE.

This publication is now outsourced and offers little opportunity for freelance photography.

NEEDS Buys 1-2 photos from freelancers/issue; 12-24 photos/year. Needs "students in classroom and job training settings; teachers; students in work situations." Model release preferred for children. Photo caption preferred; include location, explanation of situation.

SPECS Uses 5×7 color prints; 35mm transparencies.

MAKING CONTACT & TERMS Send query letter with list of stock photo subjects. Send unsolicited photos by mail for consideration. Provide résumé, business card, brochure, flyer or tearsheets to be kept on file for possible future assignments. Responds as needed. Simultaneous submissions and previously published work OK. Pays on publication. Credit line given. Buys one-time rights; sometimes buys all rights; negotiable.

TEXAS REALTOR MAGAZINE
P.O. Box 2246, Austin TX 78768. (800)873-9155; (512)370-2286. **Fax:** (512)370-2390. **E-mail:** jmathews@texasrealtors.com. **Website:** www.texasrealtors.com. **Contact:** Joel Mathews, art director;

Brandi Alderetti. Estab. 1972. Circ. 50,000. Monthly magazine of the Texas Association of Realtors. Emphasizes real estate sales and related industries. Readers are male and female realtors, ages 20-70. Sample copy free with SASE.

NEEDS Buys 10 photos from freelancers/issue; 120 photos/year. Needs photos of architectural details, business, office management, telesales, real estate sales, commercial real estate, nature. Property release required.

MAKING CONTACT & TERMS Buys one-time rights; negotiable.

💲 🔘 TEXTILE RENTAL MAGAZINE

1800 Diagonal Rd., Suite 200, Alexandria VA 22314. (703) 519-0026; (877)770-9274. **Fax:** (703)519-0026. **E-mail:** jmorgan@trsa.org. **Website:** www.trsa.org. Monthly magazine of the Textile Rental Services Association of America. Emphasizes the linen supply, industrial and commercial textile rental and service industry. Readers are "heads of companies, general managers of facilities, predominantly male; national and international readers."

NEEDS Photos needed on assignment basis only. Model release preferred. Photo captions preferred or required "depending on subject."

MAKING CONTACT & TERMS "We contact photographers on an as-needed basis from a directory. We also welcome inquiries and submissions." Cannot return material. Previously published work OK. Pays $350 for color cover plus processing; "depends on the job." **Pays on acceptance.** Credit line given if requested. Buys all rights.

💲 TOBACCO INTERNATIONAL

Lockwood Publications, Inc., 26 Broadway, Floor 9M, New York NY 10004. (212)391-2060. **Fax:** (212)827-0945. **E-mail:** editor@tobaccointernational.com. **Website:** www.tobaccointernational.com. **Contact:** Murdoch McBride. Estab. 1886. Circ. 5,000. Monthly international business magazine. Emphasizes cigarettes, tobacco products, tobacco machinery, supplies and services. Readers are executives, ages 35-60. Sample copy free with SASE.

NEEDS Uses 20 photos/issue. "Photography that represents tobacco industry activity, processing or growing tobacco products from all around the world, but any interesting newsworthy photos relevant to subject matter is considered." Model or property release preferred.

MAKING CONTACT & TERMS Send query letter with photocopies, transparencies, slides or prints. Does not keep samples on file; include SASE for return of material. Responds in 3 weeks. Simultaneous submissions OK (not if competing journal). Pays $50/color photo. Pays on publication. Credit line may be given.

🌙 💲💲 🔘 TOBACCO JOURNAL INTERNATIONAL

Quartz Business Media, Westgate House, 120/130 Station Road, Redhill, Surrey RH1 1ET, United Kingdom. +44(0)1737 855000. **Fax:** +44(0)1737 855327. **E-mail:** joseph.mapother@konradin.de; anja.helk@konradin.de; william.mcewen@konradin.de. **Website:** www.worldtobacco.co.uk. **Contact:** Anja Helk, editor; William McEwen, editor. Circ. 4,300. Trade magazine. "Focuses on all aspects of the tobacco industry from international trends to national markets, offering news and views on the entire industry from leaf farming to primary and secondary manufacturing, to packaging, distribution and marketing." Sample copies available. Request photo guidelines via e-mail.

NEEDS Buys 5-10 photos from freelancers/issue; agriculture, product shots/still life. "Anything related to tobacco and smoking. Abstract smoking images considered, as well as international images."

SPECS Accepts almost all formats. Minimum resolution of 300 dpi at the size to be printed. Prefers TIFFs to JPEGs, but can accept either.

MAKING CONTACT & TERMS E-mail query letter with link to photographer's website, JPEG samples at 72 dpi. Provide self-promotion piece to be kept on file for possible future assignments. Pays £200 maximum for cover photo. **Pays on acceptance.** Credit line given.

TIPS "Check the features list on our website."

🔘 TODAY'S PHOTOGRAPHER

American Image Press, P.O. Box 42, Hamptonville NC 27020-0042. (336)468-1138. **Fax:** (336)468-1899. **E-mail:** homeoffice@ainewsservice.net. **Website:** www.aipress.com. **Contact:** Vonda H. Blackburn, editor-in-chief. Estab. 1986. Circ. 78,000. Published once a year in print, twice/year online. Magazine of the International Freelance Photographers Organization. Emphasizes making money with photography. Readers are 90% male photographers. Sample copy available for 9×12 SASE. Photo guidelines free with SASE.

NEEDS Buys 40 photos from freelancers/issue; 240 photos/year. Model release required. Photo captions

preferred. Only buys content from members of IFPO ($74 membership fee, plus $7 shipping).

MAKING CONTACT & TERMS Send 35mm, 2¼×2¼, 4×5, 8×10 b&w and color prints or transparencies by mail for consideration; include SASE for return of material. Responds at end of quarter. Simultaneous submissions and previously published work OK. Payment negotiable. Credit line given. Buys one-time rights, per contract.

⑤⑤ TOP PRODUCER

383 N. Downey St., P.O. Box 958 Mexico, MO 65265, Walcott IA 52773. (573) 581-6387; (563)284-5054. **E-mail:** drafferty@farmjournal.com. **Website:** www.agweb.com. **Contact:** Dana Rafferty, art director; Jeanne Bernick, editor. Circ. 120,000. Monthly. Emphasizes American agriculture. Readers are active farmers, ranchers or agribusiness people. Sample copy and photo guidelines free with SASE.

NEEDS Buys 5-10 photos from freelancers/issue; 60-100 photos/year. "We use studio-type portraiture (environmental portraits), technical, details and scenics." Model release preferred. Photo captions required.

MAKING CONTACT & TERMS Send query letter with résumé of credits along with business card, brochure, flyer or tearsheets to be kept on file for possible future assignments. "Do not send originals!" Please send information for online portfolios/websites, as we often search for stock images on such sites. Digital files and portfolios may be sent via CD to the address noted above." Simultaneous submissions and previously published work OK. **Pays on acceptance.** Credit line given. Buys one-time rights.

TIPS In portfolio or samples, likes to see "about 40 samples showing photographer's use of lighting and ability to work with people. Know your intended market. Familiarize yourself with the magazine and keep abreast of how photos are used in the general magazine field."

⑤ TRANSPORTATION MANAGEMENT & ENGINEERING

Scranton Gillette Communications, Inc., 3030 W. Salt Creek Lane, Suite 201, Arlington Heights IL 60005. (847)391-1029. **E-mail:** bwilson@sgcmail.com. **Website:** www.roadsbridges.com. **Contact:** Bill Wilson, editor. Estab. 1994. Circ. 18,000. Quarterly supplement. "*TM&E* is a controlled publication targeted toward 18,000 traffic/transit system planners, designers,

engineers and managers in North America." Sample copies available.

NEEDS Buys 1-2 photos from freelancers/issue; 5-10 photos/year. Needs photos of landscapes/scenics, transportation-related, traffic, transit. Reviews photos with or without ms. Property release preferred. Photo captions preferred.

SPECS Uses 5×7 glossy prints; 35mm transparencies. Accepts images in digital format. Send via CD as TIFF, EPS files at 300 dpi.

MAKING CONTACT & TERMS Send query letter with prints. Portfolio may be dropped off every Monday. Responds in 3 weeks to queries. Responds only if interested; send nonreturnable samples. Pays on publication. Credit line sometimes given. Buys all rights; negotiable.

TIPS "Read our magazine."

TRANSPORT TOPICS

950 N. Glebe Rd., Suite 210, Arlington VA 22203. (703)838-1770. **Fax:** (703)838-7916. **E-mail:** gdively@ttnews.com. **Website:** www.ttnews.com. **Contact:** George Dively, art director. Estab. 1935. Circ. 31,000. Weekly tabloid. Publication of American Trucking Associations. Emphasizes the trucking industry and freight transportation. Readers are executives, ages 35-65.

NEEDS Uses approximately 12 photos/issue; amount supplied by freelancers "depends on need." Needs photos of truck transportation in all modes. Model/property release preferred. Photo captions preferred.

MAKING CONTACT & TERMS Send unsolicited JPEGs by e-mail for consideration. Provide résumé, business card, brochure, flyer or tearsheets to be kept on file for possible future assignments. Does not keep samples on file; include SASE for return of material. Responds in 1 month. Simultaneous submissions and previously published work OK. Payment negotiable. Pays standard "market rate" for color cover photo. **Pays on acceptance.** Credit line given. Buys one-time or permanent rights; negotiable.

TIPS "Trucks/trucking must be dominant element in the photograph—not an incidental part of an environmental scene."

TREE CARE INDUSTRY MAGAZINE

Tree Care Industry Association, 136 Harvey Rd., Suite 101, Londonderry NH 03053. (800)733-2622 or (603)314-5380. **Fax:** (603)314-5386. **E-mail:** editor@tcia.org. **Website:** www.tcia.org. **Contact:** Don Sta-

ruk, editor. Estab. 1990. Circ. 27,500. Monthly trade magazine for arborists, landscapers and golf course superintendents interested in professional tree care practices. Sample copy available for $5.

NEEDS Buys 3-6 photos/year. Needs photos of environment, landscapes/scenics, gardening. Reviews photos with or without a ms.

SPECS Uses color prints. Accepts images in digital format. Send via e-mail as TIFF files at 300 dpi.

MAKING CONTACT & TERMS Send query letter with stock list. Does not keep samples on file; include SASE for return of material. Pays $100 maximum for color cover; $25 minimum for color inside. Pays on publication. Credit line given. Buys one-time rights and online rights.

UNDERGROUND CONSTRUCTION

Oildom Publishing Company of Texas, Inc., P.O. Box 941669, Houston TX 77094-8669. (281)558-6930, ext. 220. **Fax:** (281)558-7029. **E-mail:** rcarpenter@oildom.com; oklinger@oildom.com. **Website:** www.undergroundconstructionmagazine.com. **Contact:** Robert Carpenter, editor; Oliver Klinger, publisher. Circ. 38,000. Monthly trade journal. Emphasizes construction and rehabilitation of sewer, water, gas, telecom, electric, and oil underground pipelines/conduit. Readers are contractors, utilities and engineers. Sample copy available for $3.

NEEDS Uses photos of underground construction and rehabilitation.

SPECS Uses high-resolution digital images (minimum 300 dpi); large-format negatives or transparencies.

MAKING CONTACT & TERMS Query before sending photos. Generally responds within 30 days. Pays $100-400 for color cover; $50-250 for color inside. Buys one-time rights.

TIPS "Freelancers are competing with staff as well as complimentary photos supplied by equipment manufacturers. Subject matter must be unique, striking and/or off the beaten track. People on the job are always desirable."

VETERINARY ECONOMICS

8033 Flint St., Lenexa KS 66214. (800)255-6864. **Fax:** (913)871-3808. **E-mail:** ve@advanstar.com. **Website:** veterinarybusiness.dvm360.com. Estab. 1960. Circ. 54,000. Monthly trade magazine emphasizing practice management for veterinarians.

NEEDS Photographers on an "as needed" basis for editorial portraits; must be willing to sign license agreement; 2-3 photo portraits/year. License agreement required. Photo captions preferred.

SPECS Prefers images in digital format. Send via FTP, e-mail as JPEG files at 300 dpi.

MAKING CONTACT & TERMS Send 1 e-mail with sample image less than 1 MB; repeat e-mails are deleted. Does not keep samples on file. **Pays on acceptance.** Credit line given.

WATER WELL JOURNAL

National Ground Water Association, 601 Dempsey Rd., Westerville OH 43081. **Fax:** (614)898-7786. **E-mail:** tplumley@ngwa.org. **Website:** www.ngwa.org. **Contact:** Thad Plumley, director of publications; Mike Price, associate editor. Circ. 24,000. Monthly association publication. Emphasizes construction of water wells, development of ground water resources and ground water cleanup. Readers are water well drilling contractors, manufacturers, suppliers, and ground water scientists. Sample copy available for $15 US, $36 foreign.

NEEDS Buys 1-3 freelance photos/issue plus cover photos; 12-36 photos/year. Needs photos of installations and how-to illustrations. Model release preferred. Photo captions required.

SPECS Accepts images in digital format. Send via CD, ZIP as TIFF files at 300 dpi.

MAKING CONTACT & TERMS Send query letter with samples. "We'll contact you." Pays $250 for color cover; $50 for b&w or color inside; "flat rate for assignment." Pays on publication. Credit line given. Buys all rights.

TIPS "E-mail or send written inquiries; we'll reply if interested. Unsolicited materials will not be returned."

THE WHOLESALER

2615 Shermer Rd., Suite A, Northbrook IL 60062. (847)564-1127. **E-mail:** editor@thewholesaler.com. **Website:** www.thewholesaler.com. Estab. 1946. Circ. 35,000. Monthly news tabloid. Emphasizes wholesaling/distribution in the plumbing, heating, air conditioning, piping (including valves), fire protection industry. Readers are owners and managers of wholesale distribution businesses; manufacturer representatives. Sample copy free with 11×15¾ SASE and 5 first-class stamps.

NEEDS Buys 3 photos from freelancers/issue; 36 photos/year. Interested in field and action shots in the

warehouse, on the loading dock, at the job site. Property release preferred. Photo captions preferred—"just give us the facts."

MAKING CONTACT & TERMS Send query letter with stock list. Send any size glossy color and b&w prints by mail with SASE for consideration. Responds in 2 weeks. Simultaneous submissions and previously published work OK. Pays on publication. Buys one-time rights.

WINES & VINES

Wine Communications Group, 65 Mitchell Blvd., Suite A, San Rafael CA 94903. (415)453-9700. **Fax:** (415)453-2517. **E-mail:** edit@winesandvines.com; info@winesandvines.com. **Website:** www.winesandvines.com. **Contact:** Jim Gordon, editor; Kate Lavin, managing editor. Estab. 1919. Circ. 5,000. Monthly. Emphasizes winemaking, grape growing, and marketing in North America and internationally for wine industry professionals, including winemakers, grape growers, wine merchants, and suppliers.

NEEDS Color cover subjects—on a regular basis.

SPECS Accepts images in digital format. Send via CD, ZIP, e-mail as TIFF, or JPEG files at 400 dpi.

MAKING CONTACT & TERMS Prefers e-mail query with link to portfolio; or send material by mail for consideration. Will e-mail if interested in reviewing photographer's portfolio. Provide business card to be kept on file for possible future assignments. Responds in 3 months. Previously published work considered. Pays $100-350 for color cover, or negotiable ad trade out. Pays on publication. Credit line given. Buys one-time rights.

⑤ WISCONSIN ARCHITECT

321 S. Hamilton St., Madison WI 53703-4000. (608)257-8477. **E-mail:** editor@aiaw.org. **Website:** www.aiaw.org. Estab. 1931. Circ. 3,700. Annual magazine of the American Institute of Architects Wisconsin. Emphasizes architecture. Readers are design/construction professionals.

NEEDS Uses approximately 100 photos/issue. "Photos are almost exclusively supplied by architects who are submitting projects for publication. Of these, approximately 65% are professional photographers hired by the architect."

MAKING CONTACT & TERMS "Contact us using online submission/contact form." Keeps samples on file. Responds when interested. Simultaneous submis-

sions and previously published work OK. Pays on publication. Credit line given. Rights negotiable.

WOMAN ENGINEER

Equal Opportunity Publications, Inc., 445 Broad Hollow Rd., Suite 425, Melville NY 11747. (631)421-9421. **Fax:** (631)421-1352. **E-mail:** info@eop.com; jschneider@eop.com. **Website:** www.eop.com. **Contact:** James Schneider, editor. Estab. 1968. Circ. 16,000. Equal Opportunity Publications, Inc. Circ. 16,000. Magazine published 3 times/year. Emphasizes career guidance for women engineers at the college and professional levels. Readers are college-age and professional women in engineering. Sample copy free with 9×12 SAE and 6 first-class stamps.

NEEDS Uses at least 1 photo/issue (cover); planning to use freelance work for covers and possibly editorial; most of the photos are submitted by freelance writers with their articles. Model release preferred. Photo captions required.

TIPS "We are looking for strong, sharply focused photos or slides of women engineers. The photo should show a woman engineer at work, but the background should be uncluttered. The photo subject should be dressed and groomed in a professional manner. Cover photo should represent a professional woman engineer at work and convey a positive and professional image. Read our magazine, and find actual women engineers to photograph. We're not against using cover models, but we prefer cover subjects to be women engineers working in the field."

WOODSHOP NEWS

Cruz Bay Publishing Inc., 10 Bokum Rd., Essex CT 06426. (860)767-8227. **Fax:** (860)767-1048. **E-mail:** editorial@woodshopnews.com. **Website:** www.woodshopnews.com. **Contact:** Tod Riggio, editor. Estab. 1986. Circ. 60,000. Monthly trade magazine (tabloid format) covering all areas of professional woodworking. Sample copies available.

NEEDS Buys 12 sets of cover photos from freelancers/year. Photos of celebrities, architecture interiors/decorating, industry, product shots/still life. Interested in documentary. "We assign our cover story, which is always a profile of a professional woodworker. These photo shoots are done in the subject's shop and feature working shots, portraits and photos of subject's finished work." Photo captions required; include description of activity contained in shots. "Photo cap-

tions will be written in-house based on this information."

SPECS Prefers digital photos.

MAKING CONTACT & TERMS Send query letter with résumé, photocopies, tearsheets. Provide self-promotion piece to be kept on file for possible future assignments. Responds only if interested; send nonreturnable samples. Previously published work OK occasionally. Pays $600-800 for color cover. Note: "We want a cover photo 'package'—one shot for the cover, others for use inside with the cover story." **Pays on acceptance.** Credit line given. Buys "perpetual" rights, but will pay a lower fee for one-time rights.

TIPS "I need a list of photographers in every geographical region of the country—I never know where our next cover profile will be done, so I need to have options everywhere. Familiarity with woodworking is a definite plus. Listen to our instructions! We have very specific lighting and composition needs, but some photographers ignore instructions in favor of creating 'artsy' photos, which we do not use, or poorly lighted photos, which we cannot use."

WRITER'S DIGEST

F+W Media, Inc., 10151 Carver Rd., Suite #200, Blue Ash OH 45242. (513)531-2690. **E-mail:** wdsubmissions@fwmedia.com. **Website:** www.writersdigest.com. Estab. 1920. Monthly consumer magazine. "Our readers write fiction, nonfiction, plays and scripts. They're interested in improving their writing skills and the ability to sell their work, and finding new outlets for their talents." Photo guidelines free with SASE or via e-mail.

NEEDS Occasionally buys photos from freelancers. Needs photos of education, hobbies, writing life, business concepts, product shots/still life. Other specific photo needs: photographers to shoot authors on location for magazine cover. Model/property release required. Photo captions required; include your copyright notice.

SPECS Uses 8×10 color or digital (resizable) images. Accepts images in digital format if hired. Send via CD as TIFF, EPS, JPEG files at 300 dpi (at hire).

MAKING CONTACT & TERMS Prefers postal mail submissions to keep on file. Final art may be sent via e-mail. Buys one-time rights. **Pays on acceptance:** $500-1,000 for color cover; $100-800 for color inside. Responds only if interested; send nonreturnable samples. Credit line given. Buys one-time rights.

TIPS "I like having several samples to look at. Online portfolios are great. Submissions are considered for other *Writer's Digest* publications as well. For stock photography, please include pricing/sizes of b&w usage if available."

BOOK PUBLISHERS

//

There are diverse needs for photography in the book publishing industry. Publishers need photos for the obvious (covers, jackets, text illustrations, and promotional materials), but they may also need them for use on CD-ROMs and websites. Generally, though, publishers either buy individual or groups of photos for text illustration, or they publish entire books of photography.

Those in need of text illustration use photos for cover art and interiors of textbooks, travel books, and nonfiction books. For illustration, photographs may be purchased from a stock agency or from a photographer's stock, or the publisher may make assignments. Publishers usually pay for photography used in book illustration or on covers on a per-image or per-project basis. Some pay photographers hourly or day rates, if on an assignment basis. No matter how payment is made, however, the competitive publishing market requires freelancers to remain flexible.

To approach book publishers for illustration jobs, send a cover letter with photographs or slides and a stock photo list with prices, if available. (See sample stock list in "Running Your Business.") If you have a website, provide a link to it. If you have published work, tearsheets are very helpful in showing publishers how your work translates to the printed page.

PHOTO BOOKS

Publishers who produce photography books usually publish books with a theme, featuring the work of one or several photographers. It is not always necessary to be well-known to publish your photographs as a book. What you do need, however, is a unique perspective, a salable idea, and quality work.

For entire books, publishers may pay in one lump sum or with an advance plus royalties (a percentage of the book sales). When approaching a publisher for your own book of photographs, query first with a brief letter describing the project, and include sample photographs. If the publisher is interested in seeing the complete proposal, you can send additional information in one of two ways depending on the complexity of the project.

Prints placed in sequence in a protective box, along with an outline, will do for easy-to-describe, straightforward book projects. For more complex projects, you may want to create a book dummy. A dummy is basically a book model with photographs and text arranged as they will appear in finished book form. Book dummies show exactly how a book will look, including the sequence, size, format and layout of photographs and accompanying text. The quality of the dummy is important, but keep in mind that the expense can be prohibitive.

To find the right publisher for your work, first check the Subject Index in the back of the book to help narrow your search, then read the appropriate listings carefully. Send for catalogs and guidelines for those publishers that interest you. You may find guidelines on publishers' websites as well. Also, become familiar with your local bookstore or visit the site of an online bookstore such as Amazon.com. By examining the books already published, you can find those publishers who produce your type of work. Check for both large and small publishers. While smaller firms may not have as much money to spend, they are often more willing to take risks, especially on the work of new photographers. Keep in mind that photo books are expensive to produce and may have a limited market.

💲💲 🌓 ALLYN & BACON PUBLISHERS

445 Hutchinson Ave., Columbus OH 43235. **Website:** www.allynbaconmerrill.com. Find local rep to submit materials via online rep locator. Publishes college textbooks. Photos used for text illustrations, book covers. Examples of recently published titles: *Criminal Justice*; *Including Students With Special Needs*; *Social Psychology* (text illustrations and promotional materials). Offers one assignment plus 80 stock projects/year.

NEEDS Photos of babies/children/teens, celebrities, couples, multicultural, families, parents, senior citizens, disasters, education, special education, science, technology/computers. Interested in fine art, historical/vintage. Also uses multi-ethnic photos in education, health and fitness, people with disabilities, business, social sciences, and good abstracts. Reviews stock photos. Model/property release required.

SPECS Uses b&w prints, any format; all transparencies. Accepts images in digital format.

MAKING CONTACT & TERMS Send via CD, ZIP, e-mail as TIFF, EPS, PICT, GIF, JPEG files at 72 dpi for review, 300 dpi for use. See photo and art specifications online.

TIPS "Send tearsheets and promotion pieces. Need bright, strong, clean abstracts and unstaged, nicely lit people photos."

💲💲 ◎ 🌓 APPALACHIAN MOUNTAIN CLUB BOOKS

5 Joy St., Boston MA 02108. (617)523-0636. **Fax:** (617)523-0722. **E-mail:** amcbooks@outdoors.org. **Website:** www.outdoors.org. Estab. 1876. Publishes hardcovers and trade paperbacks. Photos used for text illustrations, book covers. Examples of recently published titles: *Discover* series, *Best Day Hikes* series, *Trail Guide* series. Model release required. Photo captions preferred; include location, description of subject, photographer's name and phone number. Uses print-quality color and gray-scale images.

NEEDS Looking for photos of nature, hiking, backpacking, biking, paddling, skiing in the Northeast.

MAKING CONTACT & TERMS E-mail light boxes. Art director will contact photographer if interested. Keeps samples on file. Responds only if interested.

◎ AUTONOMEDIA

P.O. Box 568, Williamsburg Station, Brooklyn NY 11211. **Website:** www.autonomedia.org. Estab. 1974. Publishes books on radical culture and politics. Photos used for text illustrations, book covers. Examples of recently published titles: *TAZ* (cover illustration); *Cracking the Movement* (cover illustration); *Zapatistas* (cover and photo essay).

NEEDS "The number of photos bought annually varies, as does the number of assignments offered." Model/property release preferred. Photo captions preferred.

MAKING CONTACT & TERMS Send query letter with samples. Does not keep samples on file; include SASE for return of material. Responds in 1 month. Works on assignment only. Payment negotiable. Pays on publication. Buys one-time and electronic rights.

🚩 ● BARBOUR PUBLISHING INC.

1810 Barbour Dr., P.O. Box 719, Urichsville OH 44683. (740)922-6045. **E-mail:** editors@barbourbooks.com; aschrock@barbourbooks.com; fictionsubmit@barbourbooks.com. **Website:** www.barbourbooks.com. **Contact:** Ashley Schrock, creative director. Estab. 1981. Publishes adventure, humor, juvenile, romance, religious, young adult, coffee table, cooking and reference books. Specializes in inspirational fiction. "We're an inspirational company—no graphic or provocative images are used. Mostly scenic, non-people imagery/illustration."

NEEDS Inspirational/traditional. Publishes over 150 titles/year.

MAKING CONTACT & TERMS Send e-mail including digital images, samples and a URL. Follow up every 3-4 months. Responds only if interested. $400-1600 for covers, $200-600 for inside shots.

TIPS "Faithfulness to the Bible and Jesus Christ are the bedrock values behind every book Barbour's staff produces."

BEARMANOR MEDIA

P.O. Box 1129, Duncan OK 73534. (580)252-3547. **Fax:** (814)690-1559. **E-mail:** books@benohmart.com. **Website:** www.bearmanormedia.com. **Contact:** Ben Ohmart, publisher. Estab. 2000. Publishes 70 titles/year. Payment negotiable. Responds only if interested. Catalog available online or free with a 9×12 SASE submission.

TIPS "Potential freelancers should be familiar with our catalog, be able to work comfortably and timely with project managers across 12 time zones, and be computer savvy. Like many modern publishing companies, different facets of our company are located in different regions from Japan to both U.S. coasts.

Potential freelancers *must* be knowledgeable in the requirements of commercial printing in regards to resolution, colorspace, process printing and contrast levels. Please provide some listing of experience and payment requirements."

⊚ ⊕ BENTLEY PUBLISHERS

1734 Massachusetts Ave., Cambridge MA 02138. (617)547-4170. **Fax:** (617)876-9235. **E-mail:** michael. bentley@bentleypublishers.com. **Website:** www.bent leypublishers.com. **Contact:** Michael Bentley, president. Estab. 1950. Publishes professional, technical, consumer how-to books. Photos used for text illustrations, promotional materials, book covers, dust jackets. Examples of published titles: *Porsche: Genesis of Genius; Toyota Prius Repair and Maintenance Manual.*
NEEDS Buys 70-100 photos/year; offers 5-10 freelance assignments/year. Looking for motorsport, automotive technical and engineering photos. Reviews stock photos. Model/property release required. Photo captions required; include date and subject matter.
SPECS Uses 8×10 transparencies. Accepts images in digital format.
MAKING CONTACT & TERMS Send query letter with samples. Provide résumé, business card, brochure, flyer or tearsheets to be kept on file for possible future assignments. Keeps samples on file; cannot return material. Works on assignment only. Responds in 6 weeks. Simultaneous submissions and previously published work OK. Payment negotiable. Credit line given. Buys electronic and one-time rights.
TIPS "Bentley Publishers publishes books for automotive enthusiasts. We are interested in books that showcase good research, strong illustrations, and valuable technical information."

⊛ ◑ CAPSTONE PRESS

1710 Roe Crest Dr., North Mankato MN 56003. (800)747-4992. **Fax:** (888)262-0705. **E-mail:** Nonfiction, nf.il.sub@capstonepub.com; fiction, il.sub@ capstonepub.com. **Website:** www.capstonepress. com. **Contact:** Dede Barton, photo director. Estab. 1991. Publishes juvenile nonfiction and educational books. Subjects include animals, ethnic groups, vehicles, sports, history, scenics. Photos used for text illustrations, promotional materials, book covers. "To see examples of our products, please visit our website." Submission guidelines available online.
NEEDS Buys about 3,000 photos/year. "Our subject matter varies (usually 100 or more different subjects/

year); editorial-type imagery preferable although always looking for new ways to show an overused subject or title (fresh)." Model/property release preferred. Photo captions preferred; include "basic description; if people of color, state ethnic group; if scenic, state location and date of image."
SPECS Accepts images in digital format for submissions as well as for use. Digital images must be at least 8×10 at 300 dpi for publishing quality (TIFF, EPS or original camera file format preferred).
MAKING CONTACT & TERMS Send query letter with stock list. E-mail résumé, sample artwork, and a list of previous publishing credits if applicable. Keeps samples on file. Responds in 6 months. Simultaneous submissions and previously published work OK. Pays after publication. Credit line given. Looking to buy worldwide all language rights for print and digital rights. Producing online projects (interactive websites and books); printed books may be bound up into binders.
TIPS "Be flexible. Book publishing usually takes at least 6 months. Capstone does not pay holding fees. Be prompt. The first photos in are considered for covers first."

⊚ ◑ CENTERSTREAM PUBLICATION LLC

P.O. Box 17878, Anaheim CA 92807. (714)779-9390. **E-mail:** centerstrm@aol.com. **Website:** www.center stream-usa.com. **Contact:** Ron Middlebrook, owner. Estab. 1982. "Centerstream is known for its unique publications for a variety of instruments. From instructional and reference books and biographies, to fun song collections and DVDs, our products are created by experts who offer insight and invaluable information to players and collectors." Publishes music history, biographies, DVDs, music instruction (all instruments). Photos used for text illustrations, book covers. Examples of published titles: *Dobro Techniques; History of Leedy Drums; History of National Guitars; Blues Dobro; Jazz Guitar Christmas* (book covers).
NEEDS Reviews stock photos of music. Model release preferred. Photo captions preferred.
SPECS Uses color and b&w prints; 35mm, 2¼×2¼, 4×5 transparencies. Accepts images in digital format. Send via ZIP as TIFF files.
MAKING CONTACT & TERMS Send query letter with samples and stock list. Send unsolicited photos

by mail for consideration. Provide résumé, business card, brochure, flyer or tearsheets to be kept on file for possible future assignments. Works on assignment only. Responds in 1 month. Simultaneous submissions and previously published work OK. Payment negotiable. Pays on receipt of invoice. Credit line given. Buys all rights.

◎ ⑨⑨ CLEIS PRESS

Cleis Press & Viva Editions, 2246 Sixth St., Berkeley CA 94710. (510)845-8000 or (800)780-2279. **Fax:** (510)845-8001. **E-mail:** cleis@cleispress.com. **E-mail:** bknight@cleispress.com. **Website:** www.cleispress. com and www.vivaeditions.com. Kara Wuest, publishing coordinator; Frédérique Delacoste, art director. **Contact:** Brenda Knight, associate publisher. Estab. 1980. Cleis Press publishes provocative, intelligent books in the areas of sexuality, gay and lesbian studies, erotica, fiction, gender studies, and human rights. Publishes fiction, nonfiction, trade and gay/lesbian erotica. Photos used for book covers. Buys 20 photos/year. Reviews stock photos. Works with freelancers on assignment only. Keeps samples on file. Pays on publication.

NEEDS Fiction, nonfiction, trade and gay/lesbian erotica; photos used for book covers.

SPECS Uses color and/or b&w prints.

MAKING CONTACT & TERMS Query via e-mail only. Provide résumé, business card, brochure, flyer or tearsheets to be kept on file for possible future assignments.

⑨⑨ CONARI PRESS

Red Wheel/Weiser, LLC., 665 Third St., Suite 400, San Francisco CA 94107. **E-mail:** info@redwheelweiser. com. **E-mail:** submissions@rwwbooks.com. **Website:** www.redwheelweiser.com. **Contact:** Pat Bryce, acquisitions editor. Estab. 1987. Publishes hardcover and trade paperback originals and reprints. Subjects include women's studies, psychology, parenting, inspiration, home and relationships (all nonfiction titles). Photos used for text illustrations, book covers, dust jackets.

NEEDS Buys 5-10 freelance photos /year. Looking for artful photos; subject matter varies. Interested in reviewing stock photos of most anything except high-tech, corporate or industrial images. Model release required. Photo captions preferred; include photography copyright.

SPECS Prefers images in digital format.

MAKING CONTACT & TERMS Provide résumé, business card, self-promotion piece or tearsheets to be kept on file for possible future assignments. Art director will contact photographer for portfolio review if interested. Portfolio should include prints, tearsheets, slides, transparencies or thumbnails. Keeps samples on file. Simultaneous submissions and previously published work OK. Pays by the project: $400-1,000 for color cover; rates vary for color inside. Pays on publication. Credit line given on copyright page or back cover.

TIPS "Review our website to make sure your work is appropriate."

COUNTRYMAN PRESS

P.O. Box 748, Woodstock VT 05091. (802)457-4826. **Fax:** (802)457-1678. **E-mail:** countrymanpress@wwnorton.com; khummel@wwnorton.com. **Website:** www.countrymanpress.com. Estab. 1973. "Countryman Press publishes books that encourage physical fitness and appreciation for and understanding of the natural world, self-sufficiency, and adventure." Publishes hardcover originals, trade paperback originals and reprints. Subjects include travel, nature, hiking, biking, paddling, cooking, Northeast history, gardening and fishing. Examples of recently published titles: *The King Arthur Flour Baker's Companion* (book cover); *Vermont: An Explorer's Guide* (text illustrations, book cover). Catalog available for 6¾×10½ envelope.

NEEDS Photos of environmental, landscapes/scenics, wildlife, architecture, gardening, rural, sports, travel. Interested in historical/vintage, seasonal. Model/property release preferred. Photo captions preferred; include location, state, season.

SPECS Accepts high-res images in digital format. Send via CD, ZIP as TIFF files at 350 dpi.

MAKING CONTACT & TERMS Send query letter to the attention of "Submissions," with résumé, slides, tearsheets, stock list. Provide résumé, business card, self-promotion piece to be kept on file for possible future assignments. Responds in 2 months, only if interested. Simultaneous submissions and previously published work OK. Pays $100-600 for color cover. Pays on publication. Credit line given. Buys all rights for life of edition (normally 2-7 years); negotiable.

TIPS "Our catalog demonstrates the range of our titles and shows our emphasis on travel and the outdoors. Crisp focus, good lighting, and strong contrast are goals worth striving for in each shot. We prefer im-

ages that invite rather than challenge the viewer, yet also look for eye-catching content and composition."

⑨ CRABTREE PUBLISHING COMPANY

PMB 59051, 350 Fifth Ave., 59th Floor, New York NY 10118. (212)496-5040; (800)387-7650. **Fax:** (800)355-7166. **Website:** www.crabtreebooks.com. Estab. 1978. Publishes juvenile nonfiction, library and trade. Subjects include science, cultural events, history, geography (including cultural geography), sports. Photos used for text illustrations, book covers. Examples of recently published titles: *The Mystery of the Bermuda Triangle, Environmental Activist, Paralympic Sports Events, Presidents' Day, Plant Cells, Bomb and Mine Disposal Officers.*

○ This publisher also has offices in Canada, United Kingdom and Australia.

NEEDS Buys 20-50 photos/year. Wants photos of cultural events around the world, animals (exotic and domestic). Model/property release required for children, photos of artwork, etc. Photo captions preferred; include place, name of subject, date photographed, animal behavior.

SPECS Uses high-res digital files (no compressed JPEG files).

MAKING CONTACT & TERMS *Does not accept unsolicited photos.* Provide résumé, business card, brochure, flyer or tearsheets to be kept on file for possible future assignments. Simultaneous submissions and previously published work OK. Pays $100 for color photos. Pays on publication. Credit line given. Buys non-exclusive, worldwide and electronic rights.

TIPS "Since our books are for younger readers, lively photos of children and animals are always excellent." Portfolio should be diverse and encompass several subjects, rather than just 1 or 2; depth of coverage of subject should be intense so that any publishing company could, conceivably, use all or many of a photographer's photos in a book on a particular subject."

CREATIVE HOMEOWNER

One International Blvd., Suite 400, Mahwah NJ 07495. (800)631-7795. **E-mail:** info@creativehomeowner. com. **Website:** www.creativehomeowner.com. **Contact:** Rich Weisman, president; Mary Dolan, photo researcher. Estab. 1978. Publishes soft cover originals, mass market paperback originals. Photos used for text illustrations, promotional materials, book covers. Creative Homeowner's books and online information are known by consumers for their complete and

easy-to-follow instructions, up-to-date information, and extensive use of color photography. Among its best-selling titles are *Char-broil's Everybody Grills!, Ultimate Guide: Wiring,* and *Landscaping With Stone.* Catalog available. Photo guidelines available via fax.

NEEDS Buys 1,000 freelance photos/year. Needs photos of architecture, interiors/decorating, some gardening. Other needs include interior and exterior design photography; garden beauty shots. Photo captions required; include photographer credit, designer credit, location, small description, if possible.

SPECS Accepts images in digital format. Send via CD as TIFF files at 300 dpi.

MAKING CONTACT & TERMS Send query letter with résumé, photocopies, tearsheets, transparencies, stock list. Provide résumé, business card, self-promotion piece to be kept on file for possible future assignments. Responds in 2 weeks to queries. Simultaneous submissions and previously published work OK. Pays $800 for color cover; $100-150 for color inside; $200 for back cover. Pays on publication. Credit line given. Buys one-time rights.

TIPS "Be able to pull submissions for fast delivery. Label and document all transparencies for easy in-office tracking and return."

⊕ CREATIVE WITH WORDS PUBLICATIONS (CWW)

P.O. Box 223226, Carmel CA 93922. **Fax:** (831)655-8627. **E-mail:** geltrich@mbay.net. **Website:** members. tripod.com/CreativeWithWords. Estab. 1975. Publishes poetry and prose anthologies according to set themes. B&w photos used for text illustrations, book covers. Photo guidelines, theme list and submittal forms free with SASE.

NEEDS Theme-related b&w photos. Currently looking for collages. Model/property release preferred.

SPECS Uses any size b&w photos. "We will reduce to fit the page."

MAKING CONTACT & TERMS Request theme list, then query with photos. Does not keep samples on file; include SASE for return of material. Responds 3 weeks after deadline if submitted for a specific theme. Payment for illustrations negotiable. Pays on publication. Credit line given. Buys one-time rights.

DOWN THE SHORE PUBLISHING

Box 100, West Creek NJ 08092. **Fax:** (609)597-0422. **E-mail:** dtsbooks@comcast.net. **Website:** www.down-the-shore.com. Publishes regional calendars; seashore,

coastal and regional books (specific to the mid-Atlantic shore and New Jersey). Photos used for text illustrations, scenic calendars (New Jersey and mid-Atlantic only). Examples of recently published titles include *Great Storms of the Jersey Shore* (text illustrations); *NJ Lighthouse Calendar* (illustrations, cover); *Shore Stories* (text illustrations, dust jacket). Photo guidelines free with SASE or on website.

NEEDS Buys 30-50 photos/year. For calendars, needs scenic coastal shots, photos of beaches and New Jersey lighthouses (New Jersey and mid-Atlantic region). Interested in seasonal. Reviews stock photos. Model release required, property release preferred. Photo captions preferred, specific location identification essential. Digital submissions via high-res files on DVD/CD. Provide reference prints. Accepts 35mm, 2¼×2¼, 4×5, transparencies.

MAKING CONTACT & TERMS Refer to guidelines before submitting. Send query letter with stock list. Provide résumé, business card, brochure, flyer or tearsheets to be kept on file for possible future requests. Responds in 6 weeks. Previously published work OK. Pays $100-200 for b&w or cover color; $10-100 for b&w or color inside. Pays 90 days from publication. Credit line given. Buys one-time or book rights, negotiable.

TIPS "We are looking for an honest depiction of familiar scenes from an unfamiliar and imaginative perspective. Images must be specific to our very regional needs. Limit your submissions to your best work. Edit your work very carefully."

ECW PRESS

2120 Queen St. E., Suite 200, Toronto ON M4E 1E2, Canada. (416)694-3348. **Fax:** (416)698-9906. **E-mail:** info@ecwpress.com. **Website:** www.ecwpress.com. **Contact:** Jack David, publisher. Estab. 1974. Publishes hardcover and trade paperback originals. Subjects include entertainment, biography, sports, travel, fiction, poetry. Photos used for text illustrations, book covers, dust jackets.

NEEDS Buys hundreds of freelance photos/year. Looking for color, b&w, fan/backstage, paparazzi, action, original, rarely used. Reviews stock photos. Property release required for entertainment or star shots. Photo captions required; include identification of all people.

SPECS Accepts images in digital format.

MAKING CONTACT & TERMS "For photo and art submissions, it is best to contact us by e-mail and direct us to your work online. Please also describe what area(s) you specialize in. If you do send us artwork by mail that you wish returned, make sure to include a SASE with sufficient postage (for those outside Canada, include an International Reply Coupon). Since our projects vary in topic, we will keep you on file in case we publish something along the lines of your subject(s)." Pays by the project: $250-600 for color cover; $50-125 for color inside. Pays on publication. Credit line given. Buys one-time book rights (all markets).

FARCOUNTRY PRESS

P.O. Box 5630, Helena MT 59604. (800)821-3874. **Fax:** (406)443-5480. **E-mail:** will@farcountrypress.com. **Website:** www.farcountrypress.com. **Contact:** Will Harmon. Award-winning publisher Farcountry Press specializes in softcover and hardcover color photography books showcasing the nation's cities, states, national parks, and wildlife. Farcountry also publishes several children's series, as well as guidebooks, cookbooks, and regional history titles nationwide. The staff produces about 25 books annually; the backlist has grown to more than 300 titles. Photographer guidelines are available on our website.

NEEDS Color photography of landscapes (including recreation), cityscapes, and wildlife in the U.S.

SPECS For digital photo submissions, please send 8- or 16-bit TIFF files (higher preferred), at least 350 dpi or higher, formatted for Mac, RGB profile. All images should be flattened—no channels or layers. Information, including watermarks, should not appear directly on the images. Include either a contact sheet or a folder with low-res files for quick editing. Include copyright and caption data. Model releases are required for all images featuring recognizable individuals. Note on the mount or in the metadata that a model release is available. Do not submit images that do not have model releases.

MAKING CONTACT & TERMS Send query letter with stock list. Unsolicited submissions of photography WILL NOT be accepted and WILL NOT be returned. Simultaneous submissions and previously published work OK.

FIFTH HOUSE PUBLISHERS

(403)571-5230; (800)387-9776. **E-mail:** tdettman@fifthhousepublishers.ca. **Website:** www.fifthhouse

publishers.ca. **Contact:** Tracey Dettman. Estab. 1982. "Fifth House Publishers is committed to 'bringing the West to the rest' by publishing approximately 15 books a year about the land and people who make this region unique. We publish the acclaimed *Going Wild* series, Pierre Berton's *History for Young Canadians*, *Keepers of Life*, the *Western Canadian Classics* series, the *Prairie Gardening* series, and more. Our books are selected for their quality and contribution to the understanding of western-Canadian (and Canadian) history, culture and environment."

NEEDS Buys 15-20 photos/year. Looking for photos of Canadian weather. Model/property release preferred. Photo captions required; include location and identification.

MAKING CONTACT & TERMS Send query letter with samples and stock list. Keeps samples on file. Pays $400 Canadian/calendar image. Pays on publication. Credit line given. Buys one-time rights.

○ **FIREFLY BOOKS**

50 Staples Ave., Unit 1, Richmond Hill ON L4B 0A7, Canada. (416)499-8412. **E-mail:** service@fireflybooks. com. **E-mail:** valerie@fireflybooks.com. **Website:** www.fireflybooks.com. Estab. 1974. Publishes high quality non-fiction. Photos used for text illustrations, book covers and dust jackets.

NEEDS "We're looking for book-length ideas, *not* stock. We pay a royalty on books sold, plus advance."

SPECS Prefers images in digital format, but will accept 35mm transparencies.

MAKING CONTACT & TERMS Send query letter with résumé of credits. Does not keep samples on file; include SAE/IRC for return of material. Simultaneous submissions OK. Payment negotiated with contract. Credit line given.

FLASHLIGHT PRESS

527 Empire Blvd., Brooklyn NY 11225. (718)288-8300. **Fax:** (718)972-6307. **E-mail:** editor@flashlightpress. com. **Website:** www.flashlightpress.com. **Contact:** Shari Dash Greenspan, editor. Estab. 2004. Publishes hardcover and trade paperback originals. Book catalog available online.

MAKING CONTACT & TERMS E-mail with URL or low-res digital images. Submission guidelines available at www.flashlightpress.com/submissionguidelines.html. Buys all rights, accepts reprints.

● **FOCAL PRESS**

Taylor & Francis Group, 7625 Empire Dr., Florence KY 41042. (800)634-7064. **Fax:** (800)248-4724. **E-mail:** d.oconnell@elsevier.com. **Website:** www.focalpress.com. Estab. 1938.

NEEDS "We publish professional reference titles, practical guides and student textbooks in all areas of media and communications technology, including photography and digital imaging. We are always looking for new proposals for book ideas. Send e-mail for proposal guidelines."

MAKING CONTACT & TERMS Simultaneous submissions and previously published work OK. Buys all rights; negotiable.

GRYPHON HOUSE, INC.

P.O. Box 10, 6848 Leon's Way, Lewisville NC 27023. **Website:** www.gryphonhouse.com. **Contact:** Kathy Charner, editor-in-chief. Estab. 1981.

NEEDS Model release required.

SPECS Uses 5×7 glossy color (cover only) and b&w prints. Accepts images in digital format. Send via CD, ZIP, e-mail as TIFF files at 300 dpi.

MAKING CONTACT & TERMS Send query letter with samples and stock list. Keeps samples on file. Simultaneous submissions OK. Payment negotiable. Pays on receipt of invoice. Credit line given. Buys book rights.

○ **GUERNICA EDITIONS**

Box 117, Station P, Toronto ON M5S 2S6, Canada. (416)576-9403. **Fax:** (416)981-7606. **E-mail:** michaelmirolla@guernicaeditions.com. **Website:** www.guernicaeditions.com. **Contact:** Antonio D'Alfonso, editor/publisher (poetry, nonfiction, novels). Estab. 1978. Publishes adult trade (literary). Photos used for book covers. Examples of recently published titles: *Barry Callagan: Essays on His Work*, edited by Priscila Uppal; *Mary Di Michele: Essays on Her Works*, edited by Joseph Pivato; *Maria Mazziotti: Essays on Her Works*, edited by Sean Thomas Doughtery; *Mary Melfi: Essays on Her Works*, edited by William Anselmi.

NEEDS Buys varying number of photos/year; "often" assigns work. Needs life events, including characters; houses. Photo captions required.

SPECS Uses color or b&w prints. Accepts images in digital format. Send via CD, ZIP as TIFF, GIF files at 300 dpi minimum.

MAKING CONTACT & TERMS Prefers to receive manuscript queries by e-mail (via online contact form). "Before inquiring, please check our website to determine the type of material that best fits our publishing house." Sometimes keeps samples on file. Cannot return material. Responds in 2 weeks. Pays $150 for cover. Pays on publication. Credit line given. Buys book rights. "Photo rights go to photographers. All we need is the right to reproduce the work."

TIPS "Look at what we do. Send some samples. If we like them, we'll write back."

⊕ ◑ HARPERCOLLINS CHILDREN'S BOOKS/HARPERCOLLINS PUBLISHERS

10 E. 53rd, New York NY 10022. (212)207-6901. E-mail: Dana.fritts@Harpercollins.com; Kate.eng bring@Harpercollins.com. **Website:** www.harpercol lins.com. **Contact:** Kate Engbring, assistant designer; Dana Fritts, designer. Publishes hardcover originals and reprints, trade paperback originals and reprints, mass market paperback originals and reprints, and audiobooks. 500 titles/year.

NEEDS Babies/children/teens, couples, multicultural, pets, food/drink, fashion, lifestyle. "We are interested in seeing samples of map illustrations, chapter spots, full page pieces, etc. We are open to half-tone and line art illustrations for our interiors." Negotiates a flat payment fee upon acceptance. Will contact if interested. Catalog available online.

TIPS "Be flexible and responsive to comments and corrections. Hold to scheduled due dates for work. Show work that reflects the kinds of projects you *want* to get, be focused on your best technique and showcase the strongest, most successful examples."

◑ HERALD PRESS

MennoMedia, 1251 Virginia Ave., Harrisonburg VA 22802. (724)887-8500. **Fax:** (724)887-3111. **E-mail:** hp@mennomedia.org. **E-mail:** info@mennomedia. org. **Website:** www.mennomedia.org. **Contact:** Design director. Estab. 1908. Photos used for book covers, dust jackets. Examples of published titles: *Saving the Seasons, Mennonite Girls Can Cook.*

NEEDS Buys 5 photos/year; offers occasional freelance assignments. Subject matter varies. Reviews stock photos of people and other subjects including religious, environmental. Model/property release required. Photo captions preferred; include identification information.

SPECS Prefers images in digital format. Submit URL or link to web pages or light box.

MAKING CONTACT & TERMS Send query letter or e-mail with samples. Provide résumé, business card, brochure, flyer or tearsheets to be kept on file for possible future assignments. Keeps samples on file. Works on assignment only or selects from file of samples. Simultaneous submissions and previously published work OK. Payment negotiable. **Pays on acceptance.** Credit line given. Buys book rights; negotiable.

TIPS "We put your résumé and samples on file. It is best to direct us to your website."

⊕⊕ ◑ HOLT MCDOUGAL

1900 S. Batavia Ave., Geneva IL 60134. (800)462-6595. **Fax:** (888)872-8380. **E-mail:** k12orders@hmhpub. com. **Website:** www.hmhco.com. Estab. 1866. Publishes textbooks in multiple formats. Photos are used for text illustrations, promotional materials and book covers.

NEEDS Uses 6,500+ photos/year. Wants photos that illustrate content for mathematics, sciences, social studies, world languages and language arts. Model/property release preferred. Photo captions required; include scientific explanation, location and/or other detailed information.

SPECS Prefers images in digital format. Send via CD or broadband transmission.

MAKING CONTACT & TERMS Send a query letter with a sample of work (nonreturnable photocopies, tearsheets, printed promos) and a list of subjects in stock. Self-promotion pieces kept on file for future reference. Include promotional website link if available. "Do not call!" Will respond only if interested. Payment negotiable depending on format and number of uses. Credit line given.

TIPS "Our book image programs yield an emphasis on rights-managed stock imagery, with a focus on teens and a balanced ethnic mix. Though we commission assignment photography, we maintain an in-house studio with 2 full-time photographers. We are interested in natural-looking, uncluttered photographs labeled with exact descriptions, that are technically correct and include no evidence of liquor, drugs, cigarettes or brand names."

⊕⊕ HUMAN KINETICS PUBLISHERS

P.O. Box 5076, Champaign IL 61825-5076. (800)747-4457. **Fax:** (217)351-1549. **E-mail:** acquisitions@hku sa.com. **Website:** www.hkusa.com. Estab. 1979. Pub-

lishes hardcover originals, trade paperback originals, textbooks, online courses and CDs. Subjects include sports, fitness, physical therapy, sports medicine, nutrition, physical activity. Photos used for text illustrations, promotional materials, catalogs, magazines, web content, book covers. Examples of recently published titles: *Serious Tennis* (text illustrations, book cover); *Beach Volleyball* (text illustrations, book cover). Photo guidelines available via e-mail only.

NEEDS Buys 2,000 freelance photos/year. Photos of babies/children/teens, multicultural, families, education, events, food/drink, health/fitness, performing arts, sports, medicine, military, product shots/still life. All photos purchased must show some sort of sport, physical activity, health and fitness. "Expect ethnic diversity in all content photos." Model release preferred.

SPECS Prefers images in digital format. Send via CD, ZIP as TIFF, JPEG files at 300 dpi at 9×12 inches; will accept 5×7 color prints, 35mm transparencies.

MAKING CONTACT & TERMS Send query letter and URL via e-mail to view samples. Responds only if interested. Simultaneous submissions and previously published work OK. Pays extra for electronic usage of photos. Pays on publication. Credit line given. Buys one-time rights. Prefers world rights, all languages, for one edition; negotiable.

TIPS "Go to Barnes & Noble and look at our books in the sport and fitness section. We want and need peak action, emotion and razor-sharp images for future projects. The pay is below average, but there is opportunity for exposure and steady income to those with patience and access to a variety of sports and physical education settings. We have a high demand for quality shots of youths engaged in physical education classes at all age groups. We place great emphasis on images that display diversity and technical quality. Do not contact us if you charge research or holding fees. Do not contact us for progress reports. Will call if selection is made, or return images. Typically, we hold images 4 to 6 months. If you can't live without the images that long, don't contact us. Don't be discouraged if you don't make a sale in the first 6 months. We work with over 200 agencies and photographers. Photographers should check to see if techniques demonstrated in photos are correct with a local authority. Most technical photos and submitted work are rejected on content, not quality."

HYPERION BOOKS FOR CHILDREN

44 S. Broadway, Floor 16, White Plains NY 10601. (914)288-4100. **Website:** www.disneybooks.com. Publishes children's books, including picture books and books for young readers. Subjects include adventure, animals, history, multicultural, sports. Catalog available with 9×12 SASE and 3 first-class stamps.

NEEDS Photos of multicultural subjects.

MAKING CONTACT & TERMS Provide résumé, business card, self-promotion piece to be kept on file for possible future assignments. Pays royalties based on retail price of book, or a flat fee.

IMMEDIUM

P.O. Box 31846, San Francisco CA 94131. (415)452-8546. **Fax:** (360)937-6272. **E-mail:** submissions@immedium.com. **Website:** www.immedium.com. **Contact:** Amy Ma, acquisitions editor. Estab. 2005. *"Immedium* focuses on publishing eye-catching children's picture books, Asian American topics, and contemporary arts, popular culture, and multicultural issues."

NEEDS Babies/children/teens, multicultural, families, parents, entertainment, lifestyle. Photos for dust jackets, promotional materials and book covers.

MAKING CONTACT & TERMS Send query letter with résumé, samples and/or SASE. Photo captions and property releases are required. Rights are negotiated and will vary with project.

TIPS "Look at our catalog—it's colorful and a little edgy. Tailor your submission to our catalog. We need responsive workers."

INNER TRADITIONS/BEAR & COMPANY

1 Park St., Rochester VT 05767. (802)767-3174. **Fax:** (802)767-3726. **E-mail:** peris@innertraditions.com. **Website:** www.innertraditions.com. **Contact:** Peri Ann Swan, art director. Estab. 1975. Publishes adult trade and teen self-help. Subjects include new age, health, self-help, esoteric philosophy. Photos used for text illustrations, book covers. Examples of recently published titles: *Tibetan Sacred Dance* (cover, interior); *Tutankhamun Prophecies* (cover); *Animal Voices* (cover, interior).

NEEDS Buys 10-50 photos/year; offers 5-10 freelance assignments/year. Photos of babies/children/teens, multicultural, families, parents, religious, alternative medicine, environmental, landscapes/scenics. Interested in fine art, historical/vintage. Reviews

stock photos. Model/property release required. Photo captions preferred.

SPECS Prefers images in digital format. Send via CD, ZIP as TIFF, EPS, JPEG files at 300 dpi or provide comps via e-mail.

MAKING CONTACT & TERMS Provide résumé, business card, brochure, flyer or tearsheets to be kept on file for possible future assignments. Works with freelancers on assignment only. Simultaneous submissions OK. Pays $150-600 for color cover; $50-200 for b&w and color inside. Pays on publication. Credit line given. Buys book rights; negotiable.

KEY CURRICULUM PRESS

1150 65th St., Emeryville CA 94608. (800)995-6284. **Fax:** (800)541-2442. **Website:** www.keypress.com. Estab. 1971. Publishes textbooks, CDs, software. Subjects include mathematics. Photos used for text illustrations, promotional materials, book covers. Examples of recently published titles: *Discovering Algebra* (text illustrations, promotional materials, book cover); *The Heart of Mathematics* (text illustrations, promotional materials, book cover). Catalog available for first-class postage.

NEEDS Photos of babies/children/teens, couples, multicultural, families, environmental, landscapes/scenics, wildlife, architecture, cities/urban, education, rural, health/fitness/beauty, performing arts, sports, science, technology/computers. Interested in documentary, fine art. Also needs technology with female adults performing professional tasks. Female professionals, not just in office occupations. Model/property release required. Photo captions preferred; include type of technology pictured.

SPECS Accepts images in digital format. Send via CD as TIFF, EPS files at 300 dpi (72 dpi for FPOs).

MAKING CONTACT & TERMS Send query letter with résumé, photocopies, tearsheets, stock list. Provide business card, self-promotion piece to be kept on file for possible future assignments. Responds only if interested, send nonreturnable samples. Simultaneous submissions and previously published work OK. Pays $250-500 for b&w cover; $250-1,000 for color cover; by the project, $250-1,000 for cover shots; $150-200 for b&w inside; $150-300 for color inside; by the project, $100-900 for inside shots. **Pays on acceptance.** Credit line given. Buys all rights to assignment photography.

TIPS "Provide website gallery. Call prior to dropping off portfolio."

LERNER PUBLISHING GROUP

1251 Washington Ave. N., Minneapolis MN 55401. (800)452-7236; (612)332-3344. **Fax:** (612)337-7615. **E-mail:** editorial@karben.com; photoresearch@lernerbooks.com. **Website:** www.karben.com; www.lernerbooks.com. **Contact:** director of photo research. Estab. 1957. Publishes educational books for grades K-12. Subjects include animals, biography, history, geography, science, vehicles, and sports. Photos used for editorial purposes for text illustrations, promotional materials, book covers. Examples of recently published titles: *A Temperate Forest Food Chain—Follow That Food* (text illustrations, book cover); *Protecting Earth's Water Supply—Saving Our Living Earth* (text illustrations, book cover).

NEEDS Buys more than 6,000 photos/year; occasionally offers assignments. Photos of children/teens, celebrities, multicultural, families, disasters, environmental, landscapes/scenics, wildlife, cities/urban, education, pets, rural, hobbies, sports, agriculture, industry, political, science, vehicles, technology/computers. Model/property release preferred when photos are of social issues (e.g., the homeless). Photo captions required; include who, where, what and when.

SPECS Prefers images in digital format. Send via FTP, CD, or e-mail as TIFF or JPEG files at 300 dpi.

MAKING CONTACT & TERMS Send query letter with detailed stock list by mail, fax or e-mail. Provide current editorial use pricing. "No calls, please." Cannot return material. Responds only if interested. Previously published work OK. Pays by the project: $150-400 for cover; $50-150 for inside. Pays on receipt of invoice. Credit line given. Licenses images for book based on print-run rights, electronic rights, all language rights, worldwide territory rights. Submission guidelines available online.

TIPS Prefers crisp, clear images that can be used editorially. "Send in as detailed a stock list as you can (including fees for clearing additional rights), and be willing to negotiate price."

MAGENTA PUBLISHING FOR THE ARTS

151 Winchester St., Toronto ON M4X 1B5, Canada. **E-mail:** info@magentafoundation.org. **Website:** www.magentafoundation.org. **Contact:** Submissions. Estab. 2004. "The Magenta Foundation is Canada's pioneering non-profit arts publishing house. Magenta

was created to organize promotional opportunities for Canadian artists in the international arts community through circulated exhibitions and publications. Projects mounted by Magenta are supported by credible international media coverage and critical reviews in all mainstream media formats (radio, television and print)."

○ Magenta works with key international organizations and individuals to help increase recognition for Canadian artists around the world, uniting the global photography community. Through its partnerships, Magenta sets a standard for community collaboration while developing both a domestic and international presence vital to the success of Canadian artists. Magenta's good reputation is growing with each project. The attention our artists receive reinforces our organization's mandate to remain dedicated to increasing Canada's visual arts profile around the world.

◎ MBI, INC.

47 Richards Ave., Norwalk CT 06857. (203)853-2000. **E-mail:** webmail@mbi-inc.com. **Website:** www.mbi-inc.com/publishing.asp. Estab. 1965.

○ Our Book Division is Easton Press. Maintains one of America's largest private archives of specially commissioned illustrations, book introductions, and literary criticism.

⊜⊜⊜ ○ MCGRAW-HILL

1333 Burr Ridge Pkwy., Burr Ridge IL 60527. (630)789-4000. **Fax:** (800)634-3963. **E-mail:** cheryl_georgas@mcgraw-hill.com. **Website:** www.mheducation.com. Publishes hardcover originals, textbooks, CDs. Photos used for book covers.

NEEDS Buys 20 freelance photos/year. Needs photos of business concepts, industry, technology/computers.

SPECS Uses 8×10 glossy prints; 35mm, 2¼×2¼, 4×5 transparencies. Accepts images in digital format. Send via CD.

MAKING CONTACT & TERMS Contact through local sales rep (see submission guidelines online) or via online form. Provide business card, self-promotion piece to be kept on file for possible future assignments. Responds only if interested. Previously published work OK. Pays extra for electronic usage of photos. Pays on publication. Credit line given. Buys one-time rights.

⊕ ⊜ MITCHELL LANE PUBLISHERS INC.

P.O. Box 196, Hockessin DE 19707. (302)234-9426. **Fax:** (866)834-4164. **E-mail:** barbaramitchell@mitchelllane.com. **Website:** www.mitchelllane.com. **Contact:** Barbara Mitchell, publisher. Estab. 1993. Publishes hardcover originals for library market. Subjects include biography and other nonfiction for children and young adults. Photos used for text illustrations, book covers. Examples of recently published titles: *A Project Guide to Electricity and Magnetism*; *A Backyard Flower Garden for Kids* (text illustrations, book cover).

NEEDS Photo captions required.

SPECS Accepts images in digital format. Send via CD as TIFF, JPEG files at 300 dpi.

MAKING CONTACT & TERMS Send query letter with stock list (stock photo agencies only). Does not keep samples on file; cannot return material. Responds only if interested. Pays on publication. Credit line given. Buys one-time rights.

○ MONDIAL

203 W. 107th St., Suite 6C, New York NY 10025. (212)851-3252. **Fax:** (208)361-2863. **E-mail:** contact@mondialbooks.com. **Website:** www.mondialbooks.com; www.librejo.com. **Contact:** Andrew Moore, editor. Estab. 1996. Publishes mainstream fiction, romance, history and reference books. Specializes in linguistics.

NEEDS Landscapes, travel and erotic. Printing rights are negotiated according to project. Illustrations are used for text illustration, promotional materials and book covers. Publishes 20 titles/year. Responds only if interested.

MAKING CONTACT & TERMS Payment on acceptance.

⊜ MUSEUM OF NORTHERN ARIZONA

3101 N. Fort Valley Rd., Flagstaff AZ 86001. (928)774-5213. **E-mail:** publications@mna.mus.az.us. **Website:** www.musnaz.org. **Contact:** Publications Department. Estab. 1928. Subjects include biology, geology, archaeology, anthropology and history. Photos used for *Plateau: Land and People of the Colorado Plateau* magazine, published twice/year (May, October).

NEEDS Buys approximately 80 photos/year. Biology, geology, history, archaeology and anthropology—subjects on the Colorado Plateau. Reviews stock photos. Photo captions preferred; include location, description and context.

SPECS Uses 8×10 glossy b&w prints; 35mm, 2¼×2¼, 4×5 and 8×10 transparencies. Prefers 2¼×2¼ transparencies or larger. Possibly accepts images in digital format. Submit via ZIP.

MAKING CONTACT & TERMS Send query letter with samples, SASE. Responds in 1 month. Simultaneous submissions and previously published work OK. Credit line given. Buys one-time and all rights; negotiable. Offers internships for photographers.

TIPS Wants to see top-quality, natural history work. To break in, send only pre-edited photos.

🌑 💲💲 MUSIC SALES GROUP

14-15 Berners St., London W1T 3LJ, United Kingdom. +44 (020) 7612 7400. **Fax:** +44 (020) 7612 7545. **E-mail:** chris.charlesworth@musicsales.co.uk; info@omnibuspress.com. **Website:** www.musicsales.com; www.omnibuspress.com. Publishes instructional music books, song collections and books on music. Photos used for covers and interiors. Examples of recently published titles: *Bob Dylan: 100 Songs and Photos*; *Paul Simon: Surprise*; *AC/DC: Backtracks*.

NEEDS Buys 200 photos/year. Model release required on acceptance of photo. Photo captions required.

SPECS Uses 8×10 glossy prints; 35mm, 2×2, 5×7 transparencies. High-res digital 3000 x 4000 pixels.

MAKING CONTACT & TERMS Send query letter first with résumé of credits. Provide business card, brochure, flyer or tearsheets to be kept on file for possible future assignments. Responds in 2 months. Simultaneous submissions and previously published work OK.

TIPS In samples, wants to see "the ability to capture the artist in motion with a sharp eye for framing the shot well. Portraits must reveal what makes the artist unique. We need rock, jazz, classical—onstage and impromptu shots. Please send us an inventory list of available stock photos of musicians. We rarely send photographers on assignment and buy mostly from material on hand. Send business card and tearsheets or prints stamped 'proof' across them. Due to the nature of record releases and concert events, we never know exactly when we may need a photo. We keep photos on permanent file for possible future use."

💲 🕮 ◑ NICOLAS-HAYS, INC.

P.O. Box 540206, Lake Worth FL 33454-0206. **E-mail:** info@nicolashays.com; info@ibispress.net. **Website:** www.nicolashays.com. Estab. 1976. Publishes trade paperback originals and reprints. Subjects include Eastern philosophy, Jungian psychology, New Age how-to. Photos used for book covers. Example of recently published title: *Dervish Yoga for Health and Longevity: Samadeva Gestual Euphony—The Seven Major Arkanas* (book cover). Catalog available upon request.

NEEDS Buys 1 freelance photo/year. Needs photos of landscapes/scenics.

SPECS Uses color prints; 35mm, 2¼×2¼, 4×5 transparencies. Accepts images in digital format.

MAKING CONTACT & TERMS Send query letter with photocopies, tearsheets. Provide self-promotion piece to be kept on file for possible future assignments. Responds only if interested; send nonreturnable samples. Simultaneous submissions and previously published work OK. **Pays on acceptance**. Credit line given. Buys one-time rights.

TIPS "We are a small company and do not use many photos. We keep landscapes/seascapes/skyscapes on hand—images need to be inspirational."

💲 🕮 W.W. NORTON & COMPANY, INC.

500 Fifth Ave., New York NY 10110. (212)354-5500. **Fax:** (212)869-0856. **Website:** www.wwnorton.com. **Contact:** Trish Marks. Estab. 1923. Photos used for text illustrations, book covers, dust jackets.

NEEDS Variable. Photo captions preferred.

SPECS Accepts images in all formats; digital images at a minimum of 300 dpi for reproduction and archival work.

MAKING CONTACT & TERMS "Due to the workload of our editorial staff and the large volume of materials we receive, we are no longer able to accept unsolicited submissions. If you are seeking publication, we suggest working with a literary agent who will represent you to the house."

◎ 💲 ◑ RICHARD C. OWEN PUBLISHERS, INC.

P.O. Box 585, Katonah NY 10536. (914)232-3903; (800)262-0787. **E-mail:** richardowen@rcowen.com. **Website:** www.rcowen.com. **Contact:** Richard Owen, publisher. Estab. 1982. Publishes picture/storybook fiction and nonfiction for 5- to 7-year-olds; author autobiographies for 7- to 10-year-olds; professional books for educators. Photos used for text illustrations, promotional materials, book covers. Examples of recently published titles: *Maker of Things* (text illustrations, book cover); *Springs* (text illustrations, book cover).

NEEDS Number of photos bought annually varies; offers 3-10 freelance assignments/year. Needs unposed people shots and nature photos that suggest storyline. "For children's books, must be child-appealing with rich, bright colors and scenes, no distortions or special effects. For professional books, similar, but often of classroom scenes, including teachers. Nothing posed; should look natural and realistic." Reviews stock photos of children involved with books and classroom activities, ranging from kindergarten to 6th grade. Also wants photos of babies/children/teens, multicultural, families, environmental, landscapes/scenics, wildlife, architecture, cities/urban, pets, adventure, automobiles, sports, travel, science. Interested in documentary. (All must be of interest to children ages 5-9.) Model release required for children and adults. Children (under the age of 21) must have signature of legal guardian. Property release preferred. Photo captions required; include "any information we would need for acknowledgments, including if special permission was needed to use a location."
SPECS "For materials that are to be used, we need 35mm mounted transparencies or high-definition color prints. We usually use full-color photos."
MAKING CONTACT & TERMS Submit copies of samples by mail for review. Provide brochure, flyer or tearsheets to be kept on file for possible future assignments; no slides or disks. Include a brief cover letter with name, address, and daytime phone number, and indicate *Photographer's Market* as a source for correspondence. Works with freelancers on assignment only. "For samples, we like to see any size color prints (or color copies)." Keeps samples on file "if appropriate to our needs." Responds in 1 month. Simultaneous submissions OK. Pays $10-100 for color cover; $10-100 for color inside; $250-800 for multiple photo projects. "Each job has its own payment rate and arrangements." **Pays on acceptance.** Credit line sometimes given, depending on the project. "Photographers' credits appear in children's books and in professional books, but not in promotional materials for books or company." For children's books, publisher retains ownership, possession and world rights, which apply to first and all subsequent editions of a particular title and to all promotional materials. "After a project, (children's books) photos can be used by photographer for portfolio."
TIPS Wants to see "real people in natural, real life situations. No distortion or special effects. Bright, clear images with jewel tones and rich colors. Keep in mind what would appeal to children. Be familiar with what the publishing company has already done. Listen to the needs of the company. Send tearsheets, color photocopies with a mailer. No slides, please."

PAULIST PRESS

997 MacArthur Blvd., Mahwah NJ 07430. (201)825-7300. **Fax:** (201)825-8345. **Website:** www.paulistpress.com. **Contact:** Donna Crilly, managing editor. Estab. 1865. Paulist Press publishes ecumenical theology, Roman Catholic studies, and books on scripture, liturgy, spirituality, church history, and philosophy, as well as works on faith and culture. Our publishing is oriented toward adult-level nonfiction. We do not publish poetry or works of fiction, and we have scaled back our involvement in children's publishing. Guidelines available online and by e-mail.

PELICAN PUBLISHING COMPANY

1000 Burmaster St., Gretna LA 70053. (504)368-1175. **Fax:** (504)368-1195. **E-mail:** editorial@pelicanpub.com. **Website:** www.pelicanpub.com. **Contact:** Nina Kooij, editor-in-chief. Estab. 1926. Publishes adult trade, cooking and art books.
NEEDS Buys 8 photos/year; offers 3 freelance assignments/year. Needs photos of cooking/food, business concepts, nature/inspirational. Reviews royalty-free stock photos of people, nature, etc. Model/property release required. Photo captions required.
SPECS Uses 8×10 glossy color prints; 35mm, 4×5 transparencies. Accepts images in digital format. Send via CD as TIFF files at 300 dpi or higher.

PRAKKEN PUBLICATIONS, INC.

P.O. Box 8623, Ann Arbor MI 48107. (734)975-2800. **Fax:** (734)975-2787. **E-mail:** pam@eddigest.com. **E-mail:** susanne@eddigest.com. **Contact:** Susanne Peckham, book editor; Sharon K. Miller, art/design/production manager. Estab. 1934. "We publish books for educators in career/vocational and technology education, as well as books for the machine trades and machinists' education. Currently emphasizing machine trades." Publishes *The Education Digest* (magazine for teachers and administrators), *Tech Directions* (magazine for technology and career/technical educators), text and reference books for technology and career/technical education., and posters. Photos used for text illustrations, promotional materials, book covers,

magazine covers and posters. Photo guidelines available at website.

NEEDS Wants photos of education "in action," especially technology, career/technical education and general education; prominent historical figures, technology/computers, industry. Photo captions required; include scene location, activity.

SPECS Uses all media; any size. Accepts images in digital format. Send via CD, or e-mail, TIFF, EPS, JPEG files at 300 dpi.

MAKING CONTACT & TERMS Send query letter with samples. Send unsolicited photos by mail for consideration. Keeps samples on file. Payment negotiable. Methods of payment to be arranged. Credit line given. Rights negotiable.

TIPS Wants to see "high-quality action shots in tech/career tech-ed and general education classrooms" when reviewing portfolios. Send inquiry with relevant samples to be kept on file. "We buy very few freelance photographs but would be delighted to see something relevant."

⊖ ⊕ ⊙ PROSTAR PUBLICATIONS INC.

East Coast, 3 Church Circle, Suite 109, Annapolis MD 21401. (800)481-6277. **Fax:** (800)487-6277. **E-mail:** editor@prostarpublications.com. **Website:** www.prostarpublications.com. Estab. 1991. Publishes trade paperback originals (how-to, nonfiction). Subjects include history, nature, travel, nautical. Photos used for book covers. Examples of recently published titles: *The Age of Cunard*; *California's Channel Islands*; *Pacific Seaweeds*. Photo guidelines free with SASE.

NEEDS Buys less than 100 photos/year; offers very few freelance assignments/year. Reviews stock photos of nautical (sport). Prefers to review photos as part of a manuscript package. Model/property release required. Photo captions required.

SPECS Uses color and b&w prints.

MAKING CONTACT & TERMS Send query letter with stock list or contact to see if accepting submissions. Does not keep samples on file; include SASE for return of material. Responds in 1 month. Simultaneous submissions and previously published work OK. Pays on publication. Credit line given. Buys book rights; negotiable.

⊛ ⊖ ⊙ QUARTO PUBLISHING PLC.

226 City Rd., London EC1V 2TT, United Kingdom. +44 020 7700 9000. **Fax:** +44 020 7253 4437. **E-mail:** info@quarto.com. **Website:** www.quarto.com. Pub-

lishes nonfiction books on a wide variety of topics including arts, crafts, natural history, home and garden, reference. Photos used for text illustrations, book covers, dust jackets. Examples of recently published titles: *The Color Mixing Bible*; *Garden Birds*; *The Practical Geologist*. Contact for photo guidelines.

NEEDS Buys 1,000 photos/year. Subjects vary with current projects. Needs photos of multicultural, environmental, wildlife, architecture, gardening, interiors/decorating, pets, religious, adventure, food/drink, health/fitness, hobbies, performing arts, sports, travel, product shots/still life, science, technology/computers. Interested in fashion/glamour, fine art, historical/vintage. Special photo needs include arts, crafts, alternative therapies, New Age, natural history. Model/property release required. Photo captions required; include full details of subject and name of photographer.

SPECS Uses all types of prints. Accepts images in digital format. Send via CD, floppy disk, ZIP, e-mail as TIFF, EPS, JPEG files at 72 dpi for viewing, 300 dpi for reproduction.

MAKING CONTACT & TERMS Provide résumé, business card, samples, brochure, flyer or tearsheets to be kept on file for future reference. Arrange a personal interview to show portfolio. Simultaneous submissions and previously published work OK. Pays on publication. Credit line given. Buys one-time rights; negotiable.

TIPS "Be prepared to negotiate!"

⊕ ROBERTS PRESS

False Bay Books, 685 Spring St., #PMB 161, 330 False Bay Dr., Harbor WA 98250. (360)378-8760. **E-mail:** susan@susanwingate.com. **Website:** www.susanwingate.com. **Contact:** Susan Wingate, author. Estab. 2004. Publishes hardcover originals, trade paperback originals and reprints, and audio books. Publishes fiction, mostly experimental fiction, juvenile, mainstream fiction, science fiction, young adult and literary fiction. Recent titles include *Elemental*, *Drowning*, *Camouflage* and *Of the Law*. 20% requires freelance photography.

NEEDS Photos used for text illustration, promotional materials, book covers and dust jackets. Accepts images in digital format via e-mail in TIFF, GIF, JPEG and PNG formats at 300+ dpi.

SPECS Photo guidelines available via e-mail.

MAKING CONTACT & TERMS Send query letter or e-mail with resume, brochure, samples and URL to website. Keeps samples on file, provide self-promotion piece to be kept on file for possible future assignments. Responds only if interested. Considers simultaneous submissions and previously published work. Portfolio not required. Portfolios should include b&w and color. Rights purchased vary by project. Will negotiate rights with photographers. Finds freelancers through agents/reps and submissions.

⑤⑤ ◑ RUNNING PRESS BOOK PUBLISHERS

2300 Chestnut St., Suite 200, Philadelphia PA 19103. (215)567-5080. **Fax:** (215)567-4636. **E-mail:** frances. soopingchow@perseusbooks.com; perseus.promos@ perseusbooks.com. **Website:** www.runningpress.com. **Contact:** Frances Soo Ping Chow, design director. Estab. 1972. Publishes hardcover originals, trade paperback originals. Subjects include adult and children's fiction and nonfiction; cooking; crafts, lifestyle, kits; miniature editions used for text illustrations, promotional materials, book covers, dust jackets. Examples of recently published titles: *Skinny Bitch, Eat What You Love, The Ultimate Book of Gangster Movies, Fenway Park, The Speedy Sneaky Chef, Les Petits Macarons, New York Fashion Week, I Love Lucy: A Celebration of All Things Lucy, Upcycling*.

NEEDS Buys a few hundred freelance photos/year and lots of stock images. Photos for gift books; photos of wine, food, lifestyle, hobbies, and sports. Model/property release preferred. Photo captions preferred; include exact locations, names of pertinent items or buildings, names and dates for antiques or special items of interest.

SPECS Prefers images in digital format. Send via CD/DVD, via FTP/e-mail as TIFF, EPS files at 300 dpi.

MAKING CONTACT & TERMS Send URL and provide contact info. Do not send original art or anything that needs to be returned. Responds only if interested. Simultaneous submissions and previously published work OK. Pays $500-1000 for color cover; $100-250 for inside. Pays 45 days after receipt of invoice. Credits listed on separate copyright or credit pages. Buys one-time rights.

TIPS Submission guidelines available online.

SCHOLASTIC LIBRARY PUBLISHING

90 Old Sherman Turnpike, Danbury CT 06816. (203)797-3500. **Fax:** (203)797-3197. **Website:** www. scholastic.com/librarypublishing. **Contact:** Phil Friedman, vice president/publisher; Kate Nunn, editor-in-chief; Marie O'Neil, art director. Estab. 1895. "Scholastic Library is a leading publisher of reference, educational, and children's books. We provide parents, teachers, and librarians with the tools they need to enlighten children to the pleasure of learning and prepare them for the road ahead." Publishes 7 encyclopedias plus specialty reference sets in print and online versions. Photos used for text illustrations. Examples of published titles: *The New Book of Knowledge; Encyclopedia Americana*.

NEEDS Buys 5,000 images/year. Needs excellent-quality editorial photographs of all subjects A-Z and current events worldwide. All images must have clear captions and specific dates and locations, and natural history subjects should carry Latin identification.

SPECS Uses 8×10 glossy b&w and/or color prints; 35mm, 4×5, 8×10 (reproduction-quality dupes preferred) transparencies. Accepts images in digital format. Send via photo CD, floppy disk, ZIP as JPEG files at requested resolution.

MAKING CONTACT & TERMS Send query letter, stock lists and printed examples of work. Cannot return unsolicited material and does not send guidelines. Include SASE only if you want material returned. Pricing to be discussed if/when you are contacted to submit images for specific project. Please note, encyclopedias are printed every year, but rights are requested for continuous usage until a major revision of the article in which an image is used (including online images).

TIPS "Send subject lists and small selection of samples. Printed samples *only*, please. In reviewing samples, we consider the quality of the photographs, range of subjects, and editorial approach. Keep in touch, but don't overdo it—quarterly e-mails are more than enough for updates on subject matter."

SCHOOL GUIDE PUBLICATIONS

210 North Ave., New Rochelle NY 10801. (800)433-7771. **E-mail:** mridder@schoolguides.com. **E-mail:** info@schoolguides.com. **Website:** www.schoolguides. com. **Contact:** Miles Ridder, publisher. Estab. 1935. Publishes mass market paperback originals. Photos used for promotional materials, book covers.

NEEDS Photos of college students.

SPECS Accepts images in digital format; send via CD, ZIP, e-mail as TIFF or JPEG files.

MAKING CONTACT & TERMS E-mail query letter. **Pays on acceptance.**

SILVER MOON PRESS

400 E. 85th St., New York NY 10028. (800)874-3320. **Fax:** (212)988-8112. **E-mail:** mail@silvermoonpress. com. **Website:** silvermoonpress.com. Publishes juvenile fiction and general nonfiction. Photos used for text illustrations, book covers, dust jackets. Examples of recently published titles: *Leo Politi: Artist of the Angels* by Ann Stalcup; *The War Between the States* by David Rubel.

NEEDS Buys 5-10 photos/year; offers 1 freelance assignment/year. Looking for general-children, subject-specific photos and American historical fiction photos. Reviews general stock photos. Photo captions preferred.

MAKING CONTACT & TERMS Provide résumé, business card, brochure, flyer or tearsheets to be kept on file for possible future assignments. Keeps samples on file. Responds in 1 month. Simultaneous submissions and previously published work OK. Pays $25-100 for b&w photos. Pays on publication. Credit line given. Buys all rights; negotiable.

☉ TIGHTROPE BOOKS

602 Markham St., Toronto ON M6G 2L8, Canada. (647)348-4460. **E-mail:** info@tightropebooks.com. **Website:** www.tightropebooks.com. **Contact:** Shirarose Wilensky, editor. Estab. 2005.

NEEDS Publishes 12 titles/year. SASE returned. Responds only if interested. Catalog and guidelines free upon request and online.

MAKING CONTACT & TERMS Send an e-mail with résumé, digital images and artist's website, if available.

TILBURY HOUSE

Harpswell Press, Inc., 103 Brunswick Ave., Gardiner ME 04345. (800)582-1899. **Fax:** (207)582-8227. **E-mail:** tilbury@tilburyhouse.com. **Website:** www. tilburyhouse.com. **Contact:** Karen Fisk, associate children's book editor; Jennifer Bunting, publisher. Estab. 1990.

MAKING CONTACT & TERMS Send photocopies of photos/artwork.

VINTAGE BOOKS

1745 Broadway, New York NY 10019. (212)751-2600. **E-mail:** vintageanchorpublicity@randomhouse.com; jgall@randomhouse.com. **Website:** www.random house.com. **Contact:** John Gall, art director. Pub-

lishes trade paperback reprints; fiction. Photos used for book covers. Examples of recently published titles: *Selected Stories* by Alice Munro (cover); *The Fight* by Norman Mailer (cover); *Bad Boy* by Jim Thompson (cover).

NEEDS Buys 100 freelance photos/year. Model/property release required. Photo captions preferred.

MAKING CONTACT & TERMS Send query letter with samples, stock list. Portfolios may be dropped off every Wednesday. Keeps samples on file. Responds only if interested; send nonreturnable samples. Pays by the project, per use negotiation. Pays on publication. Credit line given. Buys one-time and first North American serial rights.

TIPS "Show what you love. Include samples with name, address and phone number."

☉ VISITOR'S CHOICE MAGAZINE

102 E. Fourth Ave., Vancouver BC V5T 1G2, Canada. (604)608-5180. **E-mail:** art@visitorschoice.com. **Website:** www.visitorschoice.com. Estab. 1977. Publishes full-color visitor guides for 16 communities and areas of British Columbia. Photos used for text illustrations, book covers, web sites. Photo guidelines available via e-mail upon request.

NEEDS Looking for photos of attractions, mountains, lakes, views, lifestyle, architecture, festivals, people, sports and recreation—specific to British Columbia region. Specifically looking for people/activity shots. Model release required; property release preferred. Photo captions required—make them detailed but brief.

SPECS Uses color prints; 35mm transparencies. Prefers images in digital format.

MAKING CONTACT & TERMS Send query letter or e-mail with samples; include SASE for return of material. Works with Canadian photographers. Keeps digital images on file. Responds in 3 weeks. Previously published work OK. Payment varies with size of photo published. Pays in 30-60 days. Credit line given.

VOYAGEUR PRESS

Quayside Publishing Group, 400 First Ave. N., Suite 300, Minneapolis MN 55401. (800)458-0454. **Fax:** (612)344-8691. **E-mail:** mdregni@voyageurpress.com. **Website:** voyageurpress.com. **Contact:** Michael Dregni, publisher. Estab. 1972. Publishes adult trade books, hardcover originals and reprints. Subjects include regional history, nature, popular culture, travel, wildlife, Americana, collectibles, lighthouses, quilts, tractors,

barns and farms. Photos used for text illustrations, book covers, dust jackets, calendars. Examples of recently published titles: *Legendary Route 66: A Journey Through Time Along America's Mother Road*; *Illinois Central Railroad*; *Birds in Love: The Secret Courting & Mating Rituals of Extraordinary Birds*; *Backroads of New York*; *How to Raise Cattle*; *Knitknacks*; *Much Ado About Knitting*; *Farmall: The Red Tractor That Revolutionized Farming*; *Backroads of Ohio*; *Farmer's Wife Baking Cookbook*; *John Deere Two-Cylinder Tractor Encyclopedia* (text illustrations, book covers, dust jackets). Photo guidelines free with SASE.

○ Voyageur Press is an imprint of MBI Publishing Company (see separate listing in this section).

NEEDS Buys 500 photos/year. Wants photos of wildlife, Americana, environmental, landscapes/scenics, cities/urban, gardening, rural, hobbies, humor, travel, farm equipment, agricultural. Interested in fine art, historical/vintage, seasonal. "Artistic angle is crucial—books often emphasize high-quality photos." Model release required. Photo captions preferred; include location, species, "interesting nuggets," depending on situation.

MAKING CONTACT & TERMS "Photographic dupes must be of good quality for us to fairly evaluate your photography. We prefer 35mm and large format transparencies; will accept images in digital format for review only; prefers transparencies for production. Send via CD, ZIP, e-mail as TIFF, BMP, GIF, JPEG files at 300 dpi." Simultaneous submissions OK. Pays $300 for cover; $75-175 for inside. Pays on publication. Credit line given, "but photographer's website will not be listed." Buys all rights; negotiable.

TIPS "We are often looking for specific material (crocodiles in the Florida Keys; farm scenics in the Midwest; wolf research in Yellowstone), so subject matter is important. However, outstanding color and angles and interesting patterns and perspectives are strongly preferred whenever possible. If you have the capability and stock to put together an entire book, your chances with us are much better. Though we use some freelance material, we publish many more single-photographer works. Include detailed captioning info on the mounts."

⑤ ⑪ ⓪ WAVELAND PRESS, INC.
4180 Illinois Route 83, Suite 101, Long Grove IL 60047-9580. (847)634-0081. **Fax:** (847)634-9501. E-mail: info@waveland.com. **Website:** www.waveland.com. Estab. 1975. Publishes college-level textbooks and supplements. Photos used for text illustrations, book covers. Examples of recently published titles: *Our Global Environment: A Health Perspective*, 7th edition; *Juvenile Justice*, 2nd edition.

NEEDS Number of photos purchased varies depending on type of project and subject matter. Subject matter should relate to college disciplines: criminal justice, anthropology, speech/communication, sociology, archaeology, etc. Photos of multicultural, disasters, environmental, cities/urban, education, religious, rural, health/fitness, agriculture, political, technology. Interested in fine art, historical/vintage. Model/property release required. Photo captions preferred.

SPECS Accepts images in digital format. Send via CD, ZIP, e-mail as TIFF, EPS, JPEG files at 300 dpi.

MAKING CONTACT & TERMS Send query letter with stock list. Provide résumé, business card, brochure, flyer or tearsheets to be kept on file for possible future assignments. Simultaneous submissions and previously published work OK. Pays $100-200 for cover; $50-100 for inside. Pays on publication. Credit line given. Buys one-time and book rights.

◑ WEIGL EDUCATIONAL PUBLISHERS, LTD.
6325 10th St. SE, Calgary AB T2H 2Z9, Canada. (403)233-7747. **Fax:** (403)233-7769. **E-mail:** linda@weigl.com. **Website:** www.weigl.ca. Estab. 1979. Publishes textbooks, library and multimedia resources. Subjects include social studies, biography, life skills, environment/science studies, multicultural, language arts, geography. Photos used for text illustrations, book covers. Examples of recently published titles: *Land Mammals* (text illustrations, book cover); *Fossils* (text illustrations, book cover), *Opossums* (text illustrations, book cover); *Eiffel Tower* (text illustrations, book cover).

NEEDS Buys 2,000 photos/year. Needs photos of social issues and events, politics, celebrities, technology, people gatherings, multicultural, architecture, cities/urban, religious, rural, agriculture, disasters, environment, science, performing arts, life skills, landscape, wildlife, industry, medicine, biography and people doing daily activities, Canadiana, famous landmarks, aboriginal people. Interested in historical/vintage, seasonal. Model/property release required. Photo captions required.

SPECS Prefers images in digital format. Send via CD, e-mail, FTP as TIFF files at 300 dpi. Uses 5×7, 8×10 color prints (b&w for historical only); 35mm, 2¼×2¼ transparencies.

MAKING CONTACT & TERMS Send query letter with stock list. Provide tearsheets to be kept on file for possible future assignments. "Tearsheets or samples that don't have to be returned are best. We get in touch when we actually need photos." Simultaneous submissions and previously published work OK. Pays $0-250 for color cover; $0-100 for color inside. Credit line given upon request (photo credits are listed in appendix). Buys one-time, book and all rights; negotiable.

TIPS Needs "clear, well-framed shots that don't look posed. Action, expression, multicultural representation are important, but above all, educational value is sought. People must know what they are looking at. Please keep notes on what is taking place, where and when. As an educational publisher, our books use specific examples as well as general illustrations."

WILLOW CREEK PRESS

P.O. Box 147, 9931 Highway 70 W., Minocqua WI 54548. (715)358-7010. **Fax:** (715)358-2807. **E-mail:** jpetrie@willowcreekpress.com. **Website:** www.willowcreekpress.com. **Contact:** Jeremy Petrie, vice president of sales. Estab. 1986. Publishes hardcover, paperback and trade paperback originals; hardcover and paperback reprints and calendars. Subjects include pets, outdoor sports, gardening, cooking, birding, wildlife. Photos used for text illustrations, promotional materials, book covers, dust jackets, and calendars. Examples of recently published titles: *Pug Principles*, *Just Sons*, *It's a Dad Thing*, *Spirit of the Wolf*. Catalog free with #10 SASE. Photo guidelines free with #10 SASE or on website.

NEEDS Buys 2,000 freelance photos/year. Needs photos of gardening, pets, outdoors, recreation, landscapes/scenics, wildlife. Model/property release required. Photo captions required.

MAKING CONTACT & TERMS Send query letter with sample of work. Provide self-promotion piece to be kept on file. Responds only if interested. Simultaneous submissions and previously published work OK. Pays by the project. Pays on publication. Credit line given. Buys one-time rights.

TIPS "We specialize in nature, outdoor, and sporting topics, including gardening, wildlife, and animal books. Pets, cookbooks, and a few humor books and essays round out our titles. Currently emphasizing pets (mainly dogs and cats), wildlife, outdoor sports (hunting, fishing). De-emphasizing essays, fiction."

WILSHIRE BOOK COMPANY

9731 Variel Ave., Chatsworth CA 91311. (818)700-1522. **Fax:** (818)700-1527. **E-mail:** mpowers@mpowers.com. **Website:** www.mpowers.com. **Contact:** Rights Department. Estab. 1947. Publishes trade paperback originals and reprints. Photos used for book covers. Model release required. Responds in 6 weeks. Simultaneous submissions and previously published work OK. Pays $250 for color cover. **Pays on acceptance.** Credit line given.

NEEDS photos of horses

SPECS Uses 35mm, 2¼×2¼, 4×5 transparencies. Accepts images in digital format.

MAKING CONTACT & TERMS Send via disk, e-mail. Send query letter with slides, prints, transparencies. Portfolio may be dropped off Monday–Friday. Does not keep samples on file; include SASE for return of material.

WOMEN'S HEALTH GROUP

Rodale, 33 E. Minor St., Emmaus PA 18098. (212)573-0296. **Website:** www.rodale.com. **Contact:** Yelena Nesbit, communications director. Publishes hardcover originals and reprints, trade paperback originals and reprints, one-shots. Subjects include healthy, active living for women, including diet, cooking, health, beauty, fitness and lifestyle.

NEEDS Photos of babies/children/teens, couples, multicultural, families, parents, senior citizens, food/drink, health/fitness/beauty, sports, travel, women, Spanish women, intimacy/sexuality, alternative medicine, herbs, home remedies. Model/property release preferred.

SPECS Uses color and b&w prints; 35mm, 2¼×2¼, 4×5 transparencies. Accepts images in digital format. Send via CD, ZIP, e-mail as TIFF, EPS, JPEG files at 300 dpi.

MAKING CONTACT & TERMS Send query letter with résumé, prints, photocopies, tearsheets, stock list. Provide résumé, business card, self-promotion piece to be kept on file for possible future assignments. Responds only if interested; send nonreturnable samples. Simultaneous submissions and previously published work OK. Pays additional 20% for electronic promotion of book cover and designs for retail of

book. **Pays on acceptance.** Credit line given. Buys one-time rights, electronic rights; negotiable.

TIPS "Include your contact information on each item that is submitted."

GREETING CARDS, POSTERS & RELATED PRODUCTS

The greeting card industry takes in more than $7.5 billion per year—the lion's share through the giants American Greetings and Hallmark Cards. Naturally, these big companies are difficult to break into, but there is plenty of opportunity to license your images to smaller companies.

There are more than 3,000 greeting card companies in the United States, many of which produce low-priced cards that fill a niche in the market, focusing on anything from the cute to the risqué to seasonal topics. A number of listings in this section produce items like calendars, mugs, and posters, as well as greeting cards.

Before approaching greeting card, poster, or calendar companies, it's important to research the industry to see what's being bought and sold. Start by checking out card, gift, and specialty stores that carry greeting cards and posters. Pay attention to the selections of calendars, especially the large seasonal displays during December. Studying what you see on store shelves will give you an idea of what types of photos are marketable.

Greetings etc., published by Edgell Publications, is a trade publication for marketers, publishers, designers, and retailers of greeting cards. The magazine offers industry news and information on trends, new products, and trade shows. Look for the magazine at your library or visit their website: www.greetingsmagazine.com. Also the National Stationery Show (www.nationalstationeryshow.com) is a large trade show held every year in New York City. It is the main event of the greeting card industry.

APPROACHING THE MARKET

After your initial research, query companies you are interested in working with and send a stock photo list. (See sample stock list in "Running Your Business.") You can help narrow

your search by consulting the Subject Index in the back of this book. Check the index for companies interested in the subjects you shoot.

Since these companies receive large volumes of submissions, they often appreciate knowing what is available rather than actually receiving samples. This kind of query can lead to future sales even if your stock inventory doesn't meet their immediate needs. Buyers know they can request additional submissions as their needs change. Some listings in this section advise sending quality samples along with your query while others specifically request only a list. As you plan your queries, follow the instructions to establish a good rapport with companies from the start.

Some larger companies have staff photographers for routine assignments but also look for freelance images. Usually, this is in the form of stock, and images are especially desirable if they are of unusual subject matter or remote scenic areas for which assignments—even to staff shooters—would be too costly. Freelancers are usually offered assignments once they have established track records and demonstrated a flair for certain techniques, subject matter, or locations. Smaller companies are more receptive to working with freelancers, though they are less likely to assign work because of smaller budgets for photography.

The pay in this market can be quite lucrative if you provide the right image at the right time for a client in need of it, or if you develop a working relationship with one or a few of the better-paying markets. You should be aware, though, that one reason for higher rates of payment in this market is that these companies may want to buy all rights to images. But with changes in the copyright law, many companies are more willing to negotiate sales that specify all rights for limited time periods or exclusive product rights rather than complete surrender of copyright. Some companies pay royalties, which means you will earn the money over a period of time based on the sales of the product.

⊕⊖ ◐ ADVANCED GRAPHICS

466 N. Marshall Way, Layton UT 84041. (801)499-5000 or (800)488-4144. **Fax:** (801) 499-5001. **E-mail:** info@advancedgraphics.com. **Website:** www.advancedgraphics.com. Estab. 1984. Specializes in life-size standups and cardboard displays, decorations and party supplies.

NEEDS Photos of celebrities (movie and TV stars, entertainers), babies/children/teens, couples, multicultural, families, parents, senior citizens, wildlife. Interested in seasonal. Reviews stock photos.

SPECS Uses 4×5, 8×10 transparencies. Accepts images in digital format. Send via CD, ZIP, e-mail.

MAKING CONTACT & TERMS Send query letter with stock list. Keeps samples on file. Responds in 1 month. Pays $400 maximum/image; royalties of 7-10%. Simultaneous submissions and previously published work OK. **Pays on acceptance.** Credit line given. Buys exclusive product rights; negotiable.

TIPS "We specialize in publishing life-size, standup cardboard displays of celebrities. Any pictures we use must show the entire person, head to toe. We must also obtain a license for each image that we use from the celebrity pictured or from that celebrity's estate. The image should be vertical and not too wide."

⊗ ART IN MOTION

425-625 Agnes St., New Westminster BC V3M 5Y4, Canada. (604)525-3900 or (800)663-1308. **Fax:** (604)525-6166 or (877)525-6166. **E-mail:** artistrelations@artinmotion.com. **Website:** www.artinmotion.com. **Contact:** Art relations. Specializes in open edition reproductions, framing prints, wall decor and licensing.

NEEDS "We are publishers of fine art reproductions, specializing in the decorative and gallery market. In photography, we often look for alternative techniques such as hand coloring, Polaroid transfer, or any process that gives the photograph a unique look."

SPECS Accepts unzipped digital images sent via e-mail as JPEG files at 72 dpi.

MAKING CONTACT & TERMS Submit portfolio for review. Pays royalties of 10%. Royalties paid monthly. "Art In Motion covers all associated costs to reproduce and promote your artwork."

TIPS "Contact us via e-mail, or direct us to your website; also send slides or color copies of your work (all submissions will be returned)."

⊘ ARTVISIONS™: FINE ART LICENSING

12117 SE 26th St., Bellevue WA 98005-4118. **E-mail:** See website for contact form. **E-mail:** nonospam0@gmail.com. **Website:** www.artvisions.com. **Contact:** Neil Miller, president. Estab. 1993. Licenses "fashionable, decorative fine art photography and high-quality art to the commercial print, décor and puzzle/game markets."

NEEDS Handles fine art and photography licensing only.

MAKING CONTACT & TERMS "See website. Not currently seeking new talent. However, we are always willing to view the work of top-notch established artists and photographers. If you fit this category, please contact ArtVisions via e-mail and include a link to a website where your art can be seen." Exclusive worldwide representation for licensing is required. Written contract provided.

TIPS "To gain an idea of the type of art we license, please view our website. Animals, children, people and pretty places should be generic, rather than readily identifiable (this also prevents potential copyright issues and problems caused by not having personal releases for use of a 'likeness'). We prefer that your original work be in the form of high-resolution TIFF files from a 'pro-quality' digital camera. Note: scans/digital files are not to be interpolated or compressed in any way. We are firmly entrenched in the digital world; if you are not, then we cannot represent you. If you need advice about marketing your art, please visit: www.artistsconsult.com."

⊕⊖ ◐ AVANTI PRESS, INC.

6 W. 18 St., 6th Floor, New York NY 10011. (212)414-1025; (800)228-2684. **E-mail:** artsubmissions@avantipress.com. **Website:** www.avantipress.com. Estab. 1980. Specializes in photographic greeting cards. Photo guidelines free with SASE or on website.

NEEDS Buys approximately 200 images/year; all are supplied by freelancers. Interested in humorous, narrative, colorful, simple, to-the-point photos of babies, children (4 years old and younger), mature adults, human characters (not models), animals (in humorous situations) and exceptional florals. Has specific deadlines for seasonal material. Does not want travel, sunsets, landscapes, nudes, high-tech. Reviews stock photos. Model/property release required.

SPECS Accepts all mediums and formats. Accepts images in digital format. Send via CD as TIFF, JPEG files.

MAKING CONTACT & TERMS Please submit lo-res JPEGS using the e-mail submission form at avanti-press.com. Do not submit original material. Pays on license. Credit line given. Buys 5-year worldwide, exclusive card rights.

◑ BENTLEY PUBLISHING GROUP

11100 Metric Blvd., Suite 100, Austin TX 78758. (512)467-9400 or (888)456-2254. **Fax:** (512)467-9411. **E-mail:** artist@bentleyglobalarts.com. **E-mail:** info@ bentleyglobalarts.com. **Website:** www.bentleyglo balarts.com. Estab. 1986. Publishes posters.

NEEDS Interested in figurative, architecture, cities, urban, gardening, interiors/decorating, rural, food/ drink, travel—b&w, color or hand-tinted photography. Interested in alternative process, avant garde, fine art, historical/vintage. Reviews stock photos and slides. Model/property release required. Include location, date, subject matter or special information.

SPECS Mainly uses 16×20, 22×28, 18×24, 24×30, 24×36 color and b&w prints; 4×5 transparencies from high-quality photos. Accepts images in digital format. Send via CD as TIFF or JPEG files.

MAKING CONTACT & TERMS Mail in the online artist submission form, include photos, printouts, transparencies, disks or other marketing materials. If you send a disk, please include a printout showing thumbnail images of the contents. Please include SASE. You can also e-mail JPEGs, along with contact information, to artist@bentleyglobalarts.com. All submissions will be considered. Due to the large volume of submissions received, we can only respond if interested.

◎ ◑ BON ARTIQUE.COM/ART RESOURCES INTERNATIONAL, LTD.

Bon Art, 66 Fort Point St., Norwalk CT 06855. (203)845-8888. **E-mail:** sales@bonartique.com. **Website:** www.bonartique.com. **Contact:** Art coordinator. Estab. 1980. Art publisher, poster company, licensing and design studio. Publishes/distributes fine art prints, canvas transfers, unlimited editions, offset reproductions and posters. Clients: Internet purveyors of art, picture frame manufacturers, catalog companies, distributors.

NEEDS Buys 50 images/year. Artistic/decorative photos (not stock photos) of landscapes/scenics, wild-

life, architecture, cities/urban, gardening, interiors/ decorating, rural, adventure, health/fitness, extreme sports. Interested in fine art, cutting edge b&w, sepia photography. Model release required. Photo captions preferred.

SPECS Uses high-res digital files.

MAKING CONTACT & TERMS Prefers e-mail but will accept website links. Works on assignment only. Responds in 3 months. Simultaneous submissions and previously published work OK. Pays advance against royalties—specific dollar amount is subjective to project. Pays on publication. Credit line given if required. Buys all rights; exclusive reproduction rights. Royalties are paid quarterly according to the agreement.

TIPS "Send us new and exciting material; subject matter with universal appeal. Submit color copies, slides, transparencies, actual photos of your work; if we feel the subject matter is relevant to the projects we are currently working on, we'll contact you."

◑ THE BOREALIS PRESS

35 Tenney Hill, Blue Hill ME 04614. (207)370-6020 or (800)669-6845. **E-mail:** art@borealispress.net. **Website:** www.borealispress.net. **Contact:** Mark Baldwin. Estab. 1989. Specializes in greeting cards, magnets and "other products for thoughtful people." Photo guidelines available for SASE.

NEEDS Buys more than 100 images/year; 90% are supplied by freelancers. Needs photos of humor, babies/children/teens, couples, families, parents, senior citizens, adventure, events, hobbies, pets/animals. Interested in documentary, historical/vintage, seasonal. Photos must tell a story. Model/property release preferred.

SPECS Low-res files are fine for review. Any media OK for finals. Uses 5×7 to 8×10 prints; 35mm, 2¼×2¼, 4×5, 8×10 transparencies. Accepts images in digital format. Send via CD. Send low-res files if e-mailing. Send images to art@borealispress.net.

MAKING CONTACT & TERMS Send query letter with slides (if necessary), prints, photocopies, SASE. Send no originals on initial submissions. "Artist's name must be on every image submitted." Responds in 2 weeks to queries; 3 weeks to portfolios. Previously published work OK. Pays by the project, royalties. **Pays on acceptance**, receipt of contract.

TIPS "Photos should have some sort of story, in the loosest sense. They can be in any form. We do not

want multiple submissions to other card companies. Include SASE and put your name on every image you submit."

Ⓢ Ⓞ CENTRIC CORP.

6712 Melrose Ave., Los Angeles CA 90038. (323)936-2100. Fax: (323)936-2101. E-mail: centric@juno.com. Website: www.centriccorp.com. Estab. 1986. Specializes in products that have nostalgic, humorous, thought-provoking images or sayings on them and in the following product categories: T-shirts, watches, pens, clocks, pillows, and drinkware.

NEEDS Photos of cities' major landmarks, attractions and things for which areas are well-known, and humorous or thought-provoking images. Submit seasonal material 5 months in advance. Reviews stock photos.

SPECS Uses 8×12 color and/or b&w prints; 35mm transparencies. Accepts images in digital format. Send via CD as PDF or JPEG files.

MAKING CONTACT & TERMS Submit portfolio online for review or query with résumé of credits. Provide résumé, business card, self-promotion piece or tearsheets to be kept on file for possible future assignments. Responds in 2 weeks. Works mainly with local freelancers. Pays by the job; negotiable. **Pays on acceptance.** Rights negotiable.

TIPS "Research the demographics of buyers who purchase Elvis, Lucy, Marilyn Monroe, James Dean, Betty Boop and Bettie Page products to know how to 'communicate a message' to the buyer."

Ⓢ COMSTOCK CARDS

600 S. Rock Blvd., Suite 15, Reno NV 89502. (775)856-9400 or (800)326-7825. Fax: (775)856-9406 or (888)266-2610. E-mail: production@comstockcards. com. Website: www.comstockcards.com. Estab. 1986. Specializes in greeting cards, invitations, notepads, games, gift wrap. Photo guidelines free with SASE.

NEEDS Buys/assigns 30-40 images/year; all are supplied by freelancers. Wants wild, outrageous and shocking adult humor; seductive images of men or women. Definitely does not want to see traditional, sweet, cute, animals or scenics. "If it's appropriate to show your mother, we don't want it!" Frontal nudity in both men and women is OK and now being accepted as long as it is professionally done—no snapshots from home. Submit seasonal material 10 months in advance. Model/property release required. Photo captions preferred.

SPECS Uses 5×7 color prints; 35mm, 2¼×2¼ color transparencies. Accepts images in digital format.

MAKING CONTACT & TERMS Send query letter with samples, tearsheets, SASE. Responds in 2 months. Pays $150-250 on publication. Buys all rights; negotiable.

TIPS "Submit with SASE if you want material returned."

DELJOU ART GROUP

1616 Huber St., Atlanta GA 30318. (404)350-7190 or (800)237-4638. Fax: (404)350-7195. Website: www. deljouartgroup.com. Estab. 1980. Specializes in wall decor, fine art.

NEEDS All images supplied by freelancers. Specializes in artistic images for reproduction for high-end art market. Work sold through art galleries as photos or prints. Needs nature photos, architectural images or other subjects with artistic quality. Reviews stock photos of graphics, b&w photos. No tourist photos: only high-quality, artistic photos.

SPECS Uses color and/or b&w prints. Accepts images in digital format. Prefers initial digital submissions via e-mail, but will accept CDs. Final, accepted images must be high-res, of at least 300 dpi.

MAKING CONTACT & TERMS Submit portfolio for review; include SASE for return of material. Also send portfolio via e-mail. Simultaneous submissions and previously published work OK. Pays royalties on sales. Credit line sometimes given depending upon the product. Rights negotiable.

TIPS "Abstract-looking photographs OK. Digitally created images are OK. Hand-colored b&w photographs needed."

DESIGN DESIGN, INC.

P.O. Box 2266, Grand Rapids MI 49501. (616)771-8359; (800)334-3348. Fax: (616)774-4020. E-mail: susan.birnbaum@designdesign.us. E-mail: retail help@designdesign.us. Website: www.designdesign. us. Estab. 1986. Specializes in greeting cards and paper-related product development.

NEEDS Licenses stock images from freelancers and assigns work. Specializes in humorous topics. Submit seasonal material 1 year in advance. Model/property release required.

SPECS Uses 35mm transparencies. Accepts images in digital format. Send via ZIP.

MAKING CONTACT & TERMS Submit portfolio for review. Provide résumé, business card, self-promo-

tion piece or tearsheets to be kept on file for possible future assignments. Do not send original work. Pays royalties. Pays upon sales. Credit line given.

GALLANT GREETINGS CORP.

(800)621-4279; (847)671-6500. **Fax:** (847)671-5900. **Website:** www.gallantgreetings.com. Estab. 1966. Specializes in greeting cards.

NEEDS Buys vertical images; all are supplied by freelancers. Photos of landscapes/scenics, wildlife, gardening, pets, religious, automobiles, humor, sports, travel, product shots/still life. Interested in alternative process, avant garde, fine art. Submit seasonal material 1 year in advance. Model release required. Photo captions preferred.

SPECS Accepts images in digital format. Send via CD, e-mail as TIFF files at 300 dpi. No slides accepted.

MAKING CONTACT & TERMS Send query letter with photocopies. Provide self-promotion piece to be kept on file for possible future assignments. Send nonreturnable samples. Pays by the project. Buys U.S. greeting card and allied product rights; negotiable.

IMPACT PHOTOGRAPHICS

4961 Windplay Dr., El Dorado Hills CA 95762. (916)939-9333. **E-mail:** sandeea@impactphotograph ics.com. **Website:** www.impactphotographics.com. **Contact:** Sandee Ashley. Estab. 1975. Specializes in photographic souvenir products for the tourist industry. Photo guidelines and fee schedule available.

This company sells to specific tourist destinations; their products are not sold nationally. They need material that will be sold for at least a 5-year period.

NEEDS Photos of wildlife, scenics, U.S. travel destinations, national parks, theme parks and animals. Buys stock. Buys 3,000+ photos/year. Submit seasonal material 4-5 months in advance. Model/property release required. Photo captions preferred.

SPECS Can print from digital or film. Accepts images in digital format (for initial review). Send via CD, ZIP (or Dropbox such as you send it) as TIFF, JPEG files at 120 dpi for review purposes. Please make sure they can print out nicely at 4×6 for final review purposes. Will need 300 dpi for final printing.

MAKING CONTACT & TERMS "Must have submissions request before submitting samples. No unsolicited submissions." Send query letter with stock list. Provide business card, self-promotion piece or tearsheets to be kept on file for possible future as-

signments. Simultaneous submissions and previously published work OK. Request fee schedule; rates vary by size. Pays on usage. Credit line and printed samples of work given. Buys one-time and nonexclusive product rights.

INTERCONTINENTAL GREETINGS, LTD.

38 W. 32nd St., Suite 910, New York NY 10001. (212)683-5830. **Fax:** (212)779-8564. **E-mail:** interny@ intercontinental-ltd.com. **E-mail:** art@intercontinen tal-ltd.com. **Website:** www.intercontinental-ltd.com. Estab. 1967. Sells reproduction rights of designs to manufacturers of multiple products around the world. Represents artists in 50 different countries. "Our clients specialize in greeting cards, giftware, giftwrap, calendars, postcards, prints, posters, stationery, paper goods, food tins, playing cards, tabletop, bath and service ware and much more."

NEEDS Approached by several hundred artists/year. Seeking creative decorative art in traditional and computer media (Photoshop and Illustrator work accepted). Prefers artwork previously made with few or no rights pending. Graphics, sports, occasions (e.g., Christmas, baby, birthday, wedding), humorous, "soft touch," romantic themes, animals. Accepts seasonal/ holiday material any time. Prefers artists/designers experienced in greeting cards, paper products, tabletop and giftware.

MAKING CONTACT & TERMS Please submit via e-mail, a link to your website or a sampling of your work, consisting of 6-10 designs which represent your collection as a whole. The sampling should show all range of subject matter, technique, style, and medium that may exist in your collection. Digital files should be submitted as e-mail attachments and in low-resolution. Low-res (LR) image files are typically 5×7, 72 dpi, CMYK, JPEG/TIFF/PDF format and are under 100 KB. "Once your art is accepted, we require original color art—Photoshop files on disc (TIFF, 300 dpi). We will respond only if interested." Pays on publication. No credit line given. Offers advance when appropriate. Sells one-time rights and exclusive product rights. Simultaneous submissions and previously published work OK. "Please state reserved rights, if any."

TIPS Recommends the annual New York SURTEX and Licensing shows. In photographer's portfolio samples, wants to see "a neat presentation, perhaps thematic in arrangement."

JILLSON & ROBERTS

3300 W. Castor St., Santa Ana CA 92704-3908. (714)424-0111. **Fax:** (714)424-0054. **E-mail:** sales@ jillsonroberts.com. **Website:** www.jillsonroberts.com. **Contact:** art director. Estab. 1974. Specializes in gift wrap, totes, printed tissues, accessories. Photo guidelines free with SASE. Eco-friendly products.

NEEDS Specializes in everyday and holiday products. Themes include babies, sports, pets, seasonal, weddings. Submit seasonal material 3-6 months in advance.

MAKING CONTACT & TERMS Submit portfolio for review or query with samples. Provide résumé, business card, self-promotion piece or tearsheets to be kept on file for possible future assignments. The review process can take up to 4 months. Pays average flat fee of $250.

TIPS "Please follow our guidelines!"

⊕ LANTERN COURT, LLC

17175 Von Karman Ave., Suite 107, Irvine CA 92614. (800)454-4018. **Fax:** (714)798-2281. **E-mail:** art@ lanterncourt.com. **E-mail:** customerservice@lanterncourt.com. **Website:** www.lanterncourt.com. **Contact:** Seher Zaman, creative director. Estab. 2011. Lantern Court specializes in party supplies and paper goods for the Muslim community or anyone who appreciates Islamic art and design. Produces balloons, calendars, decorations, e-cards, giftbags, giftwrap/ wrapping paper, greeting cards, paper tableware, and part supplies. Buys 10-30 freelance designs/illustrations each year. Prefers freelancers with experience in stationery design. Buys stock photos and offers assignments.

NEEDS Islamic themed and Muslim holiday-related designs. Seasonal material should be submitted 10-12 months in advance. 100% of freelance work demands computer skills. Artists should be familiar with Illustrator, Photoshop, InDesign, and QuarkXPress.

SPECS Accepts images in digital format on CD as TIFF files at 300 dpi.

MAKING CONTACT & TERMS Guidelines available free online. Requires model and property release. Photo captions are preferred. E-mail query letter with link to photographer's website or with JPEG samples at 72 dpi. Keeps samples on file. Please provide a résumé. Responds only if interested. Buys one-time rights. Pays by the project. Maximum payment $750.

💲💲 ⬤ MCGAW GRAPHICS, INC.

P.O. Box 1528, Manchester VT 05255. (888)426-2429. **Fax:** (800)446-8230. **Website:** www.mcgawgraphics.com. **Contact:** Katy Daly, product development manager. Estab. 1979. Specializes in posters, framing prints, wall decor.

NEEDS Licenses over 500 images/year in a variety of media; 25% in photography. Interested in b&w: still life, floral, figurative, landscape; color: landscape, still life, floral. Also considers celebrities, environmental, wildlife, architecture, rural, fine art, historical/vintage. Does not want images that are too esoteric or too commercial. Model/property release required for figures, personalities, images including logos or copyrighted symbols. Photo captions required; include artist's name, title of image, year taken. Not interested in stock photos.

MAKING CONTACT & TERMS Submit 10-20 low resolution jpegs or a link to your web site to katy. daly@mcgawgraphics.com for review. Responds in 1 month. Pays royalties on sales. Pays quarterly following first sale. Credit line given. Buys exclusive product rights for all wall decor.

TIPS "Work must be accessible without being too commercial. Our posters/prints are sold to a mass audience worldwide who are buying art prints. Images that relate a story typically do well for us. The photographer should have some sort of unique style or look that separates him from the commercial market. It is important to take a look at our catalog or website before submitting work to get a sense of our aesthetic. We do not typically license traditional stock-type images—we are a decorative house appealing to a higher-end market.

⬤ NEW YORK GRAPHIC SOCIETY PUBLISHING GROUP

129 Glover Ave., Norwalk CT 06850. (203)847-2000 or (800)677-6947. **Fax:** (203)757-5526. **Website:** www. nygs.com. Estab. 1925. Specializes in fine art reproductions, prints, posters, canvases.

NEEDS Buys 150 images/year; 125 are supplied by freelancers. "Looking for variety of images."

SPECS Prefers digital format. Send low-res JPEGs via e-mail; no ZIP files.

MAKING CONTACT & TERMS Send query letter with samples to Attn: Artist Submissions. Does not keep samples on file; include SASE for return of material. Responds in 3 months. Payment negotiable. Pays

on usage. Credit line given. Buys exclusive product rights. No phone calls.

TIPS "Visit website to review artist submission guidelines and to see appropriate types of imagery for publication."

💲 ⓘ NOVA MEDIA INC.

1724 N. State St., Big Rapids MI 49307-9073. (231)796-4637. **E-mail:** trund@netonecom.net. **Website:** www.novamediainc.com. **Contact:** Thomas J. Rundquist, chairman. Estab. 1981. Specializes in CDs, CDs/tapes, games, limited edition plates, posters, school supplies, T-shirts. Photo guidelines free with SASE.

NEEDS Buys 100 images/year; most are supplied by freelancers. Offers 20 assignments/year. Seeking art fantasy photos. Photos of children/teens, celebrities, multicultural, families, landscapes/scenics, education, religious, rural, entertainment, health/fitness/beauty, military, political, technology/computers. Interested in documentary, erotic, fashion/glamour, fine art, historical/vintage. Submit seasonal material 2 months in advance. Reviews stock photos. Model release required. Photo captions preferred.

SPECS Uses color and b&w prints. Accepts images in digital format. Send via CD.

MAKING CONTACT & TERMS Send query letter with samples. Accepts e-mail submissions. Responds in 1 month. Keeps samples on file; does not return material. Simultaneous submissions and previously published work OK. Payment negotiable. Pays extra for electronic usage of photos. Pays on usage. Credit line given. Buys electronic rights; negotiable.

TIPS "The most effective way to contact us is by e-mail or regular mail. Visit our website."

OHIO WHOLESALE INC./KENNEDY'S COUNTRY COLLECTION

286 W. Greenwich Rd., Seville OH 44273. (330)769-1059. **Fax:** (330)769-1961. **E-mail:** annes@ohiowholesale.com. **Website:** www.ohiowholesale.com. **Contact:** Anne Secoy, vice president of product development. Estab. 1978. Home decor, giftware, seasonal. Produces home décor, wall art, canvas, tabletop, seasonal decorations, gifts, ornaments and textiles.

MAKING CONTACT & TERMS Send an e-mail query with brochure, photographs and SASE. Samples not kept on file. Company will contact artist for portfolio if interested. Pays by the project. Rights negotiated.

TIPS "Be able to work independently with your own ideas—use your 'gift' and think outside the box. *Wow me!*"

ⓘ PAPER PRODUCTS DESIGN

60 Galli Dr., Suite 1, Novato CA 94949. (800)370-9998; (415)883-1888. **Fax:** (415)883-1999. **E-mail:** carol@ppd.co. **Website:** www.paperproductsdesign.com. **Contact:** Carol Florsheim. Estab. 1992. Specializes in napkins, plates, candles, porcelain.

NEEDS Buys 500 images/year; all are supplied by freelancers. Needs photos of babies/children/teens, architecture, gardening, pets, food/drink, humor, travel. Interested in avant garde, fashion/glamour, fine art, historical/vintage, seasonal. Submit seasonal material 6 months in advance. Model release required. Photo captions preferred.

SPECS Uses glossy color and b&w prints; 35mm, 2¼×2¼, 4×5, 8×10 transparencies. Accepts images in digital format. Send via ZIP, e-mail at 350 dpi.

MAKING CONTACT & TERMS Send query letter with photocopies, tearsheets. Responds in 1 month to queries, only if interested. Simultaneous submissions and previously published work OK.

♻ 💲💲 ⓘ PI CREATIVE ART

1180 Caledonia Rd., Toronto ON M6A 2W5, Canada. (416)789-7156. **Fax:** (416)789-7159. **E-mail:** dow@pifineart.com; anna@picreativeart.com. **E-mail:** info@pifineart.com. **Website:** www.picreativeart.com. **Contact:** Darounny (Dow) Marcus, creative director. Estab. 1976. Specializes in posters/prints. Photo guidelines available.

NEEDS Photos of landscapes/scenics, floral, architecture, cities/urban, European, hobbies. Interested in alternative process, avant garde, fine art, historical/vintage. Interesting effects, Polaroids, painterly or hand-tinted submissions welcome. Submit seasonal material 2 months in advance. Model/property release preferred. Photo captions preferred; include date, title, artist, location.

SPECS Accepts images in digital format. Send via CD, ZIP, e-mail as low-res JPEG files for review. Images of interest will be requested in minimum 300 dpi TIFF files.

MAKING CONTACT & TERMS Send query letter with résumé, slides, prints, photocopies, tearsheets, transparencies, stock list. Provide business card, self-promotion piece to be kept on file for possible future assignments. Responds in 2 weeks to queries; 5 weeks

to portfolios. Simultaneous submissions OK. Pays royalties of 10% minimum. Buys worldwide rights for approximately 4-5 years to publish in poster form.

TIPS "Keep all materials in contained unit. Provide easy access to contact information. Provide any information on previously published images. Submit a number of pieces. Develop a theme (we publish in series of 2, 4, 6, etc.). B&w performs very well. Vintage is also a key genre; sepia great, too. Catalog is published with supplement 2 times/year. We show our images in our ads, supporting materials and website."

PORTFOLIO GRAPHICS, INC.

4060 S. 500 W., Salt Lake City UT 84123. (801)266-4844. **E-mail:** info@portfoliographics.com. **Website:** www.nygs.com; www.portfoliographics.com. **Contact:** Kent Barton, creative director. Estab. 1986. Publishes and distributes open edition fine art prints, posters, and canvases as well as images and designs on alternative substrates such as metal, wooden plaques and wall decals.

NEEDS Buys 100 images/year; nearly all are supplied by freelancers. Seeking creative, fashionable, and decorative art for commercial and designer markets. Clients include galleries, designers, poster distributors (worldwide), framers and retailers. For posters, "keep in mind that we need decorative art that can be framed and hung in home or office." Submit seasonal material on an ongoing basis. Reviews stock photos. Photo captions preferred.

SPECS Uses prints, transparencies, high-res digital files recommended.

MAKING CONTACT & TERMS E-mail JPEGs, PDF, or website links. Send photos, transparencies, tearsheets or gallery booklets with SASE. Does not keep samples on file; must include SASE for return of material. Art director will contact photographer for portfolio review if interested. Responds in 3 months. Pays royalties of 10% on sales. Quarterly royalties paid per pieces sold. Credit line given. Buys exclusive product rights license per piece.

TIPS "We find artists through galleries, magazines, art exhibits and submissions. We are looking for a variety of artists, styles and subjects that are fresh and unique."

RECYCLED PAPER GREETINGS, INC.

111 N. Canal St., Suite 700, Chicago IL 60606-7206. (800)777-3331. **Website:** www.recycledpapergreetings.com. **Contact:** Art director. Estab. 1971. Specializes in greeting cards. Photo guidelines available on website.

NEEDS All RPG cards are created by freelancers. Wants "primarily humorous photos for greeting cards. Unlikely subjects and offbeat themes have the best chance, but we'll consider all types. Text ideas required with all photo submissions." Photos of babies/children/teens, landscapes/scenics, wildlife, pets, humor. Interested in alternative process, fine art, historical/vintage, seasonal. Model release required.

MAKING CONTACT & TERMS "We currently don't accept submissions electronically. One reason is that with the number of people involved in the review process at RPG, we have found that everything moves along a lot quicker if we already have a hard copy version of the submission. More importantly, we want to get the best representation of what the finished product will look like, which is why we request that submissions look as much like greeting cards as possible. The standard format for a greeting card is 5×7. Artwork and any corresponding words should be on the front of the card with the message appearing on the inside. *It is also important to note that because we believe strongly that the artwork and the message go hand in hand, we also do not accept submissions that include a message without any accompanying artwork.*" See www.recycled.com/artists for complete submission guidelines.

TIPS "We believe the strongest cards come from individuals expressing their feelings in their own style, which is why we strongly recommend you send messages with your artwork. Experience has shown us that the art makes the customer pick up a card, but it is the message that makes them buy it."

RIG

500 Paterson Plank Rd., Union City NJ 07087. (201)863-4500. **E-mail:** info@rightsinternational.com. **Website:** www.rightsinternational.com. Estab. 1996. Licensing agency specializing in the representation of photographers and artists to manufacturers for licensing purposes. Manufacturers include greeting card, calendar, poster and home furnishing companies.

NEEDS Photos of architecture, entertainment, humor, travel, floral, coastal. "Globally influenced—not specific to one culture. Moody feel." See website for up-to-date needs. Reviews stock photos. Model/property release required.

SPECS Uses prints, slides, transparencies. Accepts images in digital format. Send via CD, e-mail as JPEG files.

MAKING CONTACT & TERMS Submit portfolio for review. Keeps samples on file. Simultaneous submissions and previously published work OK. Payment negotiable. Pays on license deal. Credit line given. Buys exclusive product rights.

● SANTORO GRAPHICS LTD.

Rotunda Point, 11 Hartfield Crescent, Wimbledon, London SW19 3RL, United Kingdom. (44)(208)781-1100. **Fax:** (44)(208)781-1101. **E-mail:** submissions@santorographics.com. **Website:** www.santoro-london.com. **Contact:** Submissions. Estab. 1983. Features landscapes/scenics, wildlife, humor and historical/vintage photography.

MAKING CONTACT & TERMS Model/property release required. E-mail query letter. Accepts EPS files at 300 dpi.

SPENCER'S

6826 Black Horse Pike, Egg Harbor Twp. NJ 08234-4197. **Website:** www.spencersonline.com. Estab. 1947. Specializes in packaging design, full-color art, novelty gifts, brochure design, poster design, logo design, promotional P.O.P.

○ Products offered by store chain include posters, T-shirts, games, mugs, novelty items, cards, 14K jewelry, neon art, novelty stationery. Spencer's is moving into a lot of different product lines, such as custom lava lights and Halloween costumes and products. Visit a store if you can to get a sense of what they offer.

NEEDS Photos of babies/children/teens, couples, party scenes (must have releases), jewelry (gold, sterling silver, body jewelry—earrings, chains, etc.). Interested in fashion/glamour. Model/property release required. Photo captions preferred.

SPECS Uses transparencies. Accepts images in digital format. Send via CD, DVD at 300 dpi. Contracts some illustrative artwork. All styles considered.

MAKING CONTACT & TERMS Send query letter with photocopies. Portfolio may be dropped off any weekday, 9-5. Provide self-promotion piece to be kept on file for possible future assignments. Responds only if interested; send *only* nonreturnable samples. Pays by the project, $250-850/image. Pays on receipt of invoice. Buys all rights; negotiable. Will respond upon need of services.

○ ❸ ⊕ ◑ TELDON

Unit 100 - 12751 Vulcan Way, Richmond BC V6V 3C8, Canada. **E-mail:** photo@teldon.com. **E-mail:** sales@teldon.com. **Website:** www.teldon.com. **Contact:** Photo editor. Estab. 1969. Publishes high-quality dated and nondated promotional products, including wall calendars, desk calendars, magnets, newsletters, postcards, etc. E-mail for photo guidelines—waiting list applies.

NEEDS Buys over 1,000 images/year; 70% are supplied by freelancers. Photos of lifestyles (babies/children/teens, couples, multicultural, families, parents, senior citizens (all model released), wildlife (North American), architecture (exterior residential homes–property released only), gardening, interiors/decorating (property released only), adventure, sports, travel (world), motivational, inspirational, landscape/scenic. Reviews stock photos. Model/property release required for trademarked buildings, residential houses, people. Photo captions required; include complete detailed description of destination (e.g., Robson Square, Vancouver, British Columbia, Canada), month picture taken also helpful.

SPECS Accepts mostly digital submissions now. Contact photo editor for details.

MAKING CONTACT & TERMS Send query letter or e-mail. "No submissions accepted unless photo guidelines have been received and reviewed." Responds in 1 month, depending on workload. Simultaneous submissions and previously published work OK. Works with freelancers and stock agencies. Pays $150 for one-time use, non-negotiable. Pays in September of publication year. Credit line and complementary calendar copies given. Photos used for one-time use in dated products, North American rights, unlimited print runs.

TIPS City shots should be no older than 1 year. "Examine our catalog on our website carefully, and you will see what we are looking for."

❸❸ ⊕ ◑ TIDE-MARK PRESS

P.O. Box 20, Windsor CT 06095. (860)683-4499. **Fax:** (860)683-4055. **E-mail:** scott@tide-mark.com. **Website:** www.tidemarkpress.com. **Contact:** Scott Kaeser,

acquisitions editor. Estab. 1979. Specializes in calendars. Photo guidelines available on website.

NEEDS Buys 1,000 images/year; 800 are supplied by freelancers. Categories: landscapes/scenics, wildlife, architecture, gardening, interiors/decorating, pets, religious, adventure, automobiles, entertainment, events, food/drink, health/fitness, hobbies, humor, performing arts, sports, travel. Interested in fine art, historical/vintage; Native American; African American. Needs "complete calendar concepts that are unique but also have identifiable markets; groups of photos that could work as an entire calendar; ideas and approach must be visually appealing and innovative but also have a definable audience. No general nature or varied subjects without a single theme." Submit seasonal material 18 months in advance. Reviews stock photos. Model release preferred. Photo captions required.

SPECS Uses film and digital images. Accepts low-res images in PDF or JPEG format for initial review; send high-res only on selection.

MAKING CONTACT & TERMS "Offer specific topic suggestions that reflect specific strengths of your stock." Send e-mail with sample images. Editor will contact photographer for portfolio review if interested. Responds in 3 weeks. Pays $150-350/color image for single photos; royalties on net sales if entire calendar supplied. Pays on publication or per agreement. Credit line given. Buys one-time rights.

TIPS "We tend to be a niche publisher and rely on photographers with strong stock to supply our needs. Check the website, then call or send a query suggesting a specific calendar concept."

TRAILS MEDIA GROUP

333 W. State St., Milwaukee WI 53201. **Fax:** (414)647-4723. **E-mail:** mchristiansen@wistrails.com. **E-mail:** editor@wistrails.com, clewis@jrn.com. **Website:** www.wisconsintrails.com. Estab. 1960. Specializes in calendars (horizontal and vertical) portraying seasonal scenics. Also publishes regional books and magazines, including *Wisconsin Trails.*

NEEDS Buys 300 photos/year. Needs photos of nature, landscapes, wildlife and regional (Wisconsin, Michigan, Iowa, Minnesota, Indiana, Illinois) activities. Makes selections in January for calendars, 6 months ahead for magazine issues. Photo captions required.

SPECS No longer accepts film submissions, only digital.

MAKING CONTACT & TERMS Submit via e-mail. Send your contact information including address, phone, e-mail, and website to editor@wistrails.com. Information gets entered into our database and will be added to our "photo call" e-mail list. Photos are credited and the photographer retains all rights.

TIPS "Be sure to inform us how you want materials returned and include proper postage. Calendar scenes must be horizontal to fit 8¾×11 format, but we also want vertical formats for engagement calendars. See our magazine and books and be aware of our type of photography. E-mail for an appointment."

ZITI CARDS

601 S. Sixth St., St. Charles MO 63301. (800)497-5908. **Fax:** (636)352-2146. **E-mail:** mail@ziticards.com. **Website:** www.ziticards.com. **Contact:** Salvatore Ventura, owner. Estab. 2006. Produces greeting cards. Specializes in holiday cards for architects, construction businesses and medical professionals. Art guidelines available via e-mail.

NEEDS Buys 30+ freelance photographs per year. Produces material for greeting cards, mainly Christmas. Submit seasonal material at any time. Final art size should be proportional to and at least 5×7. "We purchase exclusive rights for the use of photographs on greeting cards and do not prevent photographers from using images on other non-greeting card items. Photographers retain all copyrights and can end the agreement for any reason." Pays $50 advance and 5% royalties at the end of the season. Finds freelancers through submissions. Accepts prints, transparencies, and digital formats.

MAKING CONTACT & TERMS E-mail query letter with résumé, link and samples or send a query letter with résumé slides, prints, tearsheets and/or transparencies. Samples not kept on file, include SASE for return of material.

TIPS "Pay attention to details, look at other work that publishers use, follow up on submissions, have good presentations. We need unusual and imaginative photographs for general greeting cards and especially the Christmas holiday season. Architecture plus snow, holiday decorations/colors/symbols, etc. Present your ideas for cards if your portfolio does not include such work."

⊛⊛ ◑ THE ZOLAN COMPANY, LLC

32857 N. 74th Way, Scottsdale AZ 85266. (480)306-5680. **E-mail:** donaldz798@aol.com. **Website:** www.zolan.com. **Contact:** Jennifer Zolan, president/art director. Commercial and fine art business. Photos used for artist reference in oil paintings.

NEEDS Buys 8-10 images/year; works on assignment; looking for photographs of Farmall tractors, especially models M, C, H, 1066, 460, 1566, 1026, Farmall 1206, Farmall tractor models from the '60s and '70s. John Deere tractors are also needed. Looking for photos of puppies and dogs for paintings. Reviews stock photos.

SPECS Will only review images in digital format. Send via e-mail, PDF, GIF, JPEG files at 72 dpi for preview.

MAKING CONTACT & TERMS Request photo guidelines by e-mail. Will only review submissions in electronic files. If submissions are sent by mail or other shipping services, they will not be returned. Does not keep samples on file. Pays $100-300 per photo. **Pays on acceptance.**

TIPS "We are happy to work with amateur and professional photographers. Will work on assignment shoots with photographers who have access to Farmall tractors. Will also purchase what is in stock if it fits the needs."

STOCK PHOTO AGENCIES

//

If you are unfamiliar with how stock agencies work, the concept is easy to understand. Stock agencies house large files of images from contracted photographers and market the photos to potential clients. In exchange for licensing the images, agencies typically extract a 50-percent commission from each use. The photographer receives the other 50 percent.

In recent years, the stock industry has witnessed enormous growth, with agencies popping up worldwide. Many of these agencies, large and small, are listed in this section. However, as more and more agencies compete for sales, there has been a trend toward partnerships among some small to mid-size agencies. Other agencies have been acquired by larger agencies and essentially turned into subsidiaries. Often these subsidiaries are strategically located to cover different portions of the world. Typically, smaller agencies are bought if they have images that fill a need for the parent company. For example, a small agency might specialize in animal photographs and be purchased by a larger agency that needs those images but doesn't want to search for individual wildlife photographers.

The stock industry is extremely competitive, and if you intend to sell stock through an agency, you must know how they work. Below is a checklist that can help you land a contract with an agency.

- Build a solid base of quality images before contacting any agency. If you send an agency 50–100 images, they are going to want more if they're interested. You must have enough quality images in your files to withstand the initial review and get a contract.
- Be prepared to supply new images on a regular basis. Most contracts stipulate that photographers must send additional submissions periodically—perhaps quarterly, monthly, or annually. Unless you are committed to shooting regularly, or unless you have amassed a gigantic collection of images, don't pursue a stock agency.

- Make sure all of your work is properly cataloged and identified with a file number. Start this process early so that you're prepared when agencies ask for this information. They'll need to know what is contained in each photograph so that the images can be properly keyworded on websites.

- Research those agencies that might be interested in your work. Smaller agencies tend to be more receptive to newcomers because they need to build their image files. When larger agencies seek new photographers, they usually want to see specific subjects in which photographers specialize. If you specialize in a certain subject area, be sure to check out our Subject Index in the back of the book, which lists companies according to the types of images they need.

- Conduct reference checks on any agencies you plan to approach to make sure they conduct business in a professional manner. Talk to current clients and other contracted photographers to see if they are happy with the agency. Also, some stock agencies are run by photographers who market their own work through their own agencies. If you are interested in working with such an agency, be certain that your work will be given fair marketing treatment.

- Once you've selected a stock agency, contact them via e-mail or whatever means they have stipulated in their listing or on their website. Today, almost all stock agencies have websites and want images submitted in digital format. If the agency accepts slides, write a brief cover letter explaining that you are searching for an agency and that you would like to send some images for review. Wait to hear back from the agency before you send samples. Then send only duplicates for review so that important work won't get lost or damaged. Always include a SASE when sending samples by regular mail. It is best to send images in digital format; some agencies will only accept digital submissions.

- Finally, don't expect sales to roll in the minute a contract is signed. It usually takes a few years before initial sales are made.

SIGNING AN AGREEMENT

There are several points to consider when reviewing stock agency contracts. First, it's common practice among many agencies to charge photographers fees, such as catalog insertion rates or image duping fees. Don't be alarmed and think the agency is trying to cheat you when you see these clauses. Besides, it might be possible to reduce or eliminate these fees through negotiation.

Another important item in most contracts deals with exclusive rights to market your images. Some agencies require exclusivity to sales of images they are marketing for you. In other words, you can't market the same images they have on file. This prevents photographers from undercutting agencies on sales. Such clauses are fair to both sides as long as you can continue marketing images that are not in the agency's files.

An agency also may restrict your rights to sign with another stock agency. Usually such clauses are designed merely to keep you from signing with a competitor. Be certain your contract allows you to work with other agencies. This may mean limiting the area of distribution for each agency. For example, one agency may get to sell your work in the United States, while the other gets Europe. Or it could mean that one agency sells only to commercial clients, while the other handles editorial work. Before you sign any agency contract, make sure you can live with the conditions, including 40/60 fee splits favoring the agency.

Finally, be certain you understand the term limitations of your contract. Some agreements renew automatically with each submission of images. Others renew automatically after a period of time unless you terminate your contract in writing. This might be a problem if you and your agency are at odds for any reason. Make sure you understand the contractual language before signing anything.

REACHING CLIENTS

One thing to keep in mind when looking for a stock agent is how they plan to market your work. A combination of marketing methods seems the best way to attract buyers, and most large stock agencies are moving in that direction by offering catalogs, CDs, and websites.

But don't discount small, specialized agencies. Even if they don't have the marketing muscle of big companies, they do know their clients well and often offer personalized service and deep image files that can't be matched by more general agencies. If you specialize in regional or scientific imagery, you may want to consider a specialized agency.

MICROSTOCK

A relatively new force in the stock photography business is microstock. The term microstock comes from the "micro payments" that these agencies charge their clients—often as little as one dollar (the photographer gets only half of that), depending on the size of the image. Compare that to a traditional stock photo agency, where a rights-managed image could be licensed for hundreds of dollars, depending on the image and its use. Unlike the traditional stock agencies, microstock agencies are more willing to look at work from amateur photographers, and they consider their content "member generated." However, they do not accept all photos or all photographers; images must still be vetted by the microstock site before the photographer can upload his collection and begin selling. Microstock sites are looking for the lifestyle, people, and business images that their traditional counterparts often seek. Unlike most traditional stock agencies, microstock sites offer no rights-managed images; all images are royalty free.

So if photographers stand to make only fifty cents from licensing an image, how are they supposed to make money from this arrangement? The idea is to sell a huge quantity of photos at these low prices. Microstock agencies have tapped into a budget-minded client

that the traditional agencies have not normally attracted—the small business, nonprofit organization, and even the individual who could not afford to spend $300 for a photo for their newsletter or brochure. There is currently a debate in the photography community about the viability of microstock as a business model for stock photographers. Some say it is driving down the value of all photography and making it harder for all photographers to make a living selling their stock photos. While others might agree that it is driving down the value of photography, they say that microstock is here to stay and photographers should find a way to make it work for them or find other revenue streams to counteract any loss of income due to the effects of microstock. Still others feel no pinch from microstock: They feel their clients would never purchase from a microstock site and that they are secure in knowing they can offer their clients something unique.

If you want to see how a microstock site works, see the following websites, which are some of the more prominent microstock sites. You'll find directions on how to open an account and start uploading photos.

- www.shutterstock.com
- www.istockphoto.com
- www.bigstockphoto.com
- www.fotolia.com
- www.dreamstime.com

DIGITAL IMAGING GUIDELINES AND SYSTEMS

The photography industry is in a state of flux as it grapples with the ongoing changes that digital imaging has brought. In an effort to identify and promote digital imaging standards, the Universal Photographic Digital Imaging Guidelines (UPDIG, www.updig.org) were established. The objectives of UPDIG are to:

- Make digital imaging practices more clear and reliable
- Develop an Internet resource for imaging professionals (including photo buyers, photographers, and nonprofit organizations related to the photography industry)
- Demonstrate the creative and economic benefits of the guidelines to clients
- Develop industry guidelines and workflows for various types of image reproduction, including RAW file delivery, batch-converted files, color-managed master files, and CMYK with proofs.

PLUS (Picture Licensing Universal System) is a cooperative, multi-industry initiative designed to define and categorize image usage around the world. It does not address pricing or negotiations, but deals solely with defining licensing language and managing license data so that photographers and those who license photography can work with the same systems and use the same language when licensing images. To learn more about PLUS, visit www.useplus.com.

MARKETING YOUR OWN STOCK

If you find the terms of traditional agencies unacceptable, there are alternatives available. Many photographers are turning to the Internet as a way to sell their stock images without an agent and are doing very well. Your other option is to join with other photographers sharing space on the Internet. Check out PhotoSource International at www.photosource .com and www.agpix.com.

If you want to market your own stock, it is not absolutely necessary that you have your own website, but it will help tremendously. Photo buyers often "google" the keyword they're searching for—that is, they use an Internet search engine, keying in the keyword plus "photo." Many photo buyers, from advertising firms to magazines, at one time or another, either have found the big stock agencies too unwieldy to deal with, or they simply did not have exactly what the photo buyer was looking for. Googling can lead a photo buyer straight to your site; be sure you have adequate contact information on your website so the photo buyer can contact you and possibly negotiate the use of your photos.

One of the best ways to get into stock is to sell outtakes from assignments. The use of stock images in advertising, design, and editorial work has risen in the last five years. As the quality of stock images continues to improve, even more creatives will embrace stock as an inexpensive and effective means of incorporating art into their designs. Retaining the rights to your assignment work will provide income even when you are no longer able to work as a photographer.

LEARN MORE ABOUT THE STOCK INDUSTRY

There are numerous resources available for photographers who want to learn about the stock industry. Here are a few of the best.

- **PhotoSource International**, (715)248-3800, website: www.photosource.com, e-mail: info@photosource.com. Owned by author/photographer Rohn Engh, this company produces several newsletters that can be extremely useful for stock photographers. A few of these include *PhotoStockNotes*, *PhotoDaily*, *PhotoLetter*, and *PhotoBulletin*. Engh's *Sell & Re-Sell Your Photos* (Writer's Digest Books) tells how to sell stock to book and magazine publishers.
- **Selling Stock**, (301)251-0720, website: www.pickphoto.com, e-mail: Jim@scphoto.com. This newsletter is published by one of the photo industry's leading insiders, Jim Pickerell. He gives plenty of behind-the-scenes information about agencies and is a huge advocate for stock photographers.
- **Negotiating Stock Photo Prices**, 5th edition, by Jim Pickerell and Cheryl Pickerell DiFrank, 110 Frederick Ave., Suite A, Rockville MD 20850, (301)251-0720. This is the most comprehensive and authoritative book on selling stock photography.

- **The Picture Archive Council of America**, (800)457-7222, website: www.pacaoffice.org. Anyone researching an American agency should check to see if the agency is a member of this organization. PACA members are required to practice certain standards of professionalism in order to maintain membership.
- **British Association of Picture Libraries and Agencies**, (44)(020)7713-1780, website: www.bapla.org.uk. This is PACA's counterpart in the United Kingdom and is a quick way to examine the track record of many foreign agencies.
- **Photo District News**, website: www.pdn-pix.com. This monthly trade magazine for the photography industry frequently features articles on the latest trends in stock photography, and publishes an annual stock photography issue.
- **Stock Artists Alliance**, website: www.stockartistsalliance.org. This trade organization focuses on protecting the rights of independent stock photographers.

⊛ 911 PICTURES

P.O. Box 1679, Sag Harbor NY 11963. (631)324-2061. **Fax:** (631)329-9264. **E-mail:** 911pix@optonline.net. **Website:** www.911pictures.com. **Contact:** Michael Heller, president. Estab. 1996. Stock agency. Has 3,500 photos in files. Clients include: advertising agencies, public relations firms, audiovisual firms, businesses, book publishers, magazine publishers, calendar companies, insurance companies, public safety training facilities.

NEEDS Photos of disaster services, public safety/emergency services, fire, police, EMS, rescue, hazmat. Interested in documentary.

SPECS Accepts images in digital format on CD at minimum 300 dpi, 8 inches minimum short dimension. Images for review may be sent via e-mail, CD as BMP, GIF, JPEG files at 72 dpi.

PAYMENT & TERMS Pays 50% commission for b&w and color photos; 75% for film and videotape. Enforces minimum prices. Offers volume discounts to customers. Works with photographers on contract basis only. Offers nonexclusive contract. Charges any print fee (from negative or slide) or dupe fee (from slide). Statements issued/sale. Payment made/sale. Photographers allowed to review account records in cases of discrepancies only. Offers one-time rights. Informs photographers and allows them to negotiate when client requests all rights. Model release preferred. Photo captions preferred; include photographer's name and a short caption as to what is occurring in photo.

HOW TO CONTACT Send query letter with résumé, slides, prints, photocopies, tearsheets. "Photographers can also send e-mail with thumbnail (low-res) attachments." Does not keep samples on file; include SASE for return of material. Responds only if interested; send nonreturnable samples. Photo guidelines sheet free with SASE.

TIPS "Keep in mind that there are hundreds of photographers shooting hundreds of fires, car accidents, rescues, etc., every day. Take the time to edit your own material, so that you are only sending in your best work. We are especially in need of hazmat, police and natural disaster images. At this time, 911 Pictures is only soliciting work from those photographers who shoot professionally or who shoot public safety on a regular basis. We are not interested in occasional submissions of 1 or 2 images."

ACCENT ALASKA/KEN GRAHAM AGENCY

P.O. Box 272, Girdwood AK 99587. (907)561-5531; (800)661-6171. **Fax:** (907)783-3247. **E-mail:** info@accentalaska.com. **Website:** www.accentalaska.com. **Contact:** Ken Graham, owner. Estab. 1979. Stock agency. Has 25,000 photos online. Clients include: advertising agencies, public relations firms, audiovisual firms, businesses, book publishers, magazine publishers, newspapers, calendar companies, greeting card companies, postcard publishers, CD encyclopedias.

NEEDS Modern stock images of Alaska, Antarctica. "Please do not submit material we already have in our files."

SPECS Uses images from digital cameras 10 megapixels or greater; no longer accepting film but will review and select then you return us scanned images with metadata embedded. Send via CD, ZIP, e-mail lightbox URL.

PAYMENT & TERMS Pays 50% commission. Negotiates fees at industry-standard prices. Works with photographers on contract basis only. Offers nonexclusive contract. Payment made quarterly. "We are a rights managed agency."

HOW TO CONTACT "See our website contact page. Any material must include SASE for returns." Expects minimum initial submission of 60 images. Prefers online web gallery for initial review.

TIPS "Realize we specialize in Alaska although we do accept images from Antarctica. The bulk of our sales are Alaska-related. We are always interested in seeing submissions of sharp, colorful and professional-quality images with model-released people when applicable. Do not want to see same material repeated in our library."

🐚 ACE STOCK LIMITED

E-mail: web@acestock.com. **Website:** www.acestock.com. **Contact:** John Panton, director. Estab. 1980. Stock photo agency. Has approximately 500,000 photos on file; over 40,000 online. Clients include: ad agencies, audiovisual firms, businesses, book/encyclopedia publishers, magazine publishers, postcard companies, calendar companies, greeting card companies, design companies, direct mail companies.

NEEDS Photos of babies/children/teens, couples, multicultural, families, parents, senior citizens, environmental, landscapes/scenics, wildlife, pets, adventure, automobiles, food/drink, health/fitness, hobbies, humor, sports, travel, business concepts, indus-

try, medicine, product shots/still life, science, technology/computers. Interested in alternative process, avant garde, documentary, fashion/glamour, seasonal. **SPECS** High-quality digital submissions only. Scanning resolutions for low-res at 72 dpi and high-res at 300 dpi with 30MB minimum size. Accepts online submissions only. **PAYMENT & TERMS** Pays 50% commission on net receipts. Average price per image (to clients): $400. Works with photographers on contract basis only. Offers limited regional exclusivity. Contracts renew automatically for 2 years with each submission. No charges for scanning. Charges $200/image for catalog insertion. Statements issued quarterly. Payment made quarterly. Photographers permitted to review sales records with 1-month written notice. Offers one-time rights, first rights or mostly nonexclusive rights. Informs photographers when client requests to buy all rights, but agency negotiates for photographer. Model/property release required for people and buildings. Photo captions required; include place, date and function. "Prefer data as IPTC-embedded within Photoshop File Info 'caption' for each scanned image." **HOW TO CONTACT** Send e-mail with low-res attachments or website link or FTP. Alternatively, arrange a personal interview to show portfolio or post 50 sample transparencies. Responds within 1 month. Photo guidelines sheet free with SASE. Online tips sheet for contracted photographers. **TIPS** Prefers to see "definitive cross-section of your collection that typifies your style and prowess. Must show originality, command of color, composition and general rules of stock photography. All people must be mid-Atlantic to sell in UK. No dupes. Scanning and image manipulation is all done in-house. We market primarily via online search engines and e-mail promos. In addition, we distribute printed catalogs and CDs."

🌀 A+E

9 Hochgernstr, Stein D-83371, Germany. (49)8621-61833. **Fax:** (49)8621-63875. **E-mail:** apluse@aol.com. **Website:** www.apluse.de. **Contact:** Elisabeth Pauli, director. Estab. 1987. Picture library. Has over 30,000 photos in files. Clients include newspapers, postcard publishers, book publishers, calendar companies, magazine publishers.
NEEDS Photos of nature/landscapes/scenics, pets, "only your best material."

SPECS Uses 35mm, 6×6 transparencies, digital. Accepts images in digital format. Send via CD as JPEG files at 100 dpi for referencing purposes only.
PAYMENT & TERMS Pays 50% commission. Offers volume discounts to customers. Works with photographers on contract basis only. Offers nonexclusive contract. Subject exclusivity may be negotiated. Statements issued annually. Payment made annually. Photographers allowed to review account records in cases of discrepancies only. Offers one-time rights. Model/property release required. Photo captions must include country, date, name of object (person, town, landmark, etc.).
HOW TO CONTACT Send query letter with your qualification, description of your equipment, transparencies or CD, stock list. Include SASE for return of material in Europe. Cannot return material outside Europe. Expects minimum initial submission of 100 images with annual submissions of at least 100 images. Responds in 1 month.
TIPS "Judge your work critically. Only technically perfect photos will attract a photo editor's attention! Sharp focus, high colors, creative views."

✖ AERIAL ARCHIVES

Petaluma Airport, 561 Sky Ranch Dr., Petaluma CA 94954. (415)771-2555. **Fax:** (707)769-7277. **E-mail:** www.aerialarchives.com/contact.htm; herb@aerialarchives.com. **Website:** www.aerialarchives.com. **Contact:** Herb Lingl. Estab. 1989. Has 100,000 photos in files. Has 2,000 hours of film, video footage. Clients include: advertising agencies, public relations firms, audiovisual firms, businesses, book publishers, magazine publishers, newspapers, calendar companies.
NEEDS Aerial photography only.
SPECS Accepts images in digital format only, unless they are historical. Uses 2¼×2¼, 4×5, 9×9 transparencies; 70mm, 5 inches and 9×9 (aerial film). Other media also accepted.
PAYMENT & TERMS Buys photos, film, videotape outright only in special situations where requested by submitting party. Pays on commission basis. Average price per image (to clients): $325. Enforces minimum prices. Offers volume discounts to customers. Photographers can choose not to sell images on discount terms. Works with photographers on contract basis only. Statements issued quarterly. Payment made monthly. Photographers allowed to review account records in cases of discrepancies only. Offers one-

time rights, electronic media rights, agency promotion rights. Informs photographers and allows them to negotiate when client requests all rights. Property release preferred. Photo captions required; include date, location, and altitude if available.

HOW TO CONTACT Send query letter with stock list. Provide résumé, business card, self-promotion piece to be kept on file. Expects minimum initial submission of 100 images with quarterly submissions of at least 50 images. Responds only if interested; send nonreturnable samples. Photo guidelines sheet available via e-mail.

TIPS "Supply complete captions with date and location; aerial photography only."

AFLO FOTO AGENCY

7F Builnet 1, 6-16-9, Ginza, Chuo-ku Tokyo 104-0061, Japan. (81)3-5550-2120. **E-mail:** support@aflo.com. **Website:** www.aflo.com (Japanese); www.afloimages.com (English). Estab. 1980. Stock agency, picture library and news/feature syndicate. Japan's largest photo agency, employing over 120 staff based in Tokyo and Osaka. Clients include: advertising agencies, designers, public relations firms, new media, book publishers, magazine publishers, educational users and television. Member of the Picture Archive Council of America (PACA). Has 1 million photos in files. "We have other offices in Tokyo and Osaka."

NEEDS Photos of babies/children/teens, celebrities, couples, multicultural, families, parents, senior citizens, disasters, environmental, landscapes/scenics, wildlife, architecture, cities/urban, education, gardening, interiors/decorating, pets, religious, rural, adventure, automobiles, entertainment, events, food/drink, health/fitness, hobbies, humor, performing arts, sports, travel, agriculture, business concepts, industry, medicine, military, political, product shots/still life, science, technology/computers. Interested in alternative process, avant garde, documentary, erotic, fashion/glamour, fine art, historical/vintage, lifestyle, seasonal.

SPECS Uses 35mm, 2¼×2¼, 4×5, 8×10 transparencies. Accepts images in digital format. Send via CD, e-mail as TIFF, JPEG files. When making initial submission via e-mail, files should total less than 3MB.

PAYMENT & TERMS Pays commission. Average price per image (to clients): $195 minimum for b&w photos; $250 minimum for color photos, film, videotape. Offers volume discounts to customers; terms

specified in photographers' contracts. Photographers can choose not to sell images on discount terms. Works with photographers with or without a contract; negotiable. Contract type varies. Statements issued quarterly. Payment made quarterly. Photographers allowed to review account records. Model/property release preferred. Photo captions required.

HOW TO CONTACT Send all inquiries regarding images or submissions to support@aflo.com. Any submission inquiries should be accompanied by gallery links or image sets.

AGE FOTOSTOCK

Bretón de los Herreros, 59 bajos B E-28003 Madrid, Spain. (34)91 451 86 00. **Fax:** (34)91 451 86 01. **E-mail:** agemadrid@agefotostock.com. **Website:** www.age fotostock.com. Estab. 1973. Stock agency. Photographers may submit their images to Barcelona directly. Clients include: advertising agencies, businesses, newspapers, postcard publishers, public relations firms, book publishers, calendar companies, audio-visual firms, magazine publishers, greeting card companies. See website for other locations.

NEEDS "We are a general stock agency and are constantly uploading images onto our website. Therefore, we constantly require creative new photos from all categories."

SPECS Accepts all formats. Details available upon request, or see website ("Photographers/submitting images").

PAYMENT & TERMS Pays 50% commission for all formats. Terms specified in photographer's contract. Works with photographers on contract basis only. Offers image exclusivity worldwide. Statements issued monthly. Payment made monthly. Photographers allowed to review account records. Model/property release required. Photo captions required.

HOW TO CONTACT "Send query letter with résumé and 100 images for selection. Download the photographer's info pack from our website."

AGSTOCKUSA INC.

25315 Arriba del Mundo Dr., Carmel CA 93923. (831)624-8600. **Fax:** (831)626-3260. **E-mail:** ed young@agstockusa.com; info@agstockusa.com. **Website:** www.agstockusa.com. Estab. 1996. Stock photo agency. Has 100,000 photos. Clients include: advertising agencies, graphic design firms, businesses, public relations firms, book/encyclopedia publishers, calen-

dar companies, magazine publishers, greeting card companies.

NEEDS Photos should cover all aspects of agriculture worldwide: fruits, vegetables and grains in various growth stages; studio work, aerials; harvesting, processing, irrigation, insects, weeds, farm life, agricultural equipment, livestock, plant damage and plant disease.

SPECS Uses 35mm, 2¼×2¼, 4×5, 6×7, 6×17 transparencies. Accepts images in digital format. Send as high-res TIFF files.

PAYMENT & TERMS Pays 50% commission for color photos. Average price per image (to clients): $100-25,000 for color photos. Works with photographers on contract basis only. Offers nonexclusive contract. Contracts renew automatically with additional submissions for 2 years. Charges 50% website insertion fee. Statements issued monthly. Payment made monthly. Photographers allowed to review account records. Offers unlimited use and buyouts if photographer agrees to sale. Informs photographer when client requests all rights; final decision made by agency. Model/property release preferred. Photo captions required; include location of photo and all technical information (what, why, how, etc.).

HOW TO CONTACT "Review our website to determine if work meets our standards and requirements." Submit 50-100 low-res JPEGs on CD for review. Call first. Keeps samples on file; include SASE for return of material. Expects minimum initial submission of 250 images. Responds in 3 weeks. Photo guidelines available on website. Agency newsletter distributed yearly to contributors under contract.

TIPS "Build up a good file (quantity and quality) of photos before approaching any agency. A portfolio of 16,000 images is currently displayed on our website. CD catalog with 7,600 images available to qualified photo buyers."

AKM IMAGES, INC.

109 Bushnell Place, Mooresville NC 28115. **E-mail:** anniekmimages@gmail.com. **Website:** www.akmimages.com. **Contact:** Annie-Ying Molander, president. Estab. 2002. Stock agency. Has over 120,000 photos in files (and still increasing). Clients include: advertising agencies, book publishers, magazine publishers, newspapers, calendar and greeting card companies, and postcard publishers.

NEEDS Photos of agriculture, city/urban, food/wine, gardening, multicultural, religious, rural, landscape/scenic, birds, wildlife, wildflowers, butterflies, insects, cats, dogs, farm animals, fishing, outdoor activity, travel and underwater images. "We also need landscape and culture from Asian countries, Nordic countries (Sweden, Norway, Finland, Iceland), Alaska and Greenland. Also need culture about Sami and Lapplander from Nordic countries and Native American."

SPECS Uses 35mm transparencies. Accepts images in digital format. Send via CD/DVD at JPEG or TIFF files at low and high-res files (300 dpi) printable size 12×14 and low resolution files for PC Windows 7 and XP.

PAYMENT & TERMS Pays 48% commission for color photos. Terms specified in photographers' submission guidelines. Works with photographers with a signed contract only. Offers nonexclusive contract. Contracts renew automatically ever 5 years. Offers one-time rights. Model/property release required. Photo captions required.

HOW TO CONTACT Send query letter by e-mail with image samples and stock list. Does not keep samples on file. Include SASE for return of material. Expects minimum initial submission of 100 images. Responds in 1 month to samples. Photo submission guidelines available free with SASE or via e-mail.

⊕ ⊘ ⊘ ALAMUPHOTO.COM

12415 Archwood St., Suite 10, North Hollywood CA 91606-1350. (310)809-5929. **E-mail:** info@alamuphoto.com or Bannerimage@yahoo.com. **Website:** alamuphoto.com. **Contact:** Eric Jackson, art editor. Estab. 1989.

NEEDS Images with focus on people of African descent involved in work, play, and family events that suggest a storyline. Quality images of individuals and/or groups involved in business, leisure, travel, etc. A few examples are people involved with rural and urban communities—farms and cities, courts, law enforcement, transit, construction, aviation, military, formal balls, musicians, temples, churches, mosques, and synagogues. Sport images involving fencing, deep sea diving, sky diving, motorcycle clubs, marathons, chess clubs, etc. "Bottom line: give us something we have not seen within the communities of African-Americans, African-Europeans, African-South Americans. Buys 50 images annually; 95% are supplied by freelancers. Buys stock photos only. Spe-

cializes in calendars, posters, T-shirts, documentary books. Accepts outstanding work from beginner and established photographers; expects a high level of professionalism from all photographers who make contact. Guidelines: No nudity or pornographic.

PAYMENT & TERMS Credit line given upon use. Model release and property release are required. Photo captions preferred.

HOW TO CONTACT Contact website with 2 images that best represent your work and we will make contact if interested; JPEG samples at 72 dpi. Cannot return material, so please do not send samples. Responds only if interested. Considers simultaneous submissions or previously published work.

ALAMY

127 Milton Park, Abingdon Oxfordshire OX14 4SA United Kingdom. UK: 44 1235 844 608; US: (866)671-7305. **Fax:** 44 1235 844 650. **E-mail:** memberservices@alamy.com. **E-mail:** info@alamy.com; sales@alamy.com. **Website:** www.alamy.com. Estab. 1999.

SPECS Accepts images in digital format. Send via Internet by uploading 24MB+ uncompressed 300 dpi. Does not buy photos, film or video outright. Pays on a commission basis, 60% for b&w photos, color photos, and film; 50% for video. Average royalty fee $53. Average rights managed $76. Offers non-exclusive rolling contracts. Payments for sales of images are made once accounts reach a balance of $175. Photographers are allowed to review account records to verify sales figures or accounts for various deductions. Informs photographers and allows them to negotiate when a client requests all rights.

HOW TO CONTACT E-mail submissions or upload a test submission of 4 images after registering online at www.alamy.com/register. Expects a minimum initial submission of 4 images. Responds in 2 weeks. Does not keep samples on file. Guidelines, catalog, and market tip sheet available online to Alamy members.

TIPS Read the contract, technical specifications, and submission guidelines before submitting.

ALASKA STOCK

Design Pics, Inc., #101, 10464-176 Street, Edmonton AB T5S 1L3, Canada. (780)447-5433; (907)268-2091. **Fax:** (780)451-8568. **E-mail:** rick@designpics.com; ann@alaskastock.com. **Website:** www.alaskastock.com. **Contact:** Rick Carlson, president; Ann Matchett. Estab. 2000. Stock photo agency. Member of ASMP. Has 450,000 photos in files. Clients include: international and national advertising agencies; businesses; magazines and newspapers; book/encyclopedia publishers; calendar, postcard and greeting card publishers.

NEEDS Photos of everything related to Alaska, including babies/children/teens, couples, multicultural, families, parents, senior citizens involved in winter activities and outdoor recreation, wildlife, environmental, landscapes/scenics, cities/urban, pets, adventure, travel, industry. Interested in alternative process, avant garde, documentary (images which were or could have been shot in Alaska), historical/vintage, seasonal, Christmas.

SPECS Accepts images in digital format only. Send via CD or FTP as JPEG files at 300 dpi for review purposes. "Put together a gallery of low-res images on your website and send us the URL, or send via PC-formatted CD as JPEG files no larger than 9×12 at 72 dpi for review purposes." Do not e-mail images. Accepted images must be 60MB minimum shot as raw originals.

PAYMENT & TERMS Pays commission for color and b&w photos based on photographer. Negotiates fees below stated minimums for preferred vendors. Offers volume discounts to customers. Works with photographers on contract basis only. Guaranteed subject exclusivity. Annual contract renewal after first 5 years. Statements issued monthly. Payment made monthly. Photographers allowed to review account records. Offers negotiable rights. Informs photographer and negotiates rights for photographer when client requests all rights. Model/property release required when applicable. Photo captions required; include who, what, when, where.

HOW TO CONTACT E-mail query letter with link to photographer's website or JPEG samples at 72 dpi. Expects minimum initial submission of 100 images with periodic submissions of at least 100 images 2 times/year. Responds in 1 month. Photo guidelines free on request through e-mail. Catalog available on website. Market tips sheet free via e-mail, distributed to those with contracts.

TIPS "Interested in high-quality digital files only from full-frame cameras. Provide links to collections, galleries and websites. Show a minimum of 200 images to represent the quality of your work."

AMANAIMAGES INC.

2-2-43 Higashi-Shinagawa, Shinagawa-ku, Tokyo 140-0002, Japan. +81-3-3740-1018. **Fax:** +81-3-3740-

4036. **E-mail:** planet_info@amanaimages.com; a.ito@amanaimages.com. **Website:** amanaimages. com. **Contact:** Mr. Akihiko Ito, partner relations. Estab. 1979. Stock photo agency. Member of the Picture Archive Council of America (PACA). Has 2,500,000 digital files and continuously growing. Clients include: advertising agencies, public relations firms, businesses, book/encyclopedia publishers, magazine publishers, newspapers, postcard publishers, calendar companies, greeting card companies, and TV stations. **NEEDS** Photos of babies/children/teens, celebrities, couples, multicultural, families, parents, senior citizens, disasters, environmental, landscapes/scenics, wildlife, architecture, cities/urban, education, gardening, interiors/decorating, pets, religious, rural, adventure, automobiles, entertainment, events, food/drink, health/fitness, hobbies, humor, performing arts, sports, travel, agriculture, business concepts, medicine, military, political, industry, product shots/still life, science, technology/computers. Interested in documentary, erotic, fashion/glamour, fine art, historical/vintage, seasonal.
SPECS Digital format by single-lens reflex camera, data size should be larger than 30MB with 8-bit, Adobe RGB, JPEG format. Digital high-res image size: larger than 48MB for CG, 3D, etc., using editing software, e.g., Photoshop or Shade, digital change made by scanning, composed images, collage images.
PAYMENT & TERMS Based on agreement.
HOW TO CONTACT Send 30-50 sample images (shorter side has to be 600 pixel as JPEG file) and your profile by e-mail. "After inspection of your images we may offer you an agreement. Submissions are accepted only after signing the agreement."

AMERICAN MUSEUM OF NATURAL HISTORY LIBRARY, PHOTOGRAPHIC COLLECTION

Library Services, Central Park West at 79th St., New York NY 10024. (212)769-5400. **Fax:** (212)769-5009. **E-mail:** speccol@amnh.org. **E-mail:** mathe@amnh.org. **Website:** www.amnh.org; library.amnh.org/index.php. **Contact:** Barbara Mathe, museum archivist. Estab. 1869. Provides services for authors, film and TV producers, general public, government agencies, picture researchers, scholars, students, teachers and publishers.
NEEDS "We accept only donations with full rights (nonexclusive) to use; we offer visibility through credits." Model release required. Photo captions required.

PAYMENT & TERMS Credit line given. Buys all rights.

THE ANCIENT ART & ARCHITECTURE COLLECTION, LTD.

15 Heathfield Court, Heathfield Terrace, Chiswick, London W4 4LP, United Kingdom. +44 (0)20 8995 0895. **Fax:** +44 (0)20 8429 4646. **E-mail:** library@aaacollection.co.uk. **Website:** www.aaacollection.com. Picture library. Has 150,000 photos in files. Represents C.M. Dixon Collection. Clients include: advertising agencies, book/encyclopedia publishers, magazine publishers, newspapers.
NEEDS Photos of ancient/archaeological site, sculptures, objects, artifacts of historical nature. Interested in fine art, historical/vintage.
SPECS Digital images only. JPEG format; minimum 34MB file size.
PAYMENT & TERMS Pays commission on quarterly basis. Works with photographers on contract basis only. Non-exclusive contract. Contracts renew automatically with additional submissions. Statements issued quarterly. Payment made quarterly. Photographers allowed to review account records. Offers one-time rights. Detailed photo captions required.
HOW TO CONTACT Send query letter with samples, stock list, SASE.
TIPS "Material must be suitable for our specialist requirements. We cover historical and archeological periods from 25,000 B.C. to the 19th century A.D., worldwide. All civilizations, cultures, religions, objects and artifacts as well as art may be included. Pictures with tourists, cars, TV aerials, and other modern intrusions not accepted. Send us a submission of CD by mail with a list of other material that may be suitable for us."

ANDES PRESS AGENCY

26 Padbury Court, Shoreditch, London E2 7EH, United Kingdom. 44 (0)20 7613 5417. **Fax:** 44 (0)20 7739 3159. **E-mail:** apa@andespressagency.com. **E-mail:** val@andespressagency.com. **Website:** www.andespressagency.com. Picture library and news/feature syndicate. Has 300,000 photos in files. Clients include: magazine publishers, businesses, book publishers, non-governmental charities, newspapers.
NEEDS Photos of multicultural, senior citizens, disasters, environmental, landscapes/scenics, architecture, cities/urban, education, religious, rural, travel, agriculture, business, industry, political. "We have

color and b&w photographs on social, political and economic aspects of Latin America, Africa, Asia and Britain, specializing in contemporary world religions."

SPECS Uses 35mm and digital files.

PAYMENT & TERMS Works with photographers on contract basis only. Offers nonexclusive contract. Contracts renew with additional submissions. Statements issued bimonthly. Payment made bimonthly. Offers one-time rights. "We never sell all rights; photographer has to negotiate if interested." Model/property release preferred. Photo captions required.

HOW TO CONTACT Send query via e-mail. Do not send unsolicited images.

TIPS "We want to see that the photographer has mastered one subject in depth. Also, we have a market for photo features as well as stock photos. Please write to us first via e-mail."

ANIMALS ANIMALS/EARTH SCENES

17 Railroad Ave., Chatham NY 12037. (518)392-5500. **Fax:** (518)392-5550. **E-mail:** info@animalsanimals. com. **Website:** www.animalsanimals.com. **Contact:** Nancy Carrizales. Member of Picture Archive Council of America (PACA). Has 1.5 million photos in files. Clients include: ad agencies, public relations firms, businesses, audiovisual firms, book publishers, magazine publishers, encyclopedia publishers, newspapers, postcard companies, calendar companies, greeting card companies.

NEEDS *"We are currently not reviewing any new portfolios."*

SPECS Accepts images in digital and transparency formats.

PAYMENT & TERMS Pays 50% commission. Works with photographers on contract basis only. Offers exclusive contract. Photographers allowed to review account records to verify sales figures "if requested and with proper notice and cause." Statements issued quarterly. Payment made quarterly. Offers one-time rights; other uses negotiable. Informs photographers and allows them to negotiate when client requests all rights. Model release required if used for advertising. Photo captions required; include Latin names ("they must be correct!").

HOW TO CONTACT "Please send 200 original transparencies. If your images are not labeled individually, please send along a caption sheet. You may also submit images digitally on a CD or DVD. Digital images must have caption and credit information in the IPTC header. For review purposes you may submit JPEG images at the highest quality compression with an image size of at least 800×640 pixels. Digital Capture images should be shot on an 8MP camera or greater."

TIPS "First, pre-edit your material. Second, know your subject."

ANTHRO-PHOTO FILE

33 Hurlbut St., Cambridge MA 02138. (617)868-4784. **Fax:** (617)484-6428. **E-mail:** cdevore@anthrophoto. com. **Website:** www.anthrophoto.com. **Contact:** Claire DeVore. Estab. 1969. Stock photo agency specializing in anthropology and behavioral biology. Has 10,000 photos in files (including scientists at work, tribal peoples, peasant societies, hunter-gatherers, archeology, animal behavior, natural history). Clients include: book publishers, magazine publishers.

NEEDS Photos of anthropologists at work.

SPECS Uses b&w prints; 35mm transparencies. Accepts images in digital format.

PAYMENT & TERMS Pays 50% commission. Average price per image (to clients): $200 minimum for b&w photos; $225 minimum for color photos. Offers volume discounts to customers; discount terms negotiable. Works with photographers with contract. Contracts renew automatically. Statements issued annually. Payment made annually. Photographers allowed to review account records. Offers one-time rights. Photo captions required.

HOW TO CONTACT Send query letter with stock list. Keeps samples on file; include SASE for return of material. See website for image delivery options.

TIPS Photographers should e-mail first.

⊘ APPALIGHT

230 Griffith Run Rd., Spencer WV 25276. (304)927-2978. **E-mail:** wyro@appalight.com. **Website:** www. appalight.com. **Contact:** Chuck Wyrostok, director. Estab. 1988. Stock photo agency. Has over 30,000 photos in files. Clients include advertising agencies, public relations firms, businesses, book/encyclopedia publishers, magazine publishers, calendar companies, greeting card companies, graphic designers.

○ Currently not accepting submissions. This agency also markets images through the Photo Source Bank.

NEEDS General subject matter with emphasis on the people, natural history, culture, commerce, flora, fauna, and travel destinations of the Appalachian Mountain region.

SPECS Uses 8×10 glossy b&w prints; 35mm, 2¼×2¼, 4×5 transparencies and digital images.

PAYMENT & TERMS Pays 50% commission. Works with photographers on nonexclusive contract basis only. Contracts renew automatically for 2-year period with additional submissions. Payment made quarterly. Photographers allowed to review account records during regular business hours or by appointment. Offers one-time rights, electronic media rights. Model release preferred. Photo captions required.

HOW TO CONTACT AppaLight is not currently accepting submissions.

TIPS "We look for a solid blend of topnotch technical quality, style, content and impact. Images that portray metaphors applying to ideas, moods, business endeavors, risk-taking, teamwork and winning are especially desirable."

ARCHIVO CRIOLLO

Payamino e7-141 y, Av. 6 de Diciembre, Quito, Ecuador. (593 2) 60 38 748. **E-mail:** info@archivocriollo.com. **Website:** www.archivocriollo.com. **Contact:** Diana Santander, administrator. Estab. 1998. Picture library. Has 20,000 photos in files. Clients include: advertising agencies, businesses, newspapers, postcard publishers, calendar companies, magazine publishers, greeting card companies, travel agencies.

NEEDS Photos of multicultural, environmental, landscapes/scenics, wildlife, architecture, cities/urban, religious, rural, adventure, travel, art and culture, photo production, photo design, press photos. Interested in alternative process, documentary, fine art, historical/vintage.

SPECS Uses 35mm transparencies. Accepts images in digital format. Send via CD, ZIP, e-mail or FTP as JPEG files at 300 dpi, 11 inches.

PAYMENT & TERMS Enforces minimum prices. Offers volume discounts to customers; terms specified in photographers' contracts. Photographers can choose not to sell images on discount terms. Works with photographers with or without a contract; negotiable. Offers nonexclusive contract. Charges 50% sales fee. Payment made quarterly. Photographers allowed to review account records. Informs photographers and allows them to negotiate when client requests all rights. Photo captions preferred.

HOW TO CONTACT Send query letter with stock list. Responds only if interested. Catalog available.

ARGUS PHOTO, LTD. (APL)

Room 2007, Progress Commercial Bldg., 9 Irving St., Causeway Bay, Hong Kong. (852)2890 6970. **Fax:** (852)2881 6979. **E-mail:** argus@argusphoto.com. **Website:** www.argusphoto.com. **Contact:** Lydia Li, photo editor. Estab. 1992. Stock photo agency with branches in Beijing and Guangzhou. Has over 1 million searchable photos online. Clients include: advertising agencies, graphic houses, corporations, real estate developers, book and magazine publishers, postcard, greeting card, calendar and paper product manufacturers.

NEEDS "We are a quality image provider specializing in high-end lifestyle, luxurious interiors/home decor, club scene, food and travel, model in fashion or jewelry to promote an upscale lifestyle, well-being, gardenscape and asian/oriental images. High-quality features on home and garden, travel and leisure, fashion and accessories, and celebrities stories are welcome."

SPECS Accepts high-quality digital images only. Send 50MB JPEG files at 300 dpi via DVD or website link for review. English captions and keywords are required.

PAYMENT & TERMS Pays 50% commission. Average price per image (to U.S. clients): $100-6,000. Offers volume discounts to customers. Works with photographers on contract basis only. Statements/payment made quarterly. Informs photographers and allows them to negotiate when client requests all rights. Model/property release may be required. Expects minimum initial submission of 200 images.

ARKRELIGION.COM

Art Directors & Trip Photo Library, 57 Burdon Lane, Cheam Surrey SM2 7BY, United Kingdom. **E-mail:** images@artdirectors.co.uk. **Website:** www.arkreligion.com. Estab. 2004. Stock agency. Has 100,000 photos on file. Clients include: advertising agencies, businesses, newspapers, postcard publishers, calendar companies, magazine publishers, greeting card companies.

NEEDS Photos of major, minor and alternative religions. This covers all aspects of religion from birth to death.

SPECS Prefers digital submissions. Initial submission: 1MB JPEG. High-res requirement: 50MB TIFF. See contributors' page on website for full details. "We require an extremely broad cross-section of images from all religions, from mainstream to alternate, to

include ceremonies from birth to death, festivals and important events, peoples, priests, pilgrims, worshipers, artifacts, churches/temples—interior and exterior, holy books, worship—including inside the home, meals and food and daily rituals. If you are actively involved with your religion, we would be very interested in hearing from you and would particularly like to hear from any Muslim photographers who have undertaken or are intending to undertake the pilgrimage to Makkah."

PAYMENT & TERMS Average price per image (to clients): $25-250 for b&w or color photos. Offers volume discounts to customers. Discount sales terms not negotiable. Works with photographers on contract basis only. Offers nonexclusive contract. Statements issued quarterly. Payment made quarterly. Photographers allowed to review account records in cases of discrepancies only. Offers one-time rights, electronic media rights. Model/property release preferred. Photo captions required; include as much relevant information as possible.

HOW TO CONTACT Please use the contact page, if you have any questions, before making a submission. Contact by e-mail. Does not keep samples on file. Expects minimum initial submission of 50 images with periodic submissions of at least 50 images. Photo guidelines available on website.

TIPS "Fully caption material and follow the full requirements for digital submissions as detailed on the website."

ART DIRECTORS & TRIP PHOTO LIBRARY

57 Burdon Ln., Cheam, Surrey SM2 7BY, United Kingdom. (44)(20)8642 3593. **Fax:** (44)(20)8395 7230. **E-mail:** images@artdirectors.co.uk. **Website:** www.artdirectors.co.uk. Estab. 1992. Stock agency. Has 1 million photos in files. Clients include: advertising agencies, businesses, newspapers, postcard publishers, public relations firms, book publishers, calendar companies, magazine publishers, greeting card companies.

NEEDS Photos of babies/children/teens, couples, multicultural, families, parents, senior citizens, disasters, environmental, landscapes/scenics, wildlife, architecture, cities/urban, education, gardening, interiors/decorating, pets, religious, rural, adventure, automobiles, entertainment, events, food/drink, health/fitness, hobbies, humor, performing arts, sports, travel, agriculture, business concepts, indus-

try, medicine, military, political, product shots/still life, science, technology/computers. Interested in alternative process, avant garde, documentary, historical/vintage, seasonal.

SPECS Digital submissions only. Initial submission: 1MB JPEG. High-res requirement: 50MB TIFF or JPEG. See contributors' page on website for full details.

PAYMENT & TERMS Pays 50% commission for b&w or color photos when submitted digitally. Average price per image (to clients): $25-250 for b&w or color photos. Offers volume discounts to customers. Discount sales terms not negotiable. Works with photographers on contract basis only. Offers nonexclusive contract. Statements issued quarterly. Payment made quarterly. Photographers allowed to review account records in cases of discrepancies only. Offers one-time rights, electronic media rights. Model/property release preferred. Photo captions required; include as much relevant information as possible.

HOW TO CONTACT Contact by e-mail. Does not keep samples on file. Expects minimum initial submission of 50 images with periodic submissions of at least 50 images. Responds in 6 weeks to queries. Photo guidelines available on website.

TIPS "Fully caption material and follow the full requirements for digital submissions as detailed on the website."

ART LICENSING INTERNATIONAL

988 Boulevard of the Arts, #1217, Sarasota FL 34236. (941)966-8912. **E-mail:** artlicensinginc@gmail.com. **Website:** wwwootblicensing.com. **Contact:** Michael Woodward, president; Jane Mason, licensing manager. Estab. 1986. "We represent artists, photographers and designers who wish to establish a licensing program for their work. We are particularly interested in photographic images that we can license internationally, particularly for fine art posters, canvas giclées for mass market retailers and interior design projects and home and office decor." We also want large scale pictorial photography for murals.

NEEDS "We prefer concepts that have a unique look or theme and that are distinctive from the generic designs produced in-house by publishers and manufacturers. Images for prints and posters must be in pairs or sets of 4 or more with a regard for trends and color palettes related to the home décor and interior design trends. Nature themes, florals, b&w picturesque

images, transitional images, and landscapes are of particular interest. We need landscapes, cityscapes of New York and Paris, trees, poppies, roosters, Tuscany scenes, cafe scenes, as well as florals."

PAYMENT & TERMS "Our general commission rate is 50% with no expenses to the photographer. Photographer must provide high-resolution digital files at 300 dpi to print 30-36 inches."

HOW TO CONTACT E-mail JPEGs or details of your website. No postal submissions, please.

TIPS "We require substantial portfolios of work that can generate good incomes, or concepts that have wide commercial appeal."

ART RESOURCE

536 Broadway, 5th Floor, New York NY 10012. (212)505-8700. **Fax:** (212)505-2053. **E-mail:** requests@artres.com. **E-mail:** dreeve@artres.com. **Website:** www.artres.com. **Contact:** Ryan Jensen. Estab. 1970. Stock photo agency specializing in fine arts. Member of the Picture Archive Council of America (PACA). Has access to 3 million photos. Clients include: advertising agencies, public relations firms, audiovisual firms, businesses, book/encyclopedia publishers, magazine publishers, newspapers, postcard publishers, calendar companies, greeting card companies, all other publishing.

NEEDS Photos of painting, sculpture, architecture *only*.

SPECS Digital photos at 300 dpi.

PAYMENT & TERMS Pays 50% commission. Average price per image (to client): $185-10,000 for color photos. Negotiates fees below standard minimum prices. Offers volume discounts to customers; terms specified in photographer's contract. Discount sales terms not negotiable. Offers one-time rights, electronic media rights, agency promotion and other negotiated rights. Photo captions required.

HOW TO CONTACT Send query letter with stock list.

TIPS "We represent European fine art archives and museums in the U.S. and Europe but occasionally represent a photographer with a specialty in photographing fine art."

ARTWERKS STOCK PHOTOGRAPHY

5045 Brennan Bend, Idaho Falls ID 83406. (208)523-1545. **E-mail:** photojournalistjerry@msn.com. **Contact:** Jerry Sinkovec, owner. Estab. 1984. News/feature syndicate. Has 100,000 photos in files. Clients include: advertising agencies, public relations firms, business-

es, book publishers, magazine publishers, calendar companies, postcard publishers.

NEEDS Photos of American Indians, ski action, ballooning, British Isles, Europe, Southwest scenery, disasters, environmental, landscapes/scenics, wildlife, adventure, events, food/drink, hobbies, performing arts, sports, travel, business concepts, industry, product shots/still life, science, technology/computers. Interested in documentary, fine art, historical/vintage, lifestyle.

SPECS Uses 8×10 glossy color and/or b&w prints; 35mm, 2¼×2¼, 4×5 transparencies. Accepts images in digital format. Send via CD, ZIP as JPEG files.

PAYMENT & TERMS Pays 50% commission. Average price per image (to clients): $125-800 for b&w photos; $150-2,000 for color photos; $250-5,000 for film and videotape. Negotiates fees below stated minimums depending on number of photos being used. Offers volume discounts to customers; terms not specified in photographers' contracts. Discount sales terms not negotiable. Works with photographers with or without a contract, negotiable. Offers nonexclusive contract. Charges 100% duping fee. Statements issued quarterly. Payment made quarterly. Offers one-time rights. Does not inform photographers or allow them to negotiate when a client requests all rights. Model/property release preferred. Photo captions preferred.

HOW TO CONTACT Send query letter with brochure, stock list, tearsheets. Provide résumé, business card. Portfolios may be dropped off every Monday. Agency will contact photographer for portfolio review if interested. Portfolio should include slides, tearsheets, transparencies. Works with freelancers on assignment only. Does not keep samples on file; include SASE for return of material. Expects minimum initial submission of 20 images. Responds in 2 weeks.

🌏 ASIA IMAGES GROUP

15 Shaw Rd., #08-02, Teo Bldg., 367953, Singapore. (65)6288-2119. **Fax:** (65)6288-2117. **E-mail:** info@asiaimagesgroup.com. **Website:** www.asiapix.com. **Contact:** Alexander Mares-Manton, founder and creative director. Estab. 2001. Stock agency. We specialize in creating, distributing and licensing locally relevant Asian model-released lifestyle and business images. Our image collections reflect the visual trends, styles and issues that are current in Asia. We have 3 major collections: Asia Images (rights managed); AsiaPix (royalty free); and Picture India (royalty free).

Clients include: advertising agencies, corporations, public relations firms, book publishers, calendar companies, magazine publishers.

NEEDS Photos of babies/children/teens, couples, families, parents, senior citizens, health/fitness/beauty, science, technology. "We are only interested in seeing images about or from Asia."

SPECS Accepts images in digital format. "We want to see 72 dpi JPEGs for editing and 300 dpi TIFF files for archiving and selling."

PAYMENT & TERMS "We have minimum prices that we stick to unless many sales are given to one photographer at the same time. Works with photographers on image-exclusive contract basis only. We need worldwide exclusivity for the images we represent, but photographers are encouraged to work with other agencies with other images. Statements issued monthly. Payment made monthly. Photographers allowed to review account records. Offers one-time rights, electronic media rights. Model and property releases are required for all images."

AURORA PHOTOS

81 W. Commercial St., Suite 201, Portland ME 04101. (207)828-8787. **Fax:** (207)828-5524. **Website:** www.auroraphotos.com. **Contact:** José Azel, owner. Estab. 1993. 1.4 million digital photo archive. Clients include: advertising agencies, businesses, corporations, book publishers, magazine publishers, newspapers, calendar companies, and websites.

NEEDS Photos of outdoor adventure, travel, lifestyle, nature, landscape, wildlife, iPhone, culture, conceptual, environmental, portraits, sports, commercial, editorial, celebrities, news, multicultural, military, politics, agriculture, technology, extreme sports.

SPECS Accepts digital submissions only; contact for specs.

PAYMENT & TERMS Accepts digital submissions only; e-mail info@auroraphotos.com for specs. Offers volume discounts to customers. Statements issued monthly. Payment made monthly. Photographers allowed to review account records once/year. Offers one-time rights, electronic media rights. Model/property release preferred.

HOW TO CONTACT Aurora's Open Collection combines the user-friendliness of royalty-free licensing with a picture archive that captures the breadth of sports, recreation, and outdoor lifestyles. View Aurora's Open Collection online. If you are interested in having your images reviewed, please send a link to your website portfolio for review. Does not keep samples on file; does not return material. Responds in 1 month. Photo guidelines available after initial contact.

TIPS "Review our website closely. List area of photo expertise/interest and forward a personal website address where your photos can be found."

AUSCAPE INTERNATIONAL

P.O. Box 1024, Bowral NSW 2576, Australia. (612) 4885 2245. **E-mail:** sales@auscape.com.au. **Website:** www.auscape.com.au. **Contact:** Sarah Tahourdin, director. Has 250,000 photos in files. Clients include: advertising agencies, educational book publishers, magazine publishers, newspapers, calendar companies, greeting card companies, museums, tourism companies.

NEEDS Photos of environmental, landscapes/scenics, travel, wildlife, pets.

SPECS Uses 35mm, 6×6, 4×5 transparencies. Accepts images in digital format. Send via CD or DVD as TIFF files at 300 dpi.

PAYMENT & TERMS Pays 40% commission for color photos. Enforces minimum prices. Offers volume discounts to customers. Works with photographers on contract basis only. Requires exclusive contract. Statements issued quarterly. Payment made quarterly. Photographers allowed to review account records. Charges scan fees for all transparencies scanned in-house; all scans placed on website. Offers one-time rights. Photo captions required; include scientific names, common names, locations.

HOW TO CONTACT Does not keep samples on file. Expects minimum initial submission of 200 images with monthly submissions of at least 50 images. Responds in 3 weeks to samples. Photo guidelines sheet free.

TIPS "Send only informative, sharp, well-composed pictures. We are a specialist natural history agency and our clients mostly ask for pictures with content rather than empty-but-striking visual impact. There must be passion behind the images and a thorough knowledge of the subject."

AXIOM PHOTOGRAPHIC

Design Pics, Inc., 10 The Shaftesbury Centre, 85 Barlby Rd., London W10 6BN, United Kingdom. 44(0)20 8964 9970. **Fax:** 44(0)20 89648440. **E-mail:** sales@axiomphotographic.com. **Website:** www.axiomphotographic.com. **Contact:** Tim Hook, general manager/

sales director Europe. Estab. 1996. Stock photo agency. Member of Picture Archive Council of America. Has 160,000 photos in files. Affiliated with Alaska Stock (alaskastock.com), First Light (firstlight.com), The Irish Image Collection (theirishimagecollection.com), Design Pics (designpics.com) and Pacific Stock (pacificstock.com). Does business with advertising agencies, public relations firms, businesses, book publishers, magazine publishers, newspapers, calendar companies, greeting card companies and postcard publishers.

SPECS Accepts images in digital format only. Submit samples first. Send via e-mail with link to photographer's own website or online gallery. Full specs can be found at www.axiomphotographic.com/bin/Axiom2.dll/go?a+disp&t+tp-loader.html&tpl+contactus-submit.html. Model release and property release are preferred. Photo captions are required.

PAYMENT & TERMS Pays on a commission basis. Rights managed and royalty free. Offers volume discounts to customers. Works with photographers on contract basis only, exclusive contract. Contract does not automatically renew. Statements of photographers' sales issued monthly.

HOW TO CONTACT E-mail query letter with link to photographer's website as per specs above. Contact must be through submissions@axiomphotographic.com. Keeps samples on file. Photo guidelines available online. A copy of our catalog is available on the website

TIPS Follow the guidelines as given on our website and above.

THE BERGMAN COLLECTION

P.O. Box AG, Princeton NJ 08542-0872. (609)921-0749. **E-mail:** information@pmiprinceton.com. **Website:** pmiprinceton.com. **Contact:** Victoria B. Bergman, vice president. Estab. 1980. Collection established in the 1930s. Stock agency. Has 20,000 photos in files. Clients include: advertising agencies, book publishers, audiovisual firms, magazine publishers, other.

NEEDS "Specializes in medical, technical and scientific stock images of high quality and accuracy."

SPECS Uses color or b&w prints; 35mm, 2¼×2¼ transparencies, digital formats. Send via CD, ZIP, e-mail as TIFF, BMP, JPEG files.

PAYMENT & TERMS Pays on commission basis. Works with photographers on contract basis only. Offers one-time rights. Model/property release required. Photo captions required; must be medically, technically, scientifically accurate.

HOW TO CONTACT "Do not send unsolicited images. Call, write, or e-mail to be added to our database of photographers able to supply, on an as-needed basis, specialized images not already in the collection. Include a description of the field of medicine, technology or science in which you have images. We contact photographers when a specific need arises."

TIPS "Our needs are for very specific images that usually will have been taken by specialists in the field as part of their own research or professional practice. A good number of the images placed by The Bergman Collection have come from photographers in our database."

BIOLOGICAL PHOTO SERVICE AND TERRAPHOTOGRAPHICS

P.O. Box 490, Moss Beach CA 94038. (650)359-6219. **E-mail:** bpsterra@pacbell.net. **Website:** www.agpix.com/biologicalphoto. **Contact:** Carl W. May, photo agent. Estab. 1980. Stock photo agency. Has 80,000 photos in files. Clients include: ad agencies, businesses, book/encyclopedia publishers, magazine publishers.

NEEDS All subjects in the pure and applied life and earth sciences. Stock photographers must be scientists. Subject needs include: electron micrographs of all sorts; research techniques; modern medical imaging; marine and freshwater biology; diverse invertebrates; organisms used in research; tropical biology; and land and water conservation. All aspects of general and pathogenic microbiology, normal human biology, petrology, volcanology, seismology, paleontology, mining, petroleum industry, alternative energy sources, meteorology and the basic medical sciences, including anatomy, histology, medical microbiology, human embryology and human genetics.

SPECS Uses 4×5 through 11×14 glossy, high-contrast b&w prints for EM's; 35mm, 2¼×2¼, 4×5, 8×10 transparencies. Welcomes images in digital format as 50-100MB TIFF files.

PAYMENT & TERMS Pays 50% commission for b&w and color photos. General price range (for clients): $75-500, sometimes higher for advertising uses. Works with photographers with or without a contract, but only as an exclusive agency. Photographers may market directly on their own, but not through other agencies or portals. Statements issued quarterly.

Payment made quarterly; "one month after end of quarter." Photographers allowed to review account records to verify sales figures "by appointment at any time." Offers only rights-managed uses of all kinds; negotiable. Informs photographers and allows them veto authority when client requests a buyout. Model/property release required for photos used in advertising and other commercial areas. Thorough scientific photo captions required in IPTC metadata for digital images and on labels for analog; include complete identification of subject and location.

HOW TO CONTACT Interested in receiving work from scientific and medical photographers if they have the proper background. Send query letter or e-mail with stock list, résumé of scientific and photographic background; include SASE for return of material. Responds in 2 weeks. Photo guidelines free with query, résumé and SASE. Tips sheet distributed intermittently to stock photographers only. "Nonscientists should not apply."

TIPS "When samples are requested, we look for proper exposure, maximum depth of field, adequate visual information and composition, and adequate technical and general information in captions. Digital files should be in TIFF format have image information in IPTC and EXIF fields, and be clean and color-corrected. We avoid excessive overlap among our photographer/scientists. Our 3 greatest problems with potential photographers are: 1) inadequate captions/metadata; 2) inadequate quantities of *fresh* and *diverse* photos; 3) poor sharpness/depth of field/grain/composition in photos."

BLEND IMAGES

501 E. Pine St., Suite 200, Seattle WA 98122. (888)721-8810, ext. 5. **Fax:** (206)749-9391. **E-mail:** jerome@blendimages.com. **Website:** www.blendimages.com. **Contact:** Jerome Montalto, submission and content manager. Estab. 2005. Stock agency. Clients include: advertising agencies, businesses, public relations firms, magazine publishers. Blend Images represents a "robust, high-quality collection of ethnically diverse lifestyle and business imagery.

NEEDS Photos of babies/children/teens, couples, multicultural, families, parents, senior citizens, business concepts; interested in lifestyle. Photos must be ethnically diverse.

SPECS Accepts images in digital format only. Images should be captured using professional-level SLRs of 11+ megapixels, pro digital backs, or high-end scanners that can deliver the required quality. Final media should be 48-52MB, 24-bit RGB (8 bits per channel), uncompressed TIFF files at 300 dpi. Images should be fully retouched, color-corrected, and free from dust, dirt, posterization, artifacing or other flaws. Files should be produced in a color-managed environment with Adobe RGB 1998 as the desired color space.

HOW TO CONTACT E-mail your photographic background and professional experience, along with 30-50 tightly edited, low-res JPEGs in one of the following ways: 1. URL with your personal website. 2. Web photo gallery. (Web galleries can be created using your imaging software. Reference your owner's manual for instructions.) 3. Spring-loaded hot link—a clickable link that provides downloadable JPEGs.

BRIDGEMAN ART LIBRARY

274 Madison Ave., Suite 1604, New York NY 10016. (212)828-1238. **Fax:** (212)828-1255. **E-mail:** new york@bridgemanart.com. **E-mail:** edward.whitley@bridgemanart.com. **Website:** www.bridgemanart.com. Estab. 1972. Member of the Picture Archive Council of America (PACA). Has over 600,000 photos online, over 1 million offline. Has branch offices in London, Paris, Los Angeles and Berlin. Clients include: advertising agencies, public relations firms, TV and film production companies, audiovisual firms, graphic designers, book publishers, magazine publishers, newspapers, calendar companies, greeting card companies, postcard publishers.

NEEDS Specializes in fine art, cultural and historical photography.

SPECS Uses 4×5, 8×10 transparencies and 50MB+ digital files.

PAYMENT & TERMS Pays 50% commission for color photos. Enforces minimum prices. Offers volume discounts to customers; terms specified in photographers' contracts. Discount sales terms not negotiable. Works with photographers on contract basis only. Charges 100% duping fee. Statements issued quarterly. Photographers allowed to review account records. Offers one-time rights, electronic media rights, agency promotion rights.

HOW TO CONTACT Send query letter with photocopies, stock list. Does not keep samples on file; include SASE for return of material. Expects minimum initial submission of 20 images. Responds only if interested; send nonreturnable samples.

BSIP

36 rue Villiers-de-l'Isle-Adam, Paris 75020, France. 33(0)1 43 58 69 87. **Fax:** 33(0)1 43 58 62 14. **E-mail:** international@bsip.com. **E-mail:** info@bsip.com. **Website:** www.bsip.com. Estab. 1990. Member of Coordination of European Picture Agencies Press Stock Heritage (CEPIC). Has 200,000 downloadable high-res images online. Clients include: advertising agencies, book publishers, magazine publishers, newspapers.

NEEDS Photos of environmental, food/drink, health/fitness, medicine, science, nature and animals.

SPECS Accepts images in digital format only. Send via CD, DVD, FTP as TIFF or JPEG files at 330 dpi, 3630×2420 pixels.

PAYMENT & TERMS Offers volume discounts to customers; terms specified in photographers' contracts. Discount sales terms not negotiable. Works with photographers with or without a contract; negotiable. Offers guaranteed subject exclusivity. Contracts renew automatically with additional submissions for 5 years. Statements issued monthly. Payment made monthly. Photographers allowed to review account records. Offers one-time rights, electronic media rights, agency promotion rights. Model release required. Photo captions required.

HOW TO CONTACT Send query letter. Portfolio may be dropped off Monday–Friday. Keeps samples on file. Expects minimum initial submission of 50 images with monthly submissions of at least 20 images. Photo guidelines sheet available on website. Catalog free with SASE. Market tips sheet available.

CALIFORNIA VIEWS/THE PAT HATHAWAY HISTORICAL PHOTO COLLECTION

469 Pacific St., Monterey CA 93940-2702. (831)373-3811. **E-mail:** hathaway@caviews.com. **Website:** www.caviews.com. **Contact:** Mr. Pat Hathaway, photo archivist. Estab. 1970. Picture library; historical collection. Has 80,000 b&w images; 10,000 35mm color images in files. Clients include: advertising agencies, public relations firms, audiovisual firms, book/encyclopedia publishers, magazine publishers, museums, postcard companies, calendar companies, television companies, interior decorators, film companies.

NEEDS Historical photos of California from 1855 to today, including disasters, landscapes/scenics, rural, agricultural, automobiles, travel, military, portraits, John Steinbeck and Edward F. Rickets.

PAYMENT & TERMS Payment negotiable. Offers volume discounts to customers.

HOW TO CONTACT "We accept donations of California photographic material in order to maintain our position as one of California's largest archives. Please do not send unsolicited images." Does not keep samples on file; cannot return material.

CAMERA PRESS, LTD.

21 Queen Elizabeth St., London SE1 2PD, United Kingdom. 44 (0)20 7378 1300. **Fax:** 44 (0)20 7278 5126. **E-mail:** info@camerapress.com. **Website:** www.camerapress.com. Quality syndication service and picture library. Clients include: advertising agencies, public relations firms, audiovisual firms, book/encyclopedia publishers, magazine publishers, newspapers, postcard companies, calendar companies, greeting card companies and TV stations. Clients principally press but also advertising, publishers, etc.

Camera Press sends and receives images via ISDN, FTP, and e-mail. Has a fully operational electronic picture desk to receive/send digital images via modem/ISDN lines, FTP.

NEEDS Celebrities, world personalities (e.g., politics, sports, entertainment, arts), news/documentary, scientific, human interest, humor, women's features, stock.

SPECS Accepts images in digital format as TIFF, JPEG files, as long as they are a minimum of 300 dpi or 16MB.

PAYMENT & TERMS Standard payment term: 50% net commission. Statements issued every 2 months along with payments.

HOW TO CONTACT "Images should then be sent to us high resolution, either on CD, or via e-mail or FTP. For FTP transmission we will need to set you up with a username and password. Images should ideally be submitted in jpeg format, and should be no smaller than 25MB, up to 50MB for lifestyle and studio images."

TIPS "Camera Press, one of the oldest and most celebrated family-owned picture agencies, represents some of the top names in the photographic world but also welcome emerging talents and gifted newcomers. We seek quality celebrity images; lively, colorful features which tell a story; and individual portraits of world personalities, both established and up-and-coming. Accurate captions are essential. Remember there is a big worldwide demand for celebrity pre-

mieres and openings. Other needs include: scientific development and novelties; beauty, fashion, interiors, food and women's interests; humorous pictures featuring the weird, the wacky and the wonderful."

⬤ ⊛ CAPITAL PICTURES

85 Randolph Ave., London W9 1DL, United Kingdom. 44 (0)20 7286 2212. **E-mail:** sales@capitalpictures.com, phil@capitalpictures.com. **Website:** www.capitalpictures.com. Estab. 1980. Picture library. Has 500,000 photos on file. Clients include: advertising agencies, book publishers, magazine publishers, newspapers. Specializes in high-quality photographs of famous people (politics, royalty, music, fashion, film and television).

NEEDS "We have a lot of clients looking for 'pictures of the capital.' We need very high-quality images of London, postcard-type images for international sales. Not just large files, but great content; famous landmarks photographed at the best time, from the best angle, creating interesting and evocative images. Try looking online for pictures of London for some inspiration."

SPECS High-quality digital format only. Send via CD or e-mail as JPEG files.

PAYMENT & TERMS Pays 50% commission of money received. "We have our own price guide but will negotiate competitive fees for large quantity usage or supply agreements." Offers volume discounts to customers. Discount sales terms negotiable. Works with photographers with or without a contract; negotiable, whatever is most appropriate. No charges. Statements issued monthly. Payment made monthly. Photographers allowed to review account records. Offers any rights they wish to purchase. Informs photographers and allows them to negotiate when client requests all rights." Photo captions preferred; include date, place, event, name of subjects.

HOW TO CONTACT Send query letter with samples. Agency will contact photographer for portfolio review if interested. Keeps samples on file. Expects minimum initial submission of 24 images with monthly submissions of at least 24 images. Responds in 1 month to queries.

CATHOLIC NEWS SERVICE

3211 4th St. NE, Washington DC 20017. (202)541-3250. **Fax:** (202)541-3255. **E-mail:** cns@catholicnews.com. **E-mail:** broller@catholicnews.com. **Website:** www.catholicnews.com. News service transmitting news, features, photos and graphics to Catholic newspapers and religious publishers.

NEEDS Timely news and feature photos related to the Catholic Church or Catholics, head shots of Catholic newsmakers or politicians, and other religions or religious activities, including those that illustrate spirituality. Also interested in photos of family life, modern lifestyles, teenagers, poverty and active seniors.

SPECS Prefers high-res JPEG files, 8×10 at 200 dpi. If sample images are available online, send URL via e-mail, or send samples via CD.

PAYMENT & TERMS Pays for unsolicited news or feature photos accepted for one-time editorial use in the CNS photo service. Include full-caption information. Unsolicited photos can be submitted via e-mail for consideration. Some assignments made, mostly in large U.S. cities and abroad, to experienced photojournalists; inquire about assignment terms and rates.

HOW TO CONTACT Query by mail or e-mail; include samples of work. Calls are fine, but be prepared to follow up with letter and samples.

TIPS "See our website for an idea of the type and scope of news covered. No scenic, still life, or composite images."

⊛ CHARLTON PHOTOS, INC.

3605 Mountain Dr., Brookfield WI 53045. (262)781-9328; (888)242-7586. **Fax:** (262)781-9390. **E-mail:** jim@charltonphotos.com. **Website:** www.charltonphotos.com. **Contact:** James Charlton, director of research. Estab. 1981. Stock photo agency. Has 475,000 photos. Clients include: ad agencies, public relations firms, audiovisual firms, businesses, book/encyclopedia publishers, magazine publishers, newspapers, calendar companies.

NEEDS "We handle photos of agriculture, rural lifestyles and pets."

SPECS Uses color and b&w photos; digital only.

PAYMENT & TERMS Pays 60/40% commission. Average price per image (to clients): $500-650 for color photos. Offers volume discounts to customers; terms specified in photographers' contracts. Works with photographers on contract basis only. Prefers exclusive contract, but negotiable based on subject matter submitted. Contracts renew automatically with additional submissions for 3 years minimum. Charges duping fee, 50% catalog insertion fee and materials fee. Statements issued monthly. Payment made monthly. Photographers allowed to review account records that

relate to their work. Model/property release required for identifiable people and places. Photo captions required; include who, what, when, where. **HOW TO CONTACT** Query by e-mail before sending any material. Expects initial submission of 1,000 images. Responds in 2 weeks. Photo guidelines free with SASE. Market tips sheet distributed quarterly to contract freelance photographers; free with SASE. **TIPS** "Provide our agency with images we request by shooting a self-directed assignment each month. Visit our website."

CODY IMAGES

2 Reform St., Beith KA15 2AE Scotland. (08)(45) 223-5451. **E-mail:** ted@codyimages.com. **E-mail:** info@codyimages.com. **Website:** www.codyimages.com. **Contact:** Ted Nevill. Estab. 1989. Picture library. Has 100,000 photos in files. Clients include: advertising agencies, newspapers, book publishers, calendar companies, audiovisual firms, magazine publishers.

NEEDS Photos of historical and modern civil and military aviation and warfare, including weapons, warships, and personalities.

SPECS Accepts images in digital format.

PAYMENT & TERMS Pays commission. Average price per image (to clients): $40 minimum. Offers volume discounts to customers. Discount sales terms not negotiable. Works with photographers with or without a contract; negotiable. Offers nonexclusive contract. Contracts renew automatically with additional submissions. Statements issued quarterly. Payment made quarterly. Photographers allowed to review account records. Offers one-time rights, electronic media rights. Informs photographers and allows them to negotiate when a client requests all rights. Model/property release preferred. Photo captions preferred.

HOW TO CONTACT Send e-mail with examples and stock list. Provide résumé, business card, self-promotion piece to be kept on file. Expects minimum initial submission of 1,000 images. Responds in 1 month.

EDUARDO COMESANA AGENCIA DE PRENSA/BANCO FOTOGRÃFICO

Av. Olleros 1850 4 to. "F", Buenos Aires C1426CRH, Argentina. (54-11)4771-9418. **E-mail:** info@comesana.com. **Website:** www.comesana.com. **Contact:** Eduardo Comesaña, managing director. Estab. 1977. Stock agency, news/feature syndicate. Has 500,000 photos in files. Clients include: advertising agencies, businesses, newspapers, postcard publishers, book publishers, calendar companies, magazine publishers.

NEEDS Photos of babies/children/teens, celebrities, couples, families, parents, disasters, environmental, landscapes/scenics, wildlife, education, adventure, entertainment, events, health/fitness, humor, performing arts, travel, agriculture, business concepts, industry, medicine, political, science, technology/computers. Interested in documentary, fine art, historical/vintage.

SPECS Accepts images in JPEG format only, minimum 300 dpi.

PAYMENT & TERMS Offers volume discounts to customers; terms specified in photographer's contracts. Photographers can choose not to sell images on discount terms. Works with photographers with or without a contract; negotiable. Offers limited regional exclusivity. Contracts renew automatically with additional submissions. Statements issued quarterly. Payment made quarterly. Photographers allowed to review account records in cases of discrepancies only. Offers one-time rights. Model release preferred; property release required.

HOW TO CONTACT Send query letter with tearsheets, stock list. Provide self-promotion piece to be kept on file. Expects minimum initial submission of 200 images in low-res files with monthly submissions of at least 200 images. Responds only if interested; send nonreturnable samples.

CORBIS

250 Hudson St., 4th Floor, New York NY 10013. (800)260-0444; (212)777-6200. **Fax:** (212)375-7700. **E-mail:** contributorrelations@corbis.com. **Website:** www.corbis.com. Estab. 1991. Stock agency, picture library, news/feature syndicate. Member of the Picture Archive Council of America (PACA). Corbis also has offices in London, Paris, Dusseldorf, Tokyo, Seattle, Chicago and Los Angeles. Clients include: advertising agencies, businesses, newspapers, public relations firms, book publishers, calendar companies, audiovisual firms, magazine publishers, greeting card companies, businesses/corporations, media companies.

HOW TO CONTACT "Please check 'About Corbis' on our website for current submission information."

CRESTOCK CORPORATION

3 Concorde Gate, 4th Floor, Toronto ON M3C 3N7, Canada. **E-mail:** help@crestock.com. **Website:** www.crestock.com. "Crestock is a growing player in mi-

cropayment royalty-free stock photography, helping clients with small budgets find creative images for their projects. With a fast and reliable image upload system, Crestock gives photographers and illustrators a great platform for licensing their creative work. Over 1,700,000 photographs, illustrations and vectors are available for purchase and download online. Masterfile acquired the agency in 2010 and has since added the Crestock collection to www.masterfile.com. Crestock has a general collection of photographs, illustrations and vectors available in a wide-range of sizes. Crestock sells single images, as well offers a selection of subscription and credit packages. Clients include designers, advertising agencies, small business owners, corporations, newspapers, public relations firms, publishers as well as greeting card and calendar companies."

NEEDS Looking for model-released photographs, as well as illustrations and vectors on a wide-range of subjects, including business, finance, holidays, sports and leisure, travel, nature, animals, technology, education, health and beauty, shopping, green living, architecture, still-life as well as conceptual and general lifestyle themes.

SPECS Accepts images in digital format. Submissions must be uploaded for review via website or FTP as JPEG, EPS or AI. For full technical requirements, see www.crestock.com/technical-requirements.aspx.

PAYMENT & TERMS Pays contributors based on request, once a minimum amount is reached. Requires model and/or property releases on certain images. For more information, see: www.crestock.com/modelre lease.aspx. Artists are required to caption and keyword their own material in English before submission. In order to join Crestock, register at www.crestock. com and submit photos for approval. To see general information for artists, see www.crestock.com/infor mation-for-contributors.aspx.

TIPS "Crestock is among the most selective microstock agencies, so be prepared for strict quality standards."

DDB STOCK PHOTOGRAPHY, LLC

P.O. Box 80155, Baton Rouge LA 70898. (225)763-6235. **Fax:** (225)763-6894. **E-mail:** info@ddbstock. com. **Website:** www.ddbstock.com. **Contact:** Douglas D. Bryant, president. Estab. 1970. Stock photo agency. Member of American Society of Picture Professionals. Rights managed stock only, no RF. Currently repre-

sents 105 professional photographers. Has 500,000 original color transparencies and 25,000 b&w prints in archive, and 125,000 high-res digital images with 45,000 available for download on website. Clients include: text-trade book/encyclopedia publishers, travel industry, museums, ad agencies, audiovisual firms, magazine publishers, CD publishers and many foreign publishers.

NEEDS Specializes in picture coverage of Latin America with emphasis on Mexico, Central America, South America, and the Caribbean. Needs photos of anthropology/archeology, art, commerce, crafts, secondary and university education, festivals and ritual, geography, history, indigenous people and culture, museums, parks, political figures, religion. Also uses teens 6th-12th grade/young adults college age, couples, multicultural, families, parents, senior citizens, architecture, rural, adventure, entertainment, events, food/drink, restaurants, health/fitness, performing arts, business concepts, industry, science, technology/computers.

SPECS Prefers images in TIFF digital format on DVD at 10 megapixels or higher. Prepare digital submissions filling IPTC values. Caption, copyright, and keywords per instructions at: www.ddbstock.com/submissionguidelines.html. Accepts uncompressed JPEGs, TIFFs, and original 35mm transparencies.

PAYMENT & TERMS "Rights to reproduction of color transparencies and b&w prints are sold on a 50% commission basis with remittance made to photographers within 2 weeks following receipt of payment. Exceptions to this include sales made through our affiliate offices around the world where we receive a 60% cut, leaving the photographer with 30%. DDB Stock negotiates only one-time use rights. The pictures on file remain the property of the photographer. The agency asks only that a photographer agree to place material in the files for at least three years. This assures that the agency will have ample opportunity to recover the costs of placing a new photographer's material in the files. This also keeps the images in our files for the hottest selling period, which occurs from 12 to 36 months after they enter the files. It is important to have the images in the files when repeat interest is expressed by an editor. Photographers who want images returned from the files prior to the 3-year minimum must agree to pay a $15 hourly pull fee plus shipping charges for early return of pictures." Model/property release preferred for ad set-up shots. Photo

captions required; include location and detailed description. "We have a geographic focus and need specific location info on captions (Geocode latitude/longitude if you carry a GPS unit, and include latitude/longitude in captions)."

HOW TO CONTACT Interested in receiving work from professional photographers who regularly visit Latin America. Send query letter with brochure, tearsheets, stock list. Expects minimum initial submission of 300 digital images/original transparencies and yearly submissions of at least 500 images. Responds in 6 weeks. Photo guidelines available on website.

TIPS "Speak Spanish and spend 1-6 months shooting in Latin America and the Caribbean every year. Follow our needs list closely. Call before leaving on assignment. Shoot digital TIFFs at 12 megapixels or larger. Shoot RAW/NEF/DNG adjust and convert to TIFF or Fuji professional transparency film if you have not converted to digital. Edit carefully. Eliminate images with focus, framing, excessive grain/noise, or exposure problems. The market is far too competitive for average pictures and amateur photographers. Review guidelines for photographers on our website. Include coverage from at least 3 Latin American countries or 5 Caribbean Islands. No one-time vacation shots! Shoot subjects in demand listed on website."

⊕ DESIGN CONCEPTIONS/JOEL GORDON PHOTOGRAPHY

112 Fourth Ave., New York NY 10003. (212)254-1688. **E-mail:** joel.gordon@verizon.net. **Website:** www.joelgordon.com. Estab. 1970. Stock photo agency. Member ASMP, ASPP, SAA. Has 500,000 photos in files. Clients include: book/encyclopedia publishers, magazine publishers, advertising agencies.

NEEDS "Real people." Also interested in children/teens, couples, families, parents, senior citizens, events, health/fitness, medicine, science, technology/computers. Not interested in photos of nature. Interested in documentary, fine art.

SPECS Accepts images in digital format only. Send via CD as JPEG files (low-res for first review) with 1 PTC or meta data info.

PAYMENT & TERMS Pays 50% commission for photos. Average price per image (to clients): $200-250 minimum for b&w and color photos. Enforces minimum prices. Offers volume discounts to customers;

terms specified in photographers' contracts. Works with photographers with or without a contract. Offers limited regional exclusivity, nonexclusive. Statements issued monthly. Payment made monthly. Photographers allowed to review account records. Offers one-time electronic media and agency promotion rights. Informs photographer when client requests all rights. Model/property release preferred. Photo captions preferred.

HOW TO CONTACT Call first to explain range of files. Arrange personal interview to show portfolio or CD. Send query letter with samples.

TIPS Looks for "real people doing real, not set-up, things."

⊕ ✪ DESIGN PICS, INC.

#101, 10464-176 St., Edmonton AB T5S 1L3, Canada. (780)447-5433. **Fax:** (780)451-8568. **E-mail:** rick@designpics.com. **Website:** www.designpics.com. **Contact:** Rick Carlson, president. Estab. 2000. Stock photo agency. Member of PACA. Has 450,000 photos in files. Clients include: advertising agencies, businesses, newspapers, postcard publishers, book publishers, calendar companies, magazine publishers and greeting card companies.

SPECS Accepts images in digital format. Send via CD or FTP as TIFF files (60MB) at 300 dpi.

PAYMENT & TERMS Does not buy photos, film or video outright. Pays on a commission basis based on photographer. Average price varies. Negotiates fees below stated minimums, based on preferred vendor agreements. Offers volume discounts to costumers. Works with photographers on contract basis.

HOW TO CONTACT E-mail query letter with link to photographer's website or JPEG samples at 72 dpi. Expects minimum initial submission of 100 images with periodic submissions of at least 100 images 2 times/year. Responds in 1 month. Photo guidelines free on request through e-mail. Catalog available on website. Market tips sheet free via e-mail, distributed to those with contracts.

TIPS "Interested in high-quality digital files only from full-frame cameras. Provide links to collections, galleries and websites. Show a minimum of 200 images to represent the quality of your work."

◉ DINODIA PHOTO LIBRARY

13-17 Vithoba Ln., Vithalwadi, Kalbadevi Mumbai 400 002, India. 91(22)2240 4126. **Fax:** 91(22)2240 1675. **E-mail:** jagdish@dinodia.com. **E-mail:** info@dinodia.

com. **Website:** www.dinodia.com. **Contact:** Jagdish Agarwal, founder. Estab. 1987. Stock photo agency celebrating 25 years in business. Has 1,000,000 photos on website. Clients include: advertising agencies, public relations firms, audiovisual firms, businesses, book/encyclopedia publishers, magazine publishers, newspapers, postcard companies, calendar companies, greeting card companies.

NEEDS Photos of babies/children/teens, celebrities, couples, multicultural, families, parents, senior citizens, disasters, environment, landscapes/scenics, wildlife, architecture, cities/urban, education, gardening, interiors/decorating, pets, religious, rural, adventure, automobiles, entertainment, events, food/drink, health/fitness/beauty, hobbies, humor, performing arts, sports, travel, agriculture, business concepts, industry, medicine, military, political, product shots/still life, science, technology/computers. Interested in alternative process, avant garde, documentary, erotic, fashion/glamour, fine art, historical/vintage, seasonal.

SPECS "At the moment we are only accepting digital. Initially it is better to send a link to your website for our review."

PAYMENT & TERMS Pays 50% commission for b&w and color photos. General price range (to clients): US $50-600. Negotiates fees below stated minimum prices. Offers volume discounts to customers; inquire about specific terms. Discount sales terms not negotiable. Works with photographers on contract basis only. Offers limited regional exclusivity; "prefer exclusive for India." Contracts renew automatically with additional submissions for 5 years. Statement issued monthly. Payment made monthly. Photographers permitted to review sales figures. Informs photographers and allows them to negotiate when client requests all rights. Offers one-time rights. Model release preferred. Photo captions required.

HOW TO CONTACT Send query e-mail with résumé of credits, link to your website. Responds in 1 week. Photo guidelines free with SASE. Dinodia news distributed monthly to contracted photographers.

TIPS "We look for style—maybe in color, composition, mood, subject matter, whatever—but the photos should have above-average appeal." Sees trend that "market is saturated with standard documentary-type photos. Buyers are looking more often for stock that appears to have been shot on assignment."

DK STOCK, INC.

4531 Worthings Dr., Powder Springs GA 30127. (866)362-4705. **Fax:** (678)384-1883. **E-mail:** david@dkstock.com. **Website:** www.dkstock.com. **Contact:** David Deas, photo editor. Estab. 2000. "A multicultural stock photo company based in New York City. Prior to launching DK Stock, its founders worked for years in the advertising industry as a creative team specializing in connecting clients to the $1.6 trillion multicultural market. This market is growing, and DK Stock's goal is to service it with model-released, well composed, professional imagery." Member of the Picture Archive Council of America (PACA). Has 15,000 photos on file. Clients include: advertising agencies, public relations firms, graphic design businesses, book publishers, magazine publishers, newspapers, calendar companies, greeting card companies.

NEEDS "Looking for contemporary lifestyle images that reflect the black and Hispanic Diaspora." Wants photos of babies/children/teens, celebrities, couples, multicultural, families, parents, senior citizens, education, adventure, entertainment, health/fitness/beauty, hobbies, humor, performing arts, sports, travel, agriculture, business concepts, industry, medicine, military, political, science, technology/computers. Interested in historical/vintage, lifestyle. "Images should include models of Hispanics and/or people of African descent. Images of Caucasian models interacting with black people or hispanic people can also be submitted. Be creative, selective and current. Visit website to get an idea of the style and range of representative work. E-mail for a current copy of 'needs list.'"

SPECS Accepts images in digital format. 50MB, 300 dpi.

PAYMENT & TERMS Pays 50% commission for b&w or color photos. Average price per image (to clients): $485. Enforces minimum prices. Offers volume discounts to customers; terms specified in photographers' contracts. Photographers can choose not to sell images on discount terms. Works with photographers on contract basis only. Offers non-exclusive contract. Contracts renew automatically with additional submissions for 5 years. Statements issued monthly. Payment made monthly. Photographers allowed to review account records. Model/property release required. Photo captions not necessary.

HOW TO CONTACT Send query letter with disc or DVD. Portfolio may be dropped off every Monday-

Friday. Does not keep samples on file; include SASE for return of material. Expects minimum initial submission of 50 images with 5 times/year submissions of at least 200 images. Responds in 2 weeks to samples, portfolios. Photo guidelines free with SASE. Catalog free with SASE.

TIPS "We love working with talented people. If you have 10 incredible images, let's begin a relationship. Also, we're always looking for new and upcoming talent as well as photographers who can contribute often. There is an increasing demand for lifestyle photos of multicultural people. Our clients are based in the Americas, Europe, Asia and Africa. Be creative, original and technically proficient."

DRK PHOTO

100 Starlight Way, Sedona AZ 86351. (928)284-9808. **E-mail:** info@drkphoto.com. **Website:** www.drkpho to.com. "We handle only the personal best of a select few photographers—not hundreds. This allows us to do a better job aggressively marketing the work of these photographers." Clients include: ad agencies; PR and AV firms; businesses; book, magazine, textbook and encyclopedia publishers; newspapers; postcard, calendar and greeting card companies; branches of the government; and nearly every facet of the publishing industry, both domestic and foreign.

NEEDS "Especially need marine and underwater coverage." Also interested in S.E.Ms, African, European and Far East wildlife, and good rainforest coverage.

SPECS Digital capture preferred, digital scans accepted.

PAYMENT & TERMS General price range (to clients): $100-"into thousands." Works with photographers on contract basis only. Contracts renew automatically. Statements issued quarterly. Payment made quarterly. Offers one-time rights; "other rights negotiable between agency/photographer and client." We are not interested in images being offered by anyone else as royalty-free images. We only accept and market rights-managed images. Model release preferred. Photo captions required.

HOW TO CONTACT "With the exception of established professional photographers shooting enough volume to support an agency relationship, we are not soliciting open submissions at this time. Those professionals wishing to contact us in regards to representation should query with a brief letter of introduction."

DW STOCK PICTURE LIBRARY

108 Beecroft Rd., Beecroft NSW 2119, Australia. (61)2 9869 0717. **E-mail:** info@dwpicture.com.au. **E-mail:** admin@dwpicture.com.au. **Website:** www.dwpicture. com.au. Estab. 1997. Has more than 200,000 photos on file and 30,000 online. "Strengths include historical images, marine life, African wildlife, Australia, travel, horticulture, agriculture, people and lifestyles." Clients include: advertising agencies, designers, printers, book publishers, magazine publishers, calendar companies.

NEEDS Photos of babies/children/teens, families, parents, senior citizens, disasters, gardening, pets, rural, health/fitness, travel, industry. Interested in lifestyle.

SPECS Accepts images in digital format. Send as low-res JPEG files via CD.

PAYMENT & TERMS Average price per image (to clients): $200 for color photos. Enforces minimum prices. Offers volume discounts to customers. Works with photographers on contract basis only. Statements issued quarterly. Photographers allowed to review account records in cases of discrepancies only. Offers one-time rights. Model release preferred. Photo captions required.

HOW TO CONTACT Send query letter with images; include SASE if sending by mail. Expects minimum initial submission of 200 images.

ECOSCENE

Empire Farm, Throop Rd., Templecombe, Somerset BA8 0HR, United Kingdom. 44(0)1963 371 700. **E-mail:** sally@ecoscene.com, pictures@ecoscene.com. **Website:** www.ecoscene.com. **Contact:** Sally Morgan, director. Estab. 1988. Picture library. Has 80,000 photos in files. Clients include: advertising agencies, businesses, book/encyclopedia publishers, magazine publishers, newspapers, online, multimedia.

NEEDS Photos of disasters, environmental, energy issues, sustainable development, wildlife, gardening, rural, agriculture, medicine, science, pollution, industry, energy, indigenous peoples.

SPECS Accepts digital submissions only. High-quality JPEG at 300 dpi, minimum file size when opened of 50MB.

PAYMENT & TERMS Pays 55% commission for color photos. Negotiates fees below stated minimum prices, depending on quantity reproduced by a single client. Offers volume discounts to customers. Discount

sales terms not negotiable. Works with photographers on contract basis only. Offers nonexclusive contract. Contracts renew automatically with additional submissions, 4 years minimum. Statements issued quarterly. Payment made quarterly. Offers one-time and electronic media rights. Informs photographers and allows them to negotiate when client requests all rights. Model/property release required. Photo captions required; include location, subject matter, keywords and common and Latin names of wildlife and any behavior shown in pictures.

HOW TO CONTACT Send e-mail with résumé of credits. Digital submissions only. Keeps samples on file; include SASE for return of material. Expects minimum initial submission of 100 images with annual submissions of at least 100 images. Responds in 2 months. Photo guidelines free with SASE. Market tips sheets distributed quarterly to anybody who requests, and to all contributors.

TIPS "Photographers should carry out a tight EDT, no fillers, and be critical of their own work."

✦ ESTOCK PHOTO, LLC

27-28 Thomson Ave., Suite 628, Long Island City NY 11101. (800)284-3399. **Fax:** (212)545-1185. **E-mail:** sub missions@estockphoto.com. **Website:** www.estock photo.com. Member of Picture Archive Council of America (PACA). Specialties include: world travel, cultures, landmarks, leisure, nature and scenics. Has over 1 million photos in files. Clients include: ad agencies, public relations and AV firms; businesses; book, magazine and encyclopedia publishers; newspapers, calendar and greeting card companies; textile firms; travel agencies and poster companies.

NEEDS Exceptional travel-related imagery and people/leisure photography.

SPECS Submission guidelines available on our website under the "contact us" page.

HOW TO CONTACT Send query letter with samples, a list of stock photo subjects or submit portfolio for review. Response time depends; often the same day. Photo guidelines free with SASE.

TIPS "Photos should show what the photographer is all about. They should show technical competence—photos that are sharp, well-composed, have impact; if color, they should show color."

● EYE UBIQUITOUS

P.O. Box 2190, Shoreham-by-Sea West Sussex BN43 9EZ, United Kingdom. 44(0)1243 864005. **Fax:**

44(0)1273 440116. **Website:** www.eyeubiquitous. com. Estab. 1988. Picture library. Has 300,000+ photos in files. Clients include: ad agencies, public relations firms, businesses, book/encyclopedia publishers, magazine publishers, newspapers, television companies.

NEEDS Photos of worldwide social documentary and general stock.

SPECS Transparencies and 50MB files at 300 dpi.

PAYMENT & TERMS Offers volume discounts to customers; inquire about specific terms. Discount sales terms not negotiable. Works with photographers on contract basis only. Offers exclusive, limited regional exclusivity and nonexclusive contracts. Contracts renew automatically with additional submissions. Charges to photographers "discussed on an individual basis." Payment made quarterly. Photographers allowed to review account records. Buys one-time, electronic media and agency promotion rights; negotiable. Does not inform photographers or allow them to negotiate when client requests all rights. Model/property release preferred for people, "particularly Americans." Photo captions required; include where, what, why, who.

HOW TO CONTACT Submit portfolio for review. Works with freelancers only. Keeps samples on file. Include SASE for return. No minimum number of images expected in initial submission, but "the more the better." Responds as time allows. Photo guidelines free with SASE. Catalog free with SASE. Market tips sheet distributed to contributors "when we can" free with SASE.

TIPS "Find out how picture libraries operate. This is the same for all libraries worldwide. Amateurs can be very good photographers, but very bad at understanding the industry after reading some irresponsible and misleading articles. Research the library requirements."

● FAMOUS PICTURES & FEATURES AGENCY

13 Harwood Rd., London SW6 4QP, United Kingdom. +44(0)20 7731 9333. **Fax:** +44(0)20 7731 9330. **E-mail:** info@famous.uk.com. **E-mail:** pictures@ famous.uk.com. **Website:** www.famous.uk.com. Estab. 1985. Picture library, news/feature syndicate. Has more than 500,000 photos on database. Clients include: advertising agencies, book publishers, maga-

zine publishers, newspapers, calendar companies, postcard publishers and poster publishers.

NEEDS Photos of music, film, TV personalities; international celebrities; live, studio, party shots (paparazzi) with stars of all types.

SPECS Prefers images in digital format. Send via FTP or e-mail as JPEG files at 300 dpi or higher.

PAYMENT & TERMS Offers volume discounts to customers. Photographers can choose not to sell images on discount terms. Works with photographers with or without a contract; contracts available for all photographers. Offers limited regional exclusivity. Statements issued monthly. Payment made monthly. Photographers allowed to review account records. Offers one-time rights. Photo captions preferred.

HOW TO CONTACT E-mail, phone or write, provide samples. Provide résumé, business card, self-promotion piece or tearsheets to be kept on file. Agency will contact photographer for portfolio review if interested. Keeps samples in online database. Will return material with SAE/IRC.

TIPS "We are solely marketing images via computer networks. Our fully searchable archive of new and old pictures is online. Send details via e-mail for more information. When submitting work, please caption pictures correctly."

✪ ✺ FIRST LIGHT ASSOCIATED PHOTOGRAPHERS

10464 176th St., #101, Edmonton Alberta T5S 1L3, Canada. (416)597-8625; toll free in Canada (800)668-2003. **Fax:** (416)597-2035. **E-mail:** anne@firstlight.com; info@firstlight.com; photography@firstlight.com. **Website:** www.firstlight.com. **Contact:** Anne Bastarache, director of photography. Estab. 1984. First Light sales staff serves their clients through the e-commerce website, which includes over 7 million images.

NEEDS Represents over 200 photographers, and in combination with Design Pics Canadian-based photographers, has the most extensive collection of Canadian content available anywhere. In addition, the site has over 50 third-party providers.

SPECS "For initial review submission we prefer low-res JPEG files via e-mail; for final submissions we require clean 50MB (minimum) high-res TIFF files."

HOW TO CONTACT Send query letter via e-mail.

TIPS "Wants to see tightly edited submissions. Well-produced, non-candid imagery."

◐ THE FLIGHT COLLECTION

Quadrant House, The Quadrant, Oxford Road, Sutton Surrey SM2 5AS, United Kingdom. 44(0)20 8652 8888. **E-mail:** flight@uniquedimension.com. **E-mail:** flight@image-asset-management.com. **Website:** www.theflightcollection.com. Estab. 1983. Has 1 million+ photos in files. Clients include: advertising agencies, public relations firms, audiovisual firms, businesses, book publishers, magazine publishers, newspapers, calendar companies, greeting card companies, postcard publishers.

NEEDS Photos of aviation.

SPECS Accepts all transparency film sizes: Send a sample of 50 for viewing. Accepts images in digital format. Send via CD as TIFF files at 300 dpi.

PAYMENT & TERMS Enforces minimum prices. Offers volume discounts to customers. Discount sales terms not negotiable. Works with photographers on contract basis only. Offers nonexclusive contract. Contracts renew automatically with additional submissions, no specific time. Statements issued monthly. Payment made monthly. Offers one-time rights. Model/property release required. Photo captions required; include name, subject, location, date.

HOW TO CONTACT Send query letter with transparencies or CD. Does not keep samples on file; include SASE for return of material. Expects minimum initial submission of 50 images. Photo guidelines sheet free via e-mail.

TIPS "Caption slides/images properly. Provide a list of what's submitted."

FOODPIX

Getty Images, 605 Fifth Ave. S., Seattle WA 98103. (206)925-5000. **E-mail:** sales@gettyimages.com. **Website:** www.gettyimages.com. Estab. 1994. Stock agency. Member of the Picture Archive Council of America (PACA). Has 40,000 photos in files. Clients include: advertising agencies, businesses, newspapers, book publishers, calendar companies, design firms, magazine publishers.

NEEDS Food, beverage and food/lifestyle images.

SPECS Accepts analog and digital images. Review and complete the online submission questionnaire on the website before submitting work.

PAYMENT & TERMS Enforces minimum prices. Offers volume discounts to customers; terms specified in photographers' contracts. Works with photographers on contract basis only. Offers exclusive contract only.

Statements issued monthly. Payment made quarterly. Offers one-time rights. Model/property release required. Photo captions required.

HOW TO CONTACT Send query e-mail with samples. Expects maximum initial submission of 50 images. Catalog available.

FOTOAGENT

E-mail: werner@fotoagent.com. **Website:** www.foto agent.com. **Contact:** Werner J. Bertsch, president. Estab. 1985. Stock photo agency. Has 1.5 million photos in files. Clients include: magazines, advertising agencies, newspapers, publishers.

NEEDS General worldwide travel, medical and industrial.

SPECS Uses digital files only. Upload your files on website.

PAYMENT & TERMS Pays 50% commission for b&w or color photos. Average price per image (to clients): $175 minimum for b&w or color photos. Works with photographers on contract basis only. Offers nonexclusive contract. Contracts renew automatically with each submission for 1 year. Statements issued monthly. Payment made monthly. Photographers allowed to review account records to verify sales figures. Offers one-time rights. Model release required. Photo captions required.

HOW TO CONTACT Use the "Contact Us" feature on website.

TIPS Wants to see "clear, bright colors and graphic style. Looking for photographs with people of all ages with good composition, lighting and color in any material for stock use."

FOTO-PRESS TIMMERMANN

Speckweg 34A Moehrendorf D-91096, Germany. 49(0)9131 42801. **Fax:** 49(0)9131 450528. **E-mail:** info@f-pt.com. **Website:** www.f-pt.com. **Contact:** Wolfgage Timmermann. Stock photo agency. Has 750,000 photos in files. Clients include: advertising agencies, audiovisual firms, businesses, book/encyclopedia publishers, magazine publishers, newspapers, calendar companies.

NEEDS Landscapes, countries, travel, tourism, towns, people, business, nature, babies/children/teens, couples, families, parents, senior citizens, adventure, entertainment, health/fitness/beauty, hobbies, industry, medicine, technology/computers. Interested in erotic, fine art, seasonal, lifestyle.

SPECS Uses 2¼×2¼, 4×5, 8×10 transparencies (no prints). Accepts images in digital format. Send via CD, ZIP as TIFF files.

PAYMENT & TERMS Pays 50% commission for color photos. Works on nonexclusive contract basis (limited regional exclusivity). First period: 3 years; contract automatically renewed for 1 year. Photographers allowed to review account records. Statements issued quarterly. Payment made quarterly. Offers one-time rights. Informs photographers and allows them to negotiate when a client requests to buy all rights. Model/property release preferred. Photo captions required; include state, country, city, subject, etc.

HOW TO CONTACT Send query letter with stock list. Send unsolicited photos by mail for consideration; include SAE/IRC for return of material. Responds in 1 month.

FOTOSCOPIO

Roosevelt 3751, Piso 12, Depto. A C1430AGJ, Capital Federal, Buenos Aires 1203AAQ, Argentina. (54)(114)544-2997. **Fax:** (54)(114)542-2997. **E-mail:** online contact form. **Website:** www.fotoscopio.com.ar. **Contact:** Gustavo Di Pace, director. Estab. 1999. Latin American stock photo agency. Has 50,000 photos in files. Clients include: advertising agencies, businesses, postcard publishers, book publishers, calendar companies, magazine publishers, greeting card companies.

NEEDS Photos of Hispanic people, Latin American countries, babies/children/teens, celebrities, couples, multicultural, families, senior citizens, disasters, environmental, landscapes/scenics, wildlife, architecture, cities/urban, interiors/decorating, pets, religious, adventure, automobiles, entertainment, health/fitness/beauty, hobbies, sports, travel, agriculture, business concepts, industry, product shots/still life, technology/computers. Interested in documentary, fine art, historical/vintage.

SPECS Uses 35mm, 2¼×2¼, 4×5, 8×10 transparencies. Accepts images in digital format. Send via CD, ZIP.

PAYMENT & TERMS Average price per image (to clients): $50-300 for b&w photos; $50-800 for color photos. Negotiates fees below stated minimums. Offers volume discounts to customers; terms specified in photographer's contracts. Discount sales terms not negotiable. Works with photographers on contract basis only. Offers nonexclusive contract. Contracts renew automatically with additional submissions for 1

year. Statements issued and payment made whenever one yields rights of reproduction of his photography. Photographers allowed to review account records in cases of discrepancies only. Offers one-time and electronic media rights. Model release required; property release preferred. Photo captions preferred.

HOW TO CONTACT Send query letter with résumé, slides, prints, photocopies, tearsheets, transparencies, stock list. Provide résumé, business card, self-promotion piece to be kept on file. Expects minimum initial submission of 100 images. Responds in 1 month to samples. Photo guidelines sheet free with SASE.

FUNDAMENTAL PHOTOGRAPHS

210 Forsyth St., Suite 2, New York NY 10002. (212)473-5770. **Fax:** (212)228-5059. **E-mail:** mail@fphoto.com. **Website:** www.fphoto.com. **Contact:** Kip Peticolas, partner. Estab. 1979. Stock photo agency. Applied for membership into the Picture Archive Council of America (PACA). Member of ASPP. Has 100,000 photos in files. Searchable online database. Clients include: textbook/encyclopedia publishers, advertising agencies, science magazine publishers, travel guide book publishers, corporate industrial.

NEEDS Photos of medicine, biology, microbiology, environmental, industry, weather, disasters, science-related business concepts, agriculture, technology/computers, optics, advances in science and industry, green technologies, pollution, physics and chemistry concepts.

SPECS Accepts 35mm and all large-format transparencies but digital is strongly preferred. Send digital as RAW or TIFF unedited original files at 300 dpi, 11×14 or larger size. Please e-mail for current submission guidelines.

PAYMENT & TERMS Pays 50% commission for color photos. General price range (to clients): $100-500 for b&w photos; $150-1,200 for color photos; depends on rights needed. Enforces strict minimum prices. Offers volume discount to customers. Works with photographers on contract basis only. Offers guaranteed subject exclusivity. Contracts renew automatically with additional submissions for 2 or 3 years. Charges $5/image scanning fee; can increase to $15 if corrective Photoshop work required. Charges copyright registration fee (optional). Statements issued and payment made quarterly for any sales during previous quarter. Photographers allowed to review account records with written request submitted 2 months in advance. Offers one-time and electronic media rights. Gets photographer's approval when client requests all rights; negotiation conducted by the agency. Model release required. Photo captions required; include date and location.

HOW TO CONTACT E-mail request for current photo guidelines. Contact via e-mail to arrange digital submission. Submit link to web portfolio for review. Send query e-mail with résumé of credits, samples or list of stock photo subjects. Keeps samples on file; include SASE for return of material if sending by post. Expects minimum initial submission of 100 images. E-mail crucial for communicating current photo needs.

TIPS "Our primary market is science textbooks. Photographers should research the type of illustration used and tailor submissions to show awareness of saleable material. We are looking for science subjects ranging from nature and rocks to industrials, medicine, chemistry and physics; macro photography, photomicrography, stroboscopic; well-lit still-life shots are desirable. The biggest trend that affects us is the need for images that document new discoveries in sciences and ecology. Please avoid images that appear dated, images with heavy branding, soft focus or poorly lit subjects."

GEOSLIDES & GEO AERIAL PHOTOGRAPHY

31 Breedon St., Nottingham NG10 4ES, United Kingdom. 44(0)115 972 7250. **E-mail:** geoslides@geo-group.co.uk. **E-mail:** tourism@geo-group.co.uk. **Website:** www.geo-group.co.uk. **Contact:** John Douglas, marketing director. Estab. 1968. Picture library. Has approximately 100,000 photos in files. Clients include: advertising agencies, public relations firms, audiovisual firms, businesses, book/encyclopedia publishers, magazine publishers, newspapers, calendar companies, television.

NEEDS Accent on travel/geography and aerial (oblique) shots. Wants photos of disasters, environmental, landscapes/scenics, wildlife, architecture, rural, adventure, travel, agriculture, industry, medicine, military, political, product shots/still life, science, technology/computers. Interested in documentary, historical/vintage.

SPECS High-res digital.

PAYMENT & TERMS Pays 50% commission for b&w or color photos. Works with photographers with or

without a contract; negotiable. Offers nonexclusive contract. Charges mailing costs. Statements issued monthly. Payment made upon receipt of client's fees. Offers one-time rights and first rights. Does not inform photographers or allow them to negotiate when clients request all rights. Model release required. Photo captions required; include description of location, subject matter and sometimes the date.

HOW TO CONTACT Send query letter or e-mail with résumé of credits, stock list; include SAE/IRC for return of material. Photo guidelines available for SASE/IRC. No samples until called for.

TIPS Looks for "technical perfection, detailed captions, must fit our needs, especially location needs. Increasingly competitive on an international scale. Quality is important. Needs large stocks with frequent renewals." To break in, "build up a comprehensive (i.e., in subject or geographical area) collection of photographs that are well documented."

GETTY IMAGES

605 5th Ave. S., Seattle WA 98104. (206)925-5000, (800)462-4379. **E-mail:** sales@gettyimages.com, editorialsubmissions@gettyimages.com. **Website:** www.gettyimages.com. "Getty Images is the world's leading imagery company, creating and distributing the largest and most relevant collection of still and moving images to communication professionals around the globe and supporting their work with asset management services. From news and sports photography to contemporary and archival imagery, Getty Images' products are found each day in newspapers, magazines, advertising, films, television, books and websites. Gettyimages.com is the first place customers turn to search, purchase, download and manage powerful imagery. Seattle-headquartered Getty Images is a global company with customers in more than 100 countries."

HOW TO CONTACT Visit www.gettyimages.com/contributors.

GRANATAIMAGES.COM

Milestone Media SRL, 95 Via Vallazze, Milan 20131, Italy. (39)(02)26680702. **Fax:** (39)(02)26681126. **E-mail:** redazione@milestonemedia.it. **E-mail:** info@milestonemedia.it. **Website:** www.milestonemedia.it. Estab. 1985. Stock and press agency. Member of CEPIC. Has 2 million photos in files and 800,000 images online. Clients include: advertising agencies, newspapers, book publishers, calendar companies, audiovisual firms, magazine publishers, production houses.

NEEDS Photos of celebrities, people.

SPECS Uses high-res digital files. Send via ZIP, FTP, e-mail as TIFF, JPEG files.

PAYMENT & TERMS Negotiates fees below stated minimums in cases of volume deals. Offers volume discounts to customers. Photographers can choose not to sell images on discount terms. Works with photographers on contract basis only. Offers exclusive contract only. Contracts renew automatically with additional submissions for 1 year. Statements issued monthly. Photographers allowed to review account records in cases of discrepancies only. Offers one-time rights. Model/property release preferred. Photo captions required; include location, country and any other relevant information.

HOW TO CONTACT Send query letter with digital files.

HERITAGE IMAGES

Clerks Court, 18-20 Farringdon Lane, London EC1R 3AU, United Kingdom. U.K.: 0800 436 867, U.S.: (888)761-9293. **Fax:** 44(0) 20 7434 0673. **E-mail:** angela.davies@heritage-images.com. **Website:** www.heritage-images.com. Estab. 1998. Member of BAPLA (British Association of Picture Libraries and Agencies). Has 250,000+ images on file. Clients include: advertisers/designers, businesses, book publishers, magazine publishers, newspapers, calendar/card companies, merchandising, TV.

NEEDS Worldwide religion, faith, spiritual images, buildings, clergy, festivals, ceremony, objects, places, food, ritual, monks, nuns, stained glass, carvings, the unusual. Mormons, Shakers, all groups/sects, large or small. Death: burial, funerals, graves, gravediggers, green burial, commemorative. Ancient/heritage/Biblelands/saints/eccentricities/festivals: curiosities, unusual oddities like follies, signs, symbols. Architecture, religious or secular. Manuscripts and illustrations, old and new, linked with any of the subjects above.

SPECS Accepts images in digital format. Send via CD, JPEG files in medium to high-res. Uses 35mm, 2¼×2¼, 4×5 transparencies.

PAYMENT & TERMS Average price per image (to clients): $140-200 for color photos. Offers volume discounts to customers. Works with photographers on contract basis for 5 years, offering exclusive/non-

exclusive contract renewable automatically with additional submissions. Offers one-time rights. Model release where necessary. Photo captions very important and must be accurate; include what, where, any special features or connections, name, date (if possible), and religion.

HOW TO CONTACT Send query letter with slides, tearsheets, transparencies/CD. Expects minimum initial submission of 40 images. Photo guidelines sheet and "wants list" available via e-mail.

TIPS "Decide on exact subject of image. *Get in close and then closer.* Exclude all extraneous matter. Fill the frame. Dynamic shots. Interesting angles, light. No shadows or miniscule subject matter far away. Tell us what is important about the picture. No people in shot unless they have a role in the proceedings as in a festival or service, etc."

⬤ HUTCHISON PICTURE LIBRARY

65 Brighton Rd., Shoreham-by-Sea West Sussex BN43 6RE United Kingdom. **E-mail:** library@hutchisonpictures.co.uk. **Website:** www.hutchisonpictures.co.uk. **Contact:** Stephen Rafferty, manager. Stock photo agency, picture library. Has around 500,000 photos in files. Clients include: ad agencies, public relations firms, audiovisual firms, businesses, book/encyclopedia publishers, magazine publishers, newspapers, postcard companies, calendar companies, television and film companies.

NEEDS "We are a general, documentary library (no news or personalities). We file mainly by country and aim to have coverage of every country in the world. Within each country we cover such subjects as industry, agriculture, people, customs, urban, landscapes, etc. We have special files on many subjects such as medical (traditional, alternative, hospital, etc.), energy, environmental issues, human relations (relationships, childbirth, young children, etc., but all real people, not models). We constantly require images of Spain and Spanish-speaking countries. Also interested in babies/children/teens, couples, multicultural, families, parents, senior citizens, disasters, architecture, education, gardening, interiors/decorating, religious, rural, health/fitness, travel, military, political, science, technology/computers. Interested in documentary, seasonal. We are a color library."

SPECS Uses 35mm transparencies. Accepts images in digital format: 50MB at 300 dpi, cleaned of dust and scratches at 100%, color corrected.

PAYMENT & TERMS Pays 40% commission for exclusive; 35% for nonexclusive. Statements issued semiannually. Payment made semiannually. Sends statement with check in June and January. Offers one-time rights. Model release preferred. Photo captions required.

HOW TO CONTACT Always willing to look at new material or collections. Arrange a personal interview to show portfolio. Send letter with brief description of collection and photographic intentions. Responds in about 2 weeks, depends on backlog of material to be reviewed. "We have letters outlining working practices and lists of particular needs (they change)." Distributes tips sheets to photographers who already have a relationship with the library.

TIPS Looks for "collections of reasonable size (rarely less than 1,000 transparencies) and variety; well captioned (or at least well indicated picture subjects; captions can be added to mounts later); sharp pictures, good color, composition; and informative pictures. Prettiness is rarely enough. Our clients want information, whether it is about what a landscape looks like or how people live, etc. The general rule of thumb is that we would consider a collection which has a subject we do not already have coverage of or a detailed and thorough specialist collection. Please do not send *any* photographs without prior agreement."

⬤ ⊛ ICP DI ALESSANDRO MAROSA

Via Bressanone 8/2 - 20151, Milano, Italy. Milan: 39-02-89605794; Rome: 39-06-452217748; Torino: 39-011-23413919. **Fax:** 39-02-48195625;. **E-mail:** icp@icponline.it. **E-mail:** alessandro@icponline.it. **Website:** www.icponline.it. **Contact:** Mr. Alessandro Marosa, CEO. Estab. 1970. Stock photo agency. Clients include: advertising agencies, public relations firms, audiovisual firms, businesses, book/encyclopedia publishers, magazine publishers, postcard publishers, calendar companies and greeting card companies.

SPECS High-res digital (A3-A4, 300 dpi), keyworded (English and, if possible, Italian).

PAYMENT & TERMS Pays 50% commission for color photos. Offers volume discounts to customers; terms specified in photographer's contract. Discount sales terms not negotiable. Contracts renew automatically with additional submissions, for 3 years. Statements issued monthly. Payment made monthly. Photographers permitted to review account records to verify sales figures or deductions. Offers one-time, first and

sectorial exclusive rights. Model/property release required. Photo captions required.

HOW TO CONTACT Arrange a personal interview to show portfolio. Send query letter with samples and stock list. Works on assignment only. No fixed minimum for initial submission. Responds in 3 weeks, if interested.

THE IMAGE FINDERS

2570 Superior Ave., Suite 200, Cleveland OH 44114. (216)781-7729 or (440)413-6104. **E-mail:** jim@the imagefinders.com. **Website:** www.theimagefinders. com. **Contact:** Jim Baron, owner. Estab. 1988. Stock photo agency. Has 500,000+ photos in files. Clients include: advertising agencies, publishing firms, businesses, book/encyclopedia publishers, magazine publishers, calendar companies, greeting card companies.

NEEDS General stock agency. Always interested in good Ohio images. Also needs babies/children/teens, couples, multicultural, families, senior citizens, landscapes/scenics, wildlife, architecture, gardening, pets, automobiles, food/drink, sports, travel, agriculture, business concepts, industry, medicine, political, technology/computers. Interested in fashion/glamour, fine art, seasonal.

SPECS Accepts only digital images; see guidelines before submitting. Send via CD.

PAYMENT & TERMS "This is a small agency and we will, on occasion, go below stated minimum prices." Offers volume discounts to customers; terms specified in photographers' contracts. Works with photographers on contract basis only. Contracts renew automatically with additional submissions for 2 years. Statements issued monthly if requested. Payment made monthly. Photographers allowed to review account records. Offers one-time rights; negotiable depending on what the client needs and will pay for. Informs photographers and allows them to negotiate when client requests all rights. "This is rare for us. I would inform photographer of what the client wants and work with photographer to strike the best deal." Model/property release preferred. Photo captions required; include location, city, state, country, type of plant or animal, etc.

HOW TO CONTACT E-mail us your link to your website or link to view at least 100 of your photos. Call before you send anything that you want returned. Expects minimum initial submission of 100 images with periodic digital submissions of at least 100-250 images.

TIPS Photographers must be willing to build their file of images. "We need more people images, industry, lifestyles, wildlife, travel, etc. Scenics and landscapes must be outstanding to be considered. Please call or e-mail before submitting anything. We are taking on very few new photographers and only after we have reviewed their work."

IMAGES.DE FULFILLMENT

Potsdamer Str. 96, Berlin D-10785, Germany. +49(0)30-2579 28980. **Fax:** +49(0)30-2579 28999. **E-mail:** info@images.de. **Website:** www.images.de. Estab. 1997. News/feature syndicate. Has 50,000 photos in files. Clients include: advertising agencies, newspapers, public relations firms, book publishers, magazine publishers. "We are a service company with 10 years experience on the picture market. We offer fulfillment services to picture agencies, including translation, distribution into Fotofiner and APIS picturemaxx, customer communication, invoicing, media control, cash delivery, and usage control."

NEEDS Photos of babies/children/teens, couples, multicultural, families, parents, senior citizens, environment, entertainment, events, food/drink, health/fitness, hobbies, travel, agriculture, business concepts, industry, medicine, political, science, technology/computers.

SPECS Accepts images in digital format. Send via FTP, CD.

PAYMENT & TERMS Pays 50% commission for b&w photos; 50% for color photos. Average price per image (to clients): $50-1,000 for b&w photos or color photos. Offers volume discounts to customers. Discount sales terms not negotiable. Works with photographers with or without a contract; negotiable. Offers limited regional exclusivity. Statements issued monthly. Payment made monthly. Photographers allowed to review account records in cases of discrepancies only. Offers one-time rights, electronic media rights. Informs photographers and allows them to negotiate when client requests all rights. Model release preferred; property release required. Photo captions required.

HOW TO CONTACT Send query letter with CD or link to website. Expects minimum initial submission of 100 images.

THE IMAGE WORKS

P.O. Box 443, Woodstock NY 12498. (845)679-8500 or (800)475-8801. **Fax:** (845)679-0606. **E-mail:** info@theimageworks.com. **E-mail:** mark@theimageworks.com. **Website:** www.theimageworks.com. **Contact:** Mark Antman, president. Estab. 1983. Stock photo agency. Member of Picture Archive Council of America (PACA). Has over 1 million photos in files. Clients include: ad agencies, book/encyclopedia publishers, magazine publishers, newspapers, postcard publishers, greeting card companies, documentary video.

NEEDS "We are always looking for excellent documentary photography. Our prime subjects are people-related subjects like family, education, health care, workplace issues, worldwide historical, technology, fine arts."

SPECS All images must be in digital format; contact for digital guidelines. Rarely accepts 35mm, 2¼×2¼ transparencies and prints.

PAYMENT & TERMS Works with photographers on contract basis only. Offers nonexclusive contract. Statements issued monthly. Payments made monthly. Photographers allowed to review account records to verify sales figures by appointment. Offers one-time, agency promotion and electronic media rights. Informs photographers and allows them to negotiate when clients request all rights. Model release preferred. Photo captions required.

HOW TO CONTACT Send e-mail with description of stock photo archives. Expects minimum initial submission of 500 images.

TIPS "The Image Works was one of the first agencies to market images digitally. All digital images from photographers must be of reproduction quality. When making a new submission to us, be sure to include a variety of images that show your range as a photographer. We also want to see some depth in specialized subject areas. Thorough captions are a must. We will not look at uncaptioned images. Write or call first."

INMAGINE

315 Montgomery St., San Francisco CA 94104. (832)632-9299(800)810-3888. **Fax:** (866)998-8383. **E-mail:** photo@inmagine.com. **Website:** www.inmagine.com. Estab. 2000. Stock agency, picture library. Member of the Picture Archive Council of America (PACA). Has 6 million photos in files. Branch offices in USA Hong Kong, Australia, Malaysia, Thailand, United Arab Emirates, Singapore, Indonesia, and China. Clients include: advertising agencies, businesses, newspapers, public relations firms, magazine publishers.

NEEDS Photos of babies, children, teens, couples, multicultural, families, parents, education, business concepts, industry, medicine, environmental and landscapes, adventure, entertainment, events, food and drink, health, fitness, beauty, hobbies, sports, travel, fashion/glamour, and lifestyle.

SPECS Accepts images in digital format. Submit online via submission.inmagine.com or send JPEG files at 300 dpi.

PAYMENT & TERMS Pays 50% commission for color photos. Average price per image (to clients): $100 minimum, maximum negotiable. Negotiates fees below stated minimums. Offers volume discounts to customers, terms specified in photographers' contracts. Works with photographers on a contract basis only. Offers nonexclusive contract. Payments made monthly. Photographers are allowed to view account records in cases of discrepancies only. Offers one-time rights. Model and property release required. Photo caption required.

HOW TO CONTACT Contact through website. Expects minimum initial submission of 5 images. Responds in 1 week to samples. Photo guidelines available online.

TIPS "Complete the steps as outlined in the IRIS submission pages. E-mail us if there are queries. Send only the best of your portfolio for submission, stock-oriented materials only. EXIF should reside in file with keywords and captions."

INTERNATIONAL PHOTO NEWS

2902 29th Way, West Palm Beach FL 33407. (561)683-9090. **E-mail:** jay@jaykravetz.com. **Contact:** Jay Kravetz, photo editor. News/feature syndicate. Has 50,000 photos in files. Clients include: newspapers, magazines, book publishers. Previous/current clients include: newspapers that need celebrity photos with story.

NEEDS Photos of celebrities, entertainment, events, health/fitness/beauty, performing arts, travel, politics, movies, music and television, at work or play. Interested in avant garde, fashion/glamour.

SPECS Accepts images in digital format. Send via CD, ZIP, e-mail as TIFF, JPEG files at 300 dpi. Uses 5×7, 8×10 glossy b&w prints.

PAYMENT & TERMS Pays $10 for b&w photos; $25 for color photos; 5-10% commission. Average price per image (to clients): $25-100 for b&w photos; $50-500 for color photos. Works with photographers on contract basis only. Offers nonexclusive contract. Contracts renew automatically with additional submissions; 1-year renewal. Photographers allowed to review account records. Statements issued monthly. Payment made monthly. Offers one-time rights. Model/property release preferred. Photo captions required.

HOW TO CONTACT Send query letter with résumé of credits. Solicits photos by assignment only. Responds in 1 week.

TIPS "We use celebrity photographs to coincide with our syndicated columns. Must be approved by the celebrity."

THE IRISH IMAGE COLLECTION

#101, 10464 - 176 St., Edmonton AB T5S 1L3, Canada. (780)447-5433. **E-mail:** kristi@theirishimagecollection.com. **Website:** www.theirishimagecollection.ie. **Contact:** Kristi Bennell, office manager. Stock photo agency and picture library. Has 50,000+ photos in files. Clients include: advertising agencies, public relations firms, businesses, book/encyclopedia publishers, magazine publishers, newspapers and designers.

NEEDS Consideration is given only to Irish or Irish-connected subjects.

SPECS Uses 35mm and all medium-format transparencies.

PAYMENT & TERMS Pays 40% commission for color photos. Average price per image (to client): $85-2,000. Works on contract basis only. Offers exclusive contracts and limited regional exclusivity. Contracts renew automatically with additional submissions. Statements issued quarterly. Payment made quarterly. Photographers allowed to review account records. Offers one-time and electronic media rights. Informs photographer when client requests all rights, but "we take care of negotiations." Model release required. Photo captions required.

HOW TO CONTACT Send query letter with list of stock photo subjects. Does not return unsolicited material. Expects minimum initial submission of 250 transparencies; 1,000 images annually. "A return shipping fee is required: important that all similars are submitted together. We keep our contributor numbers down and the quantity and quality of submissions high. Send for information first by e-mail."

TIPS "Our market is Ireland and the rest of the world. However, our continued sales of Irish-oriented pictures need to be kept supplied. Pictures of Irish-Americans in Irish bars, folk singing, Irish dancing, in Ireland or anywhere else would prove to be useful. They would be required to be beautifully lit, carefully composed with attractive, model-released people."

THE IRISH PICTURE LIBRARY

69b Heather Rd., Sandyford Industrial Estate, Dublin 18, Ireland. (353)1295 0799. **Fax:** (353)1295 0705. **E-mail:** info@davison.com. **E-mail:** ipl@davisonphoto.com. **Website:** www.davisonphoto.com/ipl. Estab. 1990. Picture library. Has 60,000+ photos in files. Clients include: advertising agencies, businesses, book publishers, magazine publishers, newspapers, calendar companies.

NEEDS Photos of historic Irish material. Interested in alternative process, fine art, historical/vintage.

SPECS Uses any prints. Accepts images in digital format. Send via CD as TIFF, JPEG files at 400 dpi.

PAYMENT & TERMS Enforces minimum prices. Offers volume discounts to customers. Photographers can choose not to sell images on discount terms. Works with photographers on contract basis only. Statements issued quarterly. Payment made quarterly. Photographers allowed to review account records. Offers one-time rights, electronic media rights. Property release required. Photo captions required.

HOW TO CONTACT Send query letter with photocopies. Does not keep samples on file; include SAE/IRC for return of material.

ISOPIX

Werkhuizenstraat 7-9 Rue des Ateliers, Brussel-Bruxelles 1080, Belgium. 32 2 420 30 50. **Fax:** 32 2 420 41 22. **E-mail:** isopix@isopix.be. **Website:** www.isopix.be. Estab. 1984. News/feature syndicate. Has 2.5 million photos on website, including press (celebrities, royalty, portraits, news sports, archival), stock (contemporary and creative photography) and royalty-free. Clients include: advertising agencies, public relations firms, businesses, book publishers, magazine publishers, newspapers, calendar companies, postcard publishers.

NEEDS Photos of teens, celebrities, couples, families, parents, senior citizens, disasters, environmental, landscapes/scenics, wildlife, education, religious, events, food/drink, health/fitness, hobbies, humor, agriculture, business concepts, industry, medicine, science, technology/computers. Interested in alter-

native process, avant garde, documentary, fashion/glamour, fine art, historical/vintage, seasonal.

SPECS Accepts images in digital format; JPEG files only.

PAYMENT & TERMS Enforces strict minimum prices. Works with photographers with or without a contract; negotiable. Offers limited regional exclusivity. Contracts renew automatically with additional submissions. Statements issued monthly. Payment made monthly. Photographers allowed to review account records in cases of discrepancies only. Model/property release preferred. Photo captions required.

HOW TO CONTACT Contact through rep. Does not keep samples on file; include SAE/IRC for return of material. Expects minimum initial submission of 1,000 images with quarterly submissions of at least 500 images.

🌑 ISRAELIMAGES.COM

POB 60, Kammon 20112, Israel. (972)3-6320374. **Fax:** 972-153-4-9082023. **E-mail:** israel@israelimages.com; info@israelimages.com. **Website:** www.israelimages.com. **Contact:** Israel Talby, managing director. Estab. 1991. Has 650,000 photos in files. Clients include: advertising agencies, web designers, businesses, book publishers, magazine publishers, newspapers, calendar companies, greeting card and postcard publishers, multimedia producers, schools and universities, etc.

NEEDS "We are interested in everything about Israel, Judaism (worldwide) and The Holy Land."

SPECS Uses digital material only, minimum accepted size 2000×3000 pixels. Simply upload your pictures directly to the site. "When accepted, we need TIFF or JPEG files at 300 dpi, RGB, saved at quality '11' in Photoshop."

PAYMENT & TERMS Average price per image (to clients): $50-3,000/picture. Negotiates fees below standard minimum against considerable volume that justifies it. Offers volume discounts to customers. Works with photographers on contract basis only. Offers limited regional exclusivity, nonexclusive contract. Contracts renew automatically with additional submissions. Sales reports are displayed on the site at the Contributor's personal account. Payments are constantly made. Photographers allowed to review account records. Offers one-time rights, electronic media rights, agency promotion rights. Informs photographers and allows them to negotiate when a client requests all rights. Model/property release preferred. Photo captions required (what, who, when, where).

HOW TO CONTACT E-mail any query to: Israel@israelimages.com. No minimum submission. Responds within 1-2 days.

TIPS "We strongly encourage everyone to send us images to review. When sending material, a strong edit is a must. We don't like to get 100 pictures with 50 similars. Last, don't overload our e-mail with submissions. Make an e-mail query, or better yet, view our submission guidelines on the website. Good luck and welcome!"

🌑 JAYTRAVELPHOTOS

7A Napier Rd., Wembley, Middlesex HA0 4UA United Kingdom. (44)(208)795-3581. **Fax:** (44)(202)975-4083. **E-mail:** jaytravelphotos@aol.com. **Website:** www.jaytravelphotos.com. **Contact:** Rohith or Franco, partners. Estab. 1992. Stock photo agency and picture library. Has 250,000 photos in files. Clients include: advertising agencies, businesses, book/encyclopedia publishers, magazine publishers, newspapers, postcard publishers, tour operators/travel companies.

NEEDS Travel and tourism-related images worldwide.

SPECS Accepts digital, minimum 12 megapixel SLR (see website for guidelines). Uses 35mm up to 6×7cm original transparencies.

PAYMENT & TERMS Pays 60% commission for digital images and 50% for transparencies. Average price per image (to clients): $125-1,000. Enforces minimum prices of $125, "but negotiable on quantity purchases." Offers volume discounts to customers; inquire about specific terms. Discount sales terms not negotiable. Works with photographers on contract basis only. Offers limited regional exclusivity contract. Statements issued quarterly. Payment made quarterly, within 30 days of payment received from client. Offers one-time and exclusive rights for fixed periods. Does not inform photographers or allow them to negotiate when client requests all rights. Model/property release preferred. Photo captions required; include country, city/location, subject description.

HOW TO CONTACT Send e-mail with stock list, or call. Expects a minimum initial submission of 300 images with quarterly submissions of at least 100 images. Responds in 3 weeks.

TIPS "Study our guidelines on our website on what to submit. If you're planning a photo shoot anywhere,

you need to give us an itinerary, with as much detail as possible, so we can brief you on what kind of pictures the library may need."

JEROBOAM

120 27th St., San Francisco CA 94110. (415)312-0198. **E-mail:** jeroboamster@gmail.com. **Contact:** Ellen Bunning, owner. Estab. 1972. Has 200,000 b&w photos, 200,000 color slides in files. Clients include: text and trade book, magazine and encyclopedia publishers, editorial (mostly textbooks), greeting cards, and calendars.

NEEDS "We want people interacting, relating photos, comic, artistic/documentary/photojournalistic images, especially ethnic and handicapped. Images must have excellent print quality—contextually interesting and exciting and artistically stimulating." Photos of babies/children/teens, couples, multicultural, families, parents, senior citizens, disasters, environmental, cities/urban, education, gardening, pets, religious, rural, adventure, health/fitness, humor, performing arts, sports, travel, agriculture, industry, medicine, military, political, science, technology/computers. Interested in documentary, historical/vintage, seasonal. Needs shots of school, family, career and other living situations. Child development, growth and therapy, medical situations. No nature or studio shots.

SPECS Uses 35mm transparencies.

PAYMENT & TERMS Works on consignment only; pays 50% commission. Average price per image (to clients): $150 minimum for b&w and color photos. Works with photographers without a signed contract. Statements issued monthly. Payment made monthly. Photographers allowed to review account records to verify sales figures. Offers one-time and electronic media rights. Informs photographers and allows them to negotiate when client requests all rights. Model/property release preferred for people in contexts of special education, sexuality, etc. Photo captions preferred; include "age of subject, location, etc."

HOW TO CONTACT "Call if in the Bay Area; if not, query with samples and list of stock photo subjects; send material by mail for consideration or submit portfolio for review. Let us know how long you've been shooting." Responds in 2 weeks.

TIPS "The Jeroboam photographers have shot professionally a minimum of 5 years, have experienced some success in marketing their talent, and care about their craft excellence and their own creative vision. New

trends are toward more intimate, action shots; more ethnic images needed."

KIMBALL STOCK

1960 Colony St., Mountain View CA 94043. (650)969-0682; (888)562-5522. **Fax:** (650)969-0485. **E-mail:** sales@kimballstock.com. **E-mail:** submissions@kimballstock.com. **Website:** www.kimballstock.com. Estab. 1970. Has 1 million photos in files. Clients include: advertising agencies, businesses, newspapers, postcard publishers, public relations firms, book publishers, calendar companies, magazine publishers, greeting card companies. "Kimball Stock strives to provide automotive and animal photographers with the best medium possible to sell their images. In addition, we work to give every photographer a safe, reliable, and pleasant experience."

NEEDS Photos of dogs, cats, lifestyle with cars and domestic animals, landscapes/scenics, wildlife (outside of North America). Interested in seasonal.

SPECS Prefers images in digital format, minimum of 12-megapixel digital camera, although 16-megapixel is preferred. Send via e-mail as JPEG files or send CD to mailing address. Uses 35mm, 120mm, 4×5 transparencies.

PAYMENT & TERMS Works with photographers with a contract; negotiable. Offers nonexclusive contract. Statements issued quarterly. Payments made quarterly. Photographers allowed to review account records. Offers one-time rights, electronic media rights. Model/property release required. Photo captions required.

HOW TO CONTACT Send query letter with transparencies, digital files, stock list. Provide self-promotion piece to be kept on file. Please limit your initial submission to no more than 200 images (with at least 100 images) showing the range and variety of your work. Responds only if interested in 5-6 weeks or 3 months during busy seasons; send nonreturnable samples. Photo guidelines available online at www.kimballstock.com/submissions.asp.

⊕ JOAN KRAMER AND ASSOCIATES, INC.

10490 Wilshire Blvd., Suite 1701, Los Angeles CA 90024. (310)446-1866. **Fax:** (310)446-1856. **E-mail:** ekeeeek@earthlink.net. **Website:** www.erwinkramer.com. Joan Kramer, president. **Contact:** Erwin Kramer. Member of Picture Archive Council of America (PACA). Has 1 million photos in files. Clients include: ad agencies, magazines, recording companies, photo

researchers, book publishers, greeting card companies, promotional companies, AV producers.

NEEDS "We use any and all subjects! Stock slides must be of professional quality." Subjects on file include travel, cities, personalities, animals, flowers, lifestyles, underwater, scenics, sports and couples.

SPECS Uses 8×10 glossy b&w prints; any size transparencies.

PAYMENT & TERMS Pays 50% commission. Offers all rights. Model release required.

HOW TO CONTACT Send query letter or call to arrange an appointment. Do not send photos before calling.

🌑 LAND OF THE BIBLE PHOTO ARCHIVE

P.O. Box 8441, Jerusalem 91084, Israel. (972)(2)566-2167. **Fax:** (972)(2)566-3451. **E-mail:** radovan@net vision.net.il. **Website:** www.biblelandpictures.com. **Contact:** Zev Radovan. Estab. 1975. Picture library. Has 50,000 photos in files. Clients include: book publishers, magazine publishers, newspapers, calendar companies, postcard publishers.

NEEDS Photos of museum objects, archaeological sites. Also multicultural, landscapes/scenics, architecture, religious, travel. Interested in documentary, fine art, historical/vintage.

SPECS Uses high-res digital system.

PAYMENT & TERMS Average price per image (to clients): $80-700 for b&w, color photos. Offers volume discounts to customers; terms specified in photographers' contracts.

TIPS "Our archives contain tens of thousands of color slides covering a wide range of subjects: historical and archaeological sites, aerial and close-up views, museum objects, mosaics, coins, inscriptions, the myriad ethnic and religious groups individually portrayed in their daily activities, colorful ceremonies, etc. Upon request, we accept assignments for in-field photography."

🌑 LATITUDE STOCK

14 High St., Goring-on-Thames, Reading Berkshire RG8 9AR, United Kingdom. 44 (0)1491 873011. **Fax:** 44 (0)1491 875558. **E-mail:** info@latitudestock.com. **Website:** www.latitudestock.com. Has over 115,000 photos in files. Clients include: advertising agencies, businesses, newspapers, public relations firms, book publishers, calendar companies, audiovisual firms, magazine publishers, greeting card companies.

NEEDS Photos of multicultural, environmental, landscapes/scenics, wildlife, architecture, cities/urban, gardening, religious, rural, adventure, events, food/drink, health/fitness/beauty, hobbies, sports, travel.

SPECS Uses 35mm and medium-format transparencies. Accepts images in digital format. See website for details.

PAYMENT & TERMS Pays on a commission basis. Enforces minimum prices. Offers volume discounts to customers. Works with photographers on contract basis only. Offers exclusive contract only. Statements issued quarterly. Payment made quarterly. Photographers allowed to review account records. Offers one-time rights. Model/property release required. Photo captions required.

HOW TO CONTACT "Please e-mail first."

🌑 LEBRECHT PHOTO LIBRARY

3 Bolton Rd., London NW8 0RJ, United Kingdom. **E-mail:** pictures@lebrecht.co.uk. **Website:** www.lebrecht.co.uk. **Contact:** Ms. E. Lebrecht. Estab. 1992. Picture library has 120,000 high-res images online; thousands more not yet scanned. Clients include: advertising agencies, newspapers, public relations firms, book publishers, calendar companies, magazine publishers, greeting card companies.

NEEDS Photos of arts personalities, performing arts, instruments, musicians, dance (ballet, contemporary and folk), orchestras, opera, concert halls, jazz, blues, rock, authors, artists, theater, comedy, art, writers, historians, plays, playwrights, philosophers, etc. Interested in historical/vintage.

SPECS Accepts images in digital format only.

PAYMENT & TERMS Pays 50% commission for b&w and color photos. Offers volume discounts to customers. Works with photographers on contract basis only. Offers limited regional exclusivity. Statements issued quarterly. Offers one-time rights. Informs photographers and allows them to negotiate when a client requests all rights. Model release preferred. Photo captions required; include who is in photo, location, date.

HOW TO CONTACT Send e-mail.

LIGHTWAVE PHOTOGRAPHY

(781)354-7747. **E-mail:** paul@lightwavephoto.com. **Website:** www.lightwavephoto.com. **Contact:** Paul Light. Has 250,000 photos in files. Clients include: advertising agencies, textbook publishers.

NEEDS Candid photos of people in school, work and leisure activities, lifestyle.

SPECS Uses digital photographs.

PAYMENT & TERMS Pays $210/photo; 50% commission. Works with photographers on contract basis only. Offers nonexclusive contract. Contracts renew automatically each year. Statements issued annually. Payments made "after each usage." Offers one-time rights. Informs photographers and allows them to negotiate when client requests all rights. Model/property release preferred. Photo captions preferred.

HOW TO CONTACT "Create a small website and send us the URL."

TIPS "Photographers should enjoy photographing people in everyday activities. Work should be carefully edited before submission. Shoot constantly and watch what is being published. We are looking for photographers who can photograph daily life with compassion and originality."

🌍 LINEAIR FOTOARCHIEF BV

Rapopseweg 66, Arnhem 6824DT, Netherlands. (31) (26)4456713. **E-mail:** info@lineairfoto.nl. **Website:** www.lineairfoto.nl. **Contact:** Ron Giling, manager. Estab. 1990. Stock photo agency and since 2001 also an image-research department as service to publishers and other customers. Has nearly 2 million downloadable images available through the website. Clients include advertising agencies, public relations firms, book/encyclopedia publishers, magazine publishers. Library specializes in images from Asia, Africa, Latin America, Eastern Europe and nature in all forms on all continents. Member of WEA a group of international libraries that use the same server to market each other's images, uploading only once.

NEEDS Photos of disasters, environment, landscapes/scenics, wildlife, cities/urban, education, religious, adventure, travel, agriculture, business concepts, industry, political, science, technology/computers, health, education. Interested in everything that has to do with the development of countries all over the world, especially in Asia, Africa and Latin America.

SPECS Accepts images in digital format only. Send via CD, DVD (or use our FTP) as high-quality JPEG files at 300 dpi. "Photo files need to have IPTC information!"

PAYMENT & TERMS Pays 50% commission. Average price per image (to clients): $100-500. Enforces minimum prices. Offers volume discounts to customers; inquire about specific terms. Photographers can choose not to sell images on discount terms. Works with or without a signed contract; negotiable. Offers limited regional exclusivity. Statements issued quarterly. Payments made quarterly. Photographers allowed to review account records. "They can review bills to clients involved." Offers one-time rights. Informs photographers and allows them to negotiate when client requests all rights. Photo captions required; include country, city or region, description of the image.

HOW TO CONTACT Submit portfolio or e-mail thumbnails (20KB files) for review. There is no minimum for initial submissions. Responds in 3 weeks. Market tips sheet available upon request. View website to seesubject matter and quality.

TIPS "We like to see high-quality pictures in all aspects of photography. So we'd rather see 50 good ones than 500 for us to select the 50 out of. Send contact sheets upon our request. We will mark the selected pictures for you to send as high-res, including the very important IPTC (caption and keywords)."

LIVED IN IMAGES

1401 N. El Camino Real, Suite 203, San Clemente CA 92672. (949)361-3959. **Fax:** (949)492-1370. **E-mail:** jonathan@livedinimages.com. **Website:** www.lived inimages.com. **Contact:** Jonathan Thomas, president. Estab. 2004. Stock agency and news/feature syndicate. Member of the Picture Archive Council of America. Has 500,000+ photos on file. Clients include: advertising agencies, businesses, book publishers, magazine publishers, newspapers.

SPECS Accepts images in digital format. Send via CD, ZIP as TIFF or JPEG files at 300 dpi.

PAYMENT & TERMS Pays 50% commission for b&w photos; 50% for color photos; 50% for film; 50% for video. Offers volume discount to customers. Discount sales terms not negotiable. Works with photographers on contract basis only. Offers exclusive contract. Statements issued monthly. Payment made monthly. Photographers allowed to review account records. Offers one-time rights, electronic media and agency promotion rights. Model/property release required.

HOW TO CONTACT E-mail query letter with link to photographer's website. Samples not kept on file. Materials cannot be returned. Expects minimum initial submission of 100 images with monthly sub-

missions of at least 50 images. Photo guidelines available online. Market tips sheet distributed monthly to contributors under contract (also available online or free via e-mail).

TIPS "Think about your submission and why you are submitting to the agency. Who is the end user? We receive a great deal of work that has absolutely no value. Also, continue to submit! To make a decent monthly income, photographers need to continually submit their work. It's a numbers game. The more you have, the better you will do!"

🌀 LONELY PLANET IMAGES

Getty Images, 150 Linden St., Oakland CA 94607. (510)250-6400; (800)275-8555. **Fax:** (510)893-8572. **Website:** www.lonelyplanetimages.com; www.lonelyplanet.com. International stock photo agency with offices in Oakland, London and Footscray (outside Melbourne). Clients include: advertising agencies, public relations firms, book/encyclopedia publishers, magazine publishers, newspapers, calendar companies, greeting card companies, design firms.

NEEDS Photos of international travel destinations.

SPECS Uses original color transparencies in all formats; digital images from 10-megapixel and higher DSLRs.

PAYMENT & TERMS Pays 40% commission. Works with photographers on contract basis only. Offers image exclusive contract. Contract renews automatically. Model/property release preferred. Photo captions required.

HOW TO CONTACT Download submission guidelines from website—click on "work for us" at the bottom of www.lonelyplanet.com page.

TIPS "Photographers must be technically proficient, productive, and show interest and involvement in their work."

◐ 🌀 LONE PINE PHOTO

22 Robinson Crescent, Saskatoon SK S7L 6N9, Canada. (306)683-0889. **Fax:** (306)384-5811. **E-mail:** lonepinephoto@shaw.ca. **Website:** www.lonepinephoto.ca. **Contact:** Clarence W. Norris. Estab. 1991. "Photo stock agency specializing in well-edited images of Canada. Our library consists of: 60,000+ 35mm slides, 20,000+ digital images. All images are rights managed. A licensing fee is required for the use of all of our images. All images provided are copyrighted to the photographers that we represent. We have updated our website on which clients may browse through a variety of galleries. Each gallery bears a gallery description summarizing the contents and useful search tips. Full caption information is displayed. Click on a thumbnail for larger image and more image info. Keywords allow clients to refine their searches."

SPECS "We are seeking stock photographers who have the following attributes: Excellent technical and creative skills to produce top-quality images based on our submission guidelines, subject want lists and on their specific photographic interests and travels. The ability to carefully edit their own work and to send us only the very best with detailed captions. An existing image file to provide us with 500+ images to start. The time and resources to photograph regularly and to submit 500+ images annually for our review. The ability to work together as part of a team to develop a top-quality Canadian stock photo agency." All rights managed. Credit line.

LUCKYPIX

1132 West Fulton Market, Chicago IL 60607. (773)235-2000. **E-mail:** info@luckypix.com; mmoore@luckypix.com. **Website:** www.luckypix.com. **Contact:** Megan Moore. Estab. 2001. Stock agency. Has 9,000 photos in files (adding constantly). Clients include: advertising agencies, businesses, book publishers, design companies, magazine publishers.

NEEDS Outstanding people/lifestyle images.

SPECS 50+MB TIFFs, 300 dpi, 8-bit files. Photos for review: upload to website or e-mail info@luckypix.com. Final: CD/DVD as TIFF files.

PAYMENT & TERMS Enforces minimum prices. Offers exclusivity by image and similars. Contracts renew automatically annually. Statements and payments issued quarterly. Model/property release required.

HOW TO CONTACT Call or upload sample from website (preferred). Responds in 1 week. See website for guidelines.

TIPS "Have fun shooting. Search the archives before deciding what pictures to send."

◐ 🌀 🌀 MASTERFILE

3 Concorde Gate, 4th Floor, Toronto ON M3C 3N7, Canada. (800)387-9010. **E-mail:** info@masterfile.com. **E-mail:** swaspe@masterfile.com. **Website:** www.masterfile.com. General stock agency offering rights-managed and royalty-free images. The combined collection exceeds 2.5 million images online. Clients include: major advertising agencies, broad-

casters, graphic designers, public relations firms, book and magazine publishers, producers of greeting cards, calendars and packaging.

SPECS Accepts images in digital format only, in accordance with submission guidelines.

PAYMENT & TERMS Pays photographers 40% royalties of amounts received by Masterfile. Contributor terms outlined in photographer's contract, which is image-exclusive. Photographer sales statements and royalty payments issued monthly.

HOW TO CONTACT Refer to www.masterfile.com/info/artists/submissions.html for submission guidelines.

TIPS "Do not send transparencies or prints as a first-time submission. We also prefer not receiving discs. In order to view new work as efficiently as possible, we can only handle images submitted digitally, as follows: Submission methods: You can show us a sample in two ways: If you have a website, or are listed in a web-based visual directory, please send us your URL. You may e-mail us 20-30 of your best images following these guidelines: Images must be in RGB JPEG format. The overall file size of your e-mail cannot exceed 4MB. (Messages exceeding this size will be rejected by our mail server.) If we like what we see, you will be contacted by Artist Recruitment to submit additional work, and high resolution files for a technical review. Please note: we require images to be taken with a minimum 12 megapixel camera. Due to the large volume of submissions, we will contact only those artists we are interested in."

MICHELE MATTEI PHOTOGRAPHY

1714 Wilton Place, Los Angeles CA 90028. (323)462-6342. **Fax:** (323)462-7568. **E-mail:** michele@michelemattei.com. **Website:** michelemattei.net. **Contact:** Michele Mattei, director. Estab. 1974. Stock photo agency. Clients include: book/encyclopedia publishers, magazine publishers, television, film.

TIPS "Shots of celebrities and home/family stories are frequently requested." In samples, looking for "high-quality, recognizable personalities and current news-making material. We are interested mostly in celebrity photography. Written material on personality or event helps us to distribute material faster and more efficiently."

MAXX IMAGES, INC.

1433 Rupert St., Suite 3A North Vancouver BC V7J 1G1, Canada. (604)985-2560. **Fax:** (604)985-2590.

E-mail: newsubmissions@maxximages.com; info@maxximages.com. **Website:** www.maxximages.com. **Contact:** Dave Maquignaz, president. Estab. 1994. Stock agency. Member of the Picture Archive Council of America (PACA). Has 16 million images online. Has 40,000+ video clips. Clients include: advertising agencies, public relation firms, audiovisual firms, businesses, book publishers, magazine publishers, newspapers, calendar companies, postcard publishers, video production, graphic design studios.

NEEDS Photos of people, lifestyle, business, recreation, leisure.

SPECS Uses all formats.

HOW TO CONTACT Send e-mail. Review submission guidelines on website prior to contact.

THE MEDICAL FILE INC.

279 E. 44th St., 21st Floor, New York NY 10017. (212)883-0820 or (917)215-6301. **E-mail:** themedicalfile@gmail.com. **Website:** www.themedicalfile.com. **Contact:** Barbara Gottlieb, president. Estab. 2005. Clients include: advertising agencies, public relations firms, businesses, book/encyclopedia publishers, magazine publishers, postcard companies, calendar companies, greeting card companies.

NEEDS Any medically related imagery including fitness and food in relation to health care.

SPECS Accepts digital format images only on CD or DVD. Images can be downloaded to FTP site.

PAYMENT & TERMS Average price per image (for clients): $250 and up. Accepted work will be distributed through our partner agents worldwide. Works on exclusive and nonexclusive contract basis. Contracts renew automatically with each submission for length of original contract. Payments made quarterly. Offers one-time rights. Informs photographers when clients request all rights or exclusivity. Model release required. Photo captions required.

HOW TO CONTACT Arrange a personal interview to show portfolio. Submit portfolio for review. Tips sheet distributed as needed to contract photographers only.

TIPS Wants to see a cross-section of images for style and subject. "Photographers should not photograph people *before* getting a model release. The day of the 'grab shot' is over."

MEDISCAN

2nd Floor Patman House, 23-27 Electric Parade, George Lane South Woodford, London E18 2LS, United Kingdom. 44(0)20 8530 7589. **Fax:** 44(0)20 8989

7795. **E-mail:** info@mediscan.co.uk. **Website:** www.mediscan.co.uk. Estab. 2001. Picture library. Has over 1 million photos and over 2,000 hours of film/video footage on file. Subject matter includes medical personnel and environment, diseases and medical conditions, surgical procedures, microscopic, scientific, ultrasound/CT/MRI scans and x-rays. Online catalog on website. Clients include: advertising and design agencies, business-to-business, newspapers, public relations, book and magazine publishers in the health care, medical and science arenas.

NEEDS Photos of babies/children/teens/senior citizens; health/lifestyle/fitness/beauty; medicine, especially plastic surgery, rare medical conditions; model-released images; science, including microscopic imagery, botanical and natural history.

SPECS Accepts negatives; 35mm and medium format transparencies; digital images (make contact before submitting samples).

PAYMENT & TERMS Pays up to 50% commission. Statements issued quarterly. Payment made quarterly. Model/property release required, where necessary.

HOW TO CONTACT E-mail or call.

◎ MEGAPRESS IMAGES

1751 Richardson, Suite 2205, Montreal QC H3K 1G6, Canada. (514)279-9859. **Fax:** (514)279-9859. **E-mail:** info@megapress.ca. **Website:** www.megapress.ca. Estab. 1992. Stock photo agency. Has 500,000 photos in files. Has 2 branch offices. Clients include: book/encyclopedia publishers, magazine publishers, postcard publishers, calendar companies, greeting card companies, advertising agencies.

NEEDS Photos of people (babies/children/teens, couples, people at work, medical); animals including puppies in studio; industries; celebrities and general stock. Also needs families, parents, senior citizens, disasters, environmental, landscapes/scenics, wildlife, gardening, pets, religious, adventure, automobile, food/drink, health/fitness/beauty, sports, travel, business concepts, still life, science. "Looking only for the latest trends in photography and very high-quality images. A part of our market is Quebec's local French market."

SPECS Accepts images in digital format only. Send via CD, floppy disk, ZIP as JPEG files at 300 dpi.

PAYMENT & TERMS Pays 50% commission for color photos. Average price per image (to client): $100. Enforces minimum prices. Will not negotiate below $60. Works with photographers with or without a contract. Statements issued semiannually. Payments made semiannually. Offers one-time rights. Model release required for people and controversial news.

HOW TO CONTACT Submit link first by e-mail. "If interested, we'll get back to you." Does not keep samples on file; include SAE/IRC for return of material. Expects minimum initial submission of 250 images with periodic submission of at least 1,000 digital pictures per year. Make first contact by e-mail. Accepts digital submissions only.

TIPS "Pictures must be very sharp. Work must be consistent. We also like photographers who are specialized in particular subjects. We are always interested in Canadian content. Lots of our clients are based in Canada."

MIRA

716 Iron Post Rd., Moorestown NJ 08057. (856)231-0594. **E-mail:** mira@mira.com. **Website:** library.mira.com/gallery-list. "Mira is the stock photo agency of the Creative Eye, a photographers cooperative. Mira seeks premium rights-protected images and contributors who are committed to building the Mira archive into a first-choice buyer resource. Mira offers a broad and deep online collection where buyers can search, price, purchase and download on a 24/7 basis. Mira sales and research support are also available via phone and e-mail. "Our commitment to customer care is something we take very seriously and is a distinguishing trait." Client industries include: advertising, publishing, corporate, marketing, education.

NEEDS Mira features premium stock photo images depicting a wide variety of subjects including travel, Americana, business, underwater, food, landscape, cityscapes, lifestyle, education, wildlife, conceptual and adventure sports, among many others.

SPECS "We require you to use the enhanced version of the Online Captioning software or to embed your captions and keywords using the Photoshop File Info feature, or an application such as Extensis Portfolio 7 or iView MediaPro 2.6 to embed this info in the IPTC metadata fields. Please read over the Mira Keywording Guidelines (download PDF) before preparing your submission. For additional suggestions on Captioning and Keywording see the Metalogging section of the Controlled Vocabulary site."

HOW TO CONTACT "E-mail, call or visit our websites to learn more about participation in Mira."

TIPS "Review the submission guidelines completely. Failure to follow the submission guidelines will result in the return of your submission for appropriate corrections."

MPTV

16735 Saticoy St., Suite 109, Van Nuys CA 91406. (818)997-8292. **Fax:** (818)997-3998. **E-mail:** sales@mptvimages.com. **Website:** www.mptvimages.com. Estab. 1988. "Established over 20 years ago, mptv is a unique stock photo agency that is passionate about preserving the memory of some of the greatest legends of our time through the art of still photography. We offer one of the largest and continually expanding collections of entertainment photography in the world—images from Hollywood's Golden Age and all the way up to the present day. Our unbelievable collection includes some 1 million celebrity and entertainment-related images taken by more than 60 photographers from around the world. Many of these photographers are represented exclusively through mptv and can't be found anywhere else. While mptv is located in Los Angeles, our images are used worldwide and can be seen in galleries, magazines, books, advertising, online and in various products."

HOW TO CONTACT If interested in representation, send an e-mail to photographers@mptvimages.com.

NOVASTOCK

1306 Matthews Plantation Dr., Matthews NC 28105-2463. (888)894-8622. **Fax:** (704)841-8181. **E-mail:** Novastock@aol.com. **Website:** www.portfolios.com/novastock. **Contact:** Anne Clark, submission department. Estab. 1993. Stock agency. Clients include: advertising agencies, businesses, postcard publishers, public relations firms, book publishers, calendar companies, magazine publishers, greeting card companies, and large international network of subagents.

NEEDS "We need commercial stock subjects such as lifestyles, fitness, business, science, medical, family, etc. We also are looking for unique and unusual imagery. We have one photographer who burns, scratches and paints on his film." Wants photos of babies/children/teens, couples, multicultural, families, parents, senior citizens, disasters, environmental, wildlife, rural, adventure, health/fitness, travel, business concepts, military, science, technology/computers.

SPECS Prefers images in digital format as follows: (1) Original digital camera files. (2) Scanned images in the 30-50MB range. "When sending files for editing, please send small files only. Once we make our picks, you can supply larger files. Final large files should be JPEGs. *Never* sharpen or use contrast and saturation filters. Always flatten layers. Files and disks must be readable on Windows PC."

PAYMENT & TERMS Pays 50% commission for b&w and color photos. "We never charge the photographer for any expenses whatsoever." Works with photographers on contract basis only. "We need exclusivity only for images accepted, and similars." Photographer is allowed to market work not represented by Novastock. Statements and payments are made in the month following receipt of income from sales. Informs photographers and discusses with photographer when client requests all rights. Model/property release required. Photo captions required; include who, what and where. "Science and technology need detailed and accurate captions. Model releases must be cross-referenced with the appropriate images."

HOW TO CONTACT Contact by e-mail or send query letter with digital files, slides, tearsheets, transparencies.

TIPS "Digital files on CD/DVD are preferred. All images must be labeled with caption and marked with model release information and your name and copyright. We market agency material through more than 50 agencies in our international subagency network. The photographer is permitted to freely market non-similar work any way he/she wishes."

ONASIA

30 Cecil St., Prudential Tower Level 15, 049712, Singapore. (65)6232 2818. **Fax:** (66)2655 4682. **E-mail:** info@onasia.com. **E-mail:** sales@onasia.com. **Website:** www.onasia.com. **Contact:** Peter Charlesworth or Yvan Cohen, directors. An Asia-specialized agency offering rights-managed stock, features and assignment services. Represents over 180 photographers. Has over 180,000 high-res images available online and 400,000 photos in files. Offices in Singapore and Bangkok. Clients include: advertising and graphic design agencies, newspapers, magazines, book publishers, calendar and gift card companies.

NEEDS Model-released Asia-related conceptual, lifestyle and business imagery as well as a broad range of nonreleased editorial imagery including current affairs, historical collections, travel and leisure, economics as well as social and political trends. Please note: "We only accept images from or relating to Asia."

SPECS Accepts images in digital format. Send via CD or to our FTP site as 12×18 JPEG files at 300 dpi. All files must be retouched to remove dust and dirt. Photo captions required; include dates, location, country and a detailed description of image, including names where possible.

PAYMENT & TERMS Pays 50% commission to photographers. Terms specified in photographer contracts. Photographers are required to submit on an image-exclusive basis. Statements issued monthly.

HOW TO CONTACT E-mail queries with low-res JPEG samples or a link to photographer's website. Does not keep samples on file; cannot return material. Expects minimum initial submission of 150 images. Photo guidelines available via e-mail.

TIPS "Provide a well-edited low-res portfolio for initial evaluation. Ensure that subsequent submissions are tightly edited, sized to Onasia's specs, retouched and submitted with full captions."

ONREQUEST IMAGES

1415 Western Ave., Suite 300, Seattle WA 98101. **Website:** www.onrequestimages.com. "OnRequest Images is the leading provider of powerful, custom imagery and photo production services for the Global 2000. Having the world's largest photo production services network enables our clients to utilize the best fully vested resources the world has to offer, including photographers, stylists, locations and crews. Combined with OnPro™, our collaborative workflow system which underpins every detail of a production, OnRequest Images delivers brand-aligned, cost effective, fast photography solutions for marketers, brand leaders and creative teams. We have the talent, tenacity and technology to make things happen even on the grandest scale. OnRequest Images is headquartered in Seattle, with offices in New York, Chicago, Denver, Los Angeles, Miami, San Francisco, London, Paris and Barcelona."

NEEDS Photos of babies, multicultural, families, parents, senior citizens, environmental, landscapes/scenics, architecture, education, interiors/decorating, pets, rural, adventure, food/drink, health/fitness/beauty, travel, agriculture, business concepts, science, technology/computers. Interested in lifestyle, seasonal.

SPECS Accepts images in digital format as TIFF files at 300 dpi. Send via e-mail or upload.

PAYMENT & TERMS Offers volume discounts to customers; terms specified in photographers' contracts. Photographers can choose not to sell images on discount terms. Works with photographers on contract basis only. Offers nonexclusive contract; guaranteed subject exclusivity (within files). Statements issued quarterly. Payments made within 45 days. Rights offered depend on contract. Informs photographers and allows them to negotiate when a client requests all rights. Model release/property release required. Captions required.

HOW TO CONTACT E-mail query letter with link to photographer's website. Provide self-promotion piece to be kept on file. Expects minimum initial submission of 15 images. Photo guidelines sheet available.

TIPS "Be honest about what you specialize in."

🌎 OPÇÃO BRASIL IMAGENS

Rua Barata Ribeiro, No. 370 Gr. 215/216, Copacabana, Rio de Janeiro 22040-901, Brazil. 55 21 2256-9007. **Fax:** 55 21 2256-9007. **E-mail:** pesquisa@opcaobrasil.com.br. **Website:** www.opcaobrasil.com.br. Estab. 1993. Has 600,000+ photos in files. Clients include: advertising agencies, book publishers, magazine publishers, calendar companies, postcard publishers, publishing houses.

NEEDS Photos of babies/children/teens, couples, families, parents, wildlife, health/fitness, beauty, education, hobbies, sports, industry, medicine. "We need photos of wild animals, mostly from the Brazilian fauna. We are looking for photographers who have images of people who live in tropical countries and must be brunette."

SPECS Accepts images in digital format.

PAYMENT & TERMS Pays 50% commission for b&w or color photos. Negotiates fees below standard minimum prices only in cases of renting at least 20 images. Offers volume discounts to customers. Works with photographers on contract basis only. Offers limited regional exclusivity. Contracts renew automatically with additional submissions for 3 years. Charges $200/image for catalog insertion. Statements issued quarterly. Payment made quarterly. Photographers allowed to review account records in cases of discrepancies only. Offers one-time rights, electronic media rights, agency promotion rights. Model release required; property release preferred. Photo captions required.

HOW TO CONTACT Initial contact should be by e-mail or fax. Explain what kind of material you have. Provide business card, self-promotion piece to be kept on file. "If not interested, we return the samples." Expects minimum initial submission of 500 images with quarterly submissions of at least 300 images.

TIPS "We need creative photos presenting the unique look of the photographer on active and healthy people in everyday life at home, at work, etc., showing modern and up-to-date individuals. We are looking for photographers who have images of people with the characteristics of Latin American citizens."

● OUTDOORIA OUTDOOR IMAGE AGENCY

Valfiskengata 800, Haninge 13664, Sweden. 46 707833785. **E-mail:** info@outdooria.com. **E-mail:** contributor@outdooria.com. **Website:** www.outdooria.com. **Contact:** Patrik Lindqvist, CEO. Estab. 2009. Stock agency and picture library. Has over 6,500 photos on file. Clients include advertising agencies, businesses, newspapers, postcard publishers, public relations firms, book publishers, calendar companies, magazine publishers, and greeting card companies.

SPECS Model and property release preferred. Photo captions required.

PAYMENT & TERMS Does not offer volume discounts to customers. Works with photographers on a contract basis only. Agency contracts renew automatically with additional submissions.

HOW TO CONTACT E-mail query letter with link to photographer's website or JPEG samples at 72 dpi. Accepts images in digital format. Please send via CD, or ZIP as a TIFF or JPEG file. Expects minimum initial submission of 40 images. Responds in 1 week to samples and portfolios. Guidelines available online.

OUTSIDE IMAGERY LLC

Boulder CO 80301. (303)530-3357. **E-mail:** John@outsideimagery.com. **Website:** www.outsideimagery.com. **Contact:** John Kieffer, president. Estab. 1986. Outside Imagery has a new website featuring auto-downloads and payment, plus expanded print sales. Clients include: advertising agencies, businesses, multimedia, greeting card and postcard publishers, book publishers, graphic design firms, magazine publishers.

NEEDS Photos showing a diversity of people participating in an active and healthy lifestyle in natural and urban settings, plus landscapes and cityscapes. Photos of people enjoying the outdoors.

SPECS Requires images in high-res digital format. No film. Send low-res files via CD or e-mail in JPEG format at 72 dpi.

PAYMENT & TERMS Pays 50% commission for all imagery. Average price per image (to clients): $150-3,500 for all imagery. Will often work within a buyer's budget. Offers volume discounts to customers. Offers nonexclusive contract. Payments made quarterly. Model release required; property release preferred. Photo captions and keywords required.

HOW TO CONTACT "First review our website. Then send a query e-mail, and include a stock list or an active link to your website. If you don't hear from us in 3 weeks, send a reminder e-mail."

PACIFIC STOCK/PRINTSCAPES.COM

(808)394-5100. **Fax:** (780)451-8568. **E-mail:** info@pacificstock.com. **E-mail:** ashlee@pacificstock.com. **Website:** www.pacificstock.com. **Contact:** Ashlee Meyer, director of photographic production. Member of Picture Archive Council of America (PACA). Has 100,000 photos in files; 25,000 digital images online. "Pacific Stock specializes exclusively in imagery from throughout the Pacific, Asia and Hawaii." Clients include: advertising agencies, public relations firms, book/encyclopedia publishers, magazine publishers, postcard companies, calendar companies, greeting card companies. "Printscapes caters to the professional interior design market at our new fine art website, www.printscapes.com."

NEEDS Photos and fine art of Hawaii, Pacific Islands, and Asia. Subjects for both companies include: people (women, babies/children/teens, couples, multicultural, families, parents, senior citizens), culture, marine science, environmental, landscapes, wildlife, adventure, food/drink, health/fitness, sports, travel, agriculture, business concepts." We also have an extensive vintage Hawaii file as well as fine art throughout the Pacific Rim."

SPECS We accept images from specialized professional photographers in digital format only. Send via hard drive or DVD as 16-bit TIFF files (guidelines on website at www.pacificstock.com/photographer_guidelines.asp).

PAYMENT & TERMS Charges 60% commission. "If an image is licensed through one of our International Affiliates, you will receive 40 percent of the net amount collected by Pacific Stock, after the International Affiliate Agency retains its portion of the roy-

alty. Typically, the photographer will receive 20-24% of the International Affiliate Agent's gross sale price." Works with photographers and artists on contract basis only. Statements and payments issued monthly. Contributors allowed to review account records to verify sales figures. Offers one-time or first rights; additional rights with contributor's permission. Informs contributors and allows them to negotiate when client requests all rights. Model/property release required for all people and certain properties, e.g., homes and boats. Accurate and detailed photo captions required; include: "who, what, where." See submission guidelines for more details.

HOW TO CONTACT "E-mail or call us after reviewing our website and our photo guidelines. Want lists distributed regularly to represented photographers; free via e-mail to interested photographers."

TIPS "Photographers must be able to supply a minimum of 500 image files (must be model-released) for initial entry and must make quarterly submissions of fresh material from Hawaii, Pacific and Asia area destinations. Image files must be captioned in File Info (e.g., IPTC headers) according to our submission guidelines. Please contact us to discuss the types of imagery that sell well for us: www.pacificstock.com/contactus.asp. We are also looking for fine artists whose work is representative of Hawaii and the Pacific Rim. We are interested in working with contributors who work with us and enjoy supplying imagery requested by our valued clients."

PAINET INC.

P.O. Box 1223, 241 Tune Drive, El Prado NM 87529-1223. (701)484-1251. **E-mail:** painet@gondtc.com. **Website:** www.painetworks.com. Estab. 1985. Picture library. Has 875,000 digital photos in files. Painet is a stock photo agency that works mainly with advertising agencies, book publishers, photo researchers and graphic designers.

NEEDS "Anything and everything."

SPECS "Refer to www.painetworks.com/helppages/submit.htm for information on how to scan and submit images to Painet. The standard contract is also available from this page." We take a standard 40% agency commission and pay our photographers 60% upon sale, daily. You may view the individual contract and the agency contract by clicking the links online. Print out, complete and mail or e-mail to painet@gondtc.com, a copy of the contract when sending

your first submission. *Note: upload highest quality JPEGs only!* Images should open to 24MB, or more, in a graphics application, such as Photoshop. Due to bandwidth limitations, we no longer can support uploading of RAW or TIFF files. We have also changed our activation time period for new submissions to quarterly in lieu of weekly.

PAYMENT & TERMS Pays 60% commission (see contract). Works with photographers with or without a contract. Offers nonexclusive contract. Payment made immediately after a sale. Informs photographers and allows them to negotiate when client requests all rights. Provides buyer contact information to photographer by sending photographer copies of the original invoices on all orders of photographer's images.

HOW TO CONTACT "Occasionally receives a list of current photo requests."

TIPS "We have added an online search engine with 875,000 images. We welcome submissions from new photographers, since we add approximately 30,000 images quarterly. Painet markets color and b&w images electronically or by contact with the photographer. Because images and image descriptions are entered into a database from which searches are made, we encourage our photographers to include lengthy descriptions that improve the chances of finding their images during a database search. We prefer descriptions be included in the IPTC (File Info area of Photoshop)."

PANORAMIC IMAGES

2302 Main St., Evanston IL 60202. (847)324-7000 or (800)543-5250. **Fax:** (847)324-7004. **Website:** www.panoramicimages.com. Estab. 1987. Stock photo agency. Member of ASPP, NANPA and IAPP. Clients include: design firms, graphic designers, advertising agencies, corporate art consultants, postcard companies, magazine publishers, newspapers and calendar companies.

NEEDS Photos of landscapes/scenics, wildlife, architecture, cities/urban, cityscapes and skylines, gardens, rural, adventure, health/fitness, sports, travel, business concepts, industry, science, technology/computers. Interested in alternative process, avant garde, documentary, fine art, historical/vintage, seasonal. Works only with *panoramic formats* (2:1 aspect ratio or greater). Subjects include: cityscapes/skylines, international travel, nature, backgrounds, conceptual.

SPECS "E-mail for digital and film submission guidelines or see website."

PAYMENT & TERMS Pays 40% commission for photos. Average price per image (to clients): $300. No charge for scanning, metadata or inclusion on website. Statements issued quarterly. Payments made quarterly. Offers one-time, electronic rights and limited exclusive usage. Model release preferred "and property release, if necessary." Photo captions required. See website for submission guidelines before submitting.

HOW TO CONTACT Send e-mail with stock list or low-res scans/lightbox. Specific want lists created for contributing photographers. Photographer's work is represented on full e-commerce website and distributed worldwide through image distribution partnerships with Getty Images, National Geographic Society Image Collection, Amana, etc. See website for more detailed submission guidelines.

TIPS Wants to see "well-exposed chromes or very high-res stitched pans. Panoramic views of well-known locations nationwide and worldwide. Also, generic beauty panoramics."

PAPILIO

155 Station Rd., Herne Bay, Kent CT6 5QA United Kingdom. (44)(122)736-0996. **E-mail:** library@papiliophotos.com. **Website:** www.papiliophotos.com. **Contact:** Justine Pickett. Estab. 1984. Has 120,000 photos in files. Clients include: advertising agencies, book publishers, magazine publishers, newspapers, calendar companies, greeting card companies, postcard publishers.

NEEDS Photos of wildlife.

SPECS Prefers digital submissions. Uses digital shot in-camera as RAW and converted to TIFF for submission, minimum file size 17MB. See webpage for further details or contact for a full information sheet about shooting and supplying digital photos.

PAYMENT & TERMS Works with photographers on contract basis only. Offers nonexclusive contract. Statements issued quarterly. Payment made quarterly. Offers one-time rights, electronic media rights. Photo captions required; include Latin names and behavioral information and keywords.

HOW TO CONTACT Send query letter with résumé. Does not keep samples on file. Expects minimum initial submission of 150 images. Responds in 1 month to samples. Returns all unsuitable material with letter. Photo guidelines sheet free with SASE.

TIPS "Contact first for information about digital. Send digital submissions on either CD or DVD. Supply full caption listing for all images. Wildlife photography is very competitive. Photographers are advised to send only top-quality images."

PHOTO AGORA

3711 Hidden Meadow Ln., Keezletown VA 22832. (540)269-8283. **Fax:** (540)269-8283. **E-mail:** photoagora@aol.com. **Website:** www.photoagora.com. **Contact:** Robert Maust. Estab. 1972. Stock photo agency. Has over 65,000 photos in files. Clients include: businesses, book/encyclopedia and textbook publishers, magazine publishers, calendar companies.

NEEDS Photos of families, children, students, Virginia, Africa and other Third World areas, work situations, etc. Also needs babies/children/teens, couples, multicultural, parents, senior citizens, disasters, environmental, landscapes/scenics, wildlife, cities/urban, education, gardening, pets, religious, rural, health/fitness, travel, agriculture, industry, medicine, science, technology/computers.

SPECS Send high-res digital images. Ask for password to download agreement and submission guidelines from website.

PAYMENT & TERMS Pays 50% commission for b&w and color photos. Average price per image (to clients): $40 minimum for b&w photos; $100 minimum for color photos. Negotiates fees below standard minimum prices. Offers volume discounts to customers; inquire about specific terms. Photographers can choose not to sell images on discount terms. Works with photographers with or without a contract. Offers nonexclusive contract. Payment made quarterly. Photographers allowed to review account records. Offers one-time rights. Informs photographers and allows them to negotiate when client requests all rights. Model/property release preferred. Embedded photo captions required; include location, important dates, scientific names, etc.

HOW TO CONTACT Call, write or e-mail. No minimum number of images required in initial submission. Responds in 3 weeks. Photo guidelines free with SASE or download from website.

PHOTOEDIT, INC.

3505 Cadillac Ave., Suite P-101, Costa Mesa CA 92626. (800)860-2098. **Fax:** (800)804-3707. **E-mail:** photography@photoeditinc.com. **Website:** www.photoeditinc.com. Estab. 1987. Stock photo agency. Member

of Picture Archive Council of America (PACA). Has 600,000 photos. Clients include: textbook/encyclopedia publishers, magazine publishers, advertising agencies, government agencies. "PhotoEdit Inc. is a leading multi-ethnic and multicultural stock agency specializing in diverse, culturally relevant imagery. Whether our images are used commercially, or as positive education tools, we keep in mind all of our clients' unique needs when selecting images for our 100% digital rights-managed collection. Our images capture real life as it happens all over the globe. We're in search of photographers who have access to models of every ethnicity who will shoot actively and on spec."

SPECS Uses digital images only.

PAYMENT & TERMS Pays 40% commission for color images. Works on contract basis only. Offers non-exclusive contract. Payments and statements issued monthly. Model release preferred.

HOW TO CONTACT Submit digital portfolio for review. Photo guidelines available on website.

THE PHOTOLIBRARY GROUP

Getty Images, 75 Varick St., New York NY 10013. (646)613-4000; (800)462-4379. **Fax:** (212)633-1914. **E-mail:** sales@gettyimages.com. **Website:** www.gettyimages.com/photolibrary. "The Photolibrary Group represents the world's leading stock brands and the finest photographers around the world, to bring memorable, workable content to the creative communities in America, Europe, Asia, and the Pacific. We provide customers with access to over 5 million images and thousands of hours of footage and full composition music. The Photolibrary Group was founded in 1967 and, 40 years on has a global presence with offices in the United Kingdom (London), the USA (New York), Australia (Sydney and Melbourne), Singapore, India, Malaysia, the Philippines, Thailand, New Zealand and the United Arab Emirates. Photolibrary is always on the lookout for new and innovative photographers and footage producers. Due to the highly competitive market for stock imagery we are very selective about the types of work that we choose to take on. We specialize in high quality, creative imagery primarily orientated to advertising, business-to-business and the editorial and publishing markets. Interested contributors should go to the website and click on the Artists tab for submission information. For additional information regarding our house brands, follow the 'About Us' link."

PHOTOLIFE CORPORATION, LTD.

513 Hennessy Rd., 20/F Wellable Commercial Building, Causeway Bay, Hong Kong. (852)2808 0012. **Fax:** (852)3511 9002. **E-mail:** info@aimageworks.com. **Website:** www.photolife.com.hk. Estab. 1994. Stock photo library. Has over 1.6 million photos in files. Clients include: advertising agencies, newspapers, book publishers, calendar companies, magazine publishers, greeting card companies, corporations, production houses, graphic design firms.

NEEDS Contemporary images of architecture, interiors, garden, infrastructure, concepts, business, finance, sports, lifestyle, nature, travel, animal, marine life, foods, medical.

SPECS Accepts images in digital format only. "Use only professional digital cameras (capable of producing 24MB+ images) with high-quality interchangeable lenses; or images from high-end scanners producing a file up to 50 MB."

PAYMENT & TERMS Pays 50% commission for b&w and color photos. Average price per image (to clients): $105-1,550 for b&w photos; $105-10,000 for color photos. Offers volume discounts to customers; terms specified in photographers' contracts. Works with photographers on contract basis only. Contract can be initiated with minimum 300 selected images. Quarterly submissions needed. Informs photographers and allows them to negotiate when client requests all rights. Model release required; property release preferred. Photo captions required; include destination and country.

HOW TO CONTACT E-mail 50 low-res images (1,000 pixels or less), or send CD with 50 images.

TIPS "Visit our website. Edit your work tightly. Send images that can keep up with current trends in advertising and print photography."

PHOTO RESOURCE HAWAII

111 Hekili St., #41, Kailua HI 96734. (808)599-7773. **E-mail:** prh@photoresourcehawaii.com. **Website:** www.PhotoResourceHawaii.com. **Contact:** Tami Kauakea Winston, owner. Estab. 1983. Stock photo agency. Has e-commerce website with electronic delivery of over 16,000 images. Clients include: ad agencies, audiovisual firms, businesses, book/encyclopedia publishers, magazine publishers, calendar companies, greeting card companies, postcard publishers.

NEEDS Photos of Hawaii and the South Pacific.

SPECS Accepts images online only via website submission in digital format only; 48 MB or larger; JPEG files from RAW files preferred.

PAYMENT & TERMS Pays 40% commission. Enforces minimum prices. Offers volume discounts to customers. Discount sales terms not negotiable. Works with photographers on contract basis only. Offers nonexclusive contract. Contracts renew automatically with additional submissions. Statements issued bimonthly. Payment made bimonthly. Offers royalty-free and rights-managed images. Model/property release preferred. Photo captions and keywording online required.

HOW TO CONTACT Send query e-mail with samples. Expects minimum initial submission of 100 images with periodic submissions at least 3 times/year. Responds in 2 weeks. Offers photographer retreats in Hawaii to learn how to become a contributor and enjoy a healthy Hawaiian vacation.

PHOTOSOURCE INTERNATIONAL

Pine Lake Farm, 1910 35th Rd., Osceola WI 54020-5602. (715)248-3800. **E-mail:** info@photosource.com. **Website:** www.photosource.com. Estab. 1998. "We are the meeting place for photographers who want to sell their stock photos, and for editors and art directors who want to buy them. For more than 25 years we've been helping photographers and photo buyers from our world-wide connected electronic cottage on our farm in western Wisconsin."

⊙ SYLVIA PITCHER PHOTO LIBRARY

75 Bristol Rd., Forest Gate, London E7 8HG, United Kingdom. **E-mail:** SPphotolibrary@aol.com. **Website:** www.sylviapitcherphotos.com; www.bluesmusicphotolibrary.com. Estab. 1965. Picture library. Has 80,000 photos in files. Clients include: book publishers, magazine publishers, design consultants, record and TV companies.

NEEDS Photos of musicians—blues, country, bluegrass, old time and jazz with views of America suitable as background to this music. Also, other relevant subject matter such as recording studios, musicians' birth places, clubs, etc. Please see website for a good indication of the library's contents.

SPECS Accepts images in digital format.

PAYMENT & TERMS Pays 50% commission for b&w and color photos. Average fee per image (to clients): $100-1,000. Negotiates fees below stated minimum for budget CDs or multiple sale. Offers volume discounts

to customers; terms specified in photographers' contracts. Photographers can choose not to sell images on discount terms, if specified at time of depositing work in library. Offers nonexclusive contract. Photos should be deposited for a minimum of one year. Payment made on client's settlement of transaction. Offers one-time rights. Model/property release preferred. Photo captions required; include artist, place/venue, date taken.

HOW TO CONTACT Send query letter with CD of approximately 10 low-res sample images and stock list. Provide self-promotion piece to be kept on file. Minimum initial submission of 20 high-res images on CD with further submissions when available.

PIX INTERNATIONAL

(773)975-0158. **E-mail:** lmatlow@yahoo.com. **Website:** www.pixintl.com. **Contact:** Linda Matlow, president. Estab. 1978. Stock agency, news/feature syndicate. Has 200,000 photos in files. Clients include: advertising agencies, public relations firms, businesses, book publishers, magazine publishers, newspapers.

NEEDS Photos of celebrities, entertainment, performing arts.

SPECS Accepts images in digital format only. E-mail link to website. "Do not e-mail any images. Do not send any unsolicited digital files. Make contact first to see if we're interested."

PAYMENT & TERMS Enforces minimum prices. Offers volume discounts to customers; terms specified in photographers' contracts. Discount sales terms not negotiable. Works with photographers with or without a contract; negotiable. Statements issued monthly. Payments made monthly. Photographers allowed to review account records in cases of discrepancies only. Offers one-time rights. Informs photographers and allows them to negotiate when client requests all rights. Model release not required for general editorial. Photo captions required; include who, what, when, where, why.

HOW TO CONTACT "E-mail us your URL with thumbnail examples of your work that can be clicked for a larger viewable image." Responds in 2 weeks to samples, only if interested.

TIPS "We are looking for razor-sharp images that stand up on their own without needing a long caption. Let us know by e-mail what types of photos you have, your experience, and cameras used. We do not take images from the lower-end consumer cameras—

digital or film. They just don't look very good in publications. For photographers we do accept, we would only consider high-res 300 dpi at 6×9 or higher scans submitted on CD. Please direct us to samples on your website."

☻ PLANS, LTD. (PHOTO LIBRARIES AND NEWS SERVICES)

5-17-2 Inamura, Kamakura 248-0024, Japan. 81-467-31-0330. **Fax:** 81-467-31-0330. **E-mail:** yoshida@plans.jp. **Website:** www.plans.jp. **Contact:** Takashi Yoshida, president. Estab. 1982. Was a stock agency. Now representing JaincoTech as JaincoTech Japan as a joint project such as scanning, key wording, dust busting, or color correction for photographers in the stock photo market. Has 100,000 photos in files. Clients include: photo agencies, newspapers, book publishers, magazine publishers, advertising agencies.

NEEDS "We do consulting for photo agencies for the Japanese market."

HOW TO CONTACT Send query e-mail. Responds only if interested.

⟳ PONKAWONKA INC.

(416)638-2475. **E-mail:** contact@ponkawonka.com. **Website:** www.ponkawonka.com. Estab. 2002. Stock agency. Has 60,000+ photos in files. Clients include: advertising agencies, businesses, newspapers, public relations firms, book publishers, calendar companies, magazine publishers.

NEEDS Photos of religious events and holy places. Interested in avant garde, documentary, historical/vintage. "Interested in images of a religious or spiritual nature. Looking for photos of ritual, places of worship, families, religious leaders, ritual objects, historical, archaeological, anything religious, especially in North America."

SPECS Accepts images in digital format. Send via CD or DVD as TIFF or JPEG files.

PAYMENT & TERMS Pays 50% commission for any images. Offers volume discounts to customers. Works with photographers on contract basis only. Charges only apply if negatives or transparencies have to be scanned. Statements issued quarterly. Payments made quarterly. Offers one-time rights. Informs photographers and allows them to negotiate when client requests all rights. Model/property release preferred. Photo captions required; include complete description and cutline for editorial images.

HOW TO CONTACT Send query e-mail. Does not keep samples on file; cannot return material. Expects minimum initial submission of 200 images with annual submissions of at least 100 images. Responds only if interested; send 30-40 low-res samples by e-mail. Photo guidelines available on website.

TIPS "We are always looking for good, quality images of religions of the world. We are also looking for photos of people, scenics and holy places of all religions. Send us sample images. First send us an e-mail introducing yourself, and tell us about your work. Let us know how many images you have that fit our niche and what cameras you are using. If it looks promising, we will ask you to e-mail us 30-40 low-res images (72 dpi, no larger than 6 inches on the long side). We will review them and decide if a contract will be offered. Make sure the images are technically and aesthetically salable. Images must be well-exposed and a large file size. We are an all-digital agency and expect scans to be high-quality files. Tell us if you are shooting digitally with a professional DSLR or if scanning from negatives with a professional slide scanner."

POSITIVE IMAGES

53 Wingate St., Haverhill MA 01832. (978)556-9366. **Fax:** (978)556-9448. **E-mail:** pat@positiveimagesphoto.com. **Website:** www.agpix.com/positiveimages. **Contact:** Patricia Bruno, owner. Stock photo agency and fine art gallery. Member of ASPP, GWAA. Clients include: advertising agencies, public relations firms, book/encyclopedia publishers, magazine publishers, greeting card and calendar companies, sales/promotion firms, design firms.

NEEDS Horticultural images showing technique and lifestyle, photo essays on property-released homes and gardens, travel images from around the globe, classy and funky pet photography, health and nutrition, sensitive and thought-provoking images suitable for high-end greeting cards, calendar-quality landscapes, castles, lighthouses, country churches. Model/property releases preferred.

PAYMENT & TERMS Pays 50% commission for stock photos; 60% commission for fine art. Average price per image (to clients): $250. Works with photographers on contract basis only. Offers limited regional exclusivity. Payments made quarterly. Offers one-time and electronic media rights. "We never sell all rights."

HOW TO CONTACT "Positive Images Stock is accepting limited new collections; however, if your images are unique and well organized digitally, we will be happy to review online after making e-mail contact. Our gallery will review fine art photography portfolios online as well and will consider exhibiting non-members' work."

TIPS "Positive Images has taken on more of a boutique approach, limiting our number of photographers so that we can better service them and offer a more in-depth and unique collection to our clients. The gallery is a storefront in a small historic arts district. Our plan is to evolve this into an online gallery as well. We are always in search of new talent, so we welcome anyone with a fresh approach to contact us!"

PRESS ASSOCIATION IMAGES

Pearl House, Friar Lane, Nottingham NG1 6BT, United Kingdom. 44(0)20 7963 7000. **Fax:** 44(0)115 844 7448. **E-mail:** joel.tegerdine@pressassociation.com. **Website:** www.pressassociation.com. Formerly Empics Sports Photo Agency. Picture library. Has over 3 million news, sports and entertainment photos (from around the world, past and present) online. Clients include: advertising agencies, newspapers, public relations firms, book publishers, magazine publishers, web publishers, television broadcasters, sporting bodies, rights holders.

NEEDS Photos of news, sports and entertainment.

SPECS Uses glossy or matte color and b&w prints; 35mm transparencies. Accepts the majority of images in digital format.

PAYMENT & TERMS Negotiates fees below stated minimums. Offers volume discounts to customers. Works with photographers on contract basis only. Rights offered varies.

HOW TO CONTACT Send query letter or e-mail. Does not keep samples on file; cannot return material.

PURESTOCK

6622 Southpoint Dr. S., Suite 240, Jacksonville FL 32216. (904)565-0066; (800)828-4545. **Fax:** (904)565-1620. **E-mail:** yourfriends@superstock.com; info@purestock.com. **Website:** www.superstock.com/purestock; www.purestock.com. "The Purestock royalty-free brand is designed to provide the professional creative community with high-quality images at high resolution and very competitive pricing. Purestock offers CDs and single-image downloads in a wide range of categories including lifestyle, business, education

and sports to distributors in over 100 countries. Bold and fresh beyond the usual stock images."

NEEDS "A variety of categories including lifestyle, business, education, medical, industry, etc."

SPECS "Digital files which are capable of being output at 80MB with minimal interpolation. File must be 300 dpi, RGB, TIFF at 8-bit color."

PAYMENT & TERMS Statements issued monthly to contracted image providers. Model release required. Photo captions required.

HOW TO CONTACT Submit a portfolio including a subject-focused collection of 300+ images. Photo guidelines available on website at www.superstock.com/submissions.asp.

TIPS "Please review our website to see the style and quality of our imagery before submitting."

RAILPHOTOLIBRARY.COM

(44)(116)259-2068. **Website:** www.railphotolibrary.com. Estab. 1969. Has 400,000 photos in files relating to railways worldwide. Clients include: advertising agencies, businesses, newspapers, postcard publishers, public relations firms, book publishers, calendar companies, audiovisual firms, magazine publishers, greeting card companies.

NEEDS Photos of railways.

SPECS Uses digital images; glossy b&w prints; 35mm, 2¼×2¼ transparencies.

PAYMENT & TERMS Buys photos, film or videotape outright depending on subject; negotiable. Pays 50% commission for b&w and color photos. Average price per image (to clients): $125 maximum for b&w and color photos. Works with photographers with or without a contract; negotiable. Statements issued quarterly. Photographers allowed to review account records in cases of discrepancies only. Photo captions preferred.

HOW TO CONTACT Send query letter with slides, prints. Portfolio may be dropped off Monday-Saturday. Does not keep samples on file; include SAE/IRC for return of material. Unlimited initial submission.

TIPS "Submit well-composed pictures of all aspects of railways worldwide: past, present and future; captioned digital files, prints or slides. We are the world's leading railway picture library, and photographers to the railway industry."

REX USA

1133 Broadway, Suite 1626, New York NY 10010. (212)586-4432. **E-mail:** requests@rexusa.com. **E-mail:** orderdesk@berlinerphotography.com. **Website:**

www.rexusa.com. Estab. 1935. Stock photo agency, news/feature syndicate. Affiliated with Rex Features in London. Member of Picture Archive Council of America (PACA). Has 1.5 million photos. Clients include: advertising agencies, public relations firms, audiovisual firms, businesses, book/encyclopedia publishers, magazine publishers, newspapers, postcard companies, calendar companies, greeting card companies, TV, film and record companies.

NEEDS Primarily editorial material: celebrities, personalities (studio portraits, candid, paparazzi), human interest, news features, movie stills, glamour, historical, geographic, general stock, sports and scientific.

SPECS Digital only.

PAYMENT & TERMS Payment varies depending on quality of subject matter and exclusivity. "We obtain highest possible prices, starting at $100-100,000 for one-time sale." Works with or without contract. Offers nonexclusive contract. Statements issued monthly. Payments made monthly. Photographers allowed to review account records. Offers one-time, first and all rights. Informs photographers and allows them to negotiate when client requests all rights. Model release required. Photo captions required.

HOW TO CONTACT E-mail query letter with samples and list of stock photo subjects. Or fill out online submission form to offer material and discuss terms for representation.

ROBERTSTOCK/CLASSICSTOCK

4203 Locust St., Philadelphia PA 19104. **E-mail:** info@robertstock.com. **E-mail:** robertag@classicstock.com. **Website:** www.robertstock.com, www.classicstock.com. **Contact:** Roberta Groves, vice-president, creative. Estab. 1920. Stock photo agency. Member of the Picture Archive Council of America (PACA). Has 2 different websites: Robertstock offers contemporary rights-managed and some royalty-free images; ClassicStock offers retro and vintage images. Clients include: advertising agencies, public relations firms, design firms, businesses, book publishers, magazine publishers, newspapers, postcard publishers, calendar companies, greeting card companies, website designers.

NEEDS Offers images on all subjects in depth.

⊙ SCIENCE PHOTO LIBRARY, LTD.

327-329 Harrow Rd., London W9 3RB, United Kingdom. +44(0)20 7432 1100. **Fax:** +44(0)20 7286 8668.

E-mail: info@sciencephoto.com. **Website:** www.sciencephoto.com. Stock photo agency. Clients include: book publishers, magazines, newspapers, medical journals, advertising, design, TV and online in the U.K. and abroad. "We currently work with agents in over 30 countries, including America, Japan, and in Europe."

NEEDS Specializes in all aspects of science, medicine and technology.

SPECS Digital only via CD/DVD. File sizes at least 38MB with no interpolation. Captions, model, and property releases required.

PAYMENT & TERMS Pays 50% commission. Works on contract basis only. Agreement made for 5 years; general continuation is assured unless otherwise advised. Offers exclusivity. Statements issued quarterly. Payments made quarterly. Photographers allowed to review account records to verify sales figures; fully computerized accounts/commission handling system. Model and property release required. Photo captions required. "Detailed captions can also increase sales so please provide us with as much information as possible."

HOW TO CONTACT "Please complete the inquiry form on our website so that we are better able to advise you on the saleability of your work for our market. You may e-mail us low-res examples of your work. Once you have provided us with information, the editing team will be in contact within 2-3 business weeks. Full photo guidelines available on website."

SCIENCE SOURCE/PHOTO RESEARCHERS, INC.

307 Fifth Ave., New York NY 10016. (212)758-3420 or (800)833-9033. **E-mail:** info@sciencesource.com. **Website:** www.sciencesource.com. Stock agency. Has over 1 million photos and illustrations in files, with 250,000 images in a searchable online database. Clients include: advertising agencies; graphic designers; publishers of textbooks, encyclopedias, trade books, magazines, newspapers, calendars, greeting cards; foreign markets.

NEEDS Images of all aspects of science, astronomy, medicine, people (especially contemporary shots of teens, couples and seniors). Particularly needs model-released people, European wildlife, up-to-date travel and scientific subjects. Lifestyle images must be no older than 2 years; travel images must be no older than 5 years.

SPECS Prefers images in digital format.

PAYMENT & TERMS Rarely buys outright; pays 50% commission on stock sales. General price range (to clients): $150-7,500. Works with photographers on contract basis only. Offers limited regional exclusivity. Contracts renew automatically with additional submissions for 5 years (initial term; 1 year thereafter). Photographers allowed to review account records upon reasonable notice during normal business hours. Statements issued monthly, bimonthly or quarterly, depending on volume. Informs photographers and allows them to negotiate when a client requests to buy all rights, but does not allow direct negotiation with customer. Model/property release required for advertising; preferred for editorial. Photo captions required; include who, what, where, when. Indicate model release.

HOW TO CONTACT See submission guidelines on website.

TIPS "We seek the photographer who is highly imaginative or into a specialty (particularly in the scientific or medical fields). We are looking for serious contributors who have many hundreds of images to offer for a first submission and who are able to contribute often."

SILVER IMAGE® PHOTO AGENCY AND WEDDINGS

4104 NW 70th Terrace, Gainesville FL 32606. (352)373-5771. **E-mail:** carla@silverimagephotoagency.com. **Website:** www.silverimagephotoagency.com; www.facebook.com/silverimagefloridalink. **Contact:** Carla Hotvedt, president/owner. Estab. 1987. Stock photo agency and rep for award-winning photojournalists. Assignments in Florida/southern Georgia. Photographers are based in Florida, but available for worldwide travel. Has 5,000 photos in files. Clients include: public relations firms, brides and grooms, magazine publishers, newspapers, rebranding campaigns, and convention coverage.

NEEDS Stock photos from Florida only: nature, travel, tourism, news, people.

SPECS Accepts images in digital format only. Send via CD, FTP, e-mail as JPEG files *upon request only*. No longer accepting new photographers.

PAYMENT & TERMS Pays 50% commission for image licensing fees. Average price per image (to clients): $150-600. Works with photographers on contract basis only. Offers non-exclusive contract. Payment made monthly. Statements provided when payment is made. Photographers allowed to review account records. Offers one-time rights. Informs photographer and allows them to be involved when client requests all rights. Model release preferred. Photo captions required; include name, year shot, city, state, etc.

HOW TO CONTACT Send query letter via e-mail only. Do not submit material unless first requested.

TIPS "I will review a photographer's work to see if it rounds out our current inventory. Photographers should review our website to get a feel for our needs. Photographers interested in our agency and in receiving photo requests should follow our Facebook page."

SKYSCAN PHOTOLIBRARY

Oak House, Toddington, Cheltenham, Gloucestershire GL54 5BY, United Kingdom. (44)(124)262-1357. **Fax:** (44)(124)262-1343. **E-mail:** info@skyscan.co.uk. **Website:** www.skyscan.co.uk. **Contact:** Brenda Marks, library manager. Estab. 1984. Picture library. Member of the British Association of Picture Libraries and Agencies (BAPLA) and the National Association of Aerial Photographic Libraries (NAPLIB). Has more than 450,000 photos in files. Clients include: advertising agencies, public relations firms, businesses, book publishers, magazine publishers, newspapers, calendar companies, postcard publishers.

NEEDS "Air-to-ground photos of U.K. & Worldwide. As well as holding images ourselves, we also wish to make contact with holders of other aerial collections worldwide to exchange information."

SPECS Uses color and b&w prints; any format transparencies. Accepts images in digital format. Send via CD, e-mail.

PAYMENT & TERMS Pays 50% commission for b&w and color photos. Average price per image (to clients): $100 minimum. Enforces strict minimum prices. Offers volume discounts to customers. Photographers can choose not to sell images on discount terms. Works with photographers with or without a contract; negotiable. Offers guaranteed subject exclusivity (within files); negotiable to suit both parties. Statements issued quarterly. Payment made quarterly. Photographers allowed to review account records in cases of discrepancies only. Offers one-time, electronic media and agency promotion rights. Informs photographers and allows them to negotiate when a client requests all rights. Will inform photographers and act with photographer's agreement. Model/property release preferred for "air-to-ground of famous buildings (some now insist they have copyright to their building)." Photo captions required; include

subject matter, date of photography, location, interesting features/notes.

HOW TO CONTACT Send query letter or e-mail. Provide résumé, business card, self-promotion piece or tearsheets to be kept on file. Agency will contact photographer for portfolio review if interested. No minimum submissions. Photo guidelines sheet and catalog both free with SASE. Market tips sheet free quarterly to contributors only.

TIPS "We have invested heavily in suitable technology and training for in-house scanning, color management, and keywording, which are essential skills in today's market. Contact first by letter or e-mail with résumé of material held and subjects covered."

SOVFOTO/EASTFOTO, INC.

263 W. 20th St. #3, New York NY 10011. (212)727-8170. **Fax:** (212)727-8228. **E-mail:** info@sovfoto.com. **Website:** sovfoto.com. Estab. 1935. Stock photo agency. Has 500,000+ photos in files. Clients include: advertising firms, audiovisual firms, book/encyclopedia publishers, magazine publishers, newspapers.

NEEDS All subjects acceptable as long as they pertain to Russia, Eastern European countries, Central Asian countries or China.

SPECS Uses b&w historical; color prints; 35mm transparencies. Accepts images in digital format. Send via CD or DVD as TIFF files.

PAYMENT & TERMS Pays 50% commission. Statements issued quarterly. Payment made quarterly. Photographers allowed to review account records to verify sales figures or account for various deductions. Offers one-time print, electronic media, and nonexclusive rights. Model/property release preferred. Photo captions required.

HOW TO CONTACT Arrange personal interview to show portfolio. Send query letter with samples, stock list. Keeps samples on file. Expects minimum initial submission of 50-100 images.

TIPS Looks for "news and general interest photos (color) with human element."

TOM STACK & ASSOCIATES, INC.

154 Tequesta St., Tavernier FL 33070. (305)852-5520. **E-mail:** tomstack@earthlink.net. **Website:** tomstack associates.photoshelter.com. **Contact:** Therisa Stack. Has 500,000 photos in files. Clients include: advertising agencies, public relations firms, businesses, audiovisual firms, book publishers, magazine publishers,

encyclopedia publishers, postcard companies, calendar companies, greeting card companies.

NEEDS Photos of wildlife, endangered species, marine life, landscapes; foreign geography; photomicrography; scientific research; whales; solar heating; mammals such as weasels, moles, shrews, fisher, marten, etc.; extremely rare endangered wildlife; wildlife behavior photos; lightning and tornadoes; hurricane damage; dramatic and unusual angles and approaches to composition, creative and original photography with impact. Especially needs photos on life science, flora and fauna and photomicrography. No run-of-the-mill travel or vacation shots. Special needs include photos of energy-related topics—solar and wind generators, recycling, nuclear power and coal burning plants, waste disposal and landfills, oil and gas drilling, supertankers, electric cars, geo-thermal energy.

SPECS Only accepts images in digital format. Send sample JPEGs or link to website where your images can be viewed.

PAYMENT & TERMS Pays 50% commission. Works with photographers on contract basis only. Contracts renew automatically with additional submissions for 2 years. Statements issued quarterly. Payments made quarterly. Offers one-time and electronic media rights. Informs photographers and allows them to negotiate when client requests all rights. Model release preferred. Photo captions preferred.

HOW TO CONTACT E-mail: tomstack@earthlink. net.

TIPS "Strive to be original, creative and take an unusual approach to the commonplace; do it in a different and fresh way. We take on only the best so we can continue to give more effective service."

STILL MEDIA

714 Mission Park Dr., Santa Barbara CA 93105. (805)682-2868. **Fax:** (805)682-2659. **E-mail:** info@ stillmedia.com. **E-mail:** images@stillmedia.com. **Website:** www.stillmedia.com. Photojournalism and stock photography agency. Has 500,000 photos in files. Clients include: advertising agencies, public relations firms, businesses, book/encyclopedia publishers, magazine publishers, newspapers, calendar companies.

NEEDS Reportage, world events, travel, cultures, business, the environment, sports, people, industry.

SPECS Accepts images in digital format only. Contact via e-mail.

PAYMENT & TERMS Pays 50% commission for color photos. Works with photographers on contract basis only. Offers nonexclusive and guaranteed subject exclusivity contracts. Statements issued quarterly. Payment made quarterly. Photographers allowed to review account records. Offers one-time and electronic media rights. Model/property release preferred. Photo captions required.

STOCK CONNECTION

10319 Westlake Dr., Suite 162, Bethesda MD 20817. (301)530-8518. **Fax:** Please call first. **E-mail:** photos@scphotos.com. **Website:** www.scphotos.com. **Contact:** Cheryl DiFrank, president and photographer relations. Stock photo agency. Member of the Picture Archive Council of America (PACA). Has over 220,000 photos in files. Clients: advertising agencies, graphic design firms, magazine and textbook publishers, greeting card companies.

NEEDS "We handle many subject categories including lifestyles, business, concepts, sports and recreation, travel, landscapes and wildlife. We will help photographers place their images into our extensive network of over 35 distributors throughout the world. We specialize in placing images where photo buyers can find them."

SPECS Accepts images in digital format (high-res JPEG), minimum 50MB uncompressed, 300 dpi, Adobe RGB.

PAYMENT & TERMS Pays 65% commission. Average price per image (to client): $450-500. Works with photographers on contract basis only. Offers nonexclusive contract. Contracts renew automatically with additional submissions. Photographers may cancel contract with 60 days written notice. Charges for keywording average $2 per image, depending on volume. If photographer provides acceptable scans and keywords, no upload charges apply. Statements issued monthly. Photographers allowed to review account records. Offers rights-managed and royalty-free. Informs photographers when a client requests exclusive rights. Model/property release required. Photo captions required.

HOW TO CONTACT Please e-mail for submission guidelines. Prefer a minimum of 100 images as an initial submission.

TIPS "The key to success in today's market is wide distribution of your images. We offer an extensive network reaching a large variety of buyers all over the world. Increase your sales by increasing your exposure."

STOCKFOOD

109 Lafayette Center, Kennebunk ME 04043. (800)967-0229. **Fax:** (207)967-9895. **E-mail:** america@stockfood.com. **E-mail:** susan.dean@stockfood.com. **Website:** www.stockfood.com. Estab. 1979. Stock agency, picture library. Member of the Picture Archive Council of America (PACA). Has over 250,000 photos in files. Clients include: advertising agencies, businesses, newspapers, postcard publishers, public relations firms, book publishers, calendar companies, magazine publishers, greeting card companies.

NEEDS Photos and video clips of food/drink, health/fitness/food, wellness/spa, people eating and drinking, interiors, nice flowers and garden images, eating and drinking outside, table settings.

SPECS Uses 2¼×2¼, 4×5, 8×10 transparencies. Accepts only digital format. Send via CD/DVD as TIFF files at 300 dpi, 34MB minimum. Submission guidelines on our website.

PAYMENT & TERMS Pays 40% commission for rights managed images. Enforces minimum prices. Works with photographers on contract basis only. Offers limited regional exclusivity, guaranteed subject exclusivity (within files). Contracts renew automatically. Statements issued quarterly. Photographers allowed to review account records. Offers one-time rights. Model release required; photo captions required.

HOW TO CONTACT Send e-mail with new examples of your work as JPEG files.

STOCK FOUNDRY IMAGES

Artzooks Multimedia Inc., P.O. Box 78089, Ottawa ON K2E 1B1, Canada. (613)258-1551; (866)644-1644. **E-mail:** info@stockfoundry.com. **E-mail:** submissions@stockfoundry.com; sales@stockfoundry.com. **Website:** www.stockfoundry.com. Estab. 2006. Stock agency. Clients include: advertising agencies, businesses, newspapers, public relations firms, book publishers, audiovisual firms, magazine publishers.

NEEDS Photos of babies/children/teens, celebrities, couples, multicultural, families, parents, senior citizens, architecture, cities/urban, education, gardening, interiors/decorating, pets, religious, rural, agricul-

ture, business concepts, industry, medicine, military, political, product shots/still life, science, technology/computers, disasters, environmental, landscapes/scenics, wildlife, adventure, automobiles, entertainment, events, food/drink, health/fitness/beauty, hobbies, humor, performing arts, sports, travel. Interested in alternative process, avant garde, documentary, erotic, fashion/glamour, fine art, historical/vintage, lifestyle, seasonal.

SPECS Accepts images in digital format. Send via CD. Save as EPS, JPEG files at 300 dpi. For film and video: .MOV.

PAYMENT & TERMS Buys photos/film/video outright. Pays 50% commission. Average price per image (to clients): $60 minimum for all photos, film and videotape. Negotiates fees below stated minimums. Offers volume discounts to customers. Terms specified in photographer's contracts. Works with photographers on contract basis only. Offers guaranteed subject exclusivity (within files). Contracts renew automatically with additional submissions. "Term lengths are set on each submission from the time new image submissions are received and accepted. There is no formal obligation for photographers to pay for inclusion into catalogs, advertising, etc.; however, we do plan to make this an optional item." Statements issued monthly or in real time online. Payment made monthly. Photographers allowed to review account records in cases of discrepancies only. Informs photographers and allows them to negotiate when a client requests all rights. Negotiates fees below stated minimums. "Volume discounts sometimes apply for preferred customers." Model/property release required. Captions preferred: include actions, location, event, and date (if relevant to the images, such as in the case of vintage collections).

HOW TO CONTACT E-mail query letter with link to photographer's website. Send query letter with tearsheets, stocklist. Portfolio may be dropped off Monday–Friday. Expects initial submission of 100 images with monthly submission of at least 25 images. Responds only if interested; send nonreturnable samples. Provide résumé to be kept on file. Photo guidelines sheet available online. Market tips sheet is free annually via e-mail to all contributors.

TIPS "Submit to us contemporary work that is at once compelling and suitable for advertising. We prefer sets of images that are linked stylistically and by subject matter (better for campaigns). It is accept-able to shoot variations of the same scene (orientation, different angles, with copy space and without, etc.); in fact, we encourage it. Please try to provide us with accurate descriptions, especially as they pertain to specific locations, places, dates, etc. Our wish list for the submission process would be to receive a PDF tearsheet containing small thumbnails of all the high-res images. This would save us time, and speed up the evaluation process."

STOCK OPTIONS

P.O. Box 1048, Fort Davis TX 79734. (432)426-2777. **Fax:** (432)426-2779. **E-mail:** stockoptions@sbcglobal.net. **Contact:** Karen Hughes, owner. Estab. 1985. Stock photo agency. Member of Picture Archive Council of America (PACA). Has 150,000 photos in files. Clients include: advertising agencies, public relations firms, audiovisual firms, corporations, book/encyclopedia and magazine publishers, newspapers, postcard companies, calendar companies, greeting card companies.

NEEDS Emphasizes the southern U.S. Files include Gulf Coast scenics, wildlife, fishing, festivals, food, industry, business, people, etc. Also western folklore and the Southwest.

SPECS Uses 35mm, 2¼×2¼, 4×5 transparencies.

PAYMENT & TERMS Pays 50% commission for color photos. Average price per image (to client): $300-3,000. Works with photographers on contract basis only. Offers nonexclusive contract. Contracts renew automatically with each submission for 5 years from expiration date. When contract ends photographer must renew within 60 days. Charges catalog insertion fee of $300/image and marketing fee of $10/hour. Statements issued upon receipt of payment from client. Payment made immediately. Photographers allowed to review account records to verify sales figures. Offers one-time and electronic media rights. "We will inform photographers for their consent only when a client requests all rights, but we will handle all negotiations." Model/property release preferred for people, some properties, all models. Photo captions required; include subject and location.

HOW TO CONTACT Interested in receiving work from full-time commercial photographers. Arrange a personal interview to show portfolio. Send query letter with stock list. Contact by phone and submit 200 sample photos. Tips sheet distributed annually to all photographers.

TIPS Wants to see "clean, in-focus, relevant and current materials." Current stock requests include industry, environmental subjects, people in up-beat situations, minorities, food, cityscapes and rural scenics.

STOCKYARD PHOTOS

2500 Summer St., Suite 12A, Houston TX 77007. (713)520-0898. **Fax:** (713)820-6965. **E-mail:** jim@stockyard.com. **Website:** www.stockyard.com. Estab. 1992. Stock agency. Niche agency specializing in images of Houston and China. Has thousands of photos in files. Clients include: advertising agencies, businesses, newspapers, postcard publishers, public relations firms, book publishers, calendar companies, audiovisual firms, magazine publishers, greeting card companies, real estate firms, interior designers, retail catalogs.

NEEDS Photos relating to Houston and the Gulf Coast.

SPECS Accepts images in digital format only. To be considered, e-mail link to photographer's website, showing a sample of 20 images for review.

PAYMENT & TERMS Average price per image (to clients): $250-1,500 for color photos. Offers volume discounts to customers. Photographers can choose not to sell images on discount terms.

STSIMAGES

225, Neha Industrial Estate, Off Dattapada Rd., Borivali (East) Mumbai 400 066, India. (91)(22)2870-1586. **Fax:** (91)(22)2870-1609. **E-mail:** info@stsimages.com. **E-mail:** images@stsimages.com; pawan@stsimages.com. **Website:** www.stsimages.com. **Contact:** Mr. Pawan Tikku. Estab. 1993. Has over 200,000 photos on website. Clients include: advertising agencies, businesses, postcard publishers, public relations firms, book publishers, calendar companies, freelance web designers, audiovisual firms, magazine publishers, greeting card companies.

NEEDS Royalty-free and rights-managed images of babies/children/teens, celebrities, couples, multicultural, families, parents, senior citizens, disasters, environmental, landscapes/scenics, wildlife, architecture, cities/urban, education, gardening, interiors/decorating, pets, religious, rural, adventure, automobiles, entertainment, events, food/drink, health/fitness, hobbies, humor, performing arts, sports, travel, agriculture, business concepts, industry, medicine, military, political, product shots/still life, science, technology/computers. Interested in alternative pro-cess, avant garde, documentary, fashion/glamour, fine art, historical/vintage, seasonal. Also needs vector images.

SPECS Accepts images in digital format only. Send via DVD or direct upload to website, JPEG files at 300 dpi. Minimum file size 25MB, preferred 50MB or more. Image submissions should be made separately for royalty-free and rights-managed images

PAYMENT & TERMS Pays 50% commission. Enforces minimum prices. Offers to customers. Works with photographers on contract basis only. Offers nonexclusive contract, limited regional exclusivity. Contracts renew automatically with additional submissions for 3 years. Statements issued quarterly. Payment made monthly. Photographers allowed to review account records. Offers royalty-free images as well as one-time rights. Model release required; property release preferred. Photo captions and keyword are mandatory in the file info area of the image. Include names, description, location.

HOW TO CONTACT Send e-mail with image thumbnails. Expects minimum initial submission of 200 images with regular submissions of at least some images every month. Responds in 1 month to queries. Ask for photo guidelines by e-mail. Market tips available to regular contributors only.

TIPS 1) Strict self-editing of images for technical faults. 2) Proper keywording is essential. 3) All images should have the photographer's name in the IPTC(XMP) area. 4) All digital images must contain necessary keywords and caption information within the "file info" section of the image file. 5) Send images in both vertical and horizontal formats.

SUGAR DADDY PHOTOS

Website: www.sugardaddyphotos.com; www.facebook.com/sugardaddyphotos; www.twitter.com/sugardaddyphoto. **Contact:** Henry Salazar, editor-in-chief. Estab. 2000. Art collector and stock agency. Target audience includes advertising agencies, businesses, newspapers, postcard publishers, public relations firms, book publishers, calendar companies, audiovisual firms, magazine publishers and greeting card companies.

NEEDS Photos of babies/children/teens, celebrities, couples, multicultural, families, parents, senior citizens, architecture, cities/urban, education, gardening, interiors/decorating, pets, religious, rural, agriculture, business concepts, industry, medicine, military,

political, product shots/still life, science, technology/computers, disasters, environmental, landscapes/scenics, wildlife, adventure, automobiles, entertainment, events, food/drink, health/fitness/beauty, hobbies, humor, performing arts, sports (football, baseball, soccer, basketball, hockey), travel/family travel, hotels, beaches, exotic locations. Interested in alternative process, avant garde, documentary, erotic, fashion/glamour, fine art, historical/vintage, lifestyle, seasonal.

SPECS Accepts images in digital format. Send RAW, TIFF or JPEG files at minimum 300 dpi. Pay 15% commission level. Average price per image (to clients): $100-1,000 for photos and streaming video. Enforces strict minimum prices. "We have set prices; however, they are subject to change without notice." Negotiable. Offers nonexclusive contract. Payments made monthly. Offers one-time rights. Informs photographers and allows them to negotiate when a client requests all rights. Model/property release required. Photo captions required; include location, city, state, country, full description, related keywords, date image was taken.

HOW TO CONTACT "All prospects are to submit work from agencies or a person via any online Social media (facebook, twitter, etc.), including websites."

TIPS "Arrange your work in categories to view. Clients expect the very best in professional-quality material."

SUPERSTOCK, INC.

6622 Southpoint Dr. S., Suite 240, Jacksonville FL 32216. (904)565-0066; (800)828-4545. **Fax:** (904)565-1620. **E-mail:** yourfriends@superstock.com. **Website:** www.superstock.com. International stock photo agency represented in 192 countries. Offices in Jacksonville, New York and London. Extensive rights-managed and royalty-free content within 3 unique collections–contemporary, vintage and fine art. Clients include: advertising agencies, businesses, book and magazine publishers, newspapers, greeting card and calendar companies.

NEEDS "SuperStock is looking for dynamic lifestyle, travel, sports and business imagery, as well as fine art content and vintage images with releases."

SPECS Accepts images in digital format only. Digital files must be a minimum of 50MB (up-sized), 300 dpi, 8-bit color, RGB, JPEG format.

PAYMENT & TERMS Statements issued monthly to contracted contributors. "Rights offered vary, depending on image quality, type of content, and experience." Informs photographers when client requests all rights. Model release required. Photo captions required.

TIPS "Please review our website to see the style and quality of our imagery before submitting."

TROPIX PHOTO LIBRARY

44 Woodbines Ave., Kingston-Upon-Thames, Surrey KT1 2AY, United Kingdom. (44)(0)208-546-0823. **E-mail:** info@tropix.co.uk. **E-mail:** photographers@tropix.co.uk. **Website:** www.tropix.co.uk. **Contact:** Veronica Birley, proprietor. Picture library specialist. Has 100,000 photos in files. Clients include: book publishers, magazine publishers, newspapers, government departments, design groups, travel companies, new media.

NEEDS *"Sorry, Tropix is currently closed to new contributing photographers. But any temporary exceptions to this will be posted on our website."*

SPECS Uses large digital files only, minimum 50MB when sent as TIFF files.

PAYMENT & TERMS Pays 40% commission for color photos. Average price per image (to clients): $118 for b&w and color photos. Offers guaranteed subject exclusivity. Charges cost of returning photographs by insured post, if required. Statements made quarterly with payment. Photographers allowed to have qualified auditor review account records to verify sales figures in the event of a dispute but not as routine procedure. Offers one-time, electronic media and agency promotion rights. Informs photographers when a client requests all rights, but agency handles negotiation. Model release always required. Photo captions required; accurate, detailed data to be supplied in IPTC, electronically, and on paper. "It is essential to follow captioning guidelines available from agency."

HOW TO CONTACT "E-mail preferred. Send no unsolicited photos or JPEGs, please."

ULLSTEIN BILD

Axel-Springer-Str. 65, Berlin DE-10888, Germany. +49 30 2591 72547. **Fax:** +49 30 2591 73896. **E-mail:** ramershoven@ullsteinbild.de. **Website:** www.ullsteinbild.de. Estab. 1900. Stock agency, picture library and news/feature syndicate. Has approximately 12 million photos in files. Clients include: advertising agencies, public relations firms, audiovisual

firms, businesses, book publishers, magazine publishers, newspapers, calendar companies, greeting card companies, postcard publishers, TV companies. **NEEDS** Photos of celebrities, couples, multicultural, families, parents, senior citizens, wildlife, disasters, environmental, landscapes/scenics, architecture, cities/urban, education, pets, religious, rural, adventure, automobiles, entertainment, events, health/fitness, hobbies, humor, performing arts, sports, travel, agriculture, buildings, computers, industry, medicine, military, political, portraits, science, technology/computers. Interested in digital, documentary, fashion/glamour, historical/vintage, regional, seasonal. Other specific photo needs: German history.
SPECS Accepts images in digital format only. Send via FTP, CD, e-mail as TIFF, JPEG files at minimum 25MB decompressed.
PAYMENT & TERMS Pays on commission basis. Works with photographers on contract basis only. Offers nonexclusive contract for 5 years minimum. Statements issued monthly, quarterly, annually. Payments made monthly, quarterly, annually. Photographers allowed to review account records in cases of discrepancies only. Offers one-time rights. Photo captions required; include date, names, events, place.
HOW TO CONTACT "Please contact Mr. Ulrich Ramershoven (ramershoven@ullsteinbild.de) before sending pictures."

VIEWFINDERS STOCK PHOTOGRAPHY

3245 SE Ankeny St., Portland OR 97214. (503)222-5222. **Fax:** (503)274-7995. **E-mail:** studio@viewfindersnw.com. **Website:** www.viewfindersnw.com. **Contact:** Bruce Forster, owner. Estab. 1996. Stock agency. Member of the Picture Archive Council of America (PACA). Has 70,000 photos in files. Clients include: advertising agencies, public relations firms, businesses, book publishers, magazine publishers, design agencies.
NEEDS "We are a stock photography agency providing images of the Pacific Northwest. Founded by Bruce Forster in 1996, our image collection has content from over 10 locally known photographers. whether you're looking for landscapes and landmarks, aerials, cityscapes, urban living, industry, recreation, agriculture or green energy images, our photography collection covers it all. Contact us for your image needs."

VIREO (VISUAL RESOURCES FOR ORNITHOLOGY)

1900 Ben Franklin Pkwy., Philadelphia PA 19103. (215)299-1069. **Fax:** (215)299-1182. **E-mail:** vireo@ansp.org. **Website:** vireo.ansp.org. **Contact:** Doug Wechsler, director. Estab. 1979. Picture library. "We specialize in birds only." Has 160,000 photos in files. Clients include: advertising agencies, businesses, book publishers, magazine publishers, newspapers, calendar companies, CD publishers.
NEEDS High-quality photographs of birds from around the world with special emphasis on behavior. All photos must be related to birds or ornithology.
SPECS Uses digital format primarily. See website for specs.
PAYMENT & TERMS Pays 50% commission for b&w and color photos. Average price per image (to clients): $125. Negotiates fees below stated minimums; "we deal with many small nonprofits as well as commercial clients." Offers volume discounts to customers. Discount sales terms negotiable. Works with photographers on contract basis only. Offers nonexclusive contract. Statements issued semiannually. Payments made semiannually. Offers one-time rights. Model release preferred for people. Photo captions preferred; include date, location.
HOW TO CONTACT Read guidelines on website. To show portfolio, photographer should send 10 JPEGs or a link to web pages with the images. Follow up with a call. Responds in 1 month to queries.
TIPS "Study our website and show us some bird photos we don't have or better images than those we do have. Write to us describing the types of bird photographs you have, the type of equipment you use, and where you do most of your bird photography. Please send us a web link to a portfolio of your work if you have one. Edit work carefully."

WILDLIGHT

P.O. Box 1606, Double Bay, Sydney NSW 1360, Australia. 61 2 9043 3255. **E-mail:** wild@wildlight.net. **Website:** www.wildlight.net. Estab. 1985. Picture library specializing in Australian images only. Has 50,000 photos in files. Clients include: advertising agencies, public relations firms, audiovisual firms, businesses, book/encyclopedia publishers, magazine publishers, newspapers, postcard publishers, calendar companies, greeting card companies.

NEEDS Australian photos of babies/children/teens, couples, multicultural, families, parents, senior citizens, disasters, environmental, landscapes/scenics, wildlife, architecture, cities/urban, education, gardening, interiors/decorating, pets, religious, rural, adventure, entertainment, events, food/drink, health/fitness, hobbies, humor, performing arts, sports, travel, agriculture, business concepts, industry, medicine, military, political, product shots/still life, science, technology/computers. Interested in documentary, seasonal.

SPECS Accepts images in digital format only.

PAYMENT & TERMS Pays 40% commission for color photos. Works with photographers on contract basis only. Offers image exclusive contract within Australia. Statements issued quarterly. Payments made quarterly. Offers one-time rights. Model/property release required. Photo captions required.

HOW TO CONTACT Send CD to show portfolio. Expects minimum initial submission of 100 images with periodic submissions of at least 50 images per quarter. Photo guidelines available by e-mail.

ADVERTISING, DESIGN & RELATED MARKETS

Advertising photography is always "commercial" in the sense that it is used to sell a product or service. Assignments from ad agencies and graphic design firms can be some of the most creative, exciting, and lucrative that you'll ever receive.

Prospective clients want to see your most creative work—not necessarily your advertising work. Mary Virginia Swanson, an expert in the field of licensing and marketing fine art photography, says that the portfolio you take to the Museum of Modern Art is also the portfolio that Nike would like to see. Your clients in advertising and design will certainly expect your work to show, at the least, your technical proficiency. They may also expect you to be able to develop a concept or to execute one of their concepts to their satisfaction. Of course, it depends on the client and their needs: Read the tips given in many of the listings on the following pages to learn what a particular client expects.

When you're beginning your career in advertising photography, it is usually best to start close to home. That way, you can make appointments to show your portfolio to art directors. Meeting the photo buyers in person can show them that you are not only a great photographer but that you'll be easy to work with as well. This section is organized by region to make it easy to find agencies close to home.

When you're just starting out, you should also look closely at the agency descriptions at the beginning of each listing. Agencies with smaller annual billings and fewer employees are more likely to work with newcomers. On the flip side, if you have a sizable list of ad and design credits, larger firms may be more receptive to your work and be able to pay what you're worth.

Trade magazines such as *HOW*, *Print*, *Communication Arts*, and *Graphis* are good places to start when learning about design firms. These magazines not only provide informa-

tion about how designers operate, but they also explain how creatives use photography. For ad agencies, try *Adweek* and *Advertising Age*. These magazines are more business oriented, but they reveal facts about the top agencies and about specific successful campaigns. (See Publications in the Resources section for ordering information.) The website of American Photographic Artists (APA) contains information on business practices and standards for advertising photographers (www.apanational.org).

◎ ○ ❀ THE AMERICAN YOUTH PHILHARMONIC ORCHESTRAS

4026 Hummer Rd., Annandale VA 22003. (703)642-8051, ext. 25. **Fax:** (703)642-8054. **Website:** www.aypo.org. **Contact:** Executive director. Estab. 1964. Nonprofit organization that promotes and sponsors 4 youth orchestras. Photos used in newsletters, posters, audiovisual and other forms of promotion.

NEEDS Photographers usually donate their talents. Offers 8 assignments/year. Photos taken of orchestras, conductors and soloists. Photo captions preferred.

AUDIOVISUAL NEEDS Uses slides and videotape.

SPECS Uses 5×7 glossy color and b&w prints.

MAKING CONTACT & TERMS Arrange a personal interview to show portfolio. Works with local freelancers on assignment only. Keeps samples on file. Payment negotiable. "We're a résumé-builder, a nonprofit that can cover expenses but not service fees." **Pays on acceptance.** Credit line given. Rights negotiable.

AMPM, INC.

P.O. Box 1887, Midland MI 48641. (989)837-8800. **E-mail:** solutions@ampminc.com. **Website:** www.ampminc.com. Estab. 1969. Member of Art Directors Club, Illustrators Club, National Association of Advertising Agencies and Type Directors Club. Ad agency. Approximate annual billing: $125 million. Number of employees: 265. Firm specializes in display design, direct mail, magazine ads, packaging. Types of clients: food, industrial, retail, pharmaceutical, health and beauty and entertainment. Examples of recent clients: Cadillac (ads for TV); Oxford (ads for magazines).

NEEDS Works with 6 photographers/month. Uses photos for consumer and trade magazines, direct mail, P-O-P displays, catalogs, posters, newspapers and audiovisual. Subjects include: landscapes/scenics, wildlife, commercials, celebrities, couples, architecture, gardening, interiors/decorating, pets, adventure, automobiles, entertainment, events, food/drink, health/fitness, humor, performing arts, agriculture, business concepts, industry, medicine, product shots/still life. Interested in avant garde, erotic, fashion/glamour, historical/vintage, seasonal. Reviews stock photos of food and beauty products. Model release required. Photo caption preferred.

AUDIOVISUAL NEEDS "We use multimedia slide shows and multimedia video shows."

SPECS Uses 8×10 color and/or b&w prints; 35mm, 2¼×2¼, 4×5, 8×10 transparencies; 8×10 film; broadcast videotape. Accepts images in digital format. Send via e-mail.

MAKING CONTACT & TERMS Arrange personal interview to show portfolio. Send unsolicited photos by mail for consideration. Provide résumé, business card, brochure, flyer or tearsheets to be kept on file. Keeps samples on file. Responds in 2 weeks. Pays $50-250/hour; $500-2,000/day; $2,000-5,000/job; $50-300 for b&w photos; $50-300 for color photos; $50-300 for film; $250-1,000 for videotape. Pays on receipt of invoice. Credit line sometimes given, depending upon client and use. Buys one-time, exclusive product, electronic and all rights; negotiable.

TIPS Wants to see originality in portfolio or samples. Sees trend toward more use of special lighting. Photographers should "show their work with the time it took and the fee."

⑧⑧ ● AUGUSTUS BARNETT ADVERTISING/DESIGN

P.O. Box 197, Fox Island WA 98333. (253)549-2396. **Fax:** (253)549-4707. **E-mail:** charlieb@augustusbarnett.com. **Website:** www.augustusbarnett.com. **Contact:** Augustus Barnett, president; Charlie Barnett, president/creative director. Estab. 1981. Ad agency, design firm. Firm specializes in print, collateral, direct mail, business to business, package design and branding and identity systems. Types of clients: small business, industrial, financial, retail, small business, food & beverage, agriculture.

NEEDS Works with assignment photographers as needed. Uses photos for consumer and trade requirements. Subjects include: industrial, food-related product photography. Model release required; property release preferred for fine art, vintage cars, boats and documents. Photo captions preferred.

SPECS Accepts images in digital format. Send via CD, Jaz, ZIP, e-mail, FTP as TIFF, EPS, GIF files at 300 dpi minimum.

MAKING CONTACT & TERMS Call for interview. Keeps samples on file. Responds in 2 weeks. Fees and payments are negotiable. Credit line sometimes given "if the photography is partially donated for a nonprofit organization." Buys one-time and exclusive product rights; negotiable.

BERSON, DEAN, STEVENS

P.O. Box 3997, Westlake Village CA 91359. (877)447-0134, ext. 111. **E-mail:** info@bersondeanstevens.com. **Website:** www.bersondeanstevens.com. **Contact:** Lori Berson, owner. Estab. 1981. Specializes in brand and corporate identity, web site design and development, e-mail marketing, social media marketing, video production, collateral, direct mail, trade show booths, exhibits, signage, promotions, packaging, and publication design.

NEEDS Works with 4 photographers/month. Uses photos for billboards, trade magazines, direct mail, P-O-P displays, catalogs, posters, packaging, signage and Web. Subjects include: product shots and food. Reviews stock photos. Model/property release required.

SPECS Accepts images in digital format only. Send via CD, DVD as TIFF, EPS, JPEG files at 300 dpi.

MAKING CONTACT & TERMS Provide résumé, business card, brochure, flyer or tearsheets to be kept on file. Works on assignment only. Responds in 1-2 weeks. Payment negotiable. Pays within 30 days after receipt of invoice. Credit line not given. Rights negotiable.

🟢🟢 🔵 BOB BOEBERITZ DESIGN

247 Charlotte St., Asheville NC 28801. (828)258-0316. **E-mail:** bob@bobboeberitzdesign.com. **Website:** www.bobboeberitzdesign.com. **Contact:** Bob Boeberitz, owner. Estab. 1984. Member of American Advertising Federation—Asheville Chapter, Asheville Freelance Network and Asheville Creative Services Group. Graphic design studio. Approximate annual billing: $100,000. Number of employees: 1. Firm specializes in annual reports, collateral, direct mail, magazine ads, packaging, publication design, signage, websites. Types of clients: management consultants, retail, recording artists, mail-order firms, industrial, nonprofit, restaurants, hotels, book publishers.

NEEDS Works with 1 freelance photographer "every 6 months or so." Uses photos for consumer and trade magazines, direct mail, brochures, catalogs, posters. Subjects include: babies/children/teens, couples, multicultural, families, parents, senior citizens, environmental, landscapes/scenics, wildlife, architecture, cities/urban, education, pets, rural, adventure, entertainment, events, food/drink, health/fitness/beauty, hobbies, performing arts, sports, travel, business concepts, industry, medicine, product shots/still life,

science, technology/computers; some location, some stock photos. Interested in fashion/glamour, seasonal. Model/property release required.

SPECS Accepts images in digital format. Send via CD, e-mail as TIFF, BMP, JPEG, GIF files at 300 dpi. E-mail samples at 72 dpi. No EPS attachments.

MAKING CONTACT & TERMS Provide résumé, business card, brochure, flyer or postcard to be kept on file. Cannot return unsolicited material. Responds "when there is a need." Pays $75-200 for b&w photos; $100-500 for color photos; $75-150/hour; $500-1,500/day. Pays on per-job basis. Buys all rights; negotiable.

TIPS "Send promotional piece to keep on file. Do not send anything that has to be returned. I usually look for a specific specialty; no photographer is good at everything. I also consider studio space and equipment. Show me something different, unusual, something that sets you apart from any average local photographer. If I'm going out of town for something, it has to be for something I can't get done locally. I keep and file direct mail pieces (especially postcards). I do not keep anything sent by e-mail. If you want me to remember your website, send a postcard."

🟢 ◎ BRAGAW PUBLIC RELATIONS SERVICES

3093 Epstein Circle, Mundelein IL 60060. (847)997-3876. **E-mail:** info@bragawpr.com, rbragaw@bragawpr.com. **Website:** bragawpr.com. **Contact:** Richard Bragaw, president. Estab. 1981. Member of Publicity Club of Chicago.

NEEDS Uses photos for trade magazines, direct mail, brochures, newspapers, newsletters/news releases. Subjects include: "products and people." Model release preferred. Photo captions preferred.

SPECS Uses 3×5, 5×7, 8×10 glossy prints.

MAKING CONTACT & TERMS Provide résumé, business card, brochure, flyer or tearsheets to be kept on file. Works with freelance photographers on assignment basis only. Payment is negotiated at the time of the assignment. Pays on receipt of invoice. Credit line "possible." Buys all rights; negotiable.

TIPS "Execute an assignment well, at reasonable costs, with speedy delivery."

◎ ◐ BRAINWORKS DESIGN GROUP

177 Van Ess Hwy., Carmel Highlands CA 93923. (831)657-0650. **Fax:** (831)574-3037. **E-mail:** alfred@brainwks.com. **Website:** www.brainwks.com. **Contact:** Alfred Kahn, president. Estab. 1986. Design firm.

Approximate annual billing: $2 million. Number of employees: 8. Firm specializes in publication design and collateral. Types of clients: higher education, technology, medical, and pharmaceutical. Specializing in innovative and visually powerful communications, Brainworks pioneered Emotional Response Communications. This process, which includes photographic and conceptual images, is designed to induce an emotional reaction and connection on the part of the target market. It combines marketing, psychology, and design. Over the years, Brainworks has earned numerous awards.

NEEDS Works with 4 photographers/month. Uses photographs for direct mail, catalogs and posters. Subjects include: couples, environmental, education, entertainment, performing arts, sports, business concepts, science, technology/computers. Interested in avant garde, documentary. Wants conceptual images. Model release required.

SPECS Uses 35mm, 4×5 transparencies. Accepts images in digital format. Send via CD.

MAKING CONTACT & TERMS Arrange a personal interview to show portfolio. Send unsolicited photos by e-mail for consideration. Submit online. Works with freelancers on assignment only. Keeps samples on file. Cannot return material. Responds in 1 month. Pay negotiable. Pays on receipt of invoice. Credit line sometimes given, depending on client. Buys first, one-time and all rights; negotiable.

◎ ❀ BRAMSON + ASSOCIATES

7400 Beverly Blvd., Los Angeles CA 90036. (323)938-3595. **E-mail:** gene@bramson-associates.com. **Website:** www.bramson-associates.com. **Contact:** Gene Bramson, principal. Estab. 1970. Ad agency. Approximate annual billing: $2 million. Number of employees: 7. Types of clients: industrial, financial, food, retail, health care. Examples of recent clients: Sumitomo Metal and Mining: Biotech, Japan; Lawry's Restaurants, Inc.; AF Growlabs, Division of Hairraising Personal Care Products, Inc.

NEEDS Works with 1-2 photographers/month. Uses photos for trade magazines, direct mail, posters, newspapers, signage, websites, corporate brochures, and collateral. Subject matter varies; includes babies/children/teens, couples, multicultural, families, architecture, cities/urban, gardening, interiors/decorating, pets, automobiles, food/drink, health/fitness/beauty, business concepts, medicine, science. Interested in avant garde, documentary, erotic, fashion/glamour, historical/vintage. Reviews stock photos. Model/property release required. Photo captions preferred.

AUDIOVISUAL NEEDS Works with 1 videographer/month. Uses videotape for industrial, product.

SPECS Mostly DVD and digital format.

MAKING CONTACT & TERMS Submit portfolio for review. Send unsolicited photos by mail for consideration; include SASE for return of material. Works with local freelancers on assignment only. Provide résumé, business card, brochure, flyer or tearsheet to be kept on file. Responds in 3 weeks. Payment negotiable, depending on budget for each project. Pays on receipt of invoice. Credit line not given. Buys one-time and all rights.

TIPS "Innovative, crisp, dynamic, unique style–otherwise we'll stick with our photographers. If it's not great work, don't bother."

◎ ❀ BRIGHT LIGHT VISUAL COMMUNICATIONS

602 Main St., Suite 810, Cincinnati OH 45202. (513)721-2574. **Fax:** (513)721-3329. **E-mail:** info@brightlightusa.com. **Website:** www.brightlightusa.com. **Contact:** Linda Spalazzi, CEO. Visual communication company. Types of clients: national, regional and local companies in the governmental, educational, industrial and commercial categories. Examples of recent clients: Procter & Gamble; U.S. Grains Council; Convergys.

NEEDS Model/property release required. Photo captions preferred.

AUDIOVISUAL NEEDS "Hires crews around the world using a variety of formats."

MAKING CONTACT & TERMS Provide résumé, flyer and brochure to be kept on file. Call to arrange appointment or send query letter with résumé of credits. Works on assignment only. Pays $100 minimum/day for grip; payment negotiable based on photographer's previous experience/reputation and day rate (10 hours). Pays within 30 days of completion of job. Buys all rights.

TIPS Sample assignments include camera assistant, gaffer or grip. Wants to see sample reels or samples of still work. Looking for sensitivity to subject matter and lighting. "Show a willingness to work hard. Every client wants us to work smarter and provide quality at a good value."

⊗ ⑤ ◑ BYNUMS MARKETING AND COMMUNICATIONS, INC.

301 Grant St., Suite 4300, Pittsburgh PA 15219. (412)471-4332. **Fax:** (412)471-1383. **E-mail:** rbynum2124@earthlink.net; russell@bynums.com. **Website:** www.bynums.com. Estab. 1985. Ad agency. Number of employees: 8-10. Firm specializes in annual reports, collateral, direct mail, magazine ads, packaging, publication design, signage. Types of clients: financial, health care, consumer goods, nonprofit.

NEEDS Works with 1 photographer/month. Uses photos for billboards, brochures, direct mail, newspapers, posters. Subjects include: babies/children/teens, couples, multicultural, families, parents, senior citizens, environmental, wildlife, cities/urban, education, religious, adventure, automobiles, events, food/drink, health/fitness, performing arts, sports, medicine, product shots/still life, science, technology/computers. Interested in fine art, seasonal. Model/property release required. Photo captions preferred.

AUDIOVISUAL NEEDS Works with 1 videographer and 1 filmmaker/year. Uses slides, film, videotape.

SPECS Uses 8×10 glossy or matte color and b&w prints; 35mm, 4×5 transparencies. Accepts images in digital format. Send via ZIP, e-mail as TIFF files.

MAKING CONTACT & TERMS Send query letter with résumé, prints, tearsheets, stock list. Provide business card, self-promotion piece to be kept on file. Responds only if interested, send nonreturnable samples. Pays $150-300 for b&w and color photos. "Payment may depend on quote and assignment requirements." Buys electronic rights.

⊗ CARMICHAEL LYNCH

110 N. Fifth St., Minneapolis MN 55403. (612)334-6000. **Fax:** (612)334-6090. **E-mail:** portfolio@clynch.com. **Website:** www.clynch.com. **Contact:** Sandy Boss Febbo, executive art producer; Bonnie Brown, Jill Kahn, Jenny Barnes, art producers. Member of American Association of Advertising Agencies. Ad agency. Number of employees: 250. Firm specializes in collateral, direct mail, magazine ads, packaging. Types of clients: finance, health care, sports and recreation, beverage, outdoor recreational. Examples of recent clients: Harley-Davidson, Porsche, Northwest Airlines, American Standard.

NEEDS Uses many photographers/month. Uses photos for billboards, consumer and trade magazines, direct mail, P-O-P displays, brochures, posters, newspapers and other media as needs arise. Subjects include: environmental, landscapes/scenics, architecture, interiors/decorating, rural, adventure, automobiles, travel, product shots/still life. Model/property release required for all visually recognizable subjects.

SPECS Uses all print formats. Accepts images in digital format. Send TIFF, GIF, JPEG files at 72 dpi or higher.

MAKING CONTACT & TERMS Submit portfolio for review. Provide résumé, business card, brochure, flyer or tearsheets to be kept on file. Payment negotiable. Pay depends on contract. Buys all, one-time or exclusive product rights, "depending on agreement."

TIPS "No 'babes on bikes'! In a portfolio, we prefer to see the photographer's most creative work—not necessarily ads. Show only your most technically, artistically satisfying work."

CGT MARKETING, LLC

275-B Dixon Ave., Amityville NY 11701. (631)842-4600. **Fax:** (631)842-6301. **E-mail:** info@cgtllc.net. **Website:** www.cgtmarketing.com. Estab. 1981. **Contact:** Mitch Tobol, president. Estab. 1981. Ad agency/design studio. Clients: high-tech, industrial, business-to-business, consumer. Examples of recent clients: Weight Watchers (in-store promotion).

NEEDS Works with up to 2 photographers and videographers/month. Uses photos for billboards, consumer and trade magazines, direct mail, P-O-P displays, catalogs, posters, newspapers, audiovisual. Subjects are varied; mostly still-life photography. Reviews business-to-business and commercial video footage. Model release required.

AUDIOVISUAL NEEDS DVD, CD.

SPECS "Digital photos in all formats, BetaSP, digital video." Uses 4×5, 8×10, 11×14 b&w prints; 35mm, 2¼×2¼, 4×5 transparencies; ½" videotape. Accepts images in digital format. Send via e-mail or link to website.

MAKING CONTACT & TERMS Send query letter with samples; include SASE for return of material. Provide résumé, business card, brochure, flyer or tearsheets to be kept on file; follow up with phone call. Works on assignment only. Responds in 3 weeks. Pays $100-10,000/job. Pays net 30 days. Credit line sometimes given, depending on client and price. Rights purchased depend on client.

TIPS In freelancer's samples or demos, wants to see "the best—any style or subject as long as it is done

well. Trend is photos or videos to be multi-functional. Show me your *best* and what you enjoy shooting. Get experience with existing company to make the transition from still photography to audiovisual."

◎ ⊛ DYKEMAN ASSOCIATES, INC.

4115 Rawlins St., Dallas TX 75219. (214)528-2991. E-mail: info@dykemanassociates.com. Website: www. dykemanassociates.com. Estab. 1974. Member of Public Relations Society of America. PR, marketing, video production firm. Firm specializes in website creation and promotion, crisis communication plans, media training, collateral, direct marketing. Types of clients: industrial, financial, sports, technology.

NEEDS Works with 4-5 photographers and videographers. Uses photos for publicity, consumer and trade magazines, direct mail, catalogs, posters, newspapers, signage, websites.

AUDIOVISUAL NEEDS "We produce and direct video. Just need crew with good equipment and people and ability to do their part."

MAKING CONTACT & TERMS Arrange a personal interview to show portfolio. Pays $800-1,200/day; $250-400/1-2 days. "Currently we work only with photographers who are willing to be part of our trade dollar network. Call if you don't understand this term." Pays up to 30 days after receipt of invoice.

TIPS Reviews portfolios with current needs in mind. "If video, we would want to see examples. If for news story, we would need to see photojournalism capabilities."

⑤ ◐ ⊛ FLINT COMMUNICATIONS

101 N. 10th St., Suite 300, Fargo ND 58107. (701)237-4850. **Fax:** (701)234-9680. **E-mail:** gerril@flintcom. com, dawnk@flintcom.com. **Website:** www.flintcom. com. **Contact:** Gerri Lien, creative director; Dawn Koranda, creative director. Estab. 1946. Ad agency. Approximate annual billing: $9 million. Number of employees: 30. Firm specializes in display design, direct mail, magazine ads, publication design, signage, annual reports. Types of clients: industrial, financial, agriculture, health care and tourism.

NEEDS Works with 2-3 photographers/month. Uses photos for direct mail, P-O-P displays, posters and audiovisual. Subjects include: babies/children/teens, couples, parents, senior citizens, architecture, rural, adventure, automobiles, events, food/drink, health/fitness, sports, travel, agriculture, industry, medicine, political, product shots/still life, science, technology,

manufacturing, finance, health care, business. Interested in documentary, historical/vintage, seasonal. Reviews stock photos. Model release preferred.

AUDIOVISUAL NEEDS Works with 1-2 filmmakers and 1-2 videographers/month. Uses slides and film.

SPECS Uses 35mm, 2¼×2¼, 4×5 transparencies. Accepts images in digital format. Send via CD, ZIP as TIFF, EPS, JPEG files.

MAKING CONTACT & TERMS Send query letter with stock list. Submit portfolio for review. Provide résumé, business card, brochure, flyer or tearsheets to be kept on file. Responds in 1-2 weeks. Pays $50-150 for b&w photos; $50-1,500 for color photos; $50-130/hour; $400-1,200/day; $100-2,000/job. Pays on receipt of invoice. Buys one-time rights.

⑤ ◐ ⊛ FRIEDENTAG PHOTOGRAPHICS

314 S. Niagara St., Denver CO 80224-1324. (303)333-0570. **E-mail:** harveyfriedentag@msn.com. Estab. 1957. AV firm. Approximate annual billing: $500,000. Number of employees: 3. Firm specializes in direct mail, annual reports, publication design, magazine ads. Types of clients: business, industry, financial, publishing, government, trade and union organizations. Produces slide sets, motion pictures and videotape. Examples of recent clients: Perry Realtors annual report (advertising, mailing); Lighting Unlimited catalog (illustrations).

NEEDS Works with 5-10 photographers/month on assignment only. Buys 1,000 photos and 25 films/year. Reviews stock photos of business, training, public relations, and industrial plants showing people and equipment or products in use. Other subjects include agriculture, business concepts, industry, medicine, military, political, science, technology/computers. Interested in avant garde, documentary, erotic, fashion/glamour. Model release required.

AUDIOVISUAL NEEDS Uses freelance photos in color slide sets and motion pictures. "No posed looks." Also produces mostly 16mm Ektachrome and some 16mm × ¾"and VHS videotape. Length requirement: 3-30 minutes. Interested in stock footage on business, industry, education and unusual information. "No scenics, please!"

SPECS Uses 8×10 glossy b&w and color prints; 35mm, 2¼×2¼, 4×5 color transparencies. Accepts images in digital format. Send via CD as JPEG files.

MAKING CONTACT & TERMS Send material by mail for consideration. Provide flyer, business card, brochure and nonreturnable samples to show clients. Responds in 3 weeks. Pays $500/day for still; $700/day for motion picture plus expenses; $100 maximum for b&w photos; $200 maximum for color photos; $700 maximum for film; $700 maximum for videotape. **Pays on acceptance.** Buys rights as required by clients.
TIPS "More imagination needed—be different; *no scenics, pets or portraits*, and above all, technical quality is a must. There are more opportunities now than ever, especially for new people. We are looking to strengthen our file of talent across the nation."

🌐 ◎ ✿ GIBSON ADVERTISING

P.O. Box 20735, Billings MT 51904. (406)670-3412. **E-mail:** mike@gibsonad.com. **Website:** www.gibsonad.com. **Contact:** Mike Curtis, president. Estab. 1984. Ad agency. Number of employees: 2. Types of clients: industrial, financial, retail, food, medical.
NEEDS Works with 1-3 freelance photographers and 1-2 videographers/month. Uses photos for direct mail, P-O-P displays, catalogs, posters, newspapers, signage, audiovisual. Subjects vary with job. Reviews stock photos. "We would like to see more Western photos." Model release required. Property release preferred.
AUDIOVISUAL NEEDS Uses slides and videotape.
SPECS Uses color and b&w prints; 35mm, 2¼×2¼, 4×5, 8×10 transparencies; 16mm, VHS, Betacam videotape; and digital formats.
MAKING CONTACT & TERMS Send query letter with résumé of credits or samples. Provide résumé, business card, brochure, flyer or tearsheets to be kept on file. Works with local freelancers on assignment only. Keeps samples on file. Cannot return material. Responds in 2 weeks. Pays $75-150/job; $150-250 for color photo; $75-150 for b&w photo; $100-150/hour for video. Pays on receipt of invoice, net 30 days. Credit line sometimes given. Buys one-time and electronic rights. Rights negotiable.

✿ GOLD & ASSOCIATES, INC.

6000-C Sawgrass Village Circle, Ponte Vedra Beach FL 32082. (904)285-5669. **Fax:** (904)285-1579. **E-mail:** gold@strikegold.com. **Website:** www.strikegold.com. **Contact:** Keith Gold, creative director/CEO. Estab. 1988. Marketing/design/advertising firm. Approximate annual billing: $50 million in capitalized billings. Multiple offices throughout Eastern U.S. Firm specializes in health care, publishing, tourism, entertainment industries. Examples of clients: State of Florida; Harcourt; Time-Warner; GEICO; the PGA Tour.
NEEDS Works with 1-4 photographers/month. Uses photos for print advertising, posters, brochures, direct mail, television spots, packaging. Subjects vary. Reviews stock photos and reels. Tries to buy out images.
AUDIOVISUAL NEEDS Works with 1-2 filmmakers/month. Uses 35mm film; no video.
SPECS Uses digital images.
MAKING CONTACT & TERMS Contact through rep. Provide samples to be kept on file. Works with freelancers from across the U.S. Cannot return material. Only responds to "photographers being used." Pays 50% on receipt of invoice, 50% on completion. Credit line given only for original work where the photograph is the primary design element; never for spot or stock photos. Buys all rights worldwide.

✿ HALLOWES PRODUCTIONS & ADVERTISING

11260 Regent St., Los Angeles CA 90066-3414. (310)390-4767. **Fax:** (310)745-1107. **E-mail:** adjim@aol.com. **Website:** www.jimhallowes.com; www.hallowesproductions.com. **Contact:** Jim Hallowes, creative director/producer-director. Estab. 1984. Creates and produces TV commercials, corporate films and videos, and print and electronic advertising.
NEEDS Buys 8-10 photos/year. Uses photos for magazines, posters, newspapers and brochures. Reviews stock photos; subjects vary.
AUDIOVISUAL NEEDS Uses film and video for TV commercials and corporate films.
SPECS Uses 35mm, 4×5 transparencies; 35mm/16mm film; Beta SP videotape; all digital formats.
MAKING CONTACT & TERMS Send query letter with résumé of credits. "Do not fax unless requested." Keeps samples on file. Responds if interested. Payment negotiable. Pays on usage. Credit line sometimes given, depending upon usage, usually not. Buys first and all rights; rights vary depending on client.

✚ 🅢🅢🅢 ◑ HAMPTON DESIGN GROUP

(610)821-0963. **E-mail:** wendy@hamptondesigngroup.com. **Website:** www.hamptondesigngroup.com. **Contact:** Wendy Ronga, creative director. Estab. 1997. Member of Type Director Club, Society of Illustrators, Art Directors Club, Society for Publication Designers. Design firm. Approximate annual billing: $450,000.

Number of employees: 3. Firm specializes in annual reports, magazine and book design, editorial packaging, advertising, collateral, direct mail. Examples of recent clients: Conference for the Aging, Duke University/Templton Foundation (photo shoot/5 images); Religion and Science, UCSB University (9 images for conference brochure).

NEEDS Works with 2 photographers/month. Uses photos for billboards, brochures, catalogs, consumer magazines, direct mail, newspapers, posters, trade magazines. Subjects include: babies/children/teens, multicultural, senior citizens, environmental, landscapes/scenics, wildlife, pets, religious, health/fitness/beauty, business concepts, medicine, science. Interested in alternative process, avant garde, fine art, historical/vintage, seasonal. Model/property release required. Photo captions preferred.

SPECS Prefers images in digital format. Send via CD as TIFF, EPS, JPEG files at 300 dpi.

MAKING CONTACT & TERMS Send query letter. Keeps samples on file. Responds only if interested; send nonreturnable samples or web address to see examples. Pays $150-1,500 for color photos; $75-1,000 for b&w photos. Pays extra for electronic usage of photos, varies depending on usage. Price is determined by size, how long the image is used and if it is on the home page. **Pays on receipt of invoice.** Credit line given. Buys one-time rights, all rights, electronic rights; negotiable.

TIPS "Use different angles and perspectives, a new way to view the same old boring subject. Try different films and processes."

BERNARD HODES GROUP

220 E. 42nd St., New York NY 10017. (888)438-9911; (212)999-9000. **Website:** www.hodes.com. **Contact:** Andy Ross, creative director. Estab. 1970. Member of Western Art Directors Club, San Francisco Ad Club. Ad agency, design firm. Has over 90 offices and affiliates worldwide; approximately 700 employees. Firm specializes in annual reports, collateral, direct mail, magazine ads, packaging, publication design. Types of clients: industrial, retail, nonprofit.

NEEDS Works with 1 or more photographers/month. Uses photos for brochures, catalogs, consumer and trade magazines, direct mail. Model release preferred.

AUDIOVISUAL NEEDS Uses slides.

SPECS Uses 35mm, 2¼×2¼, 4×5 transparencies. Accepts images in digital format. Send via CD, SyQuest, ZIP, e-mail as TIFF, EPS, JPEG files.

MAKING CONTACT & TERMS Send query letter with résumé. Works with local freelancers only. Provide résumé, business card, self-promotion piece to be kept on file. Pays net 30 days. Buys all rights.

⊙ ◑ HOWARD, MERRELL AND PARTNERS, INC.

8521 Six Forks Rd., 4th Floor, Raleigh NC 27615. (919)848-2400. **Fax:** (919)845-9845. **Website:** www.merrellgroup.com. **Contact:** Stephanie Dunford. Estab. 1945. Number of employees: 25.

NEEDS Works with approximately 1 photographer/month. Uses photos for consumer and trade magazines, newspapers, collateral, outdoor boards and websites. Purchases stock images. Model/property release required.

MAKING CONTACT & TERMS Works on assignment and buys stock photos. Pays on receipt of invoice. Buys one-time and all rights.

⊙⊙⊙ ◑ HUTCHINSON ASSOCIATES INC.

822 Linden Ave., Suite 200, Oak Park IL 60302. (312)455-9191. **Fax:** (312)455-9190. **E-mail:** hutch@hutchinson.com. **Website:** www.hutchinson.com. **Contact:** Jerry Hutchinson, president. Estab. 1988. Member of American Institute of Graphic Arts. Design firm. Number of employees: 3. Firm specializes in identity development, website development, annual reports, collateral, magazine ads, publication design, marketing brochures. Types of clients: industrial, financial, real estate, retail, publishing, nonprofit and medical. Recent client: Cardinal Growth.

NEEDS Works with 1 photographer/month. Uses photographs for annual reports, brochures, consumer and trade magazines, direct mail, catalogs, websites and posters. Subjects include: still life, real estate. Reviews stock photos.

SPECS Accepts images in digital format.

MAKING CONTACT & TERMS Send query letter with samples. Keeps samples on file. Responds "when the right project comes along." Payment rates depend on the client. Pays within 30-45 days. Credit line sometimes given. Buys one-time, exclusive product and all rights; negotiable.

TIPS In samples, "print quality and composition count."

IDEA BANK MARKETING

P.O. Box 2117, Hastings NE 68902. (402)463-0588. **Fax:** (402)463-2187. **Website:** www.ideabankmarketing.com. **Contact:** Sherma Jones, vice president/creative director. Estab. 1982. Member of Lincoln Ad Federation. Ad agency. Approximate annual billing: $1.5 million. Number of employees: 14. Types of clients: industrial, financial, tourism and retail.

NEEDS Works with 1-2 photographers/quarter. Uses photos for direct mail, catalogs, posters and newspapers. Subjects include people and products. Reviews stock photos. Model release required; property release preferred.

AUDIOVISUAL NEEDS Works with 1 videographer/quarter. Uses slides and videotape for presentations.

SPECS Uses digital images.

MAKING CONTACT & TERMS Provide résumé, business card, brochure, flyer or tearsheets to be kept on file. Works with freelancers on assignment only. Responds in 2 weeks. Pays $75-125/hour; $650-1,000/day. Pays on acceptance with receipt of invoice. Credit line sometimes given depending on client and project. Buys all rights; negotiable.

IMAGE INTEGRATION

2619 Benvenue Ave. #A, Berkeley CA 94704. (510)841-8524. **E-mail:** vincesail@aol.com. **Contact:** Vince Casalaina, owner. Estab. 1971. Firm specializes in material for TV productions and Internet sites. Approximate annual billing: $100,000. Examples of recent clients: "Internet coverage of Melges 32 World Championship, 505 World Championship, Snipe World Championship, Snipe Women's World Championship. 30-Minute Documentary on the Snipe Class as it turns 80 in 2011."

NEEDS Works with 1 photographer/month. Reviews stock photos of sailing only. Property release preferred. Photo captions required; include regatta name, regatta location, date.

AUDIOVISUAL NEEDS Works with 1 videographer/month. Uses videotape. Subjects include: sailing only.

SPECS Uses 4×5 or larger matte color and b&w prints; 35mm transparencies; 16mm film and Betacam videotape. Prefers images in digital format. Send via e-mail, ZIP, CD (preferred).

MAKING CONTACT & TERMS Send unsolicited photos of sailing by mail with SASE for consideration. Keeps samples on file. Responds in 2 weeks. Payment depends on distribution. Pays on publication. Credit line sometimes given, depending upon whether any credits included. Buys nonexclusive rights; negotiable.

JUDE STUDIOS

8000 Research Forest, Suite 115-266, The Woodlands TX 77382. (281)364-9366. **E-mail:** jdollar@judestudios.com. **Contact:** Judith Dollar, art director. Estab. 1994. Number of employees: 2. Firm specializes in collateral, direct mail, packaging. Types of clients: nonprofits, builder, retail, destination marketing, event marketing, service. Examples of recent clients: home builder; festivals and events; corporate collateral; banking.

NEEDS Works with 1 photographer/month. Uses photos for newsletters, brochures, catalogs, direct mail, trade and trade show graphics. Needs photos of families, active adults, shopping, recreation, concert, music, education, business concepts, industry, product shots/still life. Stock photos also used. Model release required; property release preferred.

SPECS Accepts images in digital format. Do not e-mail attachments.

MAKING CONTACT & TERMS Send e-mail with link to website, blog, or portfolio. Provide business card, self-promotion piece to be kept on file. Responds only if interested; send nonreturnable samples. Pays by the project. Pays on receipt of invoice.

KINETIC, THE TECHNOLOGY AGENCY

200 Distillery Commons, Suite 200, Louisville KY 40206-1990. (502)719-9500. **Fax:** (502)719-9509. **Website:** www.thetechnologyagency.com. Estab. 1968. Types of clients: industrial, financial, fashion, retail and food.

NEEDS Works with freelance photographers and/or videographers as needed. Uses photos for audiovisual and print. Model and/or property release required.

SPECS Prefers images in digital format. Send via CD, DVD, ZIP as TIFF files.

MAKING CONTACT & TERMS Provide résumé, business card, brochure, flyer or tearsheets to be kept on file. Responds only when interested. Payment negotiable. Pays within 30 days. Buys all rights.

KOCHAN & COMPANY

800 Geyer Ave., St. Louis MO 63104. (314)621-4455. **Fax:** (314)621-1777. **Website:** www.kochanandcompany.com. Estab. 1987. Member of AAAA. AAF/St. Louis. Ad agency. Number of employees: 10. Firm specializes in brand identity, print and magazine

ads, outdoor, direct mail, signage. Recent clients: Argosy Casino (billboards/duratrans); Pasta House Co. (menu inserts); Mystique Casino/billboards/print ads.

NEEDS Uses photos for billboards, brochures, catalogs, direct mail, newspapers, posters, signage. Reviews stock photos. Model/property release required. Photo captions required.

MAKING CONTACT & TERMS Send query letter with samples, brochure, stock list, tearsheets. To show portfolio, photographer should follow up with call and letter after initial query. Portfolio should include b&w, color, prints, tearsheets, slides, transparencies. Works with freelancers on assignment only. Keeps samples on file. Responds only if interested; send nonreturnable samples. Pays on receipt of invoice. Credit line given. Buys all rights.

🟢🟢 LOHRE & ASSOCIATES, INC.

126A W. 14th St., 2nd Floor, Cincinnati OH 45202-7535. (513)961-1174. **Website:** www.lohre.com. **Contact:** Chuck Lohre, president. Ad agency. Types of clients: industrial.

NEEDS Uses photos for trade magazines, direct mail, catalogs and prints. Subjects include: machine-industrial themes and various eye-catchers.

SPECS Uses high-res digital images.

MAKING CONTACT & TERMS Send query letter with résumé of credits. Provide business card, brochure, flyer or tearsheets to be kept on file.

⊘ THE MILLER GROUP

1516 Bundy Dr., Suite 200, Los Angeles CA 90025. **E-mail:** gary@millergroupmarketing.com. **Website:** www.millergroupmarketing.com. **Contact:** Gary Bettman, vice president. Estab. 1990. Member of WSAAA. Approximate annual billing: $12 million. Number of employees: 10. Firm specializes in print advertising. Types of clients: consumer.

NEEDS Uses photos for billboards, brochures, consumer magazines, direct mail, newspapers. Model release required.

MAKING CONTACT & TERMS Contact through rep or send query letter with photocopies. Provide self-promotion piece to be kept on file. Buys all rights; negotiable.

TIPS "Please, no calls!"

🟢 MONDERER DESIGN, INC.

2067 Massachusetts Ave., 3rd Floor, Cambridge MA 02140. (617)661-6125. **Fax:** (617)661-6126. **E-mail:** info@monderer.com. **Website:** www.monderer.com. stewart@monderer.com. **Contact:** Stewart Monderer, president. Estab. 1981. Specializes in corporate identity, branding, print collateral, website, event and interactive solutions. Clients: corporations (technology, education, consulting and life science). Current clients include Solidworks, Thermo Scientific, MIT Sloan, Northeastern University, Progress Software, Kronos, Greenlight Fund, and Canaccord Genuity.

NEEDS Works with 2 photographers/month. Uses photos for advertising, annual reports, catalogs, posters and brochures. Subjects include: environmental, architecture, cities/urban, education, adventure, automobiles, entertainment, events, performing arts, sports, travel, business concepts, industry, medicine, product shots/still life, science, technology/computers, conceptual, site specific, people on location. Interested in alternative process, avant garde, documentary, historical/vintage, seasonal. Model release preferred; property release sometimes required.

SPECS Accepts images in digital format. Send via CD as TIFF, EPS files at 300 dpi.

MAKING CONTACT & TERMS Send unsolicited photos by mail for consideration. Keeps samples on file. Follow up from photographers recommended. Payment negotiable. Pays on receipt of invoice. Credit line sometimes given depending upon client. Rights always negotiated depending on use.

◎ 🌓 MYRIAD PRODUCTIONS

415 Barlow Court, Johns Creek GA 30022. (678)417-0041. **E-mail:** myriad@mindspring.com. **Contact:** Ed Harris, president. Estab. 1965. Primarily involved with entertainment productions and sporting events. Types of clients: publishing, nonprofit.

NEEDS Works with photographers on assignment-only basis. Uses photos for portraits, live-action and studio shots, special effects, advertising, illustrations, brochures, TV and film graphics, theatrical and production stills. Subjects include: celebrities, entertainment, sports. Model/property release required. Photo captions preferred; include names, location, date, description.

SPECS Uses 8×10 b&w and color prints; 2¼×2¼ transparencies. Accepts images in digital format. Send "Mac-compatible CD or DVD. No floppy disks or ZIPs!"

MAKING CONTACT & TERMS Provide brochure, résumé or samples to be kept on file. Send material by

mail for consideration. "No telephone or fax inquiries, please!" Cannot return material. Response time "depends on urgency of job or production." Payment negotiable. Credit line sometimes given. Buys all rights. **TIPS** "We look for an imaginative photographer—one who captures all the subtle nuances. Working with us depends almost entirely on the photographer's skill and creative sensitivity with the subject. All materials submitted will be placed on file and not returned, pending future assignments. Photographers should not send us their only prints, transparencies, etc., for this reason."

😊😊 ◎ ◑ ✳ NOVUS VISUAL COMMUNICATIONS

59 Page Ave., Suite 300, Tower One, Yonkers NY 10704. (212)473-1377. **Fax:** (212)505-3300. **E-mail:** novuscom@aol.com. **E-mail:** robert@nakinc.com. **Website:** www.novuscommunications.com. **Contact:** Robert Antonik, managing director. Estab. 1988. Integrated marketing and communications company. Lectures and presents seminars on new marketing techniques. Clients include B2B, B2C and nonprofits. Uses the services of music houses, independent songwriters/composers and lyricists for scoring, background music for documentaries, commercials, multimedia applications, website, film shorts, and commercials for radio and TV. Commissions 2 composers and 4 lyricists/year. Pay varies per job. Buys one-time rights. **NEEDS** Works with 1 photographer/month. Uses photos for integrated campaigns, business-to-business, B2C, direct mail, digital displays, online and print catalogs, posters, packaging and signage. Subjects include: babies/children/teens, couples, multicultural, families, parents, senior citizens, environmental, landscapes/scenics, wildlife, architecture, cities/urban, education, gardening, interiors/decorating, pets, religious, rural, adventure, automobiles, entertainment, events, food/drink, health/fitness, hobbies, humor, performing arts, sports, travel, agriculture, business concepts, industry, medicine, military, political, product shots/still life, science, technology/computers. Interested in alternative process, avant garde, documentary, fashion/glamour, fine art, historical/vintage, seasonal. Reviews stock photos. Model/property release required. Photo captions preferred. **SPECS** Digital and film, videotape, DVD. Prefers links to websites to review content.

MAKING CONTACT & TERMS Arrange a personal interview to show portfolio. Works on assignment only. Keeps samples on file. Cannot return material. Responds in 1-2 weeks. Pays $85-175 for b&w photos; $175-800 for color photos; $300-1,000 for digital film; $175-800 for videotape. Pays upon client's payment. Credit line given. Rights negotiable. **TIPS** "The marriage of photos and illustrations continues to evolve. Being knowledgeable in Photoshop is very important. It helps shape the vision and enhances the visual. More illustrators and photographers add stock usage as part of their creative vision. E-mail with link to website. Send a sample postcard; follow up with phone call. Use low-tech marketing like direct mail, it works."

OMNI PRODUCTIONS

P.O. Box 302, Carmel IN 46082-0302. (317)846-2345. **Fax:** (317)846-6664. **E-mail:** omni@omniproductions.com. **Website:** www.omniproductions.com. **Contact:** Winston Long, president. Estab. 1984. AV firm. Types of clients: industrial, corporate, educational, government, medical. **NEEDS** Works with 6-12 photographers/month. Uses photos for AV presentations. Subject matter varies. Also works with freelance filmmakers to produce training films and commercials. Model release required. **SPECS** Uses b&w and color prints; 35mm transparencies; 16mm and 35mm film and videotape. Accepts images in digital format. **MAKING CONTACT & TERMS** Provide complete contact info, rates, business card, brochure, flyer, digital samples or tearsheets to be kept on file. Works with freelance photographers on assignment basis only. Cannot return unsolicited material. Payment negotiable. **Pays on acceptance.** Credit line given "sometimes, as specified in production agreement with client." Buys all rights on most work; will purchase one-time use on some projects.

◎ POINTBLANK AGENCY

(818)539-2282. **Fax:** (818)551-9681. **E-mail:** valn@pointblankagency.com. **Website:** www.pointblankagency.com. **Contact:** Valod Nazarian. Ad and design agency. Serves travel, high-technology and consumer-technology clients. **NEEDS** Uses photos for trade show graphics, websites, consumer and trade magazines, direct mail, P-O-P displays, newspapers. Subject matter of photography

purchased includes: conceptual shots of people and table top (tight shots of electronics products). Model release required. Photo captions preferred.

SPECS Uses 8×10 matte b&w and color prints; 35mm, 2¼×2¼, 4×5, 8×10 transparencies. Accepts images in digital format. Send via CD.

MAKING CONTACT & TERMS Arrange a personal interview to show portfolio. Provide résumé, business card, brochure, flyer or tearsheets to be kept on file. Works on assignment basis only. Does not return unsolicited material. Responds in 3 weeks. Pay is negotiable. Pays on receipt of invoice. Buys one-time, exclusive product, electronic, buy-outs, and all rights (work-for-hire); negotiable.

TIPS Prefers to see "originality, creativity, uniqueness, technical expertise" in work submitted. There is more use of "photo composites, dramatic lighting and more attention to detail" in photography.

🕒 Ⓓ POSEY SCHOOL

57 Main St., Northport NY 11768. (631)757-2700. **E-mail:** msposey@optonline.net. **Website:** www.poseyschool.com. **Contact:** Elsa Posey, president. Estab. 1953. Sponsors a school of dance, art, music, drama; regional dance company and acting company. Uses photos for brochures, news releases, newspapers.

NEEDS Buys 12-15 photos/year; offers 4 assignments/year. Special subject needs include children dancing, ballet, modern dance, jazz/tap (theater dance) and "photos showing class situations in any subjects we offer. Photos must include girls and boys, women and men. " Interested in documentary, fine art, historical/vintage. Reviews stock photos. Model release required.

SPECS Uses 8×10 glossy b&w prints. Accepts images in digital format. Send via CD, e-mail.

MAKING CONTACT & TERMS "Call us." Responds in 1 week. Pays $35-50 for most photos, b&w or color. Credit line given if requested. Buys one-time rights; negotiable.

TIPS "We are small but interested in quality (professional) work. Capture the joy of dance in a photo of children or adults. Show artists, actors or musicians at work. We prefer informal action photos, not posed pictures. We need photos of *real* dancers dancing. Call first. Be prepared to send photos on request."

QUALLY & COMPANY, INC.

(312)280-1898. **E-mail:** michael@quallycompany.com. **Website:** www.quallycompany.com. **Contact:** Michael Iva, creative director. Estab. 1979. Ad agency. Types of clients: new product development and launches.

NEEDS Uses photos for every media. "Subject matter varies, but it must always be a 'quality image' regardless of what it portrays." Model/property release required. Photo captions preferred.

SPECS Uses b&w and color prints; 35mm, 4×5, 8×10 transparencies. Accepts images in digital format.

MAKING CONTACT & TERMS Send query letter with photocopies, tearsheets. Provide résumé, business card, brochure, flyer or tearsheets to be kept on file. Responds only if interested; send nonreturnable samples. Payment negotiable. Pays net 30 days from receipt of invoice. Credit line sometimes given, depending on client's cooperation. Rights purchased depend on circumstances.

Ⓓ QUON DESIGN

543 River Rd., Fair Haven NJ 07704-3227. (732)212-9200. **E-mail:** studio@quondesign.com. **Website:** www.quondesign.com. **Contact:** Mike Quon, president/creative director. Specializes in corporate identity, collateral, packaging, publications and web design. Types of clients: industrial, financial, retail, publishers, nonprofit.

NEEDS Limited use of photography. Works with 1-3 photographers/year. Uses photos for direct mail, packaging, signage. Model/property release preferred. Photo captions required; include company name.

SPECS Uses color and b&w digital images.

MAKING CONTACT & TERMS Submit portfolio for review by mail only. No drop-offs. "Please, do not call office. Contact through mail only." Keeps samples on file. Responds only if interested; send nonreturnable samples. Pays net 30 days. Credit line given when possible. Buys first rights, one-time rights; negotiable.

TIPS "Currently using more stock photography and less assignment work."

🕒🕒 Ⓕ TED ROGGEN ADVERTISING AND PUBLIC RELATIONS

101 Westcott St., Unit 306, Houston TX 77007. (713)426-2314. **Fax:** (713)869-3563. **E-mail:** ted@tedroggen-advertising.com. **Website:** www.tedroggen-advertising.com. **Contact:** Ted Roggen. Estab. 1945. Ad agency and PR firm. Number of employees: 3. Firm specializes in magazine ads, direct mail. Types of clients: construction, entertainment, food, finance, publishing, travel.

NEEDS Buys 25-50 photos/year; offers 50-75 assignments/year. Uses photos for billboards, direct mail, radio, TV, P-O-P displays, brochures, annual reports, PR releases, sales literature and trade magazines. Subjects include adventure, health/fitness, sports, travel. Interested in fashion/glamour. Model release required. Photo captions required.

SPECS Uses 5×7 glossy or matte b&w and color prints; 4×5 transparencies. "Contact sheet OK."

MAKING CONTACT & TERMS Provide résumé to be kept on file. Pays $75-250 for b&w photos; $125-300 for color photos; $150/hour. **Pays on acceptance.** Rights negotiable.

ARNOLD SAKS ASSOCIATES

118 E. 28th St., Suite 401, New York NY 10016. (212)861-4300. **Fax:** (212)861-4374. **E-mail:** afiorillo@saksdesign.com. **Website:** www.saksdesign.com. **Contact:** Anita Fiorillo, vice president. Estab. 1967. Graphic design firm. Number of employees: 6. Approximate annual billing: $2 million. Types of clients: industrial, financial, legal, pharmaceutical, hospitals. Examples of recent clients: Alcoa; UBS; Hospital for Special Surgery; and Watson Pharmaceuticals.

NEEDS Works with approximately 10 photographers during busy season. Uses photos for annual reports and corporate brochures. Subjects include corporate situations and portraits. Wants photos of babies/children/teens, couples, multicultural, families, parents, senior citizens, automobiles, health/fitness/beauty, performing arts, sports, business concepts, industry, medicine, product shots/still life, science, technology/computers. Reviews stock photos; subjects vary according to the nature of the annual report. Model release required. Photo captions preferred.

SPECS Accepts images in digital format. Send via e-mail as TIFF, EPS, JPEG files.

MAKING CONTACT & TERMS "Appointments are set up during the spring for summer review on a first-come only basis. We have a limit of approximately 30 portfolios each season." Call to arrange an appointment. Responds as needed. Payment negotiable, "based on project budgets. Generally we pay $1,500-2,500/day." Pays on receipt of invoice and payment by client; advances provided. Credit line sometimes given depending upon client specifications. Buys one-time and all rights; negotiable.

TIPS Specializes in annual reports and corporate communications. Clients: Fortune 500 corporations. Client list available upon request.

⑤⑤ ◑ HENRY SCHMIDT DESIGN

P.O. Box 67204, Portland OR 97268. (503)652-1114. **E-mail:** studio@hankink.com. **Website:** www.hankink.com. **Contact:** Hank Schmidt, president. Estab. 1976. Design firm. Number of employees: 2. Approximate annual billing: $160,000. Firm specializes in branding, packaging, P-O-P displays, catalog/sales literature.

NEEDS Works with 1-2 photographers/month. Uses photos for catalogs and packaging. Subjects include product shots/still life. Interested in fashion/glamour. Model/property release required.

MAKING CONTACT & TERMS Contact via e-mail with samples attached and link to website. Buys all rights.

⑤⑤⑤ ✣ SIDES & ASSOCIATES

222 Jefferson St., Suite B, Lafayette LA 70501. (337)233-6473. **E-mail:** info@sides.com. **Website:** www.sides.com. **Contact:** Larry Sides, agency president. Estab. 1976. Member of AAAA, PRSA, Association for Strategic Planning, Chamber of Commerce, Better Business Bureau. Ad agency. Number of employees: 13. Firm specializes in publication design, display design, signage, video and radio production. Types of clients: governmental, healthcare, financial, retail, nonprofit. Examples of recent clients: U.S. Dept of Homeland Security, ESF #14 (web, brochure, and special event planning); Lafayette Regional Airport (signs, brochures), Our Lady of Lourdes Regional Medical Center (TV, outdoor, print ads, brochures).

NEEDS Works with 2 photographers/month. Uses photos for billboards, brochures, newspapers, P-O-P displays, posters, signage. Subjects include: setup shots of people. Reviews stock photos of everything. Model/property release required.

AUDIOVISUAL NEEDS Works with 2 filmmakers and 2 videographers/month. Uses slides and/or film or video for broadcast, TV, newspaper.

SPECS Uses 35mm, 2¼×2¼, 4×5 transparencies.

MAKING CONTACT & TERMS Provide résumé, business card, self-promotion piece or tearsheets to be kept on file. Works with local freelancers only. Responds only if interested; send nonreturnable samples. Payment determined by client and usage. Pays "when paid by our client." Rights negotiable.

⑤ ○ ❀ SOUNDLIGHT

5438 Tennessee Ave., New Port Richey FL 34652. (727)842-6788. **E-mail:** keth@soundlight.org. **Website:** www.soundlight.org. **Contact:** Keth Luke. Estab. 1972. Approximate annual billing: $150,000. Number of employees: 2. Firm specializes in websites, direct mail, magazine ads, model portfolios, publication design. Types of clients: businesses, astrological and spiritual workshops, books, calendars, fashion, magazines, models, special events, products, non-profit, webpages. Examples of recent clients: Sensual Women of Hawaii (calendars, post.cards).

NEEDS Works with 1 freelance photographer every 7 months. Subjects include: women, celebrities, couples, Goddess, people in activities, landscapes/scenics, animals, religious, adventure, health/fitness/beauty, humor, alternative medicine, spiritual, travel sites and activities, exotic dance and models (art, glamour, lingerie, nude). Interested in alternative process, avant garde, erotic, fine art. Reviews stock photos, slides, computer images. Model release preferred for models and advertising people. Photo captions preferred; include who, what, where.

AUDIOVISUAL NEEDS Uses freelance photographers for slide sets, multimedia productions, videotapes, websites.

SPECS Accepts images in digital format. Send via CD, floppy disk, dropbox, e-mail as TIFF, GIF, JPEG files at 70-100 dpi.

MAKING CONTACT & TERMS Send query letter with résumé, stock list. Provide prints, slides, business card, computer disk, CD, contact sheets, self-promotion piece or tearsheets to be kept on file. Works on assignment; sometimes buys stock nude model photos. May not return unsolicited material. Responds in 3 weeks. Pays $100 maximum for b&w and color photos; $10-1,800 for videotape; $10-100/hour; $50-750/day; $2,000 maximum/job; sometimes also pays in "trades." Pays on publication. Credit line sometimes given. Buys one-time, all rights; various negotiable rights depending on use.

TIPS "In portfolios or demos, we look for unique lighting, style, emotional involvement; beautiful, artistic, sensual, erotic viewpoints. We see a trend toward manipulated computer images. Send query about what you have to show, to see what we can use at that time."

♻ ⑤ ◎ ❀ SUN.ERGOS

130 Sunset Way, Priddis AB T0L 1W0, Canada. (403)931-1527. **Fax:** (403)931-1534. **E-mail:** walter moke@sunergos.com. **Website:** www.sunergos.com. **Contact:** Robert Greenwood, artistic and managing director. Estab. 1977. "A unique, professional, two-man company of theater and dance, touring nationally and internationally as cultural ambassadors to urban and rural communities."

NEEDS Buys 10-30 photos/year; offers 3-5 assignments/year. Uses photos for brochures, newsletters, posters, newspapers, annual reports, magazines, press releases, audiovisual uses, catalogs. Reviews theater and dance stock photos. Property release required for performance photos for media use. Photo captions required; include subject, date, city, performance title.

AUDIOVISUAL NEEDS Uses digital images, slides, film and videotape for media usage, showcases and international conferences. Subjects include performance pieces/showcase materials.

SPECS Uses 8×10, 8½×11 color and b&w prints; 35mm, 2¼×2¼ transparencies; 16mm film; NTSC/PAL/SECAM videotape.

MAKING CONTACT & TERMS Arrange a personal interview to show portfolio. Send query letter with résumé of credits. Provide résumé, business card, self-promotion piece or tearsheets to be kept on file. Works on assignment only. Response time depends on project. Pays $100-150/day; $150-300/job; $2.50-10 for color or b&w photos. Pays on usage. Credit line given. Buys all rights.

TIPS "You must have experience shooting dance and *live* theater performances."

⑤⑤⑤ ❀ MARTIN THOMAS, INTERNATIONAL

42 Riverside Dr., Barrington RI 02806. (401)245-8500. **Fax:** (866)899-2710. **E-mail:** contact@martinthomas. com. **Website:** www.martinthomas.com. Estab. 1987. Ad agency, PR firm. Approximate annual billing: $7 million. Number of employees: 5. Firm specializes in collateral. Types of clients: industrial and business-to-business. Examples of recent clients: NADCA Show Booth, Newspaper 4PM Corp. (color newspaper); Pennzoil-Quaker State "Rescue," PVC Container Corp. (magazine article); "Bausch & Lomb," GLS Corporation (magazine cover); "Soft Bottles," McKechnie (booth graphics); "Perfectly Clear," ICI Acrylics (brochure).

NEEDS Works with 3-5 photographers/year. Uses photos for trade magazines. Subjects include: location shots of equipment in plants and some studio. Model release required.

AUDIOVISUAL NEEDS Uses videotape for 5- to 7-minute capabilities or instructional videos.

SPECS Uses 8×10 color and b&w prints; 35mm, 4×5 transparencies. Accepts images in digital format (call first). Send via CD, e-mail, floppy disk as GIF, JPEG files.

MAKING CONTACT & TERMS Send stock list. Provide résumé, business card, brochure, flyer or tearsheets to be kept on file. Send materials on pricing, experience. "No unsolicited portfolios will be accepted or reviewed." Cannot return material. Pays $1,000-1,500/day; $300-900 for b&w photos; $400-1,000 for color photos. Pays 30 days following receipt of invoice. Buys exclusive product rights; negotiable.

TIPS To break in, demonstrate you can be aggressive, innovative, realistic, and can work within our clients' parameters and budgets. Be responsive; be flexible.

VIDEO I-D, TELEPRODUCTIONS

105 Muller Rd., Washington IL 61571. (309)444-4323. **E-mail:** videoid@videoid.com. **Website:** www.videoid.com. **Contact:** Sam B. Wagner, president. Estab. 1977. Number of employees: 10. Types of clients: health, education, industry, service, cable and broadcast.

NEEDS Works with 2 photographers/month to shoot digital stills, multimedia backgrounds and materials, films and videotapes. Subjects "vary from commercial to industrial—always high quality." Somewhat interested in stock photos/footage. Model release required.

AUDIOVISUAL NEEDS Uses digital stills, videotape, DVD, CD.

SPECS Uses digital still extension, Beta SP, HDV and HD. Accepts images in digital format. Send via DVD, CD, e-mail, FTP.

MAKING CONTACT & TERMS Provide résumé, business card, self-promotion piece or tearsheets to be kept on file. Also send video sample reel. Include SASE for return of material. Works with freelancers on assignment only. Responds in 3 weeks. Pays $10-65/hour; $160-650/day. Usually pays by the job; negotiable. **Pays on acceptance.** Credit line sometimes given. Buys all rights; negotiable.

TIPS "Sample reel—indicate goal for specific pieces. Show good lighting and visualization skills. Show me you can communicate what I need to see, and have a willingness to put out effort to get top quality."

WORCESTER POLYTECHNIC INSTITUTE

100 Institute Rd., Worcester MA 01609-2280. (508)831-6715; (508)831-5099. **Fax:** (508)831-5820. **E-mail:** mdeiana@wpi.edu. **Website:** www.wpi.edu. **Contact:** Maureen Deiana, director of marketing programs. Estab. 1865. Publishes periodicals; promotional, recruiting and fund-raising printed materials. Photos used in brochures, newsletters, posters, audiovisual presentations, annual reports, catalogs, magazines, press releases, online.

NEEDS On-campus, comprehensive and specific views of all elements of the WPI experience.

SPECS Prefers images in digital format, but will use 5×7 (minimum) glossy b&w and color prints.

MAKING CONTACT & TERMS Arrange a personal interview to show portfolio or query with website link. Provide résumé, business card, brochure, flyer or tearsheets to be kept on file. "No phone calls." Responds in 6 weeks. Payment negotiable. Credit line given in some publications. Buys one-time or all rights; negotiable.

GALLERIES

The popularity of photography as a collectible art form has improved the market for fine art photographs over the last decade. Collectors now recognize the investment value of prints by Ansel Adams, Irving Penn, and Henri Cartier-Bresson, and therefore frequently turn to galleries for photographs to place in their private collections.

The gallery/fine art market can make money for many photographers. However, unlike commercial and editorial markets, galleries seldom generate quick income for artists. Galleries should be considered venues for important, thought-provoking imagery, rather than markets through which you can make a substantial living.

More than any other market, this area is filled with photographers who are interested in delivering a message. Many photography exhibits focus on one theme by a single artist. Group exhibits feature the work of several artists, and they often explore a theme from many perspectives, though not always. These group exhibits may be juried (i.e., the photographs in the exhibit are selected by a committee of judges who are knowledgeable about photography). Some group exhibits also may include other mediums such as painting, drawing, or sculpture. In any case, galleries want artists who can excite viewers and make them think about important subjects. They, of course, also hope that viewers will buy the photographs shown in their galleries.

As with picture buyers and art directors, gallery directors love to see strong, well-organized portfolios. Limit your portfolio to twenty top-notch images. When putting together your portfolio, focus on one overriding theme. A director wants to be certain you have enough quality work to carry an entire show. After the portfolio review, if the director likes your style, then you might discuss future projects or past work that you've done. Directors

who see promise in your work, but don't think you're ready for a solo exhibition, may place your photographs in a group exhibition.

HOW GALLERIES OPERATE

In exchange for brokering images, a gallery often receives a commission of 40–50 percent. They usually exhibit work for a month, sometimes longer, and hold openings to kick off new shows. They also frequently provide pre-exhibition publicity. Some smaller galleries require exhibiting photographers to help with opening night reception expenses. Galleries also may require photographers to appear during the show or opening. Be certain that such policies are put in writing before you allow them to show your work.

Gallery directors who foresee a bright future for you might want exclusive rights to represent your work. This type of arrangement forces buyers to get your images directly from the gallery that represents you. Such contracts are quite common, usually limiting the exclusive rights to specified distances. For example, a gallery in Tulsa, Oklahoma, may have exclusive rights to distribute your work within a 200-mile radius of the gallery. This would allow you to sign similar contracts with galleries outside the 200-mile range.

FIND THE RIGHT FIT

As you search for the perfect gallery, it's important to understand the different types of exhibition spaces and how they operate. The route you choose depends on your needs, the type of work you do, your long-term goals, and the audience you're trying to reach.

- **Retail or commercial galleries.** The goal of the retail gallery is to sell and promote artists while turning a profit. Retail galleries take a commission of 40–50 percent of all sales.
- **Co-op galleries.** Co-ops exist to sell and promote artists' work, but they are run by artists. Members exhibit their own work in exchange for a fee, which covers the gallery's overhead. Some co-ops also take a commission of 20–30 percent to cover expenses. Members share the responsibilities of gallery-sitting, sales, housekeeping, and maintenance.
- **Rental galleries.** The rental gallery makes its profit primarily through renting space to artists and consequently may not take a commission on sales (or will take only a very small commission). Some rental spaces provide publicity for artists, while others do not. Showing in this type of gallery is risky. Rental galleries are sometimes thought of as "vanity galleries," and, consequently, they do not have the credibility other galleries enjoy.
- **Nonprofit galleries.** Nonprofit spaces will provide you with an opportunity to sell work and gain publicity, but will not market your work aggressively, because their goals are not necessarily sales-oriented. Nonprofits normally take a commission of 20–30 percent.

- **Museums.** Don't approach museums unless you have already exhibited in galleries. The work in museums is by established artists and is usually donated by collectors or purchased through art dealers.
- **Art consultancies.** Generally, art consultants act as liaisons between fine artists and buyers. Most take a commission on sales (as would a gallery). Some maintain small gallery spaces and show work to clients by appointment.

If you've never exhibited your work in a traditional gallery space before, you may want to start with a less traditional kind of show. Alternative spaces are becoming a viable way to help the public see your work. Try bookstores (even large chains), restaurants, coffee shops, upscale home furnishings stores, and boutiques. The art will help give their business a more pleasant, interesting environment at no cost to them, and you may generate a few fans or even a few sales.

Think carefully about what you take pictures of and what kinds of businesses might benefit from displaying them. If you shoot flowers and other plant life, perhaps you could approach a nursery about hanging your work in their sales office. If you shoot landscapes of exotic locations, maybe a travel agent would like to take you on. Think creatively and don't be afraid to approach a business person with a proposal. Just make sure the final agreement is spelled out in writing so there will be no misunderstandings, especially about who gets what money from sales.

COMPOSING AN ARTIST'S STATEMENT

When you approach a gallery about a solo exhibition, they will usually expect your body of work to be organized around a theme. To present your work and its theme to the public, the gallery will expect you to write an artist's statement, a brief essay about how and why you make photographic images. There are several things to keep in mind when writing your statement: Be brief. Most statements should be 100–300 words long. You shouldn't try to tell your life's story leading up to this moment. Write as you speak. There is no reason to make up complicated motivations for your work if there aren't any. Just be honest about why you shoot the way you do. Stay focused. Limit your thoughts to those that deal directly with the specific exhibit for which you're preparing.

Before you start writing your statement, consider your answers to the following questions: Why do you make photographs (as opposed to using some other medium)? What are your photographs about? What are the subjects in your photographs? What are you trying to communicate through your work?

440 GALLERY

440 Sixth Ave., Brooklyn NY 11215. (718)499-3844. **E-mail:** gallery440@verizon.net. **Website:** www.440gallery.com. **Contact:** Nancy Lunsford, co-founder and director. Estab. 2005. 440 is a Cooperative gallery. We maintain our membership at approximately 14 artists and occasionally seek a new member when an individual moves or leaves the collective. There is a co-op membership fee plus a donation of time. All prospective members must submit a portfolio and be interviewed. In addition, to members' solo exhibitions, we host 2 national juried exhibitions each year, in the summer and winter, with an outside curator making selections. Located in Park Slope (Brooklyn), the gallery is approximately 400 sq. ft. with two exhibition areas (the solo gallery in the front and members' gallery in the back). Open Tuesday-Friday, 4-7; weekends 11-7; closed in August. Patrons are primarily from the New York City regions, especially Brooklyn. Due to our proximity to popular Brooklyn destinations, we are visited often by tourists interested in culture and art. Overall price range $100-12,000 with prices set by the artist. Average length of an exhibition is 5 weeks.

EXHIBITS Our artists most frequently exhibit painting, collage/assemblage, photography and sculpture.

MAKING CONTACT & TERMS Artwork is accepted on consignment and there is a 20% commission on sales for members and 30-40% on juried shows. Gallery provides promotion.

SUBMISSIONS For consideration as a member, please e-mail a query including a link to your website, which should include a résumé. For an application to our juried shows, visit our website and find the "Call for Entry" link.

ADDISON/RIPLEY FINE ART

1670 Wisconsin Ave. NW, Washington DC 20007. (202)338-5180. **Fax:** (202)338-2341. **E-mail:** addisonrip@aol.com. **Website:** www.addisonripleyfineart.com. **Contact:** Christopher Addison, owner. Estab. 1981. Art consultancy, for-profit gallery. Approached by 100 artists/year; represents or exhibits 25 artists. Average display time 6 weeks. Gallery open Tuesday–Saturday, 11-6 and by appointment. Closed end of summer. Located in Georgetown in a large, open, light-filled gallery space. Overall price range $500-80,000. Most work sold at $2,500-10,000.

EXHIBITS Works of all media.

MAKING CONTACT & TERMS Gallery provides insurance, promotion, contract. Accepted work should be framed, mounted, matted.

SUBMISSIONS Mail portfolio for review. Send query letter with artist's statement, bio, photocopies, résumé, SASE. Responds in 1 month.

TIPS "Submit organized, professional-looking materials."

ADIRONDACK LAKES CENTER FOR THE ARTS

3446 St. Rt. 28, Blue Mountain Lake NY 12812. (518)752-7715; (518)352-7715. **Fax:** (518)352-7333. **E-mail:** office@adirondackarts.org. **Website:** www.adirondackarts.org. **Contact:** Stephen Svoboda, executive director. Estab. 1967. "ALCA is a 501c, nonprofit organization showing national and international work of emerging to established artists. A tourist and second-home market, demographics profile our client as highly educated, moderately affluent, environmentally oriented and well-travelled. In addition to its public programs, the Arts Center also administers the New York State Decentralization Regrant Program for Hamilton County. This program provides grants to local nonprofit organizations to sponsor art and cultural events, including concerts, workshops, and lectures in their own communities. The area served by the Arts Center includes Hamilton County, and parts of Essex, Franklin, Warren, and Herkimer counties. Our intent, with this diversity, is to enrich and unite the entire Adirondacks via the arts. The busy season is June through September."

EXHIBITS Solo, group, call for entry exhibits of color and b&w work. Sponsors 15-20 exhibits/year. Average display time 1 month. Overall price range $100-2,000. Most work sold at $250.

MAKING CONTACT & TERMS Consignment gallery, fee structure on request. Payment for sales follows within 30 days of close of exhibit. White mat and black frame required, except under prior agreement. ALCA pays return shipping only or cover work in transit.

SUBMISSIONS Apply by CD or slides, résumé and bio. Must include SASE for return of materials. Upon acceptance notification, price sheet and artist statement required.

TIPS "ALCA offers a residency program, maintains a fully-equipped darkroom with 24-hour access."

AKEGO AND SAHARA GALLERY

P.O. Box 7152, Endicott NY 13760. (607)821-2540. E-mail: info@africaresource.com. **Website:** www.africa resource.com/house. **Contact:** Azuka Nzegwu, managing director. Estab. 2007. A for-profit, alternative space, for-rent gallery, and art consultancy. Exhibits emerging, mid-career, and established artists. Represents or exhibits 3-4 artists per year. Sponsors 3 total exhibits a year. Average display time 3-4 months. Model release and property release required. Open Monday-Friday, 9-6. Clients include local community, students, tourists, and upscale. Has contests and residencies available. See website for further details.

MAKING CONTACT & TERMS Artwork is accepted on consignment and there is a 40% commission. There is a rental fee for space covering 1 month. Retail price set by the gallery and the artist. Gallery provides insurance, promotion, and contract. Does not require exclusive representation locally. Artists should call, e-mail query letter with a link to the artist's website, mail portfolio for review, or send query letter with artist's statement, bio, résumé, and reviews. Responds in 1 week. Finds artists through word of mouth, submissions, portfolio reviews, referrals by other artists, as well as other means.

⊘ AKRON ART MUSEUM

One S. High St., Akron OH 44308. (330)376-9185. **Fax:** (330)376-1180. **E-mail:** erudolph@akronartmuseum. org. **Website:** www.akronartmuseum.org. **Contact:** Ellen Rudolph, senior curator. Located on the corner of East Market and South High Streets in the heart of downtown Akron. Open Wednesday–Sunday, 11-5; Thursday, 11-9. Closed Monday and Tuesday. Closed holidays.

○ Annually awards the Knight Purchase Award to a living artist working with photographic media.

EXHIBITS To exhibit, photographers must possess "a notable record of exhibitions, inclusion in publications, and/or a role in the historical development of photography. We also feature area photographers (northeast Ohio)." Interested in innovative works by contemporary photographers; any subject matter. Interested in alternative process, documentary, fine art, historical/vintage.

MAKING CONTACT & TERMS Payment negotiable. Buys photography outright.

SUBMISSIONS "Please submit a brief letter of interest, résumé, and 20-25 representative images (slides, snapshots, JPEGs on CD, DVDs or website links). Do not send original artworks. If you would like your material returned, please include a SASE." Allow 2-3 months for review.

TIPS "Send professional-looking materials with high-quality images, a résumé and an artist's statement. Never send original prints."

ALASKA STATE MUSEUM

395 Whittier St., Juneau AK 99801-1718. (907)465-2901. **Fax:** (907)465-2976. **E-mail:** jackie.manning@ alaska.gov. **Website:** www.museums.alaska.gov. **Contact:** Steve Henrikson, curator of exhibits. Estab. 1900. Approached by 40 artists/year. Sponsors 1 photography exhibit every 2 years. Average display time 10 weeks. Downtown location.

EXHIBITS Interested in historical and fine art.

SUBMISSIONS Finds artists through portfolio reviews.

THE ALBUQUERQUE MUSEUM OF ART & HISTORY

2000 Mountain Rd. NW, Albuquerque NM 87104. (505)243-7255. **Website:** www.cabq.gov/museum. Glenn Fye, photo archivist. **Contact:** Andrew Connors, curator of art. Estab. 1967.

SUBMISSIONS Submit portfolio of slides, photos, or disk for review. Responds in 2 months.

⊕ CHARLES ALLIS ART MUSEUM

1801 N. Prospect Ave., Milwaukee WI 53202. (414)278-8295. **E-mail:** mcostello@cavtmuseums. org. **Website:** www.charlesallis.org. **Contact:** Maria Costello, executive director. Estab. 1947. Approached by 20 artists/year. Represents 6 emerging, mid-career and established artists that have lived or studied in Wisconsin. Exhibited artists include Anne Miotke (watercolor); Evelyn Patricia Terry (pastel, acrylic, multi-media). Sponsors 4 exhibits/year. Average display time: 3 months. Open all year; Wednesday–Sunday, 1-5. Located in an urban area, historical home, 3 galleries. Clients include local community, students and tourists. 10% of sales are to corporate collectors. Overall price range: $200-6,000.

EXHIBITS Considers acrylic, collage, drawing, installation, mixed media, oil, pastel, pen & ink, sculpture, watercolor and photography. Print types include engravings, etchings, linocuts, lithographs, serigraphs

and woodcuts. Most frequently exhibits acrylic, oil and watercolor.

MAKING CONTACT & TERMS Artwork is accepted on consignment. Artwork can be purchased during run of an exhibition. There is a 30% commission. Retail price set by the artist. Museum provides insurance, promotion and contract. Accepted work should be framed. Does not require exclusive representation locally. Accepts only artists from or with a connection to Wisconsin.

SUBMISSIONS Send query letter with artist's statement, bio, business card, résumé, reviews, SASE and slides. Material is returned if the artist is not chosen for exhibition. Responds to queries in 1 year. Finds artists through art exhibits, referrals by other artists, submissions and word of mouth.

TIPS "All materials should be typed. Slides should be labeled and accompanied by a complete checklist."

AMERICAN PRINT ALLIANCE

302 Larkspur Turn, Peachtree City GA 30269-2210. **E-mail:** director@printalliance.org. **Website:** www. printalliance.org. **Contact:** Carol Pulin, director. Estab. 1992.

EXHIBITS "We only exhibit original prints, artists' books and paperworks." Usually sponsors 2 travelling exhibits/year—all prints, paperworks and artists' books; photography within printmaking processes but not as a separate medium. Most exhibits travel for 2 years. Hours depend on the host gallery/museum/arts center. "We travel exhibits throughout the U.S. and occasionally to Canada." Overall price range for Print Bin: $150-3,200; most work sold at $300-500. "We accept all styles, genres and subjects; the decisions are made on quality of work." Individual subscription: $32-39. Print Bin is free with subscription."

MAKING CONTACT & TERMS Subscribe to journal, *Contemporary Impressions* (www.printalliance. org/alliance/al_subform.html), send one slide and signed permission form (www.printalliance.org/gallery/printbin_info.html). Returns slide if requested with SASE. Usually does not respond to queries from non-subscribers. Files slides and permission forms. Finds artists through submissions to the gallery or Print Bin, and especially portfolio reviews at printmakers conferences.

AMERICAN SOCIETY OF ARTISTS

P.O. Box 1326, Palatine IL 60078. (847)991-4748 or (312)751-2500. **E-mail:** asoaartists@aol.com. **Website:**

www.americansocietyofartists.org. **Contact:** Helen Del Valle, membership chairman. American Society of Artists. Fine arts & fine selected crafts show held annually in mid-July. Outdoors. Event held in various locations in Illinois. Accepts photography, paintings, sculpture, glass works, jewelry and more. Juried. Exhibition space is approximately 100 sq. ft. for single space; other sizes available.

EXHIBITS Members and nonmembers may exhibit. "Our members range from internationally known artists to unknown artists—quality of work is the important factor. We have about 25 shows throughout the year that accept photographic art."

MAKING CONTACT & TERMS Accepted work should be framed, mounted or matted.

SUBMISSIONS Send SASE and 4 slides/photos representative of your work or 1 slide or photo of your display, #10 SASE, a résumé or show listing is helpful. Number of exhibitors: 50. See our website for online jury. To jury via e-mail: submit only to: Asoaartists@aol.com. If you pass jury you will receive a non-member jury/approval number. Deadline for entry is 2 months prior or earlier if spaces fill. Entry fee: $145. For more information artists should send SASE

TIPS "Remember that when you are at work in your studio, you are an artist. But when you are at a show, you are a business person selling your work."

⊕ THE ANN ARBOR ART CENTER GALLERY SHOP

117 W. Liberty St., Ann Arbor MI 48104. (734)994-8004. **Fax:** (734)994-3610. **E-mail:** afarnum@annarbor artcenter.org; nrice@annarborartcenter.org. **Website:** www.annarborartcenter.org. **Contact:** Amy Farnum, gallery shop director; Nathan Rice, exhibitions manager. Estab. 1909. Represents over 350 artists, primarily Michigan and regional. Gallery shop purchases support the Art Center's community outreach programs. "We are the only organization in Ann Arbor that offers hands-on art education, art appreciation programs and exhibitions all in one facility." Open Monday–Saturday, 11-6; Sunday, 12-5.

○ The Ann Arbor Art Center also has exhibition opportunities for Michigan artists in its exhibition gallery and art consulting program.

EXHIBITS Considers original work in virtually all 2D and 3D media, including jewelry, prints and etchings, ceramics, glass, fiber, wood, photography and painting.

MAKING CONTACT & TERMS Submission guidelines available online. Accepts work on consignment. Retail price set by artist. Offers member discounts and payment by installments. Exclusive area representation not required. Gallery provides contract; artist pays for shipping.

SUBMISSIONS "The Art Center seeks out artists through the exhibition visitation, wholesale and retail craft shows, networking with graduate and undergraduate schools, word of mouth, in addition to artist referral and submissions."

ARC GALLERY

Attn: Exhibition Committee, 2156 N. Damen Ave., Chicago IL 60647. (773)252-2232. **E-mail:** info@arcgallery.org. **Website:** www.arcgallery.org. **Contact:** Iris Goldstein, president. Estab. 1973. Sponsors 5-8 exhibits/year. Average display time 1 month. Overall price range $100-1,200.

"ARC Gallery and Educational Foundation is a not-for-profit gallery and foundation whose mission is to bring innovative, experimental visual art to a wide range of viewers, and to provide an atmosphere for the continued development of artistic potential, experimentation and dialogue. ARC serves to educate the public on various community-based issues by presenting exhibits, workshops, discussion groups and programs for, and by, underserved populations."

EXHIBITS All styles considered. Contemporary fine art photography, documentary and journalism.

MAKING CONTACT & TERMS Charges no commission, but there is a space rental fee.

SUBMISSIONS Must send slides, résumé and statement to gallery for review; include SASE. Reviews JPEGs. Responds in 1 month.

TIPS Photographers "should have a consistent body of work. Show emerging and experimental work."

ARIZONA STATE UNIVERSITY ART MUSEUM

P.O. Box 872911, 10th St. and Mill Ave., Tempe AZ 85287-2911. (480)965-2787. **Fax:** (480)965-5254. **Website:** asuartmuseum.asu.edu. **Contact:** Gordon Knox, director. Estab. 1950. Has 2 facilities and approximately 8 galleries of 2,500 square feet each; mounts approximately 15 exhibitions/year. Average display time 3-4 months.

EXHIBITS Only a small number of solo shows are presented, but all proposals are reviewed by curatorial staff.

MAKING CONTACT & TERMS Accepted work should be framed, mounted, matted.

SUBMISSIONS Send query letter with résumé, reviews, images of current work and SASE. "Allow several months for a response since we receive many proposals and review monthly."

ARNOLD ART

210 Thames St., Newport RI 02840. (401)847-2273; (800)352-2234. **Fax:** (401)848-0156. **E-mail:** info@arnoldart.com. **Website:** www.arnoldart.com. **Contact:** William Rommel, owner. Estab. 1870. For-profit gallery. Represents or exhibits 40 artists. Average display time 1 month. Gallery open Monday–Saturday, 9:30-5:30; Sunday, 12-5. Closed Christmas, Thanksgiving, Easter. Art gallery is 17×50 ft., open gallery space (3rd floor). Overall price range $100-35,000. Most work sold at $300.

EXHIBITS Marine (sailing), classic yachts, America's Cup, wooden boats, sailing/racing. Artwork is accepted on consignment, and there is a 45% commission. Gallery provides promotion. Accepted work should be framed.

MAKING CONTACT & TERMS E-mail to arrange personal interview to show portfolio.

THE ARSENAL GALLERY

The Arsenal Bldg., Room 20, Central Park, 830 Fifth Ave., New York NY 10065. (212)360-8163. **Fax:** (212)360-1329. **E-mail:** artandantiquities@parks.nyc.gov; jennifer.lantzas@parks.nyc.gov. **Website:** www.nycgovparks.org/art. Jennifer Lantzas, public art coordinator. Estab. 1971.

EXHIBITS Photos of environmental, landscapes/scenics, wildlife, architecture, cities/urban, adventure, NYC parks. Interested in alternative process, avant garde, documentary, fine art, historical/vintage. Artwork is accepted on consignment, and there is a 15% commission. Gallery provides promotion. Contact parks for submission deadlines.

MAKING CONTACT & TERMS Mail portfolio for review. Send query letter with artist's statement, bio, brochure, business card, photocopies, résumé, reviews, SASE. Responds within 6 months, only if interested. Finds artists through word of mouth, portfolio reviews, art exhibits, referrals by other artists.

TIPS "Appear organized and professional."

ART@NET INTERNATIONAL GALLERY

E-mail: artnetg@yahoo.com. **Website:** www.design bg.com. **Contact:** Yavor Shopov-Bulgari, director. Estab. 1998. Artwork is accepted on consignment; there is a 10% commission and a rental fee for space of $1/image per month or $5/image per year. First 6 images are displayed free of rental fee. Gallery provides promotion. Accepted work should be matted. Main usage of all works exhibited in our gallery is for limited edition (photos) or original (paintings) wall decoration of offices and homes, so photos must have quality of paintings.

EXHIBITS Photos of creative photography including: travel, landscapes/scenics, fashion/glamour, erotic, figure landscapes, beauty, abstracts, avant garde, fine art, silhouettes, architecture, buildings, cities/urban, science, astronomy, education, seasonal, wildlife, sports, adventure, caves, crystals, minerals and luminescence.

MAKING CONTACT & TERMS "We accept computer scans only; no slides, please. E-mail attached scans, 900×1200 px (300 dpi for prints or 900 dpi for 36mm slides), as JPEG files for PCs." E-mail query letter with artist's statement, bio, résumé. Responds in 6 weeks. Finds artists through submissions, portfolio reviews, art exhibits, art fairs, referrals by other artists." E-mail a tightly edited selection of less than 20 scans of your best work. All work must force any person to look over it again and again.

TIPS "We like to see strong artistic sense of mood, composition, light, color and strong graphic impact or expression of emotions. For us, only quality of work is important, so newer, lesser-known artists are welcome."

ART 3 GALLERY

44 W. Brook St., Manchester NH 03101. (603)668-6650; (800)668-9983. **Fax:** (603)668-5136. **E-mail:** info@art3gallery.com. **Website:** www.art3gallery.com. **Contact:** Joni Taube, owner. Estab. 1985. For-profit gallery and art consultancy. Exhibits emerging, mid-career, and established artists. Approached by 50+ artists a year; exhibits 180+ artists. Exhibited artists include James Aponorich (oil painting) and Stan Moeller (oil painting). Sponsors 4 exhibits/year. Average display time 2-3 months. Open Monday-Friday 9-4. Located in downtown Manchester in a two-story, 2,000 sq. ft. exhibit space. Clients include local community, tourists, and upscale clients. Overall price range $150-20,000. Most work sold at $1,000.

MAKING CONTACT & TERMS Artwork is accepted on consignment and there is a 50% commission. Retail price set by the gallery and artist. Gallery provides insurance, promotion, and contract. Accepted artwork should be framed, mounted, and matted. Does not require exclusive local representation.

SUBMISSIONS E-mail query letter with link to artist's website or JPEG samples at 72 dpi. Materials returned with SASE. Responds if interested in 4 weeks. Finds artists through word of mouth, submissions, art exhibits, art fairs, and referrals by other artists.

ARTEFACT/ROBERT PARDO GALLERY

805 Lake Ave., Lake Worth FL 33460. (561)585-2881; (561)329-6264. **E-mail:** robert@theartefactgallery.com. **Website:** www.theartefactgallery.com. **Contact:** Robert Pardo. Estab. 1986. Approached by 500 artists/year; represents or exhibits 18 artists. Sponsors 3 photography exhibits/year. Average display time 4-5 weeks. Gallery open 7 days a week until 6.

EXHIBITS Interested in avant garde, fashion/glamour, fine art.

SUBMISSIONS Arrange personal interview to show portfolio of slides, transparencies. Responds in 1 month.

ARTISTS' COOPERATIVE GALLERY

405 S. 11th St., Omaha NE 68102. (402)342-9617. **E-mail:** bronzesculptor@yahoo.com;acgoldmarket@yahoo.com. **Website:** www.artistsco-opgallery.com. Estab. 1974. Gallery sponsors all-member exhibits and outreach exhibits; individual artists sponsor their own small group exhibits throughout the year. Overall price range $100-5,000. "Artist must be willing to work 13 days per year at the gallery. Sponsors 12 exhibits/year. Average display time 1 month. Fine art photography only. We are a member-owned-and-operated cooperative. Artist must also serve on one committee. Write for membership application. Membership committee screens applicants August 1-15 each year. Responds by September 1. New membership year begins October 1. Members must pay annual fee of $325. Our community outreach exhibits include local high school photographers and art from local elementary schools." Open Tuesday–Thursday, 11-5; Friday-Saturday, 11-10; Sunday, 12-6. Thursdays during holiday season and summer hours until 10 p.m.

EXHIBITS Interested in all types, styles and subject matter. Charges no commission. Reviews transparencies. Accepted work should be framed work only.
SUBMISSIONS Send query letter with résumé, SASE. Responds in 2 months.

THE ART MUSEUM AT THE UNIVERSITY OF KENTUCKY

116 Singletary Center, Rose St. and Euclid Ave., Lexington KY 40506. (859)257-5716. **Fax:** (859)323-1994. **E-mail:** dorothyfreeman@uky.com. **Website:** www.uky.edu/artmuseum. **Contact:** Janie Welker, curator. Estab. 1979. Museum. The Art Museum at the University of Kentucky serves Central and Eastern Kentucky through art exhibitions, educational outreach, and other special events including lectures, symposia and family festivals.
EXHIBITS Annual photography lecture series and exhibits.
SUBMISSIONS Prefers e-mail query with digital images. Responds in 6 months.

ARTPROJECTA

P.O. Box 5732, Ketchum ID 883340. (208)726-3036; (208)726-9900. **E-mail:** submissions@artprojecta.com; info@artprojecta.com. **Website:** www.artprojecta.com. **Contact:** Barbi Reed (barbi@annereedgallery.com). Estab. 1912. Represents emerging talent and established artists. Barbi Reed, Claudia Aulum, co-founders. Exhibited artists include: Kirk Anderson, Bennett Bean, Jamie Brunson, Simon Casson, Imogen Cunningham, Harold Feinstein, Josh Garber, Jenny Gummersall, Greg Gummersall, Gary Mankus, Kathryn McNeal, Owen Mortensen, Andrew Romanoff, Andrew Saftel, Sandra Sallin, Ruth Silverman, Bob Smith, Larry Stephenson, David Wharton, Lana Wilson, among others. All art retails from $65-4500. Clientele: 90% private collectors, 10% corporate collectors, art consultants, designers.
EXHIBITS Most frequently exhibits sculpture, paintings, fine art prints, photography, fine art jewelry, ceramics, glass. Exhibits expressionism, abstraction, conceptualism, photorealism, realism. Prefers contemporary.
MAKING CONTACT & TERMS Retail price set by gallery and artist. Sometimes we offer client discounts. Gallery provides promotion, networking on artist's behalf, shipping costs to clients. ARTprojectA is not responsible for materials sent that are unsolicited.

SUBMISSIONS E-mail your work and include your artist website's URL. Make sure the latest work and an updated résumé are on your site.
TIPS Spend time on our website prior to contacting us.

THE ARTS COMPANY

215 Fifth Ave., Nashville TN 37219. (615)254-2040; (877)694-2040. **Fax:** (615)254-9289. **E-mail:** art@theartscompany.com. **Website:** www.theartscompany.com. **Contact:** Anne Brown, owner. Estab. 1996. Art consultancy, for-profit gallery. Sponsors 6-10 photography exhibits/year. Average display time 1 month. Open Tuesday-Saturday, 11-5. Located in downtown Nashville, the gallery has 6,000 sq. ft. of contemporary space in a historic building. Overall price range $10-35,000. Most work sold at $300-3,000.
EXHIBITS Photos of celebrities, architecture, cities/urban, rural, environmental, landscapes/scenics, entertainment, performing arts. Interested in documentary, fine art, historical/vintage.
MAKING CONTACT & TERMS "We prefer an initial info packet via e-mail." Send query letter with artist's statement, bio, brochure, business card, photocopies, résumé, reviews, SASE, CD. Returns material with SASE.
SUBMISSIONS "Provide professional images on a CD along with a professional bio, résumé." Artwork is accepted on consignment. Gallery provides insurance, contract. Accepted work should be framed.
TIPS Finds artists through word of mouth, art fairs, art exhibits, submissions, referrals by other artists.

ARTS IOWA CITY

114 S. Dubuque St., Iowa City IA 52240. **E-mail:** gallery@artsiowacity.org. **Website:** www.artsiowacity.org. **Contact:** gallery director. Estab. 1975. Nonprofit gallery. Approached by more than 65 artists/year; represents or exhibits more than 45 artists. Average display time 1-2 months. Ped Mall gallery open limited hours. Several locations open during business hours; satellite galleries at Starbucks downtown, US Bank, Melrose Meadows, and Englert Theatre. Overall price range: $200-6,000. Most work sold at $500.
EXHIBITS Photos of landscapes/scenics, architecture, cities/urban, rural. Interested in fine art.
MAKING CONTACT & TERMS Artwork is accepted on consignment, and there is a 20% commission. Gallery provides insurance (in gallery, not during transit to/from gallery) up to $1,500, promotion and contract. Accepted work should be framed, mounted and mat-

ted. "We represent artists who are members of Arts Iowa City; to be a member, one must pay a membership fee. Most members are from Iowa City and the surrounding area."

SUBMISSIONS Call, write or e-mail to arrange personal interview to show portfolio of photographs, transparencies. No slides; JPEG advisable. Send query letter with artist's statement, bio, brochure, business card, photographs, résumé, reviews, CD and JPEGs. Responds to queries in 1 month. Finds artists through referrals by other artists, submissions and word of mouth.

TIPS "We are a nonprofit gallery with limited staff. Most work is done by volunteers. Artists interested in submitting work should visit our website to gain a better understanding of the services we provide and to obtain membership and show proposal information. Please submit applications according to our guidelines online."

ARTS ON DOUGLAS

123 Douglas St., New Smyrna Beach FL 32168. (386)428-1133. **Fax:** (386)428-5008. **E-mail:** mmartin@artsondouglas.net. **Website:** www.artsondouglas.net. **Contact:** Meghan Martin, gallery director. Estab. 1996. For-profit gallery. Represents 50 Florida artists in ongoing group exhibits and features 8 artists/year in solo exhibitions. Average display time 1 month. Gallery open Tuesday-Friday, 10-5; Saturday, 11-3; by appointment. Location has 5,000 sq. ft. of exhibition space. Overall price range varies.

EXHIBITS Interested in alternative process, documentary, fine art.

MAKING CONTACT & TERMS Artwork is accepted on consignment, and there is a 50% commission. Gallery provides insurance, promotion. Accepted work should be framed. Requires exclusive representation locally. *Accepts only professional artists from Florida.*

SUBMISSIONS Call in advance to inquire about submissions/reviews. Send a query letter and include a CD with 6 current images, bio, CV and artist's statement. Finds artists through referrals by other artists.

ART SOURCE L.A., INC.

2801 Ocean Park Blvd., #7, Santa Monica CA 90405. (310)452-4411; (800)721-8477. **Fax:** (310)452-0300. **E-mail:** info@artsourcela.com; francinee@artsourcela.com. **Website:** www.artsourcela.com. **Contact:** Francine Ellman, president. Estab. 1980. Overall price range $300-15,000. Most work sold at $600.

EXHIBITS Photos of multicultural, environmental, landscapes/scenics, wildlife, architecture, cities/urban, gardening, interiors/decorating, rural, automobiles, food/drink, travel, technology/computers. Interested in alternative process, avant garde, fine art, historical/vintage, seasonal. "We do projects worldwide, putting together fine art for corporations, health care, hospitality, government and public space. We use a lot of photography."

MAKING CONTACT & TERMS Interested in receiving work from emerging and established photographers. Charges 50% commission.

SUBMISSIONS Prefers digital submissions via e-mail. Send a minimum of 10 JPEGs, photographs, or slides, clearly labeled with name, title and date of work; plus résumé, statement, and SASE. Responds in 30 days in interested.

TIPS "Show a consistent body of work, well marked and presented so it may be viewed to see its merits."

[ARTSPACE] AT UNTITLED

1 NE Third St., Oklahoma City OK 73104. (405)815-9995. **Fax:** (405)813-2070. **E-mail:** info@artspaceatuntitled.org. **Website:** www.artspaceatuntitled.org. Estab. 2003. Alternative space, nonprofit art center. Contemporary art center. Average display time 8-12 weeks. Open Tuesday–Friday, 10-5; Saturday, 10-4. Closed Sunday and Monday. "Located in a reclaimed industrial space abandoned by decades of urban flight. Damaged in the 1995 Murrah Federal Building bombing, Untitled [ArtSpace] has emerged as a force for creative thought. As part of the Deep Deuce historic district in downtown Oklahoma City, Untitled [ArtSpace] brings together visual arts, performance, music, film, design and architecture with a focus on new media art. Our mission is to stimulate creative thought and new ideas through contemporary art. We are committed to providing access to quality exhibitions, educational programs, performances, publications, and to engaging the community in collaborative outreach efforts." Most work sold at $500-2,500, but not primarily a sales gallery.

MAKING CONTACT & TERMS There is a 50% commission for any works sold.

SUBMISSIONS Mail portfolio for review. Send query letter with artist's statement, bio, résumé, slides, or CD of images. Prefers 10-15 images on a CD. Include SASE for return of materials or permission to file the portfolio. Reviews occur twice annually, in January

and July. Finds artists through submissions and portfolio reviews. Responds to queries within 3 months.

TIPS "Review our previous programming to evaluate if your work is along the lines of our mission. Take the time to type and proof all written submissions. Make sure your best work is represented in the images you choose to show. Nothing takes away from the review like poorly scanned or photographed work."

⊕ THE ART STORE

1013 Bridge Rd., Charleston WV 25314. (304)345-1038. **Fax:** (304)345-1858. **E-mail:** gallery@theartstorewv. com. **Website:** www.theartstorewv.com. "The Art Store is dedicated to showing original 20th-century and contemporary American art by leading local, regional and nationally recognized artists. Professional integrity, commitment and vision are the criteria for artist selection, with many artists having a history of exhibitions and museum placement. Painting, sculpture, photography, fine art prints and ceramics are among the disciplines presented. A diverse series of solo, group and invitational shows are exhibited throughout the year in the gallery." Retail gallery. Represents 50 mid-career and established artists. Sponsors 11 shows/year. Average display time 4 weeks. Open Tuesday–Friday, 10-5:30; Saturday, 10-5; anytime by appointment. Located in a upscale shopping area; 2,000 sq. ft.; 50% of space for special exhibitions. Clientele: professionals, executives, decorators. 80% private collectors, 20% corporate collectors. Overall price range $200-8,000; most work sold at $2,000.

MAKING CONTACT & TERMS Accepts artwork on consignment (50% commission). Retail price set by gallery and artist. Gallery provides insurance, promotion and shipping costs from gallery. Prefers artwork unframed.

TIPS Send query e-mail.

ART WITHOUT WALLS, INC.

P.O. Box 341, Sayville NY 11782. (631)567-9418. **Fax:** (631)567-9418. **E-mail:** artwithoutwalls@msn.com. **Website:** www.artwithoutwalls.net. **Contact:** Sharon Lippman, executive director. Estab. 1985. Nonprofit gallery. Approached by 300 artists/year; represents or exhibits 100 artists. Sponsors 3 photography exhibits/year. Average display time 1 month. Open daily, 9-5. Closed December 22–January 5 and Easter week. Traveling exhibits in various public spaces. Overall price range $1,000-25,000. Most work sold at $3,000-5,000. "Price varies—especially if student work."

EXHIBITS Photos of multicultural, families, parents, senior citizens, disasters, environmental, landscapes/scenics, wildlife, architecture, cities/urban, education, rural, adventure, events, food/drink, health, performing arts, sports, travel, agriculture, medicine, political, product shots/still life, science, technology/computers. Interested in alternative process, avant garde, documentary, fashion, fine art, historical/vintage, seasonal.

MAKING CONTACT & TERMS Artwork is accepted on consignment, and there is a 20% commission. Gallery provides promotion, contract. Accepted work should be framed, mounted, matted.

SUBMISSIONS Mail portfolio for review. Send query letter with artist's statement, brochure, photographs, résumé, reviews, SASE, slides. Responds in 1 month. Finds artists through submissions, portfolio reviews, art exhibits.

TIPS "Work should be properly framed with name, year, medium, title, size."

ASIAN AMERICAN ARTS CENTRE

111 Norfolk St., New York NY 10002. **Fax:** (360)283-2154. **E-mail:** aaacinfo@artspiral.org. **Website:** www.artspiral.org. Estab. 1974. "Our mission is to promote the preservation and creative vitality of Asian American cultural growth through the arts, and its historical and aesthetic linkage to other communities." Exhibits should be Asian American or significantly influenced by Asian culture and should be entered into the archive-a historical record of the presence of Asia in the U.S. Interested in "creative art pieces." Average display time 6 weeks. Open Monday–Friday, 12:30-6:30 (by appointment).

MAKING CONTACT & TERMS To be considered for the AAAC Artist Archive and artasiamerica.org, please submit 20 images either as 35mm slides (labeled with artist's name, title, date, materials, techniques and dimensions) or digital images of work as TIFF or JPEG on CD or DVD, at minimum 2000 pixel width with resolution of 300 dpi; corresponding artwork list with artist's name, title, date, materials, techniques and dimensions; 1 page artist statement (to be dated); artists not of Asian descent should mention specifically how they consider themselves influenced by Asia; Artist bio and résumé (to be dated); other support materials (catalogs, newspaper/journal articles, reviews, announcement cards, press releases, project plans, etc.); completed AAAC information

form located at www.artspiral.org/archive_submission.

ATELIER GALLERY

153 King St., Charleston SC 29401. **E-mail:** gabrielle@theateliergalleries.com. **Website:** www.theateliergalleries.com. **Contact:** Gabrielle Egan, curator and owner. Estab. 2008. For-profit gallery and art consultancy. Exhibits emerging, mid-career, and established artists. Approached by 100s of artists a year; represents or exhibits 140 artists. Exhibited artists include Nancy Jean (painting) and Marlise Newman (painting). Average display time is 6 months. Open Monday-Friday, 10-6; weekends, 10-7. Some Sundays open in the summer, 12-5. Closed Holidays. Clients include local community, students, tourists, upscale, and artists and designers. Overall price range $50-15,000. Most work sold in the $2,000-3,000 range.

MAKING CONTACT & TERMS Artwork is accepted on consignment with a 50% commission. Retail price set by the gallery and artist. Gallery provides insurance, promotion, and contract. Accepted work should be framed, mounted, and matted. Atelier requires exclusive representation locally.

SUBMISSIONS E-mail query letter with link to artist's website or mail portfolio for review. Query letter should be sent with artist's statement, bio, photocopies, and photographs. Materials returned with SASE. Responds with decision in 2-4 weeks. Finds artists through word of mouth, submissions, portfolio reviews, art exhibits, art fairs, and referrals by other artists.

TIPS "Submit images that are current and be clear about your goals for your art!"

ATLANTIC GALLERY

548 W. 28th St., Suite 540, New York NY 10001. (212)219-3183. **E-mail:** contact@atlanticgallery.org. **Website:** www.atlanticgallery.org. **Contact:** Jeff Miller, president. Estab. 1974. Cooperative gallery. There is a co-op membership plus a donation of time required. Approached by 50 artists/year; represents 24 emerging, mid-career and established artists. Exhibited artists include Ragnar Naess (sculptor), Sally Brody (oil, acrylic), and Whitney Hansen (oil). Average display time 4 weeks. Gallery open Tuesday, Wednesday, Friday, Saturday, 12-6; Thursday, 12-9. Closed August. Located in Chelsea. Has kitchenette. Clients include local community, tourists and upscale clients. 2% of sales are to corporate collectors. Overall price range $100-13,000. Most work sold at $1,500-5,000. Finds artists through word of mouth, submissions, art exhibits, referrals by other artists.

EXHIBITS Interested in fine art.

MAKING CONTACT & TERMS Call or write to arrange a personal interview.

SUBMISSIONS "Submit an organized folder with slides, CD, bio, and 3 pieces of actual work. If we respond with interest, we then review again." Responds in 1 month. Views submitted works monthly.

AXIS GALLERY

71 Burnet Terrace, West Orange NJ 07052. (212)741-2582. **E-mail:** info@axisgallery.com. **Website:** www.axisgallery.com. **Contact:** Lisa Brittan, director. Estab. 1997. For-profit gallery. Approached by 40 African artists/year; representive of 30 artists. Located in Williamsburg, 900 sq. ft. Hours during exhibitions: check gallery hours online; other times by appointment. Closed during summer. Overall price range $500-50,000.

EXHIBITS Interested in alternative process, avant garde, documentary, erotic, fine art, historical/vintage. Also interested in photojournalism, resistance.

MAKING CONTACT & TERMS Artwork is accepted on consignment, and there is a 50% commission. Gallery provides insurance, promotion, contract. *Only accepts artists from Africa.*

SUBMISSIONS Send query letter with résumé, reviews, SASE, slides, photographs or CD. Responds in 3 months. Finds artists through research, recommendations, submissions, portfolio reviews, art exhibits, referrals by other artists.

TIPS "Send letter with SASE and materials listed above. Photographers should research galleries first to check if their work fits the gallery program. Avoid bulk mailings."

BAKER ARTS CENTER

624 N. Pershing Ave., Liberal KS 67901. (620)624-2810. **Fax:** (620)624-7726. **E-mail:** bakerartscenter2@sbcglobal.net. **Website:** www.bakerartscenter.org. **Contact:** Diane Marsh, art director. Estab. 1986. Nonprofit gallery. Exhibits emerging, mid-career, and established artists. Approached by 6-10 artists a year. Represents of exhibits 6-10 artists. Exhibited artists include J. McDonald (glass) and J. Gustafson (assorted). Sponsors 5 total exhibits/year. 1 photography exhibit/year. Model and property release are preferred. Average display time 40-50 days. Open Tuesday-Friday,

9-5; weekends, 2-5. Closed Christmas, Thanksgiving and New Year's Eve. Clients include local community, students, and tourists. Overall price range $10-1,000. Most work sold at $400.

MAKING CONTACT & TERMS Artwork is accepted on consignment and there is a 10% commission fee. Retail price set by the artist. Gallery provides insurance, promotion, and contract. Accepted work should be framed, mounted, and matted.

SUBMISSIONS Write to arrange personal interview to show portfolio or e-mail query letter with link to artist's website or JPEG samples at 72 dpi. Returns material with SASE. Responds in 2-4 weeks. Finds artists through word of mouth, submissions, art exhibits, and referrals by other artists.

BALZEKAS MUSEUM OF LITHUANIAN CULTURE ART GALLERY

6500 S. Pulaski Rd., Chicago IL 60629. (773)582-6500. **Fax:** (773)582-5133. **E-mail:** info@balzekasmuseum. org. **Website:** www.balzekasmuseum.org. **Contact:** Stanley Balzekas, Jr., president. Estab. 1996. Museum, museum retail shop, nonprofit gallery, rental gallery. Approached by 20 artists/year. Sponsors 2 photography exhibits/year. Average display time 6 weeks. Open daily, 10-4. Closed Christmas, Easter and New Year's Day. Overall price range $150-6,000. Most work sold at $545.

EXHIBITS Photos of babies/children/teens, celebrities, couples, multicultural, families, parents, senior citizens, disasters, environmental, landscapes/scenics, wildlife, architecture, cities/urban, education, gardening, interiors/decorating, pets, religious, rural, adventure, automobiles, entertainment, events, food/drink, health/fitness, hobbies, humor, performing arts, sports, travel, agriculture, buildings, business concepts, industry, medicine, military, political, product shots/still life, science, technology/computers. Interested in alternative process, avant garde, documentary, erotic, fashion/glamour, fine art, historical/vintage, seasonal.

MAKING CONTACT & TERMS Artwork is accepted on consignment, and there is a 33⅓% commission. Gallery provides promotion. Accepted work should be framed.

SUBMISSIONS Write to arrange personal interview to show portfolio. Responds in 2 months. Finds artists through word of mouth, art exhibits, referrals by other artists.

BARRON ARTS CENTER

582 Rahway Ave., Woodbridge NJ 07095. (732)634-0413. **E-mail:** barronarts@twp.woodbridge.nj.us. **Website:** www.twp.woodbridge.nj.us/Departments/BarronArtsCenter/tabid/251/Default.aspx. **Contact:** Cynthia Knight, director. Estab. 1977. The Barron Arts Center serves as a center for the arts for residents of Woodbridge Township and Central New Jersey. Overall price range $150-400. Most work sold at $150. Charges 20% commission.

"In terms of the market, we tend to hear that there are not enough galleries that will exhibit photography."

SUBMISSIONS Reviews transparencies but prefers portfolio. Submit portfolio for review; include SASE for return. Responds "depending upon date of review, but generally within a month of receiving materials." CDs of photos acceptable for review. "Make a professional presentation of work with all pieces matted or treated in a like manner."

BELIAN ART CENTER

5980 Rochester Rd., Troy MI 48085. (248)828-1001. **E-mail:** zabelbelian@gmail.com. **Website:** www.belianart.com. **Contact:** Zabel Belian, gallery director. Estab. 1985. Sponsors 1-2 exhibits/year. Average display time 3 weeks. Sponsors openings. Average price range $200-2,000.

EXHIBITS Looks for originality, capturing the intended mood, perfect copy, mostly original editions. Subjects include landscapes, cities, rural, events, agriculture, buildings, still life.

MAKING CONTACT & TERMS Charges 40-50% commission. Buys photos outright. Reviews transparencies. Requires exclusive representation locally. Arrange a personal interview to show portfolio. Send query letter with résumé and SASE.

CECELIA COKER BELL GALLERY

Coker College Art Dept., 300 E. College Ave., Hartsville SC 29550. (843)383-8156. **E-mail:** ccbg@coker.edu. **Website:** www.ceceliacokerbellgallery.com. **Contact:** Larry Merriman. "A campus-located teaching gallery that exhibits a variety of media and styles to expose students and the community to the breadth of possibility for expression in art. Exhibits include regional, national and international artists with an emphasis on quality and originality. Shows include work from emerging, mid, and late career artists." Sponsors 5 solo shows/year, with a 4-week run for each

show. Open Monday–Friday, 10-4 (when classes are in session).

EXHIBITS Considers all media including installation and graphic design. Most frequently exhibits painting, photography, sculpture/installation and mixed media.

MAKING CONTACT & TERMS Retail price set by artist (sales are not common). Exclusive area representation not required. Gallery provides insurance, promotion and contract; shipping costs are shared.

SUBMISSIONS Send résumé, 15-20 JPEG files on CD (or upload them to a Dropbox account) with a list of images, statement, résumé, and SASE. Reviews, web pages, and catalogues are welcome, though not required. If you would like response, but not your submission items returned, simply include an e-mail address. Visits by artists are welcome; however, the exhibition committee will review and select all shows from the JPEGs submitted by the artists.

BELL STUDIO

3428 N. Southport Ave., Chicago IL 60657. (773)281-2172. **Fax:** (773)281-2415. **E-mail:** paul@bellstudio.net. **Website:** www.bellstudio.net. **Contact:** Paul Therieau, director. Estab. 2001. For-profit gallery. Approached by 60 artists/year; represents or exhibits 10 artists. Interested in alternative process, avant garde, fine art. Artwork is accepted on consignment, and there is a 50% commission. Gallery provides insurance, promotion, contract. Accepted work should be framed. Requires exclusive representation locally. Finds artists through referrals by other artists, submissions, word of mouth. Requires local representation.

EXHIBITS Sponsors 3 photography exhibits/year. Average display time 6 weeks. Open all year; hours vary. Located in brick storefront; 750 sq. ft. of exhibition space; high traffic. Overall price range: $150-3,500. Most work sold at $600.

MAKING CONTACT & TERMS Write to arrange personal interview to show portfolio; include bio and résumé. Responds to queries within 3 months, only if interested.

SUBMISSIONS Send SASE; type submission letter; include show history, résumé.

BENNETT GALLERIES AND COMPANY

5308 Kingston Pike, Knoxville TN 37919. (865)584-6791. **Fax:** (865)588-6130. **E-mail:** info@bennettgalleries.com. **Website:** www.bennettgalleries.com. Estab. 1985. For-profit gallery. Represents or exhibits 40 artists/year. Sponsors 1-2 photography exhibits/year. Average display time 1 month. Gallery open Monday–Thursday, 10-6; Friday–Saturday, 10-5:30. Conveniently located a few miles from downtown Knoxville in the Bearden area. The formal art gallery has over 2,000 sq. ft. and 20,000 sq. ft. of additional space. Overall price range $100-12,000. Most work sold at $400-600.

EXHIBITS Photos of landscapes/scenics, architecture, cities/urban, humor, sports, travel. Interested in alternative process, fine art, historical/vintage.

MAKING CONTACT & TERMS Artwork is accepted on consignment, and there is a 50% commission. Gallery provides insurance, promotion, contract. Accepted work should be framed. Requires exclusive representation locally.

SUBMISSIONS Mail portfolio for review. Send query letter with artist's statement, bio, photographs, SASE, CD. Responds within 1 month, only if interested. Finds artists through word of mouth, submissions, art exhibits, referrals by other artists.

TIPS When submitting material to a gallery for review, the package should include information about the artist (neatly written or typed), photographic material, and SASE if you want your materials back.

BONNI BENRUBI GALLERY

41 E. 57th St., 13th Floor, New York NY 10022-1908. (212)888-6007. **Fax:** (212)751-0819. **E-mail:** Benrubi@BonniBenrubi.com. **Website:** www.bonnibenrubi.com. Estab. 1987. Sponsors 7-8 exhibits/year. Average display time 6 weeks. Overall price range $500-50,000.

EXHIBITS Interested in 19th- and 20th-century photography, mainly contemporary.

MAKING CONTACT & TERMS Charges commission. Buys photos outright. Accepted work should be matted. Requires exclusive representation locally. No manipulated work.

SUBMISSIONS Submit portfolio for review; include SASE. Responds in 2 weeks. Portfolio review is the first Thursday of every month. Out-of-towners can send slides with SASE, and work will be returned.

MONA BERMAN FINE ARTS

78 Lyon St., New Haven CT 06511. (203)562-4720. **E-mail:** info@monabermanfinearts.com. **Website:** www.monabermanfinearts.com. **Contact:** Mona Berman, director. Estab. 1979. Sponsors 0-1 exhibit/year. Average display time 1 month. Overall price range $500-20,000.

○ "We are art consultants serving corporations, architects and designers as well as private clients. We hold few exhibits. Initial contact should be by e-mail, with link to website, etc. Always include a retail price list. Ms. Berman provides professional development consulting services to individual artists. Other services include entrance and portfolio development for those seeking entry to higher-ed fine art and interior design programs. Ms. Berman also provides post-secondary curriculum development for higher education programs in fine arts and interior design. Also provides professional development consulting services to individual artists. Other services include entrance and portfolio development for those seeking entry to higher-ed fine art and interior design programs and post-secondary curriculum development for fine ares and interior design programs."

EXHIBITS "Photographers must have been represented by us for over 2 years. Interested in all except figurative, although we do use some portrait work."

MAKING CONTACT & TERMS Charges 50% commission. "Payment to artist 30 days after receipt of payment from client." Interested in seeing unframed, unmounted, unmatted work only.

SUBMISSIONS "E-mail digital images or web links. Inquire by e-mail; no calls, please. Always include retail prices." Materials returned with SASE only. Responds in 1 month.

TIPS "Looking for new perspectives, new images, new ideas, excellent print quality, ability to print in *very* large sizes, consistency of vision. Digital prints must be archival. Not interested in giclée prints."

⊕ BIRMINGHAM BLOOMFIELD ART CENTER

1516 S. Cranbrook Rd., Birmingham MI 48009. (248)644-0866. **E-mail:** annievangelderen@bbart center.org. **Website:** www.bbartcenter.org. **Contact:** Annie VanGelderen, president and CEO. Estab. 1962. Nonprofit gallery shop and gallery exhibit space. Represents emerging, mid-career and established artists. Presents ongoing exhibitions in 4 galleries. Open all year; Monday-Thursday, 9-6; Friday-Saturday, 9-5; second Sundays, 1-4. Suburban location. 70% of space for gallery artists. Clientele upscale, local. 100% private collectors. Overall price range $50-25,000.

EXHIBITS Considers 2D and 3D fine art in all media. Most frequently exhibits 3D work: jewelry, glass, ceramics, fiber, mixed media sculpture; and 2D work: painting, printmaking, drawing, mixed media and video.

MAKING CONTACT & TERMS Accepts work on consignment (45% commission). Retail price set by the artist. Gallery provides contract and some promotion; artist pays for shipping costs to gallery.

SUBMISSIONS Send query letter with résumé, website address, digital images (preferred), photographs, review, artist's statement and bio.

TIPS "We consider conceptual content, technique, media, presentation and condition of work as well as professionalism of the artist."

BLOUNT-BRIDGERS HOUSE/HOBSON PITTMAN MEMORIAL GALLERY

130 Bridgers St., Tarboro NC 27886. (252)823-4159. **E-mail:** edgecombearts@embarqmail.com. **Website:** www.edgecombearts.org. Estab. 1982. Museum. Gallery hours vary by time of year, see website for details. Closed major holidays, Christmas-New Year. Located in historic house in residential area of small town. Gallery is approximately 48×20 ft. Overall price range $250-5,000. Most work sold at $500.

○ Interested in fine art, historical/vintage.

EXHIBITS Photos of landscapes/scenics, wildlife. Approached by 1-2 artists/year; represents or exhibits 6 artists. Sponsors 1 exhibit/year. Average display time 6 weeks.

MAKING CONTACT & TERMS Artwork is accepted on consignment, and there is a 30% commission. Gallery provides insurance, limited promotion. Accepted work should be framed. Accepts artists from the Southeast and Pennsylvania. Finds artists through word of mouth, submissions, art exhibits, referrals by other artists.

SUBMISSIONS Mail portfolio review. Send query letter with artist's statement, bio, SASE, slides. Responds in 3 months.

BLUE GALLERY

118 Southwest Blvd., Kansas City MO 64108. (816)527-0823. **E-mail:** kellyk@bluegalleryonline.com. **Website:** www.bluegalleryonline.com. **Contact:** Kelly Kuhn, owner/director. Estab. 2000. A for-profit gallery. Exhibits emerging, mid-career, and established artists. Approached by hundreds of artists a year; represents or exhibits 45 artists a year. Sponsors 12 to-

tal exhibits/year. Average display time 30 days. Open Tuesday-Saturday, 10-5:30 or by appointment. Clients include local community, tourists, and upscale establishments among others. A large percentage is sold to corporate collectors. Overall price range $50-80,000. Finds artists through word of mouth, submissions, portfolio reviews, art exhibits, art fairs, and referrals by other artists.

MAKING CONTACT & TERMS Artwork is accepted on consignment. Retail price set by the artist. Gallery provides insurance, promotion, and contract. Accepted work should be framed. Requires exclusive representation locally.

SUBMISSIONS E-mail query letter with link to artist's website and JPEG samples at 72 dpi. Mail portfolio for review. Send query letter with artist's statement, bio, brochure, business card, photocopies, résumé, reviews, and SASE. Returns material with SASE. Responds in 3 months.

BLUE SKY/OREGON CENTER FOR THE PHOTOGRAPHIC ARTS

122 NW Eighth Ave., Portland OR 97209. (503)225-0210. **Website:** www.blueskygallery.org. **Contact:** Lisa Martel, exhibition coordinator. Estab. 1975.

EXHIBITS All photography and videography considered. Exhibits documentary, photojournalism, and conceptual art. Considers all genres.

MAKING CONTACT & TERMS Artwork is accepted on consignment and there is a 50% commission. Retail price set by the artist. Gallery provides insurance, promotion, and contract. Does not require exclusive local representation.

SUBMISSIONS Submit CD of JPEG samples at 72 dpi. Include artist's statement, bio, and résumé. Returns materials with SASE. Responds in 6 weeks. Finds artists through submissions, portfolio reviews, and art fairs.

TIPS "Follow website instructions."

BOOK BEAT GALLERY

26010 Greenfield, Oak Park MI 48237. (248)968-1190. **Fax:** (248)968-3102. **E-mail:** info@thebookbeat.com; bookbeat@aol.com. **Website:** www.thebookbeat.com. **Contact:** Cary Loren, director. Estab. 1982. Sponsors 6 exhibits/year. Average display time 6-8 weeks. Overall price range $300-5,000. Most work sold at $600.

EXHIBITS "Book Beat is a bookstore specializing in fine art and photography. We have a backroom gallery devoted to photography and folk art. Our inven-

tory includes vintage work from 19th- to 20th-century, rare books, issues of *Camerawork*, and artist books. Book Beat Gallery is looking for courageous and astonishing image makers, high quality digital work is acceptable. Artists are welcome to submit a handwritten or typed proposal for an exhibition, include artist bio, statement, and website, book or CD with sample images. We are especially interested in photographers who have published book works or work with originals in the book format, also those who work in 'dead media' and extinct processes."

SUBMISSIONS Responds in 6 weeks.

RENA BRANSTEN GALLERY

77 Geary St., San Francisco CA 94108. (415)982-3292. **Fax:** (415)982-1807. **E-mail:** info@renabranstengallery.com; calvert@renabranstengallery.com; rena@renabranstengallery.com. **Website:** www.renabranstengallery.com. **Contact:** Rena Bransten, owner. Estab. 1974. For-profit gallery. Approached by 200 artists/year; represents or exhibits 12-15 artists. Average display time 4-5 weeks. Open Tuesday–Friday, 10:30-5:30; Saturday, 11-5.

SUBMISSIONS E-mail JPEG samples at 72 dpi. Finds artists through word of mouth, art exhibits, submissions, art fairs, portfolio reviews, referrals by other artists.

J.J. BROOKINGS GALLERY

330 Commercial St., San Jose CA 95112. (408)287-3311. **Fax:** (408)287-6705. **E-mail:** info@jjbrookings.com. **Website:** www.jjbrookings.com. Sponsors rotating group exhibits. Sponsors openings. Overall price range $500-30,000.

EXHIBITS Interested in photography created with a "painterly eye."

MAKING CONTACT & TERMS Charges 50% commission.

SUBMISSIONS Send material by mail for consideration. Responds in 3-5 weeks if interested; immediately if not acceptable.

TIPS Wants to see "professional presentation, realistic pricing, numerous quality images. We're interested in whatever the artist thinks will impress us the most. 'Painterly' work is best. No documentary or politically oriented work."

BUSINESS OF ART CENTER

513 Manitou Ave., Manitou Springs CO 80829. (719)685-1861. **E-mail:** director@thebac.org. **Website:** www.thebac.org. Estab. 1988. Nonprofit gallery

situated in 2 renovated landmark buildings in the Manitou Springs National Historic District—Studio 513 and Venue 515. Art studios for rent. Sponsors 16 exhibits/year. Average display time 1 month. Gallery open Tuesday–Saturday, 11-6. Overall price range $50-3,000. Most work sold at $300.

EXHIBITS Photos of environmental, landscapes/scenics, wildlife, gardening, rural, adventure, health/fitness, performing arts, travel. Interested in alternative process, avant garde, documentary, fashion/glamour, fine art.

MAKING CONTACT & TERMS Artwork is accepted on consignment, and there is a 40% commission. Gallery provides insurance, promotion, contract. Accepted work should be framed.

SUBMISSIONS Write to arrange a personal interview to show portfolio. Send query letter with artist's statement, bio, slides. Finds artists through word of mouth, submissions, portfolio reviews, art exhibits, referrals by other artists.

WILLIAM CAMPBELL CONTEMPORARY ART

4935 Byers Ave., Ft. Worth TX 76107. (817)737-9566. **Fax:** (817)737-5466. **E-mail:** wcca@flash.net. **Website:** www.williamcampbellcontemporaryart.com. **Contact:** William Campbell, owner/director. Estab. 1974. Sponsors 8-10 exhibits/year. Average display time 5 weeks. Sponsors openings; provides announcements, press releases, installation of work, insurance, cost of exhibition. Overall price range $500-20,000.

MAKING CONTACT & TERMS Charges 50% commission. Reviews transparencies. Accepted work should be mounted. Requires exclusive representation within metropolitan area.

SUBMISSIONS Send CD (preferred) and résumé by mail with SASE. Responds in 1 month.

CAPITOL COMPLEX EXHIBITIONS

500 S. Bronough St., R.A. Gray Bldg., 3rd Floor, Department of State, The Capitol, Tallahassee FL 32399-0250. (850)245-6470. **Fax:** (850)245-6492. **E-mail:** sshaughnessy@dos.state.fl.us. **Website:** www.florida-arts.org. Average display time 3 months. Overall price range $200-1,000. Most work sold at $400.

EXHIBITS "The Capitol Complex Exhibitions Program is designed to showcase Florida artists and art organizations. Exhibitions are displayed in the Capitol Gallery (22nd Floor) and the Cabinet Meeting Room in Florida's capitol. Exhibitions are selected based on quality, diversity of media, and regional representation."

MAKING CONTACT & TERMS Does not charge commission. Accepted work should be framed. *Interested only in Florida artists or arts organizations.*

SUBMISSIONS Download application from website, complete and send with image CD. Responds in 3 weeks.

CENTER FOR CREATIVE PHOTOGRAPHY

University of Arizona, P.O. Box 210103, 1030 North Olive Rd., Tucson AZ 85721-0103. (520)621-7968. **Fax:** (520)621-9444. **E-mail:** info@ccp.library.arizona.edu. **Website:** www.creativephotography.org. Estab. 1975. Museum/archive, research center, museum retail shop. Sponsors 3-4 photography exhibits/year. Average display time 3-4 months. Gallery open Monday–Friday, 9-5; weekends, 1-4. Closed most holidays. 5,500 sq. ft.

⊕ CENTER FOR DIVERSIFIED ART

P.O. Box 641062, Beverly Hills FL 34465. **E-mail:** diversifiedart101@gmail.com. **Website:** www.diversifiedart.org. **Contact:** Anita Walker, founder and director. Estab. 2010. Nonprofit gallery. Exhibits emerging, mid-career and established artists. Approached by 12 artists/year; represents or exhibits about 24 artists currently. Exhibited artists include David Kontra (acrylics) and Linda Litteral (sculptor). We specialize in visual art that has a social and/or environmental theme that raises awareness. Sponsors 1 exhibit/year, photography is included in our annual exhibit. One piece from each of our artists is shown indefinitely in our online gallery and publications. We are a web-based gallery and sponsor 1 brick and mortar exhibition a year. We also use visual art to go with educational material that we produce and publish. Many of our artists have a strong commitment to raising awareness. Clients include the local community and students. Price range: $150-4,000.

EXHIBITS Considers all media and all types of prints (prints must be a limited edition and include a certificate of authenticity).

MAKING CONTACT & TERMS Artwork is accepted on consignment and there is a 20% commission. Retail price set by the artist. Gallery provides promotion. Accepted work should be framed.

SUBMISSIONS Please make sure your work has a social and/or environmental theme that raises awareness before submitting. E-mail query letter with link

to artist's website, 3 JPEG samples at 72 dpi, résumé and how your work relates to raising awareness on social and/or environmental issues. Responds only if interested within 1 month. Finds artists through word of mouth, art exhibits, submissions, portfolio reviews and referrals by other artists.

TIPS Follow the directions above.

✹ CENTER FOR EXPLORATORY AND PERCEPTUAL ART

617 Main St., Suite 201, Buffalo NY 14203. (716)856-2717. **Fax:** (716)270-0184. **E-mail:** info@cepagallery.com. **Website:** www.cepagallery.org. **Contact:** Sean J. Donaher, executive director. Estab. 1974. "CEPA is an artist-run space dedicated to presenting photographically based work that is under-represented in traditional cultural institutions." Sponsors 5-6 exhibits/year. Average display time 6 weeks. Call or see website for hours. Total gallery space is approximately 6,500 sq. ft. Overall price range $200-3,500.

○ CEPA conducts an annual Emerging Artist Exhibition for its members. You must join the gallery in order to participate.

EXHIBITS Interested in political, digital, video, culturally diverse, contemporary and conceptual works. Extremely interested in exhibiting work of newer, lesser-known photographers.

MAKING CONTACT & TERMS Sponsors openings; reception with lecture. Accepted work should be framed or unframed, mounted or unmounted, matted or unmatted.

SUBMISSIONS Send query letter with artist's statement, résumé that will give insight into your work. "Up to 20 numbered slides with a separate checklist (work will not be considered without a complete checklist). Each slide must have your name, a number, and an indication of 'top.' The checklist must have your name, address, phone/fax/e-mail, title of the work, date, image size, process, and presentation size. Do not send prints or original works. CDs running on a MAC platform may be submitted." Include SASE for return of material. Responds in 3 months.

TIPS "We review CD portfolios and encourage digital imagery. We will be showcasing work on our website."

CENTER FOR PHOTOGRAPHIC ART

Sunset Cultural Center, P.O. Box 1100, Carmel CA 93921. (831)625-5181. **Fax:** (831)625-5199. **E-mail:** info@photography.org. **Website:** www.photography.org. Estab. 1988. Nonprofit gallery. Sponsors 7-8 exhibits/year. Average display time 5-7 weeks. Hours: Tuesday-Sunday, 1-5.

EXHIBITS Interested in fine art photography.

SUBMISSIONS "Currently not accepting unsolicited submissions. Please e-mail the center and ask to be added to our submissions contact list if you are not a member." Photographers should see website for more information.

THE CENTER FOR PHOTOGRAPHY AT WOODSTOCK

59 Tinker St., Woodstock NY 12498. (845)679-9957. **Fax:** (845)679-6337. **E-mail:** info@cpw.org. **Website:** www.cpw.org. **Contact:** Ariel Shanberg, executive director. Estab. 1977. Alternative space, nonprofit arts and education center. Approached by more than 500 artists/year. Hosts 10 photography exhibits/year. Average display time 7 weeks. Gallery open all year; Wednesday–Sunday, 12-5.

EXHIBITS Interested in presenting all aspects of contemporary creative photography including digital media, film, video, and installation by emerging and under-recognized artists. "We host 5 group exhibitions and 5 solo exhibitions annually. Group exhibitions are curated by guest jurors, curators, and CPW staff. Solo exhibition artists are selected by CPW staff. Visit the exhibition archives on our website to learn more."

MAKING CONTACT & TERMS CPW hosts exhibition and opening reception; provides insurance, promotion, a percentage of shipping costs, installation and de-installation, and honorarium for solo exhibition artists who give gallery talks. CPW takes 25% commission on exhibition-related sales. Accepted work should be framed and ready for hanging.

SUBMISSIONS Send introductory letter with samples, résumé, artist's statement, SASE. Responds in 4 months. Finds artists through word of mouth, art exhibits, open calls, portfolio reviews, referrals by other artists.

TIPS "CPW accepts submissions in CD-ROMs and accepts video works in DVD format. Please send 10-20 digital work samples on CD (3×5 no larger than 300 dpi) by mail (include an image script with your name, telephone number, image title, image media, size). Include a current résumé, statement, SASE for return. We are not responsible for unlabeled submission. We *do not* welcome solicitations to visit websites. We *do* advise artists to visit our website and become familiar with our offerings."

⊕ CENTRAL MICHIGAN UNIVERSITY ART GALLERY

University Art Gallery Wightman 132, Central Michigan University, Mt. Pleasant MI 48859. (989)774-3800. **E-mail:** goche1as@cmich.edu. **Website:** www.uag.cmich.edu. **Contact:** Anne Gochenour, gallery director. Estab. 1970. Nonprofit academic gallery. Exhibits emerging, mid-career and established contemporary artists. Past artists include Sandy Skoglund, Michael Ferris, Blake Williams, John Richardson, Valerie Allen, Randal Crawford, Jane Gilmor, Denise Whitebread Fanning, Alynn Guerra, Dylan Miner. Sponsors 14 exhibits/year (2-4 curated). Average display time: 1 month. Open all year while exhibits are present; Tuesday–Friday, 11-6; Saturday, 11-3. Clients include local community, students and tourists.

EXHIBITS Considers all media and all types of prints. Most frequently exhibits sculpture, prints, ceramics, painting and photography.

MAKING CONTACT & TERMS Buyers are referred to the artist. Gallery provides insurance, promotion and contract. Accepted work should be framed. Does not require exclusive representation locally.

SUBMISSIONS Send query letter with artist's statement, bio, résumé, reviews, and images on CD. Responds within 2 months, only if interested. Finds artists through word of mouth, submissions, portfolio reviews, art exhibits, and referrals by other artists.

CHABOT FINE ART GALLERY

379 Atwells Ave., Providence RI 02909. (401)432-7783. **Fax:** (401)432-7783. **E-mail:** chris@chabotgallery.com. **Website:** www.chabotgallery.com. **Contact:** Chris Chabot, director. Estab. 2007. Fine art rental gallery. Approached by 50 artists/year; represents 30 emerging, mid-career and established artists. Exhibited artists include Lee Chabot (owner of the gallery). Sponsors 12 total exhibits/year; 1 photography exhibit/year. Average display time 30 days. Open Tuesday-Saturday, 12-6, or by appointment or chance. The gallery is located on Historic Federal Hill in Providence. It has over 1,000 sq. ft. of exhibition space and a courtyard sculpture garden that is open in the warmer months. Clients include local community, tourists, upscale. 10% corporate collectors. Overall price range: $1,200-10,000. Most work sold at $3,500.

EXHIBITS Considers all media except craft. Most frequently exhibits oil, acrylics and watercolor. Considers all styles and genres. Most frequently exhibits abstract, impressionism, abstract expressionism.

MAKING CONTACT & TERMS Artwork is accepted on consignment with a 50% commission. Retail price is set by the gallery and artist. Gallery provides insurance, promotion, and contract. Accepted work should be framed, mounted, and matted.

SUBMISSIONS Mail portfolio for review. Send query letter with artist's statement, bio, résumé, CD with images, and SASE. Returns material with SASE. Responds in 1 month. Files all submitted material. Finds artist through word of mouth, submissions, portfolio reviews, art exhibits, and referrals by other artists.

TIPS Be professional in your presentation, have good images in your portfolio, and submit all necessary information.

○ THE CHAIT GALLERIES DOWNTOWN

218 E. Washington St., Iowa City IA 52240. (319)338-4442. **Fax:** (319)338-3380. **E-mail:** info@thegalleriesdowntown.com; terri@thegalleriesdowntown.com; bpchait@aol.com. **Website:** www.thegalleriesdowntown.com. **Contact:** Benjamin Chait, director. Estab. 2003. For-profit gallery. Approached by 100 artists/year; represents or exhibits 150 artists. Open Monday–Friday, 10-6; Saturday, 11-5; Sunday by appointment or by chance. Located in a downtown building renovated to its original look of 1882 with 14-ft.-high molded ceiling and original 9-ft. front door. Professional museum lighting and Scamozzi-capped columns complete the elegant gallery. Overall price range: $50-10,000.

EXHIBITS Landscapes, oil and acrylic paintings, sculpture, fused glass wall pieces, jewelry, all types of prints.

MAKING CONTACT & TERMS Artwork is accepted on consignment, and there is a 50% commission. Gallery provides insurance, promotion and contract. Accepted work should be framed. Requires exclusive representation locally.

SUBMISSIONS Call; mail portfolio for review. Responds to queries in 2 weeks. Finds artists through art fairs, art exhibits, portfolio reviews and referrals by other artists.

CHAPMAN FRIEDMAN GALLERY

624 W. Main St., Suite 100F, Louisville KY 40202. (502)584-7954. **E-mail:** friedman@imagesol.com. **Website:** www.imagesol.com. **Contact:** Julius Friedman, owner. Estab. 1992. For-profit gallery. Ap-

proached by 100 or more artists/year; represents or exhibits 25 artists. Sponsors 1 photography exhibit/year. Average display time 1 month. Open by appointment only. Located downtown; approximately 3,500 sq. ft. with 15-ft. ceilings and white walls. Overall price range: $75-10,000. Most work sold at more than $1,000.

EXHIBITS Photos of landscapes/scenics, architecture. Interested in alternative process, avant garde, erotic, fine art.

MAKING CONTACT & TERMS Artwork is accepted on consignment, and there is a 50% commission. Gallery provides insurance, promotion and contract. Accepted work should be framed. Requires exclusive representation locally.

SUBMISSIONS Send query letter with artist's statement, bio, brochure, photographs, résumé, slides and SASE. Responds to queries within 1 month, only if interested. Finds artists through portfolio reviews and referrals by other artists.

CLAMPART

521-531 W. 25th St., Ground Floor, New York NY 10001. (646)230-0020. **E-mail:** info@clampart.com. **E-mail:** portfolioreview@clampart.com. **Website:** www.clampart.com. **Contact:** Brian Paul Clamp, director. Estab. 2000. For-profit gallery. Specializes in modern and contemporary paintings and photographs. Approached by 1,200 artists/year; represents 15 emerging, mid-career and established artists. Exhibited artists include Jill Greenberg (photography), Lori Nix (photography) and Mark Beard (painting). See portfolio review guidelines at www.clampart.com/portfolio.html.

EXHIBITS Photos of couples, disasters, environmental, landscapes/scenics, architecture, cities/urban, humor, performing arts, travel, science, technology/computers. Interested in alternative process, avant garde, documentary, erotic, fashion/glamour, fine art, historical/vintage.

MAKING CONTACT & TERMS Artwork is accepted on consignment, and there is a 50% commission. Gallery provides insurance, promotion and contract. Accepted work should be framed, mounted and matted.

SUBMISSIONS E-mail query letter with artist's statement, bio and JPEGs (JPEGs larger than 72 dpi at 8×8 will not be accepted). Responds to queries in 2 weeks. Finds artists through portfolio reviews, submissions and referrals by other artists.

TIPS "Include a bio and well-written artist's statement. Do not submit work to a gallery that does not handle the general kind of work you produce."

CATHARINE CLARK GALLERY

150 Minna St., Ground Floor, San Francisco CA 94105. (415)399-1439. **Fax:** (415)543-1338. **E-mail:** info@cclarkgallery.com. **Website:** www.cclarkgallery.com. **Contact:** Catherine Clark, owner/director. Estab. 1991. For-profit gallery. Approached by 1,000 artists/year; represents or exhibits 28 artists. Sponsors 1-3 photography exhibits/year. Average display time 4-6 weeks. Overall price range $200-150,000. Most work sold at $5,000. Charges 50% commission. Gallery provides insurance, promotion.

SUBMISSIONS Accepted work should be ready to hang. Requires exclusive representation locally. "Do not call." No unsolicited submissions. Finds artists through word of mouth, art exhibits, art fairs, referrals by other artists and colleagues.

TIPS Interested in alternative process, avant garde. "The work shown tends to be vanguard with respect to medium, concept and process."

STEPHEN COHEN GALLERY

7354 Beverly Blvd., Los Angeles CA 90036. (323)937-5525. **Fax:** (323)937-5523. **E-mail:** info@stephencohengallery.com; claudia@stephencohengallery.com. **Website:** www.stephencohengallery.com. Estab. 1992. Photography, photo-related art, works on paper gallery. Exhibits vintage and contemporary photography and photo-based art from the U.S., Europe, Asia, and Latin America. The gallery is also able to locate work by photographers not represented in the gallery. The Cohen Gallery works with contemporary artists/photographers and has a large inventory of classic photography. Average display time 7-8 weeks. Open Tuesday-Saturday, 11-6. Overall price range $500-20,000. Most work sold at $2,000.

EXHIBITS All styles of photography and photo-based art. "The Gallery has exhibited vintage and contemporary photography and photo-based art from the United States, Europe and Latin America. The gallery is also able to locate work by photographers not represented by the gallery. As host gallery for Photo LA, the gallery has helped to expand the awareness of photography as an art form to be appreciated by the serious collector."

SUBMISSIONS Send query letter, or e-mail, with artist's statement, bio, brochure, photographs, résumé,

reviews, SASE. Responds within 3 months, only if interested. Finds artists through word of mouth, published work.

TIPS "Photography is still the best bargain in 20th-century art. There are more people collecting photography now, increasingly sophisticated and knowledgeable people aware of the beauty and variety of the medium."

THE CONTEMPORARY ARTS CENTER (CINCINNATI)

44 E. Sixth St., Cincinnati OH 45202. (513)345-8400. **Fax:** (513)721-7418. **E-mail:** jludwig@contemporary artscenter.org; motoole@contemporaryartscenter.org. **Website:** www.contemporaryartscenter.org. **Contact:** Justine Ludwig, adjunct curator. Nonprofit arts center. Without a permanent collection, all exhibitions on view are temporary and ever-changing. Sponsors 9 exhibits/year. Average display time 6-12 weeks. Sponsors openings; provides printed invitations, music, refreshments, cash bar. Open Monday, 10-9; Wednesday–Friday, 10-6; Saturday and Sunday, 11-6. Closed Thanksgiving, Christmas and New Year's Day.

EXHIBITS Photographer must be selected by the curator and approved by the board. Exhibits photos of multicultural, disasters, environmental, landscapes/scenics, gardening, technology/computers. Interested in avant garde, innovative photography, fine art.

MAKING CONTACT & TERMS Photography sometimes sold in gallery. Charges 15% commission.

SUBMISSIONS Send query with résumé, slides, SASE. Responds in 2 months.

CONTEMPORARY ARTS CENTER (LAS VEGAS)

107 E. Charleston Blvd., Suite 120, Las Vegas NV 89104. (702)382-3886. **E-mail:** info@lasvegascac.org. **Website:** www.lasvegascac.org. Estab. 1989. "The CAC is a non-profit 501(c)3 art organization dedicated to presenting new, high quality, visual, and performing art, while striving to build, educate, and sustain audiences for contemporary art." Sponsors more than 9 exhibits/year. Average display time 1 month. Gallery open Tuesday–Saturday, 12-5, and by appointment; Preview Thursday, 6-9; 1st Friday, 6-10. Closed Thanksgiving, Christmas, New Year's Day. 1,200 sq. ft. Overall price range $200-4,000. Most work sold at $400.

"The CAC is accepting submissions of work for East Side Projects, a series of monthly projects in the gallery's front window space facing Charleston Blvd. This ongoing call is open to all contemporary artists working in any media. Artists must be current CAC members (defined as dues-paying members starting at the $25 level) in order to be eligible for consideration. To become a member go to lasvegascac.org/support/join. Site-specific work for the space is encouraged. We encourage artists to visit or e-mail the gallery to see the space."

MAKING CONTACT & TERMS Artwork is accepted through annual call for proposals of individual or group shows. Gallery provides insurance, promotion, contract.

SUBMISSIONS Finds artists through annual call for proposals, membership, word of mouth, submissions, portfolio reviews, art exhibits, art fairs, referrals by other artists and walk-ins. Check website for dates and submission guidelines. Submissions must include a proposal, current CV/résumé, artist bio/statement, disc with JPEG images of original artwork (300 dpi) and image reference sheet (including artist, title, media, dimensions, and filename). Send SASE for return.

TIPS Submitted slides should be "well labeled and properly exposed with correct color balance."

CONTEMPORARY ARTS CENTER (NEW ORLEANS)

900 Camp, New Orleans LA 70130. (504)528-3805. **Fax:** (504)528-3828. **E-mail:** jfrancino@cacno.org; info@cacno.org; smead@cacno.org. **Website:** www.cacno.org. **Contact:** Jennifer Francino, visual arts coordinator. Estab. 1976.

EXHIBITS Interested in alternative process, avant garde, fine art. Cutting-edge contemporary preferred.

MAKING CONTACT & TERMS Send query letter with bio, SASE, slides or CD. Responds in 4 months. Finds artists through word of mouth, submissions, art exhibits, art fairs, referrals by other artists, professional contacts, art periodicals.

TIPS Submit only 1 slide sheet with proper labels (title, date, media, dimensions) or CD-ROM with the same information.

CORCORAN FINE ARTS LIMITED, INC.

12610 Larchmere Blvd., Cleveland OH 44120. (216)767-0770. **Fax:** (216)767-0774. **E-mail:** corcoranfinearts@gmail.com; gallery@corcoranfinearts.com. **Website:** www.corcoranfinearts.com. **Contact:** James Corcoran, director/owner. Estab. 1986. 36 years

of gallery and certified appraisal expertise. Represents 30 artists, many Cleveland School 1900-2013 paintings, drawings, prints and graphics. 18th-, 19th- and 20th-century American, Canadian and European art. Open Monday-Friday, 12-6; Saturday, 12-5 and by appointment.

EXHIBITS Interested in fine art. Specializes in representing high-quality 19th- and 20th-century work.

MAKING CONTACT & TERMS Gallery receives 50% commission. Requires exclusive representation. Few contemporary artists represented locally.

SUBMISSIONS For first contact, send a query letter, résumé, bio, slides, JPEGs and catalog details, SASE. Responds within 1 month. After initial contact, drop-off or mail-in appropriate materials for review by gallery director Gary Marshall and owner James Corcoran. Portfolio should include photographs/slides. Additionally finds artists through solicitation.

CORPORATE ART SOURCE/CAS GALLERY

2960-F Zelda Rd., Montgomery AL 36106. (334)271-3772. **E-mail:** casjb@mindspring.com. **Website:** www.casgallery.com. Estab. 1990. Approached by 100 artists/year; represents or exhibits 50 artists. Sponsors 1 photography exhibit/year. Average display time 6 weeks. Gallery open Monday-Friday, 10-5:30; Overall price range $200-20,000. Most work sold at $1,000.

EXHIBITS Photos of landscapes/scenics, architecture, rural. Interested in alternative process, avant garde, fine art, historical/vintage.

MAKING CONTACT & TERMS Artwork is accepted on consignment, and there is a 50% commission. Gallery provides contract.

SUBMISSIONS E-mail from the website, or mail portfolio for review. Send query letter. Responds within 6 weeks, only if interested. Finds artists through submissions, portfolio reviews, art exhibits, art fairs, referrals by other artists.

TIPS "Have good photos of work, as well as websites with enough work to get a feel for the overall depth and quality."

CO/SO: COPLEY SOCIETY OF ART

158 Newbury St., Boston MA 02116. (617)536-5049. **Fax:** (617)267-9396. **E-mail:** info@copleysociety.org. **Website:** www.copleysociety.org. **Contact:** Suzan Redgate, executive director. Estab. 1879. Co/So is the oldest non-profit art association in the U.S. Sponsors 20-30 exhibits/year, including solo exhibitions, thematic group shows, juried competitions and fund-raising events. Average display time 4-6 weeks. Open Tuesday–Saturday, 11-6; Sunday, 12-5, Monday by appointment. Overall price range $100-10,000. Most work sold at $700.

EXHIBITS Interested in all styles.

MAKING CONTACT & TERMS Must apply and be accepted as an artist member. "Once accepted, artists are eligible to compete in juried competitions. Artists can also display or show smaller works in the lower gallery throughout the year." Guaranteed showing in annual Small Works Show. There is a possibility of group or individual show, on an invitational basis, if merit exists. Charges 40% commission. Reviews digital images only with application. Preliminary application available via website. "If invited to apply to membership committee, a date would be agreed upon."

SUBMISSIONS Digital images must be saved on CD as JPEG files of 300 dpi resolution (approx. size: 4×6) with file names in the format: "LastName_First Name_Number_Title" (for example: Doe_John_1_Ti tleofFirstPiece). Three views of each 3D artwork are recommended. All images must be professionally presented: frames should not be visible, and colors should match those of the original piece as closely as possible.

TIPS Wants to see "professional, concise and informative completion of application. The weight of the judgment for admission is based on quality of work. Only the strongest work is accepted. We are in the process of strengthening our membership, especially photographers. We look for quality work in any genre, medium or discipline."

COURTHOUSE GALLERY, LAKE GEORGE ARTS PROJECT

1 Amherst St., Lake George NY 12845. (518)668-2616. **E-mail:** mail@lakegeorgearts.org. **Website:** www.lakegeorgearts.org. **Contact:** Laura Von Rosk, gallery director. Estab. 1986. Nonprofit gallery. Approached by more than 200 artists/year; represents or exhibits 10-15 artists. Sponsors 1-2 photography exhibits/year. Average display time 5-6 weeks. Gallery open Tuesday-Friday, 12-5; weekends, 12-4. Closed mid-December to mid-January. Overall price range $100-5,000. Most work sold at $500.

MAKING CONTACT & TERMS Artwork is accepted on consignment and there is a 25% commission. Gallery provides insurance, promotion, contract. Accepted work should be framed, mounted, matted.

SUBMISSIONS Mail portfolio for review. Deadline: January 31. Send query letter with artist's statement,

bio, résumé, 10-12 JPEG images (approximately 4-6 inches and no more than 1200×1200 pixels) on a CD, SASE. Responds in 4 months. Finds artists through word of mouth, submissions, portfolio reviews, art exhibits, art fairs, referrals by other artists.

⊕ CATHERINE COUTURIER GALLERY

2635 Colquitt St., Houston TX 77098. (713)524-5070. **E-mail:** gallery@catherinecouturier.com. **Website:** www.catherinecouturier.com. Estab. 1996. Fine art photography. Average display time 5 weeks. Open Tuesday–Saturday, 10-5 and by appointment. Located in upper Kirby District of Houston, Texas. Overall price range $500-40,000. Most work sold at $1,000-2,500.

EXHIBITS Photos of babies/children/teens, celebrities, couples, multicultural, families, parents, senior citizens, landscapes/scenics, wildlife, architecture, cities/urban, education, pets, religious, rural, adventure, automobiles, entertainment, events, humor, performing arts, travel, agriculture, industry, military, political, portraits, product shots/still life, science, technology/computers. Interested in alternative process, documentary, fashion/glamour, fine art, historical/vintage.

MAKING CONTACT & TERMS Artwork is bought outright or accepted on consignment with a 50% commission. Gallery provides insurance, promotion, contract.

SUBMISSIONS Call to show portfolio of photographs. Finds artists through submissions, art exhibits. Due to the volume of submissions, only able to review work once or twice a year.

◯ CREALDÉ SCHOOL OF ART

600 St. Andrews Blvd., Winter Park FL 32792. (407)671-1886. **Fax:** (407)671-0311. **E-mail:** rickpho@aol.com. **E-mail:** rberrie@crealde.org. **Website:** www.crealde.org. **Contact:** Rick Lang, director of photography. Estab. 1975. "The school's gallery holds 6-7 exhibitions/year, representing artists from regional/national stature." Open Monday–Thursday, 9-4; Friday–Saturday, 9-1.

EXHIBITS All media.

MAKING CONTACT & TERMS Send 20 slides or digital images, résumé, statement and return postage.

CROSSMAN GALLERY

950 W. Main St., Whitewater WI 53190. (262)472-5708 (office); (262)472-1207 (gallery). **E-mail:** flanagam@uww.edu. **Website:** blogs.uww.edu/crossman.

Contact: Michael Flanagan, director. Estab. 1971. Photography is regularly featured in thematic exhibits at the gallery. Average display time 1 month. Overall price range $250-3,000. Located on the 1st floor of the Center of the Arts on the campus of the University of Wisconsin-Whitewater. Open Monday–Friday, 10-5; Monday–Thursday evening, 6-8; Saturday, 1-4. Special hours may apply when school is not in session. Please call before visiting to insure access.

EXHIBITS "We primarily exhibit artists from the Midwest but do include some from national and international venues. Works by Latino artists are also featured in a regular series at ongoing exhibits." Interested in all types of innovative approaches to photography. Sponsors openings; provides food, beverage, show announcement, mailing, shipping (partial) and possible visiting artist lecture/demo.

SUBMISSIONS Submit 10-20 images on CD, artist's statement, résumé, SASE.

TIPS "The Crossman Gallery operates within a university environment. The focus is on exhibits that have the potential to educate viewers about processes and techniques and have interesting thematic content."

⊕ CUSHING-MARTIN GALLERY

320 Washington St., Easton MA 02357. **Contact:** Candice Smith Corby, gallery director. Nonprofit, college gallery. Approached by 4-8 artists/year, represents/exhibits 10-20 artists/year. Closed during the summer when school is not in session. Clients include local community and students.

MAKING CONTACT & TERMS Proceeds of sales go to the artist; sales are not common. Price set by the artist. Gallery provides insurance and promotion. Accepted work should be framed and mounted.

SUBMISSIONS Mail portfolio for review. Include artist's statement, bio, résumé, SASE and CD. Returns material with SASE. Responds in 6 months. Files "interesting" materials. Finds artists through word of mouth, submissions, art exhibits and referrals by other artists.

THE DALLAS CENTER FOR CONTEMPORARY ART

191 Glass St., Dallas TX 75207. (214)821-2522. **Fax:** (214)821-9103. **E-mail:** peter.doroshenko@dallascontemporary.org; info@dallascontemporary.org. **Website:** www.dallascontemporary.org. **Contact:** Peter Doroshenko, director. Estab. 1981. Nonprofit gallery. Sponsors 1-2 photography exhibits/year. Other ex-

hibits may include photography as well as other mediums. Average display time 6-8 weeks. Gallery open Tuesday-Saturday, 11-6; Sunday, 12-5.

EXHIBITS Variety of subject matter and styles.

MAKING CONTACT & TERMS Charges no commission. "Because we are nonprofit, we do not sell artwork. If someone is interested in buying art in the gallery, they get in touch with the artist. The transaction is between the artist and the buyer."

SUBMISSIONS Reviews slides/CDs. Send material by mail for consideration; include SASE. Responds October 1 annually.

TIPS "Memberships available starting at $50. See our website for info and membership levels."

DARKROOM GALLERY

12 Main St., Essex Junction VT 05452. (802)777-3686. **E-mail:** info@darkroomgallery.com. **Website:** www.darkroomgallery.com. **Contact:** Ken Signorello, owner. Estab. 2010. For-profit and rental gallery. Exhibits 300 emerging, mid-career and established artists. Sponsors 14 photography exhibits/year. Average display time 3½ weeks . Open Monday-Sunday, 11-4; closed on major holidays. The gallery is a freshly renovated 1300-sq.-ft. first floor store front air conditioned space with hardwood floors and an 11-ft. ceiling. Our lighting system uses 3000K LED flood lights. Nearly every image has a dedicated light and hangs from a fully adjustable hanging system. We are located at the "Five Corners" right next to Martone's Market and Café. The Village of Essex Junction is located within 10 miles of the University of Vermont and 3 other colleges, downtown Burlington and Burlington International Airport. Clients include local community, students, tourists and upscale. Overall price range $50-300. Most work sold at $200.

EXHIBITS Most frequently exhibits photography. Considers all styles.

MAKING CONTACT & TERMS Artwork is accepted on consignment and there is a 34-66% commission. Retail price of the art is set by the artist. Accepted work should be framed, mounted and matted.

SUBMISSIONS Returns material with SASE. Responds in 1 week. Files prints up to 13×19. Finds artists through submissions.

THE DAYTON ART INSTITUTE

456 Belmonte Park N., Dayton OH 45405-4700. (937)223-5277. **Fax:** (937)223-3140. **E-mail:** info@daytonart.org. **Website:** www.daytonartinstitute.org.

Estab. 1919. Museum. Galleries open Tuesday-Friday, 11-8; Saturday, 10-5; Sunday, 12-5.

EXHIBITS Interested in fine art.

DELAWARE CENTER FOR THE CONTEMPORARY ARTS

200 S. Madison St., Wilmington DE 19801. (302)656-6466. **Website:** www.thedcca.org. **Contact:** Maxine Gaiber, director. Alternative space, museum retail shop, nonprofit gallery. Approached by more than 800 artists/year; exhibits 50 artists. Sponsors 30 total exhibits/year. Average display time 6 weeks. Gallery open Tuesday, Thursday, Friday, and Saturday, 10-5; Wednesday and Sunday, 12-5. Closed on Monday and major holidays. Seven galleries located along rejuvenated Wilmington riverfront.

EXHIBITS Interested in alternative process, avant garde.

MAKING CONTACT & TERMS Gallery provides PR and contract. Accepted work should be framed, mounted, matted. Prefers only contemporary art.

SUBMISSIONS Send query letter with artist's statement, bio, SASE, 10 digital images. Returns material with SASE. Does not accept original art work or slides for consideration. Responds within 6 months. Finds artists through calls for entry, word of mouth, submissions, portfolio reviews, art exhibits, referrals by other artists.

DEMUTH MUSEUM

120 E. King St., Lancaster PA 17602. (717)299-9940. **E-mail:** information@demuth.org. **Website:** www.demuth.org. **Contact:** Gallery director. Estab. 1981. Museum. Average display time 2 months. Open Tuesday–Saturday, 10-4; Sunday, 1-4. Located in the home and studio of Modernist artist Charles Demuth (1883-1935). Exhibitions feature the museum's permanent collection of Demuth's works with changing, temporary exhibitions.

DETROIT FOCUS

P.O. Box 843, Royal Oak MI 48068-0843. (248)541-2210. **E-mail:** michael@sarnacki.com. **Website:** www.detroitfocus.org. Estab. 1978. Artist alliance. Approached by 100 artists/year; represents or exhibits 100 artists. Sponsors 1 or more photography exhibit/year.

EXHIBITS Interested in photojournalism, avant garde, documentary, erotic, fashion/glamour, fine art.

MAKING CONTACT & TERMS No charge or commission.

SUBMISSIONS Call or e-mail. Responds in 1 week. Finds artists through word of mouth, submissions, art exhibits, referrals by other artists.

SAMUEL DORSKY MUSEUM OF ART

1 Hawk Dr., New Paltz NY 12561. (845)257-3844. **Fax:** (845)257-3854. **E-mail:** sdma@newpaltz.edu. **Website:** www.newpaltz.edu/museum. **Contact:** Committee. Estab. 1964. Sponsors ongoing photography exhibits throughout the year. Average display time 4 months. Museum open Wednesday–Sunday, 11-5. Closed legal and school holidays and during intersession; check website to confirm your visit.

EXHIBITS Interested in alternative process, avant garde, documentary, fine art, historical/vintage.

SUBMISSIONS Finds artists through art exhibits.

○ DOT FIFTYONE GALLERY

187 NW 27th St., Miami FL 33127. (305)573-9994, ext. 450. **E-mail:** info@dotfiftyone.com; dot@dotfiftyone.com. **Website:** www.dotfiftyone.com. Estab. 2003. Sponsors 6 photography exhibits per year. Average display time: 30 days. Clients include the local community, tourists, and upscale corporate collectors. Art sold for $1,000-20,000 (avg. $5,000) with a 50% commission. Prices are set by the gallery and the artist. Gallery provides insurance, promotion and contract. Work should be framed, mounted and matted. Will respond within 1 month if interested.

MAKING CONTACT & TERMS E-mail 5 JPEG samples at 72 dpi.

DRKRM

933 Chung King Rd., Los Angeles CA 90012. (213)928-0973. **Website:** www.drkrm.com. **Contact:** John Matkowsky, owner. Estab. 2005. For-profit gallery. Exhibits emerging, mid-career, and established artists. Approached by 30 artists a year; represents or exhibits 10 artists. Exhibited artists include Anthony Friedkin (photography) and Ansel Adams (photography). Sponsors 10 total exhibits a year. Model and property release are preferred. Average display time is 4 weeks. Open Wednesday-Saturday, 12–6; Sunday, 12–4. A 1,200-sq.-ft. establishment located in the Chinatown section of Los Angeles. Clientele include local community, students, and upscale clients. 20% of sales are to corporate collectors. Overall price range is $500-3,000. Most work sold at $1,000.

MAKING CONTACT & TERMS Gallery provides insurance, promotion, and contract. Accepted work should be framed, mounted, and matted. Does not require exclusive local representation. Prefers photo journalistic/documentary artists.

SUBMISSIONS Artists should e-mail query letter with link to artist's website. Responds only if interested within 1 week. Files prints from website. Finds artists through word of mouth, submissions, art exhibits, and referrals by other artists.

TIPS "Follow the rules of submission."

GEORGE EASTMAN HOUSE

900 East Ave., Rochester NY 14607. (585)271-3361. **Website:** www.eastmanhouse.org. Estab. 1947. Museum. "As the world's preeminent museum of photography, Eastman House cares for and interprets hundreds of thousands of photographs encompassing the full history of this medium. We are also one of the oldest film archives in the U.S. and now considered to be among the top cinematic collections worldwide." Approached by more than 400 artists/year. Sponsors more than 12 photography exhibits/year. Average display time 3 months. Gallery open Tuesday-Saturday, 10-5; Sunday, 11-5. Closed Thanksgiving and Christmas. Museum has 7 galleries that host exhibitions, ranging from 50- to 300-print displays.

EXHIBITS GEH is a museum that exhibits the vast subjects, themes and processes of historical and contemporary photography.

SUBMISSIONS See website for detailed information: eastmanhouse.org/inc/collections/submissions.php. Mail portfolio for review. Send query letter with artist's statement, résumé, SASE, slides, digital prints. Responds in 3 months. Finds artists through word of mouth, art exhibits, referrals by other artists, books, catalogs, conferences, etc.

TIPS "Consider as if you are applying for a job. You must have succinct, well-written documents; a well-selected number of visual treats that speak well with written document provided; an easel for reviewer to use."

CATHERINE EDELMAN GALLERY

300 W. Superior St., Lower Level, Chicago IL 60654. (312)266-2350. **Fax:** (312)266-1967. **E-mail:** catherine@edelmangallery.com. **Website:** www.edelmangallery.com. **Contact:** Catherine Edelman, director. Estab. 1987. Sponsors 7 exhibits/year. Average display time 8-10 weeks. Open Tuesday–Saturday, 10-5:30. Overall price range $1,500-25,000.

EXHIBITS "We exhibit works ranging from traditional photography to mixed media photo-based work."

MAKING CONTACT & TERMS Charges 50% commission. Requires exclusive representation in the Midwest.

SUBMISSIONS Currently not accepting unsolicited submissions. Submissions policy on the website.

TIPS Looks for "consistency, dedication and honesty. Try to not be overly eager and realize that the process of arranging an exhibition takes a long time. The relationship between gallery and photographer is a partnership."

PAUL EDELSTEIN STUDIO AND GALLERY

540 Hawthorne St., Memphis TN 38112-5029. (901)496-8122. **E-mail:** henrygrove@yahoo.com. **Website:** www.pauledelsteinstudioandgallery.com. **Contact:** Paul R. Edelstein, director/owner. Estab. 1985. "Shows are presented continually throughout the year." Overall price range: $300-10,000. Most work sold at $1,000.

EXHIBITS Photos of celebrities, children, multicultural, families. Interested in avant garde, historical/vintage, C-print, dye transfer, ever color, fine art and 20th-century photography that intrigues the viewer—figurative still life, landscape, abstract—by upcoming and established photographers.

MAKING CONTACT & TERMS Charges 50% commission. Buys photos outright. Reviews transparencies. Accepted work should be framed or unframed, mounted or unmounted, matted or unmatted work. There are no size limitations. Submit portfolio for review. Send query letter with samples. Cannot return material. Responds in 3 months.

TIPS "Looking for figurative and abstract figurative work."

THOMAS ERBEN GALLERY

526 W. 26th St., Floor 4, New York NY 10001. (212)645-8701. **Fax:** (212)645-9630. **E-mail:** info@thomaserben.com. **Website:** www.thomaserben.com. Estab. 1996. For-profit gallery. Approached by 100 artists/year; represents or exhibits 15 artists. Average display time 5-6 weeks. Gallery open Tuesday–Saturday, 10-6 (Monday–Friday in July). Closed Christmas/New Year's Day and August.

SUBMISSIONS Mail portfolio for review. Responds in 1 month.

ETHERTON GALLERY

135 S. Sixth Ave., Tucson AZ 85701. (520)624-7370. **Fax:** (520)792-4569. **E-mail:** info@ethertongallery.com. **Website:** www.ethertongallery.com. **Contact:** Terry Etherton. Estab. 1981. Retail gallery and art consultancy. Specializes in vintage, modern and contemporary photography. Represents 50+ emerging, mid-career and established artists. Exhibited artists include Kate Breakey, Harry Callahan, Jack Dykinga, Elliott Erwitt, Mark Klett, Danny Lyon, Rodrigo Moya, Luis Gonzalez Palma, Lisa M. Robinson, Frederick Sommer, Joel-Peter Witkin and Alex Webb. Sponsors 3-5 shows/year. Average display time 8 weeks. Open year round. Located in downtown Tucson; 3,000-sq.-ft. gallery in historic building with wood floors and 16-ft. ceilings. Clientele: 50% private collectors, 25% corporate collectors, 25% museums. Overall price range $800-50,000; most work sold at $2,000-5,000. Media: Considers all types of photography, painting, works on paper. Etherton Gallery regularly purchases 19th-century, vintage, and classic photography; occasionally purchases contemporary photography and artwork. Interested in seeing work that is "well-crafted, cutting-edge, contemporary, issue-oriented."

MAKING CONTACT & TERMS Usually accepts work on consignment (50% commission). Retail price set by gallery and artist. Gallery provides insurance and promotion; shipping costs are shared; prefers framed artwork.

SUBMISSIONS Send CD or DVD, artist statement, résumé, reviews, bio; materials not returned. No unprepared, incomplete or unfocused work. Responds in 6 weeks only if interested.

TIPS "Become familiar with the style of our gallery and with contemporary art scene in general."

EVENTGALLERY 910ARTS

910 Santa Fe Dr., Denver CO 80204. (303)815-1779. **E-mail:** spector@910arts.com; info@910arts.com. **Website:** www.910arts.com. **Contact:** Cheryl Spector, owner. Estab. 2007. Community outreach gallery and event rental space whose mission is to create an open dialogue between artists and the community by raising awareness of social and environmental issues through creation of exceptional art. Average exhibition time is 2 months. Located in Denver's art district on Santa Fe with 1,400 sq. ft. of event space including full-service bar, colorful open-air courtyard and ca-

tering kitchenette. Open Thursday-Saturday, 10-5 or by appointment; first Friday, 12-9, ArtsBar open later; third Friday, 12-8, ArtsBar open later.

EXHIBITS Interested in fine art.

MAKING CONTACT & TERMS Interested in fine art, scenic, fashion, obscure, and all other types of photography. Artwork is accepted on a rental fee basis with 60/40% commission split. Gallery provides insurance, promotion, contract. Artwork must be professionally displayed. See website for artist submission and event space rental guidelines. Responds to queries as soon as possible. Finds artists through word of mouth, art fairs, portfolio reviews, submissions, referrals by other artists.

EVERSON MUSEUM OF ART

401 Harrison St., Syracuse NY 13202. (315)474-6064. **Fax:** (315)474-6943. **E-mail:** everson@everson.org; smassett@everson.org. **Website:** www.everson.org. **Contact:** Steven Kern, executive director; Debora Ryan, senior curator; Sarah Massett, assistant director. Estab. 1897. "In fitting with the works it houses, the Everson Museum building is a sculptural work of art in its own right. Designed by renowned architect I.M. Pei, the building itself is internationally acclaimed for its uniqueness. Within its walls, Everson houses roughly 11,000 pieces of art; American paintings, sculpture, drawings, graphics and one of the largest holdings of American ceramics in the nation." Open all year; Tuesday-Friday, 12-5; Saturday, 10-5; Sunday, 12-5. The museum features 4 large galleries with 24-ft. ceilings, back lighting and oak hardwood, a sculpture court, Art Zone for children, a ceramic study center and 5 smaller gallery spaces.

EVOLVE THE GALLERY

2907 35th St., Historic Oak Park, Sacramento CA 95817. **E-mail:** info@evolvethegallery.com. **Website:** www.evolvethegallery.com. **Contact:** A. Michelle Blakeley, co-owner. Estab. 2010. For-profit and art consultancy gallery. Approached by 250+ artists/year. Represents emerging, mid-career and established artists. Exhibited artists include Richard Mayhew (master fine artist, watercolor), Corinne Whitaker (pioneer digital painter), Ben F. Jones (prominent international artist). Sponsors 12+ exhibits/year. Model and property release required. Average display time 1 month. Open Thursday-Saturday, by appointment. Clients include local community, students, tourists, upscale.

1% of sales are to corporate collectors. Overall price range $1-10,000. Most work sold at $3,000.

EXHIBITS Considers all media (except craft), all types of prints, conceptualism, geometric abstraction, neo-expressionism, postmodernism and painterly abstraction.

MAKING CONTACT & TERMS Artwork is accepted on consignment and there is a 50% commission. Retail price of the art set by the artist; reviewed by the gallery. Gallery provides insurance, promotion, contract. Accepted work should be framed, mounted.

SUBMISSIONS E-mail with link to artist's website, JPEG samples at 72 dpi. Must include artist statement and CV. Materials returned with SASE. Responds only if interested (within weeks). Finds artists through word of mouth, submissions, portfolio reviews, art exhibits, art fairs, referrals by other artists.

FAHEY/KLEIN GALLERY

148 N. La Brea Ave., Los Angeles CA 90036. (323)934-2250. **Fax:** (323)934-4243. **E-mail:** contact@faheykleingallery.com. **Website:** www.faheykleingallery.com. **Contact:** David Fahey or Ken Devlin, co-owners. Estab. 1986. For-profit gallery. "Devoted to the enhancement of the public's appreciation of the medium of photography through the exhibition and sale of 20th-century and contemporary fine art photography. The gallery, with over 8,000 photographs in stock, deals extensively in photographs as works of art in all genres including portraits, nudes, landscapes, still-life, reportage and contemporary photography. The website contains a broad range of over 10,000 images." Approached by 200 artists/year; represents or exhibits 60 artists. Sponsors 10 exhibits/year. Average display time 5-6 weeks. Open Tuesday–Saturday, 10-6. Closed on all major holidays. Sponsors openings; provides announcements and beverages served at reception. Overall price range $500-500,000. Most work sold at $2,500. Located in Hollywood; gallery features 2 exhibition spaces with extensive work in back presentation room.

EXHIBITS Interested in established work; photos of celebrities, landscapes/scenics, wildlife, architecture, entertainment, humor, performing arts, sports. Interested in alternative process, avant garde, documentary, erotic, fashion/glamour, fine art, historical/vintage. Specific photo needs include iconic photographs, Hollywood celebrities, photojournalism, music-related, reportage and still life.

MAKING CONTACT & TERMS Artwork is accepted on consignment, and the commission is negotiated. Gallery provides insurance, promotion, contract. Accepted work should be unframed, unmounted and unmatted. Requires exclusive representation within metropolitan area. Photographer must be established for a minimum of 5 years; preferably published.

SUBMISSIONS Prefers website URLs for initial contact, or send material (CD, reproductions, no originals) by mail with SASE for consideration. Responds in 2 months. Finds artists through art fairs, exhibits, portfolio reviews, submissions, word of mouth, referrals by other artists.

TIPS "Please be professional and organized. Have a comprehensive sample of innovative work. Interested in seeing mature work with resolved photographic ideas and viewing complete portfolios addressing one idea."

FALKIRK CULTURAL CENTER

1408 Mission Ave., San Rafael CA 94915-1560. (415)485-3328. **E-mail:** Beth.Goldberg@cityofsan rafael.org. **Website:** www.falkirkculturalcenter.org. **Contact:** Beth Goldberg, curator. Estab. 1974. Nonprofit gallery and national historic place (1888 Victorian) converted to multi-use cultural center. Approached by 500 artists/year; exhibits 300 artists. Sponsors 2 photography exhibits/year. Average display time 2 months. Open Tuesday–Friday, 1-5; Saturday, 10-1; by appointment.

MAKING CONTACT & TERMS Gallery provides insurance.

SUBMISSIONS Send query letter with artist's statement, bio, slides, résumé. Returns material with SASE. Please prepare a written proposal explaining the exhibition scope and content. Thematic exhibits are encouraged, and shows must include at least three artists. Include slides and/or photo samples of work to be included. Proposals should be delivered to Falkirk or mailed to Exhibition Committee, Falkirk Cultural Center. Finds artists through word of mouth, submissions, portfolio reviews, art exhibits, art fairs, referrals by other artists.

FAVA (FIRELANDS ASSOCIATION FOR THE VISUAL ARTS)

New Union Center for the Arts, 39 S. Main St., Oberlin OH 44074. (440)774-7158. **Fax:** (440)775-1107. **E-mail:** favagallery@oberlin.net. **Website:** www.fava gallery.org. Estab. 1979. Nonprofit gallery. Features changing exhibits of high-quality artwork in a variety of styles and media. Sponsors 1 photography exhibit/year. Average display time 1 month. Open Tuesday–Saturday, 11-5; Sunday, 1-5. Overall price range $75-3,000. Most work sold at $200.

EXHIBITS Open to all media, including photography. Exhibits a variety of subject matter and styles.

MAKING CONTACT & TERMS Charges 30% commission. Accepted work should be framed or matted. Sponsors 1 regional juried photo exhibit/year: Six-State Photography, open to residents of Ohio, Kentucky, West Virginia, Pennsylvania, Indiana, Michigan. Deadline for applications: March. Send annual application for 6 invitational shows by mid-December of each year; include 15-20 slides, slide list, résumé.

SUBMISSIONS Send SASE for exhibition opportunity flyer or 6-state photo show entry form.

TIPS "As a nonprofit gallery, we do not represent artists except during the juried show. Present the work in a professional format; the work, frame and/or mounting should be clean, undamaged, and (in cases of more complicated work) well organized."

⊕ FINE ARTS CENTER GALLERY

P.O. Box 842, Jonesboro AR 72467. (870)972-3050. **Fax:** (870)972-3932. **Website:** www.astate.edu/col lege/fine-arts/art. Estab. 1968. Represents/exhibits 3-4 emerging, mid-career and established artists/year. Sponsors 3-4 shows/year. Average display time: 1 month. Open fall, winter and spring, Monday-Friday 10-5. Located on Arkansas State University campus; 1,868 sq. ft.; 60% pf time devoted to special exhibitions, 40% to student work. Clientele include students and community.

EXHIBITS Considers all media and prints. Most frequently exhibits painting, sculpture and photography.

MAKING CONTACT & TERMS Exhibition space only, artist responsible for sales. Retail price set by the artist. Gallery provides promotion and contract; shipping costs are shared. Prefers artwork framed.

SUBMISSIONS Send query letter with résumé, CD/DVD and SASE to FAC Gallery Director, c/o Department of Art, Arkansas State University, P.O. Box 1920, State University AR 72467. Portfolio should be submitted on CD/DVD only. Responds only if interested within 2 months. Files résumé. Finds artists through call for artists published in regional and national art journals.

TIPS Show us 20 digital images of your best work. Don't overload us with lots of collateral materials (reprints of reviews, articles, etc.). Make your vita as clear as possible.

⊕ HOWARD FINSTER VISION HOUSE

177 Greeson St., Summerville GA 30747. (706)857-2926. **E-mail:** david@dlg-gallery.com. **Website:** www.howardfinstervisionhouse.com. **Contact:** David Leonardis, owner. Estab. 1992. For-profit gallery. Approached by 100 artists/year; represents or exhibits 12 artists. Average display time 30 days. Gallery open Tuesday–Saturday, 12-7; Sunday, 12-6. "One big room, four big walls." Overall price range $50-5,000. Most work sold at $500.

EXHIBITS Photos of celebrities. Interested in fine art.

MAKING CONTACT & TERMS Artwork is accepted on consignment, and there is a 50% commission. Gallery provides promotion. Accepted work should be framed.

SUBMISSIONS E-mail to arrange a personal interview to show portfolio. Mail portfolio for review. Send query letter via e-mail. Responds only if interested. Finds artists through word of mouth, art exhibits, referrals by other artists.

TIPS "Artists should be professional and easy to deal with."

⊕ FLORIDA STATE UNIVERSITY MUSEUM OF FINE ARTS

530 W. Call St., Room 250, Fine Arts Bldg., Tallahassee FL 32306-1140. (850)644-6836. **Fax:** (850)644-7229. **E-mail:** apalladinocraig@fsu.edu. **Website:** www.mofa.fsu.edu. Estab. 1970. Shows work by over 100 artists/year; emerging, mid-career and established. Sponsors 12-22 shows/year. Average display time 3-4 weeks. Located on the university campus; 16,000 sq. ft. 50% for special exhibitions.

EXHIBITS Considers all media, including electronic imaging and performance art. Most frequently exhibits painting, sculpture and photography.

MAKING CONTACT & TERMS "Interested collectors are placed into direct contact with the artists; the museum takes no commission." Retail price set by the artist. Museum provides promotion and shipping costs to and from the museum for invited artists.

TIPS "The museum offers a yearly international competition and catalog: The Tallahassee International. Visit website for more information."

FOCAL POINT GALLERY

321 City Island Ave., City Island NY 10464. (718)885-1403. **E-mail:** ronterner@gmail.com. **Website:** www.focalpointgallery.net. **Contact:** Ron Terner, photographer/director. Estab. 1974. Overall price range $175-750. Most work sold at $300-500.

EXHIBITS All mediums and subjects accepted.

MAKING CONTACT & TERMS Retail gallery and alternative space. Interested in emerging and mid-career artists. Sponsors 12 group shows/year. Average display time: 3-4 weeks. Clients include locals and tourists. Overall price range: $175-750; most work sold at $300-500. Charges 30% commission.

⊘ THE STORE AND SALLY D. FRANCISCO GALLERY AT PETERS VALLEY CRAFT CENTER

19 Kuhn Rd., Layton NJ 07851. (973)948-5202. **Fax:** (973)948-0011. **E-mail:** store@petersvalley.org. **Website:** www.petersvalley.org. **Contact:** Brienne Rosner, store and gallery manager. Estab. 1977. "National Delaware Water Gap Recreation Area in the Historic Village of Bevans, Peters Valley Craft Center hosts a large variety of workshops in the spring and summer. The Store and Gallery is located in an old general store; first floor retail space and second floor rotating exhibition gallery."

FREEPORT ART MUSEUM

121 N. Harlem Ave., Freeport IL 61032. (815)235-9755. **Fax:** (815)235-6015. **E-mail:** info@freeportartmuseum.org. **Website:** www.freeportartmuseum.org. **Contact:** Jennifer J. Caddell, director. Formerly Freeport Arts Center. Sponsors 6 exhibits/year. Average display time: 8 weeks.

EXHIBITS All artists are eligible to submit exhibition proposals. Exhibits photos of contemporary, abstract, avant garde, multicultural, families, landscapes/scenics, architecture, cities/urban, rural, performing arts, travel, agriculture. Interested in fine art.

MAKING CONTACT & TERMS Charges 30% commission. Accepted work should be ready to hang.

SUBMISSIONS Send material by mail with SASE for consideration. Retains exhibition proposal on file for future inquiries.

⊘ THE G2 GALLERY

1503 Abbot Kinney Blvd., Venice CA 90291. (310)452-2842. **Fax:** (310)452-0915. **E-mail:** info@theg2gallery.com. **Website:** www.theg2gallery.com. **Contact:** Jolene Hanson, gallery director. Estab. 2008. For-

profit gallery exhibiting emerging, mid-career, and established artists. Approached by 150+ artists/year; represents or exhibits 45 artists. Exhibited photography by Ansel Adams and Robert Glenn Ketchum. Average display time is 6 weeks. Open Sunday-Thursday, 11-7; Friday-Saturday, 11-9. "The G2 Gallery is a green art space. The first floor features a gift shop and some additional exhibition space. In 2008, before the gallery opened, the building was renovated to be as eco-friendly as possible. The space is rich in natural light with high ceilings and there are large-screen televisions and monitors for exhibition-related media. The G2 Gallery donates 100% of all proceeds to environmental causes and partners with conservation organizations related to exhibition themes. Our motto is 'Supporting Art and the Environment.'" Clients include local community, tourists, upscale. Price range of work: $150-15,000.

EXHIBITS Photography featuring environmental, landscapes/scenics, wildlife, alternative process, documentary, fine art, historical/vintage.

MAKING CONTACT & TERMS Art is accepted on consignment with a 40% commission. Retail price of the art is set by the artist. Gallery provides insurance, promotion, and contract. Accepted work should be framed, mounted, matted. Accepts photography only.

SUBMISSIONS All prospective artists are vetted through a juried application process. Please e-mail to request an application or download the application from website. Responds only if interested. "The G2 Gallery will contact artist with a confirmation that application materials have been received." Accepts only electronic materials. Physical portfolios are not accepted. Finds artists through word of mouth, submissions.

TIPS "Preferred applicants have a website with images of their work, inventory list, and pricing. Please do not contact the gallery once we have confirmed that your application has been received."

GALLERY 72

1806 Vinton St., Omaha NE 68108. (402)496-4797. E-mail: info@gallery72.com. **Contact:** John A. Rogers, owner. Estab. 1972. Represents or exhibits 20 artists. Sponsors 6 solo and 4 group shows/year. Average display time: 4-5 weeks. Gallery open Wednesday-Saturday, 10-6, by appointment and for special events. 1,800 sq. ft. of gallery space, 160 ft. of wall space.

EXHIBITS Photos of senior citizens, landscapes/scenics, cities/urban, interiors/decorating, rural, performing arts, travel.

MAKING CONTACT & TERMS Artwork is accepted on consignment, and there is a 50% commission. Gallery provides insurance, promotion. Requires exclusive representation locally. "No Western art."

SUBMISSIONS Call, e-mail, or write to arrange personal interview to show portfolio. Send query letter with artist's statement, brochure, photocopies, résumé. Accepts digital images. Finds artists through word of mouth, submissions, art exhibits.

GALLERY 110 COLLECTIVE

110 Third Ave. S., Seattle WA 98104. (206)624-9336. **E-mail:** director@gallery110.com. **Website:** www.gallery110.com. **Contact:** Paula Maratea Fuld, director. Estab. 2002. "Gallery 110 presents contemporary art in a wide variety of media in Seattle's premiere gallery district, historic Pioneer Square. Our artists are emerging and established professionals, actively engaged in their artistic careers. We aspire to present fresh exhibitions of the highest professional caliber. The exhibitions change monthly and consist of solo, group and/or thematic shows in the main gallery and solo shows in our Small Space." Open Wednesday-Saturday, 12-5; hosts receptions every first Thursday of the month, 6-8. Overall price range: $125-3,000; most work sold at $500-800.

MAKING CONTACT & TERMS Yearly active membership with dues, art on consignment, or available for rent.

TIPS "The artist should research the gallery to confirm it is a good fit for their work. The artist should be interested in being an active member, collaborating with other artists and participating in the success of the gallery. The work should challenge the viewer through concept, a high sense of craftsmanship, artistry, and expressed understanding of contemporary art culture and history. Artists should be emerging or established individuals with a serious focus on their work and participation in the field."

GALLERY 218

207 E. Buffalo St., Suite 218, Milwaukee WI 53202. (414)643-1732. **E-mail:** director@gallery218.com. **Website:** www.gallery218.com. **Contact:** Judith Hooks, president/director. Estab. 1990. Located in the Marshall Building of Milwaukee's historic Third Ward. Sponsors 12 exhibits/year. Average display

time 1 month. Sponsors openings. "If a group show, we make arrangements and all artists contribute. If a solo show, artist provides everything." Overall price range $200-5,000. Most work sold at $200-600.

EXHIBITS Interested in alternative process, avant garde, abstract, fine art. Membership dues: $55/year plus $55/month rent. Artists help run the gallery. Group and solo shows. Photography is shown alongside fine arts painting, printmaking, sculpture, etc.

MAKING CONTACT & TERMS Charges 25% commission. There is an entry fee for each month. Fee covers the rent for 1 month. Accepted work must be framed.

SUBMISSIONS Send SASE for an application. "This is a cooperative space. A fee is required."

TIPS "Get involved in the process if the gallery will let you. We require artists to help promote their show so that they learn what and why certain things are required. Have inventory ready. Read and follow instructions on entry forms; be aware of deadlines. Attend openings for shows you are accepted into locally."

GALLERY 400

University of Illinois, Chicago, 400 S. Peoria St., Chicago IL 60607. (312)996-6114. **Fax:** (312)355-3444. **Website:** gallery400.uic.edu. **Contact:** Lorelei Stewart, director. Estab. 1983. Nonprofit gallery. Approached by 500 artists/year; exhibits 80 artists. Sponsors 1 photography exhibit/year. Average display time 6 weeks. Gallery open Tuesday–Friday, 10-6; Saturday, 12-6. Clients include local community, students, tourists and upscale.

MAKING CONTACT & TERMS Gallery provides insurance and promotion.

SUBMISSIONS Interact, propose an exhibition. Check info section of website for guidelines (gallery400.uic.edu/interact-page/propose-an-exhibition--2). Responds in 4 months. Finds artists through word of mouth, art exhibits, referrals by other artists.

TIPS "Follow the proposal guidelines on the website. We do not respond to e-mail submissions that do not follow the guidelines."

GALLERY 825

Los Angeles Art Association, 825 N. La Cienega Blvd., Los Angeles CA 90069. (310)652-8272. **E-mail:** peter@laaa.org. **Website:** www.laaa.org. **Contact:** Peter Mays, executive director. Estab. 1925. Holds approximately 1 exhibition/year. Average display time 4-5 weeks. Fine art only. Exhibits all media.

MAKING CONTACT & TERMS Gallery provides promotion, exhibition venues and resources.

SUBMISSIONS To become an LAAA Artist member, visit website for screening dates and submission requirements.

GALLERY FIFTY SIX

2256 Central Ave., Memphis TN 38104. (901)276-1251. **E-mail:** rollin@galleryfiftysix.com. **Website:** www.galleryfiftysix.com. Blog: www.galleryfiftysix.blogspot.com. **Contact:** Rollin Kocsis, curator. Estab. 2008. For-profit gallery. Approached by 50 artists/year; represents or exhibits 24 emerging, mid-career and established artists. Exhibited artists include John Armistead, oil on canvas, and Bryan Blankenship, painting and ceramics. Sponsors 12 exhibits/year; 1 photography exhibit/year. Model and property release are preferred. Average display time 1 month. Open Wednesday-Friday, 12-4; Saturday, 11-4. Contains over 2,900 sq. ft, three galleries, upper and lower level, archives. Clients include local community, students, tourists and upscale. 5% of sales are to corporate collectors. Overall price range $200-3,000. Most work sold at $650.

EXHIBITS Considers acrylic, ceramics, collage, drawing, fiber, glass, mixed media, oil, pastel, pen & ink, sculpture, watercolor. Most frequently exhibits oil on canvas, acrylic on canvas, assemblages. Considers engravings, etchings, linocuts, serigraphs, woodcuts. Considers color field, expressionism, geometric abstraction, imagism, impressionism, pattern painting, postmodernism, primitivism realism, surrealism, painterly abstraction. Most frequently exhibits realism, abstract, expressionism. Considers all genres. No nudes.

MAKING CONTACT & TERMS Artwork is accepted on consignment and there is a 50% commission. Gallery provides promotion and contract. Accepted work should be gallery wrapped or frames with black or natural wood finish. Requires exclusive representation locally.

SUBMISSIONS E-mail 8-12 JPEGs. Write to arrange personal interview to show portfolio of photographs, e-mail JPEG samples at 72 dpi or send query letter with artist's statement, bio, brochure, business card, photographs, résumé, reviews and SASE. Material returned with SASE. Responds in 2 weeks. Files JPEGs, CDs, photos. Finds artists through word of mouth,

submissions, portfolio reviews, art exhibits and referrals by other artists.

TIPS "Send good quality photos, by e-mail, with all important information included. Not interested in installations or subject matter that is offensive, political, sexual or religious."

GALLERY NORTH

90 N. Country Rd., Setauket NY 11733. (631)751-2676. **E-mail:** info@gallerynorth.org. **Website:** www.gallerynorth.org. **Contact:** Judith Levy, director. Regional arts center. "Our mission is to present exhibitions of exceptional contemporary artists and artisans, especially those from Long Island and the nearby regions; to assist and encourage artists by bringing their work to the attention of the public; and to stimulate interest in the arts by presenting innovative educational programs. Exhibits the work of emerging, mid-career and established artists from Long Island and throughout the Northeast. The Gallery North community involves regional and local artists, collectors, art dealers, corporate sponsors, art consultants, businesses and schools, ranging from local elementary students to the faculty and staff at Long Island's many colleges and universities including our neighbor, Stony Brook University and the Stony Brook Medical Center. With our proximity to New York City and the East End, our region attracts a wealth of talent and interest in the arts." Located in the Historic District of Setauket, Long Island, NY, in an 1840s farm house, 1 mile from the State University at Stony Brook. Open year-round; Tuesday–Saturday, 10-5; Sunday, 12-5; closed Monday. **EXHIBITS** "Works to be exhibited are selected by our director, Judith Levy, with input from our Artist Advisory Board. We encourage artist dialogue and participation in gallery events and community activities and many artists associated with our gallery offer ArTrips and ArTalks, as well as teaching in our education programs. Along with monthly exhibitions in our 1,000-sq.-ft. space, our Gallery Shop strives to present the finest handmade jewelry and craft by local and nationally recognized artisans."

SUBMISSIONS To present work to the gallery, send an e-mail with 2-5 medium-sized images, price list (indicating title, size, medium, and date), artist's statement, biography and link to website. "We encourage artists to visit the gallery and interact with our exhibitions." Visit the website for more information.

GALLERY NRC

4424 Tennyson St., Denver CO 80212. **E-mail:** info@gallerynrc.com; submissions@gallerynrc.com. **Website:** www.gallerynrc.com. **Contact:** Neil Corman, owner. Estab. 2009. For-profit gallery. Exhibits emerging, mid-career, and established artists. Approached by 50 artists a year; represents or exhibits 5 artists. Exhibited artists include Neil Corman (photography) and Chris Rice (photography). Sponsors 11 total photography exhibits a year. Average display time is 4 weeks. Open Thursday-Friday, 1-5; Saturday, 10-4. 400-sq.-ft. space located in an art district in Denver. Clients are mostly from the local community. 5% of sales are to corporate collectors. Overall price range $50-1,000.

MAKING CONTACT & TERMS Artwork is accepted on consignment and there is a 45% commission. Gallery provides promotion and contract. Accepted work should be framed. Prefers western United States artists.

SUBMISSIONS E-mail query letter, artist statement, bio/résumé, and JPEG samples at 72 dpi. Returns material with SASE. Responds if interested in 2 months. Files all provided materials. Finds artists through word of mouth, submissions, portfolio reviews, and referrals by other artists.

✚ GALLERY OF ART AT SPRINGFIELD ART ASSOCIATION

700 N. 4th St., Springfield IL 62702. (217)523-2631. **Fax:** (217)523-3866. **E-mail:** director@springfieldart.org. **Website:** www.springfieldart.org. **Contact:** Betsy Dollar, executive director. Estab. 1913. Nonprofit gallery. Exhibits emerging, mid-career and established artists. Sponsors 13 total exhibits/year, including theme-based shows 2-3 times/year. 1 exclusive photo show every couple of years. Average display time: 1 month. Open Monday-Friday, 9-5; Saturday, 10-3. Closed Sundays and Christmas-New Year's Day. Located at the Springfield Art Association, campus includes a historic house, museum and community art school. Clients include local community, students, tourists and upscale clients. 5% of sales are to corporate collectors. Overall price range: $10-5,000; most work sold under $100.

EXHIBITS Considers all media.

MAKING CONTACT & TERMS Model and property release are required. Artwork is accepted on consignment and there is a 30% commission. Retail price

set by the artist. Gallery provides insurance, promotion and contract. Accepted work should be framed, mounted and matted—ready to hang.

SUBMISSIONS Call or e-mail query letter with link to artist's website or JPEG samples at 72 dpi. Responds in 2 weeks. Will return material with SASE. Files CV, résumé, printed samples and business cards. Find artists through word of mouth, submissions, portfolio reviews, art exhibits, art fairs and referrals by other artists.

TIPS "Good quality images with artist's name included in file name."

⊘ GERING & LÓPEZ GALLERY

730 Fifth Ave., New York NY 10019. (646)336-7183. **E-mail:** info@geringlopez.com; laura@geringlopez.com. **Website:** www.geringlopez.com. **Contact:** Laura Bloom, director. Estab. 1991. For-profit gallery. Approached by 240 artists/year; represents or exhibits 12 artists. Sponsors 1 photography exhibit/year. Average display time 5 weeks. Gallery open Tuesday–Friday, 10-6; Saturday, 11-5.

EXHIBITS Interested in alternative process, avant garde; digital, computer-based photography.

MAKING CONTACT & TERMS Artwork is accepted on consignment.

SUBMISSIONS E-mail with link to website or send postcard with image. Responds within 6 months, only if interested. Finds artists through word of mouth, art exhibits, art fairs, referrals by other artists. *Gering & López Gallery is currently NOT accepting unsolicited submissions.*

TIPS "Most important is to research the galleries and only submit to those that are appropriate. Visit websites if you don't have access to galleries."

⊕ GLOUCESTER ARTS ON MAIN

6580-B Main St., Gloucester VA 23061. (804)824-9464. **Fax:** (804)824-9469. **E-mail:** curator@gloucesterarts.org. **Website:** www.gloucesterarts.org. **Contact:** Pam Doss, curator. Estab. 2010. Nonprofit, rental gallery. Alternative space. Exhibits emerging, mid-career and established artists. Approached by 15 artists/year; represents or exhibits 60 artists currently. Exhibited artists include Harriett McGee (repoussee and mixed media) and Beth Massie (oil painting on canvas). Sponsors 12 exhibits/year, 1-2 photography exhibits/year. There are always photos on exhibit. Average display is one month or length of rental contract. Open Tuesday-Saturday, 12-6; weekend events, 6-9.

Located on walkable Main Street near restaurants and other shops, small town near major cities in Eastern Virginia. Very flexible gallery space with 120+ ft. of perimeter exhibition space and 96 ft. of movable walls. 4,000 sq. ft. total exhibition space. Clients include the local community, students, tourists and upscale clients. 10% of sales are to corporate collectors. Price range: $20-7,500. Most work sold at $300.

EXHIBITS Considers all media. Most frequently exhibits paintings (oil, acrylic and watercolor), 2D and 3D metal work, and photography. Considers all types of prints except posters.

MAKING CONTACT & TERMS Artwork is accepted on consignment and there is a 40% commission. There is a rental fee of space. The fee covers 6 months and there is a 30% commission. Retail price set by the artist. Gallery provides promotion and contract. Accepted work should be framed, matted and mounted. Prefers to represent artists from Eastern Virginia.

SUBMISSIONS E-mail query letter with link to artist's website, JPEG samples at 72 dpi, résumé, artist's statement and bio; or call for appointment to show portfolio. Responds within 2 weeks. Finds artists through word of mouth, art exhibits, submissions, portfolio reviews and referrals by other artists.

TIPS Work should be presented for jury ready to exhibit, i.e., framed or mounted appropriately. Digital images presented for review should be clear, cropped and professional in appearance at high resolution.

GRAND RAPIDS ART MUSEUM

101 Monroe Center, Grand Rapids MI 49503. (616)831-1000. **E-mail:** nthomas@artmuseumgr.org. **Website:** www.artmuseumgr.org. Estab. 1910. Museum. Usually sponsors 1 photography exhibit/year. Average display time 4 months. Open all year; Tuesday-Thursday, 10-5; Friday, 10-9; Sunday, 12-5. Closed Mondays and major holidays. Located in the heart of downtown Grand Rapids, the Grand Rapids Art Museum presents exhibitions of national caliber and regional distinction.

EXHIBITS Interested in fine art, historical/vintage.

ANTON HAARDT GALLERY

2858 Magazine St., New Orleans LA 70130. (504)891-9080. **E-mail:** anton3@earthlink.net. **Website:** www.antonart.com. Estab. 2001. For profit gallery. Represents or exhibits 25 artists. Overall price range $500-5,000. Most work sold at $1,000.

EXHIBITS Photos of celebrities. Mainly photographs (portraits of folk artists).

MAKING CONTACT & TERMS Prefers only artists from the South. Self-taught artists who are original and pure, specifically art created from 1945 to 1980. "I rarely take on new artists, but I am interested in buying estates of deceased artist's work or an entire body of work by artist."

SUBMISSIONS Send query letter with artist's statement.

TIPS "I am only interested in a very short description if the artist has work from early in his or her career."

CARRIE HADDAD GALLERY

622 Warren St., Hudson NY 12534. (518)828-1915. **Fax:** (518)828-3341. **E-mail:** carrie.haddad@carrie haddadgallery.com. **Website:** www.carriehaddad gallery.com. **Contact:** Carrie Haddad, owner. Estab. 1990. Art consultancy, for-profit gallery. "Hailed as the premier gallery of the Hudson Valley, the Carrie Haddad Gallery presents 8 large exhibits/year and includes all types of painting, both large and small sculpture, works on paper and a variety of techniques in photography." Approached by 50 artists/year; represents or exhibits 60 artists. Open daily, 11-5; Sunday, 12-5. Overall price range $350-6,000. Most work sold at $1,000.

EXHIBITS Photos of nudes, landscapes/scenics, architecture, pets, rural, product shots/still life.

MAKING CONTACT & TERMS Artwork is accepted on consignment, and there is a 50% commission. Gallery provides insurance, promotion. Requires exclusive representation locally.

SUBMISSIONS Send query letter with bio, photocopies, photographs, price list, SASE. Responds in 1 month. Finds artists through word of mouth, submissions, art exhibits, referrals by other artists.

THE HALSTED GALLERY INC.

P.O. Box 250321, Franklin MI 48025. (248)895-0204; (248)894-0353. **E-mail:** tomhalsted@hotmail.com. **Website:** www.halstedgallery.com. **Contact:** Wendy or Thomas Halsted. Sponsors 3 exhibits/year. Average display time 2 months. Sponsors openings. Overall price range $500-25,000.

EXHIBITS Interested in 19th- and 20th-century photographs.

SUBMISSIONS Call to arrange a personal interview to show portfolio only. Prefers to see scans. Send no slides or samples. Unframed work only.

TIPS No limitations on subjects. Wants to see creativity, consistency, depth and emotional work.

LEE HANSLEY GALLERY

225 Glenwood Ave., Raleigh NC 27603. (919)828-7557. **Fax:** (919)828-7550. **Website:** www.leehansley gallery.com. **Contact:** Lee Hansley, gallery director. Estab. 1993. "Located in Raleigh's bustling Glenwood South, we are dedicated to showcasing quality fine art through a series of changing exhibitions, both group and solo shows, featuring works from professional artists from North Carolina, the Southeast and the nation. There are 35 artists in the gallery whose works are shown on a rotating basis. The gallery also hosts invitational exhibitions in which non-gallery artists show alongside stable artists. The gallery organizes at least 1 historical exhibition annually exploring the work of a single artist or group of stylistically-related artists." Sponsors 3 exhibits/year. Average display time 4-6 weeks. Overall price range $250-1,600. Most work sold at $400. Open Tuesday–Friday, 11-6; 1st Friday, 11-10; Saturday, 11-6; or by appointment.

EXHIBITS Photos of environmental, landscapes/scenics, architecture, cities/urban, gardening, rural, performing arts. Interested in alternative process, avant garde, erotic, fine art. Interested in new images using the camera as a tool of manipulation; also wants minimalist works. Looks for top-quality work with an artistic vision.

MAKING CONTACT & TERMS Charges 50% commission. Payment within 1 month of sale.

SUBMISSIONS Send material by mail for consideration; include SASE. May be on CD. Does not accept e-mails. Responds in 2 months.

TIPS "Looks for originality and creativity—someone who sees with the camera and uses the parameters of the format to extract slices of life, architecture and nature."

✪ JOEL AND LILA HARNETT MUSEUM OF ART AND PRINT STUDY CENTER

University of Richmond Museums, 28 Westhampton Way, Richmond VA 23173. (804)289-8276. **Fax:** (804)287-1894. **E-mail:** rwaller@richmond.edu; mu seums@richmond.edu. **Website:** museums.richmond. edu. **Contact:** Richard Waller, executive director. Estab. 1968. Represents emerging, mid-career and established artists. Sponsors 6 exhibitions/year. Average display time 6 weeks. Open academic year; with limited summer hours May-August. Located on uni-

versity campus; 5,000 sq. ft. 100% of space for special exhibitions.

EXHIBITS Considers all media and all types of prints. Most frequently exhibits painting, sculpture, prints, photography and drawing.

MAKING CONTACT & TERMS Work accepted on loan for duration of special exhibition. Retail price set by the artist. Museum provides insurance, promotion, contract and shipping costs. Prefers artwork framed.

SUBMISSIONS Send query letter with résumé, 8-12 images on CD, brochure, SASE, reviews and printed material if available. Write for appointment to show portfolio of "whatever is appropriate to understanding the artist's work." Responds in 1 month. Files résumé and other materials the artist does not want returned (printed material, CD, reviews, etc.).

JAMES HARRIS GALLERY

604 Second Ave. S., Seattle WA 98104. (206)903-6220. **Fax:** (206)903-6226. **E-mail:** mail@jamesharrisgallery.com. **Website:** www.jamesharrisgallery.com. **Contact:** Jim Harris, director. Estab. 1999. Approached by 40 artists/year; represents or exhibits 26 artists. Average display time 6 weeks. Open Tuesday–Wednesday, by appointment; Thursday–Saturday, 11-5.

EXHIBITS Photos of landscapes and portraits. Interested in fine art.

SUBMISSIONS E-mail with JPEG samples at 72 dpi.

O.K. HARRIS WORKS OF ART

383 W. Broadway, New York NY 10012. (212)431-3600. **Fax:** (212)925-4797. **E-mail:** okharris@okharris.com. **Website:** www.okharris.com. **Contact:** Dr. Marilyn Karp, director. Estab. 1969. Commercial exhibition gallery. Represents 38 emerging, mid-career and established artists. Sponsors 30 solo shows/year. Average display time 1 month. Open Tuesday–Saturday, 10-6; in July, Tuesday–Friday, 12-5; closed from mid-July through August and December 24–January 1. "Four separate galleries for 4 separate one-person exhibitions. The back room features selected gallery artists which also change each month." 90% of sales are to private collectors, 10% corporate clients. Overall price range $50-250,000; most work sold at $12,500-100,000.

EXHIBITS Considers all media. Most frequently exhibits painting, sculpture and photography.

MAKING CONTACT & TERMS Accepts work on consignment (50% commission). Retail price set by gallery. Exclusive area representation required. Gallery provides insurance and limited promotion. Prefers artwork ready to exhibit.

SUBMISSIONS Send query letter with 1 CD of recent work with labeled images size, medium, etc., and SASE. Responds in 1 week.

TIPS "We suggest the artist be familiar with the gallery's exhibitions and the kind of work we prefer to show. Visit us either in person or online. Always include SASE. Common mistakes artists make in presenting their work are: submissions without return envelope, inappropriate work. We affiliate about 1 out of 10,000 applicants."

WILLIAM HAVU GALLERY

1040 Cherokee St., Denver CO 80204. (303)893-2360. **Fax:** (303)893-2813. **E-mail:** info@williamhavugallery.com. **Website:** www.williamhavugallery.com. **Contact:** Bill Havu, owner and director; Nick Ryan, gallery administrator. For-profit gallery. "Engaged in an ongoing dialogue through its 7 exhibitions a year with regionalism as it affects and is affected by both national and international trends in realism and abstraction. Strong emphasis on mid-career and established artists." Approached by 120 artists/year; represents or exhibits 50 artists. Sponsors 1 photography exhibit/year. Average display time 6-8 weeks. Open Tuesday–Friday, 10-6; Saturday, 11-5; 1st Friday of each month, 10-9; Sundays and Mondays by appointment. Closed Christmas and New Year's Day. Overall price range $250-15,000. Most work sold at $1,000-4,000.

EXHIBITS Photos of multicultural, landscapes/scenics, religious, rural. Interested in alternative process, documentary, fine art.

MAKING CONTACT & TERMS Gallery provides insurance, promotion, contract. Accepted work should be framed. Requires exclusive representation locally. Accepts only artists from Rocky Mountain, Southwestern region.

SUBMISSIONS *Not accepting unsolicited submissions.* Mail portfolio for review. Send query letter with artist's statement, bio, brochure, résumé, SASE, slides. Responds within 1 month, only if interested. Finds artists through word of mouth, submissions, referrals by other artists.

TIPS "Always mail a portfolio packet. We do not accept walk-ins or phone calls to review work. Explore website or visit gallery to make sure work would fit

with the gallery's objective. We only frame work with archival quality materials and feel its inclusion in work can 'make' the sale."

⊘ HEMPHILL

1515 14th St. NW, Suite 300, Washington DC 20005. (202)234-5601. **Fax:** (202)234-5607. **E-mail:** gallery@ hemphillfinearts.com. **Website:** www.hemphill finearts.com. Estab. 1993. Art consultancy and for-profit gallery. Represents or exhibits 30 artists/year. Hemphill is a member of the Association of International Photography Art Dealers (AIPAD). Gallery open Tuesday–Saturday, 10-5, and by appointment. Overall price range $900-300,000.

EXHIBITS Photos of landscapes/scenics, architecture, cities/urban, rural. Interested in alternative process, fine art, historical/vintage.

SUBMISSIONS Gallery does not accept or review portfolio submissions.

⊕ THE HENRY ART GALLERY

University of Washington, 15th Ave. NE and NE 41st St., Seattle WA 98195. (206)543-2280. **Fax:** (206)685-3123. **E-mail:** press@henryart.org. **Website:** www. henryart.org. **Contact:** Dana Van Nest, associate director of marketing, communications and public relations. Estab. 1927. Contemporary Art Museum. Exhibits emerging, mid-career, and established artists. Presents 20 exhibitions/year. Open Wednesday, 11-4; Thursday-Friday, 11-9; Saturday-Sunday, 11-4. Located "on the western edge of the University of Washington campus. Parking is available in the underground Central Parking garage at NE 41st St. On Sundays, parking is free. Visitors include local community, students, and tourists.

EXHIBITS Considers all media. Most frequently exhibits photography, video, and installation work. Exhibits all types of prints.

MAKING CONTACT & TERMS Does not require exclusive representation locally.

SUBMISSIONS Send query letter with artist statement, résumé, SASE, 10-15 images. Returns material with SASE. Finds artists through art exhibitions, exhibition announcements, individualized research, periodicals, portfolio reviews, referrals by other artists, submissions, and word of mouth.

HENRY STREET SETTLEMENT/ABRONS ART CENTER

466 Grand St., New York NY 10002. (212)598-0400; (212)766-9200. **E-mail:** info@henrystreet.org; jdur

ham@henrystreet.org. **Website:** www.abronsartscen ter.org. **Contact:** Jonathan Durham, director of visual arts. Alternative space, nonprofit gallery, community center. "The Abrons Art Center brings innovative artistic excellence to Manhattan's Lower East Side through diverse performances, exhibitions, residencies, classes and workshops for all ages and arts-in-education programming at public schools. Holds 9 solo photography exhibits/year. Open Tuesday–Friday, 10-10; Saturday, 9-10; Sunday, 11-6. Closed major holidays.

EXHIBITS Photos of multicultural, environmental, landscapes/scenics, architecture, cities/urban, rural. Interested in alternative process, avant garde, documentary, fine art, historical/vintage.

MAKING CONTACT & TERMS Artwork is accepted on consignment, and there is a 20% commission. Gallery provides insurance, space, contract.

SUBMISSIONS Send query letter with artist's statement, SASE. Finds artists through word of mouth, submissions, referrals by other artists.

HERA EDUCATIONAL FOUNDATION AND ART GALLERY

P.O. Box 336, Wakefield RI 02880. (401)789-1488. **E-mail:** info@heragallery.org. **Website:** www.hera gallery.org. Estab. 1974. Cooperative gallery. "Hera Gallery/Hera Educational Foundation was a pioneer in the development of alternative exhibition spaces across the U.S. in the 1970s and one of the earliest women's cooperative galleries. Although many of these galleries no longer exist, Hera is proud to have not only continued, but also expanded our programs, exhibitions and events." The number of photo exhibits varies each year. Average display time: 6 weeks. Open Wednesday-Friday, 1-5; Saturday, 10-4; or by appointment. Closed during the month of January. Sponsors openings; provides refreshments and entertainment or lectures, demonstrations and symposia for some exhibits. Call for information on exhibitions. Overall price range: $100-10,000.

EXHIBITS Photos of disasters, environmental, landscapes/scenics. Interested in all types of innovative contemporary art that explores social and artistic issues. Interested in fine art.

MAKING CONTACT & TERMS Charges 25% commission. Works must fit inside a 6'6"×2'6" door. Photographer must show a portfolio before attaining membership.

SUBMISSIONS Inquire about membership and shows. Membership guidelines and application available on website or mailed on request.

TIPS "Hera exhibits a culturally diverse range of visual and emerging artists. Please follow the application procedure listed in the Membership Guidelines. Applications are welcome at any time of the year."

GERTRUDE HERBERT INSTITUTE OF ART

506 Telfair St., Augusta GA 30901-2310. (706)722-5495. **Fax:** (706)722-3670. **E-mail:** ghia@ghia.org. **Website:** www.ghia.org. **Contact:** Rebekah Henry, executive director. Estab. 1937. Nonprofit gallery. Has 5 solo or group shows annually; exhibits approximately 40 artists annually. Average display time 6-8 weeks. Open Monday–Friday, 10-5; weekends by appointment only. Closed 1st week in August, and December 17-31. Located in historic 1818 Ware's Folly mansion.

MAKING CONTACT & TERMS Artwork is accepted on consignment, and there is a 35% commission.

SUBMISSIONS Send query letter with artist's statement, bio, brochure, résumé, reviews, slides or CD of work, SASE. Responds to queries in 1-3 months. Finds artists through art exhibits, submissions, referrals by other artists.

HEUSER ART CENTER GALLERY & HARTMANN CENTER ART GALLERY

Bradley University, 1400 W. Bradley Ave., Peoria IL 61625. (309)677-2989. **Website:** art.bradley.edu/bug. **Contact:** Erin Buczynski, director of galleries, exhibitions and collections. Estab. 1984. Alternative space, nonprofit gallery, educational. "We have 2 formal exhibition spaces, one in the Heuser Art Center, where the art department is located, and one in the Hartmann Center, where the theatre department is housed." Approached by 260 artists/year; represents or exhibits 50 artists. Sponsors 1 photography exhibit/year. Average display time 4-6 weeks. Heuser Art Gallery open Monday–Thursday, 9-7; Friday, 9-5; and by appointment. Hartmann Center Gallery open Monday–Friday, 9-5; and by appointment. See website for more information.

EXHIBITS Photos of babies/children/teens, celebrities, couples, multicultural, families, parents, senior citizens, disasters, environmental, landscapes/scenics, wildlife, architecture, cities/urban, education, rural, entertainment, events, performing arts, travel, agriculture, business concepts, industry, medicine, military, political, product shots/still life, science, tech-

nology/computers. Interested in alternative process, avant garde, documentary, fashion/glamour, fine art, historical/vintage, large-format Polaroid.

MAKING CONTACT & TERMS Artwork is accepted on consignment, and there is a 30% commission. Gallery provides promotion and contract. Accepted work should be framed or glazed with Plexiglas. "We consider all professional artists."

SUBMISSIONS Mail portfolio of 20 slides for review. Send query letter with artist's statement, bio, brochure, business card, photocopies, photographs, résumé, reviews, SASE, slides and CD. Finds artists through art exhibits, portfolio reviews, referrals by other artists and critics, submissions and national calls.

TIPS "No handwritten letters. Print or type slide labels. Send only 20 slides total."

EDWARD HOPPER HOUSE ART CENTER

82 N. Broadway, Nyack NY 10960. (845)358-0774. **E-mail:** info@edwardhopperhouse.org; caroleperry@edwardhopperhouse.org. **Website:** www.edwardhopperhouse.org. **Contact:** Carole Perry, director. Estab. 1971. Nonprofit gallery and historic house. Approached by 200 artists/year; exhibits 100 artists. Sponsors 1-2 photography exhibits/year. Average display time 1 month. Also offers an annual summer jazz concert series. Open Thursday–Sunday, 1-5; or by appointment. The house was built in 1858; there are 4 gallery rooms on the 1st floor. Overall price range: $100-12,000. Most work sold at $750.

EXHIBITS Photos of all subjects. Interested in alternative process, avant garde, documentary, fine art, historical/vintage, seasonal.

MAKING CONTACT & TERMS Artwork is accepted on consignment, and there is a 35% commission. Gallery provides insurance, promotion and contract. Accepted work should be framed, mounted and matted.

SUBMISSIONS "Exhibits are scheduled 18 months to 2 years in advance. E-mail 10 images identifying each image with your name, title of work, medium and dimensions, as well as a résumé/bio and artist statement."

EDWYNN HOUK GALLERY

745 Fifth Ave., Suite 407, New York NY 10151. (212)750-7070. **Fax:** (212)688-4848. **E-mail:** info@houkgallery.com; julie@houkgallery.com; tess@houkgallery.com. **Website:** www.houkgallery.com. **Contact:** Julie Castellano, director; Tess Vinnedge,

assistant director. For-profit gallery. The gallery is a member of the Art Dealers Association of America and Association of International Photography Art Dealers. The gallery represents the Estates of Ilse Bing, Bill Brandt, Brassaï and Dorothea Lange, and is the representative for such major contemporary photographers as Robert Polidori, Joel Meyerowitz, Sally Mann, Herb Ritts, Bettina Rheims, Lalla Essaydi, Hannes Schmid, Sebastiaan Bremer, Danny Lyon and Elliott Erwitt. Open Tuesday–Saturday, 11-6.

EXHIBITS Specializes in masters of 20th-century photography with an emphasis on the 1920s and 1930s and contemporary photography.

HUDSON GALLERY

5621 N. Main St., Sylvania OH 43560. (419)885-8381. **Fax:** (419)885-8381. **E-mail:** info@hudsongallery.net. **Website:** www.hudsongallery.net. **Contact:** Scott Hudson, director. Estab. 2003. For-profit gallery. Approached by 30 artists/year; represents or exhibits 90 emerging, mid-career and established artists. Sponsors 10 exhibits/year. Average display time 1 month. Open Tuesday-Friday, 10-6; Saturday, 10-3. This street-level gallery has over 2,000 sq. ft. of primary exhibition space. Clients include local community, tourists and upscale. 5% of sales are to corporate collectors. Overall price range $50-10,000.

EXHIBITS Considers acrylic, ceramics, collage, drawing, fiber, glass, mixed media, oil, paper, pastel, sculpture, watercolor, engravings, etchings, linocuts, lithographs, mezzotints, serigraphs, woodcuts. Most frequently exhibits acrylic, oil, ceramics; considers all styles and genres.

MAKING CONTACT & TERMS Artwork is accepted on consignment and there is a 40% commission. Retail price of the art set by the gallery and artist. Gallery provides insurance, promotion and contract.

SUBMISSIONS Call, e-mail, write or send query letter with artist's statement, bio, JPEGs; include SASE. Material returned with SASE. Responds within 4 months. Finds artists through word of mouth, submissions, portfolio reviews and referrals by other artists.

TIPS Follow guidelines on our website.

HUNTSVILLE MUSEUM OF ART

300 Church St. S, Huntsville AL 35801-4910. (256)535-4350. **E-mail:** cmadkour@hsvmuseum.org. **Website:** www.hsvmuseum.org. **Contact:** Christopher Madkour, executive director. Estab. 1970. This nationally-accredited museum fills its 13 galleries with a variety of exhibitions throughout the year, including prestigious traveling exhibits and the work of nationally and regionally acclaimed artists. The museum's own 2,522-piece permanent collection also forms the basis for several exhibitions each year. Sponsors 1-2 exhibits/year. Average display time 2-3 months. Open Sunday, 1-4; Tuesday, Wednesday, Friday, Saturday, 11-4; Thursday, 11-8.

EXHIBITS No specific stylistic or thematic criteria. Interested in alternative process, avant garde, documentary, fine art, historical/vintage.

MAKING CONTACT & TERMS Buys photos outright. Accepted work may be framed or unframed, mounted or unmounted, matted or unmatted. Must have professional track record and résumé, slides, critical reviews in package (for curatorial review).

SUBMISSIONS Regional connection strongly preferred. Send material by mail with SASE for consideration.

ICEBOX QUALITY FRAMING & GALLERY

1500 Jackson St. NE, Suite #443, Minneapolis MN 55413. (612)788-1790. **E-mail:** icebox@bitstream.net. **Website:** www.iceboxminnesota.com. Estab. 1988. Exhibition, promotion and sales gallery. Represents photographers and fine artists in all media, predominantly photography. "A sole proprietorship gallery, Icebox sponsors installations and exhibits in the gallery's 1,700 sq. ft. space in the Minneapolis Arts District." Overall price range $200-1,500. Most work sold at $200-800. Open Thursday and Friday, 10-6; Saturday, 12-5; Tuesday and Wednesday, by appointment only.

EXHIBITS Photos of multicultural, environmental, landscapes/scenics, rural, adventure, travel. Interested in alternative process, documentary, erotic, fine art, historical/vintage. Specifically wants "fine art photographs from artists with serious, thought-provoking work."

MAKING CONTACT & TERMS Charges 50% commission.

SUBMISSIONS "Send letter of interest telling why and what you would like to exhibit at Icebox. Include only materials that can be kept at the gallery and updated as needed. Check website for more details about entry and gallery history."

TIPS "We are experienced with the out-of-town artist's needs."

ILLINOIS STATE MUSEUM CHICAGO GALLERY

100 W. Randolph, Suite 2-100, Chicago IL 60601. (312)814-5322. **E-mail:** jstevens@museum.state.il.us. **Website:** www.museum.state.il.us./ismsites/chicago/exhibitions.html. **Contact:** Jane Stevens, gallery administrator. Estab. 1985. Sponsors 2-3 exhibits/year. Average display time 4 months. Sponsors openings; provides refreshments at reception and sends out announcement cards for exhibitions.

EXHIBITS *Must be an Illinois photographer.* Interested in contemporary and historical/vintage, alternative process, fine art.

SUBMISSIONS Send résumé, artist's statement, 2-20 JPEGs or slides, SASE. Responds in 6 months.

INDIANAPOLIS ART CENTER

Marilyn K. Glick School of Art, 820 E. 67th St., Indianapolis IN 46220. (317)255-2464. **E-mail:** pflaherty@indplsartcenter.org. **Website:** www.indplsartcenter.org. **Contact:** Patrick Flaherty, director of exhibitions. Estab. 1934. "Started in 1934 during the Great Depression to provide employment for artists, the IAC stays true to its mission by hiring professional artists as faculty, exhibiting the work of working artists and selling artist-made gifts and art." Sponsors 1-2 photography exhibits/year. Average display time 8 weeks. Overall price range $50-5,000. Most work sold at $500.

EXHIBITS Interested in alternative process, avant garde, documentary, fine art and "very contemporary work, preferably unusual processes." Prefers artists who live within 250 miles of Indianapolis.

MAKING CONTACT & TERMS Charges 35% commission. One-person show: $300 honorarium; 2-person show: $200 honorarium; 3-person show: $100 honorarium; plus $0.32/mile travel stipend (one way). Accepted work should be framed (or other finished-presentation formatted).

SUBMISSIONS Send minimum of 20 digital images with résumé, reviews, artist's statement and SASE between July 1 and December 31. No wildlife or landscape photography. Interesting color and mixed media work is appreciated.

TIPS "We like photography with a very contemporary look that incorporates unusual processes and/or photography with mixed media. Submit excellent images with a full résumé, a recent artist's statement, and reviews of past exhibitions or projects. Please, no glass-mounted slides. Always include a SASE for noti-fication and return of materials, ensuring that correct return postage is on the envelope. Exhibition materials will not be returned. Currently booking 2014."

INDIVIDUAL ARTISTS OF OKLAHOMA

P.O. Box 60824, Oklahoma City OK 73146. (405)232-6060. **Fax:** (405)232-6061. **E-mail:** kbrown@iaogallery.org. **Website:** www.iaogallery.org. **Contact:** Kendall Brown. Estab. 1979. Alternative space. "IAO creates opportunities for Oklahoma artists by curating and developing socially relevant exhibitions in one of the finest gallery spaces in the region." Approached by 60 artists/year; represents or exhibits 30 artists. Sponsors 10 photography exhibits/year. Average display time 3-4 weeks. Open Tuesday–Saturday, 12-6. Gallery is located in downtown art district, 3,500 sq. ft. with 10-ft. ceilings and track lighting. Overall price range $100-2,000. Most work sold at $400.

EXHIBITS Interested in alternative process, avant garde, documentary, fine art, historical/vintage photography. Other specific subjects/processes: contemporary approach to variety of subjects.

MAKING CONTACT & TERMS Charges 30% commission. Gallery provides insurance, promotion, contract. Accepted work must be framed.

SUBMISSIONS Mail portfolio for review with artist's statement, bio, photocopies or slides, résumé, SASE. Reviews quarterly. Finds artists through word of mouth, art exhibits, referrals by other artists.

INTERNATIONAL CENTER OF PHOTOGRAPHY

1133 Avenue of the Americas, New York NY 10036. (212)857-0000; (212)857-9707. **E-mail:** portfolio@icp.org. **E-mail:** kheisler@icp.org. **Website:** www.icp.org. **Contact:** Department of Exhibitions & Collections. Estab. 1974.

SUBMISSIONS "Due to the volume of work submitted, we are only able to accept portfolios in the form of CDs or e-mail attachments. JPEG files are preferable; each image file should be a maximum of 1000 pixels at the longest dimension, at 72 dpi. CDs must be labeled with a name and address. Submissions must be limited to no more than 20 images. All files should be accompanied by a list of titles and dates. Portfolios of more than 20 images will not be accepted. Photographers may also wish to include the following information: cover letter, résumé or curriculum vitae, artist's statement and/or project description. ICP can only accept portfolio submissions via e-mail with

"portfolio review" in the subject line or mail (or FedEx, etc.). Please include a SASE for the return of materials. ICP cannot return portfolios submitted without return postage."

INTERNATIONAL VISIONS GALLERY

2629 Connecticut Ave. NW, Washington DC 20008. **E-mail:** intvisionsgallery@gmail.com. **Website:** www.inter-visions.com. **Contact:** Timothy Davis, owner/director. Estab. 1997. For-profit gallery. Approached by 60 artists/year; represents or exhibits 50 artists. Sponsors 1 photography exhibit/year. Average display time 4-6 weeks. Gallery open Wednesday–Saturday, 11-6. Located in the heart of Washington DC; features 1,000 sq. ft. of exhibition space. Overall price range $1,000-8,000. Most work sold at $2,500.

EXHIBITS Photos of babies/children/teens, multicultural.

MAKING CONTACT & TERMS Artwork is accepted on consignment, and there is a 50% commission. Gallery provides insurance, promotion, contract. Accepted work should be framed. Requires exclusive representation locally.

SUBMISSIONS Call. Send query letter with artist's statement, bio, photocopies, résumé, SASE. Responds in 2 months. Finds artists through word of mouth, art exhibits, referrals by other artists.

⊕ IRON WILLOW

440 Main St., Placerville CA 95667. (530)621-4799. **E-mail:** mail@ironwillow.com. **Website:** www.ironwillow.com. **Contact:** Barbara Tankersley, owner. Estab. 1998. For-profit gallery. Exhibits emerging, mid-career and established artists. Approached by 15+ artists/year; represents or exhibits 28 artists currently. Exhibited artists include Tom Tankersley (metal sculpture and furniture) and Dale Laitinen (water media). Sponsors 28 exhibits/year, 2 photography exhibits/year. Model release and property release are required. Displays are ongoing. Open Monday, Thursday-Saturday, 11-5; Sunday, 11-4. Located on Main Street in historic downtown Placerville. 2,000 sq. ft. exhibition space. Clients include the local community, tourists and upscale clients. 15% of sales are to corporate collectors. Price range: $35-15,000. Most work sold at $2,500.

EXHIBITS Considers acrylic, ceramics, collage, fiber, glass, installation, mixed media, oil, paper, pastel, pen & ink, sculpture, watercolor. Most frequently exhibits sculpture, watercolor and oil. Considers prints of engravings, etchings, linocuts, woodcuts, giclée, and photos on aluminum.

MAKING CONTACT & TERMS Artwork is accepted on consignment and there is a 20% commission. There is a rental fee of space. The fee is month-to-month, no long-term commitment, give 30 days notice to terminate. Retail price set by the artist with assistance from gallery owner, if requested. Gallery provides promotion. Accepted work should be framed and mounted.

SUBMISSIONS E-mail query letter with link to artist's website and JPEG samples at 72 dpi. Responds within 2 weeks. Files artists whose work is considered for future representation in the gallery. Finds artists through word of mouth, submissions, and referrals by other artists.

JACKSON FINE ART

3115 E. Shadowlawn Ave., Atlanta GA 30305. (404)233-3739. **Fax:** (404)233-1205. **Website:** www.jacksonfineart.com. **Contact:** Courtney Lee, director. Estab. 1990. Specializes in 20th-century and contemporary photography. Exhibitions are rotated every 2 months. Gallery open Tuesday-Saturday, 10-5. Overall price range $600-500,000. Most work sold at $5,000.

EXHIBITS Interested in innovative photography, avant garde, fine art.

MAKING CONTACT & TERMS Only buys vintage photos outright. Requires exclusive representation locally. Exhibits only nationally known artists and emerging artists who show long-term potential. "Photographers must be established, preferably published in books or national art publications. They must also have a strong biography, preferably museum exhibitions, national grants."

SUBMISSIONS Send JPEG files via e-mail. Responds in 3 months, only if interested. Unsolicited original work is not accepted.

ELAINE L. JACOB GALLERY AND COMMUNITY ARTS GALLERY

80 W. Hancock St., Detroit MI 48202. (313)577-2423; (313)993-7813. **E-mail:** tpyrzewski@wayne.edu. **Website:** www.art.wayne.edu. **Contact:** Tom Pyrzewski. Estab. 1995. Nonprofit university gallery. Approached by 30 artists/year; exhibits solo and group shows. Sponsors 1-2 photography exhibits/year. Average display time 1 month. Open Tuesday–Thursday, 10-6; Friday, 10-7. Closed Thanksgiving weekend and Christmas. Community Arts Gallery: 3,000

sq. ft.; Elaine L. Jacob Gallery, level 1: 2,000 sq. ft.; level 2: 1,600 sq. ft.

EXHIBITS Interested in fine art. "The Elaine L. Jacob Gallery and the Community Arts Gallery are university galleries, displaying art appropriate for an academic environment."

MAKING CONTACT & TERMS Gallery provides insurance, promotion. Accepted work should be framed.

SUBMISSIONS Send query letter with artist's statement, bio, résumé, SASE, slides, exhibition proposal, video, slide list. Responds in 3 months. Finds artists through word of mouth, portfolio reviews, art exhibits, referrals by other artists.

JADITE GALLERIES

413 W. 50th St., New York NY 10019. (212)315-2740. **Fax:** (212)315-2793. **Website:** www.jadite.com. **Contact:** Roland Sainz, director. Estab. 1985. "Exhibitions cover the spectrum of art form created by a myriad of talented artists from the U.S., Europe, Latin America and Asia. With 3 exhibition spaces, we have fostered a number of promising artists and attracted many serious collectors over the years." Sponsors 3-4 exhibits/year. Average display time 1 month. Open Monday–Saturday, 12-6. Overall price range $300-5,000. Most work sold at $1500.

EXHIBITS Photos of landscapes/scenics, architecture, cities/urban, travel. Interested in avant garde, documentary and b&w, color and mixed media.

MAKING CONTACT & TERMS Gallery receives 40% commission. There is a rental fee for space (50/50 split of expenses such as invitations, advertising, opening reception, etc.). Accepted work should be framed.

SUBMISSIONS Arrange a personal interview to show portfolio. Responds in 5 weeks.

ALICE AND WILLIAM JENKINS GALLERY

600 St. Andrews Blvd., Winter Park FL 32804. (407)671-1886. **Fax:** (407)671-0311. **E-mail:** rberrie@crealde.org. **Website:** www.crealde.org. **Contact:** Rick Lang, director of photo department. Estab. 1980. The Jenkins Gallery mission is to exhibit the work of noted and established Florida artists, as well as to introduce national and international artists to the Central Florida region. Each of the four to six annual exhibitions are professionally curated by a member of the Crealdé Gallery Committee or a guest curator.

JHB GALLERY

26 Grove St., Suite #4C, New York NY 10014. (212)255-9286. **Fax:** (212)229-8998. **E-mail:** info@jhbgallery.com. **Website:** www.jhbgallery.com. **Contact:** Jayne Baum. Estab. 1982. Private art dealer and consultant. Gallery open by appointment only. Overall price range $1,500-40,000. Most work sold at $1,500-100,000.

MAKING CONTACT & TERMS Artwork is accepted on consignment, and there is a 50% commission. Gallery provides promotion.

SUBMISSIONS Accepts online submissions. Send query letter with résumé, CD, slides, artist's statement, reviews, SASE. Finds artists through submissions, portfolio reviews, art exhibits, art fairs, referrals by other curators.

STELLA JONES GALLERY

201 St. Charles Ave., New Orleans LA 70170. (504)568-9050. **E-mail:** stellajonesgallery.manalia@gmail.com. **Website:** www.stellajonesgallery.com. **Contact:** Stella Jones. Estab. 1996. For-profit gallery. "The gallery provides a venue for artists of the African diaspora to exhibit superior works of art. The gallery fulfills its educational goals through lectures, panel discussions, intimate gallery talks and exhibitions with artists in attendance." Approached by 40 artists/year; represents or exhibits 45 artists. Sponsors 1 photography exhibit/year. Average display time 6-8 weeks. Open Monday–Saturday, 12-5. Located on 1st floor of corporate 53-story office building downtown, 1 block from French Quarter. Overall price range $500-150,000. Most work sold at $5,000.

EXHIBITS Photos of babies/children/teens, multicultural, families, cities/urban, education, religious, rural.

MAKING CONTACT & TERMS Artwork is accepted on consignment, and there is a 50% commission. Gallery provides insurance, promotion, contract. Accepted work should be framed. Requires exclusive representation locally.

SUBMISSIONS Call to show portfolio of photographs, slides, transparencies. Mail portfolio for review. Send query letter with artist's statement, bio, brochure, business card, photocopies, photographs, résumé, reviews, slides, SASE. Responds in 1 month. Finds artists through word of mouth, submissions, portfolio reviews, art exhibits, referrals by other artists.

TIPS "Photographers should be organized with good visuals."

JRB ART AT THE ELMS

2810 North Walker, Oklahoma City OK 73103. (405)528-6336. **Fax:** (405)528-6337. **E-mail:** jreed belt@jrbartgallery.com. **Website:** www.jrbartgallery.com. **Contact:** Joy Reed Belt, director. Estab. 2003. JRB Art at the Elms presents a diverse roster of emerging, established and internationally-exhibited artists who create in a wide range of media, including: paintings, drawings, sculpture, ceramics, glass, fine crafts, functional objects, fiber art, fine art prints and photographs. This award-winning gallery in Oklahoma City's Paseo Arts District, with its historic 8,000-sq.-ft. exhibition space, changes its exhibits monthly in a gracious environment that fosters a dialogue between the arts and the larger community while providing quality art for first-time buyers as well as individual, corporate and museum collections.

⊕ KALAMAZOO INSTITUTE OF ARTS

314 S. Park St., Kalamazoo MI 49007. (269)349-7775. **Fax:** (269)349-9313. **E-mail:** museum@kiarts.org. **Website:** www.kiarts.org. **Contact:** Vicki Wright, director of collections and exhibitions; Phil Meade, marketing and public relations coordinator. Estab. 1924. Museum. Exhibits established artists. Exhibits 15 artists, including Ansel Adams (photography) and Dale Chihuly (sculpture). Sponsors 15 total exhibits/year, including 2 photography exhibits/year. Average display time: 3 months. Open Tuesday-Saturday, 10-5; Sunday, 12-5. Closed Mondays and holidays. Located downtown, museum has 10 galleries varying in size. Clients include local community, students, tourists and upscale clients.

EXHIBITS Considers all media.

MAKING CONTACT & TERMS Model and property release are preferred. Artwork is accepted on consignment and there is a 30% commission. Retail price set by the artist. Gallery provides insurance, promotion and contract. Accepted work should be framed, mounted and matted.

SUBMISSIONS Call or e-mail query letter with link to artist's website. Responds in 1 month. Will return material with SASE. Finds artists through word of mouth, submissions and art exhibits.

KENT STATE UNIVERSITY SCHOOL OF ART GALLERIES

P.O. Box 5190, Kent OH 44242. (330)672-7853. **E-mail:** haturner@kent.edu. **Website:** galleries.kent.edu. **Contact:** Anderson Turner, director of galleries. Located in six locations throughout northeast Ohio, please see website for location and hours. Sponsors at least 6 photography exhibits/year. Average display time 4 weeks.

EXHIBITS Interested in all types, styles and subject matter of photography. Photographer must present quality work.

MAKING CONTACT & TERMS Photography can be sold in gallery. Charges 40% commission. Buys photography outright.

SUBMISSIONS Send proposal, résumé, and a CD of 10-20 digital images of work to be included in the exhibition. Send material by mail for consideration; include SASE. Responds "usually in 4 months, but it depends on time submitted."

KIRCHMAN GALLERY

P.O. Box 115, 213 N. Nuget St., Johnson City TX 78636. (830)868-9290. **E-mail:** susan@kirchmangallery.com. **Website:** www.kirchmangallery.com. **Contact:** Susan Kirchman, owner/director. Estab. 2005. Art consultancy and for-profit gallery. Represents or exhibits 25 artists. Average display time 1 month. Sponsors 4 photography exhibits/year. Open Sunday, Monday and Thursday, 12-5; Friday and Saturday, 11-6; anytime by appointment. Located across from Johnson City's historic Courthouse Square in the heart of Texas hill country. Overall price range $250-25,000. Most work sold at $500-1,000.

EXHIBITS Photos of landscapes/scenics. Interested in alternative process, avant garde, fine art.

MAKING CONTACT & TERMS Artwork is accepted on consignment, and there is a 50% commission.

SUBMISSIONS "Send 20 digital-format examples of your work, along with a résumé and artist's statement."

ROBERT KLEIN GALLERY

38 Newbury St., Boston MA 02116. (617)267-7997. **Fax:** (617)267-5567. **E-mail:** inquiry@robertklein gallery.com. **Website:** www.robertkleingallery.com. **Contact:** Robert L. Klein, owner; Eunice Hurd, director. Estab. 1980. Devoted exclusively to fine art photography, specifically 19th and 20th century and contemporary. Sponsors 10 exhibits/year. Average display time 5 weeks. Overall price range $1,000-200,000.

GALLERIES

Open Tuesday–Friday, 10-5:30; Saturday, 11-5 and by appointment.

EXHIBITS Interested in fashion, documentary, nudes, portraiture, and work that has been fabricated to be photographs.

MAKING CONTACT & TERMS Charges 50% commission. Buys photos outright. Accepted work should be unframed, unmatted, unmounted. Requires exclusive representation locally. Must be established a minimum of 5 years; preferably published.

SUBMISSIONS "The Robert Klein Gallery is not accepting any unsolicited submissions. Unsolicited submissions will not be reviewed or returned."

ROBERT KOCH GALLERY

49 Geary St., 5th Floor, San Francisco CA 94108. (415)421-0122. **Fax:** (415)421-6306. **E-mail:** info@kochgallery.com. **Website:** www.kochgallery.com. Estab. 1979. "Our gallery has exhibited and offered a wide range of museum quality photography that spans the history of the medium from the 19th century to the present. Our extensive inventory emphasizes Modernist and experimental work from the 1920s and 1930s, 19th-century and contemporary photography." Sponsors 6-8 photography exhibits/year. Average display time 2 months. Located in the heart of San Francisco's downtown Union Square. Open Tuesday–Saturday, 11-5:30.

MAKING CONTACT & TERMS Artwork is accepted on consignment. "E-mail artist, title or description of subject matter, date, medium, dimensions and any other pertinent information with a low-res JPEG. Also include your name, e-mail address, phone number and the best time to reach you." Gallery provides insurance, promotion, contract. Requires West Coast or national representation.

SUBMISSIONS Finds artists through publications, art exhibits, art fairs, referrals by other artists and curators, collectors, critics.

LANDING GALLERY

8 Elm St., Rockland ME 04841. (207)594-4544. **E-mail:** landinggallery@gmail.com. **Website:** www.landingart.com. **Contact:** Bruce Busko, president. Estab. 1985. For-profit gallery. Approached by 40 artists/year. Exhibits 35 emerging, mid-career and established artists.

EXHIBITS Photos of landscapes/scenics, architecture, cities/urban, rural, adventure, automobiles, entertainment. Interested in alternative process, avant garde, erotic, fine art, historical/vintage. Seeking photos "with hand color or embellishment."

MAKING CONTACT & TERMS Artwork is accepted on consignment, and there is a 50% commission. Gallery provides insurance, promotion, contract. Accepted work should be framed. Requires exclusive representation locally.

SUBMISSIONS Call to show portfolio. Mail portfolio for review. Send query letter with artist's statement, bio, brochure, business card, photocopies, photographs, résumé, reviews, slides, SASE. Responds in 2 weeks. Finds artists through word of mouth, submissions, portfolio reviews, art exhibits, art fairs, referrals by other artists.

⊕ SHAUNA LEE LANGE: THE GALLERY OF ART JOURNALS, VISUAL DIARIES AND SKETCHBOOKS

(941)875-5190. **E-mail:** shaunaleelange@gmail.com. **Website:** www.shaunaleelange.com. **Contact:** Shauna Lee Lange, founder. Estab. 2006. Art consultancy. Approached by 5 artists/year; represents or exhibits 12 artists currently, 6 emerging, 6 mid-career. Sponsors 12 exhibits/year, 3-4 photography exhibits/year. Average display is 30 days.

MAKING CONTACT & TERMS Artwork is accepted on consignment and there is a 20% commission. Retail price set by collaboration of artist and gallery. Gallery provides bio and critical essay. Most works submitted in image form, we decide on sale. Requires exclusive representation locally. Prefer self-taught women, but will consider all.

SUBMISSIONS E-mail query letter with link to artist's website and JPEG samples at 72 dpi, artist's statement and bio. Responds within 4 weeks. Finds artists through word of mouth and art exhibits.

TIPS Provide complete and clear contact info.

LAW WARSCHAW GALLERY

Macalester College, Janet Wallace Fine Arts Center, 1600 Grand Ave., St. Paul MN 55105. (651)696-6416. **Fax:** (651)696-6266. **E-mail:** gallery@macalester.edu. **Website:** www.macalester.edu/gallery. **Contact:** Gregory Fitz, curator. Estab. 1964. Nonprofit gallery. Approached by 15 artists/year; represents or exhibits 3 artists. Sponsors 1 photography exhibit/year. Average display time 4-5 weeks. Gallery open Monday-Friday, 10-4; weekends, 12-4. Closed major holidays, summer and school holidays. Located in the core of the Janet Wallace Fine Arts Center on the campus of Ma-

calester College. While emphasizing contemporary, the gallery also hosts exhibitions on a wide-range of historical and sociological topics. Gallery is approx. 1,100 sq. ft. and newly renovated. Overall price range: $200-1,000. Most work sold at $350.

EXHIBITS Photos of multicultural, environmental, landscapes/scenics, architecture, rural. Interested in avant garde, documentary, fine art, historical/vintage.

MAKING CONTACT & TERMS Gallery provides insurance. Accepted work should be framed, mounted, matted.

SUBMISSIONS Send query letter with artist's statement, bio, brochure, business card, photocopies, photographs, résumé, reviews, SASE, slides. Finds artists through word of mouth, portfolio reviews, referrals by other artists.

TIPS "Photographers should present quality slides which are clearly labeled. Include a concise artist's statement. Always include a SASE. No form letters or mass mailings."

⊘ ELIZABETH LEACH GALLERY

417 NW Ninth Ave., Portland OR 97209-3308. (503)224-0521. **Fax:** (503)224-0844. **Website:** www.elizabethleach.com. Currently not accepted unsolicited submissions. Sponsors 3-4 exhibits/year. Average display time 1 month. "The gallery has extended hours every first Thursday of the month for our openings." Overall price range $300-5,000.

EXHIBITS Photographers must meet museum conservation standards. Interested in "high-quality concept and fine craftsmanship."

MAKING CONTACT & TERMS Charges 50% commission. Accepted work should be framed or unframed, matted. Requires exclusive representation locally.

SUBMISSIONS Not accepting submissions at this time.

⊕ SHERRY LEEDY CONTEMPORARY ART

2004 Baltimore Ave., Kansas City MO 64108. (816)221-2626. **Fax:** (816)221-8689. **E-mail:** sherryleedy@sherryleedy.com. **Website:** www.sherryleedy.com. **Contact:** Sherry Leedy, director. Estab. 1985. Retail gallery. Represents 50 mid-career and established artists. Exhibited artists include Jun Kaneko, Mike Schultz, Vera Mercer, and more. Sponsors 6 shows/year. Average display time 6 weeks. 5,000 sq. ft. of exhibit area in 3 galleries. Clients include established and beginning collectors. 50% of sales are to private collectors, 50%

corporate clients. Price range $50-100,000; most work sold at $3,500-35,000. Open Tuesday–Saturday, 11-5, and by appointment.

EXHIBITS Considers all media and one-of-a-kind or limited-edition prints; no posters. Most frequently exhibits painting, photography, ceramic sculpture and glass.

MAKING CONTACT & TERMS Accepts work on consignment (50% commission). Retail price set by gallery in consultation with the artist. Sometimes offers customer discounts and payment by installment. Exclusive area representation required. Gallery provides insurance, promotion; shipping costs are shared. Prefers artwork framed.

SUBMISSIONS E-mail query letter, résumé, artist's statement, and digital images or link to website. No work will be reviewed in person without a prior appointment. Bio, vita, slides, articles, etc., are filed if they are of potential interest.

TIPS "Please allow 3 months for gallery to review submissions."

LEEPA-RATTNER MUSEUM OF ART

P.O. Box 1545, Tarpon Springs FL 34688. (727)712-5762. **E-mail:** lrma@spcollege.edu. **Website:** www.spcollege.edu/museum. **Contact:** R. Lynn Whitelaw, curator. The museum's 20th-century collection is made up of art from Abraham Rattner's estate, donated by Allen and Isabelle Leepa, and a large donation made by the Tampa Museum of Art. The museum is filled with Rattner's retrospective works: lithographs, tapestries, sculptures, paintings and stained glass." Open Tuesday, Wednesday, Saturday, 10-5; Thursday, 10-8; Friday, 10-4; Sunday, 1-5. Closed Mondays and national holidays. Located on the Tarpon Springs campus of St. Petersburg College.

EXHIBITS Photos of babies/children/teens, celebrities, couples, multicultural, families, parents, senior citizens, architecture, cities/urban, education, gardening, interiors/decorating, pets, religious, rural, agriculture, business concepts, industry, medicine, military, political, product shots/still life, science, technology/computers, disasters, environmental, landscapes/scenics, wildlife, adventure, automobiles, entertainment, events, food/drink, health/fitness/beauty, hobbies, humor, performing arts, sports, travel. Interested in alternative process, avant garde, documentary, erotic, fashion/glamour, fine art, historical/vintage, seasonal.

⊕ LEGION ARTS

1103 Third St. SE, Cedar Rapids IA 52401-2305. (319)364-1580. **Fax:** (319)362-9156. **E-mail:** info@legionarts.org. **Website:** www.legionarts.org. **Contact:** Mel Andringa, producing director. Estab. 1991. Alternative space. Approached by 50 artists/year; represents or exhibits 15 artists. Sponsors 4 photography exhibits/year. Average display time 2 months. Open Wednesday–Sunday, 11-6. Closed July and August. Overall price range $50-500. Most work sold at $200.
EXHIBITS Interested in alternative process, avant garde, documentary, fine art.
MAKING CONTACT & TERMS Artwork is accepted on consignment and there is a 30% commission. Gallery provides insurance, promotion. Accepted work should be framed.
SUBMISSIONS Send query letter with artist's statement, bio, slides, SASE. Responds in 6 months. Finds artists through word of mouth, art exhibits, referrals by other artists, art trade magazine.

LEHIGH UNIVERSITY ART GALLERIES

420 E. Packer Ave., Bethlehem PA 18015. (610)758-3619; (610)758-3615. **Fax:** (610)758-4580. **E-mail:** rv02@lehigh.edu. **Website:** www.luag.org. **Contact:** Ricardo Viera, director/curator. Sponsors 5-8 exhibits/year. Average display time 6-12 weeks. Sponsors openings.
EXHIBITS Fine art/multicultural, Latin American. Interested in all types of works. The photographer should "preferably be an established professional."
MAKING CONTACT & TERMS Reviews transparencies. Arrange a personal interview to show portfolio. Send query letter with SASE. Responds in 1 month.
TIPS "Don't send more than 10 slides or a CD."

⊕ DAVID LEONARDIS GALLERY

1346 N. Paulina St., Chicago IL 60622. (312)863-9045. **E-mail:** david@dlg-gallery.com. **Website:** www.dlg-gallery.com. **Contact:** David Leonardis, owner. Estab. 1992. For-profit gallery. Approached by 100 artists/year. Represents 12 emerging, mid-career and established artists. Average display time: 30 days. Open by appointment. Clients include local community, tourists, upscale. 10% of sales are to corporate collectors. Overall price range: $50-5,000; most work sold at $500.
EXHIBITS Photos of celebrities. Interested in fine art.
MAKING CONTACT & TERMS Artwork is accepted on consignment, and there is a 50% commission.

Gallery provides promotion. Accepted work should be framed.
SUBMISSIONS E-mail to arrange a personal interview to show portfolio. Mail portfolio for review. Send query letter via e-mail. Responds only if interested. Finds artists through word of mouth, art exhibits, referrals by other artists.
TIPS "Artists should be professional and easy to deal with."

LEOPOLD GALLERY

324 W. 63rd St., Kansas City MO 64113. (816)333-3111. **Fax:** (816)333-3616. **E-mail:** email@leopoldgallery.com. **Website:** www.leopoldgallery.com. **Contact:** Paula Busser, assistant director. Estab. 1991. For-profit gallery. Approached by 100+ artists/year; represents 40 artists/year. Sponsors 8 exhibits/year. Average display time 4 weeks. Open Monday–Friday, 10-6; Saturday, 10-5. Closed holidays. The gallery has two levels of exhibition space. Clients include H&R Block, Warner Bros., Kansas City Royals, local community, tourists. 65% of sales are to corporate collectors. Overall price range: $50-25,000; most work sold at $1,500. "We are located in Brookside, a charming retail district built in 1920 with more than 70 shops and restaurants. The gallery has 2 levels of exhibition space, with the upper level dedicated to artist openings/exhibitions."
EXHIBITS Photos of architecture, cities/urban, rural, environmental, landscapes/scenics, wildlife, entertainment, performing arts. Interested in alternative process, avant garde, documentary, fine art.
MAKING CONTACT & TERMS Artwork is accepted on consignment; there is a 50% commission. Gallery provides insurance, promotion, contract. Accepted work should be framed, mounted, matted. **Accepts artists from Kansas City area only.** Send query letter with artist's statement, bio, brochure, business card, résumé, reviews, SASE, disk with images. Responds in 2 weeks. Finds artists through word of mouth, art exhibitions, submissions, art fairs, portfolio reviews, referrals by other artists.
SUBMISSIONS E-mail 5-10 JPEG images of your body of work to email@leopoldgallery.com. Before sending, please scan your e-mail for viruses, as any viral e-mails will be deleted upon receipt. Images should be saved at 72 dpi, approximately 5×7 and compressed to level 3 JPEG. Please save for Windows. Or, send e-mail query letter with link to artist's website.

⊕ LICHTENSTEIN CENTER FOR THE ARTS

28 Renne Ave., Pittsfield MA 01201. (413)499-9348. **Fax:** (413)442-8043. **Website:** www.discoverpittsfield. com. **Contact:** Dan Gigliotti, gallery manager. Estab. 1975. Sponsors 10 exhibits/year. Open Wednesday–Saturday, 12-5. Overall price range $50+

MAKING CONTACT & TERMS Charges 20% commission. Will review transparencies of photographic work. Accepted work should be framed, mounted, matted.

SUBMISSIONS "Photographer should send SASE with 20 slides or prints, résumé and statement by mail only to gallery."

TIPS "To break in, send portfolio, slides and SASE. We accept all art photography. Work must be professionally presented and framed. Send in by July 1 each year. Expect exhibition 2-3 years from submission date. We have a professional juror look at slide entries once a year (usually July-September). Expect that work to be tied up for 2-3 months in jury."

LIMITED EDITIONS & COLLECTIBLES

697 Haddon Ave., Collingswood NJ 08108. (856)869-5228. **Fax:** (856)869-5228. **E-mail:** jdl697ltd@juno. com. **Website:** www.ltdeditions.net. **Contact:** John Daniel Lynch, Sr., owner. Estab. 1997. For-profit online gallery. Approached by 24 artists/year; represents or exhibits 70 artists. Sponsors 20 photography exhibits/year. Overall price range $100-3,000. Most work sold at $450.

EXHIBITS Photos of landscapes/scenics, wildlife, adventure, automobiles, entertainment, events, food/drink, health/fitness/beauty, hobbies, humor, performing arts, sports, travel. Interested in alternative process, documentary, erotic, fashion/glamour, historical/vintage, seasonal.

MAKING CONTACT & TERMS Artwork is accepted on consignment, and there is a 30% commission. Gallery provides insurance, promotion, contract.

SUBMISSIONS Call or write to show portfolio. Send query letter with bio, business card, résumé. Responds in 1 month. Finds artists through word of mouth, portfolio reviews, art exhibits, referrals by other artists.

LIMNER GALLERY

123 Warren St., Hudson NY 12534. (518)828-2343. **E-mail:** thelimner@aol.com. **Website:** www.slowart. com. **Contact:** Tim Slowinski, director. Estab. 1987. Alternative space. Established in Manhattan's East Village. Approached by 200-250 artists/year; represents or exhibits 90-100 artists. Sponsors 2 photography exhibits/year. Average display time 4 weeks. Open Tuesday-Saturday, 12-5; Sunday, 12-4. Closed January, July-August (weekends only). Located in the art and antiques center of the Hudson Valley. Exhibition space is 1,000 sq. ft.

EXHIBITS Interested in alternative process, avant garde, documentary, erotic, fine art, historical/vintage.

SUBMISSIONS Artists should e-mail a link to their website; or download exhibition application at www. slowart.com/prospectus; or send query letter with artist's statement, bio, brochure or photographs/slides, SASE. Finds artists through submissions.

TIPS "Artist's website should be simple and easy to view. Complicated animations and scripted design should be avoided, as it is a distraction and prevents direct viewing of the work. Not all galleries and art buyers have cable modems. The website should either work on a telephone line connection or 2 versions of the site should be offered—one for telephone, one for cable/high-speed Internet access."

LIZARDI/HARP GALLERY

P.O. Box 91895, Pasadena CA 91109. (626)791-8123. **Fax:** (626)791-8887. **E-mail:** lizardiharp@earthlink. net. **Contact:** Grady Harp, director. Estab. 1981. Sponsors 3-4 exhibits/year. Average display time 4-6 weeks. Overall price range $250-1,500. Most work sold at $500.

EXHIBITS Primarily interested in the figure. Also exhibits photos of celebrities, couples, performing arts. Must have more than one portfolio of subject, unique slant and professional manner. Interested in avant garde, erotic, fine art, figurative, nudes, "maybe" manipulated work, documentary and mood landscapes, both b&w and color.

MAKING CONTACT & TERMS Charges 50% commission. Accepted work should be unframed, unmounted; matted or unmatted.

SUBMISSIONS Submit portfolio for review. E-mail query letter with résumé, samples. Responds in 1 month.

TIPS Include 20 labeled slides, résumé and artist's statement with submission. "Submit at least 20 images that represent bodies of work. I mix photography of figures, especially nudes, with shows on painting."

LOS ANGELES MUNICIPAL ART GALLERY

4800 Hollywood Blvd., Los Angeles CA 90027. **Website:** www.lamag.org. Estab. gallery: 1971; support group: 1954. Nonprofit, municipally-owned gallery. Exhibits emerging, mid-career, and established artists. Sponsors 8 total exhibits/year. Average display time 8 weeks. Open Thursday-Sunday, 12-5. 10,000-sq.-ft. city-run facility located in Barnsdall Park in Hollywood CA. Clients include local community, students, tourists, and upscale clientele.

EXHIBITS Accepts all media.

MAKING CONTACT & TERMS Gallery provides insurance and promotion.

SUBMISSIONS "Visit our website for upcoming show opportunities." Files artists and proposals of interests. Finds artists through word of mouth, submissions, portfolio review, art exhibits, art fairs, referrals by other artists and the DCA Slide Registry.

BILL LOWE GALLERY

1555 Peachtree St. NE, Suite 100, Atlanta GA 30309. (404)352-8114. **Fax:** (404)352-0564. **E-mail:** contact@lowegallery.com. **E-mail:** alexis@lowegallery.com. **Website:** www.lowegallery.com. For-profit gallery. Approached by 300 artists/year; represents or exhibits approximately 67 artists. Average display time 4-6 weeks. Open Tuesday–Friday, 10-5:30; Saturday, 11-5:30; Sunday by appointment. Exhibition space is 6,000 sq. ft. with great architectural details, such as 22-ft.-high ceilings. Exhibition spaces range from monumental to intimate.

EXHIBITS Photos of babies/children/teens, multicultural. Interested in alternative process, mixed media.

MAKING CONTACT & TERMS Artwork is accepted on consignment, and there is a 50% commission. Requires exclusive representation locally.

SUBMISSIONS Send query letter with artists's statement, bio, images on CD (including titles, media, dimensions, retail price), résumé, reviews, SASE. Prefers mail to e-mail. If submitting through e-mail, it should not exceed 2MB. Include contact information website link, biographical information, exhibition history, artist statement, reviews or any other supplemental material (within reason). Response time approximately 6 weeks. Finds artists through word of mouth, art exhibits, submissions, art fairs, portfolio reviews, referrals by other artists. Submission guidelines available online.

TIPS "Look at the type of work that the gallery already represents, and make sure your work is an aesthetic fit first! Send lots of great images with dimensions and pricing."

LUX CENTER FOR THE ARTS

2601 N. 48th St., Lincoln NE 68504. (402)466-8692. **Fax:** (402)466-3786. **E-mail:** info@luxcenter.org. **Website:** www.luxcenter.org. Estab. 1978. Non-profit gallery. Over 450 fine arts prints collected by the art center's benefactor are preserved in the Gladys M. Lux Historical Gallery. Exhibited artists include Guy Pene DuBois, Joseph Hirsch, Dois Emrick Lee, Fletcher Martin, Georges Schreiber, Marguerite Zorach and many more. Represents or exhibits 60+ artists. Sponsors 3-4 photography exhibits/year. Average display time 1 month. Open Tuesday–Friday, 11-5; Saturday, 10-5; 1st Friday, 11-8.

EXHIBITS Photos of landscapes/scenics. Interested in alternative process, avant garde, fine art.

MAKING CONTACT & TERMS Artwork is accepted on consignment, and there is a 50% commission.

SUBMISSIONS Mail current résumé, artist's statement, biography, 10-20 digital images of your work, and accompanying image identification information.

TIPS "To make your submission professional, you should have high-quality images (either slides or high-res digital images), cover letter, bio, résumé, artist's statement and SASE."

MACNIDER ART MUSEUM

303 Second St. SE, Mason City IA 50401. (641)421-3666. **Fax:** (641)422-9612. **E-mail:** eblanchard@masoncity.net; macniderinformation@masoncity.net. **Website:** www.macniderart.org. Estab. 1966. Nonprofit gallery. Represents or exhibits 1-10 artists. Sponsors 2-5 photography exhibits/year (1 is competitive for the county). Average display time 2 months. Gallery open Tuesday, Wednesday, Friday, and Saturday, 9-5; Thursday, 9-9; closed Sunday and Monday. Overall price range $50-2,500. Most work sold at $200.

MAKING CONTACT & TERMS Artwork is accepted on consignment, and there is a 40% commission. Gallery provides insurance, promotion, contract. Accepted work should be framed.

SUBMISSIONS Mail portfolio for review. Responds within 3 months, only if interested. Finds artists through word of mouth, submissions, portfolio reviews, art exhibits, art fairs, referrals by other artists. Exhibition opportunities: exhibition in galleries,

presence in museum shop on consignment or booth at Festival Art Market in June.

⊕ MAIN STREET GALLERY

330 Main St., Ketchikan AK 99901. (907)225-2211. **E-mail:** info@ketchikanarts.org. **Website:** www.ketchikanarts.org. **Contact:** Marni Rickelmann, program director. Estab. 1953. Nonprofit gallery. Exhibits emerging, mid-career and established artists. Number of artists represented or exhibited varies based on applications. Applications annually accepted for March 1 deadline. Sponsors 11 total exhibits/year. Model and property release are preferred. Average display time 20 days-1 month. Open Monday-Friday, 9-5; Saturday, 11-3. Closed last 2 weeks of December. Located in downtown Ketchikan, housed in renovated church. 800 sq. ft. Clients include local community, students, tourists, upscale. Overall price range of work sold $20-4,000. Most work sold at $150.

MAKING CONTACT & TERMS There is a membership fee plus a donation of time. There is a 25% commission. Retail price set by the artist. Gallery provides insurance, promotion and contract. Accepted work should be framed and mounted.

SUBMISSIONS E-mail query letter with link to artist's website, 10 JPEG samples at 72 dpi or résumé and proposal. March 1 gallery exhibit deadline for September-August season. Returns material with SASE. Responds in 2 months from March 1 deadline. Files all application materials. Finds artists through word of mouth, submissions, art exhibits and referrals from other artists.

TIPS Respond clearly to application.

⊕ BEN MALTZ GALLERY

Otis College of Art & Design, Ground Floor, Bronya and Andy Galef Center for Fine Arts, 9045 Lincoln Blvd., Los Angeles CA 90045. (310)665-6905. **E-mail:** galleryinfo@otis.edu. **Website:** www.otis.edu/ben maltzgallery. Estab. 1957. Nonprofit gallery. Exhibits local, national and international emerging, mid-career and established artists. Sponsors 4-6 exhibits/year. Average display time: 1-2 months. Open Tuesday–Friday, 10-5 (Thursday, 10-9); Saturday-Sunday, 12-4; closed Mondays and major holidays. Located near Los Angeles International Airport (LAX); approximately 3,520 sq. ft.; 14-ft. walls. Clients include students, Otis community, local and city com-munity, regional art community, artists, collectors and tourists.

EXHIBITS Fine art/design. Considers all media, most frequently exhibits paintings, drawings, mixed media, sculpture and video.

SUBMISSIONS Submission guidelines available online. Submissions via internet only. Do not send other materials unless requested by the gallery after your initial submission has been reviewed.

TIPS "Follow submission guidelines and be patient. Attend opening receptions when possible to familiarize yourself with the gallery, director, curators and artists."

MARIN MUSEUM OF CONTEMPORARY ART

500 Palm Dr., Novato CA 94949. (415)506-0137. **Fax:** (415)506-0139. **E-mail:** info@marinmoca.org. **Website:** www.marinmoca.org. **Contact:** Heidi LaGrasta, executive director. Estab. 2007. Nonprofit gallery. Exhibits emerging, mid-career and established artists. Sponsors 15+ exhibits/year; 1 photography exhibit/year. Model and property release is preferred. Average display time 5 weeks. Open Wednesday-Sunday, 11-4; closed Thanksgiving, Christmas, New Year's Day. MarinMOCA is located in historic Hamilton Field, a former Army Air Base. The Spanish-inspired architecture makes for a unique and inviting exterior and interior space. Houses 2 exhibition spaces—the Main Gallery (1,633 sq. ft.) and the Hamilton Gallery (750 sq. ft.). Part of the Novato Arts Center, which also contains approximately 40 artist studios and a classroom (offers adult classes and a summer camp for children). Clients include local community, students, tourists, upscale. Overall price range $200-20,000. Most work sold at $500-1,000.

EXHIBITS Considers all media except video. Most frequently exhibits acrylic, oil, sculpture/installation. Considers all prints, styles and genres.

MAKING CONTACT & TERMS Artwork is accepted on consignment and there is a 40% commission. Retail price of the art set by the artist. Gallery provides insurance, promotion (for single exhibition only, not representation), contract (for consignment only, not representation). Accepted work should be framed (canvas can be unframed, but prints/collage/photos should be framed). "We do not have exclusive contracts with, nor do we represent artists."

SUBMISSIONS "We are currently not accepting portfolio submissions at this time. Please visit our

website for updates. If you are interested in gallery rental, please visit our website and follow the instructions." Finds artists through word of mouth and portfolio reviews.

TIPS "Keep everything clean and concise. Avoid lengthy, flowery language and choose clear explanations instead. Submit only what is requested and shoot for a confident, yet humble tone. Make sure images are good quality (300 dpi) and easily identifiable regarding title, size, medium."

MARKEIM ART CENTER

104 Walnut St., Haddonfield NJ 08033. (856)429-8585. **E-mail:** markeim@verizon.net. **Website:** www.markeimartcenter.org. **Contact:** Elizabeth H. Madden, managing director. Estab. 1956. Sponsors 10-11 exhibits/year. Average display time 4 weeks. The exhibiting artist is responsible for all details of the opening. Overall price range $75-1,000. Most work sold at $350.

EXHIBITS Interested in all types work. Exhibits photos of babies/children/teens, celebrities, couples, multicultural, families, parents, senior citizens, environmental, landscapes/scenics, wildlife, architecture, cities/urban, education, rural, adventure, automobiles, entertainment, performing arts, sports, travel, agriculture, product shots/still life. Interested in alternative process, avant garde, documentary, fine art, historical/vintage, seasonal.

MAKING CONTACT & TERMS Charges 30% commission. Accepted work should be framed and wired, ready to hang, mounted or unmounted, matted or unmatted. Artists from New Jersey and Delaware Valley region are preferred. Work must be professional and high quality.

SUBMISSIONS Send slides by mail or e-mail for consideration. Include SASE, résumé and letter of intent. Responds in 1 month.

TIPS "Be patient and flexible with scheduling. Look not only for one-time shows, but for opportunities to develop working relationships with a gallery. Establish yourself locally and market yourself outward."

MARLBORO GALLERY

Prince George's Community College, 301 Largo Rd., Largo MD 20774. (301)322-0965. **E-mail:** beraulta@pgcc.edu. **Website:** academic.pgcc.edu/art/gallery. **Contact:** Tom Berault, curator-director. Estab. 1976. Average display time 6 weeks. Overall price range $50-2,000. Most work sells at $75-350.

EXHIBITS Fine art, photos of celebrities, portraiture, landscapes/scenics, wildlife/adventure, entertainment, events and travel. Also interested in alternative processes, experimental/manipulated, avant garde photographs. Not interested in commercial work.

MAKING CONTACT & TERMS "We do not take commission on artwork sold." Accepted work must be framed and suitable for hanging.

SUBMISSIONS "We are most interested in fine art photos and need 10-20 examples to make assessment. Reviews are done on an ongoing basis. We prefer to receive submissions February through April." Please send cover letter with résumé, CD with 15 to 20 JPEGs (300 ppi, 5×7), image list with titles, media and dimensions, artist's statement, and SASE to return. Responds in 1 month.

TIPS "Send examples of what you wish to display, and explanations if photos do not meet normal standards (e.g., out of focus, experimental subject matter)."

MASUR MUSEUM OF ART

1400 S. Grand St., Monroe LA 71202. (318)329-2237. **Fax:** (318)329-2847. **E-mail:** info@masurmuseum.org; evelyn.stewart@ci.monroe.la.us. **Website:** www.masurmuseum.org. **Contact:** Evelyn Stewart, director. Estab. 1963. Approached by 500 artists/year; represents or exhibits 150 artists. Sponsors 2 photography exhibits/year. Average display time 2 months. Museum open Tuesday–Friday, 9-5; Saturday, 12-5. Closed Mondays, between exhibitions and on major holidays. Located in historic home, 3,000 sq. ft. Overall price range $100-12,000. Most work sold at $300.

EXHIBITS Photos of babies/children/teens, celebrities, environmental, landscapes/scenics. Interested in alternative process, avant garde, documentary, fine art, historical/vintage.

MAKING CONTACT & TERMS Artwork is accepted on consignment, and there is a 20% commission. Gallery provides insurance, promotion. Accepted work should be framed.

SUBMISSIONS Send query letter with artist's statement, bio, résumé, reviews, slides, SASE. Responds in 6 months. Finds artists through word of mouth, submissions, art exhibits, referrals by other artists.

MAUI HANDS

P.O. Box 974, Makawao, HI 96768 (808)573-2021. **Fax:** (808)573-2022. **E-mail:** panna@mauihands.com. **Website:** www.mauihands.com. **Contact:** Panna Cappelli, owner. Estab. 1992. For-profit gallery. Ap-

proached by 50-60 artists/year. Continuously exhibits 300 emerging, mid-career and established artists. Exhibited artists include Linda Whittemore (abstract monotypes) and Steven Smeltzer (ceramic sculpture). Sponsors 15-20 exhibits/year; 2 photography exhibits/year. Average display time: 1 month. Open Monday-Sunday, 10-7; weekends, 10-6. Closed on Christmas and Thanksgiving. Four spaces: #1 on Main Highway, 1,200-sq.-ft. gallery, 165-sq.-ft. exhibition; #2 on Main Highway, 1,000-sq.-ft. gallery, 80-sq.-ft. exhibition; #3 in resort, 900-sq.-ft. gallery, 50-sq.-ft. exhibition; #4 1169 Makawao Ave., Makawao HI 96768. Clients include local community, tourists and upscale. 3% of sales are to corporate collectors. Overall price range: $10-7,000. Most work sold at $350.

EXHIBITS Considers all media. Most frequently exhibits oils, pastels, and mixed media. Considers engravings, etchings, linocuts, lithographs, and serigraphs. Styles considered are painterly abstraction, impressionism and primitivism realism. Most frequently exhibits impressionism and painterly abstraction. Genres include figurative work, florals, landscapes and portraits.

MAKING CONTACT & TERMS Artwork accepted on consignment with a 55% commission. Retail price of the art set by the gallery and artist. Gallery provides insurance and promotion. Artwork should be framed, mounted and matted, as applicable. Only accepts artists from Hawaii.

SUBMISSIONS Artists should call, write to arrange personal interview to show portfolio of original pieces, e-mail query letter with link to artist's website (JPEG samples at 72 dpi) or send query letter with artist's statement, bio, brochure, photographs, résumé, business cards and reviews. Responds in days. All materials filed. Finds artists through word of mouth, submissions, portfolio reviews, art exhibits, art fairs and referrals by other artists.

TIPS "Best to submit your work via e-mail."

ERNESTO MAYANS GALLERY

601 Canyon Rd., Santa Fe NM 87501. (505)983-8068. **E-mail:** arte2@aol.com. **Website:** ernestomayansgallery.com. **Contact:** Ernesto Mayans, director. Estab. 1977. Publishers, retail gallery and art consultancy. Publishes books, catalogs and portfolios. Overall price range: $200-$5,000. Considers oil, acrylic, watercolor, pastel, pen & ink, drawings, mixed media, sculpture, photography, and original, handpulled prints. Most frequently exhibits oil, photography and lithographs. Exhibits 20th-century American and Latin American art. Genres include landscapes and figurative work. "We exhibit Photogravures by Unai San Martin; Pigment prints by Pablo Mayans, Silver Gelatin prints by Richard Faller (Vintage Southwest Works) and Johanna Saretzki and Sean McGann (Nudes)."

MAKING CONTACT & TERMS Accepts work on consignment (50% commission). Retail price set by gallery and artist. Requires exclusive representation within area. "Please call before submitting." Arrange a personal interview to show portfolio. Send query by mail with SASE for consideration. Size limited to 11×20 maximum. Responds in 2 weeks.

MCDONOUGH MUSEUM OF ART

525 Wick Ave., Youngstown OH 44555-1400. (330)941-1400. **E-mail:** labrothers@ysu.edu. **Website:** mcdonoughmuseum.ysu.edu. **Contact:** Leslie Brothers, director. Estab. 1991. A center for contemporary art, education and community, the museum offers exhibitions in all media, experimental installation, performance, and regional outreach programs to the public. The museum is also the public outreach facility for the Department of Art and supports student and faculty work through exhibitions, collaborations, courses and ongoing discussion. Open Tuesday-Saturday, 11-4.

SUBMISSIONS Send exhibition proposal.

MESA CONTEMPORARY ARTS AT MESA ARTS CENTER

P.O. Box 1466, Mesa AZ 85211. (480)644-6561; (480)644-6560. **E-mail:** patty.haberman@mesaartscenter.com. **Website:** www.mesaartscenter.com. **Contact:** Patty Haberman, curator. Estab. 1980. Not-for-profit art space. "Mesa Contemporary Arts is the dynamic visual art exhibition space at Mesa Arts Center. In 5 stunning galleries, Mesa Contemporary Arts showcases curated and juried exhibitions of contemporary art by emerging and internationally recognized artists. We also offer lectures by significant artists and arts professionals, art workshops and a volunteer docent program." Public admission: $3.50; free for children ages 7 and under; free on Thursdays (sponsored by Salt River Project); free on the first Sunday of each month, via the "3 for Free" program sponsored by Target (also includes free admission to the Arizona Museum for Youth and the Arizona Mu-

seum of Natural History). "Currently not accepting unsolicited proposals. Artists who do not follow the guidelines outlined in the Prospectus and were not contracted directly by Mesa Contemporary Arts staff about participating in an exhibition are considered unsolicited artists. Artists who apply for an opportunity and follow the guidelines in the Prospectus are not considered unsolicited. Unsolicited materials will be returned without comment."

EXHIBITS Photos of babies/children/teens, celebrities, couples, multicultural, families, parents, senior citizens, disasters, environmental, landscapes/scenics, wildlife, architecture, cities/urban, interiors/decorating, rural, adventure, automobiles, entertainment, events, performing arts, travel, industry, political, science, technology/computers. Interested in alternative process, avant garde, documentary, fine art, historical/vintage, seasonal, and contemporary photography.

MAKING CONTACT & TERMS Charges $25 entry fee, 25% commission.

TIPS "We do invitational or national juried exhibits. Submit professional-quality slides."

⊘ R. MICHELSON GALLERIES

132 Main St., Northampton MA 01060. (413)586-3964. **Fax:** (413)587-9811. **E-mail:** RM@RMichelson.com. **Website:** www.rmichelson.com. **Contact:** Richard Michelson, owner and president. Estab. 1976. Retail gallery. Sponsors 1 exhibit/year. Average display time 6 weeks. Open all year; Monday-Wednesday, 10-6; Thursday-Saturday, 10-9; Sunday, 12-5. Located downtown; Northampton gallery has 3,500 sq. ft.; Amherst gallery has 1,800 sq. ft. 50% of space for special exhibitions. Clientele 80% private collectors, 20% corporate collectors. Sponsors openings. Overall price range $1,200-15,000.

EXHIBITS Interested in contemporary, landscape and/or figure work.

MAKING CONTACT & TERMS Sometimes buys photos outright. Accepted work can be framed or unframed, mounted or unmounted, matted or unmatted. Requires exclusive representation locally. Not taking on new photographers at this time.

MILL BROOK GALLERY & SCULPTURE GARDEN

236 Hopkinton Rd., Concord NH 03301. (603)226-2046. **E-mail:** artsculpt@mindspring.com. **Website:** www.themillbrookgallery.com. Estab. 1996. Exhibits 70 artists. Sponsors 1 photography exhibit/year. Average display time 6 weeks. Gallery open Tuesday–Sunday, 11-5, April 1–December 24; and by appointment. Outdoor juried sculpture exhibit. Three rooms inside for exhibitions, 1,800 sq. ft. Overall price range $8-30,000. Most work sold at $500-1,000.

MAKING CONTACT & TERMS Artwork is accepted on consignment, and there is a 50% commission. Gallery provides insurance, promotion, contract. Accepted work should be framed, matted.

SUBMISSIONS Write to arrange a personal interview to show portfolio of photographs, slides. Send query letter with artist's statement, bio, photocopies, photographs, résumé, slides, SASE. Responds within 1 month, only if interested. Finds artists through word of mouth, submissions, art exhibits, referrals by other artists.

PETER MILLER GALLERY

118 N. Peoria St., Chicago IL 60607. (312)226-5291; (312)951-1700. **Fax:** (312)226-5441. **E-mail:** director@petermillergallery.com. **Website:** www.peter millergallery.com. **Contact:** Peter Miller and Natalie R. Domchenko, directors. Estab. 1979. The Peter Miller Gallery exhibits contemporary art by emerging and mid-career artists. The gallery's current direction spans a broad range of contemporary art practice, including photo-based work, sound and video installations as well as painting and sculpture. The current location in Chicago's West Loop Gallery District occupies approximately 1,800 sq. ft. on the ground floor. The main exhibition gallery has its own project space and the office/reception area has 2 smaller project rooms. Overall price range $1,000-40,000. Most work sold at $5,000.

EXHIBITS Painting, sculpture, photography and new media.

MAKING CONTACT & TERMS Charges 50% commission. Accepted work can be framed or unframed, mounted or unmounted, matted or unmatted. Requires exclusive representation locally.

SUBMISSIONS Send CD with minimum of 20 images (no details) from the last 18 months with SASE, or e-mail a link to your website to director@petermillergallery.com.

TIPS "We look for work we haven't seen before; i.e., new images and new approaches to the medium."

MILLS POND HOUSE GALLERY

Smithtown Township Arts Council, 660 Route 25 A, St. James NY 11780. **E-mail:** gallery@stacarts.org.

Website: www.stacarts.org. **Contact:** Gallery coordinator. Nonprofit gallery. Sponsors 9 exhibits/year (1-2 photography). Average display time is 5 weeks. Hours: Monday–Friday 10-5; weekends, 12-4. Considers all types of prints, media and styles. Prices set by the artist. Gallery provides insurance and promotion. Work should be framed. Clients: local and national community.

MOBILE MUSEUM OF ART

4850 Museum Dr., Mobile AL 36608-1917. (251)208-5200; (251)208-5221. **E-mail:** dklooz@mobilemuseum ofart.com. **Website:** www.mobilemuseumofart.com. **Contact:** Donan Klooz, curator of exhibitions. Sponsors 4 exhibits/year. Average display time 3 months. Sponsors openings; provides light hors d'oeuvres and cash bar.

EXHIBITS Open to all types and styles.

MAKING CONTACT & TERMS Photography sold in gallery. Charges 20% commission. Occasionally buys photos outright. Accepted work should be framed.

SUBMISSIONS Arrange a personal interview to show portfolio; send material by mail for consideration. Returns material when SASE is provided "unless photographer specifically points out that it's not required."

TIPS "We look for personal point of view beyond technical mastery."

MONTEREY MUSEUM OF ART

559 Pacific St., Monterey CA 93940. (831)372-5477. **Fax:** (831)372-5680. **E-mail:** info@montereyart.org. **Website:** www.montereyart.org. Estab. 1969. One museum, two fabulous locations. Additional location at 720 Via Mirada, Monterey CA 93940. Presents up to 20 exhibitions annually. Open Wednesday-Saturday, 11-5; Sunday, 1-4. Closed Thanksgiving, Christmas, New Year's, and July 4. Check website for location details, exhibition schedule and calendar of events including free-admission days, family day activities and programs for children, exhibition opening event dates, and more.

EXHIBITS Interested in all subjects.

MAKING CONTACT & TERMS Accepted work should be framed.

SUBMISSIONS Send slides by mail for consideration; include SASE. Responds in 1 month.

TIPS "Send 20 slides and résumé at any time to the attention of the museum curator."

MULTIPLE EXPOSURES GALLERY

Torpedo Factory Art Center, 105 N. Union St. #312, Alexandria VA 22314. (703)683-2205. **E-mail:** info@ multipleexposuresgallery.com. **Website:** www.mul tipleexposuresgallery.com. Estab. 1986. Cooperative gallery. Represents or exhibits 15 artists. Sponsors 12 photography exhibits/year. Average display time 1-2 months. Open daily, 10-6. Closed on 5 major holidays throughout the year. Located in Torpedo Factory Art Center; 10-ft. walls with about 40 ft. of running wall space; 1 bin for each artist's matted photos, up to 20×24 in size with space for 25 pieces.

EXHIBITS Photos of landscapes/scenics, architecture, beauty, cities/urban, religious, rural, adventure, automobiles, events, travel, buildings. Interested in alternative process, documentary, fine art. Other specific subjects/processes: "We have on display roughly 300 images that run the gamut from platinum and older alternative processes through digital capture and output."

MAKING CONTACT & TERMS There is a co-op membership fee, a time requirement, a rental fee and a 15% commission. Accepted work should be matted. *Accepts only artists from Washington DC, region.* Accepts only photography. "Membership is by jury of active current members. Membership is limited. Jurying for membership is only done when a space becomes available; on average, 1 member is brought in about every 2 years."

SUBMISSIONS Send query letter with SASE to arrange a personal interview to show portfolio of photographs, slides. Responds in 2 months. Finds artists through word of mouth, referrals by other artists, ads in local art/photography publications.

TIPS "Have a unified portfolio of images mounted and matted to archival standards."

MICHAEL MURPHY GALLERY M

2701 S. MacDill Ave., Tampa FL 33629. (813)902-1414. **Fax:** (813)835-5526. **Website:** www.michaelmur phygallery.com. **Contact:** Michael Murphy. Estab. 1988. (Formerly Michael Murphy Gallery, Inc.) For-profit gallery. Approached by 100 artists/year; exhibits 35 artists. Sponsors 1 photography exhibit/year. Average display time 1 month. See website for current gallery hours. Overall price range $500-15,000. Most work sold at less than $1,000. "We provide elegant, timeless artwork for our clients' home and office environment as well as unique and classic framing design.

We strongly believe in the preservation of art through the latest technology in archival framing."

EXHIBITS Photos of babies/children/teens, celebrities, couples, multicultural, families, parents, senior citizens, disasters, environmental, landscapes/scenics, wildlife, architecture, cities/urban, education, gardening, interiors/decorating, pets, religious, rural, agriculture, business concepts, industry, medicine, military, political, product shots/still life, science, technology/computers. Interested in alternative process, avant garde, documentary, erotic, fashion/glamour, fine art, historical/vintage, seasonal.

MAKING CONTACT & TERMS Artwork is accepted on consignment, and there is a 50% commission. Accepted work should be framed. Requires exclusive representation locally.

SUBMISSIONS Send query with artist's statement, bio, brochure, business card, photocopies, photographs, résumé, reviews, slides and SASE. Responds to queries in 1 month, only if interested.

MUSEO DE ARTE DE PONCE

2325 Las Americas Ave., Ponce Puerto Rico 00717. (787)848-0505, ext. 231; (787)840-1510. **Fax:** (787)841-7309. **E-mail:** info@museoarteponce.org. **Website:** www.museoarteponce.org. **Contact:** Curatorial department. Estab. 1959. Museum. Approached by 50 artists/year; mounts 3 exhibitions/year. Satellite gallery in Plaza las Americas, San Juan. Open Wednesday-Monday, 10-6. Closed New Year's Day, January 6, Good Friday, Thanksgiving and Christmas Day. Admission: $6 for adults, $3 for senior citizens, students with an ID card, and children.

EXHIBITS Interested in avant garde, fine art, European and Old Masters.

SUBMISSIONS Send query letter with artist's statement, résumé, images, reviews, publications. Responds in 3 months. Finds artists through research, art exhibits, studio and gallery visits, word of mouth, referrals by other artists.

MUSEO ITALOAMERICANO

Fort Mason Center, Bldg. C, San Francisco CA 94123. (415)673-2200. **Fax:** (415)673-2292. **E-mail:** sfmuseo@sbcglobal.net. **Website:** www.museoitalo americano.org. Estab. 1978. Museum. "The first museum in the U.S. devoted exclusively to Italian and Italian-American art and culture." Approached by 80 artists/year; exhibits 15 artists. Sponsors 1 photography exhibit/year (depending on the year). Average display

time 2-3 months. Open Tuesday–Sunday, 12-4; Monday by appointment. Closed major holidays. Gallery is located in the San Francisco Marina District, with a beautiful view of the Golden Gate Bridge, Sausalito, Tiburon and Alcatraz; 3,500 sq. ft. of exhibition space.

EXHIBITS Photos of babies/children/teens, celebrities, couples, multicultural, families, parents, senior citizens, environmental, landscapes/scenics, architecture, cities/urban, education, religious, rural, entertainment, events, food/drink, hobbies, humor, performing arts, sports, travel, product shots/still life. Interested in alternative process, avant garde, documentary, fine art, historical/vintage.

MAKING CONTACT & TERMS "The museum rarely sells pieces. If it does, it takes 20% of the sale." Museum provides insurance, promotion. Accepted work should be framed, mounted, matted. *Accepts only Italian or Italian-American artists.*

SUBMISSIONS Call or write to arrange a personal interview to show portfolio of photographs, slides, catalogs. Send query letter with artist's statement, bio, brochure, photographs, résumé, reviews, slides, SASE. Responds in 2 months. Finds artists through word of mouth, submissions.

TIPS "Photographers should have good, quality reproduction of their work with slides, and clarity in writing their statements and résumés. Be concise."

MUSEUM OF CONTEMPORARY ART SAN DIEGO

700 Prospect St., La Jolla CA 92037-4291. (858)454-3541. **E-mail:** info@mcasd.org. **Website:** www.mcasd.org. Estab. 1941. Museum. With 2 locations, MCASD is the region's foremost forum devoted to the exploration and presentation of the art of our time, presenting works across all media since 1950. Located in the heart of downtown San Diego and the coastal community of La Jolla. Open daily, 11–5. Closed Wednesdays and during installation (both locations).

EXHIBITS Photos of families, architecture, education. Interested in avant garde, documentary, fine art.

SUBMISSIONS See artist proposal guidelines at mcasd.org/about/artist-proposals.

MUSEUM OF CONTEMPORARY PHOTOGRAPHY, COLUMBIA COLLEGE CHICAGO

600 S. Michigan Ave., Chicago IL 60605. (312)369-7104; (312)663-5554. **Fax:** (312)369-8067; (312)344-8067. **E-mail:** curatorialcommittee@colum.edu. **Web-**

site: www.mocp.org. **Contact:** Portfolio review coordinator. Estab. 1984. "We offer our audience a wide range of provocative exhibitions in recognition of photography's roles within the expanded field of imagemaking." Sponsors 6 main exhibits and 4-6 smaller exhibits/year. Average display time 2 months. Open Monday–Friday, 10-5; Thursday, 10-8; Saturday, 10-5; Sunday 12-5.

EXHIBITS Collects and exhibits national and international works including portraits, environment, architecture, urban, rural, performance art, political issues, journalism, social documentary, mixed media, video. Primarily interested in experimental work of the past ten years.

SUBMISSIONS Reviews of portfolios for purchase and/or exhibition held monthly. Submission protocols on website. Responds in 2-3 months. No critical review guaranteed.

TIPS "Professional standards apply; only very high-quality work considered."

MUSEUM OF PHOTOGRAPHIC ARTS

1649 El Prado, San Diego CA 92101. (619)238-7559. **Fax:** (619)238-8777. **E-mail:** klochko@mopa.org; curate@mopa.org. **Website:** www.mopa.org. **Contact:** Debra Klochko, executive director. Estab. 1983. MOPA is devoted to collecting, conserving and exhibiting the entire spectrum of the photographic medium. Sponsors 12 exhibits/year. Average display time 3 months.

EXHIBITS Interested in the history of photography, from the 19th century to the present.

MAKING CONTACT & TERMS "The criteria is simply that the photography be of advanced artistic caliber, relative to other fine art photography. MoPA is a museum and therefore does not sell works in exhibitions." Exhibition schedules planned 2-3 years in advance. Holds a private members' opening reception for each exhibition.

SUBMISSIONS "For space, time and curatorial reasons, there are few opportunities to present the work of newer, lesser-known photographers." Send a CD, website or JPEGs to curator. Curator will respond, and if interested, will request materials for future consideration. Include a résumé, short statement and any other supplementary material. "We ask that all submitted materials be no larger than 8½×11." Files are kept on contemporary artists of note for future ref-

erence. Send return address and postage if you wish your materials returned. Responds in 2 months.

TIPS "Exhibitions presented by the museum represent the full range of artistic and journalistic photographic works. There are no specific requirements. The executive director and curator make all decisions on works that will be included in exhibitions. There is an enormous stylistic diversity in the photographic arts. The museum does not place an emphasis on one style or technique over another."

MUSEUM OF PRINTING HISTORY

1324 W. Clay, Houston TX 77019. (713)522-4652. **E-mail:** kburrows@printingmuseum.org. **Website:** www.printingmuseum.org. **Contact:** Ann Kasman, executive director; Keelin Burrows, curator. Estab. 1982. "The mission of the museum is to promote, preserve and share the knowledge of printed communication and art as the greatest contributors to the development of the civilized world and the continuing advancement of freedom and literacy." Represents or exhibits approximately 12 exhibitions/year. Sponsors 1 photography exhibit/year. Average display time 12 weeks. Open Tuesday–Saturday, 10-5. Closed 4th of July, Thanksgiving, Christmas Eve, Christmas, New Year's Eve/Day.

MUSEUM OF THE PLAINS INDIAN

P.O. Box 410, Browning MT 59417. (406)338-2230. **Fax:** (406)338-7404. **E-mail:** mpi@3rivers.net. **Website:** www.doi.gov/iacb/museums/museum_plains. html. Estab. 1941. Open daily, 9-4:45 (June-September); Monday–Friday, 10-4:30 (October-May). Admission is free of charge October–May. Contact for additional information.

NEVADA MUSEUM OF ART

160 W. Liberty St., Reno NV 89501. (775)329-3333. **Fax:** (775)329-1541. **E-mail:** rachel.milon@nevadaart. org. **Website:** www.nevadaart.org. **Contact:** Ann Wolfe, senior curator. Estab. 1931. Sponsors 12-15 exhibits/year in various media. Average display time 4-5 months.

SUBMISSIONS See website for detailed submission instructions. No phone calls, please."

TIPS "We are a museum of ideas. While building upon our founding collections and values, we cultivate meaningful art and societal experiences, and foster new knowledge in the visual ares by encouraging interdisciplinary investigation. The Nevada Museum

of Art serves as a cultural and educational resource for everyone."

NEW GALLERY/THOM ANDRIOLA

3225 Milam, Houston TX 77006. (832)830-8778. **Fax:** (713)520-1145. **E-mail:** info@newgalleryhouston.com. **Website:** www.newgalleryhouston.com. **Contact:** Thom Andriola, director. For-profit gallery. Represents or exhibits 22 artists/year. Sponsors 3 photography exhibits/year. Average display time 1 month. Open Tuesday–Saturday, 11-5.

MAKING CONTACT & TERMS Artwork is accepted on consignment, and there is a 50% commission. Requires exclusive representation locally.

NEW MEXICO STATE UNIVERSITY ART GALLERY

P.O. Box 30001, Las Cruces NM 88003-8001. (575)646-2545. **Fax:** (575)646-8036. **E-mail:** artglry@nmsu.edu. **Website:** www.nmsu.edu/~artgal. **Contact:** director. Estab. 1969. Museum. Average display time 2-3 months. Gallery open Tuesday–Saturday, 12-4; Wednesday evenings, 6-8. Closed Christmas through New Year's Day and university holidays. See website for summer hours. Located on university campus, 3,900 sq. ft. of exhibit space.

NEW ORLEANS MUSEUM OF ART

P.O. Box 19123, New Orleans LA 70179-0123. (504)658-4100. **Fax:** (504)658-4199. **E-mail:** staylor@noma.org. **Website:** www.noma.org. **Contact:** Susan Taylor, director. Estab. 1973. "The city's oldest fine arts institution, NOMA has a magnificent permanent collection of more than 40,000 objects. The collection, noted for its extraordinary strengths in French and American art, photography, glass, African and Japanese works, continues to grow." Sponsors exhibits continuously. Average display time 1-3 months. Open Tuesday–Thursday, 11-6; Friday, 11-9; Saturday and Sunday, 11-5.

EXHIBITS Interested in all types of photography.

MAKING CONTACT & TERMS Buys photography outright; payment negotiable. "Current budget for purchasing contemporary photography is very small." Sometimes accepts donations from established artists, collectors or dealers.

SUBMISSIONS Send query letter with color photocopies (preferred) or slides, résumé, SASE. Accepts images in digital format; submit via website. Responds in 3 months.

TIPS "Send thought-out images with originality and expertise. Do not send commercial-looking images."

NEXUS/FOUNDATION FOR TODAY'S ART

1400 N. American St., Philadelphia PA 19122. **E-mail:** info@nexusphiladelphia.org. **Website:** www.nexusphiladelphia.org. Estab. 1975. Alternative space; co-operative, nonprofit gallery. Approached by 40 artists/year; represents or exhibits 20 artists. Sponsors 2 photography exhibits/year. Average display time 1 month. Open Wednesday–Sunday, 12-6; closed July and August. Located in Fishtown, Philadelphia; 2 gallery spaces, approximately 750 sq. ft. each. Overall price range: $75-1,200. Most work sold at $200-400.

EXHIBITS Photos of multicultural, families, environmental, architecture, rural, entertainment, humor, performing arts, industry, political. Interested in alternative process, documentary, fine art.

SUBMISSIONS Send query letter with artist's statement, bio, photocopies, photographs, slides, SASE. Finds artists through portfolio reviews, referrals by other artists, submissions, and juried reviews 2 times/year. "Please visit our website for submission dates."

TIPS "Learn how to write a cohesive artist's statement."

NICOLAYSEN ART MUSEUM & DISCOVERY CENTER

400 E. Collins St., Casper WY 82601. (307)235-5247. **E-mail:** info@thenic.org. **Website:** www.thenic.org. **Contact:** Connie Gibbons, executive director. Estab. 1967. Regional contemporary art museum. Average display time 3-4 months. Interested in emerging, mid-career and established artists. Sponsors 10 solo and 10 group shows/year. Open all year. Clientele 90% private collectors, 10% corporate clients.

EXHIBITS Considers all media with special attention to regional art.

SUBMISSIONS Send résumé, statement and biography as well as images in digital format. "Due to the volume of correspondence we receive, we may not be able to respond directly to each and every submission and we cannot assume responsibility for or guarantee the return of any materials that are submitted."

NICOLET COLLEGE ART GALLERY

5355 College Dr., P.O. Box 518, Rhinelander WI 54501. (715)365-4556. **E-mail:** kralph@nicoletcollege.edu. **Website:** www.nicoletcollege.edu/about/creative-arts-series/art-gallery/index.html. **Contact:** Katy Ralph, gallery director. Exhibits 9-11 different shows

each year including the Northern National Art Competition. The deadline for the annual competition is in May. For a prospectus, or more information, contact gallery director, Katy Ralph.

MAKING CONTACT & TERMS Call or e-mail for further information.

NKU GALLERY

Northern Kentucky University, Art Galleries, Nunn Dr., Highland Heights KY 41099. (859)572-5148. **Fax:** (859)572-6501. **E-mail:** knight@nku.edu. **Website:** artscience.nku.edu/departments/art/galleries.html. **Contact:** David Knight, director of collections and exhibitions. Estab. 1970. The NKU Art Department Galleries are located on the 3rd floor of the Fine Arts Center. There are 2 gallery spaces: The Main Gallery and the Third Floor Gallery. Approached by 30 artists/year; represents or exhibits 5-6 artists. Average display time 1 month. Open Monday–Friday, 9-9; closed weekends and major holidays. Main Gallery is 2,500 sq. ft.; Third Floor Gallery is 600 sq. ft. Overall price range $25-3,000. Most work sold at $500.

MAKING CONTACT & TERMS Gallery provides insurance, promotion, contract. Accepted work should be framed, mounted, matted.

SUBMISSIONS Finds artists through word of mouth, art exhibits, referrals by other faculty.

TIPS "Submission guidelines, current exhibitions and complete information available on our website."

NORTHWEST ART CENTER

Minot State University, 500 University Ave. W., Minot ND 58707. (701)858-3264. **Fax:** (701)858-3894. **E-mail:** nac@minotstateu.edu. **Website:** www.minotstateu.edu/nac. Estab. 1969. Nonprofit gallery. Represents emerging, mid-career and established artists. Represents 20 artists. Sponsors 20 total exhibits/year; 2 photography exhibits/year. Model and property release preferred. Average display time: 4 weeks. Open Monday-Friday, 9-4. Two galleries located on university campus, each gallery approximately 100 linear feet. Clients include local community and students. 50% of sales are to corporate collectors. Overall price range: $100-1,000; most work sold at $350.

EXHIBITS Special interest in printmaking, works on paper, contemporary art and drawings.

MAKING CONTACT & TERMS Accepted work should be framed and mounted. Artwork is accepted on consignment with a 30% commission. Retail price set by the artist. Gallery provides insurance, promotion and contract.

SUBMISSIONS Send query letter with artist's statement, photocopies bio, résumé and reviews. Returns material with SASE. Responds, if interested, within 3 months. Finds artists through art exhibits, submissions, referrals by other artists and entries in our juried competitions.

NORTHWESTERN UNIVERSITY DITTMAR MEMORIAL GALLERY

1999 Campus Dr., Norris University Center, Evanston IL 60208. (847)491-2348. **E-mail:** dittmargallery@u.northwestern.edu. **Website:** www.dittmar.northwestern.edu. **Contact:** gallery coordinator. Estab. 1972. Nonprofit, student-operated gallery. Approached by over 100 artists/year, including 10-15 photographers; represents or exhibits more than 10 artists. Sponsors 1-2 photography exhibits/year. Average display time 6 weeks. Open daily 10-10. Closed in December during winter break. The gallery is located within the Norris Student Center on the main floor behind the information desk.

EXHIBITS Photos of babies/children/teens, couples, multicultural, families, parents, disasters, environmental, landscapes/scenics, wildlife, architecture, cities/urban, education, gardening, adventure, automobiles, entertainment, events, food/drink, health/fitness, hobbies, humor, performing arts, sports, travel. Interested in avant garde, fashion/glamour, fine art, historical/vintage, seasonal.

MAKING CONTACT & TERMS Artwork is accepted on consignment, and there is a 20% commission. Gallery provides promotion, contract. Accepted work should be mounted.

SUBMISSIONS Mail portfolio for review. Send query letter with 5 images that "demonstrate the work you are proposing for a show" or previous work with proposal for a new show, work list for the images including title, medium, size and year, artist's statement, résumé, and any available contact information. Responds in 3 months. Finds artists through word of mouth, submissions, referrals by other artists.

TIPS "Do not send photocopies. Send a typed letter and good photos, images need to be high resolution. Send résumé of past exhibits, or if emerging, a typed statement."

THE NOYES MUSEUM OF ART

733 Lily Lake Rd., Oceanville NJ 08231. (609)652-8848. **Fax:** (609)652-6166. **E-mail:** info@noyesmuseum.org. **Website:** www.noyesmuseum.org. **Contact:** Michael Cagno, executive director; Dorrie Papademetriou, director of exhibitions. Estab. 1983. Sponsors 10-12 exhibits/year. Average display time 12 weeks. The Noyes Museum of Art of The Richard Stockton College of New Jersey presents exhibitions and events that benefit students and enthusiasts of the arts, as well as the entire southern New Jersey community. In 2010, Stockton partnered with the Noyes Museum, bringing an expanded array of educational opportunities, events, exhibits and performances to the nearby off-campus facility. Stockton is also home to one of the area's top performing arts centers, and its own art gallery.

EXHIBITS Interested in alternative process, avant garde, fine art, historical/vintage.

MAKING CONTACT & TERMS Charges commission. Accepted work must be ready for hanging, preferably framed. Infrequently buys photos for permanent collection.

SUBMISSIONS Any format OK for initial review; most desirable is a challenging, cohesive body of work. Send material by mail for consideration; include résumé, artist's statement, slide samples or CD, handwritten proposals not accepted. May include photography and mixed media. See website for further details.

TIPS "Send a challenging, cohesive body of work."

OAKLAND UNIVERSITY ART GALLERY

208 Wilson Hall, Rochester MI 48309-4401. (248)370-3005. **E-mail:** jaleow@oakland.edu. **Website:** www.oakland.edu/ouag. Estab. 1962. Nonprofit gallery. Represents 10-25 artists/year. Sponsors 6 exhibits/year. Average display time 4-6 weeks. Open September–May: Tuesday–Sunday, 12-5; evenings during special events and theater performances (Wednesday–Friday, 7 through 1st intermission, weekends, 5 through 1st intermission). Closed Monday, holidays and June–August. Located on the campus of Oakland University; exhibition space is approximately 2,350 sq. ft. of floor space, 301-ft. linear wall space, with 10-ft. 7-in. ceiling. The gallery is situated across the hall from the Meadow Brook Theatre. "We do not sell work, but do make available price lists for visitors with contact information noted for inquiries."

EXHIBITS Considers all styles and all types of prints and media.

MAKING CONTACT & TERMS Charges no commission. Gallery provides insurance, promotion and contract. Accepted work should be framed, mounted, matted. No restrictions on representation; however, prefers emerging Detroit artists.

SUBMISSIONS E-mail bio, education, artist's statement and JPEG images. Mail portfolio for review. Send query letter with artist's statement, bio, photocopies, curriculum vitae. Returns material with SASE. Responds to queries in 1-2 months. Finds artists through referrals by other artists, word of mouth, art community, advisory board and other arts organizations.

OPALKA GALLERY

The Sage Colleges, 140 New Scotland Ave., Albany NY 12208. (518)292-7742. **E-mail:** opalka@sage.edu. **E-mail:** lynchj2@sage.edu. **Website:** www.sage.edu/opalka. **Contact:** Jacqueline Lynch, gallery assistant. Estab. 2002. Nonprofit gallery. Approached by 90-120 artists/year; mounts 3-4 exhibitions per academic calendar year. Average display time 5 weeks. Open Monday-Friday, 10-8; Sundays, 12-4; June-July, 10-4 and by appointment only during installations and when classes are not in session. Closed July 4. Located on the Sage Albany campus, The gallery's primary concentration is on work by professional artists from outside the region. The gallery frequently features multidisciplinary projects and hosts poetry readings, recitals and symposia in conjunction with exhibitions. The 7,400-sq.-ft. facility includes a vaulted gallery and a 75-seat lecture/presentation hall with Internet connectivity.

EXHIBITS Interested in fine art.

MAKING CONTACT & TERMS Reviews work by artists from outside the region and those who have ties to the Sage Colleges, a local photography regional is hosted every 3 years requiring artists to have exclusive local representation.

SUBMISSIONS Under terms of an exhibition loan agreement, artwork may be sold by the artist while on exhibit. The gallery does not take commissions or sell artwork.

TIPS "Contact the gallery by e-mail or phone to inquire about submission policy."

OPENING NIGHT GALLERY

2836 Lyndale Ave. S., Minneapolis MN 55408-2108. (612)872-2325. **Fax:** (612)872-2385. **E-mail:** deen@ onframe-art.com; info@onframe-art.com. **Website:** www.onframe-art.com. **Contact:** Deen Braathen. Estab. 1975. Rental gallery. Approached by 40 artists/year; represents or exhibits 15 artists. Sponsors 1 photography exhibit/year. Average display time 6-10 weeks. Gallery open Monday–Friday, 8:30-5; Saturday, 10:30-4. Overall price range $300-12,000. Most work sold at $2,500.

EXHIBITS Photos of landscapes/scenics, architecture, cities/urban.

MAKING CONTACT & TERMS Artwork is accepted on consignment, and there is a 50% commission. Gallery provides insurance, promotion, contract. "Accepted work should be framed by our frame shop." Requires exclusive representation locally.

SUBMISSIONS Mail slides for review. Send query letter with artist's statement, bio, résumé, slides, SASE. Responds in 2 months. Finds artists through word of mouth, submissions, portfolio reviews.

PALO ALTO ART CENTER

1305 Middlefield Rd., Palo Alto CA 94301. (650)329-2366. **Fax:** (650)326-6165. **E-mail:** artcenter@cityof paloalto.org. **Website:** www.cityofpaloalto.org/art center. **Contact:** Exhibitions Department. Estab. 1971. Average display time 1-3 months. Hours: Tuesday–Saturday, 10-5; Thursday, 10-9; Sunday, 1-5. Sponsors openings.

EXHIBITS "Exhibit needs vary according to curatorial context." Seeks "imagery unique to individual artist. No standard policy. Photography may be integrated in group exhibits." Interested in alternative process, avant garde, fine art; emphasis on art of the Bay Area.

SUBMISSIONS Send slides/CD, bio, artist's statement, SASE.

PARKLAND ART GALLERY

2400 W. Bradley Ave., Champaign IL 61821. (217)351-2485. **Fax:** (217)373-3899. **E-mail:** parklandartgal lery@parkland.edu. **Website:** www.parkland.edu/ gallery. **Contact:** Lisa Costello, director. Estab. 1980. Nonprofit gallery. Approached by 130 artists/year; 7 exhibitions per year. Average display time 4- 6 weeks. Open Monday–Thursday, 10-7; Friday 10-3; Saturday, 12-2 (fall and spring semesters). Summer: Monday-Thursday, 10-7. Parkland Art Gallery at Parkland College seeks exhibition proposals in all genres of contemporary approaches to art making by single artists, collaborative groups, or curators. Parkland Art Gallery is a professionally designed gallery devoted primarily to education through contemporary art. Parkland Art Gallery hosts 7 exhibitions per year including 2 student exhibitions, one art and design faculty show, and a Biennial Watercolor Invitational that alternates with a National Ceramics Invitational. Other shows vary depending on applications and the vision of the Art Gallery Advisory Board. Exhibits are scheduled on a 4- to 6-week rotation. Closed college and official holidays. Overall price range $100-5,000. Most work sold at $900.

EXHIBITS Interested in alternative process, avant garde, documentary, fine art, historical/vintage.

MAKING CONTACT & TERMS Gallery provides insurance, promotion. Accepted work should be framed.

SUBMISSIONS Send 20 slides or a CD containing 20 images; an identifying list with titles, sizes, dates, and media; a résumé; an artist statement; and a SASE (if necessary) to attention of the Director, Parkland Art Gallery, Parkland College. Only complete proposal packages including all information listed on the Proposal Guidelines will be reviewed. Responds in 4 months. No online proposals accepted. Finds artists through word of mouth, portfolio reviews, art exhibits, referrals by other artists. Call for entry.

LEONARD PEARLSTEIN GALLERY

Drexel University, 3401 Filbert St., Philadelphia PA 19104. (215)895-1029; (215)895-2548. **E-mail:** gal lery@drexel.edu; degroff@drexel.edu. **Contact:** Jacqueline DeGroff, curator. Estab. 1986. Nonprofit gallery. Located in Nesbitt Hall in the Antoinette Westphal College of Media Arts and Design at Drexel. Committed to exhibiting the work of local, national and international contemporary artists and designers. Sponsors 8 total exhibits/year; 1 or 2 photography exhibits/year. Average display time 1 month. Open Monday–Saturday, 11-5. Closed during summer.

MAKING CONTACT & TERMS Artwork is bought outright. Gallery takes 20% commission. Gallery provides insurance, promotion. Accepted work should be framed, mounted, matted. "We will not pay transport fees."

SUBMISSIONS Write to arrange a personal interview to show portfolio. Send query letter with artist's statement, bio, résumé, SASE. Returns material with SASE. Responds by February, only if interested.

Finds artists through referrals by other artists, academic instructors.

PETERS VALLEY CRAFT CENTER

19 Kuhn Rd., Layton NJ 07851. (973)948-5202. **Fax:** (973)948-0011. **E-mail:** store@petersvalley.org. **Website:** www.petersvalley.org. **Contact:** Brienne Rosner, gallery manager. Estab. 1970. Nonprofit gallery and store. Approached by about 100 artists/year; represents about 350 artists. Average display time 1 month in gallery; varies for store items. Open year round; call for hours. Located in northwestern New Jersey in Delaware Water Gap National Recreation Area; 2 floors, approximately 3,000 sq. ft. Overall price range $5-3,000. Most work sold at $100-300. "Focuses its programs on fine contemporary crafts in mediums such as ceramics, metals (both fine and forged), glass, wood, photography, fibers (both surface design and structural), print."

EXHIBITS Considers all media and all types of prints. Also exhibits non-referential, mixed media, collage and sculpture.

MAKING CONTACT & TERMS Artwork is accepted on consignment, and there is a 60% commission to artist. "Retail price set by the gallery in conjunction with artist." Gallery provides insurance and promotion. Accepted work should be framed, mounted and matted.

SUBMISSIONS Reviewed on an ongoing basis. Send query letter with artist's statement, bio, résumé and images (slides or CD of JPEGs). Returns material with SASE. Responds in 2 months. Finds artists through submissions, art exhibits, art fairs, referrals by other artists.

TIPS "Submissions must be neat and well-organized throughout."

PHILLIPS GALLERY

444 E. 200 S., Salt Lake City UT 84111. (801)364-8284. **Fax:** (801)364-8293. **Website:** www.phillips-gallery. com. **Contact:** Meri DeCaria, director/curator. Estab. 1965. Commercial gallery. We represent artists working in a variety of media including painting, drawing, sculpture, photography, ceramics, printmaking, jewelry, and mixed media. Our artists, many of whom have been with us since 1965, are primarily from Utah or the surrounding area. Phillips Gallery also represents national and international artists who have an association with Utah. You will discover a full range of subject matter from traditional to contemporary.

Average display time 4 weeks. Sponsors openings; provides refreshments, advertisement, and half of mailing costs. Overall price range $100-18,000. Most work sold at $600.

EXHIBITS Accepts all types and styles.

MAKING CONTACT & TERMS Charges 50% commission. Accepted work should be matted. Requires exclusive representation locally. *Photographers must have Utah connection.* Must be actively pursuing photography.

SUBMISSIONS Submit portfolio for review; include SASE. Responds in 2 weeks.

THE PHOENIX GALLERY

210 11th Ave., 902, New York NY 10001. (212)226-8711. **Fax:** (212)343-7303. **E-mail:** info@phoenix-gallery.com. **Website:** www.phoenix-gallery.com. **Contact:** Linda Handler, director. Estab. 1958. Sponsors 10-12 exhibits/year. Average display time 1 month. Overall price range $100-10,000. Most work sold at $3,000-8,000.

EXHIBITS "The gallery is an artist-run nonprofit organization; an artist has to be a member in order to exhibit in the gallery. There are 3 types of membership: active, inactive and associate." Interested in all media; alternative process, documentary, fine art.

MAKING CONTACT & TERMS Charges 25% commission.

SUBMISSIONS Artists wishing to be considered for membership must submit an application form, slides and résumé. Call, e-mail or download membership application from website.

PHOTO-EYE GALLERY

376 Garcia St., Santa Fe NM 87501. (505)988-5122, ext. 202; (505)988-5159, ext. 121; (800)227-6941. **Fax:** (505)988-4487. **E-mail:** gallery@photoeye.com. **Website:** www.photoeye.com. **Contact:** Anne Kelly, associate gallery director. Estab. 1991. Approached by 40+ artists/year. Exhibits 30 established artists/year. Exhibited artists include Nick Brandt, Julie Blackmon, Tom Chambers (all fine-art photographers). Sponsors 3-4 photography exhibits/year. Average display time 3 months. Open Tuesday–Saturday, 10-5. Closed Sunday and Monday. The gallery is located approximately 1 mile from The Plaza; approximately 1,000 sq. ft. Clients include: local community, tourists, upscale and collectors. 30% of sales are to corporate collectors. Overall price range: $100-50,000. Most work sold at $2,500.

EXHIBITS Photography only. Fine-art photographs using only archival methods. Considers all styles. Most frequently exhibits contemporary photography projects and bodies of work.

MAKING CONTACT & TERMS Retail price of the art set by the artist. Gallery provides insurance, promotion and contract. Accepted work should be matted. "Prefers fine-art photography with exciting, fresh projects that are cohesive and growing."

SUBMISSIONS "Submit your work via 'The Photographer's Showcase' on our website." Material cannot be returned. Responds in 2 weeks if dropped off at gallery, but prefers online submissions. Finds artists through word of mouth, art fairs, portfolio review and online through "The Photographer's Showcase."

TIPS "Be consistent, professional and only submit approximately 20 images. Call or e-mail gallery to find out the submission policy."

PHOTOGRAPHIC RESOURCE CENTER

832 Commonwealth Ave., Boston MA 02215. (617)975-0600. **Fax:** (617)975-0606. **E-mail:** info@prcboston.org. **Website:** www.prcboston.org. "The PRC is a nonprofit arts organization founded to facilitate the study and dissemination of information relating to photography." The PRC brings in nationally recognized artists to lecture to large audiences and host workshops on photography. Open Tuesday-Friday, 10-5; Saturday, 12-4. Closed Sunday-Monday. Please check our website for the current exhibition schedule. Offers monthly portfolio reviews for PRC members. "Due to overwhelming numbers, we do not review unsolicited submissions for exhibitions on the web or through the mail. Please do not send materials unless they are specifically requested; please do not expect a response to unrequested submissions."

PHOTOGRAPHY ART

107 Myers Ave., Beckley WV 25801. (304)252-4060 or (304)575-6491. **Fax:** (304)252-4060 (call before faxing). **E-mail:** bruceburgin@photographyart.com. **Website:** www.photographyart.com. **Contact:** Bruce Burgin, owner. Estab. 2003. Internet rental gallery. "Each artist deals directly with his/her customers. I do not charge commissions and do not keep records of sales."

EXHIBITS Photos of landscapes/scenics, wildlife. Interested in fine art.

MAKING CONTACT & TERMS There is a rental fee for space. The rental fee covers 1 year. The standard gallery is $240 to exhibit 40 images with biographical and contact info for 1 year. No commission charged for sales. Artist deals directly with customers and receives 100% of any sale. Gallery provides promotion.

SUBMISSIONS Internet sign-up. No portfolio required.

TIPS "An artist should have high-quality digital scans. The digital images should be cropped to remove any unnecessary background or frames, and sized according to the instructions provided with their Internet gallery. I recommend the artist add captions and anecdotes to the images in their gallery. This will give a visitor to your gallery a personal connection to you and your work."

THE PHOTOMEDIA CENTER

P.O. Box 8518, Erie PA 16505. (617)990-7867. **E-mail:** info@photomediacenter.org. **Website:** www.photomediacenter.org. **Contact:** Eric Grignol, executive director. Estab. 2004. Nonprofit gallery. Sponsors 12 several new photography exhibits/year. "Previously featured exhibits are archived online. We offer many opportunities for artists, including sales, networking, creative collaboration and promotional resources, active social networking forum, and hold an open annual juried show in the summer."

EXHIBITS Interested in alternative process, avant garde, documentary, fine art.

MAKING CONTACT & TERMS Gallery provides promotion. Prefers only artists working in photographic, digital and new media.

SUBMISSIONS "For portfolio reviews, which happen on a rolling basis, send query letter with artist's statement, bio, résumé, slides, SASE." Responds in 2-6 months. Finds artists through word of mouth, submissions, portfolio reviews, art exhibits, referrals by other artists.

TIPS "We are looking for artists who have excellent technical skills, a strong sense of voice and cohesive body of work. Pay careful attention to our guidelines for submissions on our website. Label everything. Must include a SASE for reply."

PIERRO GALLERY OF SOUTH ORANGE

Baird Center, 5 Mead St., South Orange NJ 07079. (973)378-7754. **Fax:** (973)378-7833. **E-mail:** pierrogallery@southorange.org. **E-mail:** smartiny@southorange.org. **Website:** www.pierrogallery.org. **Contact:** Sandy Martiny, gallery director. Estab. 1994. Nonprofit gallery. Approached by 75-185 artists/year; repre-

sents or exhibits 25-50 artists. Average display time 7 weeks. Open Wednesday and Thursday, 2-7; Friday, 2-5; Saturday, 1-4, and by appointment. Closed mid-December through mid-January and the month of August. Overall price range $100-10,000. Most work sold at $800.

EXHIBITS Interested in fine art, "which can be inclusive of any subject matter."

MAKING CONTACT & TERMS Artwork is accepted on consignment, and there is a 15% commission. Gallery provides insurance, promotion, contract. Accepted work should be framed.

SUBMISSIONS Mail portfolio for review. Send cover letter, biography and/or résumé, brief artist statement, up to 3 reviews/press clippings, representation of work in either CD or DVD format; no more than 10 labeled representative images up to 72 dpi. "Portfolios must be received by the first week of February, June or October to be included in that month's review." Finds artists through word of mouth, submissions, portfolio reviews, referrals by other artists.

POLK MUSEUM OF ART

800 E. Palmetto St., Lakeland FL 33801-5529. (863)688-7743, ext. 241 or 289. **Fax:** (863)688-2611. **E-mail:** kpope@polkmuseumofart.org. **Website:** www.polkmuseumofart.org. **Contact:** Kalisa Pope, curatorial assistant. Estab. 1966. Approached by 75 artists/year; represents or exhibits 3 artists. Sponsors 1-3 photography exhibits/year. Galleries open Tuesday–Saturday, 10-5; Sunday, 1-5. Closed major holidays. Four different galleries of various sizes and configurations.

EXHIBITS Interested in alternative process, avant garde, documentary, fine art, historical/vintage.

MAKING CONTACT & TERMS Museum provides insurance, promotion, contract. Accepted work should be framed.

SUBMISSIONS Mail portfolio for review. Send query letter with artist's statement, bio, résumé, slides or CD, SASE.

POUDRE RIVER GALLERY

406 N. College Ave., Fort Collins CO 80524. **E-mail:** gallery@poudrestudioartists.com; poudrestudio artists@gmail.com. **Website:** www.poudrestudio artists.com. **Contact:** Gallery administrator. Estab. 2006. Nonprofit cooperative, rental gallery with alternative space. Approached by 100+ artists/year; exhibits 200+ emerging, mid-career and established

artists/year. Exhibited artists include Barbara Mc-Culloch (watermedia) and Carol Simmons (polymer clay). Exhibits rotate monthly. Open Thursday-Friday, 11-6; first Fridays, 11-9; Saturday, 11-5. Closed major holidays. Located just north of Old Town Fort Collins and participates in the city's monthly Gallery Walk. "Our gallery is 1,100 sq. ft, L-shaped with wood floors in a funky old building." Clients: local community, students, tourists and upscale. Overall price range: $50-10,000.

EXHIBITS Considers all media, prints, genres and styles. Most frequently exhibits acrylics, mosaic and watercolor and painterly abstraction.

MAKING CONTACT & TERMS Artwork accepted on consignment with a 25% commission. There is a co-op membership fee, plus a donation of time with a 25% commission. Contact museum for details on rental fee. Retail price of art set by the artist. Gallery provides promotion. Accepted work should be framed, mounted and matted.

SUBMISSIONS E-mail (poudrestudioartists@gmail. com) with link to artist's website and JPEG samples at 72 dpi or send query letter with artist's statement, bio, brochure and résumé. Material returned with SASE. Responds in 2-3 weeks. Brochures and printed materials filed. Finds artists through word of mouth, submissions and referrals by other artists.

TIPS "Read instructions carefully and follow them to the letter!"

THE PRINT CENTER

1614 Latimer St., Philadelphia PA 19103. (215)735-6090. **Fax:** (215)735-5511. **E-mail:** info@printcenter. org. **Website:** www.printcenter.org. **Contact:** Ashley Peel Pinkham, assistant director. Estab. 1915. Nonprofit gallery and Gallery Store. Represents over 75 artists from around the world in Gallery Store. Sponsors 5 photography exhibits/year. Average display time 2 months. Open all year Tuesday-Saturday, 11-6; closed Christmas Eve to New Year's Day. Three galleries. Overall price range $15-15,000. Most work sold at $200.

EXHIBITS Contemporary prints and photographs of all processes. Accepts original artwork only—no reproductions.

MAKING CONTACT & TERMS Accepts artwork on consignment (50%). Gallery provides insurance, promotion, contract. Artists must be printmakers or photographers.

SUBMISSIONS Must be member to submit work. Member's work is reviewed by curator and gallery store manager. See website for membership application. Finds artists through submissions, art exhibits and membership.

PUCKER GALLERY, INC.

171 Newbury St., Boston MA 02116. (617)267-9473. **Fax:** (617)424-9759. **E-mail:** contactus@puckergallery.com; destiny@puckergallery.com. **Website:** www.puckergallery.com. **Contact:** Bernard H. Pucker, owner/director; Destiny M. Barletta, director. Estab. 1967. For-profit gallery. Pucker Gallery is always willing to review artist's slides and submissions. Approached by 100 artists/year; represents or exhibits 50 artists. Sponsors 2 photography exhibits/year. Average display time 1 month. Open Monday–Saturday, 10-5:30; Sunday, 10:30-5. Five floors of exhibition space. Overall price range $500-75,000.

EXHIBITS Photos of multicultural, environmental, landscapes/scenics, architecture, cities/urban, religious, rural. Interested in fine art, abstracts, seasonal.

MAKING CONTACT & TERMS Gallery provides promotion.

SUBMISSIONS Send query letter with artist's statement, bio, slides/CD, SASE. Maximum 20 images (slides, prints or hi-res digital files on a disc). "We do not accept e-mail submissions nor do we visit artists' websites." Finds artists through submissions, referrals by other artists.

PUMP HOUSE CENTER FOR THE ARTS

P.O. Box 1613, Chillicothe OH 45601. **E-mail:** info@pumphouseartgallery.com; pumphouseartgallery@aim.com. **Website:** www.pumphouseartgallery.com. **Contact:** Priscilla V. Smith, director. Estab. 1991. Nonprofit gallery. Approached by 6 artists/year; represents or exhibits more than 50 artists. Average display time 6 weeks. Open Tuesday-Saturday, 11-4; Sunday, 1-4. Overall price range $150-600. Most work sold at $300. Facility is also available for rent (business, meetings, reunions, weddings, receptions or rehearsals, etc.).

EXHIBITS Photos of landscapes/scenics, wildlife, architecture, gardening, travel, agriculture. Interested in fine art, historical/vintage.

MAKING CONTACT & TERMS Artwork is accepted on consignment, and there is a 30% commission. Gallery provides insurance, promotion. Accepted work should be framed, matted, wired for hanging. Call

or stop in to show portfolio of photographs, slides. Send query letter with bio, photographs, slides, SASE. Responds in 1 month. Finds artists through word of mouth, submissions, portfolio reviews, art exhibits, art fairs, referrals by other artists.

TIPS "All artwork must be original designs, framed, ready to hang (wired—no sawtooth hangers)."

QUEENS COLLEGE ART CENTER

Benjamin S. Rosenthal Library, Flushing NY 11367. (718)997-3770. **Fax:** (718)997-3753. **E-mail:** suzanna.simor@qc.cuny.edu; artcenter@qc.cuny.edu. **Website:** www.queenscollegeartcenter.org. **Contact:** Suzanna Simor, director; Alexandra de Luise, associate director; Tara Tye Mathison, curator. Estab. 1955. Queens College Art Center is a successor since 1987 of the Klapper Library Art Center that was based in the Queens College Art Library's gallery founded in 1960. Focuses on modern and contemporary art, presenting the works of both emerging and established artists in diverse media, in programming expressive of the best of the art of our time. Open Monday–Thursday, 9-9; Friday, 9-5. Closed weekends and holidays. Average display time approximately 6-8 weeks. Overall price range $100-3,000.

EXHIBITS Open to all types, styles, subject matter; decisive factor is quality.

MAKING CONTACT & TERMS Charges 40% commission. Accepted work can be framed or unframed, mounted or unmounted, matted or unmatted. Sponsors openings. Photographer is responsible for providing/arranging refreshments and cleanup.

SUBMISSIONS Online preferred, or send query letter with résumé, samples and SASE, as appropriate. Responds within 1-2 months.

☺ MARCIA RAFELMAN FINE ARTS

10 Clarendon Ave., Toronto ON M4V 1H9, Canada. (416)920-4468. **Fax:** (416)968-6715. **E-mail:** info@mrfinearts.com. **Website:** www.mrfinearts.com. **Contact:** Marcia Rafelman, president; Meghan Richardson, gallery director. Estab. 1984. Semi-private gallery. Average display time 1 month. Gallery is centrally located in Toronto; 2,000 sq. ft. on 2 floors. Overall price range $800-25,000. Most work sold at $1,500.

EXHIBITS Photos of environmental, landscapes. Interested in alternative process, documentary, fine art, historical/vintage.

MAKING CONTACT & TERMS Charges 50% commission. Gallery provides insurance, promotion, contract. Requires exclusive representation locally.

SUBMISSIONS Mail (must include SASE) or e-mail portfolio (preferred) for review; include bio, photographs, reviews. Responds only if interested. Finds artists through word of mouth, submissions, art fairs, referrals by other artists.

TIPS "We only accept work that is archival."

THE RALLS COLLECTION INC.

1516 31st St. NW, Washington DC 20007. **E-mail:** rallscollection@gmail.com. **Website:** www.rallscollection.com. **Contact:** Marsha Ralls, owner. Estab. 1991. Approached by 125 artists/year; represents or exhibits 60 artists. Sponsors 7 photography exhibits/year. Average display time 1 month. Gallery open Tuesday-Saturday, 11-4, and by appointment. Closed Thanksgiving, Christmas. Overall price range $1,500-50,000. Most work sold at $2,500-15,000.

EXHIBITS Photos of babies/children/teens, celebrities, parents, landscapes/scenics, architecture, cities/urban, gardening, interiors/decorating, pets, rural, entertainment, health/fitness, hobbies, performing arts, sports, travel, product shots/still life. Interested in alternative process, avant garde, documentary, fashion/glamour, fine art, historical/vintage.

MAKING CONTACT & TERMS Artwork is accepted on consignment, and there is a 50% commission. Gallery provides insurance, promotion, contract. Accepted work should be framed, matted. Requires exclusive representation locally. Accepts only artists from America.

SUBMISSIONS Mail portfolio for review. Send query letter with artist's statement, bio, brochure, business card, photocopies, photographs, résumé, reviews, slides, SASE. Responds in 2 months. Finds artists through word of mouth, submissions, portfolio reviews, art exhibits, art fairs, referrals by other artists.

ELLA WALTON RICHARDSON FINE ART

58 Broad St., Charleston SC 29401. (843)722-3660. **Fax:** (843)722-4330. **E-mail:** ella@ellarichardson.com. **Website:** www.ellarichardson.com. **Contact:** Ella Richardson, owner. Estab. 2001. For-profit galley. Exhibits established artists. Approached by 100s of artists a year; represents or exhibits 28 artists. Exhibited artists include Aleksander and Lyuba Titovets, Lindsay Goodwin, the Baranovs, Jeff Jamison, and Micheal Coleman. Model and property release are re-

quired. Open Monday-Saturday, 10-5. Located in historic downtown Charleston, the gallery has 3 rooms of artwork. The gallery is in the heart of the gallery district. It is an elegant and inviting space with hardwood floors, granite counters, and dual fireplaces. Clients included local community, students, tourists, and upscale. 5% of sales are to corporate collectors. Overall price range: $500-16,000.

MAKING CONTACT & TERMS Artwork is accepted on consignment and there is a 50% commission. Retail price set by the gallery and artist. Gallery provides insurance and promotion. Accepted artwork should be framed. Requires exclusive representation locally.

SUBMISSIONS Mail or e-mail query letter with link to artist's website, JPEG samples at 72 dpi. Include artist's statement, bio, brochure, business card, photocopies, photographs, résumé, and reviews. Materials returned with SASE.

TIPS "Address the gallery individually. Sound knowledgeable about our space and artists. Organization, and preparation."

✪ RIVER GALLERY

400 E. Second St., Chattanooga TN 37403. (423)265-5033, ext. 5. **E-mail:** art@river-gallery.com. **Website:** www.river-gallery.com. **Contact:** Mary R. Portera, owner/director. Estab. 1992. Retail gallery. Represents 100 emerging, mid-career and established artists/year. Exhibited artists include Michael Kessler and Scott E. Hill. Sponsors 12 shows/year. Open Monday–Saturday, 10-5; Sunday, 1-5; and by appointment. Located in Bluff View Art District in downtown area; 2,500 sq. ft.; restored early New Orleans-style 1900s home; arched openings into rooms. 20% of space for special exhibitions; 80% of space for gallery artists. Clients include upscale tourists, local community. 95% of sales are to private collectors, 5% corporate collectors. Overall price range $5-10,000; most work sold at $200-2,000.

EXHIBITS Considers all media. Most frequently exhibits oil, original prints, photography, watercolor, mixed media, fiber, clay, jewelry, wood, glass and sculpture.

MAKING CONTACT & TERMS Accepts work on consignment (50% commission). Retail price set by the gallery. Gallery provides free gift wrap, insurance, promotion and contract; shipping costs are shared. Prefers artwork framed.

SUBMISSIONS Send query letter with résumé, slides, bio, photographs, SASE, reviews and artist's statement. Call or e-mail for appointment to show portfolio of photographs and slides. Files all material unless we are not interested then we return all information. Can also submit via form on website. Finds artists through word of mouth, referrals by other artists, visiting art fairs and exhibitions, submissions, ads in art publications.

ROCHESTER CONTEMPORARY

137 East Ave., Rochester NY 14604. (585)461-2222. **Fax:** (585)461-2223. **E-mail:** info@rochestercontemporary.org. **E-mail:** bleu@rochestercontemporary.org. **Website:** www.rochestercontemporary.org. **Contact:** Bleu Cease, executive director. Estab. 1977. Located in Rochester's downtown "East End" cultural district. The 4,500-sq.-ft. space is handicap-accessible. Sponsors 10-12 exhibits/year. Average display time 4-6 weeks. Gallery open Wednesday–Sunday, 1-5; Friday, 1-10. Overall price range $100-500.
MAKING CONTACT & TERMS Charges 25% commission.
SUBMISSIONS Send up to 20 images via CD/DVD. Discs "must be labeled with your name and contact information. The checklist must have your name, address, phone number, e-mail address, and website (if available) at the top, followed by the title of the work, date, materials, and presentation size for each image submitted. Do not send prints or original works." Also include letter of intent, résumé and statement.

ROCKPORT CENTER FOR THE ARTS

902 Navigation Circle, Rockport TX 78382. (361)729-5519. **Fax:** (361)729-3551. **E-mail:** info@rockportartcenter.com. **Website:** www.rockportartcenter.com. Estab. 1969. Rockport Center for the Arts is a hub of creative activity on the Texas Gulf Coast. Two parlor galleries are dedicated entirely to the works of its member artists, while the main gallery allows the center to host local, regional, national, and internationally acclaimed artists in both solo and group exhibitions. In 2000, the Garden Gallery was added, allowing the center for the first time to simultaneously feature 3 distinct exhibitions, at times displaying over 100 original works of art. Today, the building also houses 2 visual arts classrooms and an outdoor sculpture garden featuring works by internationally acclaimed artists. A well-furnished pottery studio is always active, and includes a kiln room which hosts daily firings. Visitors enjoy the exhibitions, education programs and gift shop, as well as the Annual Rockport Art Festival every July 4th weekend. Gallery hours vary. Call, e-mail or visit website for more information.

THE ROTUNDA GALLERY

33 Clinton St., Brooklyn NY 11201. (718)875-4047; (718)683-5604. **E-mail:** jtaylor@bricartsmedia.org. **Website:** www.briconline.org/rotunda. **Contact:** Johanna Taylor. Estab. 1981. Nonprofit gallery. Average display time 6 weeks. Open Tuesday–Saturday, 12-6.
EXHIBITS Interested in contemporary works.
MAKING CONTACT & TERMS Gallery provides photographer's contact information to prospective buyers. Shows are limited by walls that are 22 feet high.
SUBMISSIONS Send material by mail for consideration; include SASE. "View our website for guidelines and artist registry form."

SAN DIEGO ART INSTITUTE

1439 El Prado, San Diego CA 92101. (619)236-0011. **Fax:** (619)236-1974. **E-mail:** director@sandiego-art.org; admin@sandiego-art.org. **Website:** www.sandiego-art.org. **Contact:** Timothy Field, executive director. Estab. 1941. Nonprofit gallery. SDAI's most visible activity focuses on showcasing the work of San Diego's emerging area visual artists through a program of over 30 juried shows a year. Different art professionals are selected as jurors for each show assuring exhibitions of high-quality and great variety. Jurors' Choice and Honorable Mention certificates are awarded at monthly public receptions. Represents or exhibits 500 member artists. Overall price range $50-3,000. Most work sold at $700. Open Tuesday–Saturday, 10-4; Sunday, 12-4.
EXHIBITS Photos of babies/children/teens, couples, multicultural, families, parents, senior citizens, disasters, environmental, landscapes/scenics, wildlife, architecture, cities/urban, education, gardening, pets, rural, adventure, entertainment, events, food/drink, health/fitness/beauty, hobbies, humor, performing arts, sports, travel, agriculture, political, product shots/still life, science, technology. Interested in alternative process, avant garde, documentary, erotic, fine art, historical/vintage, seasonal.
MAKING CONTACT & TERMS Artwork is accepted on consignment with a 40% commission. Membership fee: $125. Accepted work should be framed.

Work must be carried in by hand for each monthly show except for annual international show, JPEG online submission.

SUBMISSIONS Membership not required for submission in monthly juried shows, but fee required. Artists interested in membership should request membership packet. Finds artists through referrals by other artists.

TIPS "All work submitted must go through jury process for each monthly exhibition. Work must be framed in professional manner. No glass—Plexiglas or acrylic only."

⊘ THE JOSEPH SAXTON GALLERY OF PHOTOGRAPHY

520 Cleveland Ave. NW, Canton OH 44702. (330)438-0030. **Fax:** (330)456-9566. **E-mail:** gallery@jo sephsaxton.com. **E-mail:** maria@josephsaxton.com. **Website:** www.josephsaxton.com. **Contact:** Maria Hadjian. Estab. 2009. A premier photography gallery with nearly 7,000 sq. ft. of display space with more than 160 master photographers represented, and over 200 pieces on display. Upscale clients. 20% of sales are to corporate collectors. Overall price range of work sold is from $200-20,000. Most work sold at $1,500. Approached by 150 artists/year; represents or exhibits 4-6 artists. Exhibited artists include: Steve McCurry, Art Wolfe, Lewis Wickes Hine, Eddie Adams, Annie Leibovitz, Sally Mann, etc. Average display time 2-3 months for special exhibits. Houses a store offering books, magazines, DVDs, apparel, novelty cameras and camera equipment. Open Wednesday–Saturday, 12-5. Tim Belden is the owner and Maria Hadjian is the "acting" curator and general manager of the gallery.

EXHIBITS Color field, expressionism, surrealism, painterly abstraction, conceptualism, impressionism, postmodernism, minimalism, primitivism realism, geometric abstraction. Considers all genres. Exhibits people: celebrities, multicultural, families; home & garden: architecture, cities/urban, religious, rural; business & technology: agriculture, industry, military, political, product shots/still life; outdoors: disasters, environmental, landscapes/scenics, wildlife; recreation: adventure, automobiles, entertainment, events, performing arts, sports, travel; style: alternative process, avant garde, documentary, fashion/glamour, fine art, historical/vintage, lifestyle, seasonal.

MAKING CONTACT & TERMS Artwork is accepted on consignment with a commission fee. Retail price of the art is set by the artist. Gallery provides insurance, promotion, contract. Requires exclusive representation locally. Also offers a limited contract. Model release and property release are preferred.

SUBMISSIONS Accepted work should be framed. E-mail query letter with link to artists's website. Responds only if interested within 2 weeks. Returns material with SASE. Finds artists through word of mouth, portfolio reviews, referrals by other artists, our annual Canton Luminaries Photography Competition.

TIPS "We prefer to see work which was created as a cohesive body and exhibits a personal style or technique.

WILLIAM & FLORENCE SCHMIDT ART CENTER

Southwestern Illinois College, 2500 Carlyle Ave., Belleville IL 62221. (618)222-5278. **Website:** www.swic.edu/sac. Estab. 2002. Nonprofit gallery. Sponsors 1-2 photography exhibits/year.

EXHIBITS Interested in fine art and historical/vintage photography.

SUBMISSIONS Mail portfolio for review. Send query letter with artist's statement, bio and 12-20 digital images on a CD with image list. Finds artists through art fairs and exhibits, portfolio reviews, referrals by other artists, submissions and word of mouth.

SCHMIDT/DEAN

1719 Chestnut St., Philadelphia PA 19103. (215)569-9433. **Fax:** (215)569-9434. **E-mail:** schmidtdean@netzero.com. **Website:** www.schmidtdean.com. **Contact:** Christopher Schmidt, director. Estab. 1988. For-profit gallery. Houses eclectic art. Sponsors 4 photography exhibits/year. Average display time 6 weeks. Gallery open Tuesday–Saturday, 10:30-6. August hours are Tuesday–Friday, 10:30-6. Overall price range $1,000-70,000.

EXHIBITS Interested in alternative process, documentary, fine art.

MAKING CONTACT & TERMS Charges 50% commission. Gallery provides insurance, promotion. Accepted work should be framed, mounted, matted. Requires exclusive representation locally.

SUBMISSIONS Call/write to arrange a personal interview to show portfolio. Send query letter with SASE. "Send digital images on CD and a résumé that gives a sense of your working history. Include a SASE."

SECOND STREET GALLERY

115 Second St. SE, Charlottesville VA 22902. (434)977-7284. **E-mail:** curator@secondstreetgallery.org. **Website:** www.secondstreetgallery.org. **Contact:** Rebecca Schoenthal, executive director. Estab. 1973. Sponsors approximately 2 photography exhibits/year. Average display time 1 month. Open Tuesday–Saturday, 11-6; 1st Friday of every month, 6-8 with artist talk at 6:30. Overall price range $300-2,000.

MAKING CONTACT & TERMS Charges 30% commission.

SUBMISSIONS Reviews slides/CDs in fall; $15 processing fee. Submit 10 slides or a CD for review; include artist statement, cover letter, bio/résumé, and most importantly, a SASE. Responds in 2 months. See website for further details.

TIPS Looks for work that is "cutting edge, innovative, unexpected."

SIOUX CITY ART CENTER

225 Nebraska St., Sioux City IA 51101-1712. (712)279-6272. **Fax:** (712)255-2921. **E-mail:** siouxcityartcenter@sioux-city.org. **Website:** www.siouxcityartcenter.org. **Contact:** Todd Behrens, curator. Estab. 1938. Museum. Exhibits emerging, mid-career and established artists. Approached by 50 artists/year; represents or exhibits 2-3 artists. Sponsors 15 total exhibits/year. Average display time: 10-12 weeks. Gallery open Tuesday, Wednesday, Friday, Saturday, 10-4; Thursday, 10-9; Sunday, 1-4. Closed on Mondays and municipal holidays. Located in downtown Sioux City; 2 galleries, each 40×80 ft. Clients include local community, students and tourists.

EXHIBITS Considers all media and types of prints. Most frequently exhibits paintings, sculpture and mixed media.

MAKING CONTACT & TERMS Artwork is accepted on consignment with a 30% commission. "However, the purpose of our exhibitions is not sales." Retail price of the art set by the artist. Gallery provides insurance, promotion and contract.

SUBMISSIONS Artwork should be framed. Only accepts artwork from upper-Midwestern states. E-mail query letter with link to artist's website; 15-20 JPEG samples at 72 dpi. Or send query letter with artist's statement, résumé and digital images. Returns materials if SASE is enclosed. Do not send original works. Responds, only if interested, within 6 months. Files résumé, statement and images if artist is suitable. Finds artists through word of mouth, art exhibits, submissions, art fairs, portfolio reviews and referrals by other artists.

TIPS "Submit good photography with an honest and clear statement."

SOHN FINE ART—GALLERY & GICLÉE PRINTING

6 Elm St., 1B-C, P.O. Box 1392, Stockbridge MA 01262. (413)298-1025. **E-mail:** info@sohnfineart.com. **Website:** www.sohnfineart.com. **Contact:** Cassandra Sohn, owner. Estab. 2011. Alternative space and for-profit gallery. Approached by 50-100 artists/year; represents or exhibits 12-20 emerging, mid-career and established artists. Exhibited artists include Fran Forman, photography, and John Atchley, photography. Average display time 1-3 months. Open Thursday-Monday, 10-5. Located in the Berkshires of Western Massachusetts. The area is known for arts and culture and full of tourists. Also, 80% of the population are 2nd home owners from New York and Boston. Clients include local community, tourists and upscale. Overall price range $300-6,000. Most work sold for $500-1,500.

EXHIBITS Considers all media and types of prints. Most frequently exhibits photography. Considers all styles and genres.

MAKING CONTACT & TERMS Artwork is accepted on consignment and there is a 50% commission. Retail price of the art set by the artist. Gallery provides insurance, promotion and contract. Accepted work should be framed, mounted and matted. Requires exclusive representation locally.

SUBMISSIONS E-mail query letter with link to artist's website and JPEG samples at 72 dpi. Material cannot be returned. Responds only if interested. Finds artists through word of mouth, art exhibits, submissions, art fairs, portfolio reviews and referrals by other artists.

SOHO MYRIAD

1250 Menlo Dr., Atlanta GA 30318. (404)351-5656. **Fax:** (404)351-8284. **E-mail:** info@sohomyriad.com. **Website:** www.sohomyriad.com. Estab. 1977. Art consulting firm and for-profit gallery. Represents and/or exhibits over 2,000 artists. Sponsors 1 photography exhibit/year. Average display time: 2 months. Overall price range $500-20,000. Most work sold at $500-5,000.

○ Additional offices in Los Angeles and London. See website for contact information.

EXHIBITS Photos of landscapes/scenics, architecture, floral/botanical and abstracts. Interested in alternative process, avant garde, fine art, historical/vintage.

MAKING CONTACT & TERMS Artwork is accepted on consignment, and there is a 50% commission. Gallery provides insurance.

SOUTH DAKOTA ART MUSEUM

South Dakota State University, Medary Ave. & Harvey Dunn St., P.O. Box 2250, Brookings SD 57007. (605)688-5423. **Fax:** (605)688-4445. **Website:** www.southdakotaartmuseum.com. Museum. Sponsors 1-2 photography exhibits/year. Average display time 4 months. Gallery open Monday-Friday, 10-5; Saturday, 10-4; Sunday, 12-4. Closed state holidays and Sundays from January through March. Seven galleries offer 26,000 sq. ft. of exhibition space.

EXHIBITS Interested in alternative process, documentary, fine art.

MAKING CONTACT & TERMS Please visit website for additional details.

SOUTHSIDE GALLERY

150 Courthouse Square, Oxford MS 38655. (662)234-9090. **E-mail:** southside@southsideartgallery.com. **Website:** www.southsideartgallery.com. **Contact:** Will Cook, director. Estab. 1993. For-profit gallery. Average display time 4 weeks. Gallery open Tuesday–Saturday, 10-6; Sunday, 12-5. Overall price range $300-20,000. Most work sold at $425.

EXHIBITS Photos of landscapes/scenics, architecture, cities/urban, rural, entertainment, events, performing arts, sports, travel, agriculture, political. Interested in avant garde, fine art.

MAKING CONTACT & TERMS Artwork is accepted on consignment, and there is a 55% commission. Gallery provides promotion. Accepted work should be framed.

SUBMISSIONS Mail between 10 and 25 slides that reflect current work with SASE for review. CDs are also accepted with images in JPEG or TIFF format. Include artist statement, biography, and résumé. Responds within 4-6 months. Finds artists through submissions.

B.J. SPOKE GALLERY

299 Main St., Huntington NY 11743. (631)549-5106. **E-mail:** manager@bjspokegallery.com. **Website:** www.bjspokegallery.com. **Contact:** Marilyn Lavi, gallery manager. Estab. 1978.

MAKING CONTACT & TERMS Arrange a personal interview to show portfolio. Send query letter with SASE.

SUBMISSIONS Charges 35% commission. Photographer sets price.

SRO PHOTO GALLERY AT LANDMARK ARTS

School of Art, Texas Tech University, Box 42081, Lubbock TX 79409-2081. (806)742-1947. **Fax:** (806)742-1971. **E-mail:** srophotogallery.art@ttu.edu. **Website:** www.landmarkarts.org. **Contact:** Joe R. Arredondo, director. Estab. 1984. Nonprofit gallery. Hosts an annual competition to fill 8 solo photography exhibition slots each year. Average display time 4 weeks. Open Monday–Friday, 8-5; Saturday, 10-5; Sunday, 12-4. Closed university holidays.

EXHIBITS Interested in art utilizing photographic processes.

MAKING CONTACT & TERMS "Exhibits are for scholarly purposes. Gallery will provide artist's contact information to potential buyers." Gallery provides insurance, promotion, contract. Accepted work should be matted.

SUBMISSIONS Exhibitions are determined by juried process. See website for details (under call for entries). Deadline for submissions is end of March.

THE STATE MUSEUM OF PENNSYLVANIA

300 North St., Harrisburg PA 17120. (717)787-4980. **E-mail:** hpollman@state.pa.us; jconcepcio@pa.gov. **Website:** www.statemuseumpa.org. Offers visitors 4 floors representing Pennsylvania's story, from Earth's beginning to the present. Features archaeological artifacts, minerals, paintings, decorative arts, animal dioramas, industrial and technological innovations, and military objects representing the Commonwealth's heritage. Number of exhibits varies. Average display time 3 months. Open Wednesday–Saturday, 9-5; Sunday 12-5.

EXHIBITS Fine art photography is a new area of endeavor for The State Museum, both collecting and exhibiting. Interested in works produced with experimental techniques.

MAKING CONTACT & TERMS Artwork is sold in gallery as part of annual Art of the State exhibition only. Overall price range $50-3,000. Connects artists with interested buyers. Art must be created by a native or resident of Pennsylvania to be considered for Art of the State, and/or contain subject matter relevant to Pennsylvania to be considered for permanent collection. Send material by mail for consideration; include SASE. Responds in 1 month.

STATE OF THE ART GALLERY

120 W. State St., Ithaca NY 14850. (607)277-1626. **E-mail:** gallery@soag.org. **Website:** www.soag.org. Estab. 1989. Cooperative gallery. Sponsors 2 juried exhibits/year. Average display time 1 month. Gallery open Wednesday–Friday, 12-6; weekends, 12-5. Located in downtown Ithaca, 2 rooms about 1,100 sq. ft. Overall price range $100-6,000. Most work sold at $200-500.

EXHIBITS Photos in all media and subjects. Interested in alternative process, avant garde, fine art, computer-assisted photographic processes.

MAKING CONTACT & TERMS There is a co-op membership fee plus a donation of time. There is a 10% commission for members, 30% for nonmembers. Gallery provides promotion, contract. Accepted work must be ready to hang. Write for membership application. See website for further details.

✪ STATE STREET GALLERY

1804 State St., La Crosse WI 54601. (608)782-0101. **Contact:** Ellen Kallies, president. Estab. 2000. Wholesale, retail and trade gallery. Approached by 15 artists/year; exhibits 12-14 artists/quarter in gallery. Average display time 4-6 months. Open Tuesday, Thursday and Friday, 10-4, Saturday, 10-2; other times by chance or appointment. Located across from the University of Wisconsin/La Crosse. Overall price range $50-12,000. Most work sold at $500-1,200 and above.

EXHIBITS Photos of environmental, landscapes/scenics, architecture, cities/urban, gardening, rural, travel, medicine.

MAKING CONTACT & TERMS Artwork is accepted on consignment, and there is a 40% commission. Gallery provides insurance, promotion, contract. Accepted work should be framed, matted.

SUBMISSIONS Call or mail portfolio for review. Send query letter with artist's statement, photographs, slides, SASE. Responds in 1 month. Finds artists through word of mouth, art exhibits, art fairs, referrals by other artists.

TIPS "Be organized, professional in presentation, flexible."

PHILIP J. STEELE GALLERY

Rocky Mt. College of Art + Design, 1600 Pierce St., Denver CO 80214. (303)753-6046. **Fax:** (303)759-4970. **Website:** www.rmcad.edu/gallery-exhibitions/philip-j-steele-gallery. **Contact:** Lisa Spivak, director. Estab. 1962. Located in the Mary Harris Auditorium building on the southeast corner of the quad. Approached by 25 artists/year; represents or exhibits 6-9 artists. Sponsors 1 photography exhibit/year. Average display time 1 month. Open Monday–Saturday, 11-4. Photographers should call or visit website for more information.

EXHIBITS No restrictions on subject matter.

MAKING CONTACT & TERMS No fee or percentage taken. Gallery provides insurance, promotion. Accepted work should be framed.

SUBMISSIONS Send query letter with artist's statement, bio, slides, résumé, reviews, SASE. Reviews in May, deadline April 15. Finds artists through word of mouth, submissions, referrals by other artists.

STEVENSON UNIVERSITY ART GALLERY

1525 Greenspring Valley Rd., Stevenson MD 21153. (443)334-2163. **Fax:** (410)486-3552. **E-mail:** exhibitions@stevenson.edu. **Website:** www.stevenson.edu/explore/gallery/index.asp. **Contact:** Diane DiSalvo, director of cultural programs. Estab. 1997. University gallery. Sponsors at least 2 photography exhibits/year. Average display time 6 weeks. Gallery open Monday, Wednesday, Friday, 11-5; Thursday, 11-8; Saturday, 1-4. "Two beautiful spaces." "Since its 1997 inaugural season, the Stevenson University Art Gallery has presented a dynamic series of substantive exhibitions in diverse media and has achieved the reputation as a significant venue for regional artists and collectors. The museum quality space was designed to support the Baltimore arts community, provide greater opportunities for artists, and be integral to the educational experience of Stevenson students. Our exhibitions program offers a series of 7 shows per year in a variety of media including paintings, prints, sculpture and photography."

EXHIBITS Interested in alternative process, avant garde, documentary, fine art, historical/vintage. "We

are looking for artwork of substance by artists from the mid-Atlantic region."

MAKING CONTACT & TERMS "We facilitate inquiries directly to the artist." Gallery provides insurance. *Accepts artists from mid-Atlantic states only; emphasis on Baltimore artists.*

SUBMISSIONS Write to show portfolio of slides. Send artist's statement, bio, résumé, reviews, slides, SASE. Responds in 3 months. Finds artists through word of mouth, submissions, portfolio reviews, referrals by other artists.

TIPS "Be clear, concise. Have good representation of your images."

STILL POINT ART GALLERY

193 Hillside Rd., Brunswick ME 04011. (207)837-5760. **Website:** www.stillpointartgallery.com. **Contact:** Christine Cote, owner/director. Estab. 2009. For-profit online gallery. Exhibits emerging, mid-career and established artists. Approached by 300 artists/year. Represents 25 artists. Sponsors 4 juried shows/year. Distinguished artists earn representation and publication in gallery's art journal, *Still Point Arts Quarterly*. Model and property release preferred. Average display time: 14 months. Overall price range: $200-5,000.

EXHIBITS Considers all media and styles. Most frequently exhibits painting and photography. Considers engravings, etchings, serigraphs, linocuts, woodcuts, lithographs and mezzotints. Considers all genres.

MAKING CONTACT & TERMS Retail price set by the artist. Gallery takes no commission from sales. Gallery provides promotion. Respond to calls for artists posted on website.

TIPS "Follow the instructions posted on our website."

SYNCHRONICITY FINE ARTS

106 W. 13th St., New York NY 10011. (646)230-8199. **E-mail:** jsa@synchroncityspace.com; contact@synchroncityspace.com. **Website:** www.synchronicityspace.com. **Contact:** John Amato, director. Estab. 1989. Nonprofit gallery. Approached by hundreds of artists/year; represents or exhibits over 60 artists. Sponsors 2-3 photography exhibits/year. Gallery open Wednesday-Saturday, 1-7. Closed 2 weeks in August. Overall price range $1,500-20,000. Most work sold at $3,000.

EXHIBITS Photos of multicultural, environmental, landscapes/scenics, architecture, cities/urban, education, rural, events, agriculture, industry, medicine,

political. Interested in avant garde, documentary, fine art, historical/vintage.

MAKING CONTACT & TERMS Gallery provides insurance, promotion, contract. Accepted work should be framed, mounted, matted.

SUBMISSIONS May be made via electronic or e-mail as JPEG small files as well as the other means. Write to arrange a personal interview to show portfolio of photographs, transparencies, slides. Send query letter with photocopies, SASE, photographs, slides, résumé. Responds in 3 weeks. Finds artists through art exhibits, submissions, portfolio reviews, referrals by other artists.

LILLIAN & COLEMAN TAUBE MUSEUM OF ART

2 N. Main St., Minot ND 58703. (701)838-4445. **E-mail:** taube@srt.com. **Website:** www.taubemuseum.org. **Contact:** Nancy Walter, executive director. Estab. 1970. Established nonprofit organization. Sponsors 1-2 photography exhibits/year. Average display time 4-6 weeks. Museum is located in a renovated historic landmark building with room to show 2 exhibits simultaneously. Overall price range $15-225. Most work sold at $40-100.

EXHIBITS Photos of babies/children/teens, couples, multicultural, families, parents, senior citizens, disasters, landscapes/scenics, wildlife, beauty, rural, travel, agriculture, buildings, military, portraits. Interested in avant garde, fine art.

MAKING CONTACT & TERMS Charges 30% commission for members; 40% for nonmembers. Sponsors openings.

SUBMISSIONS Submit portfolio along with a minimum of 6 examples of work in digital format for review. Responds in 3 months.

TIPS "Wildlife, landscapes and floral pieces seem to be the trend in North Dakota. We get many portfolios to review for our photography exhibits each year. We also appreciate figurative, unusual and creative photography work."

NATALIE AND JAMES THOMPSON ART GALLERY

School of Art Design, San Jose State University, San Jose CA 95192-0089. (408)924-4723. **Fax:** (408)924-4326. **E-mail:** thompsongallery@sjsu.edu. **Website:** www.sjsu.edu. **Contact:** Jo Farb Hernandez, director. Nonprofit gallery. Approached by 100 artists/year. Sponsors 1-2 photography exhibits/year. Average dis-

play time 1 month. Gallery open Monday, Wednesday-Friday, 11-4; Tuesday, 11-4 and 6-7:30.

EXHIBITS All genres, aesthetics and techniques.

MAKING CONTACT & TERMS Works not generally for sale. Gallery provides insurance, promotion. Accepted work should be framed or ready to hang.

SUBMISSIONS Send query letter with artist's statement, bio, résumé, reviews, slides, SASE. Responds as soon as possible. Finds artists through word of mouth, submissions, portfolio reviews, art exhibits, art fairs, referrals by other artists.

THROCKMORTON FINE ART

145 E. 57th St., 3rd Floor, New York NY 10022. (212)223-1059. **Fax:** (212)223-1937. **E-mail:** info@throckmorton-nyc.com. **Website:** www.throckmorton-nyc.com. **Contact:** Spencer Throckmorton, owner; Norberto Rivera, photography. Estab. 1993. For-profit gallery. A New York-based gallery specializing in vintage and contemporary photography of the Americas for over 25 years. Its primary focus is Latin American photographers. The gallery also specializes in Chinese jades and antiquities, as well as pre-Columbian art. Located in the Hammacher Schlemmer Building; 4,000 sq. ft.; 1,000 sq. ft. exhibition space. Clients include local community and upscale. Approached by 50 artists/year; represents or exhibits 20 artists. Sponsors 5 photography exhibits/year. Average display time 2 months. Overall price range $1,000-10,000. Most work sold at $2,500. Open Tuesday–Saturday, 11-5.

EXHIBITS Photos of babies/children/teens, landscapes/scenics, architecture, cities/urban, rural. Interested in erotic, fine art, historical/vintage, Latin American photography.

MAKING CONTACT & TERMS Charges 50% commission. Gallery provides insurance, promotion.

SUBMISSIONS Write to arrange a personal interview to show portfolio of photographs/slides/CD, or send query letter with artist's statement, bio, photocopies, slides, CD, SASE. Responds in 3 weeks. Finds artists through word of mouth, portfolio reviews.

TIPS "Present your work nice and clean."

TILT GALLERY

7046 E. Main St., Scottdale AZ 85251. (602)716-5667. **E-mail:** info@tiltgallery.com. **E-mail:** melanie@tiltgallery.com. **Website:** www.tiltgallery.com. **Contact:** Melanie Craven, gallery owner. Estab. 2005. For-profit gallery. "A contemporary fine art gallery specializing in historical to alternative photographic processes and mixed media projects." Approached by 30 artists/year; represents or exhibits 20 emerging and established artists. Exhibited artists include France Scully, Mark Osterman, Aline Smithson. Sponsors 8 exhibits/year; 7 photography exhibits/year. Average display time 1 month. Open Tuesday-Saturday, 10:30-5:30; Thursday, 7-9; and by appointment. Closed June-mid August. The gallery is located in the Grand Avenue Arts District of downtown Phoenix. Operates in a 100-year-old historically-restored house. Property features the main gallery building, as well as a Tilt 2 community space in the adjacent historically-restored structure. Clients include local community, students, tourists, upscale. 75% of sales are to corporate collectors. Overall price range $700-10,000. Most work sold at $2,500.

EXHIBITS Considers fiber, installation, mixed media, paper, sculpture. Most frequently exhibits fine art photography, mixed media, installation. Considers photogravure, collotype and bromoil prints. Considers conceptualism and historical photographic processes. Most frequently exhibits conceptualism. Exhibits figurative work, landscapes, portraits and conceptual.

MAKING CONTACT & TERMS Represented artists and Tilt each receive 50% of sale. Retail price of the art set by the gallery. Gallery provides insurance, promotion, contract. Accepted work should be mounted, matted. Requires exclusive representation locally. Prefers fine art photography, historic and alternative photographic processes and mixed media.

SUBMISSIONS E-mail with link to artist's website and JPEG samples at 72 dpi, mail portfolio for review, or send query letter. Material cannot be returned. Responds in 1-3 months. Finds artists through word of mouth, submissions, portfolio reviews, art exhibits, art fairs and referrals by other artists.

TIPS "Submit a complete body of work exhibiting cohesiveness, with attention to presentation."

TOUCHSTONE GALLERY

901 New York Ave. NW, Washington DC 20001-2217. (202)347-2787. **E-mail:** info@touchstonegallery.com. **Website:** www.touchstonegallery.com. Estab. 1976. Contemporary fine art gallery featuring 50 artists working in a variety of original art in all media—oil, acrylic, sculpture, photography, printing, engraving, etc.—exhibiting a new show monthly. This brand new

1,600+-sq.-ft. space features tall ceilings, great lighting, and polished flooring. The Gallery is available for rent for brunch meetings, rehearsal dinners, cocktail parties, and life celebrations of all kinds. Located near the heart of the bustling Penn Quarter district in downtown Washington DC one block from the Washington Convention Center, the gallery is easily accessible at street level. Open Wednesday-Friday, 11-6; Saturday-Sunday, 12-5. Overall artwork price range: $100-20,000. Visit the website or contact the gallery directly for further information.

⊕ UAB VISUAL ARTS GALLERY

UAB Department of Art & Art History, 113 Humanities, 900 13th St. S., Birmingham AL 35294-1260. (205)934-0815. **Fax:** (205)975-2836. **E-mail:** blevine@uab.edu. **Website:** www.uab.edu/art/vagallery.php; uabvisualartsgallery.wordpress.com. **Contact:** John Fields, interim director. Nonprofit university gallery. Sponsors 1-3 photography exhibits/year. Average display time 3-4 weeks. Gallery open Monday–Thursday, 11-6; Friday, 11-5; Saturday, 1-5. Closed major holidays and last 2 weeks of December.
EXHIBITS Photos of multicultural. Interested in alternative process, avant garde, fine art, historical/vintage.
MAKING CONTACT & TERMS Gallery provides insurance, promotion. Accepted work should be framed.
SUBMISSIONS Does not accept unsolicited exhibition proposals. Write to arrange a personal interview to show portfolio of slides. Send query letter with artist's statement, bio, brochure, photographs, résumé, reviews, slides, SASE.

UCR/CALIFORNIA MUSEUM OF PHOTOGRAPHY

University of California, 3824 Main St., Riverside CA 92501. **E-mail:** cmpcollections@ucr.edu; cmppress@ucr.edu; jonathan.green@ucr.edu. **Website:** www.cmp.ucr.edu. **Contact:** Jonathan Green, executive director. Sponsors 10-15 exhibits/year. Average display time 8-14 weeks. Open Tuesday–Saturday, 12-5. Located in a renovated 23,000-sq.-ft. building. "It is the largest exhibition space devoted to photography in the West."
EXHIBITS Interested in technology/computers, alternative process, avant garde, documentary, fine art, historical/vintage.

MAKING CONTACT & TERMS Curatorial committee reviews CDs, slides and/or matted or unmatted work. Photographer must have highest-quality work.
SUBMISSIONS Exhibition proposals should include a project description, cover letter, résumé, and selection of images. Artists can send either a link to a website or e-mail up to 10MB of digital files for consideration by the curatorial committee. These proposals will be reviewed as they are received. The museum's curators will actively solicit submissions for individuals whose work they would like to consider for future projects.
TIPS "This museum attempts to balance exhibitions among historical, technological, contemporary, etc. We do not sell photos but provide photographers with exposure. The museum is always interested in newer, lesser-known photographers who are producing interesting work. We're especially interested in work relevant to underserved communities. We can show only a small percent of what we see in a year."

UNI GALLERY OF ART

University of Northern Iowa, 104 Kamerick Art Bldg., Cedar Falls IA 50614-0362. (319)273-6134. **Fax:** (319)273-7333. **E-mail:** galleryofart@uni.edu. **Website:** www.uni.edu/artdept/gallery/home.html. **Contact:** Darrell Taylor, director. Estab. 1978. Sponsors 9 exhibits/year. Average display time 1 month. Approximately 5,000 sq. ft. of space and 424 ft. of usable wall space. Interested in all styles of high-quality contemporary art works.
MAKING CONTACT & TERMS "We do not sell work."
SUBMISSIONS Please provide a cover letter and proposal as well as an artist's statement, CV, and samples. Send material by mail for consideration or submit portfolio for review; include SASE for return of material. Response time varies.

UNION STREET GALLERY

1527 Otto Blvd., Chicago Heights IL 60411. (708)754-2601. **E-mail:** unionstreetart@sbcglobal.net. **Website:** www.unionstreetgallery.org. **Contact:** Jessica Segal, gallery director. Estab. 1995. Nonprofit gallery. Represents or exhibits more than 100 artists. "We offer group invitations and juried exhibits every year." Average display time 5 weeks. Hours: Wednesday and Thursday, 12-5; Friday, 12-6; Saturday, 11-4. Overall price range $30-3,000. Most work sold at $300-500.

SUBMISSIONS Finds artists through submissions, referrals by other artists and juried exhibits at the gallery. "To receive prospectus for all juried events, call, write or e-mail to be added to our mailing list. Prospectus also available on website. Artists interested in studio space or solo/group exhibitions should contact the gallery to request information packets."

UNIVERSITY ART GALLERY IN THE D.W. WILLIAMS ART CENTER

P.O. Box 30001, Las Cruces NM 88003. (575)646-2545 or (575)646-5423. **Fax:** (575)646-8036. **E-mail:** art glry@nmsu.edu. **Website:** www.nmsu.edu/~artgal. **Contact:** Stephanie Taylor, director. Estab. 1973. The largest visual arts facility in South Central New Mexico, the gallery presents 6-9 exhibitions annually. Overall price range $300-2,500. Features contemporary and historical art of regional, national and international importance. Focus includes the work of NMSU Art Department faculty, graduate students, undergraduates, traveling exhibitions and over 3,000 works from the university's permanent collection. The latter includes the country's largest collection of Mexican retablos (devotional paintings on tin) as well as photographs, paintings, prints and graphics, book art, and small scale sculpture and metals.

MAKING CONTACT & TERMS Buys photos outright.

SUBMISSIONS Arrange a personal interview to show portfolio. Submit portfolio for review. Send query letter with samples. Send material by mail with SASE by end of October for consideration. Responds in 3 months.

TIPS Looks for "quality fine art photography. The gallery does mostly curated, thematic exhibitions. Very few one-person exhibitions."

UNIVERSITY OF RICHMOND MUSEUMS

28 Westhampton Way, Richmond VA 23173. (804)289-8276. **Fax:** (804)287-1894. **E-mail:** rwaller@richmond.edu; museums@richmond.edu. **Website:** museums.richmond.edu. **Contact:** Richard Waller, director. Estab. 1968. University Museums comprises Joel and Lila Harnett Museum of Art, Joel and Lila Harnett Print Study Center, and Lora Robins Gallery of Design from Nature. The museums are home to diverse collections and exhibitions of art, artifacts and natural history specimens. Sponsors 18-20 exhibits/year. Average display time 8-10 weeks. See website for hours for each gallery.

EXHIBITS Interested in all subjects.

MAKING CONTACT & TERMS Charges 10% commission. Work must be framed for exhibition.

SUBMISSIONS Send query letter with résumé, samples. Send material by mail for consideration. Responds in 1 month.

TIPS "If possible, submit material that can be left on file and fits standard letter file. We are a nonprofit university museum interested in presenting contemporary art as well as historical exhibitions."

UPSTREAM GALLERY

26B Main St., Dobbs Ferry NY 10522. (914)674-8548. **E-mail:** upstreamgallery26@gmail.com. **Website:** www.upstreamgallery.com. Estab. 1990. "Upstream Gallery is a cooperative with up to 25 members practicing various disciplines including sculpture, painting, printmaking, photography, digital imagery and more." Requires membership to exhibit. Annual dues reflect an equal sharing of the yearly expenses of maintaining the gallery. Applicants can apply for a full (includes a 1 person show in 1 of the 2 galleries, rotating between the two every 18 or 24 months) or associate membership (sharing on of the galleries with another artist every 18-24 months and rotating similar to full membership). See website for more details.

EXHIBITS Only fine art. Accepts all subject matters and genres for jurying.

MAKING CONTACT & TERMS There is a co-op membership fee plus a donation of time. There is a 20% commission. Gallery provides insurance. Accepted work should be framed, mounted and matted.

SUBMISSIONS Write to arrange a personal interview to show portfolio of photographs and slides. Send query letter with artist's statement, bio, brochure, business card, photographs, résumé, reviews, slides and SASE. Responds to queries within 2 months, only if interested. Finds artists through referrals by other artists and submissions.

UPSTREAM PEOPLE GALLERY

5607 Howard St., Omaha NE 68106-1257. (402)991-4741. **E-mail:** shows@upstreampeoplegallery.com. **Website:** www.upstreampeoplegallery.com. **Contact:** Laurence Bradshaw, curator. Estab. 1998. Exclusive online virtual gallery with over 40 international exhibitions in the archives section of the website. Represents mid-career and established artists. Approached by approximately 1,500 artists/year; represents or exhibits 20,000 artists. Sponsors 12 total exhibits/

year and 7 photography exhibits/year. Average display time is 12 months to 4 years. Overall price range $100-60,000. Most work sold at $300. 15% of sales are to corporate collectors.

EXHIBITS Considers all media except video and film. Most frequently exhibits oil, acrylic and ceramics. Considers all prints, styles and genres. Most frequently exhibits Neo-Expressionism, Realism and Surrealism.

MAKING CONTACT & TERMS Artwork is accepted on consignment; there is no commission if the artists sells, but a 20% commission if the gallery sells. Retail price set by the artist. Gallery provides promotion and contract.

SUBMISSIONS Accepted work should be photographed. Call or write to arrange personal interview to show portfolio, e-mail query letter with link to website and JPEG samples at 72 dpi or send query letter with artist's statement and CD/DVD. Returns material with SASE. Responds to queries within 1 week. Files résumés. Finds artists through art exhibits, referrals and online and magazine advertising.

TIPS "Make sure all photographs of works are in focus."

URBAN INSTITUTE FOR CONTEMPORARY ARTS

2 W. Fulton St., Grand Rapids MI 49503. (616)454-7000. **E-mail:** jteunis@uica.org. **Website:** www.uica.org. **Contact:** Janet Teunis, director of operations. Estab. 1977. Alternative space and nonprofit gallery. Approached by 250 artists/year; represents or exhibits 20 artists. Sponsors 3-4 photography exhibits/year. Average display time 6 weeks. Gallery open Tuesday-Thursday, 5-9; Friday-Saturday, 12-9; Sunday, 12-7.

EXHIBITS Most frequently exhibits mixed media, avant garde, and nontraditional work. Style of exhibits are conceptual and postmodern.

SUBMISSIONS Please check our website for gallery descriptions and how to apply. Artists should visit the website, go to Exhibitions, then Apply for a Show and follow the instructions. UICA exhibits artists through submissions.

VIRIDIAN ARTISTS, INC.

548 W. 28th St., Suite 632, New York NY 10001. (212)414-4040. **Website:** www.viridianartists.com. **Contact:** Vernita Nemec, director. Estab. 1968. Artist-owned gallery. Approached by 200 artists/year. Exhibits 25-30 emerging, mid-career and established

artists/year. Sponsors 15 total exhibits/year; 2-4 photography exhibits/year. Average display time 3 weeks. Open Tuesday–Saturday, 12-6. Closed in August. "Classic gallery space with 3 columns, hardwood floor, white walls and track lights, approximately 1,100 sq. ft. The gallery is located in Chelsea, the prime area of contemporary art galleries in New York City." Clients include: local community, students, tourists, upscale and artists. 15% of sales are to corporate collectors. Overall price range: $100-8,000. Most work sold at $1,500.

EXHIBITS Considers all media except craft, traditional glass and ceramic, unless it is sculpture. Most frequently exhibits paintings, photography and sculpture. Considers engravings, etchings, linocuts, lithographs, mezzotints, serigraphs, woodcuts and monoprints/limited edition digital prints. Considers all styles (mostly contemporary). Most frequently exhibits painterly abstraction, imagism and neo-expressionism. "We are not interested in particular styles, but in professionally conceived and professionally executed contemporary art. Eclecticism is our policy. The only unifying factor is quality. Work must be of the highest technical and aesthetic standards."

MAKING CONTACT & TERMS Artwork accepted on consignment with a 30% commission. There is a co-op membership fee plus a donation of time with a 30% commission. Retail price of the art is set by the gallery and artist. Gallery provides promotion and contract. "Viridian is an artist-owned gallery with a director and gallery assistant. Artists pay gallery expenses through monthly dues, but the staff takes care of running the gallery and selling the art. The director writes the press releases, helps install exhibits and advises artists on all aspects of their career. We try to take care of everything but making the art and framing it." Prefers artists who are familiar with the NYC art world and are working professionally in a contemporary mode which can range from realistic to abstract to conceptual and anything in between.

SUBMISSIONS Submitting art for consideration is a 2-step process: first through website or JPEGs, then if accepted at that level, by seeing 4-6 samples of the actual art. Artists should call, e-mail query letter with link to artist's website or JPEG samples at 72 dpi (include image list) or send query letter with artist's statement, bio, reviews, CD with images and SASE. Materials returned with SASE. Responds in 2-4 weeks. Files materials of artists who become members. Finds

artists through word of mouth, submissions, art exhibits, portfolio reviews or referrals by other artists.

TIPS "Present current art completed within the last 2 years. Our submission procedure is in 2 stages: first we look at websites, JPEGs that have been e-mailed, or CDs that have been mailed to the gallery. When e-mailing JPEGs, include an image list with title, date of execution, size, media. Also, include a bio and artist's statement. Reviews about your work are helpful if you have them, but not necessary. If you make it through the first level, then you will be asked to submit 4-6 actual art works. These should be framed or matted, and similar to the work you want to show. Realize it is important to present a consistency in your vision. If you do more than one kind of art, select what you feel best represents you, for the art you show will be a reflection of who you are."

VISUAL ARTS CENTER OF NORTHWEST FLORIDA

19 E. Fourth St., Panama City FL 32401. (850)769-4451. **E-mail:** vacoffice@knology.net. **Website:** www.vacnwf.org. **Contact:** Exhibition manager. Estab. 1988. Approached by 20 artists/year; represents local and national artists. Sponsors 1-2 photography exhibits/year. Average display time 6 weeks. Open Tuesday and Thursday, 10-8; Wednesday, Friday and Saturday, 10-5; closed Sunday and Monday. The Center features a large gallery (200 running ft.) upstairs and a smaller gallery (80 running ft.) downstairs. Overall price range $50-1,500.

EXHIBITS Photos of all subject matter, including babies/children/teens, couples, families, parents, senior citizens, environmental, landscapes/scenics, wildlife, architecture, product shots/still life. Interested in alternative process, avant garde, documentary, fashion/glamour, fine art, historical/vintage, seasonal, digital, underwater.

MAKING CONTACT & TERMS Artwork is accepted on consignment, and there is a 30% commission. Gallery provides promotion, contract, insurance. Accepted work must be framed, mounted, matted.

SUBMISSIONS Send query letter with artist's statement, bio, résumé, SASE, 10-12 slides or images on CD. Responds within 4 months. Finds artists through word of mouth, submissions, art exhibits.

THE WAILOA ART & CULTURAL CENTER

P.O. Box 936, Hilo HI 96721. (808)933-0416. **Fax:** (808)933-0417. **E-mail:** wailoa@yahoo.com. **Contact:** Ms. Codie King, director. Estab. 1967. A division of State Parks, Department of Land and Natural Resources. Also includes multi-media exhibits. Free and open to the public. Sponsors 24 exhibits/year. Average display time 1 month. Open Monday, Tuesday, Thursday, Friday, 8:30-4:30; Wednesday, 12-4:30. Closed Saturday, Sunday and state holidays.

EXHIBITS Photos must be submitted to director for approval. "All entries accepted must meet professional standards outlined in our pre-entry forms."

MAKING CONTACT & TERMS Gallery receives 10% "donation" on works sold. No fee for exhibiting. Accepted work should be framed. "Photos must also be fully fitted for hanging. Expenses involved in installation, shipping, insurance, invitations and reception, etc., are the responsibility of the exhibitor."

SUBMISSIONS Submit portfolio for review. Send query letter with résumé of credits, samples, SASE. Responds in 3 weeks.

TIPS "The Wailoa Art & Cultural Center is operated by Hawaii State Parks, a division of the Department of Land and Natural Resources. We are unique in that there are no costs to the artist to exhibit here as far as rental or commissions are concerned. We welcome artists from anywhere in the world who would like to show their works in Hawaii. Wailoa Art & Cultural Center is booked 2-3 years in advance. The gallery is also a visitor information center with thousands of people from all over the world visiting."

WASHINGTON COUNTY MUSEUM OF FINE ARTS

P.O. Box 423, 401 Museum Dr., Hagerstown MD 21741. (301)739-5727. **Fax:** (301)745-3741. **E-mail:** info@wcmfa.org. **E-mail:** jsmith@wcmfa.org. **Website:** www.wcmfa.org. **Contact:** Curator. Estab. 1929. The museum has a long tradition of cultural leadership in the Cumberland Valley region, providing residents and visitors with access to a permanent collection and an active schedule of exhibitions, musical concerts, lectures, film, art classes and special events for children and adults. Approached by 30 artists/year. Sponsors 1 juried photography exhibit/year. Average display time 6-8 weeks. Open Tuesday-Friday, 9-5; Saturday, 9-4; Sunday, 1-5. Closed Mondays and major holidays. Overall price range $50-7,000.

EXHIBITS Photos of babies/children/teens, celebrities, couples, multicultural, families, parents, senior citizens, disasters, environmental, landscapes/scenics, wildlife, architecture, cities/urban, education,

gardening, interiors/decorating, pets, religious, rural, adventure, automobiles, entertainment, events, food/drink, health/fitness/beauty, hobbies, humor, performing arts, sports, travel, agriculture, business concepts, industry, medicine, military, political, product shots/still life, science, technology/computers. Interested in alternative process, avant garde, documentary, fashion/glamour, fine art, historical/vintage, seasonal.

MAKING CONTACT & TERMS Museum handles sale of works, if applicable, with 40% commission. Accepted work shall not be framed.

SUBMISSIONS Write to show portfolio of photographs, slides. Mail portfolio for review. Responds in 1 month. Finds artists through word of mouth, portfolio reviews, art exhibits, referrals by other artists.

TIPS "We sponsor an annual juried competition in photography. Entry forms are available in the fall of each year. Send name and address to be placed on list."

⊕ WASHINGTON PROJECT FOR THE ARTS

10 I St. SW, Washington DC 20024. (202)234-7103. **Fax:** (202)234-7106. **E-mail:** info@wpadc.org. **Website:** www.wpadc.org. **Contact:** Christopher Cunetto, membership manager. Estab. 1975. Alternative space that exhibits emerging, mid-career and established artists. Approached by 1,500 artists/year, exhibits 800 artists. Sponsors 12 exhibits/year. Average display time of 4 weeks. WPA is located in the Capitol Skyline Hotel. We exhibit throughout the hotel and in various museums and venues throughout the region. Clients include local community, students, tourists and upscale. 5% of sales are to corporate collectors. Overall price range of works sold $100-5,000. Most work sold at $500-1,000.

EXHIBITS Considers all media. Most frequently exhibits performance, painting, drawing and photography.

MAKING CONTACT & TERMS Artwork is accepted on consignment and there is a 50% commission. Retail price set by the artist. Gallery provides insurance, promotion and contract. Accepted work should be framed.

SUBMISSIONS E-mail query letter with link to artist's website. Responds in 2 months. Finds artists through word of mouth, submissions, portfolio reviews, art exhibits and referrals by other artists.

TIPS Use correct spelling, make sure packages/submissions are tidy.

⊘ WEINSTEIN GALLERY

908 W. 46th St., Minneapolis MN 55419. (612)822-1722. **Fax:** (612)822-1745. **E-mail:** weingall@aol.com. **Website:** www.weinstein-gallery.com. **Contact:** Leslie Hammons, director. Estab. 1996. For-profit gallery. Approached by hundreds of artists/year; represents or exhibits 12 artists. Average display time 6 weeks. Open Tuesday–Saturday, 12-5, or by appointment. Overall price range $4,000-250,000.

EXHIBITS Interested in fine art. Most frequently exhibits contemporary photography.

SUBMISSIONS "We do not accept unsolicited submissions."

WISCONSIN UNION GALLERIES

WUD Art Committee, 1308 W. Payton St., Room 235, Madison WI 53715. (608)890-4432; (608)262-7592. **Fax:** (608)890-4411. **E-mail:** art@union.wisc.edu. **E-mail:** schmoldt@wisc.edu. **Website:** www.union.wisc.edu/wud/art-events.htm. **Contact:** Robin Schmoldt, art collection manager. Estab. 1928. Nonprofit gallery. Estab. 1928. Approached by 100 artists/year; exhibits 30 shows/year. Average display time 4-6 weeks. Open 10-8 daily. Gallery 1308 in Union South is open 7 a.m.-10 p.m. weekdays and 8-10 weekends. Closed during winter break and when gallery exhibitions turn over. Visit the website for the gallery's features.

EXHIBITS Interested in fine art. "Photography exhibitions vary based on the artist proposals submitted."

MAKING CONTACT & TERMS All sales through gallery during exhibition only.

SUBMISSIONS Current submission guidelines available at www.union.wisc.edu/wud/art-submissions.htm. Finds artists through art fairs, art exhibits, referrals by other artists, submissions, word of mouth.

WOMEN & THEIR WORK ART SPACE

1710 Lavaca St., Austin TX 78701. (512)477-1064. **Fax:** (512)477-1090. **Website:** www.womenandtheirwork.org. **Contact:** Chris Cowden, executive director. Estab. 1978. Alternative space, nonprofit gallery. Approached by more than 400 artists/year; represents or exhibits 6 solo exhibitions from Texas artists and 1 show/year for artists outside of Texas. Encourages the creation of new work. Types of media vary. Average display time 6 weeks. Gallery open Monday–Friday, 10-6; Saturday, 12-5. Closed December 24–January 2, and other major holidays. Exhibition space is 2,000

sq. ft. Overall price range $500-5,000. Most work sold at $800-2,000.

EXHIBITS Interested in contemporary, alternative process, avant garde, fine art.

MAKING CONTACT & TERMS "We select artists through a juried process and pay them to exhibit. We take 25% commission if something is sold." Gallery provides catalog, insurance, promotion, contract. Texas women in majority of solo shows. "Online Artist Slide Registry on website."

SUBMISSIONS Finds artists through nomination by art professional.

TIPS "Provide quality images, typed résumé and a clear statement of artistic intent."

WORLD FINE ART GALLERY

179 E. Third St., Suite 16, New York NY 10009-7705. (646)539-9622. **Fax:** (646)478-9361. **E-mail:** info@worldfineart.com. **Website:** www.worldfineart.com. **Contact:** O'Delle Abney, director. Estab. 1992. Online gallery since 2010. Services include online websites (www.worldfineart.com/join.html) and personal marketing. Group exhibitions around the New York City Area.

SUBMISSIONS Responds to queries in 1 week. Nonexclusive agent to 12 current portfolio artists. Finds artists online.

TIPS "Have website available or send JPEG images for review."

YESHIVA UNIVERSITY MUSEUM

15 W. 16th St., New York NY 10011. (212)294-8330. **Fax:** (212)294-8335. **E-mail:** info@yum.cjh.org. **Website:** www.yumuseum.org. Estab. 1973. The museum's changing exhibits celebrate the culturally diverse intellectual and artistic achievements of 3,000 years of Jewish experience. Sponsors 6-8 exhibits/year; at least 1 photography exhibit/year. Average display time 4-6 months. The museum occupies 4 galleries and several exhibition arcades. All galleries are handicapped accessible. Open Sunday, Tuesday and Thursday, 11-5; Monday and Wednesday, 11-8; Friday, 11-2:30.

EXHIBITS Seeks "individual or group exhibits focusing on Jewish themes and interests; exhibition-ready work essential."

MAKING CONTACT & TERMS Accepts images in digital format. Send CD and accompanying text with SASE for return. Send color slide portfolio of 10-12 slides or photos, exhibition proposal, résumé

with SASE for consideration. Reviews take place 3 times/year.

TIPS "We exhibit contemporary art and photography based on Jewish themes. We look for excellent quality, individuality, and work that reveals a connection to Jewish identity and/or spirituality."

MIKHAIL ZAKIN GALLERY

561 Piermont Rd., Demarest NJ 07627. (201)767-7160. **Fax:** (201)767-0497. **E-mail:** maria@tasoc.org; gallery@tasoc.org. **Website:** www.tasoc.org. **Contact:** Maria Danzinger, executive director. Estab. 1974. Nonprofit gallery associated with the Art School at Old Church. "10-exhibition season includes contemporary, emerging, and established regional artists, NJ Annual Small Works show, student and faculty group exhibitions, among others." Gallery hours: Monday–Friday, 9:30-5. Call for weekend and evening hours. Exhibitions are mainly curated by invitation. However, unsolicited materials are reviewed and will be returned with the inclusion of a SASE. The gallery does not review artist websites, e-mail attachments or portfolios in the presence of the artist. Please follow the submission guidelines on our website.

EXHIBITS All styles and genres are considered.

MAKING CONTACT & TERMS Charges 35% commission fee on all gallery sales. Gallery provides promotion and contract. Accepted work should be framed, mounted.

SUBMISSIONS Guidelines are available on gallery's website. Small Works prospectus is available online. Mainly finds artists through referrals by other artists and artist registries.

TIPS "Follow guidelines available online."

ZENITH GALLERY

1429 Iris St. NW, Washington DC 20012. (202)783-2963. **Fax:** (202)783-0050. **E-mail:** margery@zenithgallery.com. **E-mail:** art@zenithgallery.com. **Website:** www.zenithgallery.com. **Contact:** Margery E. Goldberg, founder/owner/director. Estab. 1978. For-profit gallery. Open by appointment. Open Friday and Saturday, 12-6, and by appointment. Curates The Gallery at 1111 Pennsylvania Ave. NW, Washington DC, open Monday–Friday, 8-7; Saturday and Sunday, by appointment. Overall price range: $500-15,000.

EXHIBITS Photos of landscapes/scenics and other. Interested in avant garde, fine art.

SUBMISSIONS Mail portfolio for review. Send query letter with artist's statement, bio, brochure, busi-

ness card, résumé, reviews, photocopies, photographs, slides, CD, SASE. Responds to queries within 1 year, only if interested. Finds artists through art fairs and exhibits, portfolio reviews, referrals by other artists, submissions and word of mouth.

ART FAIRS

///

How would you like to sell your art from New York to California, showcasing it to thousands of eager art collectors? Art fairs (also called art festivals or art shows) are not only a good source of income for artists but an opportunity to see how people react to their work. If you like to travel, enjoy meeting people, and can do your own matting and framing, this could be a great market for you.

Many outdoor fairs occur during the spring, summer, and fall months to take advantage of warmer temperatures. However, depending on the region, temperatures could be hot and humid, and not all that pleasant! And, of course, there is always the chance of rain. Indoor art fairs held in November and December are popular because they capitalize on the holiday shopping season.

To start selling at art fairs, you will need an inventory of work—some framed, some unframed. Even if customers do not buy the framed paintings or prints, having some framed work displayed in your booth will give buyers an idea of how your work looks framed, which could spur sales of your unframed prints. The most successful art fair exhibitors try to show a range of sizes and prices for customers to choose from.

When looking at the art fairs listed in this section, first consider local shows and shows in your neighboring cities and states. Once you find a show you'd like to enter, visit its website or contact the appropriate person for a more detailed prospectus. A prospectus is an application that will offer additional information not provided in the art fair's listing.

Ideally, most of your prints should be matted and stored in protective wraps or bags so that customers can look through your inventory without damaging prints and mats. You will also need a canopy or tent to protect yourself and your wares from the elements as well as some bins in which to store the prints. A display wall will allow you to show off your

best framed prints. Generally, artists will have 100 square feet of space in which to set up their tents and canopies. Most listings will specify the dimensions of the exhibition space for each artist.

If you see the ☊ icon before a listing in this section, it means that the art fair is a juried event. In other words, there is a selection process artists must go through to be admitted into the fair. Many art fairs have quotas for the categories of exhibitors. For example, one art fair may accept the mediums of photography, sculpture, painting, metal work, and jewelry. Once each category fills with qualified exhibitors, no more will be admitted to the show that year. The jurying process also ensures that the artists who sell their work at the fair meet the sponsor's criteria for quality. So, overall, a juried art fair is good for artists because it means they will be exhibiting their work along with other artists of equal caliber.

Be aware there are fees associated with entering art fairs. Most fairs have an application fee or a space fee, or sometimes both. The space fee is essentially a rental fee for the space your booth will occupy for the art fair's duration. These fees can vary greatly from show to show, so be sure to check this information in each listing before you apply to any art fair.

Most art fair sponsors want to exhibit only work that is handmade by the artist, no matter what medium. Unfortunately, some people try to sell work that they purchased elsewhere as their own original artwork. In the art fair trade, this is known as "buy/sell." It is an undesirable situation because it tends to bring down the quality of the whole show. Some listings will make a point to say "no buy/sell" or "no manufactured work."

For more information on art fairs, pick up a copy of *Sunshine Artist* (www.sunshine artist.com) or *Professional Artist* (www.artcalendar.com), and consult online sources such as www.artfairsource.com.

4 BRIDGES ARTS FESTIVAL

30 Frazier Ave., Chattanooga TN 37405. (423)265-4282. **Fax:** (423)265-5233. **E-mail:** katdunn@avarts.org. **Website:** www.avarts.com. **Contact:** Kat Dunn. Estab. 2001. Fine arts & crafts show held annually in mid-April. Held in a covered, open-air pavilion. Accepts photography and 24 different mediums. Juried by 3 different art professionals each year. Awards: $10,000 in artist merit awards; the on-site jurying for merit awards will take place Saturday morning. Number of exhibitors: 150. Public attendance: 20,000. Public admission: $7/day or a 2-day pass for $10; children are free. Artists should apply at www.zapplication.org. Deadline for entry: early November (see website for details). Application fee: $40. Space fee: $425 for 10×12 ft. Exhibit space: 10×12 ft.; double: 20×12 ft. Average gross sales/exhibitor: $3,091. For more information, e-mail, visit website or call.

TIPS "Have a compelling, different body of work that stands out among so many other photographers and artists."

AKRON ARTS EXPO

Hardesty Park, 1615 W. Market, Akron OH 44313. (330)375-2836. **Fax:** (330)375-2883. **E-mail:** PBomba@akronohio.gov. **Website:** www.akronartsexpo.org. **Contact:** Penny Bomba, artist coordinator. Estab. 1979. Held in late July. "The Akron Arts Expo is a nationally recognized juried fine arts & crafts show held outside with over 160 artists, ribbon and cash awards, great food, an interactive children's area, and entertainment for the entire family. Participants in this festival present quality fine arts and crafts that are offered for sale at reasonable prices. For more information, see the website." Application fee $5. Booth fee: $200.

ALDEN B. DOW MUSEUM SUMMER ART FAIR

1801 W. St. Andrews Rd., Midland MI 48640. **Fax:** (989)631-7890. **E-mail:** mills@mcfta.org. **Website:** www.mcfta.org. **Contact:** Emmy Mills, business manager/art fair coordinator. Estab. 1966. Fine art & crafts show held annually in early June. Outdoors. Accepts photography, ceramics, fibers, jewelry, mixed media 3D, painting, wood, drawing, glass, leather, sculpture, basket, furniture. Juried by a panel. Awards: $500 1st Place, $300 2nd Place, $100 3rd Place. Average number of exhibitors: 150. Public attendance: 5,000-8,000. Free to public. Artists should apply at www.mcfta.org/specialevents.html. Deadline for entry: late March; see website for details. Application fee: jury $25, second medium $5/each. Space fee: $195/single booth, $365/double booth. Exhibition space: approximately 12×12 ft. Average gross sales/exhibitor: $1,500. Artists should e-mail or visit website for more information.

ALLEN PARK ARTS & CRAFTS STREET FAIR

16850 Southfield Rd., Allen Park MI 48101-2599. (313)928-0940; (734)258-7720. **Fax:** (313)382-7946. **E-mail:** allenparkstreetfair@gmail.com. **Website:** www.allenparkstreetfair.org. **Contact:** Allen Park Festivities Commission. Estab. 1981. Arts & crafts show held annually the 1st Friday and Saturday in August. Outdoors. Accepts photography, sculpture, ceramics, jewelry, glass, wood, prints, drawings, paintings. All work must be of fine quality and original work of entrant. Such items as imports, velvet paintings, manufactured or kit jewelry and any commercially produced merchandise are not eligible for exhibit or sale. Juried by 3 photos (no slides) of work. Number of exhibitors: 400. Free to the public. Deadline: Applications must be postmarked by late February (see website for specifics). Application fee: $5. Space fee: $150. Exhibition space: 10×10 ft. Artists should call or see website for more information.

ALLENTOWN ART FESTIVAL

P.O. Box 1566, Buffalo NY 14205. (716)881-4269. **E-mail:** allentownartfestival@verizon.net. **Website:** www.allentownartfestival.com. **Contact:** Mary Myszkiewicz, president. Estab. 1958. Fine arts & crafts show held annually 2nd full weekend in June. Outdoors. Accepts photography, painting, watercolor, drawing, graphics, sculpture, mixed media, clay, glass, acrylic, jewelry, creative craft (hard/soft). Slides juried by hired professionals that change yearly. Awards/prizes: 41 cash prizes totaling over $20,000; includes Best of Show awarding $1,000. Number of exhibitors: 450. Public attendance: 300,000. Free to public. Artists should apply by downloading application from website. Deadline for entry: late January. Exhibition space: 10×13 ft. Application fee: $15. Booth fee $275. For more information, artists should e-mail, visit website, call or send SASE.

TIPS "Artists must have attractive booth and interact with the public."

ALTON ARTS & CRAFTS EXPRESSIONS

P.O. Box 1326, Palatine IL 60078. (312)751-2500. **Fax:** (847)221-5853. **E-mail:** Asoaartists@aol.com. **Website:** www.americansocietyofartists.org. **Contact:** Office personnel. Estab. 1979. Fine arts & crafts show held annually indoors in Walton, Illinois, in spring and fall, usually March and September. Accepts quilting, fabric crafts, artwear, photography, sculpture, jewelry, glass works, woodworking and more. Please submit 4 images representative of your work you wish to exhibit, 1 of your display set-up, your first/last name, physical address, daytime telephone number - résumé/show listing helpful. "See our website for online jury information." Number of exhibitors: 50. Free to the public. Artists should apply by submitting jury materials. If you want to jury via internet see our website and follow directions given there. To jury via e-mail submit to: Asoaartists@aol.com. If juried in, you will receive a jury/approval number. Deadline for entry: 2 months prior to show or earlier if spaces fill. Space fee: to be announced. Exhibition space: approximately 100 sq. ft. for single space; other sizes available. For more information, artists should send SASE, submit jury material.

TIPS "Remember that when you are at work in your studio, you are an artist. But when you are at a show, you are a business person selling your work."

AMERICAN ARTISAN FESTIVAL

P.O. Box 41743, Nashville TN 37204. (615)429-7708. **E-mail:** americanartisanfestival@gmail.com. **Website:** www.facebook.com/theamericanartisanfestival. Estab. 1971. Fine arts & crafts show held annually mid-June, Father's Day weekend. Outdoors. Accepts photography and 21 different medium categories. Juried by 3 different art professionals each year. 3 cash awards presented. Number of exhibitors: 165. Public attendance: 30,000. No admission fee for the public. Artists should apply online at www.zapplication.org. Deadline for entry: early March (see website for details). For more information, e-mail or visit the website.

AMISH ACRES ARTS & CRAFTS FESTIVAL

1600 W. Market St., Nappanee IN 46550. (574)773-4188 or (800)800-4942. **E-mail:** amishacres@amishacres.com; jenniwysong@amishacres.com; beckymaust@amishacres.com. **Website:** www.amishacres.com. **Contact:** Jenni Pletcher Wysong and Becky Maust Cappert, contact coordinators. Estab. 1962. Arts & crafts show held annually first weekend in August. Outdoors. Accepts photography, crafts, floral, folk, jewelry, oil, acrylic, sculpture, textiles, watercolors, wearable, wood. Juried by 5 images, either 35mm slides or e-mailed digital images. Awards/prizes: $5,000 Cash including Best of Show and $1,000 Purchase Prizes. Number of exhibitors: 300. Public attendance: 60,000. Children under 12 free. Artists should apply by sending SASE or printing application from website. Deadline for entry: April 1. Exhibition space: 10×12, 15×12, 20×12 or 30×12 ft.; optional stable fee, with tent, also available. For more information, artists should e-mail, visit website, call or send SASE.

TIPS "Create a vibrant, open display that beckons to passing customers. Interact with potential buyers. Sell the romance of the purchase."

ANACORTES ARTS FESTIVAL

505 O Ave., Anacortes WA 98221. (360)293-6211. **Fax:** 360-299-0722. **E-mail:** staff@anacortesartsfestival.com. **Website:** www.anacortesartsfestival.com. Fine arts & crafts show held annually 1st full weekend in August. Accepts photography, painting, drawings, prints, ceramics, fiber art, paper art, glass, jewelry, sculpture, yard art, woodworking. Juried by projecting 3 images on a large screen. Works are evaluated on originality, quality and marketability. Each applicant must provide high-quality digital images of 3-5 works that will be available for sale. Awards/prizes: festival matches funds with 3 sponsors to award $10,500 in cash prizes. Number of exhibitors: 250. We only accept online applications. Application fee: $35. Deadline for entry: early March. Space fee: $300. Exhibition space: 10×10 ft. For more information, artists should see website.

ANN ARBOR STREET ART FAIR

721 E. Huron, Suite 200, Ann Arbor MI 48104. (734)994-5260. **Fax:** (734)994-0504. **E-mail:** production@artfair.org. **E-mail:** mriley@artfair.org. **Website:** www.artfair.org. Estab. 1958. Fine arts & crafts show held annually 3rd Saturday in July. Outdoors. Accepts photography, fiber, glass, digital art, jewelry, metals, 2D and 3D mixed media, sculpture, clay, painting, drawing, printmaking, pastels, wood. Juried based on originality, creativity, technique, craftsmanship and production. Awards/prizes: cash prizes for outstanding work in any media. Number of ex-

hibitors: 190. Public attendance: 500,000. Free to the public. Artists should apply through www.zapplication.org. Deadline for entry: January. Application fee: $40. Space fee: $650. Exhibition space: 10×12 ft. Average gross sales/exhibitor: $7,000. For more information, artists should e-mail, visit website, call.

ANN ARBOR SUMMER ART FAIR

118 N. Fourth Ave., Ann Arbor MI 48104. (734)662-3382. **Fax:** (734)662-0339. **E-mail:** info@theguild.org. **E-mail:** nicole@theguild.org. **Website:** www.annarborsummerartfair.org. Estab. 1970. Fine arts and craft show held annually on the third Wednesday through Saturday in July. Outdoors. Accepts all fine art categories. Juried. Number of exhibitors: 325. Attendance: 500,000-750,000. Free to public. Deadline for entry is January; enter online at www.juriedartservices.com. Exhibition space: 10×10, 10×13, 10×17 ft. For information, artists should visit the website, call, or e-mail.

APPLE ANNIE CRAFTS & ARTS SHOW

4905 Roswell Rd., Marietta GA 30062. (770)552-6400, ext. 6110. **Fax:** (770)552-6420. **E-mail:** sagw4905@gmail.com. **Website:** www.st-ann.org/womens-guild/apple-annie. Estab. 1981. Handmade arts & crafts show held annually the 1st weekend in December. Juried. Indoors. Accepts handmade arts and crafts like photography, woodworking, ceramics, pottery, painting, fabrics, glass, etc. Number of exhibitors: 120. Public attendance: 4,000. Artists should apply by visiting website to print application form. **Deadline: March 1** (see website for details). Application fee: $15, nonrefundable. Booth fee $200. Exhibition space: 80 sq. ft. minimum, may be more. For more information, artists may visit website.

TIPS "We are looking for vendors with an open, welcoming booth, who are accessible and friendly to customers."

ART FAIR ON THE COURTHOUSE LAWN

P.O. Box 795, Rhinelander WI 54501. (715)365-7464. **E-mail:** info@rhinelanderchamber.com. **E-mail:** assistant@rhinelanderchamber.com. **Website:** www.explorerhinelander.com. **Contact:** Events coordinator. Estab. 1985. Arts & crafts show held annually in June. Outdoors. Accepts woodworking (includes furniture), jewelry, glass items, metal, paintings and photography. Number of exhibitors: 150. Public attendance: 3,000. Free to the public. Space fee: $75-300. Exhibit space: 10×10 to 10×30 ft. For more information, artists should e-mail, call or visit website.

TIPS "We accept only items handmade by the exhibitor."

ART FESTIVAL BETH-EL

400 Pasadena Ave. S., St. Petersburg FL 33707. (727)347-6136. **Fax:** (727)343-8982. **E-mail:** administrator@templebeth-el.com. **Website:** www.templebeth-el.com. Estab. 1972. Fine arts & crafts show held annually the last weekend in January. Indoors. Accepts photography, painting, jewelry, sculpture, woodworking, glass. Juried by special committee on-site or through slides. Awards/prizes: over $7,000 prize money. Number of exhibitors: over 170. Public attendance: 8,000-10,000. Free to the public. Artists should apply by application with photos or slides; show is invitational. Deadline for entry: September. For more information, artists should call or visit website. A commission is taken.

TIPS "Don't crowd display panels with artwork. Make sure your prices are on your pictures. Speak to customers about your work."

ART IN THE PARK (ARIZONA)

P.O. Box 748, Sierra Vista AZ 85636-0247. (520)803-1511. **E-mail:** dragnfly@theriver.com. **Website:** www.artintheparksierravista.com. **Contact:** Georgia MaKellar. Estab. 1972. Oldest longest running Arts & crafts fair in Southern Arizona. Fine arts & crafts show held annually 1st full weekend in October. Outdoors. Accepts photography, all fine arts and crafts created by vendor. No resale retail strictly applied. Juried by Huachaca Art Association Board. Artists submit 5 photos. Returnable with SASE. Number of exhibitors: 240. Public attendance: 15,000. Free to public. Artists should apply by downloading the application www.artintheparksierravista.com. Deadline for entry: postmarked by late June. Last minute/late entries always considered. No application fee. Space fee: $200-275, includes jury fee. Exhibition space: 15×30 ft. Some electrical; additional cost of $25. Some RV space available at $15/night. For more information, artists should see website, e-mail, call or send SASE.

ART IN THE PARK (GEORGIA)

P.O. Box 1540, Thomasville GA 31799. (229)227-7020. **Fax:** (229)227-3320. **E-mail:** roseshowfest@rose.net; laura@thomasville.org. **Website:** www.downtownthomasville.com. **Contact:** Laura Beggs. Estab. 1998-

1999. Art in the Park (an event of Thomasville's Rose Show and Festival) is a one-day arts & crafts show held annually in April. Outdoors. Accepts photography, handcrafted items, oils, acrylics, woodworking, stained glass, other varieties. Juried by a selection committee. Number of exhibitors: 60. Public attendance: 2,500. Free to public. Artists should apply by submitting official application. Deadline for entry: early February. Space fee varies by year. Exhibition space: 20×20 ft. For more information, artists should e-mail, call or visit website.

TIPS "Most important, be friendly to the public and have an attractive booth display."

ART IN THE PARK (HOLLAND, MICHIGAN)

Holland Friends of Art, P.O. Box 1052, Holland MI 49422. **E-mail:** info@hollandfriendsofart.com. **Website:** www.hollandfriendsofart.com. **Contact:** Bonnie Lowe, art fair chairperson. This annual fine arts and crafts fair is held on the first Saturday of August in Holland. The event draws one of the largest influx of visitors to the city on a single day, second only to Tulip Time. More than 300 fine artists and artisans from 8 states will be on hand to display and sell their work. Juried. All items for sale must be original. Public attendance: 15,000+. Entry fee: $90 (HFA members $80); includes a $20 application fee. Deadline: late March. Space fee: $160 for a double-wide space; $150 for a double-deep space. Exhibition space: 12×12 ft. Details of the jury and entry process are explained on the application. Application available online. Call, e-mail or visit website for more information.

TIPS "Create an inviting and neat booth. Offer well-made quality artwork and crafts at a variety of prices."

ART IN THE PARK (VIRGINIA)

20 S. New St., Staunton VA 24401. (540)885-2028. **E-mail:** info@saartcenter.org. **E-mail:** director@saartcenter.org. **Website:** www.saartcenter.org. **Contact:** Beth Hodges, exec. director; Leah Dubinski, office manager. Estab. 1966. Fine arts & crafts show held annually 3rd Saturday in May. Outdoors. Accepts photography, oil, watercolor, pastel, acrylic, clay, porcelain, pottery, glass, wood, metal, almost anything as long as it is handmade fine art/craft. Juried by submitting 4 photos or slides that are representative of the work to be sold. Award/prizes: $1,500. Number of exhibitors: 100. Public attendance: 3,000-4,000. Free to public. Artists should apply by sending in application. Exhibition space: 10×10 ft. For more information, artists should e-mail, call or visit website.

ART IN THE PARK (WARREN, MICHIGAN)

Halmich Park, Warren MI 48093. (586)795-5471. **E-mail:** MGPPhotography@gmail.com. **Website:** www.warrenfinearts.org. **Contact:** Mighael Peychich, chairperson (248)259-2315. Estab. 1990. Fine arts & crafts show held annually 2nd weekend in July. Indoors and outdoors. Accepts photography, sculpture, basketry, pottery, stained glass. Juried. Awards/prizes; monetary awards. Number of exhibitors: 70. Public attendance: 7,500. Free to public. Deadline for entry: mid-May. Jury fee: $25. Space fee: $125/outdoor; $135/indoor. Exhibition space: 12×12 ft./tent; 12×10 ft./pavilion. For more information, artists should e-mail, visit website or send SASE.

ART IN THE PARK FALL FOLIAGE FESTIVAL

P.O. Box 1447, Rutland VT 05701. (802)775-0356. **Fax:** (802)775-6242. **E-mail:** info@chaffeeartcenter.org. **E-mail:** mbarros@chaffeeartcenter.org. **Website:** www.chaffeeartcenter.org. Estab. 1961. Juried and fine arts & craft festival held at Main Street Park in Rutland VT annually in October over Columbus Day weekend. Accepts fine art, specialty foods, fiber, jewelry, glass, metal, wood, photography, clay, floral, etc. All applications will be juried by a panel of experts. The Art in the Park Festivals are dedicated to high quality art and craft products. Number of exhibitors: 100. Public attendance: 9,000-10,000. Public admission: voluntary donation. Artists should apply online and submit a CD of 3 photos of work and one of booth (photos upon pre-approval). Deadline for entry: ongoing but to receive discount for doing both shows, must apply by late May; $25 late fee after that date. Space fee: $200-350. Exhibit space: 10×12 or 20×12 ft. For more information, artists should e-mail, visit website, or call.

TIPS "Have a good presentation and variety, if possible (in pricing also), to appeal to a large group of people. Apply early as there may be a limited amount of accepted vendors per category. Applications will be juried on a first come, first served basis until the category is determined to be filled."

ART IN THE PARK—FINE ARTS FESTIVAL

9251 W. Hill Rd., Swartz Creek MI 48473. (810)449-3030. **E-mail:** rpmattsonenterp@aol.com. **Website:**

www.swartzcreekkiwanis.org/art. **Contact:** Richard Mattson, co-chairman. Estab. 2008. Annual outdoor fine art festival held in August. Accepts all fine art. Juried by art professionals hired by the committee, monetary prizes given. Average number of exhibitors: 50. Average number of attendees: 2,500-3,000. Free admission. Artists should apply by accessing the website. Deadline: early July. Jury fee of $20, space fee of $150. Space is 144 sq. ft. For more information artists should e-mail or visit the website.

TIPS "Bring unique products."

ART IN THE PARK SUMMER FESTIVAL

16 S. Main St., Rutland VT 05701. (802)775-8836; (802)775-0356. **Fax:** (802)773-0672; (802)775-6242. **E-mail:** info@chaffeeartcenter.org. **Website:** www. chaffeeartcenter.org/art_park.html. Estab. 1961. Fine arts & crafts show held at Main Street Park in Rutland VT annually in mid-August. Accepts fine art, specialty foods, fiber, jewelry, glass, metal, wood, photography, clay, floral, etc. All applications will be juried by a panel of experts. The Art in the Park Festivals are dedicated to high quality art and craft products. Number of exhibitors: 100. Public attendance: 9,000-10,000. Public admission: voluntary donation. Artists should apply online and submit a CD with 3 photos of work and 1 of booth (photos upon pre-approval). Deadline for entry: on-going but to receive discount for doing both shows, must apply by late March; $25 late fee after that date. Space fee: $200-350. Exhibit space: 10×12 or 20×12 ft. For more information, artists should e-mail, visit website, or call.

TIPS "Have a good presentation, variety if possible (in price ranges, too) to appeal to a large group of people. Apply early as there may be a limited amount of accepted vendors per category. Applications will be juried on a first come, first served basis until the category is determined to be filled."

ARTISPHERE

16 Augusta St., Greenville SC 29601. (864)271-9355. **Fax:** (864)467-3133. **E-mail:** liz@greenvillearts.com. **Website:** www.artisphere.us. **Contact:** Liz Rundorff, program director; Kerry Murphy, executive director. Fine arts & crafts show held annually in early May (see website for details). Showcases local artists and top regional galleries in a gallery row at various venues along Main Street. Free to public. E-mail, call or visit website for more information and to display your work.

ART ON THE LAWN

Village Artisans, 100 Corry St., Yellow Springs OH 45387. (937)767-1209. **E-mail:** villageartisans.email@ yahoo.com. **Website:** www.shopvillageartisans.com. Blog: www.villageartisans.blogspot.com. **Contact:** Village Artisans. Estab. 1983. Fine arts & crafts show held annually the 2nd Saturday in August. Outdoors. Accepts photography, all hand-made media and original artwork. Juried, as received, from photos accompanying the application. Awards: "Best of Show" receives a free booth space at next year's event. Number of exhibitors: 90-100. Free to public. Request an application by calling or e-mailing, or download an application from the website. Deadline for entry: early August; however, the sooner received, the better the chances of acceptance. Jury fee: $15. Space fee: $75 before May; $85 until late July; $105 thereafter. Exhibition space: 10×10 ft. Average gross sales vary. For more information, artists should visit website, e-mail, call, send SASE or stop by Village Artisans at above address.

ARTS & CRAFTS ADVENTURE

P.O. Box 1326, Palatine IL 60078. (312)751-2500. **Fax:** (847)221-5853. **E-mail:** asoaartists@aol.com. **Website:** www.americansocietyofartists.org. **Contact:** Office personnel. Estab. 1991. Fine arts & crafts show held annually in early May and mid-September. Outdoors. Event held in Park Ridge IL. Accepts photography, pottery, paintings, sculpture, glass, wood, woodcarving, and more. Juried by 4 slides or photos of work and 1 slide or photo of display; #10 SASE; a résumé or show listing is helpful. See our website for online jury. To jury via e-mail: asoaartists@aol.com. Number of exhibitors: 75. Free to the public. Artists should apply by submitting jury materials. If juried in, you will receive a jury/approval number. Deadline for entry: 2 months prior to show or earlier if spaces fill. Space fee: to be announced. Exhibition space: approximately 100 sq. ft. for single space; other sizes available. For more information, artists should send SASE, submit jury material.

TIPS "Remember that when you are at work in your studio, you are an artist. But when you are at a show, you are a business person selling your work."

AN ARTS & CRAFTS AFFAIR, AUTUMN & SPRING TOURS

P.O. Box 655, Antioch IL 60002. (402)331-2889. **E-mail:** hpifestivals@cox.net. **Website:** www.hpifes

tivals.com. **Contact:** Huffman Productions. Estab. 1983. An arts & crafts show that tours different cities and states. The Autumn Festival tours annually October-November; Spring Festival tours annually in April. Artists should visit website to see list of states and schedule. Indoors. Accepts photography, pottery, stained glass, jewelry, clothing, wood, baskets. All artwork must be handcrafted by the actual artist exhibiting at the show. Juried by sending in 2 photos of work and 1 of display. Awards/prizes: 4 $30 show gift certificates; $50, $100 and $150 certificates off future booth fees. Number of exhibitors: 300-500 depending on location. Public attendance: 15,000-35,000. Public admission: $8-9/adults; $7-8/seniors; 10 & under, free. Artists should apply by calling to request an application. Deadline for entry: varies for date and location. Space fee: $350-1,350. Exhibition space: 8×11 ft. up to 8×22 ft. For more information, artists should e-mail, call, or visit website.

TIPS "Have a nice display, make sure business name is visible, dress professionally, have different price points, and be willing to talk to your customers."

ARTS & CRAFTS FESTIVAL

Simsbury Woman's Club, P.O. Box 903, Simsbury CT 06070. (860)658-2684. **E-mail:** simsburywomansclub@hotmail.com; swc_artsandcrafts@yahoo.com. **Website:** www.simsburywomansclub.org. **Contact:** Shirley Barsness, co-chairman. Estab. 1978. Arts & crafts show held in mid-September. Juried event. Outdoors rain or shine. Original artwork, photography, clothing, accessories, jewelry, toys, wood objects and floral arrangements accepted. Manufactured items or items made from kits not accepted. Individuals should apply by submitting completed application, 4 photos or JPEG files, including 1 of display booth. Exhibition space: 11×14 ft. or 15×14 ft. frontage. Space fee: $150-175. Number of exhibitors: 120. Public attendance: 5,000-7,000. Free to public. Deadline for entry: August 15. For more information, artists should e-mail swc_artsandcrafts@yahoo.com or call Jean at (860)658-4490 or Shirley at (860)658-2684. Applications available on website.

TIPS "Display artwork in an attractive setting."

ARTS ADVENTURE

P.O. Box 1326, Palatine IL 60078. (312)571-2500 or (847)991-4748. **Fax:** (847)221-5853. **E-mail:** asoaartists@aol.com. **Website:** www.americansocietyofartists.org. Estab. 2001. American Society of Art-

ists. Fine arts & crafts show held annually the end of July. Event held in Chicago. Outdoors. Accepts photography, paintings, pottery, sculpture, jewelry and more. Juried. Please submit 4 images representative of your work you wish to exhibit, 1 of your display set-up, your first/last name, physical address, daytime telephone number (résumé/show listing helpful). See our website for online jury. To jury: submit via e-mail to asoaartists@aol.com or to the above address. Include a business-size (#10) SASE please. Number of exhibitors: 50. Free to the public. If juried in, you will receive a jury/approval number. Deadline for entry: 2 months prior to show or earlier if spaces fill. Entry fee: TBA. Exhibition space: approximately 100 sq. ft. for single space; other sizes available. For more information, artists should send SASE.

TIPS "Remember that when you are at work in your studio, you are an artist. But when you are at a show, you are a business person selling your work."

ART'S ALIVE

Ocean City City Hall, 301 Baltimore Ave., Ocean City MD 21842. (410)250-0125. **Fax:** (410)250-5409. **Website:** oceancitymd.gov/recreation_and_parks/specialevents.html. **Contact:** Brenda Moore, event coordinator. Estab. 2000. Fine art show held annually in mid-June. Outdoors. Accepts photography, ceramics, drawing, fiber, furniture, glass, printmaking, jewelry, mixed media, painting, sculpture, fine wood. Juried. Awards/prizes: $5,250 in cash prizes. Number of exhibitors: 100. Public attendance: 10,000. Free to public. Artists should apply by downloading application from website or call. Deadline for entry: February 28. Space fee: $200. Jury Fee: $25. Exhibition space: 10×10 ft. For more information, artists should visit website, call or send SASE.

TIPS Apply early.

ARTS EXPERIENCE

P.O. Box 1326, Palatine IL 60078. (312)751-2500 or (847)991-4748. **E-mail:** asoaartists@aol.com. **Website:** www.americansocietyofartists.org. Estab. 1979. Fine arts & crafts show held in summer in Chicago. Outdoors. Accepts photography, paintings, graphics, sculpture, quilting, woodworking, fiber art, handcrafted candles, glass works, jewelry and more. Juried by 4 images representative of work being exhibited; 1 image of display set-up, #10 SASE, résumé with show listings helpful. Number of exhibitors: 50. Free to public. Artists should apply by submitting jury ma-

terial and indicate you are interested in this particular show. If you wish to jury online please see our website and follow directions given there. To jury via e-mail: submit only at asoaartists@aol.com. When you pass the jury, you will receive jury approval number and application you requested. You may also submit to ASA, P.O. Box 1326, Palatine IL 60078. Include a SASE (business size, #10). Deadline for entry: 2 months prior to show or earlier if space is filled. Space fee: to be announced. Exhibition space: 100 sq. ft. for single space; other sizes are available. For more information, artists should send SASE to submit jury material. **TIPS** "Remember that at work in your studio, you are an artist. When you are at a show, you are a business person selling your work."

ARTS IN THE PARK

302 Second Ave. E., Kalispell MT 59901. (406)755-5268. **E-mail:** information@hockadaymuseum.com. **Website:** www.hockadaymuseum.org. **Contact:** LeAnn. Estab. 1968. Fine arts & crafts show held annually 4th weekend in July (see website for details). Outdoors. Accepts photography, jewelry, clothing, paintings, pottery, glass, wood, furniture, baskets. Juried by a panel of 5 members. Artwork is evaluated for quality, creativity and originality. Jurors attempt to achieve a balance of mediums in the show. Number of exhibitors: 100. Public attendance: 10,000. Artists should apply by completing the online application form and sending 5 images in JPEG format; 4 images of work and 1 of booth. Application fee: $25. Exhibition space: 10×10 or 10×20 ft. Booth fees: $170-435 For more information, artists should e-mail, call or visit website.

ARTS ON FOOT

1250 H St. NW, Suite 1000, Washington DC 20005. (202)638-3232. **E-mail:** artsonfoot@downtowndc. org. **Website:** www.artsonfoot.org. Fine arts & crafts show held annually in September. Outdoors. Accepts photography, painting, sculpture, fiber art, furniture, glass, jewelry, leather. Juried by 5 color images of the artwork. Send images as 35mm slides, TIFF or JPEG files on CD or DVD. Also include artist's résumé and SASE for return of materials. Free to the public. Deadline for entry: July. Exhibition space: 10×10 ft. For more information, artists should call, e-mail, visit website.

ARTS ON THE GREEN

Arts Association of Oldham County, 104 E. Main St., LaGrange KY 40031. (502)222-3822. **Fax:** (502)222-3823. **E-mail:** maryklausing@bellsouth.net. **Website:** www.aaooc.org. **Contact:** Mary Klausing, director. Estab. 1999. Fine arts & crafts festival held annually 1st weekend in June. Outdoors. Accepts photography, painting, clay, sculpture, metal, wood, fabric, glass, jewelry. Juried by a panel. Awards/prizes: cash prizes for Best of Show and category awards. Number of exhibitors: 100. Public attendance: 7,500. Free to the public. Artists should apply online or call. Deadline for entry: April 15. Jury fee: $25. Space fee: $180. Electricity fee: $15. Exhibition space: 10×10 or 10×12 ft. For more information, artists should e-mail, visit website, call.

TIPS "Make potential customers feel welcome in your space. Don't overcrowd your work. Smile!"

ARTSPLOSURE

313 S. Blount St., #200B, Raleigh NC 27601. (919)832-8699. **Fax:** (919)832-0890. **E-mail:** info@artsplosure. org. **Website:** www.artsplosure.org. **Contact:** Dylan Morris, operations manager. Estab. 1979. Annual outdoor art/craft fair held the 3rd weekend of May. Accepts ceramics, glass, fiber art, jewelry, metal, painting, photography, wood, 2D and 3D artwork. Juried event. Awards: 6 totaling $3,500 cash. Number of exhibitors: 170. Public attendance: 75,000. Free admission to the public. Applications available in October, deadline is mid-January. Application fee: $32. Space fee: $225 for 12×12 ft.; $450 for a double space. Average sales: $2,500. For more information visit website or e-mail.

TIPS "Professional quality photos of work submitted for jurying are preferred, as well as a well executed professional booth photo. Keep artist statements concise and relevant."

BEVERLY HILLS ART SHOW

Show site: Beverly Gardens Park, 9450 N. Santa Monica Blvd., Beverly Hills CA 90210. (310)285-6836. **E-mail:** kmclean@beverlyhills.org. **Website:** www.beverlyhills.org/artshow. Estab. 1973. Fine arts & crafts show held bi-annually 3rd weekend in May and 3rd weekend in October. Outdoors, 4 blocks in the center of Beverly Hills. Accepts photography, painting, sculpture, ceramics, jewelry, glass, traditional printmaking and digital media. Juried. Awards/prizes: 1st place in category, cash awards, Best in Show cash

award; Mayor's Purchase Award in May show. Number of exhibitors: 230-250. Public attendance: 30,000-50,000. Free to public. Deadline for entry: mid-February for the May show; mid-July for the October show. For more information, artists should e-mail, visit website, call or send SASE.

TIPS "Art fairs tend to be commercially oriented. It usually pays off to think in somewhat commercial terms—what does the public usually buy? Personally, I like risky and unusual art, but the artists who produce esoteric art sometimes go hungry! Be nice and have a clean presentation."

BLACK SWAMP ARTS FESTIVAL

P.O. Box 532, Bowling Green OH 43402. (419)354-2723. **E-mail:** info@blackswamparts.org. **Website:** www.blackswamparts.org. The Black Swamp Arts Festival (BSAF), held early September, connects art and the community by presenting an annual arts festival and by promoting the arts in the Bowling Green community. Apply online at www.zapplication.org. Call, e-mail or visit website for more information. Application fee: $35. Single booth fee: $275. Double booth fee: $550.

- Awards: Best in Show ($1,500); Best 2D ($1,000); Best 3D ($1,000); Second ($750); Third ($500); Honorable Mentions (3 awards, $200 each).

BOCA RATON FINE ART SHOW

Hot Works, P.O. Box 1425, Sarasota FL 34230. (941)755-3088. **E-mail:** info@hotworks.org; patty@hotworks.org. **Website:** www.hotworks.org. **Contact:** Patty Naronzny. Estab. 2008. The annual Boca Raton Fine Art Show brings high-quality juried artists to sell their art works in the heart of downtown Boca Raton. All work is original and personally handmade by the artist. We offer awards to attract the nation's best artists. Our goal is to create an atmosphere that enhances the artwork and creates a relaxing environment for art lovers. All types of disciplines for sale including sculpture, paintings, clay, glass, printmaking, fiber, wood, jewelry, photography, and more. Art show also has artist demonstrations, live entertainment, and food. Awards: two $500 Juror's Awards and five $100 Awards of Excellence.

BRICK STREET MARKET

E-mail: info@zionsvillechamber.org. **Website:** www.zionsvillechamber.org. **Contact:** Dusky Loebel. Estab. 1985. Fine art, antique & craft show held annually the Saturday after Mother's Day. Outdoors. In collaboration with area merchants, this annual event is held on the Main Street Gallery District in the Historic Downtown of Zionsville IN. Please submit application found on line at www.zionsvillechamber.org and up to 3 JPEG images. All mediums are welcome. Artists are encouraged to perform demonstrations of their work and talk with visitors during the event. Tents will be provided. Artists may use their own white 10×10 ft. tents. Artists must supply display equipment. Selection committee chooses from the following categories: antiques, art, food, green/organic products, photography, plants/flowers, and handmade/hand crafted textiles. Committee will not accept catalog or mass-produced products. Number of exhibitors: 150-175. Public attendance: 3,000-4,000. Free to public. Space fee: $175.

CAIN PARK ARTS FESTIVAL

40 Severance Circle, Cleveland Heights OH 44118-9988. (216)291-3669. **Fax:** (216)291-3705. **E-mail:** jhoffman@clvhts.com; artsfestival@clvhts.com. **Website:** www.cainpark.com. Estab. 1976. Fine arts & crafts show held annually 2nd full week in July. Outdoors. Accepts photography, painting, clay, sculpture, wood, jewelry, leather, glass, ceramics, clothes and other fiber, paper, block printing. Juried by a panel of professional artists; submit 5 slides. Awards/prizes: cash prizes of $750, $500 and $250; also Judges' Selection, Director's Choice and Artists' Award. Number of exhibitors: 155. Public attendance: 30,000. Free to the public. Artists should apply by requesting an application by mail, visiting website to download application or by calling. Deadline for entry: early March. Application fee: $35. Space fee: $400. Exhibition space: 10×10 ft. Average gross sales/exhibitor: $4,000. For more information, artists should e-mail, call or visit website.

TIPS "Have an attractive booth to display your work. Have a variety of prices. Be available to answer questions about your work."

CALABASAS FINE ARTS FESTIVAL

100 Civic Center Way, Calabasas CA 91302. (818)224-1657. **E-mail:** artscouncil@cityofcalabasas.com. **Website:** www.calabasasartscouncil.com. Estab. 1997. Fine arts & crafts show held annually in late April/early May. Outdoors. Accepts photography, painting, sculpture, jewelry, mixed media. Juried. Number of

exhibitors: 150. Public attendance: 10,000+. Free to public. Application fee: $25. Artists should apply online through www.zapplication.org; must include 3 photos of work and 1 photo of booth display. For more information, artists should call, e-mail or visit website.

CAREFREE FINE ART & WINE FESTIVAL

101 Easy St., Carefree AZ 85377. (480)837-5637. **Fax:** (480)837-2355. **E-mail:** info@thunderbirdartists.com. **Website:** www.thunderbirdartists.com. **Contact:** Dale, president. Estab. 1993. Fine arts & crafts show held annually in mid-January, the first weekend in March, and the first weekend in November (see website for specifics). Outdoors. Accepts photography and paintings, bronzes, baskets, jewelry, stone and pottery. Juried; CEO blind juries by medium. Number of exhibitors: 165. Public attendance: 45,000. Public admission: $3. Applications available at www.zapplication.org. Deadline for entry: mid-August (for January festival); late November (for March festival); early June (for November festival). See website for specifics. Application fee: $30. Space fee: $420. Exhibition space: 10×10 to 10×30 ft. For more information, artists should e-mail, call or visit website.

TIPS "A clean gallery-type presentation is very important."

CEDARHURST CRAFT FAIR

P.O. Box 923, 2600 Richview Rd., Mt. Vernon IL 62864. (618)242-1236, ext. 234. **Fax:** (618)242-9530. **E-mail:** linda@cedarhurst.org; sarah@cedarhurst. org. **Website:** www.cedarhurst.org. **Contact:** Linda Wheeler, staff coordinator. Estab. 1977. Arts & crafts show held annually on the 1st weekend after Labor Day each September. Outdoors. Accepts photography, paper, glass, metal, clay, wood, leather, jewelry, fiber, baskets, 2D art. Juried. Awards/prizes: Best of most category. Number of exhibitors: 125+. Public attendance: 12,000. Public admission: $10. Artists should apply by filling out online application form. Deadline for entry: March. Application fee: $25. Exhibition space: 10×15 ft. For more information, artists should e-mail, call or visit website.

CENTERVILLE–WASHINGTON TOWNSHIP AMERICANA FESTIVAL

P.O. Box 41794, Centerville OH 45441-0794. (937)433-5898. **Fax:** (937)433-5898. **E-mail:** americanafestival@sbcglobal.net. **Website:** www.americanafestival. org. Estab. 1972. Arts & crafts show held annually on the 4th of July, except when the 4th falls on a Sunday and then festival is held on Monday the 5th. Festival includes entertainment, parade, food, car show and other activities. Accepts photography and all mediums. "No factory-made items accepted." Awards/prizes: 1st, 2nd, 3rd Places; certificates and ribbons for most attractive displays. Number of exhibitors: 275-300. Public attendance: 75,000. Free to the public. Artists should send SASE for application form, or apply online. Deadline for entry: early June (see website for details). Space fee: $50. Exhibition space: 12×10 ft. For more information, artists should e-mail, call or visit website.

TIPS "Artists should have moderately priced items, bring business cards and have an eye-catching display."

CHARDON SQUARE ARTS FESTIVAL

PO Box 1063, Chardon OH 44024. (440)285-8686; (440)285-3519. **E-mail:** sgipson@aol.com. **Website:** www.chardonsquareassociation.org. **Contact:** Jan Gipson, chairman. Estab. 1980. Fine arts & crafts show held annually in early August (see website for details). Outdoors. Accepts photography, pottery, weaving, wood, paintings, jewelry. Juried. Number of exhibitors: 105. Public attendance: 4,000. Free to public. Artists should apply by calling for application. Exhibition space: 12×12 ft. For more information, artists should call or visit website.

TIPS "Make your booth attractive; be friendly and offer quality work."

CHARLOTTE FINE ART SHOW

Hot Works, LLC, Charlotte Convention Center, 501 S. College St., Charlotte NC 28202. (248)684-2613. **E-mail:** patty@hotworks.org. **Website:** www.hotworks.org. **Contact:** Patty Narozny, show director. Estab. 2008. Produced by Hot Works, LLC Fine Art & Craft Shows. Annual arts & crafts show. "Approximately 150 of the highest quality juried artists from around the world will sell their art in all forms of media, including paintings, clay, glass, sculpture, wood, fiber, photography, and more. All work is personally hand-made by the artist who is present at the show and happy to answer any questions about how they made the work, and why, and what inspires them." Juried, by art professionals based on technique/execution, quality and originality. Awards presented. Public admission: $10 for 3-day pass, children 12 and under

are free. Artists should call, e-mail or see website for more information.

CHATSWORTH CRANBERRY FESTIVAL

P.O. Box 286, Chatsworth NJ 08019. (609)726-9237. **Fax:** (609)726-1459. **E-mail:** lgiamalis@aol.com. **Website:** www.cranfest.org. **Contact:** Lin Giamalis. Estab. 1983. Arts & crafts show held annually in mid-October (see website for details). Outdoors. The festival is a celebration of New Jersey's cranberry harvest, the 3rd largest in the country, and offers a tribute to the Pine Barrens and local culture. Accepts photography. Juried. Number of exhibitors: 200. Public attendance: 75,000-100,000. Free to public. Artists should apply by sending SASE to above address (application form online). Requires 3 pictures of products and 1 of display. Deadline: September 1. Space fee: $225 for 2 days. Exhibition space: 15×15 ft. For more information, artists should visit website.

CHUN CAPITOL HILL PEOPLE'S FAIR

1290 Williams St., Suite 102, Denver CO 80218. (303)830-1651. **Fax:** (303)830-1782. **E-mail:** nicole anderson@chundenver.org. **Website:** www.peoples fair.com; www.chundenver.org. **Contact:** Nicole Anderson, operations manager. Estab. 1972. Arts & music festival held annually 1st weekend in June. Outdoors. Accepts photography, ceramics, jewelry, paintings, wearable art, glass, sculpture, wood, paper, fiber, children's items, and more. Juried by professional artisans representing a variety of mediums and selected members of fair management. The jury process is based on originality, quality and expression. Awards/prizes: Best of Show. Number of exhibitors: 300. Public attendance: 225,000. Free to public. Artists should apply by downloading application from website. Deadline for entry: March. Application fee: $35. Space fee: $300-400, depending on type of art. Exhibition space: 10×10 ft. For more information, artists should e-mail, visit website or call.

CHURCH STREET ART & CRAFT SHOW

Downtown Waynesville Association, P.O. Box 1409, Waynesville NC 28786. (828)456-3517. **E-mail:** down townwaynesville@charter.net. **Website:** www.down townwaynesville.com. Estab. 1983. Fine arts & crafts show held annually 2nd Saturday in October. Outdoors. Accepts photography, paintings, fiber, pottery, wood, jewelry. Juried by committee: submit 4 slides or digital photos of work and 1 of booth display.

Prizes: $100-400 Number of exhibitors: 100. Public attendance: 15,000-18,000. Free to public. Entry fee: $20. Space fee: $110 ($200 for two booths). Exhibition space: 10×12 ft. (option of two booths for 12×20 space). For more information and application, see website. Deadline: mid-August.

TIPS Recommends "quality in work and display."

CITY OF FAIRFAX FALL FESTIVAL

4401 Sideburn Rd., Fairfax VA 22030. (703)385-7949. **Fax:** (703)246-6321. **E-mail:** leslie.herman@fairfaxva. gov; parksrec@fairfaxva.gov. **Website:** www.fairfax va.gov. **Contact:** Leslie Herman, special events manager. Estab. 1975. Arts & crafts show held annually the 2nd Saturday in October. Outdoors. Accepts photography, jewelry, glass, pottery, clay, wood, mixed media. Juried by a panel of 5 independent jurors. Number of exhibitors: 500. Public attendance: 35,000. Free to the public. Deadline for entry: March 15. Application fee: $12. Space fee: $155. Exhibition space: 10×10 ft. For more information, artists should e-mail.

TIPS "Be on site during the event. Smile. Price according to what the market will bear."

CITY OF FAIRFAX HOLIDAY CRAFT SHOW

10455 Armstrong St., Fairfax VA 22030. (703)385-7949. **Fax:** (703)246-6321. **E-mail:** parksrec@fair faxva.gov; leslie.herman@fairfaxva.gov. **Website:** www.fairfaxva.gov. **Contact:** Leslie Herman, special events coordinator. Estab. 1985. Arts & crafts show held annually 3rd weekend in November. Indoors. Accepts photography, jewelry, glass, pottery, clay, wood, mixed media. Juried by a panel of 5 independent jurors. Number of exhibitors: 247. Public attendance: 7,000. Public admission: $5 for age 18 an older. $8 for two day pass. Artists should apply by contacting Leslie Herman for an application. Deadline for entry: early March (see website for details). Application fee: $12. Space fee: 10×6 ft. $190; 11×9 ft. $240; 10×10 ft. $265. For more information, artists should e-mail.

TIPS "Be on-site during the event. Smile. Price according to what the market will bear."

COLORSCAPE CHENANGO ARTS FESTIVAL

P.O. Box 624, Norwich NY 13815. (607)336-3378. **E-mail:** info@colorscape.org. **Website:** www.color scape.org. Estab. 1995. A juried exhibition of art & fine crafts held annually the weekend after Labor Day. Outdoors. Accepts photography and all types of me-

dia. Juried. Awards/prizes: $5,000. Number of exhibitors: 100. Public attendance: 12,000-14,000. Free to public. Deadline for entry: see website for details. Application fee: $15 jury fee. Space fee: $175. Exhibition space: 12×12 ft. For more information, artists should e-mail, visit website, call or send SASE.

TIPS "Interact with your audience. Talk to them about your work and how it is created. People like to be involved in the art they buy and are more likely to buy if you involve them."

CONYERS CHERRY BLOSSOM FESTIVAL

1996 Centennial Olympic Pkwy., Conyers GA 30013. (770)860-4190; (770)860-4188. **E-mail:** rebecca.hill@conyersga.com. **Website:** www.conyerscherryblossomfest.com. **Contact:** Rebecca Hill. Estab. 1981. Arts & crafts show held annually in late March (see website for details). Outdoors. The festival is held at the Georgia International Horse Park at the Grand Prix Plaza overlooking the Grand Prix Stadium used during the 1996 Centennial Olympic Games. Accepts photography, paintings and any other handmade or original art. Juried. Submit 5 images: 1 picture must represent your work as it is displayed; 1 must represent a workshop photo of the artist creating their work; the other 3 need to represent your items as an accurate representation in size, style, and quality of work. Number of exhibitors: 300. Public attendance: 40,000. Free to public. Space fee: $135. Exhibition space: 10×10 ft. Electricity fee: $30. Application fee: $10; apply online. For more information, artists should e-mail, call or visit website.

CRAFT FAIR AT THE BAY

38 Charles St., Rochester NH 03867. (603)332-2616. **Fax:** (603) 332-8413. **E-mail:** info@castleberryfairs.com. **Website:** www.castleberryfairs.com. Estab. 1988. Arts & crafts show held annually in July in Alton Bay NH. Outdoors. Accepts photography and all other mediums. Juried by photo, slide or sample. Number of exhibitors: 85. Public attendance: 7,500. Free to the public. Artists should apply by downloading application from website. Deadline for entry: until full. Exhibition space: 100 sq. ft. For more information, artists should visit call, e-mail or visit website.

TIPS "Do not bring a book; do not bring a chair. Smile and make eye contact with everyone who enters your booth. Have them sign your guest book; get their e-mail address so you can let them know when you are

in the area again. And, finally, make the sale—they are at the fair to shop, after all."

CRAFTS AT RHINEBECK

P.O. Box 28, Woodstock NY 12498. (845)331-7900. **Fax:** (845)331-7484. **E-mail:** crafts@artrider.com. **Website:** www.artrider.com. **Contact:** Stacey Jaret. Estab. 1981. Fine arts & crafts show held biannually in late June and early October. Indoors and outdoors. Accepts photography, fine art, ceramics, wood, mixed media, leather, glass, metal, fiber, jewelry. Juried. Submit 5 high-res digital images of your work on a CD clearly marked with the primary artistname. Four of the images must consist of individual pieces and one of the booth display containing artwork. Sharp,accurate color reproduction is important. Images cannot be any larger the 1920×1920 pixels at 72 dpi. Photographs not accepted. Number of exhibitors: 350. Public attendance: 25,000. Public admission: $7. Artists should apply by calling for application or downloading application from website. Deadline for entry: early February. Application fees: $0 first time, $40 mailed in or online, $65 late. Space fee: $495-990, $100 deposit. Exhibition space: inside: 10×10 and 10×20 ft. For more information, artists should e-mail, visit website or call.

TIPS "Presentation of work within your booth is very important. Be approachable and inviting."

CRAFTWESTPORT

P.O. Box 28, Woodstock NY 12498. (845)331-7484. **Fax:** (845)331-7484. **E-mail:** crafts@artrider.com. **Website:** www.craftwestport.com. Estab. 1975. Fine arts & craft show held annually in mid-November. Indoors. Accepts photography, wearable and nonwearable fiber, metal and nonmetal jewelry, clay, leather, wood, glass, painting, drawing, prints, mixed media. Juried by 5 images of work and 1 of booth, viewed sequentially. Number of exhibitors: 160. Public attendance: 5,000. Public admission: $9. Artists should apply by downloading application from www.artrider.com or can apply online at www.zapplication.org. Deadline for entry: end of May. Application fee: $40. Space fee: $545. Exhibition space: 10×10 ft. For more information, artists should e-mail, visit website, call.

CUSTER'S LAST STAND FESTIVAL OF THE ARTS

P.O. Box 6013, Evanston IL 60204. (847)328-2204. **Fax:** (847)823-2295. **E-mail:** office@custerfair.com. **Website:** www.custerfair.com. Estab. 1972. Outdoor

fine art craft show held in June. Accepts photography and all mediums. Number of exhibitors: 400. Public attendance: 70,000. Free to the public. Application fee: $10. Booth fee: $250-400. Deadline for entry: early May. Space fee varies, e-mail, call or visit website for more details.

TIPS "Be prepared to speak with patrons; invite them to look at your work and discuss."

A DAY IN TOWNE

Boalsburg Memorial Day Committee, 117 E. Boal Ave., Boalsburg PA 16827. (814)466-6311 or (814)466-9266. **E-mail:** office@boalmuseum.com. **Website:** www.boalmuseum.com/memorialdayvillage.html. Arts & crafts show held annually the last Monday in May/Memorial Day weekend. Outdoors. Accepts photography, country fabric & wood, wool knit, soap, jewelry, dried flowers, children, pottery, blown glass. Vendor must make own work. Number of exhibitors: 125-135. Public attendance: 20,000. Artists should apply by writing an inquiry letter and sending 2-3 photos; 1 of booth and 2 of the craft. Deadline for entry: January 1–February 1. Space fee: $75. Exhibition space: 10×15 ft.

TIPS "Please do not send fees until you receive an official contract. Have a neat booth and nice smile. Have fair prices—if too high, product will not sell here."

DEERFIELD FINE ARTS FESTIVAL

3417 R.F.D., Long Grove IL 60047. (847)438-4517; (847)726-8669. **E-mail:** dwevents@comcast.net. **Website:** www.dwevents.org. **Contact:** D&W Events, Inc. Estab. 2003. Fine arts & crafts show held annually during the first weekend of June; hours are 10-5. Outdoors. Accepts photography, fiber, oil, acrylic, watercolor, mixed media, jewelry, sculpture, metal, paper, ceramics, painting. Juried by 3 jurors. Awards/prizes: Best of Show; 1st Place, Awards of Excellence. Number of exhibitors: 150. Public attendance: 20,000. Free to public. Artists should apply by downloading application from website, e-mail or call. Exhibition space: 100 sq. ft. For more information artists should e-mail, visit website, call.

TIPS "Artists should display professionally and attractively, and interact positively with everyone."

DELAWARE ARTS FESTIVAL

P.O. Box 589, Delaware OH 43015. **E-mail:** info@delawareartsfestival.org. **Website:** www.delawareartsfestival.org. Estab. 1973. Fine arts & crafts show held annually the Saturday and Sunday after Mother's Day.

Outdoors. Accepts photography; all mediums, but no buy/sell. Juried by committee members who are also artists. Awards/prizes: Ribbons, cash awards, free booth for the following year. Number of exhibitors: 160. Public attendance: 25,000. Free to the public. Submit 3 slides or photographs that best represent your work. Your work will be juried in accordance with our guidelines. Photos will be returned only if you provide a SASE. Artists should apply by visiting website for application. Application fee: $10, payable to the Delaware Arts Festival. Space fee: $125. Exhibition space: 120 sq. ft. For more information, artists should e-mail or visit website.

TIPS "Have high-quality, original stuff. Engage the public. Applications will be screened according to originality, technique, craftsmanship and design. The Delaware Arts Festival, Inc. will exercise the right to reject items during the show that are not the quality of the media submitted with the applications. No commercial buy and resell merchandise permitted. Set up a good booth."

DOWNTOWN FESTIVAL & ART SHOW

P.O. Box 490, Gainesville FL 32627. (352)393-8536. **Fax:** (352)334-2249. **E-mail:** piperlr@cityofgainesville.org. **Website:** www.gvlculturalaffairs.org. **Contact:** Linda Piper, events coordinator. Estab. 1981. Fine arts & crafts show held annually in mid-November (see website for more details). Outdoors. Accepts photography, wood, ceramic, fiber, glass, and all mediums. Juried by 3 digital images of artwork and 1 digital image of booth. Awards/prizes: $15,000 in cash awards; $3,000 in purchase awards. Number of exhibitors: 250. Public attendance: 100,000. Free to the public. Artists should apply by mailing 4 digital images. Deadline for entry: May. Space fee: $235, competitive, $215 noncompetitive. Exhibition space: 12×12 ft. Average gross sales/exhibitor: $6,000. For more information, artists should e-mail, visit website, call.

TIPS "Submit the highest quality digital images. A proper booth image is very important."

DURANGO AUTUMN ARTS FESTIVAL

802 E. Second Ave., Durango CO 81301. (970)259-2606. **Fax:** (970)259-6571. **E-mail:** daaf@durangoarts.org. **Website:** www.durangoarts.org. Estab. 1993. Fine arts & crafts show held in mid-September. Outdoors. Accepts photography and all mediums. Juried. Number of exhibitors: 80. Public attendance: 5,000. Free to public. Exhibition space:

10×10 ft. Space fee $300. Application fee of $30. Apply via www.zapplication.org. For more information, artists should e-mail, visit website/facebook or send SASE.

⊕ EDENS ART FAIR

P.O. Box 1326, Palatine IL 60078. (312)751-2500. E-mail: asoa@webtv.net; asoaartists@aol.com. **Website:** www.americansocietyofartists.com. **Contact:** Office personnel. Estab. 1995 (after renovation of location; held many years prior to renovation). American Society of Artists. Fine arts & fine selected crafts show held annually in mid-July. Outdoors. Event held in Wilmette, Illinois. Accepts photography, paintings, sculpture, glass works, jewelry and more. Juried. Send 4 slides or photos of your work and 1 slide or photo of your display; #10 SASE; a résumé or show listing is helpful. Number of exhibitors: 50. Free to the public. Artists should apply by submitting jury materials. If you wish to jury online please see our website and follow directions given. To jury via e-mail: asoaartists@aol.com. If you pass jury you will receive a non-member jury approval number. If juried in, you will receive a jury/approval number. Deadline for entry: 2 months prior to show or earlier if spaces fill. Entry fee: to be announced. Exhibition space: approximately 100 sq. ft. for single space; other sizes available. For more information, artists should send SASE, submit jury material.
TIPS "Remember that when you are at work in your studio, you are an artist. But when you are at a show, you are a business person selling your work."

⊕ EL DORADO COUNTY FAIR

100 Placerville Drive, Placerville CA 95667. (530)621-5860. **Fax:** (530)295-2566. **E-mail:** fair@eldoradocountyfair.org. **Website:** www.eldoradocountyfair.org. Estab. 1859. County fair held annually in June. Indoors. Accepts photography, fine arts and handicrafts. Awards/prizes given, see entry guide on web site for details. Number of exhibitors: 350-450. Average number of attendees: 55,000. Admission fee: $9. Deadline: mid-May. Application fee: varies by class, see entry guide. For more information, visit web site.
TIPS "Not a lot of selling at fair shows, competition mostly."

⊕ ELMWOOD AVENUE FESTIVAL OF THE ARTS INC.

P.O. Box 786, Buffalo NY 14213-0786. (716)830-2484. **E-mail:** directoreafa@aol.com. **Website:** www.elmwoodartfest.org. Estab. 2000. Arts & crafts show held annually in late August, the weekend before Labor Day weekend. Outdoors. Accepts photography, metal, fiber, ceramics, glass, wood, jewelry, basketry, 2D media. Juried. Awards/prizes: to be determined. Number of exhibitors: 170. Public attendance: 80,000-120,000. Free to the public. Artists should apply by e-mailing their contact information or by downloading application from website. Deadline for entry: April. Application fee: $25. Space fee: $295. Exhibition space: 10×15 ft. Average gross sales/exhibitor: $3,000. For more information, artists should e-mail, call or visit website.
TIPS "Make sure your display is well designed, with clean lines that highlight your work. Have a variety of price points—even wealthy people don't always want to spend $500 at a booth where they may like the work."

⊕ ⊕ ESTERO FINE ART SHOW

Hot Works, LLC, Miromar Outlets, 10801 Corkscrew Road, Estero FL 33928. (941)755-3088. **E-mail:** patty@hotworks.org. **Website:** www.hotworks.org. **Contact:** Patty Narozny, executive director. Estab. 2008. Biannual fine art show held for two days in early January and early November (2013-14 Dates: November 16-17, 2013 and January 4-5, 2014). Outdoors. "This event showcases artists from around the globe. Art includes glass, clay, wood, fiber, jewelry, sculpture, painting, photography, and metal. There is artwork for every budget. Focus is on technique/execution, quality and originality." Juried by art professionals in the industry. 3 images of work, 1 of booth. Awards: $1,500 distributed as follows; 2 $500 Juror's Award of Excellence (purchase awards) and 5 $100 Awards of Excellence. Number of exhibitors: 110. Average number of attendees: 10,000. Free admission and free parking. Application fee: $30. Space fee: $385. Space: 11×11. For more information, artists should e-mail, call, see website or visit www.zapplication.org for details.
TIPS "Bring enough work to sell that people want to see—original work! Stay positive."

⊕ EVERGREEN FINE ARTS FESTIVAL

Evergreen Artists Association, 22528 Blue Jay Rd., Morrison CO 80465. (303)618-9834. **E-mail:** tjaunting@aol.com. **Website:** www.evergreenartists.org/

shows_festivals.htm; www.fairsandfestivals.net/events/details/evergreen-fine-arts-festival-2011. **Contact:** Beth Erlund, festival coordinator. Estab. 1966. Fine arts show held annually the last weekend in August. Outdoors in Historic Grove Venue, next to Hiwan Homestead. Accepts both 2D and 3D media, including photography, fiber, oil, acrylic, pottery, jewelry, mixed media, ceramics, wood, watercolor. Juried event with jurors that change yearly. Artists should submit a CD with 3 views of work and 1 of booth display by digital photograph high-res. Awards/prizes: Best of Show; 1st, 2nd, 3rd Places in 2D and 3D. Number of exhibitors: approximately 96. Public attendance: 3,000-6,000. Free to public. Deadline for entry: April 15. Application fee: $30. Space is limited. Exhibition space: 10×10 ft. Submissions only on www.zapplication.org begin in December and jurying completed in early May. For more information, artists should call or send SASE.

TIPS "Have a variety of work. It is difficult to sell only high-ticket items."

FAIRE ON THE SQUARE

117 W. Goodwin St., Prescott AZ 86303. (928)445-2000, ext. 112. **Fax:** (928)445-0068. **E-mail:** chamber@prescott.org; scott@prescott.org. **Website:** www.prescott.org. Estab. 1985. Arts & crafts show held annually Labor Day weekend. Outdoors. Accepts photography, ceramics, painting, sculpture, clothing, woodworking, metal art, glass, floral, home décor. No resale. Juried. Photos of work and artist creating work are required. Number of exhibitors: 170. Public attendance: 10,000-12,000. Free to public. Application can be printed from website or obtained by phone request. Deadline: spaces are sold until show is full. Exhibition space; 10×15 ft. For more information, artist should e-mail, visit website or call.

A FAIR IN THE PARK

6300 Fifth Ave., Pittsburgh PA 15232. **E-mail:** fairdirector@craftsmensguild.org. **Website:** www.afairinthepark.org. Estab. 1969. Contemporary fine arts & crafts show held annually the weekend after Labor Day outdoors. Accepts photography, clay, fiber, jewelry, metal, mixed media, wood, glass, 2D visual arts. Juried. Awards/prizes: 1 Best of Show and 4 Craftsmen's Guild Awards. Number of exhibitors: 105. Public attendance: 25,000+. Free to public. Submit 5 JPEG images; 4 of artwork, 1 of booth display. Application fee: $25. Booth fee: $300 or $350 for corner

booth. Deadline for entry: early March. Exhibition space: 10×10 ft. Average gross sales/exhibitor: $1,000 and up. For more information artists should e-mail or visit website.

TIPS "It is very important for artists to present their work to the public, to concentrate on the business aspect of their artist career. They will find that they can build a strong customer/collector base by exhibiting their work and by educating the public about their artistic process and passion for creativity."

FALL FEST IN THE PARK

117 W. Goodwin St., Prescott AZ 86303. (928)445-2000 or (800)266-7534. **E-mail:** chamber@prescott.org; scott@prescott.org. **Website:** www.prescott.org. Estab. 1981. Arts & crafts show held annually in mid-October. Outdoors. Accepts photography, ceramics, painting, sculpture, clothing, woodworking, metal art, glass, floral, home décor. No resale. Juried. Photos of work, booth, and artist creating work are required. Number of exhibitors: 150. Public attendance: 6,000-7,000. Free to public. Application can be printed from website or obtained by phone request. Deposit: $50, non-refundable. Electricity is limited and has a fee of $15. Deadline: Spaces are sold until show is full. Exhibition space; 10×15 ft. For more information, artists should e-mail, visit website or call.

FALL FESTIVAL OF ART AT QUEENY PARK

P.O. Box 31265, St. Louis MO 63131. (314)889-0433. **E-mail:** info@gslaa.org. **Website:** artfairatqueenypark.com. Estab. 1976. Fine arts & crafts show held annually Labor Day weekend at Queeny Park. Indoors. Accepts photography, all fine art and fine craft categories. Juried by 5 jurors; 5 slides shown simultaneously. Awards/prizes: 3 levels, ribbons, $4,000+ total prizes. Number of exhibitors: 130-140. Public attendance: 4,000-6,000. Admission: $5. Artists should apply online. Application fee: $25 Booth fee: $200; $225 for corner booth. Deadline for entry: late May, see website for specific date. Exhibition space: 80 sq. ft. (8×10) For more information, artists should e-mail or visit website.

TIPS "Excellent, professional slides; neat, interesting booth. But most important—exciting, vibrant, eye-catching art work."

FALL FINE ART & CRAFTS AT BROOKDALE PARK

473 Watchung Ave., Bloomfield NJ 07003. (908)874-5247. **Fax:** (908)874-7098. **E-mail:** info@rosesquared.com. **Website:** www.rosesquared.com. **Contact:** Howard Rose, vice president. Estab. 1998. Fine arts & crafts show held annually in mid-October. Outdoors. Accepts photography and all other mediums. Juried. Number of exhibitors: 160. Public attendance: 12,000. Free to public. Artists should apply on the website. Deadline for entry: mid-September. Application fee: $25. Space fee varies by booth size; see application form on website for details. For more information, artists should visit the website.

TIPS "Have a range of products and prices."

FARGO'S DOWNTOWN STREET FAIR

Downtown Community Partnership, 210 Broadway N., #202, Fargo ND 58102. (701)241-1570; (701)451-9062. **Fax:** (701)241-8275. **E-mail:** steph@downtownfargo.com. **Website:** www.fmdowntown.com. **Contact:** Stephanie Holland, street fair consultant. Estab. 1975. Fine arts & crafts show held annually in July (see website for dates). Outdoors. Accepts photography, ceramics, glass, fiber, textile, jewelry, metal, paint, print/drawing, sculpture, 3D mixed media, wood. Juried by a team of artists from the Fargo-Moorehead area. Awards/prizes: Best of Show and best in each medium. Number of exhibitors: 300. Public attendance: 130,000-150,000. Free to pubic. Artists should apply online and submit 3 JPEGs (at 300 dpi) of work, 1 image of booth, and 4 images of process. Deadline for entry: mid-February. Space fee: $325-700 depending on size and location. Exhibition space: 11×11 ft. or 11×22 ft. For more information, artists should e-mail, visit website or call.

FAUST FINE ARTS & FOLK FESTIVAL

Greensfelder Recreation Complex, 15185 Olive St., St. Louis MO 63017. (314)615-8482. **E-mail:** toconnell@stlouisco.com. **Website:** www.stlouisco.com/parks. **Contact:** Tonya O'Connell, recreation supervisor. Fine arts & crafts show held annually in May. Outdoors. Accepts photography, oil, acrylic, clay, fiber, sculpture, watercolor, jewelry, wood, floral, baskets, prints, drawing, mixed media, folk art. Juried by a committee. Number of exhibitors: 90-100. Public attendance: 5,000. Public admission: $3. Deadline for entry: March. Application fee: $15. Space fee: $85. Ex-

hibition space: 10×10 ft. For more information, artists should call.

FESTIVAL IN THE PARK

1409 East Blvd., Charlotte NC 28203. (704)338-1060. **E-mail:** festival@festivalinthepark.org. **Website:** www.festivalinthepark.org. Estab. 1964. Fine arts & crafts show held annually in late September (3rd Friday after Labor Day). Outdoors. Accepts photography and all arts mediums. Awards/prizes: $4,000 in cash awards. Number of exhibitors: 150. Public attendance: 85,000. Free to the public. Artists should apply by visiting website for application. Application fee: $45. Space fee: $390. Exhibition space: 10×10 ft. For more information, artists should e-mail, visit website, call.

FILLMORE JAZZ FESTIVAL

Steven Restivo Event Services, LLC, P.O. Box 151017, San Rafael CA 94915. (800)310-6563. **Fax:** (415)456-6436. **Website:** www.fillmorejazzfestival.com. Estab. 1984. Fine arts & crafts show and jazz festival held annually 1st weekend of July in San Francisco, between Jackson & Eddy streets. Outdoors. Accepts photography, ceramics, glass, jewelry, paintings, sculpture, metal clay, wood, clothing. Juried by prescreened panel. Number of exhibitors: 250. Public attendance: 100,000. Free to public. Deadline for entry: ongoing; apply online. Exhibition space: 8×10 ft. or 10×10 ft. Average gross sales/exhibitor: $800-11,000. For more information, artists should visit website or call.

FINE ART & CRAFTS AT ANDERSON PARK

274 Bellevue Ave., Upper Montclair NJ 07043. (908)874-5247. **Fax:** (908)874-7098. **E-mail:** info@rosesquared.com. **Website:** www.rosesquared.com. Estab. 1984. Fine art & craft show held annually in mid-September. Outdoors. Accepts photography and all other mediums. Juried. Number of exhibitors: 160. Public attendance: 12,000. Free to the public. Artists should apply on the website. Deadline for entry: mid-August. Application fee: $25. Space fee varies by booth size; see application form on website for details. For more information, artists should visit the website.

TIPS "Create a range of sizes and prices."

FINE ART & CRAFTS AT VERONA PARK

542 Bloomfield Ave., Verona NJ 07044. (908)874-5247. **Fax:** (908)874-7098. **E-mail:** info@rosesquared.com. **Website:** www.rosesquared.com. **Contact:** Howard Rose, vice president. Estab. 1986. Fine arts & crafts

show held annually in mid-May. Outdoors. Accepts photography and all other mediums. Juried. Number of exhibitors: 140. Public attendance: 10,000. Free to public. Artists should apply on the website. Deadline for entry: mid-April. Application fee: $25. Space fee varies by booth size; see application form on website for details. For more information, artists should visit the website.

TIPS "Have a range of sizes and price ranges."

FOOTHILLS ARTS & CRAFTS FAIR

2753 Lynn Rd., Suite A, Tryon NC 28782-7870. (828)859-7427. **E-mail:** info@blueridgebbqfestival. com. **Website:** www.blueridgebbqfestival.com. **Contact:** Susie Gurnik. Estab. 1994. Fine arts & crafts show and Blue Ridge BBQ Festival/Championship held annually the 2nd Friday and Saturday in June. Outdoors. Accepts contemporary, traditional and fine art by artist only; nothing manufactured or imported. Juried. Number of exhibitors: 50. Public attendance: 15,000+. Public admission: $8; 12 and under free. Artists should apply by downloading application from website or sending personal information to e-mail or mailing address. See website for deadline for entry. Jury fee: $25, nonrefundable. Space fee: $175. Exhibition space: 10×10 ft. For more information, artists should e-mail or visit website.

TIPS "Have an attractive booth, unique items, and reasonable prices."

FORD CITY HERITAGE DAYS

P.O. Box 205, Ford City PA 16226-0205. (724)763-1617. **E-mail:** fcheritagedays@gmail.com. Estab. 1980. Arts & crafts show held annually over the 4th of July weekend. Outdoors. Accepts photography, any handmade craft. Juried. Public attendance: 35,000-50,000. Free to public. Artists should apply by requesting an application by e-mail or telephone. Deadline for entry: mid-April. Application fee: $200. Space fee included with application fee. Exhibition space: 12×17 ft. For more information, artists should e-mail, call or send SASE.

TIPS "Show runs for 5 days. Have quality product, be able to stay for length of show, and have enough product."

FOREST HILLS FESTIVAL OF THE ARTS

P.O. Box 477, Smithtown NY 11787. (631)724-5966. **Fax:** (631)724-5967. **E-mail:** showtiques@aol.com. **Website:** www.showtiques.com. Estab. 2001. Fine arts & crafts show held annually in May/June. Outdoors. Accepts photography, all arts & crafts made by the exhibitor. Juried. Number of exhibitors: 300. Public attendance: 60,000. Free to public. Deadline for entry: until full. Exhibition space: 10×10 ft. For more information, artists should visit website or call.

FOUNTAIN HILLS FINE ART & WINE AFFAIRE

16810 E. Avenue of the Fountains, Fountain Hills AZ 85268. (480)837-5637. **Fax:** (480)837-2355. **E-mail:** info@thunderbirdartists.com. **Website:** www.thunderbirdartists.com. **Contact:** Dale, president. Estab. 2005. Fine arts & crafts show held annually in mid-March (see website for specifics). Outdoors. Accepts photography, paintings, bronzes, baskets, jewelry, stone, pottery. Juried; CEO blind juries by medium. Number of exhibitors: 125. Public attendance: 25,000. Public admission: $3. Apply online at www.zapplication.org. Deadline for entry: November (see website for specifics). Application fee: $30. Space fee: $420. Exhibition space: 10×10 to 10×30 ft. For more information, artists should e-mail, call or see website.

TIPS "A clean, gallery-type presentation is very important."

FOURTH AVENUE STREET FAIR

434 E. Ninth St., Tucson AZ 85705. (520)624-5004 or (800)933-2477. **Fax:** (520)624-5933. **E-mail:** kurt@fourthavenue.org. **Website:** www.fourthavenue.org. **Contact:** Kurt. Estab. 1970. Arts & crafts fair held annually in late March/early April and December (see website for details). Outdoors. Accepts photography, drawing, painting, sculpture, arts & crafts. Juried by 5 jurors. Awards/prizes: Best of Show. Number of exhibitors: 400. Public attendance: 300,000. Free to the public. Artists should apply by completing the online application at www.zapplication.org. Requires 4 photos of art/craft and 1 booth photo. $35 application fee. Booth fee $470, additional $150 for corner booth. Deadline for entry: see website for details. Exhibition space: 10×10 ft. Average gross sales/exhibitor: $3,000. For more information, artists should e-mail, visit website, call, send SASE.

FOURTH STREET FESTIVAL FOR THE ARTS & CRAFTS

P.O. Box 1257, Bloomington IN 47402. (812)575-0484; (812)335-3814. **E-mail:** info@4thstreet.org. **Website:** www.4thstreet.org. Estab. 1976. Fine arts & crafts show held annually Labor Day weekend. Out-

doors. Accepts photography, clay, glass, fiber, jewelry, painting, graphic, mixed media, wood. Juried by a 4-member panel. Awards/prizes: Best of Show ($750), 1st, 2nd, 3rd in 2D and 3D. Number of exhibitors: 105. Public attendance: 25,000. Free to public. Artists should apply by sending requests by mail, e-mail or download application from website at www.zapplication.org. Exhibition space: 10×10 ft. Average gross sales/exhibitor: $2,700. For more information, artists should e-mail, visit website, call or send for information with SASE.

TIPS Be professional.

FRANKFORT ART FAIR

P.O. Box 566, Frankfort MI 49635. (231)352-7251. **Fax:** (231)352-6750. **E-mail:** fcofc@frankfort-elberta.com. **Website:** www.frankfort-elberta.com. **Contact:** Joanne Bartley, executive director. Fine art fair held annually in August. Outdoors. Accepts photography, clay, glass, jewelry, textiles, wood, drawing/graphic arts, painting, sculpture, baskets, mixed media. Juried by 3 photos of work, 1 photo of booth display and 1 photo of work in progress. Prior exhibitors are not automatically accepted. No buy/sell allowed. Artists should apply by downloading application from website, e-mailing or calling. Deadline for entry: May 1 ($25 late fee). Jury fee: $15. Space fee: $105 for Friday and Saturday. Exhibition space: 12×12 ft. For more information, artists should e-mail or visit website.

FREDERICK FESTIVAL OF THE ARTS

22 S. Market St., Suite 3, Frederick MD 21701. (301)662-4190. **Fax:** (301)663-3084. **E-mail:** info@frederickartscouncil.org. **Website:** www.frederickartscouncil.org. Juried 2-day fine arts festival held annually the 1st weekend of June along Carroll Creek Linear Park in downtown Frederick. Features approximately 110 artists from across the country, 2 stages of musical performances, children's crafts and activities, artist demonstrations, as well as interactive classical theater performances. For more information, including application deadlines and fees, visit website.

FUNKY FERNDALE ART SHOW

Integrity Shows, P.O. Box 1070, Ann Arbor MI 48106. **E-mail:** mary@integrityshows.com. **Website:** www.michiganartshows.com. **Contact:** Mary Strope, artist relations. Estab. 2004. Fine arts & crafts show held annually in September. Outdoors. Accepts photography and all fine art and craft mediums; emphasis on fun, funky work. Juried by 3 independent jurors. Awards/prizes: purchase and merit awards. Number of exhibitors: 120. Public attendance: 30,000. Free to the public. Application fee: $25. Booth fee: $275-$625. Electricity limited; fee: $75. For more information, artists should visit our website.

TIPS "Show enthusiasm. Keep a mailing list. Develop collectors."

GARRISON ART CENTER'S JURIED FINE CRAFTS FAIR

23 Garrison's Landing, P.O. Box 4, Garrison NY 10524. (845)424-3960. **E-mail:** info@garrisonartcenter.org. **Website:** www.garrisonartcenter.org. Outdoor, riverside fine crafts show held annually on the third weekend in August. 85 exhibitors are selected to exhibit and sell handmade original work. Entries are judged based on creativity, originality and quality. Annual visitors 4,000-5,000. Visit our website for information, prospectus, and application.

TIPS "Have an inviting booth and be pleasant and accessible. Don't hide behind your product—engage the audience."

GENEVA ARTS FAIR

8 S. Third St., Geneva IL 60134. (630)232-6060. **Fax:** (630)232-6083. **E-mail:** chamberinfo@genevachamber.com. **Website:** www.genevachamber.com/festivals. Fine arts & crafts show held annually in late-July (see website for details). Outdoors. Juried. "The unprecedented Geneva Arts Fair transforms downtown Geneva into a venue for over 150 esteemed artists and draws a crowd of more than 20,000. The juried show was voted a Top 200 fine craft fair by *Art Fair Source-Book* and a previous winner of 'Best Craft or Art Show' by *West Suburban Living* magazine." Accepts photography, pottery, fiber, printmaking, mixed media, watercolor, oil/acrylic, wood, sculpture and jewelry. Application deadline: early February. Please visit www.emevents.com to apply and for further details.

GERMANTOWN FESTIVAL

P.O. Box 381741, Germantown TN 38183. (901)757-9212. **Website:** www.germantownfest.com. Estab. 1971. Arts & crafts show held annually the weekend after Labor Day. Outdoors. Accepts photography, all arts & crafts mediums. Number of exhibitors: 400+. Public attendance: 65,000. Free to public. Artists should apply by sending applications by mail. Deadline for entry: until filled. Application/space fee: $200-

250. Exhibition space: 10×10 ft. For more information, artists should e-mail, call or send SASE.

TIPS "Display and promote to the public. Price attractively."

GLOUCESTER WATERFRONT FESTIVAL

38 Charles St., Rochester NH 03867. (603)332-2616. **E-mail:** info@castleberryfairs.com; terrym@world path.net. **Website:** www.castleberryfairs.com. **Contact:** Terry Mullen, events coordinator. Estab. 1971. Arts & crafts show held the 3rd weekend in August in Gloucester MA. Outdoors in Stage Fort Park. Accepts photography and all other mediums. Juried by photo, slide or sample. Number of exhibitors: 225. Public attendance: 50,000. Free to the public. Artists should apply by downloading application from website. Deadline for entry: until full. Space fee: $375. Exhibition space: 10×10 ft. Average gross sales/exhibitor: "Generally, this is considered an 'excellent' show, so I would guess most exhibitors sell ten times their booth fee, or in this case, at least $3,500 in sales." For more information, artists should visit website.

TIPS "Do not bring a book; do not bring a chair. Smile and make eye contact with everyone who enters your booth. Have them sign your guest book; get their e-mail address so you can let them know when you are in the area again. And, finally, make the sale—they are at the fair to shop, after all."

GOLD RUSH DAYS

P.O. Box 774, Dahlonega GA 30533. **E-mail:** festival@ dahlonegajaycees.com. **Website:** www.dahlonegajaycees.com. Arts & crafts show held annually the 3rd full week in October. Accepts photography, paintings and homemade, handcrafted items. No digitally originated art work. Outdoors. Number of exhibitors: 300. Public attendance: 200,000. Application fee of $25. Free to the public. Artists should apply online under "Gold Rush," or send SASE to request application. Deadline: March. Exhibition space: 10×10 ft. Artists should e-mail, visit website for more information.

TIPS "Talk to other artists who have done other shows and festivals. Get tips and advice from those in the same line of work."

GOOD OLD SUMMERTIME ART FAIR

P.O. Box 1753, Kenosha WI 53141. (262)654-0065. **E-mail:** kenoshaartassoc@yahoo.com. **Website:** www. kenoartassoc.tripod.com/events.html. Estab. 1975. Fine arts show held annually the 1st Sunday in June. Outdoors. Accepts photography, paintings, drawings,

mosaics, ceramics, pottery, sculpture, wood, stained glass. Juried by a panel. Photos or slides required with application. Number of exhibitors: 100. Public attendance: 3,000. Free to public. Artists should apply by completing application form, and including fees and SASE. Deadline for entry: early April. Exhibition space: 12×12 ft. For more information, artists should e-mail, visit website or send SASE.

TIPS "Have a professional display, and be friendly."

GRADD ARTS & CRAFTS FESTIVAL

300 Gradd Way, Owensboro KY 42301. (270)926-4433. **Fax:** (270)684-0714. **E-mail:** bethgoetz@gradd.com. **Website:** www.gradd.com. **Contact:** Beth Goetz, festival coordinator. Estab. 1972. Arts & crafts show held annually 1st full weekend in October. Outdoors. Accepts photography taken by crafter only. Number of exhibitors: 100-150. Public attendance: 10,000+. Artists should apply by calling to be put on mailing list. Exhibition space: 15×15 ft. For more information, artists should e-mail, visit website or call.

TIPS "Be sure that only hand-crafted items are sold. No buy/sell items will be allowed."

GRAND FESTIVAL OF THE ARTS & CRAFTS

P.O. Box 429, Grand Lake CO 80447-0429. (970)627-3402. **Fax:** (940)627-8007. **E-mail:** glinfo@grandlakechamber.com. **Website:** www.grandlakechamber.com. Fine arts & crafts show held annually in June and September. Outdoors. Accepts photography, jewelry, leather, mixed media, painting, paper, sculpture, wearable art. Juried by chamber committee. Awards/prizes: Best in Show and People's Choice. Number of exhibitors: 60-75. Public attendance: 1,000+. Free to public. Artists should apply by submitting slides or photos. Deadline for entry: early June and early September. Application fee: $175; includes space fee and business license. No electricity available. Exhibition space: 10×10 ft. For more information, artists should e-mail or call.

GREAT LAKES ART FAIR

46100 Grand River Ave., Novi MI 48374. (248)348-5600. **Fax:** (248)347-7720. **E-mail:** info@greatlakes artfair.com. **Website:** www.greatlakesartfair.com. **Contact:** Andrea Picklo, event manager. Estab. 2009. Held April 12-14. Accepts paintings, sculptures, metal and fiber work, jewelry, 2D and 3D art, ceramics and glass. Cash prizes are given. Number of exhibitors: 150-200. Public attendance: 12,000-15,000. Applica-

ART FAIRS

tion fee: $30. Space fee: $400-800. Exhibition space: 10×12 ft.

TIPS E-mail, call or visit website for more information.

🎧 GREAT NECK STREET FAIR

Showtiques Crafts, Inc., P.O. Box 477, Smithtown NY 11787. (631)724-5966. **Fax:** (631)724-5967. **E-mail:** showtiques@aol.com. **Website:** www.showtiques. com. Estab. 1978. Fine arts & crafts show held annually in early May (see website for details) in the Village of Great Neck. "Welcomes professional artists, craftspeople and vendors of upscale giftware." Outdoors. Accepts photography, all arts & crafts made by the exhibitor. Juried. Number of exhibitors: 250. Public attendance: 50,000. Free to public. Deadline for entry: until full. Space fee: $150-250. Exhibition space: 10×10 ft. For more information, artists should e-mail, visit website or call.

🎧 GREENWICH VILLAGE ART FAIR

711 N. Main St., Rockford IL 61103. (815)968-2787. **Fax:** (815)316-2179. **E-mail:** nsauer@rockfordartmu seum.org. **Website:** www.rockfordartmuseum.org/ gvaf.html. **Contact:** Nancy Sauer. Estab. 1948. Juried 2-day OutdoorFine Art Fair held annually in September. $4,500 in Best of Show and Judges' Choice Awards. Number of exhibitors: 120. Public attendance: 7,000. Application fee $30. Booth fee: $225. Deadline for entry: April 30. Exhibition space: 10×10 ft. Apply on-line throughwww.zapplication.org.

🎧 GUILFORD CRAFT EXPO

P.O. Box 589, Guilford CT 06437. (203)453-5947. **E-mail:** expo@guilfordartcenter.org. **Website:** www. guilfordartcenter.org. Estab. 1957. Fine craft & art show held annually in mid-July. Outdoors. Accepts photography, wearable and nonwearable fiber, metal and nonmetal jewelry, clay, leather, wood, glass, painting, drawing, prints, mixed media. Juried by 5 images of work, viewed sequentially. Number of exhibitors: 180. Public attendance: 14,000. Public admission: $7. Artists should apply online at www. zapplication.org (preferred) or by downloading an application at www.guilfordartcenter.org. Deadline for entry: early January. Application fee: $40. Space fee: $625-650. Exhibition space: 10×10 ft. For more information, artists should e-mail, visit website, call.

🎧 GUNSTOCK SUMMER FESTIVAL

38 Charles St., Rochester NH 03867. (603)332-2616. **Fax:** (603)332-8413. **E-mail:** info@castleberryfairs. com. **Website:** www.castleberryfairs.com. Estab. 1971. Arts & crafts show held annually in early July in Gilford NH (see website for details). Indoors and outdoors. Accepts photography and all other mediums. Juried by photo, slide or sample. Number of exhibitors: 100. Public attendance: 10,000. Free to the public. Artists should apply by downloading application from website. Deadline for entry: until full. Space fee: $275. Exhibition space: 10×6 ft. (indoor) or 10×10 ft. (outdoor). For more information, artists should visit website.

TIPS "Do not bring a book; do not bring a chair. Smile and make eye contact with everyone who enters your booth. Have them sign your guest book; get their e-mail address so you can let them know when you are in the area again. And, finally, make the sale-they are at the fair to shop, after all."

🎧 HIGHLAND MAPLE FESTIVAL

P.O. Box 223, Monterey VA 24465. (540)468-2550. **Fax:** (540)468-2551. **E-mail:** highcc@cfw.com; info@ highlandcounty.org. **Website:** www.highlandcounty. org. Estab. 1958. Fine arts & crafts show held annually the 2nd and 3rd weekends in March. Indoors and outdoors. Accepts photography, pottery, weaving, jewelry, painting, wood crafts, furniture. Juried by 3 photos or slides. Number of exhibitors: 150. Public attendance: 35,000-50,000. "Vendors accepted until show is full." Exhibition space: 10×10 ft. For more information, artists should e-mail, visit website, call.

TIPS "Have quality work and good salesmanship."

🎧 HIGHLANDS ART LEAGUE'S ANNUAL FINE ARTS & CRAFTS FESTIVAL

351 West Center Ave., Sebring FL 33870. (863)385-6682. **Fax:** (863)385-6611. **E-mail:** director@high landsartleague.org. **Website:** www.highland sartleague.org. **Contact:** Martile Blackman, festival director. Estab. 1966. Fine arts & crafts show held annually first Saturday in November. Outdoors. Accepts photography, pottery, painting, jewelry, fabric. Juried based on quality of work. Awards/prizes: monetary awards. Number of exhibitors: 100+. Public attendance: more than 15,000. Free to the public. Artists should apply by calling or visiting website for application form. Deadline for entry: September 1. Exhibi-

tion space: 10×14 and 10×28 ft. Artists should e-mail for more information.

HINSDALE FINE ARTS FESTIVAL

22 E. First St., Hinsdale IL 60521. (630)323-3952. **Fax:** (630)323-3953. **E-mail:** info@hinsdalechamber.com. **Website:** www.hinsdalechamber.com. Fine arts show held annually in mid-June. Outdoors. Accepts photography, ceramics, painting, sculpture, fiber arts, mixed media, jewelry. Juried by 3 images. Awards/prizes: Best in Show, President's Award and 1st, 2nd and 3rd Place in 2D and 3D categories. Number of exhibitors: 140. Public attendance: 2,000-3,000. Free to public. Artists should apply online at www.zapplication.org. Deadline for entry: First week in March. Application fee: $30. Space fee: $250. Exhibition space: 10×10 ft. For more information, artists should e-mail or visit website.

TIPS "Original artwork sold by artist."

HOLIDAY CRAFTMORRISTOWN

P.O. Box 28, Woodstock NY 12498. (845)331-7900. **Fax:** (845)331-7484. **E-mail:** crafts@artrider.com. **Website:** www.artrider.com. Estab. 1990. Fine arts & crafts show held annually in early December. Indoors. Accepts photography, wearable and nonwearable fiber, metal and nonmetal jewelry, clay, leather, wood, glass, painting, drawing, prints, mixed media. Juried by 5 images of work and 1 of booth, viewed sequentially. Number of exhibitors: 150. Public attendance: 5,000. Public admission: $9. Artists should apply by downloading application from www.artrider.com or can apply online at www.zapplication.org. Deadline for entry: end of May. Application fee: $40. Space fee: $545. Exhibition space: 10×10 ft. For more information, artists should e-mail, visit website, call.

HOLIDAY FINE ARTS & CRAFTS SHOW

60 Ida Lee Dr., Leesburg VA 20176. (703)777-1368. **Fax:** (703)737-7165. **E-mail:** lfountain@leesburgva.gov. **Website:** www.idalee.org. Estab. 1990. Arts & crafts show held annually the 1st weekend in December. Indoors. Accepts photography, jewelry, pottery, baskets, clothing, accessories. Juried. Number of exhibitors: 95. Public attendance: 2,500. Free to public. Artists should apply by downloading application from website. Deadline for entry: August 31. Space fee: $110-150. Exhibition space: 10×7 ft. and 10×10 ft. For more information, artists should e-mail or visit website.

HOLLY ARTS & CRAFTS FESTIVAL

P.O. Box 64, Pinehurst NC 28370. (910)295-7462. **E-mail:** info@pinehurstbusinessguild.com. **Website:** www.pinehurstbusinessguild.com. Estab. 1978. Annual arts & crafts show held 3rd Saturday in October. Outdoors. Accepts quality photography, arts and crafts. Juried based on uniqueness, quality of product and overall display. Number of exhibitors: 200. Public attendance: 7,000. Free to the public. Submit 3 color photos, 2 of work to be exhibited, 1 of booth. **Deadline : Late March.** Application fee: $25 by separate check. Space fee: $75. Electricity fee: $5 Exhibition space: 10×10 ft. For more information, artists should call or visit website.

HOME, CONDO AND OUTDOOR ART & CRAFT FAIR

P.O. Box 486, Ocean City MD 21843. (410)213-8090. **Fax:** (410)213-8092. **E-mail:** events@oceanpromotions.info. **Website:** www.oceanpromotions.info. Estab. 1984. Fine arts & crafts show held annually in March. Indoors. Accepts photography, carvings, pottery, ceramics, glass work, floral, watercolor, sculpture, prints, oils, pen and ink. Number of exhibitors: 50. Public attendance: 9,000. Public admission: $4/adults; $3/seniors & students; 3 and under free. Artists should apply by e-mailing request for info and application. Deadline for entry: until full. Space fee: $250. Exhibition space: 10×10 ft. For more information, artists should e-mail, visit website or call.

HOME DECORATING & REMODELING SHOW

P.O. Box 230699, Las Vegas NV 89105-0699. (702)450-7984; (800)343-8344. **Fax:** (702)451-7305. **E-mail:** spvandy@cox.net. **Website:** www.nashvillehomeshow.com. Estab. 1983. Home show held annually in early September (see website for details). Indoors. Accepts photography, sculpture, watercolor, oils, mixed media, pottery. Awards/prizes: Outstanding Booth Award. Number of exhibitors: 400-450. Public attendance: 25,000. Public admission: $8. Artists should apply by calling. Marketing is directed to middle and above income brackets. Deadline for entry: open until filled. Space fee: $925. Exhibition space: 10×10 ft. or complements of 10×10 ft. For more information, artists should call or visit website.

HOT SPRINGS ARTS & CRAFTS FAIR

308 Pullman, Hot Springs AR 71901. (501)623-9592. **E-mail:** sephpipkin@aol.com. **Website:** www.

hotspringsartsandcraftsfair.com. **Contact:** Peggy Barnett. Estab. 1968. Fine arts & crafts show held annually the 1st full weekend in October at the Garland County Fairgrounds. Indoors and outdoors. Accepts photography and varied mediums ranging from heritage, crafts, jewelry, furniture. Juried by a committee of 12 volunteers. Number of exhibitors: 350+. Public attendance: 50,000+. Free to public. Deadline for entry: August. Space fee: $100-200. Exhibition space: 10×10 or 10×20 ft. For more information, and to apply, artists should e-mail, call or visit website.

HYDE PARK ARTS & CRAFTS ADVENTURE

P.O. Box 1326, Palatine IL 60078. (312)751-2500, (847)991-4748. **Fax:** (847)21-5853. **E-mail:** asoaartists@aol.com. **Website:** www.americansocietyofartists.org. Estab. 2006. Arts & crafts show held once a year in late September. Event held in Chicago. Outdoors. Accepts photography, painting, glass, wood, fiber arts, handcrafted candles, quilts, sculpture and more. Juried. Please submit 4 images representative of your work you wish to exhibit, 1 of your display set-up, your first/last name, physical address, daytime telephone number—résumé/show listing helpful. Number of exhibitors: 50. Free to the public. Artists should apply by submitting jury materials. To jury via e-mail: asoaartists@aol.com. If juried in, you will receive a jury/approval number. See website for jurying online. Deadline for entry: 2 months prior to show or earlier if spaces fill. Entry fee: $to be announced. Exhibition space: approximately 100 sq. ft. for single space; other sizes are available. For more information, artists should send SASE, submit jury material.
TIPS "Remember that when you are at work in your studio, you are an artist. But when you are at a show, you are a business person selling your work."

STAN HYWET HALL & GARDENS OHIO MART

714 N. Portage Path, Akron OH 44303. (330)836-5533 or (888)836-5533. **E-mail:** info@stanhywet.org. **Website:** www.stanhywet.org. Estab. 1966. Artisan crafts show held annually 1st full weekend in October. Outdoors. Accepts photography and all mediums. Juried via mail application. Awards/prizes: Best Booth Display. Number of exhibitors: 150. Public attendance: 15,000-20,000. Deadline varies. Application fee: $25, nonrefundable. Application available online. Exhibi-

tion space: 10×10 or 10×15 ft. For more information, artists should visit website or call.

INDIANA ART FAIR

650 W. Washington St., Indianapolis IN 46204. (317)232-8293. **Fax:** (317)233-8268. **E-mail:** jhahn@indianamuseum.org. **Website:** www.indianamuseum.org. Estab. 2004. Annual art/craft show held the third weekend of February. Indoors. Juried event; 5-6 judges award points in 3 categories. 80 exhibitors; 3,000 attendees. $10 admission for the public. Application fee $25. Space fee $165; 80 sq. ft. Accepts ceramics, glass, fiber, jewelry, painting, sculpture, mixed media, drawing/pastels, garden, leather, surface decoration, wood, metal, printmaking, and photography.
TIPS "Make sure that your booth space complements your product and presents well. Good photography can be key for juried shows."

INDIAN WELLS ARTS FESTIVAL

78-200 Miles Ave., Indian Wells CA 92210. (760)346-0042. **Fax:** (760)346-0042. **E-mail:** info@indianwellsartsfestival.com. **Website:** www.indianwellsartsfestival.com. **Contact:** Dianne Funk, producer. "A premier fine arts festival attracting thousands annually. The Indian Wells Arts Festival brings a splash of color to the beautiful grass concourse of the Indian Wells Tennis Garden. This spectacular venue transforms into an artisan village featuring 200 judged and juried artists and hundreds of pieces of one-of-a-kind artwork available for sale. Watch glass blowing, monumental rock sculpting, wood carving, pottery wheel demonstrations, weaving and mural painting. Wine tasting, gourmet market, children's activities, entertainment and refreshments add to the festival atmosphere." See website for information and an application.
TIPS "Have a professional display of work. Be approachable and engage in conversation. Don't give up—people sometimes need to see you a couple of times before they buy."

INTERNATIONAL FOLK FESTIVAL

301 Hay St., Fayetteville NC 28302. (910)323-1776. **Fax:** (910)323-1727. **E-mail:** bobp@theartscouncil.com. **Website:** www.theartscouncil.com. Estab. 1978. Fine arts & crafts show held annually the last weekend in September. Outdoors. Accepts photography, painting of all mediums, pottery, woodworking, sculptures. Work must be original. Number of exhibitors: 120+.

Public attendance: 85,000-100,000 over 2 days. Free to public. Artists should apply on the website. Exhibition space: 10×10 ft. For more information, artists should e-mail or visit website.

TIPS "Have reasonable prices."

ISLE OF EIGHT FLAGS SHRIMP FESTIVAL

P.O. Box 1251, Fernandina Beach FL 32035. (904)261-7020. **Fax:** (904)261-1074. **E-mail:** jimmckart1@gmail.com; mailbox@islandart.org. **Website:** www.island art.org. Estab. 1963. Fine arts & crafts show and community celebration held annually the 1st weekend in May. Outdoors. Accepts all mediums. Juried. Awards: $9,700 in cash prizes. Number of exhibitors: 300. Public attendance: 150,000. Free to public. Artists should apply by downloading application from website. Deadline for entry: late January. Application fee: $30. Space fee: $225. Exhibition space: 10×12 ft. Average gross sales/exhibitor: $1,500+. For more information, artists should visit website.

TIPS "Quality product and attractive display."

JOHNS HOPKINS UNIVERSITY SPRING FAIR

3400 N. Charles St., Mattin Suite 210, Baltimore MD 21218. (410)516-7692. **Fax:** (410)516-6185. **E-mail:** info@jhuspringfair.com; arts@jhuspringfair.com. **Website:** www.jhuspringfair.com. Estab. 1972. Fine arts & crafts, campus-wide festival held annually in April. Outdoors. Accepts photography and all mediums. Juried. Number of exhibitors: 80. Public attendance: 20,000+. Free to public. Artists should apply via website. Deadline for entry: early March. Application and space fee: $200. Exhibition space: 10×10 ft. For more information, artists should e-mail, visit website or call.

TIPS "Artists should have fun displays, good prices, good variety and quality pieces."

JUBILEE FESTIVAL

Eastern Shore Chamber of Commerce, P.O. Drawer 310, Daphne AL 36526. (251)621-8222; (251)928-6387. **Fax:** (251)621-8001. **E-mail:** lroberts@eschamber.com. **E-mail:** office@eschamber.com. **Website:** www.eschamber.com. **Contact:** Liz Roberts. Estab. 1952. Fine arts & crafts show held in late September in Olde Towne of Daphne AL. Outdoors. Accepts photography and fine arts and crafts. Juried. Awards/prizes: ribbons and cash prizes total $4,300 with Best of Show $750. Number of exhibitors: 258. Free to the

public. Space fee: $275-550. Exhibition space: 10×10 ft. or 10×20 ft. For more information, and application form, artists should e-mail, call, see website.

KALAMAZOO INSTITUTE OF ARTS FAIR

Kalamazoo Institute of Arts, 314 S. Park St., Kalamazoo MI 49007. (269)349-7775. **Fax:** (269)349-9313. **E-mail:** heatherr@kiarts.org. **Website:** www.kiarts.org/artfair. **Contact:** Heather Ricketts. Estab. 1951. Fine arts & crafts show held annually in June. The 2013 show will be held June 7-8. Outdoors. "The KIA's annual art fair has been going strong for 62 years. Still staged in shady, historic Bronson Park, the fair boasts more hours, more artists and more activities. It now spans 2 full days. The art fair provides patrons with more time to visit and artists with an insurance day in case of rain. Some 190 artists will be invited to set up colorful booths. Numerous festivities are planned, including picnics in the park, public art activities, street performers and an artist dinner. For more information, visit www.kiarts.org/artfair." Apply via www.zapplication.org. Application fee: $30. Booth fee: $250.

KENTUCK FESTIVAL OF THE ARTS

503 Main Ave., Northport AL 35476. (205)758-1257. **Fax:** (205)758-1258. **E-mail:** kentuck@kentuck.org. **Website:** www.kentuck.org. **Contact:** Shweta Gamble, Executive Director. Call or e-mail for more information. General information about the festival available on the Website. "Celebrates a variety of artistic styles ranging from folk to contemporary arts as well as traditional crafts. Each of the 250+ artists participating in the festival is either invited as a guest artist or is juried based on the quality and originality of their work. The guest artists are nationally recognized folk and visionary artists whose powerful visual images continue to capture national and international acclaim."

KETNER'S MILL COUNTY ARTS FAIR

P.O. Box 322, Lookout Mountain TN 37350. (423)267-5702. **E-mail:** contact@ketnersmill.org. **Website:** www.ketnersmill.org. **Contact:** Dee Nash, event coordinator. Estab. 1977. Arts & crafts show held annually the 3rd weekend in October held on the grounds of the historic Ketner's Mills, in Whitwell TN, and the banks of the Sequatchie River. Outdoors. Accepts photography, painting, prints, dolls, fiber arts, baskets, folk art, wood crafts, jewelry, musical instruments, sculpture, pottery, glass. Juried. Number of exhibitors: 170. Number of attendees: 10,000/day,

depending on weather. Artists should apply online. Space fee: $125. Electricity: $10 limited to light use. Exhibition space: 15×15 ft. Average gross sales/exhibitor: $1,500.

TIPS "Display your best and most expensive work, framed. But also have smaller unframed items to sell. Never underestimate a show: Someone may come forward and buy a large item."

KINGS DRIVE ART WALK

1409 East Blvd., Charlotte NC 28203. (704)338-1060. **E-mail:** festival@festivalinthepark.org. **Website:** www.festivalinthepark.org. **Contact:** Julie Whitney Austin, executive director. Estab. 1964. Fine art & craft show held annually in late April. Indoors. Accepts photography. Juried. Number of exhibitors: 70. Public attendance: 10,000. Free to public. Artists should apply online at www.festivalinthepark.org/kingsdrive.htm. Deadline for entry: April. Application fee: $25. Space fee: $250. Exhibition space: 10×10 ft. For more information, artists should e-mail, call or visit website.

KINGS MOUNTAIN ART FAIR

13106 Skyline Blvd., Woodside CA 94062. (650)851-2710. **E-mail:** kmafsecty@aol.com. **Website:** www.kingsmountainartfair.org. **Contact:** Carrie German, administrative assistant. Estab. 1963. Fine arts & crafts show held annually Labor Day weekend. Fundraiser for volunteer fire dept. Accepts photography, ceramics, clothing, 2D, painting, glass, jewelry, leather, sculpture, textile/fiber, wood. Juried. Number of exhibitors: 138. Public attendance: 10,000. Free to public. Deadline for entry: January 30. Application fee: $20 (online). Exhibition space: 10×10 ft. Average gross sales/exhibitor: $3,500. For more information, artists should e-mail or visit website.

TIPS "Read and follow the instructions. Keep an open mind and be flexible."

KRASL ART FAIR ON THE BLUFF

707 Lake Blvd., St. Joseph MI 49085. (269)983-0271. **Fax:** (269)983-0275. **E-mail:** info1@krasl.org. **Website:** www.krasl.org. **Contact:** Colleen Villa. Estab. 1962. Fine arts & fine craft show held annually in early July (see website for details). Outdoors. Accepts photography, painting, digital art, drawing, pastels, wearable and nonwearable fiber art, glass, jewelry, sculpture, printmaking, metals and woods. Number of exhibitors: 216. Number of attendees: more than

70,000. Free to public. Application fee: $30. Applications are available online through www.zapplication.org. Deadline for entry: approximately mid-January. There is on-site jurying the same day of the fair and approximately 35% are invited back without having to pay the $30 application fee. Space fee: $275. Exhibition space: 15×15 ft. or $300 for 20×20 ft. (limited). Average gross sales/exhibitor: $4,700 (gross according to AFSB). For more information, artists should e-mail or visit website.

TIPS "Be willing to talk to people in your booth. You are your own best asset!"

LAKE CITY ARTS & CRAFTS FESTIVAL

P.O. Box 876, Lake City CO 81235. (970)944-2706. **E-mail:** info@lakecityarts.org; kerrycoy@aol.com. **Website:** www.lakecityarts.org. Estab. 1975. Fine arts/arts & craft show held annually 3rd Tuesday in July. One-day event. Outdoors. Accepts photography, jewelry, metal work, woodworking, painting, handmade items. Juried by 3-5 undisclosed jurors. Prize: Winners are entered in a drawing for a free booth space in the following year's show. Number of exhibitors: 85. Public attendance: 500. Free to the public. Space fee: $75. Jury fee: $10. Exhibition space: 12×12 ft. Average gross sales/exhibitor: $500-$1,000. For more information, and application form, artists should visit website.

TIPS "Repeat vendors draw repeat customers. People like to see their favorite vendors each year or every other year. If you come every year, have new things as well as your best-selling products."

LEEPER PARK ART FAIR

16200 Continental Dr., Granger IN 46530. (574)272-8598. **E-mail:** Studio266@aol.com. **Website:** www.leeperparkartfair.org. **Contact:** Judy Ladd, director. Estab. 1967. Fine arts & crafts show held annually in June. Indoors. Accepts photography and all areas of fine art. Juried by slides. Awards/prizes: $3,700. Number of exhibitors: 120. Public attendance: 10,000. Free to public. Artists should apply by going to the website and clicking on "To Apply." Deadline for entry: early March. Booth fee: $300. Exhibition space: 12×12 ft. Average gross sales/exhibitor: $5,000. For more information, artists should e-mail or send SASE.

TIPS "Make sure your booth display is well presented and, when applying, slides are top notch!"

LES CHENEAUX FESTIVAL OF ARTS

P.O. Box 147, Cedarville MI 49719. (517)282-4950. E-mail: lcifoa@gmail.com. **Website:** www.lescheneaux. net/?annualevents. **Contact:** Rick Sapero. Estab. 1976. Fine arts & crafts show held annually 2nd Saturday in August. Outdoors. Accepts photography and all other media; original work and design only; no kits or commercially manufactured goods. Juried by a committee of 10. Submit 4 slides (3 of the artwork; 1 of booth display). Awards: monetary prizes for excellent and original work. Number of exhibitors: 70. Public attendance: 8,000. Public admission: $7. Artists should fill out application form to apply. Deadline for entry: April 1. Booth fee: $75; Jury fee: $5. Exhibition space: 10×10 ft. Average gross sales/exhibitor: $5-500. For more information, artists should call, send SASE, or visit website.

LIBERTY ARTS SQUARED

P.O. Box 302, Liberty MO 64069. **E-mail:** staff@ libertyartssquared.org; ckariotis@writersplace. org. **Website:** www.libertyartssquared.org. Estab. 2010. Outdoor fine art/craft show held annually. Accepts all mediums. Awards: prizes totaling $4,000; Literary Arts for Awards–$500; Visual Arts for Awards–$1,500; Folk Art for Awards–$1,500; Overall Best of Show Award–$500. Free admission to the public; free parking. Application fee: $25. Space fee: $200. Exhibition space: 10×10 ft. For more information, e-mail or visit website.

LILAC FESTIVAL ARTS & CRAFTS SHOW

81 Mill Rd., Rochester NY 14626. (585)723-1004. E-mail: info@rochesterevents.com; oledie@aol.com. **Website:** www.lilacfestival.com. **Contact:** Deb Schram. Estab. 1985. Arts & crafts show held annually in mid-May (see website for details). Outdoors. Accepts photography, painting, ceramics, woodworking, metal sculpture, fiber. Juried by a panel. Number of exhibitors: 150. Public attendance: 25,000. Free to public. Exhibition space: 10×10 ft. Space fee: $200. For more information, and to apply, artists should e-mail or visit website.

LOMPOC FLOWER FESTIVAL

119 E. Cypress Ave., Lompoc CA 93436. (805)737-1129. **E-mail:** lompocff13@yahoo.com. **Website:** www.lom pocvalleyartassociation.com. **Contact:** Kathy Badrak. Estab. 1942. Sponsored by Lompoc Valley Art Association, Cyprus Gallery. Show held annually last week

in June. Festival event includes a parade, food booths, entertainment, beer garden and commercial center, which is not located near arts & crafts area. Outdoors. Accepts photography, fine art, woodworking, pottery, stained glass, fine jewelry. Juried by 5 members of the LVAA. Vendor must submit 3 photos of their work and a description on how they make their art. Artists should apply by downloading application from website. Deadline for entry: early May. Application fee: $200. Exhibition space: 12×16 ft. For more information, artists should visit website.

LUTZ ARTS & CRAFTS FESTIVAL

(813)949-7060; (813)949-1937. **Contact:** Phyllis Hoedt. Estab. 1979. Fine arts & crafts show held annually in December. Outdoors. Accepts photography, sculpture. Juried. Directors make final decision. Number of exhibitors: 250. Public attendance: 35,000. Free to public. Deadline for entry: September 1 or until category is filled. Exhibition space: 12×12 ft. For more information, artists should call or send SASE.
TIPS "Have varied price range."

MADISON CHAUTAUQUA FESTIVAL OF ART

601 W. First St., Madison IN 47250. (812)265-6100. **Fax:** (812)273-3694. **E-mail:** georgie@madisonchau tauqua.com. **Website:** www.madisonchautauqua.com. **Contact:** Georgie Kelly, coordinator. Estab. 1971. Premier juried fine arts & crafts show, featuring painting, photography, stained glass, jewelry, textiles pottery and more, amid the tree-lined streets of Madison's historic district. Stop by the Riverfront FoodFest for a variety of foods to enjoy. Relax and listen to the live performances on the Lanier Mansion lawn, on the plaza and along the riverfront. Takes place in late September. Painting (2D artists may sell prints, but must include originals as well), photography, pottery, sculpture, wearable, jewelry, fiber, wood, baskets, glass, paper, leather. The number of artists in each category is limited to protect the integrity of the show.

MASON ARTS FESTIVAL

Mason-Deerfield Arts Alliance, P.O. Box 381, Mason OH 45040. (513)309-8585. **E-mail:** masonarts@gmail. com. **Website:** www.masonarts.org. Fine arts & crafts show held annually in mid-September (see website for details). Indoors and outdoors. Accepts photography, graphics, printmaking, mixed media; painting and drawing; ceramics, metal sculpture; fiber, glass, jewelry, wood, leather. Juried. Awards/prizes: $3,000+.

ART FAIRS

Number of exhibitors: 75-100. Public attendance: 3,000-5,000. Free to the public. Artists should apply by visiting website for application, e-mailing or calling. Deadline for entry: April 1. Jury fee: $25. Space fee: $75. Exhibition space: 12×12 ft.; artist must provide 10×10 ft. pop-up tent.

⬤ City Gallery show is held indoors; these artists are not permitted to participate outdoors and vice versa. City Gallery is a juried show featuring approximately 30-50 artists who may show up to 2 pieces.

⬤ MEMORIAL WEEKEND ARTS & CRAFTS FESTIVAL

38 Charles St., Rochester NH 03867. (603)332-2616. **Fax:** (603) 332-8413. **E-mail:** info@castleberryfairs.com. **Website:** www.castleberryfairs.com. **Contact:** Sherry Mullen. Estab. 1989. Arts & crafts show held annually on Memorial Day weekend in Meredith NH. Outdoors. Accepts photography and all other mediums. Juried by photo, slide or sample. Number of exhibitors: 85. Public attendance: 7,500. Free to the public. Artists should apply by downloading application from website. Deadline for entry: until full. Space fee: $225. Exhibition space: 10×10 ft. For more information, artists should visit website.

TIPS "Do not bring a book; do not bring a chair. Smile and make eye contact with everyone who enters your booth. Have them sign your guest book; get their e-mail address so you can let them know when you are in the area again. And, finally, make the sale—they are at the fair to shop, after all."

⬤ MICHIGAN STATE UNIVERSITY HOLIDAY ARTS & CRAFTS SHOW

319 MSU Union, East Lansing MI 48824. (517)355-3354. **E-mail:** uab@rhs.msu.edu; artsandcrafts@uabevents.com. **Website:** www.uabevents.com. **Contact:** Stephanie Bierlein. Estab. 1963. Arts & crafts show held annually the 1st weekend in December. Indoors. Accepts photography, basketry, candles, ceramics, clothing, sculpture, soaps, drawings, floral, fibers, glass, jewelry, metals, painting, graphics, pottery, wood. Juried by a panel of judges using the photographs submitted by each vendor to eliminate commercial products. They will evaluate on quality, creativity and crowd appeal. Number of exhibitors: 220. Public attendance: 15,000. Free to public. Artists should apply online. Exhibition space: 8×5 ft. For more information, artists should visit website or call.

⬤ MICHIGAN STATE UNIVERSITY SPRING ARTS & CRAFTS SHOW

319 MSU Union, East Lansing MI 48824. (517)355-3354. **Fax:** (517)432-2448. **E-mail:** artsandcrafts@uabevents.com. **Website:** www.uabevents.com. **Contact:** Stephanie Bierlein. Estab. 1963. Arts & crafts show held annually the weekend before Memorial Day weekend in mid-May in conjunction with the East Lansing Art Festival. Both shows are free for the public to attend. Outdoors. Accepts photography, basketry, candles, ceramics, clothing, sculpture, soaps, drawings, floral, fibers, glass, jewelry, metals, painting, graphics, pottery, wood. Juried by a panel of judges using the photographs submitted by each vendor to eliminate commercial products. They will evaluate on quality, creativity and crowd appeal. Number of exhibitors: 329. Public attendance: 60,000. Free to public. Artists can apply online beginning in February. Online applications will be accepted until show is filled. Application fee: $260 ($240 if apply online). Exhibition space: 10×10 ft. (double booth available, $500 or $480 online). For more information, artists should visit website or call.

⬤ MID-MISSOURI ARTISTS CHRISTMAS ARTS & CRAFTS SALE

P.O. Box 116, Warrensburg MO 64093. (660)747-6092. **E-mail:** rlimback@iland.net. Estab. 1970. Holiday arts & crafts show held annually in November. Indoors. Accepts photography and all original arts and crafts. Juried by 3 good-quality color photos (2 of the artwork, 1 of the display). Number of exhibitors: 50. Public attendance: 1,200. Free to the public. Artists should apply by e-mailing or calling for an application form. Deadline for entry: early November. Space fee: $50. Exhibition space: 10×10 ft. For more information, artists should e-mail or call.

TIPS "Items under $100 are most popular."

MONTAUK POINT LIONS CLUB

P.O. Box 2751, Montauk NY 11954. (631)668-2428; (631)668-5336. **E-mail:** info@montaukchamber.com; montaukart@aol.com. **Website:** montaukartistassociation.org. Estab. 1970. Arts & crafts show held annually Labor Day weekend. Outdoors. Accepts photography, arts & crafts. Number of exhibitors: 100. Public attendance: 1,000. Free to public. Exhibition space: 100 sq. ft. For more information, artists should call or visit website.

MOUNTAIN STATE FOREST FESTIVAL

P.O. Box 388, 101 Lough St., Elkins WV 26241. (304)636-1824. **Fax:** (304)636-4020. **E-mail:** msff@forestfestival.com;djudy@forestfestival.com. **Website:** www.forestfestival.com. **Contact:** Renee Heckel, executive director. Estab. 1930. Arts, crafts & photography show held annually in early October. Accepts photography and homemade crafts. Awards/prizes: cash awards for photography only. Number of exhibitors: 50. Public attendance: 50,000. Free to the public. Artists should apply by requesting an application form. For more information, artists should visit website, call, or visit Facebook page (search "Mountain State Forest Festival").

⊕ MOUNT GRETNA OUTDOOR ART SHOW

P.O. Box 637, Mount Gretna PA 17064. (717)964-3270. **Fax:** (717)964-3054. **E-mail:** mtgretnaart@comcast.net. **Website:** www.mtgretnaarts.com. Estab. 1974. Fine arts & crafts show held annually 3rd full weekend in August. Outdoors. Accepts photography, oils, acrylics, watercolors, mixed media, jewelry, wood, paper, graphics, sculpture, leather, clay/porcelain. Juried by 4 professional artists who assign each applicant a numeric score. The highest scores in each medium are accepted. Awards/prizes: Judges' Choice Awards: 30 artists are invited to return the following year, jury exempt; the top 10 are given a monetary award of $250. Number of exhibitors: 250. Public attendance: 15,000-19,000. Public admission: $8; children under 12 free. Artists should apply via www.zapplication.org. Deadline for entry: early April. Application fee: $25. Space fee: $350 per 10×12 ft. space; $700 per 10×24 ft. double space. For more information, artists should e-mail, visit website, call.

⊕ NAPA RIVER WINE & CRAFTS FAIR

After the Gold Rush, P.O. Box 5171, Walnut Creek CA 94596. (707)257-0322. **E-mail:** craig@donapa.com. **Website:** www.napadowntown.com; www.afterthe goldrushfestivals.com; www.DoNapa.com. **Contact:** Craig Smith. Wine and crafts show held annually in early September (see website for details). Outdoors. Accepts photography, jewelry, clothing, woodworking, glass, dolls, candles and soaps, garden art. Juried based on quality, uniqueness, and overall craft mix of applicants. Number of exhibitors: over 200. Public attendance: 20,000-30,000. Artists should apply online. Jury fee: $20. Space fee: $200. Exhibition space:

10×10 ft. For more information, artists should e-mail, visit website or call.

TIPS "Electricity is available, but limited. There is a $40 processing fee for cancellations."

⊕ NEW ENGLAND ARTS & CRAFTS FESTIVAL

38 Charles St., Rochester NH 03867. **Fax:** (603)332-8413. **E-mail:** info@castleberryfairs.com. **Website:** www.castleberryfairs.com. Estab. 1988. Arts & crafts show held annually on Labor Day weekend in Topsfield, MA. Indoors and outdoors. Accepts photography and all other mediums. Juried by photo, slide or sample. Number of exhibitors: 250. Public attendance: 25,000. Artists should apply by downloading application from website. Deadline for entry: until full. Exhibition space: 100 sq. ft. Booth fee: $350. Average gross sales/exhibitor: "Generally, this is considered an 'excellent' show, so I would guess most exhibitors sell ten times their booth fee, or in this case, at least $3,500 in sales." For more information, artists should visit website.

TIPS "Do not bring a book; do not bring a chair. Smile and make eye contact with everyone who enters your booth. Have them sign your guest book; get their e-mail address so you can let them know when you are in the area again. And, finally, make the sale—they are at the fair to shop, after all."

⊕ NEW ENGLAND CRAFT & SPECIALTY FOOD FAIR

38 Charles St., Rochester NH 03867. (603)332-2616. **Fax:** (603) 332-8413. **E-mail:** info@castleberryfairs.com. **Website:** www.castleberryfairs.com. Estab. 1995. Arts & crafts show held annually on Veterans Day weekend in Salem NH. Indoors. Accepts photography and all other mediums. Juried by photo, slide or sample. Number of exhibitors: 200. Public attendance: 15,000. Artists should apply by downloading application from website. Deadline for entry: until full. Space fee: $350-450. Exhibition space: 10×6 or 10×10 ft. Average gross sales/exhibitor: "Generally, this is considered an 'excellent' show, so I would guess most exhibitors sell 10 times their booth fee, or in this case, at least $3,000 in sales." For more information, artists should visit website.

TIPS "Do not bring a book; do not bring a chair. Smile and make eye contact with everyone who enters your booth. Have them sign your guest book; get their e-mail address so you can let them know when you are

in the area again. And, finally, make the sale—they are at the fair to shop, after all."

NEW MEXICO ARTS AND CRAFTS FAIR
2501 San Pedro St. NE, Suite 110, Albuquerque NM 87110. (505)884-9043. **E-mail:** info@nmartsand-craftsfair.org. **Website:** www.nmartsandcraftsfair.org. Estab. 1962. Fine arts & craft show held annually in June. Indoors. Accepts decorative and functional ceramics, digital art, drawing, fiber, precious and non-precious jewelry, photography, paintings, printmaking, mixed media, metal, sculpture and wood. *Only New Mexico residents 18 years and older are eligible.* See website for more details.

NEW ORLEANS JAZZ & HERITAGE FESTIVAL
336 Camp St., Suite 250, New Orleans LA 70130. (504)410-4100. **Fax:** (504)410-4122. **Website:** www.nojazzfest.com. **Contact:** Mandy Dillon. Estab. 1970. This festival showcases music, cuisine, arts and crafts from the region and around the world. The Louisiana Heritage Fair is held at the Fair Grounds Race Course over the course of 2 weekends (late April/early May; see website for details). Apply online via www.zapplication.org. Must submit 5 images, 4 of artwork, 1 of booth. Application fee: $30. Deadline: late December (see website for details). Call or visit website for more information.

NEW SMYRNA BEACH ART FIESTA
New Smyrna Beach Visitors Bureau, 2238 State Road 44, New Smyrna Beach FL 32168. (386)424-2175; (800)541-9621. **Fax:** (386)424-2177. **E-mail:** kshelton@cityofnsb.com. **Website:** www.cityofnsb.com; nsbfla.com/index.cfm. **Contact:** Kimla Shelton. Estab. 1952. Arts & crafts show held annually the last full weekend in February. Outdoors. Accepts photography, oil, acrylics, pastel, drawings, graphics, sculpture, crafts, watercolor. Awards/prizes: $15,000 prize money; $1,600/category; Best of Show. Number of exhibitors: 250. Public attendance: 14,000. Free to public. Artists should apply by calling to get on mailing list. Applications are always mailed out the day before Thanksgiving. Deadline for entry: until full. Exhibition space: 10×10 ft. For more information, artists should call.

NEW WORLD FESTIVAL OF THE ARTS
P.O. Box 246, Manteo NC 27954. (252)473-2838; (252)473-2133. **E-mail:** edward@outerbankschrist

mas.com. **Website:** www.townofmanteo.com. **Contact:** Edward Greene. Estab. 1963. Fine arts & crafts show held annually in mid-August (see website for details). Outdoors. Juried. Location is the Waterfront in downtown Manteo. Features 80 selected artists from Vermont to Florida exhibiting and selling their works. Application fee: $15. Space fee: $85.

NORTH CONGREGATIONAL PEACH & CRAFT FAIR
17 Church St., New Hartford CT 06057. (860)379-2466. **Contact:** K.T. "Sully" Sullivan. Estab. 1966. Arts & crafts show held annually in mid-August. Outdoors on the Green at Pine Meadow. Accepts photography, most arts and crafts. Number of exhibitors: 50. Public attendance: 500-2,000. Free to public. Artists should call for application form. Deadline for entry: August. Application fee: $60. Exhibition space: 11×11 ft. **TIPS** "Be prepared for all kinds of weather."

OAK PARK AVENUE-LAKE ARTS & CRAFTS SHOW
P.O. Box 1326, Palatine IL 60078. (312)751-2500, (847)991-4748. **E-mail:** asoaartists@aol.com. **Website:** www.americansocietyofartists.org. Estab. 1974. Fine arts & crafts show held annually in mid-August. Event held in Oak Park IL. Outdoors. Accepts photography, painting, graphics, sculpture, glass, wood, paper, fiber arts, mosaics and more. Juried. Please submit 4 images representative of your work you wish to exhibit, 1 of your display set-up, your first/last name, physical address, daytime telephone number—résumé/show listing helpful. Number of exhibitors: 150. Free to the public. Artists should apply by submitting jury materials. If you want to jury online please see our website and follow directions given there. To jury via e-mail: asoaartists@aol.com. If juried in, you will receive a jury/approval number. Deadline for entry: 2 months prior to show or earlier if spaces fill. Entry fee: $170. Exhibition space: approximately 100 sq. ft. for single space; other sizes available. For more information, artists should send SASE with jury material to the above address.
TIPS "Remember that when you are at work in your studio, you are an artist. But when you are at a show, you are a business person selling your work."

OC FAIR VISUAL ARTS COMPETITION
88 Fair Dr., Costa Mesa CA 92626. (714)708-1718. **E-mail:** visualarts@ocfair.com. **Website:** www.oc

fair.com/competitions. **Contact:** Barbara Thompson, program coordinator, visual arts. Annual fine art and craft show held from mid-July to mid-August. Indoors. Accepted media includes: photography, 2D media, sculpture, ceramics, graphic arts, fine woodworking. Juried event with cash and purchase awards. Over 2,000 exhibitors each year. 1.3 million attendees. 20,000 sq. ft. exhibition space. Admission fee $11. Artists should apply online at www.ocfair.com/competitions after April 1. Deadline for entry: May 31. Application fee of $10 per entry. E-mail or visit website for more information.

TIPS List the price on the entry form so we can put it on the tag. Be reasonable about your price. If you are an amateur artist, price accordingly.

OLD TOWN ART FAIR

1763 N. North Park Ave., Chicago IL 60614. (312)337-1938. **E-mail:** info@oldtowntriangle.com. **Website:** www.oldtownartfair.com. Fine art festival held annually in early June (see website for details). Located in the city's historic Old Town Triangle District. Artists featured are chosen by an independent jury of professional artists, gallery owners and museum curators. Features a wide-range of art mediums, including 2D and 3D mixed media, drawing, painting, photography, printmaking, ceramics, fiber, glass, jewelry and works in metal, stone and wood. Apply online at www.zapplication.org. For more information, call, e-mail or visit website.

ON THE GREEN FINE ART & CRAFT SHOW

Hubbard Green, Corner of Hubbard & Main St., Glastonbury CT 06033. (860)659-1196. **Fax:** (860)633-4301. **E-mail:** info@glastonburyarts.org. **Website:** www.glastonburyarts.org. **Contact:** Jane Fox, administrator. Estab. 1961. Fine art & craft show held annually 2nd week of September. Outdoors. Accepts photography, pastel, prints, pottery, jewelry, drawing, sculpture, mixed media, oil, acrylic, glass, watercolor, graphic, wood, fiber, etc. Juried (with 3 photos of work, 1 photo of booth). Awards/prizes: $3,000 total prize money in different categories. Number of exhibitors: 200. Public attendance: 15,000. Free to public. Artists should apply online. Deadline for entry: early June. Jury fee: $15. Space fee: $275. Exhibition space: 12×15 ft. Average gross sales/exhibitor varies. For more information, artists should visit website.

ORCHARD LAKE FINE ART SHOW

P.O. Box 79, Milford MI 48381-0079. (248)684-2613; (248)685-3748. **Fax:** (248)684-0195. **E-mail:** info@hotworks.org. **Website:** www.hotworks.org. **Contact:** Patty Narozny, show director. Estab. 2003. This event is held outside of Detroit, in the heart of West Bloomfield, and has been voted in the top 100 art shows in the country the last six years in a row. Held annually in late July. Outdoors. Accepts photography, clay, glass, fiber, wood, jewelry, painting, prints, drawing, sculpture, metal, multimedia. Artist applications available via www.zapplication.org, Juried Art Services, or via "manual" application. No buy/sell please. Also home to the Chadwick Group PC's Youth Art competition for grades K-8. Admission $5; 12 & under free; free parking. Deadline: early March (see website for details). Space fee: $200. Exhibition space: 10×10, 10×15 or 10×20 ft. For more information, call, e-mail or visit website.

TIPS "Be attentive to your customers. Do not ignore anyone."

PANOPLY ARTS FESTIVAL

The Arts Council Inc., 700 Monroe St., SW, Suite. 2, Huntsville AL 35801. (256)519-2787. **Fax:** (256)533-3811. **E-mail:** info@artshuntsville.org; vhinton@artshuntsville.org. **Website:** www.panoply.org. Estab. 1982. Fine arts show held annually the last weekend in April. Also features music and dance. Outdoors. Accepts photography, painting, sculpture, drawing, printmaking, mixed media, glass, fiber. Juried by a panel of judges chosen for their in-depth knowledge and experience in multiple mediums, and who jury from slides or disks in January. During the festival 1 judge awards various prizes. Number of exhibitors: 60-80. Public attendance: 140,000+. Public admission: $5/day or $10/weekend (children 12 and under free). Artists should e-mail, call, or go online for an application form. Deadline for entry: January. Space fee: $185. Exhibition space: 10×10 ft. (tent available, space fee $390). Average gross sales/exhibitor: $2,500. For more information, artists should e-mail or visit website.

PARADISE CITY ARTS FESTIVALS

30 Industrial Dr. E., Northampton MA 01060. (800)511-9725. **Fax:** (413)587-0966. **E-mail:** artist@paradisecityarts.com. **Website:** www.paradisecityarts.com. Estab. 1995. 4 fine arts & crafts shows held annually in March, May, October and November. Indoors. Accepts photography, all original art and fine

craft media. Juried by 5 digital images of work and an independent board of jury advisors. Number of exhibitors: 150-275. Public attendance: 5,000-20,000. Public admission: $12. Artists should apply by submitting name and address to be added to mailing list or print application from website. Deadlines for entry: April 1 (fall shows); September 9 (spring shows). Application fee: $30-45. Space fee: $855-1,365. Exhibition space varies by show, see website for more details . For more information, artists should e-mail, visit website or call.

PATTERSON APRICOT FIESTA

P.O. Box 442, Patterson CA 95363. (209)892-3118. **Fax:** (209)892-3388. **E-mail:** patterson_apricot_fiesta@hot mail.com. **Website:** www.apricotfiesta.com. **Contact:** Jaclyn Camara, chairperson. Estab. 1984. Arts & crafts show held annually in May/June. Outdoors. Accepts photography, oils, leather, various handcrafts. Juried by type of product. Number of exhibitors: 140-150. Public attendance: 30,000. Free to the public. Deadline for entry: mid-April. Application fee/space fee: $225/craft, $325/commercial. Exhibition space: 12×12 ft. For more information, artists should call, send SASE.
TIPS "Please get your applications in early!"

PEND OREILLE ARTS COUNCIL

P.O. Box 1694, Sandpoint ID 83864. (208)263-6139; (208)255-1869. **E-mail:** art@sandpoint.net. **Website:** www.artinsandpoint.org. Estab. 1978. Arts & crafts show held annually, second week in August. Outdoors. Accepts photography and all handmade, noncommercial works. Juried by 8-member jury. Number of exhibitors: 120. Public attendance: 5,000. Free to public. Artists should apply by sending in application, available in February, along with 4 images (3 of your work, 1 of your booth space). Deadline for entry: April. Application fee: $15. Space fee: $185-280, no commission taken. Electricity: $50. Exhibition space: 10×10 ft. or 10×15 ft. (shared booths available). For more information, artists should e-mail, call or visit website.

PETERS VALLEY ANNUAL CRAFT FAIR

19 Kuhn Rd., Layton NJ 07851. (973)948-5200. **E-mail:** craftfair@petersvalley.org; info@petersval ley.org. **Website:** www.petersvalley.org. Estab. 1970. Arts & crafts show held annually in late September at the Sussex County Fairgrounds in Augusta. Indoors. Accepts photography, ceramics, fiber, glass, basketry,

metal, jewelry, sculpture, printmaking, paper book art, drawing, painting. Juried. Awards/prizes: cash awards. Number of exhibitors: 185. Public attendance: 7,000-8,000. Public admission: $8. Artists should apply at www.zapplication.org. Deadline for entry: May. Application fee: $35. Space fee: $415. Exhibition space: 10×10 ft. Average gross sales/exhibitor: $2,000-5,000. For more information artists should e-mail, visit website or call.

PRAIRIE ARTS FESTIVAL

201 Schaumburg Court, Schaumburg IL 60193. (847)923-3605. **Fax:** (847)923-2458. **E-mail:** rbenve nuti@ci.schaumburg.il.us. **Website:** www.prairiecen ter.org. **Contact:** Roxane Benvenuti, special events coordinator. Outdoor fine art show & sale featuring artists, food vendors, live entertainment and children's activities. Held over Saturday-Sunday of Memorial Day weekend. Located in the Robert O. Atcher Municipal Center grounds, adjacent to the Schaumburg Prairie Center for the Arts. Artist applications available in mid-January; due online or postmarked by March 1. 155 spaces available. Application fee: $110 (for 15×10 space); $220 (30×10 space). No jury fee. "With thousands of patrons in attendance, an ad in the Prairie Arts Festival program is a great way to get your business noticed. Rates are reasonable, and an ad in the program gives you access to a select regional market. Sponsorship opportunities are also available." For more information, call, e-mail or visit the website.
TIPS "Submit your best work for the jury since these images are selling your work."

PUNGO STRAWBERRY FESTIVAL

P.O. Box 6158, Virginia Beach VA 23456. (757)721-6001. **Fax:** (757)721-9335. **E-mail:** pungofestival@ aol.com. **Website:** www.pungostrawberryfestival. info. Estab. 1983. Arts & crafts show held annually on Memorial Day weekend. Outdoors. Accepts photography and all media. Number of exhibitors: 60. Public attendance: 120,000. Free to public; $5 parking fee. Artists should apply by calling for application or downloading a copy from the website and mail in. Deadline for entry: early March; applications accepted from that point until all spaces are full. Notice of acceptance or denial by early April. Application fee: $50 refundable deposit. Space fee: $200 (off road location); $500 (on road location). Exhibition space: 10×10 ft. For more information, artists should e-mail, visit website or call.

PYRAMID HILL ANNUAL ART FAIR

1763 Hamilton Cleves Rd., Hamilton OH 45013. (513)868-8336. **Fax:** (513)868-3585. **E-mail:** pyramid@pyramidhill.org. **Website:** www.pyramidhill.org. **Contact:** Kelly Malone. Art fair held the last Saturday and Sunday of September. Application fee: $25. Booth fee: $100 for a single, $200 for a double. Call, e-mail or visit website for more information.

TIPS "Make items affordable! Quality work at affordable prices will produce profit."

QUAKER ARTS FESTIVAL

P.O. Box 202, Orchard Park NY 14127. (716)667-2787. **E-mail:** opjaycees@aol.com. **Website:** www.opjaycees.com. Estab. 1961. Fine arts & crafts show held annually in mid-September (see website for details). Outdoors. Accepts photography, painting, graphics, sculpture, crafts. Juried by 4 panelists during event. Awards/prizes: over $10,000 total cash prizes. Number of exhibitors: 330. Public attendance: 75,000. Free to the public. Artists should apply online, or by sending SASE. Deadline for entry: late August (see website for details). Space fee: $185 ($370 for double space). Exhibition space: 10×12 ft. (outdoor), 10×6 ft. (indoor). For more information, artists should call or visit website.

TIPS "Have an inviting booth and be pleasant and accessible. Don't hide behind your product—engage the audience."

RATTLESNAKE ROUNDUP

P.O. Box 292, Claxton GA 30417. (912)739-3820. **E-mail:** rattlesnakewildlifefestival@yahoo.com; thall@claxtonevanschamber.com. **Website:** www.claxtonevanschamber.com. Estab. 1968. Arts & crafts show held annually 2nd weekend in March. Outdoors. Accepts photography and various mediums. Number of exhibitors: 150-200. Public attendance: 15,000-20,000. Artists should apply by filling out an application. Click on the "Registration Tab" located on the Rattlesnake Roundup home page. Deadline for entry: late February/early March (see website for details). Space fee: $85. Exhibition space: 10×16 ft. For more information, artists should e-mail, visit website or call.

TIPS "Your display is a major factor in whether people will stop to browse when passing by. Offer a variety."

RILEY FESTIVAL

312 E. Main St., Suite C, Greenfield IN 46140. (317)462-2141. **Fax:** (317)467-1449. **E-mail:** info@rileyfestival.com. **Website:** www.rileyfestival.com.

Contact: Sarah Kesterson, public relations. Estab. 1970. Fine arts & crafts festival held in October. Outdoors. Accepts photography, fine arts, home arts, quilts. Juried. Awards/prizes: small monetary awards and ribbons. Number of exhibitors: 450. Public attendance: 75,000. Free to public. Artists should apply by downloading application on website. Deadline for entry: mid-September. Space fee: $185. Exhibition space: 10×10 ft. For more information, artists should visit website.

TIPS "Keep arts priced for middle-class viewers."

RIVERBANK CHEESE & WINE EXPOSITION

6618 3rd St., Riverbank CA 95367-2317. (209)863-9600. **Fax:** (209)863-9601. **E-mail:** events@riverbankcheeseandwine.org. **Website:** www.riverbankcheeseandwine.org. **Contact:** Chris Elswick, event coordinator. Estab. 1977. Arts & crafts show and food show held annually 2nd weekend in October. Outdoors. Accepts photography, other mediums depends on the product. Juried by pictures and information about the artists. Number of exhibitors: 250. Public attendance: 60,000. Free to public. Artists should apply by calling and requesting an application. Applications also available on website. Deadline for entry: early September. Space fee: $300-500. Exhibition space: 12×12 ft. For more information, artists should e-mail, visit website, call or send SASE.

TIPS Make sure your display is pleasing to the eye.

RIVERFRONT MARKET

The Riverfront Market Authority, P.O. Box 586, Selma AL 36702-0565. (334)874-6683; (334)872-4672. **E-mail:** info@selmaalabama.com. **Website:** historicselma.org/riverfront-market-day-2. **Contact:** Ed Greene. Estab. 1972. Arts & crafts show held annually the 2nd Saturday in October. Outdoors. Accepts photography, painting, sculpture. Number of exhibitors: 200. Public attendance: 8,000. Public admission: $2. Artists should apply by calling or mailing to request application. Deadline for entry: September 1. Space fee: $50; limited covered space available at $100; electrical hookups $25. Exhibition space: 10×10 ft. For more information, artists should call or visit website.

ROYAL OAK OUTDOOR ART FAIR

Recreation Dept., P.O. Box 1453, Royal Oak MI 48068. (248)246-3180. **E-mail:** mail@royaloakartscouncil.com. **E-mail:** todg@ci.royal-oak.mi.us. **Website:** www.ci.royal-oak.mi.us. **Contact:** Recreation office

staff. Estab. 1970. Fine arts & crafts show annually in July. Outdoors. Accepts photography, collage, jewelry, clay, drawing, painting, glass, wood, metal, leather, soft sculpture. Juried. Number of exhibitors: 110. Public attendance: 25,000. Free to pubic. Artists should apply with online application form and 3 slides of current work. Space fee: $250 (plus a $20 non-refundable processing fee per medium). Exhibition space: 15×15 ft. For more information, artists should e-mail, call or visit website.

TIPS "Be sure to label your slides on the front with name, size of work and 'top.'"

⊙ SACO SIDEWALK ART FESTIVAL

P.O. Box 336, 12½ Pepperell Square, Suite 2A, Saco ME 04072. (207)286-3546. **E-mail:** sacospirit@hotmail.com. **Website:** www.sacospirit.com. Estab. 1970. Event held in late June. Annual event organized and managed by Saco Spirit Inc., a non-profit organization committed to making Saco a better place to live and work by enhancing the vitality of our downtown. Dedicated to promoting art and culture in our community. Space fee: $75. Exhibition space: 10×10 ft. See website for more details.

TIPS "Offer a variety of pieces priced at various levels."

⊙ SANDY SPRINGS FESTIVAL

P.O. Box 422571, Atlanta GA 30342. (404)851-9111; (404)845-0793. **E-mail:** info@sandyspringsfestival.org; rmurphy@heritagesandysprings.org; patrick@affps.com; randall@affps.com. **Website:** www.sandyspringsfestival.com. Estab. 1985. Annual arts & crafts show held annually in mid-September. See website for details. Outdoors. Accepts photography, painting, sculpture, jewelry, furniture, clothing. Juried by artist committee. Awards/prizes: ribbons for Best in Show, 2nd Place, 3rd Place and Best Booth. Number of exhibitors: 135 maximum. Public attendance: 20,000. Public admission $5. Artists may apply via application on website or online at www.zapplication.org. Application fee: $25. Space fee: $250 for 10×10, $500 for 10×20. Average gross sales per exhibitor: $1,000. For more information, artists should e-mail or visit website.

TIPS "Many of the purchases made at Sandy Springs Festival are priced under $100. The look of the booth and its general attractiveness are very important, especially to those who might not know art."

⊙ SANTA CALI GON DAYS FESTIVAL

210 W. Truman Rd., Independence MO 64050. (816)252-4745. **E-mail:** info@independencechamber.org; tsingleton@independencechamber.org; tfreeland@independencechamber.org. **Website:** www.santacaligon.com. **Contact:** Terri Singleton or Teresa Freeland. Estab. 1973. Market vendors show held annually Labor Day weekend. Outdoors. Accepts photography, all other mediums. Juried by committee. Number of exhibitors: 240. Public attendance: 225,000. Free to public. Artists should apply by requesting application. Application requirements include completed application, application fee, 4 photos of product/art and 1 photo of display. Exhibition space: 8×8 ft. and 10×10 ft. For more information, artists should e-mail, visit website or call.

SANTA FE COLLEGE SPRING ARTS FESTIVAL

3000 NW 83rd St., Gainesville FL 32606. (352)395-5355. **Fax:** (352)336-2715. **E-mail:** kathryn.lehman@sfcollege.edu. **Website:** www.springartsfestival.com. **Contact:** Kathryn Lehman, cultural programs coordinator. Fine arts festival held in mid-April (see website for details). "The festival is one of the 3 largest annual events in Gainesville and is known for its high quality, unique artwork." Held in the downtown historic district. Public attendance: 130,000+. Call, e-mail or visit website for more information.

⊙ SAUSALITO ART FESTIVAL

P.O. Box 10, Sausalito CA 94966. (415)332-3555. **Fax:** (415)331-1340. **E-mail:** info@sausalitoartfestival.org. **Website:** www.sausalitoartfestival.org. **Contact:** Colleen Marlo. Estab. 1952. Fine arts & crafts show held annually Labor Day weekend. Outdoors. Accepts painting, photography, 2D and 3D mixed media, ceramics, drawing, fiber, functional art, glass, jewelry, printmaking, sculpture, watercolor, woodwork. Juried. Jurors are elected by their peers from the previous year's show (1 from each category). They meet for a weekend at the end of March and give scores of 1, 2, 4 or 5 to each applicant (5 being the highest). 5 images must be submitted, 4 of art and 1 of booth. Number of exhibitors: 280. Public attendance: 40,000. Artists should apply by visiting website for instructions and application. Applications are through Juried Art Services. Deadline for entry: March. Exhibition space: 100 or 200 sq. ft. Booth fees range from $1,425-3,125.

Average gross sales/exhibitor: $7,700. For more information, artists should visit website.

SCOTTSDALE ARTS FESTIVAL

7380 E. Second St., Scottsdale AZ 85251. (480)874-2787; (480)994-2787. **Fax:** (480)874-4699. **Website:** www.scottsdaleartsfestival.org. Estab. 1970. Fine arts & crafts show held annually in March. Outdoors. Accepts photography, jewelry, ceramics, sculpture, metal, glass, drawings, fiber, paintings, printmaking, mixed media, wood. Juried. Awards/prizes: 1st, 2nd, 3rd Places in each category and Best of Show. Number of exhibitors: 200. Public attendance: 40,000. Public admission: $8. Artists should apply through www.zapplication.org. Deadline for entry: October. Exhibition space: 100 sq. ft. For more information, artists should visit website.

SIDEWALK ART MART

Downtown Helena, Inc., Mount Helena Music Festival, 225 Cruse Ave., Suite B, Helena MT 59601. (406)447-1535. **Fax:** (406)447-1533. **E-mail:** jmchugh@mt.net. **Website:** www.downtownhelena.com. **Contact:** Jim McHugh. Estab. 1974. Arts, crafts and music festival held annually in June. Outdoors. Accepts photography. No restrictions except to display appropriate work for all ages. Number of exhibitors: 50+. Public attendance: 5,000. Free to public. Artists should apply by visiting website to download application. Space fee: $100-125. Exhibition space: 10×10 ft. For more information, artists should e-mail, visit website or call.

TIPS "Greet people walking by and have an eye-catching product in front of booth. We have found that high-end artists or expensively priced art booths that had business cards with e-mail or website information received many contacts after the festival."

SIERRA MADRE WISTARIA FESTIVAL

20 W. Monticello Ave., Suite C, Sierra Madre CA 91024. (626)355-5111; (626)233-5524. **Fax:** (626)306-1150. **E-mail:** info@sierramadrechamber.com. **Website:** www.sierramadrechamber.com/wistaria/photos.htm. Fine arts, crafts and garden show held annually in March. Outdoors. Accepts photography, anything handcrafted. Juried. Craft vendors send in application and photos to be juried. Most appropriate are selected. Awards/prizes: Number of exhibitors: 175. Public attendance: 12,000. Free to public. Artists should apply by sending completed and signed application, 3-5 photographs of their work, application fee, license

application, space fee and 2 SASEs. Deadline for entry: late December. Application fee: $25. Public Safety Fee (non-refundable) $25. Space fee: $185. Exhibition space: 10×10 ft. For more information, artists should e-mail, visit website or call. Applications can be found on chamber website.

TIPS "Have a clear and simple application. Be nice."

SKOKIE ART GUILD'S ART FAIR

Devonshire Cultural Center, 4400 Greenwood St., Skokie IL 60077. (847)677-8163. **E-mail:** info@skokieartguild.org; skokieart@aol.com. **Website:** www.skokieartguild.org. Outdoor fine art/craft show open to all artists (18+). Held on second weekend of July. Space fee: $150 for 10×10 ft. space. Awards: Guild awards, a Mayor's award and community business gift certificates are rallied. Deadline for application: mid-May.

TIPS Display your work in a professional manner: matted, framed, etc.

SMITHVILLE FIDDLERS' JAMBOREE AND CRAFT FESTIVAL

P.O. Box 83, Smithville TN 37166. (615)597-8500. **E-mail:** eadkins@smithvillejamboree.com. **Website:** www.smithvillejamboree.com. **Contact:** Emma Adkins, craft coordinator. Estab. 1971. Arts & crafts show held annually the weekend nearest the Fourth of July holiday. Indoors. Juried by photos and personally talking with crafters. Awards/prizes: ribbons and free booth for following year for Best of Show, Best of Appalachian Craft, Best Display, Best New Comer. Number of exhibitors: 235. Public attendance: 130,000. Free to public. Artists should apply online. Deadline: May. Space fee: $125. Exhibition space: 12×12 ft. Average gross sales/exhibitors: $1,200+. For more information, artists should call or visit website.

SOLANO AVENUE STROLL

1563 Solano Ave., #PMB 101, Berkeley CA 94707. (510)527-5358. **E-mail:** info@solanostroll.org. **Website:** www.solanostroll.org. **Contact:** Allen Cain. Estab. 1974. Fine arts & crafts show held annually 2nd Sunday in September. Outdoors. "Since 1974, the merchants, restaurants, and professionals, as well as the twin cities of Albany and Berkeley have hosted the Solano Avenue Stroll, the East Bay's largest street festival." Accepts photography and all other mediums. Juried by board of directors. Number of exhibitors: 150 spaces for crafts; 600 spaces total. Public attendance: 250,000. Free to the public. Artists should ap-

ART FAIRS

ply online in April, or send SASE. Space fee: $150. Exhibition space: 10×10 ft. For more information, artists should e-mail, visit website, send SASE.

TIPS "Artists should have a clean presentation; small-ticket items as well as large-ticket items; great customer service; enjoy themselves."

THE SOUTHWEST ARTS FESTIVAL

Indio Chamber of Commerce, 82921 Indio Blvd., Indio CA 92201. (760)347-0676. **Fax:** (763)3476069. **E-mail:** jonathan@indiochamber.org. **E-mail:** swaf@indiochamber.org. **Website:** www.southwestartsfest.com. Estab. 1986. Featuring over 275 acclaimed artists showing traditional, contemporary and abstract fine works of art and quality crafts, the festival is a major, internationally recognized cultural event attended by nearly 10,000 people. The event features a wide selection of clay, crafts, drawings, glass work, jewelry, metal works, paintings, photographs, printmaking, sculpture and textiles. Application fee: $55. Easy check-in and check-out procedures with safe and secure access to festival grounds for setup and breakdown. Allow advance set-up for artists with special requirements (very large art requiring the use of cranes, forklifts, etc., or artists with special needs). Artist parking is free. Disabled artist parking is available. Apply online. For more information, artists should call, e-mail or visit website.

⊕ SPRING CRAFTMORRISTOWN

P.O. Box 28, Woodstock NY 12498. (845)331-7900. **Fax:** (845)331-7484. **E-mail:** crafts@artrider.com. **Website:** www.artrider.com. Estab. 1990. Fine arts & crafts show held annually in March or April. Indoors. Accepts photography, wearable and nonwearable fiber, metal and nonmetal jewelry, clay, leather, wood, glass, painting, drawing, prints, mixed media. Juried by 5 images of work and 1 of booth, viewed sequentially. Number of exhibitors: 150. Public attendance: 5,000. Public admission: $9. Artists should apply by downloading application from www.artrider.com or apply online at www.zapplication.org. Deadline for entry: January 1. Application fee: $40. Space fee: $495. Exhibition space: 10×10 ft. For more information, artists should e-mail, visit website, call.

⊕ SPRING CRAFTS AT LYNDHURST

P.O. Box 28, Woodstock NY 12498. (845)331-7900. **Fax:** (845)331-7484. **E-mail:** crafts@artrider.com. **Website:** www.artrider.com. Estab. 1984. Fine arts & crafts show held annually in early May. Outdoors.

Accepts photography, wearable and nonwearable fiber, metal and nonmetal jewelry, clay, leather, wood, glass, painting, drawing, prints, mixed media. Juried by 5 images of work and 1 of booth, viewed sequentially. Number of exhibitors: 250. Public attendance: 14,000. Public admission: $10. Artists should apply by downloading application from www.artrider.com or can apply online at www.zapplication.org. Deadline for entry: January 1. Application fee: $40. Space fee: $755-855. Exhibition space: 10×10 ft. For more information, artists should e-mail, visit website, call.

SPRINGFEST

Southern Pines Business Association, P.O. Box 831, Southern Pines NC 28388. (910)315-6508. **E-mail:** spbainfo@southernpines.biz. **Website:** www.southernpines.biz. **Contact:** Susan Harris. Estab. 1979. Arts & crafts show held annually last Saturday in April. Outdoors. Accepts photography and crafts. We host over 160 vendors from all around North Carolina and the country. Enjoy beautiful artwork and crafts including paintings, jewelry, metal art, photography, woodwork, designs from nature and other amazing creations. Event is held in conjunction with Tour de Moore, an annual bicycle race in Moore County, and is cosponsored by the town of Southern Pines. Public attendance: 8,000. Free to the public. Deadline: March (see website for more details). Space fee: $75. Exhibition space: 10×12 ft. For more information, artists should e-mail, visit website, call, send SASE. Apply online.

⊕ SPRING FINE ART & CRAFTS AT BROOKDALE PARK

473 Watchung Ave., Bloomfield NJ 07003. (908)874-5247. **Fax:** (908)874-7098. **E-mail:** info@rosesquared.com. **Website:** www.rosesquared.com. Estab. 1988. Fine arts & craft show held annually at Brookdale Park on the border of Bloomfield and Montclair NJ. Event takes place in mid-June on Father's Day weekend. Outdoors. Accepts photography and all other mediums. Juried. Number of exhibitors: 180. Public attendance: 16,000. Free to the public. Artists should apply by downloading application from website or call for application. Deadline: 1 month before show date. Application fee: $25. Space fee: $365. Exhibition space: 120 sq. ft. For more information, artists should e-mail, visit website, call.

TIPS "Create a professional booth that is comfortable for the customer to enter. Be informative, friendly and outgoing. People come to meet the artist."

ST. CHARLES FINE ART SHOW

213 Walnut St., St. Charles IL 60174. (630)443-3967. **E-mail:** info@downtownstcharles.org; jblair@downtownstcharles.org. **Website:** www.downtownstcharles.org. **Contact:** Jamie Blair. Fine art fair held annually in late May. Outdoors. Accepts photography, painting, sculpture, glass, ceramics, jewelry, nonwearable fiber art. Juried by committee: submit 4 slides of art and 1 slide of booth/display. Awards/prizes: Cash awards of $3,500 awarded in several categories. Number of exhibitors: 100. Free to the public. Artists should apply by downloading application from website or call for application. Deadline for entry: February. Jury fee: $45. Space fee: $350. Exhibition space: 10×10 ft. For more information, artists should e-mail, or visit website.

ST. GEORGE ART FESTIVAL

86 S. Main St., George UT 84770. (435)627-4500. **E-mail:** artadmn@sgcity.org; deborah.reeder@sgcity.org; leisure@sgcity.org. **Website:** www.sgcity.org/artfestival. **Contact:** Deborah Reeder. Estab. 1979. Fine arts & crafts show held annually Easter weekend in either March or April. Outdoors. Accepts photography, painting, wood, jewelry, ceramics, sculpture, drawing, 3D mixed media, glass. Juried from digital submissions, CDs and slides. Awards/prizes: $5,000 Purchase Awards. Art pieces selected will be placed in the city's permanent collections. Number of exhibitors: 110. Public attendance: 20,000/day. Free to public. Artists should apply by completing application form, nonrefundable application fee, slides or digital format of 4 current works in each category and 1 of booth, and SASE. Deadline for entry: January. Exhibition space: 10×11 ft. For more information, artists should check website or e-mail.
TIPS "Artists should have more than 50% originals. Have quality booths and set-up to display art in best possible manner. Be outgoing and friendly with buyers."

ST. JAMES COURT ART SHOW

P.O. Box 3804, Louisville KY 40201. (502)635-1842. **Fax:** (502)635-1296. **E-mail:** mesrock@stjamescourtartshow.com. **Website:** www.sjcas.com. Estab. 1957. Annual fine arts & crafts show held the first full weekend in October. Accepts photography; has 17 medium categories. Juried in April; there is also a street jury held during the art show. Number of exhibitors: 270. Public attendance: 210,000. Free to the public. Artists should apply by visiting website and printing out an application or via www.zapplication.org. Deadline for entry: late March (see website for details). Application fee: $30. Space fee: $550. Exhibition space: 10×12 ft. For more information, artists should e-mail or visit website.
TIPS "Have a variety of price points. Don't sit in the back of the booth and expect sales."

ST. LOUIS ART FAIR

225 S. Meramec Ave., Suite 105, St. Louis MO 63105. **E-mail:** info@culturalfestivals.com. **Website:** www.culturalfestivals.com. **Contact:** Laura Miller, director of operations. Estab. 1994. Fine art/craft show held annually in September, the weekend after Labor Day. Outdoors. Accepts photography, ceramics, drawings, digital, glass, fiber, jewelry, mixed-media, metalwork, printmaking, paintings, sculpture and wood. Juried event, uses 5 jurors using 3 rounds, digital app. Total prize money available: $21,000—26 awards ranging from $500-1,000. Number of exhibitors: 180. Average attendance: 130,000. Admission free to the public. 2014 Deadline for applications: March 22. $40 application fee. Space fee: $625-725. 100 sq. ft. space. Average gross sales for exhibitor: $8.500. Apply at www.zapplication.org under St. Louis Art Fair. For more information, call, e-mail or visit website.
TIPS "Look at shows and get a feel for what it is."

ST. PATRICK'S DAY CRAFT SALE & FALL CRAFT SALE

P.O. Box 461, Maple Lake MN 55358-0461. **Website:** www.maplelakechamber.com. **Contact:** Kathy. Estab. 1988. Arts & crafts show held bi-annually in March and early November. Indoors. Number of exhibitors: 30-40. Public attendance: 300-600. Free to public. Deadline for entry: 2 weeks before the event. Exhibition space: 10×10 ft. For more information or an application, artists should visit website.
TIPS "Don't charge an arm and a leg for the items. Don't overcrowd your items. Be helpful, but not pushy."

STEPPIN' OUT

Downtown Blacksburg, Inc., P.O. Box 233, Blacksburg VA 24063. (540)951-0454. **E-mail:** dbi@downtownblacksburg.com. **E-mail:** events@downtownblacksburg.com. **Website:** www.blacksburgsteppinout.com. Estab. 1981. Arts & crafts show held annually 1st Friday and Saturday in August. Outdoors. Accepts photography, pottery, painting, drawing, fiber

arts, jewelry, general crafts. All arts and crafts must be handmade. Number of exhibitors: 170. Public attendance: 45,000. Free to public. Space fee: $150. An additional $10 is required for electricity. Exhibition space: 10×16 ft. Artists should apply by e-mailing, calling or downloading an application on website. Deadline for entry: early May.

TIPS "Visit shows and consider the booth aesthetic—what appeals to you. Put the time, thought, energy and money into your booth to draw people in to see your work."

STILLWATER ARTS FESTIVAL

P.O. Box 1449, Stillwater OK 74076. (405)533-8539; (405)747-8510. **E-mail:** stillwaterartsfestival@stillwater.org; rpalmer@stillwater.org. **Website:** www.stillwater.org/stillwater_arts_festival/index.php. Estab. 1977. Fine arts & crafts show held annually in April. Outdoors. Accepts photography, oil, acrylic, watercolor and multimedia paintings, pottery, pastel work, fiber arts, jewelry, sculpture, glass art. Juried. Awards are based on entry acceptance on quality, distribution and various media entries. Awards/prizes: Best of Show, $500; 1st Place, $200; 2nd Place, $150; 3rd Place, $100. Number of exhibitors: 80. Public attendance: 7,500-10,000. Free to public. Artists should apply online at the website. Deadline for entry: early spring (visit website for details). Jury fee: $20. Booth fee $140. Exhibition space: 10×10 ft. Average gross sales/exhibitor: $700. For more information, artists should e-mail.

STOCKLEY GARDENS FALL ARTS FESTIVAL

801 Boush St., Suite 302, Norfolk VA 23510. (757)625-6161. **Fax:** (757)625-7775. **E-mail:** aknox@hope-house.org. **Website:** www.hope-house.org. **Contact:** Anne Knox, development coordinator. Estab. 1984. Fine arts & crafts show held biannually in the 3rd weekends in May and October. Outdoors. Accepts photography and all major fine art mediums. Juried. Number of exhibitors: 150. Public attendance: 25,000. Free to the public. Artists should apply by submitting application, jury and booth fees, 5 slides. Deadline for entry: February and July. Exhibition space: 10×10 ft. For more information, artists should visit the website.

STONE ARCH BRIDGE FESTIVAL

(651)228-1664. **E-mail:** stacy@weimarketing.com. **Website:** www.stonearchbridgefestival.com. heatherwmpls@gmail.com. **Contact:** Sara Collins, manager. Estab. 1994. Fine arts & crafts and culinary arts show held annually on Father's Day weekend in the Riverfront District of Minneapolis. Outdoors. Accepts drawing/pastels, printmaking, ceramics, jewelry (metals/stone), mixed media, painting, photography, sculpture metal works, bead work (jewelry or sculpture), glass, fine craft, special consideration. Juried by committee. Awards/prizes: free booth the following year; $100 cash prize. Number of exhibitors: 250+. Public attendance: 80,000. Free to public. Artists should apply by application found on website or through www.zapplication.org. Application fee: $25. Deadline for entry: early April. Space fee: depends on booth location (see website for details). Exhibition space: 10×10 ft. For more information, artists should call (651)228-1664 or e-mail Stacy De Young at stacy@weimarketing.com.

TIPS "Have an attractive display and variety of prices."

STRAWBERRY FESTIVAL

2815 Second Ave. N., Billings MT 59101. (406)294-5060. **Fax:** (406)294-5061. **E-mail:** info@strawberryfun.com; natashap@downtownbillings.com. **Website:** www.strawberryfun.com. **Contact:** Natasha. Estab. 1991. Fine arts & crafts show held annually 2nd Saturday in June. Outdoors. Accepts photography and only finely crafted work. Hand crafted works by the selling artist will be given priority. Requires photographs of booth set up and 2-3 of work. Juried. Public attendance: 15,000. Free to public. Artists should apply online. Deadline for entry: April. Space fee: $150. Exhibition space: 10×10 ft. For more information, artists should e-mail or visit website.

SUMMER ARTS & CRAFTS FESTIVAL

38 Charles St., Rochester NH 03867. **E-mail:** info@castleberryfairs.com. **Website:** www.castleberryfairs.com. Estab. 1992. Arts & crafts show held annually 2nd weekend in August in Lincoln NH. Outdoors. Accepts photography and all other mediums. Juried by photo, slide or sample. Number of exhibitors: 100. Public attendance: 7,500. Free to the public. Artists should apply by downloading application from website. Application fee: $50. Space fee: $225. Exhibition space: 10×10 ft. For more information, artists should visit website.

TIPS "Do not bring a book; do not bring a chair. Smile and make eye contact with everyone who enters your booth. Have them sign your guest book; get their e-mail address so you can let them know when you are

in the area again. And, finally, make the sale—they are at the fair to shop, after all."

🎧 SUMMERFAIR

7850 Five Mile Rd., Cincinnati OH 45230. (513)531-0050. **Fax:** (513)531-0377. **E-mail:** exhibitors@summerfair.org. **Website:** www.summerfair.org. Estab. 1968. Fine arts & crafts show held annually the weekend after Memorial Day. Outdoors. Accepts photography, ceramics, drawing, printmaking, fiber, leather, glass, jewelry, painting, sculpture, metal, wood and mixed media. Juried by a panel of judges selected by Summerfair, including artists and art educators with expertise in the categories offered at Summerfair. Submit application with 5 digital images (no booth image) through www.zapplication.org. Awards/prizes: $11,000 in cash awards. Number of exhibitors: 300. Public attendance: 20,000. Public admission: $10. Deadline: February. Application fee: $30. Space fee: $375, single; $750, double space; $75 canopy fee (optional—exhibitors can rent a canopy for all days of the fair). Exhibition space: 10×10 ft. for single space; 10×20 ft. for double space. For more information, artists should e-mail, visit website, call.

🎧 SUN FEST, INC.

P.O. Box 2404, Bartlesville OK 74005. (918)977-1836. **Fax:** (918)331-3217. **E-mail:** stephanielief@yahoo.com. **E-mail:** sunfestbville@gmail.com. **Website:** www.bartlesvillesunfest.org. Estab. 1982. Fine arts & crafts show held annually in early June. Outdoors. Accepts photography, painting and other arts and crafts. Juried. Awards: $2,000 in cash awards along with a ribbon/award to be displayed. Number of exhibitors: 95-100. Number of attendees: 25,000-30,000. Free to the public. Artists should apply by e-mailing or calling for an entry form, or completing online, along with 3-5 photos showing your work and booth display. Deadline: April. Space fee: $125. An extra $20 is charged for use of electricity. Exhibition space: 10×10 ft. For more information, artists should e-mail, call or visit website.

🎧 SYRACUSE ARTS & CRAFTS FESTIVAL

572 S. Salina St., Syracuse NY 13202. (315)422-8284. **Fax:** (315)471-4503. **E-mail:** mail@downtownsyracuse.com. **Website:** www.syracuseartsandcrafts festival.com. **Contact:** Laurie Reed, director. Estab. 1970. Fine arts & crafts show held annually in late July. Outdoors. Accepts photography, ceramics, fab-

ric/fiber, glass, jewelry, leather, metal, wood, computer art, drawing, printmaking, painting. Juried by 4 independent jurors. Jurors review 4 slides of work and 1 slide of booth display. Number of exhibitors: 170. Public attendance: 50,000. Free to public. Artists should through www.zapplication.org. Application fee: $25. Space fee: $280. Exhibition space: 10×10 ft. For more information, artists should e-mail, visit website or call.

🎧 TARPON SPRINGS FINE ARTS FESTIVAL

111 E. Tarpon Ave., Tarpon Springs FL 34689. (727)937-6109. **Fax:** (727)937-2879. **E-mail:** scottie@ tarponspringschamber.org. **Website:** www.tarponspringschamber.com. Estab. 1974. Fine arts & crafts show held annually in early April. Outdoors. Accepts photography, acrylic, oil, ceramics, fiber, glass, graphics, drawings, pastels, jewelry, leather, metal, mixed media, sculpture, watercolor, wood. Juried by CD. Awards/prizes: cash and ribbons. Number of exhibitors: 200. Public attendance: 20,000. Public admission: $5 (includes free drink ticket: wine, beer, soda or water); free-age 12 and under and active duty military. Artists should apply by submitting signed application, CD, slides, fees and SASE. Deadline for entry: early December. Jury fee: $30. Space fee: $230. Exhibition space: 10×12 ft. For more information, artists should e-mail, call or send SASE.
TIPS "Produce good CDs for jurors."

🎧 TEXAS STATE ARTS & CRAFTS FAIR

4000 Riverside Dr. East, Kerrville TX 78028. (830)896-5711; (888)835-1455; (940)447-3235. **Fax:** (830)896-5569. **E-mail:** fair@tacef.org; tamara@tacef.org. **Website:** www.tacef.org. **Contact:** Tamara Allison. Event date: May 24-26. Fine arts & crafts show held annually Memorial Day weekend on the grounds of the River Star Arts & Event Park. One of the top ranked arts & crafts events in the nation. Outdoors. Public admission: $5 adult, Children 12 and under free with ticket holding adult. Application fee: $50. Space fee: $375-$650. Exhibition space: 10×10 or 10×20 ft. Outdoor fair tent or open air spaces available. Application form online at www.zapplication.org. Deadline: April 25. For more information, artists should call, e-mail or visit website.
TIPS "Market and advertise."

THREE RIVERS ARTS FESTIVAL

803 Liberty Ave., Pittsburgh PA 15222. (412)471-3191. **Fax:** (412)471-6917. **Website:** www.3riversartsfest.org.

Contact: Sonja Sweterlitsch, director. Estab. 1960. "Three Rivers Arts Festival has presented, during its vast and varied history, more than 10,000 visual and performing artists and entertained millions of residents and visitors. Three Rivers Arts Festival faces a new turning point in its history as a division of The Pittsburgh Cultural Trust, further advancing the shared mission of each organization to foster economic development through the arts and to enhance the quality of life in the region." Application fee: $35. Booth fee: $410. See website for more information.

TUBAC FESTIVAL OF THE ARTS

P.O. Box 1866, Tubac AZ 85646. (520)398-2704. **Fax:** (520)398-3287. **E-mail:** assistance@tubacaz.com. **Website:** www.tubacaz.com. Estab. 1959. Fine arts & crafts show held annually in early February (see website for details). Outdoors. Accepts photography and considers all fine arts and crafts. Juried. A 7-member panel reviews digital images and artist statement. Names are withheld from the jurists. Number of exhibitors: 170. Public attendance: 65,000. Free to the public; parking: $6. Deadline for entry: late October (see website for details). Application fee: $30. Artists should apply online and provide images on a labeled CD (see website for requirements). Space fee: $575. Electrical fee: $50. Exhibition space: 10×10 ft. (a limited number of double booths are available). For more information, artists should e-mail, call or visit website.

TULIP FESTIVAL STREET FAIR

(360)336-3801; (360)336-3431. **E-mail:** artintheval leysmv@gmail.com; edmvdt@gmail.com. **Website:** www.mountvernondowntown.org. Estab. 1984. Arts & crafts show held annually 3rd weekend in April. Outdoors. Accepts photography and original artists' work only. No manufactured work. Juried by a board. Jury fee: $10 with application and prospectus. Number of exhibitors: 220. Public attendance: 30,000-35,000. Free to public. Artists should apply by calling or e-mailing. Deadline for entry: late January. Application fee: $25. Space fee: $300. Exhibition space: 10×10 ft. Average gross sales/exhibitor: $2,500-4,000. For more information, artists should e-mail, visit website, call or send SASE.

TIPS "Keep records of your street fair attendance and sales for your résumé. Network with other artists about which street fairs are better to return to or apply for."

TULSA INTERNATIONAL MAYFEST

2 W. Second St., Suite 109, Tulsa OK 74103. (918)582-6435. **Fax:** (918)517-3518. **E-mail:** comments@tulsa mayfest.org. **Website:** www.tulsamayfest.org. Estab. 1972. Fine arts & crafts show annually held in May. Outdoors. Accepts photography, clay, leather/fiber, mixed media, drawing, pastels, graphics, printmaking, jewelry, glass, metal, wood, painting. Juried by a blind jurying process. Artists should apply online at www.zapplication.org and submit 4 images of work and 1 photo of booth set-up. Awards/prizes: Best in Category and Best in Show. Number of exhibitors: 125. Public attendance: 350,000. Free to public. Artists should apply by downloading application in the fall. See website for deadline entry. Application fee: $35. Space fee: $350. Exhibition space: 10×10 ft. For more information, artists should e-mail or visit website.

UPTOWN ART FAIR

1406 W. Lake St., Lower Level C, Minneapolis MN 55408. (612)823-4581. **Fax:** (612)823-3158. **E-mail:** maude@uptownminneapolis.com; info@uptown minneapolis.com. **E-mail:** jessica@uptownminne apolis.com. **Website:** www.uptownartfair.com. Estab. 1963. Fine arts & crafts show held annually 1st full weekend in August. Outdoors. Accepts photography, painting, printmaking, drawing, 2D and 3D mixed media, ceramics, fiber, sculpture, jewelry, wood and glass. Juried by 4 images of artwork and 1 of booth display. Awards/prizes: Best in Show in each category; Best Artist. Number of exhibitors: 350. Public attendance: 375,000. Free to the public. The Uptown Art Fair uses www.zapplication.org. Each artist must submit 5 images of his or her work. All artwork must be in a high-quality digital format. Five highly qualified artists, instructors, and critics handpick Uptown Art Fair exhibitors after previewing projections of the images on 6-ft. screens. The identities of the artists remain anonymous during the entire review process. All submitted images must be free of signatures, headshots or other identifying marks. Three rounds of scoring determine the final selection and waitlist for the show. Artists will be notified shortly after of their acceptance. For additional information, see the links on website. Deadline for entry: early March. Application fee: $40. Space fee: $525 for 10×10 space; $1050 for 10×20 space. For more information, artists should call or visit website.

A VICTORIAN CHAUTAUQUA

1101 E. Market St., Jeffersonville IN 47130. (812)283-3728 or (888)472-0606. **Fax:** (812)283-6049. **E-mail:** hsmsteam@aol.com. **Website:** www.steamboatmuseum.org. Estab. 1993. Fine arts & crafts show held annually 3rd weekend in May. Outdoors. Accepts photography, all mediums. Juried by a committee of 5. Number of exhibitors: 80. Public attendance: 3,000. Exhibition space: 12×12 ft. For more information, artists should e-mail, call or visit website.

VILLAGE SQUARE ARTS & CRAFTS FAIR

P.O. Box 176, Saugatuck MI 49453. **E-mail:** artclub@saugatuckdouglasartclub.org. **Website:** www.saugatuckdouglasartclub.org. **Contact:** Bonnie Lowe, art fair co-chairperson. Estab. 2004. The art club offers two fairs each summer. See website for upcoming dates. This fair has some fine artists as well as crafters. Both fairs take place on the two busiest weekends in the resort town of Saugatuck's summer season. Both are extremely well attended. Generally the vendors do very well. Booth fee: $95-130.

TIPS "Create an inviting booth. Offer well-made artwork and crafts for a variety of prices."

VIRGINIA CHRISTMAS MARKET

The Exhibition Center at Meadow Event Park, 13111 Dawn Blvd., Doswell VA 23047. (804) 253-6284. **Fax:** (804) 253-6285. **E-mail:** bill.wagstaff@virginiashows.com. **Website:** www.virginiashows.com. Indoors. Virginia Christmas Market is held the 2nd weekend in November at the Exhibition Center at Meadow Event Park. Virginia Christmas Market will showcase over 300 quality artisans, crafters, boutiques and specialty food shops. Features porcelain, pottery, quilts, folk art, fine art, reproduction furniture, flags, ironwork, carvings, leather, toys, tinware, candles, dollcraft, wovenwares, book authors, musicians, jewelry, basketry, gourmet foods—all set amid festive Christmas displays. Accepts photography and other arts and crafts. Juried by 3 photos of artwork and 1 of display. Attendance: 12,000. Public admission: $7; children FREE (under 10). Artists should apply by calling, e-mailing or downloading application from website. Space fee: $335. Exhibit spaces: 10×10 ft. For more information, artists should call, e-mail or contact through website.

VIRGINIA CHRISTMAS SHOW

P.O. Box 305, Chase City VA 23924. (434)372-3996. **Fax:** (434)372-3410. **E-mail:** vashowsinc@aol.com;

vashowsinc@comcast.net. **Website:** www.vashowsinc.com. **Contact:** Patricia Wagstaff. Estab. 1986. Arts and crafts show held annually in November in Richmond, Virginia. Accepts photography and other arts and crafts. Juried by 3 slides of artwork and 1 of display. Attendance: 30,000. Public admission: $7 adults; $1.50 children (2-12). Artists should apply by calling or e-mailing for application or downloading online application. Exhibition space: 10×10 ft. Included in this fee are booth curtains, 24-hour security in the show exhibit area, signage, a complimentary listing in the show directory and an extensive multi-media advertising campaign—radio, television, billboards, direct mail, magazines and newspapers—we do it all! Set-up is always easy, organized and convenient. The building is climate-controlled and many RVs may park on the premises for a nominal fee.

TIPS "If possible, attend the shows before you apply."

VIRGINIA SPRING MARKET

11050 Branch Rd., Glen Allen VA 23059. (804)253-6284. **Fax:** (804)253-6285. **E-mail:** bill.wagstaff@virginiashows.com. **Website:** www.virginiashows.com. **Contact:** Bill Wagstaff. Estab. 1988. Holiday arts & crafts show held annually 3rd weekend in March at The Exhibition Center at Meadow Event Park, 13111 Dawn Blvd., Doswell, VA. Virginia Spring Market will showcase up to 300 quality artisans, crafters, boutiques and specialty food shops. Features porcelain, pottery, quilts, folk art, fine art, reproduction furniture, flags, ironwork, carvings, leather, toys, tinware, candles, dollcraft, wovenwares, book authors, musicians, jewelry, basketry and gourmet foods, all set amid festive spring displays. Accepts photography and other arts and crafts. Juried by 3 slides of artwork and 1 of display. Public attendance: 12,000. Public admission: $7; children free (under 10). Artists should apply by calling, e-mailing or downloading application from website. Space fee: $335. Exhibition space: 10×10 ft. For more information, artists should call, e-mail or contact through website.

TIPS "If possible, attend the show before you apply."

VIRGINIA SPRING SHOW

11050 Branch Rd., Glen Allen VA 23059. (804)253-6284. **Fax:** (804)253-6285. **E-mail:** bill.wagstaff@virginiashows.com. **Website:** www.virginiashows.com. **Contact:** Bill Wagstaff. Estab. 1988. Holiday arts & crafts show held annually 2nd weekend in March in Richmond, VA. Indoors at the Showplace Exhibi-

tion Center. Accepts photography and other arts and crafts. Juried by 3 slides of artwork and 1 of display. Awards/prizes: Best Display. Number of exhibitors: 300. Public attendance: 20,000. Public admission: $7; children FREE (under 10). Exhibitor application is online at website. Artists can also apply by writing or e-mailing for an application. Space fee: $335. Exhibition space: 10×10 ft. For more information, artists should e-mail or visit website.

TIPS "If possible, attend the show before you apply."

WASHINGTON SQUARE OUTDOOR ART EXHIBIT

P.O. Box 1045, New York NY 10276. (212)982-6255. **Fax:** (212)982-6256. **E-mail:** jrm.wsoae@gmail.com. **Website:** www.wsoae.org. Estab. 1931. Fine arts & crafts show held semiannually Memorial Day weekend and Labor Day weekend. Outdoors. Accepts photography, oil, watercolor, graphics, mixed media, sculpture, crafts. Juried by submitting 5 slides of work and 1 of booth. Awards/prizes: certificates, ribbons and cash prizes. Number of exhibitors: 150. Public attendance: 100,000. Free to public. Artists should apply by sending a SASE or downloading application from website. Deadline for entry: March, Spring Show; July, Fall Show. Exhibition space: 5×10 ft. up to 10×10 ft., double spaces available. Jury fee of $20. First show weekend (3 days) fee of $380. Second show weekend (2 days) $285. Both shows (all 5 days) fee of $485. For more information, artists should call or send SASE.

TIPS "Price work sensibly."

WATERFRONT FINE ART & WINE FESTIVAL

7135 E. Camelback Rd., Scottsdale AZ 85251. (480)837-5637. **Fax:** (480)837-2355. **E-mail:** info@thunderbirdartists.com. **Website:** www.thunderbirdartists.com/waterfront. **Contact:** Dale, President. Estab. 2011. Fine art/craft show held annually over Valentine's Day weekend. Outdoors. Accepts photography, paintings, bronzes, baskets, jewelry, stone, pottery. Juried; blind jury by CEO. Number of exhibitors: 150. Public attendance: 40,000. Public admission: $3. Apply online at www.zapplication.org. Deadline for entry: late August (see website for specifics). Application fee: $30. Space fee: $410+. Exhibition space: 10×10 to 10×30 ft. For more information, artists should e-mail, call or visit website.

TIPS "A clean, gallery-type presentation is very important."

WATERFRONT FINE ART FAIR

P.O. Box 176, Saugatuck MI 49453. **E-mail:** artclub@saugatuckdouglasartclub.org. **Website:** www.saugatuckdouglassartclub.org. **Contact:** Bonnie Lowe and Jim Hanson, art fair co-chairs. Fee is $135. This includes application fee, booth fee, and city license. Applications juried in early April. For information, e-mail, call or visit the website.

TIPS "Create a pleasing, inviting booth. Offer well-made, top-quality fine art."

WESTMORELAND ART NATIONALS

252 Twin Lakes Rd., Latrobe PA 15650-3554. (724)834-7474. **E-mail:** info@artsandheritage.com. **E-mail:** adam@artsandheritage.com. **Website:** www.artsandheritage.com. **Contact:** Adam Shaffer, executive director. Estab. 1975. Juried fine art exhibition & crafts show held annually in early July (see website for details). Juried art exhibition is indoors. Photography displays are indoors. Accepts photography, all handmade mediums. Juried by 2 jurors. Awards/prizes: $7,000 in prizes. Number of exhibitors: 190. Public attendance: 160,000. Free to public. Artists should apply by downloading application from website. Application fee: $25/craft show vendors; $35/art nationals exhibitors. Deadline for entry: early March. Space fee: $375-750. Exhibition space: 10×10 or 10×20 ft. For more information, artists should visit e-mail, call or visit website. Please direct questions to our executive director.

WHITEFISH ARTS FESTIVAL

P.O. Box 131, Whitefish MT 59937. (406)862-5875. **E-mail:** wafdirector@gmail.com. **Website:** www.whitefishartsfestival.org. Estab. 1979. High-quality art show held annually the 1st full weekend in July. Outdoors. Accepts photography, pottery, jewelry, sculpture, paintings, woodworking. Juried. Art must be original and handcrafted. Work is evaluated for creativity, quality and originality. Awards/prizes: Best of Show awarded $100 off booth fee for following year with no application fee. Number of exhibitors: 120. Public attendance: 3,000–5,000. Free to public. Entry fee: $29. Deadline: see website for details. Space fee: $215. Exhibition space: 10×10 ft. For more information, and to apply, artists should visit website.

TIPS Recommends "variety of price range, professional display, early application for special requests."

WHITE OAK CRAFTS FAIR

P.O. Box 111, Woodbury TN 37190. (615)563-2787 or (800)235-9073. **E-mail:** mary@artscenterofcc.com. **E-mail:** carol@artscenterofcc.com. **Website:** www.artscenterofcc.com. Estab. 1985. Arts & crafts show held annually in early September (see website for details) featuring the traditional and contemporary craft arts of Cannon County and Middle Tennessee. Outdoors. Accepts photography; all handmade crafts, traditional and contemporary. Must be handcrafted displaying excellence in concept and technique. Juried by committee. Send 3 slides or photos. Awards/prizes: more than $1,000 cash in merit awards. Number of exhibitors: 80. Public attendance: 6,000. Free to public. Applications can be downloaded from website. Deadline: early July. Space fee: $110 ($80 for Artisan member) for a 10×10 ft. under tent; $85 ($55 for Artisan member) for a 12×12 ft. outside. For more information, artists should e-mail, call or visit website.

WILD WIND FOLK ART & CRAFT FESTIVAL

P.O. Box 719, Long Lake NY 12847. (814)723-0707; (814)688-1516. **E-mail:** wildwindcraftshow@yahoo.com. **Website:** www.wildwindfestival.com. **Contact:** Liz Allen and Carol Jilk, directors. Estab. 1979. Traditional crafts show held annually the weekend after Labor Day at the Warren County Fairgrounds in Pittsfield, PA. Barn locations and outdoors. Accepts traditional country crafts, photography, paintings, pottery, jewelry, traditional crafts, prints, stained glass. Juried by promoters. Need 3 photos or slides of work plus 1 of booth, if available. Number of exhibitors: 160. Public attendance: 9,000. Artists should apply by visiting website and filling out application request, calling or sending a written request.

WINNEBAGOLAND ART FAIR

South Park Ave., Oshkosh WI 54902. **E-mail:** oshkoshfaa@gmail.com. Estab. 1957. Fine arts show held annually the second Sunday in June. Outdoors. Accepts painting, wood or stone, ceramics, metal sculpture, jewelry, glass, fabric, drawing, photography, wall hangings, basketry. Artwork must be the original work of the artist in concept and execution. Juried. Applicants send in photographs to be reviewed. Awards/prizes: monetary awards, purchase, merit and Best of Show awards. Number of exhibitors: 125-160. Public attendance: 5,000-8,000. Free to public. Deadline for entry: Previous exhibitors due mid-March; new exhibitors due late March. $25 late entry fee after March. Exhibition space: 20×20 ft. For more information, artists should e-mail or see website. The updated entry form will be added to the website in early January.

TIPS "Artists should send clear, uncluttered photos of their current work which they intend to show in their booth as well as a photo of their booth setup."

WYANDOTTE STREET ART FAIR

2624 Biddle Ave., Wyandotte MI 48192. (734)324-4502; (734)324-7283. **Fax:** (734)324-7296. **E-mail:** hthiede@wyan.org. **Website:** www.wyandottestreetartfair.org. **Contact:** Heather Thiede, special events coordinator. Estab. 1961. Fine arts & crafts show held annually 2nd week in July. Outdoors. Accepts photography, 2D mixed media, 3D mixed media, painting, pottery, basketry, sculpture, fiber, leather, digital cartoons, clothing, stitchery, metal, glass, wood, toys, prints, drawing. Juried. Awards/prizes: Best New Artist $500; Best Booth Design Award $500; Best of Show $1,200. Number of exhibitors: 300. Public attendance: 200,000. Free to the public. Artists may apply online or request application. Deadline for entry: early February. Application fee: $20 jury fee. Space fee: $250/single space; $475/double space. Exhibition space: 10×12 ft. Average gross sales/exhibitor: $2,000-$4,000. For more information, and to apply, artists should e-mail, visit website, call, send SASE.

CONTESTS

Whether you're a seasoned veteran or a newcomer still cutting your teeth, you should consider entering contests to see how your work compares to that of other photographers. The contests in this section range in scope from tiny juried county fairs to massive international competitions. When possible, we've included entry fees and other pertinent information in our limited space. Contact sponsors for entry forms and more details.

Once you receive rules and entry forms, pay particular attention to the sections describing rights. Some sponsors retain all rights to winning entries or even *submitted* images. Be wary of these. While you can benefit from the publicity and awards connected with winning prestigious competitions, you shouldn't unknowingly forfeit copyright. Granting limited rights for publicity is reasonable, but you should never assign rights of any kind without adequate financial compensation or a written agreement. If such terms are not stated in contest rules, ask sponsors for clarification.

If you're satisfied with the contest's copyright rules, check with contest officials to see what types of images won in previous years. By scrutinizing former winners, you might notice a trend in judging that could help when choosing your entries. If you can't view the images, ask what styles and subject matters have been popular.

440 GALLERY ANNUAL SMALL WORKS SHOW

440 Sixth Ave., Brooklyn NY 11215. (718)499-3844. **E-mail:** gallery440@verizon.net. **Website:** www.440gallery.com. **Contact:** Nancy Lunsford, director. Annual juried exhibition hosted by 440 Gallery, a cooperative run by member artists. An exhibition opportunity for U.S. artists whose work is selected by a different curator each year. All work, including frames and mounting materials must be less than 12 cinches in all directions. Open to all 2D and 3D media. Videos are considered if the monitor provided is also under 12 inches. Three prizes awarded with small cash awards: The Curator's Choice Award (decided by the juror), the 440 Award (decided by the members of the cooperative), the People's Choice Award (decided by "liking" images posted on our Facebook page). Deadline: early November. For more information about entering submissions, visit website in late September/early October, go to "Call for Entry" page.

440 GALLERY ANNUAL THEMED SHOW

440 Sixth Ave., Brooklyn NY 11215. (718)449-3844. **E-mail:** gallery440@verizon.net. **Website:** www.440gallery.com. **Contact:** Nancy Lunsford. National juried exhibition with a stated theme, and the subject varies from year to year. Past themes have been: animals, Brooklyn, text. An outside curator is invited to judge entries. All media and styles welcome. There is no size limitation, but extremely large work is unlikely to be chosen. Open to all U.S. artists ages 18 and over. Deadline: mid-May. Interested artists should see website for more information.

☻ AESTHETICA CREATIVE WORKS COMPETITION

P.O. Box 371, York YO23 1WL, United Kingdom. **E-mail:** pauline@aestheticamagazine.com. **E-mail:** submissions@aestheticamagazine.com. **Website:** www.aestheticamagazine.com. The Aesthetica Creative Works Competition represents the scope of creative activity today, and provides an opportunity for both new and established artists to nurture their reputations on an international scale. There are 3 categories: Artwork & Photography, Fiction, and Poetry. See guidelines online.

AFI FEST

2021 N. Western Ave., Los Angeles CA 90027. (323)856-7707; (323)856-7600. **E-mail:** programming@afi.com. **Website:** www.afi.com/afifest. **Contact:** Director of festivals. Cost: $50 shorts; $70 features. "LA's most prominent annual film festival." Various cash and product prizes are awarded. Open to filmmakers of all skill levels. Deadline: August (see website for details). Photographers should write, call or e-mail for more information.

ALEXIA COMPETITION

S.I. Newhouse School of Communications, 215 University Place, Syracuse NY 13244-2100. (315)443-7388. **E-mail:** trkenned@syr.edu. **Website:** www.alexiafoundation.org. **Contact:** Tom Kennedy. Annual contest. Provides financial ability for students to study photojournalism in England, and for professionals to produce a photo project promoting world peace and cultural understanding. Students win cash grants plus scholarships to study at workshops offered by Mediastorm: 1st Place and Momenta Workshops; 2nd Place and Award of Excellence—see website for updated description. Awards vary by year, $1,000-16,000. Photographers should e-mail or see website for more information.

ARC AWARDS

500 Executive Blvd., Ossining-on-Hudson NY 10562. (914)923-9400. **Fax:** (914)923-9484. **E-mail:** info@mercommawards.com. **Website:** www.mercommawards.com. Cost: $210-330. Annual contest. The International ARC Awards, celebrating its 27th year, is the "Academy Awards of Annual Reports," according to the financial media. It is the largest international competition honoring excellence in annual reports. The competition is open to corporations, small companies, government agencies, non-profit organizations, and associations, as well as agencies and individuals involved in producing annual reports. The purpose of the contest is to honor outstanding achievement in annual reports. Major category for photography of annual report covers and interiors. "Best of Show" receives a personalized trophy. Grand Award winners receive personalized award plaques. Gold, silver, bronze and finalists receive a personalized award certificate. Every entrant receives complete judge score sheets and comments. Photographers should see website, write, call or e-mail for more information.

ARTIST FELLOWSHIP GRANTS

Oregon Arts Commission, 775 Summer St. NE, Suite 200, Salem OR 97301-1280. (503)986-0082. **Fax:** (503)986-0260. **E-mail:** oregon.artscomm@state.

or.us; kat.bell@state.or.us. **Website:** www.oregon-artscommission.org. A highly competitive juried grant process offering $3,000 in cash awards to Oregon visual artists, awarded annually. Deadline: October. See website for more information.

ARTIST FELLOWSHIPS/VIRGINIA COMMISSION FOR THE ARTS

1001 E. Broad St., Suite 330, Richmond VA 23219. (804)225-3132. **Fax:** (804)225-4427. **E-mail:** arts@arts.virginia.gov; tiffany.ferreira@arts.virginia.gov. **Website:** www.arts.virginia.gov. The purpose of the Artist Fellowship program is to encourage significant development in the work of individual artists, to support the realization of specific artistic ideas, and to recognize the central contribution professional artists make to the creative environment of Virginia. Grant amounts: $5,000. Emerging and established artists are eligible. Open only to artists who are legal residents of Virginia and are at least 18 years of age. Applications are available in July. See Guidelines for Funding and application forms on the website or write for more information.

ARTISTS ALPINE HOLIDAY

Ouray County Arts Association, P.O. Box 167, Ouray CO 81427. (970)626-3212. **E-mail:** ouraybelle@yahoo.com. **Website:** www.ourayarts.org. **Contact:** DeAnn McDaniel, president. Cost: $25, includes up to 2 entries. Annual fine arts show. Juried. Cash awards for 1st, 2nd and 3rd Prizes in all categories total $7,200. Best of Show: $750; People's Choice Award: $50. Open to all skill levels. Photographers and artists should call or see website for more information.

ART OF PHOTOGRAPHY SHOW

1439 El Prado, San Diego CA 92101. (619)825-5575. **E-mail:** steven@artofphotographyshow.com. **Website:** www.artofphotographyshow.com. **Contact:** Steven Churchill, producer. Cost: $25 for 1st entry, $10 for each additional entry. Deadline: June. International exhibition of photographic art which occurs each fall at the San Diego Art Institute in San Diego's beautiful.Balboa Park. One of the distinguishing characteristics of this competition and exhibition is that the judge is always a highly acclaimed museum curator. "The Art of Photography Show is an established and critical force in the world of contemporary photography. The show provides tangible benefits to artists trying to break into the public eye. This well thought-out exhibition provides value to artists at every turn,

from first-rate viewing in the judging process, to exhibition and publication opportunities, well-attended exhibitions and lectures, photo industry connections, and monetary awards." This competition accepts for consideration images created via any form of photography (e.g., shot on film, shot digitally, unaltered shots, alternative process, mixed media, digital manipulations, montages, photograms, etc.), so long as part of the image is photographically created. Upload via the website (preferred) or e-mail to entries@artofphotographyshow.com or mail a CD. Award: 1st Place $2,000; 2nd Place $1,600; 3rd Place $1,200; 4th Place $800; Honorable Mention $400 (11 HM awards). Photographers should e-mail or visit the website for more information.

ASTRID AWARDS

500 Executive Blvd., Ossining-on-Hudson NY 10562. (914)923-9400. **Fax:** (914)923-9484. **E-mail:** info@mercommawards.com; contacts@mercommawards.com. **Website:** www.mercommawards.com. Annual contest. Cost: $330/classification; there is a multiple entry discount. The purpose of the contest is to honor outstanding achievement in design communications. Major category for photography, including books, brochures and publications. "Best of Show" receives a personalized trophy. Grand Award winners receive personalized award plaques. Gold, silver, bronze and finalists receive a personalized award certificate. Every entrant receives complete judge score sheets and comments. Deadline: late February (see website for details). Photographers should see website, write, call or e-mail for more information.

ATLANTA PHOTOJOURNALISM SEMINAR CONTEST

PMB 420, 5579-B Chamblee Dunwoody Rd., Dunwoody GA 30338. **E-mail:** contest@photojournalism.org. **E-mail:** info@photojournalism.org; erik@photojournalism.org. **Website:** www.photojournalism.org. **Contact:** Jeremy Brooks. Annual contest. This is an all-digital contest with several different categories (all related to news and photojournalism). Photographs may have been originally shot on film or with a digital camera, but the entries must be submitted in digital form. Photographs do not have to be published to qualify. No slide or print entries are accepted. Video frame grabs are not eligible. Rules are very specific. See website for official rules. Prizes start at $100, including $1,000 and Nikon camera gear for Best Port-

folio. Open to all skill levels. Deadline: November (see website for more details).

☉ BANFF MOUNTAIN PHOTOGRAPHY COMPETITION

P.O. Box 1020, 107 Tunnel Mountain Dr., Banff AB T1L 1H5, Canada. (403)762-6347. **Fax:** (403)762-6277. **E-mail:** BanffMountainPhotos@banffcentre.ca. **Website:** www.banffmountainfestivals.ca. **Contact:** Competition coordinator. Annual contest. Maximum of 7 images (digital) in photo essay format. The 2013 theme is mountain wilderness and wildlife. Entry fee: $10/essay. Entry form and regulations available on website. Approximately $5,000 in cash and prizes to be awarded. Open to all skill levels. Photographers should write, e-mail or fax for more information.

THE CENTER FOR FINE ART PHOTOGRAPHY

400 North College Ave., Fort Collins CO 80524. (970)224-1010. **E-mail:** contact@c4fap.org. **Website:** www.c4fap.org. Cost: typically $35 for first 3 entries; $10 for each additional entry. Competitions held 10 times/year. "The Center's competitions are designed to attract and exhibit quality fine art photography created by emerging and established artists working in traditional, digital and mixed-media photography. The themes for each exhibition vary greatly. The themes, rules, details and entry forms for each call for entry are posted on the Center's website." All accepted work is exhibited in the Center gallery. Additionally, the Center offers monetary awards, scholarships, solo exhibitions and other awards. Awards are stated with each call for entry. Open to all skill levels and to all domestic and international photographers working with digital or traditional photography or combinations of both. Photographers should see website for deadlines and more information.

COLLEGE PHOTOGRAPHER OF THE YEAR

101B Lee Hills Hall, University of Missouri, Columbia MO 65211-1370. (573)884-2188. **E-mail:** info@cpoy.org. **Website:** www.cpoy.org. **Contact:** Rita Reed, director. Annual contest to recognize excellent photography by currently enrolled college students. Portfolio winner receives a plaque, cash and camera products. Other category winners receive cash and camera products. Open to beginning and intermediate photographers. Photographers should see website for more information.

COLLEGE PHOTOGRAPHY CONTEST

Serbin Communications, 813 Reddick St., Santa Barbara CA 93103. (805)963-0439 or (800)876-6425. **Fax:** (805)965-0496. **E-mail:** admin@serbin.com. **E-mail:** julie@serbin.com. **Website:** www.pfmagazine.com. **Contact:** Julie Simpson, managing editor. Annual student contest; runs September through mid-November. Sponsored by *Photographer's Forum Magazine* and Nikon. Winners and finalists have their photos published in the hardcover book *The Best of College Photography*. See website for entry form.

COMMUNICATION ARTS ANNUAL PHOTOGRAPHY COMPETITION

110 Constitution Dr., Menlo Park CA 94025-1107. (650)326-6040. **E-mail:** competition@commarts.com. **Website:** www.commarts.com/competitions. Entries must be accompanied by a completed entry form. "Entries may originate from any country. Explanation of the function in English is very important to the judges. The work will be chosen on the basis of its creative excellence by a nationally representative jury of designers, art directors and photographers." Cost: $35 single entry/$70 series. Categories include advertising, books, editorial, for sale, institutional, multimedia, self-promotion, and unpublished. Deadline: late March (see website for details). See website for more information.

CREATIVE QUARTERLY CALL FOR ENTRIES

244 Fifth Ave., Suite F269, New York NY 10001-7604. (212)591-2566. **Fax:** (212)537-6201. **E-mail:** shows@cqjournal.com. **Website:** www.cqjournal.com. Entry fee: $10/entry. Quarterly contest. "Our publication is all about inspiration." Open to all art directors, graphic designers, photographers, illustrators and fine artists in all countries. Separate categories for professionals and students. We accept both commissioned and uncommissioned entries. Work is judged on the uniqueness of the image and how it best solves a marketing problem. Winners will be requested to submit an image of a person, place or thing that inspires their work. We will reprint these in the issue and select one for our cover image. *Creative Quarterly* has the rights to promote the work through our publications and website. Complete rights and copyright belong to the individual artist, designer or photographer who enters their work. Enter online or by sending a disc. Winners will be featured in the next issue of *Creative Quarterly* corresponding with the call

for entries and will be displayed in our online gallery. Runners-up will be displayed online only. Winners and runners-up both receive a complimentary copy of the publication. Open to all skill levels. Deadline: Last Friday of January, April, July and October. See website for more information.

CURATOR'S CHOICE AWARDS

Center, P.O. Box 2483, Santa Fe NM 87504. (505)984-8353. **E-mail:** programs@visitcenter.org. **Website:** www.visitcenter.org. **Contact:** Laura Pressley, executive director. Cost: $25/members $35/non-members. Annual contest. Center's Choice Awards are in three different categories with different jurors and prizes. "You can submit to one, two or all categories. Our jurors are some of the most important and influential people in the business. Photographers are invited to submit their most compelling images. Open to all skill levels." Prizes include exhibition and more. Photographers should see submissions guidelines at: visitcenter.org/competitions.

○ Center, the organization that sponsors this competition, was formerly known as The Santa Fe Center for Photography. "Get a second opinion on your edit and your artist statement. Be very clear in your concepts and execution. Look at the work of your contemporaries and work that preceded yours. If it resembles others it will be too 'familiar' and not as potent to the national and international community. So keep going, keep working, until it is ripe, until it is mainly your voice, your vision that others see.

DIRECT ART MAGAZINE PUBLICATION COMPETITION

123 Warren St., Hudson NY 12534. **E-mail:** slowart@aol.com; limnerentry@aol.com. **Website:** www.slowart.com. **Contact:** Tim Slowinski, director. Cost: $35. Annual contest. National magazine publication of new and emerging art in all medias. Cover and feature article awards. Open to all skill levels. Send SASE or see website for more information. SlowArt Productions presents the annual group thematic exhibition. Open to all artists, national and international, working in all media. All forms of art are eligible. *Entrants must be 18 years of age or older to apply.* 96 inch maximum for wall hung work, 72 inch for free-standing sculpture.

THE EDITOR'S CHOICE AWARDS

Center, P.O. Box 2483, Santa Fe NM 87504. (505)984-8353. **E-mail:** programs@visitcenter.org. **Website:** www.visitcenter.org. Annual contest. This award recognizes outstanding photographers working in all processes and subject matter. Open to all skill levels. Awards/prizes: 1st, 2nd, 3rd Prize and Honorable Mention awarded; 1st Prize includes exhibition at Center space, $125 gift certificate for Singer Editions printing, publication in *Fraction* magazine and online exhibition at VisitCenter.org; see website for listing of prizes. Photographers should see website for more information.

○ Center, the organization that sponsors this competition, was formerly known as The Santa Fe Center for Photography.

⊕ ○ ENERGY GALLERY ART CALL

E-mail: info@energygallery.com. **Website:** www.energygallery.com. Cost: $35 for 5 images; additional images $10/each. Energy Gallery is an arts organization operated by professional artists, art instructors and curators for promoting emerging and established artists globally. Energy Gallery is a virtual gallery as well as a physical gallery that organizes exhibitions at art galleries, trade shows and public institutions. A jury selects artworks for the online exhibition at Energy Gallery's website for a period of 3 months and archived in Energy Gallery's website permanently. Selected artists also qualify to participate in Energy Gallery's annual exhibit. Photographers should visit website for submission form and more information. Deadline: late August.

⊕ EXHIBITIONS WITHOUT WALLS FOR PHOTOGRAPHERS AND DIGITAL ARTISTS

975 SE Wendy Ave., Gresham OR 97080. (503)799-7849. **Fax:** (503)328-8805. **E-mail:** ewedman@exhibitionswithoutwalls.com. **Website:** www.exhibitionswithoutwalls.com. **Contact:** Ed Wedman, co-founder. Cost: $25 for up to 5 images, each additional image up to 10 is an additional charge of $4. Contest is held quarterly. Online international juried competitions for photographers and digital artists. Prizes vary, but a minimum of $900 in cash awards and additional prizes. Open to all skill levels. Deadline: 30 days after submissions open. Contestants should see website for more information.

FIRELANDS ASSOCIATION FOR THE VISUAL ARTS

39 S. Main St., Oberlin OH 44074. (440)774-7158. **Fax:** (440)775-1107. **E-mail:** favagallery@oberlin.net. **Website:** www.favagallery.org. Cost: $15/photographer; $12 for FAVA members. Biennial juried photography contest (odd-numbered years) for residents of OH, KY, IN, MI, PA and WV. Both traditional and experimental techniques welcome. Photographers may submit up to 3 works completed in the last 3 years. Annual entry deadline: March-April (date varies, see website for details). Photographers should call, e-mail or see website for entry form and more details.

THE GALLERIST'S CHOICE AWARDS

P.O. Box 2483, Santa Fe NM 87504. (505)984-8353. **E-mail:** programs@visitcenter.org. **Website:** www.visitcenter.org. Recognizes outstanding photographers through the dealer's perspective. Cost: $25/members $35/non-members. Annual contest. Photographers are invited to submit their most compelling images. Open to all skill levels. Prizes include exhibition and more. Deadline: January (see website for details). Photographers should see website for more information.

⚲ Center, the organization that sponsors this competition, was formerly known as The Santa Fe Center for Photography.

🌐 HUMANITY PHOTO AWARD (HPA)

World Folklore Photographer's Association, Room 315, North Building, No. 1 Liupukang Street, Beijing Xicheng District 100120, China. (86)(10)62252175. **Fax:** (86)(10)62252175. **E-mail:** hpa@worldfpa.org. **Website:** www.worldfpa.org. **Contact:** Organizing Committee HPA. Cost: free. Biennial contest. Open to all skill levels. See website for more information and entry forms.

INFOCUS JURIED EXHIBITION

Palm Beach Photographic Centre, 415 Clematis St., West Palm Beach FL 33401. (561)253-2600. **E-mail:** info@workshop.org. **Website:** www.workshop.org. **Contact:** Fatima NeJame, CEO. Cost: $20/image, up to 5 images. Annual photography contest. Awards: Best of Show: $950. Two merit awards: free tuition for a Fotofusion passport or a master photography workshop of your choice. Open to members of the Palm Beach Photographic Center. Interested parties can obtain an individual membership for $95. The Centre invites photographers working in all mediums and styles to participate. Experimental and mixed tech-niques are welcome. Photographers should call or visit website for more information.

LAKE CHAMPLAIN MARITIME MUSEUM'S ANNUAL JURIED PHOTOGRAPHY EXHIBIT

4472 Basin Harbor Rd., Vergennes VT 05491. (802)475-2022. **E-mail:** eloiseb@lcmm.org. **Website:** www.lcmm.org. **Contact:** Eloise Beil. Annual exhibition, Lake Champlain Through the Lens, images of Lake Champlain. "Amateur and professional photographers are invited to submit framed prints in color or b&w. Professional photographers will judge and comment on the work." Additional prints of work accepted for exhibition can be placed on consignment at museum store. Call for entries begins in June, photograph delivery in August, on view September and October. Photographers should call, e-mail, or visit website for registration form.

LAKE SUPERIOR MAGAZINE PHOTO CONTEST

P.O. Box 16417, Duluth MN 55816-0417. (888)244-5253; (218)722-5002. **Fax:** (218)722-4096. **E-mail:** lsmphotosubmission@lakesuperior.com; edit@lakesuperior.com; kon@lakesuperior.com. **Website:** www.lakesuperior.com. **Contact:** Konnie LeMay, editor. Annual contest. Photos must be taken in the Lake Superior region and should be labeled for categories: lake/landscapes, nature, people/humor. Accepts up to 10 b&w and color images—must be digital. Images can be submitted as prints with accompanying CD or online. Grand Prize: $200 prize package, plus a 1-year subscription to *Lake Superior Magazine* and a Lake Superior wall calendar. Other prizes include subscriptions and calendars; all prize winners, including honorable mentions and finalists, receive a Certificate of Honor. Although there is no cost to enter, entries will not be returned without a SASE. No e-mailed submissions accepted. Photographers should write, e-mail or see website for more information.

⟳ LARSON GALLERY JURIED BIENNUAL PHOTOGRAPHY EXHIBITION

Yakima Valley Community College, P.O. Box 22520, Yakima WA 98907. (509)574-4875. **E-mail:** gallery@yvcc.edu. **Website:** www.larsongallery.org. **Contact:** Denise Olsen, assistant gallery director. Cost: $20/entry (limit 4 entries). National juried competition. Awards: Approximately $3,000 in prize money. Held odd years in April. First jurying held in February.

Photographers should write, fax, e-mail or visit the website for prospectus.

LOS ANGELES CENTER FOR DIGITAL JURIED COMPETITION

102 W. Fifth St., Los Angeles CA 90013. (323)646-9427. **E-mail:** lacda@lacda.com. **Website:** www.lacda.com. LACDA is dedicated to the propagation of all forms of digital art, supporting local, international, emerging and established artists in our gallery. Entry fee: $30. Its juried competition is open to digital artists around the world. It also sponsors other competitions throughout the year. Visit website, e-mail, call for more information, including deadline dates.

LOVE UNLIMITED FILM FESTIVAL & ART EXHIBITION

100 Cooper Point Rd., Suite 140-136, Olympia WA 98502. (503)482-8568. **Fax:** (888)LOVE-304 (568-3304). **E-mail:** volunteers@loveanddiversity.org. **Website:** www.loveanddiversity.org. **Contact:** Submissions administrator. Accepts art (ceramics, drawings, fiber, functional, furniture, jewelry, metal, painting, printmaking, digital or graphics, mixed media 2D, mixed media 3D, sculpture, watercolor, wood, other or beyond categorization (specify), photography, music, writing, photos and all types of designs, as well as film and scripts. Accepts poetry, hip-hop, spoken word and zine excerpts, autobiography/memoir, children's, fiction, horror, humor, journalism, mystery, nature, novels, short stories, non-fiction, poetry, romance, science fiction/fantasy, screenwriting, travel, young adult and other topic areas. We accept writing in all these topic areas provided these topic areas are directly, indirectly, literally or symbolically related to love. Awards: over $30,000 in cash and prizes and 120 given out during a red carpet gala event in Los Angeles and in Austin TX. Photos and videos of past events are online. Open to all skill levels. Deadlines: October for art, November for all other categories. See website for more information.

MERCURY AWARDS

500 Executive Blvd., Ossining-on-Hudson NY 10562. (914)923-9400. **Fax:** (914)923-9484. **E-mail:** info@mercommawards.com. **Website:** www.mercommawards.com. **Contact:** Ms. Reni L. Witt, president. Cost: $190-325/entry (depending on category). Annual contest. The purpose of the contest is to honor outstanding achievement in public relations and corporate communications. Major category for photography, including ads, brochures, magazines, etc. "Best of Show" receives a personalized trophy. Grand Award winners receive award plaques (personalized). Gold, silver, bronze and finalists receive a personalized award certificate. All nominators receive complete judge score sheets and evaluation comments. Deadline: mid-November. Photographers should write, call or e-mail for more information.

THE MOBIUS AWARDS FOR ADVERTISING

713 S. Pacific Coast Hwy., Suite A, Redondo Beach CA 90277-4233. (310)540-0959. **Fax:** (310)316-8905. **E-mail:** mobiusinfo@mobiusawards.com. **Website:** www.mobiusawards.com. **Contact:** Kristen Gluckman, exec. director. Annual international awards competition founded in 1971 for TV, cinema/in-flight and radio commercials, print, outdoor, new media, direct, logo/trademark, online, mixed media campaigns and package design. Student and spec work welcome. Deadline: October 1. Late entries accepted. "Entries are judged by an international jury on their effectiveness and creativity. Mobius Awards reflects the most current trends in the advertising industry by updating the competition regularly, such as adding new media types and categories. We are dedicated to consistently providing a fair competition with integrity."

MYRON THE CAMERA BUG

Educational Dept., 2106 Hoffnagle St., Philadelphia PA 19152-2409. **E-mail:** cambug8480@aol.com. **Website:** www.shutterbugstv.com. **Contact:** Len Friedman, director. Open to all photography students and enthusiasts. Photographers should e-mail for details or questions.

NEW YORK STATE FAIR PHOTOGRAPHY COMPETITION AND SHOW

581 State Fair Blvd., Syracuse NY 13209. (315)487-7711, ext. 1337. **Website:** www.nysfair.org/competitions. You may enter by downloading and mailing in the entry form, or directly online (any competition marked "N/A" is not available for online entry). All works must be received in person at the entry department office at the State Fairgrounds by 4:30 p.m. or online by 12:00 midnight on the specified competition deadline date. See website for complete details, and to enter.

THE GORDON PARKS PHOTOGRAPHY COMPETITION

Fort Scott Community College, 2108 S. Horton, Fort Scott KS 66701-3140. (620)223-2700. **Fax:** (620)223-6530. **E-mail:** gordonparkscenter@fortscott.edu. **Website:** www.gordonparkscenter.org. **Contact:** Jill Warford. The annual Gordon Parks Photography Competition is in tribute to Fort Scott KS native Gordon Parks. This competition is open to anyone. Photographs submitted should have been taken within the last 5 years. "I used my camera as a weapon against all I disliked about America—poverty, racism, discrimination," Parks said. Each photographer may submit up to 4 photographs which will be judged as an individual entry. Each photo entry is $15. Awards: $350 1st Place, $200 2nd Place, $100 3rd Place will be awarded and up to 3 Honorable Mentions will receive $50 each. See complete details and access entry forms online. Submission deadline: early August.

PERKINS CENTER FOR THE ARTS JURIED PHOTOGRAPHY EXHIBITION

395 Kings Hwy., Moorestown NJ 08057. (856)235-6488 or (800)387-5226. **Fax:** (856)235-6624. **E-mail:** create@perkinscenter.org. **Website:** www.perkins center.org. Cost: $10/entry; up to 3 entries. Regional juried photography exhibition. Works from the exhibition are considered for inclusion in the permanent collection of the Philadelphia Museum of Art and the Woodmere Art Museum. Past jurors include Merry Foresta, former curator of photography at the Smithsonian American Art Museum; Katherine Ware, curator of photographs at the Philadelphia Museum of Art; and photographers Emmett Gowin, Ruth Thorne-Thomsen, Matthew Pillsbury, and Vik Muniz. All work must be framed with wiring in back and hand-delivered to Perkins Center. Prospectus must be downloaded from the Perkins site. Photographers should call, e-mail or see website for more information.

PHOTOGRAPHY NOW

Center for Photography at Woodstock, 59 Tinker St., Woodstock NY 12498. (845)679-9957. **Fax:** (845)679-6337. **E-mail:** info@cpw.org. **Website:** www.cpw.org. **Contact:** Ariel Shanberg, executive director. Annual contest for exhibitions. Juried annually by renowned photographers, critics, museum and gallery curators. Deadlines vary. General submission is ongoing. Photographers must call or write for guidelines.

THE PHOTO REVIEW ANNUAL PHOTOGRAPHY COMPETITION

140 E. Richardson Ave., Suite 301, Langhorne PA 19047. (215)891-0214. **E-mail:** info@photoreview.org. **Website:** www.photoreview.org. **Contact:** Stephen Perloff, editor. Cost: $35 for up to 3 images; $8 each for up to 3 additional images. International annual contest. All types of photographs are eligible—b&w, color, nonsilver, computer-manipulated, etc. Submit images to smarterentry.com or prints unmatted, unframed, 16x20 or smaller. All entries must be labeled. Awards include an Olympus Pen camera, SilverFast HDR Studio digital camera, RAW conversion software from LaserSoft Imaging ($499), a $250 gift certificate from Calumet Photographic, a 24×50 roll of Museo Silver Rag ($240), a 20×24 silver gelatin fiber print from Digital Silver Imaging ($215), camera bags from Lowepro, and $250 in cash prizes. All winners reproduced in the competition issue of *Photo Review* magazine and prizewinners exhibited at photography gallery of the University of Arts/Philadelphia. Open to all skill levels. Deadline: May 15. Photographers should see www.photoreview.org for more information.

PHOTOSPIVA

222 W. Third St., Joplin MO 64801. (417)623-0183. **Fax:** (417)623-3805. **E-mail:** spiva@spivaarts.org. **Website:** www.spivaarts.org; www.photospiva.org. **Contact:** Jo Mueller, director. Annual national fine art photography competition. Awards: over $2,000 cash. Open to all photographers in the U.S. and its territories; any photographic process welcome. Enter online. See website for updates on deadlines and exhibition dates.

PICTURES OF THE YEAR INTERNATIONAL

University of Missouri, 315 Reynolds Journalism Institute, Columbia MO 65211. (573)884-7351; (573)884-2188. **E-mail:** info@poyi.org. **Website:** www.poyi.org. **Contact:** Rick Shaw. Cost: $50/entrant. Annual contest to reward and recognize excellence in photojournalism, sponsored by the Missouri School of Journalism and the Donald W. Reynolds Journalism Institute. Over $20,000 in cash and product awards. Open to all skill levels. January deadline. Photographers should write, call, e-mail or see website for more information.

The Missouri School of Journalism also sponsors College Photographer of the Year. See website for details.

PROFESSIONAL WOMEN PHOTOGRAPHERS INTERNATIONAL WOMEN'S CALL FOR ENTRY

119 W. 72nd St., #223, New York NY 10023. (212)410-4388. **E-mail:** open.calls@pwponline.org. **Website:** www.pwponline.org. **Contact:** Terry Berenson, development director. Contest held annually. "Professional Women Photographers (PWP) helps fulfill its mission of advancing women in photography by hosting international Calls for Entry open to all women photographers around the world." Awards: "1st Prize: One photographer will receive $600 and her selected image will appear in the Spring/Summer issue of *Imprints* magazine. Her image will be exhibited in the Soho Photo Gallery show and the online exhibition. 2nd Prize: One photographer will receive $500 and her image will appear in *Imprints* Spring/Summer issue. Her image will be exhibited in the SohoPhoto Gallery show and the online exhibition. 3rd Prize: One photographer will receive $400 and her image will appear in the Spring/Summer issue of *Imprints*. Her image will be exhibited in the SohoPhoto Gallery show and the online exhibition." Deadlines vary; see website for details.

THE PROJECT COMPETITION

P.O. Box 2483, Santa Fe NM 87504. (505)984-8353. **Website:** www.visitcenter.org. Annual contest. The Project Competition honors committed photographers working on documentary projects and fine-art series. Three jurors reach a consensus on the First Prize and 10-25 Honorable Mentions. Each individual juror also selects a project to receive 1 of the 3 Juror's Choice Awards. Prizes include $5,000, a 2-person exhibition and reception during Review Santa Fe, a year-long Photographer's Showcase at Photoeve.com, publication in *Fraction* magazine, workshop tuition vouchers, $250 gift certificate to Blurb books and an online exhibition at VisitCenter.org. Photographers should see website for more information.

RHODE ISLAND STATE COUNCIL ON THE ARTS FELLOWSHIPS

One Capitol Hill, 3rd Floor, Providence RI 02908. (401)222-3880. **Fax:** (401)222-3018. **Website:** www.arts.ri.gov/grants/guidelines/fellow.php. Rhode Island residents only. Cost: free. Annual contest "to encourage the creative development of Rhode Island artists by enabling them to set aside time to pursue their work and achieve specific career goals." Awards $5,000 fellowship; $1,000 merit award. Open to advanced photographers. Deadline: April 1. Photographers should go to www.arts.ri.gov/grants/guidelines/fellow.php for more information.

THE MANUEL RIVERA-ORTIZ FOUNDATION FOR DOCUMENTARY PHOTOGRAPHY & FILM

1110 Park Ave., Rochester NY 14610-1729. (917)720-5769. **Fax:** (585)256-6462. **E-mail:** submissions@mrofoundation.org. **Website:** www.mrofoundation.org. **Contact:** Competition coordinator, annual contest. Our mission is to support underrepresented photographers in communities throughout the developing and developed world. We encourage emerging and established photographers and filmmakers in the fields of Photojournalism/Photo Reportage and Documentary Film to submit their work on topics such as the plight of the poor, the forgotten, and the disenfranchised. Each year, shortlisted entries in two categories (selected from international submissions) in the genres of "Documentary-Still Photography" and "Documentary Short-Short Film," will compete for a grant in photography and a prize in film of $5,000 each. The grant is to complete a documentary photo project, the prize is for an already completed "Short-Short" documentary film. Call is open to all skill levels. For more information, please see our website. There are no entry fees.

SAN DIEGO COUNTY FAIR ANNUAL EXHIBITION OF PHOTOGRAPHY

2260 Jimmy Durante Blvd., Del Mar CA 92014. (858)792-4207. **E-mail:** entry@sdfair.com. **E-mail:** photo@sdfair.com. **Website:** www.sdfair.com. **Contact:** Entry office. Sponsor: San Diego County Fair (22nd District Agricultural Association). Annual event for still photos/prints. This is a juried competition open to individual photographers. Entry information is posted on the website as it becomes available in February and March. Pre-registration deadline: April/May. Access the dates and specifications for entry on website. Entry form can be submitted online.

SPRING PHOTOGRAPHY CONTEST

Serbin Communications, 813 Reddick St., Santa Barbara CA 93103. (805)963-0439 or (800)876-6425. **Fax:** (805)965-0496. **E-mail:** admin@serbin.com. **Website:** www.pfmagazine.com. Annual amateur contest, runs January thru mid-May. Sponsored by *Photographer's Forum Magazine*. Winners and finalists have their

photos published in the hardcover book, *Best of Photography*. Entry fee: $4.95-5.95 per photo. See website for entry form.

TAYLOR COUNTY PHOTOGRAPHY CLUB MEMORIAL DAY CONTEST

P.O. Box 613, Grafton WV 26354-0613. (304)265-5405. **E-mail:** hsw123@comcast.net. **Website:** tcphotoclub. webplus.net. **Contact:** Harry S. White Jr., club secretary. Cost: $4/print (maximum of 10). Annual juried contest (nationally judged) held in observance of Memorial Day in Grafton WV. Color and b&w, all subject matter except nudes. All prints must be mounted or matted, with a minimum overall size of 8×10 and maximum overall size of 16×20. No framed prints or slides. No signed prints or mats. All prints must be identified on the back as follows: name, address, phone number, title, and entry number of print (e.g., 1 of 6). Entries need to have hangers on the back for display purposes. All entries must be delivered in a reusable container. Entrant's name, address and number of prints must appear on the outside of the container. Open to amateur photographers only. Six award categories. E-mail hsw123@comcast.net to receive an entry form.

TEXAS PHOTOGRAPHIC SOCIETY ANNUAL MEMBERS' ONLY SHOW

6338 N. New Braunfels #174, San Antonio TX 78209. **Website:** www.texasphoto.org. Photographers should see website for more information. Cost: $25 for 5 images, plus $5 for each image over 5, and membership fee if joining Texas Photographic Society. You must be a member to enter. TPS has a membership of 1,300 from 48 states and 12 countries. Contest held annually. Cash awards: 1st Place $500; 2nd Place $300; 3rd Place $200; 5 Honorable Mentions at $100 each. The Members' Only show opens in different cities with a juror from that city and has opened in Austin, Beaumont, Longview, Lubbock, El Paso, Dallas, Galveston, San Marcos, San Antonio; and San Francisco CA. Open to all skill levels. See website or call Clarke for more information.

TEXAS PHOTOGRAPHIC SOCIETY NATIONAL COMPETITION

6338 N. New Braunfels #174, San Antonio TX 78209. (210)824-4123. **E-mail:** clarke@texasphoto.org. **Website:** www.texasphoto.org. Cost: $25 for 5 images, plus $5 for each image over 5, and membership fee if joining Texas Photographic Society. You do not have to be a member to enter. See website or call for information on membership fees. TPS has a membership of 1,300 from 49 states and 12 countries. Contest held annually. Cash awards: 1st Place $750; 2nd Place $350; 3rd Place $200; 5 Honorable Mentions at $100 each. The exhibition will open in Austin TX and be exhibited at galleries in Odessa, Abilene, and San Antonio. Open to all skill levels. See website or call for more information.

☻ ◐ UNLIMITED EDITIONS INTERNATIONAL JURIED PHOTOGRAPHY COMPETITIONS

198 Brittany Place, Dr., Suite V, Hendersonville NC 28792. (828)489-9609. **E-mail:** gregoryleng@aol.com; ultdeditionsIntl@aol.com. **Contact:** Gregory Hugh Leng, president/owner. Sponsors juried photography competitions several times yearly offering cash, award certificates and prizes. Photography accepted from amateurs and professionals. Open to all skill levels and ages. Prizes awarded in different categories or divisions such as commercial, portraiture, journalism, landscape, digital imaging, and retouching. We accept formats in print film, transparencies and digital images. B&w, color, and digital imaging CDs or DVDs may be submitted for consideration. Prints and large transparencies may be in mats, no frames. All entries must be delivered in a reusable container with prepaid postage to insure photography is returned. Unlimited Editions International also offers the unique opportunity to purchase photography from those photographers who wish to sell their work. All images submitted in competition remain the property of the photographer/entrants unless an offer to purchase their work is accepted by the photographer. All photographers must send SASE (with $1.44 postage) for entry forms, contest dates, and detailed information on how to participate in our International juried photography competitions.

YOUR BEST SHOT

(212)779-5468. **E-mail:** yourbestshot@bonniercorp. com. **Website:** www.popphoto.com. Monthly contest. "Every month, we choose 3 images submitted by our readers to feature in the pages of *Popular Photography*. There are no category restrictions, we just want to see your most creative and well-done work. A gallery of the judges' picks will appear online and the overall winner will be revealed in an upcoming issue of the magazine." Awards/prizes: 1st Place $300, 2nd Place

$200, 3rd Place $100. See website for complete details
and submission deadlines.

PHOTO REPRESENTATIVES

//

Many photographers are good at promoting themselves and seeking out new clients, and they actually enjoy that part of the business. Other photographers are not comfortable promoting themselves and would rather dedicate their time and energy solely to producing their photographs. Regardless of which camp you're in, you may need a photo rep.

Finding the rep who is right for you is vitally important. Think of your relationship with a rep as a partnership. Your goals should mesh. Treat your search for a rep much as you would your search for a client. Try to understand the rep's business, who they already represent, etc., before you approach them. Show you've done your homework.

When you sign with a photo rep, you basically hire someone to get your portfolio in front of art directors, make cold calls in search of new clients, and develop promotional ideas to market your talents. The main goal is to find assignment work for you with corporations, advertising firms, or design studios. And, unlike stock agencies or galleries, a photo rep is interested in marketing your talents rather than your images.

Most reps charge a 20- to 30-percent commission. They handle more than one photographer at a time, usually making certain that each shooter specializes in a different area. For example, a rep may have contracts to promote three different photographers—one who handles product shots, another who shoots interiors, and a third who photographs food.

DO YOU NEED A REP?

Before you decide to seek out a photo representative, consider these questions:

- Do you already have enough work, but want to expand your client base?
- Are you motivated to maximize your profits? Remember that a rep is interested in working with photographers who can do what is necessary to expand their businesses.

- Do you have a tightly edited portfolio with pieces showing the kind of work you want to do?
- Are you willing to do what it takes to help the rep promote you, including having a budget to help pay for self-promotional materials?
- Do you have a clear idea of where you want your career to go, but need assistance in getting there?
- Do you have a specialty or a unique style that makes you stand out?

If you answered yes to most of these questions, perhaps you would profit from the expertise of a rep. If you feel you are not ready for a rep or that you don't need one, but you still want some help, you might consider a consultation with an expert in marketing and/or self-promotion.

As you search for a rep, there are numerous points to consider. First, how established is the rep you plan to approach? Established reps have an edge over newcomers in that they know the territory. They've built up contacts in ad agencies, magazines, and elsewhere. This is essential since most art directors and picture editors do not stay in their positions for long periods of time. Therefore, established reps will have an easier time helping you penetrate new markets.

If you decide to go with a new rep, consider paying an advance against commission in order to help the rep financially during an equitable trial period. Usually it takes a year to see returns on portfolio reviews and other marketing efforts, and a rep who is relying on income from sales might go hungry if he doesn't have a base income from which to live.

Whatever you agree upon, always have a written contract. Handshake deals won't cut it. You must know the tasks that each of you is required to complete, and having your roles discussed in a contract will guarantee there are no misunderstandings. For example, spell out in your contract what happens with clients that you had before hiring the rep. Most photographers refuse to pay commissions for these "house" accounts, unless the rep handles them completely and continues to bring in new clients.

Also, it's likely that some costs, such as promotional fees, will be shared. For example, photographers often pay 75 percent of any advertising fees (such as sourcebook ads and direct mail pieces).

ACHARD & ASSOCIATES

611 Broadway, Suite 803, New York NY 10009. (212)614-0962. **Fax:** (212)254-9751. **E-mail:** philippe@p-achard.com. **Website:** www.p-achard.com; www.achardimages.com. **Contact:** Philippe Achard, art director. Estab. 1990. Commercial photography representative. Represents 12 photographers. Agency specializes in fashion, portraiture, interiors and still life. Markets include advertising agencies, editorial/magazines, direct mail firms, corporate/client direct, design firms, publishing/books.

HANDLES Photography only.

TERMS Rep receives 25% commission. Exclusive area representation required. For promotional purposes, talent must provide images and money. Advertises in *Le Book*.

HOW TO CONTACT Send portfolio. Responds only if interested within 1 week. Portfolios may be dropped off every day. To show portfolio, photographer should follow up with a call.

TIPS Finds new talent through recommendations from other artists, magazines. "Be original."

ROBERT BACALL REPRESENTATIVES INC.

4 Springwood Dr., Princeton Junction NJ 08550. (917)763-6554. **E-mail:** rob@bacall.com. **Website:** www.bacall.com. **Contact:** Robert Bacall. Estab. 1988. "We represent commercial photographers, CGI and motion content providers for both print and video animation needs." Agency specializes in digital imaging, healthcare, food, still life, fashion, beauty, kids, corporate, environmental, portrait, lifestyle, location, landscape. Markets include advertising agencies, corporations/clients direct, design firms, editorial/magazines, publishing/books, sales/promotion firms.

TERMS Rep receives 30-35% commission. Exclusive area representation required. For promotional purposes, talent must provide portfolios, cases, tearsheets, prints, etc. Advertises in *Found Folios*, *Workbook*, *Le Book*, *Alternative Pick*, *PDN-Photoserve*, *At-Edge* and all of their respective websites. Bacall reps can also be found on Facebook, Twitter and LinkedIn.

HOW TO CONTACT Send query letter/e-mail, direct mail flier/brochure. Responds only if interested. After initial contact, drop off or mail materials for review.

TIPS "Seek representation when you feel your portfolio is unique and can bring in new business." Also offering consulting services to photographers that are not represented but are looking to improve their business potential.

MARIANNE CAMPBELL ASSOCIATES

136 Bella Vista Ave., Belvedere CA 94920. (415)433-0353. **E-mail:** marianne@mariannecampbell.com; quinci@mariannecampbell.com. **Website:** www.mariannecampbell.com. **Contact:** Marianne Campbell or Quinci Kelly (149 Madison Ave.,#1102, New York NY 10016). Estab. 1989. Commercial photography representative. Member of APA, SPAR, Western Art Directors Club. Represents 7 photographers. Markets include advertising agencies, corporations/clients direct, design firms, editorial/magazines.

HANDLES Photography.

TERMS Negotiated individually with each photographer.

HOW TO CONTACT Send printed samples of work. Responds in 2 weeks, only if interested.

CASEY

20 W. 22nd St., #1605, New York NY 10010. (212)858-3757; (212)929-3757. **E-mail:** info@wearecasey.com. **Website:** www.wearecasey.com. Represents photographers. Agency specializes in representing commercial photographers. Markets include advertising agencies, corporate/client direct, design firms, editorial/magazines, direct mail firms.

HANDLES Photography.

HOW TO CONTACT Send brochure, promo cards. Responds only if interested. Portfolios may be dropped off Monday through Friday. To show portfolio, photographer should follow up with call. Rep will contact photographer for portfolio review if interested.

TIPS Finds new talent through submission, recommendations from other artists.

RANDY COLE REPRESENTS, LLC

115 W. 30th St., Suite 404, New York NY 10001. (212)760-1212. **Fax:** (212)760-1199. **E-mail:** randy@randycole.com. **Website:** www.randycole.com. Estab. 1989. Commercial photography, video, and CGI representative. Member of SPAR. Represents 10 talents. Staff includes an assistant. Markets include advertising agencies, corporate clients, design firms, magazine, newspaper and book publishers as well as entertainment and music companies.

HANDLES Photography.

TERMS Agent receives commission on the creative fees, dependent upon specific negotiation. Adver-

tises in *At Edge*, *Archive* and *Le Book* as well as online creative directories. Social media includes Facebook, LinkedIn, and Twitter. Randy Cole Represents is certified by Women's Business Enterprise National Council as a woman owned, operated, and controlled business meeting the criteria of diversity supplies status.

HOW TO CONTACT Send e-mail or promo piece and follow up with call. Portfolios may be dropped off; set up appointment.

TIPS Finds new talent through submissions and referrals.

MICHAEL GINSBURG & ASSOCIATES, INC.

345 E. 94th St. #10F, New York NY 10128. (212)369-3594. **E-mail:** mg@michaelginsburg.com. **Website:** www.michaelginsburg.com. **Contact:** Michael Ginsburg. Estab. 1978. Commercial photography representative. Represents 9 photographers. Agency specializes in advertising and editorial photographers. Markets include advertising agencies, corporations/clients direct, design firms, editorial/magazines, sales/promotion firms.

HANDLES Photography.

TERMS Rep receives 30% commission. Charges for messenger costs, FedEx expenses. Exclusive area representation required. Advertising costs are paid 100% by talent. For promotional purposes, talent must provide a minimum of 5 portfolios—direct mail pieces 2 times per year—and at least 1 sourcebook per year. Advertises in *Workbook*, source books and online source books.

HOW TO CONTACT Send query letter, direct mail flier/brochure, or e-mail. Responds only if interested within 2 weeks. After initial contact, call for appointment to show portfolio of tearsheets, slides, photographs.

TIPS Obtains new talent through personal referrals and solicitation.

CAROL GUENZI AGENTS, INC.

865 Delaware St., Denver CO 80204. (303)820-2599; (800)417-5120. **E-mail:** carol@artagent.com; art@artagent.com. **Website:** www.artagent.com. **Contact:** Carol Guenzi, president. Estab. 1984. Commercial illustration, photography, new media, film/animation representative. Member of Art Directors Club of Denver, AIGA and ASMP. Represents 30 illustrators, 8 photographers, 6 computer multimedia designers, 3 copywriters, 2 film/video production companies.

Agency specializes in a "worldwide selection of talent in all areas of visual communications." Markets include advertising agencies, corporations/clients direct, design firms, editorial/magazine, paper products/greeting cards, sales/promotions firms.

HANDLES Illustration, photography, new media, film and animation. Looking for unique styles and applications and digital imaging.

TERMS Rep receives 25-30% commission. Exclusive area representation required. Advertising costs are split: 70-75% paid by talent; 25-30% paid by representative. For promotional purposes, talent must provide promotional material after 6 months, some restrictions on portfolios." Advertises in *Directory of Illustration* and *Workbook*.

HOW TO CONTACT E-mail JPEGs or send direct mail piece, tearsheets. Responds in 2-3 weeks, only if interested. After initial contact, call or e-mail for appointment or to drop off or ship materials for review. Portfolio should include tearsheets, prints, samples and a list of current clients.

TIPS Obtains new talent through solicitation, art directors' referrals and active pursuit by individual. "Show your strongest style and have at least 12 samples of that style before introducing all your capabilities. Be prepared to add additional work to your portfolio to help round out your style. We do a large percentage of computer manipulation and accessing on network. All our portfolios are both electronic and prints."

TRICIA JOYCE, INC.

79 Chambers St., New York NY 10007. (212)962-0728. **E-mail:** jen@triciajoyce.com. **Website:** www.triciajoyce.com. **Contact:** Tricia Joyce; Jess Griffin; Kimberley Latza; Jen Ng. Estab. 1988. Commercial photography representative. Represents photographers and stylists, art directors and scenic designers. Agency specializes in fashion, advertising, lifestyle, travel, interiors, portraiture. Markets include advertising agencies, corporations/clients direct, design firms, editorial/magazines, retail stores and catalogs.

HANDLES Photography, stylists, art directors, scenic designers, backdrops, hair and makeup artists and fine art.

TERMS Agent receives 25% commission for photography; 20% for stylists, 50% for stock.

HOW TO CONTACT Send query letter, résumé, direct mail flier/brochure and photocopies. Responds

only if interested. After initial contact, "wait to hear, please don't call."

CRISTOPHER LAPP—STILL & MOVING IMAGES

1211 Sunset Plaza Dr., Suite 413, Los Angeles CA 90069. (310)612-0040. **E-mail:** cristopherlapp.photo@gmail.com. **Website:** www.cristopherlapp.com. **Contact:** Cristopher Lapp. Estab. 1994. Specializes in fine art prints, hand-pulled originals, limited edition, monoprints, monotypes, offset reproduction, unlimited edition, posters.

HANDLES Decorative art, fashionable art, commercial and designer marketing. Clients include: Posner Fine Art, Gilanyi Inc., Jordan Designs.

TERMS Keeps samples on file.

HOW TO CONTACT Send an e-mail inquiry.

LEE + LOU PRODUCTIONS INC.

211 N. Dianthus St., Manhattan Beach CA 90266. (310)374-1918. **Fax:** (310)287-1814. **E-mail:** leelou@earthlink.net. **Website:** www.leelou.com. **Contact:** Lee Pisarski. Estab. 1981. Commercial illustration and photography representative, digital and traditional photo retouching. Represents 2 retouchers, 5 photographers, 5 film directors, 2 visual effects companies, 1 CGI company. Specializes in automotive. Markets include advertising agencies.

HANDLES Photography, commercial film, CGI, visual effects.

TERMS Rep receives 25% commission. Charges for shipping, entertainment. Exclusive area representation required. Advertising costs are paid by talent. For promotional purposes, talent must provide direct mail advertising material. Advertises in *Creative Black Book, Workbook* and *Single Image, Shoot, Boards.*

HOW TO CONTACT Send direct mail flyer/brochure, tearsheets. Responds in 1 week. After initial contact, call for appointment to show portfolio of photographs.

TIPS Obtains new talent through recommendations from others, some solicitation.

THE BRUCE LEVIN GROUP

305 Seventh Ave., Suite 1101, New York NY 10001. (212)627-2281. **E-mail:** brucelevin@mac.com. **Website:** www.brucelevingroup.com. **Contact:** Bruce Levin, president. Estab. 1983. Commercial photography representative. Member of SPAR and ASMP. Represents 10 photographers. Specializes in advertising, editorial and catalog; heavy emphasis on fashion, lifestyle and computer graphics.

HANDLES Photography.

TERMS Rep receives 25% commission. Exclusive area representation required. Advertising costs are paid by talent. Advertises in *Workbook* and other sourcebooks.

HOW TO CONTACT Send brochure, photos; call. Portfolios may be dropped off every Monday–Friday.

TIPS Obtains new talent through recommendations, research, word of mouth, solicitation.

NORMAN MASLOV AGENT INTERNATIONALE

879 Florida St., San Francisco CA 94110. (415)641-4376. **Fax:** (415)695-0921. **E-mail:** maslov@maslov.com. **Website:** maslov.com. Estab. 1986. Member of APA. Represents 10 photographers. Markets include advertising agencies, corporations/clients direct, design firms, editorial/magazines, paper products/greeting cards, publishing/books, private collections.

HANDLES Photography. Looking for "original work not derivative of other artists. Artist must have developed style."

TERMS Rep receives 30% commission. Exclusive U.S. national representation required. Advertising costs split varies. For promotional purposes, talent must provide 3-4 direct mail pieces/year. Advertises in *Archive, Workbook* and *At Edge.*

HOW TO CONTACT Send query letter, direct mail flier/brochure, tearsheets. Do not send original work. Responds in 2-3 weeks, only if interested. After initial contact, call to schedule an appointment, or drop off or mail materials for review. Individual and group consulting available in person or via phone or website.

TIPS Obtains new talent through suggestions from art buyers and recommendations from designers, art directors, other agents, sourcebooks and industry magazines and social networks. "We prefer to follow our own leads rather than receive unsolicited promotions and inquiries. It's best to have represented yourself for several years to know your strengths and be realistic about your marketplace. The same is true of having experience with direct mail pieces, developing client lists, and having a system of follow up. We want our talent to have experience with all this so they can properly value our contribution to their growth and success—otherwise that 30% becomes a burden and point of resentment. Enter your best work into competitions such as *Communication Arts* and *Graphis*

photo annuals. Create a distinctive promotion mailer if your concepts and executions are strong."

JUDITH MCGRATH

P.O. Box 133, 32W040 Army Trail Rd., Wayne IL 60184. (312)945-8450. **Fax:** (312)465-1638. **E-mail:** judy@judymcgrath.net. **Website:** www.judymcgrath. net. Estab. 1980. Commercial photography/videography representative. Represents photographers and videographers. Markets include advertising agencies, corporate/client direct, design firms, editorial/magazines, paper products/greeting cards, publishing/books, direct mail firms.

HANDLES Photography, videography.

TERMS Rep receives 25% commission. Exclusive area representation required. Advertising costs paid by talent. Advertises in *Workbook*.

HOW TO CONTACT Send query letter, bio, tearsheets, photocopies. Rep will contact artist for portfolio review if interested.

MUNRO CAMPAGNA ARTISTS REPRESENTATIVES

630 N. State St., #2109, Chicago IL 60654. (312)335-8925. **E-mail:** steve@munrocampagna.com. **Website:** www.munrocampagna.com. **Contact:** Steve Munro, president. Estab. 1987. Commercial photography and illustration representative. Member of SPAR, CAR (Chicago Artist Representatives). Represents 1 photographer, 30 illustrators. Markets include advertising agencies, corporations/clients direct, design firms, publishing/books.

HANDLES Illustration, photography.

TERMS Rep receives 30% commission. Exclusive national representation required. Advertising costs are paid by talent. For promotional purposes, talent must provide 2 portfolios, leave-behinds, several promos. Advertises in *Workbook*, other sourcebooks.

HOW TO CONTACT Send query letter, bio, tearsheets, SASE. Responds within 2 weeks, only if interested. After initial contact, write to schedule an appointment.

PHOTOKUNST

725 Argyle Ave., Friday Harbor WA 98250. (360)378-1028. **Fax:** (360)370-5061. **E-mail:** info@photokunst. com; anne@photokunst.com. **Website:** www.photokunst.com. **Contact:** Barbara Cox, principal. Estab. 1998. Consulting and marketing of photography archives and fine art photography, nationally and internationally. "Accepting select number of photogra-phers on our website. Works with artists on licensing, curating and traveling gallery and museum exhibi-tions; agent for photo books."

HANDLES Emphasis on cause-oriented photography, photojournalism, documentary and ethnographic photography. Vintage and contemporary photography.

TERMS Charges for consultation, per project rate or annual for full representation; for representation, website fee and percentage of sales and licensing.

HOW TO CONTACT Send website information. Responds in 2 months.

TIPS Finds new talent through submissions, recommendations from other artists, publications, art fairs, portfolio reviews. "In order to be placed in major galleries, a book or catalog must be either in place or in serious planning stage."

PHOTOTHERAPY CONSULTANTS

11977 Kiowa Ave., Los Angeles CA 90049-6119. **E-mail:** rhoni@phototherapists.com. **Website:** www.phototherapists.com. **Contact:** Rhoni Epstein, acquisitions. Estab. 1983. Commercial and fine art photography consultant. "Consulting with a knowledgeable and well-respected industry insider is a valuable way to get focused and advance your career in a creative and cost-efficient manner. You will see how to differentiate yourself from other photographers. Inexpensive ways to customize your portfolio, marketing program, branding materials and websites will show the market who you are and why they need you. You will be guided to embrace your point of view and learn how to focus your images on making money!" Rhoni Epstein is an Adjunct Assistant Professor at Art Center College of Design, a panel moderator, portfolio reviewer, lecturer and contest judge.

HOW TO CONTACT Via e-mail.

TIPS "Work smart, remain persistent and enthusiastic; there is always a market for creative and talented people."

➕ PICTURE MATTERS

(323)464-2492. **Fax:** (323)465-7013. **E-mail:** info@picturematters.com. **Website:** www.picturematters.com. Estab. 1985. Commercial photography representative. Member of APA. Represents 12 photographers. Staff: Sherwin Taghdiri, sales rep. Agency specializes in photography. Markets include advertising agencies, design firms.

HANDLES Photography.

TERMS Rep receives 25% commission. Charges shipping expenses. Exclusive representation required. No geographic restrictions. Advertising costs are paid by talent. For promotional purposes, talent must provide promos, advertising and a quality portfolio. Advertises in various source books.

HOW TO CONTACT Send direct mail flyer/brochure.

MARIA PISCOPO

1684 Decoto Rd., #271, Union City CA 94587. (714)356-4260. **E-mail:** maria@mpiscopo.com. **Website:** www.mpiscopo.com. **Contact:** Maria Piscopo. Estab. 1978. Commercial photography representative. Member of SPAR, Women in Photography, Society of Illustrative Photographers. Markets include advertising agencies, design firms, corporations.

HANDLES Photography. Looking for "unique, unusual styles; established photographers only."

TERMS Rep receives 25% commission. Exclusive area representation required. No geographic restrictions. Advertising costs are split: 50% paid by talent; 50% paid by representative. For promotional purposes, talent must have a website and provide 3 traveling portfolios, leave-behinds and at least 6 new promo pieces per year. Plans web, advertising and direct mail campaigns.

HOW TO CONTACT Send query letter and samples via PDF to maria@mpiscopo.com. Do not call. Responds within 2 weeks, only if interested.

TIPS Obtains new talent through personal referral and photo magazine articles. "Do lots of research. Be very businesslike, organized, professional and follow the above instructions!"

ALYSSA PIZER

13121 Garden Land Rd., Los Angeles CA 90049. (310)440-3930. **Fax:** (310)440-3830. **E-mail:** alyssa@ alyssapizer.com. **Website:** www.alyssapizer.com. Estab. 1990. Represents 11 photographers. Agency specializes in fashion, beauty and lifestyle (catalog, image campaign, department store, beauty and lifestyle awards). Markets include advertising agencies, corporations/clients direct, design firms, editorial/magazines.

HANDLES Established photographers only.

HOW TO CONTACT Send query letter or direct mail flier/brochure or e-mail website address. Responds in a couple of days. After initial contact, call to schedule an appointment or drop off or mail materials for review.

VICKI SANDER/FOLIO FORUMS

48 Gramercy Park N., Suite 5, New York NY 10010. (212)420-1333. **E-mail:** vicki@vickisander.com. **Website:** www.vickisander.com. **Contact:** Vicki Sander. Estab. 1985. Commercial photography representative. Member of SPAR, The One Club for Art and Copy, The New York Art Directors Club. Represents photographers. Markets include advertising agencies, corporate/client direct, design firms, editorial/magazines, paper products/greeting cards. "Folio Forums is a company that promotes photographers by presenting portfolios at agency conference rooms in catered breakfast reviews. Accepting submissions for consideration on a monthly basis."

HANDLES Photography, fine art. Looking for lifestyle, fashion, food.

TERMS Rep receives 30% commission. Exclusive representation required. Advertising costs are paid by talent. For promotional purposes, talent must provide direct mail and sourcebook advertising. Advertises in *Workbook*.

HOW TO CONTACT Send tearsheets. Responds in 1 month. To show portfolio, photographer should follow up with a call and/or letter after initial query.

TIPS Finds new talent through recommendation from other artists, referrals. Have a portfolio put together and have promo cards to leave behind, as well as mailing out to rep prior to appointment.

WALTER SCHUPFER MANAGEMENT CORPORATION

401 Broadway, Suite 14, New York NY 10013. (212)366-4675. **Fax:** (212)255-9726. **E-mail:** mail@ wschupfer.com. **Website:** www.wschupfer.com. **Contact:** Walter Schupfer, president. Estab. 1996. Commercial photography representative. Represents photographers, stylists, designers. Staff includes producers, art department, syndication. Agency specializes in photography. Markets include advertising agencies, corporate/client direct, design firms, editorial/magazines, record labels, galleries.

HANDLES Photography, design, stylists, make-up artists, specializing in complete creative management.

TERMS Charges for messenger service. Exclusive area representation required. For promotional purposes, talent must provide several commercial and editorial portfolios. Advertises in *Le Book*.

HOW TO CONTACT Send promo cards, "then give us a call." To show portfolio, photographer should follow up with call.

TIPS Finds new talent through submissions, recommendations from other artists. "Do research to see if your work fits our agency."

FREDA SCOTT, INC.

302 Costa Rica Ave., San Mateo CA 94402. (650)548-2446. **E-mail:** freda@fredascott.com. **Website:** www.fredascott.com. **Contact:** Freda Scott, rep/president. Estab. 1980. Commercial photography, illustration or photography, commercial illustration representative and licensing agent. Represents 12 photographers, 8 illustrators. Licenses photographers and illustrators. Markets include advertising agencies, architects, corporate/client direct, designer firms, developers, direct mail firms, paper products/greeting cards.

HANDLES Illustration, photography.

TERMS Rep receives 25% as standard commission. Advertising costs paid entirely by talent. For promotional purposes, talent must provide mailers/postcards. Advertises in *The Workbook* and *American Showcase/Illustrators.*

HOW TO CONTACT Send link to website. Responds, only if interested, within 2 weeks. Rep will contact the talent for portfolio review, if interested.

TIPS Obtains new talent through submissions and recommendations from other artists, art directors and designers.

⊕ ♡ TAENDEM AGENCY

P.O. Box 29115, 1535 W. Broadway, Vancouver BC V6J 5C2, Canada. (604)569-6544. **E-mail:** talent@taendem.com. **Website:** www.taendem.com. **Contact:** Corwin Hiebert, principal. Estab. 2006. International management agency. Represents a handful of photographers and videographers. Specializes in consulting with freelancers and assisting them with building and growing a successful small creative business. Also full-service business administration and marketing management for creative entrepreneurs. Offerings include: business planning, branding, marketing strategy, portfolio development, website development, social media planning, contract management, client management, project management, proposal writing, estimates and invoicing, itinerate speaking engagements, travel logistics, and production.

HANDLES Illustration, photography, fine art, design and videography.

TERMS Upon acceptance, we charge a minimum monthly retainer of $200 for access and management rights; for specific tasks we use project costing—quoted and applied upon talent's approval. Additional work is quoted and billed upon talent request/approval. Itinerate speaking commission rate is negotiated on a case-by-case basis. Management representation is non-exclusive. Business development consultation available to qualified talent only; full-service management representation is selectively offered at the discretion of the agency. 100% of advertising costs paid by talent. Standard offering includes no paid advertising. Talent must provide full contact information, current headshot, website link and a sample of their work. For photographers, we require 10 select portfolio images.

HOW TO CONTACT Send link to website and full contact information and a brief business description. Portfolio should include large thumbnails, videographers should provide demo reel (Vimeo or YouTube). A business manager will be in contact within 1 week.

TIPS Obtains new talent through submissions and recommendations from other artists. Keep e-mails short and friendly. No phone calls. "Creatives are more likely to generate demand when their business is well-organized and their marketing efforts elicit curiosity instead of trying to stand out in a crowd of talented peers. Growing your business network and developing your portfolio through personal and collaborative projects makes you more attractive to both reps and buyers. If you need help growing your creative small business, just remember: You are Batman. We are Robin."

♋ TM ENTERPRISES

Ave. Bartolomeu de Gusmao, 46, Suite 909-B, Santos 11045-400 SP, Brazil. **E-mail:** tmarques1@hotmail.com. **Contact:** Tony Marques. Estab. 1985. Commercial photography representative and photography broker. Member of Beverly Hills Chamber of Commerce. Represents 50 photographers. Agency specializes in photography of women only: high fashion, swimsuit, lingerie, glamour and fine (good taste) *Playboy*-style pictures, erotic. Markets include advertising agencies, corporations/clients direct, editorial/magazines, paper products/greeting cards, publishing/books, sales/promotion firms, medical magazines.

HANDLES Photography.

TERMS Rep receives 50% commission. Advertising costs are paid by representative. "We promote the

standard material the photographer has available, unless our clients request something else." Advertises in Europe, South and Central America, and magazines not known in the U.S.

HOW TO CONTACT Send everything available. Responds in 2 days. After initial contact, drop off or mail appropriate materials for review. Portfolio should include slides, photographs, transparencies, printed work.

TIPS Obtains new talent through worldwide famous fashion shows in Paris, Rome, London and Tokyo; by participating in well-known international beauty contests; recommendations from others. "Send your material clean and organized. Do not borrow other photographers' work in order to get representation. Always protect yourself by copyrighting your material. Get releases from everybody who is in the picture (or who owns something in the picture)."

DOUG TRUPPE

121 E. 31st St., New York NY 10016. (212)685-1223. **E-mail:** doug@dougtruppe.com. **Website:** www. dougtruppe.com. **Contact:** Doug Truppe, artist representative. Estab. 1998. Commercial photography representative. Member of SPAR, Art Directors Club. Represents 10 photographers. Agency specializes in lifestyle, food, still life, portrait and children's photography. Markets include advertising agencies, corporate, design firms, editorial/magazines, publishing/books, direct mail firms.

HANDLES Photography. "Always looking for great commercial work." Established, working photographers only.

TERMS Rep receives 25% commission. Exclusive area representation required. Advertising costs are paid by talent. For promotional purposes, talent must provide directory ad (at least 1 directory per year), direct mail promo cards every 3 months, e-mail promos every month, website. Advertises in *Workbook*.

HOW TO CONTACT Send e-mail with website address. Responds within 1 month, only if interested. To show portfolio, photographer should follow up with call.

TIPS Finds artists through recommendations from other artists, source books, art buyers. "Please be willing to show some new work every 6 months. Have 2-3 portfolios available for representative. Have website and be willing to do direct mail every 3 months. Be professional and organized."

WORKSHOPS & PHOTO TOURS

Taking a photography workshop or photo tour is one of the best ways to improve your photographic skills. There is no substitute for the hands-on experience and one-on-one instruction you can receive at a workshop. Besides, where else can you go and spend several days with people who share your passion for photography?

Photography is headed in a new direction. Digital imaging is here to stay and is becoming part of every photographer's life. Even if you haven't invested a lot of money into digital cameras, computers or software, you should understand what you're up against if you plan to succeed as a professional photographer. Taking a digital imaging workshop can help you on your way.

Outdoor and nature photography are perennial workshop favorites. Creativity is another popular workshop topic. You'll also find highly specialized workshops, such as underwater photography. Many photo tours specialize in a specific location and the great photo opportunities that location affords.

As you peruse these pages, take a good look at the quality of workshops and the skill level of photographers the sponsors want to attract. It is important to know if a workshop is for beginners, advanced amateurs, or professionals. Information from a workshop organizer can help you make that determination.

These workshop listings contain only the basic information needed to make contact with sponsors, and a brief description of the styles or media covered in the programs. We also include information on costs when possible. Write, call, or e-mail the workshop/photo tour sponsors for complete information. Most have websites with extensive information about their programs, when they're offered, and how much they cost.

A workshop or photo tour can be whatever the photographer wishes—a holiday from the normal working routine, or an exciting introduction to new skills and perspectives on the craft. Whatever you desire, you're sure to find in these pages a workshop or tour that fulfills your expectations.

◐ ◑ EDDIE ADAMS WORKSHOP

(646)263-8596. **E-mail:** info@eddieadamsworkshop. com; eawstaff@gmail.com. **Website:** www.eddiead amsworkshop.com. **Contact:** Miriam Evers, workshop producer. Annual, tuition-free photojournalism workshop. The Eddie Adams Workshop brings together 100 promising young photographers with over 150 of the most influential picture journalists, picture editors, managing editors and writers from prestigious organizations such as the Associated Press, CNN, The White House, *Life, National Geographic, Newsweek, Time, Parade, Entertainment Weekly, Sports Illustrated, The New York Times, The Los Angeles Times* and *The Washington Post*. Pulitzer-prize winning photographer Eddie Adams created this program to allow young photographers to learn from experienced professionals about the storytelling power and social importance of photography. Participants are divided into 10 teams, each headed by a photographer, editor, producer, or multimedia person. Daily editing and critiquing help each student to hone skills and learn about the visual, technical, and emotional components of creating strong journalistic images. Open to photography students and professional photographers with 3 years or less of experience. Photographers should e-mail for more information.

◐ ◑ ● ANCHELL PHOTOGRAPHY WORKSHOPS

990 20th St. NE, Salem OR 97301. (503)884-3882. **Fax:** (503)588-4003. **E-mail:** info@anchellworkshops. com. **Website:** www.anchellworkshops.com. **Contact:** Steve Anchell. Film or digital, group or private workshops held throughout the year, including large-format, 35mm, studio lighting, figure, darkroom, both color and b&w. Open to all skill levels. Since 2001, Steve has been leading successful humanitarian missions for photographers to Cuba. On each visit, the photographers deliver medicine to a community clinic in Havana and then have time to explore Havana and the Vinales tobacco region. This is a legal visit with each member possessing a U.S. Treasury license allowing them to travel for humanitarian reasons. Though we will be in Cuba for humanitarian reasons, there will be discussion and informal instruction on street photography. See website for more information.

◑ ● ANDERSON RANCH ARTS CENTER

P.O. Box 5598, Snowmass Village CO 81615. (970)923-3181. **Fax:** (970)923-3871. **E-mail:** info@anderson ranch.org. **Website:** www.andersonranch.org. Digital media and photography workshops featuring distinguished artists and educators from around the world. Classes range from traditional silver and alternative photographic processes to digital formats and use of the computer as a tool for time-based and interactive works of art. Program is diversifying into video, animation, sound and installations.

◐ ◑ ● ANIMALS OF MONTANA INC.

170 Nixon Peak Rd., Bozeman MT 59715. (406)686-4224. **Fax:** (406)686-4224. **E-mail:** animals@animal sofmontana.com. **Website:** www.animalsofmontana. com. See website for pricing information. Held annually. Workshops held year round. "Whether you're a professional/amateur photographer or artist, or just looking for a Montana Wildlife experience, grab your camera and leave the rest to us! Visit our tour page for a complete listing of tours." Open to all skill levels. Photographers should call, e-mail, or see website for more information.

APOGEE PHOTO WORKSHOP

(904)619-2010. **Website:** www.apogeephoto.com. **Contact:** Marla Meier, editor/manager. To take our online photography class, visit our website for details.

◐ ◑ ● SEAN ARBABI

508 Old Farm Rd., Danville CA 94526-4134. (925)855-8060. **Fax:** (925)855-8060. **E-mail:** work shops@seanarbabi.com. **Website:** www.seanarbabi. com/workshops.html. **Contact:** Sean Arbabi, photographer/instructor. Online and seasonal workshops held in spring, summer, fall, winter. Taught around the world—online with PPSOP.com, and on location with Calumet, Point Reyes Field Institute, as well as places and companies around the U.S. and Iceland. Sean Arbabi teaches through computer presentations, software demonstrations, slide shows, field shoots and hands-on instruction. All levels of workshops are offered from beginner to advanced. Subjects include digital photography, nature, composition, exposure, personal vision, high-dynamic range imagery, how to run a photo business, lighting, panoramas, utilizing equipment, and a philosophical approach to the art.

○ ◐ ● **ARIZONA HIGHWAYS PHOTO WORKSHOPS**

2039 W. Lewis Ave., Phoenix AZ 85009. (888)790-7042. **Fax:** (602)256-2873. **E-mail:** info@ahpw.org. **Website:** www.ahpw.org. **Contact:** Roberta Lites, executive director. AHPW is a non-profit, full-service provider of photographic education from capture to print, taught by premier instructors at inspirational locations throughout the Southwest and beyond.

○ ◐ **ARROWMONT SCHOOL OF ARTS AND CRAFTS**

556 Parkway, Gatlinburg TN 37738. (865)436-5860. **Fax:** (865)430-4101. **E-mail:** info@arrowmont.org. **Website:** www.arrowmont.org. Offers weekend, 1- and 2-week workshops in photography, drawing, painting, clay, metals/enamels, kiln glass, fibers, surface design, wood turning and furniture. Residencies, studio assistantships, work-study, and scholarships are available. See individual course descriptions for pricing.

➕ ○ ◐ ● **ART IMMERSION TRIP WITH WORKSHOP IN NEW MEXICO**

P.O. Box 1473, Cullowhee NC 28723. (828)342-6913. **E-mail:** contact@cullowheemountainarts.org. **Website:** www.cullowheemountainarts.org. **Contact:** Norma Hendrix, director. Cost: $1,379-$1,579 (includes lodging, 2-4 day workshop, breakfasts, 1 dinner, some transportation and museums). "Cullowhee Mountain Arts offers exceptional summer artist workshops in painting, drawing, printmaking, book arts, ceramics, photography and mixed media. Our distinguished faculty with national and international reputations will provide a week-long immersion in their topic supplemented with lectures, demonstrations or portfolio talks. Cullowhee Mountain Arts is committed to supporting the personal and professional development of every artist, whatever their level, by providing the setting and facilities for intense learning and art making, shared in community. We believe that are enlivens community life and that in a supportive community, art thrives best. Our studios are located on Western Carolina University's campus, surrounded by the natural beauty of the Blue Ridge Mountains in North Carolina." Upcoming workshops in New Mexico include: Debra Fitts (Ceramic Sculpture: Intermediate to Advanced), "The Spirit & The Figure"; Ron Pokrasso (Printmaking: All Levels), "Monotype and More: Mixed Media Printmaking"; Nancy Reyner (Acrylic: Intermediate, Advanced, Masters), "Acrylic Innovation: Inventing New Painting Techniques & Styles"; and Sandra Wilson (Painting: All Levels), "Acrylic Textures, Transfers and Layers." Call, e-mail or see website for more detailed information including exact dates and locations.

○ ◐ **ART NEW ENGLAND SUMMER WORKSHOPS @ BENNINGTON, VERMONT**

621 Huntington Ave., Boston MA 02115. (617)879-7200; (617)879-7175. **E-mail:** ce@massart.edu; nancy mccarthy@massart.edu. **Website:** ane.massart.edu. **Contact:** Nancy McCarthy. Week-long workshops, run by Massachusetts College of Art. Areas of concentration include b&w, alternative processes, digital printing and many more. See website for more information and upcoming workshops.

○ ◐ ● **ART OF NATURE PHOTOGRAPHY WORKSHOPS**

211 Kirkland Ave., Suite 503, Kirkland WA 98033-6408. (425)968-2884. **E-mail:** charles@charlesneedle photo.com. **Website:** www.charlesneedlephoto.com. **Contact:** Charles Needle, founder/instructor. U.S. and international locations such as Monet's Garden (France); Keukenhof Gardens (Holland), and Butchart Gardens (Canada); includes private access with personalized one-on-one field and classroom instruction and supportive image evaluations. Emphasis on creative camera techniques in the field and digital darkroom, allowing students to express "the art of nature" with unique personal vision. Topics include creative macro, flower/garden photography, multiple-exposure impressionism, intimate landscapes and scenics, dynamic composition and lighting, etc. Open to all skill levels. Upcoming workshops include: Monet's Garden in summertime, Atlanta Botanical Garden, Creative Smartphone Photography in Seattle, and Nova Scotia. See website for more information and all upcoming workshops.

ART WORKSHOPS IN GUATEMALA

4758 Lyndale Ave. S., Minneapolis MN 55419-5304. (612)825-0747. **E-mail:** info@artguat.org. **Website:** www.artguat.org. **Contact:** Liza Fourre, director. Estab. 1995. Annual workshops held in Antigua, Guatemala. See website for a list of upcoming workshops.

◐ ◑ ● BACHMANN TOUR OVERDRIVE

P.O. Box 950833, Lake Mary FL 32746. (407)333-9988. **E-mail:** Bill@Billbachmann.com. **Website:** www.billbachmann.com. **Contact:** Bill Bachmann, owner. "Bill Bachmann shares his knowledge and adventures with small groups several times a year. Past trips have been to China, Tibet, South Africa, Antarctica, India, Nepal, Australia, New Zealand, New Guinea, Greece, Vietnam, Laos, Cambodia, Malaysia, Singapore, Guatemala, Honduras, Greece and Cuba. Future trips will be back to Cuba, Antarctica, Eastern Canada, Italy, Eastern Europe, Peru, Argentina, Brazil and many other destinations. Programs are designed for adventure travelers who love photography and want to learn stock photography from a top stock photographer." Open to all skill levels.

◐ ◑ ● NOELLA BALLENGER & ASSOCIATES PHOTO WORKSHOPS

P.O. Box 457, La Canada CA 91012. (818)954-0933. **Fax:** (818)954-0910. **E-mail:** Noella1B@aol.com. **Website:** www.noellaballenger.com. **Contact:** Noella Ballenger. A variety of online photo classes are offered through www.apogeephoto.com. Work at your own speed. Small class sizes. Emphasize visual awareness, composition and techniques. One-on-one evaluations and comments on all images submitted in class. Articles available at www.apogeephoto.com.

◑ ● FRANK BALTHIS PHOTOGRAPHY WORKSHOPS

P.O. Box 255, Davenport CA 95017. (831)426-8205. **E-mail:** frankbalthis@yahoo.com. **Website:** pa.photoshelter.com/c/frankbalthis. **Contact:** Frank S. Balthis, photographer/owner. "Workshops emphasize natural history, wildlife and travel photography, often providing opportunities to photograph marine mammals." Worldwide locations range from Baja California to Alaska. Frank Balthis runs a stock photo business and is the publisher of the Nature's Design line of cards and other publications.

✛ BEGINNING DIGITAL PHOTOGRAPHY WORKSHOP

P.O. Box 5219, St. Marys GA 31558. (912)580-5308. **E-mail:** jackie@debuskphoto.com. **Website:** www.debuskphoto.com. **Contact:** Jackie DeBusk, photographer. $59 for 4-hour individual workshop at mutually-agreed location within 50 miles of St. Marys GA; 51-100 miles, $79; 101-150 miles, $99. Public workshops have varying fees and are announced on website. Instructor and participants are each responsible for any meals, parking or entrance fees (parks, zoos, etc.). Private workshops by request and public workshops announced throughout the year on website. Please see website for dates of upcoming workshops. Participants will learn how to take their SLR and bridge or prosumer cameras off of auto and begin to creatively apply exposure, metering and white balance settings, as well as learn about focus area, histograms and principles of sound composition. Workshop emphasis is on outdoor photography. Private workshops are conducted at mutually-agreed locations, public workshops are typically held at state parks or other public venues that offer excellent photography opportunities. Open to beginners. Interested parties should call, e-mail or see website for more information.

◐ ◑ ● BETTERPHOTO.COM ONLINE PHOTOGRAPHY COURSES

23515 NE Novelty Hill Rd., Suite B221, #183, Redmond WA 98052. **E-mail:** course.sales@betterphoto.com, kerry@betterphoto.com. **Website:** www.betterphoto.com. **Contact:** Kerry Drager, managing director. BetterPhoto is the worldwide leader in online photography education, offering an approachable resource for photographers who want to improve their skills, share their photos, and learn more about the art and technique of photography. BetterPhoto offers over 100 photography courses that are taught by top professional photographers. Courses begin the 1st Wednesday of every month. Courses range in skill level from beginner to advanced and consist of inspiring weekly lessons and personal feedback on students' photos from the instructors. "We provide websites for photographers, photo sharing solutions, free online newsletters, lively Q&A and photo discussions, a monthly contest, helpful articles and online photography courses." Open to all skill levels.

◑ BIRDS AS ART/INSTRUCTIONAL PHOTO-TOURS

P.O. Box 7245, 4041 Granada Dr., Indian Lake Estates FL 33855. (863)692-0906. **Fax:** (877)265-6955. **E-mail:** birdsasart@verizon.net. **Website:** www.birdsasart.com. **Contact:** Arthur Morris, instructor. The tours, which visit the top bird photography hot spots in North America, feature evening in-classroom lectures, breakfast and lunch, in-the-field instruction, 6

or more hours of photography, and most importantly, easily approachable yet free and wild subjects.

○ ◑ ● BLUE PLANET PHOTOGRAPHY WORKSHOPS AND TOURS

201 N. Kings Rd., Suite 107, Nampa ID 83687. (208)466-9340. **Website:** www.blueplanetphoto.com. Award-winning professional photographer and former wildlife biologist Mike Shipman conducts small group workshops/tours emphasizing individual expression and "vision-finding" by Breaking the Barriers to Creative Vision™. Workshops held in beautiful locations away from crowds and the more-often-photographed sites. Some workshops are semi-adventure-travel style, using alternative transportation such as hot air balloons, horseback, llama, and camping in remote areas. Group feedback sessions, digital presentations and film processing whenever possible. Workshops and tours held in western U.S., Alaska, Canada and overseas. On-site transportation and lodging during workshop usually included; meals included on some trips. Specific fees, optional activities and gear list outlined in tour materials. Digital photographers welcome. Workshops and tours range from 2 to 12 days, sometimes longer; average is 9 days. Custom tours and workshops available upon request. Open to all skill levels. Photographers should write, call, e-mail or see website for more information.

BLUE RIDGE WORKSHOPS

4831 Keswick Court, Montclair VA 22025. (571)294-1383. **E-mail:** elliot@blueridgeworkshops.com. **E-mail:** brian@blueridgeworkshops.com. **Website:** www.blueridgeworkshops.com. **Contact:** Elliot Stern, owner/photographer. These workshops sell out, so book early. See website for more information and a list of all upcoming workshops.

○ ◑ ● NANCY BROWN HANDS-ON WORKSHOPS

3100 NW Boca Raton Blvd., Suite 403, Boca Raton FL 33431. (561)347-1243. **Fax:** (561)988-1791. **E-mail:** nbrown50@bellsouth.net. **Website:** www.nancybrown.com. **Contact:** Nancy Brown. Offers one-on-one intensive workshops all year long in studio and on location in Florida. You work with Nancy, the models and the crew to create your images. Photographers should call, fax, e-mail or see website for more information.

◐ ○ ◑ ● BURREN COLLEGE OF ART WORKSHOPS

(353)65-7077200. **Fax:** (353)65-7077201. **E-mail:** julia@burrencollege.ie. **Website:** www.burrencollege.ie/programmes. **Contact:** Julia Long, photography. These workshops present unique opportunities to capture the qualities of Ireland's western landscape. The flora, prehistoric tombs, ancient abbeys and castles that abound in the Burren provide an unending wealth of subjects in an ever-changing light. "Introduction to Digital Photography," "Nature and Landscape Photography," and "Portrait Photography and Learning More About Your Camera: An Introduction to Digital Photography, Photoshop and Printing," are just some of the workshops on offer at Burren College of Art this summer. 3-, 4- and 5-day courses are available and accommodation packages have been arranged to facilitate participants. See website for the full range on offer.

● CALIFORNIA PHOTOGRAPHIC WORKSHOPS

2500 N. Texas St., Fairfield CA 94533. (888)422-6606. **E-mail:** director@cpwschool.com; cpwschool@sbcglobal.net. **Website:** www.cpwschool.com. **Contact:** James Inks, director. 3- and 5-day workshops in professional photography. Varies in location.

◐ ● CAMARGO FOUNDATION VISUAL ARTS FELLOWSHIP

1, Avenue Jermini, Cassis 13260, France. **E-mail:** apply@camargofoundation.org. **Website:** www.camargofoundation.org. Residencies awarded to visual artists, creative writers, composers and academics. Artists may work on a specific project, develop a body of work, etc. Fellows must live on-site at foundation headquarters for the duration of the fellowship. Apartments with kitchens provided. Open to photographers of any nationality. See website for deadline. Photographers should visit website to apply. If you are interested in applying for future fellowships, please check the website for announcements.

○ ◑ ● JOHN C. CAMPBELL FOLK SCHOOL

One Folk School Rd., Brasstown NC 28902. (828)837-2775 or (800)365-5724. **Fax:** (828)837-8637. **Website:** www.folkschool.org. The Folk School offers year-round weekend and weeklong courses in photography. Please call for free catalog or see website for more information and upcoming workshops.

THE CENTER FOR PHOTOGRAPHY AT WOODSTOCK

59 Tinker St., Woodstock NY 12498. (845)679-9957. E-mail: info@cpw.org. Website: www.cpw.org. Contact: Lindsay Stern, education coordinator. Woodstock Photography Workshops & Lecture Series. Held at CPW in Woodstock NY, our hands-on workshops allow you to expand your craft, skills and vision under the mentorship of a leading image-maker. Workshops are kept intimate by limited enrollment and taught by highly qualified support staff. Photographers should call, e-mail or see website for more information and a list of upcoming workshops.

CHICAGO PHOTO SAFARIS

(312)470-6704. E-mail: info@chicagophotosafaris.com. Website: www.chicagophotosafaris.com. gary@photosafarinetwork.com. Contact: Gary Gullett, president. Held daily. "Local travel photography workshops are held daily in convenient locations in Chicago. These are 'hands-on' workshops with participants learning the creative camera controls and concepts of photography in easy-to-understand language. There are also regional, national and worldwide safaris for the more adventurous. Extreme photography opportunities include adventures such as mountain climbing or scuba diving, all in great photographic venus. Check the website for details." Open to photographers of all skill levels and types of cameras (film or digital).

CATHY CHURCH PERSONAL UNDERWATER PHOTOGRAPHY COURSES

P.O. Box 479, GT Grand Cayman KY1 1106, Cayman Islands. (345)949-7415 or (607)330-3504 (U.S. callers). Fax: (345)949-9770 or (607)330-3509 (U.S.). E-mail: cathy@cathychurch.com. Website: www.cathychurch.com. Contact: Cathy Church. Hotel/dive package available at Sunset House Hotel. Private and group lessons available for all levels throughout the year; classroom and shore diving can be arranged. Lessons available for professional photographers expanding to underwater work. Photographers should e-mail for more information.

CLICKERS & FLICKERS PHOTOGRAPHY NETWORK—LECTURES & WORKSHOPS

P.O. Box 60508, Pasadena CA 91116-6508. (310)457-6130. E-mail: dawnhope@clickersandflickers.com. E-mail: dawn5palms@yahoo.com. Website: www. clickersandflickers.com. Contact: Dawn Hope Stevens, organizer. Estab. 1985. Monthly networking dinners with outstanding guest speakers (many award winners, including the Pulitzer Prize), events and free activities for members. "Clickers & Flickers Photography Network, Inc., was created to provide people with an interest and passion for photography (cinematography, filmmaking, image making) the opportunity to meet others with similar interests for networking and camaraderie. It creates an environment in which photography issues, styles, techniques, enjoyment and appreciation can be discussed and viewed as well as experienced with people from many fields and levels of expertise (beginners, students, amateur, hobbyist, or professionals, gallery owners and museum curators). We publish a bimonthly color magazine listing thousands of activities for photographers and lovers of images." Most of its content is not on our website for a reason. Membership and magazine subscriptions help support this organization. Clickers & Flickers Photography Network, Inc. is a 21-year-old professional photography network association that promotes information and offers promotional marketing opportunities for photographers, cinematographers, individuals, organizations, businesses, and events. "C&F also provides referrals for photographers. Our membership includes photographers, videographers, and cinematographers who are skilled in the following types of photography: outdoor and nature, wedding, headshots, fine art, sports, events, products, news, glamour, fashion, macro, commercial, landscape, advertising, architectural, wildlife, candid, photojournalism, marquis gothic—fetish, aerial and underwater; using the following types of equipment: motion picture cameras (Imax, 70mm, 65mm, 35mm, 16mm, 8mm), steadicam systems, video, high-definition, digital, still photography—large format, medium format and 35mm." Open to all skill levels. Photographers should call or e-mail for more information.

COMMUNITY DARKROOM

Genesse Center for the Arts, 713 Monroe Ave., Rochester NY 14607. (585)271-5920. E-mail: darkroom@geneseearts.org. Website: www.geneseearts.org. The Genesee Center for the Arts & Education offers programs in all of our visual arts areas: Community Darkroom, Genesee Pottery, and the Printing and Book Arts Center. We offer youth programs, classes and workshops, rent studio space to individuals

and exhibit work in our galleries. Anyone may take classes, though you must be a member to use some of the facilities. See website for more information and upcoming workshops.

○ ◐ ● **CONE EDITIONS WORKSHOPS**

P.O. Box 51, East Topsham VT 05076. (802)439-5751, ext. 101. **E-mail:** cathy@cone-editions.com. **Website:** www.cone-editions.com. **Contact:** Cathy Cone. See website for details on workshop dates and prices. Cone Editions digital printmaking workshops are hands-on and cover a wide range of techniques, equipment and materials. The workshops take place in the studios of Cone Editions Press and offer attendees the unique opportunity to learn workflow and procedures from the masters. These workshops are an excellent opportunity to learn proven workflow in a fully equipped digital printmaking studio immersed in the latest technologies. Open to all skill levels. See website for more information and upcoming workshops.

◐ ● **THE CORTONA CENTER OF PHOTOGRAPHY, ITALY**

665 Cooledge Ave. NE Atlanta GA 30306. (404)876-6341. **E-mail:** workshop.inquiry@cortonacenter.com. **Website:** www.cortonacenter.com. Robin Davis leads a personal, small-group photography workshop in the ancient city of Cortona, Italy, centrally located in Tuscany, once the heart of the Renaissance. Dramatic landscapes; Etruscan relics; Roman, Medieval and Renaissance architecture; and the wonderful and photogenic people of Tuscany await. Photographers should write, e-mail or see website for more information.

○ ◐ ● **CORY NATURE AND TRAVEL WORKSHOPS**

P.O. Box 42, Signal Mountain TN 37377. (423)886-1004. **E-mail:** tompatcory@aol.com. **Website:** www.tomandpatcory.com. **Contact:** Tom or Pat Cory. Small workshops/field trips (8-12 maximum participants) with some formal instruction, but mostly one-on-one instruction in the field. "Since we tailor this instruction to each individual's interests, our workshops are suitable for all experience levels. Participants are welcome to use digital or film cameras or even video. Our emphasis is on nature and travel photography. We spend the majority of our time in the field, exploring our location. Cost and length vary by workshop. Workshop locations vary from year to year. See Strabo Tours website at phototc.com for a list of our current international workshops. We also offer

a number of short workshops throughout the year in and around Chattanooga TN. Individual instruction and custom-designed workshops for groups." Photographers should write, call, e-mail or see our website for more information.

○ ◐ **CREALDÉ SCHOOL OF ART**

600 St. Andrews Blvd., Winter Park FL 32792. (407)671-1886. **E-mail:** pschreyer@crealde.org; rick pho@aol.com; rberrie@crealde.org. **Website:** www. crealde.org. **Contact:** Peter Schreyer, executive director; Rick Lang, director of photography. Crealdé School of Art is a community based non-profit arts organization established in 1975. It features a year-round curriculum of over 100 visual arts classes for students of all ages, taught by a faculty of over 40 working artists; a renowned summer art camp for children and teens; a visiting artist workshop series, 3 galleries, the contemporary sculpture garden, and award-winning outreach programs. Offers classes covering traditional and digital photography; b&w darkroom techniques; landscape, portrait, documentary, travel, wildlife and abstract photography; and educational tours. See website for more information and upcoming workshops.

○ ◐ ● **CREATIVE ARTS WORKSHOP**

80 Audubon St., New Haven CT 06511. (203)562-4927. **E-mail:** haroldshapirophoto@gmail.com. **Website:** www.creativeartsworkshop.org. **Contact:** Harold Shapiro, photography department head. A nonprofit regional center for education in the visual arts that has served the Greater New Haven area since 1961. Located in the heart of the award-winning Audubon Arts District, CAW offers a wide-range of classes in the visual arts in its own three-story building with fully equipped studios and an active exhibition schedule in its well-known Hilles Gallery. Offers exciting classes and advanced workshops. Digital and traditional b&w darkroom. See website for more information and upcoming workshops.

➕ ○ ◐ ● **CULLOWHEE MOUNTAIN ARTS SUMMER WORKSHOP SERIES**

P.O. Box 1473, Cullowhee NC 28723. (828)342-6913. **E-mail:** contact@cullowheemountainarts.org. **Website:** www.cullowheemountainarts.org. **Contact:** Norma Hendrix, director. Cost: $500-900 for 5-day tuition, lab fees and Sunday reception (housing and partial meal plans are available at an additional cost, ranging from $500-700 a week). "Cullowhee Moun-

tain Arts offers exceptional summer artist workshops in painting, drawing, printmaking, book arts, ceramics, photography and mixed media. Our distinguished faculty with national and international reputations will provide a week-long immersion in their topic supplemented with lectures, demonstrations or portfolio talks. Cullowhee Mountain Arts is committed to supporting the personal and professional development of every artist, whatever their level, by providing the setting and facilities for intense learning and art making, shared in community. We believe that are enlivens community life and that in a supportive community, art thrives best. Our studios are located on Western Carolina University's campus, surrounded by the natural beauty of the Blue Ridge Mountains in North Carolina." Upcoming workshops on the WCU campus include: Lisa Pressman (Mixed Media with Encaustic Painting: All Levels), "Layers, Richness and Personal Vision"; Rebecca Crowell (Oil and Wax Painting: Advanced, Masters), "Oil and Wax: Abstract Painting with Cold Wax Medium"; Jeff Oestereich (Ceramics: Intermediate, Advanced), "A Closer Look at Function and Detail": Greg Newington (Photography: All Levels), "Five Days as a Photojournalist"; Jody Alexander (Book Arts/Mixed Media/Sculpture: All Levels), "The Stitcherly Book." Call, e-mail or see website for more detailed information including full workshop schedule, exact dates, fees and locations.

CULTURAL PHOTO TOURS WITH RALPH VELASCO

422½ Carnation Ave., Corona del Mar CA 92625. (888)9PHOTO9 (974-6869) ext. 2. **Fax:** (888)974-6869. **E-mail:** ralph@ralphvelasco.com. **Website:** ralphvelasco.com/blog/tours. **Contact:** Ralph Velasco, founder/lead instructor. Designed to provide a unique opportunity for hands-on experience with a professional photography instructor. Learn to see like a photographer, develop skills that will allow you to readily notice and take advantage of more and better photo opportunities and begin to "think outside the camera!" Includes: local (Southern California), domestic (San Francisco, Chicago) and international photo tours with award-winning photography instructor, international photo tour guide, app creator, and author Ralph Velasco. Tours concentrate on various locations throughout Southern California including Orange County (Newport Beach, Corona del Mar, Crystal Cove, Long Beach, Laguna Beach, the Mis-

sion San Juan Capistrano), San Diego County (Balboa Park, Old Town San Diego, Point Loma, La Jolla Cove, downtown, San Diego by Train) and Los Angeles/Pasadena (Santa Monica Pier, Walt Disney Concert Hall, Downtown L.A. Theatre District, The Huntington, San Gabriel Mission). Other parts of California include Temecula, Catalina Island, Joshua Tree National Park, Death Valley and the Central California Coast. International destinations include Morocco, Mexico's Copper Canyon, Cambodia. People-to-people programs to Cuba, Central Europe, Egypt, Spain, India, Turkey, and much more. Other destinations are being added all the time. Many more will follow. Costs: varies depending on tour, some by appointment or special arrangement. Open to all levels of photographers and non-photographers alike, with any equipment. Photographers should call, e-mail or visit the website for more information.

DAWSON COLLEGE CENTRE FOR TRAINING AND DEVELOPMENT

4001 de Maisonneuve Blvd. W., Suite 2G.1, Montreal QC H3Z 3G4, Canada. (514)933-0047. **Fax:** (514)937-3832. **E-mail:** ctd@dawsoncollege.qc.ca. **Website:** www.dawsoncollege.qc.ca/ciait. Workshop subjects include imaging arts and technologies, computer animation, photography, digital imaging, desktop publishing, multimedia, and web publishing and design. See website for course and workshop information.

THE JULIA DEAN PHOTO WORKSHOPS

755 Seward St., Los Angeles CA 90038. (323)464-0909. **Fax:** (323)464-0906. **E-mail:** workshops@juliadean.com. **Website:** www.juliadean.com. **Contact:** Brandon Gannon, director. The Julia Dean Photo Workshops (JDPW) is a practical education school of photography devoted to advancing the skills and increasing the personal enrichment of photographers of all experience levels and ages. Photography workshops of all kinds held throughout the year, including alternative and fine art, photography & digital camera fundamentals, lighting & portraiture, specialized photography, Photoshop and printing, photo safaris, and travel workshops. Open to all skill levels. Photographers should call, e-mail or see website for more information.

◐ ● CYNTHIA DELANEY PHOTO WORKSHOPS

168 Maple St., Elko NV 89801. (775)753-5833. **Fax:** (775)753-5833. **E-mail:** cynthia@cynthiadelaney.com. **E-mail:** cynthiad@gwmail.gbcnv.edu. **Website:** www.cynthiadelaney.com. **Contact:** Cynthia Delaney. "In addition to her photography classes, Cynthia offers outdoor photography workshops held in many outstanding locations. It is our hope to bring photographers to new and unusual places where inspiration comes naturally." See website for more information and upcoming workshops.

◐ ◑ DIGITAL WILDLIFE PHOTOGRAPHY FIELD SCHOOL

P.O. Box 236, S. Wellfleet MA 02663. (508)349-2615. **E-mail:** wellfleet@massaudubon.org. **Website:** www.massaudubon.org/wellfleetbay. Enjoy learning in the beautiful coastal setting of Cape Cod. Mass Audubon's Wellfleet Bay Wildlife Sanctuary offers a wide variety of field courses for adults which focus on the unique coastal environment and wildlife of Cape Cod. Sponsored by Massachusetts Audubon Society. Classes held on a regular basis. For a more detailed course descriptions and itineraries, call, e-mail or see website.

◐ ◑ ELOQUENT LIGHT PHOTOGRAPHY WORKSHOPS

903 W. Alameda St., #115, Santa Fe NM 87501. (505)983-2934. **E-mail:** cindylane@eloquentlight.com. **Website:** www.eloquentlight.com. **Contact:** Cindy Lane, managing director. Estab. 1986. "Eloquent Light Photography Workshops was founded in 1986 to provide exceptional educational photographic workshop experiences based on the history, character and beauty of the American Southwest. We pride ourselves on offering real photographic education that helps participants become better photographers. We keep our group sizes small in order to address participants' needs. Open to all skill levels. In our traditional workshops, you are encouraged to bring your own images with you for informal comment by the instructor and fellow participants. Photographs made during the week of your workshop will also be reviewed. The instructor and assistant are available to look at digital captures on participants' laptops during our adventure workshops when requested." This is a shooting-intensive workshop providing hands-on, one-on-one guidance in the field as needed. See website for the current workshop schedule, more information and registration. Mentoring and private workshops also available. "The experience just got better. The workshop itself was packed with information and activity. The instructors and staff were always available, ready to instruct and answer questions, but careful to let each student work at their own pace."—Mary E., Texas. "It was a wonderful and very pleasant workshop. I learned a lot of things for the handling of my digital camera. I wish to express my hearty thanks."—Shiro T., Japan.

● JOE ENGLANDER PHOTOGRAPHY WORKSHOPS & TOURS

P.O. Box 1261, Manchaca TX 78652. (512)922-8686. **E-mail:** info@englander-workshops.com. **Contact:** Joe Englander. Instruction in beautiful locations throughout the world, all formats and media, color/b&w/digital, photoshop instruction. Locations include Europe, Asia with special emphasis on Bhutan and the Himalayas and the U.S. See website for more information.

◐ ◑ ● EUROPA PHOTOGENICA PHOTO TOURS TO EUROPE

3920 W. 231st Place, Torrance CA 90505. (310)378-2821. **Fax:** (310)378-2821. **E-mail:** fraphoto@aol.com. **Website:** www.europaphotogenica.com. **Contact:** Barbara Van Zanten-Stolarski, owner. (Formerly France Photogenique/Europa Photogenica Photo Tours to Europe). Tuition provided for beginners/intermediate and advanced level. Workshops held in spring (1-2) and fall (1-2). 5- to 11-day photo tours of the most beautiful regions of Europe. Shoot landscapes, villages, churches, cathedrals, vineyards, outdoor markets, cafes and people in France, Paris, Provence, England, Italy, Greece, etc. Tours change every year. Open to all skill levels. Photographers should call or e-mail for more information.

◐ ◑ ● EXPOSURE36 PHOTOGRAPHY

P.O. Box 964, Caldwell ID 83605. (503)707-5293. **E-mail:** workshop@exposure36.com. **Website:** www.exposure36.com. **Contact:** Jim Altengarten. Open to all skill levels. Workshops offered at prime locations in the U.S. and Canada, including Nova Scotia, Smoky Mountains, Acadia and the bears in Alaska. International workshops include Russia, Southeast Asia, Guatemala and the Northern Lights in Finland. Also offers classes on the basics of photography in Seattle, Washington (through the Experimental College of the University of Washington). Photographers should

write, call, e-mail, see website for more information and upcoming workshops.

FINDING & KEEPING CLIENTS

1684 Decoto Rd. #271, Union City CA 94587. (714)356-4260. **E-mail:** maria@mpiscopo.com. **Website:** www.mpiscopo.com. **Contact:** Maria Piscopo, instructor. "How to find new photo assignment clients and get paid what you're worth!" Maria Piscopo is the author of *The Photographer's Guide to Marketing & Self Promotion*, 4th edition (Allworth Press). See website for more information and upcoming workshops.

FINE ARTS WORK CENTER

24 Pearl St., Provincetown MA 02657. (508)487-9960 ext. 103. **Fax:** (508)487-8873. **E-mail:** workshops@fawc.org. **Website:** www.fawc.org. Estab. 1968. 2013 faculty includes Amy Arbus, Nick Flynn, Catherine Kernan, Salvatore Scibona, John Murillo, Alison Bechdel, Daniel Heyman, Linda Bond and many more.

PETER FINGER PHOTOGRAPHER

1143 Blakeway St., Daniel Island SC 29492. (843)377-8652. **E-mail:** images@peterfinger.com. **Website:** www.peterfinger.com. **Contact:** Peter Finger, president. Offers over 20 weekend and week-long photo workshops, held in various locations. Workshops planned include Charleston, Savannah, Carolina Coast, Outer Banks, and the Islands of Georgia. "Group instruction from dawn till dusk." Write or visit website for more information.

FIRST LIGHT PHOTOGRAPHIC WORKSHOPS AND SAFARIS

10 Roslyn, Islip Terrace NY 11752. (631)581-0400. **E-mail:** info@firstlightphotography.com. **Website:** www.firstlightphotography.com. **Contact:** Bill Rudock, president. Photo workshops and photo safaris for all skill levels, specializing in national parks, domestic and international; also presents workshops for portrait and wedding photographers. "We will personally teach you through our workshops and safaris, the techniques necessary to go from *taking pictures* to *creating* those unique, magical images while experiencing some of life's greatest adventures." See website for more information, pricing and registration.

FOCUS ADVENTURES

P.O. Box 771640, Steamboat Springs CO 80477. (970)879-2244. **E-mail:** karen@focusadventures.com. **Website:** www.focusadventures.com. **Contact:** Karen Gordon Schulman, owner. Photo workshops and tours emphasize photography and the creative spirit and self-discovery through photography. Summer photo workshops in Steamboat Springs, Colorado and at Focus Ranch, a private guest ranch in NW Colorado. Customized private and small-group lessons available year-round. Karen is an experienced photographic artist and educator based out of Steamboat Springs CO. Her current passion is the new and exciting world of iPhoneography. International photo tours run with Strabo Photo Tour Collection to various destinations including Ecuador, Bali, Morocco and Western Ireland. Recent and upcoming workshops and tours: "Photography and the Creative Spirit in Western Ireland, June 6-16, 2013"; "Photography and Personal Vision at Focus Guest Ranch, Slater CO, June 30-July 6, 2013"; "Beautiful Bali, September 4-15, 2013, various locations around the island." Accommodations, meals, photo instruction included in all of the above programs. See website for more details and registration.

FOTOFUSION

Palm Beach Photographic Centre, 415 Clematis St., West Palm Beach FL 33401. (561)253-2600. **Fax:** (561)276-9132. **E-mail:** info@workshop.org. **Website:** www.fotofusion.org. America's foremost festival of photography and digital imaging is held each January. Learn from more than 90 master photographers, picture editors, picture agencies, gallery directors, and technical experts, over 5 days of field trips, seminars, lectures and Photoshop workshops. Open to all skill levels interested in nature, landscape, documentary, portraiture, photojournalism, digital, fine art, commercial, etc. Details available online.

FREEMAN PATTERSON PHOTO WORKSHOPS

Shamper's Cove Limited, 3487 Route 845, Long Reach NB E5S 1X4, Canada. (506)763-2189. **Fax:** (506)763-2035. **E-mail:** freepatt@nbnet.nb.ca. **Website:** www.freemanpatterson.com. Freeman made several visits to Africa between 1967 and 1983, three of them at the request of the Photographic Society of Southern Africa. As a result of these contacts and others, he co-founded (with Colla Swart) the Namaqualand Photographic Workshops in 1984, and travels to the desert village of Kamieskroon once or twice a year to teach three or four week-long workshops. This project has expanded so rapidly that Freeman now works with several other instructors and no longer participates

in every program. Freeman has also given numerous, week-long workshops in the U.S., New Zealand, and Israel and has completed lecture tours in the United Kingdom, South Africa and Australia. See website for more information and a list of upcoming workshops.

◑ ● GALÁPAGOS TRAVEL

783 Rio Del Mar Blvd., Suite 49, Aptos CA 95003. (831)689-9192 or (800)969-9014. **E-mail:** info@galapagostravel.com. **Website:** www.galapagostravel.com. **Contact:** Mark Grantham. Landscape and wildlife photography tour of the islands with an emphasis on natural history. Spend either 11 or 15 days aboard the yacht in Galápagos, plus three nights in a first-class hotel in Quito, Ecuador. 25+ departures annually see website for additional information and registration.

○ ◑ ● GERLACH NATURE PHOTOGRAPHY WORKSHOPS & TOURS

P.O. Box 642, Ashton ID 83420. (208)652-4444. **E-mail:** michele@gerlachnaturephoto.com. **Website:** www.gerlachnaturephoto.com. **Contact:** Michele Smith, office manager. Professional nature photographers John and Barbara Gerlach conduct intensive field workshops in the beautiful Upper Peninsula of Michigan in August and during October's fall color period. They lead a photo safari to the best game parks in Kenya each year. They also lead winter photo tours of Yellowstone National Park and conduct high-speed flash hummingbird photo workshops in British Columbia in late May and early June. Barbara and John work for an outfitter a couple weeks a year leading photo tours into The Yellowstone Back Country and Lee Metcalf Wilderness with the use of horses. This is a wonderful way to experience Yellowstone. They conduct an inspirational one-day seminar on how to shoot beautiful nature images in major cities each year. Their 3 highly-rated books, *Digital Nature Photography: The Art and the Science*, *Digital Wildlife Photography* and *Digital Landscape Photography* have helped thousands master the art of nature photography. Photographers should visit their website for more information.

○ ◑ ● GLOBAL PRESERVATION PROJECTS

P.O. Box 30866, Santa Barbara CA 93130. (805)682-3398 or (805)455-2790. **E-mail:** timorse@aol.com. **Website:** www.globalpreservationprojects.com. **Contact:** Thomas I. Morse, director. Offers photographic workshops and expeditions promoting the preserva-

tion of environmental and historic treasures. Produces international photographic exhibitions and publications. GPP uses a 24-ft. motor home with state-of-the art digital imaging and printer systems for participants use. Workshops and expeditions in order normally done: Arches & Canyonlands, Winter Train Durango, Big Sur, Slot Canyons, Monument Valley, Eastern Sierra, Northern California & Oregon coasts, Colorado Fall Color, Death Valley and Alabama Hills. See website for details.

● ⊘ GOLDEN GATE SCHOOL OF PROFESSIONAL PHOTOGRAPHY

P.O. Box F, San Mateo CA 94402-0018. (650)367-1265. **E-mail:** goldengateschool@yahoo.com. **Website:** www.goldengateschool.org. **Contact:** Julie Olson, co-director. Offers 1-3 day workshops in traditional and digital photography for professional and aspiring photographers in the San Francisco Bay Area.

○ ◑ ● ROB GOLDMAN CREATIVE PHOTOGRAPHY WORKSHOPS

R. Goldman, Inc., 755 Park Ave., Suite 190, Huntington NY 11743. (631)424-1650. **E-mail:** rob@rgoldman.com. **Website:** www.rgoldman.com. **Contact:** Rob Goldman, photographer. 1-on-1 private instruction for photographers of all levels, customized to each student's needs. "For over 15 years, beginner photographers through seasoned pros have received priceless instruction and support from Rob Goldman's private sessions. He possesses an uncanny ability to inspire and draw out a photographer's absolute best! Whether you're brand new to photography or looking to refine your vision or your craft, Rob's private lessons are the way to go!"

○ ◑ GREAT SMOKY MOUNTAINS INSTITUTE AT TREMONT

9275 Tremont Rd., Townsend TN 37882. (865)448-6709. **Fax:** (865)448-9250. **E-mail:** mail@gsmit.org. **E-mail:** heather@gsmit.org. **Website:** www.gsmit.org. **Contact:** Registrar. Workshop instructors: Bill Lea, Will Clay and others. Emphasizes the use of natural light in creating quality scenic, wildflower and wildlife images.

◑ ● HALLMARK INSTITUTE OF PHOTOGRAPHY

241 Millers Falls Rd., Turners Falls MA 01376. (413)863-2478. **E-mail:** info@hallmark.edu. **Website:** www.hallmark.edu. Casey McMullen, vice pres-

ident, enrollment management. **Contact:** Deb Carson, school president. Offers an intensive 10-month resident program teaching the technical, artistic and business aspects of professional photography for the career-minded individual.

JOHN HART PORTRAIT SEMINARS

344 W. 72nd St., New York NY 10023. (212)877-0516. **E-mail:** johnhartstudio1@mac.com. **Website:** www. headshotsbyjohnhart.com. Mr. Hart is a professor of photography at New York University. His photography sessions concentrate on "1-on-1" instruction that emphasizes advanced portrait techniques—concentrating mainly on lighting the subject in a truly professional manner, whether inside the studio or outside in natural lighting. He is the author of *50 Portrait Lighting Techniques, Professional Headshots, Lighting for Action,* and *The Art of the Storyboard.* His portrait seminars place a new emphasis on digital portrait photography, the subject of a new book he is working on.

○ ◑ ● HAWAII WORKSHOPS RETREATS PRIVATE PHOTO TOURS INSTRUCTION & FINE ART PRINT SALES

P.O. Box 335, Honaunau HI 96726. (808)328-2162. **E-mail:** workshops@kathleencarr.com. **E-mail:** kcarr@kathleencarr.com. **Website:** www.kathleencarr.com. **Contact:** Kathleen T. Carr. Photographing special places, digital infrared, model shoots, Photoshop, Polaroid/Fuji transfers, handcoloring and more. Location is Tropical Hideaway, South Kona, Big Island of Hawaii. See website for more information and registration.

○ ◑ ● HEART OF NATURE PHOTOGRAPHY WORKSHOPS & PHOTO TOURS

P.O. Box 1033, Volcano HI 96785. (808)345-7179. **E-mail:** rfphoto@jps.net. **Website:** www.hawaiiphototours.org. **Contact:** Robert Frutos. Adventure, excitement and the experience of a lifetime await you on the breathtaking big island of Hawaii! Explore the majestic beauty of Hawaii. Discover the unique splendor of the big island. Experience exotic photo ops and little known awe-inspiring locations. Photograph and capture that potential once-in-a-lifetime image. Photographers can e-mail or see website for more information.

○ ◑ ● HORIZONS: ARTISTIC TRAVEL

P.O. Box 634, Leverett MA 01054. (413)367-9200. **Fax:** (413)367-9522. **E-mail:** horizons@horizons-art.com. **Website:** www.horizons-art.com. **Contact:** Jane Sinauer, director. "Horizons offers one-of-a-kind small-group travel adventures in Southern Africa: Sea to Safari; Peru: the Inca Heartland; Ecuador: Andes to the Amazon; Southeast Asia: Burma and Laos (2014); and new for 2013, A Foodie's Italy: Parma and Bologna. As of 2013, our catalog will solely be online to ensure that you always have the most up-to-date information. If you would like a detailed itinerary for any trip or have specific questions, please let us know."

○ ◑ ● HUI HO'OLANA

P.O. Box 280, Kualapùu, Molokài HI 96757. (808)567-6430. **E-mail:** hui@huiho.org; huihoolana@gmail.com. **Website:** www.huiho.org. **Contact:** Rik Cooke. "Hui Ho'olana is a non-profit organization on the island of Molokai HI. We are dedicated to the fine art of teaching. Through workshops and volunteer residencies, our mission is to create a self-sustaining facility that supports educational programs and native Hawaiian reforestation projects. Our goal is to provide an environment for inspiration, a safe haven for the growth and nurturing of the creative spirit." Photographers should e-mail, call or visit website for more information, including the current workshop schedule.

◑ IN FOCUS WITH MICHELE BURGESS

20741 Catamaran Lane, Huntington Beach CA 92646. (714)536-6104. **E-mail:** maburg5820@aol.com. **Website:** www.infocustravel.com. **Contact:** Michele Burgess, president. Offers overseas tours to photogenic areas with expert photography consultation at a leisurely pace and in small groups (maximum group size: 20).

○ ◑ ● INTERNATIONAL EXPEDITIONS

One Environs Park, Helena AL 35080. (800)633-4734; (800)234-9620; (205)428-1700. **Fax:** (205)428-1714. **E-mail:** nature@ietravel.com. **Website:** www.ietravel.com. **Contact:** Charlie Weaver, photo tour coordinator. Includes scheduled ground transportation; extensive pre-travel information; services of experienced English-speaking local guides; daily educational briefings; all excursions, entrance fees and permits; all accommodations; meals as specified in the respective itineraries; transfer and luggage handling when

taking group flights. Guided nature expeditions all over the world: Amazon, Costa Rica, Machu Picchu, Galapagos, Laos & Vietnam, Borneo, Kenya, Patagonia and many more. Open to all skill levels. Photographers should write, call, e-mail, see website for more information.

◯ ◑ ● JIVIDEN'S NATURALLY WILD PHOTO ADVENTURES

P.O. Box 333, Chillicothe OH 45601. (800)866-8655 or (740)774-6243. **Fax:** (740)774-2272 (call first). **E-mail:** mail@naturallywild.net. **Website:** www.naturally wild.net. **Contact:** Jerry or Barbara Jividen. "Offering a limited number of photo workshops as we undertake several photo and writing projects and speaking engagements." See website for more information and a list of upcoming workshops.

◑ ● JORDAHL PHOTO WORKSHOPS

P.O. Box 3998, Hayward CA 94540. (510)785-7707. **E-mail:** kate@jordahlphoto.com. **Website:** www.jordahlphoto.com. **Contact:** Kate or Geir Jordahl, directors. Intensive 1- to 5-day workshops dedicated to inspiring creativity and community among artists through critique, field sessions and exhibitions.

BOB KORN IMAGING

46 Main St., P.O. Box 1687, Orleans MA 02653. (508)255-5202. **E-mail:** bob@bobkornimaging.com. **Website:** www.bobkornimaging.com. **Contact:** Bob Korn, director. For photographers and artists who are interested in digital photography and digital printmaking. All skill levels. Workshops run year-round. Photographers should call, e-mail or see website for more information.

✵ ◯ ◑ ● THE LIGHT FACTORY

Spirit Square, Suite 211, 345 N. College St., Charlotte NC 28202. (704)333-9755. **E-mail:** dkiel@lightfactory.org; info@lightfactory.org. **Website:** www.lightfactory.org. **Contact:** Dennis Kiel, chief curator. Estab. 1972. The Light Factory is a nonprofit arts center dedicated to exhibition and education programs promoting the power of photography and film. From classes in basic point-and-shoot to portraiture, Photoshop, and more, TLF offers 3-8 week-long courses that meet once a week in our uptown Charlotte location. Classes are taught by professional instructors and cater to different expertise levels: introductory, intermediate and advanced in both photography and filmmaking. See website for a listing of classes and registration.

LIGHT PHOTOGRAPHIC WORKSHOPS

1062 Los Osos Valley Rd., Los Osos CA 93402. (805)528-7385. **Fax:** (888)254-6211. **E-mail:** info@lightworkshops.com. **Website:** www.lightworkshops.com. "LIGHT Photographic Workshops is located on the beautiful coast of California in the small town of Los Osos. We are halfway between Los Angeles and San Francisco near the Paso Robles wine area. It's a fantastic location for all sorts of photography! Offers small group workshops, private tutoring, Alaska and worldwide photography instruction cruises and tours, printing and canvas gallery wrap services, Canon gear rental, studio and classroom rental. New focus on digital tools to optimize photography, make the most of your images and improve your photography skills at the premier digital imaging school on the West Coast."

◔ ◯ ◑ PETER LLEWELLYN PHOTOGRAPHY WORKSHOPS & PHOTO TOURS

645 Rollo Rd., Gabriola BC VOR 1X3, Canada. (250)247-9109. **E-mail:** peter@peterllewellyn.com. **Website:** www.peterllewellyn.com. **Contact:** Peter Llewellyn. "Sports and wildlife photography workshops and photo tours at locations worldwide. Sports photography workshops feature instruction by some of the best sports photographers in the world. Workshops include photography, Photoshop skills, and digital workflow. Photo Tours are design to provide maximum photographic opportunities to participants with the assistance of a professional photographer. Trips include Brazil, Africa, Canada, and U.S. New destinations coming soon." Open to all skill levels. For further information, e-mail or see website. Costs vary.

◯ ◑ ● C.C. LOCKWOOD WILDLIFE PHOTOGRAPHY WORKSHOP

P.O. Box 14876, Baton Rouge LA 70898. (225)769-4766. **Fax:** (225)767-3726. **E-mail:** cactusclyd@aol.com. **Website:** www.cclockwood.com. **Contact:** C.C. Lockwood, photographer. Lockwood periodically teaches hands-on photography workshops in the Grand Canyon, Colorado, Alaska, Louisiana marshes and rookeries, and the Atchafalaya Basin Swamp. Informative slide show lectures precede field trips into these great photo habitats. Call, write, e-mail or see website for a list of upcoming workshops.

○ ◐ ● **ANDY LONG'S FIRST LIGHT PHOTOGRAPHY WORKSHOPS TOURS**

P.O. Box 280952, Lakewood CO 80228. (303)601-2828. E-mail: andy@firstlighttours.com. **Website:** www. firstlighttours.com. **Contact:** Andy Long, owner. Tours cover a variety of locations and topics, including: Penguins of Falkland Islands, Alaskan northern lights, birds of Florida, south Texas birds, France, Iceland, eagles of southwest Alaska, Mt. Rainier National Park, Colorado wildflowers, Alaska bears, and more. See website for more information on locations, dates and prices. Open to all skill levels. See website for more details, schedule, detailed pricing information and registration.

◐ **THE MACDOWELL COLONY**

100 High St., Peterborough NH 03458. (603)924-3886. **Fax:** (603)924-9142. **E-mail:** admissions@macdowell colony.org. **Website:** www.macdowellcolony.org. Estab. 1907. Provides creative artists with uninterrupted time and seclusion to work and enjoy the experience of living in a community of gifted artists. Residencies of up to 8 weeks for writers, playwrights, composers, film/video makers, visual artists, architects and interdisciplinary artists. Artists in residence receive room, board and exclusive use of a studio. Average length of residency is 5 weeks. Ability to pay for residency is not a factor; there are no residency fees. Limited funds available for travel reimbursement and artist grants based on need. Application deadlines: January 15: summer (June-September); April 15: fall/winter (October-January); September 15: winter/spring (February-May). Visit website for online application and guidelines. Questions should be directed to the admissions director.

MADELINE ISLAND SCHOOL OF THE ARTS

978 Middle Road, P.O. Box 536, LaPointe WI 54850. (715)747-2054. **E-mail:** misa@cheqnet.net. **Website:** www.madelineschool.com. **Contact:** Jenna J. Erickson, director of programs. Workshop tuition $425-760 for 5-day workshops. Lodging and meals are separate, both are provided on-site. Workshops held annually between May-October. Workshops offered in writing, painting, quilting, photography and yoga. Open to all skill levels. Interested parties should call, e-mail or see website for more information.

○ ◐ ● **MAINE MEDIA WORKSHOPS**

70 Camden St., P.O. Box 200, Rockport ME 04856. (207)236-8581 or (877)577-7700. **Fax:** (207)236-2558. **E-mail:** info@mainemedia.edu. **Website:** www. mainemedia.edu. "Maine Media Workshops is a non-profit educational organization offering year-round workshops for photographers, filmmakers and media artists. Students from across the country and around the world attend courses at all levels, from absolute beginner and serious amateur to working professional; also high school and college students. Professional certificate and low-residency MFA degree programs are available through Maine Media College." See website for the fall calendar.

○ ◐ ● **WILLIAM MANNING PHOTOGRAPHY**

6396 Birchdale Ct., Cincinnati OH 45230. (513)624-8148. **E-mail:** william@williammanning.com. **Website:** www.williammanning.com. Digital photography workshops worldwide with emphasis on travel, nature, and architecture. Offers small group tours. Participants will learn how to photograph with an open mind and shoot with post-production in mind and all of its possibilities. Participants should have a basic knowledge of Adobe Photoshop and own 1 or more plug-ins such as Topaz Adjust, Nik software and/or Auto FX (Mystical Lighting and Ambiance) software. See website for more information and registration.

○ ◐ ● **JOE & MARY ANN MCDONALD WILDLIFE PHOTOGRAPHY WORKSHOPS AND TOURS**

73 Loht Rd., McClure PA 17841-9340. (717)543-6423. **Fax:** (717)543-5342. **E-mail:** info@hoothollow.com. **Website:** www.hoothollow.com. **Contact:** Joe Mc-Donald, owner. "We are wildlife photographers who not only maintain a huge inventory of stock images for editorial and advertising use, but who have dedicated ourselves to the sharing of photographic and natural history information through our various courses, tours, workshops, and safaris." Offers small group, quality instruction with emphasis on nature and wildlife photography. See website for more information and a list of upcoming workshops.

○ ◐ ● **MENTOR SERIES WORLDWIDE PHOTO TREKS**

Bonnier Technology Group, 2 Park Ave., 9th Floor, New York NY 10016. (888)676-6468; (212)779-5473. **Fax:** (212)779-5508. **E-mail:** michelle.cast@bonnier

corp.com; erica.johnson@bonniercorp.com. **Website:** www.mentorseries.com. **Contact:** Michelle Cast, director of events. "For the past 15 years the Mentor Series program has taken photo enthusiasts to destinations across the country and around the world. With top Nikon professional photographers accompanying participants every day and giving advice on how and what to shoot, there is nothing like a Mentor Series trek. You and your photography will never be the same!" Designed to cater to all skill levels. Photographers should call, e-mail or see website for more information.

○ ◐ ● MID-ATLANTIC REGIONAL SCHOOL OF PHOTOGRAPHY

121 Webster Ave., Stratford NJ 08084. (888)267-MARS (6277). **E-mail:** registrar@marsschool.com. **E-mail:** john@marsschool.com. **Website:** www.photoschools.com. Covers many aspects of professional photography from digital to portrait to wedding. Open to photographers of all skill levels. Check website for information on the next workshop.

○ ◐ ● MIDWEST PHOTOGRAPHIC WORKSHOPS

28830 W. Eight Mile Rd., Farmington Hills MI 48336. (248)471-7299. **E-mail:** officemanager@mpw.com. **E-mail:** bryce@mpw.com. **Website:** www.mpw.com. **Contact:** Bryce Denison, owner. "One-day weekend and week-long photo workshops, small group sizes and hands-on shooting seminars by professional photographers/instructors on topics such as portraiture, landscapes, nudes, digital, nature, weddings, product advertising and photojournalism." Workshops held regularly. See website for more information and registration.

MISSOURI PHOTOJOURNALISM WORKSHOP

109 Lee Hills Hall, Columbia MO 65211. (573)882-4882. **Fax:** (573)884-4999. **E-mail:** reesd@missouri.edu. **Website:** www.mophotoworkshop.org. **Contact:** Photojournalism department. Workshop for photojournalists. Participants learn the fundamentals of documentary photo research, shooting, and editing. Held in a different Missouri town each year.

MIXED MEDIA PHOTOGRAPHY

498 Ripka St., Philadelphia PA 19128. (610)247-9964. **E-mail:** leahwax@aol.com; info@blissbooks.net. **Website:** www.blissbooks.net; www.leahmacdonald.

com. **Contact:** Leah Macdonald. Quarterly 2-day workshop; and held via personal appointment. Also conducts one-on-one workshops with students. "The purpose of the workshop is to alter the surface of the photograph, using organic beeswax and oil paints in multiple forms and techniques to create surface textures and color enhancements that personalize and intensify the photographic image. My mixed media techniques are used with both traditional darkroom papers and inkjet papers. I encourage creativity and self-expression through image surface enhancement and mixed media techniques to create original one-of-a-kind artwork." Cost: $600; lunch is included, lodging is not. Instructor is available hourly, as well as part-time, for private instruction. Open to all skill levels. Photographers should call, e-mail or see website for more information.

● ⊘ MOUNTAIN WORKSHOPS

Western Kentucky University, 1906 College Heights, MMTH 131, Bowling Green KY 42101-1070. (270)745-8927. **E-mail:** mountainworkshops@wku.edu; jim.bye@wku.edu. **Website:** www.mountainworkshops.org. **Contact:** Jim Bye, workshop coordinator. Annual documentary photojournalism workshop held in October. Open to intermediate and advanced shooters. See website for upcoming dates.

○ TOM MURPHY PHOTOGRAPHY

402 S. Fifth, Livingston MT 59047. (406)222-2302; (406)222-2986. **E-mail:** tom@tmurphywild.com. **Website:** tmurphywild.com. **Contact:** Tom Murphy, president. Offers programs in wildlife and landscape photography in Yellowstone National Park and special destinations.

◐ NATURAL HABITAT ADVENTURES

P.O. Box 3065, Boulder CO 80307. (303)449-3711 or (800)543-8917. **Fax:** (303)449-3712. **E-mail:** info@nathab.com. **Website:** www.nathab.com. Guided photo tours for wildlife photographers. Tours last 5-27 days. Destinations include North America, Latin America, Canada, the Arctic, Galápagos Islands, Africa, the Pacific and Antarctica. See website for more information.

○ ◐ ● NEVERSINK PHOTO WORKSHOP

P.O. Box 641, Woodbourne NY 12788. (212)929-0009. **E-mail:** louisjawitz@mac.com. **Website:** www.neversinkphotoworkshop.com. **Contact:** Louis Jawitz, owner. "Neversink photo workshops concentrate on

scenic and nature photography with supervised field trip shooting, as well as portfolio review and critique, discussions related to composition and perspective, technical skills, visual design, using color for impact, exposure control, basic digital workflow and developing a personal style. Individual or group workshops will be held any day during the summer months, with a possibility of an additional 'Fall Foliage' weekend in October (dates to be determined). See Application page to schedule dates. There will be no private/individual workshops scheduled any day that group workshops are in session." Call, e-mail or see website for more detailed pricing information and specifics on what all is included in the registration fees.

◗ ● NEW ENGLAND SCHOOL OF PHOTOGRAPHY

537 Commonwealth Ave., Boston MA 02215. (617)437-1868 or (800)676-3767. **E-mail:** info@nesop.com. **Website:** www.nesop.com. Instruction in professional and creative photography in the form of workshops or a professional photography program. See website for details on individual workshops.

○ ◗ ● NEW JERSEY HERITAGE PHOTOGRAPHY WORKSHOPS

124 Diamond Hill Rd., Berkeley Heights NJ 07922. (908)790-8820. **E-mail:** nancyori@comcast.net. **Website:** www.nancyoriphotography.com. **Contact:** Nancy Ori, director. Estab. 1990. Workshops held every spring. Nancy Ori, well-known instructor, freelance photographer and fine art exhibitor of landscape and architecture photography, teaches how to use available light and proper metering techniques to document the man-made and natural environments of Cape May. A variety of film and digital workshops taught by guest instructors are available each year and are open to all skill levels, especially beginners. Topics include hand coloring of photographs, creative camera techniques with Polaroid materials, intermediate and advanced digital, landscape and architecture with alternative cameras, environmental portraits with lighting techniques, street photography; as well as pastel, watercolor and oil painting workshops. All workshops include an historic walking tour of town, location shooting or painting, demonstrations and critiques.

○ ◖ ● NEW JERSEY MEDIA CENTER LLC WORKSHOPS AND PRIVATE TUTORING

124 Diamond Hill Rd., Berkeley Heights NJ 07922. (908)790-8820. **E-mail:** nancyori@comcast.net. **Website:** www.nancyoriworkshops.com. **Contact:** Nancy Ori. 1. Italy Photography Workshop: Delicious Photography in Italy with Nancy Ori. Explore the Italian countryside, cities and small villages, with emphasis on architecture, documentary, portrait and landscape photography. The group will venture in non-tourist areas to explore the culture with cooking lessons and visits to small shops and industrial locations to see how the real people live and eat. Significant others welcome and will have plenty to see and do while you photograph, sketch or paint. Cost: call for this year's price; includes tuition, accommodations at a 15th century fully-renovated hilltop retreat with all the modern amenities, breakfasts and some dinners. Open to all skill levels. 2. Private Photography Tutoring with Nancy Ori in Berkeley Heights NJ. This unique and personalized approach to learning photography is designed for the beginning or intermediate student who wants to expand his/her understanding of the craft and work more creatively with the camera, develop a portfolio and create an exhibit. The goal is to refine individual style while exploring the skills necessary to make expressive photographs. The content will be tailored to individual needs and interests. Cost: $350 for a total of 8 hours. 3. Capturing the Light of the Southwest, a painting, sketching and photography workshop with Nancy Ori, held every other year in October, will focus on the natural landscape and man-made structures of the area around Santa Fe and Taos. Participants can be at any level in their media. All will be encouraged to produce a substantial body of work worthy of portfolio or gallery presentation. Features special evening guest lecturers from the photography community in the Santa Fe area. Artists should e-mail for more information. 4. Cape May Photography Workshops are held annually in April and May. Also, a variety of subjects such as photojournalism, environmental portraiture, landscape, alternative cameras, Polaroid techniques, creative digital techniques, on-location wedding photography, large-format, and how to photograph birds in the landscape are offered by several well-known East-Coast instructors. Open to all skill levels. Includes critiques, demonstrations, location shooting of Victorian architecture, gardens,

seascapes, and, in some cases, models in either film or digital. E-mail for dates, fees and more information. Workshops are either 3 or 4 days. 5: Capture the Light and Color of New England will emphasize time for careful study of the relationship between the natural environment, light, color and simple country architecture, which may effectively lead to paintings or photographs with insight and emotional value.

◯ ◑ ● NIKON SCHOOL DIGITAL SLR PHOTOGRAPHY

1300 Walt Whitman Rd., Melville NY 11747. (631)547-8666. **Fax:** (631)547-0309. **E-mail:** nikonschool@nikon.net. **Website:** www.nikonschool.com. Weekend seminars traveling to 30 major U.S. cities 9:30–4:30; lunch is included; no camera equipment is required. Intro to Digital SLR Photography—Cost: $129; those new to digital SLR photography or those coming back after many years away. Expect a good understanding of the basics of photography, terminology, techniques and solutions for specific challenges allowing you to unleash your creative potential. Next Steps—Cost: $159; for experienced digital SLR photographers and those comfortable with the basics of digital photography and key camera controls. Take your digital photography to a higher level creatively and technically.

◑ ● NORTHERN EXPOSURES

5129 Evergreen Way #D383, Everett WA 98203. (425)347-7650. **E-mail:** abenteuerbc@yahoo.com. **Contact:** Linda Moore, director. Offers 3- to 8-day intermediate to advanced nature photography workshops in several locations in Pacific Northwest and western Canada; spectacular settings including coast, alpine, badlands, desert and rain forest. Also, 1- to 2-week Canadian Wildlife and Wildlands Photo Adventures and nature photo tours to extraordinary remote wildlands of British Columbia, Alberta, Saskatchewan and Yukon.

◯ ◑ ● NYU TISCH SCHOOL OF THE ARTS

Department of Photography & Imaging, 721 Broadway, 8th Floor, New York NY 10003. (212)998-1930. **E-mail:** photo.tsoa@nyu.edu. **Website:** www.photo.tisch.nyu.edu. **Contact:** Department of Photography and Imaging. Summer classes offered for credit and noncredit covering digital imaging, career development, basic to advanced photography, darkroom tech-

niques, photojournalism, and human rights & photography. Open to all skill levels.

◯ ◑ ● OREGON COLLEGE OF ART AND CRAFT

8245 SW Barnes Rd., Portland OR 97225. (503)297-5544 or (800)390-0632. **Fax:** (503)297-9651. **E-mail:** admissions@ocac.edu. **E-mail:** lradford@ocac.edu. **Website:** www.ocac.edu. Offers workshops and classes in photography, book arts, drawing & painting, fiber, wood, metal and ceramics. Also offers MFA in craft and design. For schedule information, call or visit website.

◯ ◑ ● OTTER CREEK PHOTOGRAPHY

(304)478-3586. **E-mail:** ottercreekphotography@yahoo.com. **Contact:** John Warner. Intensive week-long, hands-on workshops held throughout the year in the most visually rich, and safest, regions of Mexico. Photograph snow-capped volcanoes, thundering waterfalls, pre-Columbian ruins, botanical gardens, vibrant street life, fascinating people, markets and colonial churches in jungle, mountain, desert and alpine environments. Photographers should call or e-mail for more information.

◯ ◑ ● PACIFIC NORTHWEST ART SCHOOL/PHOTOGRAPHY

15 NW Birch St., Coupeville WA 98239. (360)678-3396. **E-mail:** info@pacificnorthwestartschool.org. **Website:** www.pacificnorthwestartschool.org. **Contact:** Registrar. "Join us on beautiful Whidbey Island and enjoy high-quality photography instruction from our renowned visiting faculty including Sam Abell, Keith Carter, Arthur Meyerson and many more. Workshops held April-October, 2-6 days in duration.

◯ ◑ ● PALM BEACH PHOTOGRAPHIC CENTRE

415 Clematis St., West Palm Beach FL 33401. (561)253-2600. **Fax:** (561)253-2604. **E-mail:** info@workshop.org. **Website:** www.workshop.org. The center is an innovative learning facility offering 1- to 5-day seminars in photography and digital imaging year round. Also offered are travel workshops to cultural destinations such as South Africa, Bhutan, Myanmar, Peru, and India. Emphasis is on photographing the indigenous cultures of each country. Also hosts the annual Fotofusion event (see separate listing in this section). Photographers should call for details.

○ ◑ ● RALPH PAONESSA PHOTOGRAPHY WORKSHOPS

509 W. Ward Ave., Suite B-108, Ridgecrest CA 93555-2542. (760)384-8666. **E-mail:** ralph@rpphoto.com. **Website:** www.rpphoto.com. **Contact:** Ralph Paonessa, director. Various workshops repeated annually. Nature, bird and landscape trips to the Eastern Sierra, Death Valley, Falkland Islands, Alaska, Costa Rica, Ecuador, and many other locations. Open to all skill levels. Upcoming workshop: "Ecuador Hummingbirds," September 23-October 6 in Quito. See website for more information.

○ ◑ ● PETERS VALLEY CRAFT CENTER

19 Kuhn Rd., Layton NJ 07851. (973)948-5200. **Fax:** (973)948-0011. **E-mail:** info@petersvalley.org. **Website:** www.petersvalley.org. Offers workshops May, June, July, August and September; 3-6 days long. Offers instruction by talented photographers in a wide range of photographic disciplines—from daguerrotypes to digital and everything in between. Also offers classes in blacksmithing/metals, ceramics, fibers, fine metals, weaving and woodworking. Located in northwest New Jersey in the Delaware Water Gap National Recreation Area, 70 miles west of New York City. Artists and photographers should call for catalog or visit website or more information.

○ ◑ ● PHOTO EXPLORER TOURS

2506 Country Village, Ann Arbor MI 48103-6500. (800)315-4462 or (734)996-1440. **E-mail:** decoxphoto@gmail.com. **Website:** www.photoexplorertours.com. **Contact:** Dennis Cox, director. Photographic explorations of China, southern Africa, India, Turkey, Indonesia, Morocco, Burma, Iceland, Croatia, Bhutan, and Vietnam. "Founded in 1981 as China Photo Workshop Tours by award-winning travel photographer and China specialist Dennis Cox, Photo Explorer Tours has expanded its tours program since 1996. Working directly with carefully selected tour companies at each destination who understand the special needs of photographers, we keep our groups small (usually 5-16 photographers) to ensure maximum flexibility for both planned and spontaneous photo opportunities." On most tours, individual instruction is available from professional photographer leading tour. Open to all skill levels. Photographers should write, call or e-mail for more information.

○ ◑ ● PHOTOGRAPHERS' FORMULARY

P.O. Box 950, 7079 Hwy 83 N, Condon MT 59826-0950. (800)922-5255. **Fax:** (406)754-2896. **E-mail:** lynnw@blackfoot.net; formulary@blackfoot.net. **Website:** www.photoformulary.com; www.workshopsinmt.com. **Contact:** Lynn Wilson, workshop program director. Photographers' Formulary workshops include a wide variety of alternative processes, and many focus on the traditional darkroom. Located in Montana's Swan Valley, some of the best wilderness lands in the Rocky Mountains. See website for details on costs and lodging. Open to all skill levels. Workshops held frequently throughout the year. See website for listing of dates and registration.

○ ◑ PHOTOGRAPHIC ARTS WORKSHOPS

P.O. Box 1791, Granite Falls WA 98252. (360)691-4105. **Fax:** (360)691-4105. **E-mail:** PhotoArtsWrkshps@aol.com. **E-mail:** barnbaum@aol.com. **Website:** www.barnbaum.com. **Contact:** Bruce Barnbaum. Offers a wide range of workshops across the U.S., Latin America and Europe. Instructors include masters of both traditional and digital imagery. Workshops feature instruction in the understanding and use of light, composition, exposure, development, printing, photographic goals and philosophy. All workshops include reviews of student portfolios. Sessions are intense but highly enjoyable, held in field, darkroom and classroom with outstanding photographer/instructors. Ratio of students to instructors is always 8:1 or fewer, with detailed attention to problems students want solved. All camera formats, color and b&w. The deposit for each workshop is $150, except the Escalante backpack, which is $200. Final payment is requested 5 weeks prior to the start of the workshop. The deposit is non-refundable. If a workshop is cancelled for any reason, your deposit will be returned in full. Upcoming workshops: October 16-21, "Autumn Complete Photographic Process Workshop" (Granite Falls, Washington), Cost: $1,125 (includes complete lab fees); November 13-19, "The High Sierra to Death Valley: The Highs and Lows of the American West," Cost: $1,125. See website for more information and registration.

PHOTOGRAPHIC CENTER NORTHWEST

900 12th Ave., Seattle WA 98122. (206)720-7222. **E-mail:** pcnw@pcnw.org; jbrendicke@pcnw.org. **Web-**

site: www.pcnw.org. **Contact:** Rafael Soldi, marketing director. Frequent day and evening classes and workshops in fine art photography (b&w, color, digital) for photographers of all skill levels; accredited certificate program. See website for more information and a listing of upcoming workshops. We also have a renowned photography gallery, photographic rental facilities for the public and professionals, and artist support programs.

PHOTOGRAPHY AT THE SUMMIT: JACKSON HOLE

Rich Clarkson & Associates, LLC, 1099 18th St., Suite 2840, Denver CO 80202. (303)295-7770 or (800)745-3211. **Fax:** (303)295-7771. **E-mail:** info@richclarkson.com; bwilhelm@richclarkson.com. **Website:** www.photographyatthesummit.com. **Contact:** Brett Wilhelm, administrator. Annual workshops held in spring (May) and fall (October). Weeklong workshops with top journalistic, nature and illustrative photographers and editors. See website for more information.

PHOTOGRAPHY IN PROVENCE

La Chambre Claire, Rue du Buis, Ansouis 84240, France. **E-mail:** andrew.squires@photography-provence.com. **Website:** www.photography-provence.com. **Contact:** Andrew Squires, M.A. Workshops May to October. Theme: What to Photograph and Why? Designed for people who are looking for a subject and an approach they can call their own. Explore photography of the real world, the universe of human imagination, or simply let yourself discover what touches you. Explore Provence and photograph on location. Possibility to extend your stay and explore Provence if arranged in advance. Open to all skill levels. E-mail for workshop dates and more information.

PRAGUE SUMMER SEMINARS

Division of International Education, 2000 Lakeshore Dr., ED 120, University of New Orleans, New Orleans LA 70148. (504)280-6388. **E-mail:** prague@uno.edu. **Website:** inst.uno.edu/Prague. **Contact:** Mary I. Hicks, program director. Challenging courses which involve studio visits, culture series, excursions within Prague and field trips to Vienna, Austria, and Cesky Krumlov, Bohemia. Open to beginners and intermediate photographers. Photographers should call, e-mail or see website for more information.

PROFESSIONAL PHOTOGRAPHER'S SOCIETY OF NEW YORK STATE PHOTO WORKSHOPS

2175 Stuyvesant St., Niskayuna NY 12309. (518)377-5935. **E-mail:** tmack1@nycap.rr.com; linda@ppsnysworkshop.com. **Website:** www.ppsnysworkshop.com. **Contact:** Tom Mack, director. Weeklong, specialized, hands-on workshops for professional photographers in mid-July. See website for more information.

PYRENEES EXPOSURES

Laroque des Albères, Pyrénées-Orientales , France. **E-mail:** explorerimages@yahoo.com. **Website:** www.explorerimages.com. **Contact:** Martin N. Johansen, director. Workshops held year-round. Offers 1- to 7-day workshops and photo expeditions in northern Catalonia (Spain & France) the Pyrenees mountains and Corsica island, with emphasis on landscapes, wildlife and culture. Workshops and tours are limited to small groups. Open to all skill levels. Photographers should e-mail or see website for more information.

JEFFREY RICH WILDLIFE PHOTOGRAPHY TOURS

P.O. Box 66, Millville CA 96062. (530)410-8428. **E-mail:** jrich@jeffrichphoto.com. **Website:** www.jeffrichphoto.com. **Contact:** Jeffrey Rich. Estab. 1990. Leading wildlife photo tours in Alaska and western U.S.—bald eagles, whales, birds, Montana babies and predators, Brazil's Pantanal, Borneo, and Japan's winter wildlife. Photographers should call or e-mail for brochure.

ROCKY MOUNTAIN FIELD SEMINARS

1895 Fall River Rd., Estes Park CO 80517. (970)586-3262. **E-mail:** fieldseminars@rmna.org. **E-mail:** rachel.balduzzi@rmna.org. **Website:** www.rmna.org. Rachel Balduzzi, field seminar director and NGF manager. **Contact:** Seminar coordinator. Day and weekend seminars covering photographic techniques for wildlife and scenics in Rocky Mountain National Park. Professional instructors include W. Perry Conway, Don Mammoser, Glenn Randall, Eli Vega and Lee Kline. Call or e-mail for a free seminar catalog listing over 200 seminars.

ROCKY MOUNTAIN SCHOOL OF PHOTOGRAPHY

216 N. Higgins, Missoula MT 59802. (406)543-0171 or (800)394-7677. **Fax:** (406)721-9133. **E-mail:** rmsp@

rmsp.com. **Website:** www.rmsp.com. "RMSP offers three types of photography programs: Career Training, Workshops and Photo Weekend events. There are varied learning opportunities for students according to their individual goals and educational needs. In a non-competitive learning environment, we strive to instill confidence, foster creativity and build technical skills."

SAN FRANCISCO PHOTO SAFARIS

(415)891-7092. **E-mail:** info@sanfranphotosafaris.com. **Website:** www.sanfranphotosafaris.com. gary@photosafarinetwork.com. **Contact:** Gary Gullett, president. "Local travel photography workshops are held daily in convenient locations in San Francisco. These are hands-on workshops with participants learning the creative camera controls and concepts of photography in an easy-to-understand language. There are also regional, national and worldwide safaris for the more adventurous. Extreme photography opportunities include adventures such as mountain climbing or scuba diving, all in great photographic venues." See the website for more details. Open to all skill levels and types of cameras (film or digital).

○ ◑ ● **SANTA FE PHOTOGRAPHIC WORKSHOPS**

P.O. Box 9916, Santa Fe NM 87504-5916. (505)983-1400. **Fax:** (505)989-8604. **E-mail:** info@santafeworkshops.com. **E-mail:** carrie@santafeworkshops.com. **Website:** www.santafeworkshops.com. Over 120 week-long workshops encompassing all levels of photography and more than 35 digital lab workshops and 12 week-long workshops in Mexico—all led by top professional photographers. The workshops campus is located near the historic center of Santa Fe. Call or e-mail to request a free catalog.

○ ◑ ● **SELLING YOUR PHOTOGRAPHY**

1684 Decoto Rd. #271, Union City CA 94587. (714) 356-4260. **E-mail:** maria@mpiscopo.com. **Website:** www.mpiscopo.com. **Contact:** Maria Piscopo. One-day workshops cover techniques for pricing, marketing and selling art and photography services. Open to photographers and creative professionals of all skill levels. See website for dates and locations. Maria Piscopo is the author of *Photographer's Guide to Marketing & Self-Promotion*, 4th edition (Allworth Press).

◐ ● **SELLPHOTOS.COM**

Pine Lake Farm, 1910 35th Rd., Osceola WI 54020. (715)248-3800, ext. 21. **Fax:** (715)248-3800. **E-mail:** psi2@photosource.com; info@photosource.com. **Website:** www.sellphotos.com; www.photosource.com. **Contact:** Rohn Engh. Offers half-day workshops in major cities. Marketing critique of attendees' photographs follows seminar.

◐ ● **JOHN SEXTON PHOTOGRAPHY WORKSHOPS**

P.O. Box 30, Carmel Valley CA 93924. (831)659-3130. **Fax:** (831)659-5509. **E-mail:** info@johnsexton.com. **Website:** www.johnsexton.com. Director: John Sexton. **Contact:** Laura Bayless, administrative assistant. Offers a selection of intensive workshops with master photographers in scenic locations throughout the U.S. All workshops offer a combination of instruction in the aesthetic and technical considerations involved in making expressive b&w prints. Instructors include John Sexton, Charles Cramer, Ray McSavaney, Anne Larsen and others.

○ ◐ **THE SHOWCASE SCHOOL OF PHOTOGRAPHY**

1135 Sheridan Road, Atlanta GA 30324. (404)965-2205. **E-mail:** staff@theshowcaseschool.com. **E-mail:** jan@theshowcaseschool.com. **Website:** www.theshowcaseschool.com. Offers photography classes to the general public, including beginning digital camera, people photography, nature photography and Photoshop. Open to beginner and intermediate amateur photographers. Classes offered frequently throughout the year; see website for upcoming dates.

○ ○ ◐ ● **SINGING SANDS WORKSHOPS**

207 Millbank, London ON N6C 4V1, Canada. (519)984-6329. **E-mail:** donmartelca@yahoo.ca. **Website:** www.singingsandsworkshops.com. Digital photography workshops. Semiannual workshops held in June and October. Creative photo techniques in the rugged coastline of Georgian Bay and the flats of Lake Huron taught by Don Martel. Open to all skill levels. Photographers should send SASE call, e-mail or see website for more information.

◐ **SKELLIG PHOTO TOURS**

00353 66 9479022. **E-mail:** michaelherrmann@email.de. **Website:** www.skelligphototours.com. **Contact:** Michael Herrmann. Several held throughout the year

and on demand. Learn new, or improve, your photography skills through landscape photography, exposure, composition, low-light photography. A variety of technical and artistic aspects of photography will be covered according to your needs; Also photo editing in Photoshop and Lightroom. Open to all skill levels. Photographers should call, e-mail or see website for more information.

SOHN FINE ART—MASTER ARTIST WORKSHOPS

6 Elm Street, 1B-C, Stockbridge MA 01230. (413)298-1025. **E-mail:** info@sohnfineart.com. **Website:** www.sohnfineart.com. **Contact:** Cassandra Sohn, owner. Workshops held every 1-3 months, usually during the artist's exhibition at our gallery. Most workshops relate to the current exhibition. Cost $100-500 depending on the workshop (meals and lodging not included). Frequent areas of concentration are unique workshops within the photographic field. This includes all levels of students: beginner, intermediate and advanced, as well as Photoshop courses, alternative process courses and many varieties of traditional and digital photography courses. Interested parties should call, e-mail, or see the website for more information.

◐ ◑ ● SOUTH SHORE ART CENTER

119 Ripley Rd., Cohasset MA 02025. (781)383-2787. **Fax:** (781)383-2964. **E-mail:** info@ssac.org. **Website:** www.ssac.org. South Shore Art Center is a nonprofit organization based in the coastal area south of Boston. The facility features appealing galleries and teaching studios. Offers exhibitions and gallery programs, sales of fine art and studio crafts, courses and workshops, school outreach and special events. See website for more information and a list of upcoming workshops and events.

◑ ● SPORTS PHOTOGRAPHY WORKSHOP: COLORADO SPRINGS, COLORADO

Rich Clarkson & Associates, 1099 18th St., Suite 2840, Denver CO 80202. (303)295-7770 or (800)745-3211. **Fax:** (303)295-7771. **E-mail:** info@richclarkson.com. **E-mail:** bwilhelm@richclarkson.com. **Website:** www.sportsphotographyworkshop.com. **Contact:** Brett Wilhelm, administrator. Annual workshop held in June. Weeklong workshop in sports photography at the U.S. Olympic Training Center with *Sports Illustrated* and Associated Press photographers and editors. See website for more information.

◐ ◑ ● SUMMIT PHOTOGRAPHIC WORKSHOPS

P.O. Box 67459, Scotts Valley CA 95067. **E-mail:** summitphotographic@gmail.com. **Website:** www.summitphotographic.com. **Contact:** Allen Kuhlow and Barbara Brundege, owners. Offers several workshops per year, including nature and landscape photography; wildlife photography classes; photo tours from 5 days to 3 weeks. Open to all skill levels. Photographers should see website for more information and a listing of upcoming workshops.

◑ ● SUPERIOR/GUNFLINT PHOTOGRAPHY WORKSHOPS

P.O. Box 19286, Minneapolis MN 55419. (612)824-2999. **E-mail:** lk@laynekennedy.com. **Website:** www.laynekennedy.com. **Contact:** Layne Kennedy, director. Lodging and meals for North Shore session are paid for by participants. Offers wilderness adventure photo workshops 3 times/year. Winter session includes driving your own dogsled team in northeastern Minnesota. Summer sessions include kayaking/camping trip in the Apostle Islands with first and last nights in lodges, and a new session along Minnesota's North Shore, at the famed North House Folk School, covering Lake Superior's north shore. All trips professionally guided. Workshops stress how to shoot effective and marketable magazine photos in a storytelling format. Photographers should call, e-mail or see website for more information and a list of upcoming workshops.

◐ ◑ ● SYNERGISTIC VISIONS WORKSHOPS

2435 E. Piazza Ct., Grand Junction CO 81506. (970)245-6700. **Fax:** (970)245-6700. **E-mail:** steve@synvis.com. **Website:** www.synvis.com. **Contact:** Steve Traudt, director. Offers a variety of digital photography and Photoshop classes at various venues in Grand Junction, Moab, Ouray, and others. "Steve is also available to present day-long photo seminars to your group." See website for more information and upcoming workshops.

◐ ◑ ● TEXAS SCHOOL OF PROFESSIONAL PHOTOGRAPHY

(979)272-5200; (806)296-2276. **Fax:** (979)272-5201. **E-mail:** don@texasschool.org. **Website:** texasschool.org/index.html. **Contact:** Don Dickson, director. Twenty-five different classes offered, including portrait, wedding, marketing, background painting and

video. See website for more information and a list of upcoming workshops.

○ ◐ ● TRAVEL IMAGES

P.O. Box 2434, Eagle ID 83616. (800)325-8320. E-mail: phototours@travelimages.com. Website: www.travelimages.com. Contact: John Baker, owner/guide. Small-group photo tours. Locations include U.S., Canada, Wales, Scotland, Ireland, England, New Zealand, Tasmania, Galapagos Islands, Machu Picchu, Patagonia, Provence, Tuscany, Cinque Terre, Venice, Austria, Switzerland, Germany and polar bears of Manitoba.

⊕ TRIPLE D GAME FARM

P.O. Box 5072, Kalispell MT 59903. (406)755-9653. Fax: (406)755-9021. E-mail: info@tripledgamefarm. com. Website: www.tripledgamefarm.com. Contact: Kathleen O'Neil, assistant manager. We raise wildlife and train our species for photographers, artists, and cinema. Wolves, bears, mountain lions, bobcats, lynx, tigers, snow leopards, coyotes, fox, fisher, otter, porcupine and more are available. Open to all skill levels. Interested parties should write, call, e-mail, or see website for more information.

○ ◐ ● JOSEPH VAN OS PHOTO SAFARIS INC.

P.O. Box 655, Vashon Island WA 98070. (206)463-5383. Fax: (206)463-5484. E-mail: info@photosafaris.com. Website: www.photosafaris.com. Contact: Joseph Van Os, director. Offers over 50 different photo tours and workshops worldwide. At least 1 tour offered each month; several 2014 tours already planned. See website for more details and a list of all upcoming tours.

○ ◐ ● VIRGINIA CENTER FOR THE CREATIVE ARTS

154 San Angelo Dr., Amherst VA 24521. (434)946-7236. Fax: (434)946-7239. E-mail: vcca@vcca.com. Website: www.vcca.com. VCCA (Virginia Center for the Creative Arts) is an international working retreat for writers, artists and composers. Nestled on 450 acres in the foothills of the Blue Ridge Mountains of central Virginia, VCCA offers residential fellowships ranging from 2 weeks to 2 months. VCCA can accommodate 25 fellows at a time and provides private working and living quarters and all meals. There is one fully equipped b&w darkroom at VCCA. Artists provide their own materials. VCCA application and work samples required. Call or see website for more information. Application deadlines are January 15, May 15, and September 15 each year.

○ ◐ ● VISION QUEST PHOTO WORKSHOPS

2370 Hendon Ave., St. Paul MN 55108-1453. (651)644-1400. Fax: (651)644-2122. E-mail: info@douglasbeasley.com. Website: www.vqphoto.com. Contact: Doug Beasley, director. Annual workshops held January through November. Hands-on photo workshops that emphasize content, vision and creativity over technique or gimmicks. Workshops held in a variety of national and international locations. Open to all skill levels. Upcoming workshops: Zen and the Art of Photography in Rockport ME; Breitenbush Hot Springs OR; Woodstock NY; Renewing Your Creative Spirit, Trade River Retreat Center WI. Photographers should e-mail or visit website for more information.

◐ ● VISUAL ARTISTRY WORKSHOP SERIES

P.O. Box 963, Eldersburg MD 21784. (410)552-4664. Fax: (410)552-3332. E-mail: tony@tonysweet.com. Website: tonysweet.com. Contact: Tony Sweet or Susan Milestone, susan@tonysweet.com. 5-day workshops, limit 5-10 participants. Extensive personal attention and instructional slide shows. Post-workshop support and image critiques for 6 months after the workshop (for an additional fee). Frequent attendees discounts and inclement weather discounts on subsequent workshops. Dealer discounts available from major vendors. "The emphasis is to create in the participant a greater awareness of composition, subject selection, and artistic rendering of the natural world using the raw materials of nature: color, form and line." Open to intermediate and advanced photographers. See website for more information.

○ ◐ ● WILDLIFE PHOTOGRAPHY WORKSHOPS AND LECTURES

Len Rue Enterprises, LLC, 138 Millbrook Rd., Blairstown NJ 07825. (908)362-6616. E-mail: rue@rue.com. Website: www.rue.com; www.rueimages.com. Contact: Len Rue, Jr. Taught by Len Rue, Jr., who has over 35 years experience in outdoor photography by shooting photographic stock for the publishing industry. Also leads tours and teaches photography.

○ ◐ ● **WILD PHOTO ADVENTURES TV SHOW**

2035 Buchanan Rd., Manning SC 29102. (803)460-7705. **E-mail:** doug@totallyoutdoorsimaging.com. **Website:** www.wildphotoadventures.com. **Contact:** Doug Gardner, host/photographer/cinematographer. "Wild Photo Adventures is the only wildlife and nature photography television show of its kind to ever be aired. Join us each week as we travel around the globe to great locations to photograph wildlife, its behavior and its environment. Each week, we will show you where to go, how to find wild subjects and how to photograph them in new and creative ways. *Wild Photo Adventures* delivers exciting and educational entertainment for anyone who has a love for the great outdoors or photography. Tag along with host Doug Gardner through adverse conditions and terrain in search of that one great photograph. Take a look behind the scenes at what it takes to be a professional nature photographer. Learn new tips and techniques that will bring life back into your photographs. Contact your local PBS station for air dates/times, or watch all the episodes online at www.wildphotoadventures.com/watchshow.html."

◐ ● **ROBERT WINSLOW PHOTO INC.**

P.O. Box 334, Durango CO 81302-0334. (970)259-4143. **E-mail:** rwinslow@mydurango.net. **Website:** www.robertwinslowphoto.com. **Contact:** Robert Winslow, president. "We arrange and lead custom wildlife and natural history photo tours to East Africa and other destinations around the world." See website for more information.

○ ◐ ● **WORKING WITH ARTISTS**

(303)837-1341. **E-mail:** stephanie@cpacphoto.org. **E-mail:** info@cpacphoto.org. **Website:** www.cpacphoto.org. Offers monthly workshops on Photoshop, digital, alternative process, portraiture, landscape, creativity, studio lighting and more. Open to all skill levels. They also have a gallery with changing juried photo exhibits. Photographers should call, e-mail, see website for more information and a list of upcoming workshops.

THE HELENE WURLITZER FOUNDATION

P.O. Box 1891, Taos NM 87571. (575)758-2413. **Fax:** (575)758-2559. **E-mail:** hwf@taosnet.com. **Website:** www.wurlitzerfoundation.org. **Contact:** Michael A. Knight, executive director. Estab. 1953. The foundation offers residencies to artists in the creative fields-visual, literary and music composition. There are 3 12-week sessions from mid-January through November annually. Application deadline: January 18 for following year. For application, request by e-mail or visit website to download.

◐ ● **YADDO**

The Corporation of Yaddo Residencies, Box 395, 312 Union Ave., Saratoga Springs NY 12866-0395. (518)584-0746. **Fax:** (518)584-1312. **E-mail:** chwait@yaddo.org; lleduc@yaddo.org. **Website:** www.yaddo.org. **Contact:** Candace Wait, program director. Estab. 1900. Two seasons: large season is May-August; small season is October-May (stays from 2 weeks to 2 months; average stay is 5 weeks). Accepts 230 artists/year. Accommodates approximately 35 artists in large season. Those qualified for invitations to Yaddo are highly qualified writers, visual artists (including photographers), composers, choreographers, performance artists and film and video artists who are working at the professional level in their fields. Artists who wish to work collaboratively are encouraged to apply. An abiding principle at Yaddo is that applications for residencies are judged on the quality of the artists' work and professional promise. Site includes four small lakes, a rose garden, woodland, swimming pool, tennis courts. Yaddo's non-refundable application fee is $30, to which is added a fee for media uploads ranging from $5-10 depending on the discipline. Application fees must be paid by credit card. Two letters of recommendation are requested. Applications are considered by the Admissions Committee and invitations are issued by March 15 (deadline: January 1) and October 1 (deadline: August 1). Information available on website.

○ ◐ ● **YELLOWSTONE ASSOCIATION INSTITUTE**

P.O. Box 117, Yellowstone National Park WY 82190. (406)848-2400. **Fax:** (406)848-2847. **E-mail:** Registrar@yellowstoneassociation.org. **Website:** www.yellowstoneassociation.org. Offers workshops in nature and wildlife photography during the summer, fall and winter. Custom courses can be arranged. Photographers should see website for more information.

○ ◐ ● **YOSEMITE OUTDOOR ADVENTURES**

P.O. Box 230, El Portal CA 95318. (209)379-2646. **Fax:** (209)379-2486. **E-mail:** info@yosemiteconservancy.org. **E-mail:** kchappell@yosemiteconservancy.

org. **Website:** www.yosemiteconservancy.org. Offers workshops of 12-20 people in Yosemite National Park in outdoor field photography and natural history year round. Photographers should see website for more information and a list of upcoming workshops.

STOCK PHOTOGRAPHY PORTALS

These sites market and distribute images from multiple agencies and photographers.

AGPix www.agpix.com
Alamy www.alamy.com
Digital Railroad www.digitalrailroad.net
Find a Photographer www.asmp.org/find-a-photographer
Independent Photography Network (IPNStock) www.ipnstock.com
PhotoServe www.pdnonline.com/PhotoServe328.shtml
PhotoSource International www.photosource.com
Shutterpoint Photography www.shutterpoint.com
Veer www.veer.com
Workbook Stock www.workbook.com

PORTFOLIO REVIEW EVENTS

Portfolio review events provide photographers the opportunity to show their work to a variety of photo buyers, including photo editors, publishers, art directors, gallery representatives, curators, and collectors.

Art Director's Club, International Annual Awards Exhibition, New York City, www.adc global.org

Atlanta Celebrates Photography, held annually in October, Atlanta GA, www.acpinfo. org

Center for Photography at Woodstock, New York City, www.cpw.org

Festival of Light International Directory of Photography Festivals, an international collaboration of twenty photography festivals, www.festivaloflight.net

Fotofest, March, biennial—held in even-numbered years, Houston TX, www.fotofest.org

Fotofusion, January, West Palm Beach FL, www.fotofusion.org

North American Nature Photographers Association, annual summit held in January. Location varies. www.nanpa.org

Photo LA, January, Los Angeles CA, www.photola.com

Photolucida, March, biennial—held in odd-numbered years, Portland OR, www.photo lucida.org

The Print Center, events held throughout the year, Philadelphia PA, www.printcenter.org

Review Santa Fe, July, the only juried portfolio review event, Santa Fe NM, visitcenter.org

Society for Photographic Education National Conference, March, different location each year, www.spenational.org

GRANTS

State, Provincial & Regional

//

Arts councils in the United States and Canada provide assistance to artists (including photographers) in the form of fellowships or grants. These grants can be substantial and confer prestige upon recipients; however, only state or province residents are eligible. Because deadlines and available support vary annually, query first (with a SASE) or check websites for guidelines.

UNITED STATES ARTS AGENCIES

Alabama State Council on the Arts, 201 Monroe St., Montgomery AL 36130-1800. (334)242-4076. E-mail: staff@arts.alabama.gov. Website: www.arts.state.al.us.

Alaska State Council on the Arts, 161 S. Klevin St., Suite 102, Anchorage AK 99508-1506. (907)269-6610 or (888)278-7424. E-mail: aksca.info@alaska.gov. Website: www.eed.state.ak.us/aksca.

Arizona Commission on the Arts, 417 W. Roosevelt St., Phoenix AZ 85003-1326. (602)771-6501. E-mail: info@azarts.gov. Website: www.azarts.gov.

Arkansas Arts Council, 1500 Tower Bldg., 323 Center St., Little Rock AR 72201-2606. (501)324-9766. E-mail: info@arkansasarts.com. Website: www.arkansasarts.org.

California Arts Council, 1300 I St., Suite 930, Sacramento CA 95814. (916)322-6555 or (800)201-6201. E-mail: info@cac.ca.gov. Website: www.cac.ca.gov.

Colorado Creative Industries, 1625 Broadway, Suite 2700, Denver CO 80202. (303)892-3802. E-mail: online form. Website: www.coloradocreativeindustries.org.

Connecticut Commission on Culture & Tourism, One Constitution Plaza, 2nd Floor, Hartford CT 06103. (860)256-2800. Website: www.cultureandtourism.org.

Delaware Division of the Arts, Carvel State Office Bldg., 4th Floor, 820 N. French St., Wilmington DE 19801. (302)577-8278 (New Castle County) or (302)739-5304 (Kent or Sussex Counties). E-mail: delarts@state.de.us. Website: www.artsdel.org.

District of Columbia Commission on the Arts & Humanities, 200 I St., Washington DC 20003. (202)724-5613. E-mail: cah@dc.gov. Website: www.dcarts.dc.gov.

Florida Division of Cultural Affairs, R.A. Gray Building, 3rd Floor, 500 S. Bronough St., Tallahassee FL 32399-0250. (850)245-6470. E-mail: info@florida-arts.org. Website: www.florida-arts.org.

Georgia Council for the Arts, 75 Fifth St., Suite 1200, Atlanta GA 30308. (404)685-2787. E-mail: gaarts@gaarts.org. Website: www.gaarts.org.

Guam Council on the Arts & Humanities, P.O. Box 2950, Hagatna, Guam 96932. (671)300-1204/1205/1206/1207/1208. E-mail: info@guamcaha.org. Website: www.guamcaha.org.

Hawai'i State Foundation on Culture & the Arts, 250 S. Hotel St., 2nd Floor, Honolulu HI 96813. (808)586-0300. E-mail: vivien.lee@hawaii.gov. Website: www.state.hi.us/sfca.

Idaho Commission on the Arts, P.O. Box 83720, Boise ID 83720-0008. (208)334-2119 or (800)278-3863. E-mail: info@arts.idaho.gov. Website: www.arts.idaho.gov.

Illinois Arts Council, James R. Thompson Center, 100 W. Randolph, Suite 10-500, Chicago IL 60601-3230. (312)814-6750 or (800)237-6994. E-mail: iac.info@illinois.gov. Website: www.arts.illinois.gov.

Indiana Arts Commission, 100 N. Senate Ave., Room N505, Indianapolis IN 46204. (317)232-1268. E-mail: IndianaArtsCommission@iac.in.gov. Website: www.in.gov/arts.

Iowa Arts Council, 600 E. Locust, Des Moines IA 50319-0290. (515)242-6194. Website: www.iowaartscouncil.org.

Kansas Arts Commission, 1000 Jackson St., Suite 100, Topeka KS 66612. (785)296-3335 or (866)433-0688. E-mail: kac@arts.ks.gov. Website: arts.ks.gov.

Kentucky Arts Council, Capital Plaza Tower, 21st Floor, 500 Mero St., Frankfort KY 40601-1987. (502)564-3757 or (888)833-2787. E-mail: kyarts@ky.gov. Website: www.artscouncil.ky.gov.

Louisiana Division of the Arts, P.O. Box 44247, Baton Rouge LA 70804-4247. (225)342-8180. E-mail: arts@crt.la.us. Website: www.crt.state.la.us/arts.

Maine Arts Commission, 193 State St., 25 State House Station, Augusta ME 04333-0025. (207)287-2724. E-mail: MaineArts.info@maine.gov. Website: mainearts.maine.gov.

Maryland State Arts Council, 175 W. Ostend St., Suite E, Baltimore MD 21230. (410)767-6555. E-mail: msac@msac.org. Website: www.msac.org.

Massachusetts Cultural Council, 10 St. James Ave., 3rd Floor, Boston MA 02116-3803. (617)727-3668. E-mail: mcc@art.state.ma.us. Website: www.massculturalcouncil. org.

Michigan Council for Arts & Cultural Affairs, 300 N. Washington Square, Lansing MI 48913. (888)522-0103. E-mail: online form. Website: www.themedc.org/Arts.

Minnesota State Arts Board, Park Square Court, Suite 200, 400 Sibley St., St. Paul MN 55101-1928. (651)215-1600 or (800)866-2787. E-mail: msab@arts.state.mn.us. Website: www.arts.state.mn.us.

Mississippi Arts Commission, 501 N. West St., Suite 1101A, Woolfolk Bldg., Jackson MS 39201. (601)359-6030 or (800)582-2233. Website: www.arts.state.ms.us.

Missouri Arts Council, 815 Olive St., Suite 16, St. Louis MO 63101-1503. (314)340-6845 or (866)407-4752. E-mail: moarts@ded.mo.gov. Website: www.missouriartscouncil. org.

Montana Arts Council, P.O. Box 202201, Helena MT 59620-2201. (406)444-6430. E-mail: mac@mt.gov. Website: art.mt.gov.

National Assembly of State Arts Agencies, 1029 Vermont Ave. NW, 2nd Floor, Washington DC 20005. (202)347-6352. E-mail: nasaa@nasaa-arts.org. Website: www. nasaa-arts.org.

Nebraska Arts Council, 1004 Farnam St., Burlington Bldg., Plaza Level, Omaha NE 68102. (402)595-2122 or (800)341-4067. E-mail: nac.info@nebraska.gov. Website: www. nebraskaartscouncil.org.

Nevada Arts Council, 716 N. Carson St., Suite A, Carson City NV 89701. (775)687-6680. E-mail: infonvartscouncil@nevadaculture.org. Website: nac.nevadaculture.org.

New Hampshire State Council on the Arts, 19 Pillsbury St., 1st Floor, Concord NH 03301. (603)271-3584. Website: www.nh.gov/nharts.

New Jersey State Council on the Arts, 225 W. State St., 4th Floor, P.O. Box 306, Trenton NJ 08608. (609)292-6130. E-mail: online form. Website: www.njartscouncil.org.

New Mexico Arts, Bataan Memorial Building, 407 Galisteo St., Suite 270, Santa Fe NM 87501. (505)827-6490 or (800)879-4278. Website: www.nmarts.org.

New York State Council on the Arts, 300 Park Ave., 10th Floor, New York NY 10010. (212)459-8800. E-mail: info@arts.ny.gov. Website: www.nysca.org.

North Carolina Arts Council, 109 East Jones St., Cultural Resources Building, Raleigh NC 27601. (919)807-6500. E-mail: ncarts@ncdcr.gov. Website: www.ncarts.org.

North Dakota Council on the Arts, 1600 E. Century Ave., Suite 6, Bismarck ND 58503-0649. (701)328-7590. E-mail: comserv@nd.gov. Website: www.state.nd.us/arts.

Ohio Arts Council, 30 E. Broad St., 33rd Floor, Columbus OH 43215-3414. (614)466-2613. Website: www.oac.state.oh.us.

Oklahoma Arts Council, Jim Thorpe Building, 2101 N. Lincoln Blvd., Suite 640, Oklahoma City OK 73152-2001. (405)521-2931. E-mail: okarts@arts.ok.gov. Website: www.arts.ok.us.

Oregon Arts Commission, 775 Summer St. NE, Suite 200, Salem OR 97301-1280. (503)986-0082. E-mail: oregon.artscomm@state.or.us. Website: www.oregonartscommission.org.

Pennsylvania Council on the Arts, 216 Finance Bldg., Harrisburg PA 17120. (717)787-6883. Website: www.pacouncilonthearts.org.

Institute of Puerto Rican Culture, P.O. Box 9024184, San Juan, Puerto Rico 00902-4184. (787)724-0700. E-mail: webicp@icp.gobierno.pr. Website: www.icp.gobierno.pr.

Rhode Island State Council on the Arts, One Capitol Hill, 3rd Floor, Providence RI 02908. (401)222-3880. E-mail: info@arts.ri.gov. Website: www.arts.ri.gov.

American Samoa Arts Council, P.O. Box 1540, Pago Pago, American Samoa 96799. (684)731-6433. E-mail: cach@as.gov. Website: bit.ly/AmericanSamoaArtsCouncil.

South Carolina Arts Commission, 1026 Sumter St., Suite 200, Columbia SC 29201. (803)734-8696. E-mail: info@arts.sc.us. Website: www.southcarolinaarts.com.

South Dakota Arts Council, 711 E. Wells Ave., Pierre SD 57501-3369. (605)773-3301. E-mail: sdac@state.sd.us. Website: www.artscouncil.sd.gov.

Tennessee Arts Commission, 401 Charlotte Ave., Nashville TN 37243-0780. (615)741-1701. Website: www.arts.state.tn.us.

Texas Commission on the Arts, E.O. Thompson Office Bldg., 920 Colorado, Suite 501, Austin TX 78701. (512)463-5535. E-mail: front.desk@arts.state.tx.us. Website: www.arts.state.tx.us.

Utah Arts Council, 617 E. South Temple, Salt Lake City UT 84102-1177. (801)236-7555. Website: arts.utah.gov.

Vermont Arts Council, 136 State St., Montpelier VT 05633-6001. (802)828-3291. E-mail: online form. Website: www.vermontartscouncil.org.

Virgin Islands Council on the Arts, 5070 Norre Gade, Suite 1, St. Thomas, Virgin Islands 00802-6876. (340)774-5984. Website: vicouncilonarts.org.

Virginia Commission for the Arts, 1001 East Broad St., Richmond VA 23219. (804)225-3132. E-mail: arts@arts.virginia.gov. Website: www.arts.virginia.gov.

Washington State Arts Commission, 711 Capitol Way S., Suite 600, P.O. Box 42675, Olympia WA 98504-2675. (360)753-3860. E-mail: online form. Website: www.arts.wa.gov.

West Virginia Commission on the Arts, The Cultural Center, Capitol Complex, 1900 Kanawha Blvd. E., Charleston WV 25305-0300. (304)558-0220. Website: www.wvculture.org/arts.

Wisconsin Arts Board, 101 E. Wilson St., 1st Floor, Madison WI 53702. (608)266-0190. E-mail: artsboard@wisconsin.gov. Website: artsboard.wisconsin.gov.

Wyoming Arts Council, 2320 Capitol Ave., Cheyenne WY 82002. (307)777-7742. E-mail: online form. Website: wyoarts.state.wy.us.

CANADIAN PROVINCES ARTS AGENCIES

Alberta Foundation for the Arts, 10708 - 105 Ave., Edmonton AB T5H 0A1. (780)427-9968. Website: www.affta.ab.ca.

British Columbia Arts Council, P.O. Box 9819, Stn. Prov. Govt., Victoria BC V8W 9W3. (250)356-1718. E-mail: BCArtsCouncil@gov.bc.ca. Website: www.bcartscouncil.ca.

The Canada Council for the Arts, 350 Albert St., P.O. Box 1047, Ottawa ON K1P 5V8. (613)566-4414 or (800)263-5588 (within Canada). E-mail: online form. Website: www.canadacouncil.ca.

Manitoba Arts Council, 525-93 Lombard Ave., Winnipeg MB R3B 3B1. (204)945-2237 or (866)994-2787 (within Manitoba). E-mail: info@artscouncil.mb.ca. Website: www. artscouncil.mb.ca.

New Brunswick Arts Board (NBAB), 649 Queen St., Fredericton NB E3B 1C3. (506)444-4444 or (866)460-2787. E-mail: online form. Website: www.artsnb.ca.

Newfoundland & Labrador Arts Council, P.O. Box 98, St. John's NL A1C 5H5. (709)726-2212 or (866)726-2212 (within Newfoundland). E-mail: nlacmail@clac.ca. Website: www.nlac.nf.ca.

Nova Scotia Department of Communities, Culture, and Heritage, 1741 Brunswick St., 3rd Floor, P.O. Box 456, Stn. Central, Halifax NS B3J 2R5. (902)424-4510. E-mail: cch@gov.ns.ca. Website: www.gov.ns.ca/cch.

Ontario Arts Council, 151 Bloor St. W., 5th Floor, Toronto ON M5S 1T6. (416)961-1660 or (800)387-0058 (within Ontario). E-mail: info@arts.on.ca. Website: www.arts.on.ca.

Prince Edward Island Council of the Arts, 115 Richmond St., Charlottetown PE C1A 1H7. (902)368-4410 or (888)734-2784. E-mail: info@peica.ca. Website: www.peiartscouncil.com.

Québec Council for Arts & Literature, 79 boul. René-Lévesque Est, 3e étage, Québec QC G1R 5N5. (418)643-1707 or (800)897-1707. E-mail: info@calq.gouv.qc.ca. Website: www.calq.gouv.qc.ca.

The Saskatchewan Arts Board, 1355 Broad St., Regina SK S4P 7V1. (306)787-4056 or (800)667-7526 (within Saskatchewan). E-mail: info@artsboard.sk.ca. Website: www.artsboard.sk.ca.

Yukon Arts Section, Cultural Services Branch, Dept. of Tourism & Culture, Government of Yukon, Box 2703, Whitehorse YT Y1A 2C6. (867)667-8589 or (800)661-0408 (within Yukon). E-mail: arts@gov.yk.ca. Website: www.tc.gov.yk.ca/arts.html.

REGIONAL GRANTS & AWARDS

The following opportunities are arranged by state since most of them grant money to artists in a particular geographic region. Because deadlines vary annually, check websites or call for the most up-to-date information.

California

Flintridge Foundation Awards for Visual Artists, 236 W. Mountain St., Suite 106, Pasadena CA 91103. (626)449-0839 or (800)303-2139. Website: www.flintridge.org. For artists in California, Oregon, and Washington only.

James D. Phelan Art Awards, Kala Art Institute, Don Porcella, 1060 Heinz Ave., Berkeley CA 94710. (510)549-2977. Website: www.kala.org. For artists born in California only.

Connecticut

Martha Boschen Porter Fund, Inc., 145 White Hallow Rd., Sharon CT 06064. E-mail: grants@berkshiretaconic.org. For artists in northwestern Connecticut, western Massachusetts, and adjacent areas of New York (except New York City).

Idaho

Betty Bowen Memorial Award, c/o Seattle Art Museum 1300 First Ave., Seattle, WA 98101. (206)654-3131. E-mail: bettybowen@seattleartmuseum.org. Website: www.seattle artmuseum.org/bettybowen. For artists in Washington, Oregon and Idaho only.

Illinois

Illinois Arts Council, Individual Artists Support Initiative, James R. Thompson Center, 100 W. Randolph, Suite 10-500, Chicago IL 60601. (312)814-6750. E-mail: iac.info@ illinois.gov. Website: www.arts.illinois.gov/grants-programs/funding-programs/ individual-artist-support. For Illinois artists only.

Kentucky

Kentucky Foundation for Women Grants Program, 1215 Heyburn Bldg., 332 W. Broadway, Louisville KY 40202. (502)562-0045 or (866)654-7564. E-mail: team@kfw. org. Website: www.kfw.org/grants.html. For female artists living in Kentucky only.

Massachusetts

See **Martha Boschen Porter Fund, Inc.,** under Connecticut.

Minnesota

McKnight Artist Fellowships for Photographers, University of Minnesota Dept. of Art, Regis Center for Art, E-201, 405 21st Ave. S., Minneapolis MN 55455. (612)626-9640. E-mail: info@mnartists.org. Website: www.mcknightphoto.org. For Minnesota artists only.

New York

A.I.R. Gallery Fellowship Program, 111 Front St., #228, Brooklyn NY 11201. (212)255-6651. E-mail: info@airgallery.org. Website: www.airgallery.org. For female artists from New York City metro area only.

Arts & Cultural Council for Greater Rochester, 277 N. Goodman St., Rochester NY 14607. (585)473-4000. E-mail: artsandculturalcouncil@artsrochester.org. Website: www.artsrochester.org.

Constance Saltonstall Foundation for the Arts Grants and Fellowships, 435 Ellis Hollow Creek Rd., Ithaca NY 14850. (607)539-3146. E-mail: artscolony@saltonstall.org. Website: www.saltonstall.org. For artists in the central and western counties of New York.

See **Martha Boschen Porter Fund, Inc.,** under Connecticut.

New York Foundation for the Arts: Artists' Fellowships, 20 Jay St., 7th Floor, Brooklyn NY 11201. (212)366-6900. E-mail: fellowships@nyfa.org. Website: www.nyfa.org. For New York artists only.

Oregon

See **Betty Bowen Memorial Award,** under Idaho.

See **Flintridge Foundation Awards for Visual Artists,** under California.

Pennsylvania

Leeway Foundation—Philadelphia, Pennsylvania Region, The Philadelphia Building, 1315 Walnut St., Suite 832, Philadelphia PA 19107. (215)545-4078. E-mail: online form. Website: www.leeway.org. For female artists in Philadelphia only.

Texas

Individual Artist Grant Program—Houston, Texas, Houston Arts Alliance, 3201 Allen Pkwy., Suite 250, Houston TX 77019-1800. (713)527-9330. E-mail: online form. Website: www.houstonartsalliance.com. For Houston artists only.

Washington

See **Betty Bowen Memorial Award,** under Idaho.

See **Flintridge Foundation Awards for Visual Artists,** under California.

PROFESSIONAL ORGANIZATIONS

//

American Photographic Artists, National, P.O. Box 725146, Atlanta GA 31139. (800)272-6264, ext. 12. E-mail: membershiprep@apanational.com. Website: www.apanational.com

American Photographic Artists, Atlanta, 2221-D Peachtree Rd. NE, Suite #553, Atlanta GA 30309. (888)889-7190, ext. 50. E-mail: info@apaatlanta.com. Website: www.apaatlanta.com

American Photographic Artists, Los Angeles, 9190 W. Olympic Blvd., #212, Beverly Hills CA, 90212. (323)933-1631. E-mail: director@apa-la.org. Website: www.apa-la.org

American Photographic Artists, Midwest, 332 S. Michigan Ave., Suite 1032 #A855, Chicago IL 60604. (312)834-4563. E-mail: apamidwest@gmail.com. Website: www.apamidwest.org

American Photographic Artists, New York, 419 Lafayette, 2nd Floor, New York NY 10011. (212)807-0399. E-mail: jocelyn@apany.com. Website: www.apany.com

American Photographic Artists, San Diego, E-mail: membershiprep@apanational.com. Website: apasd.org

American Photographic Artists, San Francisco, 560 Fourth St., San Francisco CA 94107. (415)882-9780. E-mail: info@apasf.com. Website: sanfrancisco.apanational.com

American Society of Media Photographers (ASMP), 150 N. Second St., Philadelphia, PA 19106. (215)451-2767. Website: www.asmp.org

American Society of Picture Professionals (ASPP), 12126 Highway 14 N., #A-4, Cedar Crest NM 87008. (505)281-3177. Website: www.aspp.com

The Association of Photographers, 21 Downham Rd., London N1 5AA, United Kingdom. (44) (020) 7739-6669. E-mail: info@aophoto.co.uk. Website: www.the-aop.org

British Association of Picture Libraries and Agencies, 59 Tranquil Vale, Blackheath, London SE3 OBS, United Kingdom. (44) (0) 20 8297 1198. Fax: (44) (020) 8852-7211. E-mail: enquiries@bapla.org.uk. Website: www.bapla.org.uk

British Institute of Professional Photography (BIPP), The Coach House, The Firs, High St., Whitchurch, Aylesbury, Buckinghamshire, HP22 4SJ, United Kingdom. (44) (012) 9671-8530. Fax: (44) (012) 9633-6367. E-mail: membership@bipp.com. Website: www.bipp.com

Canadian Association for Photographic Art, Box 357, Logan Lake BC V0K 1W0, Canada. E-mail: capa@capacanada.ca. Website: www.capacanada.ca

Canadian Association of Journalists, Box 280, Brantford ON N3T 5N8 Canada. E-mail: online form. Website: www.caj.ca

Canadian Association of Photographers & Illustrators in Communications, 720 Spadina Ave., Suite 202, Toronto ON M5S 2T9, Canada. (416)462-3677 or (888)252-2742. Fax: (416)929-5256. E-mail: info@capic.org. Website: www.capic.org

The Center for Photography at Woodstock (CPW), 59 Tinker St., Woodstock NY 12498. (845)679-9957. Fax: (845)679-6337. E-mail: info@cpw.org. Website: www.cpw.org

Evidence Photographers International Council, Inc. (EPIC), 229 Peachtree St. NE, Suite 2200, Atlanta GA 30303. (866)868-3742. Fax: (404)614-6406. E-mail: csc@evidence photographers.com. Website: www.evidencephotographers.com

International Association of Panoramic Photographers, E-mail: online form. Website: www.panoramicassociation.org

International Center of Photography (ICP), 1133 Avenue of the Americas at 43rd St., New York NY 10036. (212)857-0003. E-mail: membership@icp.org. Website: www.icp.org

The Light Factory (TLF), 345 N. College St., Charlotte NC 28202. (704)333-9755. E-mail: info@lightfactory.org. Website: www.lightfactory.org

National Association of Photoshop Professionals (NAPP), 333 Douglas Rd. E., Oldsmar FL 34677. (813)433-5000 or (800)201-7323. E-mail: online form. Website: www.photoshopuser.com

National Press Photographers Association (NPPA), 3200 Croasdaile Dr., Suite 306, Durham NC 27705. (919)383-7246. Fax: (919)383-7261. E-mail: info@nppa.org. Website: www.nppa.org

North American Nature Photography Association (NANPA), 6382 Charleston Rd., Alma IL 62807. (618)547-7616. Fax: (618)547-7438. E-mail: info@nanpa.org. Website: www.nanpa.org

Photo Marketing Association International, 2282 Springport Rd., Suite F, Jackson MI 49202. (517)788-8100. Fax: (517)788-8371. E-mail: PMA_Information_Central@pmai.org. Website: www.pmai.org

Photographic Society of America (PSA), 3000 United Founders Blvd., Suite 103, Oklahoma City OK 73112-3940. (405)843-1437. E-mail: hq@psa-photo.org. Website: www.psa-photo.org

Picture Archive Council of America (PACA), 23046 Avenida de la Carlota, Suite 600, Leguna Hills CA 92653-1537. (714)815-8427. Fax: (949)679-8224. E-mail: execdirector@pacoffice.org. Website: www.pacaoffice.org

Professional Photographers of America (PPA), 229 Peachtree St. NE, Suite 2200, Atlanta GA 30303. (404)522-8600 or (800)786-6277. Fax: (404)614-6400. E-mail: csc@ppa.com. Website: www.ppa.com

Professional Photographers of Canada (PPOC), (519)537-2555 or (888)643-7762. Fax: (888)831-4036. Website: www.ppoc.ca

The Royal Photographic Society, Fenton House, 122 Wells Rd., Bath BA2 3AH, United Kingdom. (44) (012) 2532-5733. E-mail: reception@rps.org. Website: www.rps.org

Society for Photographic Education, 2530 Superior Ave., #403, Cleveland OH 44114. (216)622-2733. Fax: (216)622-2712. E-mail: online form. Website: www.spenational.org

Volunteer Lawyers for the Arts, 1 E. 53rd St., 6th Floor, New York NY 10022. (212)319-2787, ext. 1. Fax: (212)752-6575. E-mail: vlany@vlany.org. Website: www.vlany.org

Wedding & Portrait Photographers International (WPPI), Nielsen Expositions, 770 Broadway, New York NY 10003. (646)654-4500. Website: www.wppionline.com

White House News Photographers' Association (WHNPA), 7119 Ben Franklin Station, Washington DC 20044-7119. E-mail: online form. Website: www.whnpa.org

PUBLICATIONS

PERIODICALS

Advertising Age: www.adage.com

 Weekly magazine covering marketing, media and advertising.

Adweek: www.adweek.com

 Weekly magazine covering advertising agencies.

American Photo: www.americanphotomag.com

 Monthly magazine emphasizing the craft and philosophy of photography.

ASMP Bulletin: www.asmp.org

 Newsletter of the American Society of Media Photographers published five times/year. Subscription with membership.

Communication Arts: www.commarts.com

 Trade journal for visual communications.

Editor & Publisher: www.editorandpublisher.com

 Monthly magazine covering latest developments in journalism and newspaper production. Publishes an annual directory issue listing syndicates and another directory listing newspapers.

Folio: www.foliomag.com

 Monthly magazine featuring trends in magazine circulation, production, and editorial.

Graphis: www.graphis.com

 Magazine for the visual arts.

HOW: www.howdesign.com

Bimonthly magazine for the design industry.

News Photographer: www.nppa.org

Monthly news tabloid published by the National Press Photographers Association. Subscription with membership.

Outdoor Photographer: www.outdoorphotographer.com

Monthly magazine emphasizing equipment and techniques for shooting in outdoor conditions.

Photo District News: www.pdnonline.com

Monthly magazine for the professional photographer.

Photosource International: www.photosource.com

This company publishes several helpful newsletters, including PhotoLetter, Photo-Daily, and PhotoStockNotes.

Popular Photography & Imaging: www.popphoto.com

Monthly magazine specializing in technical information for photography.

Print: www.printmag.com

Bimonthly magazine focusing on creative trends and technological advances in illustration, design, photography, and printing.

Professional Artist: www.professionalartistmag.com

Monthly magazine listing galleries reviewing portfolios, juried shows, percent-for-art programs, scholarships, and art colonies.

Professional Photographer: www.ppmag.com

Professional Photographers of America's monthly magazine emphasizing technique and equipment for working photographers.

Publishers Weekly: www.publishersweekly.com

Weekly magazine covering industry trends and news in book publishing; includes book reviews and interviews.

Rangefinder: www.rangefindermag.com

Monthly magazine covering photography technique, products, and business practices.

Selling Stock: www.selling-stock.com

Newsletter for stock photographers; includes coverage of trends in business practices such as pricing and contract terms.

Shutterbug: www.shutterbug.com

Monthly magazine of photography news and equipment reviews.

BOOKS & DIRECTORIES

Adweek Agency Directory, VNU Business Publications. Annual directory of advertising agencies in the U.S.

Adweek Brand Directory, VNU Business Publications. Directory listing top 2,000 brands, ranked by media spending.

ASMP Copyright Guide for Photographers, American Society of Media Photographers.

ASMP Professional Business Practices in Photography, 7th edition, American Society of Media Photographers. Handbook covering all aspects of running a photography business.

Bacon's Media Directories, Cision. Contains information on all daily and community newspapers in the U.S. and Canada, and 24,000 trade and consumer magazines, newsletters, and journals.

The Big Picture: The Professional Photographer's Guide to Rights, Rates & Negotiation by Lou Jacobs, Writer's Digest Books, F+W Media, Inc. Essential information on understanding contracts, copyrights, pricing, licensing and negotiation.

Blogging for Creatives: How Designers, Artists, Crafters and Writers Can Blog to Make Contacts, Win Business and Build Success by Robin Houghton, HOW Books, F+W Media, Inc. Approachable guide to the blogosphere, complete with hundreds of tips, tricks and motivational stories from artistic bloggers.

Business and Legal Forms for Photographers, 4th edition by Tad Crawford, Allworth Press. Negotiation book with thirty-four forms for photographers.

The Business of Photography: Principles and Practices by Mary Virginia Swanson, available through her Website (www.mvswanson.com) or by e-mailing Lisa@mvswanson.com.

The Business of Studio Photography, 3rd edition by Edward R. Lilley, Allworth Press. A complete guide to starting and running a successful photography studio.

Children's Writers & Illustrator's Market, Writer's Digest Books, F+W Media, Inc. Annual directory including photo needs of book publishers, magazines and multimedia producers in the children's publishing industry.

Color Confidence: The Digital Photographer's Guide to Color Management by Tim Grey, Sybex.

Color Management for Photographers: Hands-On Techniques for Photoshop Users by Andrew Rodney, Focal Press.

Creative Careers in Photography: Making a Living With or Without a Camera by Michal Heron, Allworth Press.

Digital Stock Photography: How to Shoot and Sell by Michal Heron, Allworth Press.

How to Grow as a Photographer: Reinventing Your Career by Tony Luna, Allworth Press.

How to Succeed in Commercial Photography: Insights From a Leading Consultant by Selina Maitreya, Allworth Press.

LA 411, 411 Publishing. Music industry guide, including record labels.

Legal Guide for the Visual Artist, 4th Edition by Tad Crawford, Allworth Press. The author, an attorney, offers legal advice for artists and includes forms dealing with copyright, sales, taxes, etc.

Licensing Photography by Richard Weisgrau and Victor Perlman, Allworth Press.

Literary Market Place, Information Today. Directory that lists book publishers and other book publishing industry contacts.

O'Dwyer's Directory of Public Relations Firms, J.R. O'Dwyer Company, available through website (www.odwyerpr.com). Annual directory listing public relations firms, indexed by specialties.

The Photographer's Guide to Marketing & Self-Promotion, 4th edition by Maria Piscopo, Allworth Press. Marketing guide for photographers.

Photographer's Market Guide to Building Your Photography Business, 2nd edition by Vic Orenstein, Writer's Digest Books, F+W Media, Inc. Practical advice for running a profitable photography business.

Photo Portfolio Success by John Kaplan, Writer's Digest Books, F+W Media, Inc.

Pricing Photography: The Complete Guide to Assignment & Stock Prices by Michal Heron and David MacTavish, Allworth Press.

The Professional Photographer's Legal Handbook by Nancy Wolff, Allworth Press.

Profitable Photography in the Digital Age: Strategies for Success by Dan Heller, Allworth Press. By explaining how business is done now, this book helps photographers understand what it takes to sell, deliver, and compete in today's market.

Real World Color Management: Industrial-Strength Production Techniques, 2nd edition by Bruce Fraser, Chris Murphy, and Fred Bunting, Peachpit Press.

Sell & Resell Your Photos, 5th edition by Rohn Engh, Writer's Digest Books, F+W Media, Inc. Revised edition of the classic volume on marketing your own stock.

Selling Your Photography: How to Make Money in New and Traditional Markets by Richard Weisgrau, Allworth Press.

Shooting & Selling Your Photos by Jim Zuckerman, Writer's Digest Books, F+W Media, Inc.

Songwriter's Market, Writer's Digest Books, F+W Media, Inc. Annual directory listing record labels.

Standard Rate and Data Service (SRDS), Kantar Media. Directory listing magazines and their advertising rates.

Starting Your Career as a Freelance Photographer by Tad Crawford, Allworth Press.

Starting Your Career as a Photo Stylist: A Comprehensive Guide to Photo Shoots, Marketing, Business, Fashion, Wardrobe, Off Figure, Product, Prop, Room Sets, and Food Styling by Susan Linnet Cox, Allworth Press. This invaluable career manual explores the numerous directions a career in photo styling can take.

Workbook, Scott & Daughter Publishing. Numerous resources for the graphic arts industry.

Writer's Market, Writer's Digest Books, F+W Media, Inc. Annual directory listing markets for freelance writers. Many listings include photo needs and payment rates.

WEBSITES

//

PHOTOGRAPHY BUSINESS

The Alternative Pick www.altpick.com

Black Book www.blackbook.com

Copyright Website www.benedict.com

APA/EP: Editorial Photographers www.editorialphoto.com

MacTribe www.mactribe.com

ShootSmarter.com www.shootsmarter.com

Small Business Administration www.sba.gov

MAGAZINE AND BOOK PUBLISHING

American Journalism Review's News Links www.ajr.org

Bookwire www.bookwire.com

STOCK PHOTOGRAPHY

Global Photographers Search www.photographers.com

PhotoSource International www.photosource.com

Selling Stock www.selling-stock.com

Stock Artists Alliance www.stockartistsalliance.org

The STOCKPHOTO Network www.stockphoto.net

Stock Photo Price Calculator www.photographersindex.com/stockprice.htm

ADVERTISING PHOTOGRAPHY

Advertising Age www.adage.com
Adweek, Mediaweek and Brandweek www.adweek.com
Communication Arts Magazine www.commarts.com

FINE ART PHOTOGRAPHY

Art List www.artdeadlineslist.com
TheArtList.com www.theartlist.com
Art Support www.art-support.com
Mary Virginia Swanson www.mvswanson.com

PHOTOJOURNALISM

The Digital Journalist www.digitaljournalist.org
Foto8 www.foto8.com
National Press Photographers Association www.nppa.org

MAGAZINES

Afterimage www.vsw.org
Aperture www.aperture.org
Black and White Photography www.bandwmag.com
Blind Spot www.blindspot.com
British Journal of Photography www.bjp-online.com
LensWork www.lenswork.com
Photo District News www.pdnonline.com
Photograph Magazine photographmag.com
The Photo Review www.photoreview.org
Popular Photography www.popphoto.com
Professional Artist www.professionalartistmag.com
Shots Magazine www.shotsmag.com
View Camera www.viewcamera.com

E-ZINES

The following publications exist online only. Some offer opportunities for photographers to post their personal work.
American Museum Photography www.photographymuseum.com
Apogee Photo www.apogeephoto.com

Art Business News www.artbusinessnews.com

Art in Context www.artincontext.org

Art-Support www.art-support.com

Artists Register artistsregister.com

Digital Journalist www.digitaljournalist.org

En Foco www.enfoco.org

Fabfotos www.fabfotos.com

Foto8 www.foto8.com

Fotophile www.fotophile.com

Musarium www.musarium.com

One World Journeys www.oneworldjourneys.com

PhotoArts www.photoarts.com

Photoimaging Information Council www.takegreatpictures.com

PhotoLinks www.photolinks.com

Photoworkshop.com www.photoworkshop.com

Picture Projects www.pictureprojects.com

PixelPress www.pixelpress.org

Zone Zero www.zonezero.com

TECHNICAL

About.com www.photography.about.com

BetterPhoto.com® www.betterphoto.com

Photo.net www.photo.net

PhotoflexLightingSchool® www.photoflex.com/pls

Shoot Smarter www.shootsmarter.com

Wilhelm Imaging Research www.wilhelm-research.com

HOW-TO

Adobe Tutorials www.adobe.com/designcenter.html

Digital Photography Review www.dpreview.com

Fred Miranda www.fredmiranda.com/forum/index.php

Imaging Resource www.imaging-resource.com

Lone Star Digital www.lonestardigital.com

National Association of Photoshop Professionals www.photoshopuser.com

Photography Review www.photographyreview.com

Steve's Digicams www.steves-digicams.com

GLOSSARY

Absolute-released images. Any images for which signed model or property releases are on file and immediately available. For working with stock photo agencies that deal with advertising agencies, corporations and other commercial clients, such images are absolutely necessary to sell usage of images. Also see *Model release, Property release.*

Acceptance (payment on). The buyer pays for certain rights to publish a picture at the time it is accepted, prior to its publication.

Agency promotion rights. Stock agencies request these rights in order to reproduce a photographer's images in promotional materials such as catalogs, brochures and advertising.

Agent. A person who calls on potential buyers to present and sell existing work or obtain assignments for a client. A commission is usually charged. Such a person may also be called a photographer's rep.

All rights. A form of rights often confused with work for hire. Identical to a buyout, this typically applies when the client buys all rights or claim to ownership of copyright, usually for a lump sum payment. This entitles the client to unlimited, exclusive usage and usually with no further compensation to the creator. Unlike work for hire, the transfer of copyright is not permanent. A time limit can be negotiated, or the copyright ownership can run to the maximum of 35 years.

Alternative processes. Printing processes that do not depend on the sensitivity of silver to form an image. These processes include cyanotype and platinum printing.

Archival. The storage and display of photographic negatives and prints in materials that are harmless to them and prevent fading and deterioration.

Artist's statement. A short essay, no more than a paragraph or two, describing a photographer's mission and creative process. Most galleries require photographers to provide an artist's statement.

Assign (designated recipient). A third-party person or business to which a client assigns or designates ownership of copyrights that the client purchased originally from a creator such as a photographer. This term commonly appears on model and property releases.

Assignment. A definite OK to take photos for a specific client with mutual understanding as to the provisions and terms involved.

Assignment of copyright, rights. The photographer transfers claim to ownership of copyright over to another party in a written contract signed by both parties.

Audiovisual (AV). Materials such as filmstrips, motion pictures and overhead transparencies which use audio backup for visual material.

Automatic renewal clause. In contracts with stock photo agencies, this clause works on the concept that every time the photographer delivers an image, the contract is automatically renewed for a specified number of years. The drawback is that a photographer can be bound by the contract terms beyond the contract's termination and be blocked from marketing the same images to other clients for an extended period of time.

Avant garde. Photography that is innovative in form, style or subject matter.

Biannual. Occurring twice a year. Also see *Semiannual*.

Biennial. Occurring once every two years.

Bimonthly. Occurring once every two months.

Bio. A sentence or brief paragraph about a photographer's life and work, sometimes published along with photos.

Biweekly. Occurring once every two weeks.

Blurb. Written material appearing on a magazine's cover describing its contents.

Buyout. A form of work for hire where the client buys all rights or claim to ownership of copyright, usually for a lump sum payment. Also see *All rights*, *Work for hire*.

Caption. The words printed with a photo (usually directly beneath it), describing the scene or action.

CCD. Charged coupled device. A type of light detection device, made up of pixels, that generates an electrical signal in direct relation to how much light strikes the sensor.

CD-ROM. Compact disc read-only memory. Non-erasable electronic medium used for digitized image and document storage and retrieval on computers.

Chrome. A color transparency, usually called a slide.

Cibachrome. A photo printing process that produces fade-resistant color prints directly from color slides.

Clips. See *Tearsheet.*

CMYK. Cyan, magenta, yellow and black. Refers to four-color process printing.

Color correction. Adjusting an image to compensate for digital input and output characteristics.

Commission. The fee (usually a percentage of the total price received for a picture) charged by a photo agency, agent or gallery for finding a buyer and attending to the details of billing, collecting, etc.

Composition. The visual arrangement of all elements in a photograph.

Compression. The process of reducing the size of a digital file, usually through software. This speeds processing, transmission times and reduces storage requirements.

Consumer publications. Magazines sold on newsstands and by subscription that cover information of general interest to the public, as opposed to trade magazines, which cover information specific to a particular trade or profession. See *Trade magazine.*

Contact sheet. A sheet of negative-size images made by placing negatives in direct contact with the printing paper during exposure. They are used to view an entire roll of film on one piece of paper.

Contributor's copies. Copies of the issue of a magazine sent to photographers in which their work appears.

Copyright. The exclusive legal right to reproduce, publish and sell the matter and form of an artistic work.

Cover letter. A brief business letter introducing a photographer to a potential buyer. A cover letter may be used to sell stock images or solicit a portfolio review. Do not confuse cover letter with query letter.

C-print. Any enlargement printed from a negative.

Credit line. The byline of a photographer or organization that appears below or beside a published photo.

Cutline. See *Caption.*

Day rate. A minimum fee that many photographers charge for a day's work, whether a full day is spent on a shoot or not. Some photographers offer a half-day rate for projects involving up to a half-day of work.

Demo. A sample reel of film or sample videocassette that includes excerpts of a filmmaker's or videographer's production work for clients.

Density. The blackness of an image area on a negative or print. On a negative, the denser the black, the less light that can pass through.

Digital camera. A filmless camera system that converts an image into a digital signal or file.

DPI. Dots per inch. The unit of measure used to describe the resolution of image files, scanners and output devices. How many pixels a device can produce in one inch.

DSLR. Digital single-lens reflex camera. Combines the parts of a single-lens reflex camera (SLR) and a digital camera back, replacing the photographic film. The reflex design scheme differentiates a DSLR from other digital cameras.

Electronic submission. A submission made by modem or on computer disk, CD-ROM or other removable media.

Emulsion. The light-sensitive layer of film or photographic paper.

Enlargement. An image that is larger than its negative, made by projecting the image of the negative onto sensitized paper.

Exclusive property rights. A type of exclusive rights in which the client owns the physical image, such as a print, slide, film reel or videotape. A good example is when a portrait is shot for a person to keep, while the photographer retains the copyright.

Exclusive rights. A type of rights in which the client purchases exclusive usage of the image for a negotiated time period, such as one, three or five years. May also be permanent. Also see *All rights*, *Work for hire*.

Fee-plus basis. An arrangement whereby a photographer is given a certain fee for an assignment—plus reimbursement for travel costs, model fees, props and other related expenses incurred in completing the assignment.

File format. The particular way digital information is recorded. Common formats are TIFF and JPEG.

First rights. The photographer gives the purchaser the right to reproduce the work for the first time. The photographer agrees not to permit any publication of the work for a specified amount of time.

Format. The size or shape of a negative or print.

Four-color printing, four-color process. A printing process in which four primary printing inks are run in four separate passes on the press to create the visual effect of a full-color photo, as in magazines, posters and various other print media. Four separate negatives of the color photo—shot through filters—are placed identically (stripped) and exposed onto printing plates, and the images are printed from the plates in four ink colors.

GIF. Graphics interchange format. A graphics file format common to the Internet.

Glossy. Printing paper with a great deal of surface sheen. The opposite of matte.

Hard copy. Any kind of printed output, as opposed to display on a monitor.

Honorarium. Token payment—small amount of money and/or a credit line and copies of the publication.

Image resolution. An indication of the amount of detail an image holds. Usually expressed as the dimension of the image in pixels and the color depth each pixel has. Example: a 640×480, 24-bit image has higher resolution than a 640×480, 16-bit image.

IRC. International reply coupon. IRCs are used with self-addressed envelopes instead of stamps when submitting material to buyers located outside a photographer's home country.

JPEG. Joint photographic experts group. One of the more common digital compression methods that reduces file size without a great loss of detail.

Licensing/leasing. A term used in reference to the repeated selling of one-time rights to a photo.

Manuscript. A typewritten document to be published in a magazine or book.

Matte. Printing paper with a dull, nonreflective surface. The opposite of glossy.

Metadata. Information written into a digital photo file to identify who owns it, copyright and contact information, what camera created the file, exposure information and descriptive keywords, making the file searchable on the Internet.

Model release. Written permission to use a person's photo in publications or for commercial use.

Multi-image. A type of slide show that uses more than one projector to create greater visual impact with the subject. In more sophisticated multi-image shows, the projectors can be programmed to run by computer for split-second timing and animated effects.

Multimedia. A generic term used by advertising, public relations and audiovisual firms to describe productions using more than one medium together—such as slides and full-motion, color video—to create a variety of visual effects.

News release. See *Press release*.

No right of reversion. A term in business contracts that specifies once a photographer sells the copyright to an image, a claim of ownership is surrendered. This may be unenforceable, though, in light of the 1989 Supreme Court decision on copyright law. Also see *All rights, Work for hire*.

On spec. Abbreviation for "on speculation." Also see *Speculation*.

One-time rights. The photographer sells the right to use a photo one time only in any medium. The rights transfer back to the photographer on request after the photo's use.

Page rate. An arrangement in which a photographer is paid at a standard rate per page in a publication.

Photo CD. A trademarked, Eastman Kodak-designed digital storage system for photographic images on a CD.

PICT. The saving format for bit-mapped and object-oriented images.

Picture Library. See *Stock photo agency*.

Pixels. The individual light-sensitive elements that make up a CCD array. Pixels respond in a linear fashion. Doubling the light intensity doubles the electrical output of the pixel.

Point-of-purchase, point-of-sale (P-O-P, P-O-S). A term used in the advertising industry to describe in-store marketing displays that promote a product. Typically, these highly-illustrated displays are placed near checkout lanes or counters, and offer tear-off discount coupons or trial samples of the product.

Portfolio. A group of photographs assembled to demonstrate a photographer's talent and abilities, often presented to buyers.

PPI. Pixels per inch. Often used interchangeably with DPI, PPI refers to the number of pixels per inch in an image. See *DPI*.

Press release. A form of publicity announcement that public relations agencies and corporate communications staff people send out to newspapers and TV stations to generate news coverage. Usually this is sent with accompanying photos or videotape materials.

Property release. Written permission to use a photo of private property or public or government facilities in publications or for commercial use.

Public domain. A photograph whose copyright term has expired is considered to be "in the public domain" and can be used for any purpose without payment.

Publication (payment on). The buyer does not pay for rights to publish a photo until it is actually published, as opposed to payment on acceptance.

Query. A letter of inquiry to a potential buyer soliciting interest in a possible photo assignment.

Raw image file. A file format that contains minimally processed data from the digital camera image sensor. Also called digital negatives, raw files save, with minimum loss of information, data obtained from the sensor and the metadata.

Rep. Trade jargon for sales representative. Also see *Agent*.

Resolution. The particular pixel density of an image, or the number of dots per inch a device is capable of recognizing or reproducing.

Résumé. A short written account of one's career, qualifications and accomplishments.

RGB. An additive color model in which red, green, and blue light are combined to create a variety of colors. Used for the sensing, representation, and display of images on televisions, computers and other electronic systems.

Royalty. A percentage payment made to a photographer/filmmaker for each copy of work sold.

R-print. Any enlargement made from a transparency.

SAE. Self-addressed envelope.

SASE. Self-addressed, stamped envelope. (Most buyers require an SASE if a photographer wishes unused photos returned to him, especially unsolicited materials.)

GEOGRAPHIC INDEX

ALABAMA
Alabama Game & Fish 141
Alabama Living 108
Civitan Magazine 220
Commercial Carrier Journal 221
Corporate Art Source/CAS Gallery 379
Huntsville Museum of Art 395
International Expeditions 512
Jubilee Festival 459
Kentuck Festival of the Arts 459
Mobile Museum of Art 409
Panoply Arts Festival 465
Riverfront Market 467
UAB Visual Arts Gallery 428

ALASKA
Accent Alaska/Ken Graham Agency 288
Alaska 108
Alaska State Museum 362
Alaska Stock 292
Main Street Gallery 405
Mushing.com Magazine 161

ARIZONA
Arizona Highways Photo Workshops 503

Arizona State University Art Museum 364
Arizona Wildlife Views 113
Art in the Park 440
Carefree Fine Art & Wine Festival 446
Center for Creative Photography 374
DRK Photo 307
Etherton Gallery 383
Faire on the Square 451
Fall Fest in the Park 451
Fountain Hills Fine Art & Wine Affaire 453
Fourth Avenue Street Fair 453
Mesa Contemporary Arts at Mesa Arts
 Center 407
Museum of Northern Arizona 261
Native Peoples Magazine 162
Scottsdale Arts Festival 469
Thin Air Magazine 190
Tilt Gallery 427
Tubac Festival of the Arts 474
Waterfront Fine Art & Wine Festival 476
Zolan Company LLC, The 281

ARKANSAS
Arkansas Sportsman 141
Fine Arts Center Gallery 385

Foliate Oak Literary Magazine 139
Hot Springs Arts & Crafts Fair 457

CALIFORNIA
4-Wheel ATV Action 106
Aerial Archives 289
AFI Fest 479
AGStockUSA Inc. 290
Alamuphoto.com 291
American Fitness 110
American Sports Network 204
Arbabi, Sean 502
Art of Photography Show 480
Art Source L.A. Inc. 367
Asian Enterprise Magazine 215
Auto Restorer 114, 216
Automated Builder 216
Ballenger, Noella, & Associates Photo
 Workshops 504
Balthis, Frank, Photography Workshops
 504
Berson, Dean, Stevens 345
Beverly Hills Art Show 444
Biological Photo Service and Terraphoto-
 graphics 299
Brainworks Design Group 345
Bramson + Associates 346
Bransten, Rena, Gallery 373
Brookings, J.J., Gallery 373
Calabasas Fine Arts Festival 445
California Game & Fish 141
California Photographic Workshops 505
California Views/The Pat Hathaway Histori-
 cal Photo Collection 301
Campbell, Marianne, Associates 492
Canoe & Kayak 122
Carlsbad Magazine 124
Cat Fancy 124
Center for Photographic Art 375
Centerstream Publication LLC 253
Centric Corp. 274
Clark, Catharine, Gallery 377

Cleis Press 254
Clickers & Flickers Photography Network—
 Lectures & Workshops 506
Cohen, Stephen, Gallery 377
College Photography Contest 481
Communication Arts Annual Photography
 Competition 481
Conari Press 254
Continental Newstime 130
Creative With Words Publications 255
Cultural Photo Tours With Ralph Velasco
 508
Cycle California! Magazine 132
Cycle World 133
Dean, Julia, Photo Workshops, The 508
Dog Fancy 134
drkrm 382
Easyriders 135
El Dorado County Fair 450
Entrepreneur 135
Europa Photogenica Photo Tours to Eu-
 rope 509
Evolve the Gallery 384
Fahey/Klein Gallery 384
Falkirk Cultural Center 385
Fillmore Jazz Festival 452
Finding & Keeping Clients 510
FireRescue 225
Flaunt 138
G2 Gallery, The 386
Galápagos Travel 511
Gallery 825 388
Global Preservation Projects 511
Golden Gate School of Professional Pho-
 tography 511
Golf Tips 143
Government Technology 227
Hallowes Productions & Advertising 349
Highways 147
Image Integration 351
Immedium 259

Impact Photographics 275
In Focus With Michele Burgess 512
Indian Wells Arts Festival 458
Inmagine 315
Inside Triathlon 149
Instinct Magazine 149
Iron Willow 397
Jeroboam 318
Jillson & Roberts 276
Jordahl Photo Workshops 513
Journal of Psychoactive Drugs 230
Key Curriculum Press 260
Kimball Stock 318
Kings Mountain Art Fair 460
Koch, Robert, Gallery 400
Kramer, Joan, and Associates Inc. 318
Lantern Court LLC 276
Lapp, Cristopher—Still & Moving Images 494
Lee + Lou Productions Inc. 494
Light Photographic Workshops 513
Lived In Images 320
Lizardi/Harp Gallery 403
Log Newspaper, The 206
Lompoc Flower Festival 461
Lonely Planet Images 321
Los Angeles Center for Digital Juried Competition 484
Los Angeles Municipal Art Gallery 404
Maltz, Ben, Gallery 405
Marin Museum of Contemporary Art 405
Maslov, Norman, Agent Internationale 494
Mattei, Michele, Photography 322
Miller Group, The 352
Mobius Awards for Advertising, The 484
Monterey Museum of Art 409
Mother Jones 159
mptv 324
Museo ItaloAmericano 410
Museum of Contemporary Art San Diego 410
Museum of Photographic Arts 411
NailPro 232
Nails Magazine 233
Napa River Wine & Crafts Fair 463
National Masters News 206
National Notary, The 233
OC Fair Visual Arts Competition 464
Palo Alto Art Center 415
Paonessa Photography Workshops, Ralph 518
Paper Products Design 277
Patterson Apricot Fiesta 466
Pet Product News 235
PhotoEdit Inc. 328
Photographer's Forum Magazine 172
PhotoTherapy Consultants 495
Picture Matters 495
Pilot Getaways Magazine 173
Piscopo, Maria 496
Pizer, Alyssa 496
PointBlank Agency 353
Ponds USA and Water Gardens 238
Rich, Jeffrey, Wildlife Photography Tours 519
Riverbank Cheese & Wine Exposition 467
Romantic Homes 177
San Diego Art Institute 421
San Diego County Fair Annual Exhibition of Photography 486
San Francisco Photo Safaris 520
Santa Barbara Magazine 181
Sausalito Art Festival 468
Scott, Freda, Inc. 497
Sea 182
Selling Your Photography 520
Sexton, John, Photography Workshops 520
Shotgun Sports Magazine 183
Sierra 184
Sierra Madre Wistaria Festival 469
Solano Avenue Stroll 469

Southwest Arts Festival, The 470
Specialty Travel Index 244
Spillway 187
Sports Afield 187
Spring Photography Contest 486
Still Media 335
Sugar Daddy Photos 338
Summit Photographic Workshops 521
Surfing Magazine 189
Thompson, Natalie and James, Art Gallery 426
Tikkun 191
Track & Field News 191
Travelworld International Magazine 193
UCR/California Museum of Photography 428
Ventura County Reporter 208
Watercraft World 196
Western Outdoors 197
Wilshire Book Company 268
Wines & Vines 248
Yosemite Outdoor Adventures 523

COLORADO

Anderson Ranch Arts Center 502
Apogee Photo Workshop 502
Artists Alpine Holiday 480
Backpacker Magazine 115
Business of Art Center 373
Center for Fine Art Photography, The 481
Chun Capitol Hill People's Fair 447
Drake Magazine, The 134
Durango Autumn Arts Festival 449
EventGallery 910Arts 383
Evergreen Fine Arts Festival 450
Focus Adventures 510
Friedentag Photographics 348
gallery nrc 389
Grand Festival of the Arts & Crafts 455
Guenzi, Carol, Agents Inc. 493
Havu, William, Gallery 392
Healing Lifestyles & Spas Magazine 146

Lake City Arts & Crafts Festival 460
Long's, Andy, First Light Photography Workshops Tours 514
Mountain Living 160
Natural Habitat Adventures 515
Outside Imagery LLC 326
Photography at the Summit: Jackson Hole 519
Poudre River Gallery 418
Racquetball Magazine 176
Rocky Mountain Field Seminars 519
Skiing Magazine 184
Soldier of Fortune 185
Sports Photography Workshop: Colorado Springs, Colorado 521
Steele, Philip J., Gallery 425
Surgical Technologist, The 244
Synergistic Visions Workshops 521
Trail Runner 192
VeloNews 194
Winslow, Robert, Photo Inc. 523
Working With Artists 523

CONNECTICUT

Art Resources International Ltd. 273
Arts & Crafts Festival 443
Berman, Mona, Fine Arts 371
Beverage Dynamics 218
Bon Artique.com 273
CEA Advisor 219
Centerstream Publication LLC 253
Cleis Press 254
Conari Press 254
Creative Arts Workshop 507
Creative With Words Publications 255
Guilford Craft Expo 456
Immedium 259
Key Curriculum Press 260
New York Graphic Society Publishing Group 276
North Congregational Peach & Craft Fair 464

On the Green Fine Art & Craft Show 465
Power & Motoryacht 174
Tide-Mark Press 279
Wilshire Book Company 268
Woodshop News 248

DELAWARE
Delaware Center for the Contemporary
 Arts 381
Mitchell Lane Publishers Inc. 261

FLORIDA
Apogee Photo Magazine 113
Art Festival Beth-el 440
Art Licensing International 296
Artefact/Robert Pardo Gallery 365
Arts on Douglas 367
Babytalk 114
Bachmann Tour Overdrive 504
Ballinger Publishing 217
Birds as Art/Instructional Photo-Tours 504
Boca Raton Fine Art Show 445
Brown, Nancy, Hands-On Workshops 505
Capitol Complex Exhibitions 374
Caribbean Travel & Life 124
Center for Diversified Art 374
Charisma 125
Chief of Police 237
Crealdé School of Art 380, 507
Dot Fiftyone Gallery 382
Downtown Festival & Art Show 449
Estero Fine Art Show 450
Florida Game & Fish 141
Florida Sportsman 139
Florida State University Museum of Fine
 Arts 386
FOTOAGENT 310
FOTOfusion 510
Ft. Myers Magazine 140
Gold & Associates Inc. 349
Highlands Art League's Annual Fine Arts &
 Crafts Festival 456

InFocus Juried Exhibition 483
International Photo News 315
Interval World 150
Islands 150
Isle of Eight Flags Shrimp Festival 459
Jenkins, Alice and William, Gallery 398
Leepa-Rattner Museum of Art 401
Lutz Arts & Crafts Festival 461
Marlin 157
Motor Boating Magazine 159
Murphy, Michael, Gallery M 409
New Smyrna Beach Art Fiesta 464
Nicolas-Hays Inc. 262
Onboard Media 168
Palm Beach Photographic Centre 517
Police Times 237
Polk Museum of Art 418
Popular Photography & Imaging 173
Purestock 332
Recommend 240
Relay Magazine 241
Salt Water Sportsman 180
Santa Fe College Spring Arts Festival 468
Silver Image Photo Agency and Weddings
 334
Skydiving 184
Soundlight 356
Southern Boating 186
Sport Fishing 187
Stack, Tom, & Associates Inc. 335
Stickman Review 188
Sun 207
Superstock Inc. 339
Tarpon Springs Fine Arts Festival 473
Visual Arts Center of Northwest Florida
 431
Water Skier, The 197
WaterSki 197

GEORGIA
American Angler 109
American Print Alliance 363

Apple Annie Crafts & Arts Show 440
Aquarius 204
Art in the Park 440
Atlanta Homes and Lifestyles 114
Atlanta Photojournalism Seminar Contest 480
Beginning Digital Photography Workshop 504
Conyers Cherry Blossom Festival 448
Cortona Center of Photography, Italy, The 507
Deljou Art Group 274
Display Design Ideas 223
DK Stock Inc. 306
Finster, Howard, Vision House 386
Forest Landowner 226
Fulton County Daily Report 205
Game & Fish 141
Georgia Sportsman 141
Gold Rush Days 455
Herbert, Gertrude, Institute of Art 394
Jackson Fine Art 397
KNOWAtlanta 153
Lowe, Bill, Gallery 404
Lullwater Review 156
Myriad Productions 352
North American Whitetail 165
Professional Photographer 238
Rattlesnake Roundup 467
Sandy Springs Festival 468
Security Dealer & Integrator 243
Showcase School of Photography, The 520
Soho Myriad 423

HAWAII
Hawaii Workshops, Retreats, Private Photo Tours, Instruction & Fine Art Print Sales 512
Heart of Nature Photography Workshops & Photo Tours 512
Hui Ho'olana 512
Maui Hands 406
Photo Resource Hawaii 329
Wailoa Art & Cultural Center, The 431

IDAHO
Appaloosa Journal 113
ArtProjectA 366
Artwerks Stock Photography 297
Blue Planet Photography Workshops and Tours 505
exposure36 Photography 509
Gerlach Nature Photography Workshops & Tours 511
Pend Oreille Arts Council 466
Travel Images 522

ILLINOIS
AAP News 212
ALARM 108
Alton Arts & Crafts Expressions 439
American Bar Association Journal 212
American Bee Journal 213
American Society of Artists 363
ARC Gallery 364
Arts & Crafts Adventure 442
Arts & Crafts Affair, Autumn & Spring Tours, An 442
Arts Adventure 443
Arts Experience 443
Balzekas Museum of Lithuanian Culture Art Gallery 370
Bell Studio 371
Bragaw Public Relations Services 345
Catholic Library World 219
Cedarhurst Craft Fair 446
Chicago Photo Safaris 506
Collectible Automobile 129
Complete Woman 129
Custer's Last Stand Festival of the Arts 448
Deerfield Fine Arts Festival 449
DownBeat 134
Edelman, Catherine, Gallery 382
Edens Art Fair 450

El Restaurante Mexicano 224
Electrical Apparatus 223
Elks Magazine, The 135
Fire Chief 224
Freeport Art Museum 386
Gallant Greetings Corp. 275
Gallery 400 388
Gallery of Art at Springfield Art Association 389
Geneva Arts Fair 454
Grain Journal 227
Greenwich Village Art Fair 456
Heuser Art Center Gallery & Hartmann Center Art Gallery 394
Hinsdale Fine Arts Festival 457
Holt McDougal 258
Human Kinetics Publishers 258
Hutchinson Associates Inc. 350
Hyde Park Arts & Crafts Adventure 458
IGA Grocergram 229
Illinois Game & Fish 141
Illinois State Museum Chicago Gallery 396
Lakeland Boating Magazine 154
Leonardis, David, Gallery 402
LION 155
Loyola Magazine 156
Luckypix 321
Lutheran, The 157
Marketing & Technology Group 232
McGrath, Judith 495
McGraw-Hill 261
Miller, Peter, Gallery 408
Munro Campagna Artists Representatives 495
Museum of Contemporary Photography, Columbia College Chicago 410
Northwestern University Dittmar Memorial Gallery 413
Oak Park Avenue-Lake Arts & Crafts Show 464
Old Town Art Fair 465

Oyez Review 170
Panoramic Images 327
Parkland Art Gallery 415
PHOTO Techniques 172
Pix International 330
Planning 236
Prairie Arts Festival 466
Qually & Company Inc. 354
Recycled Paper Greetings Inc. 278
Rental Management 241
Rotarian, The 178
Schmidt, William & Florence, Art Center 422
Skokie Art Guild's Art Fair 469
SpeciaLiving 186
St. Charles Fine Art Show 471
Transportation Management & Engineering 246
Union Street Gallery 428
Video I-D, Teleproductions 357
Village Profile 195
Waveland Press Inc. 267
West Suburban Living Magazine 198
Wholesaler, The 247

INDIANA
Amish Acres Arts & Crafts Festival 439
Brick Street Market 445
Fourth Street Festival for the Arts & Crafts 453
Indiana Art Fair 458
Indiana Game & Fish 141
Indianapolis Art Center 396
Indianapolis Monthly 149
Kiwanis 153
Leeper Park Art Fair 460
Madison Chautauqua Festival of Art 461
Muzzle Blasts 161
Notre Dame Magazine 166
OMNI Productions 353
Riley Festival 467
Victorian Chautauqua, A 475

IOWA

Arts Iowa City 366
Chait Galleries Downtown, The 376
Guideposts 144
Iowa Game & Fish 141
Iowan Magazine, The 150
Judicature 152, 230
Legion Arts 402
MacNider Art Museum 404
Rural Heritage 178
Sioux City Art Center 423
Top Producer 246
UNI Gallery of Art 428

KANSAS

Baker Arts Center 369
Capper's 123
CareerFOCUS 123
College PreView 129
Greyhound Review, The 144
Grit 123
Kansas! 152
Parks, Gordon, Photography Competition, The 485
Produce Retailer 238
Veterinary Economics 247

KENTUCKY

Art Museum at the University of Kentucky, The 366
Arts on the Green 444
Chapman Friedman Gallery 376
Focal Press 257
Gradd Arts & Crafts Festival 455
Horse Illustrated 148
Horse, The 148
Kentucky Game & Fish 141
Kentucky Monthly 153
Kinetic, the Technology Agency 351
Mountain Workshops 515
NKU Gallery 413
SouthComm Publishing Company Inc. 185

St. James Court Art Show 471

LOUISIANA

Contemporary Arts Center (New Orleans) 378
DDB Stock Photography LLC 304
Haardt, Anton, Gallery 390
Jones, Stella, Gallery 398
Lockwood, C.C., Wildlife Photography Workshop 513
Masur Museum of Art 406
Mississippi/Louisiana Game & Fish 141
New Orleans Jazz & Heritage Festival 464
New Orleans Museum of Art 412
Pelican Publishing Company 263
Prague Summer Seminars 519
Prick of the Spindle 175
Sides & Associates 355
THEMA 190

MAINE

Aurora Photos 298
Binnacle, The 116
Borealis Press, The 273
Fly Rod & Reel 139
Landing Gallery 400
Maine Media Workshops 514
Nature Photographer 163
Off the Coast 167
Saco Sidewalk Art Festival 468
Still Point Art Gallery 426
StockFood 336
Tilbury House 266

MARYLAND

AOPA Pilot 214
Art's Alive 443
Avionics Magazine 217
Chesapeake Bay Magazine 125
Childhood Education 220
Frederick Festival of the Arts 454
German Life 142

Girls' Life 142
Home, Condo and Outdoor Art & Craft Fair 457
Insight Magazine 149
Johns Hopkins University Spring Fair 459
Journal of Adventist Education 230
Lacrosse Magazine 154
Marlboro Gallery 406
Naval History 233
Potomac Review 174
Proceedings 238
ProStar Publications Inc. 264
Stevenson University Art Gallery 425
Stock Connection 336
Visual Artistry Workshop Series 522
Washington County Museum of Fine Arts 431

MASSACHUSETTS
AMC Outdoors 109
Anthro-Photo File 294
Appalachian Mountain Club Books 252
Art New England Summer Workshops @ Bennington, Vermont 503
Bentley Publishers 253
Cape Cod Life 123
Co/So: Copley Society of Art 379
Cushing-Martin Gallery 380
Digital Wildlife Photography Field School 509
Fine Arts Work Center 510
Hallmark Institute of Photography 511
Horizons: Artistic Travel 512
Klein, Robert, Gallery 399
Korn, Bob, Imaging 513
Lichtenstein Center for the Arts 403
Lightwave Photography 319
Michelson, R., Galleries 408
Monderer Design Inc. 352
New England School of Photography 516
NFPA Journal 234
Pakn Treger 170

Paradise City Arts Festivals 465
Photographic Resource Center 417
Positive Images 331
Pucker Gallery Inc. 419
Sail 179
Sohn Fine Art—Gallery & Giclée Printing 423
Sohn Fine Art—Master Artist Workshops 521
South Shore Art Center 521
Worcester Polytechnic Institute 357

MICHIGAN
Alden B. Dow Museum Summer Art Fair 438
Allen Park Arts & Crafts Street Fair 438
American Power Boat Association 213
AMPM Inc. 344
Ann Arbor Art Center Gallery Shop, The 363
Ann Arbor Street Art Fair 439
Ann Arbor Summer Art Fair 440
Art in the Park (Holland) 441
Art in the Park (Warren) 441
Art in the Park—Fine Arts Festival 441
Automotive News 216
Belian Art Center 370
Birmingham Bloomfield Art Center 372
Book Beat Gallery 373
Casino Journal 219
Central Michigan University Art Gallery 376
Community Observer 129
Design Design Inc. 274
Detroit Focus 381
Frankfort Art Fair 454
Fruit Growers News 226
Funky Ferndale Art Show 454
Grand Rapids Art Museum 390
Grand Rapids Business Journal 206
Grand Rapids Family Magazine 143
Grand Rapids Magazine 144
Great Lakes Art Fair 455

Halsted Gallery Inc., The 391
Jacob, Elaine L., Gallery and Community Arts Gallery 397
Kalamazoo Institute of Arts 399
Kalamazoo Institute of Arts Fair 459
Krasl Art Fair on the Bluff 460
Les Cheneaux Festival of Arts 461
MacGuffin, The 157
Michigan Out-of-Doors 158
Michigan Sportsman 141
Michigan State University Holiday Arts & Crafts Show 462
Michigan State University Spring Arts & Crafts Show 462
Midwest Photographic Workshops 515
Nova Media Inc. 277
Oakland University Art Gallery 414
Orchard Lake Fine Art Show 465
Photo Explorer Tours 518
Prakken Publications Inc. 263
Royal Oak Outdoor Art Fair 467
SHINE brightly 183
Urban Institute for Contemporary Arts 430
Village Square Arts & Crafts Fair 475
Waterfront Fine Art Fair 476
Wyandotte Street Art Fair 477

MINNESOTA
AMPM Inc. 344
Art Workshops in Guatemala 503
Bowhunting World 119
Capstone Press 253
Gardening How-To 141
Geosynthetics 227
Icebox Quality Framing & Gallery 395
Lake Superior Magazine 154
Lake Superior Magazine Photo Contest 483
Land, The 231
Law Warschaw Gallery 400
Lerner Publishing Group 260
Minnesota Golfer 158
Minnesota Sportsman 141
Opening Night Gallery 415
Shots 183
St. Patrick's Day Craft Sale & Fall Craft Sale 471
Stone Arch Bridge Festival 472
Superior/Gunflint Photography Workshops 521
Uptown Art Fair 474
Vision Quest Photo Workshops 522
Voyageur Press 266
Weinstein Gallery 432

MISSISSIPPI
Bridge Bulletin, The 120
Clarion-Ledger, The 205
Mississippi/Louisiana Game & Fish 141
Southside Gallery 424

MISSOURI
AAA Midwest Traveler 106
Angus Beef Bulletin 213
Angus Journal 213
Beef Today 218
Blue Gallery 372
College Photographer of the Year 481
Dairy Today 222
Fall Festival of Art at Queeny Park 451
Farm Journal 224
Faust Fine Arts & Folk Festival 452
FCA Magazine 137
Heartland Boating 146
Hereford World 228
Kochan & Company 351
Leedy, Sherry, Contemporary Art 401
Leopold Gallery 402
Liberty Arts Squared 461
Mid-Missouri Artists Christmas Arts & Crafts Sale 462
Missouri Life 159
Missouri Photojournalism Workshop 515
Necrology Shorts 164

Photospiva 485
Pictures of the Year International 485
Relocating to the Lake of the Ozarks 176
Santa Cali Gon Days Festival 468
St. Louis Art Fair 471
Ziti Cards 280

MONTANA
Adventure Cyclist 107
Animals of Montana Inc. 502
Arts in the Park 444
Farcountry Press 256
Gibson Advertising 349
Murphy, Tom, Photography 515
Museum of the Plains Indian 411
Photographers' Formulary 518
Rocky Mountain School of Photography
 519
Sidewalk Art Mart 469
Strawberry Festival 472
Triple D Game Farm 522
Whitefish Arts Festival 476

NEBRASKA
Artists' Cooperative Gallery 365
Gallery 72 387
Idea Bank Marketing 351
Lux Center for the Arts 404
Upstream People Gallery 429
Woodmen Living 199

NEVADA
Comstock Cards 274
Contemporary Arts Center (Las Vegas) 378
Delaney, Cynthia, Photo Workshops 509
Home Decorating & Remodeling Show 457
Nevada Farm Bureau Agriculture and Live-
 stock Journal 234
Nevada Museum of Art 411

NEW HAMPSHIRE
Art 3 Gallery 365

Babybug 124
Business NH Magazine 120
Calliope 120
Carus Publishing Company 124
Cicada 124
Cobblestone 128
Craft Fair at the Bay 448
Cricket 124
Faces 136
Gloucester Waterfront Festival 455
Gunstock Summer Festival 456
Hearth and Home 228
Ladybug 124
Living Free 155
MacDowell Colony, The 514
Memorial Weekend Arts & Crafts Festival
 462
Mill Brook Gallery & Sculpture Garden 408
New England Arts & Crafts Festival 463
New England Craft & Specialty Food Fair
 463
Summer Arts & Crafts Festival 472
Tree Care Industry Magazine 246
Yankee Magazine 199

NEW JERSEY
Axis Gallery 369
Bacall, Robert, Representatives Inc. 492
Barron Arts Center 370
Bartender Magazine 217
Bergman Collection, The 299
Chatsworth Cranberry Festival 447
Contemporary Bride 130
Creative Homeowner 255
Down the Shore Publishing 255
Fall Fine Art & Crafts at Brookdale Park 452
Fine Art & Crafts at Anderson Park 452
Fine Art & Crafts at Verona Park 452
Fire Engineering 225
Francisco, Sally D., Gallery and the Store at
 Peters Valley Craft Center 386
Limited Editions & Collectibles 403

Markeim Art Center 406

Mid-Atlantic Regional School of Photography 515

Mira 323

New Jersey Heritage Photography Workshops 516

New Jersey Media Center LLC Workshops and Private Tutoring 516

Noyes Museum of Art, The 414

Paulist Press 263

Pediatric Annals 235

Perkins Center for the Arts Juried Photography Exhibition 485

Peters Valley Annual Craft Fair 466

Peters Valley Craft Center 416, 518

Pierro Gallery of South Orange 417

Princeton Alumni Weekly 175

Quick Frozen Foods International 239

Quon Design 354

RIG 278

Spencer's 279

Spring Fine Art & Crafts at Brookdale Park 470

Successful Meetings 244

Wildlife Photography Workshops and Lectures 522

Zakin, Mikhail, Gallery 433

NEW MEXICO

Albuquerque Museum of Art & History, The 362

American Archaeology 110

Curator's Choice Awards 482

Editor's Choice Awards, The 482

Eloquent Light Photography Workshops 509

Gallerist's Choice Awards, The 483

Journal of Asian Martial Arts 151

Mayans, Ernesto, Gallery 407

New Mexico Arts and Crafts Fair 464

New Mexico Magazine 164

New Mexico State University Art Gallery 412

Painet Inc. 327

photo-eye Gallery 416

Project Competition, The 486

Santa Fe Photographic Workshops 520

University Art Gallery in the D.W. Williams Art Center 429

Wurlitzer, Helene, Foundation, The 523

NEW YORK

440 Gallery 361

440 Gallery Annual Small Works Show 479

440 Gallery Annual Themed Show 479

911 Pictures 288

ABA Banking Journal 212

Achard & Associates 492

Adams, Eddie, Workshop 502

Adirondack Lakes Center for the Arts 361

Adirondack Life 106

Advocate, PKA's Publication 107

African American Golfer's Digest 107

Akego and Sahara Gallery 362

Alexia Competition 479

Allentown Art Festival 438

American Museum of Natural History Library, Photographic Collection 293

American Turf Monthly 111

Animals Animals/Earth Scenes 294

Aperture 112

ARC Awards 479

Archaeology 113

Arsenal Gallery, The 364

Art Resource 297

Art Without Walls Inc. 368

Asian American Arts Centre 368

Astrid Awards 480

Athletic Management 216

Atlantic Gallery 369

Autonomedia 252

Avanti Press Inc. 272

Benrubi, Bonni, Gallery 371

Boxoffice Magazine 219

Bridgeman Art Library 300

Casey 492

Center for Exploratory and Perceptual Art 375

Center for Photography at Woodstock, The 375

Center for Photography at Woodstock, The 506

CGT Marketing LLC 347

Chronogram 127

City Limits 127

CLAMPART 377

Cleaning & Maintenance Management 221

Cole, Randy, Represents LLC 492

Colorscape Chenango Arts Festival 447

Community Darkroom 506

Conde Nast Traveler 130

Corbis 303

Cosmopolitan 131

Countdown 131

Courthouse Gallery, Lake George Arts Project 379

Crabtree Publishing Company 255

Crafts at Rhinebeck 448

CraftWestport 448

Creative Quarterly Call for Entries 481

Design Conceptions/Joel Gordon Photography 305

Direct Art Magazine Publication Competition 482

DM News 223

Dorsky, Samuel, Museum of Art 382

Eastman, George, House 382

Elmwood Avenue Festival of the Arts Inc. 450

Erben, Thomas, Gallery 383

eStock Photo LLC 308

Everson Museum of Art 384

Fellowship 137

Field & Stream 138

Firehouse Magazine 225

First Light Photographic Workshops and Safaris 510

Flashlight Press 257

Focal Point Gallery 386

Food & Wine 139

Forest Hills Festival of the Arts 453

Fortune 140

Fundamental Photographs 311

Gallery North 389

Garrison Art Center's Juried Fine Crafts Fair 454

Gering & López Gallery 390

Ginsburg, Michael, & Associates Inc. 493

Go 142

Goldman, Rob, Creative Photography Workshops 511

Good Housekeeping 143

Great Neck Street Fair 456

Guernica Magazine 144

Guitar World 145

Hadassah Magazine 145

Haddad, Carrie, Gallery 391

Hard Hat News 227

Harper's Magazine 145

HarperCollins Children's Books/HarperCollins Publishers 258

Harris, O.K., Works of Art 392

Hart, John, Portrait Seminars 512

Henry Street Settlement/Abrons Art Center 393

Hodes, Bernard, Group 350

Holiday CraftMorristown 457

Hopper, Edward, House Art Center 394

Houk, Edwynn, Gallery 394

Hyperion Books for Children 259

IEEE Spectrum 229

Image Works, The 315

In the Fray 150

Intercontinental Greetings Ltd. 275

International Center of Photography 396

Jadite Galleries 398
Jewish Action 151
JHB Gallery 398
Joyce, Tricia, Inc. 493
Kashrus Magazine 153
Ladies Home Journal 154
Levin, Bruce, Group, The 494
Lilac Festival Arts & Crafts Show 461
Limner Gallery 403
Magazine Antiques, The 157
Medical File Inc., The 322
Mentor Series Worldwide Photo Treks 514
Mercury Awards 484
MetroSource Magazine 158
Mills Pond House Gallery 408
Mondial 261
Montauk Point Lions Club 462
Na'amat Woman 161
Neversink Photo Workshop 515
New York Game & Fish 141
New York State Conservationist Magazine 164
New York State Fair Photography Competition and Show 484
New York Times Magazine, The 165
New York Times on the Web, The 206
Newsweek 164
Nikon School Digital SLR Photography 517
Norton, W.W., & Company Inc. 262
Novus Visual Communications 353
NYU Tisch School of the Arts 517
One 168
Opalka Gallery 414
Owen, Richard C., Publishers Inc. 262
Penthouse 171
Phoenix Gallery, The 416
Photography Now 485
Photolibrary Group, The 329
Poets & Writers Magazine 237
Posey School 354
POZ 174

Professional Photographer's Society of New York State Photo Workshops 519
Professional Women Photographers International Women's Call for Entry 486
Quaker Arts Festival 467
Queens College Art Center 419
Rangefinder 240
Reform Judaism 176
REP. 242
Retailers Forum 242
Rex USA 332
Rivera-Ortiz, Manuel, Foundation for Documentary Photography & Film, The 486
Rochester Contemporary 421
Rolling Stone 177
Rotunda Gallery, The 421
Saks, Arnold, Associates 355
Salt Hill Literary Journal 180
Sander, Vicki/Folio Forums 496
Scholastic Magazines 181
School Guide Publications 265
Schupfer, Walter, Management Corporation 496
Science Source/Photo Researchers Inc. 333
Scientific American 181
Seventeen Magazine 182
Silver Moon Press 266
Sovfoto/Eastfoto Inc. 335
Spoke, B.J., Gallery 424
Sports Illustrated 187
Spring CraftMorristown 470
Spring Crafts at Lyndhurst 470
State of the Art Gallery 425
Surface Magazine 188
Synchronicity Fine Arts 426
Syracuse Arts & Crafts Festival 473
Syracuse New Times 208
Throckmorton Fine Art 427
TIME 191

Tobacco International 245
Travel + Leisure 192
Tricycle 193
Truppe, Doug 498
TV Guide 194
Upstream Gallery 429
Vintage Books 266
Viridian Artists Inc. 430
Washington Square Outdoor Art Exhibit 476
Wild Wind Folk Art & Craft Festival 477
Wine & Spirits 198
Woman Engineer 248
World Fine Art Gallery 433
Yaddo 523
Yeshiva University Museum 433
Your Best Shot 487

NORTH CAROLINA
AKM Images Inc. 291
Art Immersion Trip with Workshop in New Mexico 503
Artsplosure 444
BackHome 115
Blount-Bridgers House/Hobson Pittman Memorial Gallery 372
Boeberitz, Bob, Design 345
Campbell, John C., Folk School 505
Charlotte Fine Art Show 446
Church Street Art & Craft Show 447
Cullowhee Mountain Arts Summer Workshop Series 507
Festival in the Park 452
Foothills Arts & Crafts Fair 453
Gryphon House Inc. 257
Hansley, Lee, Gallery 391
Holly Arts & Crafts Festival 457
Howard, Merrell and Partners Inc. 350
International Folk Festival 458
Kings Drive Art Walk 460
Light Factory, The 513
Natural History 162

New World Festival of the Arts 464
North Carolina Game & Fish 141
North Carolina Literary Review 165
Novastock 324
Ocean Magazine 167
QSR 239
Springfest 470
Sun, The 188
Today's Photographer 245
Unlimited Editions International Juried Photography Competitions 487

NORTH DAKOTA
Ag Weekly 212
Fargo's Downtown Street Fair 452
Flint Communications 348
North Dakota Horizons 166
Northwest Art Center 413
Taube, Lillian & Coleman, Museum of Art 426

OHIO
Akron Art Museum 362
Akron Arts Expo 438
Akron Life 108
Allyn & Bacon Publishers 252
American Motorcyclist 111
Art on the Lawn 442
Barbour Publishing Inc. 252
Bee Culture 218
Bird Watcher's Digest 117
Black Swamp Arts Festival 445
Bright Light Visual Communications 346
Cain Park Arts Festival 445
Centerville–Washington Township Americana Festival 446
Chardon Square Arts Festival 446
Cleveland Magazine 128
Contemporary Arts Center (Cincinnati), The 378
Corcoran Fine Arts Limited, Inc. 378
CropLife 222

Dayton Art Institute, The 381
Delaware Arts Festival 449
Family Motor Coaching 137
FAVA (Firelands Association for the Visual Arts) 385, 483
Fur-Fish-Game 140
Hoof Beats 147
Hudson Gallery 395
Hywet, Stan, Hall & Gardens Ohio Mart 458
Image Finders, The 314
Independent Restaurateur, The 229
Jividen's Naturally Wild Photo Adventures 513
Kent State University School of Art Galleries 399
Lohre & Associates Inc. 352
Manning, William, Photography 514
Mason Arts Festival 461
McDonough Museum of Art 407
Ohio Game & Fish 141
Ohio Magazine 167
Ohio Wholesale Inc./Kennedy's Country Collection 277
Plastics News 236
Plastics Technology 236
Pump House Center for the Arts 419
Pyramid Hill Annual Art Fair 467
Restaurant Hospitality 242
Saxton, Joseph, Gallery of Photography, The 422
Summerfair 473
Water Well Journal 247
Whiskey Island Magazine 198
Writer's Digest 199, 249

OKLAHOMA
[Artspace] at Untitled 367
BearManor Media 252
Individual Artists of Oklahoma 396
JRB Art at the Elms 399
Oklahoma Game & Fish 141
Oklahoma Today 167
Persimmon Hill 172
Stillwater Arts Festival 472
Sun Fest Inc. 473
Tulsa International Mayfest 474

OREGON
540 Rider 106
Anchell Photography Workshops 502
Artist Fellowship Grants 479
Bear Deluxe Magazine, The 116
Blue Sky/Oregon Center for the Photographic Arts 373
Catholic Sentinel 204
Exhibitions Without Walls for Photographers and Digital Artists 482
Leach, Elizabeth, Gallery 401
Oregon Coast 168
Oregon College of Art and Craft 517
Schmidt, Henry, Design 355
Skipping Stones 184
Viewfinders Stock Photography 340
Washington-Oregon Game & Fish 141
Youth Runner Magazine 200
Women's Health Group 268

RHODE ISLAND
Arnold Art 364
Chabot Fine Art Gallery 376
Cruising World 132
Grace Ormonde Wedding Style 143
Hera Educational Foundation and Art Gallery 393
Rhode Island Monthly 177
Rhode Island State Council on the Arts Fellowships 486
Sailing World 179
Thomas, Martin, International 356

SOUTH CAROLINA
Artisphere 442
Atelier Gallery 369

Bell, Cecilia Coker, Gallery 370
Finger, Peter, Photographer 510
Richardson, Ella Walton, Fine Art 420
Sandlapper Magazine 180
South Carolina Game & Fish 141
Turkey Country 193
Wild Photo Adventures TV Show 523

SOUTH DAKOTA
Midwest Meetings 232
South Dakota Art Museum 424
Watertown Public Opinion 208

TENNESSEE
4 Bridges Arts Festival 438
American Artisan Festival 439
Arrowmont School of Arts and Crafts 503
Arts Company, The 366
Bennett Galleries and Company 371
Chess Life 125
Chess Life for Kids 126
Cory Nature and Travel Workshops 507
Cotton Grower Magazine 222
Ducks Unlimited Magazine 135
Edelstein, Paul, Studio and Gallery 383
Gallery Fifty Six 388
Germantown Festival 454
Great Smoky Mountains Institute at Tremont 511
Ketner's Mill County Arts Fair 459
Now & Then 166
River Gallery 420
Smithville Fiddlers' Jamboree and Craft Festival 469
Stirring 188
Tennessee Sportsman 141
White Oak Crafts Fair 477

TEXAS
Acres U.S.A. 212
AutoInc. 216
Bentley Publishing Group 273

Boys' Life 119
Campbell, William, Contemporary Art 374
Couturier, Catherine, Gallery 380
Dallas Center for Contemporary Art, The 380
Dykeman Associates Inc. 348
Englander, Joe, Photography Workshops & Tours 509
Jude Studios 351
Kirchman Gallery 399
Museum of Printing History 411
New Gallery/Thom Andriola 412
Rockport Center for the Arts 421
Roggen, Ted, Advertising and Public Relations 354
RTOHQ: The Magazine 242
Southwest Airlines Spirit 186
SRO Photo Gallery at Landmark Arts 424
Stock Options 337
Stockyard Photos 338
Streetpeoples Weekly News 207
Texas Gardener 189
Texas Highways 189
Texas Monthly 190
Texas Photographic Society Annual Members' Only Show 487
Texas Photographic Society National Competition 487
Texas Realtor Magazine 244
Texas School of Professional Photography 521
Texas Sportsman 141
Texas State Arts & Crafts Fair 473
Tide Magazine 190
Underground Construction 247
Women & Their Work Art Space 432

UTAH
Advanced Graphics 272
Classical Singer 221
Phillips Gallery 416

Portfolio Graphics Inc. 278
St. George Art Festival 471

VERMONT
Art in the Park Fall Foliage Festival 441
Art in the Park Summer Festival 442
Cone Editions Workshops 507
Countryman Press, The 254
Darkroom Gallery 381
Hunger Mountain 148
Inner Traditions/Bear & Company 259
Lake Champlain Maritime Museum's Annu-
 al Juried Photography Exhibit 483
McGaw Graphics Inc. 276
Northern Woodlands Magazine 166
Russian Life 178
Vermont Magazine 194

VIRGINIA
American Gardener, The 110
American Hunter 111
American Youth Philharmonic Orchestras,
 The 344
Animal Trails Magazine 112
Art in the Park 441
Artist Fellowships/Virginia Commission for
 the Arts 480
Baseball 115
BedTimes 217
Blue Ridge Country 118
Blue Ridge Workshops 505
Bridal Guides Magazine 119
Chronicle of the Horse, The 127
City of Fairfax Fall Festival 447
City of Fairfax Holiday Craft Show 447
Dance 133
ESL Teacher Today 224
Floral Management Magazine 226
Ghost Town 142
Gloucester Arts on Main 390
Harnett, Joel and Lila, Museum of Art and
 Print Study Center 391

Herald Press 258
Highland Maple Festival 456
Holiday Fine Arts & Crafts Show 457
Log Home Living 156
Military Officer Magazine 232
Multiple Exposures Gallery 409
Nature Friend Magazine 163
Photo Agora 328
Pungo Strawberry Festival 466
Revolutionary War Tracks 176
Roanoker, The 177
School Administrator, The 181
Science Scope 243
Second Street Gallery 423
Shooting Sports USA 183
Steppin' Out 471
Stockley Gardens Fall Arts Festival 472
Techniques 244
Textile Rental Magazine 245
Transport Topics 246
University of Richmond Museums 429
Virginia Center for the Creative Arts 522
Virginia Christmas Market 475
Virginia Christmas Show 475
Virginia Spring Market 475
Virginia Spring Show 475
Waterway Guide 197

WASHINGTON
Anacortes Arts Festival 439
Art of Nature Photography Workshops 503
ArtVisions 272
Barnett, Augustus, Advertising/Design
 344
Bellingham Review 116
BetterPhoto.com Online Photography
 Courses 504
Blend Images 300
Foodpix 309
Gallery 110 Collective 387
Getty Images 312

Harris, James, Gallery 392
Henry Art Gallery, The 393
Home Education Magazine 147
Journey Magazine 152
Larson Gallery Juried Biennual Photography Exhibition 483
Love Unlimited Film Festival & Art Exhibition 484
Northern Exposures 517
OnRequest Images 325
Pacific Northwest Art School/Photography 517
Photographic Arts Workshops 518
Photographic Center Northwest 518
Photokunst 495
Roberts Press 264
Technical Analysis of Stocks & Commodities 189
Tulip Festival Street Fair 474
Van Os, Joseph, Photo Safaris Inc. 522
Washington Trails 196
Washington-Oregon Game & Fish 141

WASHINGTON, DC
Addison/Ripley Fine Art 361
Animal Sheltering 213
APA Monitor 214
Architectural Lighting 215
Arts on Foot 444
Catholic News Service 302
Children's Defense Fund 205
Chronicle of Philanthropy, The 220
Conscience 130
Electric Perspectives 223
Hemphill 393
International Visions Gallery 397
Italian America 151
ITE Journal 229
Landscape Architecture 231
National Geographic 162
National Parks Magazine 162

Public Power 239
Ralls Collection Inc., The 420
Remodeling 241
Scrap 182
Smithsonian Magazine 185
Touchstone Gallery 427
Washington Blade, The 196
Washington Project for the Arts 432
Zenith Gallery 433

WEST VIRGINIA
Appalachian Trail Journeys 113
AppaLight 294
Art Store, The 368
Mountain State Forest Festival 463
Otter Creek Photography 517
Photography Art 417
Taylor County Photography Club Memorial Day Contest 487
West Virginia Game & Fish 141

WISCONSIN
Allis, Charles, Art Museum 362
Anchor News 112
AQUA Magazine 214
Art Fair on the Courthouse Lawn 440
Astronomy 114
Athletic Business 215
BizTimes Milwaukee 218
Charlton Photos Inc. 302
Country Woman 131
Crossman Gallery 380
Deer & Deer Hunting 133
Finescale Modeler 138
Frame Building News 226
Gallery 218 387
Good Old Summertime Art Fair 455
Madeline Island School of the Arts 514
Musky Hunter Magazine 161
Nicolet College Art Gallery 412
PhotoSource International 330
Progressive, The 175

Referee 240
Sailing Magazine 179
sellphotos.com 520
State Street Gallery 425
Trails Media Group 280
Turkey & Turkey Hunting 193
Willow Creek Press 268
Winnebagoland Art Fair 477
Wisconsin Architect 248
Wisconsin Snowmobile News 199
Wisconsin Sportsman 141
Wisconsin Union Galleries 432

WYOMING

Nicolaysen Art Museum & Discovery Center 412
Photography at the Summit: Jackson Hole 519
Yellowstone Association Institute 523

INTERNATIONAL INDEX

ARGENTINA
Comesana, Eduardo, Agencia de Prensa/
 Banco Fotográfico 303
Fotoscopio 310

AUSTRALIA
Burke's Backyard 120
Auscape International 298
DW Stock Picture Library 307
Wildlight 340

BELGIUM
Isopix 316

BRAZIL
Opção Brasil Imagens 325
TM Enterprises 497

BRITISH WEST INDIES
Times of the Islands 191

CANADA
Alaska Stock 292
Alternatives Journal 109
Anglican Journal, The 204
Art in Motion 272

ATA Magazine, The 215
Banff Mountain Photography Competition
 481
BC Outdoors Hunting and Shooting 115
BC Outdoors Sport Fishing 116
Blackflash 117
Briarpatch 119
Canada Lutheran 121
Canadian Guernsey Journal 219
Canadian Homes & Cottages 121
Canadian Organic Grower, The 121
Canadian Rodeo News 121
Canadian Yachting 122
Capilano Review, The 123
chickaDEE 126
Chirp 126
Coast&Kayak Magazine 128
Crestock Corporation 303
Dawson College Centre for Training and
 Development 508
Design Pics Inc. 305
ECW Press 256
Energy Gallery Art Call 482
Event 136
Faith & Friends 137

Fifth House Publishers 256
Firefly Books 257
First Light Associated Photographers 309
Freeman Patterson Photo Workshops 510
Georgia Straight 141
Golf Canada 142
Gospel Herald 143
Guernica Editions 257
Hamilton Magazine 145
HPAC 228
Irish Image Collection, The 316
Lawyers Weekly, The 206
Llewellyn, Peter, Photography Workshops
 & Photo Tours 513
Lone Pine Photo 321
Magenta Publishing for the Arts 260
Manitoba Teacher, The 231
Manufacturing Automation 231
Masterfile 321
MAXX Images Inc. 322
Meetings & Incentive Travel 232
Megapress Images 323
Musclemag International 160
Northwest Territories Explorer's Guide 234
Ontario Technologist, The 235
Outdoor Canada Magazine 169
OWL Magazine 169
Oxygen 169
Pacific Stock/Printscapes.com 326
Pacific Yachting 170
Photo Life 172
PI Creative Art 277
Ponkawonka Inc. 331
Prairie Journal, The 174
Prairie Messenger 175
Rafelman, Marcia, Fine Arts 419
Singing Sands Workshops 520
Ski Canada 184
Stock Foundry Images 336
Sun.Ergos 356
Taendem Agency 497

Teldon 279
Tightrope Books 266
Toronto Sun Publishing 208
Up Here 194
Visitor's Choice Magazine 266
Weigl Educational Publishers Ltd. 267
Western Producer, The 209

CAYMAN ISLANDS

Church, Cathy, Personal Underwater Pho-
 tography Courses 506

CHINA

Argus Photo Ltd. 295
Cha 125
Humanity Photo Award 483
Photolife Corporation Ltd. 329

ECUADOR

Archivo Criollo 295

FRANCE

BSIP 301
Camargo Foundation Visual Arts Fellow-
 ship 505
Photography in Provence 519
Pyrenees Exposures 519

GERMANY

A+E 289
Foto-Press Timmermann 310
Images.de Fulfillment 314
Ullstein Bild 339

INDIA

STSimages 338
Dinodia Photo Library 305

IRELAND

Burren College of Art Workshops 505
Irish Picture Library, The 316
Skellig Photo Tours 520

ISRAEL
Israelimages.com 317
Land of the Bible Photo Archive 319

ITALY
Granataimages.com 312
ICP di Alessandro Marosa 313

JAPAN
Aflo Foto Agency 290
amanaimages inc. 292
PLANS Ltd. (Photo Libraries and News Services) 331

THE NETHERLANDS
Lineair Fotoarchief BV 320
Versal 195

PUERTO RICO
Museo De Arte De Ponce 410

SCOTLAND
Cody Images 303
Sunday Post, The 207

SINGAPORE
Asia Images Group 297
OnAsia 324

SOUTH AFRICA
African Pilot 107

SPAIN
Age Fotostock 290

SWEDEN
Outdooria Outdoor Image Agency 326

UNITED KINGDOM
Ace Stock Limited 288
Aesthetica Creative Works Competition 479
Alamy 292

Ancient Art & Architecture Collection Ltd., The 293
Andes Press Agency 293
ArkReligion.com 295
Art Directors & Trip Photo Library 296
Axiom Photographic 298
Camera Press Ltd. 301
Capital Pictures 302
Church of England Newspaper, The 205
Digital Photo 133
Ecoscene 307
EOS Magazine 136
Eye Ubiquitous 308
Famous Pictures & Features Agency 308
Flight Collection, The 309
Folio 139
France Magazine 140
Geoslides & Geo Aerial Photography 311
Heritage Images 312
Heritage Railway Magazine 146
Hutchison Picture Library 313
Image by Design Licensing 148
Jaytravelphotos 317
Latitude Stock 319
Lebrecht Photo Library 319
Lincolnshire Life 155
Mediscan 322
Morpheus Tales 159
Motoring & Leisure 160
Music Sales Group 262
NewDesign 234
Papilio 328
People Management 235
Period Ideas 171
Pilot Magazine 173
Pitcher, Sylvia, Photo Library 330
Press Association Images 332
Quarto Publishing Plc. 264
Railphotolibrary.com 332
Santoro Graphics Ltd. 279
Science Photo Library Ltd. 333

Showboats International 184
Skyscan Photolibrary 334
Tobacco Journal International 245
Traveller Magazine & Publishing 192
Tropix Photo Library 339

WALES
Bird Watching 117
Planet 173

SUBJECT INDEX

ADVENTURE

4-Wheel ATV Action 106

Accent Alaska/Ken Graham Agency 288

Ace Stock Limited 288

Aflo Foto Agency 290

Age Fotostock 290

Alamuphoto.com 291

Alaska Stock 292

amanaimages inc. 292

AMC Outdoors 109

American Fitness 110

American Power Boat Association 213

AMPM Inc. 344

AOPA Pilot 214

Appalachian Mountain Club Books 252

AppaLight 294

Aquarius 204

Archivo Criollo 295

Arsenal Gallery, The 364

Art Directors & Trip Photo Library 296

Art Without Walls Inc. 368

Art@Net International Gallery 365

Aurora Photos 298

Axiom Photographic 298

Baker Arts Center 369

Balzekas Museum of Lithuanian Culture Art Gallery 370

Blue Ridge Country 118

Boeberitz, Bob, Design 345

Bon Artique.com/Art Resources International Ltd. 273

Borealis Press, The 273

Bowhunter 118

Boys' Life 119

Bridal Guides Magazine 119

Business of Art Center 373

Bynums Marketing and Communications, Inc. 347

Canoe & Kayak 122

Carmichael Lynch 347

chickaDEE 126

Chirp 126

Cleveland Magazine 128

Coast&Kayak Magazine 128

Comesana, Eduardo, Agencia de Prensa/ Banco Fotogrãfico 303

Continental Newstime 130

Couturier, Catherine, Gallery 380

Cycle California! Magazine 132

Darkroom Gallery 381

DDB Stock Photography LLC 304
Design Pics Inc. 305
Dinodia Photo Library 305
DK Stock Inc. 306
Easyriders 135
Elks Magazine, The 135
ESL Teacher Today 224
Flint Communications 348
Foto-Press Timmermann 310
Fotoscopio 310
gallery nrc 389
Gallery of Art at Springfield Art Association 389
Geoslides & Geo Aerial Photography 311
Ghost Town 142
Healing Lifestyles & Spas Magazine 146
Icebox Quality Framing & Gallery 395
Inmagine 315
Interval World 150
Iron Willow 397
Jeroboam 318
Kramer, Joan, and Associates Inc. 318
Latitude Stock 319
Leepa-Rattner Museum of Art 401
Limited Editions & Collectibles 403
Lineair Fotoarchief BV 320
Markeim Art Center 406
Megapress Images 323
Mesa Contemporary Arts at Mesa Arts Center 407
MetroSource Magazine 158
Missouri Life 159
Monderer Design Inc. 352
Multiple Exposures Gallery 409
Mushing.com Magazine 161
North Dakota Horizons 166
Northern Woodlands Magazine 166
Northwest Territories Explorer's Guide 234
Northwestern University Dittmar Memorial Gallery 413
Novastock 324

Novus Visual Communications 353
Oklahoma Today 167
OnAsia 324
OnRequest Images 325
Outdooria Outdoor Image Agency 326
Outside Imagery LLC 326
Owen, Richard C., Publishers Inc. 262
OWL Magazine 169
Pacific Stock/Printscapes.com 326
Painet Inc. 327
Panoramic Images 327
Persimmon Hill 172
photo-eye Gallery 416
PhotoSource International 330
Portfolio Graphics Inc. 278
Quarto Publishing Plc. 264
Revolutionary War Tracks 176
Roggen, Ted, Advertising and Public Relations 354
Sailing Magazine 179
Sailing World 179
Salt Water Sportsman 180
San Diego Art Institute 421
Sandlapper Magazine 180
Saxton, Joseph, Gallery of Photography, The 422
Scholastic Library Publishing 265
Soundlight 356
SouthComm Publishing Company Inc. 185
Southwest Airlines Spirit 186
Stock Foundry Images 336
STSimages 338
Sugar Daddy Photos 338
Teldon 279
Tide-Mark Press 279
Times of the Islands 191
Trail Runner 192
Tropix Photo Library 339
Ullstein Bild 339
Up Here 194
Upstream People Gallery 429

Washington County Museum of Fine Arts 431
Washington Trails 196
Wildlight 340

AGRICULTURE
Accent Alaska/Ken Graham Agency 288
Aflo Foto Agency 290
Age Fotostock 290
AGStockUSA Inc. 290
AKM Images Inc. 291
Alamuphoto.com 291
amanaimages inc. 292
AMPM Inc. 344
Andes Press Agency 293
Animal Trails Magazine 112
Animals Animals/Earth Scenes 294
AppaLight 294
Art Directors & Trip Photo Library 296
Art Without Walls Inc. 368
Aurora Photos 298
Axiom Photographic 298
Baker Arts Center 369
Balzekas Museum of Lithuanian Culture Art Gallery 370
Baseball 115
Bee Culture 218
Beef Today 218
Belian Art Center 370
Bell Studio 371
Biological Photo Service and Terraphotographics 299
Bridal Guides Magazine 119
California Views/The Pat Hathaway Historical Photo Collection 301
Canadian Guernsey Journal 219
Charlton Photos Inc. 302
Cobblestone 128
Comesana, Eduardo, Agencia de Prensa/Banco Fotográfico 303
Continental Newstime 130
Cotton Grower Magazine 222

Couturier, Catherine, Gallery 380
Creative Homeowner 255
CropLife 222
Dairy Today 222
Dance 133
Darkroom Gallery 381
DDB Stock Photography LLC 304
Design Pics Inc. 305
Dinodia Photo Library 305
DK Stock Inc. 306
DW Stock Picture Library 307
Ecoscene 307
ESL Teacher Today 224
Farm Journal 224
Flint Communications 348
Fotoscopio 310
Freeport Art Museum 386
Friedentag Photographics 348
Fruit Growers News 226
Fundamental Photographs 311
Gallery of Art at Springfield Art Association 389
Geoslides & Geo Aerial Photography 311
Ghost Town 142
Gloucester Arts on Main 390
Grain Journal 227
Hereford World 228
Hutchison Picture Library 313
Image Finders, The 314
Images.de Fulfillment 314
Iron Willow 397
Isopix 316
Jeroboam 318
Kramer, Joan, and Associates Inc. 318
Lange, Shauna Lee: The Gallery of Art Journals, Visual Diaries and Sketchbooks 400
Latitude Stock 319
Leepa-Rattner Museum of Art 401
Lerner Publishing Group 260
Lineair Fotoarchief BV 320

Marin Museum of Contemporary Art 405

Markeim Art Center 406

Medical File Inc., The 322

Murphy, Michael, Gallery M 409

National Geographic 162

Nevada Farm Bureau Agriculture and Livestock Journal 234

North Dakota Horizons 166

Northern Woodlands Magazine 166

Northwest Art Center 413

Novus Visual Communications 353

OnAsia 324

OnRequest Images 325

Outside Imagery LLC 326

Pacific Stock/Printscapes.com 326

Painet Inc. 327

Photo Agora 328

Planet 173

Planning 236

Plastics Technology 236

Portfolio Graphics Inc. 278

Poudre River Gallery 418

Produce Retailer 238

Pump House Center for the Arts 419

Quick Frozen Foods International 239

Revolutionary War Tracks 176

Rural Heritage 178

San Diego Art Institute 421

Sandlapper Magazine 180

Saxton, Joseph, Gallery of Photography, The 422

Scholastic Library Publishing 265

SouthComm Publishing Company Inc. 185

Southside Gallery 424

Stock Foundry Images 336

StockFood 336

STSimages 338

Sugar Daddy Photos 338

Sun, The 188

Synchronicity Fine Arts 426

Taube, Lillian & Coleman, Museum of Art 426

Tobacco International 245

Tobacco Journal International 245

Top Producer 246

Tropix Photo Library 339

Ullstein Bild 339

Voyageur Press 266

Washington County Museum of Fine Arts 431

Waveland Press Inc. 267

Weigl Educational Publishers Ltd. 267

Western Producer, The 209

Wildlight 340

ALTERNATIVE PROCESS

440 Gallery 361

Ace Stock Limited 288

Aflo Foto Agency 290

Akron Art Museum 362

Alaska Stock 292

American Fitness 110

Animal Trails Magazine 112

Archivo Criollo 295

Arsenal Gallery, The 364

Art Directors & Trip Photo Library 296

Art in Motion 272

Art Source L.A. Inc. 367

Arts on Douglas 367

Avionics Magazine 217

Axis Gallery 369

Baker Arts Center 369

Balzekas Museum of Lithuanian Culture Art Gallery 370

Baseball 115

Bennett Galleries and Company 371

Bentley Publishing Group 273

Blackflash 117

Blue Sky/Oregon Center for the Photographic Arts 373

Bon Artique.com/Art Resources International Ltd. 273

Bridal Guides Magazine 119
Business of Art Center 373
Capilano Review, The 123
Chapman Friedman Gallery 376
Chronogram 127
CLAMPART 377
Contemporary Arts Center (Las Vegas) 378
Couturier, Catherine, Gallery 380
Dance 133
Darkroom Gallery 381
Delaware Center for the Contemporary Arts 381
Dinodia Photo Library 305
Dorsky, Samuel, Museum of Art 382
drkrm 382
ESL Teacher Today 224
Event 136
Ft. Myers Magazine 140
G2 Gallery, The 386
Gallant Greetings Corp. 275
Gallery 110 Collective 387
Gallery 218 387
Gallery Fifty Six 388
gallery nrc 389
Gallery of Art at Springfield Art Association 389
Gering & López Gallery 390
Ghost Town 142
Gloucester Arts on Main 390
Golf Tips 143
Grand Rapids Magazine 144
Hampton Design Group 349
Harper's Magazine 145
Hemphill 393
Henry Street Settlement/Abrons Art Center 393
Huntsville Museum of Art 395
Icebox Quality Framing & Gallery 395
Illinois State Museum Chicago Gallery 396
Indianapolis Art Center 396
Individual Artists of Oklahoma 396

Irish Picture Library, The 316
Isopix 316
Journal of Asian Martial Arts 151
JRB Art at the Elms 399
Kalamazoo Institute of Arts 399
Kirchman Gallery 399
Kramer, Joan, and Associates Inc. 318
Leepa-Rattner Museum of Art 401
Leopold Gallery 402
Limited Editions & Collectibles 403
Limner Gallery 403
Markeim Art Center 406
Masur Museum of Art 406
Mesa Contemporary Arts at Mesa Arts Center 407
Monderer Design Inc. 352
Multiple Exposures Gallery 409
Murphy, Michael, Gallery M 409
Museum of Printing History 411
Necrology Shorts 164
New York Times on the Web, The 206
NEXUS/Foundation for Today's Art 412
Northwest Art Center 413
Novus Visual Communications 353
Noyes Museum of Art, The 414
Painet Inc. 327
Palo Alto Art Center 415
Panoramic Images 327
People Management 235
Phoenix Gallery, The 416
PHOTO Techniques 172
photo-eye Gallery 416
Photolibrary Group, The 329
Photomedia Center, The 417
PI Creative Art 277
Polk Museum of Art 418
Popular Photography & Imaging 173
Portfolio Graphics Inc. 278
Poudre River Gallery 418
Prairie Journal, The 174
Rafelman, Marcia, Fine Arts 419

Ralls Collection Inc., The 420
Recycled Paper Greetings Inc. 278
Revolutionary War Tracks 176
Rolling Stone 177
San Diego Art Institute 421
Saxton, Joseph, Gallery of Photography,
 The 422
Schmidt/Dean 422
Scholastic Library Publishing 265
Shots 183
Sohn Fine Art—Gallery & Giclée Printing
 423
Soho Myriad 423
Soundlight 356
South Dakota Art Museum 424
Southwest Airlines Spirit 186
Stevenson University Art Gallery 425
Stickman Review 188
Still Point Art Gallery 426
Stock Foundry Images 336
Streetpeoples Weekly News 207
STSimages 338
Sugar Daddy Photos 338
Sun, The 188
Syracuse New Times 208
Throckmorton Fine Art 427
Tilt Gallery 427
UAB Visual Arts Gallery 428
UCR/California Museum of Photography
 428
Upstream People Gallery 429
Viridian Artists Inc. 430
Visual Arts Center of Northwest Florida
 431
Washington County Museum of Fine Arts
 431
Washington Project for the Arts 432
Whiskey Island Magazine 198
Women & Their Work Art Space 432

ARCHITECTURE
Aflo Foto Agency 290

Age Fotostock 290
amanaimages inc. 292
AMPM Inc. 344
Ancient Art & Architecture Collection Ltd.,
 The 293
Andes Press Agency 293
Animal Trails Magazine 112
Architectural Lighting 215
Archivo Criollo 295
Arsenal Gallery, The 364
Art Directors & Trip Photo Library 296
Art Resource 297
Art Source L.A. Inc. 367
Art Without Walls Inc. 368
Art@Net International Gallery 365
Arts Company, The 366
Arts Iowa City 366
Asian Enterprise Magazine 215
Atelier Gallery 369
Atlanta Homes and Lifestyles 114
Atlantic Gallery 369
Aurora Photos 298
Baker Arts Center 369
Balzekas Museum of Lithuanian Culture Art
 Gallery 370
Bennett Galleries and Company 371
Bentley Publishing Group 273
Boeberitz, Bob, Design 345
Bon Artique.com/Art Resources Interna-
 tional Ltd. 273
Bramson + Associates 346
Bridal Guides Magazine 119
Calliope 120
Canadian Homes & Cottages 121
Carmichael Lynch 347
Chabot Fine Art Gallery 376
Chapman Friedman Gallery 376
CLAMPART 377
Cleveland Magazine 128
Cobblestone 128
Construction Equipment Guide 221

Continental Newstime 130

Countryman Press, The 254

Couturier, Catherine, Gallery 380

Creative Homeowner 255

Dance 133

Darkroom Gallery 381

DDB Stock Photography LLC 304

Design Pics Inc. 305

Dinodia Photo Library 305

Display Design Ideas 223

Flaunt 138

Flint Communications 348

Fotoscopio 310

Freeport Art Museum 386

Ft. Myers Magazine 140

Gallery Fifty Six 388

gallery nrc 389

Gallery of Art at Springfield Art Association 389

Geoslides & Geo Aerial Photography 311

Ghost Town 142

Gloucester Arts on Main 390

Guernica Editions 257

Haardt, Anton, Gallery 390

Haddad, Carrie, Gallery 391

Hemphill 393

Henry Street Settlement/Abrons Art Center 393

Heritage Images 312

Hutchinson Associates Inc. 350

Hutchison Picture Library 313

Image Finders, The 314

Iowan Magazine, The 150

Iron Willow 397

JRB Art at the Elms 399

Kalamazoo Institute of Arts 399

Key Curriculum Press 260

Kramer, Joan, and Associates Inc. 318

Land of the Bible Photo Archive 319

Landscape Architecture 231

Lantern Court LLC 276

Latitude Stock 319

Leepa-Rattner Museum of Art 401

Leopold Gallery 402

Lived In Images 320

Log Home Living 156

Magazine Antiques, The 157

Marin Museum of Contemporary Art 405

Markeim Art Center 406

McGaw Graphics Inc. 276

Mesa Contemporary Arts at Mesa Arts Center 407

MetroSource Magazine 158

Missouri Life 159

Monderer Design Inc. 352

Mountain Living 160

Multiple Exposures Gallery 409

Murphy, Michael, Gallery M 409

Museum of Contemporary Photography, Columbia College Chicago 410

Museum of Printing History 411

Na'amat Woman 161

Nails Magazine 233

National Geographic 162

New Mexico Magazine 164

New York Times on the Web, The 206

NEXUS/Foundation for Today's Art 412

Northwest Art Center 413

Northwestern University Dittmar Memorial Gallery 413

Novus Visual Communications 353

OnAsia 324

OnRequest Images 325

Opening Night Gallery 415

Owen, Richard C., Publishers Inc. 262

Painet Inc. 327

Panoramic Images 327

Paper Products Design 277

Period Ideas 171

Persimmon Hill 172

photo-eye Gallery 416

PhotoSource International 330

PI Creative Art 277
Planning 236
Portfolio Graphics Inc. 278
Poudre River Gallery 418
Pucker Gallery Inc. 419
Pump House Center for the Arts 419
Quarto Publishing Plc. 264
Ralls Collection Inc., The 420
Relay Magazine 241
Remodeling 241
Rhode Island Monthly 177
Richardson, Ella Walton, Fine Art 420
RIG 278
Roanoker, The 177
Running Press Book Publishers 265
San Diego Art Institute 421
Sandlapper Magazine 180
Santa Barbara Magazine 181
Saxton, Joseph, Gallery of Photography, The 422
Scholastic Library Publishing 265
Sohn Fine Art—Gallery & Giclée Printing 423
Soho Myriad 423
SouthComm Publishing Company Inc. 185
Southside Gallery 424
Southwest Airlines Spirit 186
State Street Gallery 425
Stock Foundry Images 336
STSimages 338
Sugar Daddy Photos 338
Surface Magazine 188
Synchronicity Fine Arts 426
Teldon 279
Texas Realtor Magazine 244
Throckmorton Fine Art 427
Tide-Mark Press 279
Times of the Islands 191
Ullstein Bild 339
Vermont Magazine 194
Visitor's Choice Magazine 266

Visual Arts Center of Northwest Florida 431
Washington County Museum of Fine Arts 431
Weigl Educational Publishers Ltd. 267
West Suburban Living Magazine 198
Wildlight 340
Wisconsin Architect 248
Woodshop News 248

AUTOMOBILES

Ace Stock Limited 288
Aflo Foto Agency 290
Age Fotostock 290
amanaimages inc. 292
AMPM Inc. 344
Art Directors & Trip Photo Library 296
Art Source L.A. Inc. 367
Auto Restorer 114, 216
Automotive News 216
Baker Arts Center 369
Balzekas Museum of Lithuanian Culture Art Gallery 370
Barnett, Augustus, Advertising/Design 344
Bentley Publishers 253
Bramson + Associates 346
Bynums Marketing and Communications, Inc. 347
California Views/The Pat Hathaway Historical Photo Collection 301
Capstone Press 253
Carmichael Lynch 347
Cody Images 303
Collectible Automobile 129
Couturier, Catherine, Gallery 380
Darkroom Gallery 381
Dinodia Photo Library 305
Finescale Modeler 138
Flint Communications 348
Fotoscopio 310
Gallant Greetings Corp. 275
gallery nrc 389

Gallery of Art at Springfield Art Association 389
Gloucester Arts on Main 390
Highways 147
Image Finders, The 314
Iron Willow 397
ITE Journal 229
Kramer, Joan, and Associates Inc. 318
Leepa-Rattner Museum of Art 401
Limited Editions & Collectibles 403
Markeim Art Center 406
MBI Inc. 261
Megapress Images 323
Mesa Contemporary Arts at Mesa Arts Center 407
Monderer Design Inc. 352
Motoring & Leisure 160
Multiple Exposures Gallery 409
New York Times on the Web, The 206
Northwest Territories Explorer's Guide 234
Northwestern University Dittmar Memorial Gallery 413
Novus Visual Communications 353
Owen, Richard C., Publishers Inc. 262
Painet Inc. 327
Panoramic Images 327
Planning 236
Portfolio Graphics Inc. 278
Saks, Arnold, Associates 355
Saxton, Joseph, Gallery of Photography, The 422
Scholastic Library Publishing 265
SouthComm Publishing Company Inc. 185
Southwest Airlines Spirit 186
Stack, Tom, & Associates Inc. 335
Stock Foundry Images 336
STSimages 338
Sugar Daddy Photos 338
Throckmorton Fine Art 427
Tide-Mark Press 279
Transport Topics 246

Ullstein Bild 339
Upstream People Gallery 429
Washington County Museum of Fine Arts 431

AVANT GARDE

440 Gallery 361
Ace Stock Limited 288
Aflo Foto Agency 290
Age Fotostock 290
Akego and Sahara Gallery 362
Alaska Stock 292
AMPM Inc. 344
Animal Trails Magazine 112
Arsenal Gallery, The 364
Art Directors & Trip Photo Library 296
Art Source L.A. Inc. 367
Art Without Walls Inc. 368
Art@Net International Gallery 365
Artefact/Robert Pardo Gallery 365
Avionics Magazine 217
Axiom Photographic 298
Axis Gallery 369
Baker Arts Center 369
Balzekas Museum of Lithuanian Culture Art Gallery 370
Baseball 115
Bentley Publishing Group 273
Blackflash 117
Brainworks Design Group 345
Bramson + Associates 346
Bridal Guides Magazine 119
Business of Art Center 373
Capilano Review, The 123
Chapman Friedman Gallery 376
Chronogram 127
CLAMPART 377
Contemporary Arts Center (Cincinnati), The 378
Contemporary Arts Center (Las Vegas) 378
Dance 133
Darkroom Gallery 381

Delaware Center for the Contemporary Arts 381
Detroit Focus 381
Dinodia Photo Library 305
Dorsky, Samuel, Museum of Art 382
drkrm 382
Edelstein, Paul, Studio and Gallery 383
ESL Teacher Today 224
Event 136
Flaunt 138
Friedentag Photographics 348
Ft. Myers Magazine 140
Gallant Greetings Corp. 275
Gallery 218 387
Gallery of Art at Springfield Art Association 389
Gering & López Gallery 390
Ghost Town 142
Gloucester Arts on Main 390
Hampton Design Group 349
Harper's Magazine 145
Henry Street Settlement/Abrons Art Center 393
Hunger Mountain 148
Huntsville Museum of Art 395
In the Fray 150
Indianapolis Art Center 396
Individual Artists of Oklahoma 396
International Photo News 315
Isopix 316
Jackson Fine Art 397
Journal of Asian Martial Arts 151
Journal of Psychoactive Drugs 230
JRB Art at the Elms 399
Kalamazoo Institute of Arts 399
Kirchman Gallery 399
Kramer, Joan, and Associates Inc. 318
Leepa-Rattner Museum of Art 401
Leopold Gallery 402
Limner Gallery 403
Lizardi/Harp Gallery 403

Markeim Art Center 406
Masur Museum of Art 406
Mesa Contemporary Arts at Mesa Arts Center 407
Monderer Design Inc. 352
Murphy, Michael, Gallery M 409
Museo De Arte De Ponce 410
Necrology Shorts 164
New York Times on the Web, The 206
Northwest Art Center 413
Northwestern University Dittmar Memorial Gallery 413
Novus Visual Communications 353
Noyes Museum of Art, The 414
OnAsia 324
Painet Inc. 327
Palo Alto Art Center 415
Panoramic Images 327
Paper Products Design 277
photo-eye Gallery 416
Photomedia Center, The 417
PI Creative Art 277
Polk Museum of Art 418
Ponkawonka Inc. 331
Popular Photography & Imaging 173
Portfolio Graphics Inc. 278
Ralls Collection Inc., The 420
Revolutionary War Tracks 176
Rolling Stone 177
San Diego Art Institute 421
Saxton, Joseph, Gallery of Photography, The 422
Scholastic Library Publishing 265
Sohn Fine Art—Gallery & Giclée Printing 423
Soho Myriad 423
Soundlight 356
Southside Gallery 424
Southwest Airlines Spirit 186
Stevenson University Art Gallery 425
Stickman Review 188

Stock Foundry Images 336
STSimages 338
Sugar Daddy Photos 338
Surface Magazine 188
Synchronicity Fine Arts 426
Taube, Lillian & Coleman, Museum of Art 426
Throckmorton Fine Art 427
Tilt Gallery 427
UAB Visual Arts Gallery 428
UCR/California Museum of Photography 428
Upstream People Gallery 429
Urban Institute for Contemporary Arts 430
Viridian Artists Inc. 430
Visual Arts Center of Northwest Florida 431
Washington County Museum of Fine Arts 431
Whiskey Island Magazine 198
Women & Their Work Art Space 432
Zenith Gallery 433

BABIES/CHILDREN/TEENS

440 Gallery 361
AAP News 212
Accent Alaska/Ken Graham Agency 288
Ace Stock Limited 288
Advanced Graphics 272
Aflo Foto Agency 290
Age Fotostock 290
Alamuphoto.com 291
Alaska 108
Alaska Stock 292
Allyn & Bacon Publishers 252
amanaimages inc. 292
American Fitness 110
AppaLight 294
Argus Photo Ltd. 295
Art Directors & Trip Photo Library 296
Asia Images Group 297
Aurora Photos 298

Avanti Press Inc. 272
Babytalk 114
Balzekas Museum of Lithuanian Culture Art Gallery 370
Baseball 115
Blend Images 300
Blue Ridge Country 118
Boeberitz, Bob, Design 345
Borealis Press, The 273
Boys' Life 119
Bramson + Associates 346
Bridal Guides Magazine 119
Bynums Marketing and Communications, Inc. 347
Canada Lutheran 121
Catholic News Service 302
Chess Life for Kids 126
chickaDEE 126
Childhood Education 220
Children's Defense Fund 205
Chirp 126
City Limits 127
Civitan Magazine 220
Cleveland Magazine 128
Comesana, Eduardo, Agencia de Prensa/ Banco Fotográfico 303
Couturier, Catherine, Gallery 380
Crabtree Publishing Company 255
Dance 133
Darkroom Gallery 381
DDB Stock Photography LLC 304
Design Conceptions/Joel Gordon Photography 305
Design Pics Inc. 305
Dinodia Photo Library 305
DK Stock Inc. 306
DW Stock Picture Library 307
Edelstein, Paul, Studio and Gallery 383
ESL Teacher Today 224
Farcountry Press 256
Fellowship 137

Flint Communications 348
Foto-Press Timmermann 310
Fotoscopio 310
Gallery of Art at Springfield Art Association 389
Ghost Town 142
Gospel Herald 143
Granataimages.com 312
Gryphon House Inc. 257
Hampton Design Group 349
Herald Press 258
Highlights for Children 147
Home Education Magazine 147
Howard, Merrell and Partners Inc. 350
Human Kinetics Publishers 258
Hutchison Picture Library 313
Image Finders, The 314
Images.de Fulfillment 314
In the Fray 150
Inmagine 315
Inner Traditions/Bear & Company 259
Insight Magazine 149
Intercontinental Greetings Ltd. 275
International Visions Gallery 397
Isopix 316
Jeroboam 318
Jillson & Roberts 276
Jones, Stella, Gallery 398
Journal of Adventist Education 230
Kashrus Magazine 153
Key Curriculum Press 260
Kiwanis 153
Kramer, Joan, and Associates Inc. 318
Ladies Home Journal 154
Leepa-Rattner Museum of Art 401
Lerner Publishing Group 260
Lightwave Photography 319
Luckypix 321
Lutheran, The 157
Manitoba Teacher, The 231
Markeim Art Center 406

Masur Museum of Art 406
MAXX Images Inc. 322
Mediscan 322
Megapress Images 323
Mesa Contemporary Arts at Mesa Arts Center 407
Murphy, Michael, Gallery M 409
Na'amat Woman 161
Native Peoples Magazine 162
Northwest Territories Explorer's Guide 234
Northwestern University Dittmar Memorial Gallery 413
Nova Media Inc. 277
Novastock 324
Novus Visual Communications 353
OnAsia 324
OnRequest Images 325
Opção Brasil Imagens 325
Outside Imagery LLC 326
Owen, Richard C., Publishers Inc. 262
OWL Magazine 169
Pacific Stock/Printscapes.com 326
Painet Inc. 327
Pakn Treger 170
Paper Products Design 277
Pediatric Annals 235
Photo Agora 328
photo-eye Gallery 416
PhotoEdit Inc. 328
PhotoSource International 330
Portfolio Graphics Inc. 278
Posey School 354
Ralls Collection Inc., The 420
Recycled Paper Greetings Inc. 278
Revolutionary War Tracks 176
Saks, Arnold, Associates 355
San Diego Art Institute 421
Sandlapper Magazine 180
Scholastic Library Publishing 265
Scholastic Magazines 181
School Administrator, The 181

School Guide Publications 265
Science Scope 243
Science Source/Photo Researchers Inc. 333
SHINE brightly 183
Silver Moon Press 266
Soundlight 356
SouthComm Publishing Company Inc. 185
Spencer's 279
Stock Foundry Images 336
Streetpeoples Weekly News 207
STSimages 338
Sugar Daddy Photos 338
Sun, The 188
Taube, Lillian & Coleman, Museum of Art 426
Teldon 279
Village Profile 195
Visitor's Choice Magazine 266
Visual Arts Center of Northwest Florida 431
Washington County Museum of Fine Arts 431
West Suburban Living Magazine 198
Whiskey Island Magazine 198
Wildlight 340
Women's Health Group 268
Youth Runner Magazine 200
Zolan Company LLC, The 281

BUSINESS CONCEPTS

ABA Banking Journal 212
Accent Alaska/Ken Graham Agency 288
Ace Stock Limited 288
Aflo Foto Agency 290
Age Fotostock 290
Alamuphoto.com 291
Allyn & Bacon Publishers 252
amanaimages inc. 292
American Bar Association Journal 212
AMPM Inc. 344
Andes Press Agency 293
AppaLight 294

Art Directors & Trip Photo Library 296
Artwerks Stock Photography 297
Asian Enterprise Magazine 215
Automotive News 216
Avionics Magazine 217
Balzekas Museum of Lithuanian Culture Art Gallery 370
Beverage Dynamics 218
BizTimes Milwaukee 218
Blend Images 300
Boeberitz, Bob, Design 345
Brainworks Design Group 345
Bramson + Associates 346
Business NH Magazine 120
CareerFOCUS 123
Cleveland Magazine 128
College PreView 129
Comesana, Eduardo, Agencia de Prensa/ Banco Fotográfico 303
Complete Woman 129
Dairy Today 222
Darkroom Gallery 381
DDB Stock Photography LLC 304
Design Pics Inc. 305
Dinodia Photo Library 305
DK Stock Inc. 306
Electric Perspectives 223
Entrepreneur 135
eStock Photo LLC 308
First Light Associated Photographers 309
Flint Communications 348
Floral Management Magazine 226
Fortune 140
Foto-Press Timmermann 310
Fotoscopio 310
Friedentag Photographics 348
Fundamental Photographs 311
Gallery of Art at Springfield Art Association 389
Geosynthetics 227
Grand Rapids Business Journal 206

Hampton Design Group 349
IEEE Spectrum 229
Image Finders, The 314
Image Works, The 315
Images.de Fulfillment 314
Inmagine 315
Isopix 316
Jude Studios 351
Kiwanis 153
KNOWAtlanta 153
Kramer, Joan, and Associates Inc. 318
Lange, Shauna Lee: The Gallery of Art Journals, Visual Diaries and Sketchbooks 400
Leepa-Rattner Museum of Art 401
Lightwave Photography 319
Lineair Fotoarchief BV 320
Lohre & Associates Inc. 352
Luckypix 321
Marketing & Technology Group 232
MAXX Images Inc. 322
McGraw-Hill 261
Meetings & Incentive Travel 232
Megapress Images 323
Monderer Design Inc. 352
Murphy, Michael, Gallery M 409
Novastock 324
Novus Visual Communications 353
OnAsia 324
OnRequest Images 325
Pacific Stock/Printscapes.com 326
Painet Inc. 327
Panoramic Images 327
Photolife Corporation Ltd. 329
PhotoSource International 330
Plastics Technology 236
Portfolio Graphics Inc. 278
Purestock 332
QSR 239
Rental Management 241
REP. 242

Restaurant Hospitality 242
Roanoker, The 177
Rotarian, The 178
RTOHQ: The Magazine 242
Saks, Arnold, Associates 355
Sandlapper Magazine 180
Saxton, Joseph, Gallery of Photography, The 422
Scholastic Library Publishing 265
Scrap 182
SouthComm Publishing Company Inc. 185
Southwest Airlines Spirit 186
Still Media 335
Stock Connection 336
Stock Foundry Images 336
Stock Options 337
STSimages 338
Successful Meetings 244
Sugar Daddy Photos 338
Superstock Inc. 339
Texas Realtor Magazine 244
Textile Rental Magazine 245
Vermont Magazine 194
Veterinary Economics 247
Village Profile 195
Washington County Museum of Fine Arts 431
Wholesaler, The 247
Wildlight 340
Writer's Digest 199, 249

CELEBRITIES

Advanced Graphics 272
Aflo Foto Agency 290
Age Fotostock 290
Allyn & Bacon Publishers 252
amanaimages inc. 292
American Fitness 110
American Motorcyclist 111
American Turf Monthly 111
AMPM Inc. 344
Aquarius 204

Arts Company, The 366
Aurora Photos 298
Balzekas Museum of Lithuanian Culture Art
 Gallery 370
Baseball 115
Briarpatch 119
Bridal Guides Magazine 119
Camera Press Ltd. 301
Capital Pictures 302
Centric Corp. 274
Chess Life for Kids 126
Cleveland Magazine 128
Comesana, Eduardo, Agencia de Prensa/
 Banco Fotográfico 303
Complete Woman 129
Continental Newstime 130
Cosmopolitan 131
Couturier, Catherine, Gallery 380
Dance 133
Darkroom Gallery 381
Dinodia Photo Library 305
DK Stock Inc. 306
DownBeat 134
ECW Press 256
Edelstein, Paul, Studio and Gallery 383
Famous Pictures & Features Agency 308
Flaunt 138
Fotoscopio 310
Ft. Myers Magazine 140
Gallery of Art at Springfield Art Associa-
 tion 389
Georgia Straight 141
Ghost Town 142
Government Technology 227
Granataimages.com 312
Grand Rapids Magazine 144
Howard, Merrell and Partners Inc. 350
Independent Restaurateur, The 229
Instinct Magazine 149
International Photo News 315
Isopix 316

Kentucky Monthly 153
Kramer, Joan, and Associates Inc. 318
Ladies Home Journal 154
Leepa-Rattner Museum of Art 401
Lerner Publishing Group 260
Lizardi/Harp Gallery 403
Markeim Art Center 406
Masur Museum of Art 406
Mattei, Michele, Photography 322
McGaw Graphics Inc. 276
Megapress Images 323
Mesa Contemporary Arts at Mesa Arts
 Center 407
MetroSource Magazine 158
Mitchell Lane Publishers Inc. 261
mptv 324
Murphy, Michael, Gallery M 409
Musclemag International 160
Music Sales Group 262
Myriad Productions 352
Nails Magazine 233
Native Peoples Magazine 162
New York Times on the Web, The 206
Nova Media Inc. 277
Oxygen 169
Painet Inc. 327
Penthouse 171
Persimmon Hill 172
PhotoSource International 330
Pitcher, Sylvia, Photo Library 330
Pix International 330
Portfolio Graphics Inc. 278
Ralls Collection Inc., The 420
Rex USA 332
Rolling Stone 177
Sandlapper Magazine 180
Santa Barbara Magazine 181
Saxton, Joseph, Gallery of Photography,
 The 422
Scholastic Library Publishing 265
Seventeen Magazine 182

Soundlight 356
SouthComm Publishing Company Inc. 185
Southwest Airlines Spirit 186
Stock Foundry Images 336
Streetpeoples Weekly News 207
STSimages 338
Sugar Daddy Photos 338
Sun 207
Texas Monthly 190
Toronto Sun Publishing 208
TV Guide 194
Ullstein Bild 339
Upstream People Gallery 429
Washington County Museum of Fine Arts 431
Weigl Educational Publishers Ltd. 267
Woodshop News 248

CITIES/URBAN

440 Gallery 361
911 Pictures 288
Accent Alaska/Ken Graham Agency 288
Aflo Foto Agency 290
Age Fotostock 290
AKM Images Inc. 291
Alamuphoto.com 291
Alaska Stock 292
amanaimages inc. 292
American Fitness 110
Andes Press Agency 293
Animal Trails Magazine 112
AppaLight 294
Archivo Criollo 295
Arsenal Gallery, The 364
Art Directors & Trip Photo Library 296
Art Source L.A. Inc. 367
Art Without Walls Inc. 368
Art@Net International Gallery 365
Arts Company, The 366
Arts Iowa City 366
Asian Enterprise Magazine 215
Atlantic Gallery 369

Aurora Photos 298
Axiom Photographic 298
Baker Arts Center 369
Balzekas Museum of Lithuanian Culture Art Gallery 370
Belian Art Center 370
Bell Studio 371
Bennett Galleries and Company 371
Bentley Publishing Group 273
BizTimes Milwaukee 218
Blue Sky/Oregon Center for the Photographic Arts 373
Boeberitz, Bob, Design 345
Bon Artique.com/Art Resources International Ltd. 273
Borough News 118
Bramson + Associates 346
Bridal Guides Magazine 119
Bynums Marketing and Communications, Inc. 347
Chabot Fine Art Gallery 376
City Limits 127
CLAMPART 377
Cobblestone 128
Continental Newstime 130
Couturier, Catherine, Gallery 380
Dance 133
Darkroom Gallery 381
DDB Stock Photography LLC 304
Design Pics Inc. 305
Dinodia Photo Library 305
drkrm 382
ESL Teacher Today 224
Farcountry Press 256
Flaunt 138
Foto-Press Timmermann 310
Fotoscopio 310
France Magazine 140
Freeport Art Museum 386
Gallery Fifty Six 388
gallery nrc 389

Gallery of Art at Springfield Art Association 389
Ghost Town 142
Gloucester Arts on Main 390
Hadassah Magazine 145
Hemphill 393
Henry Street Settlement/Abrons Art Center 393
Hutchison Picture Library 313
In the Fray 150
Independent Restaurateur, The 229
Instinct Magazine 149
Iron Willow 397
ITE Journal 229
Jeroboam 318
Jones, Stella, Gallery 398
JRB Art at the Elms 399
Kalamazoo Institute of Arts 399
Key Curriculum Press 260
KNOWAtlanta 153
Kramer, Joan, and Associates Inc. 318
Landscape Architecture 231
Lange, Shauna Lee: The Gallery of Art Journals, Visual Diaries and Sketchbooks 400
Lantern Court LLC 276
Latitude Stock 319
Leepa-Rattner Museum of Art 401
Leopold Gallery 402
Lerner Publishing Group 260
Lineair Fotoarchief BV 320
Luckypix 321
Lutheran, The 157
Marin Museum of Contemporary Art 405
Markeim Art Center 406
Meetings & Incentive Travel 232
Mesa Contemporary Arts at Mesa Arts Center 407
Missouri Life 159
Monderer Design Inc. 352
Motoring & Leisure 160
Multiple Exposures Gallery 409
Murphy, Michael, Gallery M 409
Museum of Printing History 411
New York State Conservationist Magazine 164
New York Times on the Web, The 206
North Dakota Horizons 166
Northwest Art Center 413
Northwestern University Dittmar Memorial Gallery 413
Novus Visual Communications 353
OnAsia 324
Opening Night Gallery 415
Owen, Richard C., Publishers Inc. 262
Painet Inc. 327
Panoramic Images 327
Photo Agora 328
photo-eye Gallery 416
PhotoSource International 330
PI Creative Art 277
Planning 236
Portfolio Graphics Inc. 278
Positive Images 331
Poudre River Gallery 418
Pucker Gallery Inc. 419
Ralls Collection Inc., The 420
Recommend 240
Relay Magazine 241
Remodeling 241
Revolutionary War Tracks 176
Richardson, Ella Walton, Fine Art 420
Roanoker, The 177
Running Press Book Publishers 265
San Diego Art Institute 421
Sandlapper Magazine 180
Saxton, Joseph, Gallery of Photography, The 422
Scholastic Library Publishing 265
Sohn Fine Art—Gallery & Giclée Printing 423
SouthComm Publishing Company Inc. 185

Southside Gallery 424
Southwest Airlines Spirit 186
State Street Gallery 425
Still Point Art Gallery 426
Stock Foundry Images 336
Stock Options 337
Streetpeoples Weekly News 207
STSimages 338
Sugar Daddy Photos 338
Sun, The 188
Surface Magazine 188
Synchronicity Fine Arts 426
Teldon 279
Throckmorton Fine Art 427
Tropix Photo Library 339
Ullstein Bild 339
Upstream People Gallery 429
Village Profile 195
Voyageur Press 266
Washington County Museum of Fine Arts 431
Waveland Press Inc. 267
Weigl Educational Publishers Ltd. 267
Whiskey Island Magazine 198
Wildlight 340

COUPLES

440 Gallery 361
Accent Alaska/Ken Graham Agency 288
Ace Stock Limited 288
Advanced Graphics 272
Aflo Foto Agency 290
Age Fotostock 290
Alamuphoto.com 291
Alaska 108
Alaska Stock 292
Allyn & Bacon Publishers 252
amanaimages inc. 292
American Fitness 110
AMPM Inc. 344
AOPA Pilot 214
AppaLight 294

Argus Photo Ltd. 295
Art Directors & Trip Photo Library 296
Asia Images Group 297
Aurora Photos 298
Avanti Press Inc. 272
Balzekas Museum of Lithuanian Culture Art Gallery 370
Baseball 115
Blend Images 300
Blue Ridge Country 118
Boeberitz, Bob, Design 345
Borealis Press, The 273
Brainworks Design Group 345
Bramson + Associates 346
Bridal Guides Magazine 119
Business NH Magazine 120
Bynums Marketing and Communications, Inc. 347
Canada Lutheran 121
Caribbean Travel & Life 124
CLAMPART 377
Cleveland Magazine 128
Comesana, Eduardo, Agencia de Prensa/ Banco Fotográfico 303
Complete Woman 129
Couturier, Catherine, Gallery 380
Dance 133
Darkroom Gallery 381
DDB Stock Photography LLC 304
Design Conceptions/Joel Gordon Photography 305
Design Pics Inc. 305
Dinodia Photo Library 305
DK Stock Inc. 306
Family Motor Coaching 137
Farcountry Press 256
Flint Communications 348
Foto-Press Timmermann 310
Fotoscopio 310
Gallery of Art at Springfield Art Association 389

Ghost Town 142
Granataimages.com 312
Herald Press 258
Highways 147
Howard, Merrell and Partners Inc. 350
Hutchison Picture Library 313
Image Finders, The 314
Images.de Fulfillment 314
In the Fray 150
Inmagine 315
Instinct Magazine 149
Isopix 316
Jeroboam 318
Key Curriculum Press 260
Kramer, Joan, and Associates Inc. 318
Ladies Home Journal 154
Leepa-Rattner Museum of Art 401
Lizardi/Harp Gallery 403
Lutheran, The 157
Markeim Art Center 406
MAXX Images Inc. 322
Megapress Images 323
Mesa Contemporary Arts at Mesa Arts Center 407
Motoring & Leisure 160
Mountain Living 160
Murphy, Michael, Gallery M 409
Native Peoples Magazine 162
Northwest Territories Explorer's Guide 234
Northwestern University Dittmar Memorial Gallery 413
Novastock 324
Novus Visual Communications 353
Opção Brasil Imagens 325
Outside Imagery LLC 326
Pacific Stock/Printscapes.com 326
Painet Inc. 327
Pakn Treger 170
Persimmon Hill 172
Photo Agora 328
PhotoEdit Inc. 328

PhotoSource International 330
Portfolio Graphics Inc. 278
Richardson, Ella Walton, Fine Art 420
Roanoker, The 177
Saks, Arnold, Associates 355
San Diego Art Institute 421
Sandlapper Magazine 180
Scholastic Library Publishing 265
Science Source/Photo Researchers Inc. 333
Silver Image Photo Agency and Weddings 334
Soundlight 356
SouthComm Publishing Company Inc. 185
Southwest Airlines Spirit 186
Spencer's 279
Stock Foundry Images 336
Streetpeoples Weekly News 207
STSimages 338
Sugar Daddy Photos 338
Sun, The 188
Taube, Lillian & Coleman, Museum of Art 426
Teldon 279
Ullstein Bild 339
Upstream People Gallery 429
Visitor's Choice Magazine 266
Visual Arts Center of Northwest Florida 431
Washington County Museum of Fine Arts 431
West Suburban Living Magazine 198
Wildlight 340
Wine & Spirits 198
Women's Health Group 268

DISASTERS

911 Pictures 288
Accent Alaska/Ken Graham Agency 288
Aflo Foto Agency 290
Age Fotostock 290
Allyn & Bacon Publishers 252
amanaimages inc. 292

Andes Press Agency 293
Animals Animals/Earth Scenes 294
AppaLight 294
Art Directors & Trip Photo Library 296
Art Without Walls Inc. 368
Artwerks Stock Photography 297
Aurora Photos 298
Balzekas Museum of Lithuanian Culture Art
 Gallery 370
Biological Photo Service and Terraphoto-
 graphics 299
California Views/The Pat Hathaway Histori-
 cal Photo Collection 301
Civitan Magazine 220
CLAMPART 377
Comesana, Eduardo, Agencia de Prensa/
 Banco Fotogrãfico 303
Contemporary Arts Center (Cincinnati),
 The 378
Continental Newstime 130
Darkroom Gallery 381
Dinodia Photo Library 305
ESL Teacher Today 224
Fellowship 137
Fire Chief 224
Fire Engineering 225
Firehouse Magazine 225
FireRescue 225
Fotoscopio 310
Fundamental Photographs 311
Gallery of Art at Springfield Art Associa-
 tion 389
Geoslides & Geo Aerial Photography 311
Ghost Town 142
Government Technology 227
Hera Educational Foundation and Art Gal-
 lery 393
Hutchison Picture Library 313
In the Fray 150
Isopix 316
Jeroboam 318

Kramer, Joan, and Associates Inc. 318
Lange, Shauna Lee: The Gallery of Art Jour-
 nals, Visual Diaries and Sketchbooks
 400
Leepa-Rattner Museum of Art 401
Lerner Publishing Group 260
Lineair Fotoarchief BV 320
Lutheran, The 157
Mediscan 322
Megapress Images 323
Mesa Contemporary Arts at Mesa Arts
 Center 407
Murphy, Michael, Gallery M 409
New York State Conservationist Magazine
 164
New York Times on the Web, The 206
Northwestern University Dittmar Memorial
 Gallery 413
Novastock 324
OnAsia 324
Painet Inc. 327
Photo Agora 328
photo-eye Gallery 416
PhotoSource International 330
Portfolio Graphics Inc. 278
Relay Magazine 241
Revolutionary War Tracks 176
San Diego Art Institute 421
Saxton, Joseph, Gallery of Photography,
 The 422
Scholastic Library Publishing 265
Stock Foundry Images 336
STSimages 338
Sugar Daddy Photos 338
Taube, Lillian & Coleman, Museum of Art
 426
Toronto Sun Publishing 208
Ullstein Bild 339
Upstream People Gallery 429
Washington County Museum of Fine Arts
 431

Waveland Press Inc. 267
Weigl Educational Publishers Ltd. 267
Whiskey Island Magazine 198
Wildlight 340

DOCUMENTARY
440 Gallery 361
911 Pictures 288
AAP News 212
Ace Stock Limited 288
Aflo Foto Agency 290
Age Fotostock 290
Akego and Sahara Gallery 362
Akron Art Museum 362
Alaska Stock 292
amanaimages inc. 292
American Power Boat Association 213
Animal Trails Magazine 112
AOPA Pilot 214
AppaLight 294
ARC Gallery 364
Archivo Criollo 295
Arsenal Gallery, The 364
Art Directors & Trip Photo Library 296
Art Without Walls Inc. 368
Arts Company, The 366
Arts on Douglas 367
Artwerks Stock Photography 297
Atelier Gallery 369
Axis Gallery 369
Baker Arts Center 369
Balzekas Museum of Lithuanian Culture Art
 Gallery 370
Baseball 115
BizTimes Milwaukee 218
Blue Sky/Oregon Center for the Photo-
 graphic Arts 373
Borealis Press, The 273
Boys' Life 119
Brainworks Design Group 345
Bramson + Associates 346
Briarpatch 119

Bridal Guides Magazine 119
Business of Art Center 373
California Views/The Pat Hathaway Histori-
 cal Photo Collection 301
Camera Press Ltd. 301
chickaDEE 126
Chief of Police 237
Chirp 126
City Limits 127
CLAMPART 377
Clarion-Ledger, The 205
Cleveland Magazine 128
Comesana, Eduardo, Agencia de Prensa/
 Banco Fotográfico 303
Commercial Carrier Journal 221
Contemporary Arts Center (Las Vegas) 378
Continental Newstime 130
Couturier, Catherine, Gallery 380
Dance 133
Darkroom Gallery 381
Design Conceptions/Joel Gordon Photog-
 raphy 305
Detroit Focus 381
Dinodia Photo Library 305
Dorsky, Samuel, Museum of Art 382
drkrm 382
ESL Teacher Today 224
Event 136
Eye Ubiquitous 308
Fire Chief 224
Fire Engineering 225
FireRescue 225
Flint Communications 348
Fotoscopio 310
Friedentag Photographics 348
Ft. Myers Magazine 140
G2 Gallery, The 386
Gallery 110 Collective 387
Gallery Fifty Six 388
gallery nrc 389

Gallery of Art at Springfield Art Association 389

Geoslides & Geo Aerial Photography 311

Ghost Town 142

Golf Tips 143

Grand Rapids Magazine 144

Harper's Magazine 145

Henry Street Settlement/Abrons Art Center 393

Heritage Images 312

Hunger Mountain 148

Huntsville Museum of Art 395

Hutchison Picture Library 313

Icebox Quality Framing & Gallery 395

Image Works, The 315

In the Fray 150

Indianapolis Art Center 396

Indianapolis Monthly 149

Individual Artists of Oklahoma 396

Isopix 316

Jeroboam 318

Jewish Action 151

Journal of Asian Martial Arts 151

JRB Art at the Elms 399

Kalamazoo Institute of Arts 399

Key Curriculum Press 260

Klein, Robert, Gallery 399

Kramer, Joan, and Associates Inc. 318

Land of the Bible Photo Archive 319

Lange, Shauna Lee: The Gallery of Art Journals, Visual Diaries and Sketchbooks 400

Leepa-Rattner Museum of Art 401

Leopold Gallery 402

Limited Editions & Collectibles 403

Limner Gallery 403

Lizardi/Harp Gallery 403

Marin Museum of Contemporary Art 405

Markeim Art Center 406

Masur Museum of Art 406

Mesa Contemporary Arts at Mesa Arts Center 407

Monderer Design Inc. 352

Multiple Exposures Gallery 409

Murphy, Michael, Gallery M 409

Museum of Printing History 411

Na'amat Woman 161

National Geographic 162

Natural History 162

Necrology Shorts 164

New York Times on the Web, The 206

Newsweek 164

NEXUS/Foundation for Today's Art 412

NFPA Journal 234

Nova Media Inc. 277

Novus Visual Communications 353

OnAsia 324

Outdooria Outdoor Image Agency 326

Owen, Richard C., Publishers Inc. 262

OWL Magazine 169

Painet Inc. 327

Panoramic Images 327

People Management 235

Persimmon Hill 172

Phoenix Gallery, The 416

photo-eye Gallery 416

Photomedia Center, The 417

PLANS Ltd. (Photo Libraries and News Services) 331

Police Times 237

Polk Museum of Art 418

Ponkawonka Inc. 331

Portfolio Graphics Inc. 278

Posey School 354

Progressive, The 175

Rafelman, Marcia, Fine Arts 419

Ralls Collection Inc., The 420

Revolutionary War Tracks 176

Rex USA 332

Rhode Island Monthly 177

Rolling Stone 177

Russian Life 178

San Diego Art Institute 421

Saxton, Joseph, Gallery of Photography, The 422

Schmidt/Dean 422

Scholastic Library Publishing 265

School Administrator, The 181

Scientific American 181

Silver Image Photo Agency and Weddings 334

Sohn Fine Art—Gallery & Giclée Printing 423

South Dakota Art Museum 424

SouthComm Publishing Company Inc. 185

Southwest Airlines Spirit 186

Stack, Tom, & Associates Inc. 335

Stevenson University Art Gallery 425

Stickman Review 188

Stock Foundry Images 336

Streetpeoples Weekly News 207

STSimages 338

Sugar Daddy Photos 338

Sun 207

Sun, The 188

Synchronicity Fine Arts 426

Thin Air Magazine 190

Throckmorton Fine Art 427

TIME 191

UCR/California Museum of Photography 428

Ullstein Bild 339

Up Here 194

Upstream People Gallery 429

Visual Arts Center of Northwest Florida 431

Washington County Museum of Fine Arts 431

Watertown Public Opinion 208

Western Producer, The 209

Whiskey Island Magazine 198

Wildlight 340

Woodshop News 248

EDUCATION

Aflo Foto Agency 290

Age Fotostock 290

Alamuphoto.com 291

Allyn & Bacon Publishers 252

amanaimages inc. 292

Andes Press Agency 293

AppaLight 294

Art Directors & Trip Photo Library 296

Art Without Walls Inc. 368

Art@Net International Gallery 365

Asian Enterprise Magazine 215

Aurora Photos 298

Balzekas Museum of Lithuanian Culture Art Gallery 370

Boeberitz, Bob, Design 345

Boys' Life 119

Brainworks Design Group 345

Bynums Marketing and Communications, Inc. 347

CareerFOCUS 123

CEA Advisor 219

Childhood Education 220

Children's Defense Fund 205

Cleveland Magazine 128

College PreView 129

Comesana, Eduardo, Agencia de Prensa/ Banco Fotográfico 303

Couturier, Catherine, Gallery 380

Darkroom Gallery 381

DDB Stock Photography LLC 304

Design Pics Inc. 305

Dinodia Photo Library 305

DK Stock Inc. 306

ESL Teacher Today 224

Farcountry Press 256

Friedentag Photographics 348

Gallery of Art at Springfield Art Association 389

Ghost Town 142

Gryphon House Inc. 257
Holt McDougal 258
Home Education Magazine 147
Human Kinetics Publishers 258
Hutchison Picture Library 313
Image Works, The 315
In the Fray 150
Inmagine 315
Isopix 316
Jeroboam 318
Jones, Stella, Gallery 398
Journal of Adventist Education 230
Jude Studios 351
Key Curriculum Press 260
Kiwanis 153
Kramer, Joan, and Associates Inc. 318
Leepa-Rattner Museum of Art 401
Lerner Publishing Group 260
Lightwave Photography 319
Lineair Fotoarchief BV 320
Lutheran, The 157
Manitoba Teacher, The 231
Markeim Art Center 406
Monderer Design Inc. 352
Murphy, Michael, Gallery M 409
Northwestern University Dittmar Memorial
 Gallery 413
Nova Media Inc. 277
Novus Visual Communications 353
OnAsia 324
OnRequest Images 325
Owen, Richard C., Publishers Inc. 262
Painet Inc. 327
Pakn Treger 170
Photo Agora 328
PhotoSource International 330
Portfolio Graphics Inc. 278
Prakken Publications Inc. 263
Princeton Alumni Weekly 175
Purestock 332
Revolutionary War Tracks 176

Roanoker, The 177
San Diego Art Institute 421
Sandlapper Magazine 180
Scholastic Library Publishing 265
Scholastic Magazines 181
School Administrator, The 181
Science Scope 243
Sohn Fine Art—Gallery & Giclée Printing
 423
SouthComm Publishing Company Inc. 185
Stock Foundry Images 336
Streetpeoples Weekly News 207
STSimages 338
Sugar Daddy Photos 338
Sun, The 188
Synchronicity Fine Arts 426
Techniques 244
Tropix Photo Library 339
Ullstein Bild 339
Video I-D, Teleproductions 357
Village Profile 195
Washington County Museum of Fine Arts
 431
Waveland Press Inc. 267
Wildlight 340
Worcester Polytechnic Institute 357
Writer's Digest 199, 249

ENTERTAINMENT

American Fitness 110
AMPM Inc. 344
Aquarius 204
Arts Company, The 366
Baker Arts Center 369
Balzekas Museum of Lithuanian Culture Art
 Gallery 370
Boeberitz, Bob, Design 345
Boxoffice Magazine 219
Brainworks Design Group 345
Bridal Guides Magazine 119
Business NH Magazine 120
Caribbean Travel & Life 124

Cleveland Magazine 128
Continental Newstime 130
Cosmopolitan 131
Couturier, Catherine, Gallery 380
Darkroom Gallery 381
Flaunt 138
Ft. Myers Magazine 140
Gallery of Art at Springfield Art Association 389
Georgia Straight 141
Hamilton Magazine 145
In the Fray 150
Instinct Magazine 149
Iowan Magazine, The 150
Kentucky Monthly 153
Leepa-Rattner Museum of Art 401
Leopold Gallery 402
Limited Editions & Collectibles 403
Markeim Art Center 406
Mesa Contemporary Arts at Mesa Arts Center 407
Missouri Life 159
Mitchell Lane Publishers Inc. 261
Monderer Design Inc. 352
Myriad Productions 352
Native Peoples Magazine 162
New York Times on the Web, The 206
NEXUS/Foundation for Today's Art 412
North Dakota Horizons 166
Northwestern University Dittmar Memorial Gallery 413
Nova Media Inc. 277
Novus Visual Communications 353
Penthouse 171
Persimmon Hill 172
photo-eye Gallery 416
Portfolio Graphics Inc. 278
Ralls Collection Inc., The 420
RIG 278
Roanoker, The 177
Rolling Stone 177

San Diego Art Institute 421
Saxton, Joseph, Gallery of Photography, The 422
Scholastic Library Publishing 265
Seventeen Magazine 182
SouthComm Publishing Company Inc. 185
Southside Gallery 424
Southwest Airlines Spirit 186
Tide-Mark Press 279
TV Guide 194
Upstream People Gallery 429
Visitor's Choice Magazine 266
Washington Blade, The 196
Washington County Museum of Fine Arts 431
West Suburban Living Magazine 198

ENVIRONMENTAL

440 Gallery 361
Accent Alaska/Ken Graham Agency 288
Ace Stock Limited 288
Aflo Foto Agency 290
Age Fotostock 290
AGStockUSA Inc. 290
Alaska Stock 292
amanaimages inc. 292
AMC Outdoors 109
Andes Press Agency 293
Animal Trails Magazine 112
Animals Animals/Earth Scenes 294
Anthro-Photo File 294
AppaLight 294
Aquarius 204
Archivo Criollo 295
Arizona Wildlife Views 113
Arsenal Gallery, The 364
Art Directors & Trip Photo Library 296
Art Source L.A. Inc. 367
Art Without Walls Inc. 368
Arts Company, The 366
Arts on Douglas 367
Asian Enterprise Magazine 215

Atlantic Gallery 369
Aurora Photos 298
Auscape International 298
Ballinger Publishing 217
Balzekas Museum of Lithuanian Culture Art
 Gallery 370
Baseball 115
Beef Today 218
Biological Photo Service and Terraphoto-
 graphics 299
Blue Sky/Oregon Center for the Photo-
 graphic Arts 373
Boeberitz, Bob, Design 345
Borough News 118
Boys' Life 119
Brainworks Design Group 345
Briarpatch 119
Bridal Guides Magazine 119
BSIP 301
Business of Art Center 373
Bynums Marketing and Communications,
 Inc. 347
Canoe & Kayak 122
Capstone Press 253
Carmichael Lynch 347
Centric Corp. 274
chickaDEE 126
Chirp 126
Chronicle of Philanthropy, The 220
Civitan Magazine 220
CLAMPART 377
Cleveland Magazine 128
Comesana, Eduardo, Agencia de Prensa/
 Banco Fotográfico 303
Contemporary Arts Center (Cincinnati),
 The 378
Continental Newstime 130
Countryman Press, The 254
Creative Homeowner 255
Dairy Today 222
Dance 133

Darkroom Gallery 381
DDB Stock Photography LLC 304
Design Pics Inc. 305
Dinodia Photo Library 305
DRK Photo 307
Ecoscene 307
ESL Teacher Today 224
Fellowship 137
Forest Landowner 226
Fotoscopio 310
Ft. Myers Magazine 140
Fundamental Photographs 311
G2 Gallery, The 386
Gallery Fifty Six 388
gallery nrc 389
Gallery of Art at Springfield Art Associa-
 tion 389
Geoslides & Geo Aerial Photography 311
Ghost Town 142
Government Technology 227
Guideposts 144
Hampton Design Group 349
Harper's Magazine 145
Healing Lifestyles & Spas Magazine 146
Henry Street Settlement/Abrons Art Cen-
 ter 393
Hera Educational Foundation and Art Gal-
 lery 393
Herald Press 258
Hutchison Picture Library 313
Icebox Quality Framing & Gallery 395
Image Works, The 315
Images.de Fulfillment 314
In the Fray 150
Inmagine 315
Inner Traditions/Bear & Company 259
Iowan Magazine, The 150
Isopix 316
Jeroboam 318
Kalamazoo Institute of Arts 399
Kashrus Magazine 153

Key Curriculum Press 260

Kramer, Joan, and Associates Inc. 318

Lange, Shauna Lee: The Gallery of Art Journals, Visual Diaries and Sketchbooks 400

Latitude Stock 319

Leepa-Rattner Museum of Art 401

Leopold Gallery 402

Lerner Publishing Group 260

Lineair Fotoarchief BV 320

Marin Museum of Contemporary Art 405

Markeim Art Center 406

Masur Museum of Art 406

McGaw Graphics Inc. 276

Meetings & Incentive Travel 232

Megapress Images 323

Mesa Contemporary Arts at Mesa Arts Center 407

Michigan Out-of-Doors 158

Missouri Life 159

Monderer Design Inc. 352

Murphy, Michael, Gallery M 409

Museum of Contemporary Photography, Columbia College Chicago 410

National Geographic 162

National Parks Magazine 162

Nature Photographer 163

Nevada Farm Bureau Agriculture and Livestock Journal 234

New York State Conservationist Magazine 164

New York Times on the Web, The 206

NEXUS/Foundation for Today's Art 412

Northern Woodlands Magazine 166

Northwest Art Center 413

Northwestern University Dittmar Memorial Gallery 413

Novastock 324

Novus Visual Communications 353

OnAsia 324

Onboard Media 168

OnRequest Images 325

Outdooria Outdoor Image Agency 326

Outside Imagery LLC 326

Owen, Richard C., Publishers Inc. 262

OWL Magazine 169

Pacific Stock/Printscapes.com 326

Painet Inc. 327

Panoramic Images 327

Photo Agora 328

photo-eye Gallery 416

PhotoSource International 330

Planet 173

Planning 236

Portfolio Graphics Inc. 278

Positive Images 331

Poudre River Gallery 418

Progressive, The 175

Pucker Gallery Inc. 419

Quarto Publishing Plc. 264

Rafelman, Marcia, Fine Arts 419

Revolutionary War Tracks 176

Richardson, Ella Walton, Fine Art 420

Salt Water Sportsman 180

San Diego Art Institute 421

Sandlapper Magazine 180

Santa Barbara Magazine 181

Saxton, Joseph, Gallery of Photography, The 422

Scholastic Library Publishing 265

Scrap 182

Sohn Fine Art—Gallery & Giclée Printing 423

SouthComm Publishing Company Inc. 185

Southwest Airlines Spirit 186

Stack, Tom, & Associates Inc. 335

State Street Gallery 425

Still Media 335

Stock Foundry Images 336

STSimages 338

Sugar Daddy Photos 338

Sun, The 188

Surface Magazine 188
Synchronicity Fine Arts 426
Tide Magazine 190
Times of the Islands 191
Top Producer 246
Trails Media Group 280
Tropix Photo Library 339
Ullstein Bild 339
Up Here 194
Upstream People Gallery 429
Village Profile 195
Visual Arts Center of Northwest Florida 431
Voyageur Press 266
Washington County Museum of Fine Arts 431
Washington Trails 196
Water Well Journal 247
Waveland Press Inc. 267
Weigl Educational Publishers Ltd. 267
Western Producer, The 209
Whiskey Island Magazine 198
Wildlight 340

EROTIC
440 Gallery 361
Aflo Foto Agency 290
Age Fotostock 290
amanaimages inc. 292
AMPM Inc. 344
Art@Net International Gallery 365
Axis Gallery 369
Baker Arts Center 369
Balzekas Museum of Lithuanian Culture Art Gallery 370
Bramson + Associates 346
Chapman Friedman Gallery 376
CLAMPART 377
Comstock Cards 274
Darkroom Gallery 381
Detroit Focus 381
Dinodia Photo Library 305

Foto-Press Timmermann 310
Friedentag Photographics 348
Gallery of Art at Springfield Art Association 389
Icebox Quality Framing & Gallery 395
Kramer, Joan, and Associates Inc. 318
Leepa-Rattner Museum of Art 401
Limited Editions & Collectibles 403
Limner Gallery 403
Lizardi/Harp Gallery 403
MetroSource Magazine 158
Murphy, Michael, Gallery M 409
Necrology Shorts 164
Northwestern University Dittmar Memorial Gallery 413
Nova Media Inc. 277
Painet Inc. 327
Penthouse 171
photo-eye Gallery 416
Portfolio Graphics Inc. 278
Roggen, Ted, Advertising and Public Relations 354
San Diego Art Institute 421
Scholastic Library Publishing 265
Soundlight 356
Stickman Review 188
Stock Foundry Images 336
Sugar Daddy Photos 338
Throckmorton Fine Art 427

EVENTS
4-Wheel ATV Action 106
Accent Alaska/Ken Graham Agency 288
Aflo Foto Agency 290
Age Fotostock 290
amanaimages inc. 292
American Fitness 110
American Power Boat Association 213
American Turf Monthly 111
AMPM Inc. 344
AppaLight 294
Appaloosa Journal 113

Aquarius 204
Art Directors & Trip Photo Library 296
Art Without Walls Inc. 368
Artwerks Stock Photography 297
Athletic Management 216
Aurora Photos 298
Balzekas Museum of Lithuanian Culture Art
 Gallery 370
BedTimes 217
Belian Art Center 370
Bell Studio 371
Boeberitz, Bob, Design 345
Borealis Press, The 273
Bridal Guides Magazine 119
Bynums Marketing and Communications,
 Inc. 347
Camera Press Ltd. 301
Canada Lutheran 121
Canadian Rodeo News 121
Capstone Press 253
Caribbean Travel & Life 124
Catholic News Service 302
Chess Life for Kids 126
chickaDEE 126
Chirp 126
Chronicle of the Horse, The 127
City Limits 127
Cleveland Magazine 128
Comesana, Eduardo, Agencia de Prensa/
 Banco Fotográfico 303
Contemporary Bride 130
Continental Newstime 130
Couturier, Catherine, Gallery 380
Crabtree Publishing Company 255
Cycle California! Magazine 132
Darkroom Gallery 381
DDB Stock Photography LLC 304
Design Conceptions/Joel Gordon Photog-
 raphy 305
Dinodia Photo Library 305
ECW Press 256

ESL Teacher Today 224
Famous Pictures & Features Agency 308
Flint Communications 348
Ft. Myers Magazine 140
Gallery of Art at Springfield Art Associa-
 tion 389
Georgia Straight 141
Ghost Town 142
Guernica Editions 257
Heritage Images 312
Human Kinetics Publishers 258
Images.de Fulfillment 314
Inmagine 315
International Photo News 315
Iowan Magazine, The 150
Isopix 316
Jude Studios 351
KNOWAtlanta 153
Kramer, Joan, and Associates Inc. 318
Latitude Stock 319
Lawyers Weekly, The 206
Leepa-Rattner Museum of Art 401
Limited Editions & Collectibles 403
Lutheran, The 157
Meetings & Incentive Travel 232
Mesa Contemporary Arts at Mesa Arts
 Center 407
Missouri Life 159
Monderer Design Inc. 352
Motoring & Leisure 160
Multiple Exposures Gallery 409
Native Peoples Magazine 162
Nevada Farm Bureau Agriculture and Live-
 stock Journal 234
New Mexico Magazine 164
New York Times on the Web, The 206
North Dakota Horizons 166
Northwest Territories Explorer's Guide 234
Northwestern University Dittmar Memorial
 Gallery 413
Novus Visual Communications 353

OWL Magazine 169
Painet Inc. 327
Period Ideas 171
Persimmon Hill 172
Pet Product News 235
photo-eye Gallery 416
Portfolio Graphics Inc. 278
Revolutionary War Tracks 176
Rhode Island Monthly 177
Roanoker, The 177
Rolling Stone 177
San Diego Art Institute 421
Sandlapper Magazine 180
Saxton, Joseph, Gallery of Photography, The 422
Scholastic Library Publishing 265
Scholastic Magazines 181
SouthComm Publishing Company Inc. 185
Southside Gallery 424
Southwest Airlines Spirit 186
Still Media 335
Stock Foundry Images 336
Stock Options 337
Streetpeoples Weekly News 207
STSimages 338
Sugar Daddy Photos 338
Synchronicity Fine Arts 426
Tide-Mark Press 279
Ullstein Bild 339
Visitor's Choice Magazine 266
Washington Blade, The 196
Washington County Museum of Fine Arts 431
Watercraft World 196
Weigl Educational Publishers Ltd. 267
West Suburban Living Magazine 198
Wildlight 340

FAMILIES
AAP News 212
Accent Alaska/Ken Graham Agency 288
Ace Stock Limited 288

Advanced Graphics 272
Aflo Foto Agency 290
Age Fotostock 290
Alamuphoto.com 291
Alaska Stock 292
Allyn & Bacon Publishers 252
amanaimages inc. 292
American Fitness 110
AppaLight 294
Argus Photo Ltd. 295
Art Directors & Trip Photo Library 296
Art Without Walls Inc. 368
Asia Images Group 297
Atlantic Gallery 369
Aurora Photos 298
Babytalk 114
Balzekas Museum of Lithuanian Culture Art Gallery 370
Baseball 115
BC Outdoors Hunting and Shooting 115
BC Outdoors Sport Fishing 116
Blend Images 300
Blue Ridge Country 118
Boeberitz, Bob, Design 345
Borealis Press, The 273
Bramson + Associates 346
Bridal Guides Magazine 119
Business NH Magazine 120
Bynums Marketing and Communications, Inc. 347
Canada Lutheran 121
Caribbean Travel & Life 124
Catholic News Service 302
Chess Life for Kids 126
Children's Defense Fund 205
City Limits 127
Civitan Magazine 220
Cleveland Magazine 128
Comesana, Eduardo, Agencia de Prensa/ Banco Fotográfico 303
Couturier, Catherine, Gallery 380

Dance 133
Darkroom Gallery 381
DDB Stock Photography LLC 304
Design Conceptions/Joel Gordon Photography 305
Design Pics Inc. 305
Dinodia Photo Library 305
DK Stock Inc. 306
DW Stock Picture Library 307
Edelstein, Paul, Studio and Gallery 383
Elks Magazine, The 135
ESL Teacher Today 224
Family Motor Coaching 137
Farcountry Press 256
Foto-Press Timmermann 310
Fotoscopio 310
Gallery of Art at Springfield Art Association 389
Ghost Town 142
Gospel Herald 143
Granataimages.com 312
Grand Rapids Magazine 144
Herald Press 258
Home Education Magazine 147
Howard, Merrell and Partners Inc. 350
Human Kinetics Publishers 258
Hutchison Picture Library 313
Image Finders, The 314
Image Works, The 315
Images.de Fulfillment 314
In the Fray 150
Inmagine 315
Inner Traditions/Bear & Company 259
Interval World 150
Isopix 316
Jeroboam 318
Jones, Stella, Gallery 398
Jude Studios 351
Key Curriculum Press 260
Kiwanis 153
Kramer, Joan, and Associates Inc. 318

Ladies Home Journal 154
Leepa-Rattner Museum of Art 401
Lerner Publishing Group 260
Living Free 155
Luckypix 321
Lutheran, The 157
Markeim Art Center 406
Mattei, Michele, Photography 322
MAXX Images Inc. 322
Megapress Images 323
Mesa Contemporary Arts at Mesa Arts Center 407
Military Officer Magazine 232
Motoring & Leisure 160
Murphy, Michael, Gallery M 409
Na'amat Woman 161
Native Peoples Magazine 162
NEXUS/Foundation for Today's Art 412
Northwest Territories Explorer's Guide 234
Northwestern University Dittmar Memorial Gallery 413
Nova Media Inc. 277
Novastock 324
Novus Visual Communications 353
OnAsia 324
OnRequest Images 325
Opção Brasil Imagens 325
Outside Imagery LLC 326
Owen, Richard C., Publishers Inc. 262
Pacific Stock/Printscapes.com 326
Painet Inc. 327
Pakn Treger 170
Pediatric Annals 235
Persimmon Hill 172
Photo Agora 328
photo-eye Gallery 416
PhotoEdit Inc. 328
PhotoSource International 330
Ponkawonka Inc. 331
Portfolio Graphics Inc. 278
Revolutionary War Tracks 176

Rhode Island Monthly 177
Richardson, Ella Walton, Fine Art 420
Roanoker, The 177
Saks, Arnold, Associates 355
San Diego Art Institute 421
Sandlapper Magazine 180
Saxton, Joseph, Gallery of Photography, The 422
Scholastic Library Publishing 265
Sea 182
Silver Image Photo Agency and Weddings 334
SouthComm Publishing Company Inc. 185
Stock Foundry Images 336
Streetpeoples Weekly News 207
STSimages 338
Sugar Daddy Photos 338
Sun, The 188
Taube, Lillian & Coleman, Museum of Art 426
Teldon 279
Ullstein Bild 339
Upstream People Gallery 429
Village Profile 195
Visitor's Choice Magazine 266
Visual Arts Center of Northwest Florida 431
Washington County Museum of Fine Arts 431
Washington Trails 196
West Suburban Living Magazine 198
Western Producer, The 209
Wildlight 340
Wisconsin Snowmobile News 199
Women's Health Group 268
Woodmen Living 199

FASHION/GLAMOUR

Ace Stock Limited 288
Aflo Foto Agency 290
Age Fotostock 290
Akego and Sahara Gallery 362
amanaimages inc. 292
American Fitness 110
AMPM Inc. 344
Animal Trails Magazine 112
Art Without Walls Inc. 368
Art@Net International Gallery 365
Artefact/Robert Pardo Gallery 365
Balzekas Museum of Lithuanian Culture Art Gallery 370
Boeberitz, Bob, Design 345
Bramson + Associates 346
Bridal Guides Magazine 119
Business of Art Center 373
Camera Press Ltd. 301
Capital Pictures 302
Chronogram 127
CLAMPART 377
Clarion-Ledger, The 205
Cleveland Magazine 128
Complete Woman 129
Contemporary Bride 130
Cosmopolitan 131
Couturier, Catherine, Gallery 380
Dance 133
Darkroom Gallery 381
Detroit Focus 381
Dinodia Photo Library 305
ESL Teacher Today 224
Friedentag Photographics 348
Ft. Myers Magazine 140
Gallery of Art at Springfield Art Association 389
Ghost Town 142
Golf Tips 143
Grand Rapids Magazine 144
Hamilton Magazine 145
Image Finders, The 314
Inmagine 315
Instinct Magazine 149
International Photo News 315
Isopix 316

Kalamazoo Institute of Arts 399
Kinetic, the Technology Agency 351
Kramer, Joan, and Associates Inc. 318
Ladies Home Journal 154
Leepa-Rattner Museum of Art 401
Limited Editions & Collectibles 403
MetroSource Magazine 158
Musclemag International 160
NailPro 232
New York Times on the Web, The 206
Northwestern University Dittmar Memorial
 Gallery 413
Nova Media Inc. 277
Novus Visual Communications 353
OnAsia 324
Painet Inc. 327
Paper Products Design 277
Penthouse 171
Photo Life 172
Portfolio Graphics Inc. 278
Quarto Publishing Plc. 264
Ralls Collection Inc., The 420
Revolutionary War Tracks 176
Rex USA 332
Roggen, Ted, Advertising and Public Rela-
 tions 354
Rolling Stone 177
Saxton, Joseph, Gallery of Photography,
 The 422
Schmidt, Henry, Design 355
Scholastic Library Publishing 265
Seventeen Magazine 182
Soundlight 356
SouthComm Publishing Company Inc. 185
Spencer's 279
Stock Foundry Images 336
STSimages 338
Sugar Daddy Photos 338
Surface Magazine 188
Toronto Sun Publishing 208
Ullstein Bild 339

Upstream People Gallery 429
Visual Arts Center of Northwest Florida
 431
Washington County Museum of Fine Arts
 431

FINE ART

440 Gallery 361
Aflo Foto Agency 290
Age Fotostock 290
Akego and Sahara Gallery 362
Akron Art Museum 362
Allyn & Bacon Publishers 252
amanaimages inc. 292
Ancient Art & Architecture Collection Ltd.,
 The 293
Animal Trails Magazine 112
Aperture 112
ARC Gallery 364
Archivo Criollo 295
Arsenal Gallery, The 364
Art in Motion 272
Art Licensing International 296
Art Resource 297
Art Source L.A. Inc. 367
Art Without Walls Inc. 368
Art@Net International Gallery 365
Artefact/Robert Pardo Gallery 365
Artists' Cooperative Gallery 365
Arts Company, The 366
Arts Iowa City 366
Arts on Douglas 367
Artwerks Stock Photography 297
Atlantic Gallery 369
Axis Gallery 369
Balzekas Museum of Lithuanian Culture Art
 Gallery 370
Barnett, Augustus, Advertising/Design 344
Baseball 115
Bennett Galleries and Company 371
Bentley Publishing Group 273
Blackflash 117

Blue Gallery 372
Blue Sky/Oregon Center for the Photographic Arts 373
Bon Artique.com/Art Resources International Ltd. 273
Book Beat Gallery 373
Bridal Guides Magazine 119
Bridgeman Art Library 300
Business of Art Center 373
Bynums Marketing and Communications, Inc. 347
Capilano Review, The 123
Center for Photographic Art 375
Chapman Friedman Gallery 376
Chronogram 127
CLAMPART 377
Cobblestone 128
Comesana, Eduardo, Agencia de Prensa/Banco Fotográfico 303
Contemporary Arts Center (Cincinnati), The 378
Contemporary Arts Center (Las Vegas) 378
Corcoran Fine Arts Limited, Inc. 378
Couturier, Catherine, Gallery 380
Cushing-Martin Gallery 380
Dance 133
Darkroom Gallery 381
Design Conceptions/Joel Gordon Photography 305
Design Pics Inc. 305
Detroit Focus 381
Dinodia Photo Library 305
Dorsky, Samuel, Museum of Art 382
Edelstein, Paul, Studio and Gallery 383
ESL Teacher Today 224
Event 136
EventGallery 910Arts 383
Fellowship 137
Foto-Press Timmermann 310
Fotoscopio 310
Freeport Art Museum 386

Ft. Myers Magazine 140
G2 Gallery, The 386
Gallant Greetings Corp. 275
Gallery 110 Collective 387
Gallery 218 387
Gallery Fifty Six 388
gallery nrc 389
Gallery of Art at Springfield Art Association 389
Ghost Town 142
Gloucester Arts on Main 390
Grand Rapids Art Museum 390
Grand Rapids Magazine 144
Guideposts 144
Hampton Design Group 349
Harper's Magazine 145
Harris, James, Gallery 392
Hemphill 393
Henry Street Settlement/Abrons Art Center 393
Hera Educational Foundation and Art Gallery 393
Heritage Images 312
Hunger Mountain 148
Huntsville Museum of Art 395
Icebox Quality Framing & Gallery 395
Illinois State Museum Chicago Gallery 396
Image Finders, The 314
Image Works, The 315
In the Fray 150
Indianapolis Art Center 396
Individual Artists of Oklahoma 396
Inner Traditions/Bear & Company 259
Irish Picture Library, The 316
Iron Willow 397
Isopix 316
Jackson Fine Art 397
Journal of Asian Martial Arts 151
JRB Art at the Elms 399
Judicature 152, 230
Kalamazoo Institute of Arts 399

Key Curriculum Press 260
Kirchman Gallery 399
Kiwanis 153
Kramer, Joan, and Associates Inc. 318
Land of the Bible Photo Archive 319
Lange, Shauna Lee: The Gallery of Art Journals, Visual Diaries and Sketchbooks 400
Lantern Court LLC 276
Leepa-Rattner Museum of Art 401
Leopold Gallery 402
Limner Gallery 403
Lizardi/Harp Gallery 403
Lutheran, The 157
Marin Museum of Contemporary Art 405
Markeim Art Center 406
Masur Museum of Art 406
Maui Hands 406
McGaw Graphics Inc. 276
Mesa Contemporary Arts at Mesa Arts Center 407
Multiple Exposures Gallery 409
Murphy, Michael, Gallery M 409
Museo De Arte De Ponce 410
Na'amat Woman 161
Native Peoples Magazine 162
Necrology Shorts 164
New York Times on the Web, The 206
NEXUS/Foundation for Today's Art 412
Northwest Art Center 413
Northwestern University Dittmar Memorial Gallery 413
Nova Media Inc. 277
Novus Visual Communications 353
Noyes Museum of Art, The 414
Opalka Gallery 414
Outdooria Outdoor Image Agency 326
Painet Inc. 327
Palo Alto Art Center 415
Panoramic Images 327
Paper Products Design 277

Persimmon Hill 172
Phoenix Gallery, The 416
Photo Life 172
photo-eye Gallery 416
Photography Art 417
Photomedia Center, The 417
PI Creative Art 277
Planet 173
PLANS Ltd. (Photo Libraries and News Services) 331
Polk Museum of Art 418
Popular Photography & Imaging 173
Portfolio Graphics Inc. 278
Posey School 354
Positive Images 331
Poudre River Gallery 418
Prairie Journal, The 174
Pucker Gallery Inc. 419
Pump House Center for the Arts 419
Quarto Publishing Plc. 264
Rafelman, Marcia, Fine Arts 419
Ralls Collection Inc., The 420
Recycled Paper Greetings Inc. 278
Revolutionary War Tracks 176
Running Press Book Publishers 265
Russian Life 178
San Diego Art Institute 421
Saxton, Joseph, Gallery of Photography, The 422
Schmidt, William & Florence, Art Center 422
Schmidt/Dean 422
Scholastic Library Publishing 265
Scholastic Magazines 181
Shots 183
Sioux City Art Center 423
Sohn Fine Art—Gallery & Giclée Printing 423
Soho Myriad 423
Soundlight 356
South Dakota Art Museum 424

Southside Gallery 424
Stevenson University Art Gallery 425
Stickman Review 188
Still Point Art Gallery 426
Stock Foundry Images 336
Streetpeoples Weekly News 207
STSimages 338
Sugar Daddy Photos 338
Sun, The 188
Surface Magazine 188
Synchronicity Fine Arts 426
Syracuse New Times 208
Taube, Lillian & Coleman, Museum of Art
 426
Throckmorton Fine Art 427
Tide-Mark Press 279
Tilt Gallery 427
UAB Visual Arts Gallery 428
UCR/California Museum of Photography
 428
Viridian Artists Inc. 430
Visual Arts Center of Northwest Florida
 431
Voyageur Press 266
Washington County Museum of Fine Arts
 431
Washington Project for the Arts 432
Waveland Press Inc. 267
Weinstein Gallery 432
Whiskey Island Magazine 198
Women & Their Work Art Space 432
Zenith Gallery 433

FOOD DRINK

Ace Stock Limited 288
Aflo Foto Agency 290
Age Fotostock 290
amanaimages inc. 292
American Fitness 110
AMPM Inc. 344
Art Directors & Trip Photo Library 296
Art Source L.A. Inc. 367
Art Without Walls Inc. 368
Artwerks Stock Photography 297
Atlanta Homes and Lifestyles 114
Baker Arts Center 369
Balzekas Museum of Lithuanian Culture Art
 Gallery 370
Barnett, Augustus, Advertising/Design 344
Bartender Magazine 217
Bentley Publishing Group 273
Berson, Dean, Stevens 345
Beverage Dynamics 218
Boeberitz, Bob, Design 345
Bramson + Associates 346
Bridal Guides Magazine 119
BSIP 301
Business NH Magazine 120
Bynums Marketing and Communications,
 Inc. 347
Camera Press Ltd. 301
Caribbean Travel & Life 124
Clarion-Ledger, The 205
Cleveland Magazine 128
Cosmopolitan 131
Darkroom Gallery 381
DDB Stock Photography LLC 304
Design Pics Inc. 305
Dinodia Photo Library 305
El Restaurante Mexicano 224
ESL Teacher Today 224
Flint Communications 348
Foodpix 309
Ft. Myers Magazine 140
Gallery of Art at Springfield Art Associa-
 tion 389
Ghost Town 142
Good Housekeeping 143
Hamilton Magazine 145
Healing Lifestyles & Spas Magazine 146
Heritage Images 312
Human Kinetics Publishers 258
IGA Grocergram 229

Image Finders, The 314
Images.de Fulfillment 314
Independent Restaurateur, The 229
Inmagine 315
Isopix 316
Kashrus Magazine 153
Kinetic, the Technology Agency 351
Kramer, Joan, and Associates Inc. 318
Latitude Stock 319
Leepa-Rattner Museum of Art 401
Limited Editions & Collectibles 403
Marketing & Technology Group 232
Medical File Inc., The 322
Meetings & Incentive Travel 232
Megapress Images 323
MetroSource Magazine 158
Motoring & Leisure 160
New York Times on the Web, The 206
Northwestern University Dittmar Memorial
 Gallery 413
Novus Visual Communications 353
OnAsia 324
OnRequest Images 325
Pacific Stock/Printscapes.com 326
Painet Inc. 327
Paper Products Design 277
Penthouse 171
Photolife Corporation Ltd. 329
PhotoSource International 330
Portfolio Graphics Inc. 278
QSR 239
Quarto Publishing Plc. 264
Quick Frozen Foods International 239
Restaurant Hospitality 242
Revolutionary War Tracks 176
Rhode Island Monthly 177
Roanoker, The 177
Running Press Book Publishers 265
San Diego Art Institute 421
Sandlapper Magazine 180
Scholastic Library Publishing 265

SouthComm Publishing Company Inc. 185
Southwest Airlines Spirit 186
Stock Foundry Images 336
Stock Options 337
StockFood 336
Streetpeoples Weekly News 207
STSimages 338
Sugar Daddy Photos 338
Tide-Mark Press 279
Travelworld International Magazine 193
Upstream People Gallery 429
Vermont Magazine 194
Village Profile 195
Washington County Museum of Fine Arts
 431
West Suburban Living Magazine 198
Wildlight 340
Wine & Spirits 198
Women's Health Group 268

GARDENING

440 Gallery 361
Aflo Foto Agency 290
Age Fotostock 290
AKM Images Inc. 291
Alamuphoto.com 291
amanaimages inc. 292
AMPM Inc. 344
Animal Trails Magazine 112
AppaLight 294
Argus Photo Ltd. 295
Art Directors & Trip Photo Library 296
Art Source L.A. Inc. 367
Atelier Gallery 369
Atlanta Homes and Lifestyles 114
Baker Arts Center 369
Balzekas Museum of Lithuanian Culture Art
 Gallery 370
Bee Culture 218
Bentley Publishing Group 273
Bird Watching 117

Bon Artique.com/Art Resources International Ltd. 273
Bramson + Associates 346
Bridal Guides Magazine 119
Business of Art Center 373
Carmichael Lynch 347
Cleveland Magazine 128
Contemporary Arts Center (Cincinnati), The 378
Countryman Press, The 254
Creative Homeowner 255
Dance 133
Darkroom Gallery 381
Dinodia Photo Library 305
DW Stock Picture Library 307
Ecoscene 307
Freeport Art Museum 386
Ft. Myers Magazine 140
G2 Gallery, The 386
Gallant Greetings Corp. 275
gallery nrc 389
Gallery of Art at Springfield Art Association 389
Gardening How-To 141
Ghost Town 142
Good Housekeeping 143
Hearth and Home 228
Hutchison Picture Library 313
Image Finders, The 314
Jeroboam 318
Kramer, Joan, and Associates Inc. 318
Landscape Architecture 231
Lange, Shauna Lee: The Gallery of Art Journals, Visual Diaries and Sketchbooks 400
Latitude Stock 319
Leepa-Rattner Museum of Art 401
Marin Museum of Contemporary Art 405
Medical File Inc., The 322
Megapress Images 323
Motoring & Leisure 160

Mountain Living 160
Murphy, Michael, Gallery M 409
New York Times on the Web, The 206
Northwestern University Dittmar Memorial Gallery 413
Novus Visual Communications 353
Painet Inc. 327
Panoramic Images 327
Paper Products Design 277
Photo Agora 328
photo-eye Gallery 416
PhotoSource International 330
Ponds USA and Water Gardens 238
Portfolio Graphics Inc. 278
Positive Images 331
Poudre River Gallery 418
Pump House Center for the Arts 419
Quarto Publishing Plc. 264
Ralls Collection Inc., The 420
Richardson, Ella Walton, Fine Art 420
Running Press Book Publishers 265
San Diego Art Institute 421
Sandlapper Magazine 180
Saxton, Joseph, Gallery of Photography, The 422
Scholastic Library Publishing 265
SouthComm Publishing Company Inc. 185
State Street Gallery 425
Stock Foundry Images 336
StockFood 336
STSimages 338
Sugar Daddy Photos 338
Teldon 279
Tide-Mark Press 279
Voyageur Press 266
Washington County Museum of Fine Arts 431
West Suburban Living Magazine 198
Western Producer, The 209
Wildlight 340
Willow Creek Press 268

Yankee Magazine 199

HEALTH/FITNESS/BEAUTY
AAP News 212
Accent Alaska/Ken Graham Agency 288
Ace Stock Limited 288
Aflo Foto Agency 290
Age Fotostock 290
Allyn & Bacon Publishers 252
amanaimages inc. 292
AMC Outdoors 109
American Fitness 110
AMPM Inc. 344
APA Monitor 214
AppaLight 294
Aquarius 204
Argus Photo Ltd. 295
Art Directors & Trip Photo Library 296
Art Without Walls Inc. 368
Asia Images Group 297
Athletic Business 215
Auscape International 298
Balzekas Museum of Lithuanian Culture Art
 Gallery 370
Bergman Collection, The 299
Boeberitz, Bob, Design 345
Bon Artique.com/Art Resources Interna-
 tional Ltd. 273
Bramson + Associates 346
Bridal Guides Magazine 119
BSIP 301
Business NH Magazine 120
Business of Art Center 373
Bynums Marketing and Communications,
 Inc. 347
Camera Press Ltd. 301
Children's Defense Fund 205
Cleveland Magazine 128
Comesana, Eduardo, Agencia de Prensa/
 Banco Fotográfico 303
Complete Woman 129
Cosmopolitan 131

Cycle California! Magazine 132
Darkroom Gallery 381
DDB Stock Photography LLC 304
Design Conceptions/Joel Gordon Photog-
 raphy 305
Design Pics Inc. 305
Dinodia Photo Library 305
DK Stock Inc. 306
DW Stock Picture Library 307
Ecoscene 307
Flint Communications 348
Foto-Press Timmermann 310
Fotoscopio 310
Ft. Myers Magazine 140
Gallery of Art at Springfield Art Associa-
 tion 389
Golf Tips 143
Good Housekeeping 143
Grand Rapids Magazine 144
Hamilton Magazine 145
Hampton Design Group 349
Healing Lifestyles & Spas Magazine 146
Human Kinetics Publishers 258
Hutchison Picture Library 313
Image Works, The 315
Images.de Fulfillment 314
Inmagine 315
Inside Triathlon 149
Instinct Magazine 149
International Photo News 315
Isopix 316
Jeroboam 318
Journal of Adventist Education 230
Journal of Asian Martial Arts 151
Key Curriculum Press 260
Kramer, Joan, and Associates Inc. 318
Ladies Home Journal 154
Latitude Stock 319
Leepa-Rattner Museum of Art 401
Limited Editions & Collectibles 403
Medical File Inc., The 322

Mediscan 322
Megapress Images 323
MetroSource Magazine 158
Military Officer Magazine 232
Motoring & Leisure 160
Multiple Exposures Gallery 409
Musclemag International 160
NailPro 232
New York Times on the Web, The 206
Northwestern University Dittmar Memorial
 Gallery 413
Nova Media Inc. 277
Novastock 324
Novus Visual Communications 353
OnAsia 324
OnRequest Images 325
Opção Brasil Imagens 325
Outside Imagery LLC 326
Oxygen 169
Pacific Stock/Printscapes.com 326
Painet Inc. 327
Panoramic Images 327
Penthouse 171
Photo Agora 328
Portfolio Graphics Inc. 278
Positive Images 331
Quarto Publishing Plc. 264
Ralls Collection Inc., The 420
Roanoker, The 177
Roggen, Ted, Advertising and Public Rela-
 tions 354
Sailing World 179
Saks, Arnold, Associates 355
San Diego Art Institute 421
Sandlapper Magazine 180
Scholastic Library Publishing 265
Seventeen Magazine 182
Soundlight 356
SouthComm Publishing Company Inc. 185
Southwest Airlines Spirit 186
Sports Illustrated 187

Stock Foundry Images 336
StockFood 336
Streetpeoples Weekly News 207
STSimages 338
Sugar Daddy Photos 338
Sun 207
Taube, Lillian & Coleman, Museum of Art
 426
Tide-Mark Press 279
Toronto Sun Publishing 208
Trail Runner 192
Tropix Photo Library 339
Ullstein Bild 339
Upstream People Gallery 429
Video I-D, Teleproductions 357
Village Profile 195
Washington County Museum of Fine Arts
 431
Waveland Press Inc. 267
West Suburban Living Magazine 198
Wildlight 340
Women's Health Group 268
Woodmen Living 199

HISTORICAL/VINTAGE

440 Gallery 361
Aflo Foto Agency 290
African American Golfer's Digest 107
Age Fotostock 290
Akego and Sahara Gallery 362
Akron Art Museum 362
Alaska Stock 292
Allyn & Bacon Publishers 252
amanaimages inc. 292
American Power Boat Association 213
AMPM Inc. 344
Anchor News 112
Ancient Art & Architecture Collection Ltd.,
 The 293
Animal Trails Magazine 112
Archivo Criollo 295
Arsenal Gallery, The 364

Art Directors & Trip Photo Library 296
Art in Motion 272
Art Source L.A. Inc. 367
Art Without Walls Inc. 368
Arts Company, The 366
Artwerks Stock Photography 297
Axis Gallery 369
Baker Arts Center 369
Balzekas Museum of Lithuanian Culture Art Gallery 370
Barnett, Augustus, Advertising/Design 344
Baseball 115
Bennett Galleries and Company 371
Benrubi, Bonni, Gallery 371
Bentley Publishing Group 273
Blue Ridge Country 118
Borealis Press, The 273
Boys' Life 119
Bramson + Associates 346
Bridal Guides Magazine 119
California Views/The Pat Hathaway Historical Photo Collection 301
Calliope 120
Chronogram 127
CLAMPART 377
Cody Images 303
Cohen, Stephen, Gallery 377
Collectible Automobile 129
Comesana, Eduardo, Agencia de Prensa/Banco Fotográfico 303
Continental Newstime 130
Countryman Press, The 254
Couturier, Catherine, Gallery 380
Crabtree Publishing Company 255
Dance 133
Darkroom Gallery 381
Design Pics Inc. 305
Dinodia Photo Library 305
DK Stock Inc. 306
Dorsky, Samuel, Museum of Art 382
Eastman, George, House 382

Edelstein, Paul, Studio and Gallery 383
ESL Teacher Today 224
Etherton Gallery 383
Farcountry Press 256
Flint Communications 348
Fotoscopio 310
Freeport Art Museum 386
Ft. Myers Magazine 140
G2 Gallery, The 386
Gallery of Art at Springfield Art Association 389
Geoslides & Geo Aerial Photography 311
Ghost Town 142
Gloucester Arts on Main 390
Grand Rapids Art Museum 390
Hampton Design Group 349
Harper's Magazine 145
Hemphill 393
Henry Street Settlement/Abrons Art Center 393
Heritage Images 312
Heritage Railway Magazine 146
Huntsville Museum of Art 395
Icebox Quality Framing & Gallery 395
Illinois State Museum Chicago Gallery 396
Image Works, The 315
In the Fray 150
Independent Restaurateur, The 229
Individual Artists of Oklahoma 396
Inner Traditions/Bear & Company 259
Iowan Magazine, The 150
Irish Picture Library, The 316
Iron Willow 397
Isopix 316
ITE Journal 229
Jackson Fine Art 397
Jeroboam 318
Journal of Asian Martial Arts 151
Judicature 152, 230
Kramer, Joan, and Associates Inc. 318
Land of the Bible Photo Archive 319

Lange, Shauna Lee: The Gallery of Art Journals, Visual Diaries and Sketchbooks 400
Leepa-Rattner Museum of Art 401
Limited Editions & Collectibles 403
Limner Gallery 403
Log Newspaper, The 206
Markeim Art Center 406
Masur Museum of Art 406
MBI Inc. 261
McGaw Graphics Inc. 276
Mesa Contemporary Arts at Mesa Arts Center 407
Military Officer Magazine 232
Missouri Life 159
Mitchell Lane Publishers Inc. 261
Monderer Design Inc. 352
Motoring & Leisure 160
mptv 324
Na'amat Woman 161
Nails Magazine 233
National Parks Magazine 162
Naval History 233
Necrology Shorts 164
New York State Conservationist Magazine 164
North Dakota Horizons 166
Northern Woodlands Magazine 166
Northwest Territories Explorer's Guide 234
Northwestern University Dittmar Memorial Gallery 413
Nova Media Inc. 277
Novus Visual Communications 353
Noyes Museum of Art, The 414
OnAsia 324
Painet Inc. 327
Pakn Treger 170
Panoramic Images 327
Paper Products Design 277
Persimmon Hill 172
PI Creative Art 277

Planet 173
Planning 236
PLANS Ltd. (Photo Libraries and News Services) 331
Polk Museum of Art 418
Ponkawonka Inc. 331
Popular Photography & Imaging 173
Portfolio Graphics Inc. 278
Posey School 354
Poudre River Gallery 418
Prakken Publications Inc. 263
ProStar Publications Inc. 264
Pump House Center for the Arts 419
Quarto Publishing Plc. 264
Rafelman, Marcia, Fine Arts 419
Railphotolibrary.com 332
Ralls Collection Inc., The 420
Recycled Paper Greetings Inc. 278
Revolutionary War Tracks 176
Rex USA 332
Running Press Book Publishers 265
Russian Life 178
San Diego Art Institute 421
Sandlapper Magazine 180
Saxton, Joseph, Gallery of Photography, The 422
Schmidt, William & Florence, Art Center 422
Scholastic Library Publishing 265
Scholastic Magazines 181
Silver Moon Press 266
Soho Myriad 423
SouthComm Publishing Company Inc. 185
Sovfoto/Eastfoto Inc. 335
Stevenson University Art Gallery 425
Stock Foundry Images 336
Streetpeoples Weekly News 207
STSimages 338
Sugar Daddy Photos 338
Synchronicity Fine Arts 426
Throckmorton Fine Art 427

Tide-Mark Press 279

Tilt Gallery 427

Times of the Islands 191

UAB Visual Arts Gallery 428

UCR/California Museum of Photography
 428

Ullstein Bild 339

Village Profile 195

Visual Arts Center of Northwest Florida
 431

Voyageur Press 266

Washington County Museum of Fine Arts
 431

Waveland Press Inc. 267

Weigl Educational Publishers Ltd. 267

Woodmen Living 199

HOBBIES

4-Wheel ATV Action 106

Accent Alaska/Ken Graham Agency 288

Ace Stock Limited 288

Aflo Foto Agency 290

African American Golfer's Digest 107

Age Fotostock 290

amanaimages inc. 292

American Angler 109

American Bee Journal 213

American Fitness 110

AppaLight 294

Appaloosa Journal 113

Art Directors & Trip Photo Library 296

Artwerks Stock Photography 297

Auto Restorer 114, 216

Balzekas Museum of Lithuanian Culture Art
 Gallery 370

Bird Watching 117

Boeberitz, Bob, Design 345

Borealis Press, The 273

Bowhunter 118

Boys' Life 119

Capstone Press 253

chickaDEE 126

Chirp 126

Cleveland Magazine 128

Coast&Kayak Magazine 128

Country Woman 131

Darkroom Gallery 381

DDB Stock Photography LLC 304

Design Pics Inc. 305

Dinodia Photo Library 305

DK Stock Inc. 306

Family Motor Coaching 137

Finescale Modeler 138

Fly Rod & Reel 139

Foto-Press Timmermann 310

Fotoscopio 310

Fur-Fish-Game 140

Gallery of Art at Springfield Art Associa-
 tion 389

Guitar World 145

Heritage Railway Magazine 146

Image Integration 351

Images.de Fulfillment 314

Inmagine 315

Isopix 316

Kramer, Joan, and Associates Inc. 318

Latitude Stock 319

Leepa-Rattner Museum of Art 401

Lerner Publishing Group 260

Limited Editions & Collectibles 403

Marlin 157

MBI Inc. 261

Missouri Life 159

Motor Boating Magazine 159

Motoring & Leisure 160

Mushing.com Magazine 161

Muzzle Blasts 161

New York Times on the Web, The 206

North Dakota Horizons 166

Northwestern University Dittmar Memorial
 Gallery 413

Novus Visual Communications 353

OWL Magazine 169

Painet Inc. 327
Pennsylvania Game News 171
Persimmon Hill 172
photo-eye Gallery 416
PhotoSource International 330
PI Creative Art 277
Ponds USA and Water Gardens 238
Portfolio Graphics Inc. 278
Quarto Publishing Plc. 264
Ralls Collection Inc., The 420
Running Press Book Publishers 265
San Diego Art Institute 421
Sandlapper Magazine 180
Scholastic Library Publishing 265
Shooting Sports USA 183
SouthComm Publishing Company Inc. 185
Southwest Airlines Spirit 186
Stock Foundry Images 336
Streetpeoples Weekly News 207
STSimages 338
Sugar Daddy Photos 338
Surfing Magazine 189
Tide-Mark Press 279
Ullstein Bild 339
Voyageur Press 266
Washington County Museum of Fine Arts 431
Washington Trails 196
WaterSki 197
Wildlight 340
Wisconsin Snowmobile News 199
Writer's Digest 199, 249

HUMOR

Accent Alaska/Ken Graham Agency 288
Ace Stock Limited 288
Aflo Foto Agency 290
Age Fotostock 290
Alamuphoto.com 291
amanaimages inc. 292
American Fitness 110
American Motorcyclist 111

AMPM Inc. 344
AppaLight 294
Art Directors & Trip Photo Library 296
Auto Restorer 114, 216
Avanti Press Inc. 272
Baker Arts Center 369
Balzekas Museum of Lithuanian Culture Art Gallery 370
Bennett Galleries and Company 371
Borealis Press, The 273
Boys' Life 119
Camera Press Ltd. 301
Centric Corp. 274
Chess Life for Kids 126
chickaDEE 126
Chirp 126
CLAMPART 377
Cleveland Magazine 128
Comesana, Eduardo, Agencia de Prensa/ Banco Fotográfico 303
Comstock Cards 274
Couturier, Catherine, Gallery 380
Darkroom Gallery 381
Design Design Inc. 274
Design Pics Inc. 305
Dinodia Photo Library 305
DK Stock Inc. 306
Fellowship 137
Gallant Greetings Corp. 275
Gallery of Art at Springfield Art Association 389
Grand Rapids Magazine 144
Highlights for Children 147
In the Fray 150
Indianapolis Monthly 149
Instinct Magazine 149
Isopix 316
Jeroboam 318
Kashrus Magazine 153
Kramer, Joan, and Associates Inc. 318
Leepa-Rattner Museum of Art 401

Limited Editions & Collectibles 403
Luckypix 321
Marin Museum of Contemporary Art 405
Musclemag International 160
NEXUS/Foundation for Today's Art 412
Northwestern University Dittmar Memorial
 Gallery 413
Novus Visual Communications 353
OWL Magazine 169
Painet Inc. 327
Pakn Treger 170
Paper Products Design 277
Penthouse 171
photo-eye Gallery 416
Ponds USA and Water Gardens 238
Portfolio Graphics Inc. 278
Recycled Paper Greetings Inc. 278
Retailers Forum 242
RIG 278
Sailing World 179
San Diego Art Institute 421
Scholastic Library Publishing 265
Soundlight 356
Southwest Airlines Spirit 186
Stock Foundry Images 336
Streetpeoples Weekly News 207
STSimages 338
Sugar Daddy Photos 338
Sun 207
Tide-Mark Press 279
Tilt Gallery 427
Ullstein Bild 339
Upstream People Gallery 429
Voyageur Press 266
Washington County Museum of Fine Arts
 431
Wildlight 340
Woodmen Living 199
Writer's Digest 199, 249

INDUSTRY
Accent Alaska/Ken Graham Agency 288

Ace Stock Limited 288
Aflo Foto Agency 290
Age Fotostock 290
Alamuphoto.com 291
Alaska Stock 292
amanaimages inc. 292
AMPM Inc. 344
Andes Press Agency 293
AOPA Pilot 214
AppaLight 294
Art Directors & Trip Photo Library 296
Artwerks Stock Photography 297
Aurora Photos 298
Avionics Magazine 217
Balzekas Museum of Lithuanian Culture Art
 Gallery 370
Barnett, Augustus, Advertising/Design 344
Boeberitz, Bob, Design 345
Borough News 118
Business NH Magazine 120
Cleveland Magazine 128
Cobblestone 128
Comesana, Eduardo, Agencia de Prensa/
 Banco Fotográfico 303
Continental Newstime 130
Couturier, Catherine, Gallery 380
Darkroom Gallery 381
Design Pics Inc. 305
Dinodia Photo Library 305
DK Stock Inc. 306
DW Stock Picture Library 307
Ecoscene 307
Electric Perspectives 223
Electrical Apparatus 223
Elks Magazine, The 135
Flint Communications 348
Foto-Press Timmermann 310
FOTOAGENT 310
Fotoscopio 310
Friedentag Photographics 348
Fundamental Photographs 311

Gallery of Art at Springfield Art Association 389
Geoslides & Geo Aerial Photography 311
Geosynthetics 227
Gloucester Arts on Main 390
Grain Journal 227
Granataimages.com 312
Grand Rapids Business Journal 206
Hutchison Picture Library 313
IEEE Spectrum 229
Image Finders, The 314
Image Works, The 315
Images.de Fulfillment 314
Inmagine 315
Isopix 316
ITE Journal 229
Jeroboam 318
Jude Studios 351
Kinetic, the Technology Agency 351
Kramer, Joan, and Associates Inc. 318
Leepa-Rattner Museum of Art 401
Lerner Publishing Group 260
Lineair Fotoarchief BV 320
Lohre & Associates Inc. 352
Manufacturing Automation 231
Marin Museum of Contemporary Art 405
Marketing & Technology Group 232
MBI Inc. 261
McGraw-Hill 261
Monderer Design Inc. 352
Murphy, Michael, Gallery M 409
Naval History 233
New York Times on the Web, The 206
NEXUS/Foundation for Today's Art 412
North Dakota Horizons 166
Novus Visual Communications 353
OnAsia 324
OnRequest Images 325
Opção Brasil Imagens 325
Pacific Stock/Printscapes.com 326
Painet Inc. 327

Panoramic Images 327
People Management 235
Pet Product News 235
Photo Agora 328
PhotoSource International 330
Planet 173
Plastics Technology 236
Popular Photography & Imaging 173
Portfolio Graphics Inc. 278
Prakken Publications Inc. 263
Proceedings 238
Professional Photographer 238
Purestock 332
Quick Frozen Foods International 239
Relay Magazine 241
Saks, Arnold, Associates 355
Sandlapper Magazine 180
Saxton, Joseph, Gallery of Photography, The 422
Scholastic Library Publishing 265
Scrap 182
SouthComm Publishing Company Inc. 185
Southwest Airlines Spirit 186
Stack, Tom, & Associates Inc. 335
Still Media 335
Stock Foundry Images 336
Stock Options 337
STSimages 338
Sugar Daddy Photos 338
Synchronicity Fine Arts 426
Textile Rental Magazine 245
Thomas, Martin, International 356
Tropix Photo Library 339
Ullstein Bild 339
Underground Construction 247
Video I-D, Teleproductions 357
Village Profile 195
Washington County Museum of Fine Arts 431
Water Well Journal 247
Weigl Educational Publishers Ltd. 267

Wholesaler, The 247
Wildlight 340
Wisconsin Architect 248
Woman Engineer 248
Woodshop News 248

INTERIOR/DECORATING
Aflo Foto Agency 290
Age Fotostock 290
amanaimages inc. 292
AMPM Inc. 344
Animal Trails Magazine 112
Architectural Lighting 215
Argus Photo Ltd. 295
Art Directors & Trip Photo Library 296
Art Source L.A. Inc. 367
Atlanta Homes and Lifestyles 114
Baker Arts Center 369
Balzekas Museum of Lithuanian Culture Art Gallery 370
Bentley Publishing Group 273
Beverage Dynamics 218
Bon Artique.com/Art Resources International Ltd. 273
Bramson + Associates 346
Bridal Guides Magazine 119
Camera Press Ltd. 301
Canadian Homes & Cottages 121
Caribbean Travel & Life 124
Carmichael Lynch 347
Cleveland Magazine 128
Country Woman 131
Creative Homeowner 255
Dance 133
Darkroom Gallery 381
Design Pics Inc. 305
Dinodia Photo Library 305
Display Design Ideas 223
Fotoscopio 310
Ft. Myers Magazine 140
gallery nrc 389

Gallery of Art at Springfield Art Association 389
Ghost Town 142
Good Housekeeping 143
Hutchinson Associates Inc. 350
Hutchison Picture Library 313
Kashrus Magazine 153
Kramer, Joan, and Associates Inc. 318
Lange, Shauna Lee: The Gallery of Art Journals, Visual Diaries and Sketchbooks 400
Leepa-Rattner Museum of Art 401
Lived In Images 320
Log Home Living 156
Meetings & Incentive Travel 232
Mesa Contemporary Arts at Mesa Arts Center 407
MetroSource Magazine 158
Mountain Living 160
Murphy, Michael, Gallery M 409
NailPro 232
Nails Magazine 233
New York Times on the Web, The 206
Novus Visual Communications 353
OnAsia 324
OnRequest Images 325
Painet Inc. 327
Panoramic Images 327
Period Ideas 171
Persimmon Hill 172
PhotoSource International 330
Portfolio Graphics Inc. 278
Poudre River Gallery 418
Quarto Publishing Plc. 264
Ralls Collection Inc., The 420
Remodeling 241
Rhode Island Monthly 177
Richardson, Ella Walton, Fine Art 420
Roanoker, The 177
Running Press Book Publishers 265
Sandlapper Magazine 180

Scholastic Library Publishing 265
SouthComm Publishing Company Inc. 185
Stock Foundry Images 336
StockFood 336
STSimages 338
Sugar Daddy Photos 338
Surface Magazine 188
Teldon 279
Tide-Mark Press 279
Upstream People Gallery 429
Washington County Museum of Fine Arts 431
West Suburban Living Magazine 198
Wildlight 340
Woodshop News 248
Yankee Magazine 199

LANDSCAPES/SCENICS

A+E 289
Accent Alaska/Ken Graham Agency 288
Ace Stock Limited 288
Aflo Foto Agency 290
Age Fotostock 290
Akego and Sahara Gallery 362
AKM Images Inc. 291
Alaska Stock 292
amanaimages inc. 292
AMC Outdoors 109
AMPM Inc. 344
Andes Press Agency 293
Animal Trails Magazine 112
Animals Animals/Earth Scenes 294
Appalachian Mountain Club Books 252
Appalachian Trail Journeys 113
AppaLight 294
Appaloosa Journal 113
Archivo Criollo 295
Arizona Wildlife Views 113
Arsenal Gallery, The 364
Art Directors & Trip Photo Library 296
Art Source L.A. Inc. 367
Art Without Walls Inc. 368

Art@Net International Gallery 365
Arts Company, The 366
Arts Iowa City 366
Artwerks Stock Photography 297
Atelier Gallery 369
Atlantic Gallery 369
Aurora Photos 298
Auscape International 298
Axiom Photographic 298
Baker Arts Center 369
Balzekas Museum of Lithuanian Culture Art Gallery 370
Baseball 115
Beef Today 218
Belian Art Center 370
Bell Studio 371
Bennett Galleries and Company 371
Biological Photo Service and Terraphotographics 299
Bird Watching 117
Blue Ridge Country 118
Blue Sky/Oregon Center for the Photographic Arts 373
Boeberitz, Bob, Design 345
Bon Artique.com/Art Resources International Ltd. 273
Borough News 118
Bowhunter 118
Boys' Life 119
Bridal Guides Magazine 119
BSIP 301
Business of Art Center 373
California Views/The Pat Hathaway Historical Photo Collection 301
Canadian Homes & Cottages 121
Canoe & Kayak 122
Capstone Press 253
Caribbean Travel & Life 124
Carmichael Lynch 347
Centric Corp. 274
Chabot Fine Art Gallery 376

Chapman Friedman Gallery 376
Civitan Magazine 220
CLAMPART 377
Cleveland Magazine 128
Coast&Kayak Magazine 128
Cobblestone 128
Comesana, Eduardo, Agencia de Prensa/ Banco Fotográfico 303
Contemporary Arts Center (Cincinnati), The 378
Country Woman 131
Countryman Press, The 254
Couturier, Catherine, Gallery 380
Creative Homeowner 255
Dairy Today 222
Dance 133
Darkroom Gallery 381
DDB Stock Photography LLC 304
Deljou Art Group 274
Design Pics Inc. 305
Dinodia Photo Library 305
DRK Photo 307
drkrm 382
Ducks Unlimited Magazine 135
Edelstein, Paul, Studio and Gallery 383
ESL Teacher Today 224
Event 136
Family Motor Coaching 137
Farcountry Press 256
Fellowship 137
Fly Rod & Reel 139
Forest Landowner 226
Foto-Press Timmermann 310
Fotoscopio 310
Freeport Art Museum 386
Ft. Myers Magazine 140
Fur-Fish-Game 140
G2 Gallery, The 386
Gallant Greetings Corp. 275
Gallery 110 Collective 387
Gallery Fifty Six 388

gallery nrc 389
Gallery of Art at Springfield Art Association 389
Geoslides & Geo Aerial Photography 311
Ghost Town 142
Gloucester Arts on Main 390
Gospel Herald 143
Grand Rapids Magazine 144
Guideposts 144
Haardt, Anton, Gallery 390
Haddad, Carrie, Gallery 391
Hampton Design Group 349
Harris, James, Gallery 392
Havu, William, Gallery 392
Healing Lifestyles & Spas Magazine 146
Hemphill 393
Henry Street Settlement/Abrons Art Center 393
Hera Educational Foundation and Art Gallery 393
Highways 147
Howard, Merrell and Partners Inc. 350
Hutchison Picture Library 313
Icebox Quality Framing & Gallery 395
Image Finders, The 314
Impact Photographics 275
Inmagine 315
Inner Traditions/Bear & Company 259
Interval World 150
Iowan Magazine, The 150
Iron Willow 397
Islands 150
Isopix 316
ITE Journal 229
Jewish Action 151
JRB Art at the Elms 399
Kalamazoo Institute of Arts 399
Kansas! 152
Kashrus Magazine 153
Kentucky Monthly 153
Key Curriculum Press 260

Kimball Stock 318
Kirchman Gallery 399
Kiwanis 153
Kramer, Joan, and Associates Inc. 318
Lake Superior Magazine 154
Lakeland Boating Magazine 154
Land of the Bible Photo Archive 319
Landscape Architecture 231
Lange, Shauna Lee: The Gallery of Art Journals, Visual Diaries and Sketchbooks 400
Latitude Stock 319
Leepa-Rattner Museum of Art 401
Leopold Gallery 402
Lerner Publishing Group 260
Limited Editions & Collectibles 403
Lincolnshire Life 155
Lineair Fotoarchief BV 320
Lizardi/Harp Gallery 403
Lutheran, The 157
Marin Museum of Contemporary Art 405
Markeim Art Center 406
Marlin 157
Masur Museum of Art 406
Maui Hands 406
McGaw Graphics Inc. 276
Meetings & Incentive Travel 232
Megapress Images 323
Mesa Contemporary Arts at Mesa Arts Center 407
Michelson, R., Galleries 408
Michigan Out-of-Doors 158
Missouri Life 159
Motoring & Leisure 160
Multiple Exposures Gallery 409
Murphy, Michael, Gallery M 409
Museum of Printing History 411
Na'amat Woman 161
National Geographic 162
National Parks Magazine 162
Natural History 162

Nature Photographer 163
Nevada Farm Bureau Agriculture and Livestock Journal 234
New Mexico Magazine 164
New York State Conservationist Magazine 164
New York Times on the Web, The 206
Nicolas-Hays Inc. 262
North Dakota Horizons 166
Northern Woodlands Magazine 166
Northwest Art Center 413
Northwest Territories Explorer's Guide 234
Northwestern University Dittmar Memorial Gallery 413
Nova Media Inc. 277
Novus Visual Communications 353
Oklahoma Today 167
OnAsia 324
Onboard Media 168
OnRequest Images 325
Opening Night Gallery 415
Outdooria Outdoor Image Agency 326
Outside Imagery LLC 326
Owen, Richard C., Publishers Inc. 262
Pacific Stock/Printscapes.com 326
Painet Inc. 327
Panoramic Images 327
Pennsylvania Magazine 171
Persimmon Hill 172
Photo Agora 328
Photo Life 172
PHOTO Techniques 172
photo-eye Gallery 416
Photography Art 417
PhotoSource International 330
PI Creative Art 277
Planning 236
Portfolio Graphics Inc. 278
Positive Images 331
Poudre River Gallery 418
ProStar Publications Inc. 264

SUBJECT INDEX

Pucker Gallery Inc. 419
Pump House Center for the Arts 419
Rafelman, Marcia, Fine Arts 419
Ralls Collection Inc., The 420
Recommend 240
Recycled Paper Greetings Inc. 278
Revolutionary War Tracks 176
Rhode Island Monthly 177
Richardson, Ella Walton, Fine Art 420
Running Press Book Publishers 265
Salt Water Sportsman 180
San Diego Art Institute 421
Sandlapper Magazine 180
Saxton, Joseph, Gallery of Photography,
 The 422
Scholastic Library Publishing 265
Sea 182
Sohn Fine Art—Gallery & Giclée Printing
 423
Soho Myriad 423
Soundlight 356
SouthComm Publishing Company Inc. 185
Southside Gallery 424
Southwest Airlines Spirit 186
Stack, Tom, & Associates Inc. 335
State Street Gallery 425
Still Point Art Gallery 426
Stock Connection 336
Stock Foundry Images 336
Stock Options 337
STSimages 338
Sugar Daddy Photos 338
Sun, The 188
Surfing Magazine 189
Synchronicity Fine Arts 426
Taube, Lillian & Coleman, Museum of Art
 426
Teldon 279
Thin Air Magazine 190
Throckmorton Fine Art 427
Tide Magazine 190

Tide-Mark Press 279
Tilt Gallery 427
Times of the Islands 191
Top Producer 246
Trail Runner 192
Trails Media Group 280
Transportation Management & Engineer-
 ing 246
Tropix Photo Library 339
Ullstein Bild 339
Up Here 194
Upstream People Gallery 429
Vermont Magazine 194
Village Profile 195
Visitor's Choice Magazine 266
Visual Arts Center of Northwest Florida
 431
Voyageur Press 266
Washington County Museum of Fine Arts
 431
Washington Trails 196
Waterway Guide 197
Weigl Educational Publishers Ltd. 267
West Suburban Living Magazine 198
Western Producer, The 209
Whiskey Island Magazine 198
Wildlight 340
Willow Creek Press 268
Yankee Magazine 199
Zenith Gallery 433

LIFESTYLE

Aflo Foto Agency 290
African American Golfer's Digest 107
Age Fotostock 290
Akego and Sahara Gallery 362
Alamuphoto.com 291
Alaska 108
American Motorcyclist 111
Appalachian Mountain Club Books 252
Appalachian Trail Journeys 113
AppaLight 294

Argus Photo Ltd. 295
Artwerks Stock Photography 297
Asia Images Group 297
Atlanta Homes and Lifestyles 114
Auscape International 298
Baker Arts Center 369
Balzekas Museum of Lithuanian Culture Art
 Gallery 370
BC Outdoors Hunting and Shooting 115
BC Outdoors Sport Fishing 116
Blend Images 300
Blue Ridge Country 118
Camera Press Ltd. 301
Caribbean Travel & Life 124
Catholic News Service 302
Charisma 125
Chesapeake Bay Magazine 125
Cosmopolitan 131
Darkroom Gallery 381
Design Pics Inc. 305
DK Stock Inc. 306
DW Stock Picture Library 307
Easyriders 135
eStock Photo LLC 308
Flaunt 138
Foodpix 309
Foto-Press Timmermann 310
Gallery Fifty Six 388
Gallery of Art at Springfield Art Associa-
 tion 389
Good Housekeeping 143
Grand Rapids Magazine 144
Hadassah Magazine 145
Hamilton Magazine 145
Highways 147
In the Fray 150
Indianapolis Monthly 149
Inmagine 315
Insight Magazine 149
Jewish Action 151
Kalamazoo Institute of Arts 399

Kansas! 152
Kimball Stock 318
Kramer, Joan, and Associates Inc. 318
Lange, Shauna Lee: The Gallery of Art Jour-
 nals, Visual Diaries and Sketchbooks
 400
Leepa-Rattner Museum of Art 401
Lightwave Photography 319
MAXX Images Inc. 322
Mediscan 322
Military Officer Magazine 232
Missouri Life 159
Mountain Living 160
Necrology Shorts 164
Novastock 324
OnRequest Images 325
Outdooria Outdoor Image Agency 326
Outside Imagery LLC 326
Painet Inc. 327
Photolibrary Group, The 329
Photolife Corporation Ltd. 329
Portfolio Graphics Inc. 278
Positive Images 331
Poudre River Gallery 418
Princeton Alumni Weekly 175
Purestock 332
Rhode Island Monthly 177
Running Press Book Publishers 265
Saxton, Joseph, Gallery of Photography,
 The 422
Scholastic Library Publishing 265
Seventeen Magazine 182
SouthComm Publishing Company Inc. 185
Southern Boating 186
Spencer's 279
Stock Foundry Images 336
Sugar Daddy Photos 338
Superstock Inc. 339
Visitor's Choice Magazine 266
Washington Blade, The 196
Washington Trails 196

Woodmen Living 199

MEDICINE
AAP News 212
Accent Alaska/Ken Graham Agency 288
Ace Stock Limited 288
Aflo Foto Agency 290
Age Fotostock 290
Alamuphoto.com 291
amanaimages inc. 292
American Fitness 110
AMPM Inc. 344
AppaLight 294
Aquarius 204
Art Directors & Trip Photo Library 296
Art Without Walls Inc. 368
Auscape International 298
Balzekas Museum of Lithuanian Culture Art
 Gallery 370
Bergman Collection, The 299
Biological Photo Service and Terraphoto-
 graphics 299
Boeberitz, Bob, Design 345
Bramson + Associates 346
BSIP 301
Bynums Marketing and Communications,
 Inc. 347
Cleveland Magazine 128
College PreView 129
Comesana, Eduardo, Agencia de Prensa/
 Banco Fotográfico 303
Continental Newstime 130
Darkroom Gallery 381
Design Conceptions/Joel Gordon Photog-
 raphy 305
Design Pics Inc. 305
Dinodia Photo Library 305
DK Stock Inc. 306
Ecoscene 307
ESL Teacher Today 224
FireRescue 225
Flint Communications 348

Foto-Press Timmermann 310
FOTOAGENT 310
Friedentag Photographics 348
Ft. Myers Magazine 140
Fundamental Photographs 311
Gallery of Art at Springfield Art Associa-
 tion 389
Geoslides & Geo Aerial Photography 311
Ghost Town 142
Hampton Design Group 349
Human Kinetics Publishers 258
Hutchinson Associates Inc. 350
Hutchison Picture Library 313
IEEE Spectrum 229
Image Finders, The 314
Image Works, The 315
Images.de Fulfillment 314
Inmagine 315
Inner Traditions/Bear & Company 259
Isopix 316
Jeroboam 318
Journal of Psychoactive Drugs 230
Kiwanis 153
KNOWAtlanta 153
Kramer, Joan, and Associates Inc. 318
Leepa-Rattner Museum of Art 401
Marin Museum of Contemporary Art 405
Medical File Inc., The 322
Mediscan 322
Megapress Images 323
Monderer Design Inc. 352
Murphy, Michael, Gallery M 409
New York Times on the Web, The 206
Novus Visual Communications 353
OnAsia 324
Opção Brasil Imagens 325
Painet Inc. 327
Panoramic Images 327
Pediatric Annals 235
People Management 235
Photo Agora 328

Photolife Corporation Ltd. 329
PhotoSource International 330
Portfolio Graphics Inc. 278
Purestock 332
Revolutionary War Tracks 176
Roanoker, The 177
Saks, Arnold, Associates 355
Sandlapper Magazine 180
Scholastic Library Publishing 265
Science Photo Library Ltd. 333
Science Source/Photo Researchers Inc. 333
Soundlight 356
SouthComm Publishing Company Inc. 185
Southwest Airlines Spirit 186
State Street Gallery 425
Stock Foundry Images 336
STSimages 338
Sugar Daddy Photos 338
Sun 207
Surgical Technologist, The 244
Synchronicity Fine Arts 426
Thomas, Martin, International 356
Tropix Photo Library 339
Ullstein Bild 339
Veterinary Economics 247
Village Profile 195
Washington County Museum of Fine Arts 431
Weigl Educational Publishers Ltd. 267
Wildlight 340

MILITARY

Accent Alaska/Ken Graham Agency 288
Aflo Foto Agency 290
Age Fotostock 290
Alamuphoto.com 291
amanaimages inc. 292
Anchor News 112
AppaLight 294
Art Directors & Trip Photo Library 296
Asian Enterprise Magazine 215
Aurora Photos 298

Baker Arts Center 369
Balzekas Museum of Lithuanian Culture Art Gallery 370
California Views/The Pat Hathaway Historical Photo Collection 301
Capstone Press 253
Cobblestone 128
Cody Images 303
College PreView 129
Continental Newstime 130
Couturier, Catherine, Gallery 380
Darkroom Gallery 381
DDB Stock Photography LLC 304
Dinodia Photo Library 305
DK Stock Inc. 306
ESL Teacher Today 224
Friedentag Photographics 348
Gallery of Art at Springfield Art Association 389
Geoslides & Geo Aerial Photography 311
Ghost Town 142
Human Kinetics Publishers 258
Hutchison Picture Library 313
IEEE Spectrum 229
Jeroboam 318
Kramer, Joan, and Associates Inc. 318
Leepa-Rattner Museum of Art 401
Marin Museum of Contemporary Art 405
MBI Inc. 261
Military Officer Magazine 232
Murphy, Michael, Gallery M 409
Naval History 233
New York Times on the Web, The 206
Northwest Art Center 413
Nova Media Inc. 277
Novastock 324
Novus Visual Communications 353
OnAsia 324
Painet Inc. 327
Panoramic Images 327
Portfolio Graphics Inc. 278

Proceedings 238
Revolutionary War Tracks 176
Sandlapper Magazine 180
Saxton, Joseph, Gallery of Photography, The 422
Scholastic Library Publishing 265
SouthComm Publishing Company Inc. 185
Stock Foundry Images 336
STSimages 338
Sugar Daddy Photos 338
Taube, Lillian & Coleman, Museum of Art 426
Ullstein Bild 339
Upstream People Gallery 429
Washington County Museum of Fine Arts 431
Wildlight 340

MULTICULTURAL

440 Gallery 361
AAP News 212
Accent Alaska/Ken Graham Agency 288
Ace Stock Limited 288
Advanced Graphics 272
Aflo Foto Agency 290
Age Fotostock 290
AKM Images Inc. 291
Alamuphoto.com 291
Alaska Stock 292
Allyn & Bacon Publishers 252
amanaimages inc. 292
American Fitness 110
Andes Press Agency 293
AppaLight 294
Aquarius 204
Archivo Criollo 295
Argus Photo Ltd. 295
Art Directors & Trip Photo Library 296
Art Source L.A. Inc. 367
Art Without Walls Inc. 368
Art@Net International Gallery 365
Asian Enterprise Magazine 215
Atlantic Gallery 369
Aurora Photos 298
Baker Arts Center 369
Balzekas Museum of Lithuanian Culture Art Gallery 370
Baseball 115
Blend Images 300
Boeberitz, Bob, Design 345
Bramson + Associates 346
Briarpatch 119
Bridal Guides Magazine 119
Bynums Marketing and Communications, Inc. 347
Capstone Press 253
CareerFOCUS 123
Caribbean Travel & Life 124
Chess Life for Kids 126
chickaDEE 126
Childhood Education 220
Children's Defense Fund 205
Chirp 126
Civitan Magazine 220
Cleveland Magazine 128
Cobblestone 128
College PreView 129
Conscience 130
Contemporary Arts Center (Cincinnati), The 378
Continental Newstime 130
Convergence 131
Cosmopolitan 131
Couturier, Catherine, Gallery 380
Crabtree Publishing Company 255
Cushing-Martin Gallery 380
Dance 133
Darkroom Gallery 381
DDB Stock Photography LLC 304
Design Pics Inc. 305
Dinodia Photo Library 305
DK Stock Inc. 306
DW Stock Picture Library 307

Ecoscene 307

Edelstein, Paul, Studio and Gallery 383

ESL Teacher Today 224

Faces 136

Fellowship 137

Fotoscopio 310

Freeport Art Museum 386

Gallery Fifty Six 388

Gallery of Art at Springfield Art Association 389

Ghost Town 142

Good Housekeeping 143

Gryphon House Inc. 257

Hampton Design Group 349

Havu, William, Gallery 392

Healing Lifestyles & Spas Magazine 146

Henry Street Settlement/Abrons Art Center 393

Herald Press 258

Heritage Images 312

Home Education Magazine 147

Howard, Merrell and Partners Inc. 350

Human Kinetics Publishers 258

Hutchison Picture Library 313

Hyperion Books for Children 259

Icebox Quality Framing & Gallery 395

Image Finders, The 314

Images.de Fulfillment 314

In the Fray 150

Inmagine 315

Inner Traditions/Bear & Company 259

International Visions Gallery 397

Iron Willow 397

Jaytravelphotos 317

Jeroboam 318

Jones, Stella, Gallery 398

Journal of Adventist Education 230

Key Curriculum Press 260

Kiwanis 153

Kramer, Joan, and Associates Inc. 318

Land of the Bible Photo Archive 319

Lange, Shauna Lee: The Gallery of Art Journals, Visual Diaries and Sketchbooks 400

Lantern Court LLC 276

Latitude Stock 319

Leepa-Rattner Museum of Art 401

Lerner Publishing Group 260

Luckypix 321

Lutheran, The 157

Markeim Art Center 406

Mesa Contemporary Arts at Mesa Arts Center 407

Mitchell Lane Publishers Inc. 261

Murphy, Michael, Gallery M 409

Museum of Printing History 411

National Geographic 162

Native Peoples Magazine 162

NEXUS/Foundation for Today's Art 412

Northwest Art Center 413

Northwest Territories Explorer's Guide 234

Northwestern University Dittmar Memorial Gallery 413

Nova Media Inc. 277

Novastock 324

Novus Visual Communications 353

OnAsia 324

OnRequest Images 325

Outside Imagery LLC 326

Owen, Richard C., Publishers Inc. 262

OWL Magazine 169

Pacific Stock/Printscapes.com 326

Painet Inc. 327

Photo Agora 328

PhotoEdit Inc. 328

PhotoSource International 330

PLANS Ltd. (Photo Libraries and News Services) 331

Portfolio Graphics Inc. 278

Pucker Gallery Inc. 419

Quarto Publishing Plc. 264

Revolutionary War Tracks 176

Roanoker, The 177
Saks, Arnold, Associates 355
San Diego Art Institute 421
Sandlapper Magazine 180
Saxton, Joseph, Gallery of Photography,
 The 422
Scholastic Library Publishing 265
Scholastic Magazines 181
School Administrator, The 181
Seventeen Magazine 182
SHINE brightly 183
SouthComm Publishing Company Inc. 185
Southwest Airlines Spirit 186
Sovfoto/Eastfoto Inc. 335
Still Media 335
Stock Foundry Images 336
Streetpeoples Weekly News 207
STSimages 338
Sugar Daddy Photos 338
Sun, The 188
Synchronicity Fine Arts 426
Taube, Lillian & Coleman, Museum of Art
 426
Teldon 279
Tropix Photo Library 339
UAB Visual Arts Gallery 428
Ullstein Bild 339
Upstream People Gallery 429
Village Profile 195
Washington County Museum of Fine Arts
 431
Waveland Press Inc. 267
Weigl Educational Publishers Ltd. 267
Whiskey Island Magazine 198
Wildlight 340
Women's Health Group 268

NUDES/FIGURE

Darkroom Gallery 381
Gallery of Art at Springfield Art Associa-
 tion 389
Haddad, Carrie, Gallery 391
Lizardi/Harp Gallery 403
Michelson, R., Galleries 408

PARENTS

Accent Alaska/Ken Graham Agency 288
Ace Stock Limited 288
Advanced Graphics 272
Aflo Foto Agency 290
Age Fotostock 290
Alamuphoto.com 291
Alaska 108
Alaska Stock 292
Allyn & Bacon Publishers 252
amanaimages inc. 292
American Fitness 110
AppaLight 294
Argus Photo Ltd. 295
Art Directors & Trip Photo Library 296
Art Without Walls Inc. 368
Asia Images Group 297
Aurora Photos 298
Babytalk 114
Balzekas Museum of Lithuanian Culture Art
 Gallery 370
Baseball 115
Blend Images 300
Blue Ridge Country 118
Boeberitz, Bob, Design 345
Borealis Press, The 273
Bridal Guides Magazine 119
Bynums Marketing and Communications,
 Inc. 347
Canada Lutheran 121
City Limits 127
Cleveland Magazine 128
Comesana, Eduardo, Agencia de Prensa/
 Banco Fotogrãfico 303
Couturier, Catherine, Gallery 380
Dance 133
Darkroom Gallery 381
DDB Stock Photography LLC 304

Design Conceptions/Joel Gordon Photography 305
Design Pics Inc. 305
Dinodia Photo Library 305
DK Stock Inc. 306
DW Stock Picture Library 307
ESL Teacher Today 224
Farcountry Press 256
Flint Communications 348
Foto-Press Timmermann 310
Gallery of Art at Springfield Art Association 389
Ghost Town 142
Gospel Herald 143
Granataimages.com 312
Home Education Magazine 147
Howard, Merrell and Partners Inc. 350
Hutchison Picture Library 313
Images.de Fulfillment 314
In the Fray 150
Inmagine 315
Inner Traditions/Bear & Company 259
Isopix 316
Jeroboam 318
Journal of Adventist Education 230
Key Curriculum Press 260
Kiwanis 153
Kramer, Joan, and Associates Inc. 318
Leepa-Rattner Museum of Art 401
Lutheran, The 157
Markeim Art Center 406
MAXX Images Inc. 322
Megapress Images 323
Mesa Contemporary Arts at Mesa Arts Center 407
Motoring & Leisure 160
Murphy, Michael, Gallery M 409
Na'amat Woman 161
Native Peoples Magazine 162
Northwestern University Dittmar Memorial Gallery 413

Novastock 324
Novus Visual Communications 353
OnAsia 324
OnRequest Images 325
Opção Brasil Imagens 325
Pacific Stock/Printscapes.com 326
Painet Inc. 327
Pakn Treger 170
Photo Agora 328
photo-eye Gallery 416
PhotoSource International 330
Portfolio Graphics Inc. 278
Ralls Collection Inc., The 420
Revolutionary War Tracks 176
Roanoker, The 177
Saks, Arnold, Associates 355
San Diego Art Institute 421
Sandlapper Magazine 180
Scholastic Library Publishing 265
School Administrator, The 181
Sea 182
Silver Image Photo Agency and Weddings 334
SouthComm Publishing Company Inc. 185
Stock Foundry Images 336
Streetpeoples Weekly News 207
STSimages 338
Sugar Daddy Photos 338
Sun, The 188
Taube, Lillian & Coleman, Museum of Art 426
Teldon 279
Ullstein Bild 339
Upstream People Gallery 429
Village Profile 195
Visitor's Choice Magazine 266
Visual Arts Center of Northwest Florida 431
Washington County Museum of Fine Arts 431
Wildlight 340

Women's Health Group 268

PERFORMING ARTS

440 Gallery 361
Accent Alaska/Ken Graham Agency 288
Aflo Foto Agency 290
Age Fotostock 290
Alamuphoto.com 291
amanaimages inc. 292
American Fitness 110
American Youth Philharmonic Orchestras,
 The 344
AMPM Inc. 344
Animal Trails Magazine 112
Aquarius 204
Art Directors & Trip Photo Library 296
Art Without Walls Inc. 368
Arts Company, The 366
Artwerks Stock Photography 297
Atlantic Gallery 369
Baker Arts Center 369
Balzekas Museum of Lithuanian Culture Art
 Gallery 370
Boeberitz, Bob, Design 345
Brainworks Design Group 345
Bridal Guides Magazine 119
Business NH Magazine 120
Business of Art Center 373
Bynums Marketing and Communications,
 Inc. 347
Camera Press Ltd. 301
chickaDEE 126
CLAMPART 377
Classical Singer 221
Cleveland Magazine 128
Comesana, Eduardo, Agencia de Prensa/
 Banco Fotográfico 303
Continental Newstime 130
Couturier, Catherine, Gallery 380
Dance 133
Darkroom Gallery 381
DDB Stock Photography LLC 304

Dinodia Photo Library 305
DK Stock Inc. 306
DownBeat 134
ECW Press 256
Famous Pictures & Features Agency 308
Flaunt 138
Freeport Art Museum 386
Ft. Myers Magazine 140
Gallery of Art at Springfield Art Associa-
 tion 389
Guitar World 145
Hamilton Magazine 145
Human Kinetics Publishers 258
International Photo News 315
Iowan Magazine, The 150
Jeroboam 318
JRB Art at the Elms 399
Kalamazoo Institute of Arts 399
Key Curriculum Press 260
KNOWAtlanta 153
Kramer, Joan, and Associates Inc. 318
Leepa-Rattner Museum of Art 401
Leopold Gallery 402
Limited Editions & Collectibles 403
Lizardi/Harp Gallery 403
Marin Museum of Contemporary Art 405
Markeim Art Center 406
Missouri Life 159
Mitchell Lane Publishers Inc. 261
Monderer Design Inc. 352
Museum of Contemporary Photography,
 Columbia College Chicago 410
Music Sales Group 262
Native Peoples Magazine 162
New York Times on the Web, The 206
NEXUS/Foundation for Today's Art 412
North Dakota Horizons 166
Northwestern University Dittmar Memorial
 Gallery 413
Novus Visual Communications 353
Oklahoma Today 167

OnAsia 324
Painet Inc. 327
PhotoSource International 330
Pitcher, Sylvia, Photo Library 330
Pix International 330
Planet 173
Portfolio Graphics Inc. 278
Posey School 354
Quarto Publishing Plc. 264
Ralls Collection Inc., The 420
Rhode Island Monthly 177
Roanoker, The 177
Rolling Stone 177
Running Press Book Publishers 265
Saks, Arnold, Associates 355
San Diego Art Institute 421
Sandlapper Magazine 180
Saxton, Joseph, Gallery of Photography,
 The 422
Scholastic Library Publishing 265
Soundlight 356
SouthComm Publishing Company Inc. 185
Southside Gallery 424
Southwest Airlines Spirit 186
Stock Foundry Images 336
STSimages 338
Sugar Daddy Photos 338
Sun.Ergos 356
Surface Magazine 188
Syracuse New Times 208
Tide-Mark Press 279
Ullstein Bild 339
Up Here 194
Upstream People Gallery 429
Washington County Museum of Fine Arts
 431
Weigl Educational Publishers Ltd. 267
West Suburban Living Magazine 198
Wildlight 340

PETS
440 Gallery 361

A+E 289
Accent Alaska/Ken Graham Agency 288
Ace Stock Limited 288
Aflo Foto Agency 290
Age Fotostock 290
Alaska Stock 292
amanaimages inc. 292
AMPM Inc. 344
Animal Sheltering 213
Animal Trails Magazine 112
Animals Animals/Earth Scenes 294
AppaLight 294
Appaloosa Journal 113
Art Directors & Trip Photo Library 296
Auscape International 298
Avanti Press Inc. 272
Balzekas Museum of Lithuanian Culture Art
 Gallery 370
Boeberitz, Bob, Design 345
Bramson + Associates 346
Bridal Guides Magazine 119
Capstone Press 253
Cat Fancy 124
Charlton Photos Inc. 302
chickaDEE 126
Couturier, Catherine, Gallery 380
Dance 133
Darkroom Gallery 381
Design Pics Inc. 305
Dinodia Photo Library 305
Dog Fancy 134
DW Stock Picture Library 307
Fotoscopio 310
Gallant Greetings Corp. 275
Gallery of Art at Springfield Art Associa-
 tion 389
Ghost Town 142
Haardt, Anton, Gallery 390
Haddad, Carrie, Gallery 391
Hampton Design Group 349
Image Finders, The 314

Intercontinental Greetings Ltd. 275
Iron Willow 397
Jeroboam 318
Jillson & Roberts 276
Jude Studios 351
Kimball Stock 318
Kramer, Joan, and Associates Inc. 318
Leepa-Rattner Museum of Art 401
Lerner Publishing Group 260
Megapress Images 323
Murphy, Michael, Gallery M 409
Mushing.com Magazine 161
Novus Visual Communications 353
OnRequest Images 325
Owen, Richard C., Publishers Inc. 262
Painet Inc. 327
Paper Products Design 277
Pet Product News 235
Photo Agora 328
Ponds USA and Water Gardens 238
Portfolio Graphics Inc. 278
Positive Images 331
Poudre River Gallery 418
Quarto Publishing Plc. 264
Ralls Collection Inc., The 420
Recycled Paper Greetings Inc. 278
Richardson, Ella Walton, Fine Art 420
San Diego Art Institute 421
Sandlapper Magazine 180
Scholastic Library Publishing 265
Soundlight 356
SouthComm Publishing Company Inc. 185
Stock Foundry Images 336
Streetpeoples Weekly News 207
STSimages 338
Sugar Daddy Photos 338
Sun 207
Tide-Mark Press 279
Ullstein Bild 339
Upstream People Gallery 429

Washington County Museum of Fine Arts 431
Whiskey Island Magazine 198
Wildlight 340
Willow Creek Press 268
Zolan Company LLC, The 281

POLITICAL
440 Gallery 361
Aflo Foto Agency 290
Age Fotostock 290
Alamuphoto.com 291
amanaimages inc. 292
Andes Press Agency 293
AppaLight 294
Art Directors & Trip Photo Library 296
Art Without Walls Inc. 368
Asian Enterprise Magazine 215
Aurora Photos 298
Ballinger Publishing 217
Balzekas Museum of Lithuanian Culture Art Gallery 370
Blue Sky/Oregon Center for the Photographic Arts 373
Borough News 118
Briarpatch 119
Camera Press Ltd. 301
Capital Pictures 302
Catholic News Service 302
Catholic Sentinel 204
Church of England Newspaper, The 205
City Limits 127
Cleveland Magazine 128
Comesana, Eduardo, Agencia de Prensa/ Banco Fotográfico 303
Continental Newstime 130
Couturier, Catherine, Gallery 380
Darkroom Gallery 381
DDB Stock Photography LLC 304
Dinodia Photo Library 305
DK Stock Inc. 306
ESL Teacher Today 224

Eye Ubiquitous 308
Fellowship 137
Flint Communications 348
Friedentag Photographics 348
Gallery of Art at Springfield Art Association 389
Geoslides & Geo Aerial Photography 311
Ghost Town 142
Government Technology 227
Harper's Magazine 145
Hutchison Picture Library 313
Image Finders, The 314
Images.de Fulfillment 314
In the Fray 150
International Photo News 315
Jeroboam 318
Judicature 152, 230
Kramer, Joan, and Associates Inc. 318
Lange, Shauna Lee: The Gallery of Art Journals, Visual Diaries and Sketchbooks 400
Leepa-Rattner Museum of Art 401
Lerner Publishing Group 260
Lineair Fotoarchief BV 320
Marin Museum of Contemporary Art 405
Mesa Contemporary Arts at Mesa Arts Center 407
Military Officer Magazine 232
Murphy, Michael, Gallery M 409
Museum of Contemporary Photography, Columbia College Chicago 410
Naval History 233
New York Times on the Web, The 206
NEXUS/Foundation for Today's Art 412
Northwest Art Center 413
Nova Media Inc. 277
Novus Visual Communications 353
OnAsia 324
Painet Inc. 327
photo-eye Gallery 416
Planet 173

Portfolio Graphics Inc. 278
Poudre River Gallery 418
Proceedings 238
Progressive, The 175
Reform Judaism 176
Revolutionary War Tracks 176
Rolling Stone 177
San Diego Art Institute 421
Saxton, Joseph, Gallery of Photography, The 422
Scholastic Library Publishing 265
SouthComm Publishing Company Inc. 185
Southside Gallery 424
Southwest Airlines Spirit 186
Stock Foundry Images 336
Streetpeoples Weekly News 207
STSimages 338
Sugar Daddy Photos 338
Sun, The 188
Synchronicity Fine Arts 426
TIME 191
Ullstein Bild 339
Upstream People Gallery 429
Washington County Museum of Fine Arts 431
Waveland Press Inc. 267
Weigl Educational Publishers Ltd. 267
Whiskey Island Magazine 198
Wildlight 340

PORTRAITS

Couturier, Catherine, Gallery 380
Darkroom Gallery 381
Gallery 110 Collective 387
Gallery of Art at Springfield Art Association 389
Harris, James, Gallery 392
Taube, Lillian & Coleman, Museum of Art 426

PRODUCT SHOTS/STILL LIFE

Accent Alaska/Ken Graham Agency 288

Ace Stock Limited 288
Aflo Foto Agency 290
Age Fotostock 290
amanaimages inc. 292
American Fitness 110
AMPM Inc. 344
Animal Trails Magazine 112
Art Directors & Trip Photo Library 296
Art Without Walls Inc. 368
Artwerks Stock Photography 297
Atlanta Homes and Lifestyles 114
Atlantic Gallery 369
Balzekas Museum of Lithuanian Culture Art
 Gallery 370
Barnett, Augustus, Advertising/Design 344
BedTimes 217
Belian Art Center 370
Bell Studio 371
Berson, Dean, Stevens 345
Beverage Dynamics 218
Boeberitz, Bob, Design 345
Bragaw Public Relationgts Services 345
Bynums Marketing and Communications,
 Inc. 347
Caribbean Travel & Life 124
Carmichael Lynch 347
CGT Marketing LLC 347
Cleveland Magazine 128
Coast&Kayak Magazine 128
Couturier, Catherine, Gallery 380
Creative Homeowner 255
Dance 133
Darkroom Gallery 381
Design Pics Inc. 305
Dinodia Photo Library 305
DM News 223
Edelstein, Paul, Studio and Gallery 383
Entrepreneur 135
ESL Teacher Today 224
Event 136
Flint Communications 348

Floral Management Magazine 226
Fotoscopio 310
Ft. Myers Magazine 140
Gallant Greetings Corp. 275
Gallery 110 Collective 387
Gallery of Art at Springfield Art Associa-
 tion 389
Geoslides & Geo Aerial Photography 311
Ghost Town 142
Gloucester Arts on Main 390
Haardt, Anton, Gallery 390
Haddad, Carrie, Gallery 391
Healing Lifestyles & Spas Magazine 146
Hearth and Home 228
Human Kinetics Publishers 258
Hutchinson Associates Inc. 350
Idea Bank Marketing 351
IEEE Spectrum 229
IGA Grocergram 229
Independent Restaurateur, The 229
Intercontinental Greetings Ltd. 275
Jude Studios 351
Kashrus Magazine 153
Kramer, Joan, and Associates Inc. 318
Lantern Court LLC 276
Leepa-Rattner Museum of Art 401
Marin Museum of Contemporary Art 405
Markeim Art Center 406
Marketing & Technology Group 232
McGaw Graphics Inc. 276
Medical File Inc., The 322
Megapress Images 323
MetroSource Magazine 158
Monderer Design Inc. 352
Murphy, Michael, Gallery M 409
Nails Magazine 233
New York Times on the Web, The 206
NewDesign 234
Novus Visual Communications 353
Painet Inc. 327
Pet Product News 235

PhotoSource International 330
PointBlank Agency 353
Popular Photography & Imaging 173
Portfolio Graphics Inc. 278
Positive Images 331
Poudre River Gallery 418
QSR 239
Quarto Publishing Plc. 264
Quick Frozen Foods International 239
Ralls Collection Inc., The 420
Restaurant Hospitality 242
Retailers Forum 242
Revolutionary War Tracks 176
Saks, Arnold, Associates 355
San Diego Art Institute 421
Sandlapper Magazine 180
Saxton, Joseph, Gallery of Photography,
 The 422
Schmidt, Henry, Design 355
Scholastic Library Publishing 265
Sides & Associates 355
SouthComm Publishing Company Inc. 185
Southwest Airlines Spirit 186
Stock Foundry Images 336
STSimages 338
Sugar Daddy Photos 338
Surface Magazine 188
Thomas, Martin, International 356
Tobacco Journal International 245
Top Producer 246
Upstream People Gallery 429
Vermont Magazine 194
Visual Arts Center of Northwest Florida
 431
Washington County Museum of Fine Arts
 431
Wildlight 340
Woodshop News 248
Writer's Digest 199, 249

RELIGIOUS

Accent Alaska/Ken Graham Agency 288
Aflo Foto Agency 290
Age Fotostock 290
AKM Images Inc. 291
Alamuphoto.com 291
amanaimages inc. 292
Ancient Art & Architecture Collection Ltd.,
 The 293
Andes Press Agency 293
Animal Trails Magazine 112
AppaLight 294
Aquarius 204
Archivo Criollo 295
ArkReligion.com 295
Art Directors & Trip Photo Library 296
Baker Arts Center 369
Balzekas Museum of Lithuanian Culture Art
 Gallery 370
Bridal Guides Magazine 119
Bynums Marketing and Communications,
 Inc. 347
Canada Lutheran 121
Catholic News Service 302
Catholic Sentinel 204
Charisma 125
Church of England Newspaper, The 205
Civitan Magazine 220
Conscience 130
Couturier, Catherine, Gallery 380
Dance 133
Darkroom Gallery 381
DDB Stock Photography LLC 304
Design Pics Inc. 305
Dinodia Photo Library 305
ESL Teacher Today 224
Faith & Friends 137
Fellowship 137
Fotoscopio 310
Gallant Greetings Corp. 275
Gallery of Art at Springfield Art Associa-
 tion 389
Ghost Town 142

Gospel Herald 143
Guideposts 144
Hadassah Magazine 145
Hampton Design Group 349
Havu, William, Gallery 392
Herald Press 258
Heritage Images 312
Hutchison Picture Library 313
In the Fray 150
Inner Traditions/Bear & Company 259
Insight Magazine 149
Isopix 316
Israelimages.com 317
Jeroboam 318
Jewish Action 151
Jones, Stella, Gallery 398
Journal of Adventist Education 230
Kalamazoo Institute of Arts 399
Kashrus Magazine 153
Kramer, Joan, and Associates Inc. 318
Land of the Bible Photo Archive 319
Lange, Shauna Lee: The Gallery of Art Journals, Visual Diaries and Sketchbooks 400
Lantern Court LLC 276
Latitude Stock 319
Leepa-Rattner Museum of Art 401
Lineair Fotoarchief BV 320
Lizardi/Harp Gallery 403
Lutheran, The 157
Megapress Images 323
Multiple Exposures Gallery 409
Murphy, Michael, Gallery M 409
Na'amat Woman 161
Nova Media Inc. 277
Novus Visual Communications 353
OnAsia 324
Painet Inc. 327
Pakn Treger 170
Paulist Press 263
Photo Agora 328

Ponkawonka Inc. 331
Portfolio Graphics Inc. 278
Poudre River Gallery 418
Pucker Gallery Inc. 419
Quarto Publishing Plc. 264
Reform Judaism 176
Revolutionary War Tracks 176
Richardson, Ella Walton, Fine Art 420
Sandlapper Magazine 180
Saxton, Joseph, Gallery of Photography, The 422
Scholastic Library Publishing 265
SHINE brightly 183
Soundlight 356
SouthComm Publishing Company Inc. 185
Stock Foundry Images 336
Streetpeoples Weekly News 207
STSimages 338
Sugar Daddy Photos 338
Sun, The 188
Tide-Mark Press 279
Tricycle 193
Tropix Photo Library 339
Ullstein Bild 339
Upstream People Gallery 429
Washington County Museum of Fine Arts 431
Waveland Press Inc. 267
Weigl Educational Publishers Ltd. 267
Whiskey Island Magazine 198
Wildlight 340

RURAL

Accent Alaska/Ken Graham Agency 288
Aflo Foto Agency 290
Age Fotostock 290
AKM Images Inc. 291
Alamuphoto.com 291
amanaimages inc. 292
American Fitness 110
Andes Press Agency 293
Animal Trails Magazine 112

AppaLight 294
Archivo Criollo 295
Art Directors & Trip Photo Library 296
Art Source L.A. Inc. 367
Art Without Walls Inc. 368
Arts Company, The 366
Arts Iowa City 366
Atelier Gallery 369
Atlantic Gallery 369
Aurora Photos 298
Axiom Photographic 298
Baker Arts Center 369
Balzekas Museum of Lithuanian Culture Art
 Gallery 370
Beef Today 218
Belian Art Center 370
Bell Studio 371
Bentley Publishing Group 273
Boeberitz, Bob, Design 345
Bon Artique.com/Art Resources Interna-
 tional Ltd. 273
Bridal Guides Magazine 119
Business NH Magazine 120
Business of Art Center 373
California Views/The Pat Hathaway Histori-
 cal Photo Collection 301
Capstone Press 253
Carmichael Lynch 347
Country Woman 131
Countryman Press, The 254
Couturier, Catherine, Gallery 380
Creative Homeowner 255
Dance 133
Darkroom Gallery 381
DDB Stock Photography LLC 304
Design Pics Inc. 305
Dinodia Photo Library 305
DW Stock Picture Library 307
Ecoscene 307
ESL Teacher Today 224
Flint Communications 348

France Magazine 140
Freeport Art Museum 386
Fur-Fish-Game 140
Gallery Fifty Six 388
gallery nrc 389
Gallery of Art at Springfield Art Associa-
 tion 389
Geoslides & Geo Aerial Photography 311
Ghost Town 142
Gloucester Arts on Main 390
Haardt, Anton, Gallery 390
Haddad, Carrie, Gallery 391
Havu, William, Gallery 392
Hemphill 393
Henry Street Settlement/Abrons Art Cen-
 ter 393
Hutchison Picture Library 313
Icebox Quality Framing & Gallery 395
In the Fray 150
Iowan Magazine, The 150
Iron Willow 397
ITE Journal 229
Jeroboam 318
Jones, Stella, Gallery 398
Kansas! 152
Kashrus Magazine 153
Key Curriculum Press 260
Kramer, Joan, and Associates Inc. 318
Lange, Shauna Lee: The Gallery of Art Jour-
 nals, Visual Diaries and Sketchbooks
 400
Latitude Stock 319
Leepa-Rattner Museum of Art 401
Lerner Publishing Group 260
Marin Museum of Contemporary Art 405
Markeim Art Center 406
MBI Inc. 261
McGaw Graphics Inc. 276
Mesa Contemporary Arts at Mesa Arts
 Center 407
Missouri Life 159

Multiple Exposures Gallery 409
Murphy, Michael, Gallery M 409
Museum of Contemporary Photography, Columbia College Chicago 410
Museum of Printing History 411
NEXUS/Foundation for Today's Art 412
North Dakota Horizons 166
Northern Woodlands Magazine 166
Northwest Art Center 413
Nova Media Inc. 277
Novastock 324
Novus Visual Communications 353
OnAsia 324
OnRequest Images 325
Outside Imagery LLC 326
Painet Inc. 327
Panoramic Images 327
Persimmon Hill 172
Photo Agora 328
PHOTO Techniques 172
PI Creative Art 277
Pitcher, Sylvia, Photo Library 330
Ponds USA and Water Gardens 238
Portfolio Graphics Inc. 278
Poudre River Gallery 418
Pucker Gallery Inc. 419
Ralls Collection Inc., The 420
Revolutionary War Tracks 176
Running Press Book Publishers 265
Rural Heritage 178
San Diego Art Institute 421
Sandlapper Magazine 180
Saxton, Joseph, Gallery of Photography, The 422
Scholastic Library Publishing 265
Sohn Fine Art—Gallery & Giclée Printing 423
SouthComm Publishing Company Inc. 185
Southside Gallery 424
State Street Gallery 425
Still Point Art Gallery 426

Stock Foundry Images 336
Stock Options 337
Streetpeoples Weekly News 207
STSimages 338
Sugar Daddy Photos 338
Sun, The 188
Synchronicity Fine Arts 426
Taube, Lillian & Coleman, Museum of Art 426
Teldon 279
Throckmorton Fine Art 427
Top Producer 246
Ullstein Bild 339
Upstream People Gallery 429
Voyageur Press 266
Washington County Museum of Fine Arts 431
Waveland Press Inc. 267
Weigl Educational Publishers Ltd. 267
Western Producer, The 209
Whiskey Island Magazine 198
Wildlight 340
Zolan Company LLC, The 281

SCIENCE

Accent Alaska/Ken Graham Agency 288
Ace Stock Limited 288
Aflo Foto Agency 290
Age Fotostock 290
Allyn & Bacon Publishers 252
amanaimages inc. 292
American Fitness 110
Anthro-Photo File 294
APA Monitor 214
AppaLight 294
Art Directors & Trip Photo Library 296
Art Without Walls Inc. 368
Art@Net International Gallery 365
Artwerks Stock Photography 297
Asia Images Group 297
Astronomy 114
Aurora Photos 298

Balzekas Museum of Lithuanian Culture Art Gallery 370

Bee Culture 218

Bergman Collection, The 299

Biological Photo Service and Terraphotographics 299

Boeberitz, Bob, Design 345

Boys' Life 119

Brainworks Design Group 345

Bramson + Associates 346

BSIP 301

Business NH Magazine 120

Bynums Marketing and Communications, Inc. 347

Camera Press Ltd. 301

CareerFOCUS 123

chickaDEE 126

CLAMPART 377

College PreView 129

Comesana, Eduardo, Agencia de Prensa/ Banco Fotogräfico 303

Continental Newstime 130

Couturier, Catherine, Gallery 380

Darkroom Gallery 381

DDB Stock Photography LLC 304

Design Conceptions/Joel Gordon Photography 305

Design Pics Inc. 305

Dinodia Photo Library 305

DK Stock Inc. 306

Ecoscene 307

ESL Teacher Today 224

Flint Communications 348

Friedentag Photographics 348

Fundamental Photographs 311

Gallery of Art at Springfield Art Association 389

Geoslides & Geo Aerial Photography 311

Ghost Town 142

Gloucester Arts on Main 390

Hampton Design Group 349

Holt McDougal 258

Hutchison Picture Library 313

IEEE Spectrum 229

Images.de Fulfillment 314

Isopix 316

Jeroboam 318

Key Curriculum Press 260

Kiwanis 153

Kramer, Joan, and Associates Inc. 318

Leepa-Rattner Museum of Art 401

Lerner Publishing Group 260

Lineair Fotoarchief BV 320

Manufacturing Automation 231

Medical File Inc., The 322

Mediscan 322

Megapress Images 323

Mesa Contemporary Arts at Mesa Arts Center 407

Mitchell Lane Publishers Inc. 261

Monderer Design Inc. 352

Murphy, Michael, Gallery M 409

Museum of Northern Arizona 261

New York Times on the Web, The 206

Northern Woodlands Magazine 166

Novastock 324

Novus Visual Communications 353

OnAsia 324

OnRequest Images 325

Owen, Richard C., Publishers Inc. 262

OWL Magazine 169

Painet Inc. 327

Panoramic Images 327

Photo Agora 328

PhotoSource International 330

Planet 173

Plastics Technology 236

Portfolio Graphics Inc. 278

Quarto Publishing Plc. 264

Revolutionary War Tracks 176

Rex USA 332

Saks, Arnold, Associates 355

San Diego Art Institute 421
Sandlapper Magazine 180
Scholastic Library Publishing 265
Scholastic Magazines 181
Science Photo Library Ltd. 333
Science Scope 243
Science Source/Photo Researchers Inc. 333
Scientific American 181
Soundlight 356
SouthComm Publishing Company Inc. 185
Southwest Airlines Spirit 186
Stack, Tom, & Associates Inc. 335
Stock Foundry Images 336
STSimages 338
Sugar Daddy Photos 338
Ullstein Bild 339
Washington County Museum of Fine Arts 431
Water Well Journal 247
Weigl Educational Publishers Ltd. 267
Western Producer, The 209
Whiskey Island Magazine 198
Wildlight 340

SEASONAL

Accent Alaska/Ken Graham Agency 288
Ace Stock Limited 288
Advanced Graphics 272
Aflo Foto Agency 290
Age Fotostock 290
Akego and Sahara Gallery 362
Alaska Stock 292
amanaimages inc. 292
American Bee Journal 213
American Fitness 110
AMPM Inc. 344
Animal Trails Magazine 112
AppaLight 294
Appaloosa Journal 113
Art Directors & Trip Photo Library 296
Art Source L.A. Inc. 367
Art Without Walls Inc. 368

Art@Net International Gallery 365
Avanti Press Inc. 272
Baker Arts Center 369
Balzekas Museum of Lithuanian Culture Art Gallery 370
Baseball 115
Blue Ridge Country 118
Boeberitz, Bob, Design 345
Borealis Press, The 273
Bridal Guides Magazine 119
Bynums Marketing and Communications, Inc. 347
Canada Lutheran 121
Capstone Press 253
Caribbean Travel & Life 124
Catholic Sentinel 204
Centric Corp. 274
chickaDEE 126
Chirp 126
Cleveland Magazine 128
Comstock Cards 274
Conscience 130
Continental Newstime 130
Country Woman 131
Countryman Press, The 254
Dance 133
Darkroom Gallery 381
Design Design Inc. 274
Design Pics Inc. 305
Dinodia Photo Library 305
ESL Teacher Today 224
Event 136
Farcountry Press 256
Flint Communications 348
Foto-Press Timmermann 310
Gallant Greetings Corp. 275
Gallery of Art at Springfield Art Association 389
Ghost Town 142
Gospel Herald 143
Hampton Design Group 349

Heritage Images 312
Hunger Mountain 148
Hutchison Picture Library 313
Image Finders, The 314
Impact Photographics 275
Indianapolis Monthly 149
Intercontinental Greetings Ltd. 275
Iowan Magazine, The 150
Iron Willow 397
Isopix 316
Jeroboam 318
Jillson & Roberts 276
Kansas! 152
Kashrus Magazine 153
Kimball Stock 318
Kramer, Joan, and Associates Inc. 318
Lange, Shauna Lee: The Gallery of Art Journals, Visual Diaries and Sketchbooks 400
Leepa-Rattner Museum of Art 401
Limited Editions & Collectibles 403
Lutheran, The 157
Mesa Contemporary Arts at Mesa Arts Center 407
MetroSource Magazine 158
Michigan Out-of-Doors 158
Missouri Life 159
Monderer Design Inc. 352
Motoring & Leisure 160
Murphy, Michael, Gallery M 409
Mushing.com Magazine 161
Na'amat Woman 161
Necrology Shorts 164
New York State Conservationist Magazine 164
North Dakota Horizons 166
Northern Woodlands Magazine 166
Northwest Territories Explorer's Guide 234
Northwestern University Dittmar Memorial Gallery 413
Nova Media Inc. 277

Novus Visual Communications 353
OnAsia 324
OnRequest Images 325
Outdooria Outdoor Image Agency 326
OWL Magazine 169
Painet Inc. 327
Panoramic Images 327
Paper Products Design 277
Persimmon Hill 172
Pet Product News 235
PhotoSource International 330
PI Creative Art 277
Portfolio Graphics Inc. 278
Pucker Gallery Inc. 419
Recycled Paper Greetings Inc. 278
Revolutionary War Tracks 176
Rhode Island Monthly 177
Roanoker, The 177
Running Press Book Publishers 265
San Diego Art Institute 421
Sandlapper Magazine 180
Saxton, Joseph, Gallery of Photography, The 422
Scholastic Library Publishing 265
Sohn Fine Art—Gallery & Giclée Printing 423
SouthComm Publishing Company Inc. 185
Stock Foundry Images 336
Streetpeoples Weekly News 207
STSimages 338
Sugar Daddy Photos 338
Surface Magazine 188
Syracuse New Times 208
Trails Media Group 280
Ullstein Bild 339
Up Here 194
Village Profile 195
Visual Arts Center of Northwest Florida 431
Voyageur Press 266

Washington County Museum of Fine Arts 431

Weigl Educational Publishers Ltd. 267

West Suburban Living Magazine 198

Whiskey Island Magazine 198

Wildlight 340

Zolan Company LLC, The 281

SENIOR CITIZENS

Accent Alaska/Ken Graham Agency 288

Ace Stock Limited 288

Advanced Graphics 272

Aflo Foto Agency 290

Age Fotostock 290

Alamuphoto.com 291

Alaska 108

Alaska Stock 292

Allyn & Bacon Publishers 252

amanaimages inc. 292

American Fitness 110

Andes Press Agency 293

AppaLight 294

Art Directors & Trip Photo Library 296

Art Without Walls Inc. 368

Asia Images Group 297

Asian Enterprise Magazine 215

Aurora Photos 298

Balzekas Museum of Lithuanian Culture Art Gallery 370

Blend Images 300

Blue Ridge Country 118

Boeberitz, Bob, Design 345

Borealis Press, The 273

Bynums Marketing and Communications, Inc. 347

Canada Lutheran 121

Catholic News Service 302

Chess Life for Kids 126

City Limits 127

Cleveland Magazine 128

Couturier, Catherine, Gallery 380

Dance 133

Darkroom Gallery 381

DDB Stock Photography LLC 304

Design Conceptions/Joel Gordon Photography 305

Design Pics Inc. 305

Dinodia Photo Library 305

DK Stock Inc. 306

DW Stock Picture Library 307

Family Motor Coaching 137

Farcountry Press 256

Flint Communications 348

Foto-Press Timmermann 310

Fotoscopio 310

Freeport Art Museum 386

Gallery of Art at Springfield Art Association 389

Granataimages.com 312

Hampton Design Group 349

Herald Press 258

Highways 147

Home Education Magazine 147

Howard, Merrell and Partners Inc. 350

Hutchison Picture Library 313

Image Finders, The 314

Images.de Fulfillment 314

In the Fray 150

Isopix 316

Jeroboam 318

Jude Studios 351

Key Curriculum Press 260

Kiwanis 153

Kramer, Joan, and Associates Inc. 318

Leepa-Rattner Museum of Art 401

Living Free 155

Lutheran, The 157

Markeim Art Center 406

MAXX Images Inc. 322

Mediscan 322

Megapress Images 323

Mesa Contemporary Arts at Mesa Arts Center 407

Murphy, Michael, Gallery M 409

Na'amat Woman 161

Native Peoples Magazine 162

Northwest Territories Explorer's Guide 234

Novastock 324

Novus Visual Communications 353

Outside Imagery LLC 326

Pacific Stock/Printscapes.com 326

Painet Inc. 327

Photo Agora 328

PhotoEdit Inc. 328

PhotoSource International 330

Portfolio Graphics Inc. 278

Roanoker, The 177

Saks, Arnold, Associates 355

San Diego Art Institute 421

Sandlapper Magazine 180

Scholastic Library Publishing 265

Science Source/Photo Researchers Inc. 333

Sea 182

Silver Image Photo Agency and Weddings 334

SouthComm Publishing Company Inc. 185

Stock Foundry Images 336

Streetpeoples Weekly News 207

STSimages 338

Sugar Daddy Photos 338

Sun, The 188

Taube, Lillian & Coleman, Museum of Art 426

Teldon 279

Ullstein Bild 339

Upstream People Gallery 429

Village Profile 195

Visitor's Choice Magazine 266

Visual Arts Center of Northwest Florida 431

Washington County Museum of Fine Arts 431

West Suburban Living Magazine 198

Wildlight 340

Women's Health Group 268

SPORTS

4-Wheel ATV Action 106

540 Rider 106

AAP News 212

Accent Alaska/Ken Graham Agency 288

Ace Stock Limited 288

Aflo Foto Agency 290

African American Golfer's Digest 107

Age Fotostock 290

Alamuphoto.com 291

amanaimages inc. 292

AMC Outdoors 109

American Angler 109

American Fitness 110

American Motorcyclist 111

American Power Boat Association 213

American Sports Network 204

American Turf Monthly 111

Appalachian Mountain Club Books 252

Argus Photo Ltd. 295

Arizona Wildlife Views 113

Art Directors & Trip Photo Library 296

Art Without Walls Inc. 368

Art@Net International Gallery 365

Artwerks Stock Photography 297

Athletic Business 215

Athletic Management 216

Aurora Photos 298

Baker Arts Center 369

Balzekas Museum of Lithuanian Culture Art Gallery 370

Baseball 115

BC Outdoors Hunting and Shooting 115

BC Outdoors Sport Fishing 116

Bennett Galleries and Company 371

Boeberitz, Bob, Design 345

Bon Artique.com/Art Resources International Ltd. 273

Bowhunter 118

Brainworks Design Group 345

Bynums Marketing and Communications, Inc. 347
Camera Press Ltd. 301
Canadian Rodeo News 121
Canadian Yachting 122
Canoe & Kayak 122
Capstone Press 253
Caribbean Travel & Life 124
chickaDEE 126
Chronicle of the Horse, The 127
Clarion-Ledger, The 205
Cleveland Magazine 128
Coast&Kayak Magazine 128
Continental Newstime 130
Countryman Press, The 254
Crabtree Publishing Company 255
Cruising World 132
Cycle California! Magazine 132
Darkroom Gallery 381
Deer & Deer Hunting 133
Dinodia Photo Library 305
DK Stock Inc. 306
Drake Magazine, The 134
ECW Press 256
Elks Magazine, The 135
ESL Teacher Today 224
Flint Communications 348
Fly Rod & Reel 139
Fotoscopio 310
Ft. Myers Magazine 140
Fur-Fish-Game 140
Gallant Greetings Corp. 275
gallery nrc 389
Gallery of Art at Springfield Art Association 389
Ghost Town 142
Golf Tips 143
Grand Rapids Magazine 144
Guideposts 144
Human Kinetics Publishers 258
Image Finders, The 314

Image Integration 351
Inmagine 315
Inside Triathlon 149
Jeroboam 318
Jillson & Roberts 276
Journal of Asian Martial Arts 151
Kansas! 152
Key Curriculum Press 260
Kramer, Joan, and Associates Inc. 318
Lacrosse Magazine 154
Latitude Stock 319
Leepa-Rattner Museum of Art 401
Lerner Publishing Group 260
Limited Editions & Collectibles 403
Log Newspaper, The 206
Marin Museum of Contemporary Art 405
Markeim Art Center 406
Marlin 157
Megapress Images 323
Michigan Out-of-Doors 158
Minnesota Golfer 158
Mitchell Lane Publishers Inc. 261
Monderer Design Inc. 352
Motoring & Leisure 160
Mushing.com Magazine 161
Muzzle Blasts 161
Myriad Productions 352
National Masters News 206
New York Times on the Web, The 206
North American Whitetail 165
Northwestern University Dittmar Memorial Gallery 413
Novus Visual Communications 353
Oklahoma Today 167
OnAsia 324
Opção Brasil Imagens 325
Outdoor Canada Magazine 169
Outdooria Outdoor Image Agency 326
Outside Imagery LLC 326
Owen, Richard C., Publishers Inc. 262
OWL Magazine 169

Pacific Stock/Printscapes.com 326
Painet Inc. 327
Panoramic Images 327
Pennsylvania Angler & Boater 170
Photolife Corporation Ltd. 329
PhotoSource International 330
PI Creative Art 277
Planet 173
Portfolio Graphics Inc. 278
Press Association Images 332
ProStar Publications Inc. 264
Purestock 332
Quarto Publishing Plc. 264
Racquetball Magazine 176
Ralls Collection Inc., The 420
Referee 240
Revolutionary War Tracks 176
Rex USA 332
Roanoker, The 177
Roggen, Ted, Advertising and Public Rela-
 tions 354
Sailing Magazine 179
Sailing World 179
Saks, Arnold, Associates 355
Salt Water Sportsman 180
San Diego Art Institute 421
Sandlapper Magazine 180
Saxton, Joseph, Gallery of Photography,
 The 422
Scholastic Library Publishing 265
Shooting Sports USA 183
Ski Canada 184
Skydiving 184
Skyscan Photolibrary 334
SouthComm Publishing Company Inc. 185
Southern Boating 186
Southside Gallery 424
Southwest Airlines Spirit 186
Sport Fishing 187
Sports Illustrated 187
Still Media 335

Stock Connection 336
Stock Foundry Images 336
STSimages 338
Sugar Daddy Photos 338
Sun 207
Sunday Post, The 207
Superstock Inc. 339
Surfing Magazine 189
Teldon 279
Texas Monthly 190
Tide-Mark Press 279
Times of the Islands 191
Toronto Sun Publishing 208
Track & Field News 191
Trail Runner 192
Ullstein Bild 339
Upstream People Gallery 429
Vermont Magazine 194
Visitor's Choice Magazine 266
Washington Blade, The 196
Washington County Museum of Fine Arts
 431
Washington Trails 196
Water Skier, The 197
Watercraft World 196
WaterSki 197
Western Outdoors 197
Wildlight 340
Willow Creek Press 268
Wisconsin Snowmobile News 199
Women's Health Group 268
Youth Runner Magazine 200
Zolan Company LLC, The 281

TECHNOLOGY/COMPUTERS

ABA Banking Journal 212
Accent Alaska/Ken Graham Agency 288
Ace Stock Limited 288
Aflo Foto Agency 290
Age Fotostock 290
Alamuphoto.com 291

amanaimages inc. 292

American Motorcyclist 111

AOPA Pilot 214

AppaLight 294

Aquarius 204

Art Directors & Trip Photo Library 296

Art Source L.A. Inc. 367

Art Without Walls Inc. 368

Artwerks Stock Photography 297

Asia Images Group 297

Asian Enterprise Magazine 215

Atlantic Gallery 369

Aurora Photos 298

Avionics Magazine 217

Ballinger Publishing 217

Balzekas Museum of Lithuanian Culture Art Gallery 370

Bergman Collection, The 299

Biological Photo Service and Terraphotographics 299

Boeberitz, Bob, Design 345

Borough News 118

Brainworks Design Group 345

Business NH Magazine 120

Bynums Marketing and Communications, Inc. 347

CareerFOCUS 123

chickaDEE 126

CLAMPART 377

Cleveland Magazine 128

Cody Images 303

College PreView 129

Comesana, Eduardo, Agencia de Prensa/ Banco Fotográfico 303

Contemporary Arts Center (Cincinnati), The 378

Continental Newstime 130

Couturier, Catherine, Gallery 380

Darkroom Gallery 381

DDB Stock Photography LLC 304

Design Conceptions/Joel Gordon Photography 305

Design Pics Inc. 305

Dinodia Photo Library 305

DK Stock Inc. 306

Electric Perspectives 223

Electrical Apparatus 223

Elks Magazine, The 135

Entrepreneur 135

ESL Teacher Today 224

Flint Communications 348

Foto-Press Timmermann 310

Fotoscopio 310

Friedentag Photographics 348

Fundamental Photographs 311

Gallery of Art at Springfield Art Association 389

Geoslides & Geo Aerial Photography 311

Geosynthetics 227

Ghost Town 142

Government Technology 227

Hutchinson Associates Inc. 350

Hutchison Picture Library 313

IEEE Spectrum 229

Image Finders, The 314

Image Works, The 315

Images.de Fulfillment 314

Isopix 316

ITE Journal 229

Jeroboam 318

Journal of Adventist Education 230

Journal of Psychoactive Drugs 230

Jude Studios 351

Kalamazoo Institute of Arts 399

Kashrus Magazine 153

Kiwanis 153

KNOWAtlanta 153

Kramer, Joan, and Associates Inc. 318

Leepa-Rattner Museum of Art 401

Lineair Fotoarchief BV 320

Magazine Antiques, The 157

Manufacturing Automation 231
Medical File Inc., The 322
Meetings & Incentive Travel 232
Mesa Contemporary Arts at Mesa Arts Center 407
Monderer Design Inc. 352
Motoring & Leisure 160
Murphy, Michael, Gallery M 409
New York Times on the Web, The 206
NewDesign 234
Nova Media Inc. 277
Novastock 324
Novus Visual Communications 353
OnAsia 324
OnRequest Images 325
Ontario Technologist, The 235
OWL Magazine 169
Painet Inc. 327
Panoramic Images 327
Photo Agora 328
PHOTO Techniques 172
PhotoSource International 330
Plastics News 236
Plastics Technology 236
PointBlank Agency 353
Popular Photography & Imaging 173
Portfolio Graphics Inc. 278
Professional Photographer 238
Rental Management 241
Revolutionary War Tracks 176
Roanoker, The 177
Saks, Arnold, Associates 355
San Diego Art Institute 421
Sandlapper Magazine 180
Saxton, Joseph, Gallery of Photography, The 422
Science Photo Library Ltd. 333
Scientific American 181
Scrap 182
SouthComm Publishing Company Inc. 185
Southwest Airlines Spirit 186

Stack, Tom, & Associates Inc. 335
Stock Foundry Images 336
Streetpeoples Weekly News 207
STSimages 338
Sugar Daddy Photos 338
Surface Magazine 188
Thomas, Martin, International 356
Tropix Photo Library 339
UCR/California Museum of Photography 428
Ullstein Bild 339
Village Profile 195
Washington County Museum of Fine Arts 431
Whiskey Island Magazine 198
Wildlight 340
Worcester Polytechnic Institute 357

TRAVEL

440 Gallery 361
AAP News 212
Accent Alaska/Ken Graham Agency 288
Ace Stock Limited 288
Aflo Foto Agency 290
African American Golfer's Digest 107
Age Fotostock 290
Akego and Sahara Gallery 362
AKM Images Inc. 291
Alamuphoto.com 291
Alaska Stock 292
amanaimages inc. 292
AMC Outdoors 109
American Fitness 110
American Motorcyclist 111
Ancient Art & Architecture Collection Ltd., The 293
Andes Press Agency 293
Animals Animals/Earth Scenes 294
AOPA Pilot 214
AppaLight 294
Aquarius 204
Archivo Criollo 295

Arizona Wildlife Views 113
Art Directors & Trip Photo Library 296
Art Source L.A. Inc. 367
Art Without Walls Inc. 368
Art@Net International Gallery 365
Artwerks Stock Photography 297
Asian Enterprise Magazine 215
Atlantic Gallery 369
Aurora Photos 298
Avionics Magazine 217
Axiom Photographic 298
Baker Arts Center 369
Ballinger Publishing 217
Balzekas Museum of Lithuanian Culture Art Gallery 370
Bennett Galleries and Company 371
Bentley Publishing Group 273
Bird Watching 117
Blue Ridge Country 118
Boeberitz, Bob, Design 345
Bridal Guides Magazine 119
Business NH Magazine 120
Business of Art Center 373
California Views/The Pat Hathaway Historical Photo Collection 301
Camera Press Ltd. 301
Canoe & Kayak 122
Capstone Press 253
Caribbean Travel & Life 124
Carmichael Lynch 347
chickaDEE 126
Civitan Magazine 220
CLAMPART 377
Cleveland Magazine 128
Comesana, Eduardo, Agencia de Prensa/ Banco Fotográfico 303
Contemporary Bride 130
Continental Newstime 130
Countryman Press, The 254
Couturier, Catherine, Gallery 380
Cruising World 132

Darkroom Gallery 381
DDB Stock Photography LLC 304
Design Pics Inc. 305
Dinodia Photo Library 305
DK Stock Inc. 306
DW Stock Picture Library 307
ECW Press 256
ESL Teacher Today 224
eStock Photo LLC 308
Event 136
Family Motor Coaching 137
Flint Communications 348
Foto-Press Timmermann 310
FOTOAGENT 310
Fotoscopio 310
France Magazine 140
Freeport Art Museum 386
Ft. Myers Magazine 140
Gallant Greetings Corp. 275
Gallery Fifty Six 388
gallery nrc 389
Gallery of Art at Springfield Art Association 389
Geoslides & Geo Aerial Photography 311
Ghost Town 142
Golf Tips 143
Grand Rapids Magazine 144
Hadassah Magazine 145
Healing Lifestyles & Spas Magazine 146
Highways 147
Hutchison Picture Library 313
Icebox Quality Framing & Gallery 395
Image Finders, The 314
Images.de Fulfillment 314
Impact Photographics 275
In the Fray 150
Independent Restaurateur, The 229
Inmagine 315
Instinct Magazine 149
International Photo News 315
Interval World 150

Iowan Magazine, The 150
Iron Willow 397
Islands 150
ITE Journal 229
Jaytravelphotos 317
Jeroboam 318
Jewish Action 151
JRB Art at the Elms 399
Kansas! 152
Kashrus Magazine 153
Kramer, Joan, and Associates Inc. 318
Lake Superior Magazine 154
Land of the Bible Photo Archive 319
Lange, Shauna Lee: The Gallery of Art Journals, Visual Diaries and Sketchbooks 400
Latitude Stock 319
Leepa-Rattner Museum of Art 401
Limited Editions & Collectibles 403
Lineair Fotoarchief BV 320
Living Free 155
Lonely Planet Images 321
Luckypix 321
Marin Museum of Contemporary Art 405
Markeim Art Center 406
MBI Inc. 261
Meetings & Incentive Travel 232
Megapress Images 323
MetroSource Magazine 158
Military Officer Magazine 232
Missouri Life 159
Monderer Design Inc. 352
Motoring & Leisure 160
Multiple Exposures Gallery 409
Na'amat Woman 161
Native Peoples Magazine 162
New York State Conservationist Magazine 164
New York Times on the Web, The 206
North Dakota Horizons 166
Northern Woodlands Magazine 166

Northwest Territories Explorer's Guide 234
Northwestern University Dittmar Memorial Gallery 413
Novastock 324
Novus Visual Communications 353
Oklahoma Today 167
OnAsia 324
OnRequest Images 325
Outdooria Outdoor Image Agency 326
Outside Imagery LLC 326
Owen, Richard C., Publishers Inc. 262
Pacific Stock/Printscapes.com 326
Painet Inc. 327
Panoramic Images 327
Paper Products Design 277
Pennsylvania Magazine 171
Penthouse 171
Persimmon Hill 172
Photo Agora 328
photo-eye Gallery 416
Photolife Corporation Ltd. 329
PhotoSource International 330
PI Creative Art 277
Ponkawonka Inc. 331
Portfolio Graphics Inc. 278
Positive Images 331
ProStar Publications Inc. 264
Pump House Center for the Arts 419
Quarto Publishing Plc. 264
Ralls Collection Inc., The 420
Recommend 240
Revolutionary War Tracks 176
RIG 278
Roanoker, The 177
Roggen, Ted, Advertising and Public Relations 354
Running Press Book Publishers 265
Sailing Magazine 179
Salt Water Sportsman 180
San Diego Art Institute 421
Sandlapper Magazine 180

Santa Barbara Magazine 181

Saxton, Joseph, Gallery of Photography, The 422

Scholastic Library Publishing 265

Science Source/Photo Researchers Inc. 333

Sea 182

Silver Image Photo Agency and Weddings 334

Ski Canada 184

Soundlight 356

SouthComm Publishing Company Inc. 185

Southern Boating 186

Southside Gallery 424

Southwest Airlines Spirit 186

State Street Gallery 425

Still Media 335

Stock Foundry Images 336

STSimages 338

Sugar Daddy Photos 338

Sun, The 188

Superstock Inc. 339

Surface Magazine 188

Surfing Magazine 189

Taube, Lillian & Coleman, Museum of Art 426

Teldon 279

Texas Monthly 190

Tide-Mark Press 279

Times of the Islands 191

Trail Runner 192

Traveller Magazine & Publishing 192

Travelworld International Magazine 193

Tropix Photo Library 339

Ullstein Bild 339

Upstream People Gallery 429

Vermont Magazine 194

Voyageur Press 266

Washington County Museum of Fine Arts 431

Watercraft World 196

WaterSki 197

Waterway Guide 197

West Suburban Living Magazine 198

Wildlight 340

Wine & Spirits 198

Wisconsin Snowmobile News 199

Women's Health Group 268

WILDLIFE

Accent Alaska/Ken Graham Agency 288

Ace Stock Limited 288

Advanced Graphics 272

Aflo Foto Agency 290

Age Fotostock 290

AGStockUSA Inc. 290

AKM Images Inc. 291

Alaska Stock 292

amanaimages inc. 292

AMC Outdoors 109

American Angler 109

AMPM Inc. 344

Animal Sheltering 213

Animal Trails Magazine 112

Animals Animals/Earth Scenes 294

Anthro-Photo File 294

Appalachian Trail Journeys 113

AppaLight 294

Archivo Criollo 295

Arizona Wildlife Views 113

Arsenal Gallery, The 364

Art Directors & Trip Photo Library 296

Art Source L.A. Inc. 367

Art Without Walls Inc. 368

Art@Net International Gallery 365

Artwerks Stock Photography 297

Atlantic Gallery 369

Aurora Photos 298

Auscape International 298

Axiom Photographic 298

Balzekas Museum of Lithuanian Culture Art Gallery 370

Baseball 115

BC Outdoors Hunting and Shooting 115
BC Outdoors Sport Fishing 116
Bee Culture 218
Biological Photo Service and Terraphoto-
 graphics 299
Bird Watcher's Digest 117
Bird Watching 117
Blue Ridge Country 118
Boeberitz, Bob, Design 345
Bon Artique.com/Art Resources Interna-
 tional Ltd. 273
Bowhunter 118
Bridal Guides Magazine 119
BSIP 301
Business of Art Center 373
Bynums Marketing and Communications,
 Inc. 347
Capstone Press 253
Caribbean Travel & Life 124
Centric Corp. 274
Chabot Fine Art Gallery 376
chickaDEE 126
Chirp 126
Comesana, Eduardo, Agencia de Prensa/
 Banco Fotográfico 303
Continental Newstime 130
Countryman Press, The 254
Couturier, Catherine, Gallery 380
Crabtree Publishing Company 255
Dance 133
Darkroom Gallery 381
DDB Stock Photography LLC 304
Deer & Deer Hunting 133
Deljou Art Group 274
Design Pics Inc. 305
Dinodia Photo Library 305
DRK Photo 307
Ducks Unlimited Magazine 135
DW Stock Picture Library 307
Ecoscene 307
ESL Teacher Today 224

Farcountry Press 256
Fellowship 137
Fly Rod & Reel 139
Forest Landowner 226
Fotoscopio 310
Ft. Myers Magazine 140
Fur-Fish-Game 140
G2 Gallery, The 386
Gallant Greetings Corp. 275
Gallery Fifty Six 388
Gallery of Art at Springfield Art Associa-
 tion 389
Geoslides & Geo Aerial Photography 311
Ghost Town 142
Gospel Herald 143
Grand Rapids Magazine 144
Hampton Design Group 349
Hereford World 228
Image Finders, The 314
Image Works, The 315
Impact Photographics 275
Intercontinental Greetings Ltd. 275
Iowan Magazine, The 150
Iron Willow 397
Isopix 316
Kalamazoo Institute of Arts 399
Kentucky Monthly 153
Key Curriculum Press 260
Kimball Stock 318
Kramer, Joan, and Associates Inc. 318
Lake Superior Magazine 154
Lange, Shauna Lee: The Gallery of Art Jour-
 nals, Visual Diaries and Sketchbooks
 400
Latitude Stock 319
Leepa-Rattner Museum of Art 401
Leopold Gallery 402
Lerner Publishing Group 260
Limited Editions & Collectibles 403
Lineair Fotoarchief BV 320
Marin Museum of Contemporary Art 405

Markeim Art Center 406
Marlin 157
MBI Inc. 261
McGaw Graphics Inc. 276
Megapress Images 323
Mesa Contemporary Arts at Mesa Arts Center 407
Michigan Out-of-Doors 158
Missouri Life 159
Motoring & Leisure 160
Murphy, Michael, Gallery M 409
Mushing.com Magazine 161
Muzzle Blasts 161
National Geographic 162
National Parks Magazine 162
Natural History 162
Nature Friend Magazine 163
Nature Photographer 163
New York State Conservationist Magazine 164
New York Times on the Web, The 206
North American Whitetail 165
North Dakota Horizons 166
Northern Woodlands Magazine 166
Northwest Art Center 413
Northwest Territories Explorer's Guide 234
Northwestern University Dittmar Memorial Gallery 413
Novastock 324
Novus Visual Communications 353
OnAsia 324
Opção Brasil Imagens 325
Outdoor Canada Magazine 169
Outside Imagery LLC 326
Owen, Richard C., Publishers Inc. 262
OWL Magazine 169
Pacific Stock/Printscapes.com 326
Painet Inc. 327
Panoramic Images 327
Papilio 328
Pennsylvania Game News 171

Pennsylvania Magazine 171
Persimmon Hill 172
Pet Product News 235
Photo Agora 328
Photo Life 172
photo-eye Gallery 416
Photography Art 417
Photolife Corporation Ltd. 329
PhotoSource International 330
Portfolio Graphics Inc. 278
Positive Images 331
Poudre River Gallery 418
ProStar Publications Inc. 264
Pump House Center for the Arts 419
Quarto Publishing Plc. 264
Recommend 240
Recycled Paper Greetings Inc. 278
Revolutionary War Tracks 176
Richardson, Ella Walton, Fine Art 420
Running Press Book Publishers 265
Rural Heritage 178
Salt Water Sportsman 180
San Diego Art Institute 421
Sandlapper Magazine 180
Saxton, Joseph, Gallery of Photography, The 422
Scholastic Library Publishing 265
Science Source/Photo Researchers Inc. 333
Soundlight 356
SouthComm Publishing Company Inc. 185
Southwest Airlines Spirit 186
Stack, Tom, & Associates Inc. 335
Stock Connection 336
Stock Foundry Images 336
Stock Options 337
STSimages 338
Sugar Daddy Photos 338
Taube, Lillian & Coleman, Museum of Art 426
Teldon 279
Thin Air Magazine 190

Tide Magazine 190

Tide-Mark Press 279

Times of the Islands 191

Trails Media Group 280

Traveller Magazine & Publishing 192

Tropix Photo Library 339

Ullstein Bild 339

Up Here 194

Upstream People Gallery 429

Vermont Magazine 194

Village Profile 195

VIREO (Visual Resources for Ornithology)
 340

Visual Arts Center of Northwest Florida
 431

Voyageur Press 266

Washington County Museum of Fine Arts
 431

Washington Trails 196

Weigl Educational Publishers Ltd. 267

Whiskey Island Magazine 198

Wildlight 340

Willow Creek Press 268

Yankee Magazine 199

GENERAL INDEX

4 Bridges Arts Festival 438
4-Wheel ATV Action 106
440 Gallery 361
440 Gallery Annual Small Works Show 479
440 Gallery Annual Themed Show 479
540 Rider 106
911 Pictures 288

A
A+E 289
AAA Midwest Traveler 106
AAP News 212
ABA Banking Journal 212
Accent Alaska/Ken Graham Agency 288
Ace Stock Limited 288
Achard & Associates 492
Acres U.S.A. 212
Adams, Eddie, Workshop 502
Addison/Ripley Fine Art 361
Adirondack Lakes Center for the Arts 361
Adirondack Life 106
Advanced Graphics 272
Adventure Cyclist 107
Advocate, PKA's Publication 107
Aerial Archives 289

Aesthetica Creative Works Competition 479
AFI Fest 479
Aflo Foto Agency 290
African American Golfer's Digest 107
African Pilot 107
Ag Weekly 212
Age Fotostock 290
AGStockUSA Inc. 290
Akego and Sahara Gallery 362
AKM Images Inc. 291
Akron Art Museum 362
Akron Arts Expo 438
Akron Life 108
Alabama Game & Fish 141
Alabama Living 108
Alamuphoto.com 291
Alamy 292
ALARM 108
Alaska 108
Alaska State Museum 362
Alaska Stock 292
Albuquerque Museum of Art & History, The 362

Alden B. Dow Museum Summer Art Fair 438

Alexia Competition 479

Allen Park Arts & Crafts Street Fair 438

Allentown Art Festival 438

Allis, Charles, Art Museum 362

Allyn & Bacon Publishers 252

Alternatives Journal 109

Alton Arts & Crafts Expressions 439

amanaimages inc. 292

AMC Outdoors 109

American Angler 109

American Archaeology 110

American Artisan Festival 439

American Bar Association Journal 212

American Bee Journal 213

American Fitness 110

American Gardener, The 110

American Hunter 111

American Motorcyclist 111

American Museum of Natural History Library, Photographic Collection 293

American Power Boat Association 213

American Print Alliance 363

American Society of Artists 363

American Sports Network 204

American Turf Monthly 111

American Youth Philharmonic Orchestras, The 344

Amish Acres Arts & Crafts Festival 439

AMPM Inc. 344

Anacortes Arts Festival 439

Anchell Photography Workshops 502

Anchor News 112

Ancient Art & Architecture Collection Ltd., The 293

Anderson Ranch Arts Center 502

Andes Press Agency 293

Anglican Journal, The 204

Angus Beef Bulletin 213

Angus Journal 213

Animal Sheltering 213

Animal Trails Magazine 112

Animals Animals/Earth Scenes 294

Animals of Montana Inc. 502

Ann Arbor Art Center Gallery Shop, The 363

Ann Arbor Street Art Fair 439

Ann Arbor Summer Art Fair 440

Anthro-Photo File 294

AOPA Pilot 214

APA Monitor 214

Aperture 112

Apogee Photo Magazine 113

Apogee Photo Workshop 502

Appalachian Mountain Club Books 252

Appalachian Trail Journeys 113

AppaLight 294

Appaloosa Journal 113

Apple Annie Crafts & Arts Show 440

AQUA Magazine 214

Aquarius 204

Arbabi, Sean 502

ARC Awards 479

ARC Gallery 364

Archaeology 113

Architectural Lighting 215

Archivo Criollo 295

Argus Photo Ltd. 295

Arizona Highways Photo Workshops 503

Arizona State University Art Museum 364

Arizona Wildlife Views 113

Arkansas Sportsman 141

ArkReligion.com 295

Arnold Art 364

Arrowmont School of Arts and Crafts 503

Arsenal Gallery, The 364

Art 3 Gallery 365

Art Directors & Trip Photo Library 296

Art Fair on the Courthouse Lawn 440

Art Festival Beth-el 440

Art Immersion Trip with Workshop in New Mexico 503
Art in Motion 272
Art in the Park (Arizona) 440
Art in the Park (Georgia) 440
Art in the Park (Holland, Michigan) 441
Art in the Park (Virginia) 441
Art in the Park (Warren, Michigan) 441
Art in the Park Fall Foliage Festival 441
Art in the Park Summer Festival 442
Art in the Park-Fine Arts Festival 441
Art Licensing International 296
Art Museum at the University of Kentucky, The 366
Art New England Summer Workshops @ Bennington, Vermont 503
Art of Nature Photography Workshops 503
Art of Photography Show 480
Art on the Lawn 442
Art Resource 297
Art Resources International Ltd. 273
Art Source L.A. Inc. 367
Art Store, The 368
Art Without Walls Inc. 368
Art Workshops in Guatemala 503
Art's Alive 443
Art@Net International Gallery 365
Artefact/Robert Pardo Gallery 365
Artisphere 442
Artist Fellowship Grants 479
Artist Fellowships/Virginia Commission for the Arts 480
Artists Alpine Holiday 480
Artists' Cooperative Gallery 365
ArtProjectA 366
Arts & Crafts Adventure 442
Arts & Crafts Affair, Autumn & Spring Tours, An 442
Arts & Crafts Festival 443
Arts Adventure 443
Arts Company, The 366

Arts Experience 443
Arts in the Park 444
Arts Iowa City 366
Arts on Douglas 367
Arts on Foot 444
Arts on the Green 444
[Artspace] at Untitled 367
Artsplosure 444
ArtVisions 272
Artwerks Stock Photography 297
Asia Images Group 297
Asian American Arts Centre 368
Asian Enterprise Magazine 215
Astrid Awards 480
Astronomy 114
ATA Magazine, The 215
Atelier Gallery 369
Athletic Business 215
Athletic Management 216
Atlanta Homes and Lifestyles 114
Atlanta Photojournalism Seminar Contest 480
Atlantic Gallery 369
Aurora Photos 298
Auscape International 298
Auto Restorer 114, 216
AutoInc. 216
Automated Builder 216
Automotive News 216
Autonomedia 252
Avanti Press Inc. 272
Avionics Magazine 217
Axiom Photographic 298
Axis Gallery 369

B
Babybug 124
Babytalk 114
Bacall, Robert, Representatives Inc. 492
Bachmann Tour Overdrive 504
BackHome 115
Backpacker Magazine 115

Baker Arts Center 369

Ballenger, Noella, & Associates Photo Workshops 504

Ballinger Publishing 217

Balthis, Frank, Photography Workshops 504

Balzekas Museum of Lithuanian Culture Art Gallery 370

Banff Mountain Photography Competition 481

Barbour Publishing Inc. 252

Barnett, Augustus, Advertising/Design 344

Barron Arts Center 370

Bartender Magazine 217

Baseball 115

BC Outdoors Hunting and Shooting 115

BC Outdoors Sport Fishing 116

Bear & Company 259

Bear Deluxe Magazine, The 116

BearManor Media 252

BedTimes 217

Bee Culture 218

Beef Today 218

Beginning Digital Photography Workshop 504

Belian Art Center 370

Bell Studio 371

Bell, Cecilia Coker, Gallery 370

Bellingham Review 116

Bennett Galleries and Company 371

Benrubi, Bonni, Gallery 371

Bentley Publishers 253

Bentley Publishing Group 273

Bergman Collection, The 299

Berman, Mona, Fine Arts 371

Berson, Dean, Stevens 345

BetterPhoto.com Online Photography Courses 504

Beverage Dynamics 218

Beverly Hills Art Show 444

Binnacle, The 116

Biological Photo Service and Terraphotographics 299

Bird Watcher's Digest 117

Bird Watching 117

Birds as Art/Instructional Photo-Tours 504

Birmingham Bloomfield Art Center 372

BizTimes Milwaukee 218

Black Swamp Arts Festival 445

Blackflash 117

Blend Images 300

Blount-Bridgers House/Hobson Pittman Memorial Gallery 372

Blue Gallery 372

Blue Planet Photography Workshops and Tours 505

Blue Ridge Country 118

Blue Ridge Workshops 505

Blue Sky/Oregon Center for the Photographic Arts 373

Boca Raton Fine Art Show 445

Boeberitz, Bob, Design 345

Bon Artique.com 273

Book Beat Gallery 373

Borealis Press, The 273

Borough News 118

Bowhunter 118

Bowhunting World 119

Boxoffice Magazine 219

Boys' Life 119

Bragaw Public Relations Services 345

Brainworks Design Group 345

Bramson + Associates 346

Bransten, Rena, Gallery 373

Briarpatch 119

Brick Street Market 445

Bridal Guides Magazine 119

Bridge Bulletin, The 120

Bridgeman Art Library 300

Bright Light Visual Communications 346

Brookings, J.J., Gallery 373

Brown, Nancy, Hands-On Workshops 505

BSIP 301
Burke's Backyard 120
Burren College of Art Workshops 505
Business NH Magazine 120
Business of Art Center 373
Bynums Marketing and Communications Inc. 347

C
Cain Park Arts Festival 445
Calabasas Fine Arts Festival 445
California Game & Fish 141
California Photographic Workshops 505
California Views/The Pat Hathaway Historical Photo Collection 301
Calliope 120
Camargo Foundation Visual Arts Fellowship 505
Camera Press Ltd. 301
Campbell, John C., Folk School 505
Campbell, Marianne, Associates 492
Campbell, William, Contemporary Art 374
Canada Lutheran 121
Canadian Guernsey Journal 219
Canadian Homes & Cottages 121
Canadian Organic Grower, The 121
Canadian Rodeo News 121
Canadian Yachting 122
Canoe & Kayak 122
Cape Cod Life 123
Capilano Review, The 123
Capital Pictures 302
Capitol Complex Exhibitions 374
Capper's 123
Capstone Press 253
CareerFOCUS 123
Carefree Fine Art & Wine Festival 446
Caribbean Travel & Life 124
Carlsbad Magazine 124
Carmichael Lynch 347
Carus Publishing Company 124
Casey 492

Casino Journal 219
Cat Fancy 124
Catholic Library World 219
Catholic News Service 302
Catholic Sentinel 204
CEA Advisor 219
Cedarhurst Craft Fair 446
Center for Creative Photography 374
Center for Diversified Art 374
Center for Exploratory and Perceptual Art 375
Center for Fine Art Photography, The 481
Center for Photographic Art 375
Center for Photography at Woodstock, The 375, 506
Centerstream Publication LLC 253
Centerville-Washington Township Americana Festival 446
Central Michigan University Art Gallery 376
Centric Corp. 274
CGT Marketing LLC 347
Cha 125
Chabot Fine Art Gallery 376
Chait Galleries Downtown, The 376
Chapman Friedman Gallery 376
Chardon Square Arts Festival 446
Charisma 125
Charlotte Fine Art Show 446
Charlton Photos Inc. 302
Chatsworth Cranberry Festival 447
Chesapeake Bay Magazine 125
Chess Life 125
Chess Life for Kids 126
Chicago Photo Safaris 506
chickaDEE 126
Chief of Police 237
Childhood Education 220
Children's Defense Fund 205
Chirp 126
Chronicle of Philanthropy, The 220
Chronicle of the Horse, The 127

Chronogram 127

Chun Capitol Hill People's Fair 447

Church of England Newspaper, The 205

Church Street Art & Craft Show 447

Church, Cathy, Personal Underwater Photography Courses 506

Cicada 124

City Limits 127

City of Fairfax Fall Festival 447

City of Fairfax Holiday Craft Show 447

Civitan Magazine 220

CLAMPART 377

Clarion-Ledger, The 205

Clark, Catharine, Gallery 377

Classical Singer 221

ClassicStock 333

Cleaning & Maintenance Management 221

Cleis Press 254

Cleveland Magazine 128

Clickers & Flickers Photography Network-Lectures & Workshops 506

Co/So: Copley Society of Art 379

Coast&Kayak Magazine 128

Cobblestone 128

Cody Images 303

Cohen, Stephen, Gallery 377

Cole, Randy, Represents LLC 492

Collectible Automobile 129

College Photographer of the Year 481

College Photography Contest 481

College PreView 129

Colorscape Chenango Arts Festival 447

Comesana, Eduardo, Agencia de Prensa/Banco Fotográfico 303

Commercial Carrier Journal 221

Communication Arts Annual Photography Competition 481

Community Darkroom 506

Community Observer 129

Complete Woman 129

Comstock Cards 274

Conari Press 254

Conde Nast Traveler 130

Cone Editions Workshops 507

Conscience 130

Construction Equipment Guide 221

Contemporary Arts Center (Cincinnati), The 378

Contemporary Arts Center (Las Vegas) 378

Contemporary Arts Center (New Orleans) 378

Contemporary Bride 130

Continental Newstime 130

Convergence 131

Conyers Cherry Blossom Festival 448

Cooling Journal, The 222

Corbis 303

Corcoran Fine Arts Limited, Inc. 378

Corporate Art Source/CAS Gallery 379

Cortona Center of Photography, Italy, The 507

Cory Nature and Travel Workshops 507

Cosmopolitan 131

Cotton Grower Magazine 222

Countdown 131

Country Woman 131

Countryman Press, The 254

Courthouse Gallery, Lake George Arts Project 379

Couturier, Catherine, Gallery 380

Crabtree Publishing Company 255

Craft Fair at the Bay 448

Crafts at Rhinebeck 448

CraftWestport 448

Crealdé School of Art 380, 507

Creative Arts Workshop 507

Creative Homeowner 255

Creative Quarterly Call for Entries 481

Creative With Words Publications 255

Crestock Corporation 303

Cricket 124

CropLife 222

Crossman Gallery 380

Cruising World 132

Cullowhee Mountain Arts Summer Workshop Series 507

Cultural Photo Tours With Ralph Velasco 508

Curator's Choice Awards 482

Cushing-Martin Gallery 380

Custer's Last Stand Festival of the Arts 448

Cycle California! Magazine 132

Cycle World 133

D

Dairy Today 222

Dallas Center for Contemporary Art, The 380

Dance 133

Darkroom Gallery 381

Dawson College Centre for Training and Development 508

Day in Towne, A 449

Dayton Art Institute, The 381

DDB Stock Photography LLC 304

Dean, Julia, Photo Workshops, The 508

Deer & Deer Hunting 133

Deerfield Fine Arts Festival 449

Delaney, Cynthia, Photo Workshops 509

Delaware Arts Festival 449

Delaware Center for the Contemporary Arts 381

Deljou Art Group 274

Demuth Museum 381

Design Conceptions/Joel Gordon Photography 305

Design Design Inc. 274

Design Pics Inc. 305

Detroit Focus 381

Digital Photo 133

Digital Wildlife Photography Field School 509

Dinodia Photo Library 305

Direct Art Magazine Publication Competition 482

Display Design Ideas 223

DK Stock Inc. 306

DM News 223

Dog Fancy 134

Dorsky, Samuel, Museum of Art 382

Dot Fiftyone Gallery 382

Down the Shore Publishing 255

DownBeat 134

Downtown Festival & Art Show 449

Drake Magazine, The 134

DRK Photo 307

drkrm 382

Ducks Unlimited Magazine 135

Durango Autumn Arts Festival 449

DW Stock Picture Library 307

Dykeman Associates Inc. 348

E

Eastfoto Inc. 335

Eastman, George, House 382

Easyriders 135

Ecoscene 307

ECW Press 256

Edelman, Catherine, Gallery 382

Edelstein, Paul, Studio and Gallery 383

Edens Art Fair 450

Editor's Choice Awards, The 482

El Dorado County Fair 450

El Restaurante Mexicano 224

Electric Perspectives 223

Electrical Apparatus 223

Elks Magazine, The 135

Elmwood Avenue Festival of the Arts Inc. 450

Eloquent Light Photography Workshops 509

Energy Gallery Art Call 482

Englander, Joe, Photography Workshops & Tours 509

Entrepreneur 135

EOS Magazine 136
Erben, Thomas, Gallery 383
ESL Teacher Today 224
Estero Fine Art Show 450
eStock Photo LLC 308
Etherton Gallery 383
Europa Photogenica Photo Tours to Europe 509
Event 136
EventGallery 910Arts 383
Evergreen Fine Arts Festival 450
Everson Museum of Art 384
Evolve the Gallery 384
Exhibitions Without Walls for Photographers and Digital Artists 482
exposure36 Photography 509
Eye Ubiquitous 308

F
Faces 136
Fahey/Klein Gallery 384
Fair in the Park, A 451
Faire on the Square 451
Faith & Friends 137
Falkirk Cultural Center 385
Fall Fest in the Park 451
Fall Festival of Art at Queeny Park 451
Fall Fine Art & Crafts at Brookdale Park 452
Family Motor Coaching 137
Famous Pictures & Features Agency 308
Farcountry Press 256
Fargo's Downtown Street Fair 452
Farm Journal 224
Faust Fine Arts & Folk Festival 452
FAVA (Firelands Association for the Visual Arts) 385, 483
FCA Magazine 137
Fellowship 137
Festival in the Park 452
Field & Stream 138
Fifth House Publishers 256
Fillmore Jazz Festival 452

Finding & Keeping Clients 510
Fine Art & Crafts at Anderson Park 452
Fine Art & Crafts at Verona Park 452
Fine Arts Center Gallery 385
Fine Arts Work Center 510
Finescale Modeler 138
Finger, Peter, Photographer 510
Finster, Howard, Vision House 386
Fire Chief 224
Fire Engineering 225
Firefly Books 257
Firehouse Magazine 225
FireRescue 225
First Light Associated Photographers 309
First Light Photographic Workshops and Safaris 510
Flashlight Press 257
Flaunt 138
Flight Collection, The 309
Flint Communications 348
Floral Management Magazine 226
Florida Game & Fish 141
Florida Sportsman 139
Florida State University Museum of Fine Arts 386
Fly Rod & Reel 139
Focal Point Gallery 386
Focal Press 257
Focus Adventures 510
Foliate Oak Literary Magazine 139
Folio 139
Food & Wine 139
Foodpix 309
Foothills Arts & Crafts Fair 453
Ford City Heritage Days 453
Forest Hills Festival of the Arts 453
Forest Landowner 226
Fortune 140
Foto-Press Timmermann 310
FOTOAGENT 310
FOTOfusion 510

Fotoscopio 310
Fountain Hills Fine Art & Wine Affaire 453
Fourth Avenue Street Fair 453
Fourth Street Festival for the Arts & Crafts 453
Frame Building News 226
France Magazine 140
Francisco, Sally D., Gallery and the Store at Peters Valley Craft Center 386
Frankfort Art Fair 454
Frederick Festival of the Arts 454
Freeman Patterson Photo Workshops 510
Freeport Art Museum 386
Friedentag Photographics 348
Fruit Growers News 226
Ft. Myers Magazine 140
Fulton County Daily Report 205
Fundamental Photographs 311
Funky Ferndale Art Show 454
Fur-Fish-Game 140

G
G2 Gallery, The 386
Galápagos Travel 511
Gallant Greetings Corp. 275
Gallerist's Choice Awards, The 483
Gallery 72 387
Gallery 110 Collective 387
Gallery 218 387
Gallery 400 388
Gallery 825 388
Gallery Fifty Six 388
Gallery North 389
gallery nrc 389
Gallery of Art at Springfield Art Association 389
Game & Fish 141
Gardening How-To 141
Garrison Art Center's Juried Fine Crafts Fair 454
Geneva Arts Fair 454
Georgia Sportsman 141

Georgia Straight 141
Geoslides & Geo Aerial Photography 311
Geosynthetics 227
Gering & López Gallery 390
Gerlach Nature Photography Workshops & Tours 511
German Life 142
Germantown Festival 454
Getty Images 312
Ghost Town 142
Gibson Advertising 349
Ginsburg, Michael, & Associates Inc. 493
Girls' Life 142
Global Preservation Projects 511
Gloucester Arts on Main 390
Gloucester Waterfront Festival 455
Go 142
Gold & Associates Inc. 349
Gold Rush Days 455
Golden Gate School of Professional Photography 511
Goldman, Rob, Creative Photography Workshops 511
Golf Canada 142
Golf Tips 143
Good Housekeeping 143
Good Old Summertime Art Fair 455
Gospel Herald 143
Government Technology 227
Grace Ormonde Wedding Style 143
Gradd Arts & Crafts Festival 455
Grain Journal 227
Granataimages.com 312
Grand Festival of the Arts & Crafts 455
Grand Rapids Art Museum 390
Grand Rapids Business Journal 206
Grand Rapids Family Magazine 143
Grand Rapids Magazine 144
Great Lakes Art Fair 455
Great Neck Street Fair 456

Great Smoky Mountains Institute at Tremont 511
Greenwich Village Art Fair 456
Greyhound Review, The 144
Grit 123
Gryphon House Inc. 257
Guenzi, Carol, Agents Inc. 493
Guernica Editions 257
Guernica Magazine 144
Guideposts 144
Guilford Craft Expo 456
Guitar World 145
Gunstock Summer Festival 456

H
Haardt, Anton, Gallery 390
Hadassah Magazine 145
Haddad, Carrie, Gallery 391
Hallmark Institute of Photography 511
Hallowes Productions & Advertising 349
Halsted Gallery Inc., The 391
Hamilton Magazine 145
Hampton Design Group 349
Hansley, Lee, Gallery 391
Hard Hat News 227
Harnett, Joel and Lila, Museum of Art and Print Study Center 391
Harper's Magazine 145
HarperCollins Children's Books/HarperCollins Publishers 258
Harris, James, Gallery 392
Harris, O.K., Works of Art 392
Hart, John, Portrait Seminars 512
Havu, William, Gallery 392
Hawaii Workshops, Retreats, Private Photo Tours, Instruction & Fine Art Print Sales 512
Healing Lifestyles & Spas Magazine 146
Heart of Nature Photography Workshops & Photo Tours 512
Hearth and Home 228
Heartland Boating 146

Hemphill 393
Henry Art Gallery, The 393
Henry Street Settlement/Abrons Art Center 393
Hera Educational Foundation and Art Gallery 393
Herald Press 258
Herbert, Gertrude, Institute of Art 394
Hereford World 228
Heritage Images 312
Heritage Railway Magazine 146
Heuser Art Center Gallery & Hartmann Center Art Gallery 394
Highland Maple Festival 456
Highlands Art League's Annual Fine Arts & Crafts Festival 456
Highlights for Children 147
Highways 147
Hinsdale Fine Arts Festival 457
Hodes, Bernard, Group 350
Holiday CraftMorristown 457
Holiday Fine Arts & Crafts Show 457
Holly Arts & Crafts Festival 457
Holt McDougal 258
Home Decorating & Remodeling Show 457
Home Education Magazine 147
Home, Condo and Outdoor Art & Craft Fair 457
Hoof Beats 147
Hopper, Edward, House Art Center 394
Horizons: Artistic Travel 512
Horse Illustrated 148
Horse, The 148
Hot Springs Arts & Crafts Fair 457
Houk, Edwynn, Gallery 394
Howard, Merrell and Partners Inc. 350
HPAC 228
Hudson Gallery 395
Hui Ho'olana 512
Human Kinetics Publishers 258
Humanity Photo Award 483

Hunger Mountain 148
Huntsville Museum of Art 395
Hutchinson Associates Inc. 350
Hutchison Picture Library 313
Hyde Park Arts & Crafts Adventure 458
Hyperion Books for Children 259
Hywet, Stan, Hall & Gardens Ohio Mart 458

I

Icebox Quality Framing & Gallery 395
ICP di Alessandro Marosa 313
Idea Bank Marketing 351
IEEE Spectrum 229
IGA Grocergram 229
Illinois Game & Fish 141
Illinois State Museum Chicago Gallery 396
Image by Design Licensing 148
Image Finders, The 314
Image Integration 351
Image Works, The 315
Images.de Fulfillment 314
Immedium 259
Impact Photographics 275
In Focus With Michele Burgess 512
In the Fray 150
Independent Restaurateur, The 229
Indian Wells Arts Festival 458
Indiana Art Fair 458
Indiana Game & Fish 141
Indianapolis Art Center 396
Indianapolis Monthly 149
Individual Artists of Oklahoma 396
InFocus Juried Exhibition 483
Inmagine 315
Inner Traditions 259
Inside Triathlon 149
Insight Magazine 149
Instinct Magazine 149
Intercontinental Greetings Ltd. 275
International Center of Photography 396
International Expeditions 512
International Folk Festival 458

International Photo News 315
International Visions Gallery 397
Interval World 150
Iowa Game & Fish 141
Iowan Magazine, The 150
Irish Image Collection, The 316
Irish Picture Library, The 316
Iron Willow 397
Islands 150
Isle of Eight Flags Shrimp Festival 459
Isopix 316
Israelimages.com 317
Italian America 151
ITE Journal 229

J

Jackson Fine Art 397
Jacob, Elaine L., Gallery and Community Arts Gallery 397
Jadite Galleries 398
Jaytravelphotos 317
Jenkins, Alice and William, Gallery 398
Jeroboam 318
Jewish Action 151
JHB Gallery 398
Jillson & Roberts 276
Jividen's Naturally Wild Photo Adventures 513
Johns Hopkins University Spring Fair 459
Jones, Stella, Gallery 398
Jordahl Photo Workshops 513
Journal of Adventist Education 230
Journal of Asian Martial Arts 151
Journal of Psychoactive Drugs 230
Journey Magazine 152
Joyce, Tricia, Inc. 493
JRB Art at the Elms 399
Jubilee Festival 459
Jude Studios 351
Judicature 152, 230

K

Kalamazoo Institute of Arts 399
Kalamazoo Institute of Arts Fair 459
Kansas! 152
Kashrus Magazine 153
Kent State University School of Art Galleries 399
Kentuck Festival of the Arts 459
Kentucky Game & Fish 141
Kentucky Monthly 153
Ketner's Mill County Arts Fair 459
Key Curriculum Press 260
Kimball Stock 318
Kinetic, the Technology Agency 351
Kings Drive Art Walk 460
Kings Mountain Art Fair 460
Kirchman Gallery 399
Kiwanis 153
Klein, Robert, Gallery 399
KNOWAtlanta 153
Koch, Robert, Gallery 400
Kochan & Company 351
Korn, Bob, Imaging 513
Kramer, Joan, and Associates Inc. 318
Krasl Art Fair on the Bluff 460

L

Lacrosse Magazine 154
Ladies Home Journal 154
Ladybug 124
Lake Champlain Maritime Museum's Annual Juried Photography Exhibit 483
Lake City Arts & Crafts Festival 460
Lake Superior Magazine 154
Lake Superior Magazine Photo Contest 483
Lakeland Boating Magazine 154
Land of the Bible Photo Archive 319
Land, The 231
Landing Gallery 400
Landscape Architecture 231

Lange, Shauna Lee: The Gallery of Art Journals, Visual Diaries and Sketchbooks 400
Lantern Court LLC 276
Lapp, Cristopher-Still & Moving Images 494
Larson Gallery Juried Biennual Photography Exhibition 483
Latitude Stock 319
Law Warschaw Gallery 400
Lawyers Weekly, The 206
Leach, Elizabeth, Gallery 401
Lebrecht Photo Library 319
Lee + Lou Productions Inc. 494
Leedy, Sherry, Contemporary Art 401
Leepa-Rattner Museum of Art 401
Leeper Park Art Fair 460
Legion Arts 402
Lehigh University Art Galleries 402
Leonardis, David, Gallery 402
Leopold Gallery 402
Lerner Publishing Group 260
Les Cheneaux Festival of Arts 461
Levin, Bruce, Group, The 494
Liberty Arts Squared 461
Lichtenstein Center for the Arts 403
Light Factory, The 513
Light Photographic Workshops 513
Lightwave Photography 319
Lilac Festival Arts & Crafts Show 461
Limited Editions & Collectibles 403
Limner Gallery 403
Lincolnshire Life 155
Lineair Fotoarchief BV 320
LION 155
Lived In Images 320
Living Free 155
Lizardi/Harp Gallery 403
Llewellyn, Peter, Photography Workshops & Photo Tours 513

Lockwood, C.C., Wildlife Photography Workshop 513
Log Home Living 156
Log Newspaper, The 206
Lohre & Associates Inc. 352
Lompoc Flower Festival 461
Lone Pine Photo 321
Lonely Planet Images 321
Long's, Andy, First Light Photography Workshops Tours 514
Los Angeles Center for Digital Juried Competition 484
Los Angeles Municipal Art Gallery 404
Love Unlimited Film Festival & Art Exhibition 484
Lowe, Bill, Gallery 404
Loyola Magazine 156
Luckypix 321
Lullwater Review 156
Lutheran, The 157
Lutz Arts & Crafts Festival 461
Lux Center for the Arts 404

M

MacDowell Colony, The 514
MacGuffin, The 157
MacNider Art Museum 404
Madeline Island School of the Arts 514
Madison Chautauqua Festival of Art 461
Magazine Antiques, The 157
Magenta Publishing for the Arts 260
Main Street Gallery 405
Maine Media Workshops 514
Maltz, Ben, Gallery 405
Manitoba Teacher, The 231
Manning, William, Photography 514
Manufacturing Automation 231
Marin Museum of Contemporary Art 405
Markeim Art Center 406
Marketing & Technology Group 232
Marlboro Gallery 406
Marlin 157

Maslov, Norman, Agent Internationale 494
Mason Arts Festival 461
Masterfile 321
Masur Museum of Art 406
Mattei, Michele, Photography 322
Maui Hands 406
MAXX Images Inc. 322
Mayans, Ernesto, Gallery 407
MBI Inc. 261
McDonald, Joe & Mary Ann, Wildlife Photography Workshops and Tours 514
McDonough Museum of Art 407
McGaw Graphics Inc. 276
McGrath, Judith 495
McGraw-Hill 261
Medical File Inc., The 322
Mediscan 322
Meetings & Incentive Travel 232
Megapress Images 323
Memorial Weekend Arts & Crafts Festival 462
Mentor Series Worldwide Photo Treks 514
Mercury Awards 484
Mesa Contemporary Arts at Mesa Arts Center 407
MetroSource Magazine 158
Michelson, R., Galleries 408
Michigan Out-of-Doors 158
Michigan Sportsman 141
Michigan State University Holiday Arts & Crafts Show 462
Michigan State University Spring Arts & Crafts Show 462
Mid-Atlantic Regional School of Photography 515
Mid-Missouri Artists Christmas Arts & Crafts Sale 462
Midwest Meetings 232
Midwest Photographic Workshops 515
Military Officer Magazine 232
Mill Brook Gallery & Sculpture Garden 408

Miller Group, The 352
Miller, Peter, Gallery 408
Mills Pond House Gallery 408
Minnesota Golfer 158
Minnesota Sportsman 141
Mira 323
Mississippi/Louisiana Game & Fish 141
Missouri Life 159
Missouri Photojournalism Workshop 515
Mitchell Lane Publishers Inc. 261
Mixed Media Photography 515
Mobile Museum of Art 409
Mobius Awards for Advertising, The 484
Monderer Design Inc. 352
Mondial 261
Montauk Point Lions Club 462
Monterey Museum of Art 409
Morpheus Tales 159
Mother Jones 159
Motor Boating Magazine 159
Motoring & Leisure 160
Mount Gretna Outdoor Art Show 463
Mountain Living 160
Mountain State Forest Festival 463
Mountain Workshops 515
mptv 324
Multiple Exposures Gallery 409
Munro Campagna Artists Representatives 495
Murphy, Michael, Gallery M 409
Murphy, Tom, Photography 515
Musclemag International 160
Museo De Arte De Ponce 410
Museo ItaloAmericano 410
Museum of Contemporary Art San Diego 410
Museum of Contemporary Photography, Columbia College Chicago 410
Museum of Northern Arizona 261
Museum of Photographic Arts 411
Museum of Printing History 411

Museum of the Plains Indian 411
Mushing.com Magazine 161
Music Sales Group 262
Musky Hunter Magazine 161
Muzzle Blasts 161
Myriad Productions 352
Myron the Camera Bug 484

N

Na'amat Woman 161
NailPro 232
Nails Magazine 233
Napa River Wine & Crafts Fair 463
National Geographic 162
National Masters News 206
National Notary, The 233
National Parks Magazine 162
Native Peoples Magazine 162
Natural Habitat Adventures 515
Natural History 162
Nature Friend Magazine 163
Nature Photographer 163
Naval History 233
Necrology Shorts 164
Nevada Farm Bureau Agriculture and Livestock Journal 234
Nevada Museum of Art 411
Neversink Photo Workshop 515
New England Arts & Crafts Festival 463
New England Craft & Specialty Food Fair 463
New England Game & Fish 141
New England School of Photography 516
New Gallery/Thom Andriola 412
New Jersey Heritage Photography Workshops 516
New Jersey Media Center LLC Workshops and Private Tutoring 516
New Mexico Arts and Crafts Fair 464
New Mexico Magazine 164
New Mexico State University Art Gallery 412

New Orleans Jazz & Heritage Festival 464

New Orleans Museum of Art 412

New Smyrna Beach Art Fiesta 464

New World Festival of the Arts 464

New York Game & Fish 141

New York Graphic Society Publishing Group 276

New York State Conservationist Magazine 164

New York State Fair Photography Competition and Show 484

New York Times Magazine, The 165

New York Times on the Web, The 206

NewDesign 234

Newsweek 164

NEXUS/Foundation for Today's Art 412

NFPA Journal 234

Nicolas-Hays Inc. 262

Nicolaysen Art Museum & Discovery Center 412

Nicolet College Art Gallery 412

Nikon School Digital SLR Photography 517

NKU Gallery 413

North American Whitetail 165

North Carolina Game & Fish 141

North Carolina Literary Review 165

North Congregational Peach & Craft Fair 464

North Dakota Horizons 166

Northern Exposures 517

Northern Woodlands Magazine 166

Northwest Art Center 413

Northwest Territories Explorer's Guide 234

Northwestern University Dittmar Memorial Gallery 413

Norton, W.W., & Company Inc. 262

Notre Dame Magazine 166

Nova Media Inc. 277

Novastock 324

Novus Visual Communications 353

Now & Then 166

Noyes Museum of Art, The 414

NYU Tisch School of the Arts 517

O

Oak Park Avenue-Lake Arts & Crafts Show 464

Oakland University Art Gallery 414

OC Fair Visual Arts Competition 464

Ocean Magazine 167

Off the Coast 167

Ohio Game & Fish 141

Ohio Magazine 167

Ohio Wholesale Inc./Kennedy's Country Collection 277

Oklahoma Game & Fish 141

Oklahoma Today 167

Old Town Art Fair 465

OMNI Productions 353

On the Green Fine Art & Craft Show 465

OnAsia 324

Onboard Media 168

One 168

OnRequest Images 325

Ontario Technologist, The 235

Opção Brasil Imagens 325

Opalka Gallery 414

Opening Night Gallery 415

Orchard Lake Fine Art Show 465

Oregon Coast 168

Oregon College of Art and Craft 517

Otter Creek Photography 517

Outdoor Canada Magazine 169

Outdooria Outdoor Image Agency 326

Outside Imagery LLC 326

Owen, Richard C., Publishers Inc. 262

OWL Magazine 169

Oxygen 169

Oyez Review 170

P

Pacific Northwest Art School/Photography 517

Pacific Stock 326
Pacific Yachting 170
Painet Inc. 327
Pakn Treger 170
Palm Beach Photographic Centre 517
Palo Alto Art Center 415
Panoply Arts Festival 465
Panoramic Images 327
Paonessa Photography Workshops, Ralph 518
Paper Products Design 277
Papilio 328
Paradise City Arts Festivals 465
Parkland Art Gallery 415
Parks, Gordon, Photography Competition, The 485
Patterson Apricot Fiesta 466
Paulist Press 263
Pearlstein, Leonard, Gallery 415
Pediatric Annals 235
Pelican Publishing Company 263
Pend Oreille Arts Council 466
Pennsylvania Angler & Boater 170
Pennsylvania Game & Fish 141
Pennsylvania Game News 171
Pennsylvania Magazine 171
Penthouse 171
People Management 235
Period Ideas 171
Perkins Center for the Arts Juried Photography Exhibition 485
Persimmon Hill 172
Pet Product News 235
Peters Valley Annual Craft Fair 466
Peters Valley Craft Center 416, 518
Phillips Gallery 416
Phoenix Gallery, The 416
Photo Agora 328
Photo Explorer Tours 518
Photo Life 172
Photo Resource Hawaii 329

Photo Review Annual Photography Competition, The 485
Photo Review, The 236
PHOTO Techniques 172
photo-eye Gallery 416
PhotoEdit Inc. 328
Photographer's Forum Magazine 172
Photographers' Formulary 518
Photographic Arts Workshops 518
Photographic Center Northwest 518
Photographic Resource Center 417
Photography Art 417
Photography at the Summit: Jackson Hole 519
Photography in Provence 519
Photography Now 485
Photokunst 495
Photolibrary Group, The 329
Photolife Corporation Ltd. 329
Photomedia Center, The 417
PhotoSource International 330
Photospiva 485
PhotoTherapy Consultants 495
PI Creative Art 277
Picture Matters 495
Pictures of the Year International 485
Pierro Gallery of South Orange 417
Pilot Getaways Magazine 173
Pilot Magazine 173
Piscopo, Maria 496
Pitcher, Sylvia, Photo Library 330
Pix International 330
Pizer, Alyssa 496
Planet 173
Planning 236
PLANS Ltd. (Photo Libraries and News Services) 331
Plastics News 236
Plastics Technology 236
Poets & Writers Magazine 237
PointBlank Agency 353

Police and Security News 237

Police Times 237

Polk Museum of Art 418

Ponds USA and Water Gardens 238

Ponkawonka Inc. 331

Popular Photography & Imaging 173

Portfolio Graphics Inc. 278

Posey School 354

Positive Images 331

Potomac Review 174

Poudre River Gallery 418

Power & Motoryacht 174

POZ 174

Prague Summer Seminars 519

Prairie Arts Festival 466

Prairie Journal, The 174

Prairie Messenger 175

Prakken Publications Inc. 263

Press Association Images 332

Prick of the Spindle 175

Princeton Alumni Weekly 175

Print Center, The 418

Printscapes.com 326

Proceedings 238

Produce Retailer 238

Professional Photographer 238

Professional Photographer's Society of New
 York State Photo Workshops 519

Professional Women Photographers Inter-
 national Women's Call for Entry 486

Progressive, The 175

Project Competition, The 486

ProStar Publications Inc. 264

Public Power 239

Pucker Gallery Inc. 419

Pump House Center for the Arts 419

Pungo Strawberry Festival 466

Purestock 332

Pyramid Hill Annual Art Fair 467

Pyrenees Exposures 519

Q

QSR 239

Quaker Arts Festival 467

Qually & Company Inc. 354

Quarto Publishing Plc. 264

Queens College Art Center 419

Quick Frozen Foods International 239

Quon Design 354

R

Racquetball Magazine 176

Rafelman, Marcia, Fine Arts 419

Railphotolibrary.com 332

Ralls Collection Inc., The 420

Rangefinder 240

Rattlesnake Roundup 467

Recommend 240

Recycled Paper Greetings Inc. 278

Referee 240

Reform Judaism 176

Relay Magazine 241

Relocating to the Lake of the Ozarks 176

Remodeling 241

Rental Management 241

REP. 242

Restaurant Hospitality 242

Retailers Forum 242

Revolutionary War Tracks 176

Rex USA 332

Rhode Island Monthly 177

Rhode Island State Council on the Arts Fel-
 lowships 486

Rich, Jeffrey, Wildlife Photography Tours
 519

Richardson, Ella Walton, Fine Art 420

RIG 278

Riley Festival 467

River Gallery 420

Rivera-Ortiz, Manuel, Foundation for Doc-
 umentary Photography & Film, The
 486

Riverbank Cheese & Wine Exposition 467
Riverfront Market 467
Roanoker, The 177
Roberts Press 264
Robertstock 333
Rochester Contemporary 421
Rockport Center for the Arts 421
Rocky Mountain Field Seminars 519
Rocky Mountain Game & Fish 141
Rocky Mountain School of Photography
 519
Roggen, Ted, Advertising and Public Rela-
 tions 354
Rolling Stone 177
Romantic Homes 177
Rotarian, The 178
Rotunda Gallery, The 421
Royal Oak Outdoor Art Fair 467
RTOHQ: The Magazine 242
Running Press Book Publishers 265
Running Times 178
Rural Heritage 178
Russian Life 178

S
Saco Sidewalk Art Festival 468
Sail 179
Sailing Magazine 179
Sailing World 179
Saks, Arnold, Associates 355
Salt Hill Literary Journal 180
Salt Water Sportsman 180
San Diego Art Institute 421
San Diego County Fair Annual Exhibition of
 Photography 486
San Francisco Photo Safaris 520
Sander, Vicki/Folio Forums 496
Sandlapper Magazine 180
Sandy Springs Festival 468
Santa Barbara Magazine 181
Santa Cali Gon Days Festival 468
Santa Fe College Spring Arts Festival 468

Santa Fe Photographic Workshops 520
Santoro Graphics Ltd. 279
Sausalito Art Festival 468
Saxton, Joseph, Gallery of Photography,
 The 422
Schmidt, Henry, Design 355
Schmidt, William & Florence, Art Center
 422
Schmidt/Dean 422
Scholastic Library Publishing 265
Scholastic Magazines 181
School Administrator, The 181
School Guide Publications 265
Schupfer, Walter, Management Corpora-
 tion 496
Science Photo Library Ltd. 333
Science Scope 243
Science Source/Photo Researchers Inc. 333
Scientific American 181
Scott, Freda, Inc. 497
Scottsdale Arts Festival 469
Scrap 182
Sea 182
Second Street Gallery 423
Security Dealer & Integrator 243
Selling Your Photography 520
sellphotos.com 520
Seventeen Magazine 182
Sexton, John, Photography Workshops 520
SHINE brightly 183
Shooting Sports USA 183
Shotgun Sports Magazine 183
Shots 183
Showboats International 184
Showcase School of Photography, The 520
Sides & Associates 355
Sidewalk Art Mart 469
Sierra 184
Sierra Madre Wistaria Festival 469
Silver Image Photo Agency and Weddings
 334

Silver Moon Press 266
Singing Sands Workshops 520
Sioux City Art Center 423
Skellig Photo Tours 520
Ski Canada 184
Skiing Magazine 184
Skipping Stones 184
Skokie Art Guild's Art Fair 469
Skydiving 184
Skyscan Photolibrary 334
Smithsonian Magazine 185
Smithville Fiddlers' Jamboree and Craft
 Festival 469
Sohn Fine Art-Gallery & Giclée Printing 423
Sohn Fine Art-Master Artist Workshops
 521
Soho Myriad 423
Solano Avenue Stroll 469
Soldier of Fortune 185
Soundlight 356
South Carolina Game & Fish 141
South Dakota Art Museum 424
South Shore Art Center 521
SouthComm Publishing Company Inc. 185
Southern Boating 186
Southside Gallery 424
Southwest Airlines Spirit 186
Southwest Arts Festival, The 470
Sovfoto 335
SpeciaLiving 186
Specialty Travel Index 244
Spencer's 279
Spillway 187
Spoke, B.J., Gallery 424
Sport Fishing 187
Sports Afield 187
Sports Illustrated 187
Sports Photography Workshop: Colorado
 Springs, Colorado 521
Spring CraftMorristown 470
Spring Crafts at Lyndhurst 470

Spring Fine Art & Crafts at Brookdale Park
 470
Spring Photography Contest 486
Springfest 470
SRO Photo Gallery at Landmark Arts 424
St. Charles Fine Art Show 471
St. George Art Festival 471
St. James Court Art Show 471
St. Louis Art Fair 471
St. Patrick's Day Craft Sale & Fall Craft Sale
 471
Stack, Tom, & Associates Inc. 335
State Museum of Pennsylvania, The 424
State of the Art Gallery 425
State Street Gallery 425
Steele, Philip J., Gallery 425
Steppin' Out 471
Stevenson University Art Gallery 425
Stickman Review 188
Still Media 335
Still Point Art Gallery 426
Stillwater Arts Festival 472
Stirring 188
Stock Connection 336
Stock Foundry Images 336
Stock Options 337
StockFood 336
Stockley Gardens Fall Arts Festival 472
Stockyard Photos 338
Stone Arch Bridge Festival 472
Strawberry Festival 472
Streetpeoples Weekly News 207
STSimages 338
Successful Meetings 244
Sugar Daddy Photos 338
Summer Arts & Crafts Festival 472
Summerfair 473
Summit Photographic Workshops 521
Sun 207
Sun Fest Inc. 473
Sun, The 188

Sun.Ergos 356
Sunday Post, The 207
Superior/Gunflint Photography Workshops 521
Superstock Inc. 339
Surface Magazine 188
Surfing Magazine 189
Surgical Technologist, The 244
Synchronicity Fine Arts 426
Synergistic Visions Workshops 521
Syracuse Arts & Crafts Festival 473
Syracuse New Times 208

T
Taendem Agency 497
Tarpon Springs Fine Arts Festival 473
Taube, Lillian & Coleman, Museum of Art 426
Taylor County Photography Club Memorial Day Contest 487
Technical Analysis of Stocks & Commodities 189
Techniques 244
Teldon 279
Tennessee Sportsman 141
Texas Gardener 189
Texas Highways 189
Texas Monthly 190
Texas Photographic Society Annual Members' Only Show 487
Texas Photographic Society National Competition 487
Texas Realtor Magazine 244
Texas School of Professional Photography 521
Texas Sportsman 141
Texas State Arts & Crafts Fair 473
Textile Rental Magazine 245
THEMA 190
Thin Air Magazine 190
Thomas, Martin, International 356

Thompson, Natalie and James, Art Gallery 426
Three Rivers Arts Festival 473
Throckmorton Fine Art 427
Tide Magazine 190
Tide-Mark Press 279
Tightrope Books 266
Tikkun 191
Tilbury House 266
Tilt Gallery 427
TIME 191
Times of the Islands 191
TM Enterprises 497
Tobacco International 245
Tobacco Journal International 245
Today's Photographer 245
Top Producer 246
Toronto Sun Publishing 208
Touchstone Gallery 427
Track & Field News 191
Trail Runner 192
Trails Media Group 280
Transport Topics 246
Transportation Management & Engineering 246
Travel + Leisure 192
Travel Images 522
Traveller Magazine & Publishing 192
Travelworld International Magazine 193
Tree Care Industry Magazine 246
Tricycle 193
Triple D Game Farm 522
Tropix Photo Library 339
Truppe, Doug 498
Tubac Festival of the Arts 474
Tulip Festival Street Fair 474
Tulsa International Mayfest 474
Turkey & Turkey Hunting 193
Turkey Country 193
TV Guide 194

U

UAB Visual Arts Gallery 428
UCR/California Museum of Photography
 428
Ullstein Bild 339
Underground Construction 247
UNI Gallery of Art 428
Union Street Gallery 428
University Art Gallery in the D.W. Williams
 Art Center 429
University of Richmond Museums 429
Unlimited Editions International Juried Pho-
 tography Competitions 487
Up Here 194
Upstream Gallery 429
Upstream People Gallery 429
Uptown Art Fair 474
Urban Institute for Contemporary Arts 430

V

Van Os, Joseph, Photo Safaris Inc. 522
VeloNews 194
Ventura County Reporter 208
Vermont Magazine 194
Versal 195
Veterinary Economics 247
Victorian Chautauqua, A 475
Video I-D, Teleproductions 357
View From Here, The 195
Viewfinders Stock Photography 340
Village Profile 195
Village Square Arts & Crafts Fair 475
Vintage Books 266
VIREO (Visual Resources for Ornithology)
 340
Virginia Center for the Creative Arts 522
Virginia Christmas Market 475
Virginia Christmas Show 475
Virginia Spring Market 475
Virginia Spring Show 475
Viridian Artists Inc. 430

Vision Quest Photo Workshops 522
Visitor's Choice Magazine 266
Visual Artistry Workshop Series 522
Visual Arts Center of Northwest Florida
 431
Voyageur Press 266

W

Wailoa Art & Cultural Center, The 431
Washington Blade, The 196
Washington County Museum of Fine Arts
 431
Washington Project for the Arts 432
Washington Square Outdoor Art Exhibit
 476
Washington Trails 196
Washington-Oregon Game & Fish 141
Water Skier, The 197
Water Well Journal 247
Watercraft World 196
Waterfront Fine Art & Wine Festival 476
Waterfront Fine Art Fair 476
WaterSki 197
Watertown Public Opinion 208
Waterway Guide 197
Waveland Press Inc. 267
Weigl Educational Publishers Ltd. 267
Weinstein Gallery 432
West Suburban Living Magazine 198
West Virginia Game & Fish 141
Western Outdoors 197
Western Producer, The 209
Westmoreland Art Nationals 476
Whiskey Island Magazine 198
White Oak Crafts Fair 477
Whitefish Arts Festival 476
Wholesaler, The 247
Wild Photo Adventures TV Show 523
Wild Wind Folk Art & Craft Festival 477
Wildlife Photography Workshops and Lec-
 tures 522

Wildlight 340
Willow Creek Press 268
Wilshire Book Company 268
Wine & Spirits 198
Wines & Vines 248
Winnebagoland Art Fair 477
Winslow, Robert, Photo Inc. 523
Wisconsin Architect 248
Wisconsin Snowmobile News 199
Wisconsin Sportsman 141
Wisconsin Union Galleries 432
Woman Engineer 248
Women & Their Work Art Space 432
Women's Health Group 268
Woodmen Living 199
Woodshop News 248
Worcester Polytechnic Institute 357
Working With Artists 523
World Fine Art Gallery 433
Writer's Digest 199, 249
Wurlitzer, Helene, Foundation, The 523
Wyandotte Street Art Fair 477

Y
Yaddo 523
Yankee Magazine 199
Yellowstone Association Institute 523
Yeshiva University Museum 433
Yosemite Outdoor Adventures 523
Your Best Shot 487
Youth Runner Magazine 200

Z
Zakin, Mikhail, Gallery 433
Zenith Gallery 433
Ziti Cards 280
Zolan Company LLC, The 281